Exploring Art

A Global, Thematic Approach

Exploring Art

A Global, Thematic Approach

Margaret Lazzari

The School of Fine Arts
University of Southern California

Dona Schlesier

Divine Word College

Australia • Canada • Mexico • Singapore • Spain United Kingdom • United States

THOMSON LEARNING

Acquisitions Editor: John Swanson Development Editor: Stacey Sims Marketing Manager: Mark Orr Project Editor: Laura Hanna

Manufacturing Manager: Kimberly Dolejsi

Permissions Editor: Shirley Webster

Art Director: Vicki Whistler

COPYRIGHT © 2002 Thomson Learning, Inc. Thomson Learning TM is a trademark used herein under license.

ALL RIGHTS RESERVED. No part of this work covered by the copyright hereon may be reproduced or used in any form or by any means—graphic, electronic, or mechanical, including but not limited to photocopying, recording, taping, Web distribution, information networks, or information storage and retrieval systems—without the written permission of the publisher.

Printed in the United States of America 1 2 3 4 5 6 7 05 04 03 02 01

For more information about our products, contact us at:
Thomson Learning Academic Resource Center
1-800-423-0563

For permission to use material from this text, contact us by:

Phone: 1-800-730-2214

Fax: 1-800-730-2215

Web: http://www.thomsonrights.com

Library of Congress Number: 2001098015

ISBN: 0-15-505796-0

Production Manager: Serena Sipho, Lois West

Photo Researcher: **Susan Holtz**Copy Editor: **Charles Naylor**Cover Printer: **Courier Kendallville**

Compositor: Graphic Arts Center of Indianapolis

Printer: Courier Kendallville

Asia

Thomson Learning 60 Albert Street, #15-01 Albert Complex Singapore 189969

Australia

Nelson Thomson Learning 102 Dodds Street South Melbourne, Victoria 3205 Australia

Canada

Nelson Thomson Learning 1120 Birchmount Road Toronto, Ontario M1K 5G4 Canada

Europe/Middle East/Africa

Thomson Learning Berkshire House 168-173 High Holborn London WC1 V7AA United Kingdom

Latin America

Thomson Learning Seneca, 53 Colonia Polanco 11560 Mexico D.F. Mexico

Spain

Paraninfo Thomson Learning Calle/Magallanes, 25 28015 Madrid, Spain

To Mike and Julia Rose, with love and thanks. Margaret Lazzari

For Douglas, Kimberly, Robert, Jackson Calder (Jake) and Luca, with gratitude and love.

Dona Schlesier

Art embodies human dreams, visions, and speculation. It renders the process of creativity in concrete form. It provides entry into the great ideas and issues of our personal lives and of the world beyond. It is visually rich, sometimes difficult, and often beautiful. When we began our work on this project, we were inspired first and foremost by our love of art and a desire to open that world to others. That's why we wrote this book.

What is important for students to learn from art courses? Most beginning art students are eager to engage the world of art. They are searching for clues to help them interpret a visual language they may not comprehend and feel a little fearful that they just won't "get it." *Exploring Art* is an introductory art textbook, designed to allay those fears and to help them understand. It introduces students to the world of art, its various media, its terminology, its visual elements, and even its history. But more importantly, it focuses on ideas and the ways those ideas are artistically expressed in actual works. We know from personal experience that students are more interested in concepts that enrich, challenge, and enlighten them than in rote memorization or recitation of chronologies. For that reason we've developed a global, thematic approach to the subject matter.

The traditional art appreciation textbook has tended to focus on the historical development of stylistic periods and to highlight great artists and great works of the western tradition. Unfortunately, this approach tends to marginalize or ignore the works of other cultures and traditions and to limit the effort to appreciate specific works to a single context. We, on the other hand, wanted to do something different. It was important to us to provide a balance of western and non-western approaches to art. We live in a global economy and are enmeshed in world affairs. Our own students have come from increasingly diverse ethnic backgrounds, many with non-European cultural heritages, and we wanted to acknowledge their backgrounds and traditions in our introduction to the material. We also wanted to develop an approach that would focus on similarities that unite cultures rather than distinctions and differences, one that would ultimately reveal the universality of the human impulse to create art.

STRUCTURE OF THE BOOK

All artworks deal with powerful ideas regardless of the culture from which they come. What are those ideas? How can we discuss them in relation to world art? We organized the book around questions that a beginning student might ask about art. The most basic questions serve as the titles for the three main parts of the book. The first part, What Is Art and How Does It Work?, provides an overview of the nature of art. It consists of five introductory chapters that deal with art as a human phenomenon, the language of art and architecture, deriving meaning from art, and looking at art within cultures. Chapter five provides a chronological overview of the history of art that includes summaries of major world cultures. It also includes an eight-page timeline that allows students to chronologically locate every image presented in the text and a series of maps to help locate works and traditions geographically.

Part II, Why Do We Make Art?, is the core of the book. It is subdivided into four major sections—Beyond Survival, Religion, The State, and Self and Society—that organize the central chapters of the book. These sections, and the fourteen, indepth chapters that comprise them, cover the major themes and ideas common to art from around the world. Every image in the book is discussed in relation to one of those potent ideas as well as its formal properties, and within the individual chapters, works appear in their chronological order. Modular in design for ease of use, instructors can pick topics of particular interest to their students, and the students will still have some sense of world art. No culture or era has to be sacrificed because of time constraints. Part III, Who Are the Artists, and Who Uses Art?, covers the individual artist, collective art making, the social role of artists, and training for artists and support for art making. We also investigate what happens to art once it is made and the social, commercial, cultural, and institutional structures around it. Finally, we conclude with how people today can find art and use it in their lives.

FEATURES OF THIS TEXT

To accomplish our goals, we have incorporated several distinct features into this book that are not found in other art appreciation texts.

Illustration Program

We have worked tirelessly to prepare the best illustration program possible for this book. We provide well over 850 images, including 5 maps, 22 pieces of line art, and 839 photos, over half of those in color. The artworks represented reflect an almost equal balance of western and non-western traditions from around the globe and throughout time. Traditional media like painting, sculpture, and architecture are well represented, but we also include examples of ceramics, textiles, jewelry, photography, film, and newer multi-media forms. A number of women and minority artists have been included, and we also represent an unusually large number of contemporary and American artists so that students will understand that the arts are as actively pursued in the present as they were in the past.

Artworks in Multiple Contexts

Throughout the book, we examine artworks in multiple contexts to give students a sense of the diversity of meaning possible in a single work. Leonardo da Vinci's Last Supper, for example, is variously discussed in terms of its subject matter (as simply a depiction of a meal), in the context of religious art, in the context of questions surrounding art restoration, and in terms of its formal composition. In each instance, the work is presented in relation to other works that deal with similar themes. To avoid cumbersome cross-referencing and to encourage students to look at and think about them in greater depth, many of the artworks we present in this way are reproduced more than once in the book. Also, to facilitate access to the many discussions of a single work, captions in Exploring Art serve double duty. Besides providing the usual information about the name of an artwork, its date, and medium, they also tell you the other places in the book where the work is discussed.

Text Links

We have also provided a set of "text links" throughout the book. These shaded boxes, many of them illustrated, appear within the text of each chapter to help students make connections across chapters by providing cross-references to related topics. For example, issues associated with the human body may be found in chapters on "Reproduction" and also on "Race, Sexuality, and Gender." Art about food may be related to religious practices and prayers to deities. Text links (we like to think of them as lateral thinking devices) help students make those important connections.

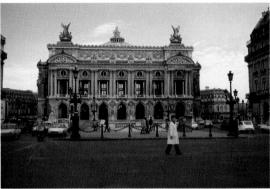

Text Link
Michelangelo's Vestibule for the
Laurentian Library (figure 8.34) is an
other structure that influenced the design
of the Paris Opera House.

As mentioned before, the opera house became part of the vernacular of Western architecture. One recent innovative example is in Australia, the graceful Sydnay Opena House that majestically stands on the edge of the harbor and greets the visitor from air, land, or sea (figure 184.) The sulpturelike complex, designed by Danish architect Joern Utzon, is indeed threathilating.

Egypt and accredit flowing according to the complex of the compl

rk of Frank

Musuum, on page 482). He also felt that architecture should express democratic ideals rather than simply intact a Greek temple, like so many governmental buildings, museums, libraries, churches, etc. With new building materials such as reinforced concrete, the limited forms of past architecture were freed to take practically any shape desired. This style of architecture, rooted in the sork of Wright and incorporating flowing lines, was called "Organic" architecture, Joern Uton was influenced by this thinking and also by the platform architecture of Mesonamerics.

on was held in 1956 for the design of the use. The judge was Eero Saarinen, designer Terminal at Kennedy International Airport, is similar to Utzon's. In the design of the

Obera House Utzon expanded the p Open House, Utzon expanded the par architecture so much that it caused Contention centered around wheth necessary for its construction was suf This delayed construction, which beg not completed until 1972, during whi spending occurred, the governmen 1966 Utzon himself resigned. Fortuna

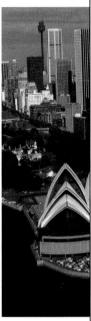

Text Links help students

make connections across chapters by providing cross-references to related

topics.

marked by greater movement and emotionalism, and grandeur, and individualism in the arts and architecture.

They share their functions, specifically that of housing books and manuscripts. Both are closely associated with places of worship, one Roman Catholic and the other Buddhist, and date from eras when learning was closely

326 CHAPTER 12 POWER, POLITICS, AND GLORY

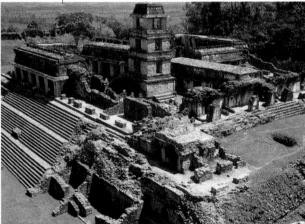

Like the Persians, the Mayans of Central America used high platforms, relief sculpture, and large build-ings to create palace structures. The Mayan culture at Palenque is dated c. 514 to 784 Ab. Located deep in a

stone carvings. Large painted stucco masks of human faces once adorned the ends of the terraces. The palace's design has four courts, each surrounded with rooms and galleries, likely used for administrative pur-

Active Looking and Questioning

We want to encourage readers to be active and questioning as they encounter new works of art, and for that reason this book is structured around questions. Each of the major parts carries a question as its title, and each chapter starts with a boxed list of questions to consider while reading. At the end of each chapter, a short "Food for Thought" section asks students to enter into the unresolved debates and moral issues associated with art in our times and in the past.

ANCILLARY PACKAGE

Instructor's Manual with Testbank We have prepared an Instructor's Manual to accompany this book. Features include chapter outlines that lay out the major topics in each chapter and indicate the artwork that illustrates those points, discussion questions, studio and class projects for instructors who wish to integrate art making into the study of art, and a listing of support materials that provides information on relevant books, videos, films, and CD-ROMs for more information related to the chapter topic. Finally, the instructor's manual includes a testbank that provides multiple choice and short essay questions, with answers provided for both. An electronic version of the testbank is also available in various formats.

ExamView. Enhance your range of assessment and tutorial activities and save yourself time in the meantime. With ExamView from Wadsworth Group, you can easily create and customize tests. ExamView's Quick Test Wizard guides you step-by-step through the process of creating and printing a test in minutes, and ExamView is the only test generator that offers a "WYSIWYG" (what you see is what you get) feature that allows you to see the test you are creating on the screen exactly as it will print.

Web site A text-specific site for this title can be accessed at http://art.wadsworth.com. Features include chapter outlines, learning objectives, tutorial quizzing, chapter tests, and an online glossary. Links to artists, artworks, and subjects presented in the text are also provided.

Slide package A slide package is available with this title consisting of 35 diagrams and maps and 65 artworks presented in the textbook. Some qualifying restrictions may apply, so see your local sales representative for more information.

ACKNOWLEDGEMENTS

Exploring Art has taken a different approach to teaching art. As a result, there were many years of preparation, and our publishing team has given us ongoing support through this project. There are many people to acknowledge and thank. Barbara Rosenberg was our original Acquisitions Editor, and we want to thank her for having the insight to see the need for such a textbook, and to John Swanson, current Acquisitions Editor, for following through with it. We wish to thank Stacey Sims, our unfailing and most supportive Developmental Editor. Her creative suggestions contributed much to the growth of the book. Thank you to Laura Hanna, senior project editor, and Serena Sipho, senior production manager, who both guided the book through the production process; to Vicki Whistler and Brian Salisbury, who worked closely with us on the design of the book; and to Susan G. Holtz, in charge of acquiring the images, some of which presented considerable challenge. Shirley Webster, literary and picture rights editor, was invaluable in coordinating that effort. And thanks to our colleagues and friends, who never tired of asking us how the book was going!

We are especially grateful to the many reviewers who gave us healthy criticisms and suggestions, which helped both in writing and in choosing images. They include: Alan Atkinson, University of Alabama—Birmingham; Ann Stewart Balakier, University of South Dakota; Martin W. Ball, Kent State University; Gleny Beach, Southeastern Oklahoma State University; Jasmin W. Cyril, University of Minnesota—Morris; Paula Drewek, Macomb Community College; Jaymes Dudding, University of Science and Arts of Oklahoma; William B. Folkestad, Central Washington University; Robert Hardy, Cypress College; M. L. Heivly, California State University—Bakersfield; Janette Hopper, Columbia Basin College; Joyce Howell, Virginia Wesleyan College; Jeffrey A. Hughes, Webster University; Susan Josepher, Metropolitan State College; Ellen Konowitz, Vanderbilt University; Jeff Kowalski, Northern Illinois University; Charles Licka, University of Alaska—Anchorage; Sheila Lynch, Rio Hondo College; Nancy Magner, Bakersfield College; Carol Miura, Rancho Santiago College; Johanna D. Movassat, San Jose State University; Ken Nelsen, Northwest Missouri State University; Richard Nicksic, Yakima Valley Community College; Frank Oehlschlaeger, Notre Dame College; Thomas Parker, Drury College; Brian Percival, Queens College—CUNY; Robert T. Soppelsa, Washburn University; Judy Sund, Queens College—CUNY; Dianne Taylor,

University of North Texas; Joe Thomas, Clarion University of Pennsylvania; Keith Williams, Concordia College—St. Paul; Kristin Woodward, Mississippi State University.

We send special thanks and acknowledgement to Divine Word College, President Fr. Michael Hutchins S.V.D, and the Administration for arranging and granting a full year sabbatical for Dona Schlesier for research and writing. Thank you to the faculty and staff of the college for their support and to Brother Dan Holman S.V.D. who gave his time to teach her classes in her absence. We especially would like to thank Dona's students of Divine Word College, who showed her clearly the need for a global art appreciation textbook, and gave her the motivation to work on it.

Likewise, we wish to thank the School of Fine Arts of the University of Southern California for granting Margaret Lazzari two mini-sabbaticals that enabled her to work on the book. By covering for her duties in many ways, Margaret was greatly supported by the Dean of the School, Ruth Weisberg, and her colleagues. USC's excellent research facilities were a great help in this project. Similarly, we would like to thank all of Margaret's students, who come from many different countries and ethnic backgrounds, and who helped her to imagine an art appreciation book with a global approach.

Both of us wish to thank our families and friends. Sandra Low helped compile and draft materials for several chapters of the Instructor's Manual. Douglas Schlesier, Dona's husband, is an accomplished artist who has given excellent advice and technical assistance throughout our work. Margaret's husband and daughter, Michael Dean and Julia Lazzari-Dean, have been truly supportive throughout the process of developing the original idea, and then all the subsequent work to bring it to life. Mike especially helped with the technology hurdles, while Julia assisted with clerical work. Both Dona's and Margaret's family members and friends have provided interesting perspectives, good advice, and moral support throughout. They are too many to name.

And we acknowledge each other. We have been a good writing team, and together we have been able to accomplish what neither could have done on her own.

May this book, in its own way, foster a greater appreciation of art, and a greater understanding among all the peoples of the world.

Margaret Lazzari Dona Schlesier November 2001

Brief Contents

Part 1		Part 3		
What Is Art and How Does	Who Are the Artists and			
It Work?	3	Who Use	es Art?	
Chapter 1 A Human Phenomenon	5	Chapter 20	Who Makes Art?	
Chapter 2 The Language of Art	19	Chapter 21	What Do Humans Do	
Chapter 3 The Language of Architecture	51		with Art?	
Chapter 4 Deriving Meaning from Art and Architecture		Chapter 22	Where Do You Find Art and	
Chapter 5 Looking at Art within Culture	75 93		How Can You Use It in Your Life?	
Part 2		Pronunciation	on Guide	
		Glossary		
Why Do We Make Art?	129	Bibliography	y	
SECTION 1 Survival and Beyond	131	Credits		
Chapter 6 Food	133	Index		
Chapter 7 Reproduction	161			
Chapter 8 Shelter	181			
SECTION 2 Religion	211			
Chapter 9 Gods and Goddesses	213			
Chapter 10 Places of Worship	245			
Chapter 11 Mortality and Immortality	277			
SECTION 3 The State	311			
Chapter 12 Power, Politics, and Glory	313			
Chapter 13 War and Peace	341			
Chapter 14 Social Protest/Affirmation	373			
SECTION 4 Self and Society	397			
Chapter 15 The Body	399			
Chapter 16 Clan and Class	425			
Chapter 17 Race, Sexuality, and Gender	451			
Chapter 18 Entertainment	477			
Chapter 19 Nature, Knowledge, and Technology	505			

Preface	ix	ix Art Materials and Media		
		Natural and Synthetic Materials	44	
Devil		Art Media	45	
Part 1				
What Is Art and How Does		a/		
It Work?	3	Chapter 3 The Language of Architecture		
It Work:		Architecture	51	
		Introduction	51	
Chapter 1 A Human Phenomenon	5	Structural Systems	51	
Introduction	5	Traditional Building Methods	51	
Towards a Definition of Art	5	Recent Methods and Materials	59	
Function	5	Aesthetic Design Decisions	64	
Visual Form	6	Visual Elements	64	
Content	6	Organizing Principles	68	
Aesthetics	7	Ornamentation	69	
Creating Art	7	The Natural Environment	70	
Visual Perception	8	$Land scape\ Architecture$	70	
The Artist's Response to the World	8	Incorporating Nature into the Constructed		
Artistic Expression and Creativity	10	Environment	71	
Categories of Visual Arts	11	Ecological Concerns	73	
High Art	13			
Popular Culture	13			
Kitsch	14	Charter A. Deriving Meaning from		
Other Categories	16	Chapter 4 Deriving Meaning from Art and Architecture	75	
onar dangones	10			
		Introduction	75	
Chapter 2 The Language of Art	19	Formal Analysis	75	
L .		Reading the Content	77	
Introduction	19	Subject Matter	77	
Formal Elements	19	Iconography	78	
Line	19	Art Writings	80	
Light and Value	22	Personal Interpretation	86	
Color	23	The Influence of Context	87	
Texture and Pattern	29	Ways That Humans Encounter Art	87	
Shape and Volume	30			
Space	31			
Time and Motion	35	Chapter 5 Looking at Art		
Chance/Improvisation/Spontaneity	36	within Culture	93	
Engaging All the Senses	38			
Principles of Composition	39	Introduction	93	
Balance	39	Style	93 93	
Rhythm	40	3 2		
Proportion and Scale	41	Cultural Styles	97	
Emphasis	42	Styles of Artists within Their Cultures	99	
Unity and Variety	43	The Styles of Major Cultures	102	

Paleolithic and Neolithic Cultures	102	Fertility Goddesses and Gods	16	
Civilizations of the Ancient Near East:		Fertility Figures	16.	
8000 BC-300 BC	103	Rituals		
Ancient Egypt: 3000 BC-30 BC	103	Art Depicting Primordial and Human Couple		
Aegean Civilizations and Ancient Greece:		Art about Lovemaking	17.	
3000–First Century BC	104	Images of Pregnancy, Childbirth, and Progeny	17'	
India: 3000 BC-AD 1500	104	0 0 7		
China: 4000 BC to the Present	105			
Mesoamerica and South America		Chapter 8 Shelter	183	
c. 1500 BC-AD 1519	106			
Native North American Art:	200	Introduction	18	
1500 BC to the Present	107	Domestic Architecture	18	
Etruria, Rome, and Byzantium:	107	Group Living	18	
Seventh Century BC-AD 1453	107	Individual Homes	180	
Islamic Art: The Middle East, Western Asia,	107	Commercial Architecture	19'	
	108	Markets	19'	
and Northern India after the Sixth Century	108	Late Twentieth-Century Commercial Architecture	199	
Japan: 600 to the Present	109	Comparison of Public Architecture	203	
Europe from the Middle Ages to 1780		Two Meeting Places	203	
Africa to the Present	110	Two Libraries	200	
Indonesia, Oceania, and Australia	111			
Europe and the United States:	110	SECTION 2 Religion	211	
Late Eighteenth through Nineteenth Centuries	112			
The Twentieth Century	113	Chapter 9 Gods and Goddesses	213	
Timeline	116	, ,		
World Maps	124	Introduction	213	
		Images of Spiritual Beings	213	
		Earth Mother	214	
Part 2		Egyptian Deities	215	
	100	The Greek Gods	21'	
Why Do We Make Art?	129	Hinduism	21'	
SECTION 1 Survival and Panad	131	Buddhism	219	
SECTION 1 Survival and Beyond	131	Judaism	22	
•		Christianity	223	
Charter 6 Food	133	Gods for Special Purposes	226	
Chapter 6 Food		Humans Respond to God	228	
Introduction	133	Ceremonies	229	
Art and Securing the Food Supply	133	Offerings	230	
Art of Hunters, Gatherers, and Farmers	133	Sacrifices	233	
Art and Food in Industrial Societies	136	Prayers	235	
Structures and Containers for Storing		The Cosmos	238	
and Serving Food	137			
Storage Structures	137	Charles Di CXV II	0.45	
Storage Containers	138	Chapter 10 Places of Worship	245	
Dishes and Utensils for Serving Food	140	Introduction	245	
Art That Glorifies Food	145	General Characteristics of Places of Worship	245	
Images of Bounty	145	Elements of Nature	245	
Celebrating the Beauty of Food	147	Sites of Sacred Ceremonies	247	
Food as a Symbol of Honor	151	Symbolic Geometry	248	
Art and the Act of Eating	153	Housing for Sacred Objects	25]	
Ritual Meals	153	Destinations for Pilgrimages	25]	
Art and Eating	156	Sheltering Congregations	252	
<u> </u>		Temple Complexes and Large-Scale Sacred	_02	
		Architecture	254	
Chapter 7 Reproduction	161	The Greek Temple	254	
Introduction	161	The Greek Temple The Egyptian Temple	259	
The Promise of Fertility	161	The Egyptian Temple The Mesoamerican Temple	262	

The Hindu Temple	265	Chapter 14 Social Protest/	
The Gothic Cathedral	267	Affirmation	373
The Buddhist Temple	269		
The Islamic Mosque	272	Introduction	373 373
		Protests Against Military Action	379
		Fighting for the Oppressed	379 379
Chapter 11 Mortality and		Strategies for Protesting Oppression	385
Chapter 11 Mortality and Immortality	277	Affirming the Values of the Oppressed	388
	277	Questioning the Status Quo The Social Environment	388
Introduction	277		392
Mounds and Mountains	277	Art vs. Politics	394
Ancient Burials	280		
Furnished Tombs	200	STICITION A COLFAND COCIOTA	397
Development of Cemeteries and	291	SECTION 4 Self and Society	397
Grave Monuments	294		
Burial in Places of Worship	294	Charter of The Rody	399
Christian Burials	297	Chapter 15 The Body	
Islamic Mausolea	301	Introduction	399
Reliquaries Modern Commemorative Art	302	Depictions of the Body	399
Modern Commemorative Art Modern Cemeteries	302	Portraits	399
Contemporary Memorial Art and Practices	304	Self-Portraits	404
Contemporary Memorial III and Fractices	301	The Physical Body	407
		The Limits of the Self	414
SECTION 3 The State	311	Sickness and Death	417
SECTION 5 The State	J11	The Body in Art and as Art	418
		The Body as Art Material	418
Charter as Power Politics		The Body as an Art Tool	422
Chapter 12 Power, Politics, and Glory	019		
and Glory	313		
Introduction	313	Charten of Class and Class	425
The Glory of the Ruler	313	Chapter 16 Clan and Class	
Divine Rulers and Royalty	313	Introduction	425
Objects of Royalty and Prestige	316	Clan	425
Contemporary Political Leaders	321	The Extended Family	425
The Power of the State	323	The Nuclear Family	433
Palaces	323	Class	437
Seats of Government	333	Class Status and Body Styles	437
Monuments	336	Class Activities and Life-styles	438
		Art Objects That Indicate Class Status	446
Chapter 13 War and Peace	341		
Introduction	341	Charter at Dogs Somelity	
The Warrior	341	Chapter 17 Race, Sexuality, and Gender	, r =
Art Depicting Warriors	341	and Gender	451
Warrior Vestments	344	Introduction	451
Weapons	349	Race and Art	452
War	352	Art That Promotes Ethnic History and Values	452
Architecture of War	352	Art That Criticizes Racism	456
Art about War	353	Who Is Looking at Whom?	458
War Trophies and Prisoners	362	Erotic Sexuality	459
War Monuments and Memorials	363	Images of Sexual Union	459
Peace	364	The Female Body and the Gaze	460
Art about Peace	365	Abstracted Sexual Imagery	464
Treaties	367	Gender Issues	465
Peace Offerings and Peace Monuments	368	Art and Ritual Perpetuating Gender Roles	465

Gender Reflected in Art, Architecture,	Training of Artists			
and Fashion	467	The Context for Art Making		
Critiquing Gender Roles	472	The Role of Artists in Various Cultures		
		Art Making Based on Gender	548	
		The Artist as Skilled Worker	550	
Chapter 18 Entertainment	477	The Artist Scientist	551	
Introduction	477	The Artist Priest	553	
"Houses" for the Arts	477	The Creative Genius	554	
Theaters, Museums, and Opera Houses	477	Rulers as Artists	555	
Other Visual and Performing	111	Support for Art Making	556	
Art Environments	482	Family Support	556	
The Visual Arts within the	102	Ordinary People	557	
Performing Arts	485	The University	558	
Art and Theater	485	Religions	558	
Art and Music	490	Rulers as Patrons	558	
Dance	491	The Market	558	
Music and Dance Imagery	492	Tax-Supported Art	560	
The Technology Revolution	134	11		
in Entertainment	495			
Film and Television	495	Chapter 21 What Do Humans Do		
Animation and Digital Imaging	497	Chapter 21 What Do Humans Do with Art?	563	
Sports and Sports Arenas	497			
Sport Sites	497	Introduction	563	
Sport Imagery	500	Using Art	563	
Sport Imagery	300	Keeping Art	564	
		Why Cultures Keep Art	564	
Charter 10 Nature Knowledge		Art Collections	572	
Chapter 19 Nature, Knowledge,	202	Art Maintenance	579	
and Technology	505	When Art Is Not Saved	583	
Introduction	505	Art Destroyed in Conflicts	585	
Nature	505	Art Used Dynamically in Rituals	587	
Animals	505	Non-Object Art	587	
$The\ Land$	511	Studying Art	587	
Knowledge	521	Art History	587	
Informative Images	522	Aesthetics and Criticism	589	
Art and Intuited Knowledge	525	Archeology	589	
The Critique of Learning	526	$Cultural\ Anthropology$	590	
Technology	527	Psychology and Human Development	590	
Technological Advances	528			
Evaluating the Constructed World	528			
		Chapter 22 Where Do You Find Art		
		and How Can You		
		Use It in Your Life?	593	
Part 3		Introduction		
Who Are the Artists and		Art in Your Community	593 593	
		Museums and Galleries	593	
Who Uses Art?	535	Schools	593	
		Public and Private Buildings	594	
Chapter 20 Who Makes Art?	537	Places of Worship Parks	595	
Introduction	537	rarks Art Online	595	
Art Production as a Social Activity	537		595	
About Artists	538	Living with Art	596	
The Creative Act	538	Art in Everyday Life	596	
The Chambe Her	336	Popular Culture	598	

Enjoying Art	599	Pronunciation Guide	604
Take Notice: Look Around You	599	Glossary	606
Take Art: Develop Your Own Artistic Expression Take Trips: See the World	599 601	Bibliography	616
Art in Your Own Home: Start Your		Credits	622
Own Collection	602	Index	624

xvii

CONTENTS

		9 -1		

		,

Part 1

Chapter 1: A Human Phenomenon

Chapter 2: The Language of Art

Chapter 3: The Language of Architecture

Chapter 4: Deriving Meaning from Art

Chapter 5: Looking at Art within Culture

What Is Art and How Does It Work?

Art has no single definition, but within its myriad manifestations is a richness and intelligence that illuminates our lives. But before that richness is available to us, we need to study the structure of art and the ways that its meaning is delivered. What are the components of art, and of architecture? Why do they have meaning? How does cultural context influence meaning?

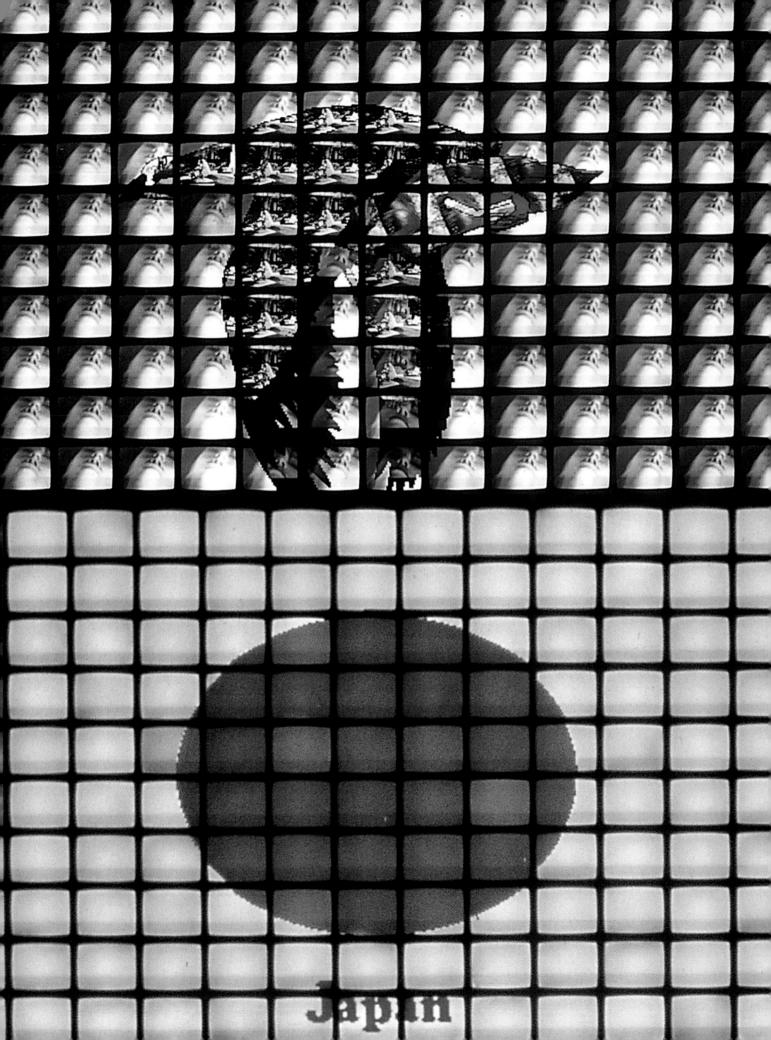

Chapter 1 A Human Phenomenon

INTRODUCTION

What is art? We will spend this chapter considering that very question along with how art is made, what it does, how we categorize it, and what values we place on it. But one thing is clear throughout our discussion. Art is strictly a human phenomenon. A chimpanzee might be very sophisticated when creating a tool out of a branch that will extract ants from a hill for a snack. However, that animal does not consider the aesthetics of that tool. Nor does it attempt to carve a beautiful handle, or decorate it with finely rendered ant imagery that might empower it with magic. The chimpanzee apparently does not consider the tool as a means of better understanding his life experience, nor a way to communicate its ideas about the world to other chimps. Humans with art have the potential to do all these things.

In this chapter, we will consider a number of knotty questions regarding the nature of art as a human activity, among which are these:

What are some ways to approach a definition of art?
What are the components of art making?
What is creativity, and who is creative?
How does art reflect humankind's response to its own reality?

How does culture influence what we think about art? How do we categorize visual arts within cultures?

TOWARD A DEFINITION OF ART

There are no definitions that are universal, timeless, and absolute. All definitions are framed within larger systems of knowledge, and these systems shift and evolve, and in some cases disappear.

Therefore, to answer the question "What is Art?" we would have to ask: What is art for whom, and when? For the United States at the beginning of the twenty-first century, a good definition of art would be as follows: Art is a primarily visual medium that is used to express ideas about our human experience and the world around us. This defini-

tion holds true for many other cultures and periods, but not for all. In addition, how that definition gets translated into reality changes for each culture.

To get a better idea of what art is for a specific culture, we will center our inquiry on three major areas: function, visual form, and content. We will study the answers that various cultures have provided to the question of what is art. In addition, we will look at the area of knowledge within Western culture called aesthetics.

Function

Art functions. At the time a work of art is made, it is intended to do a job within a culture. That job can be in many different categories, including but not limited to the following:

- Art assists us in rituals that promote our spiritual or physical well-being.
- Art gives us pictures of deities, or helps us conceive what divinity might be.
- Art serves and/or commemorates the dead.
- Art makes evident the power of the state and its rulers
- Art celebrates war and conquest, and sometimes also peace.
- Art is a means for protesting political and social injustice.
- Art promotes cohesion within a social group.
- Art records the likenesses of individuals and the context in which the individuals exist.
- Art entertains.
- Art educates us about ourselves and the world around us
- Art communicates thoughts, ideas, and emotions.

Now of course, visual art is not alone in doing these jobs within a culture. The other arts contribute, as well as other fields of human endeavor. However, all of these functions are things that artists and their social group intend and want their art to do. One way to measure whether a work of art is "good" is to determine what its function was to be, and then see how well it fulfills that function.

Art can also function as an area for study. As cultural "documents," artworks can tell us volumes about existing and past cultures. For example, the study of art can reveal power structures within a culture, allude to what a people thought was the essence of human nature, tell us what the "ideal" body looked like in a culture, show attitudes towards sexuality, indicate what gender roles existed, and so on.

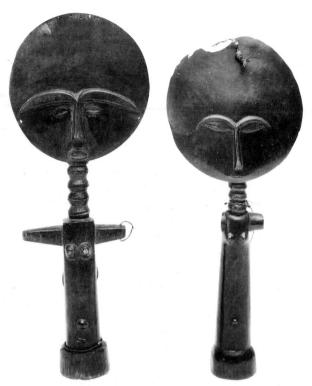

1.1 Ashanti Akua'mma Dolls. c. twentieth century. Wood, 13" high. Ghana, Africa. The British Museum. For more on this artwork, see also the text accompanying figures 7.13, 21.12, and 22.10.

Let us illustrate these concepts for you by examining a work of art. Figure 1.1 shows two sculptures called Akua'mma dolls, from the Ashanti (Asante) people of Africa from the twentieth century. At the time they were made, the purpose of such sculptures was to help women become pregnant if they were having problems conceiving. They were part of a ritual, and therefore were only effective if the women use these sculptures in a ritually prescribed way. They would likely be considered successful if the woman using them was able to have a healthy baby.

Several decades have passed since these dolls were made, and they are no longer in the possession of the peoples who made them. Now they are in the British Museum. Their original ritual function has been replaced, and their function for users today is to educate them about another culture, to provide visual pleasure, and to entertain. Scholars also study these works, and have gleaned considerable information about Ashanti culture from them. For example, the *Akua'mma* dolls show us that the Ashanti people place a great value on children, that a woman's reproductive role is heavily emphasized, and that balanced, abstracted, simple, geometricized forms express the visual ideal within this culture.

This is but one example. From Chapter 6 onward, we will have the opportunity to study the functions of hundreds of artworks, in greater depth.

Visual Form

Art has a visual form. That form has been carefully considered and manipulated to help it better fulfill its function. That visual form includes:

- the materials from which it is made
- its formal elements, such as line, shape, color, texture, and so on
- its overall composition, size, internal balance, and so on.

What is the visual form of the *Akua'mma* dolls? They are made from wood, which is the most common sculptural material in sub-Saharan Africa. In addition, the one on the right has beads on its head and around its neck. Their formal elements consist of generally geometric shapes, with round heads and rectangular or cylindrical bodies. Facial features are also simplified geometric shapes. Pattern is important as we see the necks are stacks of repeated disks, while the texture of the surfaces have been polished smooth. In the overall composition, each doll is symmetrical and balanced, except where broken. They are small compared to the size of an average adult. In proportion, they emphasize the head, as it is oversized compared to the body.

The visual form is critically important to a work of art. It is the material embodiment of an idea. Its physicality is what allows it to be seen, and the idea to be communicated. The subtleties of visual form are what make nuances of meaning possible. The visual form of the *Akua'mma* embodies Ashanti ideals and ritual function.

Every work of art has visual form. As we go through this book, we point out to you the highlights of the visual form of every piece we cover. In addition, we deal with visual form in depth in Chapter 2, The Language of Art, and Chapter 3, The Language of Architecture.

Content

Art has content. Content is the mass of ideas associated with a work of art, communicated through the following:

- the art's representational imagery
- its surroundings where it is used or displayed
- its symbolic meaning
- the customs, beliefs, and values of the culture that uses it.
- the text incorporated with the work, or writings about the work

Content can be both immediately apparent and also require considerable study. Let us return once more to the *Akua'mma*. If we see them for the very first time without any explanation or context, we could still understand some of their content. They contain representational imagery, so that even the most casual observer can readily see that these sculptures are based on the human

form. It is also readily apparent that these sculptures are abstracted from the human form. They are not photographic representations of any one individual, but rather generalized entities with simplified and geometric bodies. Closer observation shows them to be females.

If we spent time observing these sculptures in the surroundings in which they are used, we could grasp more of their content. If they were being carried or cared for by the Ashanti women, we might guess that they were associated with motherhood. If we first saw them in a museum, we would understand them to be valuable cultural artifacts or works of art. Even if you are seeing them for the first time in this art book, you know that they are considered works of art. That is part of their content.

However, some content is not readily apparent, such as an artwork's symbolic meaning or the customs and beliefs of the culture that uses it. Without study or being part of Ashanti culture, we would not likely know that these sculptures represent future children, yet that is the case. We would not know that they were part of fertility rituals, how the rituals work, or what happens to them after a woman conceives. Without study, we would not know that the Ashanti consider these to be ideal forms. We could do library research to investigate these sculptures from other than an art point of view. For example, we could find out what the Ashanti people themselves say about the *Akua'mma*. Or we could read anthropological studies that relate these to cultural ideas about art, about ritual, and about play.

For every work of art in this book, we will discuss both its obvious content and those other content areas that may not be apparent at first glance. In addition, two chapters focus in particular on how an audience gets the content in a work of art. Chapter 4, How Does Art Work?, covers how meaning is derived from art. Chapter 5, Looking at Art within Cultures, shows how cultural context supplies the customs and beliefs that form a content basis for all artworks.

Aesthetics

Aesthetics is the branch of philosophy originating in ancient Greece that deals with art, its creative sources, its various forms, and its effects on individuals and cultures. A number of Western philosophers and other thinkers have considered the questions: What is art? How do we interpret art? What qualities make some works of art more memorable than others? In addition, many Eastern cultures such as those of India, Japan, and China have a long history of writing about aesthetic issues. In several African, Oceanic, and Native American cultures, art practice had demonstrated a clear aesthetic, long before there was written material about it. You are thinking aesthetically when you read a book like this one.

Modern aesthetic theory in the West became a field of study in the eighteenth century, and like its ancient precursor was mostly concerned with the concept of beauty. At that time, many Western philosophers thought that art dealt with beauty, and that beauty could be universally defined for all times and places. One significant standard of beauty in the eighteenth century was ancient Greek sculpture, which had been excavated in Europe for some time and was enormously influential on later Western art. That universalist position is discredited now, as we recognize that there is no worldwide agreement about what is beauty. In addition, philosophers consider many other qualities besides beauty as significant attributes of art. Each culture develops its own set of standards that define art. While aesthetics philosophers may ask the same questions in their inquiry into art, they receive different answers from culture to culture.

The Akua'mma dolls embody and express the aesthetic preferences of the Ashanti people. If we consider only the faces, there is a distinct preference for geometrically round heads, with the face occupying the lower half or third of the disk. The chin is generally nonexistent, with the mouth positioned at the very bottom of the face. Eyes are half-moons or almond-shaped. Eyebrows are long arcs connected above the nose. Incisions on the cheeks are medicinal scars that are meant to protect children from illnesses. The neck is a stacked set of disks. Overall there is a great preference for symmetry. We know that the Ashanti people consider these qualities to be aesthetically superior to others, as a woman took care to gaze only on well-formed children or dolls, so that her future baby would also be well-formed. In west central Africa, aesthetics tend to favor qualities such as composure, clarity, balance, and youthfulness.

A very different aesthetic sensibility is apparent if we study the image of Jane Avril (figure 1.2), a 1899 French poster by Henri de Toulouse-Lautrec. Jane Avril was a popular nightclub performer, and therefore embodied idealized, attractive, or desirable qualities. Yet how these are expressed is different than in the composed and balanced Akua'mma! As advertisement, the Jane Avril poster was meant to capture the excitement and allure of her show. We see a preference for elongated forms, serpentine lines, bright colors, and expressive gestures. Her pose is twisted and off-balance. The promise of a sexual encounter and the potential of some danger was important in Jane Avril, as evident in the snake image encircling her body.

CREATING ART

We will now present a brief overview of the process of creating an art object. We will start with visual perception, and then go on to talk about human response, creativity and expression.

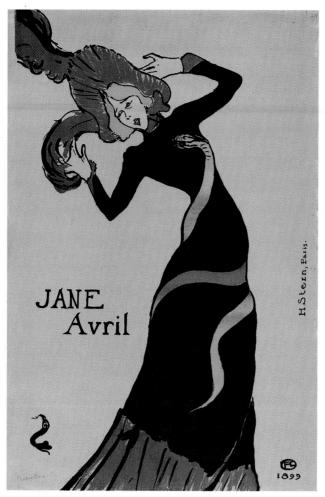

1.2 HENRI DE TOULOUSE-LAUTREC. *Jane Avril*. Lithographic poster, 22" × 14", Paris, France, 1899. The Museum of Modern Art, New York. See also the text accompanying figure 18.12 for more on this artwork.

This material is amplified in Chapter 20, Who Makes Art?, where we focus on artists themselves, the different social roles they play, their function within different cultures, and the status they are awarded. That chapter covers the various ways by which artists are supported for their work. But for now, our focus is on perception, creativity and expression.

Visual Perception

We perceive ourselves, others, and the environment through our senses: seeing, hearing, smelling, touching, and tasting. Information is sensed and processed by the brain and internalized into thoughts and feelings. These feelings and thoughts can be made manifest and communicated to others in a mathematical language, in a musical language, in an oral or written language, or though visual representations. The visual arts embody a kind of language that generally involves visual perception.

Let us talk for a few minutes about visual perception in our everyday lives and what it involves. Visual perceptions trigger the process of sensing that involves the eye and brain, and of course light has to be present or else we cannot see. Another necessary element is movement. If both you and your environment are totally fixed and unmoving, you will cease to see clearly as your eyes cannot detect an unchanging stimulus for longer than a minute or two. In this respect, your eyes are like your nose in that you can detect new odors—for example, really noticing cooking odors when you just come into a house, but no longer be able to detect them moments afterward.

Sight evolved in humans as an aid to survival. From our most primitive beginnings, humans had to be able to locate food, find mates, and detect foes. As a result, our eyes are especially equipped to do two things: 1) to perceive movement; and 2) to detect edges and shapes, by perceiving differences in adjoining areas of color, brightness, or texture. These abilities allowed early humans to move through their environment, and identify other objects within it.

We have inherited the same eye structure that our ancestors had, and respond to the same stimuli as they did, namely, movement, edge, color, brightness, and texture. Interestingly, our eye and brain are actually set up to filter out and ignore most visual stimuli. It may seem strange, but in fact, by filtering out most stimuli, we are able to focus our attention rather than be helplessly bombarded by a never-ending stream of visual information. So, therefore, we generally pay less attention to things that are not moving. Because of the placement of our eyes, we see only what is in front of us, in contrast to many creatures that have near 360-degree vision. Only a small part of what we see is sharp, while the bulk of our visual field is blurry. And finally, our brain tends to shut off visual stimuli much of the time if we are preoccupied with our own thoughts. How often have you been lost in thought while driving, and later had absolutely no recollection of seeing what you passed along the way?

Looking at art is different from our everyday, ordinary seeing. Visually, it is comprised of organized colors and shapes. Art offers a specific set of ideas. It is not simply a copy of our everyday environment, much of which we ignore. It fulfills some function within our culture. Art is designed to be arresting, to engage our attention, to make us look and to be aware of our act of looking, and potentially be enriched as a result. That gift of engaged vision, in contrast to our everyday inattentiveness, is one of the greatest benefits of art.

The Artist's Response to the World

While everyone sees by means of the same process, we do not all interpret our perceptions in the same manner. This of course can be seen in art. All artists base their work on visual perceptions of the world around them. But almost every artist's work is different from any

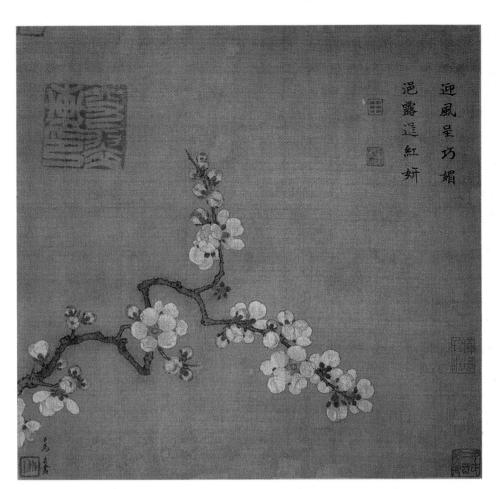

1.3 MA YUAN. Apricot Blossoms. Album leaf with ink and color on silk, height 10". China, Southern Sung Dynasty, early thirteenth century. National Palace Museum, Taiwan. See also figure 19.12 for more on this painting.

other's. Their work is subject not only to their own visual perception, but also to their cultural values and their individual experiences. They also learn from the work of other artists. In figure 1.3 we see a delicate rendering of an Apricot Blossom by Ma Yuan, from thirteenth-century China. His image is not a direct copy from life. He singled out a branch and removed it from a distracting background to best present the blossoms' delicate outlines, irregular but rhythmic groupings, and the twisting shape of the nubby branch. Before making this painting, Ma Yuan certainly studied the blossoms carefully, and perhaps even sketched them from life. Yet this painting was made from memory, as the Chinese valued paintings in which memory and repeated experience allowed the artist to capture the essence of the apricot blossoms along with a feeling for their delicateness and scent.

In contrast now, think of some of the thousands of flower pictures you have seen in your life, from oil paintings, to watercolors, to photographs, and on to calendar images, wallpaper, wrapping paper, linoleum, and fabric designs. Each has its own visual form. Each has its own content. Every one of those representations of flowers was based on the visual perceptions of some artist or designer. They reinterpreted the flower through their own perception, combined with the values of their cultures and the expectations of their audience for a certain kind of product.

Clearly art reflects humankind's perceptions and responses to its reality, in all ages in life, and at all times in history. This reality includes all aspects of life, from birth to death and the hereafter, and of everything inbetween. These perceptions and responses to life manifested in art can be beautiful, ugly, persuasive; can induce happiness and peacefulness, or sadness, anger, and violence. In figure 1.4, we see Edward Hicks' The Peaceable Kingdom, in which he painted his response to the world as he would like it to be, as his religion had taught him. Young children and beasts appear peacefully side by side while adults sign a peace treaty in the distance. The whole composition exudes a peaceful mood. Looking at another painting, Echo of a Scream by David Alfaro Siqueiros (figure 1.5), we see disturbing imagery of babies crying in despair, invoking sadness and perhaps anger. Here the artist's response to his reality, and contrary to Hicks' painting, is what he wants the world not to be.

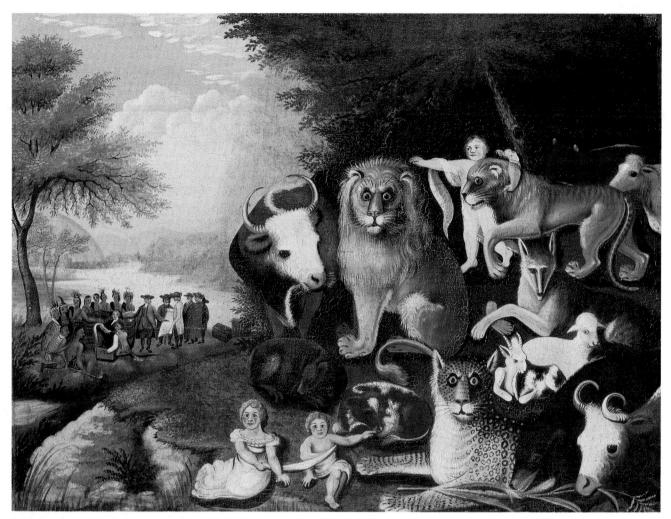

1.4 EDWARD HICKS. The Peaceable Kingdom. Oil painting. USA, 1830–1840. New York: Brooklyn Museum. See also figure 13.30 for more on this painting.

Artistic Expression and Creativity

Creativity is the quality that allows us to originate something or to cause some object to come into being. What that means exactly can vary from culture to culture. In the United States today, creativity is often thought to have two essential ingredients. The first is innovation, or the making of something that is new. The second is artistic self-expression. In the Hicks and Siquieros paintings we have just seen, their imagery and their art styles convey different ideas about the world, and therefore are different forms of artistic self-expression. This expression refers to individual artists' own artistic styles and personal concepts of the world, all of which are embedded in their unique works of art.

However, innovation and artistic self-expression are not always a necessary ingredient in creating artwork. In this book, we will see several examples of great art where the artist followed formulas or copied other works, because their culture valued the re-creation of old forms more than innovation.

Psychologists have not fully identified the components of the creative process in art making. However, some contemporary artists have delineated their own

idea of the creative process. They begin with a formative stage, in which the artist decides to make a work in response to a problem, an vivid experience, or a commission. The artist may research intensely, read, look at other art, explore freely, and/or makes sketches. This period may be very short and intense, or may be extended or punctuated with rest times, or with work on other projects. Often artists try to stay open to the possibility of unexpected results that may come from internal play or speculation, or may come from external sources.

The making of the artwork comes next. For some artists the execution might be very rapid, as it was for Vincent Van Gogh. He painted quickly, with creative and unexpected results happening in the process of painting. Other works may take many years or be ongoing, as was the construction of the Great Wall of China. In some cases, the execution of the work is the actual piece itself, as in Janine Antoni's 1992 performance/installation called *Gnaw* (figure 1.6). What we see in our image is a partly gnawed 600-pound block of chocolate, with 600 pounds of lard in the background. But the act of eating was a primary part of this artwork. The art changed dur-

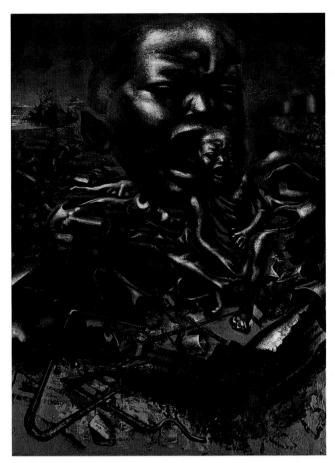

1.5 David Alfaro Siqueiros. *Echo of a Scream*. Duco on wood, $48^{\prime\prime}\times36^{\prime\prime}$. Mexico, 1937. Museum of Modern Art, New York. See also figures 2.24 and 14.5.

ing the exhibit as Antoni ate away at the block. The artist is interested in everyday body rituals and converting the

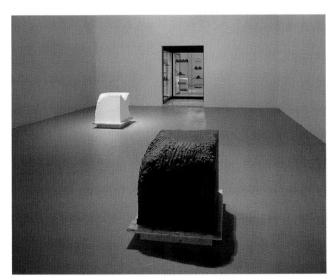

1.6 Janine Antoni. *Gnaw.* 1992. Three-part installation. Chocolate: 600 lbs. of chocolate gnawed by the artist; lard: 600 lbs. of lard gnawed by the artist; display: 130 lipsticks made with pigment, beeswax, and chewed lard removed from the lard cube; 27 heart-shaped packaging trays made from the chewed chocolate removed from the chewed cube, dimensions variable. See also figure 6.33.

most basic sorts of activities, such as bathing, mopping, and eating, into sculptural processes.

Another important component in the creative process is critique or review. Once the work has been completed, or even while it is in process, artists critically assess their work. Other critiques come from the artist's peers, curators, writers, academics, and the audience. All this provides a certain degree of affirmation. Some works or ideas may never be completed, keeping them in a constant state of revision.

Who is creative? It is easy, but inaccurate, to think that the only creative people are artists, designers, or someone in an art-related field. We all have the potential for creativity. It is not limited to art fields, but can be found among mathematicians, scientists, health care professionals, social workers, teachers, parents, gardeners, and so on. While we think of creativity as residing in the individual, it has a social dimension as well. With broad support, someone's artistic abilities can blossom! Negative social pressures can cause someone to squelch or divert creativity, or be embarrassed or ridiculed to the point of avoiding it. Creativity must be fostered.

We often see this phenomenon in children. Young artists perceive the world around them and without being inhibited, and express it freely in their art. Their range of artistic expression can rival that of Hicks and Sigueiros. In A Farm Is a Place to Grow (figure 1.7) Kimberly Dawn Schlesier, age 6½ and while living in Iowa, painted a cattle and hog farm, something very common in her environment. Noticing many details, Kimberly included not only the hogs in a pen, the cattle in a corral, the barn, trees, flowers and birds in the sky, but also the farmer riding on his tractor. The stimuli to which children respond includes not only the physical world around them, but also the world of books, television, and the imagination. Everything is new and fresh to them. Julia Rose Lazzari-Dean, age 4, drew Dinosaur Eating a Man (figure 1.8) after seeing books on dinosaurs, on insects, and on observing insects in her back yard. The "dinosaur," a composite of her perception of insects and dinosaurs, is dramatically drawn with details of menacing jaw, tongue, head, and body. The human victim is drawn smaller, making the dinosaur even more impressive. By the time children reach teenage years, peer pressure and their self-perception of nontalent may cause many to abandon art making, unless there is strong family encouragement, and support from teachers, the community, and figures of authority.

CATEGORIES OF VISUAL ARTS

A few decades ago there was a definition of art that was circulated in the United States, saying in effect that "art is whatever the artist says is art." There is some truth in this, as often artists have taken the lead in defining new art forms long before society accepted them. However, when

1.7 KIMBERLY DAWN SCHLESIER. A Farm is a Place to Grow. Tempera paint on paper, USA, 1970. Collection of Dona and Douglas Schlesier. See also the text accompanying figure 22.2.

1.8 Julia Rose Lazzari-Dean. *Dinosaur Eating a Man.* Markers on paper, $8" \times 6"$, USA, 1997. Collection of Margaret Lazzari and Mike Dean. See also figure 22.15.

we take an overview of the long history of art, there is even more truth to this definition: Art is whatever a society or culture says is art. What does this mean? Basically, the definition of art is not universal and fixed in all its details, as we saw above. It fluctuates. You are alive and operating in a living culture. Your cultural environment (including art) is growing, changing, and responding to a host of economic, political, and social pressures.

In the United States today we are inundated with images. They surround us in galleries and museums, and

are everywhere on billboards, on television, on the computer, and in print. All of these images have uses and values. Some are considered art, and others not. In Western culture today, some artists, art historians, and art critics tend to divide these visual arts into three rough categories: high art, popular culture, and kitsch. These divisions are controversial, as some feel these categories are elitist in thinking. Let us look at what these terms mean, and who thinks what goes where, and you can decide for yourselves.

Before we begin, however, it is important to realize that these distinctions are relevant mostly to highly industrialized countries and are relatively recent. These categories do not exist at all in most areas of the world. Up to 150 years ago, these categories did not exist even in the United States or in other Western nations. Then, art viewing was seen as a form of entertainment:

"highbrow" and "lowbrow"... were both popular. Shakespeare appealed to lower class audiences; and the same can be said of most stage literature, of music (including grand opera), and of the visual arts. Norms now taken for granted did not exist; audiences were not demurely appreciative but highly demonstrative; there was an endless indiscriminate mixing of genres, of high art and kitsch. Relatively little was sacred.... (Wallach 1998: 14)

In other cultures, distinctions about the visual arts never exist at all. Some peoples, both past and in the present, have no word that corresponds to ours for art. As we have seen with the *Akua'mma* dolls, the Ashanti blur the boundaries between areas that Western cultures might consider very distinct, such as art, ritual, and play. Before the nineteenth century, the Japanese did not consider much of their painting to be a fine art as we do. When Western Art History was exported to Japan in the late nineteenth century, then the concept of painting as fine art was also exported.

All visual arts are part of the same "extended family" within our culture. But because the categories of high art, popular art, and kitsch are in common use in the United States today, it is important to understand what these terms mean and how they are applied. These distinctions help explain how art objects are used in different ways and why they are worthless, cheap, or expensive. Let us look at definitions and examples of high art, popular culture, and kitsch.

High Art

In Western countries, high art (or fine art) is a category of refined objects, that are considered to be among the supreme cultural achievements of the human race. High art is believed to transcend average human works. High art is believed to be produced by only the best artists with unique sensibilities and require sensitivity to be appreciated by its audience. If an art object attains the category of high art, it is generally accorded museum display, and high prices are attached to it.

In fact, the category of high art came into existence at the same time as the invention of the art museum, roughly 200 years ago. One definition of high art is simply that it is what is displayed in art museums:

Art museums sacralize their contents: the art object, shown in an appropriate formal setting, becomes high art, the repository of society's loftiest ideals.

Indeed, without art museums, the category high art is practically unthinkable. (Wallach 1998: 3)

High art has tended to be media-defined: its most traditional forms include painting, sculpture, and architecture. It has been expanded to include film, photography, prints, and most recently installation, performance, video, and computer art. High art also is promoted and taught in college and university art departments.

Despite this definition of high art, the category of high art is by no means clear-cut in real life. It is evolving. In the early and mid-nineteenth century, it was defined in Western industrialized nations solely in terms of classical art: Greek, Roman, and Italian Renaissance art, mostly sculpture. Early art museums were not necessarily filled with original art, but had plaster cast copies of the most famous works of Greek art to elevate and educate the masses. High art changed at the beginning of the twentieth century when contemporary painting and drawing were favored. Later, the mid-twentiethcentury critic Clement Greenberg identified high art as "avant-garde," which he saw as detached from society, as "'art for art's sake' and 'pure poetry'. . ." "The avantgarde poet or artist tries in effect to imitate God by creating something valid solely on its own terms, in the way that nature itself is valid . . . a work of art or literature cannot be reduced in whole or in part to anything not itself" (Greenberg 1939: 5-6).

Definitions of high art are also in flux when Western people look at art from other cultures. At the beginning of the twentieth century, *Akua'mma* sculptures would not have been displayed in art museums in the United States or Europe, but they are now. For more on art museums, their purposes and the ways they have evolved, see the section on "Art Collections" in Chapter 21, What Do Humans Do with Art?

Popular Culture

Popular culture is full of imagery. Look at magazines, comics, television, tourist art, advertising, folk art, tattooes, customized cars, graffiti, video games, posters, Internet sites, calendars, greeting cards, dolls, toys, movies (as opposed to film or cinema), and snapshots and commercial photography (as opposed to fine photography). Perhaps the most pervasive and accessible form of popular art now is television programming, with the Internet not far behind. Another important and accessible area of popular art are crafts, such as weaving, woodworking, ceramics and so on, but these areas cross over heavily into the fine (or high) arts. Popular art is often perceived as being more accessible, inexpensive, entertaining, commercial, political, naive, primitive, amateur, colorful, folksy, or touristy than fine art.

Fine arts and popular culture are distinct categories. However, there is no clear dividing line between the two. Rather, they are part of a continuum which contains all the visual imagery that a culture produces. The division between the two came about in part with the rise of the middle class during the Industrial Revolution, as the bourgeois sought to emulate nobility by creating art museums for the appreciation of art, and to separate themselves from lower classes who presumably appreciate only popular art. The existence of high art "proves" the merits of a modern culture beyond mere consumerism. Popular culture is often called "low" when discussed in relationship to "high" art.

Art in popular culture may share many attributes of high art. It is often highly creative, innovative and expressive work. It shares the same attributes of function, visual form and content. It reflects the values and structures of our social systems, political hierarchies, and religious beliefs. Popular culture is studied in many academic areas, including visual theory, art history, philosophy, and anthropology. It is often collected, and may be displayed in museums.

Some artists find the blur between high art and popular culture to be an exciting and fertile area for activity, and purposely situate themselves so that their work operates in both spheres. For example, Barbara Kruger is an artist, a social and political observer, and also agitator. Her background is in both fine arts and mass media. For a period in the 1980s, she was chief designer for the popular fashion magazine, *Mademoiselle*. Like other artists interested in effecting a difference in "real life," Kruger produces unique, costly artworks for gallery, and also distributes her work to the larger public as inexpensive street posters, billboards, and matchbook covers. *Your Body Is a Battleground* (figure 1.9) is an artwork in a famous art collection, but it has also been reproduced as street posters, T-shirts, book covers, and postcards.

In many more ways, popular art shares important qualities with high art, as listed below:

- Many "works of art" were originally made for popular entertainment, as we saw with *Jane Avril*.
 See Chapter 18, Entertainment, for many more such examples.
- Many media are used for both high art and popular culture, resulting in a lack of distinction between the two. Who is to say where the snapshot ends and high art photography begins? Or take a work such as *Your Body Is a Battleground*, which was produced in both fine art media and print media.
- High art often deals with the same imagery as popular culture. Nam June Paik's Megatron (figure 1.10) is a grid of two hundred monitors displaying an intense barrage of images from high art and popular culture from Asia and the West. Paik believes that the recombination of dislocated images is a playful, constructive way to reshape modern life.
- Items from popular culture can become high art.
 In this book we will see numerous examples of this

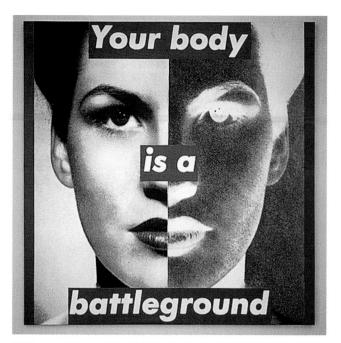

1.9 Barbara Kruger. Your Body Is a Battleground. USA, 1989. Photographic silkscreen on vinyl. $112" \times 112"$. Eli Broad Family Foundation Collection. See also figures 17.1 and 21.14.

phenomenon, such as functional pottery that was made for everyday use or for rituals, but now are considered to be art. The *Akua'mma* were not intended as high art when they were made.

Kitsch

Webster's New World Dictionary defines kitsch as "art, writing, etc. of a pretentious but shallow kind, calculated to have popular appeal." Clement Greenberg condemned kitsch as "mechanical and [it] operates by formulas. Kitsch is vicarious experience and faked sensations. Kitsch changes according to style but always remains the same. Kitsch is the epitome of all that is spurious in the life of our times. Kitsch pretends to ask nothing of its customers except their money—not even their time" (Atkins 1997: 109). The writer Milan Kundera described kitsch in terms of mass emotional appeal: "The feeling induced by kitsch must be a kind the multitudes can share . . . : the ungrateful daughter, the neglected father, children running on the grass, the motherland betrayed, first love" (Kundera 1984: 251). Tomas Kulka defines kitsch as ". . . objects or themes that are highly charged with stock emotions" (Kulka 1996: 28). "Kitsch" is generally considered to be a derogatory term.

Objects or images are kitsch if they display strong emotional appeal, but of a particular kind. The emotions are generalized, superficial, and sentimental to be common to a broad range of people. Kitsch is the opposite of an original experience, a uniquely felt emotion, or a thoughtful, introspective moment. As a result of its broad appeal, kitsch imagery is often used in advertising

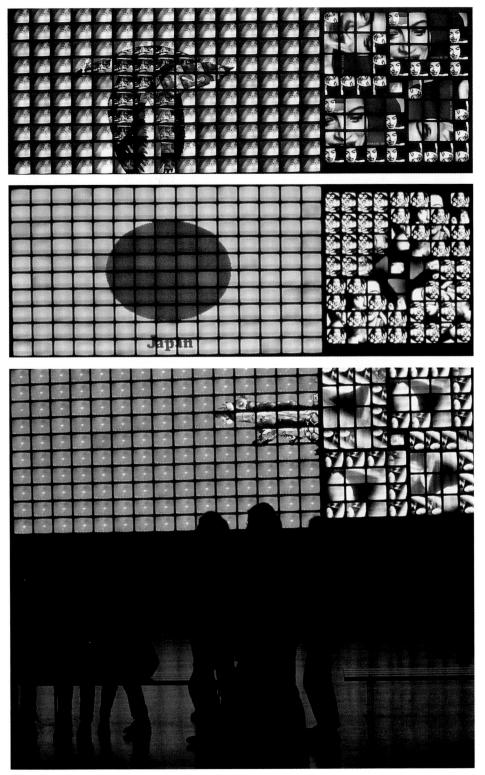

1.10 Nam June Paik (IN COLLABORATION WITH SHUYA ABE). Megatron (three views). Eight channel video and two-channel sound installation in two parts; overall size 12 feet × 24 feet × 2 feet. Korea, 1995. Courtesy Holly Solomon Gallery, New York. See also figure 19.34.

and in political propaganda. We see several instances below:

Christian kitsch—exemplified by plastic Jesus babies, pictures of the Virgin Mary, or scenes of the Crucifixion—combine universal elements of kitsch with symbolism relation to the articles of Christian

faith. Communist kitsch—depicting smiling workers in factories, young couples on tractors cultivating a collective farm or building a hydroelectric power station—played on the mythical values of the joy of work and the enthusiasm for building a classless society. Capitalist kitsch, exemplified by advertising, on the other hand, uses class distinctions and status

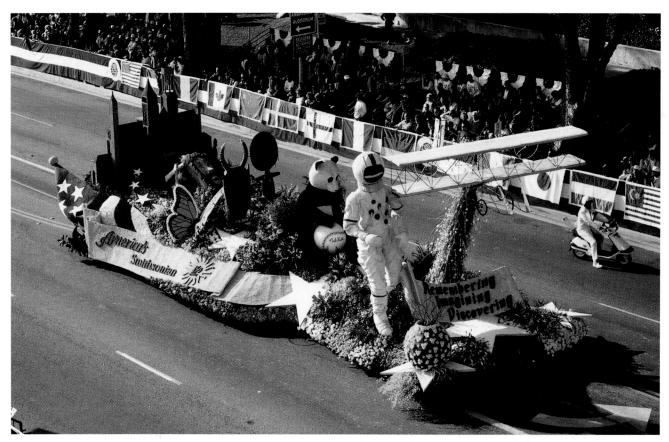

1.11 The Smithsonian Institution's 150th anniversary float in the 1996 Rose Parade in Pasadena, CA. Photograph courtesy of the Pasadena Tournament of Roses. See also 21.13.

symbols to create artificial needs and illusions to foster the ideology of the consumer society. (Kulka 1996: 28)

The Smithsonian Institution's 150th anniversary Rose Parade float (figure 1.11) exhibits many properties of kitsch because of its sentimentalized emotional message. The collection of images, from astronauts to the first airplane to pandas to butterflies to baseball evoke a variety of kitsch emotions: Technology is wonderful! Come to the museum to understand the world! Wild animals are cute! All of America loves the Smithsonian Museum! The splattering of scrolls, stars, and flags are all sentimentalized symbols of the nation. A representation of the oldest building of the Smithsonian Museum rides at the back of the float. The building has been scaled down, its windows made proportionally larger, the most exotic features—its towers—emphasized. The building is much smaller in scale than the objects in front of it, to make the museum appear diminutive, cute, and fun. In this float, it does not appear to be a site of serious research. Finally, the translation of an Akua'ba sculpture into a six-foot-high maquette of seaweed and flowers is kitsch (Akua'ba is the singular form of Akua'mma).

But like all other categories of visual art, the idea of kitsch is evolving and changing. Greenberg's definition of kitsch dated from an article written in 1939, in which he labeled all advertising, jazz, and Hollywood movies as kitsch. While some particular works may be kitsch, we no longer necessarily place the entire category of jazz or movies into the kitsch category. In addition, later critics such as Susan Sontag have reclaimed some kitsch as "camp," which means objects and images of such extreme artifice (and often banality) as to have a perverse sophisticated and aesthetic appeal. Sontag believed that an appreciation of camp was "the sensibility of failed seriousness." It revealed "another kind of truth about the human situation . . . " (Sontag 1966: 287).

Other Categories

There are many other ways to categorize art, and we shall see several in this book. For example, we can categorize art around style, both an individual artist's style and broad cultural styles. You may be very familiar with some of these categories, such as Ancient Egyptian art, Japanese prints from the seventeenth to nineteenth centuries, or the Impressionist period. Scan ahead to Chapter 5, Looking at Art within Cultures, for more on categorizing art according to style.

Disciplines such as drawing, painting, or sculpture may be grouped as separate categories. Other such categories could include book arts, pottery, or jewelry. Some cultures have art forms that do not translate directly into Western categories, such as ancient puppet theater in Japan, or the masquerade in Africa. We will see all these come up again in subsequent chapters.

Art can be categorized by content or theme. In this book, we have clustered the artworks around fourteen humanistic themes. They are found in Part II, Why Do We Make Art?, and are divided into the following four sections: Section 1, Sustaining Life; Section 2, Religion; Section 3, The State; and Section 4, Self and Society. Each section has several related categories that make up each chapter.

Other divisions are possible. Certainly all observers of art could create their own categories for grouping artworks, and these areas can vary according to preference. You are part of a living, growing culture, and the final word has not been written about it.

SYNOPSIS

There is no single definition of art that absolutely applies for all times and places. Generally, however, art is a specific set of ideas expressed with organized colors, shapes, textures, and so on, that fulfills some function within a culture. Art engages our attention in a way that our everyday environment cannot. Various cultures have developed their own aesthetic systems that identify in greater detail what art is for their cultures.

Creating art is a complex process that begins with perception. While humans visually perceive in the same physical way, they respond differently and also may interpret what they perceive differently. Artists are also influenced by other artwork and by the way art is defined in their cultures.

Creativity is the quality that allows us to originate something or to cause some object to come into being. In some cultures creativity is tied to artistic expression and innovation, while in others it is essential to follow formulae or precedents. The creative process is not entirely understood, but many contemporary artists have described their experience of the act of creation.

Societies may group visual arts into various categories. In the United States today, most visual products are grouped as high art, popular culture, or kitsch. Other categories may be created such as styles or disciplines, or humanistic themes, as used in this book.

FOOD FOR THOUGHT

When we started this chapter, we stated that art making is strictly a human phenomenon. This brings several questions to mind.

- Could the evolutionary theory of the development of humankind include the ability to make art?
- If all humankind has the potential to be creative, can we all be artists?
- Why in some cultures are artists separated out as "geniuses" or considered to be blessed with a gift, whereas in other cultures artists are much more part of everyday life?

EUTRILINS ARE GODE

THE NOT MONDGAMOUS BY MATURE

A IS A PREREQUISITE OF SUCCESS

Chapter 2 The Language of Art

INTRODUCTION

"Communication" often means the use of oral and written language. However, humans use other languages to communicate their ideas to others. These include the languages of numbers, music, and of course the language of art. Like the others, the language of art is composed of elements arranged into a structure, in order that it can make sense to others. In this chapter, we will examine those elements, and also the principles by which they are composed, structured, or organized into a work of art.

We will limit our discussion here to the plastic arts (art pieces that are tangible and permanent, i.e., drawing, painting, and sculpture) and the ephemeral arts (art pieces that are intangible, passing, and not permanent, i.e., ritual and performances). The plastic arts primarily engage the sense of vision, whereas in the ephemeral arts, all the senses might be utilized, such as the human voice uttering sounds, words, or songs, the use of odors, the smelling and tasting of a substance, or the touching of a surface. We will examine here the formal qualities of art, which are its physical characteristics, and the principles of composition by which those characteristics are arranged. Turn to Chapter 3, The Language of Architecture, for the elements and structure of architecture. To find a discussion of content issues, read Chapter 4, How Does Art Work?

This chapter contains many art terms, and introduces the basic vocabulary that will be used throughout this book. Terms are defined within the chapter, and definitions are also repeated in the glossary at the end of the book. There are many works of art shown in this chapter to illustrate formal qualities. To keep focused, we omit almost all discussion of the art's meaning. Look for all these artworks to appear again in Part II, Why Do We Make Art?, with more complete coverage.

As we examine the language of art, keep in mind the following questions:

If art is a language, what is its grammar?

How can communication be visual?

How can a visual language be composed?

Instead of words, what do artists use to make their statement?

FORMAL ELEMENTS

Words are the basic elements of oral and written languages. Likewise, visual arts have basic units, which are the **formal elements**. They are line, light and value, color, shape and volume, texture, space, time, and motion. Other art forms might also include the elements of chance, improvisation and spontaneity. Also, some artworks engage other senses beside sight, and so we will look at those elements too.

Line

When children first encounter crayons, the results are lines—lines on paper, on walls, on any available surface. Those first marks begin a lifelong career of making lines, whether those children become artists or not. Line is a basic element of visual and written communication. Every letter form, word, map, diagram, flowchart, or doodle uses lines to record an idea.

What is a line? Mathematically, **line** is defined as a moving point, having length and no width. In art, line almost always has both length and width, but its length is the more important dimension.

Lines that are made with some material are **actual lines**. They physically exist and have a great variety in the ways they look—some broad, some thin, some straight, some jagged. **Implied lines** in art works do not physically exist, yet they seem quite real to viewers. One example is the dotted line, where several individual, unconnected elements can be grouped into a single "line." Implied lines are also created when a person in a picture is gazing in a certain direction. Our eyes follow that direction, almost as if a line were drawn to mark the path. A hand gesture or an arrow give the same result—we look wherever it is pointing.

2.1 PADDY CARROLL TJUNGURRAYI. Witchetty Grub Dreaming. Paint on canvas. Australia, Aboriginal, from Papunya, 1980. See also the text accompanying figure 6.2.

We see examples of actual and implied lines in the Australian aboriginal painting, Witchetty Grub Dreaming (1980) figure 2.1. While some of the lines in this painting are actual lines, created by a continuous stripe of paint, others are implied lines, created by aligning discrete dots of paint that we perceive as lines. In fact, in this painting, we can see the image simultaneously as lines, dots, and areas. Lines come in great varieties, and this adds to the richness of the artwork. Witchetty Grub Dreaming contains primarily curved, straight, and short choppy lines, but lines can also be jagged, smooth, razorthin, bold and thick, and so on. We see jagged, stabbing lines in Käthe Kollwitz's Outbreak (1903) figure 2.2.

Lines have **direction.** They are horizontal, vertical, diagonal, curved or meandering. In artwork, the direction of lines can be used to describe spatial relationships in the world. Something is above something else; some path leads from left to right; something started at one location, and then moved to another. Certain ideas can be conventionally associated with line direction. For example, horizontal lines may imply sleep, quiet, or inactivity, an association resulting from the human body at rest. Vertical lines may imply aspiration and yearning, like the defiance of gravity. Diagonal lines may suggest movement, because they occur in the posture of running animals and blowing trees, while curving lines may also suggest flowing movement.

2.2 Kāthe Kollwitz. *Outbreak*. Mixed technique print, 20" × 23.25". Germany, 1903. Library of Congress, Washington. See also the text accompanying figure 14.2.

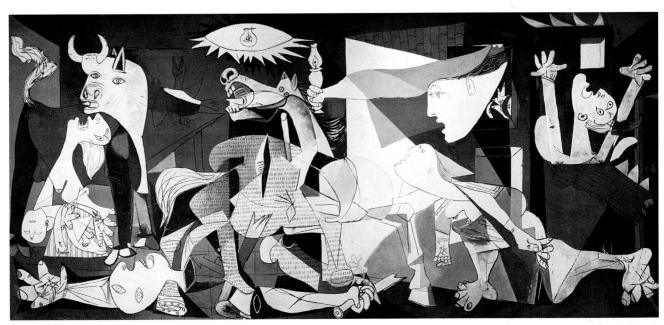

2.3 Pablo Picasso. Guernica. Oil on canvas, $11' \times 28'8''$. Spain, 1939. The Prado Museum, Madrid. See also the text accompanying figures 5.10 and 13.25.

Of course, these meanings are not absolute, and can change, given the subject matter of a work of art. Thus, in some cases, vertical line may seem as static as a horizontal line, or curving lines may suggest aimlessness, compulsive behavior, or elegance. In Kollwitz's *Outbreak*, diagonal lines do indeed suggest movement—the peasants to the right are charging forward in revolt. But horizontal lines at the far left do not indicate rest, but rather show people running at the greatest speed, even faster than figures drawn with diagonals! The important point to remember is that the direction of lines can help communicate complex visual meaning, in addition to describing spatial relationships in the world.

When several lines occur together, their arrangement can be also significant. Lines that are all parallel or repetitive in some way may suggest structure or restfulness, while lines that collide or tangle may seem random, conflicting, or unbalanced, like the mass of lines that describe the rioters in *Outbreak*.

Our eyes see a world full of areas of varying gray tones and shapes, yet many art works contain nothing but lines. Outlines can be used to show **shape**, which is a two-dimensional entity we will discuss more on page 30. Outlines mark the outer edges of an object, allowing artists to reduce internal detail but still retain recognizability. If artists choose to draw only the outline, then they would be rendering the image in a **contour** line. In *Guernica* (1939) figure 2.3, Pablo Picasso uses contour lines to make shapes that stand for heads, arms, radiating light, and so on. Artists also can use lines to describe **tones**, or different areas of gray, some lighter and some darker. Again, in *Guernica*, the horse's body at the center of the painting appears gray because of an accumulation

of lines. (Other grays in the painting are actually gray paint.) Lines put down in parallel or crisscross patterns are called **hatching**. Hatching produces tonal gradation, or the appearance of subtly varying shades of gray. The portrait on the U.S. dollar bill is an example of precisely placed lines that describe the different lights and darks on George Washington's face.

Lines can also express emotion, because they come in such great variety. Some are precise and controlled. Others are blunt, rough, or heavy, as if the result of a gouging, jabbing action. Others may be fine, wavering, or delicate, and others still may be sweeping, broad, and vigorous. Artists use the range of possible line qualities not only to describe the world they see, but also to express their own emotions about it. Our examples vary greatly in their line quality. The lines in Witchetty Grub Dreaming are orderly, controlled, and either smoothly curving or parallel and straight. These qualities permeate the entire art work. In contrast, Outbreak has jagged and jabbing lines, appropriate for an image of a riot. These are expressive gesture lines, and they give a sense of the fury of a riot. The heavy, blunt, dark, diagonals of the woman in the foreground, combined with her pose, communicate a sense of terrible anger. The almost-horizontal woman at the far left speak of out-of-control, breakneck speed. Thus, with Kollwitz, lines are used as gestures that communicate emotion and action.

Linear elements can exist in three dimensions, in architecture as well as in sculpture. Any thin string, rope, wire, chain, stick, or rod used in a sculpture can function like a line. Even substantial logs can appear linear when placed in an open space, where their thickness is less important than their height. Artist Paddy Dhatangu uses a series of vertical standing logs in his piece entitled *The Aboriginal Memorial* (1988) figure 2.4. Even though some logs are thick and are decorated with horizontal bands of paint, the upward linear emphasis remains a dominant element in the piece.

Artists make lines in a variety of ways. Pencils, pens, charcoal, paint, and brush, just to name a few, can make lines on a surface. Lines can be scratched into surfaces, such as rock, metal, or clay. In figure 2.5, we see a ceramic figure of an *Infantry General* (221–206 BC) from ancient China. This full sized soldier is detailed with incised lines which enhance the texture of his armor, his necktie, the fabric of his uniform and the tassels that adorn it. Some printmaking procedures, such as etching and engraving, are based on lines gouged or eaten into a surface of a smooth metal plate. We will further discuss different art media later in this chapter, under "Art Material and Media."

Light and Value

Without light, this book could not be written. Humans need light to start the process of perception from which the formation of ideas come about. Without light, form and spatial relationships could not be visually defined. Only with light is art possible.

What is **light?** It is electromagnetic energy. It is the first cousin of x-rays, microwaves, radio waves, radar, ultraviolet rays, infrared, and other forms of radiation

that come originally from the sun. Light, however, is radiation in certain specific wavelengths that stimulates the eyes and brain. Light produce visual sensations.

There are two kinds of light, one natural and the other artificial. The sun, moon, stars, lightning, and fire are natural sources, while incandescent, fluorescent, neon, and laser are artificial. In art, light might be used as an actual element. In figure 2.6, we see the interior of *Notre Dame du Haut* (1950–1955) in which architect Le Corbusier masterfully incorporates the light of the patterned windows to radiate into the worship space of the church, producing an awesome and moving atmosphere. If we were in the church itself, the light coming into the windows would be an actual and important element. Other artists use light in their works through light-emitting media, such as neon, video projects, or computer displays.

However, more artists do not use actual light as an element. Rather they depend upon general illumination to make their work visible because the art reflects light. And they also create lighter or darker surfaces within their artwork to make a picture of something. **Value** refers to lightness or darkness of a surface in non-light-emitting media. White is the lightest tone, black is the darkest and all the gray tones form a continuum in between, as we see in the value scale in figure 2.7. This is called an **achromatic** value scale, as it deals only with grays. Value can also be associated with color. So red can still be red, but it can be lighter or darker, or different

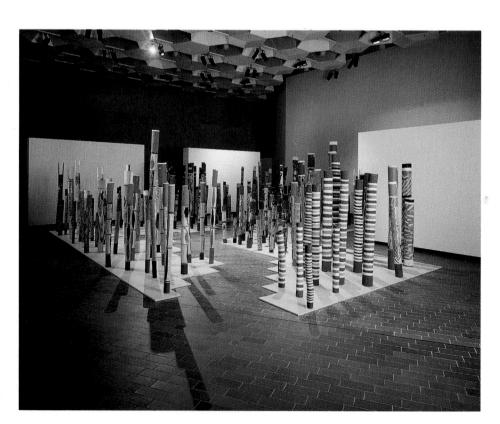

2.4 PADDY DHATANGU, DAVID MALANGI, GEORGE MILPURRURRU, JIMMY WULULU AND OTHER ARTISTS FROM RAMINGINING. *The Aboriginal Memorial*. Australia, 1988, natural pigments on 200 logs. Heights: 16 to 128 inches. National Gallery of Art, Canberra. See also the text accompanying figure 14.18.

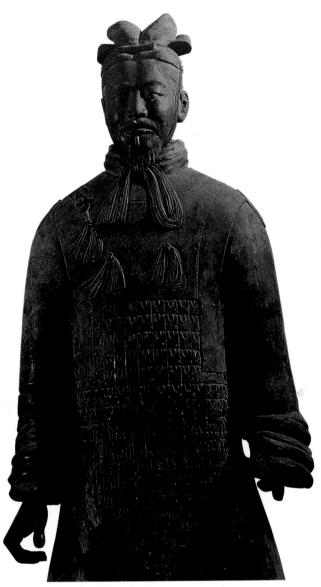

2.5 *Infantry General*. From the tomb of the Emperor Shi Huangdi. Painted ceramic. 6' 4" tall. Shaanxi, China, 221–206 BC. See also the text accompanying figure 11.10.

values of the color, as we see in the **chromatic** value scale also in figure 2.7. Artists can carefully manipulate gradations in values to create the appearance of natural light on objects. This is called **shading**, and can be seen in the drawing of the ball in figure 2.7C.

Artists use the element of value in various ways. With it, artists can depict depth and volume, or they might express an emotion, and or they can create emphasis in an image. In figure 2.8, we see Raphael's *Madonna of the Meadow* (c. 1505), where value creates the illusion of depth and volume. The figures look rounded because of the chromatic and achromatic gradations in value, but the surface of the painting is actually flat. Raphael also achieved the illusion of deep space because the background fades into light, low-contrast values. Both uses of value were popular beginning with fifteenth-century Italian painters. They used the term **chiaroscuro** for the

light-dark gradations that give the illusion of rounded form on a flat painting, and atmospheric perspective (or aerial perspective) for the light, bleached out, fuzzy handling of distant forms to make them seem far away. Raphael also used value for emphasis. In the foreground, he painted strongly contrasting values in the clothing and the flesh, so that viewers' attention would go there first.

Artists also use the element of value in their work when they want to express an emotion or an idea with emotion, or to arouse the emotion of a viewer. We already saw Käthe Kollwitz's *Outbreak* (figure 2.2). She used strong contrasts in value to create a disturbing scene. Likewise, in *Guernica*, the flashing lights and darks add to the horror of the scene, which shows victims of a bombing raid. Picasso also used value for emphasis and balance. By creating a pattern of values distributed throughout the work, he visually balanced the other elements and images. We will see more on balance and emphasis later in this chapter, under "Principles of Composition."

Many media lend themselves easily to the creation of value. Charcoal, graphite, pastels, and oil paint are just a few of the traditional materials with which a great variety of values can be rendered. Newer media include photography and film, especially in their earlier forms when they were only in black and white. Again, we will see more on these media later in this chapter.

Color

Color is a wonderful phenomenon that humans are lucky to enjoy. This section is saturated with color terminology. But through all the terms, remember the intense associations that colors bring to us, including delight, pleasure, sensuality, or in contrast even revulsion.

Humans see color because there is **ambient light**, which is the light all around us in our world. It is the light that comes directly from sources such as the sun or from lamps, or the light reflected off surfaces all around us. Some of that ambient light passes into our eyes. It has various wavelengths, which stimulate light-sensitive structures in our eye. We call these sensations "colors."

We can see colors in two ways, in either refracted light or in the reflection of light from an object. We see color in refracted light when a prism breaks a light beam into a **spectrum** of color, or naturally occurring in a rainbow after a storm. We see color in reflected light when we look at the objects around us, because their surfaces reflect certain rays of ambient light while absorbing others. Those rays that are reflected to our eyes are the color of the object. For example, a green chair absorbs all the other wavelengths of visible light except the "green" wavelength, which is reflected back into our eyes.

The properties of color are hue, value, and intensity. **Hue** is the pure state of color the eye sees in the color

2.6 LE CORBUSIER. *Interior, Notre Dame du Haut.* Ronchamps, France, 1950–1955. See also the text accompanying figure 10.11.

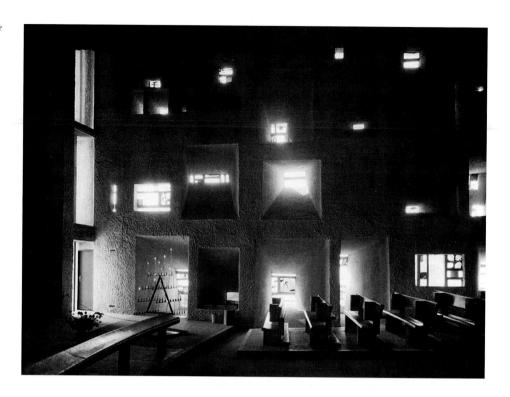

spectrum, and the name given to those colors, such as red, blue, yellow, green, purple, and orange. **Value** in color is lightness and darkness within a hue, as we already saw in *Madonna of the Meadow* (figure 2.8). When black is added to a hue, a **shade** of that color is created, and when white is added, a **tint** of that color is created. **Intensity** in color is the brightness and dullness of a hue. Another word for intensity is **chroma**. A high intensity color is considered brilliant, vivid, and saturated, while a low-intensity color is faded or dull. *Madonna of the Meadow* had both high and low intensity colors. High-intensity colors can be seen in the spectrum. All colors in figure 2.9 are high-intensity. Black and white have value, but do not have intensity among their properties.

Mixing colors is an important skill that artists must acquire. Artists mix colors through one of two systems: additive and subtractive (figure 2.9). The **additive color system** is mixture of one light wavelength with another, resulting in mixed colors in a light-emitting medium. In additive color systems, no light is darkness (or black), and all light added together results in the brightest, whitest light at the center of the figure 2.9a. In our diagram, we see what happens as red, green, and blue lights are mixed. This system is used in theater lighting, performance art, light displays, and computer and video monitors.

In the **subtractive color system**, artists mix pigments to manipulate and control the exact light wavelengths that they want an object to reflect. Thus the mixture of pigments subtracts (or absorbs) available light in order to let us see certain colors. Pigments are color matter

that occur naturally, such as melanin in our skins or chlorophyll in plants. **Pigments** are also powdered substances that can be mixed with oil, water, or other binders to create paints (see more on media in figure 2.41). In the subtractive color system, white is a pigment that reflects almost the entire spectrum of light. Our diagram shows the mixing of red, yellow, and blue. Mixing more and more pigments gives darker results, as the available light is increasingly aborbed by the mixture, as we see in the center of figure 2.9b. Many artists use the subtractive color system in creating their work.

Primary colors are those colors that combine to produce the largest number of new colors. Various art media have their distinct primary colors. For example, for light-emitting media, the primary colors are red, blue, and green, as we see on our additive color system diagram. Secondary colors are the results of the mixture of two primary colors. Again, in light-emitting media, the secondary colors are yellow, cyan, and magenta. For paints, the primary and secondary colors are different than they are in light-emitting media, because paints use pigments to create colors in the subtractive system. For paint, the primary colors are red, yellow, and blue, while the secondary colors are orange, green, and purple. Tertiary colors are created by mixing one primary color and one of its neighboring secondary colors. Blue-green is a tertiary color in paint.

We can see the primary, secondary, and tertiary colors on the **color wheel** in figure 2.9c, which is a diagram that applies only to color mixing with paints and pigments. Interestingly, the color wheel shows the ideals of such

A. Achromatic value scale

B. Chromatic value scale

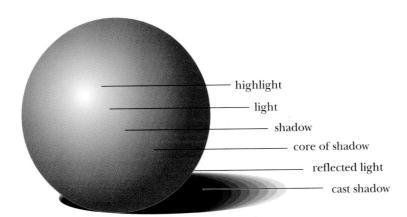

C. Values creating the illusion of volume

color mixture. On the color wheel, all colors and mixtures are intense, vivid colors. But your actual experience in mixing paints is likely to be quite different. In the art supply store, various blues, reds, and yellows are for sale, and none of them really match the "ideal" colors of the color wheel. Mixing blue and red paint is more likely to result in a dull brown color than a vivid purple. If you want a purple color, you may need to buy the paint. Thus, mixing paints often gives low intensity results, even though in theory that should not happen. This is not the case in mixing colors with light-emitting media. Light has none of the physical substance of paint that can interfere with intense color mixtures. So, mixtures with two light primaries always give very vivid colors.

Here are more color terms. **Analogous colors** are those that are similar in appearance, especially those in which we can see related hues, such as yellow, yellow-orange, and orange. Analogous colors are next to each other on the color wheel. **Complementary colors** are considered opposites of each other, and when mixed give a dull result. In paint, red and green are complementary colors. The color wheel again shows us this relationship.

We need to look at the primary and secondary colors in one more medium before we move along. Many color images we encounter in our lives have been commercially printed, including the color images in this book. Commercial printers use semi-transparent inks and the

2.7 VALUE DIAGRAM.

A. Achromatic value scale, showing only black, white and gray tones.

B. Chromatic value scale, showing various values of red.

C. Values can create the illusion of volume.

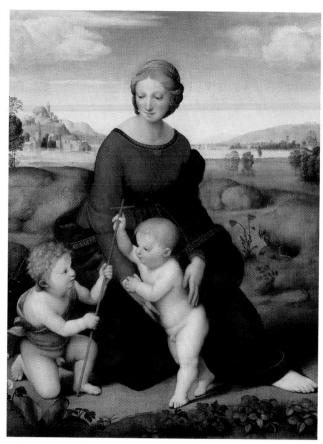

2.8 RAPHAEL. Madonna of the Meadow. Panel painting, $44.5" \times 34.25"$. Italy, c. 1505. Kunsthistorisches Museum, Vienna. See also the text accompanying figure 9.10.

color mixtures in printed images are all derived from the following primary colors: yellow, magenta (a bright pink), and cyan (a bright blue-green), plus black added for darkness and contrast. The secondary colors are blue, red, and green. You can easily see these primaries, and their resulting mixtures, if you use a strong magnifying glass while looking at a color image on a newspaper. You encounter these same inks and the same **CYMK** (cyan, yellow, magenta, black; black = K) primaries in your home computer printer, and your print-outs of color images are made from mixtures of these colors.

The chart in figure 2.10 sums up the primary and secondary colors in various media, plus other color attributes.

Color perception is **relative**, meaning that we see colors differently depending upon their surroundings. Low or high light levels in our environment affect our perception of color. Light-emitting media are much more dramatic in a dark room. Watch TV in the dark, and you will see this effect. The television image, however, can barely be seen in a very bright room. Conversely, reflective media need a lot of light in order to be seen well. A spotlight on a painting makes its colors vivid, while a dim room makes it hard to see. Since natural light is constantly changing, our visual perception is also. As

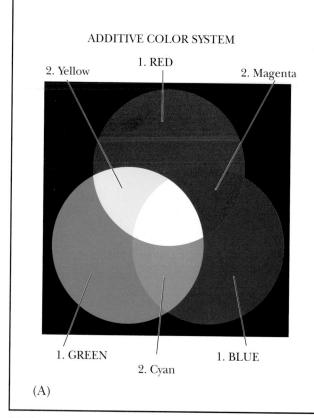

2.9 Diagram showing the additive and subtractive color systems. Also included is the color wheel, which is a diagram of the subtractive color system as it applies to paint. Note that all three diagrams show the primary colors labeled with "1", secondary colors labeled with "2", and tertiary colors with "3".

more light is cast on our environment, the brighter the colors become in paintings. As the light fades, so does color. There is no single fixed, permanent state that the painting "looks like."

We also experience relativity of color perception when we look at certain combinations of colors. In figure 2.11, the colors in the center of the top row of squares of the chart appear to be different even though they are exactly the same, while the dull pink squares in the lower row appear the same, but are different. Eye fatigue also affects our color perception. Stare at the black dot in the center of the "flag" printed in figure 2.11 for one minute. You will notice as the minute wears on that you have trouble seeing the colors which were so clear and bright at first. After the minute has finally passed, turn to look at a white wall, and you will see an afterimage of the flag, but the colors have shifted and appear to be red, white and blue, the complementary colors of the colors used in the printed "flag." As a result of eye fatigue, your eyes see the opposite of the printed colors.

In an artwork, color can be used for emphasis. Let us return to Raphael's *Madonna of the Meadow* (figure 2.8). The red of Mary's dress acts as a magnet for our eyes. Color can also create balance, which we can see again in

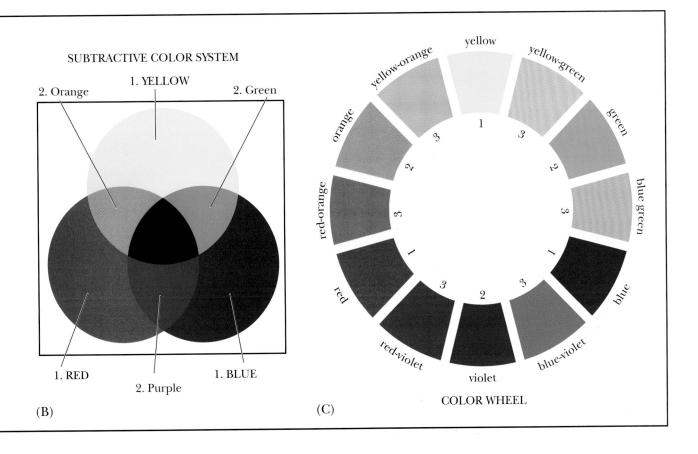

COLOR PROPERTIES IN VARIOUS MEDIA			
	Paint	Light-Emitting Media (e.g., Computer Monitor)	Commercial Printing or Computer Printer
Color System	subtractive	additive	subtractive
Effects of Environmental Light Levels	more room light, the brighter the colors	less room light, the brighter the color	more room light, the brighter the colors
Primary Colors	blue, red, yellow	red, green, blue	cyan, magenta, yellow, black (CMYK)
Secondary Colors	<pre>purple (blue + red) green (yellow + blue) orange (red + yellow)</pre>	yellow (red + green) cyan (green + blue) magenta (red + blue)	red (magenta + yellow) blue (cyan + magenta) green (yellow + cyan)
Complementaries	blue – orange red – green yellow – purple	red – cyan green – magenta blue – yellow	cyan – red magenta – green yellow – blue
Mixture of All Primaries	gray or dull neutral	white	black

2.10 Chart showing Color Properties in Various Media.

the *Madonna of the Meadow*, with the placement of the golden flesh color of Mary and the two babies. Color can create the illusion of depth on the two-dimensional plane of the painting. The light blues and greens in the distance recede from and are separated from the darker

browns and golds in the foreground. Color can be used to depict **local colors**, which are the colors we normally find in the objects around us. The paint in the *Madonna* of the *Meadow* gives a convincing representation of the local colors of landscape, sky, and figures.

Color can identify ideas, suggest sensations, and even evoke emotions. It can make us feel warm or cool, happy or sad, peaceful or angry, motivated or discouraged. There are some colors that are considered to be warm while others are deemed cool. Colors associated with the sun and fire would be **warm**, such as yellows, reds, and oranges. Colors associated with plant life, sky, and water would be **cool**, such as greens, blues, and purples. Warm and cool colors can affect an audience both physically and emotionally. Certain colors in the surroundings can actually influence your alertness, sense of well-being, and sense of inner peace. In figure 2.12 we see Wayne

Thiebaud's painting, *The Pie Counter* (1963). The artist expressively used color to increase the visual appeal of the brightly colored food, and also to allude to the modern phenomenon of artificial light, artificial food coloring, and the standardization of food production.

Colors can be symbolic, and thus associated with ideas or events. The colors of a country's flag are tied to concepts of national identity and patriotism. Certain colors might mean a holiday or a celebration such as red and green for Christmastime in Western cultures, or red for a wedding in Asian cultures. The colors used in *The Aboriginal Memorial* (figure 2.4) are those used in

The three small center squares above seem to be different shades of orange, but they are all the same.

The two small pink squares above seem to be the same . . .

... but they are different.

Stare at the white dot at the center of the flag for 30 seconds, then look at a white wall. It will appear to be red, white, and blue. Color perception shifts due to eye fatigue.

2.11 The Relativity of Color Perception. Color perception changes, depending upon surrounding colors and eye fatigue. The inner orange squares are the same on the top row, but look different. The pink inner squares look the same on the second row, but they are different. The flag at the bottom demonstrates the relativity of color perception due to eye fatigue. Stare at the white dot in the center of the flag for 60 seconds, then look at a blank white wall to see an afterimage of the flag in red, white, and blue.

2.12 Wayne Thiebaud. *Pie Counter.* Oil on canvas. $30^{\circ} \times 36^{\circ}$. USA, 1963. The Whitney Museum of American Art. See also the text accompanying figure 6.24.

traditional Aboriginal art, and thus they represent Aboriginal culture.

Different cultures may associate colors with various attributes. For example, you might think of blue in relation with the ethereal, with purity, or with being depressed. Yellow might mean cowardice, or might mean youth, spring, and rebirth. Associations change from culture to culture (so the red for weddings in Asia becomes white in Western cultures). Even within the same culture, the same color may have contradictory meanings—like blue and yellow do.

Texture and Pattern

Texture is a surface characteristic that is tactile or visual. Tactile texture consists of physical surface variations that can be felt by the sense of touch. Sculptures often have distinctive tactile textures, such as Louise Bourgeois' Blind Man's Bluff (1984), figure 2.13, a marble sculpture with some velvety smooth areas and some roughly gouged areas. Even a painting or drawing may have a tactile texture, if the canvas or paper surface is rough, or if the medium produces a tactile texture. There are thick, textured brushstrokes in Thiebaud's The Pie Counter (figure 2.12). Sometimes a medium has an inherent texture. Mosaic is an example. Mosaic is a method of creating a picture out of small colored glass or stone pieces, which are glued to a surface. In the ancient Roman mosaic, Scraps of a Meal (second century, AD) by Heraclitus (figure 2.14), thousands of small pieces of stone result in a tactile texture.

Visual texture, on the other hand, is an illusionary texture on a surface which may be **simulated, abstracted,** or **invented.** Returning to *Scraps of a Meal*, we see that it has not only the tactile texture of the mosaic stones, but also illusionary visual textures that simulate actual

food scraps. The scraps appear bristly, smooth, fibery, or rough, giving the illusion that the mosaic floor of this room actually needs sweeping. Texture can be **abstracted** as well, meaning that they are based on some texture in reality, but have been simplified and regularized. Look back at the first illustration in this chapter, *Witchetty Grub Dreaming* (figure 2.1), where the curving grubs and the texture of dirt have been abstracted. The painting also has **invented** textures, which are apparently products of human imagination. The closely placed dots and strokes of paint that fill many areas are examples.

Pattern is a configuration with a repeated visual form (or forms). Texture and pattern are related, because if a pattern is reduced drastically in size, it is often perceived as a texture, and if a texture is greatly increased in size, it is likely to be perceived as a pattern. Natural patterns occur all around us, in leaves and flowers, in cloud and crystal formations, in wave patterns, and so on. In natural patterns the repeated elements may resemble each other, but not be exactly alike. The intervals between elements also may vary. Geometric patterns have regular elements spaced at regular intervals. They are common in math, interior design, and art.

Pattern in art is often an organizing element, and it may appear irregularly or with great regularity. In Thiebaud's *The Pie Counter* (figure 2.12), the pies repeat in an irregular pattern. The pies themselves, and the space, are not rigid. Figure 2.15 shows the exquisite wall pattern in the main portal of the *Masjid-i-Shah* (1612–1637), an Islamic mosque. Area upon area of pattern creates a striking visual impression. Some patterns are totally invented, some are geometric pattern, some contain highly abstracted plant forms, and some are highly sophisticated writing. Pattern can also have symbolic value. In our example here, the overwhelming variety and richness of the pattern is an Islamic device to

2.13 Louise Bourgeois. Blind Man's Bluff. USA, 1984. Marble, $91.5\times89\times63.5$ cms. Robert Miller Gallery, New York. See also the text accompanying figure 17.16.

express the idea that all the wonder of creation originates in Allah. Like texture, pattern can also simulate reality, be abstracted from reality, or be invented, as we can see in this portal.

2.14 HERACLITUS. *Scraps of a Meal*. Copy after Sosos of Pergamun's "The Unswept Room." Mosaic. Roman, second century. See also the text accompanying figure 6.20.

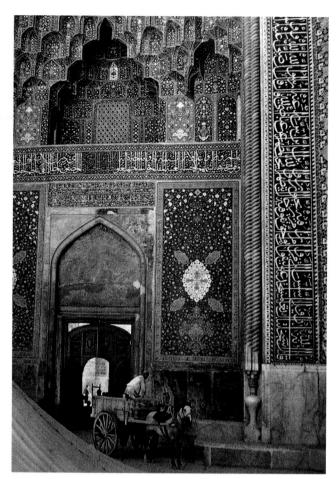

2.15 Detail of the main portal of the *Masjid-i-Shah*, or Royal Mosque, Isfahan, Iran. 1612–1637. See also the text accompanying figure 10.30.

We often see pattern used as **decoration**, for example, on wrapping paper, wall paper, fabric design, and so on. Pattern's function in these instances is to give visual pleasure. Yet pattern is also an important tool for thinking visually. Pattern helps organize ideas and concepts into visual diagrams that makes relationships clear. We see pattern as the basis of flow charts, street maps, mechanical diagrams, floorplans, and even in everyday doodles that people make to plan a project. We often used pattern in this book's diagrams to help explain certain concepts to you. Pattern is also the basis of the interface that allows you to use many computer programs—the windows, the toolbox, and the bar across the top of the screen allow you to navigate a program and make links between bodies of information. Patterns can be seen in the creative work of many artists, engineers, scientists, and untrained persons.

Shape and Volume

Two more elements in an artwork are shape and volume. **Shape** is a two-dimensional visual entity. **Regular shapes** are **geometric.** We have names for many regular shapes,

such as circle, square, triangle, hexagon, teardrop and so on. **Irregular shapes** are unique and often complex, and therefore have no simple, defining names. Instead, they are the shapes of mysterious rug stains, color patches of a cat's fur, star clusters in space, or the outline of a human body. Irregular shapes are often **organic** or **biomorphic**, in that they resemble living beings. Shapes can be created by defining their outer edges through line, or with color or value changes.

Volume is a three-dimensional entity, in contrast to shape which is two-dimensional. Like shape, volumes can be regular or irregular, geometric or biomorphic. And again, like pattern and texture above, shape and volume may have **simulated** reality, may be **abstracted** from reality, or may be **invented**. Volumes may have more or less physical bulk, or **mass**. An open or wireframe volume, like a bird cage, can be a large volume but have little mass. A large block of solid stone has both considerable mass and volume.

Let us discuss shape and volume as they appear in a couple works of art. Arthur Shaughnessy's Interior House Post carved in 1907 (figure 2.16) is a three-dimensional mass of shaped wood, abstracted from a bird and a bear. In addition, its surface is painted with various geometric two-dimensional shapes, which in turn are abstracted from feathers, eyes, claws, beaks, and so on. Louise Bourgeois' Blind Man's Bluff (figure 2.13) has different qualities. Its organic forms simulate women's breasts. The overall silhouette of her sculpture resembles a phallus, while it sits on a block that resembles a raw stone. Both Interior House Post and Blind Man's Bluff, however, are examples of sculpture as solid mass. In contrast, Cubi XXVI (figure 2.17), by David Smith from 1965, is a volume that incorporates voids and solids. Smith's geometric shapes and volumes seem to be invented, rather than simulated or abstracted, although his sculpture does recall the machine age and industrialism in its general appearance.

Space

When one hears the word space, one might think of the void of outer space, or perhaps of one's own personal space, or a work space. In art, space is the element that allows the object to exist. All artwork occupies space. Even "two-dimensional" works, such as paintings, are in actuality three-dimensional objects. In this section, we will look at three kinds of space in relation to art: 1) the kinds of space that exist on the flat picture plane; 2) the space of sculpture, which is both the area it occupies and the voids it contains; and 3) the space of performance art, installation, and intermedia work.

First, let us look at the many kinds of space in twodimensional art. The first kind is **planar space**, the height and width of the picture surface. The imagery in figure 2.18, *Nightway: Whirling Logs* (twentieth century), exists on the surface plane. Both images and back-

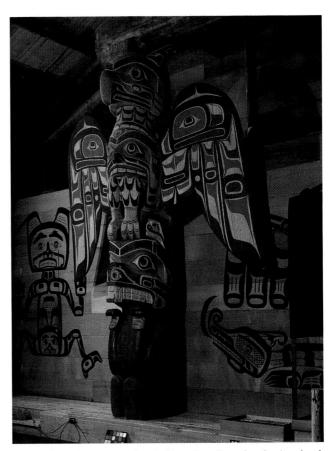

2.16 ARTHUR SHAUGHNESSY. *Interior House Post.* Carved and painted red cedar. 190" × 132" × 34". Kwakiutl, Gilford Island, British Columbia, 1907. Seattle Art Museum. See also the text accompanying figures 4.14 and 16.5.

2.17 David Smith. *Cubi XXVI*. Steel, approximately $10' \times 12'6'' \times 2'3''$. USA, 1965. National Gallery of Art, Washington, DC. See also the text accompanying figure 19.31.

ground appear flat. In *Self-Portrait with Monkey* painted in 1938 (figure 2.19), Frida Kahlo's imagery has the illusion of some depth. Her face and neck seems to have

2.18 Franc J. Newcomb. *Nightway: Whirling Logs*. Navajo, Native North American, prior to 1933. 22%" × 28%". Natural pigments and sand. Wheelwright Museum of the American Indian, Santa Fe, New Mexico.

volume because of **shading** (see "Value" above). Because of **overlapping**, her body appears to be in front of the monkey and plants, creating a shallow space.

To create the appearance of deeper space in pictures, artists use **perspective**, which are a group of methods for creating the illusion of depth on a flat picture plane. We already saw one example under "Value," where we discussed **atmospheric perspective** or **aerial perspective**, in which distant objects appear in low contrast and faded. Another kind is **linear perspective**, which operates on the theory that parallel lines appear to converge as they recede. They seem to meet on an imaginary line called the **horizon line**, or on eye level. The horizon line is the division between objects that are above the viewer's eye level in a picture, and those that are below.

There are three types of linear perspective, one, two, and three point, which are shown in the diagram in figure 2.20. In **one-point perspective**, the frontal plane of a volume is closest to the viewer, and all other planes appear to recede to a single vanishing point. In twopoint perspective, a single edge (or line) of a volume is closest to the viewer, and all planes appear to recede to one of two vanishing points. In three-point perspective, only a single point of a volume is closest to the viewer. and all planes seem to recede to one of three vanishing points. In figure 2.21, we see Leonardo da Vinci's Last Supper (1495–1498), a precise exercise in one-point perspective. The vanishing point is Christ's head, located exactly in the center of the pictorial space. All the parallel planes in the room converge behind to that vanishing point, which emphatically emphasizes the Christian symbolism of redemption through Christ.

Two other systems to show space in a picture are isometric perspective and oblique perspective. **Isometric perspective**, which is especially used in architectural drafting, renders planes on a diagonal that do not recede in space (figure 2.22). The side planes are drawn

at a thirty-degree angle to the left and right. In **oblique perspective**, a three-dimensional object is rendered with the front and back sides parallel (figure 2.22). The side planes are drawn at a forty-five degree angle from the front plane. In figure 2.23, *Babur Supervising the Layout of the Garden of Fidelity* (c. 1590), we see the box-like gardens painted in oblique perspective. The parallel planes of the gardens do not visually recede.

Text Link
Compare the deep space and use of the horizon line in this painting of the Harvesters (figure 6.18) with the shallow space in Nightway: Whirling Logs.

Finally, artists may use **multipoint perspective** in an image, where they may employ many different systems for various details, all in the same drawing. Picasso mastered the use of multipoint perspective in his works in Cubism. In *Guernica* (1939) for example (figure 2.3), he uses this pictorial device in the imagery of the bull's

2.19 Frida Kahlo. *Self-Portrait with Monkey*. Oil on masonite, $16" \times 12"$. Mexico, 1938. Albright-Knox Art Gallery, Buffalo, NY. Bequest of A. Conger Goodyear, 1966. See also the text accompanying figure 15.8.

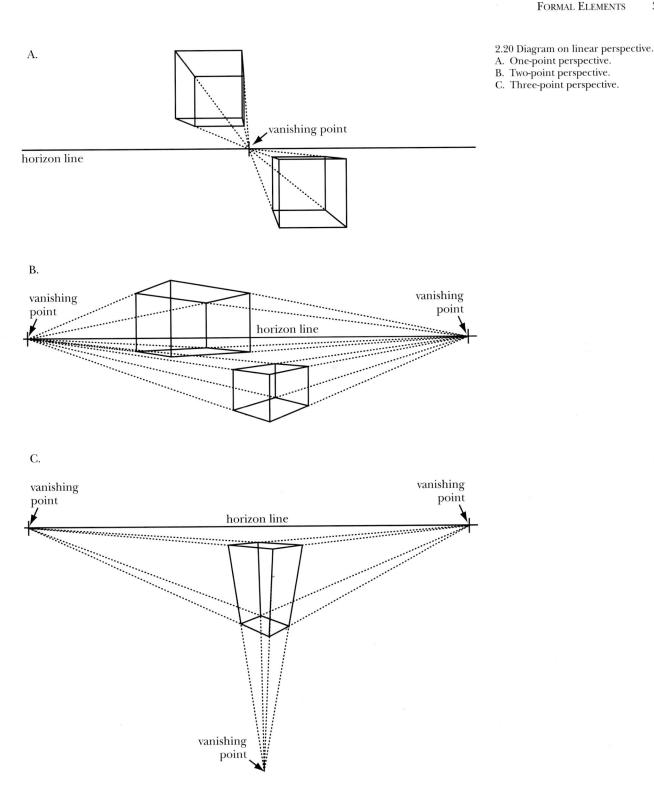

head. The head is depicted in both a frontal and profile view. In fact the overall composition of the painting is faceted with shapes and values that emphasize several multipoint perspectives. With this technique the space in the painting is contrived and appears ambiguous. Artists also may use amplified perspective in order to give their imagery dramatic emphasis as seen in figure 2.24, Echo of a Scream (1937). The baby's face is exaggerated, achieving a harsh visual impact, which is the intent of the piece.

Now, let us turn to space in sculpture. First, that space consists of voids and solids within the sculpture itself. We already saw David Smith's Cubi XXVI (figure 2.17), where the voids within the sculpture are important parts of the

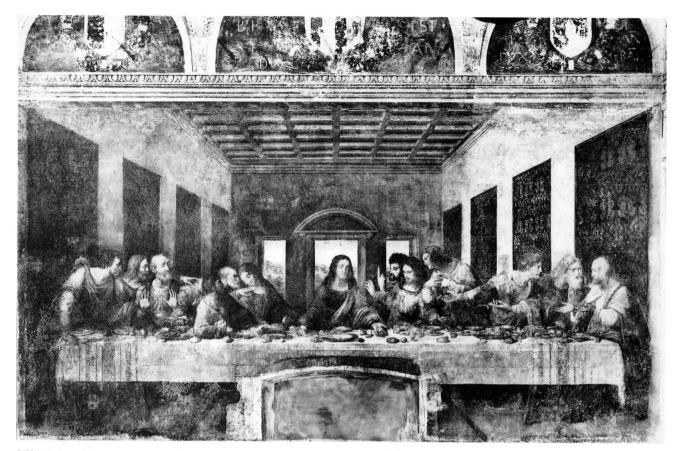

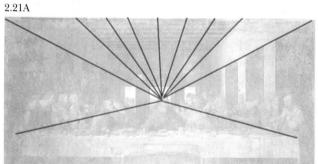

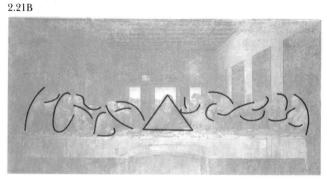

2.21 Leonardo da Vinci. Last Supper. Experimental paint on plaster. $14^{\circ}5^{\circ} \times 28^{\circ}$. Milan, Italy. 1495-1498. Diagram 2.21A shows one-point perspective. Diagram 2.21B shows the curving and pointing gestures that capture the moment of betrayal. See also the text accompanying figures 6.27, 20.22, 21.4, and 21.24.

2.22 A. An example of an OBLIQUE projection. B. Example of a ISOMETRIC projection.

overall design. They create the suggestion of other "missing" geometric shapes. These voids are called the **negative space** in an artwork. Sculptural space includes the volume that a sculpture occupies. *Cubi XXVI* occupies a considerable amount of floor and air space, giving it a presence that is beyond just the mass of the materials alone.

Space is an essential element in installation, performance and intermedia art. In figure 2.25 we see Jenny Holzer's installation, *Untitled (Selected Writings)*, dated 1989, which she created specifically for the interior space of the Solomon R. Guggenheim Museum in New York. This piece can only appear as it is in this space. To

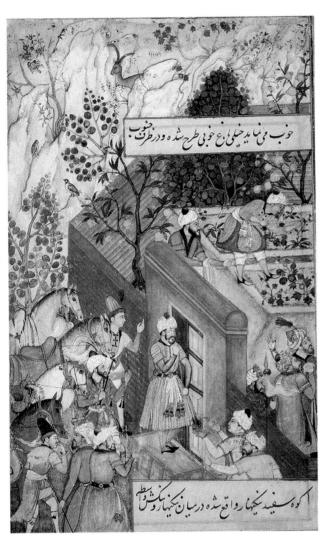

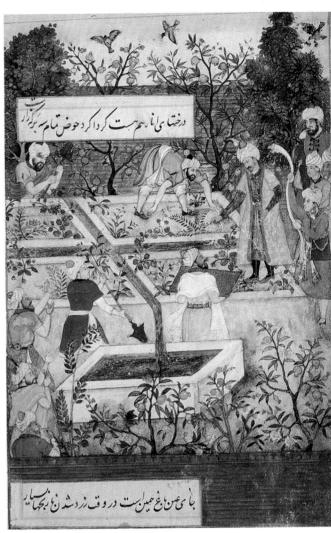

2.23 BISHNDAS, PORTRAITS BY NANHA. Babur Supervising the Layout of the Garden of Fidelity. Manuscript painting, gouache and gold on paper, 21.9×14.4 cms. Mughal, India, c. 1590. Victoria and Albert Museum, IM 276–1913. See also the text accompanying figures 19.14 and 20.26.

install it in another space, the elements in the piece would have to be rearranged to fit the space of its installation, thus creating a new piece, even though it might be a variation of the former work.

Time and Motion

Something that is invisible, but certainly impacts everyone's life, is time. Time is an important element in all artwork. For static work, or art that does not move, time is the period when the audience receives the artwork, for example, the interval during which someone stands in front of a painting and contemplates it. For artists who make nonstatic works of art, **time** is the continuum in which they present images and events. Related to time is **motion**, the act or process of something changing place. Obviously, motion cannot exist without time, and motion is also one way to illustrate the passage of time.

Time and motion are important components in Jenny Holzer's installation, *Untitled (Selected Writings)*. Short sentences scroll upward at a fast pace on a long spiral flashing display that circles the inside of the Guggenheim museum. The words are in motion, and move fast, and so we have only limited time to try to make sense of them as they rush by. The longer we stand there, the more phrases move past us. Motion and time are important components of performance or ritual art. Figure 2.26 shows a performance by *Kanaga Masked Dancers* of the Dogon people of Mali, Africa. The human body in motion is a frequent component in performance art. Film and video are two time- and motion-based media.

Artists have found ways to express time and motion in static art. We already saw one example early in this chapter, with Käthe Kollwitz's *Outbreak*, where line direction implied motion. Another way is visually to

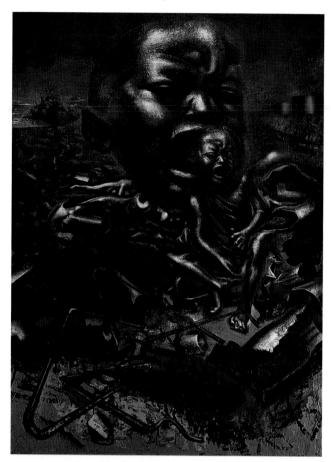

2.24 DAVID ALFARO SIQUEIROS. *Echo of a Scream*. Duco on wood. Mexico, 1937. Museum of Modern Art, New York. See also the text accompanying figures 1.5 and 14.5.

recreate a narrative sequence in which some action occurs. We see this in the Last Supper (figure 2.21B), where Jesus has informed his followers that one of them will betray him, and the followers recoil in response. Implied motion is another device to express movement. Umberto Boccioni used implied motion in his sculpture, Unique Forms of Continuity in Space, dated 1931 (figure 2.27). The forward attitude and flowing forms of the figure suggests acceleration and speed, almost as if a race was going on. Repeated imagery also express motion in static art. In 1885 Eadweard Muybridge photographed Handspring, a flying pigeon interfering (figure 2.28), with two sequences of images that arrest motion at specific time intervals. His work was a precursor to film.

Chance/Improvisation/Spontaneity

Many artists purposely structure their work so that it allows for the introduction of the elements chance, improvisation, or spontaneity. Those chance, improvised or spontaneous occurrences strongly affect the visual organization of the artwork. It may seem strange to include the "uncontrolled" as elements of composition. Yet to many artists, they are opportunities to incorporate the unexpected into a work, or to make it unique each time it is seen.

In Household (1964), figure 2.29, the artist Allan Kaprow carefully planned the event, but in doing so he did not control the outcome. His role as artist was to

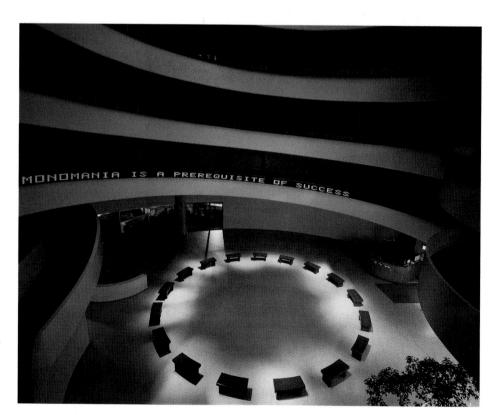

2.25 JENNY HOLZER. Untitled (Selected Writings). Extended helical LED electronic signboard, with selected writings: 17 Indian Red granite benches. Installation view at Solomon R. Guggenheim Museum. USA, 1989. Photo: David Heald, courtesy Solomon R. Guggenheim Museum. See also the text accompanying figure 14.24.

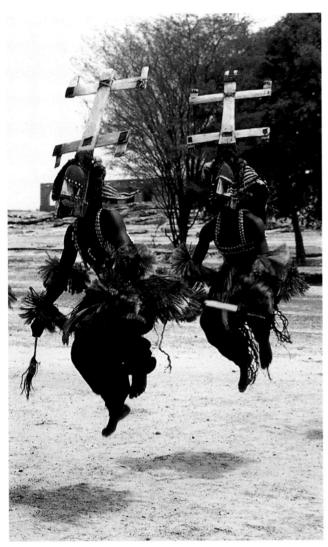

2.26 Kanaga Masked Dancers. Dogon people, Mali, Africa, twentieth century. See also the text accompanying figure 18.18.

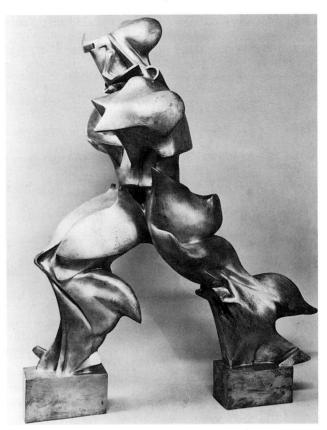

2.27 UMBERTO BOCCIONI. *Unique Forms of Continuity in Space*. Bronze cast 1931, approx. 43.3" high. Italy, 1913. The Museum of Modern Art, New York; acquired through the Lillie P. Bliss Bequest. See also the text accompanying figure 15.19.

set up certain parameters that allowed for audience improvisation. Likewise, in Yves Tingueley's *Homage to New York* (1960), figure 2.30, it was important that the artwork self-destruct in an uncontrolled way, even though Tingueley set it up to do so. With Lynn Herschmann's *Deep Contact* (1990), figure 2.31, the viewers/participants have unique experiences of the artwork

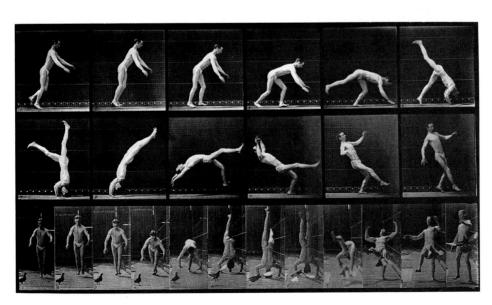

2.28 EADWEARD MUYBRIDGE.

Handspring, a flying pigeon interfering,
June 26, 1885. Print from an original
masternegative, Plate 365 of
"Animal Locomotion." British
Scottish–American, 1887.
International Museum of
Photography at George Eastman
House, Rochester, New York.
See also the text accompanying
figure 15.17.

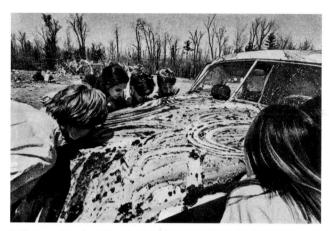

2.29 ALIAN KAPROW. *Household, Performance "Happening"*. Commissioned by Cornell University, NY, May 1964. See also the text accompanying figure 18.14.

that are different from everyone else's, because of the choices they make as the program is running. In addition, their faces are introduced into the art piece by means of a video camera that is trained on them as they interact with *Deep Contact*.

Chance can be incorporated into traditional artworks through found objects and collage. By incorporating these "ready-mades" into their work, artists allow for the introduction of elements which they did not create, and therefore do not entirely control (even though they selected them). The ready-mades bring with them a host of meanings and associations.

Engaging All the Senses

While we tend to think of art in visual terms, many artworks appeal to other senses as well. The *Kanaga Masked*

Dancers (figure 2.26) is one obvious example. The dancers perform to music, and that sound component is completely integral to the art. Many artworks appear to be strictly visual, especially when on display in an art museum. Some of them, however, have been taken from their original context, and were not simply visual in their original state. The *Interior House Post* (figure 2.16), which we saw earlier, sits mutely on display at the Seattle Art Museum, but it was actually made originally to be part of a large ritual celebration that included feasting, dancing, and storytelling.

For the last several centuries, most Western art has emphasized the visual component. Examples are too numerous to count, but just in this chapter alone we have already seen this phenomenon with Leonardo's Last Supper, Raphael's Madonna of the Meadow, Picasso's Guernica, and so on. Recently, however, that has changed. The erotic nature of Louise Bourgeois' Blind Man's Bluff (figure 2.13) invites touch, while museum protocol forbids it, creating some of the tension in the piece. Other works are more accommodating to all the senses. Film and video have entered the fine arts area, and sound again is an essential formal element, as essential to the whole as the visual. Yves Tingueley's Homage to New York: A Self-Constructing, Self-Destructing Work of Art (figure 2.30) was not so much an object as a spectacular event, as an artwork/machine destroyed itself amid the sound of crashing machine parts and the smell of smoke.

Other works of art invite spectators to become participants, where their own actions and sounds create the piece. In some cases, they may experience a piece through taste, touch, and smell, in addition to sight and

2.30 JEAN TINGUELY. Homage to New York: A Self-Constructing, Self-Destructing Work of Art. Mixed media sculpture; photograph of the work as it self-destroyed in New York on March 17, 1960. Photo by David Gahr. See also the text accompanying figure 19.33.

2.31 Lynn Hershmann. *Deep Contact.* USA, 1990. Interactive computervideo installation at the Museum of Modern Art, San Francisco. See also the text accompanying figures 17.14 and 21.22.

sound. Allan Kaprow's *Household* (figure 2.14) was an art event called a Happening, with many participants—who were also the audience members! In the course of the Happening, they ate, fought, built, screamed, destroyed, and did many other things, in a loosely scripted event that dealt with gender tensions. Obviously, this was a work that engaged all the senses.

PRINCIPLES OF COMPOSITION

Now that we have the formal elements of art, it is necessary to see how artists put them all together successfully in an artwork. The arrangement of the formal elements in a work of art is called its **composition**. There are guides that facilitate the composing of an artwork, and they are called the principles of composition. Those principles include balance, rhythm, scale, proportion, emphasis, variety, and unity. We'll look at each principle and see how they function in an artwork.

Balance

Balance in an artwork is the placement of all the elements of the composition so that their visual weights seem evenly distributed. What does it mean for a visual element to have "weight"? Generally it is the amount of attention an element commands from the viewer. For example, large shapes demand more attention than small; complex forms have greater visual weight than simple ones; and vivid colors are visually weightier than faded colors. When artists compose their artwork, they arrange the visual elements to balance them in a way that helps express the work's theme. Now let us look at the several types of balance to be seen in artwork.

In **symmetrical balance**, equal weight is distributed evenly throughout the composition. If an imaginary line could be drawn vertically down the center of the work, one side would mirror the other. Arthur Shaughnessy's *Interior House Post* (figure 2.16) is an example of symmetrical balance. All elements are flipped, but are the same, on both sides of the imaginary vertical line. When artists use symmetrical balance to organize their compositions, they often want to express formality, order, and stability. Because symmetrical balance is so visually obvious, it often creates an impression of clarity, and not ambiguity.

In **asymmetrical balance**, visual weights are still evenly distributed, but there is no mirror image on each half of the composition. Balance is achieved by the careful distribution of uneven elements. Look at Marisol's sculpture, *The Family* (1962), figure 2.32. The work is balanced, but it is visually challenging and rewarding to see how the artist achieved that balance. The mother figure is off-center, as are the doors in the background. This apparent lack of balance is compensated for by the two girls on one side versus the boy and the baby on one knee. The painted decoration keeps your eye at the center of the composition. Works of art with asymmetrical balance are more unexpected, less predictable, and often more dynamic than symmetrically balanced works.

Radial balance occurs when all of the elements in the composition visually radiate outward from a central point. We have already talked about the line quality in Witchetty Grub Dreaming (figure 2.1), but the radiating lines also unite the entire composition. The small curved lines create an overall interlace pattern, while the larger lines form a bold shape. The patterns and shapes radiate out from the center, and all is in balance. Although it certainly can communicate other ideas, radial balance is often an organizing principle in spiritually based art, featured in mandalas, church windows, temple plans, and mosque domes.

Balance does not have to always occur around a vertical axis. Elements can also be balanced along a diagonal in the composition. Equally weighted elements can be scattered throughout a composition. Balance sometimes happens across time, in performance art, video, or film. For example, in *Household* (figure 2.29), the women

built a "house" that resembled a nest, an action balanced by the men who built a tall tower. Subsequently the men destroyed the women's nest, and later still the women destroyed the tower, another set of balanced actions.

Balance, of course, can be achieved in other ways beside these few outlined here. Whatever system is used, it is interesting for viewers to see how artists arrange their compositions so that balance is achieved in any work of art.

Rhythm

Rhythm in music or poetry consists of repetitive beats, separated by intervals. In an artwork, **rhythm** is the regular repetition of elements carefully placed in a composition, again separated by intervals. These beats may be regular, eccentric, smooth, jerky, fast, slow, progressive, circular, up and down, and alternating. These recurrent visual "beats" move the viewer's eye through

the composition to give it its rhythm. Rhythm is related to pattern, which we discussed on page 29. Rhythm, however, relates to the entire composition, while pattern can be merely one element within a composition. We will take a look at a few examples of the several types rhythm woven into art compositions.

Regular rhythm is smooth and even, where some visual element is systematically repeated, with a standard interval in between. Closely related is alternating rhythm, where different elements are repeatedly placed side by side, which produces a regular and anticipated sequence. The *Primordial Couple*, c. nineteenth century (figure 2.33), from the Dogon people of Africa, is an excellent example of visual rhythm. Look at it from side to side. The dark sculptural forms alternate with the voids, or negative spaces. The artist used a rhythmic progression to determine the placement of forms within the composition. The Dogon people associate that rhythmic placement with a sense of order and clarity.

2.32 Marisol.. *The Family*. Mixed media construction. USA, 1962. Museum of Modern Art, New York. See also the text accompanying figure 16.10.

2.33 *The Dogon Primordial Couple.* Mali, Africa, c. nineteenth–twentieth centuries. Wood, 29" high. The Brooklyn Museum. See also the text accompanying figure 7.14.

Eccentric rhythm is irregular, but not so much so that the visual beats do not connect. Magdalena Abakanowicz' *Backs* (1976–1982), figure 2.34, shows a group of hunched figures, slightly irregular in size, with slightly irregular intervals in between. Her work addresses the conditions of humans in oppressive conditions. The visual rhythm seen in the placement of the backs in linear formation communicates the idea of forced conformity.

A wide range of rhythmic possibilities exist in art, just as they exist in music. For example, **progressive rhythm** occurs when the visual beat of the composition may change from slow to fast, or fast to slow. Rhythm is also inherent in any pattern. Review the pattern section, with the examples of Thiebaud's *The Pie Counter* (figure 2.13) and the Main Portal of the *Masjid-i-Shah* (figure 2.15). Rhythm can also happen in actual time, in performance, video, and computer art. We have already seen that the performance art, *Household* (figure 2.19), consisted of rhythmic alternating actions by the women and men performers. *Deep Contact* (figure 2.31), an interactive

computer piece by Lynn Herschmann, featured a seductively dressed "guide" or "hostess," Marion, who regularly reappears throughout the piece, alternating with other imagery and text.

Proportion and Scale

Proportion refers to the size of one part in relation to another within a work of art, or the size of one part in relation to the whole. Let us compare the use of proportion in two works of art.

The Doryphoros (c. 450–440 BC), figure 2.35, is an ancient Greek sculpture in which proportion was tremendously important. The sculptor Polykleitos was well-known for having developed a canon of proportions, and this work illustrated it. Thus, the size of the face is one-ninth the size of the whole figure. The length of the middle finger is exactly one-half that of the entire hand, and the length of the arm is proportional to that of the hand, and so on. The ancient Greeks translated the proportions of part to part into mathematical ratios. They believed that certain ratios expressed beauty and perfection in the human figure, and in art, architecture, and music. Furthermore, those proportional relationships echoed the harmonies of the entire cosmos. Doryphoros is a relatively sturdy, squarish figure because of the proportional relationships that guided Polykleitos as he made this work. Doryphoros resembles a stocky, youthful male with a well-developed physique.

By comparison, the *Venus of Willendorf* (c. 25,000 –20,000 BC) figure 2.36 exhibits different kinds of proportions, and for different reasons. This sculpture certainly resembles a female figure, but the proportions are exaggerated. Breasts, belly, and buttocks are bulbous and proportionally enlarged compared to the rest of the figure. Conversely, the arms are greatly shrunken, face is deemphasized, and feet are nonexistent. The unknown sculptor of the *Venus of Willendorf* chose these proportions to guide the composition of this sculpture. The exaggerated body parts correspond to female reproductive forms, presumably making this a fertility goddess or charm.

Scale is the size of something in relation to what we assume to be "normal." *Doryphoros* was sculpted on a large scale, larger than life-size. The *Venus of Willendorf*, on the other hand, is small-scale at just over four inches high! Scale is an important early decision an artist makes about a work. The size of the work affects its overall impression and meaning. In the case of figurative sculptures, it matters to us, the viewers, whether we are looking at a human form that is our size, bigger than we are, or smaller.

Scale is very deceptive when we are looking at art only in books. You often have no way of knowing how large an artwork is, just by looking at its reproduction. Reading the caption gives you some information, but you have to exert your imagination to really "see" the *Doryphoros* standing in front of you, nearly seven feet tall, and the *Venus of*

Willendorf easily fitting into your hand. Whenever possible, it is always best to see the original art work rather than rely on the impression given in reproductions.

We saw with the *Venus of Willendorf* that proportion could be changed to express a certain idea. The same thing holds true with scale, including the scale relationships within a picture. *Otto III Enthroned Receiving the Homage of Four Parts of the Empire*, dated 997–1000 (figure 2.37) shows the Emperor Otto III seated on a throne in the center of the composition. Even seated, he is larger than the standing figures who attend to him. This is an example of **hieratic scaling**, when the higher rank of Otto III dictates that he is rendered larger than

other figures in the composition. The picture clearly shows Otto's royal status.

Emphasis

Emphasis is the creation of one or more focal points in an artwork. When there are several focal points, the ones with lesser emphasis are called **accents.** Emphasis enables the viewers to know what is the most important element within a composition.

Going back to *Otto II Enthroned Receiving the Homage of Four Parts of the Empire*, we have no doubt that the artist intended Otto to be the focal point of the composition. How did the artist achieve that effect? First of all, size: as

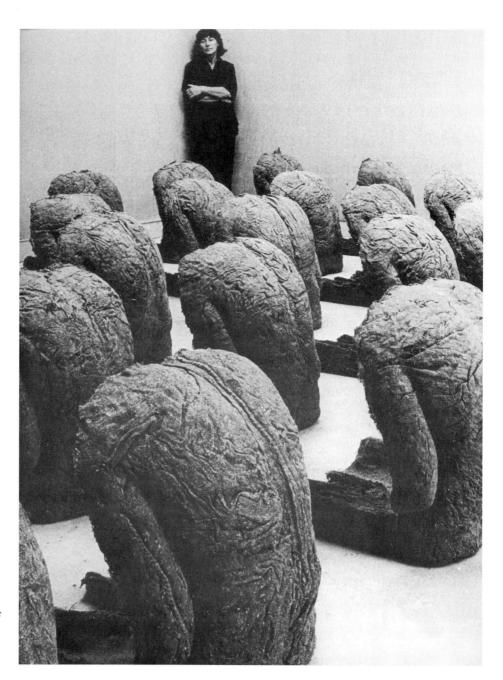

2.34 MAGDALENA ABAKANOWICZ. Backs. (Detail, with the artist standing in the background.) 80 pieces, burlap and glue, each over life-size. Poland, 1976–1982. See also the text accompanying figure 14.23.

2.35 POLYKLEITOS. *Doryphoros (Spear-Bearer)*. Roman marble after a bronze original of c. 450–440 BC. 6'11" high. Museo Nazionale, Naples. See also the text accompanying figures 5.3 and 15.12.

we already noted, Otto is bigger than the rest. Another way to create focal points is by placement: Otto's face is at the upper center of the image, a natural resting point for our eyes as we first study a picture. Directional forces are also important factors. The glances of the attendants lead us to Otto's face. Contrast is also important. Otto's light face strikingly contrasts with the dark background, drawing our eyes to that area. Pattern helps too, aligning eye-catching background details with Otto's face and crown. Moving down the priority list, we can see that the faces of the attendants and the background architecture compete next in importance, while the garb of the attendants is less emphasized.

Sometimes there are no particular parts that are emphasized within a composition. Magdalena Abakanowicz' *Backs* (figure 2.34) has a uniformity to all its parts, but again that fits with the theme of her work.

Unity and Variety

Unity is the quality of overall cohesion within an artwork. **Variety** is the element of difference within an artwork. They would seem on the surface to be mutually exclusive qualities, but in fact they coexist in all artworks, evoking in viewers a fascination that makes them keep coming back, and keep looking. The sameness of Abakanowicz' *Backs* seems to be an obvious expression of unity. The figures hunch forward, side by side, without motion. Yet even within this piece, there is subtle variety in the posture and texture that gives us a sense of individuality within an image of deadening uniformity.

2.36 Venus of Willendorf. Early fertility figure. Stone, height 4% . Austria c. 25,000–20,000 BC. See also the text accompanying figure 7.1.

2.37 Otto III Enthroned Receiving the Homage of Four Parts of the Empire. From the Gospel Book of Otto III, illumination, 14" × 10", 997–1000, European. See also the text accompanying figure 12.5.

How is unity achieved, though, in an artwork that has much more variety than *Backs*, an artwork like *Otto III Enthroned* . . .? In cases like that, the quality of unity is necessary so that the composition works together as a whole. In this instance, color is a significant unifying element, as all forms are colored in bright blues, purples, reds, and oranges. Also, all forms are clearly outlined with only a minimal amount of shading, which again unifies all the imagery. The overall near-symmetrical balance also helps unify the image, as one form has an echo of itself on the opposite side of the painting. The singular focus on Otto III also unifies the work.

Of course, the way unity is achieved is different from artwork to artwork. All artists have the visual elements and the principles of composition at their disposal, but the exact way that each creates a successful work of art can be endlessly varied. Returning to the *Doryphoros*, we see a unified work of art, but with unity achieved in a much different way than *Otto III Enthroned*. . . . The unity of *Doryphoros* is achieved by the assymetrical balancing of opposites. A straight arm balances a curved one; likewise we see this with the legs. Balance is the unity part, while the asymmetry represents variety. The turn of the head suggests movement in one direction, balanced by the direction suggested by the feet. The tensed arm is curved, and is located diagonally opposite to the straight leg, which is also tensed. That diagonal opposition is also

evident in the bent leg and straight arm, which are both relaxed states.

ART MATERIALS AND MEDIA

We have seen the visual elements of the language of art, and the principles by which they are composed. But artworks are realized through the material and media. **Material** is the physical substance that the artist uses to make a work of art. A **medium** is a mode of artistic expression and communication, such as oil painting, film, or silkscreen printing. Obviously medium and materials are related. They are what the artist uses to create the work. Materials and media affect meaning as well as enable the artwork to exist. We will look at a variety of art materials and media, some traditional and some nontraditional.

Natural and Synthetic Materials

Art can be made from an astounding array of materials. Not the least of these is the human body. Humans have used their bodies in performance, have had them painted and tattooed as art forms, have participated in ritual dances in costumes and masks, have practiced scarification, and so on. In Chapter 15, The Body, we will look at a number of works where the body is material for art.

2.38 Mesquakie Bearclaw Necklace. Detail. Tama, Iowa, USA, c. 1860. See also the text accompanying figure 12.9.

2.39 Walter De Maria. *The Lightning Field.* 400 stainless-steel poles, average height 20'7"; land area 1 mile × 1 kilometer in New Mexico. USA, 1971–1977. Photograph by John Cliett. © Dia Art Foundation 1980. See also the text accompanying figure 19.18.

Materials that are readily available in nature are commonly used for art. Sculpture and architecture often use stone, clay, and wood. A fine example of the use of animal materials can be seen in the Mesquakie Bearclaw Necklace (1860), figure 2.38, made of fur and grizzly bear claws. Sand and natural pigments of pollen, charcoal, and crushed stone were art materials for the Navajo. We already saw Nightway: Whirling Logs (figure 2.18), a painting created directly on the ground with natural pigments for the healing ritual, connecting the artwork to nature itself. Natural fibers can be woven into baskets, mats, and clothing. Even lightning has been used as an art material in Walter De Maria's Lightning Field (1971–1977) figure 2.39, where 400 stainless-steel poles over a large area in New Mexico attract lightning strikes during the electrical storms that seasonally occur

Manufactured or synthetic materials have provided artists with more art materials. Metals, glass, ferroconcrete, fiberglass, synthetic pigments, and plastics are just a few artists have explored. Unexpected elements can become material for art. Mierle Laderman Ukeles combined glass and metal with a New York City garbage truck in *The Social Mirror* (1983), figure 2.40. The mirrored sides of the garbage truck reflect the onlookers, dramatically showing us the individuals that together comprise the society that has created an immense waste problem on the planet. **Found objects,** such as old doors and shoes can be incorporated into art, as happened in Marisol's *The Family* (figure 2.32). Fragments

from newspapers and magazines can be **collage** material for artists.

Art materials are significant, important elements in the language of art. The material used affects the formal qualities of an artwork. Even if it is the same in every other way, a sculpture is different if it is carved out of wood or if it is made from poured concrete. Wood is flexible; its grain adds pattern to the work; its colors are often yellow-, red-, or brown-based; and it is warm to the touch. Poured concrete by contrast is rigid, often gray, and colder to the touch. In addition to those formal qualities, the materials often change the meaning of the work of art. We will see more of this in Chapter 4, when we delve more into how meaning is built into art. But for now, we can say that wood is associated with warmth, with nature, and with tradition, while concrete seems colder, bland, and modern. Those attributes of material come to be associated with the artwork that is made out of them. In addition, material can affect monetary value, for example, if a work of art is made out of gold or goldtoned plastic.

Art Media

Art media refers to the particular techniques for making art that often use materials that have been specially developed for those techniques. There are many art media that have well-established histories and have been used repeatedly by artists in many cultures. We can subdivide them into painting media, printmaking media, sculptural media, and technology-based media. Figure 2.41

2.40 MIERLE LADERMAN UKELES. The Social Mirror. 20-cubic-yard New York garbage collection truck fitted with hand-tempered glass mirror with additional strips of mirrored acrylic. USA, 1983. Photograph: The New York City Department of Sanitation. See also the text accompanying figure 19.20.

PAINTING

Painting media consist of three basic components: pigment, binder, and support. **PIGMENTS** are intense colors in powder form, derived from animals, plants, minerals, and synthetic chemicals. The **BINDER** is the liquid into which the pigments are ground, and which holds the pigment particles together once the paint dries. The **SUPPORT** is the surface upon which the painting is made. Supports include canvas, wood panel, paper, plaster walls, and so on

ACRYLIC: Paint made with pigment ground into a synthetic polymer liquid, which quickly dries into flexible film. A 20th century invention. Acrylics can be used thickly, or thinned with water to give thin stains. They can be applied directly to paper, canvas, or wood supports. One example is Paddy Carrol Tjungurrayi's *Witchetty Grub Dreaming* (see Chapter 6, Figure 6.2).

ENCAUSTIC: One of the most ancient forms of paint. Pigments are mixed into hot beeswax, and can be manipulated until the wax cools. Encaustic paintings thousands of years old still have brilliant colors and lustrous surfaces.

FRESCO: Fresco is often used for big murals. There are two kinds of fresco. In **buon fresco**, or true fresco, finely ground pigment suspended in water is

applied to a wet plaster surface. The pigment becomes totally bonded with the wall surface once the plaster dries, resulting in a very durable painting. Since plaster dries quickly, however, the fresco painter must work quickly, and in small areas rather than working over the entire painting. Colors are generally muted in buon fresco, because they are soaked into the plaster. In **secco fresco**, paint is applied to an already dry plaster wall. Colors are more brilliant, but the painting is less durable and more likely to flake off the wall because the pigment has not bonded with the plaster. Diego Rivera's *Dia de Los Muertos* (Chapter 11, figure 11.28) is an example of fresco painting.

INK WASH/WATERCOLOR: Ink is a black or colored material used for writing and drawing. It usually comes in liquid form, but it is also available in dry sticks that must be ground in water to become liquid. Ink can be diluted with water and applied to paper with a brush to make a light-toned wash. An example of ink drawing is Sheng Maoye's *Beyond the Solitary Bamboo Grove* (Chapter 19, figure 19.8).

Watercolor is related to ink wash, except that watercolors are pigments suspended in a gum arabic solution (gum arabic is a natural glue). Both ink wash and watercolor are applied as thin stains to the paper, and depend upon paper quality and color for much of their effect.

OIL: Powdered pigments are mixed with oil, usually linseed, and often with varnishes and turpentine. Oil paint is applied onto a support, most often wood or canvas, that has been primed. The oil dries slowly to a hard, durable, flexible film. Artists have an extended time to mix and manipulate their colors before the paint dries. When dry, the paintings can have high-intensity color with lustrous, glowing surfaces. Oil painting was invented in Northern Europe more than 500 years ago, and is popular for easel painting. Jan Davidsz de Heem's *A Table of Desserts* is an oil painting (see Chapter 6, figure 6.22).

TEMPERA: Traditional tempera painting consists of pigments mixed with egg yolk as the binder. Egg tempera is a very strong, quick-drying medium that is excellent for sharp lines and fine details. Gradual tonal transitions must be created by hatching, as wet areas cannot be easily blended together because they dry so quickly. Egg tempera is usually painted on a wood panel support, because it is not flexible and cracks easily. Egg tempera should not be confused with common school tempera paints, which water-based and are not durable.

PRINTMAKING

Printmaking includes any media that can create multiple copies of the same image.

INTAGLIO: Intaglio comes from the Italian verb meaning "to cut into." Artists cut into a flat surface, usually a metal plate, to make the design. Ink is applied into the cutaway areas (and wiped off the rest of the surface), and then plate and paper are sent through a press to transfer the image to paper.

Intaglio prints can have fine lines, a high level of detail, and rich dark tones. There are several intaglio processes. With **drypoint**, artists scratch a mental plate with a thin, pointed tool. **Engraving** entails cutting lines into a polished metal plate with a sharp tool. In **etching**, the metal plate is coated with a sticky protective substance called a ground, into which the artist scratches away a design. The plate is then put into an acid bath, which "eats away" the exposed metal surface. These etched areas hold the ink during printing. An example of engraving is the *Fourth Plate of Muscles*, by Andreas Vesalius. (Chapter 19, figure 19.21).

LITHOGRAPHY: A 19th-century invention, lithography starts with drawing with an oily crayon on a stone or metal surface. The rest of the surface is treated with water-based substances to be oil-

repellent. The printing is then done with oil-based inks that print only from the oily areas of the stone or plate. Lithographs tend to look much like drawings. Our example is from Henri de Toulouse-Lautrec's *Jane Avril* (see Chapter 18, figure 18.12). Commercial printing is an industrial version lithography: this book was printed with that process, called **offset lithography**.

RELIEF PRINTING: Areas not meant to be printed are cut away from the printing surface, so that areas to be printed are left higher. Ink is applied to those higher surfaces, and then sent through the press to transfer the image to paper. One of the most common forms of relief printing is done on wood blocks, as seen in Kitagawa Utamaro's *A Pair of Lovers* (Chapter 7, figure 7.20).

SCREEN PRINTING: A stencil is attached to a piece of fabric stretched over a frame, forming a screen, that supports and gives strength to the stencil. Ink is then squeezed through the open areas of the stencil and deposited on paper below. Andy Warhol's *Heinz 57 Tomato Ketchup and Del Monte Freestone Peaches* (see Chapter 6, figure 6.4) are examples of silkscreen on wood.

SCULPTURE

Sculpture can be **free-standing**, or meant to be seen from all sides. Or it may be **relief**, in which forms projects out from a surface, and are primarily visible from the front only. **Site-specific sculpture** has been designed for a particular place, and cannot be moved without changing its form and meaning. **Kinetic sculpture** has moving parts.

ASSEMBLING: Sculptures can be made from various fabricated parts that are then put together. Almost any material can be assembled into sculptures, including wood or metal. Sometimes found objects or readymades are included, resulting in works called **assemblages.** Marisol's *The Family* (see Chapter 16, figure 16.10) is assembled from various blocks of wood, which are carved, painted and drawn, and also found objects such as doors and shoes.

CARVING: Artists cut away unwanted material from a large block to create a carving. This is considered a subtractive sculptural process, because material is taken away. The most common carving materials are wood or stone. The *Yakshi*, from ancient India, was carved from a block of sandstone. (see Chapter 15, figure 15.11).

CASTING: A sculptural form is made first in an easily manipulated material, such as wax or clay. A mold is made around the original sculptural form, and then removed. A more durable material, such as plaster or molten metal, is poured into the mold, resulting in a solid, durable sculpture. All except the smallest sculptures, however, are hollow cast by means of the **cire perdue**, or **lost wax casting**, method. It results in hollow metal sculptures with thin walls. A thin layer of wax is suspended between an interior and exterior mold. The wax is melted out and replaced with molten metal. *Crowned Head of Oni* (see Chapter 12, figure 12.4) is a cast sculpture made with the lost wax process.

MODELING: Sculptural forms are created by pushing and pulling a malleable substance, such as clay or wax. Often this is considered an additive sculptural process, because material is built up to create the final sculptural form. Clay is a common modeling material used for sculpture and ceramic, and when fired becomes hard and very permanent. The Aztec *Eagle Warrior* is a life-sized ceramic sculpture (see Chapter 13, figure 13.7).

TECHNOLOGY-BASED MEDIA

PHOTOGRAPHY: A photosensitive surface, such as film, is exposed to light through a lens, which creates an image from the environment on that surface.

Multiple copies can be made of that original image onto other light-sensitive surfaces. Louis Daguerre's daguerreotype was an early form of photography, dating from the 1830s. Platinum prints and silver prints are two black-and-white printing processes. Color photography came into common use after the 1940s. Dorthea Lange's *Migrant Mother, Nipomo, California* (Chapter 16, figure 16.25) is a photograph.

FILM: A sequence of still photographs shot in rapid succession on a strip of film. When projected onto a screen, the sequence of still images gives the illusion of movement. Film has higher image resolution than video.

VIDEO: Audio and visual information are shot and stored simultaneously on magnetic videotape. Video cameras first became accessible to artists and the general public in 1965. Video is displayed on television monitors. Video sound and image quality are generally considered less than film's.

DIGITAL IMAGING: The computer-based creation or storage of still or moving images as digital information. All kinds of existing imagery can be scanned to become digital information. Digital images can be easily manipulated. Output from digital images can be hardcopy prints, displays on computer monitors, or projected. Nam June Paik's *Megatron* is an example of computer images displayed across 200 stacked monitors (see Chapter 19, figure 19.34).

2.41 Diagram of common media, processes, and materials. (Part 3 of 3)

contains a brief explanation of the most common art media for the plastic arts. While it covers many media, we did not include performance art, for example, nor many other art forms that engage more than the visual. Their varied materials and processes cannot be easily categorized.

Like material, media not only allow the physical reality of the art object to happen. They also affect its meaning. A detailed, highly realistic image has a different value and significance if it is painted by hand or if it is a photograph. Artists working in new media tend to encounter some resistance to having their work accepted as art. For example, for many decades after photography was introduced, it was not accepted as having any potential as an art medium.

Many artists work a long time to gain the competence they need to get the exact results they want from a particular medium. That artistic skill, realized and made concrete in a work of art, then becomes part of the value of that art object. Other artists, as we have seen, are attracted to media that allow for a lot of chance occurrence and that cannot be controlled.

SYNOPSIS

Art is another language in the human collection of languages. Art communicates information to and through the senses. Like every language, it has a structure, which is made up of elements that are arranged in a composition according to certain organizing principles. The elements of art are line, light and value, color, shape and volume, texture and pattern, space, chance, improvisation and spontaneity, and time and motion. The principles of composition are balance, rhythm, scale and proportion, emphasis, unity, and variety. Some artworks engage other senses besides just the visual, and those components are essential elements to the artwork.

Part of the structure of art are the materials and media artists choose to use in their work. Artists have explored a full range of traditional and nontraditional materials through the ages. These materials range from their own bodies to natural and synthetic materials. Media include many that have been around for centuries, such as painting, sculpture, and printmaking media. More recently, a host of new media have been introduced through nineteenth- and twentieth-century technologies. Today, the artist's art box might contain anything and everything.

FOOD FOR THOUGHT

Many components must work together for an artwork to communicate the intent of the artist. Looking at art takes some time and effort on your part. Now when you view any artwork, you examine its visual elements, analyze how they were put together, and evaluate the materials used. There are several questions that can be asked, and as you answer them, you enrich your own experience of the artwork.

- What are the basic visual elements in this artwork?
- Has one specific element been employed, or have more than one been incorporated?
- How do the elements of the art piece work together or do they not work together?
- What is the most important element in the work?
- Are the lesser elements as important?
- Does the art suggest emotion?
- If it does, how was it achieved?
- Is the material (or are the materials) used appropriate for the piece?
- What media are used?
- What do material and media add to the overall work?

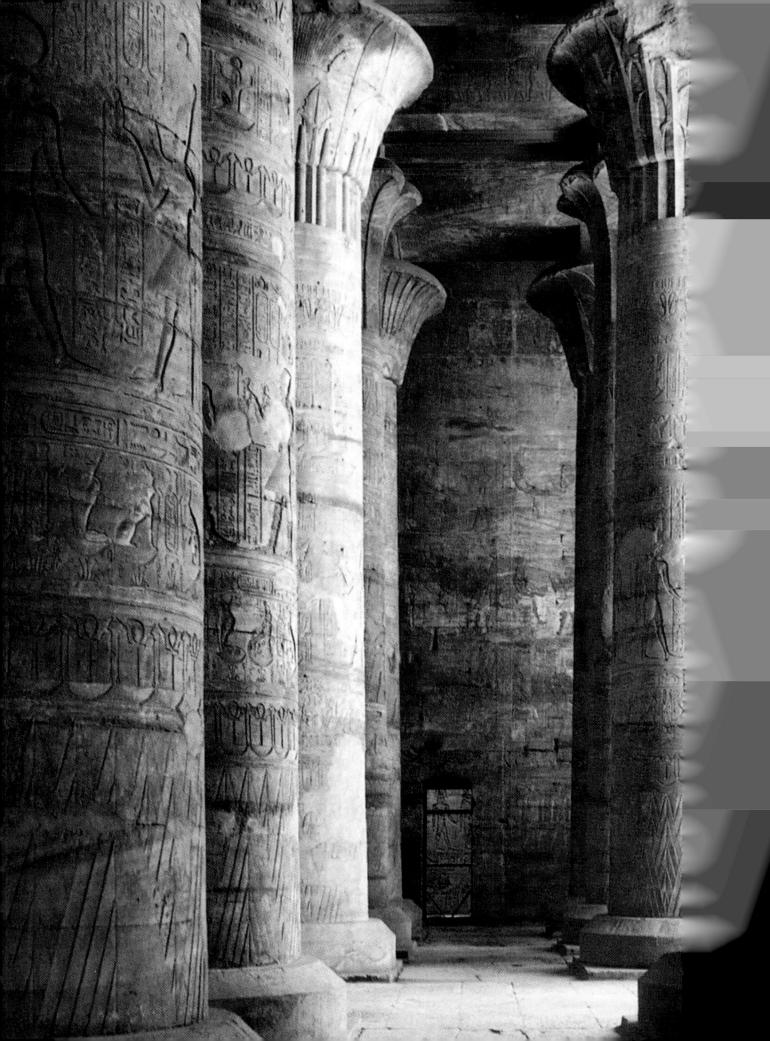

Chapter 3 The Language of Architecture

INTRODUCTION

Architecture is the science and art of designing and constructing buildings and other structures for human use. We use buildings in all kinds of ways. Buildings are practical. They shelter us from the elements, protect our possessions, and allow us to do many different kinds of work. Buildings are aesthetic, because they are visually pleasing and enrich our visual environment and experience of life. Buildings are meaningful and symbolic. They communicate a wide range of spiritual, social, and political ideas. The architect is therefore not simply a utilitarian professional, but also an expressive artist.

Architects use the basic art elements of line, color, texture, pattern, shape, volume, value and light, and space, and arrange them according to certain organizing principles, much like other visual artists. However, their concerns are much broader. Their structures need to enclose space, are functional, must be safe and in most cases must be durable. Architects employ structural systems so that their buildings resist the forces of gravity and weather, which causes constant tension and stress.

We focus in this chapter on the structural systems and design of architecture, and use several buildings to illustrate these concepts. All these buildings will reappear in later chapters, where we will discuss more fully their significance and meaning. Also, meaning and other content issues will be covered as an overview in Chapter 4, Deriving Meaning from Art and Architecture. But for now, here are our questions for this chapter:

What are the ways that architecture encloses interior spaces?

What impact do materials have on your impression of a building?

How do architects use the visual elements of line, shape, color, texture, pattern, value and light, mass, and volume? How do they use time and motion? How does architecture engage senses other than the visual?

How do architects use the organizing principles of balance, rhythm, proportion, scale, unity, and variety?

What is the relationship between architecture and the natural environment?

Text Link

In this book, the following chapters also deal with architecture in depth: Chapter 8, Shelter; Chapter 10, Places of Worship; Chapter 11, Mortality and Immortality; Chapter 12, Power, Politics, and Glory; and Chapter 18, Entertainment.

STRUCTURAL SYSTEMS

Buildings have to stand up. They have to enclose space. How can inert materials such as brick, stone, wood, steel, and concrete be shaped and arranged to do that? The answers are found in structural systems, as explained throughout this section.

Traditional Building Methods

Some structural systems date back hundreds, even thousands, of years. These older building methods show great variety, because they represent local solutions to the problem of construction. These local solutions are frequently quite different from one another because local architects had to work within the limits of available material, existing technology, and the traditional and aesthetic preferences of their cultures.

Load-Bearing Construction

Early architecture was made of shaped earth, bones, wood, or stacked stone. Whatever materials were locally available were used. The igloo made of ice blocks is one such solution. Very ancient houses in China were dug right out of the earth.

In many places, humans began to stack or pile materials, creating solid walls that were usually thicker at the

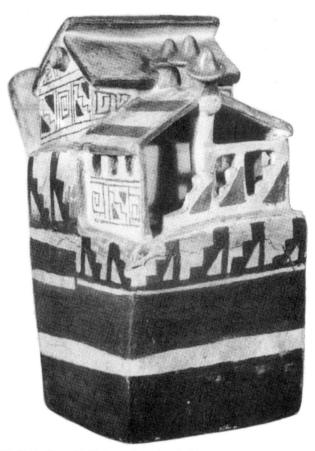

3.1 *Moche House Model*. Ceramic, red and white paint. Moche Civilization, Peru c. 500 BC–AD 600. See also the text accompanying figure 8.18.

bottom, and thinner at top to provide stability. Early roofs were often light-weight, impermanent material such as reeds or thatch. Examples of such architecture are old adobe structures in the Americas, and sun-dried brick structures in the Ancient Near East. The *Moche House Model* (figure 3.1) is a small ceramic model of a style of house made by the Moche people, who lived in coastal Peru from around 500 BC through about AD 600. The Moche house foundations were bundled reeds or willow branches, with liquid adobe poured over them. The walls were made of mass-produced adobe brick reinforced with grass. The roofs were thatch. The hearth was a stone. The houses were brightly painted.

This kind of architecture is called "load-bearing" because all areas of the walls support the roof and walls above them. With this kind of stacking construction, it is difficult to create openings in the walls, because those voids could not support the material above them. Most such buildings have heavy, thick walls with few openings. The buildings are mostly modest in size, usually enclosing only one or two small rooms. Where there were openings, as we see with the *Moche House Model*, wooden beams were used in post-and-lintel construction, which we will see next.

Solid walls let no air or light into the interior. Yet since ancient times, humans have made the aesthetic decision to have air and light in their buildings. In the rest of this section, we will look at the many ways that people have devised to build walls, open up windows, and permanently cover large interior spaces.

Post and Lintel

One ancient method of constructing walls, making openings and supporting a roof is the **post-and-lintel system.** The basic module consists of two upright posts that support a cross beam or lintel (figure 3.2). Posts can be either rectangular or cylindrical. When a cylindrical post is refined and decorated, it is often called a **column**, which we will discuss further in just a moment. A row of posts and lintel modules placed side by side is called a **colonnade.** A three-dimensional grid of posts and lintels can be the basic structure that supports the roof of a large interior space (figure 3.2). Post-and-lintel structures are marked by a strong emphasis on vertical and horizontal lines. They are very rectilinear in design.

The materials used in post-and-lintel architecture are important. If stone is used, a very durable building results. Some of the very oldest structures are stone, with post-and-lintel construction. Stone, however, is a relatively brittle material, and stone lintels cannot span large spaces, or else they will break from their own weight, or the weight of the roof above. Stone is also heavy. Therefore, posts must be thick and also closely spaced if a building has a post-and-lintel roof in stone (figure 3.2). The interiors of such buildings look like a forest of columns, as we can see in figure 3.3, the *First Hypostyle Hall at the Horus Temple at Edfu*, (c. 237–57 BC) in Egypt.

If the lintels are wood, however, a very different effect is possible. Wood is a light, flexible, strong building material that can span great distances. Larger interior spaces can be opened up, and the posts can be thinned down. In the Parthenon (447-432 BC) (figure 3.4), both wood and stone lintels were used. The exterior colonnade is heavy and closely spaced because it has stone lintels. Two rooms in the interior of the building were roofed in wood, and therefore were relatively open and airy. The walls of the Parthenon's inner chamber were load-bearing, with few openings. They held up the wood roof. In fact, it was fairly common to see load-bearing walls in structures combined with post-and-lintel construction. As we saw with the Moche House Model, above, many traditional buildings are constructed with more than one structural system.

The wooden roof of the *Parthenon* is long gone, while the stones remain. In fact the relative impermanence of wood and its ability to burn are its greatest drawbacks as a building material.

BASIC POST-AND-LINTEL MODULE Arrows indicate the downward distribution of weight

GRID OF POST-AND-LINTEL MODULES, IN STONE

Many interior posts are needed to support the stone lintels

3.2 Diagram showing post-and-lintel construction.

An important subcategory of post-and-lintel architecture are the Classical Greek and Roman architectural orders (figure 3.5). An order consists of a specifically designed column with a base, a shaft, a capital, and an entablature, all exhibiting standardized proportions and decorative ornamentation. The oldest is the Doric Order, originating in the Greek Archaic period (650-500 BC). It is the simplest in design, geometric, heavy, and relatively without ornamentation. Its column has no base, and its capital is a simple cushion. The ancient Greeks considered the Doric Order to exhibit masculine qualities. The Parthenon is a Doric structure. The second order to appear was the Ionic Order, which is taller, more slender, and more decorative than the Doric, and was considered feminine. It has a stepped base and a carved capital. It originated during the Greek Classical (Hellenic) period (500-323 BC). Later still was the Corinthian Order, which is the most complex and

GRID OF POST-AND-LINTEL MODULES, WITH WOOD LINTELS Fewer posts are needed, and longer lintels are possible

organic, with delicately carved acanthus leaves on its capital, dating from the Hellenistic period (323–100 BC). Roman variations on those orders are Tuscan, Roman Doric, and Composite.

Text Link

An example of the Roman composite order is seen in the restored interpretation of the Basilica of Constantine and Maxentius, figure 8.29.

Wood Frame Construction

The Chinese developed distinctive wood frame architecture, that is based in part on the simple post-and-lintel module. But the Chinese elaborated the post and lintel,

3.3 First Hypostyle Hall. Horus Temple at Edfu, Egypt, c. 237–57 BC. The roof slabs are 50' from the floor. See also the text accompanying figure 10.17.

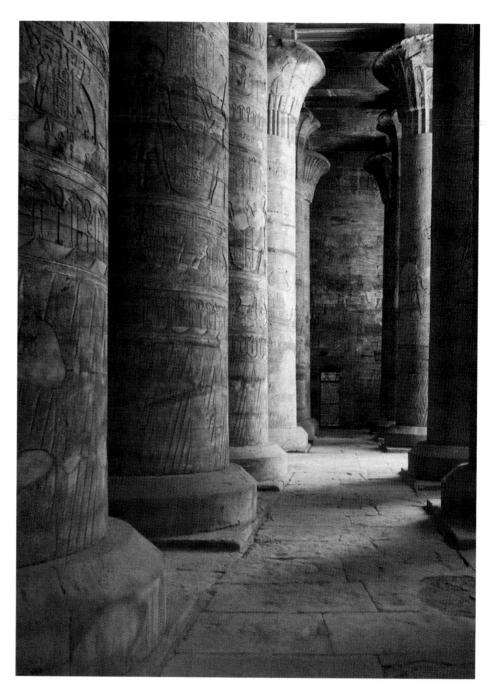

and also added some structural innovations, to create a truly distinctive building style. This building style was a **complete frame system,** which meant that the walls were totally non-load-bearing, and could be eliminated. All weight of the structure was carried by the upright posts.

To reduce the number of posts that were needed to hold up the roof, the Chinese developed **brackets**, which are clusters of interlocking pieces of wood shaped like inverted pyramids. Bracket clusters were placed at the tops of upright posts, directly beneath the roof (figure 3.6). With brackets, the amount of area each post could support was greatly increased. With fewer posts needed, the interior space was more open and uncluttered. Brackets date back as far as the fifth century BC in China, and were relatively simple at first. Brackets eventually became more complex, highly ornate, and very colorful, but we will cover that more in the following pages.

In the third century BC, the Chinese developed roof tiles that overlapped each other and were half-cylinder in shape. Ceramic tile roofs were very heavy, but their

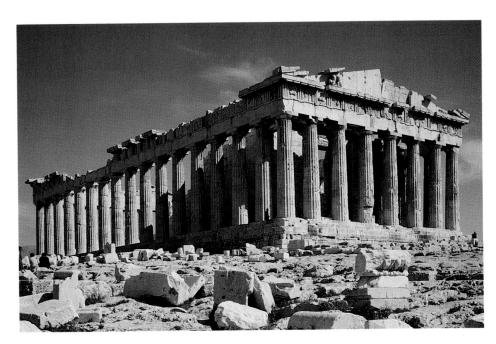

3.4 IKTINOS AND KALLIKRATES. Parthenon. Pentelic Marble. Height of columns 34', dimensions of structure 228' × 104'. Athens, Greece, 447–432 BC. See also the text accompanying figures 10.14, 20.17, and 21.8.

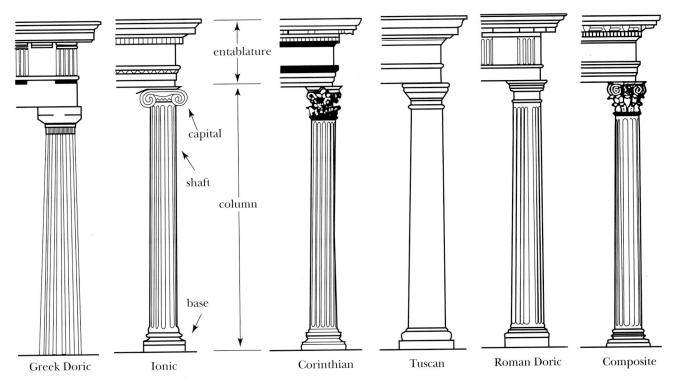

3.5 Diagram of Greek and Roman orders.

weight actually added to the stability of the wood frame structure below. In Chinese structures, the roof design is in many cases the most important and distinct feature of the building. The roofs project out away from the building, with shapes that incorporated very complex curves. Roof tiles could be glazed to many different colors. The *Hall of Supreme Harmony* (c. 1400–1922) (figure 3.7) in the Forbidden City in Beijing shows the emphasis that the Chinese placed on roofs.

Beginning in the eighth century, Chinese architects incorporated the **cantilever** in their structures. The cantilever is a supporting beam that is anchored at one end to an upright post, and then projects out from a structure (figure 3.6). The cantilever was used to create roofs with deep eaves that projected far out from their supporting upright posts, as we can see in this detail from a structure in the Forbidden City (figure 3.8). Temples from as early as the ninth century have 14-foot

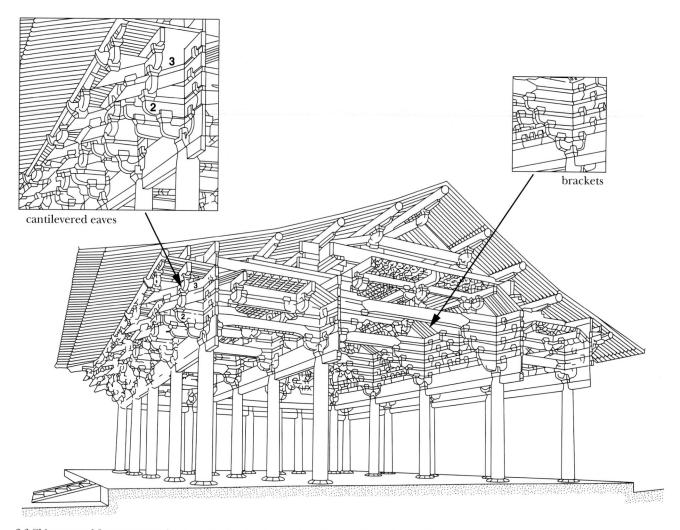

3.6 Chinese wood frame structural system, showing brackets and cantilevers. Notice the upright posts supporting the roof, and the lack of load-bearing walls. This diagram of beam-bracketing construction is based on the Foguang Si Temple, Wutai Shan, northern China, Tang dynasty, c. 857 (after L. Liu).

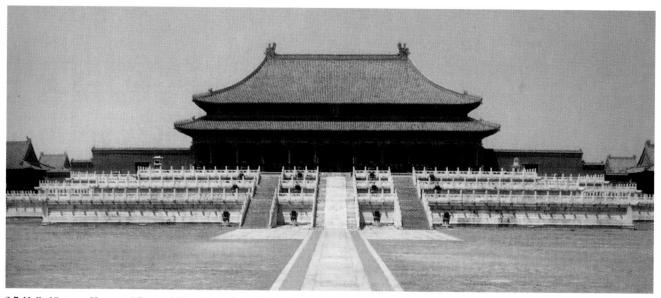

3.7 Hall of Supreme Harmony. Ming and Qing Dynasties, Beijing, China, c. 1400-1922. See also the text accompanying figure 12.16.

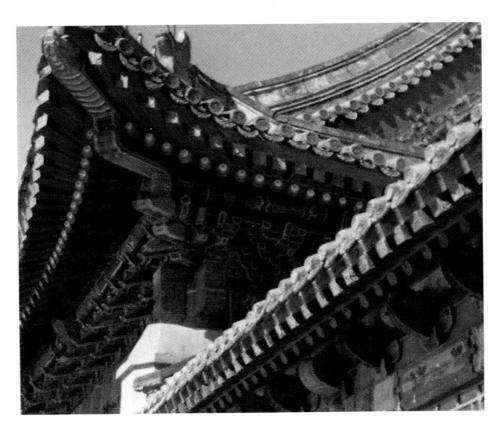

3.8 Detail showing highly ornate cantilevered eaves with brackets from a Forbidden City structure. Photo: Robert Harding Associates.

eaves. The cantilever was also used to support balconies that projected out on multistory buildings.

Thus, the distinctive visual features of Chinese wood frame architecture are large, complex-curving roofs that dominate the structure; sturdy upright posts; and generally a symmetrical design. Variations on wood frame construction can be seen throughout Asia. One example is traditional Japanese domestic and temple architecture. Another is the design of traditional houses in Indonesia, such as the *Toba Batak House*, which we will see in figure 3.26. The wood frame of the *Toba Batak House* is very visible in its lower floors, and it also sports a distinctive roof, this time in thatch. Wood frame architecture is also very common in the West, especially for houses and small apartment buildings. In contrast to the Chinese model, most wood frame structures in the West feature load-bearing walls.

Arches, Vaulting and Domes

We have seen that a stone lintel cannot span much distance, and so it would seem that stone is a very limited building material. But the round stone **arch** (figure 3.9), a structural innovation that dates back to ancient Egypt, changed that. The arch is made of wedge-shaped stones or **voussoirs** that are constructed from bottom to top, using a wooden scaffold for support. When the final **keystone** is placed in the center, the arch can support itself and the scaffolding can be removed. Arches can rest on either cylindrical **columns**, or on rectangular **piers**.

Arches can be either round or pointed (figure 3.9). With a round arch, the distance between the supports determines the height of the arch, because the arch is a semicircle. A pointed arch is actually a round arch with some of the center removed. With a pointed arch, there is complete flexibility to make an arch as high as you wish, regardless of the distance between its supports. A straight row of arches placed side by side is called an **arcade**.

Unlike post-and-lintel structures where the weight of the roof and lintel press down equally on all parts below, the weight of the arch is directed outward and then downward to the load-bearing columns or piers. There is no downward pressure over the void of the arch, and so higher and larger spaces could be spanned without need for additional support posts. Arches could be constructed of stone, brick, or concrete. Arches, however, do have to be supported from the outside to prevent lateral movement that would cause them to collapse. That support is called **buttressing** (figure 3.9), which is additional exterior masonry placed at key points to keep the arch stable. Buttresses can be solid masonry. Or they may be opened up with their own internal arches, called **flying buttresses**.

The arch can be expanded and multiplied in a number of ways to create entire roofs made of stone. These stone roofs are called **vaults** or **vaulting** and are very durable and fireproof (figure 3.9). A **barrel vault** is an arch extended in depth from front to back, forming a

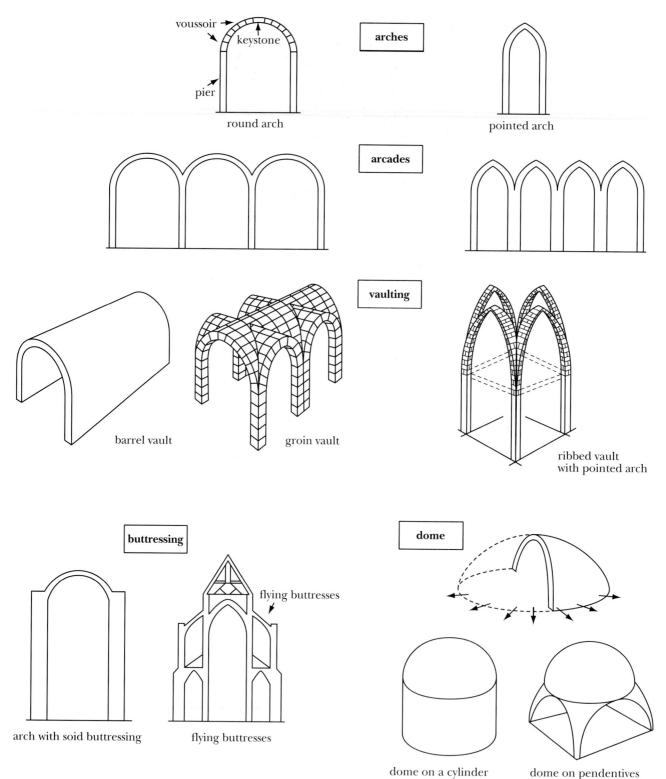

3.9 Diagram showing arches, arcades, vaulting, buttressing, and domes.

tunnel-like structure. Barrel vaults have the disadvantage of creating rather dark interiors, as there are no windows in the vault area. The sumptuous *Hall of Mirrors* (c. 1680) at Versailles is an example of a barrel vault ceiling that has been highly ornamented (figure 3.10). Unlike earlier vaults, the *Hall of Mirrors* has one

side of the walls pierced with tall windows that flood the space with light. This light is reflected in the responding line of mirrors on the opposite wall. The result is that the room is bright, while the vault is still relatively dark. **Groin vaults**, sometimes called **cross vaults**, are barrel vaults positioned at 90 degree angles so as to cross or

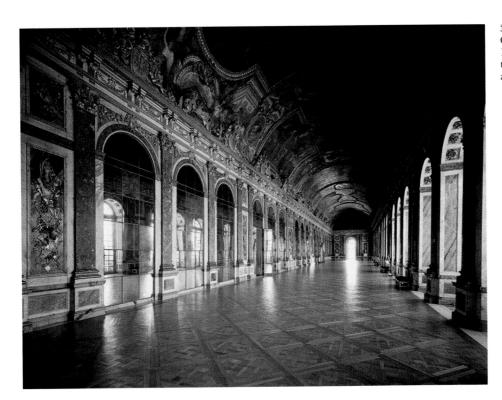

3.10 Jules Hardouin Mansart and Charles Le Brun. *Hall of Mirrors*. c. 1680, Versailles, France. See also the text accompanying figures 12.19 and 20.3.

intersect one another. This innovation allowed light to enter vaulted spaces for the first time, and also gave variation to the interior space. The *Markets of Trajan* (AD 100 –112) (figure 3.11) provided airy and lighted space for the vendors and shoppers in ancient Rome.

A **ribbed vault** (figure 3.9) is a variation of the groin vaulting system in which arches diagonally cross over the groin vault, forming skeletal ribs. When the arch is pointed in the ribbed vault, a **gothic vault** is created. This innovation allowed for large wall areas under arches to be eliminated, and instead to become glazed in gleaming stained glass. The interior of *Chartres Cathedral* (1194–1260) in France shows the ribbed gothic vault (figure 3.12).

A **dome** theoretically is an arch rotated on its vertical axis to form a hemispheric vault. There are several ways a dome can be employed; it can rest on a circular drum as in the *Pantheon* (AD 118–125) (figure 3.13) or it can be placed on **pendentives**, which are the triangular concave sections that are created when a dome is placed on arches (figure 3.9). Domes may also be placed on a square or a polygonal bases in which case the spaces created between the dome and its base are called **squinches**.

Vaulted or domed buildings are generally quite massive, because of the material used to make them—stone, brick, or concrete. Vaults are very heavy structures, and require thick supports. In many cases, architects disguise the massiveness of vaulted structures. The thick piers and heavy vaults are apparent in the Markets of Trajan (figure 3.11). But originally, the Markets of Trajan

were faced with decorative materials, such as colored brick, marble veneer, or stucco, to diminish the brute mass of the structure. The massive dome of the *Pantheon* (figure 3.13) has square sunken panels called **coffers** cut into it, which subdivide its vast expanse. *Chartres Cathedral* is also a massive structure, but the stone has been shaped to emphasize verticality, and so again mass is visually diminished.

It is important once again to mention that different structural systems could be used within a single building. The interior of *Chartres Cathedral* was roofed with vaults. However, there was an exterior wood frame pitched roof above the vaults, which protected them from the weather. You can see the wood frame roof in the flying buttress diagram in figure 3.9. In the *Markets of Trajan*, you can see that post-and-lintel systems were used to frame doors and windows for the individual shops.

Recent Methods and Materials

Modern buildings differ from older structures in many ways. New materials such as steel and steel-reinforced concrete have made new construction methods possible. Buildings now can be taller than anything ever built before the nineteenth century. Like the body, many modern buildings feature an internal skeletal support system. The outer surface of the wall is like a skin stretched over the bones.

Our expectations of "basic" comforts have changed too, and so buildings are designed with a variety of operating systems, such as heating and cooling systems, electricity, plumbing, telephone and computer wiring, and

3.11 Interior of *Markets of Trajan*. Rome, AD 100–112. See also the text accompanying figure 8.21.

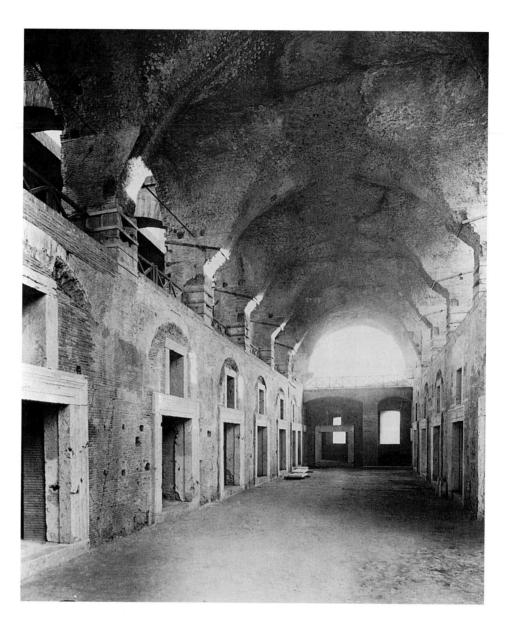

so on, down to appliances, intercoms, and surveillance systems. Two hundred years ago, this was all unknown.

Steel Frame Construction

High strength structural steel was developed in the late nineteenth century, and along with the invention of the elevator, made very tall buildings possible for the first time. **Steel frame construction** essentially expands the post-and-lintel grid both horizontally and vertically, only this time using steel instead of wood or stone. Because steel is very strong, both vertically and horizontally, it can function as a skeleton that will support multistoried buildings with large floors on each level (figure 3.14). Steel framed buildings usually have floors of reinforced concrete, which is poured concrete with metal reinforcing bars embedded in it. We will see more on reinforced concrete in the next section.

The first architects working with steel frame construction disguised the steel framework with stone facings so

that their buildings had rugged exteriors, traditional appearances, and the look of durability. In contrast to that attitude was the work of Louis Sullivan, the first architect to really redefine the steel frame building. An example is his Carson Pirie Scott building (1904) (figure 3.15). His building looks pared down, and almost insubstantial. compared to the massive stone buildings that preceded his. His building was also higher, thanks to steel frame construction. The emphasis on height was reflected in the new names for such buildings: skyscrapers. The external appearance of the Carson Pirie Scott building reflects the steel frame beneath its walls. The simple horizontal and vertical lines of the frame are emphasized and apparent. Windows are opened up and big, reaching from framing member to framing member. Sullivan did not neglect ornamentation, as we will see later in this chapter.

Steel frame construction has been widely used ever since for all kinds of structures, but especially the highrise office buildings that filled the downtowns of major cities all over the world from the mid- to late twentieth century. Called the **International Style**, this strippeddown, glass-covered, rectangular box building was enormously popular throughout the world. These buildings generally had no ornamentation at all. Some critics argued against the widespread use of the International Style. Many older, distinctive structures were torn down in cities all over the world so that steel-and-glass boxes could be build. The International Style's ubiquity resulted in many cities' civic centers losing much of their individuality and distinct character.

Reinforced Concrete

Another building innovation that resulted from the development of high strength structural steel was **reinforced concrete**, also known as ferroconcrete. Concrete was used by the Romans. The dome of the *Pantheon* (figure 3.13), which we saw already, is concrete. However, concrete is relatively brittle and cracks easily, as you might notice on your own driveway. In the late nineteenth century, steel-reinforcing bars began to be embedded in wet concrete, and the combination of the two had many advantages. The steel gives the concrete

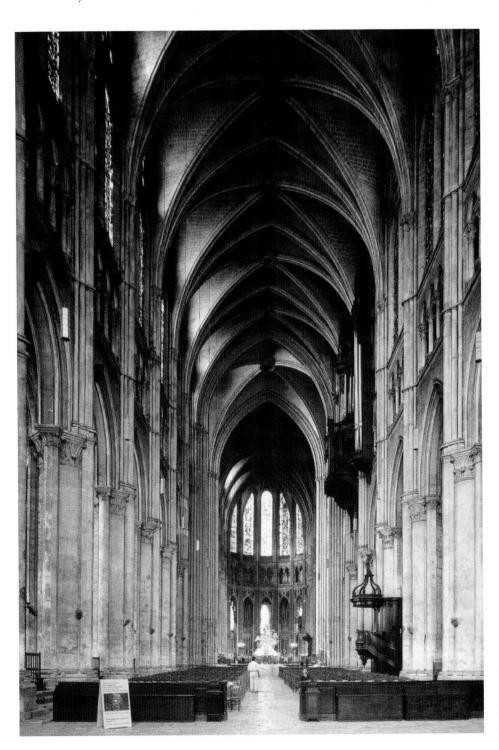

3.12 Interior of *Chartres Cathedral*. Chartres, France, completed 1194–1260. The center space, called the nave, is 130' long, 53' wide, and 122' high. See also the text accompanying figure 10.25.

3.13 *The Pantheon.* Rome, Italy. Concrete and marble. Height from floor to opening in dome is 142'. AD 118–125. See also the text accompanying figure 10.7.

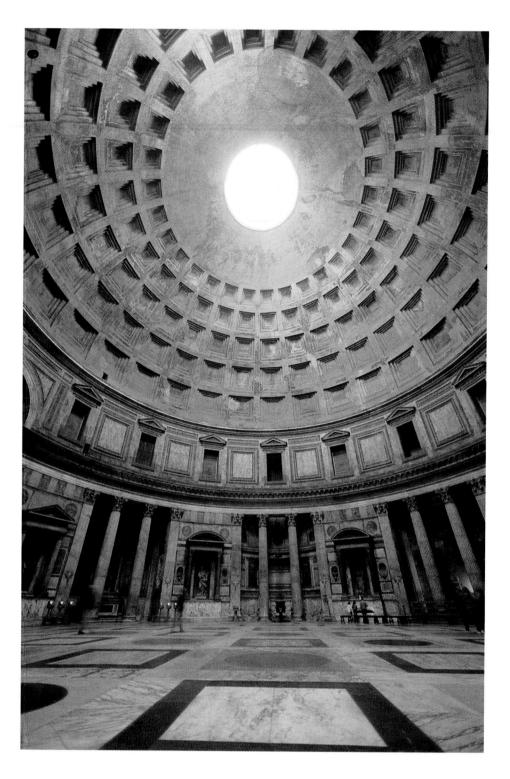

strength, while the concrete provides a durable surface. Reinforced concrete was used for the floors of skyscrapers from their early days.

Gradually, architects began using reinforced concrete as an external building material, for the finished surfaces of buildings. In *Fallingwater* (1936–1938) (figure 3.16), Frank Lloyd Wright made extensive use of ferroconcrete for the house's balconies. It contrasts with the vertical elements that are faced in stone. *Fallingwater* fea-

tures cantilevered balconies. We saw the cantilever first in connection with Chinese architecture. Ferroconcrete made it possible to expand the size and projection of cantilevered structures, so that they can extend and protrude dramatically beyond their vertical support. As you can see in *Fallingwater*, the balconies extend so far beyond their vertical supports that they overhang a waterfall, adding considerably to the distinct character of the house.

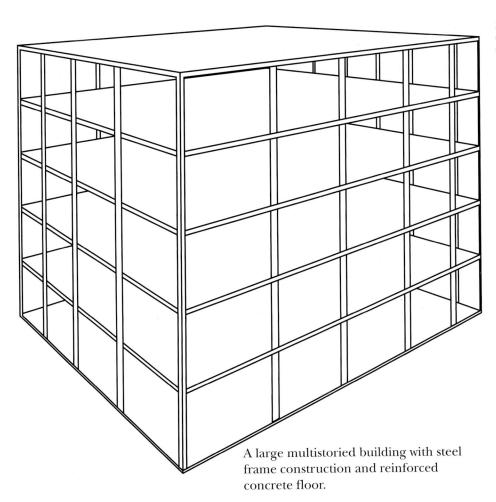

3.14 Diagram of steel frame construction and reinforced concrete.

Diagram of reinforced concrete showing a metal bar embedded in concrete. This diagram shows a reinforced concrete floor with a cantilevered balcony.

Reinforced concrete is not limited to floors, balconies, or rectangular structures. Concrete can be poured over steel reinforcing rods or mesh that can be shaped into any form the architect wishes. It makes free-form architecture possible, which has no limitations on the shape and mass that a structure can take. The *Sydney Opera House* (1959–1972) designed by Joern Utzon, is an impressive structure with cascading shells, constructed in the free-form system (figure 3.17).

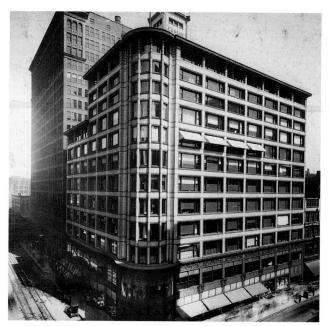

3.15 Louis H. Sullivan. *Carson Pirie Scott and Company.* Chicago, Illinois, USA, 1904. See also the text accompanying figures 8.22 and 22.13.

Text Link

Another example of free-form structures in this book is the church of Notre Dame du Haut with a roof shaped like a boat (Chapter 10, figure 10.10). Look also at the spiral-shaped Solomon R. Guggenheim Museum (Chapter 18, figure 18.5).

Truss and Geodesic Construction

Another skeletal structure is the truss, which can be constructed in wood or steel. The truss system is based on a frame made of a series of triangles (figure 3.18). Trusses are very rigid because the triangle is a rigid shape, and can be used to span great spaces, or to support other structures. You probably have seen steel trusses in railroad bridges, or wooden trusses in the attics of most frame homes in the United States. *The Bank of China* (1989) by I. M. Pei and Partners, in Hong Kong, features enormous triangular braces, which are like trusses on a grand scale, to stabilize the building, which is in an earthquake zone (figure 3.19).

An innovation on the skeletal system was made by Buckminster Fuller in his design of his geodesic dome (figure 3.20). The geodesic dome is a skeletal frame based on triangles that are grouped into very stable, strong polyhedrons, which are solid geometric figures having many faces, and are found in nature. Geodesic domes can be very large, and require no interior supports. The skeletal frame can be constructed from pre-

fabricated modular parts that can easily be assembled. The framework can be sheathed in glass, plastic, plywood or a variety of other materials. Fuller's *U.S. Pavilion* (1967) (figure 3.20) at the World's Fair Expo '67 in Montreal, was an example of a geodesic dome that was 250' in diameter.

The triangles of truss or geodesic structures may be left visible when buildings are finished. In these cases, the buildings have a pronounced geometric appearance. The linear network of the truss skeleton becomes an important visual feature.

AESTHETIC DESIGN DECISIONS

We have covered some of the most common structural systems used in architecture. But architecture is not simply a matter of engineering, nor making useful spaces. An important aspect of building is simply visual. How does it look? Is it visually appropriate, or striking and memorable? To be effective as architecture, a structure must also be visually well-designed.

Visual Elements

Like the visual arts, architects carefully arrange and employ visual elements to create striking visual effects in their buildings. The visual elements are the same as those we saw for the visual arts: line, light and value, color, texture, pattern, shape and volume, space, time, and motion. In addition, there are nonvisual elements that include chance, improvisation and spontaneity. And aspects of architecture engage other senses besides sight. All of these terms were defined and illustrated in Chapter 2, The Language of Art, as they relate to visual art. But the way the elements are employed in architecture is different. To illustrate these visual elements, we will use the Piazza d'Italia (1975–1980) (figure 3.21) by Charles Moore with I.U.G. and Perez Associates. The Piazza d'Italia is a circular plaza lined with arches and colonnades, with a raised speaker's rostrum. The Piazza is used for openair festivals.

While architecture may contain few if any lines, it does feature a number of **linear elements.** The lines of columns we see in the *Piazza d'Italia* add an element of linearity to the space. We can also speak of line as direction in relation to architecture. When seen from above, the lines of the *Piazza d'Italia* are mostly curving. *Chartres Cathedral* (figure 3.12) and the *Bank of China* (figure 3.19) feature strongly vertical lines that emphasize an upward direction. The geodesic dome of the *U.S. Pavilion* (figure 3.20) is a network of intersecting lines.

Light is an essential element in the visual design of architecture. **Light** creates areas of illumination and shadow that animate and activate a surface. A building is

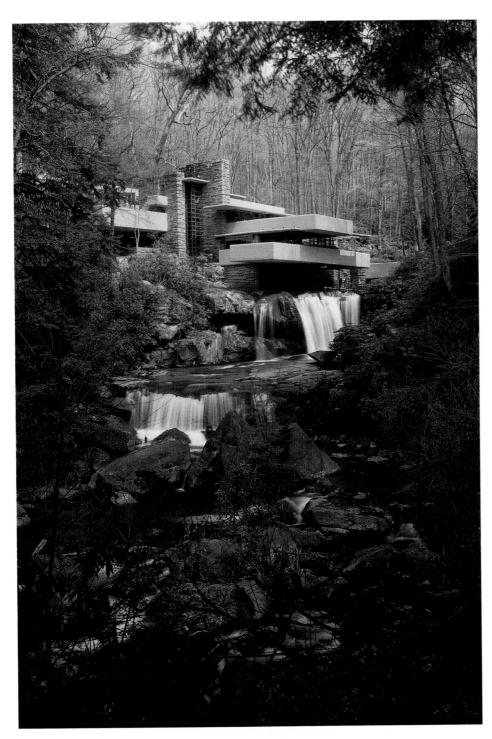

3.16 Frank Lloyd Wright.
Fallingwater. Kaufmann House,
Connellsville vicinity, Pennsylvania,
USA, 1936–1938. See also the text
accompanying figures 8.20 and 22.12.

a totally different experience on a sunny day versus an overcast day. In the case of the *Piazza d'Italia*, sunlight creates constantly shifting lights and darks, making each trip to the plaza a unique experience. Sunlit arches are distorted and recreated in their own shadows. These shadows skim across the ground and over other walls. Elements that were lost in shadow suddenly pop out in brilliance when the light hits them. At night, the *Piazza*

d'Italia is artificially illuminated, giving a totally different appearance. Colored neon lights outline the *Piazza*'s main arch.

Color is a vital element in architecture. Even in buildings that seem colorless, there is a range of neutral colors—grays, beiges, tans, whites, and creams—that enrich our visual appreciation of the building. Color in the *Piazza d'Italia* is very evident. The ochres, dull reds, and

3.17 JOERN UTZON. Sydney Opera House. Sydney, Australia, 1959–1972. See also the text accompanying figure 18.4.

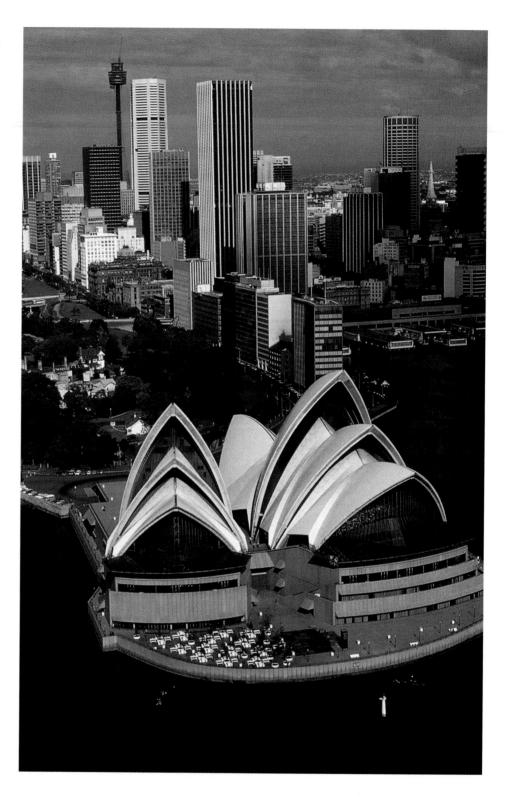

gleaming steel of the colonnades contrast with the gray stone floor and the blue and green neon that outlines the rostrum. As in a painting, color often sets a tone for architecture. The colorfulness of the *Piazza* contributes to the festivities that take place there.

Building materials each have their unique **textures**, and these textures again enhance our visual (and tactile)

appreciation of a building. Just think of the appeal of marble, stone, wood, concrete, cloth, glass, stucco, plaster, metal, bricks or glazed tiles, each with a different surface, each with its own temperature. The floor of the *Piazza d'Italia* has alternating circles of polished and rough stone. These contrasting surfaces are visually rich. And they massage our feet as we walk across them.

3.18 Truss (A) and Geodesic Dome (B) structural systems.

Pattern is an important feature in almost every building. First of all, pattern is inherent in almost all structural systems. Look at the patterns in the diagrams on structural systems throughout this chapter. Pattern may also be a feature that architects choose to incorporate, beyond those inherent in their structural systems. In these cases, pattern often adds visual distinction and identity, as is the case of the pattern of concentric circles in the *Piazza d'Italia*.

Shape, volume, and **space** are key elements in architecture. The *Piazza d'Italia* features curved shapes that enclose small volumes, but define the large open area of the plaza. The *Piazza* has relatively little architectural mass for its size. Look at the buildings around you. What are their predominate shapes? What volumes do they enclose? How much mass do the structures have? What spaces surround them?

In architecture, the elements of **improvisation** and **spontaneity** occur in the changes in style we see from one building to the next. The *Piazza d'Italia* was designed at a time when plain, rectangular, glass-and-steel skyscrapers were the architectural forms of all new center-city buildings. Charles Moore improvised on older architectural forms and translated them into a modern aesthetic. The result was a plaza that seemed almost fresh and spontaneous in style compared to the status quo of the time.

In addition to the elements of improvisation and spontaneity, architecture has features that **engage all our senses**. Buildings have sounds, smells, temperature, and texture. Large vaulted spaces, such as old stone churches, often have cool interiors with hollow and echoing sounds. They sometimes smell damp. Smaller domestic spaces are usually warm, with the cushioning of

3.19 I. M. PEI AND PARTNERS. *Bank of China*. Hong Kong, 1989. See also the text accompanying figures 4.3, 8.25, and 22.6.

wood floors or rugs underfoot that hush sounds. The *Piazza d'Italia* has many fountains, filling the air with cool mist and the sound of splashing water. It is a festival site, so there may be music and food.

Because architecture encloses spaces and contains various sides, we cannot grasp all its features in an instant, from a single point of view. Buildings unfold in **time** as we move through them. New vistas open up as a result of our **motion.** Large spaces alternate with small, and openings frame upcoming spaces. We have to take time and move around a building before we can understand all aspects of its design. If we are seeing it only in a book, we need multiple views and verbal descriptions in order to imagine what it would be like to be there. We have provided some of that for the *Piazza d'Italia*.

Organizing Principles

We also studied and defined the organizing principles of design in Chapter 2. They are balance, rhythm, proportion, scale, emphasis, unity, and variety. Let us look at them again here as they relate to architecture.

Balance is visual equilibrium, which occurs when architectural elements have been organized to achieve evenly distributed visual weight. Balance can be symmetrical, asymmetrical, and radial. Symmetry is common in many kinds of formal architecture, such as government buildings, office buildings, or places of worship. The Parthenon (figure 3.4) had a symmetrical façade. Asymmetrically balanced buildings seem more casual, dynamic, or unexpected. The Piazza d'Italia is asymmetrically balanced in its arches and colonnades. In addition, the large open space (with less visual weight) asymmetrically balances the smaller structure, with greater visual weight. Fallingwater (figure 3.16) is also asymmetrically balanced, reflecting natural order like the arrangement of trees, overhanging rocks, and waterfalls. The U.S. Pavilion (figure 3.20) is an example of radial balance in architecture.

Rhythm is the repetition of alternating elements and intervals. It is related to pattern, but here we see it as an overall organizing principle, rather than simply one of the visual elements. Like pattern, rhythm is inherent in many structural systems. Rhythm is apparent in most architecture as alternating voids and solids. The *Piazza d'Italia*'s regular rhythmic elements include the concentric floor circles, and the alternating columns and voids of the colonnades. Irregular rhythms are suggested by its staggered "rooflines."

Proportion is essential in architecture, as it represents the adjustment of one part relative to another, and the size of each part relative to the whole. As the architect, Charles Moore would carefully consider the relative size of one part of the *Piazza d'Italia* to another, and the size of the structure relative to the plaza. Proportion was an important consideration when the architects Iktinos and Kallikrates designed the *Parthenon*. Height was determined in relationship to width, and the thickness of columns was adjusted to be proportional to the entablature and the whole structure.

Scale in architecture is its overall size in relation to the human being. Large-scale buildings tend to dwarf and overwhelm humans, while smaller scale buildings may relate to the individual. The *Bank of China* (figure 3.19) towers over not only the individual, but all the buildings around it, and that scale gives it monumental importance. We do not even think of the building in reference to a single individual, but rather as representative of a powerful corporation. The scale of the *Piazza d'Italia* suggest its intended use for a group of people. The height of the arches and colonnades keeps them visible to all in the crowd. Its arches and columns make the crowd of people identify with Italian architecture and as a community celebrate it. The raised rostrum, framed by the arch, allows the community to

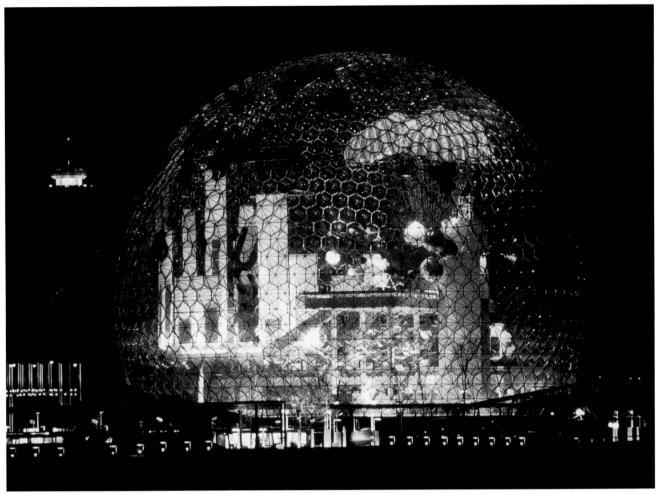

3.20 R. Buckminster Fuller. U.S. Pavilion. Geodesic Dome, 250' Diameter. 1967, Expo '67, Montreal, Canada. See also the text accompanying figure 8.24.

identify its leaders. The implied scale of the *Moche House Model* (figure 3.1), on the other hand, indicates its family use.

Emphasis in architecture means that one part of a building becomes a focal point. As important as the open plaza is to the *Piazza d'Italia*, the colonnades and arches are more emphasized, and the single most important focal point is the tallest arch that frames the rostrum. **Unity** is the quality that makes the disparate architectural parts coalesce as a whole. **Variety** provides for opposing or contrast elements that add interest without disrupting the overall unity. The color, circular shape, and classical architectural elements unify the *Piazza d'Italia*, while at the same time are varied enough to hold visual interest.

Ornamentation

Architectural ornamentation is the embellishment of forms or surfaces beyond structural necessity. Sometimes, however, ornamentation grows out of structural systems. Review the discussion of brackets in Chinese wood frame architecture (figure 3.6). As we noted there, the brackets were originally developed as a device to allow each interior column to support a greater area of the roof. Because they were wood, the brackets were painted to protect them from insects and from weathering. But as we can see in figure 3.8, the brackets themselves and the way they were painted eventually became highly ornate. That ornate aesthetic is also visible on the interior of the Hall of Supreme Harmony around the Imperial Throne (1644-1912) (figure 3.22). The lavish proliferation of color and pattern are not structural necessities, but they function to express visually the exalted state of the Chinese emperors who presided there as Sons of Heaven.

Ornamentation is often used for emphasis. We saw Louis Sullivan's *Carson Pirie Scott* building in figure 3.15. This early skyscraper is relatively plain on its upper

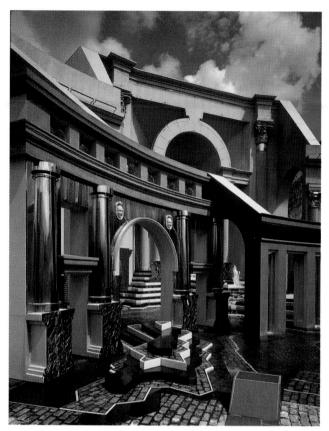

3.21 CHARLES MOORE WITH U.I.G. AND PEREZ ASSOCIATES. *Piazza D'Italia*. New Orleans, USA, 1975–80. See also the text accompanying figure 8.26.

floors, but its main entrance, on the ground floor at the center, is highly ornate (figure 3.23) and serves as a focal point for the building. This grand doorway is made of cast iron according to designs by Sullivan himself. He wanted modern buildings to retain an element of nature-based ornamentation to counter their increasingly geometric appearance.

During the mid-twentieth century, ornament was often omitted from architecture, because architects at that time felt that it was not functional, and therefore was extraneous to architecture. But in fact, ornamentation is highly functional. As we just saw, it can represent imperial power, or it can function to highlight a certain feature of a building. Ornamentation can often carry religious or symbolic meaning. We will see more of this in Chapter 4, Deriving Meaning from Art.

THE NATURAL ENVIRONMENT

The natural environment is the background to all architecture. Even the most dense urban center is not devoid of nature. The color of the sky, the sun, the wind, and the air temperature affect our visual impression of buildings. Throughout history, and increasingly in the present day, architects have been aware of nature and natural elements as they design buildings.

Text Link

One of the most popular parks in the United States is Central Park, designed by landscape architects Frederick Law Olmsted and Calvert Vaux from 1857 to 1887. Turn to Chapter 18, Entertainment (figure 18.7), for more information.

Landscape Architecture

Landscape architects plan and alter the natural environment for some desired effect. Most landscape architects modify the natural environment so that it can be better suited for human use, as in the design of national parks or large city parks. They also design nature so that it interfaces with our constructed environment, both on the architectural and urban planning levels. The earliest landscape architects were garden designers.

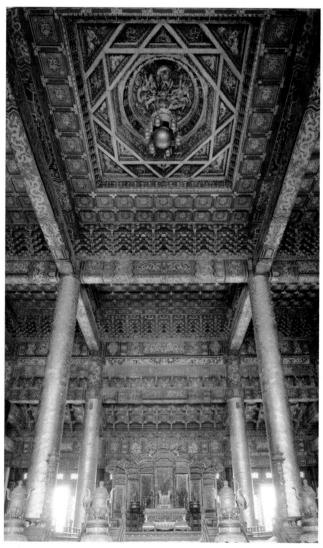

3.22 *Imperial Throne.* In Hall of Supreme Harmony, Forbidden City, Beijing, 1644–1911. See also the text accompanying figure 12.17.

3.23 Louis H. Sullivan. *Carson Pirie Scott and Company*. Chicago, Illinois, USA, 1904. Ornate decoration. See also the text accompanying figure 8.23.

The Mortuary Temple of Hatshepsut (figure 3.24) from ancient Egypt is an excellent example of architecture that was well integrated with the natural environment. The temple is sited and designed to be a wonderful transition from the fertile banks of the Nile River in front of it to the barren rock cliffs behind it. The low, horizontal flood plain of the Nile was extraordinarily fertile land, where all kinds of plants grew and wildlife abounded. The Mortuary Temple rises up from that flat land in three wide terraces, which were once gardens planted with myrrh trees, frankincense trees, and other rare plants. This continuity with the Nile is interrupted by the post-and-lintel colonnades, whose vertical stone

surfaces echo the cliffs behind them. Thus, both garden and architecture work together to integrate with the landscape.

Text Link

We will see other examples of garden designs later in this book, specifically, the courtyards and gardens of the Forbidden City in Beijing (figure 12.16), the vast garden and palace at Versailles (figure 12.18), the Taj Mahal in India (figure 11.21), and the gardens of Babur (figure 19.14). All these gardens were associated with royalty.

Another building designed to fit within the natural environment is *Fallingwater*, which we saw in figure 3.16. It is surrounded by nature, rather than plopped on a stretch of lawn bulldozed out of the forest. Its rock facing was quarried nearby. Its wide balconies are like geometric versions of rock outcroppings. The waterfalls animate it.

Incorporating Nature into the Constructed Environment

Today, the concern of landscape architects is not so much for building royal gardens or houses in the woods, but rather how to incorporate the natural environment in an increasingly urbanized world. This is not an entirely new problem. The ancient Romans who dwelt in large cities felt the loss of nature. The wealthy had houses that incorporated open courtyards and gardens into their designs, as we will see in the *House of the Vettii* in Chapter 8.

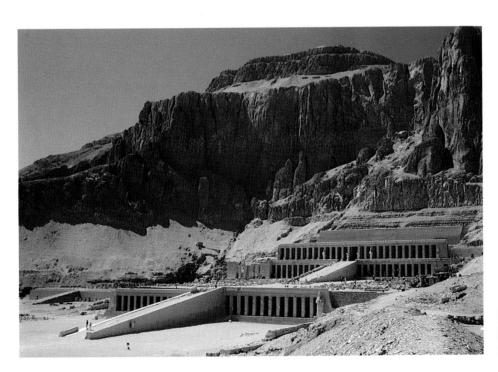

3.24 Mortuary Temple of Hatshepsut. Deir el-Bahri, c. 1490–1460 BC. See also the text accompanying figure 11.6.

Text Link
A garden courtyard is part of the design of the House of the Vettii.
See figure 8.9.

Nature is often obliterated in downtown areas. Our image of the *Carson Pirie Scott* (figure 3.15) building shows an entirely paved environment. Most cities have regulations to help ensure fresh air and sunlight for urbanites, a minimal encounter with nature indeed. High-rise office buildings can be built so high and so close together that the people on street level may be

always in shadow, breathing stale polluted air. To counter this effect, many large cities have regulations regarding building "set-backs," so that tall buildings are set back from the street and often terraced at higher levels. Most cities also have planting programs and small open plazas to enliven downtown areas. On a much larger scale, the huge *Central Park* in New York City was planned and built in the nineteenth century to counter the loss of nature in the midst of Manhattan (see Text Link on page 70).

Other architects look for ways to reintegrate nature thoroughly with the constructed environment. Moshe Hafdie's *Habitat* (1967) (figure 3.25) is an example of high-density urban living designed to include nature throughout. Prefabricated modular living units could be stacked in ways that allowed for maximum air and sun

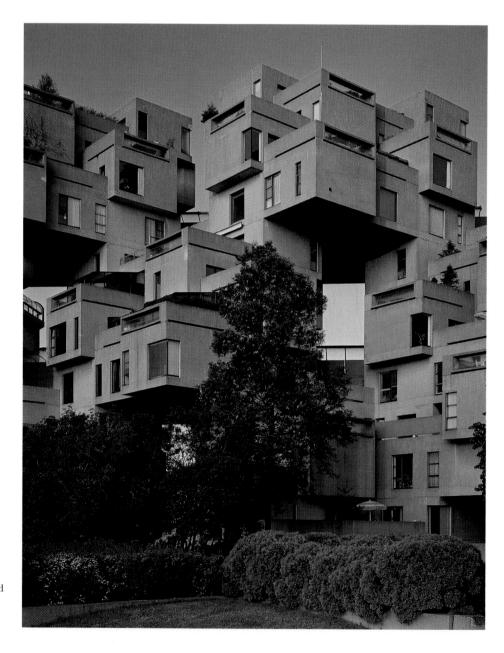

3.25 Moshe Safdie. *Habitat*. Designed for Expo '67 in Montreal, Canada. See also the text accompanying figure 8.6.

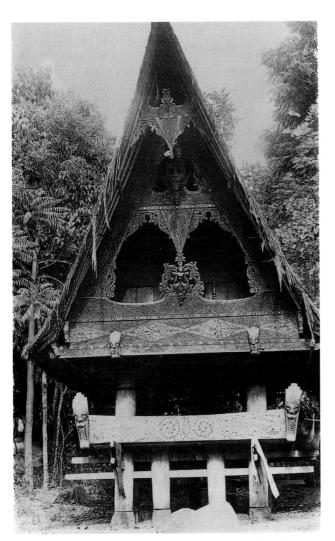

3.26 Decorated facade of *Toba Batak House*. Sumatra, Indonesia. c. nineteenth–twentieth century. See also the text accompanying figure 8.16.

exposure. Roofs of one structure became the gardens for others.

What about your city? Are open spaces incorporated with buildings? How are parks, greenbelts, and plazas designed and used? Are natural features like lakes, river fronts, or mountains incorporated into the overall city plan?

Ecological Concerns

Indigenous people around the world produced all kinds of unique buildings. As we saw earlier in this chapter, these are traditional architectural styles that made creative use of available materials. In addition, however, these buildings were designed to take advantage of desirable natural amenities, and to counter those that were undesirable. All these considerations were made in response to local conditions.

In the hot, humid climate of Indonesia, indigenous people built houses on stilts to raise them above the most humid air that hovered at ground level. We see an example of this with the *Toba Batak House* (figure 3.26) from Sumatra. The middle level has no walls, while the upper level is opened with wide windows, allowing them to catch available breezes. Thick thatched roofs, steeply pitched, shed the heavy rains common in the area. Thatch is a plentiful, lightweight material that is a renewable resource. The dual necessity of using available materials and dealing with the local climate has resulted in a house design that is distinctive and memorable.

We can find other examples from other regions. The igloos of far North America were constructed of ice blocks. They were designed to trap layers of air on the inside, which functioned as a kind of insulation. The igloos enabled people to thrive in extreme freezing conditions. Adobe construction common throughout the Southwest United States, Central America, and areas of South America featured thick walls of sun-dried brick. Like a cave, the thick walls insulated humans from high daytime and low nighttime temperatures. The shaded interior provided relief from the sun.

Now indigenous housing styles are being replaced with more standard houses designed after Western models. Imported materials are often used instead of those locally available. Central air conditioning and heating apparently mean that local conditions no longer have to be considered. Center city areas, as we have mentioned, have often conformed to the International Style, with the rectilinear glass-and-steel box building. Unfortunately, each requires materials that are sometimes not renewable. Often energy demands are higher, and result in higher energy costs and greater pollution. In addition, the uniformity of style has represented a cultural loss for our world as a whole. Architects often are called now to create buildings that are increasingly energy efficient and responsive to the local conditions in which they are placed. They are turning both to older indigenous ideas about building, and also challenged to envision new forms of architecture. The future awaits us.

SYNOPSIS

We began this chapter by looking at some of the most common structural systems. The following are seen first on traditional buildings: load-bearing walls; post-and-lintel architecture; wood frame construction; and arches, vaulting, and domes. We then examined architecture that is possible with recent innovations in structural systems or the introduction of new materials. These included steel frame buildings, reinforced concrete structures, and truss and geodesic construction.

Next we considered the visual design of buildings. We looked at the basic elements of art, which include: line, light and value, color, texture, pattern, shape and volume, space, time and motion, and chance/improvisation/spontaneity. Buildings also engage the other

senses. The organizing principles that guide their application include: balance, rhythm, proportion, scale, emphasis, and unity and variety. Some buildings feature ornamentation, which usually functions symbolically or aesthetically.

Finally, we took a quick look at the interface between the natural environment and the constructed environment. We saw a few structures that were specifically designed to be in tune with their natural surroundings. We also mentioned briefly the ecological concerns that are becoming increasingly important in building design.

FOOD FOR THOUGHT

We live our lives surrounded by architecture. Only some of it is distinctive or memorable.

There are many reasons why certain buildings are outstanding. Some reasons are formal. The building may be especially well designed and visually striking. It may represent a stylistic innovation. It may feature distinctive ornamentation or a rich color scheme. Some reasons may be structural. A building may embody a structural innovation, or it may just be really big. Finally, there may be historical, religious, or symbolic reasons for the importance of a particular building.

- What are the architectural landmarks in your hometown?
- Why have they become landmarks?

Chapter 4 Deriving Meaning from Art and Architecture

INTRODUCTION

Art and architecture have meaning. They are simultaneously expression and communication. The artist "shapes" an object to visually express a complex set of ideas, and the audience receives that expression. Architects create livable or useable spaces, but their architectural structures are also significant beyond their functionality.

But how does that process work? Here are our questions for this chapter:

How do artists or architects visually present ideas in their works?

How does the audience understand the message?

In this chapter, we will see that we derive meaning in four basic ways: 1) we analyze works formally; 2) we study their content; 3) we learn about the context in which they were created; and 4) we look at the ways that we encounter them, to see how that affects their meaning.

FORMAL ANALYSIS

As we saw in Chapters 2 and 3, every example of art and architecture has formal qualities. These consist of visual elements that are arranged into a composition, using the principles of composition. What we did not discuss thoroughly in Chapters 2 and 3 was this: formal qualities add meaning to an artwork or architectural structure. **Formal analysis** is an integrated study of all the formal qualities of an art object to see how they work together. We can then see how they add to the overall meaning of that piece of art. We will formally analyze a few works now, and tie formal qualities to meaning.

Value and texture are the primary visual elements of *Migrant Mother, Nipomo Valley* (1936) figure 4.1, by U.S. photographer Dorothea Lange. The image is composed of varying gray tones. There is no enlivening color. Texture appears primarily in the center of the photograph in clothing and hair, and is especially dense in the shirt and jacket worn by the woman.

Lange used various principles to organize the elements of value and texture into a coherent composition.

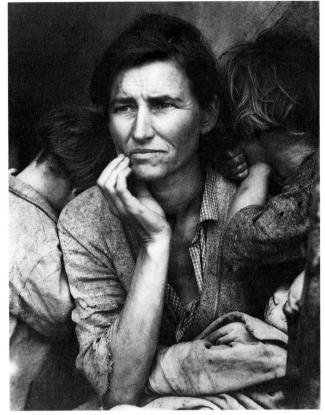

4.1 DOROTHEA LANGE. *Migrant Mother, Nipomo Valley*. Gelatin Silver Print. USA, 1936. Dorothea Lange Collection, Oakland Museum of Art. See also the text accompanying figure 16.25.

The woman's face is the focal point of the picture, as it occurs in the upper center of the image and as it is the most dramatically lit element. The strongest lights and darks of the entire photograph occur together in and around the woman's face. The face and arm make a vertical axis in the center of the picture. Symmetry is an important organizing principle, with children like wings at the woman's sides. The space of the picture is shallow. There is no deep space around the figures. The figures are shown on a large scale, almost entirely filling the available space.

What does our formal analysis of *Migrant Mother*, *Nipomo Valley* contribute to the meaning of the work? Because the woman's face is the most important element, we take care to read her expression. Symmetry and verticality are often used for religious art. Here, they suggest that the woman and children share a strong emotional, almost sacred, tie. The textures are mostly rough and unkempt. Taken together, we read the qualities of worry, fear, family devotion, and poverty in the picture.

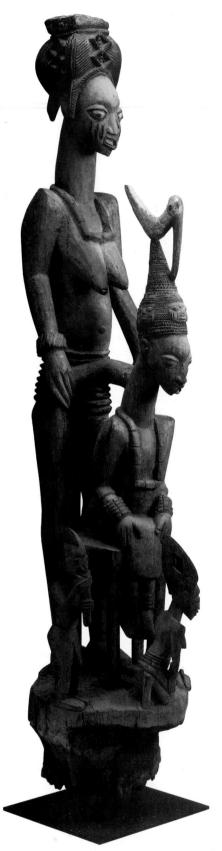

4.2 Olowe of Ise. *Palace Sculpture* from Ikere, Yoruba, Nigeria, 1910–1914. Wood and pigment, $60\%'' \times 13\%''$. See also the text accompanying figures 5.13, 12.21, and 20.4.

The formal qualities of any other art work could be similarly analyzed, for example, a piece from the Palace Sculpture, by Olowe of Ise, from Ikere, Nigeria (1910–1914) (figure 4.2). Without knowing anything about the work, we can still analyze it formally. The work is frontal and symmetrical, the most formal of all arrangements, often reserved for religious or royal representations. The sculptures are obviously human forms, but simplified and distorted for emphasis. Body parts are rendered almost geometrically. The necks are elongated and cylindrical, breasts are almost cylindrical and bellies are barrel-shaped. The bodies are smooth, but the textures on clothing and jewelry add emphasis at the heads, necks, lower torsos, and wrists. The headgear is complex, decorative, and impressive. There is a greater density of smaller shapes at the bottom of the sculpture, where human legs, chair legs, and small kneeling people all crowd. Toward the top the forms become larger, more grand, and more surrounded by empty space. Verticals dominate the composition—the postures of both figures are vertical, and so is the chair. But there are also several parallel diagonal lines that knit the composition together. We see these diagonals in the implied direction of the standing woman's glance, in the upper contour of her breasts, in the direction of her lower arms, in the conical hat of the seated figure and in the lines of the bird atop that same hat.

From our formal analysis, we can presume that the big figures represent important beings, first from the formality of their arrangement and also from their large size compared to the small squatting figures down below. Both figures seem important but in different ways: the large woman is more imposing, but she stands, rather than sits, at the back. The gesture of her arms on the back of the chair indicate a supporting role. The figure in front is seated facing forward, as if addressing an unseen audience. While his position and headgear are impressive, he seems somewhat diminutive compared to the woman.

Formal qualities add to an artwork because they are aesthetically satisfying. The arrangement of elements in the *Palace Sculpture* is balanced, hierarchical, and coherent. The thoughtful arrangement of gray tones and textures around the woman's arresting face in *Migrant Mother, Nipomo Valley* (figure 4.1) is memorable. Looking at art is a very different experience from looking at the general environment, which is visually disjointed and disorganized. The formal qualities of artworks make them satisfying visual experiences, which adds considerably to the power of art.

The last work we will examine formally here is the 1989 high-rise office building, *Bank of China* (figure 4.3), located in Hong Kong and designed by I. M. Pei and Partners. Size and scale are formal qualities that add

4.3 I. M. PEI AND PARTNERS. *Bank of China*. Hong Kong, 1989. See also the text accompanying figures 3.19, 8.25, 22.6.

to meaning. Its height is one of its most impressive qualities. When it was built, the *Bank of China* was the tallest building in all Asia, which translated into heightened prestige for the Bank of China as a corporation. The *Bank of China* also encloses huge interior spaces. The lower floors surround a 12-story atrium and the top floors have high ceilings and provide spectacular views. Materials are also important in our formal analysis. The sheen of the polished metal-and-glass exterior allude to sophistication and modernity, while the marble and granite lobby speak of acquired wealth and success.

READING THE CONTENT

Content is an artwork's themes or messages. Some aspects of content may be obvious just by looking at an artwork. Others must be learned. Content is conveyed primarily in three ways: 1) through the artwork's subject matter; 2) through interpreting (or reading) its symbolic or iconographic references that go beyond the subject

matter; and 3) by studying the art writings and cultural background that explain or expand its content.

Subject Matter

The most obvious factor in the content of an artwork is its **subject matter**. What is it about? With observation, we can grasp much of the subject matter of *Migrant Mother, Nipomo Valley* (figure 4.1). The image is not just tones and textures, but a woman surrounded by three children. Based on body language, we presume that she is the mother, as she cradles an infant in her arms, while two children cling to her shoulders. She looks outward, her face lined with anxiety, while the two older children fearfully turn away. Their clothing is worn and grimy, a sign of poverty. The title fills in more gaps: the woman is indeed a mother and a migrant farm worker. We learn the deeper meaning of the subject matter of this photograph after studying the image relationship to its title.

We may grasp some of the subject matter of the Palace Sculpture (figure 4.2) just by observation. It represents the king and queen of the palace at Ikere, a royal family portrait. This sculpture is more, however, than just a royal portrait. The seated, frontal pose of the king shows him ceremonially enthroned. Behind him is his senior wife. She is shown larger because the women were revered for their ability to procreate. Among the Yoruba people of Nigeria, the senior wife is the one who crowned the new king. It is she who bestows power on him, the procreative power of women and the link to all previous kings. That power relationship is reflected in the positions of the figures, in the forward position of the king and the supporting posture of the queen, and in their relative sizes. The sculpture seems balanced, direct, straightforward, all qualities cherished by the Yoruba. Also, the king's youthful figure and the queen's matronly maturity were both prized by the Yoruba.

All works of art have subject matter, even abstract works. In *Lucifer* (figure 4.4), painted by Jackson Pollock in 1947, the subject matter is paint itself, and how it looks when dripped and splattered in layer upon layer on a very large canvas. Three kinds of paint were used—oil, enamel, and aluminum paint—each drying to a different sheen, with different surface. Overall, *Lucifer* looks somewhat like a pattern, resembling a spread net.

Artworks also have subtexts as part of their subject matter. **Subtexts** are underlying themes or messages associated with the work of art. The subtext in *Lucifer* is the energy of the artist himself. The splattered paint marks are traces of the artist's vigorous actions as he flung, dabbed, and poured the paint. This style of art is called **Abstract Expressionism**, but Pollock's works were placed in a subcategory of that, tellingly entitled "Action Painting." Another subtext of this painting

4.4 JACKSON POLLOCK. *Lucifer*: USA, 1947. Oil, aluminum paint, and enamel on canvas, approximately 3'5" × 8'9". Collection of Harry W. and Mary Margaret Anderson. See also the text accompanying figure 15.29.

comes from its title, *Lucifer*, and the predominance of black paint on the topmost layer of paint. The work seems to be alluding to the underworld as part of its subject matter.

Iconography

Artists can use metaphors or symbols to convey content. A visual **metaphor** is an image or element that is descriptive of something else. In *Lucifer*, splashes of paint are literally only splashes of paint. But the splashes are also visual metaphors for artistic energy.

A **symbol** is an image or element that stands for or represents some other entity or concept. Symbols are culturally determined and must be taught. For example, in the United States today, a dove is a symbol of peace. But people from other cultures would not know by observation alone to connect dove and peace.

A discussion of symbols leads to iconography, which literally means "image" (icono-) and "to write" (-graphy). **Iconography** is a kind of picture writing, with images and symbols, that allows artists to refer to complex ideas. Let us look at an example. In the *Palace Sculpture*, the king's crown is topped by a bird, which is a Yoruba symbol for mothers and female reproductive power. We would not necessarily know that iconographic reference, but once we have learned it, its symbolic value adds a greater depth to our understanding of that sculpture.

Some religions and cultures have developed very complex systems of iconography. The *Mandala of Samvara* (figure 4.5), from sixteenth-century Tibet, is an example of a kind of painting used by some Hindu or Buddhist believers to help them in meditation. Almost anyone can appreciate the formal qualities of this work, its composition and colors. And possibly many would guess its relation to religious beliefs, due to the formal symmetry of the image and the serenity of the figures.

But in fact, the painting is full of iconographic symbolism. The full meaning behind the mandala is known only to those who study all the symbols, and then meditate on the relationships between them. We can give a few superficial indications of the iconography in this mandala. The mandala is organized geometrically, with circles inside squares inside circles inside squares, representing fluctuating energy states and cycles of reincarnation. The circle symbolizes unbounded cosmic energy, which is transformed into physical reality (the square). The center indicates enlightenment. The images represent Tibetan deities who each symbolize certain qualities or elements of the cosmos. Other elements symbolize either gifts from the Gods or forces that are harmful to humans.

Text Link

For more information about Hindu iconography and gods such as Shiva, see Figure 9.5.

Other complex iconographic systems were associated with ancient Egypt, Byzantine art, Medieval Europe, Buddhism, and Hinduism, to name only a few. In medieval Christian symbolism, the unicorn stood for Jesus Christ and also a faithful husband in marriage. Mary, mother of Jesus, was often shown with flowers symbolizing purity or sorrow. A "portrait" of Mary with flowers symbolically referred to many aspects of her life. In this way, iconography adds to the content of a work of art, allowing the artist to allude to complex ideas by means of symbols and their relationship to each other. Thanks to iconography, many non-Christians recognize a painting of Jesus, just as non-Buddhists recognize an image of Buddha. This is all due to the pervasiveness and strength of iconographic representation.

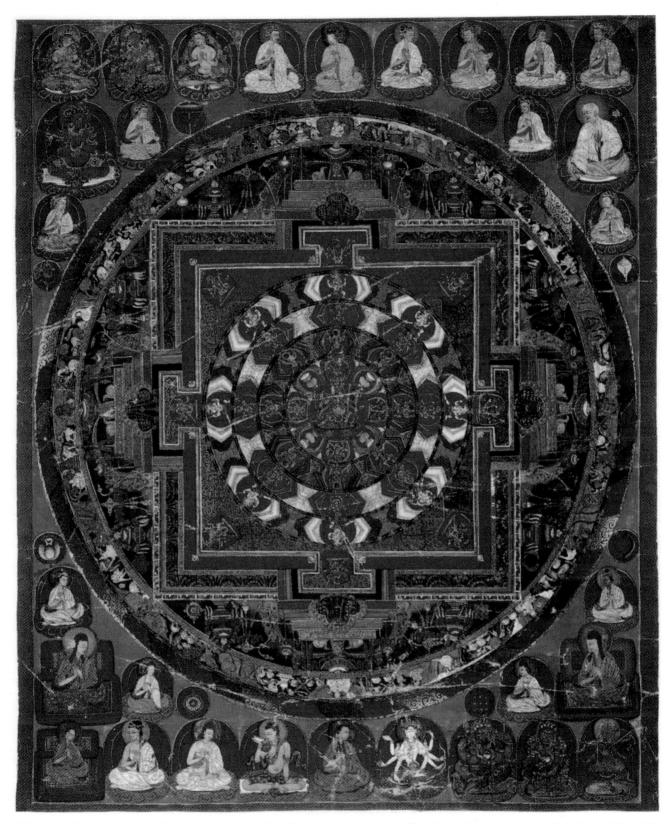

 $4.5\ \textit{Mandala of Samvara (Kharamukha Cakrasamvara Mandala)}. \ Tibet, c.\ sixteen th\ century.\ Water-based\ pigments\ on\ cotton\ cloth,\ height\ 23"\times\ width\ 18".\ The\ Zimmermann\ Family\ Collection.\ See\ also\ the\ text\ accompanying\ figure\ 9.28.$

Iconography can be embedded in architecture. *Te Mana O Turanga* (figure 4.6) is a meeting house that was built by a clan of the Maori people of New Zealand in

1883. Clan identity is very important among the Maori. The meeting house is essential in the creation of clan identity, because it is the site of clan meetings, and also

4.6 Raharuhi Rukupo and others. *Te Mana O Turanga*. Exterior of Maori meeting house. Carved and painted wood. Whakato marae, Manutuke, New Zealand, opened 1883. See also the text accompanying figures 12.23, 12.24, 16.4, and 20.25.

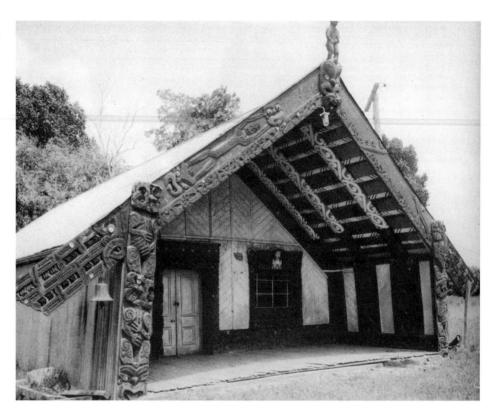

symbolizes clan identity, through its political, religious, and genealogical iconography. The house is covered with carvings showing ancestry, clan history, and religious beliefs. The very structure of the meeting house is symbolic! It is seen as the body of a powerful ancestor, for example, the insides are its belly, and the rafters its ribs.

Text Link

For a more complete explanation of the iconography of the meeting house, see the interior back wall of a Maori Meeting House (figure 16.4), shown here in our thumbnail, and also figures 12.23 and 12.24

Art Writings

What else adds to the meaning of artworks, besides their subject matter and iconography? We all rely on the writings of art professionals to help us understand the full content of what we see. There are various people who write about art. Art critics describe works of art, and then evaluating their worth, their importance as art, and their success in communicating their themes. Art historians are academics who primarily research art of the past and art of other cultures, identifying styles, attributing works to certain artists, and placing them in a chronological and cultural continuum. Museum curators write catalog essays, wall labels, and didactic mate-

rial in exhibitions to help us understand the full import of what we are seeing. We all rely on these materials when we go to a museum and encounter unfamiliar work.

All these writings develop the content of artworks. Content is not fixed and permanent in artworks from the moment they are made. Rather, content is formed over and over again, as each period reexamines and assesses work. Writers from different time periods may have different interpretations of the same works of art. Let us look at *Oath of the Horatii* (figure 4.7) painted by Jacques-Louis David in 1784. The paintings shows three young Roman men, standing together at left, vowing to their father (at center) that they will die if they do not return victorious from a duel against warriors representing a rival state. To the right, women grieve over the upcoming battle, as two women are related by blood and marriage to warriors on both sides of the conflict.

Here are excerpts from two twentieth-century writers discussing this painting. The first, John Canaday writing in 1959, focused on concepts of heroic action, virtue and duty to the state. He saw the painting as moral and revolutionary.

... David invented a new style of painting ... in order to express what amounted to a moral and philosophical revolution in art.... [T]he subject of 'The Oath of the Horatii' is dedication and sacrifice. ... we have vigorous young males pledging their lives to the defense of their honor, their family and their country. The chaste matron and swooning girl ex-

press their grief with admirable reserve, submissive to the will of the dominant men. . . . Service to a moral and social ideal is glorified as a virtue as opposed to its parallel vice, the indulgence of personal yearnings. (Canaday 1959:11)

Linda Nochlin presents another point of view in a 1988 essay. She asserted that the picture not only reflects, but also actively reinforces the status quo of social inferiority for women.

... representations of women in art are founded upon and serve to reproduce indisputably accepted assumptions held by society in general, artists in particular, and some artists more than others about men's power over, superiority to, difference from and necessary control of women, assumptions which are manifested in the visual structures as well as the thematic choices ... The binary division here [is] between male energy, tension and concentration as opposed to female resignation, flaccidity, and relaxation . . . David's message [is] about the superior claims of duty to the state over personal feeling . . . (Nochlin 1988: 1–2, 4)

Each writer represents what the painting means to a certain group at a certain point in time. These messages may be contradictory. In fact, many works of art have the capacity to convey conflicting, complex messages. Such artworks often have the greatest staying power, holding our attention longest, because they challenge us and be-

cause they are multi-layered. Such art reflects life itself, with its compromises, conflicting claims and profound (but sometimes very mixed) emotions. Meaning for a work of art develops over time. Why else would two twentieth-century writers still be occupied with a painting that is more than two hundred years old?

Some art critics and writers base their work on their personal or subjective reactions to art. Most influential critics, however, write from particular philosophical positions. The twentieth century saw the rise of five major positions from which most critics write, and we will look very briefly at each now.

Formalist Criticism

The first, from the mid-twentieth century, is **Formalist criticism**. Formalist critics emphasized the importance of formal qualities in art. Formalism first appeared in England in the early twentieth century as a way to appreciate works of art from other cultures. In particular, Japanese prints and African sculptures were widely circulated in Europe. Although their subject matter and iconography was unknown to the European audience, it seemed possible to appreciate them from a formalist point of view.

After World War II, Formalist criticism came to be associated with Modern Art in the United States. The most famous formalist critic was Clement Greenberg, who defined the important qualities of Modern Art in terms of Formalism, and who promoted the works of U. S. Abstract Expressionists. Works such as Jackson

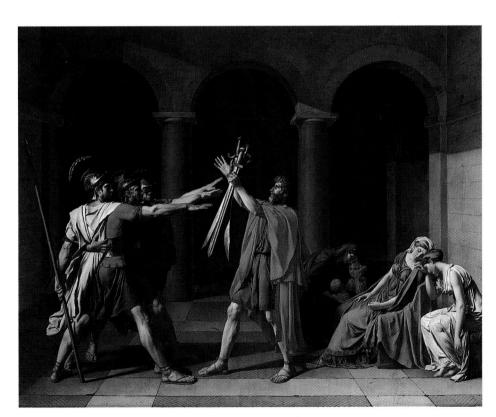

4.7 Jacques-Louis David. Oath of the Horatii. Oil on canvas. 10'10" × 14'. France, 1784. The Toledo Museum of Art. See also the text accompanying figure 17.23.

4.8 ELIZABETH MURRAY. Sail Baby.
Oil on three canvasses. 126" × 135".
USA, 1983. Walker Art Center,
Minneapolis, Minnesota.
See also the text accompanying
figure 16.11.

Pollock's *Lucifer* (figure 4.4) were hailed because they were "self-critical," focusing on what was "unique to the nature of [their] medium," so that "art would be rendered 'pure'" (Greenberg p. 13). *Lucifer* was "pure" painting because it was abstract and it emphasized paint quality and the flatness of the painting surface. Formal qualities were most important. Representational elements such as recognizable imagery, symbolism or narrative were considered distractions. Representation was unnecessary and often detrimental. Modernism viewed art as removed from society and independent of nature.

Formalist criticism has been generally discredited in the later twentieth century because it was too narrow a theory of art. It has been replaced by the four philosophical positions we will see next, which are associated with Postmodern Art. Nevertheless, formal analysis of art continues to be important, as we saw at the beginning of this chapter, for understanding the full meaning of art. Elizabeth Murray's 1983 painting, *Sail Baby* (figure 4.8) can still be analyzed in terms of composition and the arrangement of colors and shapes on the flat canvas surface, although the deeper content for the painting is family relationships.

Ideological Criticism

Of the four late twentieth-century philosophical positions for art criticism, we will look first at ideological **criticism.** Ideological criticism, rooted in the writings of Karl Marx, deals with the political implications of art. All art, according to this position, supports some particular political agenda, cultural structure, or economic/class hierarchy. We have just seen that Abstract Expressionist artworks were first written about in formalist terms. However, in the late twentieth century, even they have been reexamined in the light of ideological criticism. In Serge Guilbaut's book, How New York Stole the Idea of Modern Art, Abstract Expressionist art is analyzed not in terms of Greenberg's formalism, but rather for the political reasons for its amazing success after World War II. Guilbaut explained that Abstract Expressionism promoted the artists' individuality and self-expression. However, that ideology also fit with some aspects of U.S. Cold War politics, as the United States positioned itself as the land of democracy and freedom, versus the repressive Soviet government. In addition, Abstract Expressionism was a uniquely U.S. art style, which emerged at a moment when the United States was positioning itself as cultural leader over Europe, whereas before U.S. arts had

followed European models. This strategy was aimed especially at Paris, which had been the art capital of the Western world. As a result, Abstract Expressionism received timely support from museums and the U.S. government, which helped ensure its great success.

Not all ideological criticism is written. Hans Haacke's 1985 piece, MetroMobiltan (figure 4.9), examined the relationship between the art museum and corporate funding. Haacke used art to make the point that the Mobil Corporation was sponsoring a U.S. exhibit of African art at the New York Metropolitan Museum of Art as a publicrelations strategy. Mobil had been the target of protests because it was supplying goods to the South African police who were enforcing apartheid, or forced racial segregation. In his artwork, Haacke "argues" that by sponsoring an art exhibition, Mobil apparently hoped to improve its image with liberal protestors in the United States. MetroMobiltan points out that neither art nor art institutions were free from political entanglements. Haacke's work showed that those political entanglements could be far-reaching. In this case, an art exhibit in New York was dependent upon the continuation of apartheid in South Africa and a U.S. corporation's profits from its enforcement.

Structuralist-Based Criticism

Let us move on to a host of critical positions that emerge from **Structuralism**. Structuralists work from the theory that the study of art (or any other system of communication) cannot focus simply on the signficance of any one artwork. The study of art must be the study of the structure of art, as individual artworks are only a part of that structure. Social and cultural structures shape the meaning in art.

Structuralism was originally applied to the study of language, as was **semiotics**, which is the study of signs in verbal or written communication. These systems of communication not only represent ideas, but they can also be used to fabricate concepts about our world. However, the signs and structure of our languages have underlying biases and limitations. Language is a system of communication that both conveys and also limits knowledge. These ideas about language evolved in the first part of the twentieth century. However, in the late twentieth century, they came to be applied to any communication system, including art and mass media.

Deconstruction holds that there is a multiplicity of meanings to any text or image, and that these texts and images do not refer to any authentic, coherent world outside of themselves. Rather, they grow out of the structure of society, which is a cultural, human construction that defines and limits humans and human communication. The Western view of the world is constructed, not real, and it serves a Western point of view. Such systems of knowledge limit any knowledge outside themselves, because our ability to conceive and express ideas is

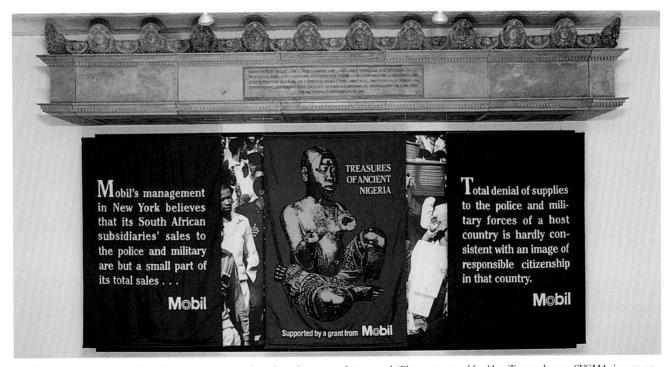

 $4.9~\mathrm{HANS}$ Haacke. MetroMobiltan. Fiberglass construction, three banners, photomural (Photo on mural by Alan Tannenbaum, SYGMA, image on central banner is "Seated Figure from Tanda, Africa, from National Museum of Lagos), $140" \times 240" \times 60"$. Fabrication assisted by Max Hyder, Richard Knox, and Paula Payne. USA, 1985. Artwork owned by the artist; first exhibited at John Weber Gallery, New York. Photo of installation by Fred Scruton. See also the text accompanying figure 14.26.

4.10 Cindy Sherman. *Untitled Film Still* #35. Gelatin Silver Print, 10" × 8". Collection of Eli and Edythe Broad, Los Angeles. See also the text accompanying figure 15.9.

limited by our systems of language and representation. Thus, from the inside, one perception of reality will come to seem universal and natural. Deconstructive artists and philosophers seek to "deconstruct" (or undermine and reveal) the myths, clichés, and stereotypes that are embedded in our language and our art and media sign systems.

Let us take a moment to illustrate these ideas with a work of art, Cindy Sherman's *Untitled Film Still #35*

(figure 4.10) a photograph from 1979. This work is one of many such "film stills" that together constitute Sherman's self-portraits. In them, she takes on feminine movie stereotypes, such as girl-next-door, vulnerable hitchhiker, and so on. She stages her work to look like film stills, which are themselves staged imagery. In her "self-portraits," there is no real Cindy Sherman. Her identity and behavior are copied. As the critic Douglas Crimp wrote,

85

[Sherman as a person] is literally self-created in these works; her self is therefore understood as contingent upon the possibilities provided by the culture in which Sherman participates, not by some inner impulse. As such, her photographs reverse the terms of art and autobiography. They use art not to reveal the artist's true self, but to show the self as an imaginary construct. There is no real Cindy Sherman in these photographs; there is only the guises she assumes. And she does not create these guises; she simply chooses them in a way that any of us do. (Crimp 1989, reprinted in Risatti:138–39)

Thus, deconstructive critics show that our very sense of self is culturally determined and limited.

Structuralist-based critics have also examined what the category of "art" means, and how that is culturally determined. Modern Art placed great importance on the unique art object, which was seen as being original, one of a kind, "handmade" by an artist who was distinguished as a person of great talent, even an artistic genius. Painting was an important Modernist medium. In contrast, Postmodernists in the late twentieth century have often focused on photography in the art world as a critical practice. Postmodernists question the unique quality of artwork and the idea that art has a single, universal meaning, or one theory to explain it. Postmodernists dispute that the artist is the author of original artworks. Photography, which easily copies existing things, allows for multiple copies, and the widespread distribution of these copies, fits with the idea common among Postmodernists that there is no original, no "real," only copies.

Psychoanalytic Criticism

Psychoanalytic criticism looks at art as the product of individuals who have been influenced and shaped by their own personal pasts, unconscious urges and their social histories. Sigmund Freud wrote what was probably the first psychoanalytic examination of art when he looked at Leonardo da Vinci's work in light of Leonardo's presumed homosexuality and episodes from his early childhood. Psychoanalytic criticism seems appropriate to apply to work that deals with strong emotional content, dream imagery or fantasy, such as the 1931 Surrealist painting, Persistence of Memory (figure 4.11). The artist, Salvador Dali, explored his own psyche, dreams, and erotic impulses as the basis of his work. The dreamscape is filled with absurd or fantastic imagery, all meticulously painted as if real. Psychoanalytic criticism helps to assign meaning to such imagery.

In addition to writing about individual artists, psychoanalytic critics have looked at the general psychological attributes of artists as a group. The critic Donald Kuspit exposes and then questions the preconceived notions about artists that psychoanalysis has given us:

... psychoanalysis generally follows Plato in believing that the artist's psychopathy, or 'madness,' is intense and intractable, 'inspiring' him or her to art yet making for a damaged life. But psychoanalysis is not alone here; many people follow Plato in this view. This preconception has led to the psychoanalytic correlation of art and madness, a correlation with profound implications yet also a great potential for shallow misuse. Psychoanalysis often seems to

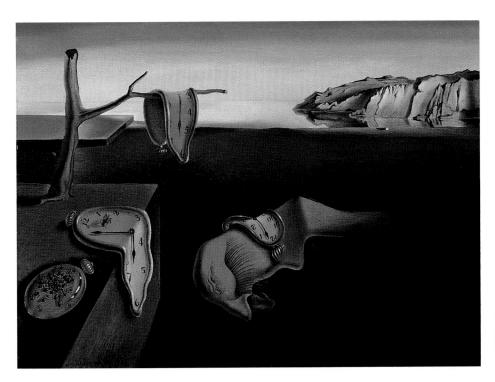

4.11 SALVADOR DALI. The Persistence of Memory. Oil on canvas. 9.5" × 13". Spanish, 1931. The Museum of Modern Art, New York. See also the text accompanying figure 19.25.

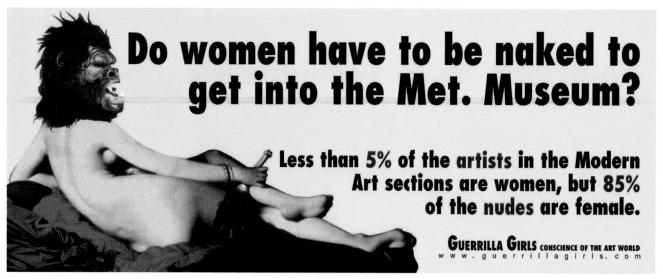

4.12 GUERRILLA GIRLS. Do Women Have to Be Naked to Get into the Met. Museum? Street Poster. USA, 1986. See also the text accompanying figure 17.28.

suggest that art does not so much overcome madness as intricately reflect it, and that the artist has a more intimate, aware experience of madness than any other human type, apart from the outright mad. (Kuspit 1987, reprinted in Risatti: 291)

Feminist Criticism

Feminist criticism is another late twentieth-century philosophical position that is concerned with the oppression of groups (especially women) in a given society along with the oppression of their belief systems. Feminism advocates equality; that is, equal social, political, and economic rights for both women and men. A specific area of **Feminist criticism** deals with the representation of gender in art, and how this representation can be used to support male-dominated social structures. Feminist criticism borrows from the ideas and methodologies of ideological criticism, structuralist-based criticism, and psychoanalytic criticism.

Linda Nochlin's quote above in reference to *Oath of the Horatii* is an example of feminist criticism. Rather than seeing the painting in terms of its heroic subject matter, Nochlin showed that the painting is based on widely held social assumptions about "women's weakness and passivity, her sexual availability for men's needs, her defining domestic and nurturing function, her identity with the realm of nature, her existence as an object rather than a creator of art; the patent ridiculousness of her attempts to insert herself actively into the realm of history..." (Nochlin 1988: 2). Feminist critics seek to reveal these power relationships because they can be "invisible and can be exercised only with the complicity of those who fail to recognize either that they submit to it or that they exercise it" (Nochlin 1988: 2).

The Guerrilla Girls' 1986 poster, *Do Women Have to Be Naked* . . . (figure 4.12) is an example of an artwork func-

tioning as feminist criticism. The poster protests the small number of female artists who had works in the New York Metropolitan Museum of Art collection. In contrast, the collection has many art works of female nudes, almost all done by men. Feminist point to this as a power relationship that is oppressive to women. Women make art, but their work is denied legitimacy by social and cultural structures. Images of women as sexually available for the presumed male audience are given the highest recognition in museums.

Gender issues are also explored in Chapter 17, Race, Sexuality, and Gender.

Personal Interpretation

Finally, in reference to meaning, let us look at how you, an individual person, may produce your own meaning for a work of art. When you look at art, its formal qualities and the subject matter outline an area of meaning for you. Your understanding can be augmented by art books like this one you are reading now, or writings you find in newspapers, museums, and galleries. But there is also another dimension, and that is you, your own ideas, personal tastes, experiences, and history. The work may mean something to you that it may not mean to everyone else.

In addition, on some level, you have an emotional response to the work. You are shocked, pleased, bored, fascinated, excited, soothed, or horrified by it. You also have an aesthetic response to it, for example, one of pleasure if the work has qualities that satisfy the eye or hand. These emotional and aesthetic reactions add to the meaning that the work has for you. Then your own background and experiences make a fertile ground for you to add meaning to the works of art that you study. That meaning often shifts as you change. A work of art may seem very different to you now than it did a few years ago.

THE INFLUENCE OF CONTEXT

Context consists of the interrelated social and political conditions that surround a work of art. Context includes a host of factors, such as historical events, economic trends, contemporary cultural developments, religious attitudes, other artworks at that time, and so on. Let us look at how the context influenced artists while they were making their art, and how that helps us understand work as we look at it today.

Indigenous customs and historical events are important in the context surrounding the Maori meeting house, *Te Mana O Turanga* (figure 4.6). The Maori people traditionally place great importance on genealogy, with all persons tracing their heritage back to powerful mythic ancestors. Therefore, the meeting house represents the body of a powerful ancestor. In addition, *Te Mana O Turanga* was built after a long period of land wars during which European settlers seized much of the land held by the native Maori people of New Zealand. Eventually, some confiscated land was returned to the Maori, but only after the clans established their tribal identity according to European standards. The meeting house was a vehicle for accomplishing this.

Let us also look at the context that surrounded Migrant Mother, Nipomo Valley (figure 4.1). This work is a black-and-white photograph, and as such, other blackand-white photographs form a context in which we assess this work. Migrant Mother, Nipomo Valley resembles documentary or news photographs, where photography is used to record a fact. It looks less like a studio portrait photograph (purpose: to record someone's likeness) or a "fine art" photograph (purpose: to create an aesthetically pleasing visual pattern). Documentary or news photographs are generally considered objective records of fact. We believe that they show us what happened. Even though we all know that photographs can be manipulated, staged, or faked, we generally accord a high degree of truth to documentary photographs. In this case, however, the artist herself wrote she made several exposures of this family and that they posed for her. Lange edited her prints and used her artistic skills to create the most effective image. Lange wrote that she felt a special rapport for the woman, and that the woman cooperated in posing for the picture taking. Nonetheless, the context of documentary photography affects how we interpret her picture. We accept the image as real, not staged, and therefore our emotional reaction is for a real family in actual, dire circumstances.

The historical and economic context for Lange's photograph is the Great Depression in the United States, a ten-year period of economic collapse. The fierce personal hardships that many people experienced during the Depression were well-known through photographs such as Lange's and through literature, such as John Steinbeck's *Grapes of Wrath*. U.S. government agen-

cies employed Lange and other artists to make pictures such as this one. In this case, the Farm Security Administration, which aided farm families impoverished and displaced by the Depression, wanted such images to advertise their services to the public and to document the agency's work. The combined efforts of artists and government have left us a comprehensive picture of life during the Great Depression. In *Migrant Mother, Nipomo Valley*, the woman was a displaced farmer who resorted to picking other people's crops to feed her seven children. However, the crop had just frozen in the field. There was no work, and thus no pay. This woman had just sold the tires from her car to buy what may have been their last food, as she could not seek further work unless she could travel.

Thus, context provides a wealth of additional information that adds to the total meaning of *Migrant Mother, Nipomo Valley*. Again, for any other work of art, we can similarly research the context, and add immeasurably to our understanding of the work.

In some cases, context may determine whether we see an object as a work of art at all. Brazilian artist Cildo Meireles' 1970 work, Insertions into Ideological Circuits: Coca-Cola Project (figure 4.13), appears at first to be plain old Coca-Cola bottles. If we happened to inspect one of the bottles closely, we might notice that some small print appears to have been added to each bottle: including "yankee, go home!" and "Projecto Coca-Cola." Even so, it is hard to know what the average viewers would make of just that. They may simply ignore it. However, in certain contexts, the work was quite meaningful and politically charged. Meireles' work was targeted at the Brazilian population. He was protesting U.S. economic ventures in Brazil. He saw U.S. companies buying Brazilian land and selling U.S. products in Brazil as a form of economic colonization that was detrimental to his country. It also resulted in the clearing of rain forests, and the uprooting and destruction of indigenous populations in Brazil. In addition, Meireles was protesting the military government in power in Brazil at that time, which profited from the U.S. ventures.

Miereles silk-screened the extra words on Coke bottles that were used over and over again (sold full, returned for a deposit, filled again, and then put out again on the market shelf). He was using an existing system of distribution to distribute his own artwork. When the bottles were empty, the message was nearly invisible. When full, and in the hands of the Brazilians drinking the beverage, the message was readable.

WAYS THAT HUMANS ENCOUNTER ART

We encounter art in all kinds of ways, and the nature of our encounter adds meaning to the artwork.

Migrant Mother, Nipomo Valley first appeared in a San Francisco newspaper just a few days after Lange took the

4.13 CILDO MEIRELES. *Insertions into Ideological Circuits: Coca-Cola Project.* Brazil, 1970. Screenprinting on Coca-Cola bottles. See also the text accompanying figure 14.16.

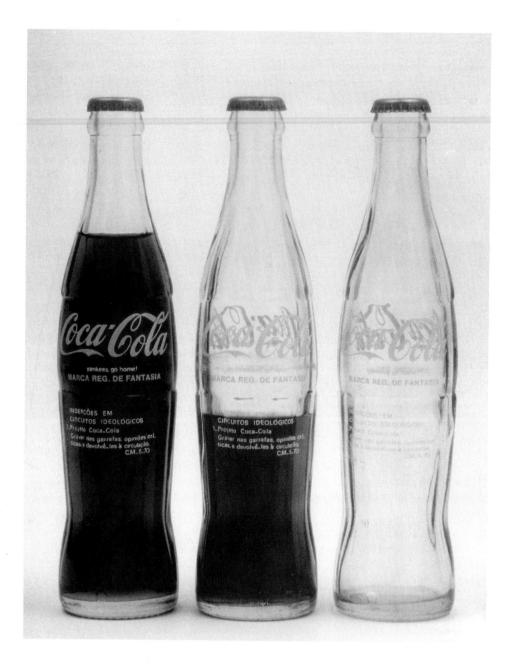

picture. People in the area were so moved by the image that they rushed donated food and supplies to the Nipomo Valley to feed the hungry workers. To those who saw it in the newspaper, the picture was a current event. Its immediacy caused them to act. Today, we see *Migrant Mother, Nipomo Valley* in art books or an art museum. To us, it is a work of art that refers to events in the past. We may feel sympathy, but we are not roused to rush aid and relief.

The way we encounter art even changes how the art looks. Lange's photograph has been reproduced in newspapers, reproduced in art books, and hung in a gallery. In each instance, the work of art looked very different. Newspaper-quality printing has coarse dot patterns, high contrast, and few intermediate grays. The photographic reproduction in your book is better than

in the newspaper. But it is still small, still rendered as patterns of dots, and still crude in its tones. The actual full-size photographic print has continuous and subtle tones, and records the textures with fine sensitivity. The newspaper image is most crude and immediate, while the photographic print in the gallery is the most aesthetically refined. A work of art is not the same if we know it only through reproductions, versus seeing the actual work. Even photographs, as we just saw, change with reproduction. If this is true for a photograph such as Lange's, then it is even more so for our experience of architecture, sculpture, large paintings, and performance art, where a single static image communicates only a fraction of the total experience.

Even when we are looking at the actual art, and not photographic reproductions, art changes as a result of where we encounter it. Art can appear in museums, in galleries, at family gatherings, as part of political events, in religious ceremonies, at outdoor festivals, at malls, at home shows, and so on. In each instance, the venue affects the value and meaning of the piece. Today, we can go to see the *Interior House Post* (figure 4.14) at the Seattle Art Museum, where we would have the opportunity to examine up close the traditional carvings and painting of the Kwakiutl, a tribe of Native Americans who live along the Northwest Coast of Washington state and of Canada. The museum favors our experiencing art with our eyes. Most museums are very quiet, and we are strictly forbidden to touch anything. Because this post is preserved with great care, we

Text Link

Here is a thumbnail image of a feast pot used at the celebration of the potlatch. See figure 6.28 for more information.

understand that it is valuable and rare. The museum setting may lead us to presume that it is an artifact from a dead and distant culture. Art displayed in museums is always more or less out of its original religious, historical, and social environment.

But the people for whom this house post was carved had a very different experience of it. The house post is one of four main supports in a large ceremonial house, called the Raven House. The house was completed and first used in 1916 for festivities celebrating the founding of a new family line. These festivities, called potlatches, were amazing, elaborate celebrations lasting several days. In addition to feasting, there were performances, singing, masquerades, and story-telling that glorified the family history. The ceremonial animals and figures carvings in the Raven House were integrated into these performances, as they represent deities and ancestors important to the family. It was also a time of drinking and sexual license. At the end of the potlatch, large quantities of gifts were given to all who attended, as giving gifts was a sign of power (and giving the most splendid gifts was the sign of the most supreme power). By accepting these gifts, the recipient acknowledged the power of the giver. After the potlatch was over, the house was subdivided, and several small families lived there.

This is so different from our modern museum experience of the *Interior House Post*. The potlatch was an experience for all the senses. And then afterwards, people lived everyday with these large carvings in their houses. The house post was part of the very structure of their house and the fabric of their family lives.

Our discussion of the *Interior House Post* brings up another aspect of art and the ways we encounter it. Art is both mimetic and performative. It is **mimetic** in that its appearance mimicks something, resembles something or represents something. Art is **performative** in that it does something. It is used and in its use it performs specific functions. Art's performative aspect is greatly influenced by the way we encounter the art.

The carvings on the Interior House Post are mimetic. They imitate the forms of bears and thunderbirds and are readily identifiable, although they do not look like wildlife photographs. The carvings record certain external features (the bear's paws, short upturned nose, and fearsome teeth) and certain characteristic qualities (such as fierceness) of the animals. The carvings are also iconographic, in that they are part of a large body of symbols and images that relate to tribal histories along the Northwest Coast. The carvings are also performative. This was apparent for those who attended the potlatch in 1916, where the house post was the visual part of performances, masquerades, and story-telling. The carvings were also performative for those who later lived in the house, as the carvings recreated their history in a vivid and proud way. Visitors to the house would be awestruck by the imposing works.

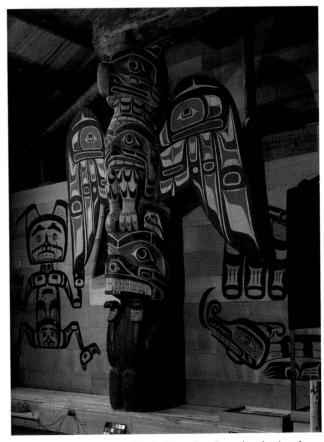

4.14 ARTHUR SHAUGHNESSY. *Interior House Post*. Carved and painted red cedar, 190" × 132" × 34". Kwakiutl, Gilford Island, British Columbia, 1907. See also the text accompanying figures 2.16 and 16.5.

But how is the Interior House Post performative to the people who visit the Seattle Art Museum today? The museum setting determines the performative dimension of this work. Rather than being something to live with, or to celebrate with, the Interior House Post in the museum becomes something to study or appreciate. The post is a record of the living history of the area, especially to the Kwakiutl people of today. We can understand from it some aspect of the underlying Kwakiutl philosophy of the physical and spiritual interrelatedness of animals and humans. The carvings are still the visual component of potlatch festivities, even though we can now only mentally reconstruct them. And the museum setting encourages us to appreciate the formal qualities of the post. At nearly 16 feet tall, it is a phenomenal visual experience, covered with strikingly bold geometric shapes, black outlines, and vivid colors. Its large scale, frontality, and symmetry are still visually impressive.

SYNOPSIS

Art communicates complex ideas and emotions. It does so because of its formal qualities, its content, its context, and the ways we encounter it.

Formal qualities are the structure and composition of a work of art. Formal qualities organize our visual perception, emphasize certain areas of an artwork, communicate general emotional moods, and add to our aesthetic pleasure in a work.

An artwork has content, sometimes in many complex layers. We "read" content through subject matter and iconography. We also rely on writings by art professionals to add to our understanding of an artwork. We saw five philosophical positions from which art has been analyzed in the twentieth century: formalist criticism, ideological criticism, structuralist-based criticism, psychoanalytic criticism, and feminist criticism. Finally, our own emotional and intellectual makeup, combined with our memory and experiences, allow us to shape very personal meanings for ourselves in artworks. The meaning of art is not permanent or fixed. Various levels of meanings, some contradictory, can come from a single work of art, depending upon who sees it and how they use it.

Every work of art was created in a specific historical, political, social, or religious context. Knowing about that context broadens and deepens our understanding of a work of art.

We encounter art in a variety of ways, and the nature of that encounter changes our understanding and use of the artwork. Our understanding of art is different if we know it through reproductions, or if we see it in a museum, or if we see it in its original environment. Every work of art we see is both mimetic (representative) and performative. The way in which we encounter art greatly affects its performative aspect.

4.15 Georgia O'Keeffe. *Grey Line with Lavender and Yellow.* Oil on canvas, $48" \times 30"$. USA, 1923. New York, The Metropolitan Museum of Art. See also the text accompanying figure 17.15.

FOOD FOR THOUGHT

We have talked a lot about writing in relationship to art in this chapter. But what do artists think of writings about art?

Some artists have left considerable verbal or written information about their work, which is passed on through their own writing, through interviews they give, or through their informal conversations about their work. Georgia O'Keeffe frequently painted details of flowers, up close and large, as in *Grey Line with Lavender and Yellow* (1923) figure 4.15. In private letters, the artist indicated that her art was concerned with emotional and formal arrangements of colors and shapes, inspired by landscape and plant forms. Her letters reveal over and over again her deep love of the colors and patterns of na-

ture, especially in New Mexico, where she lived for many years. She wrote in one letter:

There has been no rain since I came out but today a little came—enough to wet the sage and moisten the top of the dry soil—and make the world smell very fresh and fine—I drove up the canyon four or five miles when the sun was low and I wish I could send you a mariposa lily—and the smell of the damp sage—the odd dark and bright look that comes over my world in the low light after a little rain . . . (Cowart 1987: 239)

Other writers, especially later feminists, have perceived a feminist content to O'Keeffe's work. In particular, they perceived her flower imagery as representing female sexuality in a positive way. Judy Chicago, a leader in the feminist art movement, wrote:

... [O'Keeffe] seemed to have made a considerable amount of work that was constructed around a center ... There also seemed to be an implied relationship between [her] own body and that centered image ... In her paintings, the flower suggests her own femininity, through which the mysteries of life could be revealed (Chicago 1975:142).

How important is the artists' intention versus the critical reception of the work? Which should be most important in the interpretation of the meaning behind work? Are both important?

Georgia O'Keeffe disliked how many writers saw feminist content in her work. Yet she avoided writing artist's statements herself. As she wrote in personal letters, "Words and I—are not good friends at all except with some people," and later, "The painter using the word often seems to me like a child trying to walk. I think I'd rather let the painting work for itself than help it with the word" (Coward 1987:135).

Mark Rothko, whose painting we will see in Chapter 19, Nature, Knowlege and Technology, wrote frequently about art in general and his paintings in particular in the early part of his career, but ceased doing so after 1950. In a personal letter he wrote, "I simply cannot see myself proclaiming a series of nonsensical statements, making each vary from the other and which ultimately have no meaning whatsoever. . . . At this time I would have nothing to say in words which I would stand for. . . . This self-statement business has become a fad this season, and I cannot see myself just spreading myself with a bunch of statements everywhere, I do not wish to make" (Clearwater 1984: 67).

Text Link
See figure 19.26 for more information about Mark Rothko's painting Green, Red, Blue.

Yet other artists have been very prolific with the pen, or the word processor. Judy Chicago, quoted above, is a prominent artist whose writings have been very influential. She led the crews of artists who produced the *Dinner Party*, a large multimedia installation covered in Chapter 6. Donald Judd was a leading artists of the Minimalist movement in the 1960s and 1970s, and his articles and essays were widely published. These are only two such examples.

- Does the written word add to the public's experience of art?
- Do writings bias or limit our experience of art?

Chapter 5 Looking at Art within Culture

INTRODUCTION

A work of art is made within a living culture. Artists are aware of other art around them as they make their pieces. The culture also influences those people for whom the artwork was originally made. They had standards and expectations when they saw the work, based on other art they had already seen.

Artworks by the same artist often share certain recurring attributes and features. So do artworks made by different artists within the same culture or civilization. The sum of these recurring elements is called **style**. We will do two things in this chapter. First, we will discuss and analyze the word "style" and find out what are the components of style. We will discuss what is meant by the stylistic tradition of a particular culture, and also what it means for individual artists to have their own unique style within their cultures. Second, this chapter gives an overview of major cultures and the distinguishing features of their art, focusing on those we cover in this book. The following questions are important:

What are the components of an art style?
What are the major cultures whose art is illustrated in this book? What qualities distinguish the art made by these cultures?
What does it mean for artists to have their own styles? Does every artist have a unique style? If not, why?

STYLE

As we wrote above, style is the collection of recurring elements that can be seen within a single artist's works, or can be seen among the works of artists from the same culture. For cultures, these recurring traits help us identify works from ancient Egypt, for example, and see them as distinct and coherent as a group. Stylistic differences make the art of ancient Egypt readily distinguishable from the art of, say, seventeenth-century France.

Attributes of Style

What kinds of "recurring attributes and features" make up a style? There are several kinds and they cluster around the following categories: 1) formal features; 2) content/function; 3) medium; and 4) manner of execution. Let us look at each.

Formal elements can be defining features of a style. We may note that a certain style of architecture is distinguished by the formal feature of scale, and may consist predominantly of very large buildings. As another example, a certain style of painting may feature heavy, bold, black outlines, while another style of painting has fine, delicate lines. Or pattern may be a strong and obvious stylistic feature among a group of artworks, and totally lacking in another.

The function or content of artworks may influence their style. For example, religious artworks made by a group of people may be stylistically different from the works they might produce for entertainment. The style used for art that promotes war or the power of a ruler was likely chosen to enhance that message.

Medium can also be a factor in style. Available materials determine to some extent what kind of artwork is made, and therefore how it looks. In a culture where only wood is available, the artwork inevitably looks different from art in a culture where wood is scarce but stone is plentiful. The style of the twentieth-century highrise office building would have been completely impossible without metal, glass, and reinforced concrete.

Beyond all these considerations, however, art styles are distinguished by the manner of execution. So while a rose is a rose, it is not the same rose if it is handled naturalistically versus abstractly in an artwork. A group of terms are commonly used to describe different manners of execution for art. We will define the most important ones below. This list is by no means complete, nor unfortunately do all terms have only one single meaning.

Art that is **naturalistic** generally contains recognizable imagery that is depicted very much as seen in nature. Jan Bruegel's painting of a *Little Bouquet in a Clay Jar* (c. 1599) (figure 5.1), is rendered in a naturalistic style. Close observation of each flower and leaf by the artist has been translated clearly and pristinely into imagery.

In **idealized** art, natural imagery is modified in a way that strives for perfection within the bounds of the values and aesthetics of a particular culture. Among the Baule people in nineteenth-century Africa, the ideal human form was divided roughly into thirds: one part each for the head, the torso and the legs, as illustrated in

Text Link

Read about the idealized human form from ancient India in the discussion of the Yakshi, (figure 15.11.)

figure 5.2, a *Male Torso (Ancestor)* from the late nineteenth or early twentieth century. This ideal system of proportions visually expressed the importance given to each part of the body. The Baule ideal contrasts strongly with the idealized style that the fifth-century BC Greeks developed for the "perfectly" proportioned human body, such as Polykleitos' *Doryphoros* (figure 5.3). The head had to be a certain size in relation to the body, while width and length of various body parts were carefully adjusted to be in ideal harmony.

Nonobjective (nonrepresentational) art has no recognizable imagery from the outside world. The imagery is completely generated by the artist. Robert Motherwell's imagery is nonobjective in his 1954 painting, *Elegy to the Spanish Republic XXIV* (figure 5.4) even though it referred to actual historical events.

The term "abstract art" is often used to mean the same thing as "nonobjective," but there is an important distinction. **Abstracted** imagery may or may not be recognizable, but has been derived from reality. This is usually done by distorting, enlarging, and or dissecting objects or figures from nature. In figure 5.5, the *Tlaloc Vessel* (c. 1470), a face has been carved into the clay surface in an abstracted style. The facial features have been simplified and geometricized, and are therefore

5.1 JAN BRUEGEL. Little Bouquet in a Clay Jar. Oil on Panel, 20" × 15.75". Flanders, c. 1599. Kunsthistorisches Museum, Vienna. See also the text accompanying figures 19.13 and 20.2.

5.2 *Male Torso (Ancestor)*. Baule Sculpture Height 20.5". Africa. London: British Museum. nineteenth–twentieth century. See also the text accompanying figures 15.13 and 20.20.

abstracted from the natural appearance of a human face.

When an abstracted element is **stylized**, it reoccurs almost exactly the same in several works of art. For example, the simple, geometric facial features of the *Tlaloc Vessel* can be seen in other ceramic vessels from fifteenth-century Mexico. This repetition of the same abstractions can be called a stylization of that element. When stylizing, artists follow established artistic conventions rather than working from observation or imagination.

Text Link
The human figures in the Fowling
Scene from the Wall Painting from the
Tomb of Nebamun, figure 11.5, is
another example of stylization. This
manner of depicting the figure was
repeated throughout Egyptian art.

Related terms are **mannered** or **mannerist**; they refer to artificial, highly stylized, or derivative styles of art. For example, the artist Michelangelo Buonarroti was such an overwhelmingly influential artist in sixteenth-century Italy, that many artists who followed him worked in imitative, eccentric, mannered styles based on his work.

Expressive or **expressionist** styles of art are those that communicate heightened emotions and often a sense of urgency or spontaneity. Expressive styles frequently appear bold and immediate, rather than carefully considered or refined. They often feature distorted or abstracted imagery. Leon Golub's 1976 painting, *Mercenaries I* (figure 5.6) features scraped surfaces, raw marks, and harsh colors to add to the horror and cruelty of a torture scene.

The term **classical** has several related meanings in reference to style. It can be used to refer to art that is orderly, balanced, clear, and well proportioned vertically and horizontally. In this sense, classical is the opposite of expressive. Classical also describes a point in the evolution of styles: classical works represent the full development of a certain style, in contrast to its early formative stage or its late transformation into another style. When

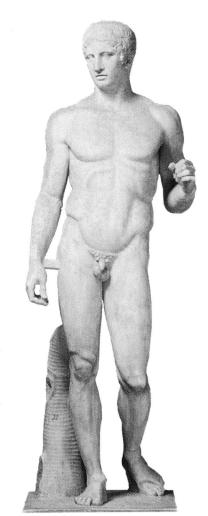

5.3 POLYKLEITOS. *Doryphoros (Spear-bearer)*. Roman marble after a bronze original of c. 450–440 BC. 6'11" high. Museo Nazionale, Naples. See also the text accompanying figures 2.35 and 15.12.

5.4 ROBERT MOTHERWELL *Elegy to the Spanish Republic XXIV.* Oil on canvas, 80" × 100", USA, 1953–1954. Albright-Knox Art Gallery, Buffalo, NY. See also the text accompanying figure 14.6.

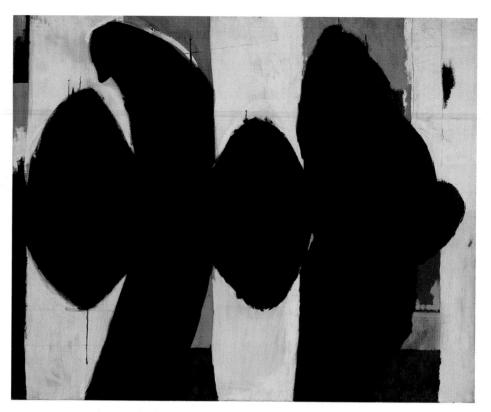

written with a capital "C," Classical refers specifically to the art made in Ancient Greece in the fifth century BC. The related term **classic** indicates a judgment of excellence, such as a classic work of art with widely recognized outstanding qualities.

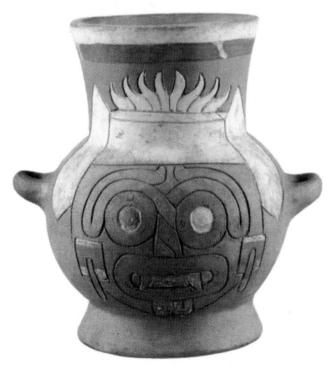

5.5 Tlaloc Vessel. Ceramic. 30.5 cm. high. Aztec. Templo Mayor, Mexico, c. 1470. See also the text accompanying figure 9.14.

Both the first and second meanings of "classical" can be used to describe the sacred center of the Mesoamerican city of Teotihuacán, with the *Pyramid of the Sun* (figure 5.7) and the Avenue of the Dead, dating from the first through sixth centuries. This sacred precinct was laid out in an orderly manner, along axes oriented north-south and east-west. Pyramids and temples were positioned at key points, and there is a sense of balance between the "positive" shapes of the enormous pyramid structures and the "negative" spaces of depressed open plazas interspersed among them. In addition, Teotihuacán represents the classical phase of Mesoamerican cultures, when great civilizations flourished in Mexico and Central America.

5.6 Leon Golub. *Mercenaries I.* Acrylic on canvas, $116" \times 186.5"$. USA, 1976. Eli Broad Family Foundation Collection, Los Angeles. See also the text accompanying figure 14.8.

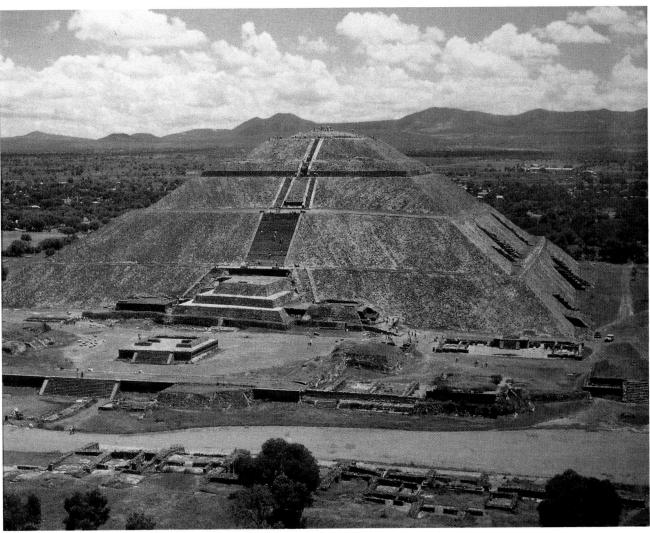

5.7 Pyramid of the Sun, with the Avenue of the Dead in the foreground, Teotihuacan, Mexico, begun before 150. Pyramid is 768 feet along one side of the base. See also the text accompanying figure 10.19.

Other terms are used to describe attributes of style. However, the ones just mentioned will give you a basic working vocabulary with which to examine broad cultural styles and styles of individual artists.

Cultural Styles

Works of art from different cultures exhibit distinct attributes. The aggregate of those attributes are what we call cultural style. A **cultural style** consists of recurring and distinctive features that we see in many of works of art emanating from a particular place and era. Cultural styles reflect and express the cultures from which they came. Along with language, religion, and social customs, the styles of art and architecture form a culture's identity.

A few definitions are helpful here. **Culture** can mean the totality of ideas, customs, skills, and arts that belong to a people or group. This cultural totality is communicated or passed along to succeeding generations. A **culture** may also mean a particular people or group, with their own ideas, customs, and arts. A **civilization** is a

highly structured society, with a written language or a very developed system of communication, organized government, and advances in the arts and sciences. A country and a people with a high degree of social and cultural development can also be called a "civilization."

So, when referring to ancient Egypt, we may call it a civilization, as it was a structured society with government, written language, and the arts and sciences. We may also refer to Egyptian culture, that is, its collective ideas, customs, and beliefs, and the articles of art that it produced. Most important here is our ability to distinguish the Egyptian style of art, as one representation of its cultural identity.

Cultural styles are recognizable across a broad spectrum of art objects created by a people. These art objects share content and many formal qualities. For example, the art of the Native Americans of the Northwest Coast has many distinct, identifying features, as we can see in two examples, the *Feast Dish* (figure 5.8), by Charlie James from 1907, and the *Echo Mask* (figure 5.9) also

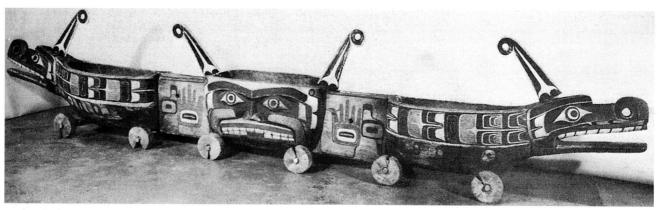

5.8 CHARLIE JAMES. Feast Dish. Wood with green, black, red, and white paint. 20 feet long. From Turnour Island, British Columbia. 1907. See also the text accompanying figure 6.28.

from the twentieth century. The *Feast Dish* is a 20-footlong serving bowl, while the *Echo Mash* fits over a performer's face and was used during dance and storytelling. Despite differences, the imagery in both objects is taken from the same iconographic system that standardized the representation of many animals and spirit forms. It was important in Northwest Coast art that the animal and spirit imagery was recognizable. Both objects are wood carvings, which is the typical art form of that area. Both share many formal attributes, such as heavy black outlines that emphasize carved areas, bright

colors, and shapes that are flat, flowing, and abstracted from nature. Both fulfilled similar functions, to delineate and celebrate the genealogy of a clan.

Similar examples can be found in almost every culture. For example, during the seventeenth-century reign of King Louis XIV of France, the court style, which was ornate and lavish, could be seen in everything from architecture to painting, furniture design, and clothing. Even hairstyles were affected. Men and women wore enormous, elaborate, powdered wigs; some apparently even had jeweled model ships "floating" among the curls

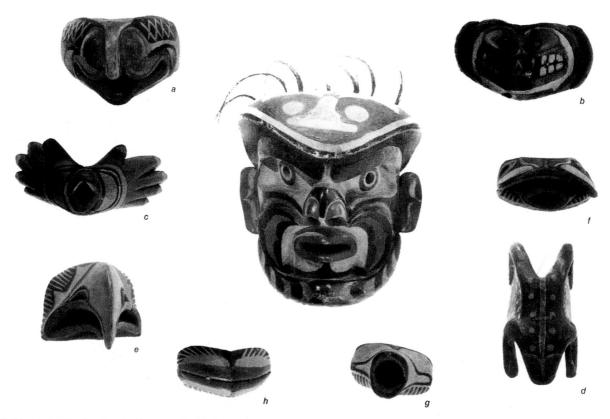

5.9 Echo Mask with nine detachable parts, Kwakiutl, British Columbia, Canada, twentieth century. See also the text accompanying figure 9.19.

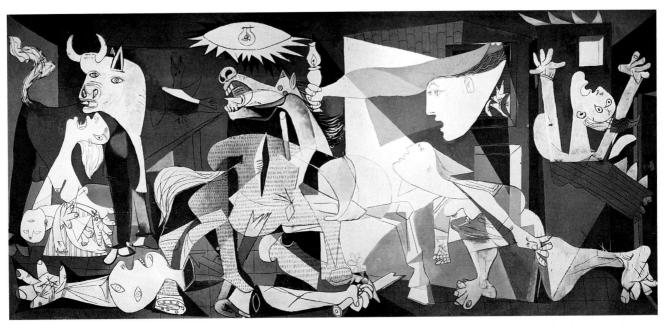

5.10 Pablo Picasso. Guernica. Oil on canvas, $11' \times 28'8''$. Spain, 1939. Prado Museum, Madrid. See also the text accompanying figures 2.3 and 13.25.

and waves. You can see broad cultural styles around you today. Do you notice certain shared qualities among some contemporary art, popular music, and the latest ads for jeans?

Text Link

The Hall of Mirrors at the Palace at Versailles (figure 12.19) is a good example of the ornate Louis XIV style.

Cultural styles are not static, but evolve due to many circumstances, such as changes in religion, historical events such as war, and contact with other cultures through trade or colonization. For example, we see that the art of Europe changed profoundly because of African influences, especially apparent in works like Guernica (figure 5.10), painted by Pablo Picasso in 1937. The human form from fifteenth-through nineteenth-century European art had been rendered in a naturalistic, idealized, or Classical Greek-inspired manner. Picasso's style is a break with that tradition. His rendering of the face and use of pattern owes much to African sculpture, such as the Mask from Zaire (figure 5.11). When viewed as a whole, Picasso's lifetime output is an amalgam of styles from Africa and Europe, dating as far back as Classical Greece and Rome, and forward to the twentieth century. Conversely, African artists are influenced by the European styles to which they have been exposed.

Styles of Artists within Their Cultures

Style can also refer to the distinguishing characteristics of one artist's work. Individual artists can develop very unique, personal styles. In some cases, their names would be known even without the signature on their

5.11 *Mask.* Wood, paint, fiber, and beads. 22" high. Zaire, Africa. African Art Collection of the Museum of Texas Tech University, Lubbock. See also the text accompanying figure 9.25.

5.12 VINCENT VAN GOGH. *Portrait of Dr. Gachet*. Oil on canvas. Netherlands, 1890. Photo courtesy Christie's. See also the text accompanying figures 15.3 and 20.12.

work. Artist Vincent van Gogh is famous for his expressive paintings rendered in rich thick paint in brilliant colors. Using a palette knife, he applied his paint quickly, allowing for a heavily textured surface on the painting as well as in the imagery. His unique style, readily distinguished from other European painters, can be seen clearly in his *Portrait of Dr. Gachet* (figure 5.12) from 1890.

Yoruba sculptor Olowe of Ise in Nigeria is also famous for his excellence in carving in his own distinct style. He was so known for his work that songs and poems were written about him. His complicated, interlocking organic forms of royal figures adorn many palaces and chiefs' houses. In his *Palace Sculpture* from 1910–1914 (figure 5.13), which is also a pillar in the structure of the palace, we see the senior wife, the queen, behind the king. The sculpture was likely carved from one piece of wood, and the skilled clear carving style of Olowe expresses brilliantly Yoruba aesthetic values of "clarity, straightness, balance, youthfulness, luminosity and character" (Blier 1998:85). His work is easily distinguished from that of other African sculptors.

Even given their unique vision and skills, Van Gogh's and Olowe's works can still be grouped with other artists working within their respective cultural milieus. Every artist's unique individual style is also a reflection of broad cultural styles. New styles might be named after groups of artists working in a similar way. For example, artists in France in the late nineteenth century were

5.13 Olowe of Ise. Palace Sculpture from Ikere. Wood and pigment, $60\%^{\circ}\times13\%^{\circ},\,1910-1914.$ Yoruba, Nigeria. See also the text accompanying figures $4.2,\,12.21,\,\mathrm{and}\,20.4.$

concerned with capturing the sensation of light in their paintings, and had similar light-filled compositions in their exhibits. A critic described their work as a mere impression rather than a painting, and the name stuck. An example of Impressionism is *Luncheon of the Boating Party* (figure 5.14) from 1881, by Pierre-Auguste Renoir.

New styles often grow from the old. For example, the painting *La Grande Jatte* (figure 5.15) seems on the one hand to be like Impressionist paintings, with sunlight

brightly shining through the grove of trees and glimmering off the water. However, Georges Seurat modified the Impressionistic style, by applying his paint in a series of small colored dabs that the viewer's eyes blend together. His painting method was painstaking; he worked for two years, from 1884 to 1886 to complete this large canvas. He was called, therefore, a Post-Impressionist, and his style merited its own name, called either "Pointillism" or "Divisionism." Van Gogh is also

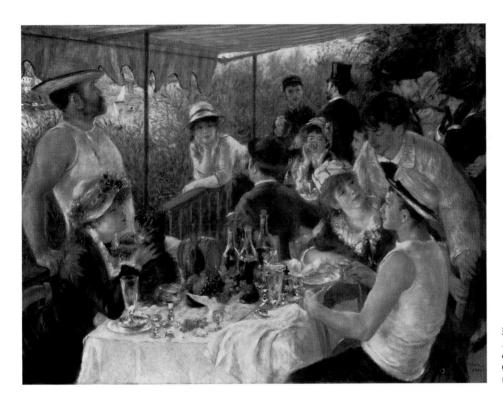

5.14 PIERRE-AUGUSTE RENOIR. The Luncheon of the Boating Party. Oil on canvas. France, 1881. Phillips Collection, Washington DC. See also the text accompanying figure 6.31.

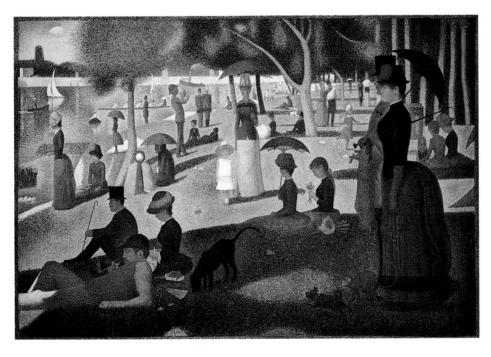

5.15 Georges Seurat. La Grande Jatte. Oil on canvas, approx. $6^{\circ}9^{\circ}\times 10^{\circ}$. France, 1884-1886. The Art Institute of Chicago, Helen Birch Bartlett Memorial Collection. See also the text accompanying figure 16.22.

considered a Post-Impressionist, as his style is also a modification of Impressionist painting.

Yet, even as we make distinctions among individual styles, we can also see what aspects of the prevailing cultural style they share. Thus, most Impressionists and Post-Impressionists are similar in the fact that their subject matter was often genre scenes, and they painted mostly in oil, the medium of choice for both groups. They used bright-colored thick paint (called impasto), rather than in thin washes of subdued color. La Grande Jatte, Portrait of Dr. Gachet, and Luncheon of the Boating Party were all painted within ten years of each other, and so display certain elements of the same cultural style.

Some artists seek to develop their own styles and some do not. European and U.S. artists in the early part of the twentieth century sought to develop their own distinct styles, as innovation and individuality were seen as marks of artistic value. This is changing somewhat in the late twentieth century, as more artists in Europe and the United States are creating work in collaborations, or even incorporating copies of other images, so that a unique, individual style no longer necessarily denotes quality.

In some cultures, copying a venerable example is valued more than producing a new, unique object. For example, as we saw, the Egyptian artists had a distinct style of rendering figures. That style was so well-established and effective for their culture that very little change was seen in it over hundreds of years. It was more important for the Egyptian artists to follow canons of representation than to invent new imagery or new ways to depict it. We see similar attitudes in some Chinese landscape paintings, and also in Medieval Europe, when new religious manuscripts were carefully copied from old manuscripts. Artists from the Pacific Northwest also copied conventional forms in order to make their imagery recognizable, as we saw previously with the Feast Dish and Echo Mask. These artists were charged with the need to copy old forms, while investing new spirit and vigor in them.

THE STYLES OF MAJOR CULTURES

We will now present brief summaries of the major cultures for artworks covered in this book. This is by no means an exhaustive list of all the major cultures of the world. Our text contains only the highlights of some of the art that the world has made.

What we have summarized are the cultural backgrounds for artworks in this text, in order to enrich your understanding of the individual pieces. For each culture, we will address distinctive features such as the social and political structure, outstanding historical events, religious information, typical art forms produced, and other significant points. The timeline (figure 5.16) places each of these cultural styles in chronological order, so you can see which were contemporaries. The timeline also lists every work illustrated in this book, so you can place it within its culture, and compare it to other works that share cultural roots. Immediately after the timeline are a group of maps (figures 5.17, 5.18, 5.19, 5.20, 5.21) that allow you to place cultures in their proper geographic location.

Paleolithic and Neolithic Cultures

Paleolithic people were nomadic. They hunted and gathered food, and used stone and bone tools. The term Paleolithic indicates a development which occurred at different times in different places. The Paleolithic era in Europe dates approximately from 25,000 BC through 8000 BC, but remains of ancient Paleolithic cultures have been found also in Africa, India, China, and North America. Twentieth-century Paleolithic cultures included the Inuit (Eskimo) people of Canada and Alaska, the San (Bushmen) of Africa, and the Aboriginal people of Australia (see the discussion on the cultures of "Indonesia, Oceania and Australia").

Most Paleolithic art falls into one of two categories: cave art and chattel art (small portable items for personal use, such as small figures and tools). Art was made from readily available materials. Bone, ivory, or stone were carved into rounded shapes resembling human or animal forms, or were engraved with patterns, lines, and pictures. Pigments for cave paintings were made from red or yellow earth (ochers), charcoal for black, and white from clay.

We really do not know the reasons why ancient Paleolithic humans created art. Cave paintings and small sculptures are commonly believed to be associated with fertility and food rituals. However, paintings and carvings may have been made to satisfy a creative urge.

Text Link

Venus of Willendorf (c. 25,000–20,000 BC) is from the Paleolithic Age. Look ahead to Chapter 7, Figure 7.1, for more information about the art of that period.

The **Neolithic** era is a further point of human development, characterized by humans using polished stone tools, making pottery, weaving cloth, farming, and rearing domestic animals. Neolithic humans were no longer nomads, but were settled in small communities. Dates for the Neolithic era in the Middle East end around 3000 BC. Neolithic Europe ends about 1500 BC. The megaliths from Neolithic cultures on the Easter Islands date from approximately 1500 AD.

Neolithic art consists of the remains of early houses, with pottery, small sculpted figures, and tools. There are

also Neolithic tombs. Again, we do not know why Neolithic art was made. Much of the sculpture found around houses is presumed to be associated with shrines related to fertility. The most spectacular examples of Neolithic art are the megaliths, which are groups of very large stones that are shaped and arranged in geometric configurations. The best known is perhaps *Stonehenge*, a circular arrangement of large stones located in southern England. Megalithic stone alignments are presumed to be associated with ritualistic practices. They are often aligned with the movements of the sun or stars, and so may have been a means of marking time and the seasons.

The Paleolithic and Neolithic cultures are prehistoric cultures, and generally end at any location with the development of writing.

Text Link
The Menec Alignment in Brittany,
France (figure 10.5), is an example of a
Neolithic stone alignment.

Civilizations of the Ancient Near East: 8,000 BC-300 BC

The Ancient Near East covered what we now call the Middle East, Iraq, Iran, eastern Turkey, and northern Saudi Arabia. The first settled communities in the Ancient Near East date from as early as 8,000 BC. The earliest settlements were agricultural towns, such as Çatal Hüyük. Scattered settlements gradually grew into city-states as the area became more and more prosperous, due to trade, better farming techniques, introduction of irrigation, and advances in metal technology (the area is rich, for example, in copper). As city-states grew, society became hierarchical, with kings, ruling classes and priests reigning over the masses of people. City-states eventually gave way to monarchies. Local deities were worshipped, with the king as the deity's primary servant. Many groups carved empires out of the lands of the Ancient Near East, but in our book we see examples from only four: Sumeria (3000-2300 BC), Old Babylon (1900-1600 BC), Assyria (900-612 BC), and the Achaemenid Persians (538–330 BC).

The religion of Judaism was founded in the Ancient Near East, a monotheistic religion based on the laws and teachings in their holy writings, and also the Talmud. Christianity developed out of Judaism during the era of the Roman Empire.

Most of the art surviving from the Ancient Near East is made of stone, ceramic, or metal, since wooden items or textiles do not survive long. From 3,000 BC onward, almost all surviving art was made in the service of the religion or of the state. This artwork was imposing—large sculptures, huge palaces, imposing temples, vast areas of wall space covered by relief carvings. The art of the ancient Near East influenced and was influenced by the art of ancient Egypt, Aegean civilizations, and ancient Greece.

Text Link
The Royal Audience Hall at Persepolis
is an example of art from Achaemenid
Persia (figure 12.12).

Ancient Egypt: 3000 BC-30 BC

Ancient Egypt is called pharaonic Egypt, because it was ruled by the pharaohs. After 30 BC, Egypt was dominated by a succession of foreign regimes, specifically the Roman Empire, Byzantine Empire, the Ottoman Empire, and the British Empire. Of course, Egypt exists to the present day.

The long reign of the Pharaohs was due primarily to geographic conditions. Ancient Egypt was isolated from its neighbors by vast expanses of desert. The sky is cloudfree with a gentle wind from the north. Egypt is sustained by the waters of the Nile River, with fertile banks for agriculture and wildlife. The religion of Egypt was polytheistic, but was based on naturally occurring cycles, such as the movements of the sun, the yearly flooding of the Nile River, and so on. The pharaoh was believed to be the son of the sun god, Re. Egyptian culture was permeated by a sense of an unchanging present, with the future as an external extension of it. Egyptians were very preoccupied with providing for the afterlife.

Text Link

Tutankhamun was a pharaoh of Egypt. With this Innermost Coffin of Tutankhamen (figure 11.4) we see a hint of the lavish materials, craft, and energy that went into burials in ancient Egypt.

From ancient Egypt, there are many craft items and utilitarian objects that were used in homes that are decorated with inventiveness and freedom. Houses were made of impermanent materials. However, architecture and art from tombs and temples were meant to

illustrate the fundamental, immutable cosmic order. They were made of stone. For these, Egyptian artists followed conventions, rather than inventing new styles. Temples were dedicated to the Gods. Tombs were houses for eternity that were built for the Egyptian royalty and nobility.

Representations of people were done in what was considered their real and permanent form, without incidental changes and details. Significant attributes of the person, whether of a God or of a pharaoh or a member of nobility, had to be clear and intelligible, to emphasize their identity and rank. Bodies were youthful and simplified. Egyptian sculptures of nobility were generally compact, simple, and formal poses, with portrait heads. Persons of lower rank could be depicted informally, in casual poses, with specific details such as pot bellies or age lines. Animals also could be depicted with relative freedom.

Text Link

This thumbnail image shows the well-known Pyramids of Gizeh, which are monuments to the pharoahs and the afterworld. Turn to figure 11.2 for more information.

Aegean Civilizations and Ancient Greece: 3000–First Century BC

The earliest civilizations around the Aegean Sea date from 3000 BC, and were located on the Greek mainland, the Cycladic Islands, and Crete. The Minoan civilization on Crete developed earliest, perhaps because it was closest to Egypt. As island people, many Minoans were traders and sailors, while Minoan farmers cultivated olive trees, vineyards, and figs for export. Large palaces were built on Crete around 1700 BC, with distinctive architecture, sophisticated pottery, and lively, colorful frescoes. Their art was influenced by the sea with wavy curvilinear imagery along with depictions of sea creatures.

The Greek mainland suffered from successive invasions of migratory peoples. But by the sixth century BC, the city-states of Greece were very well established, with famous centers such as Athens, Sparta, and Delphi. The city-states were not unified into a single political entity at this time. This resulted in setbacks from outside invaders (the Persians) and civil war between Athens and Sparta. Among the city-states, Athens held primacy in fifth century BC, which was passed on to Sparta. In the late fourth century BC, the entire area was unified

and ruled by Philip of Macedon and his son Alexander the Great.

The Greeks, and especially the Athenians, were important for the development of the arts, sciences, and government. The Greek philosophy was based on the notion that "man was the measure of all things," and as a result developed a form of democratic government, with participation by part of the male population. The Greeks worshipped a pantheon of deities who were conceived in idealized human forms. Their art. theater, and literature stressed ideal human forms and qualities. Balance in both mind and body were desired, and the first Olympic Games were held in 776 BC. They were also interested in the idea of perfection and harmony, especially as it could be expressed through geometry and numeric relationships. That interest in harmony was embedded in the proportions of their architecture and sculpture, and the ratio between notes of music. Visual harmony, achieved through carefully adjusted proportions of parts to part and parts to the whole, was an echo of cosmic harmony. They also made significant achievements in mathematics and the natural sciences.

Greek art is generally divided into three major periods. The first is the Archaic (late seventh–early fifth centuries BC), in which artwork shows a strong influence of Ancient Near East and Egypt, and tends to be more stylized and rigid. The Classical or Hellenic Period (480–323 BC) emphasized figurative art that was at once highly naturalistic and idealized. Both art and architecture reflect an emphasis on balance and composure, order, simplicity, and restraint. The Hellenistic Period (323–first c. BC) features a more emotional, dramatic, expressive art, with greater sensuality and dynamism. Physical beauty and emotional or physical anguish were common themes.

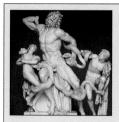

Text Link

Look back to figure 5.3, Doryphoros by Polykleitos (c. 450–440 BC). This sculpture is an example of the Classical or Hellenic Period. Laocoön and His Sons (figure 15.14) is an example of Hellenistic art.

India: 3000 BC-AD 1500

India represents great geographic and climate variety, and contains people of many ethnic backgrounds. Civilization in the region of India dates back to the third millennium BC, with major sites at Harappa and Mohenjo-Daro, which were important centers with wide streets, drainage systems, houses, and commerce.

India is the birthplace of three major religions, Hinduism, Buddhism, and Jainism. Hinduism is an amalgam of two religious traditions, one that worshipped the spirits and the powers of nature, and the other which developed an abstracted idea of the heavens and Gods of that realm. All life was a temporary physical manifestation of the Unbounded, and all were subject to cycles of reincarnation. Buddhism was founded in the sixth century BC by Siddhartha Gautama, who taught the doctrine of Four Noble Truths, which are: all existence implies suffering; the cause of suffering is the attachment to selfish craving; selfish craving can be eliminated; it can be eliminated by following the Eightfold Path. The Eightfold Path outlined the qualities necessary to achieve Enlightenment, break out of cycles of reincarnation, and find peace. They include right understanding; right purpose; right speech; right conduct; right vocation; right effort; right alertness; and right concentration. Jainism, the smallest of the three religions, resembles Hinduism and Buddhism. It emphasizes asceticism (rigorous selfdiscipline and self-denial) and reverence for all living things.

Indian art is dominated by religious monuments, painting, and sculpture. Indian artists and architects used mathematics and geometry as bases for their art to express cosmic order and mysteries. Representational art depicted deities and spirits. Although Indian art was ultimately based on direct observation of nature, Indian art does not seem to reproduce nature, but rather refigures it in sensual form and line. Indian sculptors have great craft skills and their architects exhibit tremendous originality. But individual artistic vision is not emphasized; rather it is subsumed into a collective expression of the entire artwork.

Text Link

Here we have the Kandarya Mahadeva
Temple at Khajuraho, India
(tenth–eleventh centuries). This is one
of the many Hindu temples located in
India. Turn to figure 10.22 for more
information.

From the third century BC until the thirteenth century AD, royal patronage was responsible for the building of great Hindu and Buddhist monuments. These consist of fabulous cave shrines and temples, and the sculpture and paintings that adorn them, with amorous motifs and animal and floral decorations. Wall paintings and manuscript illuminations were widely done, but not many have survived.

Indian influence spread throughout Southeast Asia in the first millennium, and also influenced the art of China during the early part of that same millennium. See "Islamic Art" for information on the Islamic impact on the art of India.

China: 4000 BC to the Present

The population of China includes Tibetans, Turks, Mongols, Koreans, and Manchurian people, as well as ethnic Chinese.

China has a continuous history of artistic production that dates back to 4000 BC. Very early in its history, China had highly developed civilizations, with writing and a calendar. These early people knew the technique of bronze casting, and made amazing vessels of high quality. They also produced lacquer vessels and pottery. Paintings on silk were already being made during the first millennium BC, as were wood carvings and large ceramic figurative sculpture.

The Chinese conceived that humans emerged from the bowels of the earth like all other plants, animals, and landscape forms, and therefore humans were one with all other natural phenomenon. The sixth century BC saw a high point in the development in Chinese philosophy (interestingly, contemporary with the Greeks and the founding of Buddhism). The philosopher Confucius (550–478 BC) organized Chinese myths, rites, and ideas into a system of moral behavior, a code of conduct that was not a religion. The parallel tradition of Daoism was more mystical. It held that all humans live and die within the laws of nature set down by the Lord of Heaven. Daoism emphasized the individual, and developed a cult of solitude, which led to a special sensitivity to the landscape, and had a great influence on the development of landscape painting. Buddhism was introduced during the first century BC, teaching the emancipation of the soul from worldly desire and the negation of self. Buddhism reached highest influence in China from the seventh to the ninth centuries. Afterwards, in China, there was a resurgence in the importance of the ethical basis of behavior, rather than religious, and Buddhism declined. Hundreds of years of accumulated wisdom and knowledge have been preserved in Chinese culture.

China was divided into a number of kingdoms until 221 BC, with the establishment of the first dynasty, the Qin. From that time forward, China was mostly ruled by succeeding dynasties, which were maintained by a large government bureaucracy. The Qin and Han Dynasties (221 BC–200 AD) saw a period of great Imperial building program and technological advancement (interestingly again, this was contemporary with similar developments in the Roman Empire). Western contact began on a regular basis in the first century BC with the silk trade. Later,

the ninth-century capital, Xi'an, was probably the greatest city in the world.

Chinese architecture grew out of the design of the family home, just as the family was the basic unit of Chinese society. Whether secular or sacred, palace or humble home, buildings were timber framed, often brightly colored, and stabilized by massive roofs. Cities and palace precincts were laid out according to cosmic calculations and oriented north-south. They were geometric and often symmetrical. Before beginning building, the Chinese tested natural forces and powers to find the most auspicious site for a new structure. This reflects the Chinese philosophy that stresses an underlying kinship among architecture, society, and nature.

Text Link

The Library of Longxingxi (eleventh century) is an example of classic Chinese architecture. See figure 8.32.

Large sculpture was made in association with Buddhism, and was strongly influenced by India. However, after AD 845, the emperor and his court patronized painting, calligraphy, and ceramics, and then those arts flourished. The Chinese exhibited excellence in pottery from Neolithic times, as well as ceramic sculpture. The tradition of making highly refined, decorated, glazed pottery dates from the Southern Song Dynasty (1127–1279) through the twentieth century.

Painting, as well as calligraphy, is based first on mental concepts from which develop visual pictures. For example, landscape was conceived first in Daoist terms, as a site where the lone philosopher is in communion with nature. The elements in the landscape painting conveyed meaning by analogy and symbolism. Painting was particularly important during Tang (618–906) and Song (960–1279) dynasties.

Twentieth century art in China continues some traditional forms. However, the Communist government actively promoted the Western-based Social Realist style of art (see below, "The 20th Century"), which depicts the everyday life of common people to support a specific political agenda.

Text Link

Apricot Blossom by Ma Yuan expresses the Chinese philosophy of depicting nature in art. Go to figure 19.12 for more information.

Mesoamerica and South America c. 1500 BC-AD 1519

Mesoamerica consists of Mexico and Central America. Before Europeans arrived, the civilizations there were based on sun worship, and also worshipped a pantheon of Gods. They believed that cosmic events had direct and forceful impact on their earthly lives. Blood sacrifices offered to the Gods were believed to be necessary to keep the cosmic order. As a result, Mesoamericans developed sophisticated systems for tracking time and astronomical movements, and were highly accomplished in mathematics and astronomy.

The prosperity of the Mesoamerican civilizations was dependent upon farming. They developed advanced agricultural techniques, included sophisticated irrigation systems, built with only stone tools. They did not use the wheel, and had no beasts of burden except llamas. Corn was the basic crop. Politically, the civilizations were governed by hierarchical rulers, the urban-based warrior and priestly classes who dominated the large farming population in the lands around them. Large urban centers also housed artisans and government workers. Cities also featured enormous ceremonial centers and temple complexes for cosmic blood offerings.

Text Link

Teotihuacán had a great urban center, filled with temples and ritual spaces. The Pyramid of the Sun (figure 10.19) is the largest temple in Teotihuacán.

These civilizations produced monumental works in architecture, sculpture, and painting. Architecture consisted of enormous stone pyramids and temples, and stone palaces. Artworks that have survived include pottery, stone, and metal. Few mural paintings and manuscripts survived to the present day. A basic chronology of Mesoamerican civilizations includes:

Preclassical or Formative era: 2000 BC-AD 300

Olmec 1500 BC-AD 100

Classical Period AD 200–900

Mayan c. AD 100-900

Teotihuacán c. AD 100-600

Huastecs 100-1519

Mixtecs c. 100–1519 expert crafting in gold and turquoise

Zapotec c. 100-1000

Post-Classical 900-conquest.

Maya/Toltecs 1000–1519 great builders and organizers

Aztecs c. 1300-1519 great warriors, manuscripts

The Spanish Conquest in the early sixteenth century destroyed those Mesoamerican civilizations that were thriving. The Spaniards were amazed at the wealth and immensity of these civilizations, but nevertheless were responsible for their destruction, for example, burning vast libraries full of ancient manuscripts and plundering sacred sites. As a result, almost all of our knowledge about these civilizations is based on Spanish histories and archeological research, and that research has been uneven. Ancient civilizations in Nicaragua, Costa Rica, and Panama have been excavated and studied much less than those of Mexico.

In South America, archeological research has concentrated on Peru (although there were other large centers in Colombia, Venezuela, Brazil, Chile, and Ecuador). In this book, we look at the Peruvian civilizations of the Moche (500 BC-AD 600), and the Nazca (500 BC-AD 600) and the Inca (1000–1532). The Moche practiced extensive agriculture with irrigation systems. Ruled by a warrior-priest class, they built immense pyramids of mud brick for ritual purposes and burial of leaders. They are renowned for their ceramic vessels and metalwork. The Nazca civilization is known for its pottery and enormous line drawings on a dry desert plain. The Incan peoples made spectacular achievements in communications, engineering, and architecture.

Native North American Art: 1500 BC to the Present

Ancient civilizations of North America are less well-known than the Mesoamerican civilizations, in part because there has been less archeological investigation of North American sites. As a result, the dating of art objects and artifacts is difficult. Civilizations date back to at least 1500 BC, but the first example in this book is from the Temple Mound cultures that existed in what is now the midwestern United States (900–1700). Mounds in the shape of animals and geometrically shaped temple mounds dot the Mississippi and Ohio river valleys.

At the time of first contact with Europeans, the native North Americans were divided into six major groups, consisting of the 1) Inuit (Eskimo) region of the Arctic; 2) the Northwest Coast tribes from Alaska, Canada, and Washington state; 3) the Plains peoples who occupied the region from the Rocky Mountains to the Mississippi; 4) the peoples of the Eastern United States and Canada; 5) the peoples of the desert Southwest Areas of Arizona, New Mexico, Colorado, and Utah; and finally 6) California tribes. Each area tended to develop a few specialized art forms. We will look in particular at the wood carvings of the Northwest Coast, consisting of ceremonial poles, archi-

tectural structures, masks, utilitarian objects, and religious items. Basketry was the outstanding feature of the peoples of California. The nomadic Plains peoples developed art forms that depended upon materials from animals, from animal-skin tipis to feathered ceremonial headdresses. The Southwestern peoples developed distinctive pottery, metal smithing, and pueblo architecture.

Text Link
Turn to the Gros Ventre Shield (figure
13.10) to read more about a Plains
peoples' artwork made from animal
materials.

Art based on these various traditions continues to be made today, as well as hybrid art forms that reflect both Western influences and Native traditions.

Etruria, Rome, and Byzantium: Seventh Century BC-AD 1453

Etruria was a group of city-states in central Italy. Their culture and art is called "Etruscan." Etruscan art was influenced by Greece, but also had its own distinctive characteristics. Etruscan power was at its height in the late seventh through the sixth centuries BC, but declined by the third century BC, as Rome came to ascendancy.

Etruscans built fortified hilltop cities as well as elaborate cities for the dead, with mound tombs laid out and furnished like houses for the living. They made large-scale terra-cotta sculptures, with images of both gods and also deceased humans on sarcophagi. They also painted lively frescoes to decorate their tombs. Later Etruscan art featured large cast bronze sculpture.

Rome began as an Etruscan-ruled city, but later overthrew the Etruscan king, and became an independent republic around 509 BC. Roman power grew dramatically until its borders reached their farthest expanse around 100 AD, extending from Spain into the Ancient Near East, north to England and south into Ethiopia. Roman concepts of law and government, calendar system, and money systems are still in effect in Western cultures today. Roman religion was based on agricultural deities and was mostly observed within the house. The family unit was strong, and patriarchally ruled. Public religion concerned only the rulers and was conducted as a matter of state policy. The emperor was perceived as divine after 27 BC.

Early Roman architecture was eclectic, with strong Greek and Etruscan influences. Greek culture had an even greater impact on all Roman arts after 221 BC, when Rome conquered the Greek city of Syracuse, and brought back Greek art as spoils of war, initiating a craze for Greek "antiques." Wall paintings, frescoes, and mosaics were also popular art forms. They featured naturalistic imagery, with landscapes and still lifes. Naturalistic portraits, used to commemorate the dead, were distinctly Roman innovations. Also, they further developed narrative sculpture.

The Roman Empire began in 27 BC (before then, Rome had been more or less a republic). The emperors, who had enormous power and funds at their disposal, initiated a huge number of public works. The Romans were great builders, undertaking all kinds of structures such as temples, arenas, theaters, baths, basilicas, markets, palaces, harbors, circuses, aqueducts, and extensive highway systems. The important buildings were generally large and lavishly decorated. Many structures, such as the aqueducts (some of which still carry water) were amazing engineering feats. Romans used the arch more extensively than any previous peoples. They also exploited concrete, which dramatically affected their architecture. Roman ruins are still spread throughout the lands they occupied, and some structures are still in use to this day.

Text Link

The Pantheon blends Greek and Roman architectural elements. See figure 10.7 for a more detailed discussion on the blending of architectural elements.

Roman power gradually disintegrated after AD 200, and the enormous empire broke up into the Eastern and Western Roman Empires in 365. The Western Roman Empire was extinguished as a political entity in 475, with invasions from nomadic peoples from northern Europe. This period was marked by the rise of Christianity and development of early Christian art, church paintings, mosaics, manuscripts, and carvings. Christianity is based on the teachings of Jesus (c. 4 BC–AD 30). Its sacred book is the Bible, which consists of holy writings from Judaism, as well as the teachings of Jesus and his followers. Christians believe in one God and Jesus as son of that God, and the necessity of following Jesus' teaching in order to be rewarded with everlasting life in Heaven.

The Eastern Roman Empire became the Byzantine Empire, which was a Christian state and lasted for nearly 1000 years, from the fifth century until 1453. The Emperor Justinian was one of the great patrons of the

arts in Byzantium. Later Byzantine art was traditional and conservative, reflecting unchanging religious dogma. Its capital, Constantinople, was the most magnificent Christian city of its time. Byzantine architecture recreated imaginatively the ancient structure of arch, dome, and vault. Rich mosaics and frescos decorated the insides of their Christian churches. Smaller art included manuscript illumination, ivory carving, and icons (small sacred paintings for devotional purposes).

Text Link

Look to Chapter 12 to see a mosaic portrait of the Emperor Justinian and His Attendants (figure 12.3).

Islamic Art: The Middle East, Western Asia, and Northern India after the Sixth Century

The religion of Islam was founded in the Arabian Peninsula by Muhammed (570–632). His revelations are codified in the Qur'an (Koran). Muslims also follow supplemental writings that offer detailed advice on moral behavior in everyday life. Adherents have five obligations binding them: to profess their submission to Allah: to pray five times per day; to give alms to the poor; to fast during Ramadan; and make a pilgrimage to Mecca. Islam built on the teachings of Judaism and Christianity. The relatively simple creed and lack of priestly hierarchy made Islam popular and it spread quickly throughout the world. The Islamic Ottoman Empire caused the collapse of the Christian Byzantine Empire.

Early Islamic art avoided the representation of the human figure. It emphasized color and designs inspired by geometry, calligraphy, and plant life. Such ornamentation was widely used, from carpet weaving to architectural decoration. Islamic artists excelled in pottery, metal smithing, weaving, miniature painting, calligraphy, architecture, and the decoration of architecture. In the history of Islamic cultures we see advances in mathematics, geometry, poetry, and medicine. Islamic scholars also absorbed and preserved much of the learning of the ancient Greeks.

Text Link

Intricate ornamentation adorns the Royal Mosque in Isfahan, Iran (1612–1637). See figure 10.29 for more information about mosques.

Because Islam spread through so much of the world, Islamic art shows the influence of many areas, including China, Turkey, and India. Later Islamic art shows even greater eclecticism.

Islam came into India in the eighth century, and by the year 1000 Islamic dynasties ruled northern India. Islamic art in India featured manuscript illuminations with secular themes, showing the lives of the rulers and the wealthy. They were greatly influenced by Persian miniatures, which stressed great detail, decoration, and delicate work. Hindu subjects also continued to be painted, as well as Christian. India also holds famous examples of Islamic mosques and mausolea.

Japan: 600 to the Present

The first emperor of Japan dates from AD 622. Prior to that time, Japan was divided into loose tribal organizations. Because the emperor was considered divine and above politics, the country actually was ruled by a succession of important feudal families, and the different periods in Japanese history are named after the ruling families of the time. Shinto is the native religion of Japan, which is based on the worship of nature, ancestors, and ancient heroes, and later upon the divinity of the emperor. Buddhism was introduced from China around AD 550, influencing the adoption of meditation and contemplation of the landscape. Potentially, landscape and life could be elevated into conscious religious practice.

The native style of Japanese art has been profoundly affected by waves of foreign influence, historically from China and Korea, but in modern times from the West. Historically, the assimilation of the foreign styles was always followed by a reassertion of the native style.

Since the islands of Japan are volcanic, there is little stone suitable for carving or building. Main architectural styles are of wooden construction and show Chinese influence. Ancient wood buildings have survived to today because the important ones are rebuilt every twenty years. House and garden are often conceived as a unified design, with the house representing geometric qualities and the garden, the organic. The garden landscape was seen as a microcosm of natural landscape. Both gardens and landscape painting were abstracted versions of nature, and the Japanese were drawn to living and moving in that abstraction. Natural forms were seen as allegories of human passage through the world.

Text Link
The Ryoanji Zen Garden of
Contemplation (figure 19.15) shows
the abstraction of landscape in Japanese
art.

Much of the art production was centered around the courts, the feudal rulers and great monasteries, including sculpture, painting, and ceramics. Sculpture was done in clay, cast bronze, or lacquered wood. The tea ceremony dates from the Momoyama period (1573–1616). It promoted an attitude of simplicity towards surroundings and utensils, and provided a period of contemplation of higher thoughts. The aesthetic sensibility of simplicity and rusticity strongly influenced Japanese ceramics.

The first popular Japanese art forms developed during the Tokugawa period (1616–1868), when the merchant class rose in power and along with it developed a group of arts aimed for that market. The inexpensive ukiyo-e prints, the art of the woodblock, date from this period.

From 1868, Japan was opened to the West after 250 years of isolation. A period of rapid westernization followed, and since that time Western culture has greatly influenced Japanese art, and vice versa.

Europe from the Middle Ages to 1780

This era begins with the disintegration of the Roman Empire and the spread of Christianity, and ends with the transformation of Europe into the modern nations. Within this time frame are several distinct periods:

The **Middle Ages** (500–1400): This period is marked by the lingering influences of Greece and Rome and the influence of the invading Celtic and Germanic peoples. Contemporary with this period is the spread of Islam and the height of the Byzantine Empire. The Christian church had a tremendous influence on people's everyday lives. The Early Middle Ages (500–1000) is marked by the migration and invasion of Celtic-Germanic peoples into Europe. The arts consist of manuscript illumination, jewelry, metalwork, and carvings, reflecting their aesthetic preferences for small decorative objects, intense patterns, and bright colors. The Romanesque Period (1000-1150) marks the end of the period of invasion, and the christianization of all of Europe. Most of the population was rural, with feudal forms of government. Large monasteries developed, with massive churches built in a modified "Roman" style, with stone construction, rounded arches, and vaulting. Numerous sculptures were integrated into the church architecture, most with Christian iconography. Learning was centered on theology and the supernatural, while the physical world was seen as a distraction to the soul. The Crusades were fought against Islam in the Holy Lands. During the Gothic Period (1140-1400), the Church in Rome and secular rulers in Europe were well established and often in competition for political power. Towns grew, and along with them we see the development of craft guilds and universities. The increase in learning began to shift the focus from the realm of God to an increased interest in the physical world. Gothic architecture is distinguished by very tall churches, with pointed arches and large stained-glass windows and elaborate sculpture on the outsides of churches. Different versions of Gothic architecture were developed in France, England, Italy, and Germany.

Text Link

The Gothic cathedral expresses the impact of the Christian religion in eleventh-century Europe. Turn to figure 10.25 for further discussion on this topic.

During the **Renaissance** (1400–1600) kings were beginning to take power from feudal barons, and cities continued to grow in power. Europeans increased their contacts with Islamic regions, Asia, and later to the "new world." Emphasis turned away from the supernatural, to focus on the physical world and human life. Humanism, a system of thought that is concerned with nature, humanity, and the ideals of man, grew in importance, along with an interest in the natural sciences. As a result of a renewed, intense interest in Classical culture, Greek and Roman writings were translated into contemporary language and ancient ruins were unearthed.

Renaissance art is marked by naturalistic depiction of human figures and the natural world. There was a new interest in painting and sculpture in their own right, not just as architectural supplements. Wealthy families and the Catholic church were patrons of the arts. Frescoes were commonly painted on church walls, while altarpieces stood in the sanctuary. Oil painting was invented in Northern Europe, and with it the practice of painting on portable panels. Subject matter was still mostly religious, but expanded into portraiture, battle scenes, and later landscape and genre scenes. Classical mythology returned as a subject matter for art. Humans were depicted with rounded forms, and artists studied human anatomy. Architecture was based on Roman models, with rounded arches and classical principles of harmony and balance. Simple geometric forms served as the basis of architecture, whether churches or palaces.

The **Baroque** period (1600–early 1700s) was a period of great expansion, discovery, and exuberance for Europe. The seventeenth century was categorized as the Age of Absolutism while the eighteenth century was called the Age of Reason or Age of Enlightenment. Europeans were thinking critically about the world and humanity in new ways, without a foundation in myth, religion, or traditional beliefs. Reason and scientific inquiry, not religion, were the methods for

examining the structure and causes of the world and the universe. Great discoveries were made in astronomy, optics, and physical sciences. Diderot undertook the *Encyclopedia* to organize all human knowledge. There was a rise in national power and the power of the kings. European explorers set out across the world, laying the foundations for the great colonial empires. The new colonies brought great wealth to Europe. The Baroque period also saw the beginnings of the Industrial Revolution. Literature was illuminated with the writings of Voltaire and many others. In music, opera and the orchestra were developed.

As a result of the growing nationalism in Europe, individual nations developed distinctive Baroque styles. In Italy, the Catholic church was a great patron of the arts, and promoted a lavish, dramatic, sensual style of art to counter the impact of the Protestant Reformation that had divided European Christians. This period is therefore often called the Counter-Reformation in Italy. Magnificent churches were built and filled with stunning paintings and sculpture. In Northern Europe, where Protestantism held sway, art patrons came from the growing bourgeois class, and they favored modest-sized oil paintings that fit in their homes. They purchased portraits, landscapes, and genre scenes promoting simple virtures and moralizing subject matter. In England and France, the aristocracy supported the arts, and so we see huge palaces, large paintings, and stately churches coming from the Baroque period.

Renaissance ideas and styles continue to evolve and develop through the Baroque period. Both eras emphasized classicism, but Renaissance art is seen as static compared to the Baroque dynamism. Baroque art was colorful, spacious, dramatic, theatrical, grand, ambitious, and extravagant. The **Rococo** style was a late version of the aristocratic Baroque style. Rococo art is marked by fashionability, elegance, and delicacy, and a decidedly brighter, pastel color scheme in painting and architectural decoration.

Text Link
The Hall of Mirrors (figure 17.24)
at the Amalienburg in Germany shows
the ornate elegance and delicacy of the
Rococo style.

Africa to the Present

African climate is extremely varied, from desert to grassland, to high mountains, to lush river valleys. Like its climate, African peoples are extremely varied, with distinct ethnic roots and cultural heritages. Egypt is the most prominent ancient culture in Africa. However, other ancient cultures existed, and produced rock paintings that have been found in the Sahara desert. The Nok culture, located in present day Nigeria, existed 2000 years ago. Later, in that same area, the Ife civilization flourished in the eleventh century, and produced impressive cast-bronze portrait heads. Another West African culture is the Benin, which flourished from the fourteenth through the nineteenth centuries.

All these historical peoples have produced a vast array of art forms, including some not recognized as art by Western cultures. The same is true for nineteenth-, twentieth-, and twenty-first-century Africans. Their art forms include sculpture, body painting, scarification, textiles, jewelry, architecture, furniture, shrine objects, song, dance, poetry, oral literature, masquerades, and festivals. Africans generally do not distinguish between fine art and crafts, and often combine visual art with the other arts such as music or dance. Art is integral to African life and beliefs; it is not seen as superfluous, or merely decorative, or for the wealthy only. Art making traditionally has been organized according to gender, with men as carvers, leather workers, metal smiths, and architects. Women are painters, potters, ceramists, sculptors, and gourd decorators. Both men and women are weavers.

Africans often do not conceive of a work of art as a permanent object that is meant to be looked at and then preserved in its finished form. There is a greater interest in process than in permanence. The works of art are fully realized when they are used in social, religious, or political ways. Most African languages do not even have a word that translates directly as our word "art." For most of sub-Saharan Africa, there is almost no surviving art that is more than 150 years old. Even wood carvings are generally not very old, as wood deteriorates quickly in the climates of Africa, and wood sculptures are often intended to be adorned with ephemeral items, such as beads, feathers, seeds, pieces of mirror, or paint. Most art forms of today, however, are probably the recent manifestations of much older art traditions.

African art is made primarily for one of three reasons: 1) to promote or make visible the power of leaders, with objects such as ceremonial spears, stools, and regalia; 2) to assist in the performance of a ritual, with sculptures of deities, spirits, ancestors, and other objects used in shrines; and 3) for masquerades, which can be part of initiation ceremonies, reenactments of ancient events, personifications of primordial ancestors, or festivals that reinforce existing customs and social order. Masquerade masks and costumes are important art forms.

In making art, most artists begin with ideals or concepts rather than attempting to copy natural appearances. Art objects can change meaning regarding how they are used. Older objects may have more reverence attached to them, for example, if they have been used in more rituals.

Since colonization, African art making has been influenced by imported styles, new materials, and new tools. Traditional values still hold much influence. Some older forms have remained, as museums and tourists have created a market for indigenous forms. Other art forms have been abandoned, as Islam and Christianity have encroached upon the indigenous religions, changing religious art and also resulting in the development of secular art. Murals are beginning to be done in cities, as well as concrete sculptures. City life has spawned a host of new urban themes.

Text Link

The Chi Wara Dancers used masks in ritual dance. See figure 6.3.

Indonesia, Oceania, and Australia

Traditional art from the South Pacific includes painting, sculpture, and other categories such as weaving, basketry, tattooing, and body painting. Sculpture is made of clay, wood, stone, and ivory. Bark is used for cloth and as a support for painting. In architecture, we see distinctive designs for homes and cult houses.

Indonesia has been greatly influenced by the art of India. Older artwork is of Hindu and Buddhist origin, while much of the area later converted to Islam. The island of Bali practices a mix of indigenous and Christian religions, and supports a large amount of art production. Balinese art consists of carving, painting, and flower and fruit arrangements.

Oceania consists of thousands of islands sprinkled across the mid- and southern Pacific Ocean. The islands were originally settled by various waves of migrants from Southeast Asia. Oceania is divided into three cultural groups: Melanesia, Micronesia, and Polynesia. The islands nearest Indonesia comprise Melanesia, were the first settled, and thus have the longest history. Their societies are relatively unstratified and thus relatively democratic. Melanesian art styles are the most varied. Their art forms are related to their cults, and are concerned with fertility, funerary rites, nature spirits, warfare, gender roles, and initiation ceremonies. Melanesian art is colorful, highly carved, intricate, detailed, and dramatic. Peoples on New Guinea built large ceremonial houses, replete with paintings, carvings, and utilitarian objects.

Micronesia consists of broadly scattered islands north of Melanesia. The art forms of Micronesia consist of tattooing, weaving, and carvings. Polynesia, which includes Hawaii, New Zealand, and the Easter Islands, are the most remote islands from Southeast Asia, and therefore were the last to be settled. The cultures of these widely scattered islands show remarkable similarities to each other. Polynesian societies were highly stratified, with priestly and ruling classes. Polynesian sculptors excelled in figurative sculpture in wood, stone, and ivory, some very large in size. Polynesian sculpture features dynamic poses, rounded figures, and intricate geometric patterns. Tattooing was a prominent art, designed to promote a person's status, spiritual power, and personal beauty.

Much of Oceanic art is fairly recent in date. In some cases, art was made with impermanent materials, so contemporary objects represent a much longer tradition. As in Africa, some art making after colonization reflects a mixing of Western and indigenous styles. Colonization and tourism have also created a large market that supports the continuation of indigenous art styles and forms.

The indigenous peoples of Australia created their art mostly as part of "Dream Time," their system of accounting for all of creation, past and present. To these people, the continuation of present life depends upon the regular reenactment of events from the cosmic past, which was accomplished in part through art making. Painting is colorful and pattern-filled, and contains symbols for Dream Time events. Animal forms sometimes are presented in x-ray style, which shows both significant internal and external features.

Text Link

Witchetty Grub Dreaming is an example of the Aboriginal art of the Dream Time. Go to figure 6.2, for information about Dream Time.

Europe and the United States: Late Eighteenth through Nineteenth Centuries

The Industrial Revolution began in England around 1760. Advances in technology were marked by experiments in steam power and electricity. Cities were growing rapidly, and the middle class rose in power. There were many moves to limit the power of the aristocracy and royalty. The American Revolution against English rule began in 1776. The French Revolution that overthrew the monarchy began in 1789. There was an increasing belief in the importance of liberty and self-determination. Along with it came the idea of progress, seen both in political affairs and technological advances. Humans became interested in controlling nature

through machines. Secular concerns replaced religion as the focus of human life.

This was also the era of the great colonial empires, with Europe and the United States essentially ruling the rest of the world. Nationalism continued to be an important force behind world events.

Traditional values and concepts were being undermined on many fronts. Freud's investigation of the unconscious revolutionized our concepts of the driving forces behind human behavior. Darwin's theory of evolution differed from the religious accounts of creation and the origin of the human race. Karl Marx critically analyzed the economic, political, and social structures in industrialized nations.

Art also was affected by these changes. As churches and aristocracy declined in secular power, they no longer patronized the arts to the degree they had in the past, necessitating a new system of support for artists. This era saw the development of commercial galleries, private and corporate collectors, and the institution of the art museum. Many new art styles blossomed in Europe and the United States. Increased trade and cultural exchange helped mix and shorten the duration of art styles. We will list some of the more important ones here:

Neoclassicism (late 1700s–early 1800s): A style of art considered restrained and severe after the excesses of the Baroque and Rococo; it borrowed compositional qualities and subject matter of Classical art.

Romanticism (early 1800s, but still influential later): An attitude towards art, rather than a particular style, that emphasized emotional expression, in reaction to the restraint of Neoclassicism and the rationalism of the Enlightenment; Romantic artists were drawn to mystery, myth, the unknown, strong emotions, subjective experience, and the majesty and power of nature.

Realism (1840–1880s): A style of art that depicts ordinary life without idealism, nostalgia, flattery, exoticism, or mythic gloss; showed common people in common activities. Realist artists were influenced by the development of photography.

Impressionism (1870–1890): A painting style in which artists sought to depict everyday reality, but also to capture the effects of light, seasons, and atmospheric conditions on our natural and constructed world; artists painted from direct observation, often with sketchy, blurry results. Impressionists were influenced by studies in optics, experimented with color mixing, and painted in brighter, more intense colors than had previous painting styles. They experimented with

composition, influenced by photography and Japanese prints.

Post-Impressionism (1885–1914): Not a single coherent style, but various painters' individual reactions to and transformation of Impressionism. Many tended to be more expressive and emotional in content than Impressionists; others returned to more Classical ideas of solid form and balanced composition.

Painting was the pivotal art form for much of the nineteenth century. However, photography was developed in the 1820s and 1830s and was both influenced by and influenced painting. In architecture, an eclectic array of styles could be found throughout the nineteenth century, with Neo-Classical, Neo-Gothic, and Oriental styles of architecture, among others.

Text Link

Eugène Delacroix' Liberty Leading the
People is a Romantic-style painting
(figure 14.9).

The Twentieth Century

The century opened with Albert Einstein advancing his theory of Relativity in 1905, which posited that motion, velocity, and mass were relative. Time, space, and matter were interdependent and matter and energy were interchangeable. The universe was no longer stable, but dynamic, and exploding.

Two world wars were caused by imperial competition and national jealousies among European nations. The First World War was like a European civil war, with 10,000,000 killed and 20,000,000 wounded. The Great Depression from 1929 through most of the 1930s was a period of great hardship and economic stagnation. The Second World War was more terrible than the first, more global in its scope and left Europe devastated. The wars brought an end to the European colonial empires. However, the globalizing trend begun with colonization has continued in the globalization of economic markets. During the Cold War from 1949 to 1989, hostilities among the United States, Soviet Union, and other powerful nations placed the world in fear of nuclear destruction. Various smaller wars have erupted throughout the century: in Korea, Vietnam, Afghanistan, the Middle East, Africa, Central America, Indonesia, Southeast Asia, Eastern Europe, and so on.

Major advances in technology filled this century, with highlights including the development of the airplane, automobile, radio, film, and television. With farm machinery, fertilizers, pesticides, and genetic engineering, a much smaller percentage of people in many nations are involved in the production of food than ever before. Humans have traveled and worked in space, placed many satellites around Earth and sent probes into deep space. In developed countries, a large middle class has come to expect healthy retirement, advanced medical care, and expanded use of computers for work, entertainment, shopping, communication, and even art.

At the same time, there has been a growing distrust in the notion of progress, and concern regarding whether all these "advances" may not actually improve human life and may rather exact hidden costs. Large numbers of peoples have migrated all over the globe, fleeing war, political tyranny, or economic hardship. Many perceive a degradation of the quality of life by the end of the twentieth century, caused by crime, pollution, poverty, a sense of alienation, and the persistence of institutionalized inequities such as racism.

Art of the twentieth century reflects these profound changes. In the early 1900s, cross-cultural influences deeply affected the art of the entire world. We have already seen how Western influence altered the course of art in colonized countries, with some indigenous art forms changed, others abandoned, and still others promoted actively with a new tourist/museum/collector market. Western art was equally affected, especially by art from Asia and Africa. The naturalism that had defined Western art since the Renaissance gave way to abstracted forms. Much of the art of the twentieth century was considered to be Modern Art, cut off from traditions of the past and echoing the progress in science. By the 1980s, Postmodernism marked the abandonment of modernism and the notion of progress. Postmodernists investigate the cultural, political, and social systems behind art, and destabilize conventional values and meaning.

Twentieth-century Western writers have defined a series of distinct art movements, which we summarize below:

Fauvism (1900–1915): The term is derived from the French word for "wild beasts." Fauve artists wanted direct spontaneous expression through color. Color was no longer tied to naturalistic description, but was used intensely and arbitrarily. Fauvism continued to be influential in Expressionist movements through the twentieth century.

Cubism (1900–1915): Artists analyze the planes that make up an entity, and then fracture and reassemble those planes into a new composition. This

style was manifest in collage, painting, sculpture and architecture, and continued to be influential throughout the twentieth century.

Futurism (1909–1914): A primarily Italian style that celebrated motion, speed, violence, war, and the machine, and threw out traditional tastes.

Dada (1920s): Dada, more an attitude than a style, developed in reaction to the horrors of World War I. Dadaists rejected past art, civilization, and moral codes as responsible for the war, and instead promoted play, spontaneity, chance, randomness, and absurdity.

Surrealism (1920s and 1930s): This art style dealt with the imagery of the subconscious mind.

Protest Art (1920s onward): Protest art is not a fixed style but an approach to art, based on the idea that art was an effective tool with which to fight inequalities, injustices, poverty, war, etc.

International Style (mid-twentieth century): A spare, pared down architectural style driven by the belief that "less is more." It consists of steel frame, curtain wall construction, with glass, metal, and concrete, and emphasized simple, geometric forms and the elimination of ornamentation.

Social Realism (1930s and later): In the United States, Europe, and Mexico, it presents everyday life of ordinary people, often to promote their virtues or gain sympathy for their situation. This style was also dictated by the governments of Russia, Nazi Germany, and Communist China to promote their political agendas.

Abstract Expressionism: (late 1940s–1950s): A painting style that emphasized intense colors, bold brushwork, and large canvases, and rejected traditional image-making in art. It was considered the first uniquely U.S. art style.

Pop Art (late 1950s and the 1960s): Art based on images from popular culture that appeared banal, impersonal, or mass produced. It continued in the 1970s as Photorealism, a highly detailed, photograph-like painting style with impersonal subject matter.

Performance Art (1960s onward): Art that is not an object, but is an event that occurs in a specific place and time, with performers and/or audience, with each event likely to be different with every performance. Performance art began with "Happenings" from the early 1960s. Photographic documentation becomes important as the existing record of the performance.

Installation Art (late 1960s onward): Art that is a fabricated interior environment, which the viewer enters, becoming part of the piece.

Minimalism (late 1960s–1970s): A movement marked by simple forms, flat colors, hard edges,

and the reduction of all properties to the most essential. It was most often expressed in large, simple, geometric sculptures, and often used industrial materials.

Site Specific Works and Earth Works (begun in the 1970s): Work built into a specific environment, where its location contributes to its meaning and formal qualities. Earth works are built directly onto the earth, often at very large scale.

Postmodernism (1980s onward). Again, an approach to art rather than a coherent style.

Postmodernism is strongly tied to art criticism and theoretical writings (see Chapter 4), with a new emphasis on photography. The period is marked by plurality, with a continuation of protest art, performance, installation, and painting. This period also saw a rise in murals and community-based art, and an increase in Public Art, which is financed through tax revenues. Also operating was an increasing awareness of art from other cultures.

SYNOPSIS

An art style exhibits recurrent characteristics that are constant and coherent. These characteristics can be formal qualities, the typical medium used, or the usual purposes for which art was made. In addition, we have several descriptive terms for styles, that include "naturalistic," "idealized," "abstracted," and "nonobjective."

There are broad cultural styles that mark the work of an entire people for a time. Usually, these styles can be easily recognized. Ancient Egyptian art is a good example of a broad cultural style.

Artists can be known for their individual style. We saw two examples, in the Dutch painter Vincent van Gogh and Yoruba sculptor Olowe of Ise in Nigeria. We also looked at Van Gogh's work in relation to other Post-Impressionist artists, to see how an individual's style not only differs from but also reflects the broad cultural style of the time.

The remainder of the chapter was devoted to brief summaries of sixteen cultures that produced most of the art in this book.

FOOD FOR THOUGHT

Any study of art is organized in one of three ways: chronologically, geographically, or thematically. A chronological approach follows a cultural style as it develops through the years. This approach is common in art books dealing with the history of Western art, with titles like "A History of Renaissance Art," or a "Survey of Art from the Middle Ages." A geographic approach studies the art from a particular area, usually also in chronologi-

cal order. Western writers often take a geographic approach to art of other cultures, and so we might see books on "The Art of Africa," or "The Art of India." The third approach (and that of much of this book) is thematic, in which a core idea is the basis for discussing art from many different cultures. Most of this book you are

reading is organized around a cluster of themes. Thematic writings on art might cover subjects like "art about animals" or "erotic art."

Any of these three methods of study has its virtues and its pitfalls. Can you think of any particular advantages of each?

NEOLITHIC ERA

8000-1500

Development of farming, village life, pottery

Newgrange, Ireland The Menec Alignment

Stonehenge

AEGEAN CIVILIZATIONS

Cypriotic Female Figure

Harp Player, Cycladic

Phoenician alphabet developed c. 2000

Çatal Hüyük, Anatolia Female Fertility Figure from Çatal Hüyük

1000

Rule of the **Ptolemies**

323-30

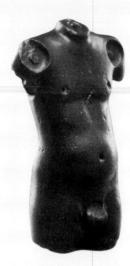

Torso, from Harappa

PALEOLITHIC ERA Hunting/gathering, stone and bone tools 25,000–8000 Hall of Bulls, Lascaux, France Venus of Willendorf, Austria

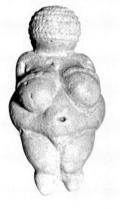

Venus of Willendorf, Austria

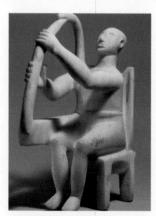

Harp Player, Cycladic

CHINA Shang Dynasty 1523–1028 Bronze Helmet Confucius c. 551-479

Indus Valley Civilizations c. 3000-1500

Torso, from Harappa

Hinduism develops 800-600 Buddha c. 563-483

EGYPT Old Kingdom New Kingdom 2575–2134 1550–1070

Hieroglyphic writing invented c. 3100 Palette of Narmer Great Pyramids Menkaure &

Khamerenebty Funerary Barque of Khufu Seated Scribe

Mortuary Temple of Queen Hatshepsut Musicians and Dancers, from tomb of Nebamun Fowling Scene, from the tomb of Nebamun Tutankhamun's knife

Coffin of Tutankhamun Temple of Ramses II Egypto-Hittite Peace Treaty

Goddess Hathor & Overseer of Sealers, Psamtik

Fertility Statuettes

CIVILIZATIONS OF THE ANCIENT NEAR EAST

Old Babylon Assyria Neo-Babylon 612–583 1900–1600 900–612 Persian (Achaemenid) 538–330 Sumerian 3000-2300

Cuneiform writing invented 2400 Law Code of Hammurabi c. 1750

Israel: Old Testament early books assembled 587

Lyre Soundbox from Tomb of Queen Puabi, Iraq Hammurabi Stela, İran

Lamassu, Assyria

Ashurbanipal Hunting Lions, Assyria Royal Audience Hall, Persepolis, Persia

ITALY

Etruscans Roman Republic 509-27 650-509

Sarcophagus with Reclining Couple Banqueters & Musicians, Tomb of Leopards

Archaic Classic (Hellenic) 650-500 500-323

Hellenistic 323-100

Pericles 490-429

Alexander the Great 336-323 Persian wars against Greece c. 494-470 Peloponnesian War, Athens v. Sparta 431–404
Women at the Fountain House, "A.D." Painter
Acropolis, Athens

Parthenon Zeus or Poseidon Doryphorus, Polykleitos Grave Stele of Hegeso City of Priene

Alexander & Darius Theater at **Epidauros**

Idol from Amorgos, Cycladic Snake Goddess, Minoan Giant Storage Jars, Minoan Bull Jumping, Minoan

MESOAMERICA Preclassical Maya 1500 BC-AD 100

MESOAMERICA Olmec Culture 1500–300 Olmec Relief Acrobat

Olmec Head Danzante Stele CHINA

Shi Huangdi Han Dynasty 206 BC-AD 220

Tomb of Shi Huangdi The Great Wall

INDIA Maura Dynasty 320-184

EGYPT

Great Stupa at Sanchi Yakshi, from Great Stupa

Pharaoh Crowned by Goddesses Nekhbet and Wadjet

Rosetta Stone

Spread of Buddhism 1-200

House Model

Calligraphic arts flourish around Nanking House Model

Buddhist cave temple complexes carved 386-906

> Indian immigrations to SE Asia

Northern India:

The Gupta Empire 320-600

Southern India:

Pallava Dynasty 300-888

Central India: Chalukya Dynasty 535-757

Seated Buddha

IAPAN Introduction of Buddhism

> Mohammed 570-632

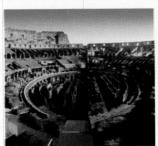

Rule of the Ptolemies 323-30

Horus Temple at Edfu

Colosseum

Iesus 4 BC-AD 33

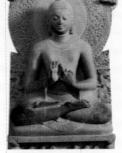

Seated Buddha

Ark of the Covenant Mosaic

Edict of Milan legalizes Christianity 313 Christianity state religion

EUROPE Barbarian

Eastern Roman Empire 286-500

Byzantine **Empire** 500-1453 Emperor

Roman persecution of Christians 249–251, 303–305

Roman Empire divided 286

of Rome 380

Western Roman Empire 286-410

Ceiling Painting from Catacomb

Basilica of Constantine and Maxentius

Justinian and Attendants

GREECE

Hellenistic 323-100

Roman Republic 509-27 Julius Caesar (100-44 BC) Pompeii destroyed 79 Roman Empire established 27 BC

Roman Empire: height of power 96-180

Head of a Roman Patrician

Gardenscape

Ara Pacis Augustae, and Tellus Panel House of the Vettii, Pompeii

Goldsmith Cupids, from House of Vettii

Colosseum

Villa of Mysteries Arch of Titus

Market of Trajan

Funerary Relief of a Circus Official

Trajan's Column

Pantheon

Scraps of a Meal, Heraclitus

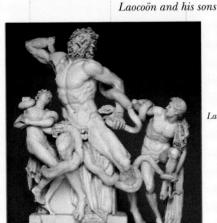

MESOAMERICA Preclassical Maya 1500 BC-AD 100 Pregnant Female (Kidder Figure)

Laocoon and his son.

PERU Nazca culture 100-700 Spider

Moche Civilization 200-1000

Royal Tomb of Sipan, Moche Peanut Necklace

Classical Maya Teotihuacán 200-600 100-1000

Quetzalcoatl Temple, Teotihuacán Pyramid of the Sun, Teotihuacán Tlalocan Painting, Teotihuacán

Palace at Palenque, Maya Mayan Relief

CHINA Tang Dynasty (618-906)

Shrine to Vairocana Buddha Portrait of the Emperors, Yan Liben Northern Song Dynasty Southern Song Dynasty 960-1127 1127-1279 Landscape painting flourished 918–1279 Movable type, gunpowder,

compass invented c. 1000

en Eight Riders in Spring, Zhao Yan Library of Longxingsi

Yuan Dynasty Ming Dynasty 1279-1368 1368-1644 Marco Polo arrives c. 1275 Waiting for Guests
by Lamplight, Ma Lin Apricot Blossom, Ma Yuan

Spring Festival Along River. Zhang Zeduan Guanyin Farm Scene

Six Persimmons, Mu Qi

IAPAN Heian Period 784-1185 First Emperor 622 Nara Period 710–784 Main Shrine at Ise

Six Persimmons, Mu Qi

Kamakura Period Ashikaga Period 1185-1392 1392-1573 Rise of the Samurai Mongol Emperor Kublai Khan invaded 1274, 1281

Burning of the Sanjo Palace

INDIA

ISLAM

Southern India: Muslim (Mughal) Dynasties rule in North c. 1000-c.1750 Chola Dynasty 850-1267

Kandarya Mahadeva Temple

Dewi Sri, Java

Shiva as Nataraja

Crowned Head of Oni

TURKEY Ottoman Empire 1300-1918

Islam spreads to Iraq, Syria, Egypt, North Africa and Persia 600–800 Turks converted to Islam 9th–10th c. **AFRICA** Ife and the beginning of Yoruba culture 800-1400

Kingdom of Benin 1300-present Crowned Head of Oni, Ife Mali Empire 1300-1500

EUROPE Early Middle Ages 500–1000

Founding of Islamic Religion 622

Viking raids 793–1000 Oseberg Ship Burial, Norway

Romanesque Era 1000–1150 Gothic Era 1140–1400

Crusades, Christians v. Muslims 1094-1204 Height of Christian Monasticism 900-1150

Black Death, one-third of population died 1348

Roman Catholic & Greek Orthodox Churches Split 1051 Rise of Towns and Guilds, First Universities Founded, 1100-1200

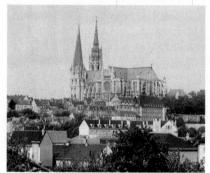

PERU Moche Civilization to 1000

Chartres Cathedral

Reliquary in the Shape of a Head, Rhenish Otto III Enthroned Receiving Homage

Chartres Cathedral, Fr.

Last Judgment, from St.-Lazare. Gislebertus. Fr. Madonna de Latte,

Ambrogio Lorenzette, It.

NORTH AMERICA Height of Pueblo cultures of Southwest 1000-1300 Temple Mound culture 900–1700 Pueblo Bonito, Anasazi Serpent Mound Mother and Nursing Child

Moche Pot depicting woman giving birth Moche Pot depicting sexual intercourse

MESOAMERICA

Moche House Model

Classical Maya to 1000 Head from Temple of Inscriptions, Palenque Portrait Heads from Tomb 6, Oaxaco Interior of Tomb 5, Oaxaca Shield Jaguar and Lady Xoc Great Ball Court, Chichen Itza

Huastec culture 900-1519 Xilonen, Goddess of Young Corn, Huastec Maya/Toltec culture 900–1600 Vessel in the Form of a Monkey Tula Warrior Columns, Toltec

Aztec Empire 13th c.-1519 Aztec Eagle Knight Aztec Knife

OCEANIA

Monumental Heads, Easter Islands

CHINA

Ming Dynasty 1368–1644

Crafts flourished under Imperial Patronage

Hall of Supreme Harmony

The Forbidden City, Beijing

Round Hall from the Temple of Heaven, Beijing

Roaming Beggars, Zhou Chen

Stem Cup & Chicken Cup

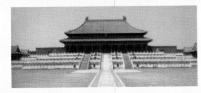

TIBET Mandala of Samvara

Hall of Supreme Harmony

JAPAN

Ryoan-ji, Garden of Contemplation

Tokugawa Shogunate 1573–1868 Development of tea ceremony Tea Bowl

Kabuki Theater begun Tokyo (Edo) became

Tokyo (Edo) became capital 1615 Japan closed to Europeans 1637 Ukiyo-e prints, 1600–1900

Qing (Manchu) Dynasty

Sheng Maoye

Leaf from Album of Landscapes,

INDIA

Mughal Dynasties in North India (Islamic) Uji Bridge

Taj Mahal

Babur Supervising Layout of Garden of Fidelity, Bishndas & Nanha Taj Mahal Eating Outdoors

ISLAM

AFRICA Portuguese traders in West Africa 1430 Atlantic Slave Trade begins 1430

Battle Axe, Egypt Saltcellar, Afro-Portuguese

Masjid-i-Shah, or Royal Mosque, Iran

Plaque with Warrior and Attendants, Benin

EUROPE Renaissance 1400–1600 Gutenberg developed

printing press 1440

Sacrifice of Isaac, Ghilberti, It.

Explusion from Paradise, Masaccio, It. Wedding Portrait, Van Eyck, Flanders

Colonial empires established by Spain, Portugal, France and England 1500–1700 Baroque Era 1600–1700

Martin Luther 1483-1564

Protestant Reformation began 1517

Counterreformation began 1545

Magellan's voyage 1519–1522

Equestrian Monument, Verrocchio, It.

Unicorn in Captivity, Fr. Last Supper, Leonardo, It. David, Michelangelo, It.

Chapel of Henry VII, Eng.
Madonna of Meadow, Raphael, It.
Isenheim Altarpiece, Grünewald, Ger.

Sistine Chapel Ceiling, Michelangelo, It. Boy's Armor of Archduke Charles, Sp.

Laurentian Library, Michelangelo, It. Fourth Plate of Muscles,

Vesalius, Brussels Villa Rotonda, Palladio, It.

Harvesters, Bruegel, Neth.

Europe: Scientific Revolution in astronomy, mathematics, physics (Copernicus, Kepler,

Galileo, Newton) c. 1600–1750 France: Reign of Louis XIV,

1643–1715 Little Bouquet in Clay Jar, Bruegel, Flanders

Abduction of Daughters of Leucippus, Rubens, Flanders

Rubens, Flanders

Raldacchino, Vatican, Be

Baldacchino, Vatican, Bernini, It. Boy Playing Flute, Leyster, Neth.

Table of Desserts, de Heem Ecstacy of St. Theresa, Bernini, It.

Bernini, It.

Louis XIV Portraying Sun

Las Meninas, Velasquez Kitchen Maid, Vermeer

Portrait of Gentleman, ter Borch

Self Portrait,

Rembrandt, Neth. Versailles, Fr.

Chapel of Sts.

Peter & Paul, Russia

David, Michelangelo

Shakespeare 1564-1616 Globe Theater

NORTH AMERICA

Native cultures flourish throughout North America Columbus reached America 1492 English colonies established in North America

LATIN AMERICA

Mexico: Aztec Empire to 1519 Aztec Marriage Couple Tlaloc Vessel Spanish conquest 1518–1536 Calendar Stone Primordial Male & Female Force Moctezuma's Headdress

Peru: Incan Empire 1476-1534 Fortress of Sacsahuaman

Royal Incan Brothers Huascar and Atahuapla

OCEANIA

New Zealand settled by British immigrants 1840s, Maori population sharply declined Hawaii: Whalers & missionaries destroyed native social structure

Captain Cook voyages to

Australia, Antartica, New Zealand, Hawaii,

Tahiti, Eastern Russia, 1769-1779

England colonizes Australia late 18th c. Royal Kahili, Hawaii

Figure of A'a Rurutu, Austral Is.

Lidded Bowl & Condiment Bowls, Hawaii War Shields, Solomon Is. Princess Ka'Iulani, Hawaii

Figure Representing the God Te Rongo, **Cook Islands**

CHINA

Opium Wars against Britain 1839–1841

IAPAN Tokugawa Shogunate until 1868

Pair of Lovers, Kitagawa Utamaro Hinazura of Chojiya, Kitagawa Utamaro Interior of a Kabuki Theater, Utagawa Toyokuni

Meiji rule 1868–1912 Japan ports open to Western nations 1854

Beneath Waves off Kanagawa, Katsushika Hokusai.

INDIA

Ruled by the English East India Company c. 1750–1857 Krishna and Radha in Pavilion

Ruled by British Empire beginning in 1857

ISLAM

AFRICA

Transition from local to colonial rule 1800-1900

Slavery abolished in British

Male Torso (Ancestor), Baule

Industrial Revolution 1725-1900: Growth of industry and industrial inventions such as the steam engine European Colonialism through mid-20th c.

British Empire extended to India, West Indies, Southeast Asia, China, Africa, Middle East, and New Zealand

French Revolution 1789 Napoleon Bonaparte ruled 1799–1815

Empire 1833

Diderot (1713-1784) compiled Encyclopedia

Pompeii

Élgin Marbles displayed excavations 1748

Rococo era to mid-18th c.

in England 1810 Romantic Movement 1800-1830 Great Exhibition of All Nations, London 1851

Florence Nightingale & Nursing Innovations 1850s

Darwin: Origin of the Species, 1859

Nobel and the invention of dynamite 1866

Marx & Engels: Communist

Manifesto 1848

Realist Movement 1850-1880

Hall of Mirrors, de Cuvilles, Germ. Breakfast Scene, Hogarth

The Swing, Fragonard, Fr. Oath of Horatii, David, Fr.

Pere Lachaise Cemetery opened Grande Odalisque, Ingres, Fr. The Executions of

Daguerre & photography 1839

May 3, 1808, Goya, Sp.
Haywain, Constable, Eng.
Liberty Leading People,

Ophelia, Millais, Eng.

Bellelli Family, Degas, Fr.

Delacroix, Fr. Fighting "Temeraire," Turner, Eng.

Houses of Parliament, Barry & Pugin, Eng. Opéra, Paris, Garnier, Fr. Third-Class

Fr.

Carriage, Daumier, Fr. Olympia, Manet,

USA: Civil War

1861-1865

NORTH AMERICA

USA: Declaration of Independence 1776 USA: Louisiana Purchase 1803

Monticello, Jefferson Penn's Treaty with Indians, West

Krishna and Radha in

Morse invented

telegraph 1835 Sheephorn Ladle,

Tlingit Central Park, NYC Olmstead & Vaux

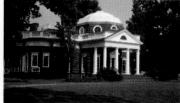

Monticello, Jefferson

Eastern Sioux Ball Head Club Potawatomi Male

Figure

Carolina Parroquet, Audubon Chief Keokuk, Catlin Peaceable Kingdom, Hicks

Shaman's Amulet, Tlingit

Dead Confederate Soldier with Gun, Brady

Bearclaw Necklace, Mesquakie

Ottawa Presentation Pipe Tomahawk

Haiti: Slave rebellion against French colonists 1801

LATIN AMERICA Mexico, Argentina, Brazil and others declared independent from Spain and Portugal 1810-1830

OCEANIA AND AUSTRALIA

Te Mana O Turanga Meeting House, Raharuhi Rukupo & others, Maori

Dewi Sri, Bali

Hunter and Kangaroo, Australia Painting from Cult House, Papua New Guinea Yipwon figure, Papua New Guinea

Tomika Te Mutu of Coromandel, Maori Chief

ASIA

Mohandas (Mahatma) Gandhi, India, 1869-1948

China: Nationalist Revolution, end of Imperial rule 1911

Study for Portrait of Okakura Tenshin, Shimomura Kanzan, Japan

AFRICA Power Figure (Nkisi n'kondo), Central Africa

Reliquary Guardian Figure, Gabon Chi Wara Headdresses, Mali Dogon Primordial Couple, Mali

European Colonization of Africa completed 1900 Sculptures for Palace at Ikere Olowe of Ise, Nigeria Palace at Oyo, Nigeria

Dogon Meeting House

Boating Party,

La Grande Jatte,

Renoir, Fr.

Seurat, Fr.

Gu Mask, Ivory Coast Royal Stool, Ghana

Fauvism 1900-1915

Cubism 1900-1915

Two Staffs & Spear, Central Africa

Ashanti Akua'mma Dolls, Ghana Mbari Shrine, Nigeria

Granary Shutters, Dogon, Mali Mask, Central Africa Dogon Meeting House, Mali

EUROPE Impressionism c. 1870-1890

Post-Impressionism c. 1885-1914 Luncheon of

Portrait of Dr. Gachet, Van Gogh, Dutch

Luncheon of

Renoir

Boating Party,

The Scream, Munch, Norway

Jane Avril,

Toulouse-Lautrec, Fr. Outbreak,

Space, Boccione, Kollwitz, Ger.

Freud: Psychoanalysis 1905

Einstein: Relativity 1905–1916

Marconi developed radio 1909

Feast Dish, James, Northwest Coast

World War I 1914–1918; 8 million die Great Depression 915 Russian Revolution 1917 USSR: Stalin Russian Revolution 1917 as dictator **Italy: Fascist Government** Futurism 1909-1914 Germany: Nazis

in power Germany: Bauhaus founded 1919 Dada 1920s Spanish Civil War 1936–1939 Surrealism 1920-1930 Existentialism

Unique Forms of International Style Continuity in 1920s-1970s Social Realism 1930s

Over Vitebsk, Torso of Chagall, Russia Young Man,

Fit for Active Brancusi, Service, Rom. Grosz, Ger.

Persistence of Memory, Dali, Sp. Goering the Executioner, Heartfield, Ger. Triumph of Will,

1930-1950

Wagenfeld, Ger.

Mocha Jug,

The City, Leger, Fr. Riefenstahl, Ger. Battleship Potemkin, Eisenstein, Russia Kalenberger

Bauernfamilie, Wissel, Ger. Guernica, Picasso, Sp.

THE AMERICAS

Women's Suffrage Movement

World War I 1914-1918

Leo, 48 inches high,

Hine, USA

Transformation & Echo

Masks, Kwakiutl

Grey Line with

Lavender &

Leonardo's

Last Supper,

Moretti, USA

Rivera, Mex.

Dia de Los Muertos,

O'Keeffe, USA

Yellow,

8 years old,

1929-1939 USA: Harlem Renaissance

Mexican revolution ended 1924

Mexico: Mural movement 1930s Artichoke, Halved,

Great Depression

Weston, USA Passion of Sacco & Vanzetti, Shahn, USA Gods of Modern

World, Orozco, Mex. Migrant Mother, Lange, USA

Fallingwater, Wright, USA

Echo of a Scream, Siqueiros, Mex. No. 36: During the

Truce Toussaint . . Lawrence, USA Gone with

the Wind, USA Society Ladies, VanDerZee, USA

Battle of Little Big Horn, Red Horse, Sioux 1880

Sioux Tipis, North America, 1880s Handspring, a flying pigeon interfering, Muybridge, USA

Sioux Eagle Feather War Bonnet Basket, Pomo

Carson Pirie Scott & Company, Sullivan, USA Hoop Dance, Sioux

Migrant Mother,

Bell: Telephone c. 1870

Edison: Electric lights 1880

First movies in New York, 1890 Ford: Motorcar 1893

Wright Brothers and flight 1903

Interior House Post,

Shaughnessy, Kwakiutl

WORLD EVENTS

World War II 1939-1945 11 million Holocaust victims

Japan: Atomic bombing of Hiroshima and Nagasaki 1945 Cold War between

Communist & Western nations 1946-1990 **United Nations** established 1947

Breakdown of old European colonial empires India, SE Asian nations' African nations independence 1945-1970 independence 1950-1975

Korean War 1950-1953 Vietnam War 1959-1975

ÚSSR: First satellite in space 1957

Space Race

USA: Man on moon 1969 USA: Martin Luther King Jr. assassination 1968

Nation of Israel established 1948 China: Mao Zedong & People's Republic 1949

USA: Civil Rights Movement 1950s-1960s

USA: Kennedy assassination 1963

Self-Portrait with Monkey,

Kahlo, Mex. Citizen Kane, Orson Welles, USA

Ahola Kachina, Kewanwytewa, Hopi (North American) Horizontal Frieze, Malagan, Northern New Ireland (Oceania) Asmat Hand Drum, Papua New Guinea Kanaga Masked Dancers of Dogon people, Africa Tokyo Station As It Is Now, Yamakawa Shuho, Japan

Clearing Winter Storm, Adams, USA

Lucifer, Pollock, USA Bamama Female Figure, Mali, Africa Bisj Poles, New Guinea Toba Batak House, Indonesia

Mohandas (Mahatma) Gandhi on a Madras Temple, India

Notre Dame du Haut, Le Corbusier, Fr.

Dogon Cliff Dwellings, Africa Elegy to Spanish Republic XXIV, Motherwell, USA U.S. Marine Corps War Memorial, de Weldon, USA

Green, Red, Blue, Rothko, USA Nightway: Whirling Logs, Navajo (North Am) Just What Is It . . .? Hamilton, UK Ngere Girl Prepared for a Festival, Africa I Love Lucy, Television Series, USA Government Bureau, George Tooker, USA Summerspace, Rauschenberg, Cage et al. USA Guggenheim Museum, Wright, USA *Opera House,* Sydney, Australia Utzon, Denmark

Homage to New York: A Self-Constructing, Self-Destructing Work of Art, Jean Tinguely, Switzerland Retablo of Maria de la Luz Casillas and Children, Mex. The Family, Marisol, USA

Accumulation No. 1, Yayoi Kusama, Japan Pie Counter, Wayne Thiebaud, USA Current, Bridget Riley, UK
Heinz 57 Tomato Ketchup and Del Monte

Freestone Peach Halves, Warhol, USA Household, Allan Kaprow, USA

Cubi XXVI, Smith, USA Rent Collection Courtyard, Ye Yushan and others, China Woman with Keloidal Scars,

Tomatsu Shomei, Japan State Hospital, Keinholz, USA

Habitat, for Expo '67, Safdie, Israel Geodesic Dome at Expo '67, Fuller, USA

Brigadier General Nguyen Ngoc Loan summarily executing, Adams, USA Hakone Open Air Museum, Japan

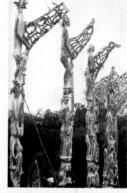

Bisj Poles, New Guinea

Lucifer, Pollock

Clement Greenberg

Abstract Expressionism New York became center of art world 1950

Commercial television began 1940s

Pop Art Op Art Happenings

The Beatles

Jazz: Gillespie, Davis Rock music: Elvis, Little Richard, Bill Haley

Guggenheim Museum, Wright

Computer chip invented 1959

WORLD EVENTS

Women's Rights movement 1970s

Emphasis on Religious and Ethnic identities 1970-present Islamic Revolution in Iran 1978–1979 USA: Watergate scandal 1972–1974

Spiral Jetty, Smithson, USA Mausoleum of Mao Zedong, China Coca Pod Shaped Coffin, Kwei, Ghana, Africa Insertions into Ideological Circuits: Coca-Cola Project, Miereles, Brazil Epa Headdress called "Orangun," Bamgboye of Odo Owa, Nigeria Lightning Field, De Maria, USA

Carving: A Traditional Sculpture, Antin, USA Liberation of Aunt Jemima, Saar, USA

Waupanal, a men's cult house, Papua New Guinea

Dinner Party. Judy Chicago, USA Meltdown Morning, Jenney, USA Piazza D'Italia, Moore & others, USA Mercenaries I, Golub, USA

Backs, Abakanowicz, Poland Arbol de la Vida, No. 294, Mendieta, Cuba/USA Untitled Film Still #35, Sherman, USA

Disneyland, California, Tseng Kwong Chi, China/USA Self-Portrait with Model, Hanson, USA

Milk Storage Jar, Kenya Witchetty Grub Dreaming, Tjungurrayi. Australia Sun Mad, Hernandez, USA Portrait of George, Arneson, USA Vietnam Veterans Memorial, Washington DC

Maya Ying Lin, USA Great Beaded Crown of Orangun-Ila, Adesina Family, Nigeria Sail Baby, Murray, USA

Social Mirror, Ukeles, USA Blind Man's Bluff, Bourgeois, USA Baby Makes 3, General Idea, Canada AIDS Memorial Quilt, Names Project, USA Offering with Cili-Shaped Crown, Bali

Fanny Fingerpainting, Close, USA Metromobiltan, Haacke, USA Punch & Judy: Kick in the Groin, Slap in the Face,

Nauman, USA Do Women Have To Be Naked To Get Into Met. Museum?

Guerrilla Girls, USA

The Artifact Piece, Luna, USA

There is No Escape, Coe, UK Sisters #2: Nefertiti's Daughter Merytaten/Devonia's Daughter Candace, O'Grady, ÚSA

Voodoo Figure, Mario Cravo Neto, Brazil

Collapse of the Soviet Union 1989

Aboriginal Memorial, Paddy Dhatangu & others, Australia Your Body is a Battleground, Kruger, USA

Massacre at Tiananmen Square, Beijing 1989

Breakup of Yugoslavia 1990s

Dingoes; Dingo Proof Fence, Onus, Australia Bank of China, I. M. Pei & Partners, Hong Kong

Untitled (Selected Writings), Holzer, USA, Trauma, Hung Liu, China/USA, 1989

Made in Heaven, Koons & Cicciolina, USA/Italy Deep Contact, Hershman, USA

Breaking of Vessels, Kiefer, Germany In Sandy's Room, Aguilar, USA Series II, No. 6, Fang Lijun, China Morgue (Hacked to Death II), Serrano, USA

Gnaw, Antoni, USA

Intra-Venus, Wilke, USA Untitled Image from "Faces," Burson, USA Leigh under Skylight, Freud, UK

Wallace & Gromit: A Close Shave, Park, UK Megatron, Nam June Paik, with Shuya Abe, Korea/USA, 1995 Lion King (Disney),

Julie Taymor, Designer

Aboriginal Memorial, Dhatangn and others,

Digital Art

Minimalism Feminism Performance Art Photorealism Site Works and Earth Works

Electronic music Reggae music

Neo-Expressionism Post Modernism

> Personal home computers became widely available 1984 AIDS epidemic began

Fanny Fingerpainting, Close

Coca Pod Shaped Coffin, Kwei, Ghana, Africa

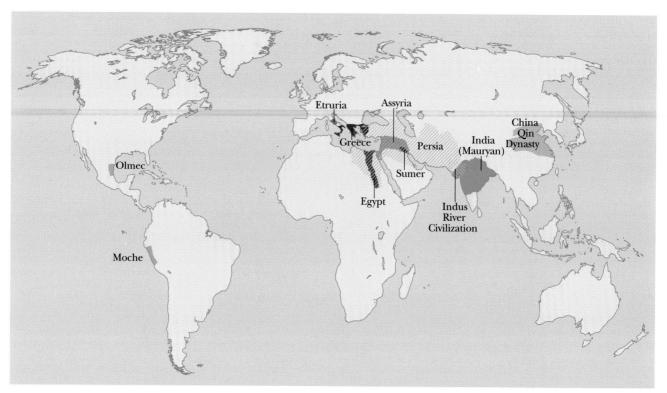

5.17 Ancient World

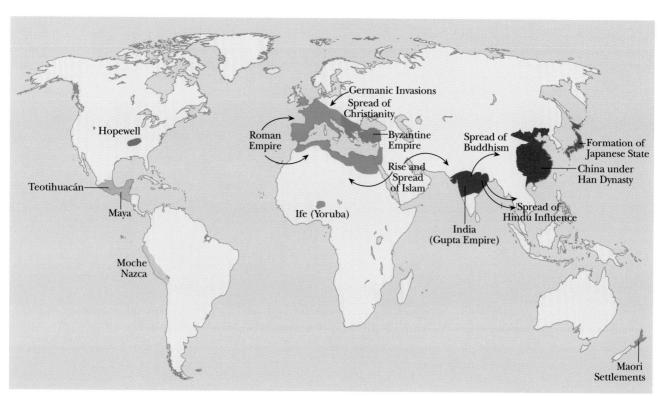

5.18 1 through 1000

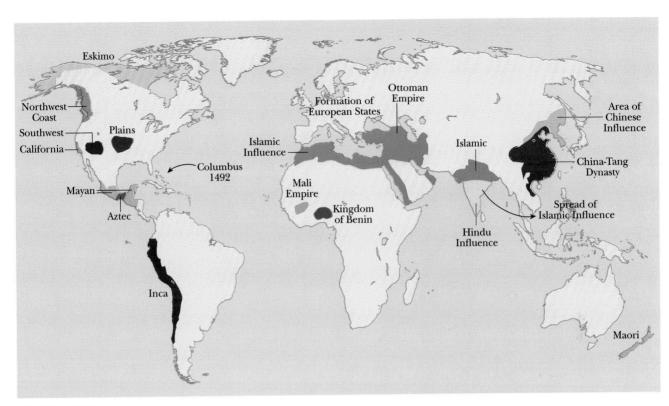

 $5.19\ 1000$ to 1500

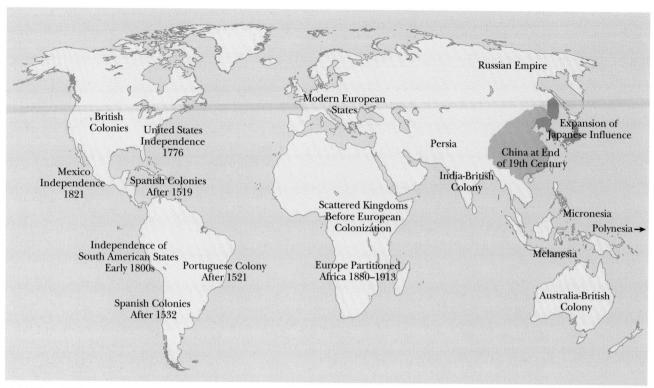

5.20 1500 to 1900

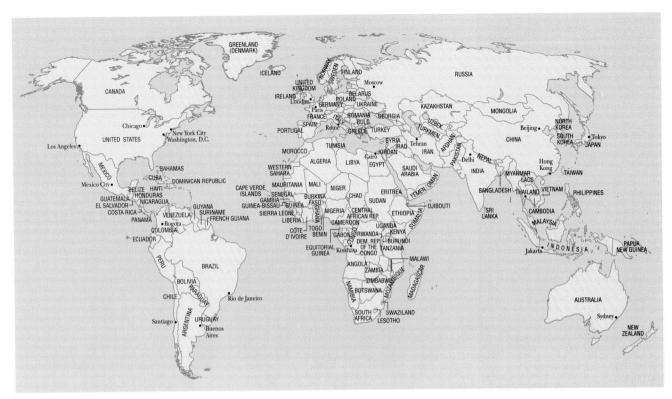

5.21 Modern World

Section 1: Survival and Beyond

Section 2: Religion Section 3: The State

Section 4: The Self and Society

Part 2

Why Do We Make Art?

The answers to the question "Why do we make art?" are many and complex. But all answers relate to the basic human concerns and needs.

We have clustered the reasons why we make art into four sections. We will look first at how art addresses our basic human needs for food, reproduction, and shelter. The second cluster deals with art as it relates to religions and spirituality. Art is an important tool to help us grasp the supernatural realm. Next we look at the political uses of art, and how art work supports or criticizes existing power structures. And in the final section, we turn to art that is a mirror in which we can see ourselves, a reflection of society, or a model by which we understand the natural world.

Section 1: Survival and Beyond

What is basic to human survival? Food, reproduction, and shelter. These are ongoing concerns of humans, regardless of how civilized, socially structured, or distracted we might be in our everyday lives. What role does art play in these? Some cultures used art to actually assist in survival, usually through ritual. For other cultures, art is an expression of social views about food, reproduction, and shelter.

Chapter 6
Food

Chapter 7
Reproduction

Chapter 8
Shelter

INTRODUCTION

Food is an essential element to life itself, along with clothing and shelter. Therefore, food has been an important subject matter in art for as long as art has been made.

Humans focus much of their daily energy on food. Each group of people, tribe or large culture, develops its own complex methods of acquiring food, preparing and serving it, and enjoying it. Each group makes art that is intertwined with its food traditions. Art objects help secure food, to serve and store it, and artworks reflect how different peoples enjoy food. You will also notice throughout this chapter the strong association between food and ritual or religion.

In this chapter, we will look at art from various cultures to answer the following questions:

How have different cultures used art to ensure their food supply?

What kinds of vessels have artists designed for storing and serving food?

How have artists glorified food in their artworks? How have artists depicted the act of eating? What significance can that act have?

In what ways are food and eating associated with ritual?

Reading this chapter has an additional benefit, besides answering the above questions. Each of us can develop eating patterns that are so habitual that we may be almost blind to them. A study of food-related art shows many different attitudes and ideas about food—how various people secured it, served it, socialized around it, and worshipped with it. This knowledge makes us see food in new ways.

ART AND SECURING THE FOOD SUPPLY

Eating food has always been a source of pleasure and satisfaction to human beings, besides keeping us alive. Every group of people has been concerned with ensuring their food supply. How does art help that happen, or help us conceive new ideas about it?

Art of Hunters, Gatherers, and Farmers

Let us look first at a group of artworks from nonindustrial cultures. Here, the link between food and ritual are very strong, so strong in fact that some works of art here could have been placed in the following chapters on Religion, and vice versa. For example, we will look at Stonehenge in Chapter 10, Places of Worship. Scholars suggest that Stonehenge was a site for ritual worship, and also was a device for predicting the movement of the sun, and would therefore be an aid to tell the best planting time for food crops. Should Stonehenge be discussed in relation to food, or to religion? We today make distinctions that do not necessarily hold true in other cultures.

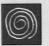

Text Link

Take a close look at Stonehenge in Chapter 10, figure 10.6

People throughout human history have used art along with ritual to invoke spiritual or magical forces to help accomplish a task, that is, bring rain for the crops, or heal someone who is ill. This is a form of "sympathetic magic" that required the talents of the artist and the shaman (who may be the same person). The art and ritual functioned together, and were meaningless without each other. Ritual-based art often was destroyed if the magic ceased, or to prevent or stop the power of the magic. The artist/shaman could attain great status in their society, and in some cultures still do to this day.

Food, art, and ritual are probably linked also in ancient cave drawings, like those at *Lascaux* in southern France, dated c. 15,000–10,000 BC (figure 6.1). Some of the most exquisite imagery of animals was produced by prehistoric Ice Age artists on remote walls located deep inside caves in Africa and southern Europe. Several of the animal drawings ranged from huge woolly mammoths to horses, rhinos, aurochs (wild cattle), and reindeer. The exact purpose of the cave drawings is unknown. Some anthropologists have proposed that the

6.1 Hall of Bulls. Cave painting, left wall. Lascaux, Dordogne, France. c. 15,000–10,000 BC. French Government Tourist Office. See Chapter 21, figure 21.20, for more on this artwork.

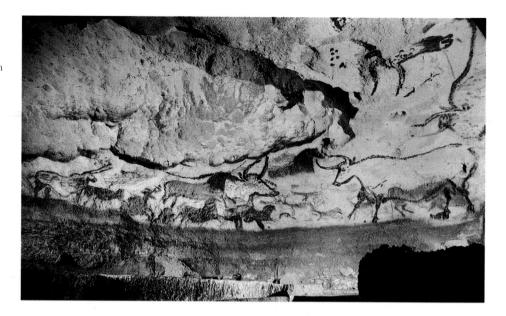

cave was an environment safe and secure from the animals themselves where rituals could be performed to ensure a successful hunt of those very animals. By capturing the likeness of the creature, the artists may have felt they also captured its spirit, thus securing it under their control. With this control, spears and arrows were painted in or actually thrown at the image of the prey, ritualistically killing it, which would ensure a successful hunt.

Other scholars disagree with this interpretation, because the painted "arrows" are few, and could be plant forms. They propose that these ancient cultures lived in harmony and in cooperation with nature, and that these drawings may have been homage given to earth and animal spirits. Either way, the current consensus is that these images had a ritual purpose linked to bounty in nature, and thus tied to the human food supply.

These drawings are accomplished, wonderful works of art. The animals appear in all sizes, all charging or fleeing. The ancient artists had a keen sense of observation and incredible memory. They painted images deep inside the caves, through narrow and difficult passages, obviously drawing from memory and not from life. Yet they rendered quite naturalistically the magnificent animals of their day, without showing landscape or deep space. They focused more on the energy and movement of their subjects, showing the side view which was the most recognizable silhouette of the animal, and adding essential details in the head. Their images were clear and energetic, due mainly to their very strong use of outline. For color, they used various naturally occurring material, such as tar and charcoal for black, colored earth for yellow and brown, and rust for red. Dry material could be used as a powder, or mixed with fat and applied with a primitive brush. The drawings are especially amazing considering the primitive materials and

the fact they were paintings on rough stone walls, which were not very forgiving if mistakes were made.

Across the world in Australia we see the same phenomenon of linked food, art, and ritual. The "Ancestor Dreaming" of the Aboriginal people of Australia is a system of beliefs and information that accounted for the cosmos, from creation to death, which included food gathering. The knowledge and beliefs in "Ancestor Dreaming" was passed on through songs, chants, dance and painting. As part of food-gathering rituals, Aboriginal artists of the past created paintings on the ground with colored dirt and natural materials. Each mark was significant and carefully executed. They were ancient symbols owned by certain members of various clans. The symbols, usually represented in dots, lines, and circles, made up a kind of contour map that gave information about the location of food and water. The combination of the various rituals would help the clans survive in an arid environment. The meaning of the ritual paintings were kept secret among a few clan members, and the paintings would be destroyed after the ritual was performed.

Since the 1970s, Aboriginal artists have been making their paintings with more permanent materials. Witchetty Grub Dreaming, dated 1980, is by Paddy Carrol Tjungurrayi (figure 6.2). Taken just formally, the painting is an array of patterned dots, lines, concentric circles and semicircles. The work is strongly patterned, with alternating lights and darks, and alternating curving and straight lines, all radiating from a center point. The marks are more than mere shapes, however; they are also symbols that give life-sustaining information. The painting shows the source of the ancestor grub, an important food, which is represented by the circles located in the center of the composition. The small squiggled lines represent other grubs beneath the ground waiting

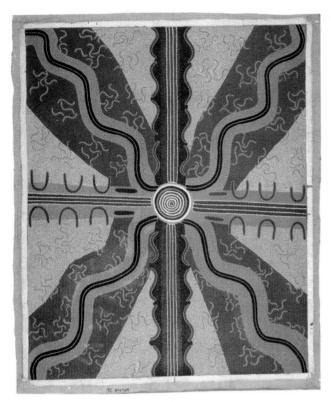

6.2 PADDY CARROLL TJUNGURRAYI. Witchetty Grub Dreaming. Paint on canvas. Australia, Aboriginal, from Papunya, 1980. Photo by Jennifer Steele. See Chapter 2, figure 2.1, for more on the line quality of this work

to be dug up for a succulent meal. The symmetrical arrangement of the painting in warm earth tones suggests the balance of the cosmos and the ancestors, which provide sustenance for human beings. Other Australian Aboriginal paintings indicate the location of other foods, such as the mounds of the honey ant. Precious water holes are also indicated in some of the works.

The Bamana peoples of Mali use masks, dance, and ritual to help ensure successful crops. They make beautifully abstracted sculptured headdresses of the antelope, representing the spirit Chi Wara (or Tyi Wara), who gave them the knowledge of agriculture. Our example of the Chi Wara Dance Headdress dates from the late nineteenth or early twentieth century (figure 6.3). There are male and female antelope masks, with the female mask bearing a baby antelope on her back. These masks are worn on the heads of young male dancers, with the rest of the dancers' bodies covered in costumes that become part of the whole masquerade. Imagine the leaping movement of the antelope dance, while the ground is being prepared for planting with the scratching stick. The ritual causes the mythical antelope to be present with the power and knowledge to ensure a bountiful crop. It also brings together the realms of plant life (crops), animal life (antelope) and humankind (ancestors). Formally, the sculptures are an intricate interplay of negative spaces and organic shapes that are abstracted

6.3 Chi Wara Dance Headdresses. Wood, brass tacks, string, cowrie shells, iron, quills. Height of female: 97.8 cm., height of male: 79.8 cm. Mali, Africa: Bamana people, late nineteenth or early twentieth century. The lower image shows similar headdresses worn in a contemporary planting ceremony. Photo by Pascal James Imperato.

from antelope antlers. Pattern and rhythm are important visual elements in these headdresses.

Text Link

Most cultures have appealed to the benevolence of a spirit for their survival and well-being. Read Chapter 9 for information on deities responsible for food production, from Mesoamerica, Ancient Greece, and modern Hindu cultures in Southeast Asia. Xilonen, the Goddess of Young Corn (figure 9.13) is one such deity.

Art and Food in Industrial Societies

Now let us turn to some radically different examples of artworks that are related to a culture's food supply.

In most contemporary industrial societies, the relationship between humans and the acquisition of their food is different from what we have seen previously. Hunting is now a sport in the United States and has lost its urgency as a means of providing food. Hunters with powerful rifles "bring down" distant animals they barely see. Like the distance between the modern hunter and hunted, most people in the industrial societies are far removed from their food sources. Few process the meat they eat. Few gather food or farm. Modern industrial societies rely on technology and business, rather than religion, to ensure their food supply. Thus, their artwork related to food production does not have the associated ritual or magic element. Rather, this artwork tends to look critically at how food is produced within the industrialized societies.

Andy Warhol's Heinz 57 Tomato Ketchup and Del Monte Freestone Peach Halves, dated 1964 (figure 6.4) are silkscreened wooden sculptures that appear to be cardboard packing boxes for common grocery store items. In the United States, packaged foods are in many cases more familiar than food in its natural condition. Warhol is celebrating commercialism and the art of packaging, indicating that most people enjoy it and are comfortable with it. In this work, he is claiming that the design of ketchup boxes is art, and therefore as meritorious and meaningful as any other work of art. We see here the formal qualities common in most packaging: bright colors, large type, simple graphics, and organized layout. Yet there is a sense of irony to the work, because the packaging he depicts is present everywhere and yet transitory, the stuff of trash heaps and landfills, and because whatever is comfortable eventually becomes hollow and meaningless.

While Warhol's sculptures may be seen as ironic, humorous, celebratory, or pathetic, British artist Sue Coe's *There Is No Escape*, from 1987 (figure 6.5) is

6.4 ANDY WARHOL. Heinz 57 Tomato Ketchup and Del Monte Freestone Peach Halves. Silkscreen on wood. 15" × 12" × 9.5". USA, 1964. Edith C. Blum Collection, Art Institute, Bard College. See also the text accompanying figure 22.14.

6.5 Sue Coe. *There Is No Escape.* Watercolor and graphite on paper. 22" × 30". British, 1987. Courtesy Gil Michaels.

6.6 Giant Pithoi (Storage Jars). Palace at Knossos, Crete. Minoan, c. 1600 BC.

unmistakably a bitter indictment of the contemporary meat industry. There Is No Escape is part of a large series of works entitled "Porkopolis," in which Coe shows the process by which living animals are transformed into packaged cuts of meat. In her depiction of the interior of a slaughterhouse, Coe emphasized the carnage and sympathizes with the panic and fear of pigs being slaughtered. She depicts the people working there as sadistic or subhuman. The image is overall very dark, with a few lurid glaring lights. The black-and-white of this image recalls a documentary photograph; while Coe's painting is emotionally heated, she still wanted us to accept it as fact. Coe was also condemning the contemporary meat-heavy Western diet for creating an overblown market for meat.

STRUCTURES AND CONTAINERS FOR STORING AND SERVING FOOD

Civilizations throughout history became increasingly successful at ensuring their food supplies. They then turned to storing their surplus, and artists and architects have designed and decorated many varieties of large and small food storage containers. Also, each civilization developed its own traditional serving vessels and dishes, whose design, decoration, and manner of use were very significant to them. In this section, we will look first at storage containers for surplus food, and afterwards take a brief survey of some serving utensils that different cultures have developed.

Storage Structures

Architectural structures for food storage, especially of surplus, have always been important to the frugal and economic society.

The Minoans of Ancient Crete were merchants and sailors who had elaborate supply chambers, called magazines, in lower areas of their multistoried palaces. These magazines were long rooms filled with storage jars. There were also lead-lined pits in the floor, where all kinds of goods could be stored, including olive oil and wine, "cash crops" that the Minoans could export to other areas and thus a source of wealth. Among the most impressive storage vessels were the Giant Pithoi, c. 1600 BC (figure 6.6), larger than most storage jars and likely for royal or ceremonial use. Although these enormous jars were probably not moved once they were in place, they are nevertheless covered with handles and rope-like designs that resemble actual ropes and handles of smaller, transportable vessels. The horizontal bands emphasize the swelling curves of the jars, while diagonals add an extra pattern element to the surface. The big vessel has an amazingly small base, but its overall balance makes it seem stable and elegant. The Minoans also created smaller, multicolored ceramic jars shaped like the Giant Pithoi that were covered with energetic swirling designs. Marine life was a favorite subject of these designs, since the Minoans were an island people who were very dependent upon the sea for trade and for fishing.

The Dogon culture of Mali, Africa, stored their harvest in granaries that have intricately carved doors and

shutters. In our example of *Granary Shutters*, from c. the nineteenth–twentieth centuries (figure 6.7), we see four rows of figures in relief modeled in a contained frontal style, forming almost a blockade or a fence of guardianlike beings. The figures exhibit idealized proportions according to the Dogon aesthetic, with relatively large heads and equal balance between torsos and legs. The figures' repetition and strict symmetry add the qualities of rigidity, strength, and immobility. Probably ancestor figures, their spirits are the doorkeepers of the grain, permitting only the owners to have safe access, and repelling would-be thieves or hungry rodents. An elaborate iron lock completes the security system.

Storage Containers

In addition to large-scale structures, many cultures used smaller containers for preserving food and beverages, both for long-term storage and also for ritual purposes.

The Ancient Chinese made bronze vessels for storing liquids, such as ritual wine. To invoke the blessings of the ancestors, such vessels may have been placed on or in front of a shrine of a deceased relative as an offering for a special favor such as a successful crop or good health. Some are elaborately and densely patterned over their entire surface, while others maintain a simple jug shape with smaller bands of patterns. The face of a monster may be placed at locations such as the handles, perhaps

6.7 Granary Shutters. Wood and iron. 29" high \times 18.5" wide. Dogon, Africa.

6.8 Three-Legged Ting with Cover. H 5%" cast bronze, Zhou Dynasty, c. sixth century BC, China. Ashmolean Museum, Oxford, UK.

to keep away evil. Many Chinese bronze vessels are elegantly balanced in proportion and ornamentation, which reflects the importance of balance and harmony, visually expressing ancient Chinese philosophy and values.

The practice of casting bronze vessels was begun in the Shang Dynasty. From the sixteenth to eleventh centuries BC, the Shang rulers, who considered themselves god-kings, created a code of ideas that included an aesthetic for the arts. New objects of art were found in their tombs, forms that had not been found in previous tombs, including beautiful bronze ritual vessels. During the later Zhou Dynasty (eleventh–third centuries BC), social status became important, and the bronze vessels became status items.

The casting of the vessels in bronze, a copper and tin alloy, was executed in the lost wax method (cire perdue), discussed in Chapter 2. Several moulds were often used in order to get the precise detailing seen in many of the vessels. In our example, (figure 6.8), we see a Zhou *Three-Legged Ting with Cover*, dated sixth century BC. The "ting" vessel is distinguished by the three legs or feet. This balanced vessel is delicately incised with abstract lines that do not detract from its overall form. The repeated circles create a sense of unity in this vessel, from the sphere of its body, to its four round handles, down to the horizontal bands that encircle its girth. Cleverly the cover of the ting, which is decorated with a quatrefoil design, can be used as a serving bowl.

Water containers, because of their contents being most essential to maintaining life, have to be one of the most valued and revered forms of storage. Various peoples have developed inventive systems for storing liquids, using clay, leather, wood, and straw. A Greek hydria is a ceramic water vessel. Our example, a Greek hydria, *Women at the Fountain House* (figure 6.9), dated 520–510 BC, has a well-designed silhouette. The body of the vessel rises up and out in a smooth, graceful curve from its short base. The handles accentuate the widest part of the pot. From that point, the "shoulders" move inward dramatically, while the vessel's "neck" exhibits curves that echo, but oppose, the curves of the body.

This hydria has been illustrated with the activity of collecting water, the purpose for the vessel itself. The decorative female figures fill their hydrias almost effortlessly from the fountainheads on the walls of the fountain house. The figures were made in the black figure style, in which the pot itself was made of a red clay, over which a thin black-firing clay was applied and details were scratched away with a needle. Black figure vase painting tends to be delicate and decorative, with silhouettes emphasized. The potter-painter framed the scene with floral and geometric designs incorporating the colonnaded composition neatly within it. There is no feeling of toil in the women carrying the heavy loads home on their heads, but more a sense of ease, perhaps reflecting the abundance and richness of Greek life, particularly in their cities. Although the scene has been idealized, the artist has given our century a window to see the routine of ancient Greek women collecting water for their household.

Basket weaving has always been a practical solution to light and portable containers that can be easily carried

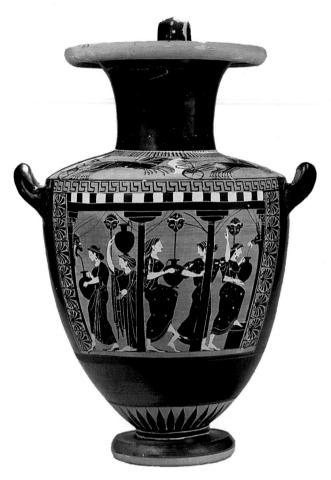

6.9 Women at the Fountain House. Greek hydria. "AD" Painter, Ceramic. 20%" height, 520–510 BC. Museum of Fine Arts, Boston, William Francis Warden Fund.

or moved about. Women of California and Pacific Northwest Coast tribes excelled at weaving baskets with thin walls of even, tight rows. Weaving materials came from willow and spruce trees, pine needles, grapevines and flax plants. By using different colored materials, geometric designs could be woven right into the wall of the basket. The designs were symbolic, which enhanced the function of the basket. They often referred to elements in the environment, such as geese flying, or to sunlight breaking through storming skies. These durable baskets could also be watertight. Plain ones could be used for boiling water or cooking acorns when hot rocks were placed in the liquid inside them.

Our *Basket*, dated 1890–1910 from the Pomo tribe (figure 6.10), shows the basic basket construction and geometric decoration, but this is a precious item that has been covered by feathers and shells. Mothers in California tribes made these special ceremonial gifts to mark significant moments in their daughters' lives, such as birth or puberty. These gift baskets were treasures and comforts for women to keep throughout their lives, and were cremated with them at their deaths. Though

extremely delicate-looking, baskets such as this were used in everyday life. Some even have berry or acorn stains on the inside. The tightly spaced rows give the basket a background texture and a solid, substantial shape, while the shells add another element of pattern. The brilliantly colored feathers make the basket especially important, for those feathers represent the qualities of bravery and courage of the birds they came from.

Tlingit women weavers from the Northwest Coast used twining to create the designs on the outside of the basket, while the inside is plain. Some basket lids had an enclosure for seeds and stones. The lids rattled when moved, a clever built-in alarm system that sounds aloud when the storage basket is opened. The rattle sound may also be a prayer of thanksgiving for the food that fills the basket.

Modern fat and milk storage containers made in Kenya contrast with the highly decorative Greek vessel and Pomo basket. The *Milk Storage Jar* (figure 6.11) shows elegant and straightforward simplicity. Made of carved wood, leather, and fiber, each vessel has a clean curvilinear shape that combines with the practicality of storing the staples and making them portable. The subtle texture of the vessel is relieved by the braided pattern of its woven handle. The complementary combination of leather and wood work together to create a handsome object that functions in everyday life. It is a far cry from plastic butter and milk containers.

Dishes and Utensils for Serving Food

Artists have also produced a wonderful variety of dishes, bowls, and platters to be used for serving and eating food. Our examples here represent only a small part of the range of artists' inventiveness. It is important to note that our examples go beyond being merely utilitarian vessels. They reflect broad cultural values and customs. Material used is also important. We will see dishes and utensils made of porcelain, ivory, leaves, gourds, sheep horn and silver. In every case, the material added an important dimension to the work's significance.

Over the centuries, the Chinese have produced a staggering number and variety of ceramic dishes, utensils, and decorative items. Let us take just a brief look at two examples. Porcelain *Stem Cup* and *Chicken Cup*, dated 1485–1487 (figure 6.12), were works produced for the Imperial Court of China during the Ming Dynasty. Two qualities are marks of imperial taste at that time. The first is the great variety of bright colors, created with enamel overglazes, and the second is the thin, translucent porcelain, which, when tapped, has a delicate ringing sound. While seemingly simple in shape, the vessels are quite subtle and delicate, with everted rims and elegant bowls. Artists painstakingly painted the detailed images on these court bowls. These examples show twining leaves and grapes, and lovely flowers with hens and a rooster.

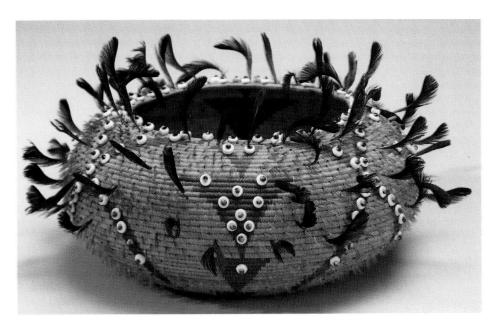

6.10 Basket. Clamshell disks, red woodpecker feathers, quail topnots, tree materials. 7" diameter. USA, Pomo tribe. 1890–1910. Newark Museum. Photo by Peter Furst.

Other kinds of bowls were made for common use in China. By contrast to imperial bowls, stoneware was used rather than porcelain, which resulted in an opaque, heavier dish, without the translucence or ring of porcelain. Common use bowls were not painted with detailed images, but rather glazed in a single color, or with easily applied glazes that resulted in splashes of color when fired. Because common use utensils did not need to conform to imperial tastes, the artists making them had much more license to experiment since the emphasis was not on technical perfection. As a result, the glaze finish on many stoneware bowls was like a wonderful surprise, an uncontrolled or accidental effect.

An interesting note in the discussion of dishes revolves around Indian culture and its concern for hygiene. The major religions of India had many rules governing food consumption that stem primarily from health concerns and the necessity for a near-vegetarian diet in high-population areas. In addition to the ban against eating beef, which was considered impure, its religions also dictated strict rules of hygiene surrounding food preparation, eating, and the dishes to be used. If persons violated the rules, they were considered religiously unclean, in addition to risking illness. In Eating Outdoors, a book illumination from the Ramayana dated 1650 (figure 6.13), two men eat on plates of woven leaves, while their wives wait on them. For hygiene reasons, Indians preferred to eat on thick, nonabsorbent leaves that were used once, and then discarded, much like the modern paper plates that are used for convenience. For grander meals for the nobility, elaborate plates and tables were created by interlacing and weaving leaves. After the meal, table, dishes, and the remains of food were all discarded.

Eating Outdoors is crisply detailed, with an emphasis on pattern overall. Foliage is rendered with different kinds of pattern, and contrast with the patterns used for the house and the background mountains. Asymmetrical balance is favored here, with the house balanced by the trees, and the two eating men opposing the woman who faces them. Color and value contrast add visual interest.

The saltceller is an interesting and historic serving container in Western culture. Saltcellars were vessels for holding salt at a table. Salt was considered an essential condiment, and so possession of it was featured and prized. Salt was at times a form of wealth; for example, the English word "salary" is derived from the same Latin source as "salt." Elaborate saltcellars were used by the wealthy as a status symbol. At feasts in Medieval Europe, they were also used to distinguish the status of guests: prestigious persons sat "above the salt," while persons of lower rank sat below.

Our example is an ivory *Saltcellar* from the sixteenth century (figure 6.14). It and many others were carved by African artists for export to Europeans, for the tourist trade. The salt is held in the orb resting on a platform held by vertical poles, some with alligators, with four figures seated in between. Atop the orb is an execution scene, showing a victim about to be sacrificed. The ivory has been worked very skillfully, with intricate patterning relieved by smooth areas, and with solid shapes punctuated by empty spaces. The style of the work reflects both African and Portuguese tastes. The sculptors often worked from designs the Portuguese drew on paper. But they incorporated some African imagery, and definitely the figure proportions echo African aesthetics, with the large heads, simplified cylinder-like bodies and short

6.11 Milk Storage Jar. Carved wood, leather, and fiber. Kenya, Africa. c. 1980. 11" high. Ernie Wolf III Collection, Los Angeles. Photo by Frank J. Thomas, Los Angeles.

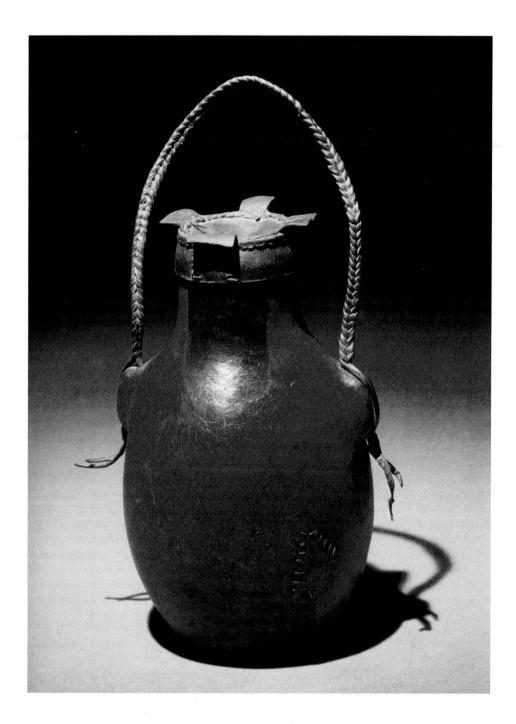

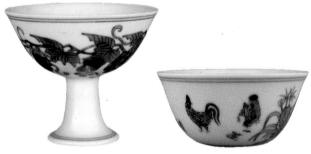

6.12 Stem Cup and Chicken Cup. Porcelain with underglaze blue and overglaze enamels. Diameter of stem cup: 3.1 inches; of chicken cup: 3.2 inches. Ming Dynasty (1465–1487). Percival David Foundation of Chinese Art, London. See also the text accompanying figure 22.12.

legs (see Chapter 15, "The Body"). Both Africans and Europeans valued ivory highly. Often ivory gifts were given in high-level diplomatic exchange, as there was an association between secular rulers and elephants.

Decorated gourds are used in many cultures and are highly valued for serving food as well as for food storage. In Northern Nigeria, gourds decorated with all kinds of geometric designs are still used for serving and storage. A set of gourds, comprising spoons, bowls, and ladles, is a treasured family heirloom, much like a set of china dinnerware.

An interesting historic example of gourd use comes from the Pacific Islands. Many centuries ago, migrants

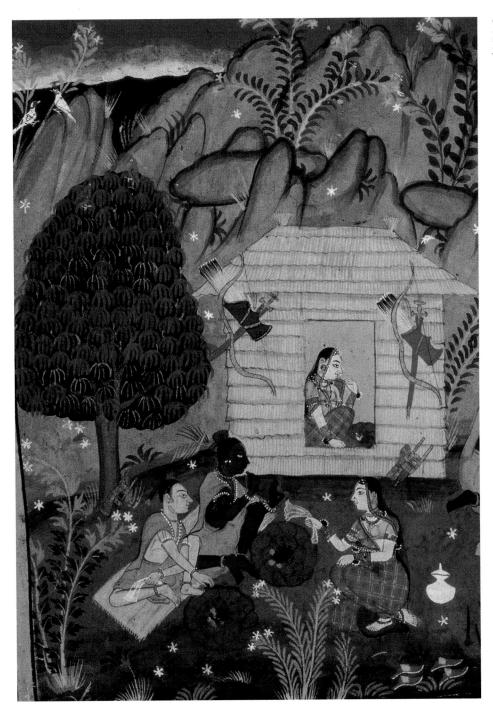

6.13 *Eating Outdoors*. Detail from a page of the second book (Ayodhya-Kanda) of the *Ramayana*. India, 1650. The British Museum, London.

traveled thousands of miles by canoe from South Pacific islands to new homes in Hawaii in the North Pacific. To sustain themselves on their incredibly long voyage, they used hollowed, decorated gourds called calabashes to store mashed taro root, called poi, to keep it from spoiling.

Once the migrants reached Hawaii, they gradually replaced the gourd calabash with vessels they hand-carved of wood, but these wooden vessels kept the influence and integrity of the curves of the gourds. Our *Lidded Bowl* (figure 6.15) from the late nineteenth or

early twentieth century, is carved from koa wood, which is then polished to a rich finish. Used by the royalty of old, this highly crafted ware was also cherished and kept as heirlooms. At times the bowls were named after members of the family who had passed away, so the Hawaiians recorded their genealogies in these treasured objects. This took on special meaning at luaus when the bowls were used for feasting, for past and present family were joined together at the banquet. The smaller double bowls (figure 6.15) connected by a bending figure are thought to have been used for condiments. The figure is

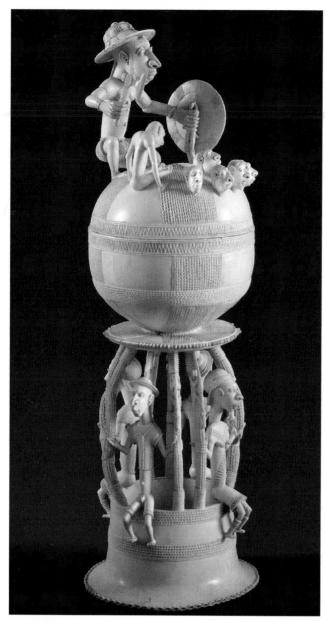

6.14 Saltcellar. Ivory. 11" high. Afro-Portuguese, sixteenth century. Sherbro Peninsula (Bulom), Sierra Leone. Museo preistorico e etnografico, Rome. 17 inches high.

inlaid with mother-of-pearl and seems to be balancing the two containers. Perhaps this is a Hawaiian version of a saltcellar, as the islands have a delicious natural red ironized salt that may have filled this dinner piece. Hawaiians made many other serving dishes, including large platters for pit-roasted pigs, 4-foot diameter bowls for feasts, and rough-cut refuse bowls, sometimes decorated with the teeth of enemies who were vanquished in battle.

Huge feast bowls were carved by many peoples along the Pacific rim, in addition to the Hawaiians. Later in this chapter, we will look at a feast bowl from the Pacific Northwest (see figure 6.28) that was used

for the potlatch, a ritual feast that marked a change in clan rulers. For now, let us look at the large North American Tlingit Feast Ladle, dated 1850–1870 (figure 6.16), an object that also would have been used at a potlatch. This ladle is formed from a mountain sheep's horn, a difficult material to carve. The long flowing handle contrasts visually with the wide curves of the bowl. The artist retained the natural curves of the horn. When seen upside down, a diving bird's head adorns the utensil's handle, along with the figure of a boy wearing an animal helmet. All figures grouped together may represent a shaman's descent into the underworld. As a material, the sheep horn adds to this piece, with delicate variations in its surface, its subtle translucence, its smoothness and warmth. It is unlike metal, which is cold in your hand. Once again we see that utilitarian objects can also be adorned with decoration and have meaningful symbolism—a very different notion from the modern use-once-and-discard sense of functionalism.

Text Link

Can a dish design be an art form, or not? In the United States today, there is a tendency to group aesthetic objects in a different category from utilitarian objects, although other cultures make no such distinction. We saw a similar discussion in Chapter 1, when we looked at high art versus popular culture.

Utilitarian objects with an aesthetic dimension are evident in the United States and in Europe in the twentieth century. The Mocha Jug (figure 6.17) is a pot for serving a chocolate-and-coffee beverage. When chocolate was introduced to Europe from America in the seventeenth century, it was an exotic drink and elaborate pitchers were used for serving it. Likewise, in Mesoamerica, chocolate was a ritual drink. In mid-twentieth-century Europe, of course, chocolate was commonplace, but specialized pots were still designed for chocolate beverages. This Mocha Jug is from the Bauhaus, a twentieth-century German design center that exalted the beauty of simple geometric shapes, and regarded almost any kind of decoration as decadent. This jug is based on the circle; all its major components are spheres, hemispheres, cylinders, or half-circles. It is a nice example of asymmetrical balance, with the large open form of the handle balancing the solid, smaller spout. The smooth metal surface emphasizes the perfection of its geometry and its lack of ornamentation. The Bauhaus' emphasis on geometric form, simple design, and lack of ornamentation had a great influence on modern art, architecture, and design. The aesthetic choices we see in the Mocha Jug have been echoed in many abstract paintings and modern office buildings.

6.15 Lidded Bowl ("Calabash") and Condiment Bowls. Koa wood and other natural materials. Hawaiian. c. eighteenth and twentieth century. Private collection. Photo Bishop Museum, Oahu, Hawaii.

Text Link

Look ahead to Constantin Brancusi's Torso of a Young Man (figure 7.10) to see a sculpture that shares many of the aesthetic qualities seen in the Mocha Jug, including emphasis on simplicity and geometric forms.

ART THAT GLORIFIES FOOD

In addition to sustaining us, food is beautiful. Artists in many cultures have made works that celebrate the glory of food or that revel in the awesome abundance of the harvest.

Images of Bounty

The richness and fertility of the land is a common theme in art. We will discuss a few such works here.

Ancient Egypt is known for its funerary art, so we will look at their artwork in the Religion section. But it is worth noting here than many of their tomb paintings celebrate nature and food. In some paintings, the air is filled with birds of all sorts, painted with care and distinction, while in others the water is thick with fish. Still others show gardens, vineyards, livestock, and farming. Some show harvesting processes; for example, one painting illustrates the whole wine-making process, from picking, washing, extracting the juice to the final bottling.

Text Link

The Fowling Scene (figure 11.5) is an Egyptian tomb painting showing a hunting scene.

We have already discussed the Minoans, who lived off the bounty of the ocean. Ceramic jars were frequently

6.16 Feasting Ladle. Carved sheep horn. 19" long. North American, Northwest Coast, Tlingit. 1850–1870. Private collection. Photo by Peter Furst.

decorated with fish and abstracted wave and water patterns. Minoan wall paintings often showed marine life and fishermen.

Art has glorified the farming landscape. Pieter Bruegel the Elder showed a vast Netherlands landscape in The Harvesters, dated 1565 (figure 6.18), filled with broad plains of golden wheat as it is being harvested. Formally, Bruegel created the effect of a glorious harvest in several ways. First, he took a bird's-eye view, so that we are able to look down and into the near field, and look out and away at distant ones. Secondly, he filled the foreground with the near field. It stretches from side to side within the painting, and across the bottom. By filling our visual field, the wheat field seems truly vast in size. In addition, Bruegel's lavish use of golds, yellows, and browns warms and enriches the image. The golden wheat glows wonderfully against the blue-green trees, sky, and sea. The expansive fields, scattered villages, and distant plains meeting the sea all combine in a vision of earth's bounty.

Bruegel's painting is not just about the land, however, but also reflects on the place of humans within it. In Bruegel's view, humans are tied to the land by more than gravity—they are heavy solid people who labor and laugh close to the earth. They eat, sleep and walk directly on the grain they harvest. Europe has a great tradition of landscape paintings, many of them showing farming scenes. Some show a different relation between humans and earth. For example, English landscape paintings of the seventeenth through the nineteenth century often show a large, well-dressed nobleman with the agrarian landscape as a distant background. Unlike Bruegel's painting where humans live intimately connected to the land, English paintings often implied that landowners may have been little linked to the soil.

Text Link
For more on the relation between humans and nature,
see Chapter 19, Nature, Knowledge and Technology.

We can see images of nature's bounty permeating U.S. culture. Artist Grant Wood painted a banquet of thanksgiving in the early twentieth century, when industrialization was growing fast in the country and the family farm run by human labor was disappearing. Dinner for Threshers (1934) figure 6.19, shows a gathering for supper, reminiscent of a last supper. The "threshers" who are seated at the table are men who worked the land and harvested the crops. Human toil is emphasized, as there is no visual reference to machinery that may have been used. Rendered in a simple and clean style, the ideal harmony of the farm with people working together for the harvest is quietly celebrated. The woman bringing in the food to the dining room is holding it as an offering, and the men outside the house are cleansing themselves in preparation to eat it. The three sections of the painting reinforce the solemnity of the scene, making the painting like the three-part altarpieces called triptychs found in churches during Medieval and Renaissance times in Europe. Grant Wood has painted an American icon, symbolizing the romantic dream of an ideal farm in Iowa.

Images of plenty may be used to decorate buildings. They represent stately abundance or a confident society with ample resources. In the nineteenth and early twentieth centuries in the United States, many anonymous artists produced sculptures of food that decorated houses, apartment buildings, office buildings, and large government structures. The interiors of several Midwestern government buildings and post offices have mural paintings of farming and harvest scenes. Cast iron grillwork and fences in New Orleans or Galveston, Texas, often show grapevines or foods such as corn. In older Eastern cities, cast-concrete urns of fruit adorn park entrances, bridges, large houses, and office

buildings from the nineteenth century. At Thanksgiving time, images of plenty abound in commercial imagery and popular culture. Food imagery can be so common that often it is not even noticed.

Celebrating the Beauty of Food

In many artworks, food itself is the subject matter, because its shapes and colors are often very beautiful and pleasurable, from ruby red tomatoes, to deep purple eggplants and bright green beans. Its surfaces can be fuzzy, luminous and delicate, or bumpy and rock hard. Let us look at the still life.

Still lifes are images of food, utensils, vessels, flowers, or cloth. These objects are not merely decorative details in a larger scene. Rather they make up independent pictures that reflect the values of the audience for which they were made. Some of the earliest still lifes are wall

paintings and mosaics from Roman houses and palaces. Judging from their still lifes, the Romans delighted in images of familiar objects shown in a way that seemed ordinary, spontaneous, or sometimes in disarray. For example, Scraps of a Meal (The Unswept Floor), dated back to the second century (figure 6.20) shows how the Romans appreciated truly humble subject matter—floor sweepings! They valued the comfort and familiarity of meals in a domestic setting. This work is a mosaic, a demanding and painstaking medium in which images are created from carefully arranged chips of colored glass, ceramic, or stone that are embedded in cement. Despite the difficulty of mosaic work, this still life shows nutshells, bean pods, fruit, and a chicken leg, all realistically depicted with texture, highlights, and shadows. A mouse has scurried out to sample the scattered bits. Notice the spacing between the elements in the mosaic.

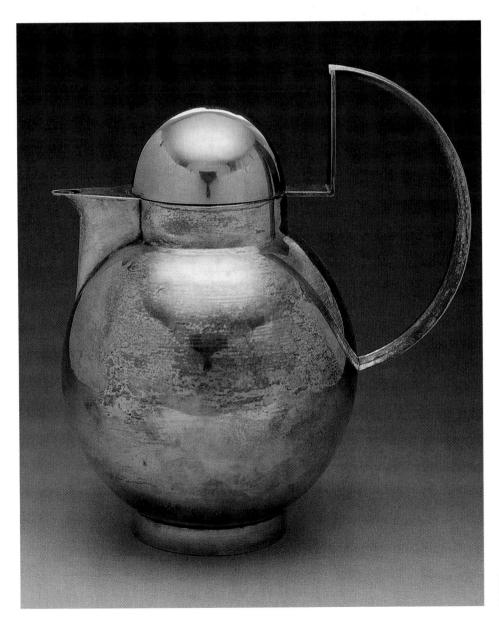

6.17 WILHELM WAGENFELD. Mocha Jug. Silver. German, Bauhaus. c. 1930. Kunstammmlungen zu.

6.18 Pieter Bruegel the Elder. The Harvesters. Oil on panel. $46.2" \times 63.25"$. Netherlands, 1565. Metropolitan Museum of Art (Rogers Fund 1919).

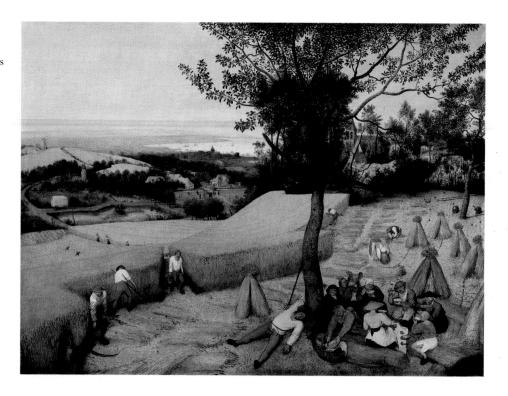

They are carefully arranged so that they do *not* look carefully arranged, but rather randomly dropped. The irregular pattern is an effective formal device here.

Foodstuffs were such a visual delight to Romans that they also made wall paintings of still life items, such as cut peaches and glass vases filled with water, with sunlight and cast shadows, arranged casually on a shelf. These wall paintings were often frescoes, in which water-soluble paint is applied directly onto wet plaster walls, creating paintings permanently bonded to the actual wall surface. Like mosaic, fresco is a very durable medium; the Romans were evidently very attached to still lifes of food to permanently embed them in their walls and floors.

Still lifes can reflect religious values also. Mu Qi's *Six Persimmons*, dated c. 1269 (figure 6.21), reflects Zen Buddhism, which emphasized the importance of meditation and simplicity in life as a means of attaining

enlightenment. Six Persimmons shows the variation in the simple shapes of fruit, the contrast between the plump fruit and the angular stem, and the spare richness of their color differences. The arrangement is simple and orderly, yet irregular. The empty space is an important element in the work, and is balanced by the persimmons. Nothing about this painting is grandiose. It embodies simplicity itself, yet upon meditation a world of thought can open up around it.

Six Persimmons is an ink painting, the medium many Zen masters chose because of its spontaneity and simplicity. Chinese brush paintings are quickly executed because the artist practiced the strokes for years in order to make them with confidence, without erasing or correction. Chinese brush paintings were influential in Japan, too. Our example, in fact, is located in a Japanese Buddhist monastery.

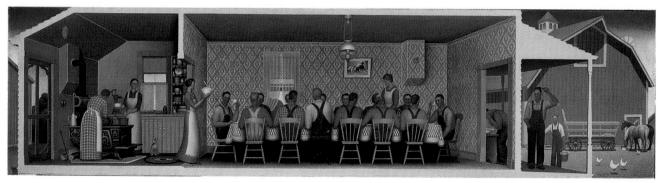

6.19 Grant Wood. Dinner for Threshers. USA, oil on masonite panel, 20" × 80", 1934. Cedar Rapids Museum of Art, Happy Y. and John B. Turner II Collection.

6.20 Heraclitus. Scraps of a Meal. Copy after Sosos of Pergamun's "The Unswept Floor." Mosaic. Roman, second century. Musei Vaticani. Museo Gregoriano Profano ex Laterneuse, Rome. See also the text accompanying figure 2.14.

European still life paintings can also reflect religious beliefs. After the fall of the Western Roman Empire in the fifth century, the still life in Europe fell into disuse. However, the seventeenth century in Europe was the golden age of the still life, with hundreds and hundreds of canvasses produced with pictures of fruit, a meal spread on a table, game and fish, and other subjects. In Northern Europe, these still life paintings originally had a moral theme. In one early painting of a sumptuous dinner, a landscape in the background shows the temptation of Christ. Thus, the appealing meal became a snare of Satan.

Later still lifes in Europe were more complex pieces, with a number of themes operating at once. Many were lavish works that boasted of wealth and abundance. They imply that food has become an aesthetic experience for refined taste and a symbol of comfort. Paintings of food took on almost a fetish quality—the food was shown grandly and lovingly, painted with almost extravagant devotion. Seventeenth-century Dutch artist Jan Davidsz de Heem painted A Table of Desserts, dated 1640 (figure 6.22), an opulent display of sumptuous fruits and sweets served on silver dishes and platters, lavishly laid on velvet and satin. De Heem did not show food as a person standing or sitting at a table would see it. Rather, the luminous fruits and vegetables are shown up high, elevated, at eye level, centralized and formally arranged, surrounded by heavy draperies and musical instruments. Oil paint makes deep rich colors possible, and a full range of values from black to glowing white. With oil paint, de Heem could also render a wealth of textures, adding to the overall richness of the image.

De Heem gave the viewers the feeling that they were present in a house of wealth. One can imagine several fabulous courses served prior to this dessert course. Painted in a sharp realistic style, the picture allows one almost to smell the sweetness of the food or to feel the uncomfortable fullness of eating it all. Yet, moral themes were still part of *A Table of Desserts*. The tipping trays and half-eaten, soon-to-spoil food alludes to the idea of "vanitas," that is, the impermanence of all earthly things and the inevitability of death.

It is interesting to compare A Table of Desserts with Six Persimmons. Where the European still life is lavish and detailed, the Chinese still life is simple, with no supporting surface, nor illusion of depth. While the European oil painting dries slowly to enable artists to render detail and texture, the ink on paper is a quick and immediate medium. In contrast, European oil painting took much longer to make. Each reflects its culture's sense of beauty.

The still life—often of food—continued to be fairly common in Europe and the United States through the twentieth century, but the ideas expressed through it changed. In the late nineteenth and early twentieth centuries, the still life became a vehicle for abstraction, new forms of representation, and experimentation with media. The early twentieth-century focus in art was on innovation, and that paralleled the emphasis on technology and invention in industry. For example, the artist Pablo Picasso produced many paintings and collages

6.21 Mu-Qt. Six Persimmons. Southern Song Dynasty, thirteenth century AD. Ink on paper, width 14¼". Dailoxu-ji, Kyoto.

6.22 Jan Davidsz de Heem. A Table of Desserts. Oil on canvas. 58.7×79.9 inches. Netherlands, 1640. The Louvre, Paris.

6.23 EDWARD WESTON. Artichoke, Halved. Photograph. USA, 1930. Museum of Modern Art, New York.

of food and drink, but experimented in showing them flattened and fragmented. Edward Weston's *Artichoke Halved*, dated 1930 (figure 6.23) reveals the complex design and grace of natural forms, but it also showed off the technical achievement of photography, with the

capacity to zoom in close and instantly capture a minutely detailed image. Amazing textures and irregular patterns are revealed in this extreme close-up. In this era, food was often rendered with almost no interest in it as sustenance.

U.S. artist Wayne Thiebaud's 1963 painting, Pie Counter (figure 6.24) deals with food as a visual display and as a popular icon, rather than as nutrition for the body. Pie Counter shows the plentifulness, standardization and bright colors in contemporary cafeteria food, so appealing to many. The thickly textured paint and bright colors are visually seductive. Notice how differently Thiebaud displays the desserts, when compared to de Heem. Thiebaud showed how food is mass-produced in the United States today-so many slices of pie and cake, all the same day after day and all interchangeable with each other. He also implies that sugary and fatty food is present all the time, and that in the modern era the abundance of food has created a kind of perverse attitude toward it. For many persons, food has become something to resist rather than something to eat, while mass media advertising pushes it.

In Thiebaud's *Pie Counter* and many other artworks such as Warhol's *Heinz 57 Tomato Ketchup and Del Monte Freestone Peach Halves* (figure 6.4), foods were shown as popular icons. The cafeteria pie counter and grocery packing boxes were familiar images, but they were separated from the rest of their environment. They are shown very colorfully to make them somehow exalted, and made nonfunctional—the pies are painted images, the boxes are made of wood and cannot be opened. But as icons, they speak of an entire era.

Food as a Symbol of Honor

Images of food can be used in artwork made to honor an individual. In our next example, we see peanuts used as a symbol of glory and honor. The Peanut Necklace, dated c. 300 (figure 6.25) was worn by a person of great rank and wealth (called the "Lord" of Sipán) in the Moche civilization from ancient Peru, so the peanut had to have been a food of royal taste, or perhaps even a food of divine status. This necklace was found in a royal tomb, along with ovewhelmingly impressive art objects crafted of gold, silver, and copper. Royal paraphernalia included masks, headpieces, nose ornaments, belts, pectorals, staffs and scepters, bracelets, necklaces, and clothing. In our example, gold and silver are combined in a design that gives them equal balance, suggesting that the values of the metals were considered to be the same. The metals may have also had symbolic meaning, perhaps representing the sun and moon, which could imply the source of life, the cycle of fertility, and the fruit of the peanut that gives life-nurturing food.

Text Link
See figure 11.12, and the accompanying
text, for more images and information on
the Lord of Sipán and the art objects from

Moche royal burials.

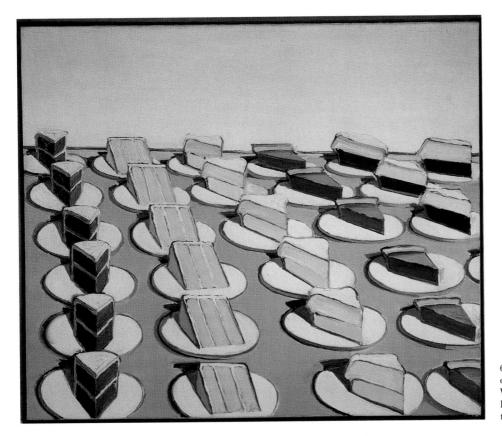

6.24 WAYNE THIEBAUD. *Pie Counter.* Oil on canvas. 30" × 36". USA, 1963. The Whitney Museum of America Art. Photo-Geoffry Clements, NY. See also the text accompanying figure 2.12.

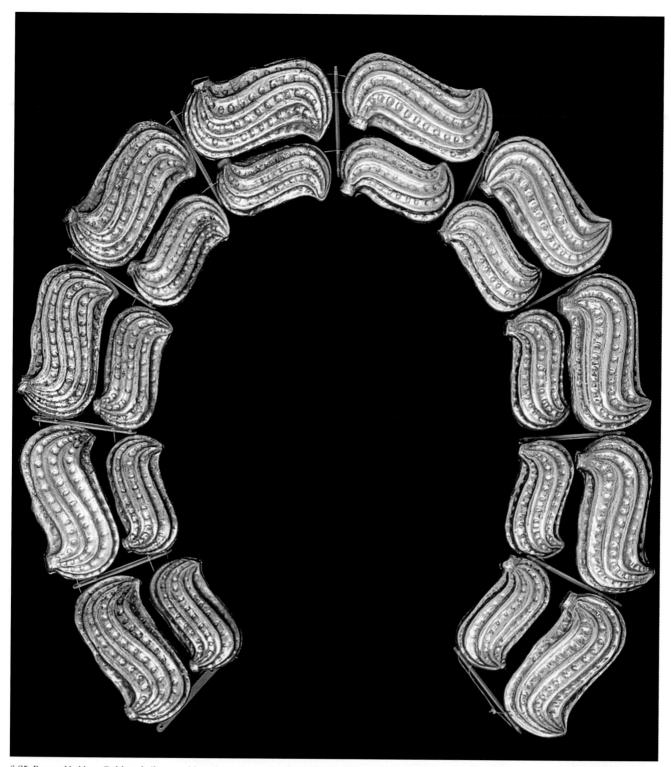

6.25 *Peanut Necklace.* Gold and silver necklace from the tomb of the "Lord of Sipan." 20" diameter. Moche civilization, Peru. c. 300. Museo Nacional Bruning de Lambayeque, Peru. For more on elaborate burials and artworks used in them, see Chapter 11, especially figures 11.11, 11.12, and 11.13.

Contemporary Ghanaian carpenter and artist Kane Kwei used representational images of food in funerary art to commemorate and bury the dead. Working in a long tradition of wood sculpture, Kwei carved coffins

whose shape and subject matter depicted the deceased's work in life. This *Cocoa Pod Coffin*, dated 1970 (figure 6.26), was made for a farmer who grew that crop in life. (Kwei also carved an onion-shaped coffin for an onion

6.26 KANE KWEI. Coca Pod Coffin. Ghana, Africa, wood and enamel paint L. 230 cm. 1970s. Collection of M. H. De Young Memorial Museum, the Fine Arts Museum of San Francisco, Gift of Vivian Burns, Inc.

farmer.) The brightly painted, oversized pod that held the body was balanced by the miniature cocoa tree at one end. The large pod's horizontal ridges reinforce its overall horizontal emphasis. The small tree holds smaller pods from its branches, providing an echo of the shape and color of the large pod. When seen life-size, the bright colors, surprising shape, and details give this coffin not a feeling of remorse or sorrow, but more of honor and even good humor. Here we see an overlapping of life's experiences with mortuary ritual. In this sculptural coffin, food is as important in death and it was in life.

Text Link

We discuss art used for funerary functions in depth in Chapter 11, Mortality/Immortality. Very elaborate coffins reflect the life-style of the deceased as can be seen in the sarcophagus of Tutankamen. Turn to figure 11.4 for more information.

ART AND THE ACT OF EATING

While the act of eating is a necessary and common activity, how we eat is full of meaning. When we look at art showing people eating, we can learn the social circumstances and customs surrounding meals, whether those meals are religious rituals, formal events, or casual snacks. These customs are distinct from culture to culture, and from era to era.

Ritual Meals

Ritual meals are more than just dining. They can be religious celebrations, meetings of heads of state, represent contractual agreements, or can culminate a holiday. These meals are very structured. There is usually a special gathering of people. Often there is a ceremony integrated with the meal. Ritual meals usually have an element of spectacle about them. There is a major event happening, which the spectators witness and approve, as signified by their partaking of the meal. Seating is predetermined; as an example, look at the seating arrangement at a wedding reception, with special handling of wedding party members and the two families. Also, the food to be served is often predetermined. For holiday eating, Thanksgiving has turkey, stuffing, and cranberries, and even the casual Fourth of July meal has a preset menu: the barbecue cookout.

Italian artist Leonardo da Vinci's *Last Supper*, dated 1495–1498 (figure 6.27), depicts the ritual meal as a religious ceremony. To emphasize the sacred nature of the event, Leonardo made a painting that is visually very formal and compositionally very geometric. The most important figure, Jesus, is in the center. His hands, arms, and head form a triangle. His face is framed by the distant doorway and further set apart by the arch overhead. His followers are symmetrically arranged around him, with six on each side, subdividing into groups of three. The perspective lines in the ceiling and wall point to—or radiate from—Jesus' head. The entire scene is staged on one side of a long table like a head table; this seating arrangement implies that a large crowd, not shown, is also present at the meal, of which we as viewers are part.

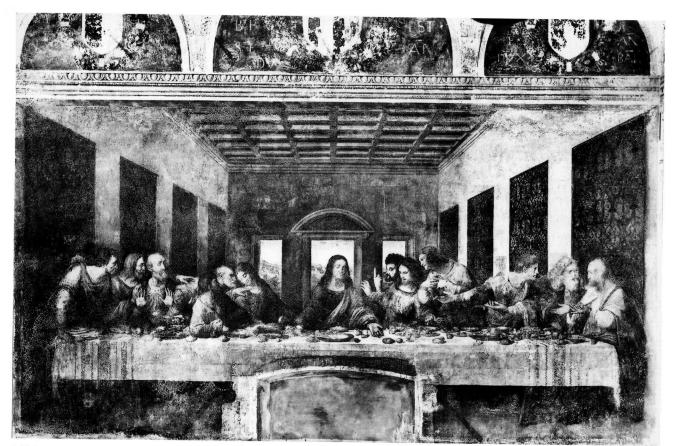

6.27 Leonardo da Vinci. Last Supper. Experimental paint on plaster. 14'5" × 28'. Milan, Italy. 1495–1498. Refractory of Santa Maria della Grazie. Alinari Art Resources, New York. See also the text accompanying figure 20.22 and 21.4.

The geometric formality of Leonardo's *Last Supper* was so effective in communicating the essence of the sacred meal that the painting has become the standard for depicting this event. Although this painting has severely deteriorated over the years, and although many other artists have painted different versions of the *Last Supper*, Leonardo's is the one that most Western Christians know, especially because it has been copied endlessly in all sizes and media.

Text Link
Review the discussion of linear perspective
in relation to da Vinci's Last Supper
with figure 2.21.

The Native Americans of the Northwest Coast developed elaborate feasting and gift-giving rituals, called potlatches. If a leader, a family, or a village claimed rank over others, that claim had to be substantiated. This was accomplished by giving an elaborate feast that lasted several days, with dances and story-telling, and by distribut-

ing gifts. Thus the potlatch was not merely a feast, but was the formal mechanism for establishing social order among the peoples of the Northwest Coast. The most powerful persons were the ones who could give the most lavish feasts and gifts.

At potlatches, less important guests arrived first and more important ones last. The guests, by partaking of the feast and accepting gifts, witnessed and acknowledged the superior status of the potlatch-givers. The largest "bowls" for potlatches were long canoe-shaped vessels from which massive quantities of food were served with large ladles (figure 6.16). Smaller bowls were used later in the feast.

Our example is Charlie James' Feast Dish (figure 6.28), a twenty-foot-long serving vessel made in 1907. The serving dish is covered with animal forms. They were abstracted from reality and rendered as geometric patterns. Animal forms were usually symmetrical, with the design repeating itself in mirror fashion on either side of an imaginary vertical axis. Certain features, such as eyes, beaks, and claws were emphasized. Black outlines were frequently used in Northwest Coast carvings to define the shape of the figure and to establish the skeletal framework for the entire design, to which other colors were added. Brightly colored works are later

pieces, when the Native American carvers used imported pigments for brighter effects.

Before food was served from any dish, however, the name of the bowl, the family who owned it, and the carved animal forms were announced. This *Feast Dish* shows the visage of Sisiutl, a double-headed serpent with a human-like face in the middle. Sisiutl could both harm people and also give them wealth and prestige, making its image appropriate for use at a potlatch, in which a leader or group was establishing power by gift-giving. Feasting bowls were prized possessions passed through families, and the animal forms were those associated with that particular family or clan.

Let us turn to Japan and examine a completely different kind of ritual with food. The tea ceremony is a formal, ritualized partaking of tea, influenced by the philosophy of Zen Buddhism. We have already seen the influence of Zen Buddhism in painting in *Six Persimmons*. It spread from China to Japan in the late twelfth and thirteenth centuries. As mentioned, in Zen, personal enlightenment comes through meditation. This meditation can include the most common of life's activities, including the making of tea, which evolved into a solemn ceremony. The ceremony is an opportunity for friends to gather, for meditation and rest, for communal religious observance, and for experiencing beauty among humble and frugal things.

The host for a tea ceremony would carefully select vessels and invite guests, guided by the idea that the experience of each tea ceremony, each gathering of friends, is a supremely intense and precious moment that could never again be recreated. The host prepared the tea room and surrounding garden before guests arrived, laying a fire, putting the kettle on to boil, hanging a scroll and arranging flowers. The guests arrived silently and rinsed hands and mouth in a stone basin. The host whisked powdered green tea into boiling water and served it to the guests. But the manner of whisking the tea and of wiping, handling, and drinking from bowls is set by ritual, so that the appreciation of the pro-

found can be experienced through the careful, and respectful, repetition of the mundane.

Pots used for tea would certainly be ordinary and familiar in their basic shape and function. But the shape of the handle, spout, and body of the pot should complement each other, and surfaces should be thoughtful and sensual, so that the mundane becomes an experience of beauty. Tea bowls were unique, often "imperfect" in design, and often not highly polished in form in order to better embody the concept of humility, and also of beauty embodied in humble things. This Tea Bowl (figure 6.29), from the seventeenth century, gracefully combines a series of opposites: smooth glazes and textured glazes, round and square shapes, horizontals and diagonals and verticals. Tea utensils were selected and combined for each ceremony for their aesthetic value. Particularly pleasing vessels were named, and their passage from collector to collector was carefully recorded.

Some artwork references a meal, although no food is shown. The Dinner Party, dated 1974–1979 (figure 6.30), is the setting for an imaginary, formal meal to celebrate significant women in Western culture who have existed through the ages but for the most part have not been formally recognized. The Dinner Party is a collaborative installation, composed of ceramics, needlework, and text, which was created by many artists over a five-year period under the direction of U.S. artist Judy Chicago. It was meant to have the solemnity and sacredness of the Last Supper, which in its various depictions, shows only men in attendance. Chicago found this an interesting interpretation of the Passover Meal, which in the Jewish tradition cannot be held unless a woman is present. Thus in Western art, women have been excluded from this important Judeo-Christian event.

Text Link

For more information about women in art and Feminism, turn to Chapters 5 and 17.

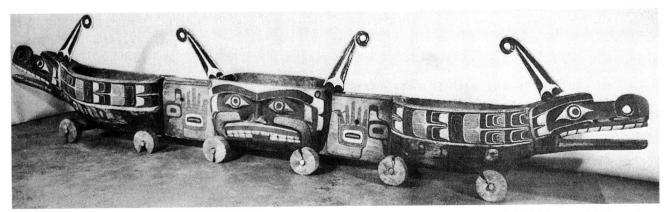

6.28 Charlie James. Feast Dish. Wood with green, black, red, and white paint. 20 feet long. From Turnour Island, 1907. Museum of Anthropology, University of British Columbia. For more on this art work, see Chapter 5, figure 5.8, where it is discussed in relation to its culture.

6.29 *Tea Bowl.* Ceramic. Satsuma ware. 4.4 inches diameter at mouth. Japan, seventeenth century.

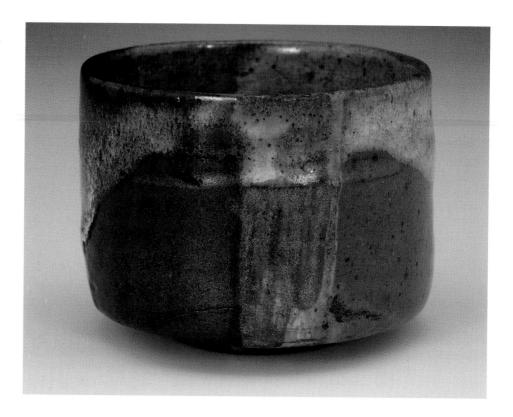

In the Dinner Party, a large triangular table is set with 39 painted porcelain plates and stitched runners, each of which contains symbols and text that honor a woman in Western history. Each side of the triangle is composed of thirteen settings, the number of men painted in renditions of the Last Supper. The number 13 is also the number of a witches coven. Depending on the gender of the sex associated with the number 13, the meaning of holiness or evil is implied. "Heritage Floor," the floor beneath the table, is covered with triangular tiles that are inscribed with the names of 999 other women whose accomplishments were important. The triangle, emphasized throughout The Dinner Party, is a female symbol and symbol of the Goddess, an ancient figure who was thought to have brought forth all of life unaided. The media used in The Dinner Party also emphasize the female. China painting and needlework are art forms usually consider to be "women's work."

The Dinner Party was intended not only as a work of art, but also as historical research. Texts accompanying the installation tell the stories of these women whose names and accomplishments may have been forgotten. An example is the story of Theodora, an actress in the sixth-century Byzantine Empire, who married and eventually became empress despite her lowly and despised profession. As empress, Theodora worked to better the lot of actresses and prostitutes, and changed marriage laws to ensure women's property rights and to protect women from mistreatment. Theodora's plate is a visual tribute to her. Its design recalls vaginal shapes, the folds

of royal robes, and the deep colors and golds of Byzantine mosaics.

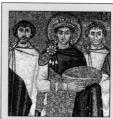

Text Link
A portrait of Theodora's husband, the
Emperor Justinian, can be seen in the
mosaic, Justinian and Attendants, in
figure 12.3.

Art and Eating

Most meals are informal. They are periodic stops to "grab a bite." However, even the most casual stops for refreshment reveal a lot about how people lived and their social habits.

Luncheon of the Boating Party, dated 1881 (figure 6.31), by French artist Pierre-Auguste Renoir, shows the pleasure of eating with friends in delightful surroundings, with plenty of food, wine, and an undercurrent of sexual excitement thrown in, as figures are grouped into twos or threes. The painting was done in bright, pastel colors with sketchy, almost casual brush strokes. The figures seem to be casually distributed across the scene. However, at both right and left sides, a pair of standing and seated figures form "parentheses" that bracket the entire casual composition and give it structure. The woman facing us near the center provides an important

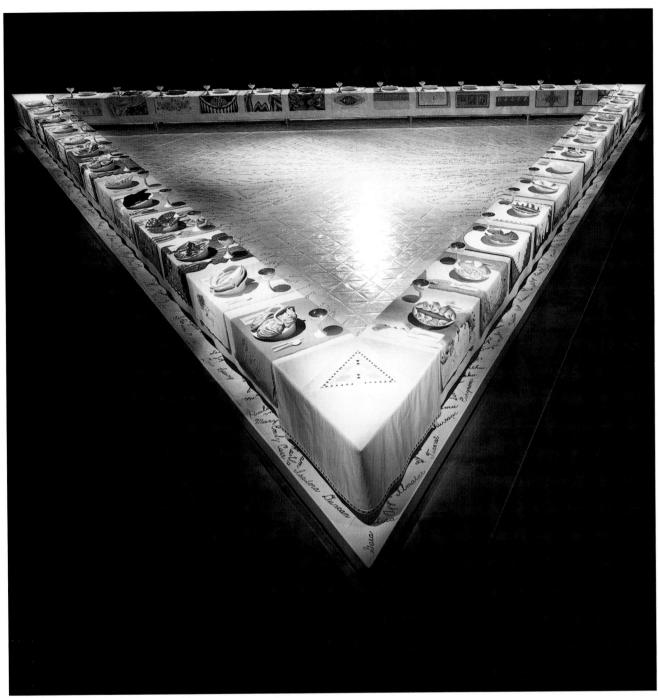

6.30 Judy Ghicago. The Dinner Party. Painted porcelain and needlework. 48' × 42' × 36'. USA, 1974–1979. Collection, "The Dinner Party" Trust.

accent in the composition. A sense of luminosity pervades the scene and pleasant breezes are suggested by the rippling awning. Renoir has combined the double delight of good food and good friends.

U.S. artist Duane Hanson's *Self-Portrait with Model*, dated 1979 (figure 6.32), again presents the meal as a site for companionship, as two persons have refreshments at a humble diner table. Yet there is more here. His sculptures are incredibly realistic, and they are life-

size. Much of the initial impact of this piece comes from the double-take you do when you realize that these are not *real* people. Hanson shows humble, familiar subjects in such a true, detailed, and labored manner as to glorify them without idealizing them. The model looks down at her magazine, while the artist studies her. But here, the artist is not an exalted genius, apart from everyday society and commenting on it. He is part of the sculpture and "breaks bread" with the model, indicating that 6.31 Pierre Auguste Renoir. *The Luncheon of the Boating Party*. Oil on canvas. 51" × 68". France, 1881. For more on this painting and Impressionist art, see Chapter 5, figure 5.14. The Phillips Collection, Washington DC.

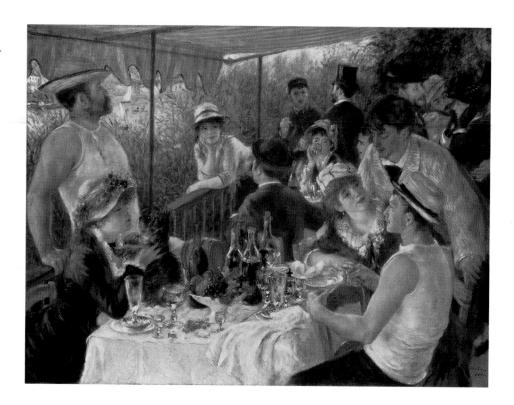

6.32 Duane Hanson. Self-Portrait with Model. Painted polyester and mixed media. Lifesize. USA, 1979.

the artist and the woman are companions and are made of the same stuff.

The last piece on the topic of eating is Gnaw, dated 1992, by New York-based artist Janine Antoni. Antoni began this complex installation by fabricating a 600pound cube of chocolate and an equally sized cube of lard. She then sculpted each block by biting and gnawing the edges. The chocolate was spat out and cast into the heart-shaped trays found inside candy boxes, turning the repulsive into objects of sentimental prettiness. The lard she spat out was mixed with pigment and beeswax and cast into 130 lipsticks. The trays and lipsticks were then shown in display cabinets. Replacing the traditional hammer and chisel with her mouth, Antoni transforms the act of eating into an artistic process. The artist's sculptural methods also become a way of intimately relating to her creations—as babies put things into their mouths in order to know them, so too the artist consciously engages in this experience. The clean cubic shapes of the chocolate and lard have become lumpy, gnawed masses—while in another part of the exhibition 27 pristine chocolate-cast trays are displayed with 130 lipsticks. Using materials and objects that are socially defined as female fetishes, she recasts them in an art historical frame to raise questions about the position of women in art.

SYNOPSIS

Ensuring food supply has been a critical endeavor in every culture, and many cultures have called upon art and ritual to guarantee it. We saw a number of such ritually based works. In addition, some contemporary artists have used art to look critically at procedures in modern food production.

Artists have designed a wide variety of structures and containers to store food. Also, they have designed and made countless dishes, platters, and utensils for serving food. These storage and serving vessels have shapes and decorative surfaces that are very meaningful to the peoples who use them. The materials used to make such vessels are often very significant, too.

Food has been a source of great pleasure to humans. Artists have made paintings, sculptures, and photographs that glorify food; that celebrate its shape, color, and texture; and that revel in the abundant bounty of the earth. These food-based works also reveal broad social values and religious beliefs.

The way food is eaten is significant. Ritual meals can be religious ceremonies or major social events. Elaborate art objects made for feasting indicate the importance and formality of these events. Paintings show us the man-

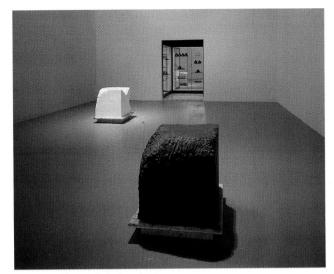

6.33 Janine Antoni. *Gnaw.* 1992. Three-part installation. Chocolate: 600 lbs. of chocolate gnawed by the artist; lard: 600 lbs. of lard gnawed by the artist; display: 130 lipsticks made with pigment, beeswax, and chewed lard removed from the lard cube; 27 heart-shaped packaging trays made from the chewed chocolate removed from the chewed cube, dimensions variable. See also the text accompanying figure 1.6.

ner in which ritual meals may be eaten. Images of informal meals reveal how and when people socialize within a particular culture.

FOOD FOR THOUGHT

No pun intended!

Food would seem to exist to provide nutrition and to satisfy hunger. Yet we have seen in this chapter how food is associated with a broad range of cultural, religious, and commercial ideas. People sometimes eat only to satisfy emotional needs. An extreme attitude toward food was expressed by the Italian Futurists of the twentieth century. The Futurists believed that humans were machines, and that in a machine-like way, the actions of people were based on what they ate. They wrote cookbooks designed to shock and excite the senses, but not to fill the stomach, for they believed a full stomach was dulling. In one recipe, "Raw Meat Torn by Trumpet Blasts," the diner is to take mouthfuls of raw electrified beef, and to blow loud blasts on a trumpet in between those mouthfuls of beef.

- What are your experiences of eating?
- What are the visual components of your meals and your eating environments?
- What besides hunger is being satisfied?
- What food images have you seen today?

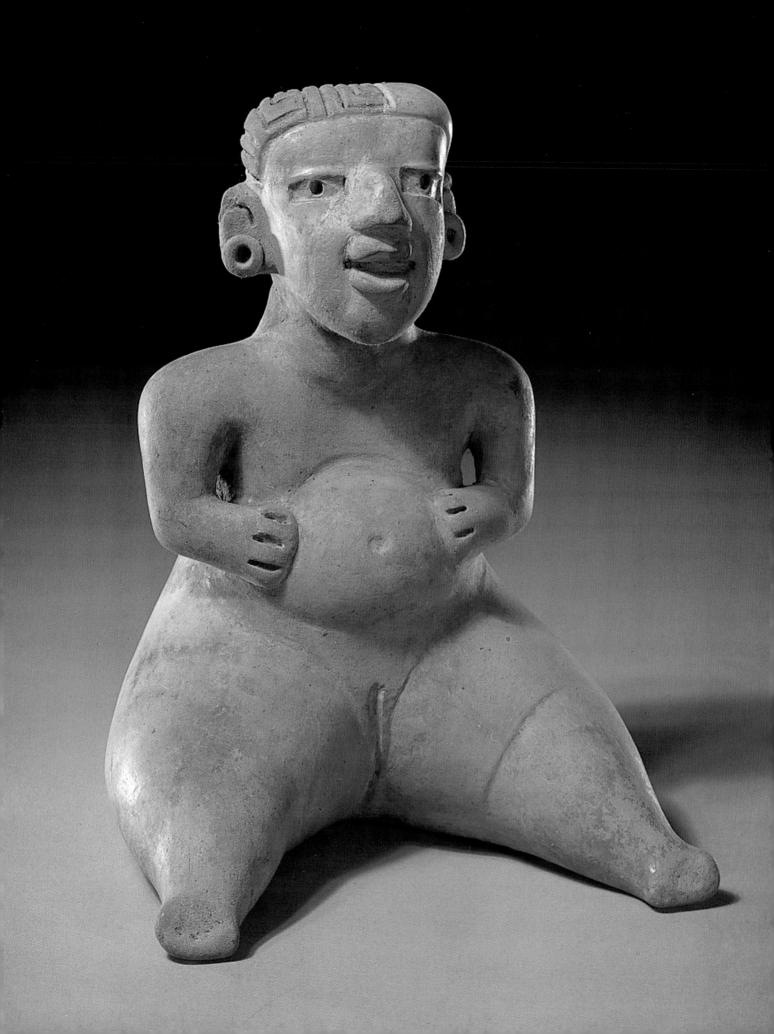

Chapter 7 Reproduction

INTRODUCTION

Besides gathering food, having children is essential to the survival of the human species. Through the ages, artists have created artworks that have aided, symbolized, and depicted human fertility. The art includes small charm-like figurines, sexually explicit sculptures, phallic symbols, fetishes, erotic prints, and photographs.

This chapter focuses specifically on reproduction. You may also want to look at Chapter 17, Race, Sexuality, and Gender, for art that deals with sexual issues not directly related to procreation. In this chapter we will look at the role art has played in human reproduction by considering the following questions:

How are art, magic, and ritual intertwined to promote human fertility?

What art was made to ensure human fertility?

What primordial couples exist in various cultures?

How do primordial couples relate to images of human couples in marriage?

Why has art documented lovemaking for the sake of procreation?

How has art depicted pregnancy and offspring?

THE PROMISE OF FERTILITY

As we have seen in the previous chapter, some art images and objects were created and used for the purpose of securing food. Cave paintings, elaborate masks, wood carvings, and ceramic sculptures helped the huntergatherer and farmer to ensure an abundant food supply. Likewise, art and art objects have functioned similarly to ensure human reproduction. While the cave paintings may have been made as part of a ritual to invoke the magic or power needed for the hunt, we will see that same "sympathetic magic" invoked through art objects was believed to secure human fertility, as all powers came together in art and ritual. The proof of this, of course, would have been the abundance of progeny.

Fertility Goddesses and Gods

Some of the earliest artifacts thought to relate to human fertility were found in the Paleolithic and Neolithic periods of history. Some were small sculptures of female figures, depicted as abundantly fleshy and swollen, with their bellies, breasts, and thighs accentuated. One example we will see visually suggests a birthing might be happening. They are called "Fertility or Mother Goddesses," suggesting that they were probably part of a fertility ritual and cult.

In figure 7.1, *Venus of Willendorf*, we see a well-rounded abstracted female figure, which is only 4½ inches high, carved from a found egg-shaped piece of limestone. The ancient artist-carver may have believed that the power of fertility was already contained in the natural egg-shape of the stone even before it was carved. Its shape may have been the reason why the artist chose it. The figure was discovered near a hearth at an excavation site near the town of Willendorf in Austria in 1908. The small Paleolithic sculpture was considered to be part of the Gravettian culture dating approximately between 30,000 and 18,000 BC. The name of "Venus" was given arbitrarily to the female figurines by the archaeologists who found them.

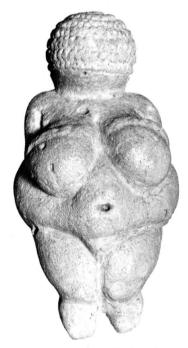

7.1 *Venus of Willendorf.* Stone, height 4% inches, Austria c. 25,000–20,000 BC. See also Chapter 2, figure 2.36, for a discussion of the formal qualities of this work.

Although sometimes labeled as a "fertility goddess" as mentioned before, it is likely the figurine was more of a charm or a fetish, used to invoke the magic of the art object and the stone itself. Both its egg shape, and the natural round indentation in the center that became the figure's navel, were starting points for the artist. The bulbous forms were then carved and painted, giving repetition and pattern to the piece, emphasizing the femininity of the figure. This repetition is evident in the swelling forms clustered in the torso. Even the head, perhaps covered with curls of hair or a headpiece of some sort, repeats the bulging round bumps. Could this featureless head symbolize a budding bloom about to burst into flower? Clearly the figure does not realistically represent someone, but rather represents the abstract essence of fertility. She is small enough to hold in the palm of your hand, yet appears to be large, strong, and robust. With her hands resting on her breasts, she suggests stability in addition to the power of fertility. She may have been held onto for her power during childbirth, to ward off death, or to wish for good health. Whatever her function, she was likely a talisman for good fortune.

Another Female Fertility Figure (figure 7.2) was found in the Neolithic village of Çatal Hüyük, which existed from 7000 to 6000 BC in what is now Turkey. Excavated in 1961–1965, the village ruins revealed an urban, agriculturally developed and artistically rich town that supported approximately 5,000 to 7,000 inhabitants. It was

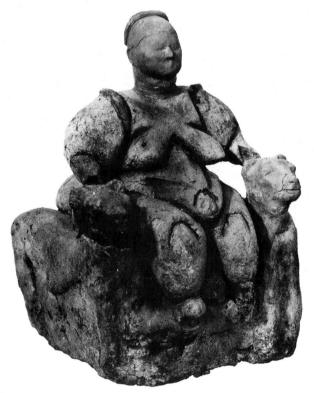

7.2 Female Fertility Figure found at Çatal Hüyük. Terra-cotta. Height 7% inches. Anatolia (modern Turkey). c. 6000 BC.

evidently a peaceful community as no weapons were found. What was found were houses that were grouped together, with rooms that were entered from the roof. Inside the rooms, called "shrines," plaster reliefs and frescos decorated the walls. Bulls' and other animal skulls were incorporated into sculptures as well. In one of those shrines, our *Female Fertility Figure* was found in a grain bin.

Text Link
For more on the design of the village of
Çatal Hüyük and its houses (figure 8.1),
read Chapter 8.

The terra-cotta figure is almost 8 inches high, about medium height for the females figures found at the site, which ranged from 2 to 12 inches. She is rendered somewhat naturally seated on a chair or a throne, with her hands resting on the felines (possibly leopards) at her sides. She might be giving birth. Like the *Venus of Willendorf*, she is fleshy and robust, with her upper torso, arms, legs, and navel accentuated. She visually depicts female fertility and suggests dominance over the felines. Since she was found in a grain bin, she may symbolize fecundity as well.

Also like the *Venus of Willendorf* and the many other female figures found at Çatal Hüyük, the figure is small but massive and weighty, which seems to emphasize her strength and power. An incised line delineates the powerful arms from the voluptuous torso. Additional detailing is seen in incised lines articulating the breasts, knees, and belly button. She was probably painted like similar female images in the frescos on the shrine room walls. This symmetrically balanced sculpture embodies the power of human reproduction in the female, and she was likely worshipped for that quality.

Text Link

Female goddesses dominated the ancient Anatolian (Turkish) pantheon for thousands of years before male gods came to dominate. For more on gods and goddesses, read Chapter 9.

Fertility figures from early Greek and Aegean cultures were found on the mainland and on islands in the eastern Mediterranean. They are also known as mother goddesses, and are likely the descendants of the figures we saw from ancient Asia Minor and the Middle East. A large and robust female nude that was found near Sparta, dating about 5000 BC, looks very much like the *Venus* figures, but more "squared off," with her shoulders

and arms fitting into a near rectilinear form. Amazingly, her shape is still seen today on some Aegean islands in the form of a loaf of bread, with a red painted egg inserted as her head.

Approximately three thousand years later we see in the Cycladic Islands off mainland Greece a probable descendant of the mother goddesses described in the previous paragraph. Figure 7.3 is called the *Idol from Amorgos*, and is dated 2500–2300 BC. She is made of fine marble and stands 30 inches high. Other figures like this were found to range from a few inches to life-size and were found buried with the dead. They were carved with obsidian blades and polished with emery. Traces of paint were found on some figures indicating that the eyes and jewelry (necklaces and bracelets) were accentuated in color. With her oval or egg-shaped head tilted back and her toes pointed, she is thought to be a reclining figure.

While these Cycladic fertility figures may have been rooted from the earlier figurines we have seen from Asia Minor and the Middle East, they have clearly developed their own distinct form and style. Slenderized, delicate, and pristine, these abstract nudes seem to have presented a new aspect of femininity. When compared to the well-developed bodies treated in the ancient Venus figures, we could be now looking at an interpretation of femininity that emphasizes youth, possibly the beginning of puberty. Since these figures were found in burials, their purpose may have been to give new life to the dead, just as the young woman has the potential to give life. Sculpted very economically, the overall shapes are angular and wedge-shaped. However, her breasts, belly, and navel are subtly swelling on an otherwise stiff planklike body (these figures are sometimes referred to as "plank idols"). The figure's delicate combination of geometric and organic forms has created an elegant and sophisticated abstract sculpture. Incised lines not only indicate the neck fold, arms, pubic area, legs, and toes, but also visually connect the subtle forms and unify the piece without effort.

Text Link
This Harp Player is a male version of
the early Cycladic figures. Turn to
Chapter 18 and figure 18.19 to read
more about it.

We will look at one more interesting fertility figure from the Aegean culture. Figure 7.4 is a *Cypriot Female Figure*, dated about 2500 BC, carved of limestone and 15 inches high. Reminiscent of the *Idol from Amorgos*, she has a wedged-shaped body, an egg-shaped head, and a polished surface with incised lines detailing the figure. She is rendered in an abstract and economical style.

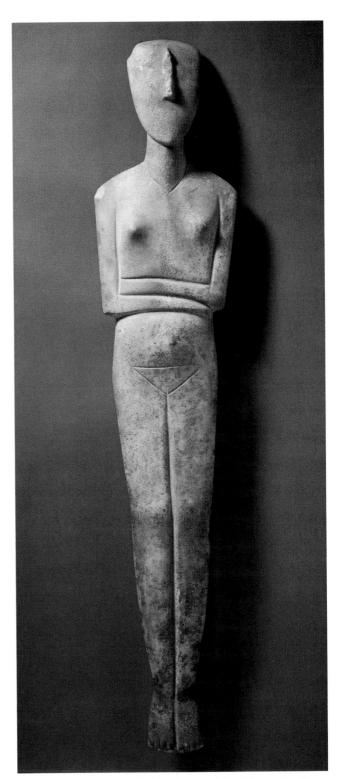

7.3 *Idol from Amorgos*. Cycladic Islands off mainland Greece. Marble. Height 30". 2500–2300 BC.

However there are some obvious differences. Being a seated figure suggests she might be giving birth. Her eyes are opened wide, indicating that she is awake and conscious. We also see knob-like arms stretched out to give space for the incised lines that appear across the

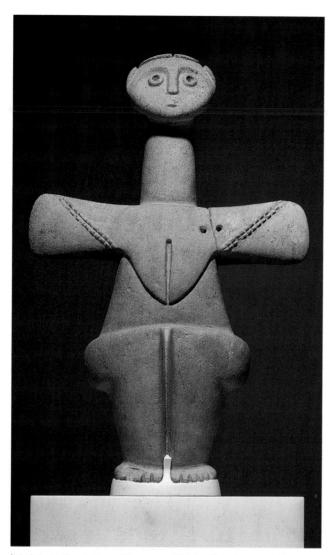

7.4 Cyprotic Female Figure. Limestone. Height 15 inches. c. 2500 BC.

chest. (Note that her left arm has been repaired). These lines are suggestive forms, combining both breasts and the female pubic area. This could be one of the earliest fertility logos found in history. With its obvious symbolism one might presume that this was a powerful fertility figure.

For the next two examples we will go to the other side of the globe and much later in time, to the nineteenth century AD, to look at some male fertility pieces from cultures in Oceania. Figure 7.5 shows the *God Te Rongo and His Three Sons* from Rarotonga, which is part of the Cook Islands in Polynesia. Carved of wood and standing over 27 inches high, he is balancing three small human figures on his belly. There are four more figures in the same style but in low relief, carved on the arm and forearm. The figure is endowed with a large penis in comparison to the rest of the figure, visually giving emphasis to the virility of *Te Rongo*. The exact character of this God is not known, as artworks such as these were collected by European Christian mission-

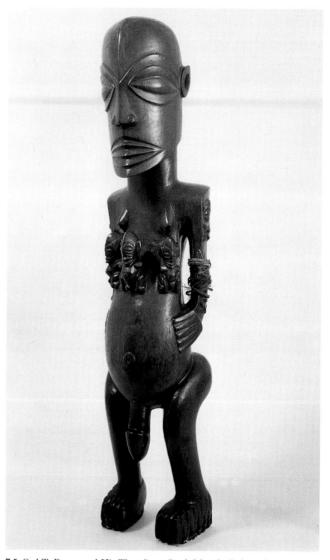

7.5 God Te Rongo and His Three Sons. Cook Islands, Polynesia. Wood. Height 27%", c. 1800-1900s. See also Chapter 20, figure 20.23, for more on this art and on the role of the artist as priest.

aries who were not interested in preserving the indigenous religion. However, there is obviously a visual connection to human reproduction.

As we take a closer look at *Te Rongo*, we can see the precise contained style of sculpture that is typical of works carved from one single block of wood. Careful planning was required to keep the proportion of the head equaling one fourth of the body height. In addition, incorporating the small figures must have been challenging to the artist. The chest, a bit sunken in order to make room for the smaller figures, exaggerates the belly and penis, again suggesting reproduction. The oval (or egg) shape of the head and the delineation of the facial features are repeated in the smaller figures, which clearly seem like infant images of the large figure. The surface of the wood is somewhat smooth and polished, keeping focus on the subject of the piece and less

on its texture. One wonders what power this piece had for its owners, especially within the context of their own fertility, virility, and reproduction.

Many sculptures and art pieces such as Te Rongo were carved for religious rituals by specialists called Ta'unga, which is also the word for priest. The specialist was trained through a long apprenticeship where he acquired the skill to control and attain the "mana" (power) in the materials and tools he used. In some cultures, the art object was created for one ceremony and then discarded, whereas others were carved to endure and be passed down from one generation to the next. The more the object was used in religious ceremony, the more mana it gained. With this power, these art objects became symbols of prestige and rank, and with them their owners visually displayed their place in the hierarchical order of the gods, priests, monarchs, chiefs, and people. There were taboos connected with these pieces in order to protect their status, restricting their use to those only of power and rank. When passed down through many generations, the artifacts again became more imbued with mana, due to their age and historical significance. They also became objects of sacred information, such as the family lineage.

Some sculptures were figures representing an ancestor. Eventually through generations of veneration, the ancestor, who was first of a lineage, would become deified or elevated to the realm of the gods. This may have happened to our next example, Figure of a Deity, A'a Rurutu (figure 7.6) from the Austral Islands in central Polynesia. These specific ancestor deities were known as the "Tangaroa" figures and represented a creator in the act of creating human beings. Family lineage was critically important in Oceanic cultures, and thus this god-like creator may well have been connected to a family ancestor. The figure is 44 inches high and carved from one block of wood. Like Te Rongo, this deity sculpture is also rendered in a contained style, compact and stiff. However, his body is covered with crawling infant-like figures. Even the facial features seem to be made up of the clinging little bodies. The back of the figure is hollowed out and contains additional small figures. We might be looking at the mythical creation of humankind in this figure, or the creation of a specific ancestral line. Unfortunately, again, there is not much information known about this piece and many others found in Polynesia, due to confiscation of the works by overly zealous missionaries.

Text Link

Ancestry is also important among the Maori of New Zealand, another Oceanic people. Read the discussion of the Maori meeting house associated with figure 12.23.

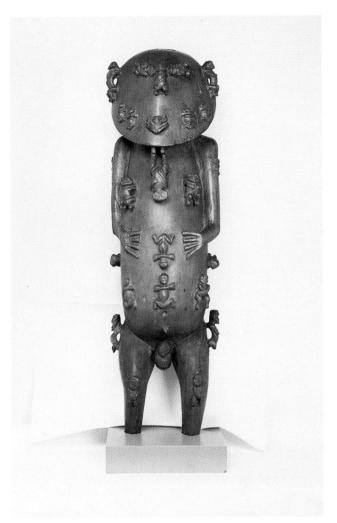

7.6 Figure of a Deity, A'a Rurutu. Wood. Height 44", Austral Islands, collected in 1820. This work is also discussed in the context of art collecting in times of national or religious conflict in Chapter 21, figure 21.27.

Fertility Figures

The sculptures we have been looking at have been labeled as possible fertility "gods or goddesses," which likely is what they represented and were worshipped for. The next few examples are considered to be "fertility figures," probably created to aid human reproduction through the magic and power they contained. Figure 7.7 shows Fertility Statuettes from the Middle-New Kingdom in Egypt, dated about 2000–1500 BC, and range from 6 to 8 inches. The materials vary from clay and "faience" (earthenware covered with opaque colored glazes), and linen and reed, as seen in the doll-like figure on the right. These figures were found in shrines of Hathor, the Goddess of Fertility. Some of the figures have their genitals emphasized with simple incising in the clay. One is wearing the "Isis Knot" on her back and is holding a baby. The Isis Knot was an amulet that was worn to ensure fertility and long life. As with all cultures, the need for successful human reproduction was important to the

7.7 Fertility Statuettes. Middle Kingdom. Egypt. Clay, faience (earthenware covered with opaque colored glazes), linen and reed. Height 6–8 inches. 2000–1500 BC.

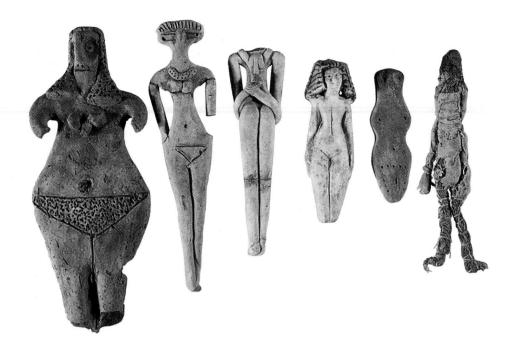

Egyptians in order to carry on the family line and to contribute to the labor force. Like a common practice in today's world, it was traditional to give a son his grandfather's name. With the prayer of these fertility statuettes placed before Hathor, women hoped for many sons.

The next small sculpture is a Native American Potawatomi Male Figure (love doll), from Wisconsin, dated AD 1800–1860, and is 9 inches in height (figure 7.8). It is carved in wood and partly adorned in wool fabric. These figure-like carvings (note the lack of arms) were used as "medicine" to control human behaviors and health. This type of figure could be used as a love charm to cast a spell on someone whose attentions were desired. The spell could be dangerous, as those under the magic of this charm found themselves powerless and would fall helplessly under its strength. Ethnologist Alanson Skinner stated: "It is often that the captor tires of his or her conquest, and leaves the victim, who is still under the spell of such a charm. Such a person will become frantic, and even go crazy, following the user of the charm everywhere" (Skinner 1923: 207).

To have successful "medicine," persons would have to be spiritually prepared. Having had a dream or a vision in which they would be given special powers by the spirits, they were now ready to have influence over the material and activity involved. In our case the owner of the love doll, if properly spiritually prepared, would have the power to cast a love spell upon the desired person. Clearly human reproduction must have benefited from such powerful spells.

The last fertility figure we will look at is a piece from the Bamana culture of Mali, Africa. The Bamana *Female* Figure, figure 7.9, is made of wood and brass, and stands 21 inches high. She is associated with a female fertility cult and was stored in special houses created for them. On occasion such figures were brought out for public display, or for elaborate rituals to aid women with difficulties in conceiving and childbearing.

This figure has a distinct style. Carved in sharp angular planes and geometric forms, she stands erect with the palms of her hands facing outward. The head is also defined in angles, with the nose dominating the front of the face. The hair is arranged in an elegant abstract coiffure. The shoulders and chest are fairly squared until the protrusion of the conical breasts. The elongated torso has a slight swell as the navel and abdomen connect to the short bent legs. The entire figure is clearly incised with geometric lines, some perhaps indicating body scarification. Interesting button-like forms vertically line her chest ending below her breasts, again suggesting body ornamentation. Attention has been paid to the rich shiny patina that causes finer details to show up well on the surface. The geometric forms are connected by line, resulting in an aesthetically rich blend of the two- and three-dimensional elements in the piece.

Finally, we conclude this section with a piece that is not a fertility figure per se, but seems very much related to those we have just seen. The fertility figures above are definitely human in form, but they certainly could also be considered as fertility symbols as well. Figure 7.10, *Torso of a Young Man* (1924) by the twentieth-century Romanian sculptor Constantin Brancusi seems to echo a fertility symbol. Influenced

 $7.8\ Potawatomi\ Male\ Figure,$ love doll. Wood and wool fabric, height 9 inches. Crandon, Wisconsin, $1800{-}60.$

 $7.9\ Bamana\ Female\ Figure,$ Mali. Wood and brass. Height 21 inches. 1947.

by the philosophy of the eleventh-century monk Milanepa, Brancusi pursued understanding the universality of all life. With this inspiration, along with the Romanian folk art of his youth and the influence of African tribal art that so strongly affected many European artists, Brancusi created works intended to capture the essence of pure form, and in it the universality of the meaning of this form. To do this he usually

7.10 Constantin Brancusi. Torso of a Young Man. Polished brass. Height 18". 1924.

worked in related themes such as creation, birth, life, and death. (He also was fascinated with flight). He would work these themes over and over again using marble, wood, or bronze, and he would finish his pieces by hand to a precious perfection, leaving no visual signs of his handicraft. Some of his pieces look as if they had been machine-tooled. As he developed an idea, his forms became more and more simplified. He is quoted saying "Simplicity is not an end in art, but one arrives at simplicity in spite of oneself, in approaching the real sense of things" (Janson 1995: 817).

As we look at the *Torso of a Young Man*, which is 18 inches high and completed in 1924, we see three cylindrical forms of highly polished bronze placed on a base composed of several simple geometric forms. One sculpture seems to be resting on another, an interesting contrast of a cylindrical "torso" with rectangular volumes. The torso is extremely simplified, and in fact hardly represents a torso, but rather becomes an obvious phallic symbol. Rather than creating an artwork that would aid human procreation, is Brancusi expressing his "real sense" of the essence of a young man as a symbol of fertility?

Rituals

Most of the fertility figures we have seen were likely used in connection with rituals, although in most cases the accompanying rituals have been lost. One ancient ritual has been preserved in a group of wall paintings found in the Villa of Mysteries (figures 7.11 and 7.12), in Pompeii, Italy, from the middle of the first century AD. Pompeii was buried in volcanic ash when Mt. Vesuvius violently erupted in 79, which preserved the city and these mystical images for modern inquiry and appreciation. This cycle of paintings, which wrap around the four walls of a room, depict a solemn ritual of the mystery cult of Dionysos that may have been associated with sexual intercourse and fertility. The exact meaning of these paintings is not known and is disputed among scholars. However, in the pictorial succession of events, we see a young female novice being prepared to be joined with Dionysos, the god of wine and fertility. The novice apparently is taking the role of Ariadne, his mythological mate, who is shown along with Dionysos and their accompanying entourage of mythological beings. Dionysos and the others appear to be witnessing the initiation. There is also an older woman who offers comfort to the frightened initiate, while nudes are dancing to the music played on a lute-like instrument. A priestess is ready to uncover and reveal the cult's draped sacred objects which likely held the secrets of the mysteries of Dionysos and perhaps a concealed phallus. The event also includes a winged figure who whips the young initiate.

The "rite" takes place in an illusionistic frieze, with the figures striking classic Greek poses against deep rich "Pompeiian Red" panels. The paintings depict a shallow

7.11 Initiation Rites of Dionysos. Fresco. Villa of Mysteries, Pompeii, Italy. c. AD 50.

space, with evenly spaced columns that subdivide the running narrative into scenes. The nearly life-size figures, with convincing volume and anatomy, move and turn in that shallow space, which is an illusionistic ledge. The frescoes in the Villa of Mysteries are excellent examples of Roman painting at that time. Even though other contemporary paintings were very pictorial with the illusion of space, this cycle of paintings was outstanding with the large figures, the running narrative, and ambitious depiction of continuous space. Special attention was paid to the preparation of the walls. In many houses in Pompeii, it was found that the plaster used to cover the walls had been mixed with marble dust. This was applied in several layers and then beaten with a smooth trowel, followed by polishing to a marble-like finish. The wall preparation contributed to the bright colors of the frescoes.

It is significant that this series of paintings was located in a villa, or private home, in the country. The rituals reference sex and fertility, which are often home-based. In addition, the Cult of Dionysos was one of various cult religions that were practiced in Rome, and were generally tolerated and even welcomed as long as they were confined to the home and did not upset the social and political order. In the case of the cult of Dionysos, the adherents were all women, who spent much time confined to the home by prevailing social customs. As a secret cult, its rituals were mostly practiced underground, in this case, in a country villa.

We know the rituals accompanying some art dealing with fertility from contemporary Africa. The twentieth-century *Akua'ba* (figure 7.13) from the Ashanti (Asante) culture in Ghana are fertility sculptures that are created solely for a ritual to help aid women who are having difficulty in conceiving, and to ensure a healthy and beautiful baby. "Akua" is the name of the first woman who used this ritual doll successfully and was able to conceive a baby. Consequently "ba" (child) was added to the name Akua; hence the dolls were called "Akua's child." Akua'mma is the plural form of the term. Akua'mma average about 12 to 13 inches in height and are carved from wood.

If a woman who was experiencing fertility problems wanted to begin this ritual, she would consult a priest, who would advise her to have a doll carved. She would then adorn the doll in beads and care for it as an actual baby. She would also carry the doll wrapped on her back as mothers traditionally carry their babies. She would take care not to gaze upon any deformity in a human or Akua'ba doll, so her baby would not be born with these traits. Instead she was to gaze upon the well-carved Akua'ba that expressed the Ashanti ideal of beauty. If the wearer of the Akua'ba doll gives birth to a healthy beautiful baby, she may place that doll in a shrine in order to recognize the power of the priest she confided in, or she may give it to her child for a toy.

As in Brancusi's sculptures, we see the interpretation of beauty reduced to uncomplicated forms. The

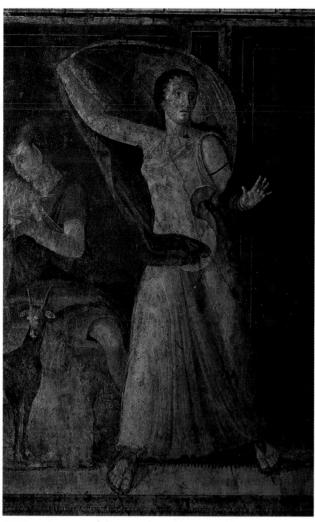

7.12 Detail of a figure in the fresco of the *Villa of Mysteries*. She is likely an initiate or a prietess taking part in the ritual. Pompeii, Italy. c. AD 50.

Akua'mma head, neck, arms, and torso are rendered in a circular disk and a series of cylinders. The figures are always female. The canon of beauty is suggested as a round face with a small mouth, a high forehead, and a long neck and torso. The linear facial features are cleanly carved in the lower half of the smooth facial disk which is supported by a stack of disk-like forms that suggests necklaces. The breasts and navel are minimal forms, but indeed express the gender invoking this fertility rite.

ART DEPICTING PRIMORDIAL AND HUMAN COUPLES

Human couples have been depicted in art throughout the ages. Some of the couples represented were the primordial or first couple, the mother and father of humankind. Others are human couples who represent the ritual of marriage and its implications within cultural contexts. These depictions were rooted in creation

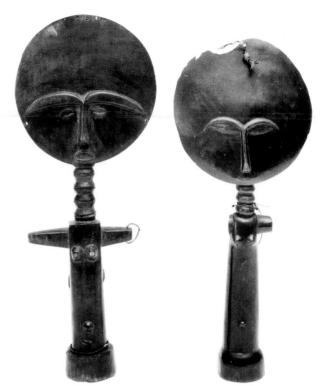

7.13 Ashanti *Akua'mma dolls*. Wood. Height 13 inches. Ghana. c. twentieth century. For more on the many uses of this sculpture, see Chapter 1, figure 1.1, and also Chapter 21, figure 21.12.

myths of many religions. They also come from marriage rituals that frame procreation in many cultures. We will look at just a few art examples, specifically from Africa, America, and Europe.

Text Link

There are many couples in cultures who are preserved in art. See Menkaure and His Wife, Khamerernebty, figure 12.1.

In figure 7.14, we see the Dogon culture of Africa representing the *Primordial Couple* seated on an "imago mundi" (image of the world) stool supported by four figures. It is carved in wood and stands 29 inches high. Its style is categorized by art historians as being part of the Sudanese Group, characterized by the use of simple tools for lack of nonferrous metals. The art objects are usually carved from one block of wood using the subtractive method. African art scholar William B. Fagg describes this style: ". . . working from the outside, (the artist) seeks a form inside the block." (Laude 1973: 37) Sometimes, naturally occurring features in the wood block are incorporated into the finished sculpture, such as a bend or a knot in the wood.

Seated in a frontal position, the *Primordial Couple* is stately and formal. They relate the harmony of the union of the first male and female, both of whom are

equally exalted in the sculpture. The union also appears to represent their fertility as well as their roles in life. The male unites the figures with his arm embracing the female at her neck and his hand resting on the upper part of her breast. His other hand is resting on his penis. Clearly the male's gestures symbolizes their sexual union. The power of their genders is also depicted. She wears four copper earrings, the number four symbolizing femininity, and he wears three rings, the number three symbolizing masculinity. On their backs are carved representations of the roles they have in life. He wears a quiver and she has a child clinging to her. He is a hunter warrior and protector, while she is the nurturer of their children.

There are other details in the sculpture that suggest their high position and perhaps their origin. She wears a mouth ornament called a "labret," and he wears a chin beard trimmed very much like the beards worn by Egyptian pharaohs. Their headgear is similar to the headgear worn by the people of the Peul culture, who were enemies of the Dogon. The fact that the couple is displaying this headgear could mean their domination over the Peul or their occupation by them. It could also suggest their union with the Peul, accounting for part of their heritage. The stool on which the couple is seated is supported by four figures. These caryatids are identical to the figures on the granary doors we looked at in Chapter 6, who represent the Dogon's ancestors. If indeed they are the same figures supporting the couple's stool, then we have additional information of their origin documented in the piece.

Text Link
This thumbnail image shows Dogon
Granary Shutters, with the figures that
are similar to the Dogon Primordial
Couple. See figure 6.7.

As previously mentioned, the *Primordial Couple* was likely carved from one block of wood. The piece is vertically emphasized not only by the two elongated figures and their proportions, but also by the negative space we see throughout the figures. Visually there is a balance between the positive mass and the negative space in the sculpture, a balance that expresses the feeling of the couple's relationship. African art scholar Barbara DeMott suggests that the interlocking of vertical and horizontal lines may relate to Dogon art and myth in which the checkerboard (design) is a symbol for an ordered human culture (Roy 1985: 31). There is a checkerboard treatment of positive and negative space in the sculpture, visually reinforcing the balance needed for an ordered human culture.

Another primordial couple is Adam and Eve, who are found in the Jewish, Christian, and Muslim religions and are depicted widely in European art. In the Bible, Book of Genesis 1:28, their creator commanded them to "Be fruitful and multiply, fill the earth and conquer it." Later on in Genesis the "Fall" is described and Adam and Eve are exiled from the Garden of Eden. It is at this point in the story that a young Italian Early Renaissance artist named Masaccio painted Adam and Eve in *The Expulsion from Paradise* (figure 7.15). This painting and others formed a group of images that Masaccio and another artist painted directly on the walls of the Brancacci Chapel in the Church of Santa Maria del Carmine, in Florence, Italy, in 1427.

Masaccio has captured Adam and Eve's anguish in *The Expulsion*. One can almost hear Eve's cry and feel Adam's pain as they shamefully walk from the gate. Their movement is slow, with every step more agonizing than the other. Now God's commandment to "... multiply, fill the earth and conquer it," has become a burden filled with pain. The artist accomplished this

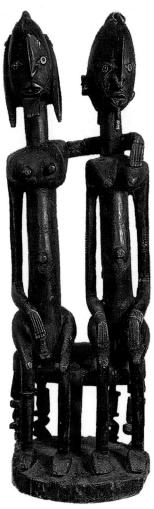

7.14 *The Dogon Primordial Couple.* Wood, height 29". Mali, ca. nineteenth–twentieth century. See also Chapter 2, figure 2.33, for more on the formal qualities of this piece.

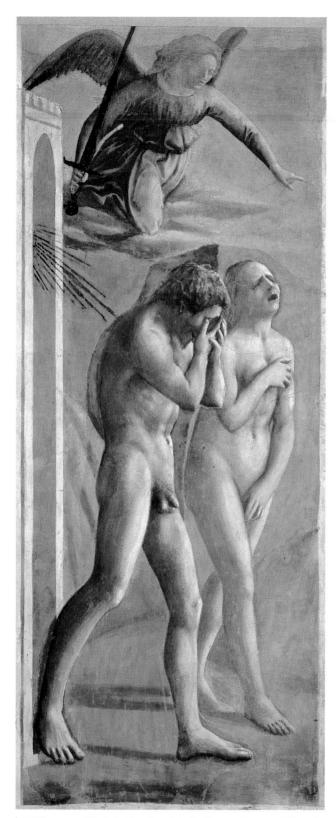

7.15 MASACCIO. *The Expulsion from Paradise.* Fresco, Brancacci Chapel, Santa. Maria del Carmine. Florence, Italy, 1427.

powerful depiction through his new and distinctive style of painting for his time. He paid particular attention to modeling the figures, using soft contrasts of values and color. Only essential details are included. The only other elements besides Adam and Eve are the gate to the Garden of Paradise, the angel with a sword barring any return, and a very simple landscape.

Masaccio was constrained in the design of this picture by the architecture of the Brancacci Chapel. The picture is tall and narrow, because it had to fit the place allotted it on the wall. With little space from side to side, Adam and Eve walk in a small foreground area. Masaccio used the natural light from a window in the chapel as his light source in the fresco. This certainly added to the convincing rendering of the figures and helped give them mobility.

Adam and Eve's body styles, raw emotions, and physical movements all add important meaning to the image. Masaccio rendered them with idealized, youthful bodies, in a style influenced by the sculpture of ancient Greece and Rome. Thus Adam and Eve were the perfect primordial couple created by God. Their intense emotions tell us that by their transgression they have set in motion the fall of the human race in the eyes of the Judeo and Christian God, and that their fate will rely on the grace of their God.

In sixteenth-century chronicles recorded in Mexico, we see another primordial couple. The Primordial Male and Female Force: Ometecuhtli-Omecihuatl (figure 7.16) are illustrated in the Borbonicus Codex as the Aztec personification of the original gendered creative forces. Painted on "amate" paper (a paper made of bark), the couple appear in a sacred enclosure, surrounded by symbolic glyphs. They represent the beginning of time and together they have set in motion the Aztec calendar by differentiating day and night. They are also the beginning of all life. Their sons, named Tonacatecuhtli and Tonacacihuatl, went on to create fire, the sun, and then the first human couple.

This painting is highly organized, symmetrical, and formal. The figures occupy the center of the picture, showing their central importance. The division of night and day is suggested in the composition of *Ometecuhtli-Omecihuatl*, as the picture splits in half in the center, in between the primordial couple. Curving contour lines define the simple, flat shapes we see in this painting. Decorative color also brightens the image.

Let us move on now to images of human couples representing the ritual of marriage. In another Mesoamerican chronicle, the *Codex Mendoza*, we see a pictorial documentation of a wedding. Figure 7.17, *Aztec Marriage Couple*, depicts a man and woman seated on a mat, literally tying the knot. Aztec marriage ceremonies took place in the groom's home in front of the hearth. The codex tells us that this man is about twenty years of age, while the woman is fourteen or fifteen. With the aid of a matchmaker, the groom's parents select a bride. The matchmaker, with the aid of a soothsayer, studies the couple's birth signs in order to ensure their compatibility.

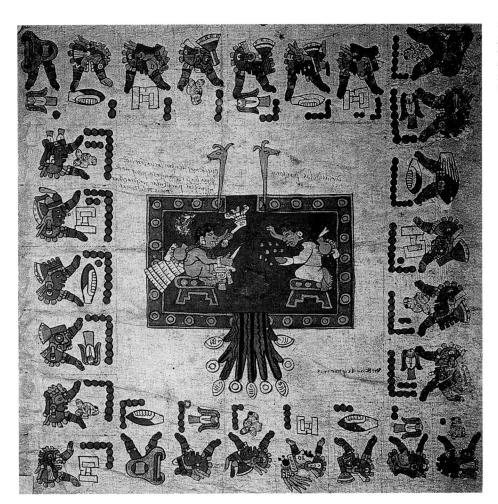

7.16 The Primordial Male and Female Force: Ometecuhtli-Omecihuatl. From the Codex Bordonicus. Aztec, Mexico, c. 1525. See also figure 21.26 for more on the historical background to this codex.

The bride's family also investigates the groom to be assured of his good manners. The bride's parents are in charge of giving the wedding banquet, which begins at noon. The bride will be powdered with yellow earth and adorned in red feathers. When darkness arrives, the bride is carried on the matchmaker's back to the groom's home, where the formal vows are performed by tying together their wedding garments, as seen in the illustration. The celebration continues after the ceremony with much feasting by the wedding guests, while the bride and groom retire to their marriage chamber to pray for four days. They can consummate their union only after their days of prayer are completed. On the fifth day the couple emerges from their chamber, are cleansed and purified, and blessed by a priest. They are now ready to begin their wedded life together. The man may marry additional wives (Townsend 1992: 188).

The Aztec Marriage Couple is obviously a simpler, less formal image than Ometecuhtli-Omecihuatl, but there are some important similarities. They both feature contour lines defining flat shapes, with color used decoratively. Their clothing is depicted with simple flowing line, which contrasts with the angular pattern of the woven mat that surrounds them. The handling of their hair

provides more pattern in the image. The formal placement and pose of the *Aztec Marriage Couple* echoes that of *Ometecuhitli-Omecihuatl*, suggesting that every human couple is derived from, and also recreates to some degree, the life-making power of the primordial couple.

Like the Aztec Marriage Couple, another work of art painted in 1434 also documented a wedding. Known as the Wedding Portrait or Giovanni Arnolfini and His Bride, (figure 7.18), Flemish artist Jan van Eyck rendered this work with oil paint, at the time that oils were first being used for paintings. This work is approximately contemporaneous with Masaccio's Expulsion, which we have just discussed. Portraiture was a popular subject matter for painters in northern Europe at this time, and van Eyck was no exception. In this work, he painted two portraits, Giovanni Arnolfini, an Italian businessman living in the Flemish city of Bruges, and his betrothed. Unlike any other portrait that simply captures the likeness of an individual, this double portrait is their wedding certificate. Van Eyck accomplished this by filling his composition with both obvious and hidden symbolism.

The obvious symbolism is the placement of the couple in their bedroom chamber rather than a church. They are joining together in marriage in the place 7.17 Aztec Marriage Couple. From the Codex Mendoza. Mexico, 1434.

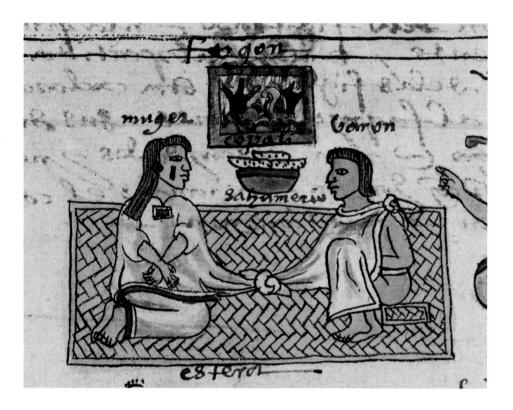

where it will be consummated, suggesting the hope of a fruitful union in which many children will be born. Indeed, the woman holds her clothing in a way that suggests she is already very pregnant. Less obvious symbols also fill the bedroom. Various objects and an animal give the viewer more hints about the sanctity of the sacrament of marriage. In the chandelier, there is one candle burning although it is daytime. The lighted candle represents the presence of God. The bedroom is now a holy place in which the wedding vows are taking place. The couple have removed their shoes, indicating they are on holy ground. In the frame of the mirror appear medallions that depict the passion of Christ. On the chest and window sill are oranges, the golden apples of the Hesperides, representing the conquest of death. There is a dog at the feet of the couple, symbolizing fidelity. Arnolfini himself raises his hand in a gesture of blessing. The prayer for fertility is also seen as the bed drapes are opened, and on the bedpost finial is a statuette of St. Margaret, the patron saint of childbirth. A whisk broom is also hanging on the post, suggesting setting up household. To complete this document, van Eyck includes witnesses to the wedding, of which he is one. In this one-point perspective rendering, the vanishing point is located above the mirror where we see written in script, "Johannes de eyck fuit hic," which translates to "Jan van Eyck was here." And in the mirror two figures appear, most likely the artist with a companion. The two figures are present and witnessing the wedding ceremony, making this visual document official.

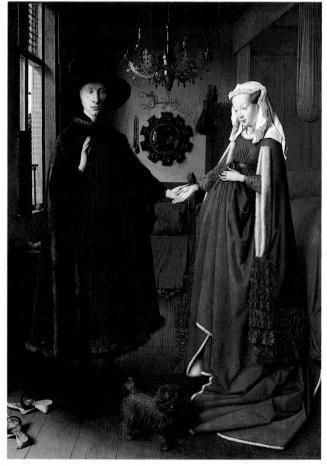

7.18 Jan Van Eyck. Wedding Portrait. Oil on wood panel, 32" \times 25", Flanders, Northern Europe, 1434.

Text Link

It is interesting that the conquest of death is represented symbolically in this painting about marriage and the hope of children. Birth and death are frequently linked in art, as we will see in other examples in this chapter. Turn to Chapter 11 to see many examples of funerary art that deals with the idea of rebirth, or life after death.

ART ABOUT LOVEMAKING

The act of lovemaking is of course essential in procreation and thus an appropriate subject for this chapter. However, art about lovemaking does not belong exclusively or cleanly to the topic of Reproduction. Some such images have strongly religious meaning. For example, there are many erotic carvings on Hindu temples, where the ecstasy of human lovemaking is seen as a reflection of being joined with the Divine. See Chapter 10, Places of Worship, for more on Hindu erotic carvings. Erotic images are also part of sexuality and gender identity, again apart from procreation. We cover these in Chapter 17, Race, Sexuality, and Gender. Now, to round out our discussion here, we will look at a few examples of art about lovemaking.

Text Link

Turn to Chapter 10 for more discussion on the erotic carvings from the Indian Kandarya Mahadeva Temple (figures 10.22 and 10.23).

The first work depicts the act of lovemaking as a matter of fact. The Moche Pottery Depicting Sexual Intercourse (figure 7.19) was probably created during the height of the culture around 1000-1250, in the desert coast of Peru. The Moche was a thriving, artistically active civilization that preceded and was brought down by the Incas. The Moche custom was to bury ceramic pots with their dead. These pots had naturalistic imagery that recorded their way of life and tribal costumes, including lovemaking (another life-death link). The depictions of lovemaking were explicit and candid, and likely were made by the women of the culture, as they usually did the work of the potter. In various pots depicting lovemaking, the figures are usually lying on or under a blanket with a rolled up pillow. Their faces exhibit no emotion. However the variety of the sexual acts and the positions in which they are sculpted indeed display a wide range of sexual pleasure and preference. Nothing was left to the imagination, as numerous sexual acts besides intercourse between a man and a woman were molded on pottery. Such sculptures may have been

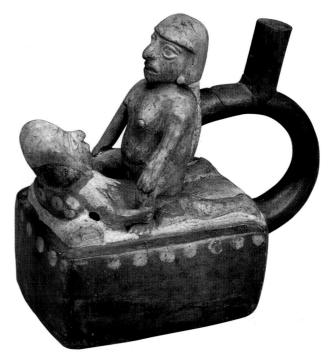

7.19 Moche Pottery Depicting Sexual Intercourse. Ceramic. Peru c. 1000–1250.

designed as visual aids for sex education, illustrating not only human reproduction but perhaps birth control as well.

Our buff clay and slip—decorated piece was made by pressing clay into a mold. We are looking down on the top of the pot, where we can see the stirrup handle and spout at the right, and the figures on the left. Thus, in addition to showing intercourse, the pot could certainly function very well as a vessel, probably to contain "chicha" (corn beer). The linked limbs of the figures create a circular shape that echoes the stirrup handle. The figures themselves are shown economically, with a minimum of detail.

One of the most beautiful works of art depicting lovers was done by the famous Japanese printmaker Kitagawa Utamaro, known as one of the best of the "Golden Age" wood block designers in Japan (1780–1810). Utamaro designed A Pair of Lovers (figure 7.20) as the frontispiece for Poem of the Pillow. The work is considered to be in the "ukiyo" or "floating world" category of subject matter, and this particular work is a "shunga" print, which provocatively depicts erotica. The printmaking technique as well as the notion of the "floating world" came to Japan with the arrival of Chinese and Korean Buddhist missionaries. The Buddhist concept of the transient characteristic of life was incorporated into the subculture of "ukiyo" in sixteenth- and seventeenthcentury Japan (known as Edo). This was translated into attitudes and value systems for non-samurai classes, who prized the fleeting moments of pleasure in life; in other words, the eat, drink and be merry point of view. "Ukiyo"

7.20 KITAGAWA UTAMARO. A Pair of Lovers. Frontispiece from "Poem of the Pillow." Wood block relief print. 9%" × 14%". Japan, 1788.

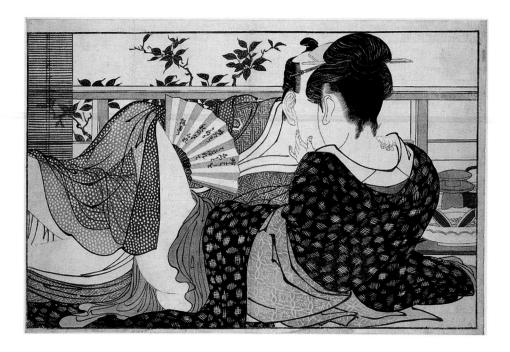

encompassed the extreme of pleasure, and the art that captured the images of these pleasures was known as "ukiyo-e." These images often centered on female beauty, the theater, and entertainment. Famous courtesans would be depicted in the latest fashion, and prints were produced and collected much like the posters or baseball cards of famous movie stars and athletes are today in the Western commercial world.

Text Link

This image is another ukiyo-e print called Komurasaki of the Tamaya Teahouse (figure 16.27). Other examples of ukiyo-e prints included in this text are Beneath the Waves off of Kanagawa (figure 16.28) and also Interior of a Kabuki Theater (figure 18.2).

The shunga print (translated as "spring pictures") we are looking at now is just under $10" \times 15"$ and is the cover of a book. Inside there are more prints illustrating the text of the poem, and these are considered to be Utamaro's finest shunga works. Gently and intimately erotic, the artist has captured a private moment in the closeness of these lovers. The exquisite interplay of pattern and line of the kimonos with the figures gives emphasis to the intertwining of their bodies as they make love. Even their heads and hands are eroticized, with the closeness of their faces and the strokes of their fingertips. This is a visual poem of line, pattern, and color that composes this "floating world" image of these lovers' pleasure.

Jeff Koons, a contemporary artist in the United States, has approached acts of love through large paintings, small sculptures, and live performances, such as *Made in Heaven* (figure 7.21). The paintings and sculptures depict various erotic poses. In the performances he and his partner Cicciolina assume various sexual positions in front of viewers, which is done without fear, guilt, or shame. He references religion in the viewers' watching the sexual performance. The artist explains, "I went through moral conflict. I could not sleep for a long time in preparation of my new work. I had to go into the depths of my own sexuality, my own morality, to be able to remove fear, guilt and shame from myself. All of this has been removed for the viewer. So when the viewer sees it, they are in the realm of the Sacred Heart of

7.21 JEFF KOONS and partner Cicciolina. Made in Heaven. USA, c. 1995.

Jesus" (Koons 130). Our example, a billboard which publicized the performances, is heavily influenced by movie publicity and the covers of romance novels. In this work, Koons has blurred many boundaries, such as the division between fine art and popular culture, representation in art and performance that may seem like "real life," and some would argue, good and bad taste.

Obviously Koons' sculptures, paintings, and performances are controversial. Whether they are works of art or pornography can be argued. Likewise, categorizing the Moche pots or the Japanese shunga prints may be equally difficult, as they are erotic works that were created to stimulate and give pleasure to the viewer.

IMAGES OF PREGNANCY, CHILDBIRTH, AND PROGENY

Images of childbirth are seen in many cultures and have existed for ages, as we have already seen in the Çatal Hüyük *Fertility Goddess* (figure 7.2). Let us look at a few more now.

An interesting ceramic figurine depicting pregnancy is found in the Guatemalan Maya culture dated between 250 BC and AD 100 (figure 7.22). She is known as a *Kidder Figure* and is about 10 inches high. The seated female has a baby-like body with a swollen belly suggesting she is pregnant. She emphasizes her enlarged stomach with the gesture of her hands gently resting on it. The expression on her face seems to be of contentment and joyous anticipation of the expected event. The Mayans developed the figurines and identified them with fertility cults. They linked general procreativity with female maternity and fertility, and related it to the earth. The small infantile figures represent the bearers of human offspring as well as the mother of nature and the progenitor of plant life.

For our next example we will return to the Peruvian Moche culture, in which artists depict childbirth in as straightforward a manner as they depicted sexual intercourse in their ceramic art. In figure 7.23, A Moche Woman Giving Birth Assisted by Midwives, we see another stirrup handle vessel with small figures connecting the handle with the body of the pot. The figures clearly illustrate the act of childbirth. With the exception of the mother giving birth who shows a bit of a grimace, the faces of the midwives seem expressionless. The scene seems to be clinically illustrating an event rather than capturing the moment of physical and emotional anticipation or even pain. It simply records the Moche childbearing position and technique that may have taught expectant mothers and students of midwifery. Again, as in our other Moche example, the figures sit on top of the pot, near the stirrup handle. The handle seems to function as the back support to the one

7.22 Kidder Figure. Ceramic vessel, $10\times7.5\times6.75$ inches. Mayan, Guatemala, 250 BC–AD 100.

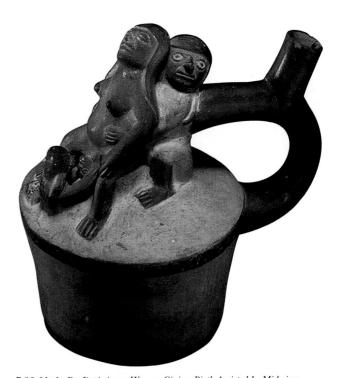

7.23 Moche Pot Depicting a Woman Giving Birth Assisted by Midwives. Ceramic. Peru c. 1000–1250.

7.24 Mother and Nursing Child. Ceramic effigy vessel, Mississippian Period. Cahokia, Illinois, USA, 1200–1400.

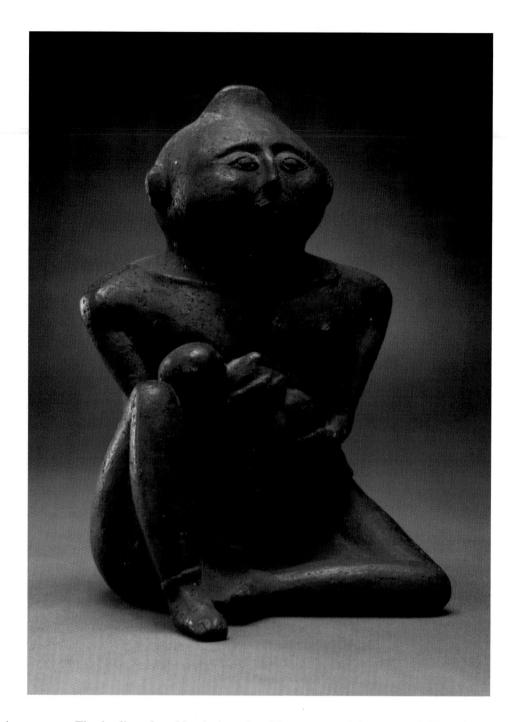

midwife who holds the laboring woman. The bodies of those two women suggest a curving shape that turns down and concludes at the head of the midwife catching the emerging infant. That implied curve echoes the curve of the stirrup handle.

Mother and child imagery is widespread across many cultures. We will look at two examples, but there are many, many more examples from which to choose. The first piece is a ceramic human effigy vessel of a *Mother and Nursing Child* (figure 7.24) from the Mississippi Period (1200–1400), in a culture located in Illinois at the confluence of the Mississippi and Illinois rivers in

North America. The ceremonial center of this culture was called Cahokia, a metropolis filled with large truncated pyramid mounds that were topped with small temples. The center may have had 30,000 inhabitants at its height. This sophisticated society was divided into chief, priest, and warrior classes, along with a well-established agricultural system. Their religion strove to predict and control nature, with much attention paid to death. Special ritual goods and artifacts were collected and created for ceremonies to placate the gods, aid in survival, and honor the dead. It is in the last category that our ceramic vessel can be placed. The *Mother and*

Nursing Child was buried in a tomb that likely belonged to a high-ranking person. Tombs contained a quantity of elaborate naturalistic and fanciful funeral pottery, mostly effigies, that captured the spirit of the dead it honored. The Mother and Nursing Child expresses a graceful and serene image of woman and her baby. A simple rendering, there is emphasis in the detail of the mother's face and in the nursing babe. Triangular shapes appear in the rest of the pose, as the mother's broad shoulders suggest an inverted triangle, and her folded legs suggest two other triangles. The simple, geometric form adds to the stability and calm of the figure. And again, we see birth and death connected in art. Representing a mother and her progeny in life, the effigy vessel may have insured her potential to bear children in the afterlife.

The mother and child is a familiar Christian icon, personified as Mary and Jesus. We see but one example of the hundreds of such existing works with Ambrogio Lorenzetti's Madonna de Latte (figure 7.25). It was painted on a wood panel around 1340 for the Chiesa di San Francesco in Siena, Italy, a chapel off a cloister. Lorenzetti captures the Virgin and Christ child as human and intimate, full of love and nurturing. The Madonna is nursing her baby as every ordinary mother does, demonstrating her own and her son's humanity rather than emphasizing their divinity as was more common in earlier European art. Because of the miracle of the virgin birth of Jesus, in which God was conceived in human form by the joining of Mary and the Holy Spirit, the only portrayals of Jesus that had been acceptable up to that time showed the divine side of Christ and the purity of his mother as Queen of Heaven. However, now the Holy Mother looks upon her baby affectionately, while the hungry child curiously looks about without taking a moment to stop nursing. He is active and alert, which can be seen as he kicks off his blanket and turns to observe the world of the viewer.

Working in the contemporary French Gothic style, Lorenzetti, along with his brother Pietro, popularized the intimate and humanized Madonna with the playful Christ. As seen in our example, Lorenzetti combined decorative rich colors, gold and silver, with subtle modeling of the Christ child along with the face and hands of the Madonna. This modeling of the baby's form helped lead the way to the naturalistic rendering of the human figure that was to come with the Italian Renaissance. This depiction of an adoring mother nursing her active child, a normal human activity, emphasized naturalism. However it is also an icon of the Divine, as this mother's progeny is also the divine promise of redemption to the Christian faithful. The development of the Christian belief in the dual nature of Christ was indeed being explored as seen in this new interpretation of the Holy Mother and Child.

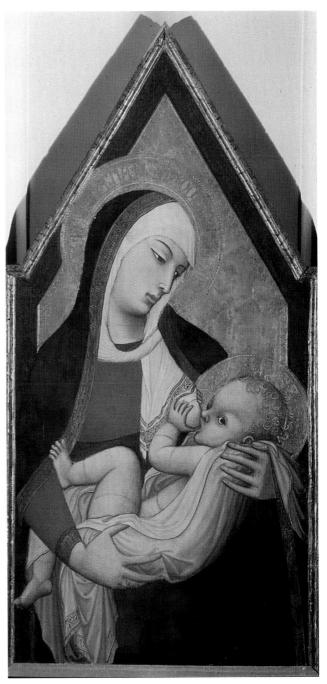

7.25 AMBROGIO LORENZETTI. Madonna de Latte. Fresco for the Chapel of San Francesco, Siena, Italy. Painted on wood. 1340.

SYNOPSIS

Art promoting human reproduction has taken many forms and contexts, among which are sculpture, drawing, painting, printmaking, photography, and performance. All are used to ensure, teach, record, and document human fertility and reproduction.

Early small figurative sculptures of fertility "gods" and "goddesses" found in the Stone Ages and later on in

early Greek cultures are interpreted to have aided human beings to reproduce. Through the power of the Venus of Willendorf, and from the Cyclades, the Idol from Amorgos, human fertility may have been secured. Rooms filled with murals depicting possible fertility rituals have preserved the sacred rites of procreation, as discovered in the shrine rooms at Catal Hüyük in ancient Anatolia and at the Villa of Mysteries in Pompeii. Similarly functioning art forms have continued to appear in recent cultures, particularly in the ethnic art forms of the Americas, Africa, and Oceania. Examples are the Native American Potawatomi Male Figure (love doll), the African Ashanti Akua'mma dolls and the A'a Rurutu fertility figure from the Austral Islands in Oceania.

Sculptures and paintings have witnessed, documented, and commemorated the coupling and marrying of human beings. We saw several examples of primordial couples and marriage scenes. *The Wedding Portrait* of Arnolfini and his bride was not only a documentation of the betrothal, but also a testament to the Christian holy sacrament and to the function of marriage, that is, "to be fruitful and multiply." Objects signifying fertility were subtly incorporated throughout the composition.

The intimacy and ecstasy of lovers has always been a subject of fine art. Literature, poetry, and music are all rich in works communicating such emotions, and the visual arts are no exception. Perhaps it is the powerful human need for emotional love and physical pleasure that motivate artists to express it. The Japanese artist Kitagawa Utamaro discreetly conveyed the intimacy between lovers in *A Pair of Lovers*. Jeff Koons, on the other hand, portrays his intimacy and ecstasy overtly in a series of performances and billboards involving various sexual acts with his partner.

Art shows the act of the human sexual union as well as the progeny resulting from it. Straightforward and clearly represented, Peruvian Moche potters rendered the act of sexual intercourse between a man and woman

on a stirrup-handle vessel, as well as the moment of childbirth. A common motif in art is the mother and child. From the Native American metropolis of Cahokia, an effigy vessel depicts a serene *Mother and Nursing Child*. In Christian beliefs, the union of the Holy Spirit and the Virgin Mary produced the Christ child Jesus, depicted as a very active and human-like child in Ambrogio Lorenzetti's *Madonna de Latte*.

The need to reproduce in order to preserve the species is basic for human survival. Also ostensibly basic is the artwork that helps, depicts, and celebrates the continuation of the human race.

FOOD FOR THOUGHT

Most of the art we have seen in this chapter comes from cultures in which human reproduction was actively promoted or even ritually aided. Having children was seen as an absolute good. Early pregnancy was common and large families were a blessing. However, in the last several decades, that attitude has changed. Neither teenage pregnancy nor marriage are viewed positively in the United States today. Abortion and birth control put more choices along the way to becoming parents. Sexuality has been more emphasized for personal pleasure rather than procreation; however, the threat of sexually transmitted diseases complicates this new attitude. As the human population tops 6 billion, many believe that there are too many people for the planet to sustain. Indeed, the world's most populous country, China, has already legislated population control measures.

- How do you see these various attitudes reflected around you in the art made today?
- What attitudes do you see in images from popular culture—in movies, comics, fashions, dolls, advertisements, magazines, calendar art, billboards, and so on?

INTRODUCTION

Humans need to be kept warm or cool, and protected from extreme weather and other threats in order to survive. And being a territorial and sometimes violent species, humans also need additional protection from enemy invasion. Finally, humans choose to live and work in settings that not only meet their basic needs, but aesthetically enhance and enrich their lives.

There are many architectural forms that humans have developed to provide an enclosed space, some more basic to survival than others. In this chapter, we will take an overview of domestic, commercial, and public architecture. Look to some later chapters for examples of other specific-use architecture:

- **PLACES OF WORSHIP:** This chapter covers architecture used in religious worship.
- **POWER, POLITICS, AND GLORY:** A sampling of palaces and government buildings from various cultures is presented here.
- **ENTERTAINMENT:** Theater and museum design is discussed here.

Keep in mind the following questions as we look now at several forms of shelter:

What kinds of shelter have been designed for group living?

How have architects met the needs of individual living?

What architecture has been developed for the commercial world?

How do structures that serve the same function compare in their designs across cultures?

Why have artists and architects designed shelter that goes beyond functional considerations?

DOMESTIC ARCHITECTURE

Our early ancestors found shelter at the mouths of caves, or laid some branches against the side of a cliff to form a

rudimentary hut. These shelters fulfilled a necessary protective function. But for our purposes, we will begin this chapter with what might be called the first forms of architecture, when people enclosed spaces with some aesthetic intent.

In this chapter segment, we will see a wide range of houses all serving the broad function of shelter, but done in amazingly different styles. Obviously we could have shown even more. In each case, a different house design is the result of one or more of the following factors:

- the need for protection, whether from human foes, from the weather or from animal predators or insects.
- historical necessity, as some event required a people to change their housing styles
- the availability of materials, since for the most part houses were built using local resources
- aesthetic choice, as a group of people may believe that certain designs are inherently superior or more pleasing than others
- the desire to follow precedent; we will see examples of houses that were designed to resemble a ruler's house, or houses that look like those from another place or time
- symbolic importance; the structure or decoration of houses may reflect important social values or religious beliefs
- self-identity, as the house can be a reflection of its owner's beliefs or aspirations.

Let us begin with examples of houses for group living, and then move on to individual houses for smaller family groups.

Group Living

Human beings, it seems, have had a tendency to cluster together in communities for fortification against danger and to increase their chances of survival. In this segment, we will see several examples of communal or group living from many centuries ago, and then see how the concept of group living has become attractive again in recent years.

Early groupings

The earliest examples of domestic architecture feature group living, which was popular among our early ancestors. To ensure survival, they pooled resources, energy, and knowledge to give everyone sufficient food and shelter, to care for the young, and to guard against foes or predators. The focus of these early homes was the fire of the hearth, providing food, warmth, and light. The first architecture built by humans that we currently know dates from the Upper Paleolithic period, 25,000–8000 BC. These were group-living structures that were circular or oval huts with animal hides covering a framework of light branches. These huts were as large as 15' or 20' in diameter. Some had floors that were enhanced with a covering of powdered ocher. These huts were centered around the hearth (Stokstad 1995, 38).

In Russia and the Ukraine, during the Upper Paleolithic period as now, the winter weather is extremely harsh. There, in treeless grasslands, early humans developed a variation of the early huts we just described. They made settlements containing up to ten houses using the bones of the woolly mammoth for frameworks. The best preserved of these villages is at Mezhirich, Ukraine, dating from 16,000-10,000 BC. The huts were constructed of tusks, jawbones, pelvis bones, shoulder blades, and skulls. The long tusks spanned the doorways and reached from wall to wall to create the roof. The bones were placed and interlocked in a way that was both functional and aesthetic. Once the bones were in place, the entire structure was likely covered with animal hides and turf, to create a relatively warm, draft-free interior. The largest hut was 24' × 33' and contained fifteen small hearths with ashes and charred bones. The large size of the hut, the skillful placement of the bones, and the creation of an interior communal space puts this structure in the realm of architecture. It was a much more ambitious structure than what is dictated by sheer necessity.

Next let us look at a Neolithic town located in Anatolia, now modern Turkey, in an area that was probably the most culturally advanced region of its time. The town of Çatal Hüyük was an early example of urban life. It dates from the era when agriculture was beginning, animals were domesticated, domestic crafts such as weaving were flourishing, and copper and lead were being smelted and worked. Çatal Hüyük itself had a fully agrarian economy around 6000 BC, and cattle and sheep were being bred. In addition, the town received added wealth through the trade in obsidian, a hard, black or darkcolored volcanic glass used as a gemstone or in mirrors. The site of Çatal Hüyük was inhabited and prospered for around 800 years. There are twelve successive layers of building at a site covering 32 acres, although only a small area has been excavated at this time. The final layer seems to have been occupied for a relatively short time, however, perhaps less than a hundred years.

The architectural design of Çatal Hüyük is clever (figure 8.1). The houses were all one story and were made of mud bricks and timber. They were all connected together and clustered around a few open courtyards placed near the center of the compound. There were no streets, and also no ground-level doors. Entry

was achieved through holes in the roofs, which also served as chimney vents. The houses vary in size, but each conformed to a regular plan. The design of the Çatal Hüyük houses has these advantages: 1) they are sturdier and more stable than individual freestanding houses; and 2) at ground level the combined houses create a solid wall without openings, an effective defense against human or natural foes. Should invaders enter, they would find themselves in a maze of spaces, none of which gave easy access to other spaces. Yet Çatal Hüyük was a peaceful town, as there is no evidence of weapons or fortification.

Inside Çatal Hüyük houses were plastered and richly painted walls and floors. Two platforms were located in each room along the walls, made of plaster or plastercovered wood. They were apparently used for working, eating, and also for sleeping. Intermingled among the houses were many shrines, roughly one shrine for every three houses (figure 8.2). The shrines were richly decorated, with wall paintings of animal hunts, showing running figures surrounding large bulls or stags. One unique image is apparently a landscape painting, showing what may be the town of Çatal Hüyük in the foreground with the 10,600-foot volcano Hasan Dag in the background. The mural paints were made from natural pigments mixed with fat. The walls were carefully prepared for the paintings, and often layers of paintings were found covering the same walls. One can only imagine the activity and likely rituals that took place in these rooms so many years ago, and how they corresponded to each layer containing a separate painting on the ancient walls.

Other shrine decoration consisted of plaster reliefs and animal heads. Especially prominent were the bull skulls displayed on walls, and bull horns mounted on benches or inset in low posts or pillars, sometimes juxtaposed with plaster breasts that represented female

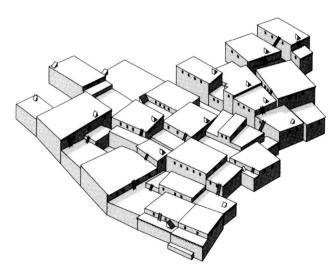

8.1 Restored drawing of Çatal Hüyük (after J. Mellaart), level VI. 6000–5000 BC.

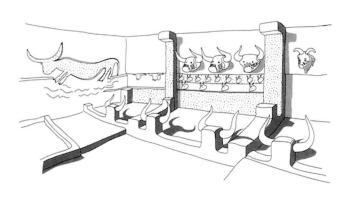

8.2 Restored drawing of the $\it Third$ $\it Shrine$ at Catal Hüyük by Mrs. G. Huxtable. The British Institute of Archeology of Ankara.

 $8.3\ Pueblo \,Bonito.$ Anasazi, eleventh century. New Mexico, USA. Photo Paul Logsdon.

sexuality. The horns represented male potency and may have also warded off evil.

Text Link

While hunting scenes predominate in the wall paintings, numerous sculptures of clay and stone were found in Catal Hüyük shrines. They were mostly of women and animals. The female figures are believed to be fertility goddesses (figure 7.2). See Chapter 7 for more information on sculpture from Catal Hüyük.

Later groupings

Our next example of architecture for group living is Pueblo Bonito at Chaco Canyon (figure 8.3), constructed by the Anasazi peoples in New Mexico, North America, around the eleventh century AD. The Anasazi, who also built the Cliff Palace at Mesa Verde, were the northernmost extension of the great cultures of Mesoamerica, and are believed to be the ancestors of the Hopi, Zuni, Acoma, and the peoples of the Rio Grande. The Anasazi were skilled farmers in a climate that is relatively hostile to agriculture. They used several strategies to grow crops, especially corn, in the canyon around Pueblo Bonito. They built diversion dams to catch the run-off from summer storms, and irrigated over one thousand acres of bordered gardens on the north side of the canyon. Another thousand acres of farmland were not irrigated. That they flourished is evident by the enormous piles of refuse in their trash pits. At their height, they may have numbered as many as seven thousand in the entire canyon.

The site of Pueblo Bonito had been inhabited for many centuries, as older structures called pit houses, dating from AD 500, and five-unit houses from AD 800, have been excavated below Pueblo Bonito. Those older structures were filled with earth and rubble to form the

platform for the newer construction. Pueblo Bonito was a ceremonial fortress that may have been built as a center for the Anasazi elite. For unknown reasons, the site was vacated around the middle of the twelfth century. It was later occupied by the Navajo. The pueblo style of domestic architecture was carried over into modern times at places such as the North Pueblo in Taos, New Mexico.

Pueblo Bonito was not built piecemeal, in small sections or with add-ons. It was a massive construction event, built in large wings, as can be seen by the precise alignment of cross-walls and the exact placement of doors, which conforms to a pattern. It is estimated to have taken 25 to 40 years to have planned and built Pueblo Bonito. The precision of the structure is such that some Anglo settlers in the United States expressed the racist belief that no native peoples could have constructed them. The structure itself is dramatic. It is a wonderful piece of smooth geometry with great sweeping lines, set against and contrasting with the rough vertical cliffs behind it.

The walls at Pueblo Bonito cover four acres. The structure rises up five stories, and contains approximately 660 rooms in all, accommodating one thousand residents. The entire complex is a highly formalized design, a huge "D" with an arc of rooms surrounding dual plazas. Various clans occupied certain sections of the pueblo. The round structures in the middle of the pueblo are kivas, numbering 32 in all. A kiva is a large round room, totally or partly underground, which was a center for ceremony and contemplation. Interior walls of kivas were frequently painted with murals depicting agricultural deities. The largest kiva at Pueblo Bonito was 60' wide.

The masonry work at Pueblo Bonito is exceedingly refined. The walls were constructed of a core of rough stones and mortar that was then finished inside and out with sandstone *ashlars*. Ashlars are thin stones, squared and set straight in careful layers, held in place by mortar,

8.4 Dogon Cliff Dwellings with Granaries, Mali, Africa.

which covered the rubble core. At Pueblo Bonito, the ashlar masonry was also coated with smooth plaster, for an even more refined finish. The stone for Pueblo Bonito was quarried locally, but the wooden beams were transported to the site from forests 60 miles away. Some 200,000 beams were needed for construction. Douglas fir and Ponderosa pine were used both as building material and also as firewood. Possibly the depletion of nearby forests was one factor in the eventual abandonment of Pueblo Bonito.

Another example of communal structures shows how group housing not only efficiently provides shelter, but can also reflect the group's social organization and religious beliefs. The villages of the Dogon people in Mali, Africa, are not archeological ruins but are currently in active use. The Dogon live along a series of steep cliffs that extend for 125 miles, called the Bandiagara Escarpment. The Dogon people are organized into lineage groups or clans. Small villages are composed of a single lineage group, while bigger ones may contain several clans. Dogon villages are located on cliffs (figure 8.4) or on flat plains below (figure 8.5).

Historically, the Dogon people displaced the Tellem people in the fifteenth century, who, in 1200, inhabited cliff caves and later the rocky escarpment. Legends, or the "memory of the ancestors," relate that small red men called the Andoumboulu were driven out by normal-sized men of the Tellum people. The Tellem were then driven from the cliff by the migrating Dogon, although some remained to be absorbed or co-exist peacefully in the area (Laude, 1973, 24). Today the villages survive with generations of Dogon families inhabiting them for years.

These villages are dense collections of houses, shrines, and granaries. Individual rooms within a single house

may be irregular in shape and on different levels to make best use of available space. Land conservation is important, as almost all Dogon exist by farming, but arable land is in short supply. Houses are connected with stone and mud walls to make clusters that become joint family households or compounds. The clustering of houses and the strong vertical emphasis also represent efficient land use. In addition, however, the houses and granaries form an aesthetically pleasing pattern of geometric shapes along the foot of the cliff. Horizontal wooden beams project out of the outer walls of the dwellings, serving both as footholds for maintaining the structures and also as an additional aesthetic pattern. Buildings are covered either with flat mud roofs or conical thatched roofs.

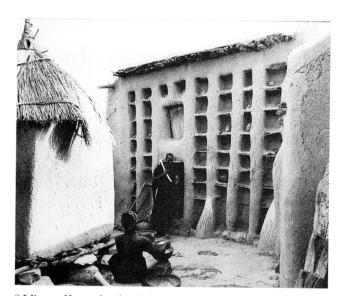

8.5 Dogon House, facade, adobe brick. The Brooklyn Museum, Photo Labelle Prussin.

As mentioned before, Dogon architectural design is both functional and symbolic. Figure 8-5 shows the house of a lineage leader made of adobe (baked mud bricks). It is designed to be the political and ritual center for the clan's activities. The house is two stories high, with a ground-level door in the center that serves as an entry to the leader's living quarters. The second floor contains a granary for common use by the clan, and is accessed through a shuttered window you can see just above the door. Outdoor rituals take place on the flat roof on top of the house, where masked dancers perform and where sacrifices and offerings to ancestors are made on an altar. As fitting a structure that serves so many important purposes, the leader's house is distinguished from other dwellings by its larger size and its outside decorations. The façade is covered with a pattern of horizontals and verticals that create a series of niches. In the sunlight, this creates a dramatic pattern. The checkerboard is important symbolically to the Dogon, as it represents to them the ideal human order, and the organized nature of human society in general. The grid not only appears in architectural decoration, but also in the Dogon weaving, sculpture, and even the pattern of their plowed fields. Basic shapes are also symbolic to the Dogon, as spiral and curvilinear forms represent the supernatural world, in contrast to horizontal and vertical forms that, as we have seen, symbolize the human world.

Text Link

The grid as an organizing structure is evident in the Dogon Granary Shutters in figure 6.7. Another example of Dogon art is the sculpture of the Primordial Couple in Chapter 7, figure 7.14.

Dogon building styles are part of a long architectural tradition. They evolved from the architecture of the great empires that existed in the past in the Sudan, which are now known primarily through oral tradition. These traditional elements consist of the emphasis on verticality, the use of pinnacles, the elaborate façades with an emphasis on pattern. All of the aforementioned characteristics are evident in Dogon structures. Architecture from the past did not survive because so much of it consists of adobe construction, which requires constant maintenance or else the weather causes its disintegration in a relatively short time. There is a certain ecological efficiency to the use of adobe in dry climates, as unneeded buildings eventually recycle back to earth.

Twentieth-century group living

The idea of group living once again has become an attractive or even necessary idea in the late twentieth century, but for different reasons than for our early ancestors. Architects and planners are reconsidering

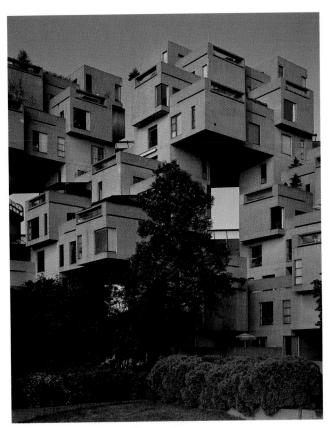

8.6 *Habitat* designed by Moshe Safdie, for Expo '67 in Montreal, Canada. Photo by Russell Thompson. See also the text accompanying figure 3.25.

group housing because of population growth, shortages of land, energy costs, traffic gridlock, and the lack of a sense of community within large cities. The example we are going to look at is called *Habitat* (figure 8.6), by the architect Moshe Safdie, originally from Israel but now living in Canada. Safdie was influenced in his thinking by his study of the North Pueblo in Taos, New Mexico, a pueblo still in use today that was likely built by the descendants of the Anasazi. Safdie was struck by several features of the pueblo: 1) it was energy efficient, because of its stacked design and shared walls; 2) it was climate oriented, which meant that it was sited to take best advantage of the available natural resources; and 3) it was designed for comfortable living for a large group of people in a relatively small space.

Safdie then went on to design stacked modular housing that would be an alternative to the two main styles of urban living: the single family houses on small lots and high-rise apartment building. Safdie saw both of these existent housing styles as flawed. The single family house created a vast, unwieldy urban sprawl of cookie-cutter houses, while the high-rise apartment was totally impersonal and gave its occupants no access to the land. In *Habitat*, Safdie wanted to create low-cost housing that minimized land use, and provided privacy and individualized living within a group setting. *Habitat* is composed

of mass-produced, prefabricated apartments. Each unit is like an individual building block that can be stacked and arranged with other blocks to create many unique configurations. With careful planning, the arrangements would allow for private living within a dense group. Each unit could also incorporate nature elements. One person's roof is another's garden or walkway. Safdie himself said, "For everyone a garden." Covered parking was incorporated into the total design of the building.

Looking at *Habitat*, you see a rectangular module, a window design, and a stacked look that are all taken from the pueblo design. *Habitat*, however, is also the product of twentieth-century modernism. The emphasis on simple geometric shapes, the lack of ornamentation, and the resemblance to modern abstract sculpture are distinctively modern features of Habitat.

Text Link
See David Smith's abstract sculpture, Cubi
XXVI (figure 19.31) for an example of
the modern aesthetic realized in sculpture.

Habitat was built for display at Expo '67, the World Exposition held in Montreal in 1967. The units were pre-

fabricated and assembled on site. *Habitat* won Safdie world acclaim, and he went on to design a 300-unit living cluster in San Juan, Puerto Rico, a 4,500-housing unit in Israel, and a student center at San Francisco State College, where individual hexagonal units could be rearranged even after their original assembly. Safdie also wrote an influential book called *Beyond Habitat* (1970), in which he wrote persuasively for the design of a "housing machine" in which all persons could structure their own dwelling to suit their needs and tastes.

INDIVIDUAL HOMES

Now let us look at the development and design of individual homes. We will start by looking at a collection of houses that show the influence of Greek Classicism, then turn to traditional house examples from China, Southeast Asia, and Peru, and conclude with a modern example from the United States.

Influences of Classicism

Our first example of Classical housing is from the Greek city of *Priene*, on the west coast of Asia Minor near Miletos (modern Turkey). In the fourth century BC, after the city was destroyed by the Persians, the Greeks rebuilt Priene according to a plan designed by Hippodamos (figure 8.7). Hippodamos' plan imposed a strict grid upon the site, regardless of the natural terrain. All streets meet at right angles, in a system called orthogonal planning. In Hippodamos' plan, separate

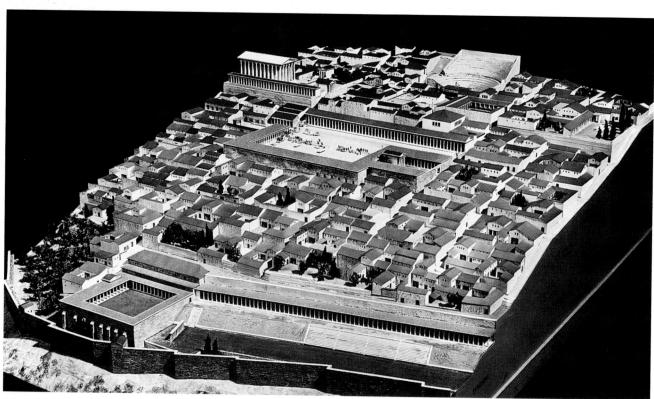

8.7 Model of city of Priene, Greek, fourth century BC, Asia Minor. Bildarchiv Preussischen Kulturbesitz, Model—Staatlich Museen, Berlin.

quarters were provided for public, private, and religious functions, which the Greeks considered a "logical" plan. This represents a significant change from the examples we have just seen above, where public, private, and religious functions tended to be more integrated in communal living quarters. To the Greek mentality, civilization imposed an order upon nature, and part of that order was to assign a proper place to various constituent part of the city within the entirety of the city plan.

Text Link

We can see this same imposition of order when we look at other concurrent Greek works of art, such as the sculpture Doryphoros in Chapter 15 (figure 15.12), or the façade of the Parthenon in Chapter 10 (figure 10.15). Each work conforms to a set of ideal mathematical proportions that was believed to be aesthetically superior to other sets of relationships.

The city of Priene was laid out on a slope. To retain the grid plan, some roads had to be transformed into stairways to get up and down the steepest parts of the slope. Each city block was uniform in size. The city center was the open square called the "agora," used for meetings and as a marketplace. The agora was bordered by covered walkways with columns, called stoas. Behind the stoas were offices and shops. Six blocks were reserved for temples and theaters. Even the population of the city was planned, as 10,000 was considered an ideal number of people living in a city this size.

Most of Priene was composed of blocks devoted to individual houses. The houses were rectangular in plan, and thus fitting into the overall grid of the city. The typical house had a single entrance from the street that led to a central court surrounded by roofed rooms. In wealthier homes, the court was paved with pebble mosaics and framed by a colonnade, called a "peristyle." This court was the center and the focus of the house. Exterior windows were rare, as adjoining houses shared exterior walls. All natural illumination came through the court, as well as rain water, which was collected and stored in cisterns underground. Most houses had a kitchen with a nearby dining room that opened onto the court, as did the bedrooms. The dining rooms were equipped with couches where men ate while reclining.

We will look next at an example of a Roman house in the first century AD that was designed for elegant living for the wealthy classes. (The less wealthy generally lived in multistory apartment buildings.) The *House of the Vettii* from the city of Pompeii was an older house that had been damaged in an earthquake in AD 62, and had been remodeled and repainted after that time. The house was owned by two brothers, Aulus Vettius Restitutus and Aulus Vettius Conviva, who were proba-

bly wealthy merchants. There were two safes in the atrium. The *House of the Vettii*, as well as the rest of Pompeii, was buried in volcanic ash in the tremendous eruption of Mount Vesuvius in AD 79. What we see now of the *House of the Vettii* is a restoration, with the atrium reconstructed, the garden replanted with vegetables and flowers, and marble furniture back in place (figures 8.8 and 8.9).

The exteriors of wealthy Roman houses were rather plain, giving no clue to the rich and palace-like interiors. Once inside, the visual delights of the *House of the Vettii* are many. Like the Greek house, the Roman house was punctuated by open spaces that brought fresh air and light into the center of the house. Older styles of Roman houses had the front atrium with a pool for collecting rainwater called the "impluvium." After the second century AD, the Roman houses also had a Greek-style garden in the back, surrounded by a peristyle. The walls of the peristyle were covered with paintings, and the garden was furnished with marble tables and fountains. The plan of such a house is shown in figure 8.10. The Roman house was organized symmetrically around an axis that

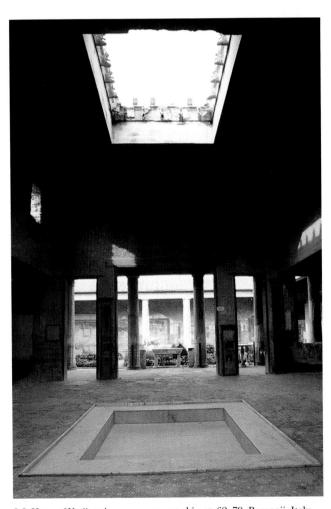

 $8.8\ House\ of\ Vettii,$ atrium, reconstructed in AD 62–79. Pompeii, Italy. Naples Archaeological Museum.

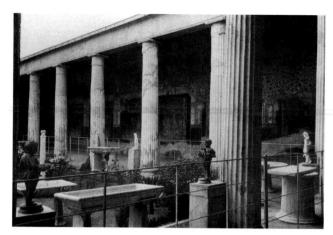

8.9 Peristyle Garden, *House of Vettii*. Pompeii, Italy. AD 62–79. Naples Archaeological Museum.

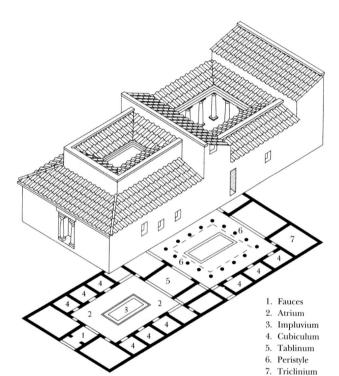

8.10 Plan of House typical of Pompeii, Italy. Illustration—Verlag, M. Dumont, Schauberg.

ran from the entrance to the back of the house. This alignment meant that the garden was in line with the atrium pool, providing a succession of lovely views and illumination throughout the house.

The floors and walls in a wealthy Roman house were faced with mosaics or murals. Wall paintings such as the *Goldsmith Cupids* (figure 8.11) are of the Fourth Style in Pompeiian paintings, in which walls were covered in an exuberant way with a variety of painted scenes and decorative details. In this style, many of the scenes are of mythological subjects, and were likely influenced by Greek paintings. Our example shows the wall paintings of amoretti or cupids. These young winged figures are

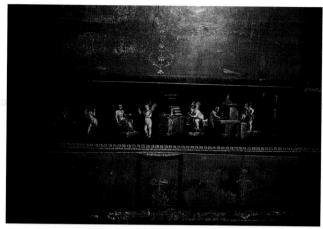

8.11 Goldsmith Cupids. Wall decoration in the House of Vettii. Pompeii, Italy. AD 62–79. Naples Archaeological Museum.

engaged in everyday occupations, such as goldsmithing, harvesting grapes, attending the wine market, selling oil, etc. The pleasant activities, curved branches of plants, friezes, and columns make for delightful wall coverings.

Text Link

You can see examples of Roman floor mosaics in Chapter 13, War and Peace, with the scene of Alexander the Great Battling Darius of Persia (figure 13.20) and again in Chapter 6 on Food, the mosaic called Scraps of a Meal. (figure 6.20).

As mentioned before, the less wealthy in Roman society lived in multistoried apartments, called "insulae." As the empire expanded, cities grew along with their populations. To meet housing needs, vertical apartment complexes were built, some reaching six stories high. Some apartment ruins have been found in Ostia and Herculaneum dating back to the third century BC. The structures were usually built of unfaced brick with occasional wood balconies. Externally they appeared bare with little or no ornamentation. The small flats were accessed by courtyards or from the street through a stairway often located between shops, much like some apartments in modern cities today. An apartment might include as many as five or six rooms connected by a wide central corridor. The corridor might have an arcade on one side opening to a small garden. Unfortunately, the apartments were cramped, often in poor repair, and structurally unsound, making them prone to fire and cave-ins. The tenements were stifling hot in the summer and bone-chilling cold in the winter. Only a small brazier supplied heat and of course there were no sanitary facilities. But there was housing, as uncomfortable as it may have been, within the protection of an often walled Roman city.

Text Link

In the Roman Empire, even the poor had access to public baths. Look to figure 18.6 to see how the rich enjoyed their luxurious bathhouses such as the Baths of Caracalla.

Our next example of domestic architecture is the Villa Rotonda, a sixteenth-century Italian house influenced by Greek and Roman designs. The house was designed by Andrea Palladio, a stonemason and decorative sculptor who turned to architecture at age 30 and eventually became the chief architect of the Venetian Republic. Palladio was responsible for designing churches, public structures, and houses, all in his version of the Greco-Roman style, which he studied in the ancient buildings in Rome. He wrote The Four Books on Architecture (I quattro libri dell'archittectura) published in 1570, which promulgated his ideas. He wrote of symmetry and stability as controlling elements of architectural design, echoing Renaissance philosophers who promoted the principles of clarity, symmetry, and order. His writings were to have far-reaching effects, influencing Neo-Classical architects in Europe and the United States in the eighteenth century. Thomas Jefferson in the United States was very influenced by Palladio, as we will see in the next few pages.

The *Villa Rotonda* (figure 8.12) reflects Palladio's ideas on architecture. It has a centralized plan, with 32 rooms and four porches, all perfectly symmetrical. A center room, the rotunda, is dome covered. All four façades are exactly alike, with an Ionic portico project-

ing out over a steep flight of steps, very much like a Roman temple or even the façade of the Parthenon (figure 10.15). Each porch provides a different view of the landscape, along with cool breezes that were vital to personal comfort in the summertime. Built up on a platform, it dominates the surrounding countryside. All parts of the building are worked out in mathematical relationship to the whole. We see geometry and symmetry in the plan (figure 8.13); it is a circle inside a square inside a Greek cross. The resulting building is very harmonious and orderly. It represents Renaissance principles of orderliness, hierarchy, and clarity applied to domestic architecture for the wealthy. For the Villa Rotonda, like other Renaissance villas, was a gentlemen's farm, essentially a social retreat and a monetary investment for the wealthy. The Villa Rotonda itself was built for a wealthy retired monsignor who wanted it for social events.

Classically inspired architecture reappeared in Europe and the United States during the Neo-Classical movement in the late eighteenth and early nineteenth centuries. A variety of circumstances brought this into being. First, the buried city of Pompeii was rediscovered and excavations began during the 1730s and 1740s, creating a fascination among Europeans with Roman architecture and painting styles. However, other styles were equally popular. The Romantic movement was very forceful in Europe at that time. Romanticism brought with it an absorbing interest in anything exotic, which included at that time a taste for Gothic architecture and Chinese architecture (see Han house model), as well as Classical architecture.

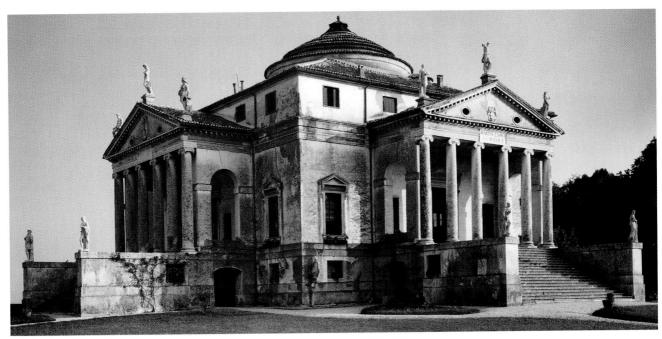

8.12 Andrea Palladio. Villa Rotonda. Vicenza, Italy, 1552. Alinari/Art Resources, New York

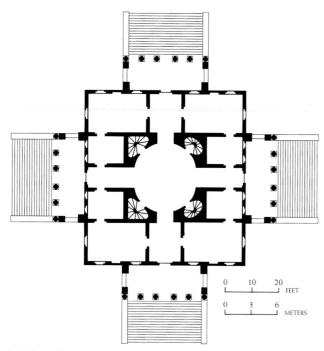

8.13 Plan of the Villa Rotonda by Palladio.

Text Link

The classic Gothic architecture is seen in European cathedrals such as Chartres. Look to the text accompanying figure 10.25 for more information on Gothic architecture.

At first, all these styles of architecture seemed equally exotic and equally fascinating to the European mind during the Romantic era. In the late eighteenth and early nineteenth century, Neo-Classicism persisted, but it came to have a wide range of values attached to it, depending

upon who was using it. Classical architecture came to mean revolutionary change, as seen in Jacques-Louis David's Oath of the Horatii; democratic fairness and equality, as seen the U.S. Capitol building; imperial ambitions, as seen in the façade of the British Museum in London; and absolute authority as exemplified by new buildings constructed in Paris under the rule of Napoleon Bonaparte. Neo-Classicism also reflected its Classical roots in the redesign of the plan of Paris and the plan of Washington, DC, a classical city plan designed by the French-American architect Major Pierre L'Enfant in 1791. Echoing Hippodamos from 23 centuries earlier, L'Enfant designed Washington, DC, to have an orderly layout of streets and clustering of public buildings. This plan was strongly endorsed by Thomas Jefferson, then secretary of state of the young United States of America.

Text Link

Turn to Chapter 17 and figure 17.23 for more information on the Oath of the Horatii. The British Museum is discussed in Chapter 21, figure 21.15.

Thomas Jefferson, then, was a supporter of Classical architecture and design. The façade of his home, *Monticello* (figure 8.14), was influenced by Palladio's *Villa Rotonda*. Jefferson, however, was never a slavish follower of Classical architecture. He was an innovator who saw Neo-Classicism as a new architecture for a new country. The porch, steps, columns, and dome resemble Palladio's designs, and the adherence to a symmetrical plan reflects Palladio's ideas. However, Jefferson's depar-

8.14 THOMAS JEFFERSON. Monticello. Virginia, USA, 1770. Photo copyright Alvin E. Staffan/Photo Researches, Inc. See also the text accompanying figure 22.7.

tures from Palladio are also evident. *Monticello* is not built of stone, but of Virginia brick and wood. The central core of the house is as compact and balanced as a Palladian design. However, there are two utility wings dropped below the grade of the rest of the house that contain service rooms, storerooms, cellars, out chambers, stables, carriage house, smoke house, and laundry. These below-grade wings form terraces and walks from which the countryside can be viewed. Overall, then, the shape of *Monticello* was a broad U.

Thomas Jefferson had many talents. He was an inventor, diplomat, political leader, botanist, educator, farmer, architect, and author. He wrote the Declaration of Independence. He was also a person of contradictions; he was a slaveholder who denounced slavery. He was always in debt. He was taken with new ideas, and changed his mind sometimes on projects in progress. His home, *Monticello* (the name means "little hill" because the house is located on a small hilltop), was begun in a completely different style, but Jefferson changed it once he encountered Palladio's writings. Although he started it at age 24 and worked on it for decades, Jefferson never finished Monticello.

Jefferson's inventiveness is evident throughout Monticello. The bedroom alcoves open for better ventilation. Jefferson's own bedroom contained both a dressing room and a study. He invented a dumbwaiter that came up from the wine cellar. Other inventions at Monticello include: a wind device to show direction and velocity; folding glass doors; a private toilet that could be removed for emptying through a tunnel on a cart; and a wall clock that recorded the days of the week and the time of day, with cannonball weights that moved down the wall through the first floor and the cellar to mark the days. He had a garden house to grow many varieties of vegetables and flowers, and a pond for fresh fish. The entrance of Monticello was like a museum, with a Mandan buffalo robe from the Lewis and Clark expedition of 1804-1806, busts, fossil bones, and mammoth tusks. Obviously Monticello was more than just a home to Jefferson. In fact, Jefferson saw Monticello as kind of retreat, a spiritual center away from the stresses of political life. He called the space under the shallow octagonal dome his "sky room."

Traditional homes

If we take a look back at the various Classical and Classically inspired houses we have just seen, we notice a emphasis on centralized designs, symmetry, and geometric shapes. But obviously these houses comprise only a small part of the world's architecture. In this section we will see several examples of houses that are built according to traditional styles within their own cultures. They contrast dramatically with Classical architecture. Thus, we will start with a house from China, with designs that emphasize verticality, extensive external decora-

tion, and use of timber construction rather than stone or brick. From both China and Indonesia, we will see houses in which the roof is the most distinctive feature, unlike Western dwellings where the roof is a more standardized and less distinctive. Finally, we will see adobe houses from the Moche civilization in Peru, and a tipi from the Plains peoples of North America.

Let us start with traditional Chinese house designs from the Han Dynasty, which spanned from approximately 200 BC through AD 200. While civilization in China goes back at least until 1500 BC, China was fragmented into many separate feudal territories, so there was no unified architectural style for its buildings at that time. The first emperor of China, Shi Huangdi, developed the first Chinese architectural style, as he had built many pleasure palaces that were amalgams of the various older feudal styles. Wealthy Chinese in the Han Dynasty, which arose after Shi Huangdi's death, built homes that were more modest versions of his palace designs. Han houses were all wood frame, and none survived. However, we know a great deal about them from ceramic models that were buried in tombs, along with ceramic models of granaries, well heads, and other rural structures, probably put there to recreate on a smaller scale the living world.

Text Link

The first emperor of China, Shi Huangdi, conquered the feudal lords, unified China, performed great military feats, and undertook an ambitious building program, which included the Great Wall of China (figure 13.16), covered in Chapter 13. When he died in 206 BC, he was buried in a lavish tomb that contained an underground palace, richly furnished as if for a living emperor, which we cover in Chapter 11.

The ceramic homes found in Han tombs show a welldeveloped architectural style, based on the design of imperial palaces. The typical Chinese house for the wealthy consisted of large multistoried halls, each story slightly smaller than the previous one. Large roofs with wide eaves cap each level, adding a horizontal emphasis to what is basically a vertical structure. Balconies encircled the house. Houses were highly decorated, with bright colors, and sculpture and painting in and on the houses. Precious materials such as gold and jade were used also as decoration. In such a house, the lower wood posts would have been finished in red lacquer, offset by white walls, with gilded doors. Roof tiles and finials would have been finished in bronze. The upper wooden surfaces featured variegated patterns. Inside, wall paintings would have illustrated Daoist fables and Confucian moralities. All this was done with floral designs in brilliant colors.

8.15 House Model. Ceramic, Han Dynasty. 3rd century. China. Nelson Gallery of Art and Atkins Museum, Kansas City.

Our Han Ceramic House Model, which dates back to third century AD (figure 8.15), shows a humbler home than the most lavish of palaces. It represents a multistoried wooden building adorned with tiles, built in a style more common in northern China. The multistoried houses may have served an additional function of a watchtower. The average rural house (especially in Southern China) generally had one or more courtyards, where household and farming chores could be carried out. Even this humbler house boasts wide roofs and the rich, ornate designs typical of the Han Dynasty. Floral designs, geometric patterns like trellises, and cloud patterns abound. The structure itself was a timber frame house, with tall wooden pillars supporting a thatched or

tiled roof. Walls were non-load bearing. They were made of brick, compressed earth or mud, and therefore were vulnerable to rainfall. The wide projecting roof eaves that became so distinctive of Chinese architecture, then, are both aesthetic and functional, as they protected the earthen walls from the elements. The eaves were supported by an elaborate wooden bracketing system that could be very ornate. The bracketing system reinforced the cantilever, which is an extended horizontal beam over vertical supports. The system was perfected in the tenth century in the Tang Dynasty and an architectural manual was written in the eleventh century documenting the aesthetics of wood construction. Molded designs often were featured on the ends of roof tiles that

complemented the exquisite wood framework in Chinese architecture.

Distinctive wooden houses were built not only in China but also in Indonesia. Like the Chinese houses, the Indonesian dwellings were typically painted with lavish designs and were capped by very distinctive roofs. Subgroups of peoples in Indonesia developed their own house styles, each visually striking. For now, however, we will look at the house designs of the Batak people.

The Indonesian climate is an important factor in their housing design. For example, the island of Sumatra is divided by the equator. Rainfall is particularly heavy from October through May, but indeed rain falls year-round—there is no dry season. Dense rain forests that once covered all the islands of Indonesia have been cleared somewhat from the more populated areas like Sumatra, but vegetation is still very thick in much of the country. The heavy rains and equatorial climate mean that the weather is consistently very warm and humid all year long. Mosquitoes and other insects are a problem.

Traditional houses in Indonesia are all distinguished by very steep roofs that shed the heavy rainfall. Roof shapes were developed when roofs were all made from some thatched material, such as grasses and palm fronds. It was necessary to make steep-pitched roofs so that the rain did not soak into the thatch and rot it, but rather ran off as quickly as possible. Overhanging eaves keep the rain away from the house, and shield the generous windows. We can see the extreme roof slope in the façade of the *Toba Batak* house (figure 8.16) a house built by the Toba subgroup of the Batak people. When seen from the side, the roof line is highest at each end, and swoops downward at the center in a gentle curve.

Besides the roof, other identifying features include the three-level design and the elaborately painted railing and gable. The middle level is a living and working area, while the top, beneath the gable, is used for family treasures, religious items, and food stores. The bottom level of the three consists of the stilts that raise the house above ground level. By raising the house on stilts, breezes enter the windows, the floor stays cooler and sleeping people are kept out of the worst of the mosquito activity. In times of conflict, the stilts make the house more secure. Sometimes pens for animals are built on ground level between the stilts.

Huge thick hardwood tree trunks form the stilts and upright supports for the Toba Batak house, necessary because the large thatched roof weighs so much. Walls, by contrast, which are non-load bearing, are often made of soft woods such as bamboo or coconut. The Toba Batak house stilts sit on stone foundations, but are not anchored into them. Also the entire house flexes, as beams are pegged into each other instead of being nailed together. Both of these features are of great advantage in an area beset by frequent earthquakes. During a tremor, the house can move without being

damaged. The A-shaped house is fairly cramped inside. Most people spend the bulk of the day outdoors, so the house is used mainly for storage and for sleeping.

In addition to the practical features of the Toba Batak house (as we have just seen above), the structure also has symbolic meaning, as do traditional houses throughout Indonesia. The internal spaces are seen as being maternal, as a womb. The house is seen as a "transformer (that) tames the terrifying vastness of the universe and at the same time inflates human concerns with cosmic grandeur" (Richter 1994, 57). The posts and lintels are male and female, while the house itself is likened to a human body: Stilts are likened to legs, the roof to the top of the head, and the trapdoor entrance of the house is the navel. On a cosmic level, the three levels are like the upper, lower, and middle worlds of the Indonesian universe, and on a social level, the three levels of the house are likened to the social hierarchy separating slaves, commoners, and nobility (Dawson 1994, 14). The house

8.16 Decorated facade of *Toba Batak* House. Sumatra, Indonesia. Institut Voor de Tropen, Amsterdam. See also the text accompanying figure 3.26.

8.17 Singha Protective Figure, for Batak House, Sumatra. Metropolitan Museum Collection, New York.

functions spiritually also, holding the family's sacred items. House posts had to be set in a certain way to avoid offending the spirits believed to be in the trees.

While some traditional Indonesia houses are left plain, other houses are highly ornate. Toba Batak houses are carved and painted with black, white (lime), and red ocher pigments. Many designs are interlocking curlicues, but others are figurative, such as rounded breasts, or lizard earth spirits. A mythological protective figure called a "singha" (figure 8.17) also appears as ornamentation. The singha is a composite beast that is part lion, serpent, buffalo, and lizard. These protective figures are

found on the gables of houses. They have heavy, blocky features with staring eyes surrounded by concentric circles. Curvilinear patterns usually surround the head. The heads are large so that they appear heroic, and the bold pattern gives them a dynamic feeling.

Text Link

Other cultures, including the Olmec of Mexico, have developed fantastic composite creatures that function like the singha with protective or supernatural powers. See the Olmec Relief, figure 19.1.

Traditional houses are still being built in rural Indonesia, but modern homes are constructed in the growing cities, where the population has developed a taste for modern conveniences and televised entertainment. Even in traditional villages, tin roofs have replaced the thatch and indigenous religions are superseded by Christianity and Islam. Yet even in modern houses, various tribes such as the Batak still produce traditional carvings, hold onto some indigenous religious beliefs, and maintain ties to traditions in village life.

As we have seen in Indonesian houses, many aspects of housing designs are the result of climate conditions. This is true also for housing designs in other parts of the world. The houses from the Moche civilization from coastal Peru also reflect climate concerns. Like the Han houses, we know about the Moche houses from ceramic models found in tombs. The Moche House Model (figure 8.18) shows four terraces, with a wide vestibule or hall built over the third terrace and the house proper over the fourth. The adobe house was elaborately painted, here in red and white, with primarily geometric patterns. The painted stair step designs match the cut-away portion of the wall. Coastal Peru has a desert climate, where rain falls only once every ten years. In this climate, humans do not need protection from rain, but rather only from winter winds and heavy sea mist. The cut-away wall provided ventilation during the midday heat, in addition to lighting the interior. The steep-pitched roof was also typical, with vents just below the highest part of the roof that would be oriented towards the sea to catch the cooler marine breezes. Some ceramic houses show courtyards attached to the house, where apparently animals were kept.

Moche houses were decorated, as we have seen. Our example shows geometric designs, but others sported images from nature such as shrubs, trees, turkeys, ducks, guinea pigs, llamas, shellfish, dogs, and maize. Designs were usually painted in red. Houses were apparently painted to the fancy of the owner. The roof line was often adorned with a serrated edge or roof combs.

Text Link

The roof combs are similar to the Mayan architectural style. See Chapter 12, figure 12.14, for more on Mayan architecture.

Moche adobe houses were made from readily available local materials. Foundations consisted of long bundles of marsh reed or willow branches, onto which was poured a liquid adobe cement. The walls were massproduced adobe bricks, composed of mud mixed with wetted grass, trampled and left in the sun until it soured. Molds were used to shape this mixture into bricks that were then sun-dried. The interior of Moche houses were

simple. The hearth consisted of a large stone and a hole in the ceiling for venting smoke. Beds were raised mud platforms with straw mattresses, topped with wool and cotton bed linens. Houses varied in size according to the status of the owner. The house of the ruler of a valley would be a "great dwelling with many pillars of adobe and great terraces and gateways and surrounding his house was a wide square" (Hagen 1965, 55).

If housing design can be shaped by climate concerns, it can also be shaped by historical necessity. Our next example of shelter is the movable house, the Tipi (c. 1880) of the Native Americans (figure 8.19). For thousands of years, the Native Americans of the Eastern Woodlands, Great Lakes, and Mississippi areas had been stable populations who hunted and gathered food for their livelihood. With the coming of the Europeans, these peoples were displaced from their homelands, and for a short time lived like nomads on the Great Plains. During that nomadic period, they lived in tipis. The tipi was originally a small tent, developed by Plains peoples for temporary use during their hunting season. Early tipis were carried or pulled by humans or by dogs. When later the tipis were used year around by nomadic peoples, they were built on a much larger scale, as big as 25'

8.18 *Moche House Model.* Ceramic, red and white paint, c. 1000–500 Bc. See also the text accompanying figure 3.1.

8.19 North American Sioux *Tipis*, decorated with equestrian warrior figures, c. 1880s. For more information, see the text accompanying figure 22.11.

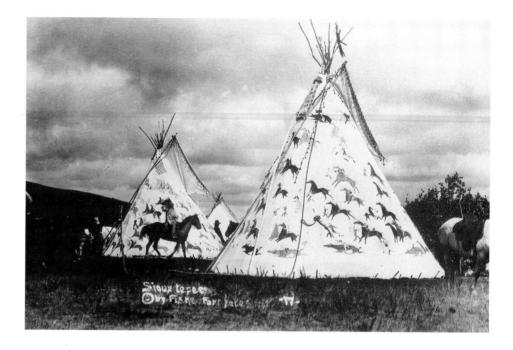

high. Since Europeans had introduced horses to North America, it was possible to move the larger tipis when necessary. Different tribes developed different styles of tipis, with the Crow having the tallest version, while the Cheyenne tipis were low and squat.

The framework of the tipi was made of slender poles. Animal skins, buffalo hide, or canvas covered the framework on the outside, and many also had inner liners that had painted decorations. The smoke vent at the top were flaps that could be adjusted to keep out wind or rain. Tipi covers and liners were often painted. Before the 1830s, the imagery consisted of stiff figures. Eventually the Great Plains artists adapted European styles of painting, and showed scenes of nature or war. The artists likely depicted the tipi owner's own adventures in war.

Modern U.S. homes

The single family house has long been a standard feature of U.S. domestic life. *Fallingwater* (1936–1938), figure 8.20, is arguably the most famous modern house in the United States. It was designed by the architect Frank Lloyd Wright for the wealthy Kaufmann family from Pittsburgh as a weekend home in the woods on their property near Connellsville, Pennsylvania. The Kaufmanns chose the site and the architect because they wanted a house that would give balance to their lives, between their everyday urban existence and returning to live with nature at *Fallingwater*. Everything about the house was meant to merge into an organic whole with its natural setting.

The house is a series of geometric blocks, some vertical but most horizontal, that sit low to the ground in an almost sprawling design. The house is built on a large

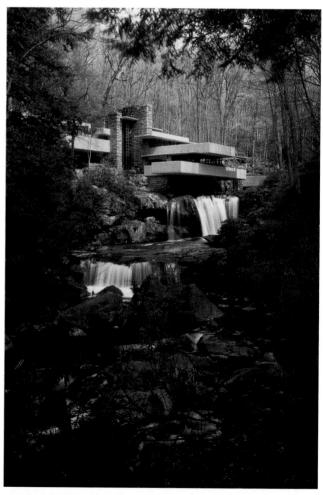

8.20 Frank Lloyd Wright. *Fallingwater*. Kaufmann House. Connellsville vicinity. Pennsylvania, USA, 1936–1938. For more information, see the text accompanying figures 3.16 and 22.12.

boulder that acts as the base of the central fireplace inside the house. The stones in the walls were taken from nearby quarries. Decoration was eliminated from the exterior of buildings, although the contrasting textures of stone and concrete give variety and distinction to the outside. The house is arranged to allow maximum sunlight inside, with long bands of rectilinear windows that frame views of the surrounding trees. One distinctive feature of *Fallingwater* is its porches, which overhang the waterfall called Bear Run. They contribute to the house's elegant, geometric, and horizontal appearance.

Fallingwater shows much influence from Japanese and Chinese architecture. For example, the porches are reinforced concrete cantilevers, which are beams or slabs extending beyond the vertical support below, giving the appearance of floating. Interestingly, neither Kaufmann nor the engineers responsible for the building of Fallingwater trusted Wright's cantilever design. They had extra reinforcing steel added to one of the cantilevers during construction, and it now droops due to the heavier weight. The cantilever was widely used in Chinese and Japanese architecture, where wide roofs and balconies projected out over their vertical supports (figure 8.15). In the Chinese example, the cantilever consisted of a series of stacked horizontal brackets that extended beyond the vertical post. Also, like much of the traditional domestic architecture of Asia, the walls in Fallingwater are not load-bearing, but act as privacy screens. The weight of Fallingwater's roof is held up by a timber framework hidden by the walls. Also from Japan was the idea of a flowing interior space, where walls were eliminated between rooms and windows were enlarged for greater light from the outside illuminating larger rooms inside.

Text Link
For more information on the Chinese
method of the stacked horizontal brackets
and cantilevers, turn to the text with
figure 3.6.

Frank Lloyd Wright was a highly influential twentieth-century architect. He believed that houses should be unified wholes that meshed well with their natural settings and climates. He thought that materials for home-building should appear as natural as possible and come from the immediate surroundings. He believed that an architect should conceive the entire house in the imagination before ever beginning to work on paper. He is also well-known for his "Prairie Houses," the low horizontal suburban houses in the Chicago area and around

the Midwest. The Prairie houses were unadorned houses with generous eaves (again, the Chinese influence) and spacious interiors that had a great influence on the later development of the very popular ranch house.

Text Link

For more on Frank Lloyd Wright, his architecture, and his ideas, see the discussion of the Solomon R. Guggenheim Museum in Chapter 18, figure 18.5.

COMMERCIAL ARCHITECTURE

Commercial architecture provides shelter for the needs of business, trade, and commerce. We could have drawn from thousands of examples of such structures, but we will confine our discussion here to a few examples of commercial architecture considered to be important milestones in the history of art.

Markets

Our first example is *Trajan's Market* (AD 110–112) figure 8.21, a large enclosed multistoried complex of administrative offices and permanent shops (the equivalent of today's shopping mall). Its design was likely influenced by the enclosed markets of the Middle East called "souks" or "bazars." It was located next to the Forum of Trajan, a public square used as a meeting place and a

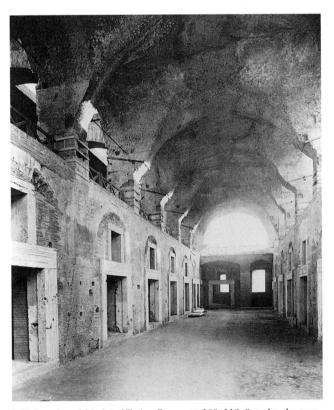

8.21 Interior of *Market of Trajan*. Rome, AD 100–112. See also the text accompanying figure 3.11.

market where vendors would sell goods from temporary booths and stalls. Each shop in *Trajan's Market* was called a "taberna," and consisted of a single wide doorway with a large window on top that gave access to a wooden storage attic above each shop. The upper levels of *Trajan's Market* consisted of long "great halls" with two levels of "tabernas" on each side; the similarity to the modern shopping mall is especially apparent here. The two floors of shops in the great hall were illuminated by skylights, while the main hall itself had large windows under the vaulted ceiling. The market housed more than 150 shops on its various levels.

Text Link

Vaulting is a kind of roof covering made of stone, brick, or concrete, in which great arches are used to span and cover interior spaces. For more on vaulting in general, see the section on "Arches, Vaulting, and Domes" in Chapter 3. Also see the Masjid-i-Shah, figure 10.29, an example of a vaulted building.

The vaulted ceiling met the new fire code that had been put in place after a terrible fire destroyed large sections of Rome in AD 64. Increasingly, concrete was used for large projects. Concrete's potential was first really discovered at this time: 1) it is cheap; 2) it is flexible, and can be poured into various forms, shaped in any way, and is not limited to straight lines and rectilinear forms as was most wood construction; 3) it is fireproof; and 4) its gray surface can be finished with a thin veneer of any material. Brick was one of the less expensive coverings, but marble, stucco, gilding, or mural paintings could be applied for more lavish projects. The interior of the great hall of Trajan's Market may seem a bit drab as we see it in our example, but imagine the impression it must have made while in use. Its gray interior was faced with brick veneer, wares of all kind were on display, and the hustle and bustle of vendors and shoppers filled the space.

The Romans were very innovative in their use of concrete construction. It enabled them to build structures on a scale that had never been seen before. Trajan's Market was built on a very steep slope. The natural terrain is so steep, in fact, that a paved street winds its way through the market at about mid-level. Yet concrete made the large multistoried project feasible. With concrete construction, walls are load-bearing, yet the Romans figured out how to incorporate large windows into even large, complex buildings with heavy vaulted roofs. This is a tremendous accomplishment architecturally. The large arches helped channel the heavy weight of the ceiling down to certain points, that is, to the massive piers. The Roman style of architecture would have been impossible with only wood construction. Wood could not span large interior spaces without internal supports. Wooden structures would not have

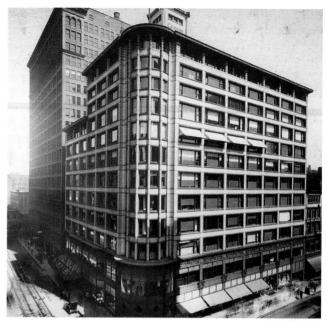

8.22 LOUIS H. SULLIVAN. *Carson Pirie Scott and Company*. Chicago, Illinois, USA. See also the text accompanying figures 3.15 and 22.13.

the massive, muscular, heroic quality that concrete construction had. And wood could burn.

Text Link

Romans were known for their ambitious public buildings, such as the Baths of Caracalla, figure 18.6, the Colosseum, figure 18.26, the Pantheon, figure 10.7, and the Basilica of Constantine and Maxentius, later in this chapter.

Our next example of commercial architecture is a downtown high-rise office building and store, which is probably very familiar to most people living in industrial nations today. It is the modern version of the ancient markets. The Carson Pirie Scott Building, dated 1904, (figure 8.22) was designed by Louis Sullivan, one of the first truly modern architects who designed tall buildings for twentieth-century cities. Sullivan was one of the first to exploit the new design possibilities of steel frame construction, coupled with the invention of the elevator. Iron and steel had been used to reinforce buildings in the past, especially in the nineteenth century, but those buildings had been sheathed in stone or brick to make them look traditional and solid and heavy. The few openly steel constructions of the nineteenth century were not typically office buildings, but were novelty structures such as the Eiffel Tower in Paris. With Sullivan's buildings, the idea of "form follows function" came into being. Essentially, it meant that buildings should not be shaped according to preconceived ideas of what a building should look like, but rather be an

innovative outgrowth of the function of the building and the materials used.

Sullivan thought of buildings as analogous to the human body, which had a rigid armature (the skeleton) with muscles and skin stretched over it. In architecture, that translated into a building with a steel skeleton and walls like a skin stretched over it. (Significantly, Frank Lloyd Wright received some of his early training working in the architectural firm headed by Louis Sullivan.) Load-bearing walls were not needed, unlike *Trajan's Market*, or the *Basilica of Constantine and Maxentius*, which we will see at the end of this chapter, that had 20-foot-thick walls. Height became more important than horizontal space. The builders were constrained only by the limits of steel construction and the difficulty of providing water and elevator service to the highest floors.

Text Link
Review the section on "Steel Frame Construction" in
Chapter 3, the Language of Architecture.

The Carson Pirie Scott Building contained a clothing store on the lower floors. Sullivan introduced the large ground-floor display windows that have become familiar fixtures in almost every retail store in the United States today. Sullivan saw these display windows as "pictures" that should be framed. As a result, Sullivan designed a band of decorative ironwork that frames the windows on the first and second floors like elaborate, ornate nineteenth-century picture frames. That ironwork frieze culminates at the main entrance to the store (figure 8.23), also visible at the bottom center in figure 8.22. The ornamentation was designed by Sullivan himself, with motifs based on the ideas of birth, flowering, decay,

8.23 Louis H. Sullivan. *Carson Pirie Scott and Company*. Chicago, Illinois, USA, ornate decoration. See also the text accompanying figure 3.23.

and rebirth of life. Sullivan believed that ornamentation should be abstracted designs from the organic world that give expression to the structure of the building. At the same time, Sullivan was very aware of modern building practices, where construction workers were relatively unskilled labor compared to the craftsmen who carved and built houses of the past. Therefore, his ornamental designs could be easily cast in metal in pieces, which construction workers simply bolted in place.

The exterior of the upper floors of the Carson Pirie Scott Building contrast with the lower two levels. The upper floors are relatively plain and simple, with each side of the building a regular grid of horizontal windows. The curved corner of the building provides vertical emphasis, with narrower, taller windows. There are no overhanging eaves or cornice to "finish off" the top of the building by providing a visual cap. Rather, the building has the appearance that several more floors, in similar design, could be added right on the top of the existing structure—again, the importance of vertical space. The large windows made visually evident the steel structure underneath by conforming to its grid. Thus Sullivan achieves a greater visual unity between the exterior of the building and its internal structure. The windows themselves are a distinctive design, called "Chicago Windows." They are long and horizontal, with vertical casements on either side. Bands of subtle decoration in white terra-cotta run around the windows, and in strips beneath and above them. All in all, Sullivan's upper window design embodied the notions of clean, functional, simple, and elegant.

Late Twentieth-Century Commercial Architecture

While Louis Sullivan had begun to exploit the new design possibilities in steel frame construction, later twentieth-century architects pushed the possibilities even further. R. Buckminster Fuller was an architectural engineer, inventor, designer, and mathematician, born in Massachusetts, who moved to Chicago as a young man to work in his father-in-law's architectural firm. Fuller developed a philosophy stressing design that results in the maximum gain for the minimum expenditure of energy. Fuller's work has a socially conscious dimension to it. He believed that well guided technology could work for the betterment of peoples all over the world at minimal cost. Thus, he believed that through invention we could "do more with less," thus giving everyone more affordable shelter with more conveniences available to them. He invented the term "Dymaxion" ("dynamic" + "maximum") to describe his ideas. Thus, Fuller looked for combinations of structural units in which there was greater strength in the combination than there was in the separate units. He designed the Dymaxion house, which was a movable house that cost no more than an automobile. The entire house was composed of glass

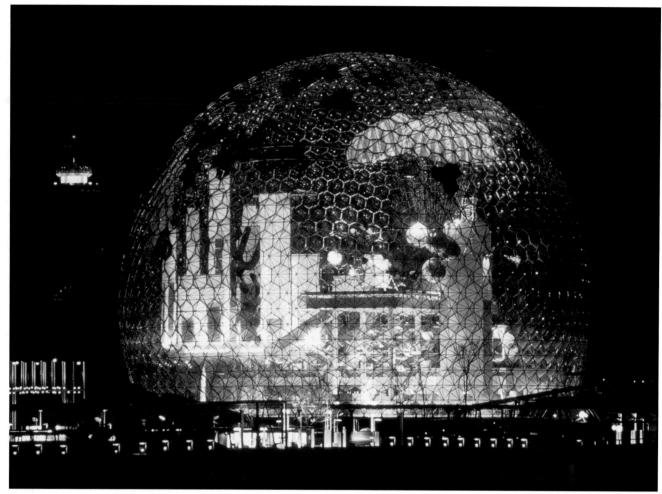

8.24 Buckminster Fuller. Geodesic Dome, American Pavilion. Expo '67, Montreal, Canada. See also the text accompanying figure 3.20.

walls suspended from a single vertical support. It had amenities such as an automatic vacuum cleaning system installed. The three-wheel car capable of speeds of 120 mph was another of his inventions.

Fuller is probably best known for his geodesic domes. With the domes, Fuller used the concept from steel frame construction in which the entire building was held up by a strong, freestanding grid of metal beams. In Fuller's structures, however, the frame was not limited to rectangles. Fuller was much more interested in the possibilities of domes that were lightweight, strong, relatively inexpensive structures composed of basic modules of triangles arranged into mathematically sophisticated tetrahedrons. A tetrahedron is a three-sided pyramid sitting on a triangular base. Depending upon the number of modules used, the domes could be relatively low and flat, or tall and nearly spherical, and could be made to any size. (Fuller even proposed building one three miles across to enclose midtown Manhattan in a climatecontrolled environment.) The domes were efficient in a number of ways: 1) the rounded surface enclosed the largest internal volume within the least amount of "wall" surface, thus saving on materials; 2) the framework was

composed of modular, linear elements that were inexpensive and could be erected in a short time; 3) the multiplication of triangular units created a structure that was very strong against both internal and external pressures; and 4) the framework could be covered with a variety of materials, such as glass, plastic, cloth, wood, or paper.

Fuller's design for the U.S. Pavilion at Montreal's Expo '67 (figure 8.24) was built along with Safdie's Habitat. The pavilion was a very tall, nearly spherical dome 250 feet in diameter, which created a dramatic silhouette. Lit from the inside at night, it glowed like an otherworldly orb. A visually striking structure, the U.S. Pavilion gained enormous attention for Fuller's ideas. The tight network of metal rods forms a kind of spherical grid that absorbs and almost equally distributes stress throughout the entire structure. Because the dome is self-supporting, the internal space is completely open and free of internal supports. This means that the internal space can be configured in any way desired. More than just an efficient structure, however, the geodesic dome came to be a symbol for twentieth-century innovation and progress. Its unusual shape came to represent new ideas in architecture, while its emphasis on geometry and its use of the flexible metal framework made it continuous with the innovations of Sullivan's *Carson Pirie Scott* Building.

Geodesic domes have been used in a variety of ways, as factory buildings, greenhouses, mobile living units for the U.S. Army, experimental "biospheres," and research stations, especially in the harsh Arctic climate where strong, easily assembled, climate-controlled buildings are absolutely necessary. Domes never became popular for businesses or homes, although the steel-frame construction and emphasis on geometric forms continued to shape the aesthetic of twentieth-century architecture.

The rectangle continued to dominate recent architectural design for modern office buildings which were often spare, rectangular shafts of steel and glass that rose from street level plazas. Ornamentation of any kind was avoided in these late twentieth-century structures, so large buildings were often one simple, geometric shape. Such buildings are examples of the International Style, so called because of its prevalence throughout the world. A visit to the downtown of any large city will provide you with multiple examples of International Style buildings. One of the most influential architects of this twentieth-century style, Ludwig Mies van der Rohe, summarized this aesthetic with the phrase "less is more." The unadorned, simple, geometric style was seen as new, modern, heroic, and even utopian, as architects sought to transform the urban centers with functional forms.

However, within a few decades, there arose a resistance to the International Style, which came to be characterized as sterile and oppressive. The International Style came to be modified in a number of ways. For example, a variation on the rectangle is evident in the Bank of China dated 1989 (figure 8.25), by the architectural firm of I.M. Pei and Partners. Many shapes of the Bank of China were based on triangular shafts. In Pei's design, the square base of the building was divided into four equal triangular sections. The skeletal support for the building is innovative, composed of four massive columns at the corners of the square and a fifth, central column that begins on the 25th floor. The load from the upper floors is transmitted diagonally to the corner supports at the 25th floor. Certain aspects of Pei's design were necessitated by the location of the Bank of China in the beautiful, mountain-ringed harbor of Hong Kong, where high winds and severe earthquakes are common. To make a more stable building, diagonal braces were added to the skeletal frame. Rather than hide the braces, Pei makes them an important part of the overall triangular and diagonal basis of his design.

The exterior of the *Bank of China* is gray anodized aluminum with reflective glass windows. It has an arched north entrance with a wide plaza, while the other sides feature landscaping. The interior features a vaulted lobby of white and gray granite and marble. The lower

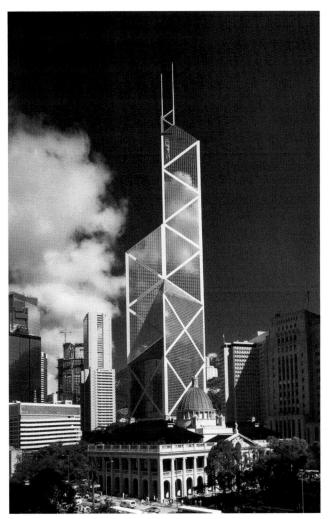

8.25 I.M. PEI AND PARTNERS. *Bank of China*. Hong Kong, 1989. See also the text accompanying figures 3.19, 4.3, and 22.6.

floors surround a twelve-story high central atrium. The top floors feature spectacular views, with dining and entertainment establishments. At the time of its construction, the *Bank of China* was the tallest structure in Hong Kong and in all of Asia, rising 70 stories tall.

I.M. Pei was an extremely important modern architect who was born in China but emigrated to the United States in the mid-1930s. In his designs, Pei was inspired and influenced by the structure of bamboo, a hollow plant that grows in sections, each thinner than the one below. Bamboo bends in the wind, and withstands extreme weather. It was an ancient philosophical and political symbol in China, and a popular subject for painters.

Other reactions against the International Style were more radical. The *Piazza d'Italia* (figure 8.26) in New Orleans was designed by Charles Moore with U.I.G. and Perez Associates. Moore was distressed by the sameness of modern commercial architecture. He believed that downtowns were beginning to look all alike and that cities had lost much of their unique character. Moore

8.26 CHARLES MOORE WITH U.I.G. AND PEREZ ASSOCIATES. *Piazza d'Italia*. New Orleans, USA, 1975–80. See also the text accompanying figure 3.21.

believed architecture should contribute to the distinctiveness of a place. He favored maintaining the "presence of the past" in any location. The architectural style of Piazza d'Italia has come to be called Postmodern. Postmodern architecture emphasizes visual complexity, individuality, and even fun. Not only is it visually complex, it is symbolically complicated as well, with references and borrowed elements from a number of sources that visually and symbolically enrich the structure. Such buildings contrast completely with the machine aesthetic and geometric "purity" of the International Style. To Postmodern architects, "less is a bore." Postmodern architecture is colorful, engaging, witty, and sometimes playful. Moore looked to Disneyland as a model for modern public spaces. He was also a student of the architect Louis Kahn, who had long been an admirer of Roman architecture, and who had also departed from strict modernism in his buildings.

To design the *Piazza d'Italia*, Moore collaborated with local architects who knew the history of New Orleans and the mixed downtown setting where the building is located. The Piazza is a public space commemorating the Italian-American community in New Orleans. It contains borrowed elements from a number of Italian sources, including the color scheme of Pompeii, the arches and columns of Rome, and the designs of

Palladio. The list of influences for the Piazza is actually quite long, and also includes Paris' Place des Victoires, the Maritime Theater, Hadrian's Villa near Tivoli, and the Trevi Fountain in Rome.

A map of Sicily sits at the center of the plaza as most New Orleans Italians immigrated from there. The Sicily map is connected to the larger map of Italy that joins the curved architectural fragments behind it. Concentric rings emanate from the center, continuing under buildings and out to the street, an ornamental device borrowed from the Italian Baroque era. The curving architecture recalls half circular apses from the plan of Trajan's Market. Water spurts up and cascades down in many places. There are various sets of columns that copy the many different kinds of columns used in ancient Greece and the Roman Empire, called the Classical orders. Latin inscriptions top the architecture. There are also modern references in the Piazza d'Italia, in addition to the references from the past. The main archway of the piazza is outlined in multicolor neon that lights up at night. The decorative tops of the columns, the capitals, are polished stainless steel.

This colorful mix of fragments is a sign of the postmodern aesthetic. Some references are probably not completely understood, as they come from the distant past and are not part of everyday knowledge today. The fragments and quotes that make up the piazza are piled upon each other. The layering of references makes the *Piazza d'Italia* like an archeological site, where layer after layer of the past's ruins build up, one on top the other. There is indeed "more" in this architectural composition that echoes the Italian Baroque spirit of celebration and festival.

COMPARISON OF PUBLIC ARCHITECTURE

Every structure we saw in the commercial architecture is also an example of public architecture. There is definitely an overlap between the previous category and this one. In this last section, we will look at just a few examples of public structures that fulfill special functions, and make cross-cultural comparisons. We will see two examples of meeting places, and two examples of libraries. All four are functional, but they are also shaped by aesthetic and symbolic considerations. The cross-cultural

comparisons will make it clear that there is a complex set of considerations that go into the design of any building.

Two Meeting Places

We will look first at two examples of meeting places: the *Basilica of Constantine and Maxentius* and the *Dogon Meeting House*. The ancient Roman basilica was used for public assemblies and also at times as a court of justice. Dogon men used the *Meeting House* as a place to deliberate village matters, to judge cases, and for elders to instruct young men in their group. Thus both serve similar functions. Yet each looks very different. Why?

Let us look at the Basilica of Constantine and Maxentius, also called the Basilica Nova. It was built at a time of great change during the Roman Empire. The Roman Empire had for years been embroiled in strife at its seat of government. Political corruption, incompetence, assassinations, and overthrow of rulers had been all too common. The sprawling empire had proven difficult to manage under one central government, and had been divided into East and West sections. One emperor, Constantine the Great (ruled 306-337) was able to reverse this disintegration. To become once again the sole ruler of the Roman Empire, he waged battle against, defeated, and then executed his Roman co-rulers, first Maxentius and later Licinius. Constantine attributed his success to the Christian God, and as a result, persecutions against Christians ceased (AD 313) and later Christianity became the official Roman religion (AD 325). In this transitory time of religions, however, old cults continued to thrive, and Constantine himself was still the High Priest of the Roman religion and still maintained devotions to the god preferred by soldiers, Mithras, and to the sun god

Helios Apollo. He himself was not baptized a Christian until his deathbed. Adding to the general upheaval was Constantine's moving his capital from Rome to Constantinople (now Istanbul, in Western Turkey). Constantine saw himself as a great builder, along the lines of the earlier emperors such as Trajan (see *Trajan's Market*, figure 8.21). In this, he did not neglect the old capital city of Rome, and sponsored an ambitious building program there.

One of the great monuments that Constantine was responsible for completing was the Basilica of Constantine and Maxentius, which had been begun by his rival Maxentius. As mentioned above, the basilica was a public meeting place and a business place that was also used by tribunals. It was the last and the biggest of all the basilicas built by the Roman emperors. It was 300 feet long by 215 feet wide. Its enormous size can be imagined from its remaining ruin (figure 8.27). The three large bays (the compartments covered by vaulting) were only a relatively small part of the whole structure, as you can see in the plan in figure 8.28. The bays themselves are massive. But the original center hall of the basilica (called the "nave" on the plan) was much larger and much higher, rising to 115 feet. These center vaults sprang upward from the top of the arched bays that we see in the ruins today! The reconstruction drawing in figure 8.29 shows how much higher and wider a space was enclosed under the vaults of the nave. You can also see both from the ruin and from the reconstruction drawing the many, large windows that illuminated the interior space, flooding it with light.

The basilica was a concrete structure. The walls are load-bearing and had to be tremendously thick—twenty feet thick in fact!—to support the weight of the ceiling.

8.27 Basilica of Constantine and Maxentius. Rome, AD 306–312.

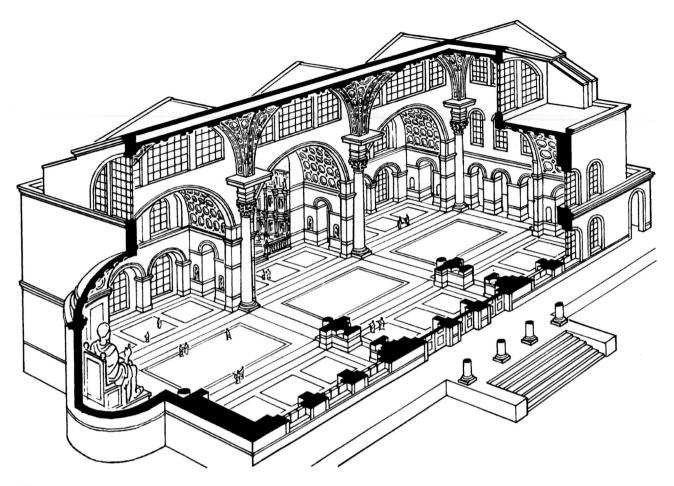

8.28 Drawing of the Basilica of Constantine and Maxentius.

Despite the need to support the ceiling, few flat expanses of wall were needed. Windows could be put in to brighten the interior because the enormous weight of the roof was channeled down to the massive piers between the arched bays on the side aisles. The building had two axes that organized its interior space, as you can see in the plan in figure 8.28. The first, long axis origi-

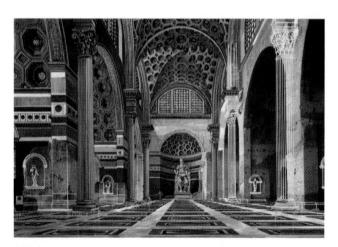

 $8.29~\mathrm{A}$ restored interpretation of the Basilica of Constantine and Maxentius.

nated at the original entrance, and terminated at the original apse, where the colossal statue of Constantine sits. The second, newer axis cut across the original at a 90 degree angle, uniting the side entrance with the opposite apse, both added by Constantine.

As the last great imperial government building built in Rome, the Basilica of Constantine and Maxentius had to be a magnificent structure. Constantine used this building for his appearances as supreme judge over the entire empire. The basilica was once lavishly decorated. The plain concrete core, which is all we see left in the ruin in figure 8.27, was originally covered with rich marble, brick, and stucco facing (figure 8.29 shows an interpretation of how the interior may have originally looked). The focal point of the basilica was a colossal statue of the enthroned Constantine, which originally was located in the basilica's new apse and was 30 feet tall (visible in figure 8.28). The remaining marble fragments of the statue are impressive enough—the head alone measures 8' 6" in height. The statue was modeled after images of Jupiter holding an orb, ruling the universe. The statue stood for eternal, unshakable authority, and was therefore a symbol of Constantine's power and a stand-in for his presence even when he was not in the city.

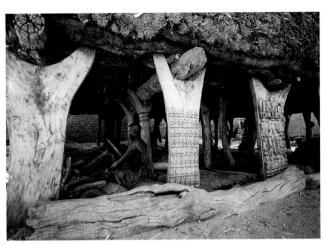

8.30 Dogon Meeting House. Togu na. adobe, millet, Mali, Africa.

The Dogon Meeting House (figure 8.30), a much more humble structure than the basilica we have just seen, is known as a "house of words" because the words spoken in this setting are more significant than ordinary speech in ordinary places (Perani and Smith 1998, 57). The house, which the Dogon call "togu na," is an important religious, political, and physical center for the village. It is the first structure built in a village, is located near the plaza at the village center, and therefore becomes a symbol of the village's founding. Men of close bloodlines use the house both for casual meetings and for deliberations on important village matters. Earlier in the chapter we discussed briefly the emigration of the Dogon people into the Bandiagara Escarpment around 1500. The area is now part of Mali, where the Dogon people continue to live today.

The Meeting House, or togu na, is a large, low space with open sides, covered by a massive roof. The thatched roof is made up of many layers of stacked millet. The thickness of the roof is often higher than the low open space below that it covers. The togu na is designed for sitting, and in fact it is hard to stand upright in it. The Dogon believe that the truth can only come from a seated person, and contributes to the harmony of the group. The heavy thatched roof is held up by eight pillars (figure 8.31), or a multiple of eight, to refer to the original Dogon ancestors who first used the togu na, and who are believed to still gather at the meeting house at the end of day. The pillars are made of brick or wood.

Imagery in the togu na refer to sources of life, thus reinforcing the importance of the togu na as the central structure for the village. The pillars of the togu na (figure 8.31) are sometimes carved or decorated with a variety of imagery, the most common being masks, mythological characters, and anthropomorphic forms such as female breasts, female torsos, or footprints. In fact, the female body, represented sculpturally, is a frequent presence in the togu na, and is likely linked to fertility (Laude 1973, 41). The footprint image most probably is associated with the first human steps on earth, or the first priests who were said to have had feet of fire and wore iron sandals (Perani and Smith 1998, 57). The carved pillars are single blocks of wood, as tall as 6 feet. Either a sculptor or a poet might propose a form that might be carved out of the wood. The bends, curves, and knots unique to a particular piece of wood are usually maintained, and incorporated into the carving. To the Dogon, a carving is conceived for, carved for, has meaning for, and continues to occupy a particular space and a particular location.

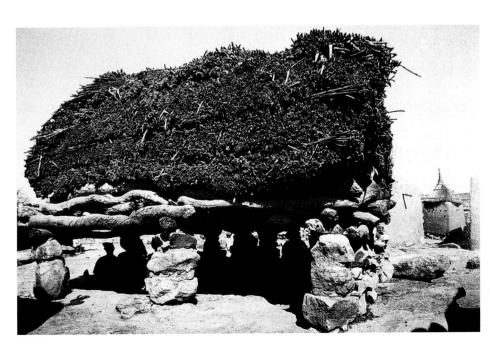

8.31 *Dogon Meeting House*. Togu na, with carved wooden pillars.

In comparing the *Dogon Meeting House* and the *Basilica of Constantine and Maxentius*, we see certain similarities. As we mentioned, they served similar functions. They were both located in the heart of the city or village. Both structures were distinctive and different from surrounding buildings serving other functions. Both structures have traditional designs. Both have sculptures that refer to power sources to legitimize the authority of those who rule: in the case of the Dogon, it is ancestors or the source of life; for Constantine, it was the absolute authority of the God-like emperor.

Of course, the two structures also differ from each other, yet underlying the difference are some similarities. The *Dogon Meeting House* is relatively small compared to the basilica, but is proportional to the size of the village for which it is a center. The larger basilica had to be proportionally larger to represent the expanse of the Western Roman Empire. The two are made of very different materials, but both use materials that are symbolically important for their peoples. Millet is grain that is a staple of the Dogon diet; the roof of the togu na is thatched with millet stalks. The basilica is faced with marble and stucco, with rich surfaces to represent the wealth and power of the emperor.

Two Libraries

Let us conclude this chapter with another cross-cultural examination, this time of library architecture. First we'll look at a structure built in China during the eleventh century. *The Library of Longxingsi* is a sutra library (figure 8.32), which meant that it housed the collections of Buddhist precepts and maxims, Buddhist scriptural narrative, and accounts of the dialogues and sermons of Buddha. The library is part of a larger Buddhist monastery. Across from it is a second structure that was a Maitreya pavilion, meaning that it was dedicated to the Bodhisattva Maitreya, an earthly saint who help the living achieve nirvana, a permanent state of great bliss. As a Buddha-to-be, the Bodhisattva Maitreya was called the "Buddha of the Future."

Chinese architecture had been standardized and subject to official regulation since the earliest times in Chinese history, at least for two thousand years. An official handbook of architectural methods was written by the end of the eleventh century which further standardized Chinese architecture. From the Western perspective, Chinese architecture has been seen as emphasizing continuity more than innovation (Boyd 1962, 5). The fundamental elements of traditional Chinese architecture are very standardized, and very simple. Almost all traditional Chinese architecture is timber frame. Almost all buildings sit on a rectangular base of rammed earth, raising it above ground level dampness and keeping the wood from rotting. This platform was faced with stone or brick. Timber columns

were placed vertically on this platform, standing on stone bases (not in them, so that the entire building could flex and move in case of an earthquake). Horizontal beams were placed on top of the vertical columns, secured by tie beams. All joints were mortise and tenon, again to allow for flexing. Mortise and tenon is a system of a slot and projection in two pieces of wood which when joined, creates a secure joint. Nails were rarely used. Ceramic-tiled roofs with wide eaves crowned the building. The heavy roofs weighed down and gave stability to the timber frame structure. The overhanging roof was made possible, as we have seen in figure 3.6, by clusters of horizontal brackets below the roof line that allowed the roof to be cantilevered out over the vertical supports. Walls were thin screens that were intended to protect the interior from the weather. Since walls were not load-bearing structures, the interior floor plans could be very flexible and buildings could also be added on to with great ease.

Within the simple format, however, Chinese architects manipulated and made expressive use of the elements at their disposal. The brick-faced platform upon which buildings stood could be made larger or smaller, or higher or lower. Generally the more impressive the platform, the more important the building was. Color was an important element in Chinese architecture, as wooden beams are painted and lacquered. Now, the *Library of Longxingsi* is an important building, but certainly more modest a structure than what one would find among the imperial palaces, where truly enormous structures with fabulous decoration sit grandly atop high and wide platforms.

Text Link
See the Hall of Supreme Harmony
(figure 12.17) in the imperial Forbidden
City in Beijing for richty ornamented
architecture, with an enormous roof and
high platform.

The roof and roof supports were another form Chinese architects could manipulate for expressive purposes. The system of brackets meant that the roofs and roof lines could be modified in many ways with great liberty, and in fact the Chinese architect had greatest play with roof design, unlike in Western buildings where roof design is very standardized (Rawson 1992, 327). We can see some of that play with roof lines in the *Library of Longxingsi*, which is a two-story building. The second floor sports two roofs, the first an awning that covers the balcony encircling the structure, and the top roof covering the entire structure. Beneath the top roof, you can see the elaborate system of brackets that allow the roof

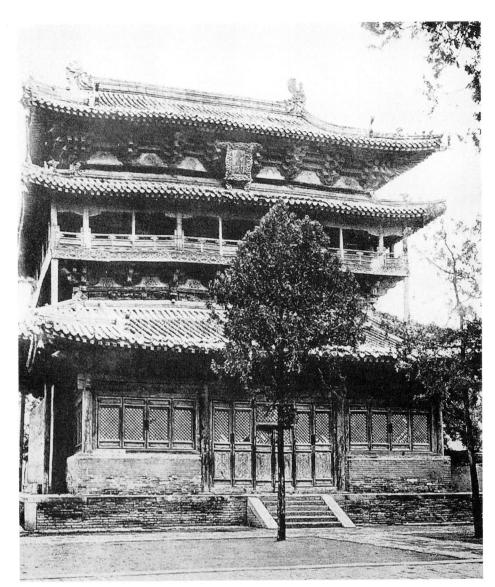

8.32 *Library of Longxingsi*. Chengting-hsien, Hopei, eleventh century,

eaves to overhang so dramatically. The roof line itself could be modified, with simple straight roofs reserved for more humble or utilitarian buildings, while curved roofs or combination straight-curved roofs were signs of more important structures (Boyd 1962, 32). The roof of the *Library of Longxingsi* is distinguished as a significant structure by its curving roof, its massive bracketing, and deep, generous eaves.

Let us now look for comparison at a library built during the Renaissance in Italy, around 1524. The *Laurentian Library* was built to house the huge collection of books and manuscripts of the Medici family of Florence. The Library layout was peculiar, as it occupies a narrow space on the third floor above monastic buildings and adjoins the existing church of San Lorenzo. Michelangelo designed the library interior as a long, horizontal space (figure 8.33) with fairly low-key adornments. There is a reverence in the atmosphere of the

reading room, perhaps expressing the great Renaissance spirit of learning. The long, tunnel-like space of the reading room contrasts dramatically with the tall vertical vestibule that fronts it (figure 8.34). The vestibule is a dramatic, compressed space. Windows are up high, as dictated by the necessities of the site. The white walls at eye level are subdivided and pushed in and out by dark columns, blank windowless niches, pediments, and scrolls. The resulting feeling is somewhat claustrophobic, with walls like plastic masses with depressions and protuberances. The structure recalls more the bulging musculature of the human body than the flat planes of architecture, and indeed the human body was always the most important theme in all of Michelangelo's artistic output.

During the time that Michelangelo was designing the library, Classical architecture, like *Trajan's Market* and the *Basilica of Constantine and Maxentius*, was extremely

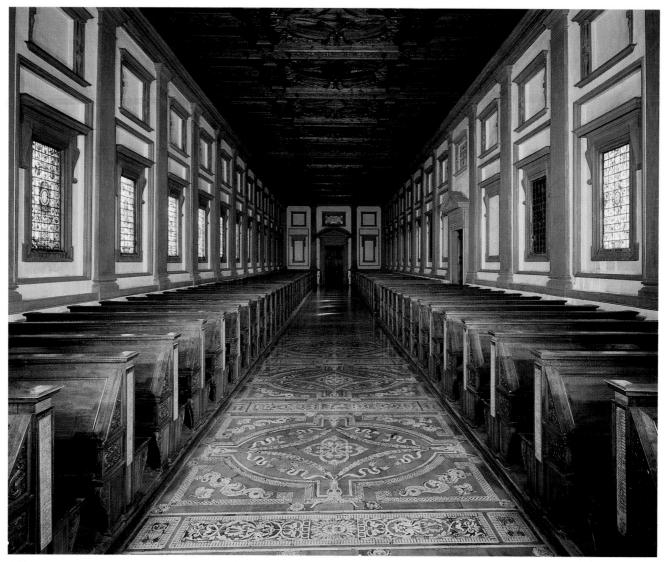

8.33 MICHELANGELO. Interior of the Laurentian Library. 1524. Florence, Italy.

influential and served as models for almost all important Italian Renaissance buildings. We saw already the architect Palladio, with his Villa Rotonda (figure 8.12), where balance, harmony, and clarity were emphasized. Michelangelo uses elements from Classical architecture, such as the columns, scrolls, niches, and pediments, but he subverts their original design and intent. Rather than conveying a sense of order, they seem dramatic and unusual. The columns are of an original design by Michelangelo, and do not reflect any classical model. The flattened columns, called pilasters, on either side of the windowless niches are broader at the top than at the bottom, which is eccentric because pilasters are generally wider at the bottom for greater stability. The corners fold inward. Columns are recessed into the wall, and heavy piers have been disguised by wall surface. Michelangelo has abandoned the clarity of Classical structures, so the supporting structure (so evident in the

Basilica of Constantine and Maxentius) is obscured. The staircase (figure 8.34) is another eccentricity that looks almost like a tongue coming out of the mouth of the doorway above it. Michelangelo's dramatic, plastic, organic, architectural innovations were made for expressive purposes.

The Medici were the most prominent family in the city of Florence in the Renaissance and Baroque eras, and their influence also spread to Rome. They were bankers, power brokers, and patrons of the arts in Florence. Thus, they were important for artists in Italy. Their commissioning Michelangelo to design their library was undoubtedly a very conscious choice intended to give it greater distinction. His use, and then subversion of, Classical elements marks the library as a structure of even greater distinction, and indeed it is often seen as a turning point from the relatively strict adherence to Classical form that marked most of the

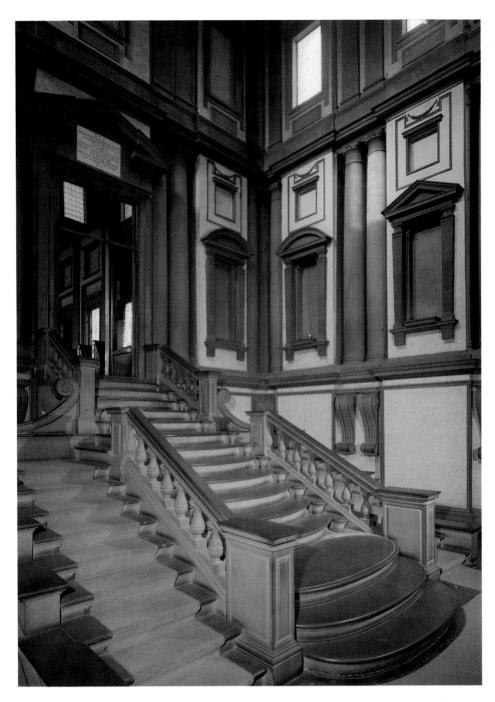

8.34 MICHELANGELO. Vestibule of the *Laurentian Library* stairway, 1558–59, Florence, Italy.

Renaissance, to the subsequent Baroque era, an era marked by greater movement and emotionalism, and grandeur, and individualism in the arts and architecture.

Text Link

For more on art patrons and patronage in general, and how it influences artists and art making, see Chapter 20, Who Makes Art?

In comparing the two libraries, the *Laurentian Library* and the *Library of Longxingsi*, we see certain similarities.

They share their functions, specifically that of housing books and manuscripts. Both are closely associated with places of worship, one Roman Catholic and the other Buddhist, and date from eras when learning was closely associated with religious bodies. Both structures are distinguished by their architectural design. Yet each structure is made memorable within the styles of its native culture. In the case of the *Laurentian Library*, Michelangelo made an impressive and memorable structure with the manipulation of architectural decoration. With the *Library of Longxingsi*, the roofs, brackets, and balconies are its distinguishing features.

SYNOPSIS

Shelter is essential for human life, and so the design of shelter has to meet certain functional criteria. But shelter is not always limited to function, as artists and architects often designed it to serve a host of religious, social, and aesthetic concerns.

We started by looking at examples of group housing from ancient through modern times. The design of ancient group housing usually joins the internal need for close community with external need for greater protection in hostile environments. *Catal Hüyük* and *Pueblo Bonito* were examples of this. Contemporary structures for group living were built for various social or ecological reasons, such as land conservation or a need for better communities within cities. The *Dogon Cliff Dwellings* and *Habitat* fit into this category.

Individual houses come in a wide range of styles. We saw a group of classically inspired houses, including those from the plan of the city of Priene, the House of the Vettii from Pompeii, the Villa Rotonda from the Italian Renaissance, and in the United States, Thomas Jefferson's Monticello. In each of these, clarity, harmony, symmetry, and geometric shapes were important. We turned next to the tall houses of the Han Dynasty in China, which had wide eaves, distinctive roofs, and elaborate ornamentation. We also saw the Toba Batak house from Indonesia, and the Moche adobe house from Peru, where climate concerns profoundly affect the house design. From North America, we saw that the Tipi was used by a displaced people. In each of these instances of house design, we also studied structural design such as load-bearing or non-load-bearing wall and various building materials, such as wood, adobe, skins, brick, and stone. Finally, we concluded with the discussion of an individual home from the United States, dating within the last century. In Fallingwater, we saw some of the reasons why a family chose a particular kind of house design to meet their needs and values.

We took a quicker look at commercial architecture, beginning with *Trajan's Market*, but focusing primarily on modern buildings, starting with the *Carson, Pirie, Scott Building*, the geodesic dome used for the *U.S. Pavilion at Expo '67*, the recent high-rise *Bank of China*, and finally the *Piazza d'Italia* in New Orleans. These buildings illustrated the evolution of steel frame construction, the rise of modernism with its "pure," simple, undecorated geometry and the postmodern reaction to modernism.

To conclude the chapter, we did two cross-cultural comparisons, looking at two governmental buildings that were meeting places and at two libraries. We saw how function, materials, tradition, and aesthetic considerations all shape how a building may look. The amazing variety of structures that humans have built is surely a testimony to human creativity and ingenuity.

FOOD FOR THOUGHT

This overview of houses, commercial buildings, and public structures presents many different perspectives on how to best meet the challenge of creating shelter.

The challenge continues today, in housing and commercial design in the United States, where housing construction makes heavy use of wood in almost all regions, for framing and for finishing. Yet hardwood forests are seriously depleted, and replacing the forests are tree farms planted with fast-growing trees whose wood is spongy and prone to warping. Some ecologists are raising alarms about deforestation. A few architects are considering other renewable materials as alternatives to wood construction such as returning to old techniques like adobe bricks. Houses have been and can continue to be made out of earth, pumice, or straw bales. Centuries-old houses in England are made out of a material called cob, which is a mixture of earth, sand, and straw that is finished with plaster inside and out. Recycled steel studs, made from steel beams of demolished buildings, have been used in commercial buildings, and are beginning to be used in residences. It is stronger than wood, and resistant to earthquakes and

What are your ideas about the following questions?

- Should architects emphasize creativity as much as artists in considering alternative building designs and materials?
- Does the grid layout of streets provide the best solution to urban design? What are its advantages and disadvantages?
- Can changes in house design or urban planning improve the quality of life?
- Should urban planners and architects have utopian concerns as the basis of their work?
- Should ecological concerns be on the mind of the artist/architect? Any other issues?
- What kinds of grassroots support is needed for new ideas in architecture and urban planning to be successful?
- Should architecture be treated more like sculpture or more like engineering?

Section 2: Religion

The supernatural realm lies beyond our senses, yet in almost every age and culture humans have attempted to form diagrams, symbols and pictures that express to some extent their understanding of divinity.

How can humans make pictures of God? How can we account for the earth, ourselves, the stars, the entire cosmos? What kinds of places of worship have humans built, where they can feel a divine presence? And what about death?

Look to art from world cultures for a wealth of answers.

Chapter 9
Gods and Goddesses

Chapter 10
Places of Worship

Chapter 11
Mortality and Immortality

living forms is a female entity, predating all male gods by hundreds of years.

Other religions depict God anthropomorphically, that is, with human attributes. We will see works that exemplify a wide range of human-like deities. Gods may be gendered and have human-like personality traits.

Let us now look at a few ways that gods and goddesses are depicted in artwork.

Earth Mother

The Earth Mother is the original deity in almost all areas of the globe, including Europe, the Near East, India, North America, and Mesoamerica. As the spirit of the earth itself, she is seen as the giver of life, nurturer, and also the carrier of death. In many ancient myths, the Goddess existed first, and then created her male counterpart, with whom she mated to produce the rest of Creation. Early deities were almost always female, lifecreating, sexual, and concerned with fertility. They were worshipped in nomadic cultures by humans who hunted and gathered food. Male forces were often depicted symbolically, or as animals. Red ocher, probably symbolizing blood, appears on some early goddesses, and was sometimes used in burials, perhaps in the hope of regeneration.

Text Link

For more on early goddesses and their role
in fertility such as this Venus figure, see
the section entitled "Fertility Gods,
Goddesses and Figures" at the beginning
of Chapter 7.

As agriculture increasingly replaced hunting and gathering as the primary source of food, human cultures and religions underwent profound changes. With agriculture came land ownership, animal breeding, the importance of paternity, the rise of cities, and hierarchical classes. Powerful goddesses continued to be worshipped in many religions, but alongside important male gods. Power struggles arose among followers of the various deities. The human view of nature shifted gradually away from one of cooperation and coexistence. Increasingly, humans viewed nature as less than themselves, meant to be dominated and even exploited. In recent centuries, the worship of the Earth Mother Goddess has been suppressed in many areas of the world.

The Earth Mother, called Tellus, was worshipped as part of the Roman religion. Although Romans regularly added the deities from conquered areas, including gods from Greece, Egypt, and the Ancient Near East, they continued to observe rituals in honor of the Earth Mother, as indicated in the following text:

Holy Goddess Tellus
Mother of Living Nature
The food of life
Thou metest out in eternal loyalty
And, when life has left us,
We take our refuge in Thee.
Thus everything Thou dolest out
Returns to Thy womb.
Rightly Thou art called the Mother of the Gods
Because by Thy loyalty
Thou hast conquered the power of the Gods.
Verily Thou art also the Mother
Of the people and the Gods,
Without Thee nothing can thrive nor be;

9.1 Tellus panel, from the east facade of the Ara Pacis Augustae, Rome, Italy, 31–9 BC. Marble, approximately 5'3" high. For more on this art, see the text accompanying figure 13.36.

Thou art powerful, of the Gods Thou art
The Queen and also the Goddess.
Thee, Goddess, and Thy power I now invoke;
Thou canst easily grant all that I ask,
And in exchange I will give Thee, Goddess, sincere
thanks.

Eulogy, 2nd century ad (Getty 1990: 4)

In the marble relief carving *Tellus*, 13–9 BC (figure 9.1), the central figure represents the earth itself, bountiful and flourishing. Alternately, the figure may represent Peace or Love. Her strong, full body is emphasized, especially in the arms, thighs, breasts, and belly. Children play on her lap, flowers bloom, personifications of breezes surround her, and all kinds of animals lie down together at her feet. The style of this sculpture was very influenced by the Greek classical style, as explained further in this chapter. Thus, as in Greek sculpture, idealized human figures moving with grace

 $9.2\ Snake$ Goddess. Glazed earthenware. Height 13.5 inches. Minoan: from the palace at Knossos. c. 1600~BC. Archeological Museum, Heraklion.

and dignity were used as images of gods. The central figures are most deeply cut from the stone, whereas details of foliage are much more shallowly carved, giving the illusion of spaciousness and airiness.

Text Link

This relief carving was part of the larger Altar of Augustan Peace (Ara Pacis Augustae) (figure 13.36), commissioned by Augustus, the first emperor of Rome, as a sign of the prosperity resulting from the establishment of imperial rule that stopped the civil wars at the end of the Roman Republic. For more on the Ara Pacis Augustae, see Chapter 13.

The *Snake Goddess*, 1600 BC (figure 9.2), probably evolved from the Earth Mother. It is one of several similar small female figures of goddesses or priestesses from the Minoan civilization that flourished sporadically on the island of Crete from 2000 to 1200 BC. The open bodice and prominent breasts tie this figure to early fertility goddesses. Her intense expression and upraised arms energize this piece. She holds snakes, which may have represented male sexuality because of their shapes, and also female fertility and regenerative powers connected to the snake's periodic shedding of its skin. The leopard-like animal on her head may have symbolized royalty. Her tiered dress and hairstyle likely represents the garb of Minoan women at that time.

Egyptian Deities

The deities of ancient Egyptian religion were mostly personifications of natural forces. Thus, the Egyptians thought of the daily rising of the sun and the annual flooding of the Nile River, so essential to Egyptian life, to be gods, who must receive worship and sacrifice from humans. Other natural entities were also given the form of god, such as the stars, the ripening of crops, etc. Very early in the Egyptian civilization, these gods were assigned certain attributes. For example, the hawk was associated with the Sky God, because the hawk flies high. The cobra was associated with the Harvest Goddess, because cobras were often found sunning themselves on the hot floors where grains were threshed. Humans appealed to certain deities for particular needs; for example there were patrons for childbearing-women, for scribes, etc.

Official cult statues of gods resided in temples. They were housed in darkness for most of the year, accessible only to priests, except when they were brought forth for special festivals or carried in ceremonies to other temples. Cult statues were believed to actually house a spirit. They were undoubtedly very spectacular and made from precious materials, but none of these have survived to this day. Numerous other depictions of deities that were part of temple and tomb decoration have survived

however. In these we see that Egyptian deities were represented most frequently as animals, or as animal-human combinations.

One of the major deities of ancient Egypt was Hathor, who had many associations and attributes, including the sky, stars, love, mirth, and joy. She was depicted as a cow, or a combination of a woman and a cow. In The Goddess Hathor and the Overseer of Sealers, Psamtik, sixth century BC (figure 9.3), she hovers protectively over Psamtik, an Egyptian official. Her horns surround the head of a cobra, a sign of royalty, and the sun disk with a crown of feathers. Even in images of Hathor as a woman, her head is usually topped by the same combination of horns and sun disk, which symbolize royalty and divinity. The side view of this piece shows the entire length of the cow striding forward, with bone and muscle beautifully sculpted. In our front view, we see more stylized features, such as the repeated ridges above the eyes and the radiating pattern in the ears. Yet this image of Hathor radiates a strong sense of calm and majesty. Psamtik is completely contained in the silhouette of Hathor. His left leg strides forward, keeping pace with Hathor's. His face and body are completely generalized, depicted in Egyptian standard style. His torso shows conventional divisions of breast, rib, and belly, while the arms and hands are presented frontally and symmetrically. He wears a long skirt rendered with a rectangular front, upon which are inscribed Psamtik's official duties. The work was likely commissioned by Psamtik as an offering that would have been placed in a temple to Hathor.

Images of humans with gods protecting them are common throughout ancient Egyptian art, but usually the deity is a detail in the overall sculpture. In The Goddess Hathor and the Overseer of Sealers, Psamtik, Hathor dominates the sculpture, indicative of the greater emphasis that the Egyptians placed on religion during this era, a relatively unstable time.

Text Link

In Chapter 11, we will see an earlier artwork that includes a depiction of an Egyptian deity, specifically, hawks representing Horus, the Sky God, whose outstretched wings protectively encircle the coffin case of the Pharaoh Tutankhamen (figure 11.4). In this work, the deity is much smaller relative to the body of Tutankhamen. Unlike Psamtik's generalized face, Tutankhamen's records his likeness, which was necessary for tomb sculpture.

Text Link

In Chapter 7 you can see the Fertility Figures (figure 7.7) that were placed in Hathor's temple.

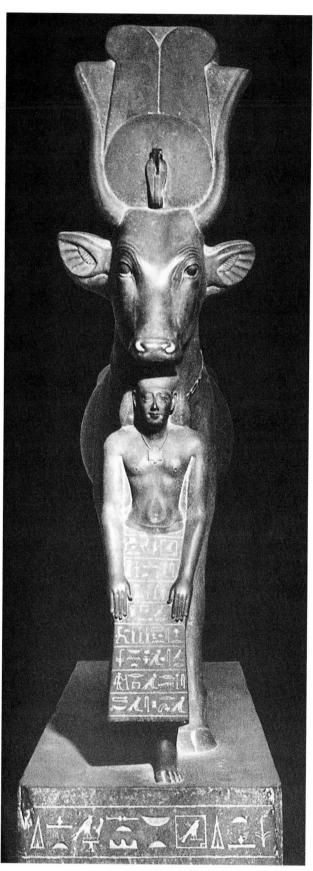

9.3 The Goddess Hathor and the Overseer of Sealers. Psamtik. Gray stone. Base: 11.5 inches \times 43.25 inches; height of cow to horns 33 inches. Saqqara, Egypt. Late 26th dynasty, 6th c. BC. Cairo Museum, Egypt.

The Greek Gods

The ancient Greeks believed that the beginning of all life on earth was Gaia, the Earth Goddess, who bore Ouranos, the Heavens. They mated to produce the twelve Titans. One of them, Kronos, slew his father Ouranos and mated with his sister Rhea to produce the Greek gods who lived on Mount Olympus and eventually overthrew the Titans. Other gods were later added to Olympus. Individual gods had distinct personalities and histories, and they formed alliances and emnities among themselves and with humans. They were responsible for many aspects of the natural world and human life, such as love, warfare, the seasons, etc. The gods were identified by certain physical features and the attributes associated with them.

The Greek gods were always in human form, as the Greeks considered themselves superior to other religions that worshipped animals or mountains. But the human form of the gods evolved over the years. The earliest images, from the Archaic period of Greek art (600–480 BC), were marked by the fewest number of gods, depicted with few defining characteristics, mostly gender distinctions. Figures were stiff and frontal, without fluid movement, similar to the Egyptian sculpture we just looked at. In the Classic period (480-323 BC), more gods appeared, with their personalities and human forms more fully "fleshed out." They had convincing anatomy and movement, but were entirely idealized and flawless, conforming to Greek standards of beauty. Our example, Zeus, or possibly Poseidon, 460-450 BC (figure 9.4), is from the Classic period. Zeus, chief among the Greek gods, is almost always shown as a mature bearded male with an ideal, god-like physique. His right hand probably once held a thunderbolt, an attribute of Zeus who is associated with the sky and storms (if he once held a trident, then his likely identification is Poseidon, God of the Sea). The over-life-size figure appears monumental, muscular, and ideally proportioned. It conveys a sense of action and energy, and at the same time of poise and dignity, the result of the fact that what is depicted here is a split-second of balance. Fully extended, Zeus' mighty body is poised between backward movement of his arm and its anticipated forward movement as he hurls a thunderbolt.

This sculpture is a rare example of an original Greek hollow-cast bronze statue. Hollow-cast bronze produces extremely strong, lightweight statues with excellent detail. Bronze also can reproduce subtleties in muscles and in stance: in this example, Zeus stands on his right toes, and rocks back on his left heel, giving spring to the pose. The whole work is energetic in a way that contrasts with static poses in previous Greek artworks. The Classical style seemed so appropriate for depicting deities that it continued to be used by later Greek artists during the Hellenistic Period (323–31 BC). During that period, gods continued to be depicted in idealized

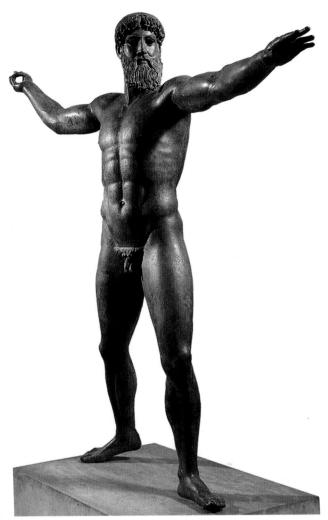

9.4 Zeus or Poseidon. Greece, 460–450 BC. Bronze, 6'10" high. National Archeological Museum, Athens.

human form, which contrasted strongly with the increasing tendency towards realism in depicting humans, showing aging, vulnerability, and death.

Text Link

Most Greek statues are known to us through Roman copies carved in marble. Marble is less strong than hollow-cast bronze and requires more supporting material to be left in place around the base of the statue. For more on hollow-cast bronze, marble, and other sculpting material, see Chapter 2.

Hinduism

Hinduism is one of the oldest religions in the world, and still survives today in various forms. Its roots go back to the ancient Vedas, which are Sanskrit writings that form the base of the belief system. The Hindu philosophy views all things as being in essence Brahman, the Absolute Spirit. The Hindu will practice meditation to absorb this view of the nature of things, including himself or "Self" (the Atman), in order to become one with Brahman. Once this is achieved, the Self becomes lost yet bonded in Brahman, and the state of Enlightenment or Nirvana is reached. Nirvana is the attainment of total peace. Salvation is sought through the liberation of the soul or spirit, which will occur when one is released from the "Wheel of Rebirth," or the cycle of reincarnation. According to the Law of Karma, the state of one's next life is determined by the life lived previously.

In the Hindu religion, there are apparently numerous gods, but in fact they are all manifestations or "Avatars" of the Unbounded, or Brahman, the Supreme Being that contains all. The multiplicity of deities is not polytheism, because Brahman is one. Brahman is pure being, pure intelligence, and pure delight, and is therefore unknowable. But all natural things, humans, and spiritual beings emanate from Brahman, and reflect some aspect of the Supreme Being. In that sense, all things share in the divine nature. By means of these many manifestations, Brahman can be known to some limited extent through the human senses. While there are no images of Brahman, there are many pictures and carvings of the numerous spirits and avatars worshipped by the Hindus.

The many deities have a long family tree. They begin with the division of Brahmanic power which appears as a trinity: Brahma, who has the Power of Creation, Vishnu, who has the Power of Preservation, and Shiva, who has the Power of Destruction and Regeneration. These three are the first Avatars of Brahman, which as mentioned above are manifestations or aspects of the Supreme Being. From them, a multitude of avatars have sprung, for example, Krishna is an avatar of Vishnu. Also believed to be avatars of Vishnu are Buddha and Jesus Christ. These beings have taken form and can be sculpted or painted. It is believed that the presence of Brahman is in sculptural images, and the devotion and contemplation of them helps one toward Enlightenment.

The faithful may worship any of the many Hindu deities that appeal to their imagination or place in life. Frequently persons will focus on devotion to two or three different deities, depending upon their occupation, where they live, and other such factors. The Hindu deities are diverse and fantastic, but reflect the fantastic diversity of the universe. Like the Greek gods, they each have certain spheres of influence. They may have several manifestations. They live, and in some cases, they die, and are submerged again into the Unbounded.

Images of deities are not viewed as representational depictions. The task of the Hindu artist is to show the gods as far more than human. Some deities are depicted as combinations of human and animal forms, while others are shown with superhuman attributes.

The God Shiva is the source of both good and evil, male and female. He is the unity in which all opposites

meet. He is the destroyer of life, who also recreates it; terrible, and at the same time mild. Since the tenth century, he has been often depicted in Hindu art as Shiva Nataraja, the Lord of the Dance, seen here in a sculpture from c. 1000 (figure 9.5). Shiva's body is shown as supple, sleek and graceful. Cobra heads form the ends of his hair, and he stands on the Demon of Ignorance. As the Lord of the unending dance, he is the embodiment of cosmic energy, yet the balanced pose also contains the concept of eternal stillness. The multiple arms tell of his power, and his divine wisdom shown by the third eye in the middle of his forehead. The far right hand holds a small hour-glass shaped drum, the beating of which stands for creation and the passing of time. The second right hand is coiled with a snake that symbolizes regeneration, while the hand itself forms a "Mudra." A mudra is one of a series of specific hand gestures that carry symbolic meaning. This particular one represents the Wheel of Law, and is a sign of protection. The left hand balances a flame that symbolizes destruction while the second left hand points to his feet. The left foot is elevated in the dance indicating release from this earth, and the right foot crushes the personification of ignorance.

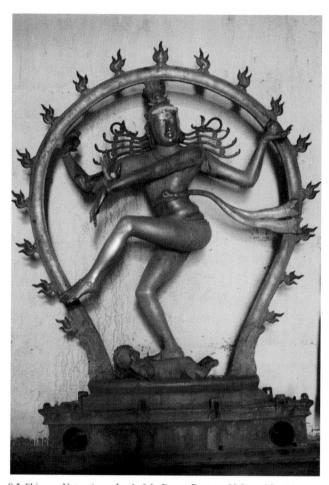

9.5 Shiva as Nataraja, or Lord of the Dance. Bronze. Naltunai Isvaram Temple, Punjai, India. c. 1000.

Shiva displays the five functions of the Hindu Godhead, that is, creation, protection, destruction, release from destiny, and enlightenment. The circle of fire that radiates around Shiva shows the unfolding and transformation of the universe, and its destruction. The entire piece is energetic, gleaming, delicate, and otherworldly.

While we do not have space to discuss the many deities, sub-deities, and spirits that are acknowledged in the Hindu religion, we will see one more later in this chapter, a deity named Dewi Sri.

Buddhism

The Buddhist religion follows the teachings of Siddhartha Gautama, a prince born in India near Nepal around 563 BC. He was miraculously conceived and born from his mother's right side. Raised in luxury and protected from worldly evils, he eventually fled from court life at age 29 to take up the homeless life of a holy man. He was instructed by religious teachers, but primarily he engaged in stringent and exhausting religious exercises on his own until he turned to meditation, which led to his eventual enlightenment at age 35. His enlightenment was a religious experience involving the complete understanding of the universe, and thus the attainment of the status of Buddha, "The Enlightened One." The Buddha, who was also known as Sakyamuni (meaning the sage of the Sakya clan), lived as a beggar-monk and continued to teach for the next 45 years until his death. Buddhists, like Hindus, hold that humans are perpetually reincarnated, most often into lives of suffering, based on the deeds of their past lives. By following the teachings of Sakyamuni, humans can overcome desires and the cycle of rebirth. Then they can attain Nirvana, a transformation of their consciousness from the material world to the eternal realm. The Buddhist religion spread throughout Asia where it continues to flourish, often as the dominant religion.

As the Buddha journeyed on his spiritual quest, his concerns included how one should live in order to obtain the end of suffering and pain. This entailed the end of the universal will "to live" and "to have," and attaining the fullness of the joy of liberation, or release from this life. With deep contemplation involving these, the Buddha developed the Four Noble Truths. These Truths are as follows:

- 1. The Noble Truth of Suffering: birth, decay, illness, death, objects we hate, separation from objects we love (clinging to existence).
- 2. The Noble Truth of the Cause of Suffering: thirst (rebirth), pleasure, lust (desires), thirst for pleasure, existence, prosperity.
- 3. The Noble Truth of Cessation of Suffering: . . . cessation of "thirst" (desires), which is absence of every passion, abandoning of "thirst," doing away with it, deliverance from it, . . . the destruction of desire.

4. The Noble Truth of the Path: which facilitates the cessation of suffering.

The fourth Noble Truth is a "Path" and is called The Holy Eight-Fold Path, which if followed in earnest, will point the way to personal enlightenment. The following is the litany of the Path:

Right Belief, Right Aspiration, Right Speech, Right Conduct, Right Means of Livelihood, Right Endeavor, Right Mindfulness, Right Meditation. (Noss 1963: 138)

Indeed the Buddha followed his prescribed path to enlightenment as droves of believers did and continue to do today. There are two major Buddhist sects. Followers of the earlier Hinayana form of Buddhism adhered to the Law of Righteousness (Dharma, similar to Hindu Karma) and The Eight-fold Path in order to work out their own salvation. Later believers deified the Buddha and considered him a savior in the Mahayana sect of Buddhism. Both forms of the religion have a profoundly contemplative character.

For several hundred years after his death, in the early purist form of the religion called Hinayana as mentioned above, Sakyamuni was represented by a set of symbols, never as a human. Since he had achieved the eternal state of Buddha, no human form seemed appropriate to depict him. As there were many narrative details known about his life, the symbols that stood for him related to specific times of his spiritual career. An empty throne with an umbrella overhead indicated Sakyamuni in his early court life. When Sakyamuni was symbolized by a tree, it indicated his enlightenment, which occurred as he meditated under the bodhi tree. A wheel, sometimes with a lotus, indicated his giving of the law for humans to follow. Empty thrones, or empty spaces with footprints indicated his presence in relief carvings and images. The final symbol for Sakyamuni was the stupa, a sign of his death and attainment of nirvana.

Originally, a stupa was a mound tomb that eventually was transformed into a monument that contained the ashes or relics of a Buddha. An example of an early Buddhist stupa is the Great Stupa at Sanchi, first century AD (figure 9.6), a solid half-dome mound of earth enclosed in brick or stone. The form of the mound represented the cosmos as the world mountain, the dwelling place of the ancient gods, and a sacred womb of the universe. The structure is encircled with a low balustrade wall containing four heraldic gates, all highly adorned with rich carvings. The gates, called toranas, are located at the four cardinal points in the circular wall. The balustrades are also densely carved. Pilgrims would come from all over the world to process around it clockwise and chant, meditate, and pray as they observe the special meanings of the carvings. The square enclosure on top of the dome symbolized the heavens, surmounted by the mast with umbrellas, called chatres, that 9.6 *Great Stupa*. Dome 50' high. Sanchi, India. Third century BC–first century AD.

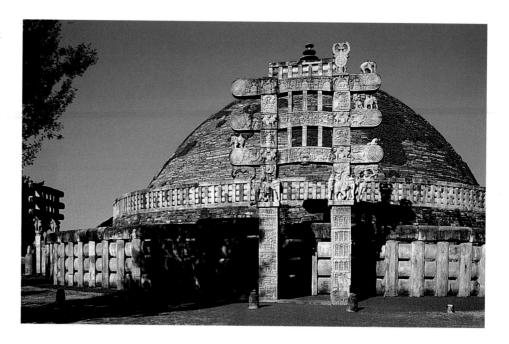

united the world with the paradises above. The chatres signified the levels of human consciousness through which the human soul ascends to enlightenment.

Let us discuss a bit more the carvings on one of the gates. The eastern torana in front of the Great Stupa rises up 34 feet. The gate contains many scenes showing episodes from the life of Sakyamuni, with Sakyamuni presented only in symbol form; such as the empty throne representing Buddha's separation from his princely life, footprints representing the Buddha's spiritual journey, the wheel, representing the cycle of reincarnation, and elephants, a bodily form assumed by the Buddha. Additionally, there are sensuous images of the nature deities which are retained from the early Vedic sculptural tradition. Small carved stupas on the gateway reliefs symbolize Sakyamuni in his attainment of Buddhahood; they look very much like the *Great Stupa* behind. The stupa as a symbol of Buddhahood spread throughout Asia, although there were local variations in its design.

Text Link
One of the carvings from the Great Stupa
at Sanchi is the Yakshi (figure 15.11).

Eventually anthropomorphic images of Sakyamuni began to be made during the Gandharan period in second century AD. Earlier, Hellenistic influences were brought to India by Alexander the Great in the fourth

century BC, and then later with Roman trade. As the Buddhist religion developed sects that emphasized a more personal Buddha, images of him in human form began to be produced, along with the traditional symbols of him that continued to be used. At first, these figurative sculptures were variations of statues of older Hindu spirits, modified with certain attributes to be identifiable as the Buddha. Several characteristics were signs of a superhuman being: the topknot of hair (a cranial bump indicating wisdom) and a circle between the eyebrows. Hair was usually shown as curly, swirling to the right. Ear lobes were long, indicating that Sakyamuni was once a bejeweled prince. The arches of his eyebrows are symbols of his lineage as royalty. The mouth is sensuous and full like a lotus petal. The down-turned eyes show deep meditation. He was dressed in a simple garb, like monk's attire. He was generally shown standing or seated in a cross-legged, "lotus" position. Less frequently he was seated in "European" fashion.

The first statues of Sakyamuni seem to be of a real person, with a substantial body. As the Buddhist religion evolved, however, less emphasis was placed on the "picture" of Sakyamuni and more on the general serenity of Buddhahood. The red sandstone of the Seated Buddha, late fifth-early sixth centuries (figure 9.7), has been carved and polished to a smooth, flawless finish. All the attributes of ears, hair, etc. are present, but the statue seems to represent a generalized rather than specific person. The body seems almost weightless. The face is rendered as a perfect oval, and the torso and limbs simplified into graceful lines and elegant shapes. Clothing is sheer and clinging, unworldly in its draping and its perfection. The tall arches of the brow, down-turned eyes, and quiet but sensual mouth all speak of a transcendent serenity. The Buddha is seated in lotus position on a

throne, under which are carved worshippers around the persistent symbol of the Wheel of the Law. Abstracted foliage above and around Sakyamuni represents the Tree of Enlightenment. His hands are posed in the preaching mudra as well as representing the first turning of The Wheel of the Law; other symbolic gestures were established and used, such as gestures for fearlessness and gift-giving.

Over the centuries, Buddhism spread throughout Asia. Buddhist beliefs became more complex, and various sects arose preaching similar but divergent dogmas. Different locations developed distinct styles of depicting Sakyamuni, and other past and future Buddhas. Other important figures in the Buddhist religion are Bodhisattvas, who are living beings who have attained the level of Buddhahood, but chose to postpone achieving Nirvana in order to remain on earth to help others who are striving toward Enlightenment. While Buddhas in their serenity in Nirvana may seem remote to humans

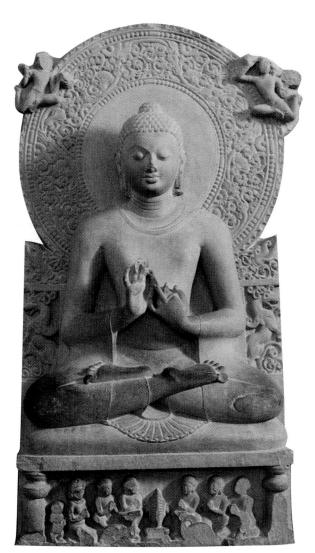

9.7 Seated Buddha. Sandstone, height 63 inches. From Sarnath, Uttar Pradesh, India, late fifth–early sixth century. Sarnath Museum.

struggling on earth, the Bodhisattvas are immediate personal intercessors who aid humans in their times of need. Guanyin, c. 1100 (figure 9.8), is the most powerful Bodhisattva with a great capacity for salvation. Guanyin is known in China also as Kuan-Yin, and seen in many representations in India as Avalokitesvara and in Japan as Kannon. Different depictions of Guanyin vary radically, with two to twelve arms, often crowned, sometimes with a muscular male body and sometimes with an effeminate body. In our example, the body is graceful and the face beautiful and serene. The elegance of the body, along with the lavish carving and rich colors, make this sculpture very sensually appealing. The pose of the right hand is especially graceful and sensual. The diagonals of the figure's right leg and arm balance the straight verticals of the torso and the left limbs, while the flowing curves of the drapery unite all.

Judaism

Judaism is one of the oldest religions of the Western world and also the foundation of Christianity and Islam. Originally the Jews as a people were thought to be traced back to Mesopotamia, and their spoken language was Aramaic. As a semi-nomadic people they camped around Canaanite cities where they adopted the Hebrew language. Eventually this area became the region of Judea, which became a Roman province in 63 BC.

The religion was based on strong ethics and strict monotheism. Also it emphasized the exclusive covenant that the Jews, "the Chosen People" have with their God and Creator, Yahweh. They believe that only Yahweh is to be worshipped and none other. This caused particular conflict with the Roman government officials, who worshipped many gods, which included emperors who were deified. The patriarchs of their religion were Abraham, Isaac, and Jacob, as recorded in the ancient scriptures. The Jews, later called the Hebrew people, settled in the land of Goshen, which was a district of Egypt. From there came Moses, the "Father of the Prophets," who led the Exodus of the Jews from Egypt into the desert. It was during this journey to the "promised land" that Moses received the Ten Commandments from God, whose presence was described in the Old Testament as the "burning bush" on the summit of Mount Sinai.

There were several sects in early Judaism, among the better known are the Sadducees, the Pharisees, the Essenes, and the Zealots. They disagreed on many points. The Sadducees date back to 200 BC, and were made up of learned Jewish aristocrats. They believed in cultural and religious solidarity and that the Messiah would be a man who would lead their people to political freedom. They also believed that the soul did not live on after the death of the body. The Pharisees were teachers (rabbis) who were the interpreters of Hebrew law. They believed in the coming of a messianic redeemer who would lead the righteous to salvation, like a shepherd

guiding his sheep. They also believed the soul does not die after death and the wicked suffer for all eternity. The Essenes lived in a monastic community located near the Dead Sea where they renounced worldly goods and practiced strict asceticism (self-denial and self-discipline). They believed the soul was immortal and would be freed from the body at death. They believed that the advent of the Messiah would happen at the end of time. The Dead Sea Scrolls are scriptures of the final apocalyptic age. The Zealot sect is dated to AD 6. They believed in violent resistance to Roman rule and had a messianic "zeal" in their activities, which included acts of terrorism.

Jewish scripture was set in AD 90 when rabbis gathered to cite the 36 books that would make up the Hebrew Bible. These scriptures were divided into 3 divisions: 1) The Law—the first 5 books called "The

Torah," 2) The Prophets, and 3) The Writings (wisdom literature).

It was thought by scholars that the making of art images in the Jewish faith was forbidden because of the Second Commandment. However, images have been found in scripture illumination and on the walls of ancient synagogues. In figure 9.9 we see the interior of the Synagogue at Dura-Europos dated AD 245–256, which is covered with paintings depicting Old Testament themes. Dura-Europos was an outpost in Syria, which was probably founded after the death of Alexander the Great in 323 BC. It was later captured by the Romans, then fell to the Sasanians. The population was evacuated, leaving the buildings intact. There were twelve different cult buildings, which included places of worship for the Jewish and Christian religions as well as shrines

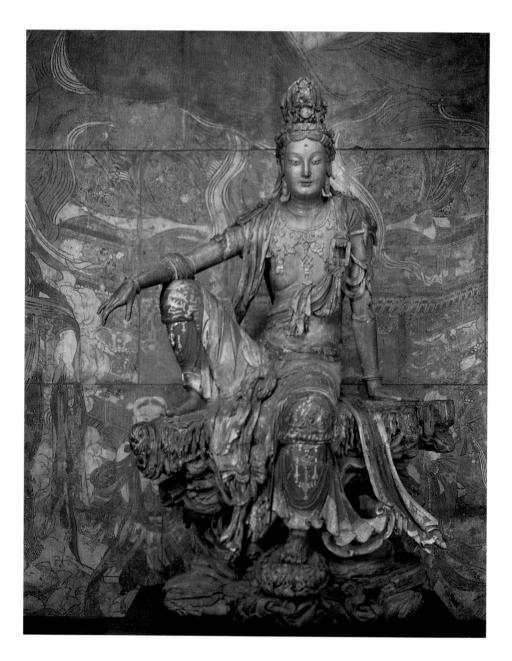

9.8 *Guanyin*. Painted wood, height 7'11". China, Song Dynasty, c. 1100. The Nelson-Atkins Museum of Art, Kansas City. Purchase: Nelson Trust.

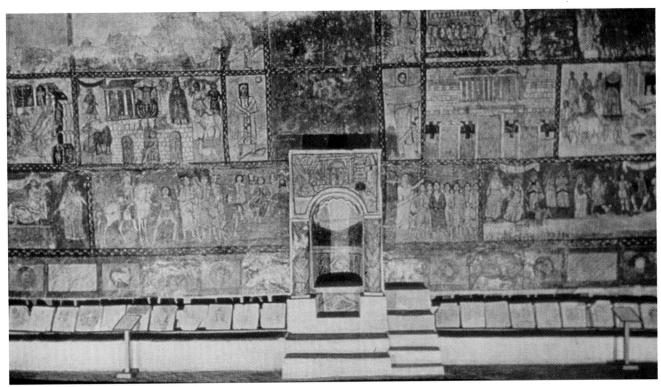

9.9 Interior of the Synogogue at Dura-Europos with wall paintings of biblical themes, 245-256. National Museum, Damascus.

for the religions of the Classical and Near Eastern cultures.

The synagogue at Dura-Europos was originally a private home and later became a place of worship. The paintings on the walls were didactic, illustrating stories found in the Hebrew Bible. The figures have stylized gestures, lack expression, mass, and depth, and for the most part stand in frontal rows. Yaweh's image was not depicted with the exception of his hand emerging from the top of the panels. Evidently this kind of image making was not forbidden for the Jews, but the worship of images was.

Text Link
Turn to Chapter 10 for information on
the Ark of the Covenant (figure 10.8).

Christianity

Unlike Judaism, the Christian tradition has many kinds of images of God. Some Christians understand God as a single being, while others conceive of God as a Trinity, with three persons in one, the Father, Son, and Holy Spirit. The Father is almost always depicted as an aged patriarch, wise, powerful, and judging. The Son was incarnated as Jesus, the fulfilled Jewish prophecy of the

advent of the Messiah, and founded the Christian religion. Jesus died by crucifixion, rose from the dead, and ascended into heaven. He is believed by Christians to be the "Savior" of souls. Images of Jesus range from a babe in arms to a young man in life, death, and resurrection. The Holy Spirit is represented as a symbol, either a dove or a flame of fire.

As an actual historical figure, Jesus is the most commonly depicted in art of all the three Divine Persons. The first images of Jesus date from the second and third centuries, when he was depicted as a youthful, protecting shepherd. The image would have been comforting to early Christians, who were often persecuted by Romans. Once Christianity became the official state religion of the Roman Empire in the fourth century, Jesus was depicted as royalty, as king and ruler. Only later was Jesus depicted as crucified. Over the centuries, images of Jesus would be extremely varied, illustrating many episodes of his life, death, and resurrection. He has been shown as a miracle worker, teacher, and judge; as divine, as human, as all powerful, and also vulnerable. These images usually combine a narration of historical events with layers of symbolism.

Text Link

For an example of a very early image of Jesus and its uses by the Early Christians, see the painting in the Catacomb of Sts. Peter and Marcellinus (figure 11.18) in Chapter 11.

In the Madonna of the Meadow (figure 9.10) by Raphael Sanzio in 1505, Jesus is the small child in the center. He is depicted as a robust, perfect child. Also important in this painting are Jesus' cousin, St. John the Baptist, at the far left, and Mary, his mother, who towers over both children. Many Catholic Christians also venerate saints, prophets, and other holy people who were important to the development and spread of Christianity, and thus we see their pictures along with that of Jesus. While the children are youthful and sweet, their solemn composure and the cross they hold portends their roles of savior and prophet. All figures are totally human, but their dignity and serenity seem divine. The blues, reds, and greens add to the sense of harmony. Mary and the two children are placed to fit into an implied triangle, which is a stable, symmetrical, sacred shape that symbolized the Trinity with its three sides. Her turning body, gentle hands, and serene gaze unite all the figures. Mary's silhouette completely contains the form of Jesus, attesting that she is Jesus' mother and also establishing her as a symbol for the Christian church, through which Jesus remains present on earth. The large sheltered body of water in the background implies a harbor, and Mary was known as the "Port of Salvation." The lovely landscape opens up behind them, luminous and spacious.

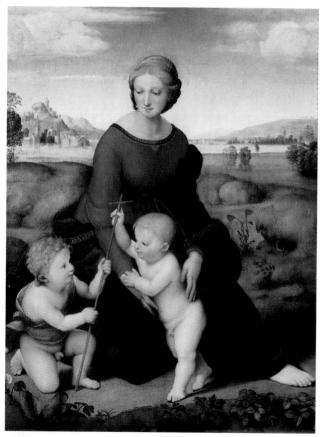

9.10 RAPHAEL. Madonna of the Meadow. Panel painting, $44.5^{\circ} \times 34.25^{\circ}$. Italy, c. 1505. Kunsthistorisches Museum, Vienna. See also the text accompanying figure 2.8 for more on this art work.

Text Link

The composition of Madonna of the Meadow brilliantly incorporates the elements of line and shape. Review how this works in Chapter 2.

In contrast, the Crucifixion from the Isenheim Altarpiece, 1510-1515 (figure 9.11) by Matthias Grünewald, shows Jesus at death, which for Christians is both a moment of annihilation and also triumph, because Jesus' death was the sacrifice that redeemed the human race from sin. The dark background adds to the gloom and obliterates any landscape detail that would alleviate the horror of the scene. The grisly details of Jesus' sore-ridden and scraped skin, convulsed body, and drooping head are meant to be a realistic picture of a terrible death. At the same time, the Isenheim Altarpiece is a conceptual rather than realistic representation. It is a multi-paneled work that shows and symbolizes complex religious teachings, summarizing the life of the historical Jesus and tying it to sixteenth-century religious practice. Thus, the bottom panel, which shows Jesus' body being placed in the tomb, would sit directly above the altar, where the body of Jesus is offered at Christian Eucharistic rituals in the form of bread and wine. The lamb in the Crucifixion panel, holding a cross and bleeding into a chalice, symbolizes animal sacrifices conducted by Jews in the past and also the Christian offering of bread and wine. Various people who were present at the historical moment of the Crucifixion, such as Roman soldiers, are omitted in this painting, while St. John the Baptist, who prophesied the coming of Jesus, is shown on the right, although he had already died. Jesus is once again surrounded by other saints, specifically, St. John the Apostle, St. Mary Magdalene, and Mary his mother in the center panel. St. Sebastian and St. Anthony, both of whom lived much later, appear on side panels. They were saints associated with cures for the sick.

The painting was made as a form of consolation for patients in a hospital, for they could see the horrendous suffering of Christ and relate it to their own suffering. Yet the *Isenheim Altarpiece* also embodied the hope of eternal life and peace through Jesus. The dark, suffering-filled *Crucifixion* panel opens in the center, and behind it are three joyful scenes from the life of Jesus, his conception, birth, and resurrection from the dead, all painted in brilliant, luminous colors that contrast with the darkness of the *Crucifixion*. The altarpiece opens once more after that, showing scenes from the lives of saints.

A final version of a Christian depiction of God will be seen later in this chapter, in the Sistine Ceiling paintings. In those paintings, God the Father is depicted as an idealized, powerfully muscled, energized, aged human being. Ideal attributes found separately in various

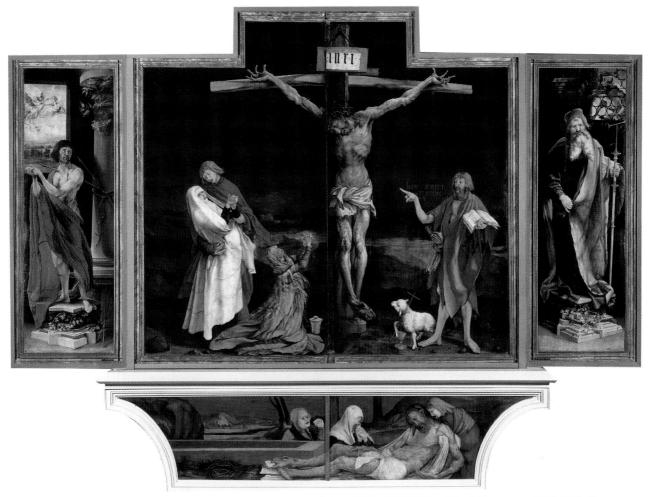

9.11 Matthias Grunewald. The Isenheim Altarpiece. Center panel: Crucifixion, $9'9.5" \times 10'9"$. Oil on Wood. Germany, c. 1510–1515. Musee d'Unterlinden, Colmar, France.

human beings, such as physical power, creative energy, wisdom, and beauty, are here combined to create an image of God in idealized human terms. The image contrasts starkly with the sweet Infant and the crucified Jesus we have just seen, yet all are manifestations of the attributes of the Christian God.

As we mentioned, some Christian religions recognize saints and angels as holy beings. An angel is a winged supernatural being with superhuman powers and intelligence, who existed before the first humans, Adam and Eve. Fallen angels became the devils, led by Lucifer or Satan, and are the source of evil in the world. Saints are deceased humans who led very holy and exemplary lives and who now live in heaven with God. Humans on earth can ask saints to intercede to God for them in cases of special need (note the similarity between the Christian saint and the Buddhist bodhisattva). There are many, many Christian saints and many depictions of them. We have already seen images of Mary, who as Mother of God and Queen of Heaven occupies a position somewhat less than God. We have also seen images of St. John the Baptist, St. Mary Magdalene, St. Sebastian, and St.

Anthony. We will confine ourselves here to one more example.

Many of the faithful find angels and saints to be more personal than God. They can pray to saints who were human like themselves, and can find inspiration in the stories of their lives. In addition, as historical persons, saints reflect the history and development of the Christian religion. St. Theresa of Avila was a significant figure for the Catholic church at a time when it was besieged from several quarters: the Protestant Reformation had split away many of the Catholic church's followers; science was promulgating a mechanistic worldview with less or no view for divine intervention; and monarchs of Europe were attacking Rome, robbing it of its secular power and wealth. The Catholic church responded in two ways; first, with the stick of harsh penalties for heresy in the areas it controlled, and second, with the carrot of beautiful churches, charismatic saints and an emotional religion that emphasized mystery and a dramatic appeal to the senses. Sensual experience was seen as a means to grasp the depths and mystery of religious faith. St. Theresa wrote vivid, appealing and readable poetry about her religious visions, in which she experienced the pain and pleasure of divine love as a fire-tipped dart in her side. This example is from a poem she had written:

When that sweet Huntsman from above First wounded me and left me prone, In the very arms of Love
My stricken soul forthwith was thrown.
Since then my life's no more my own . . .
And all my lot so changed is
That my Beloved One is mine
And I at last am surely His.

That dart wherewith He wounded me Was all embarbed around with love, And thus my spirit came to be One with its Maker, God above.

The *Ecstasy of St. Theresa* (figure 9.12), by Gianlorenzo Bernini in 1645–1652, shows spiritual passion and physical eroticism in the face and body of

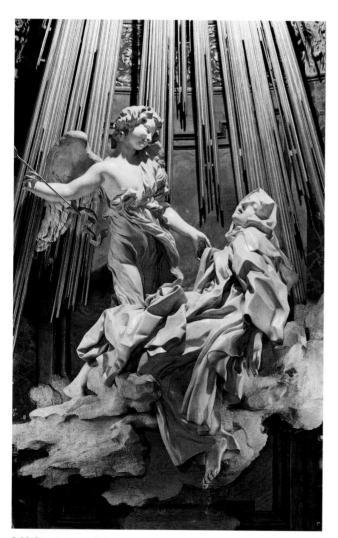

9.12 GIANLORENZO BERNINI. *Ecstacy of St. Theresa*. Statues: marble, 11'6" high. Cornaro Chapel, Santa Maria della Vittoria, Rome, Italy. 1645–1652.

the saint. The smiling angel with the arrow stands above her and gently lifts her heavy, rough monk's cloth to pierce her swooning body. The surface of the marble has been handled with extreme skill to give tactile and visual variety: the smooth skin of the angel, the dull softness of his wings, his sheer wispy clothes, the thick cloth covering St. Theresa. Heavy undercutting helped to emphasize the shapes and shadows in the choreographed lighting. The gold rays behind the figures are lit by a window hidden above, creating a mystical and holy-like glow to the scene. Diagonals abound, in the arms of the angel, the body of the saint, and the folds of the drapery, giving a sense of restless movement. The entire heavy marble sculpture seems to float, in a vision of mystic transcendence.

Bernini was an architect as well as a sculptor, and was familiar with theatrical production. *The Ecstasy of St. Theresa* is the sculptural centerpiece in a small side chapel that Bernini designed for maximum dramatic impact and visual splendor. The sculpture is framed by columns of multicolored marble, and the ceiling painting gives the illusion that the roof has opened up to descending clouds and heavenly beings. Cornaro family members, the chapel's donors, are shown as statues on the chapel side walls, witnessing the religious drama. Like the mystical and charismatic St. Theresa herself, the *Ecstasy of St. Theresa* and the entire Cornaro chapel invite us to an emotional religious experience.

Text Link
Bernini was a master at the Baroque style
that was popular in seventeenth-century
Europe. Look back to Chapter 5 for a discussion on style. You can also see another
example of Bernini's work, the
Baldacchino in St. Peter's in Rome (figure 11.19).

Gods for Special Purposes

Many religions are polytheistic, that is, they recognize and worship a number of gods. With multiple gods, a hierarchy usually develops, with some having greater power and importance. The different gods are responsible for and responsive to particular aspects of earthly life, for example, warfare, love, reproduction, the seasons, and so on. Studying all the gods worshipped around the world would be an enormous task, beyond the scope of this book. To simplify our investigation, let us focus on a few deities associated with food production. By studying the artwork that represents them, we will see the characteristic ways they are depicted, how their divine status is indicated, and their roles within their culture and religion.

Mesoamerican cultures worshipped many gods. They often linked the gods associated with corn and water.

The maize deity was central because corn was the most important edible plant in Mesoamerica and it symbolically stood for all food. The water deity was responsible for the earth's fertility. Surviving images of these gods appear in paintings, relief sculptures, and on ceramic vessels.

The maize deity was a god of many powers, but in the special role as the protector of young corn plants, she was called *Xilonen* (figure 9.13). In our image of her, dating from 1000–1200, the head is rounded, very humanlike, and is grandly adorned. She wears a headdress with ornamental bands and ears of corn, a collar with sun's rays, heavy ear pendants, and a jade necklace that symbolizes crop fertility. This sculpture is from the Huastec people, from the region around present-day Veracruz. They were later subsumed by the Aztec.

Tlaloc was the rain deity who made all forms of crops and food flourish. The most worthy of the human dead

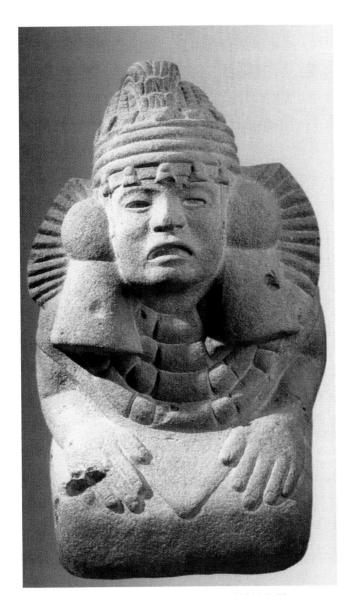

9.13 Xilonen, Goddess of Young Corn. Limestone, 33" high. Huastec. Tuxpan (Veracruz). 1000–1200.

9.14 *Tlaloc Vessel.* Ceramic. 30.5 cm. high. Aztec. Templo Mayor. c. 1470. See also the text accompanying figure 5.5.

were received into Tlaloc's heaven. Images of Tlaloc were common, as were temples dedicated to him. This ceremonial ceramic *Tlaloc* vessel, c. 1470 (figure 9.14) was a symbolic container that was used in an Aztec temple dedicated to the water deity. In temple rituals, Tlaloc's human attendants would fill such vessels with water, and break them so that the life-giving water would be symbolically poured out over the earth. Tlaloc was traditionally shown with distinctive features: circular eyes, twisted serpent nose, fanged mouth, headdress, and large ear ornaments with pendants. Tlaloc's face is flattened, with features rendered as geometric shapes, and not very much like the volumes of an actual human face.

How did the Mesoamerican artists show the divine status of Tlaloc and Xilonen? Interestingly, both deities are represented as human in the important areas of fertility and food production. Xilonen is shown naturalistically, but is grandly adorned to establish her divinity. Her staring eyes and down-turned mouth make her a remote, almost unapproachable goddess. The sculpture also has a monumental feel, which adds to the sense of distance. Tlaloc's face is abstractly human; it makes the deity seem more terrible, powerful, and removed from the experiences of everyday life. His twisted nose and fanged mouth are attributes of serpents that are associated with water. Divine status can be conveyed with features of powerful animals. Like Xilonen, he wears distinguishing ear pendants and headdress.

Just as corn and water were protected by special deities in central Mexico, so also is rice, the essential food in Southeast Asia, protected by the Hindu deity Dewi Sri (also known as Lakshmi and Shri-Devi). Let us look at two representation of her, to see how the images of a single deity may change from culture to culture. The first is a bronze sculpture of *Dewi Sri* from Java, ninth century (figure 9.15), an island in modern-day Indonesia, that show her as the Goddess of fertility, with

9.15 Dewi Sri. Bronze. 9" high. Central Java, ninth century.

special concern for the rice harvest. She grasps a shaft of rice in one hand, while her other hand is held in a gesture of giving. The figure style is reminiscent of sculptures from India, and indeed Java was a relatively cosmopolitan island. The slender body, high round breasts, cross-legged posed, expressive gestures, and overall serenity are similar to those in Indian art.

It is interesting to compare the Java image of Dewi Sri with one from Bali, a nearby island, as different peoples modify images of gods to suit their own tastes and needs. The more isolated Bali was conquered and under the rule of Java at various times, and by this means Hindu influences were introduced there. But the Balinese combined their own complex set of rituals to ensure the critically important rice crop with the Hindu deities that were personifications of natural elements. In Balinese culture, Dewi Sri, c. 1900, was the Goddess of rice plants, fertility, and wisdom (figure 9.16), depicted as a beautiful, idealized Balinese woman. She resembles their women dancers in costume and makeup. The carving is painted in ochers, reds, and greens, and Dewi Sri is bejeweled in necklaces, earrings, thick belts, and bracelets on ankles and wrists. Her dress has a flowered design. Her hair is braided and twisted, and her brows are plucked and her lips rouged. She bends forward in an attitude of giving, in great contrast to the remote gods of Mesoamerica. In Bali, statues of deities were not items of worship, but were considered decorative representations.

Text Link

Much of what we discussed above in relation to deities and religious practices is concerned with food and food production. Chapter 6 covered more ways that art and food are interrelated in various cultures.

HUMANS RESPOND TO GOD

Religious ceremonies and rituals provide ways for humans to acknowledge or respond to God. Through religions, humans can pray for what they need for their earthly or spiritual existence. Many religions require humans to make offerings to the gods, as outward signs of their devotion. In some religions, this offering is a gift, while others require sacrifices. God responds by sustaining earthly and spiritual life, in some cases in miraculous ways. The exact form of this two-way communication varies radically from religion to religion, as we shall see. Art frequently plays a part in this interchange, either as part of a ceremony, as a form of the prayer itself, or in the depiction of the act of supplication.

9.16 Dewi Sri. Wooden Polychrome Statue. Height 58 cm. Bali. c. 1900.

Ceremonies

As an example of ceremonies, we will look at the Winter Ceremonies of the Kwakiutl people of the American Northwest. Flourishing during the nineteenth century on North Vancouver Island and on the coastal mainland, the Kwakiutl lived on the abundance of the sea and land. They dwelled in two sites corresponding with summer food gathering and winter rituals, which were quite elaborate. At the winter residence, ceremonies such as marriages, initiations, feasts, potlatches, and dramatic performances were celebrated.

Special houses were built for the Winter Ceremonies where potent dramatic pantomimes and dances in masquerades of supernatural spirits would renew the Kwakiutl's spiritual legacy. We see a reenactment of *Hamatsa Great Winter Ceremony*, in a photograph taken by a U.S. anthropologist in 1914 (figure 9.17). The rites reconnected the Kwakuitl with these supernatural beings and with the unpredictable forces of nature that especially resided in the sea and sky, and in particular a man-eating spirit. Also thanks and praise were given for the richness of the land and sea that provided them with sustenance and warmth.

As important as the ceremonies were, so was the art that was created for it. The art visually connected the people with their supernatural roots, specifically through their superbly carved and painted masks. When the performers were in full masquerade and told their story, they *became* the supernatural being represented in the mask. Therefore great care and skill had to be given in the creation of the mask, in order for it to become a vehicle of transformation.

Our first example is the twentieth-century *Transformation Mask*, for when it was in performance it amazingly changed its character (figure 9.18) from representing an earthly being to become a supernatural being. At the critical moment in the story-drama, the dancer would turn and manipulate the mask with hidden strings and devices, and then turn back in a completely different mask. This miraculous transformation might be the changing of bear or a sea creature into one of the horrendous cannibal spirits. The intent of this magical event was to make humans fear the supernatural. The masks seemed powerfully awesome in performance, thus achieving the desired effect.

Our second example is a twentieth-century *Echo Mask* (figure 9.19). Designed for the wearer to make natural sounds, it comes with nine detachable mouthpieces used for each noise. The sounds were inspired by echoes that came from cliffs and waterways. The dancer wearing the echo mask would enact the story and sounds of one of the mouthpieces. Some of the mouthpieces belonging to this mask are identified as a killer whale, a bear, a wild man of the woods, an eagle, and a cannibal woman.

Besides being superbly carved, the masks are exquisitely painted. With precise attention paid to the contours and features of each mask, the artists applied bright, bold colors in undulating shapes, creating overall harmonious compositions. This distinct Kwakiutl aesthetic with its beautiful curvilinear style is visible throughout

Text Link

See Chapter 6 for information on the potlatch ceremony. Figure 6.28 shows a large Feast Dish used in a potlatch.

their art forms, both in the past and present. Artists continue today to create high quality, elegant works of art that are exhibited and collected worldwide.

Text Link
The carving of the Interior House Post
(figure 16.5) by Arthur Shaughnessy
shows a similar curvilinear style as these
masks.

Offerings

Next we turn to the Balinese, to look at the ways they use art to respond to their gods. The Balinese have many days of religious observance, which they commemorate by giving hand-made offerings. The Balinese regard these offerings as artworks, and consider many of their people to be artists. They see religion and art as integrated components in their everyday life. These offerings consist of braided palm leaves, wood carvings, small sculptures, baskets, and arrangements of food and flowers, many of which are intended to help ensure the food supply. Some are small objects, such as samples of rice on braided and cut palm leaves; these are made and placed around the house and fields everyday to thank their ancestors and gods, especially Dewi Sri, for food.

On festival days, women make and carry more elaborate offerings to temple, such as the *Offering with Cili Shaped Crown*, from the mid-1980s (figure 9.20). These intricate sculptures are made of fruit, flowers, and cut and woven palm leaves. The palm leaf ornaments are often shaped as "cili," which is an ancient symbol of wealth, fertility, and luck. The cili is a simplified woman's head with a large, fan-like headdress radiating from it. In temple rituals, the gods accept the essence of the offering; afterwards, any foodstuff that has not touched the ground is eaten in the temple or by the family making the offering. Offerings in the Balinese sense mean to give back in thanks, and do not have the connotation of sacrificing something.

In Christian religions, humans send prayers and offerings to God, in some cases through rituals performed by priests or ministers. However, private prayers are said by the ordinary faithful, and sacrifices in the form of donations can be made to worthy causes. In some cases, the form of the offering can be a work of art. Wealthy Christians have commissioned works of art or architecture as penance for sin or as thanksgiving for blessings. The Cornaro chapel, which we have seen already in this chapter, was donated by the Cornaro family for the Church of Santa Maria della Vittoria, in Rome. For the much less wealthy, small votive paintings can be left at religious shrines as a form of prayer. Ordinary persons have votive paintings made as expressions of thanks and

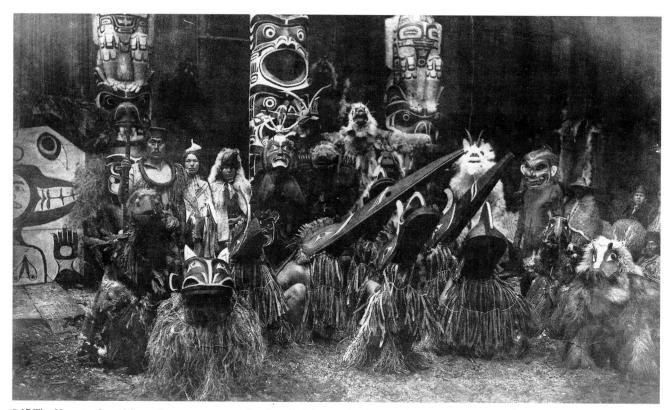

9.17 The Hamatsa Great Winter Ceremony, costumed and masked dancers, houseposts, inside the ceremonial house, Kwakiutl people, Northwest Coast, 1914, British Columbia, Canada.

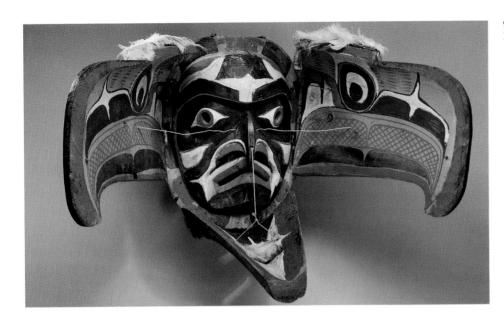

9.18 Transformation Mask, Kwakiutl, British Columbia.

devotion for a miraculous event in their lives. This practice was once common throughout Europe, but is no longer done in the twentieth century. In central Mexico, the practice is extremely popular, as votive paintings called "retablos" are left by the hundreds at certain important religious shrines.

Retablos have specific defining features. They are relatively small paintings, most often 7" × 10" or 10" × 14", executed by retablo artists who primarily paint in oil on sheets of tin. They record a miraculous event in picture and in text, with drama, bright colors, and intense emotions. Sometimes collage elements are applied, such as pictures of holy cards, loved ones, diplomas, or legal papers. The miraculous events can include deliverance from large and small dangers, to the blessings of life, health, and happiness. The persons in peril entrust

themselves to Jesus, Mary, or a particular saint, and in thanksgiving have a retablo made that gives testimony to the miracle performed. Sometimes months or years pass before the persons receiving the miracle are able to make the pilgrimage to the holy shrine and place their retablo on the particular statue.

The retablos communicate very well an overwhelming fear and subsequent gratitude felt when the peril is removed. The text frequently is formulaic: many retablos begin with "I give thanks" and "I entrusted myself to" Our Lord Jesus or Mary, and conclude with the reason for which "I dedicate this present retablo." The translated text from the *Retablo of Maria de la Luz Casillas and Children* (figure 9.21) reads, "I give thanks to the Holiest Virgin of San Juan de los Lagos for having made me so great a miracle of saving me in a dangerous operation

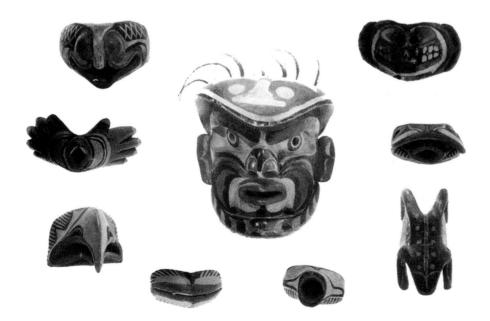

9.19 Echo Mask with nine detachable parts, Kwakiutl, British Columbia, Canada. Twentieth century. See also the text accompanying figure 5.9 for more on this artwork.

9.20 Offering with Cili-Shaped Crown. Flowers, fruit and palm leaves. Approximately 24" tall. Bali, c. 1985. See also the text accompanying figure 20.8 for more on art making in Bali.

that was performed on me for the second time on the 9th day of October 1960, in Los Angeles, California. Which put me at the doors of death but entrusted to so miraculous a Virgin I could recover my health, which I make apparent the present retablo: in sign of thanksgiving ... " (Durand and Massey 1995:164). Multiple scenes are common on retablos, and in this example we see Maria twice, both as a helpless and vulnerable patient on the operating table in a foreign land, and also as the supplicant and her children imploring the help of the Virgin of San Juan de los Lagos. In the retablo, the Virgin looms large in the bleak gray room, with golden rays, miraculously intervening in a fearful episode. Extraneous details are omitted, and the perspective in the room emphasizes the helplessness of the victim, in this case a poor, sick migrant worker, and the radiant power of the Virgin. A number of retablos in Mexican religious shrines tell of the dangers, fears, and hardships of the migrants who work illegally among strangers in this country, far away from the security of their families living across the border.

The Virgin of San Juan de los Lagos is a statue of Mary, the Mother of Jesus, in a shrine in the central Mexican state of Jalisco. The actual statue of the Virgin is only 20" tall (in contrast to her overwhelming size on the retablo), made of corn paste and orchid juice, dressed in blue and white robes, and crowned with gems. The first miracle was attributed to the Virgin in 1623, and devotion to her has increased until the present day. Priests at this and other popular shrines are faced with the problem of disposing of old retablos, which may number in the hundreds; some are stored, while others are left to deteriorate or are sold through art and antique dealers. Others are stolen.

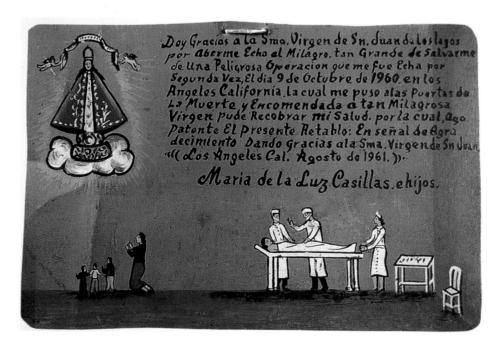

9.21 Retablo of Maria de la Luz Casillas and Children. Oil on metal. 7" × 10". Durand-Arias Collection. 1960. Central Mexico. For more on this artwork, read the text accompanying figure 21.5.

Sacrifices

In other cultures, human offerings to God did entail sacrifice, sometimes involving the spilling of human blood. The various Mesoamerican cultures—the Mayas, the Toltecs, the Aztecs, and others in Central America—practiced a particularly extreme form of human sacrifice, with elaborate rituals and many victims. These cultures believed the sun and moon at one time were frozen in a terrible balance, and that the original gods sacrificed themselves to make the cosmos move again. That danger of stopping—and thus, death—was always present, and since then, human sacrifice has been necessary to ensure the movement of

the sun and planets and the survival of all life forms. Many artworks also indicate the belief that human sacrifices maintained fertility.

The sun was believed to be ever thirsty for blood, and was symbolized by a fiery tongue. In *Shield Jaguar and Lady Xoc*, dated c. 750 (figure 9.22), we see an example of a bloodletting ceremony, where the Mayan ruler holds a torch over his principal wife as she pulls a thorny rope through a hole in her tongue. Those participating in blood sacrifices had to be high-ranking persons. The rulers' wrist bracelets, necklaces, crowns, and garb are all signs of their rank. Their flattened foreheads were signs of beauty, an unnatural effect created by

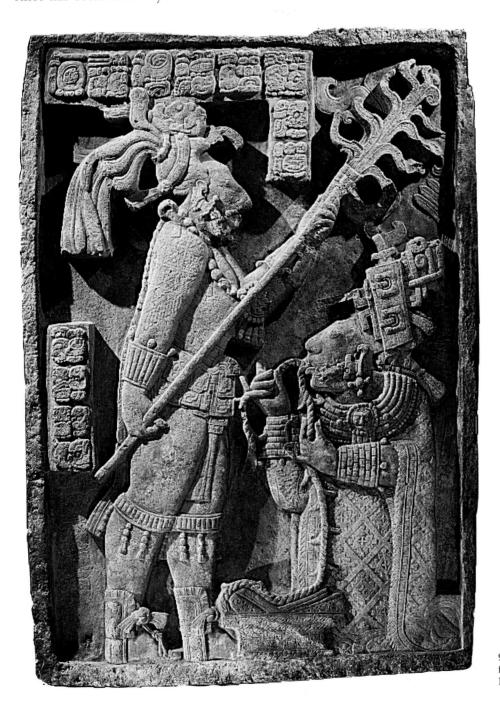

9.22 Shield Jaguar and Lady Xoc. Relief from a palace at Yaxchilan, Chiapas, Mexico. Classic Maya. c. 750.

binding boards on the soft skulls of very young children of nobility. More extreme forms of blood sacrifice were practiced, such as cutting out the hearts of captured warriors or the captains of ball teams. Ballplayers were important members of society, and ball games were important religious rituals in which the ball itself and the opposing teams symbolized the terrible balance between the sun and the moon.

Text Link

For more on the Mesoamerican ball games and their meaning, read Chapter 18, and look particularly at the Mayan ballcourt in figure 18.27.

Judeo-Christian religions recognize the offering of foodstuffs and also have a history of blood sacrifice. Cain offered farm produce to God; Abel offered an animal

and animal fat; the priest Melchizedek prepared a ritual meal for an offering for Abraham. One famous story of sacrifice concerns Abraham, who prepared to kill his son Isaac at the command of God, but at the last minute was allowed to substitute the slaughter of a ram. The gilded bronze relief panel, Sacrifice of Isaac (figure 9.23), sculpted by Lorenzo Ghiberti in 1401-1402, shows the emotionally intense moment when the youthful Isaac is bound on an altar of sacrifice, as his fierce-faced father Abraham holds the knife to his son's throat. The curves of their bodies echo each other, with Isaac pulling away as Abraham is poised to lunge forward. The nude body of Isaac is idealized and perfect, increasing the merit of the sacrifice. The intervention of an angel halted the sacrifice, and food, in the form of a ram (not visible in our detail), became an acceptable alternative offering. While blood sacrifices are no longer offered in mainstream Christian religions, the Eucharistic offering of

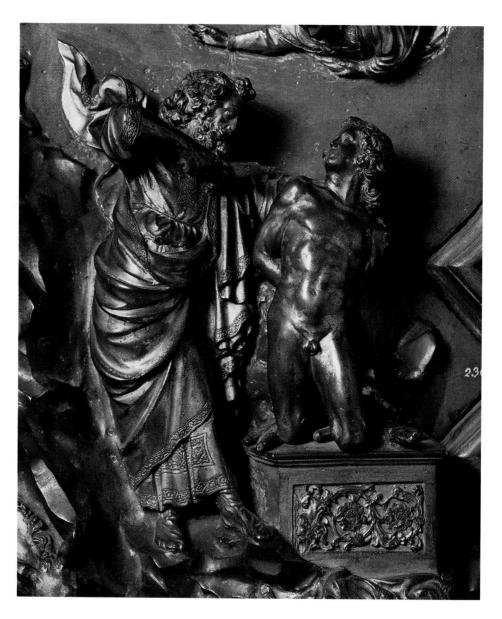

9.23 Lorenzo Ghiberti Sacrifice of Isaac (detail). 1401–1402. Gilded bronze. 21" × 17.5" size of total relief. Bargello, Florence, Italy.

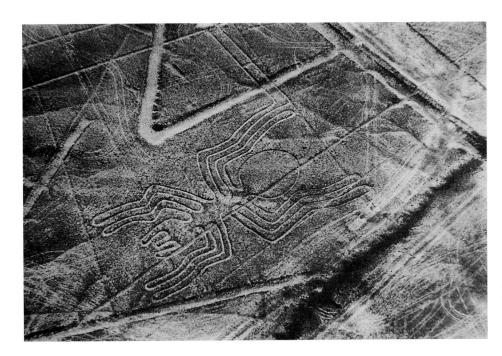

9.24 Spider. Large drawing created when brown surface rocks were scraped away to reveal yellowish surface below. Nazca, Peru. c. 200–600.

bread and wine continues to be celebrated in many Christian religions. Many skillfully crafted art items are used in these rituals.

Prayers

Prayer is a vehicle of communication between human beings and the gods. Although one might think of the spoken prayers heard in various religious practices, there are many forms of prayer that connect humankind with supreme beings. These forms may be found in music, theater, dance, as well as in the traditional visual arts. Let us look at some art that was created to commune with the divine.

A phenomenal form of a possible prayer comes from the Nazca culture, a pre-Incan civilization for which no written record exists. For cultures that have disappeared long ago, art historians and anthropologists must piece together and in some cases speculate on the ways humans communicated with gods, and the role that artworks played in that process. In southwestern Peru several centuries ago, a group of large-scale line drawings were made on a flat, rock-strewn, arid plain, essentially devoid of vegetation. No wind blows over the dry Nazca plain and it has essentially no rainfall—less than one inch over a twelve-year span. A casual footprint or scrap of litter will remain undisturbed for years. The Nazca drawings were made at least 1400 years ago by scraping the thin top brown surface of the desert floor, revealing lighter-colored sand and stone beneath. The earliest drawings were of animals, such as birds, whales, monkeys, or dogs. Our example, Spider (figure 9.24) dates around 200-600. Later drawings consisted of large geometric shapes, spirals, and a large number of long straight lines that extend for miles or radiate from certain center points. Many drawings were made right on top of previous ones.

The Nazca drawings are remarkable for their regularity. Straight lines extend for long distances and curved lines coil perfectly back on themselves. All lines in a drawing are a single standard width. Each outline is executed as a continuous path. The Nazca people probably used rudimentary surveying instruments and string to plot the paths. The drawings are so large and the plain so flat that the images cannot be discerned from ground level. Some of the drawings can be seen from nearby mountains. The imagery of some of the drawings is very similar to some Nazca ceramic and cloth designs.

The exact meaning or use of the lines and drawings is unknown. Current research indicates that the lines may have had several purposes. Some of the long straight lines may have been used for astronomical sightings, while others may have been paths that crossed the plain, while others still may have connected the plain's various shrines, which were piles of stones or cairns where offerings were left in pottery vessels. The animal drawings may have been messages or offerings to the gods, especially water gods. In such a parched environment, underground water sources were more important than rainfall, and the later Incas believed that water gods resided in mountains, a belief perhaps shared by the earlier Nazca. The spider is still highly regarded in areas of Peru and Bolivia where ancient rituals are still observed, coexisting with Christianity. Spiders augur weather changes, and certain series of actions are believed to foretell rainfall.

We will now look at two religions in which religious sculptures and masks are forms of prayer. We will look first at some examples from Africa. African religions developed in the small family groups and tribes that were scattered across the sub-Saharan continent before colonization by Europeans. Most religions recognize a Supreme Being who is rarely invoked in prayer, and almost never pictured. Rather, African religions are centered on the well-being of individuals and the community, and therefore focus on the many spirits who affect everyday life, positively or adversely. The spirits emanate from animals, places, and people, both living and dead. Forests and bush lands are seen as potentially dangerous places. The spirits of animals or plants killed in harvests or hunts must be placated to avoid future catastrophes. Wandering, dissatisfied spirits come from people who have died childless. Death itself is usually viewed as unnatural, due to the influence of some dissatisfied spirit.

Masks are important parts of African religious rituals and dances, whereby humans communicate with the spirit world. One very important point: the mask we see in books and in museums is completely taken out of context. Masks are dramatic in action. They are meant to be worn as part of a full-body costume, seen often at night by torch or firelight, and animated by energetic dancers. For Africans, masks are considered "good" when they are effective in dances, whereas the museum-goer appreciates their formal qualities. Museums and books cannot really describe the meaning and importance of a particular mask, which evolves with every use. Also, each tribe and group has its own distinct set of meanings. Even the museum's everyday display of masks is antithetical to their actual use, as many are only seen on special occasions, and a few are not meant to be seen at all—they are worn on top of the head and obscured by a ruff, so that the masquerade is directed to spirits only. Especially large masks may be worn on top of the head, with eye holes carved low, to increase the height of the dancer, who in some cases performs on stilts. Some large masks are steadied by ropes held by the dancer.

Text Link

We have already seen an example of African masks in action in Chi Wara Dance Headdress in figure 6.3. The Bamana people of Mali do antelope dances to aid the fertility of fields newly cleared for cultivation. Several qualities of the antelope are associated with these farmers working in Mali's adverse climate; for example, alertness, speed, body strength, and recognition of fragility. We will also see masks again in reference to entertainment, with the Gu Mask in figure 18.9.

Masks may depict human features, animals, natural elements such as sun disks, and sometimes combinations

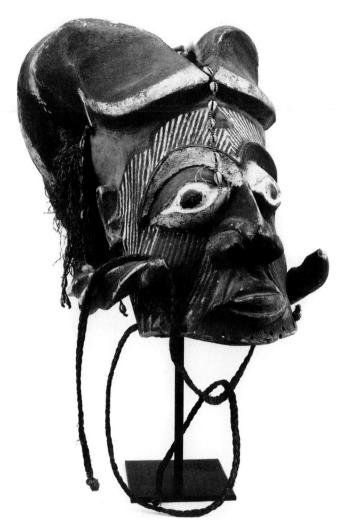

9.25 *Mask.* Wood, paint, fiber and beads. 22" high. Zaire, Africa. African Art Collection of the Museum of Texas Tech University, Lubbock. See also the text accompanying figure 5.11.

of the above. Shamans wearing masks with animal features believed they absorbed that animal's power, such as strength, ability to fly, speed, long life, etc. The Mask in figure 9.25 was used for initiations, where young men were made full members of the community, and also for funerals for initiated men. The lines under the eyes apparently represent the tears wept at an initiated man's death, while on the forehead the lines frame a clan marking. Holes along the bottom were used to connect the mask to the rest of the costume. The curved ram horns symbolize both fertility and masculine strength, as the ram is especially fierce in head-on combat. Rams were also often sacrificed in religious rituals. Horned animals, in particular the antelope, ram, and buffalo, were often the most revered and most valued among African people.

Another example of an art object used as a form of prayer is the *Power Figure*, such as the sculpture in figure 9.26, which would be used to counter the evil influence of enemies, whether human, animal, or spiritual. This

example is dated c. 1875–1900. Sculptors carve the power figure with an open mouth, indicating that the sculpture will "speak out" on behalf of persons beset by evil. Shamans activate them, first by ritually placing medicines in cavities in the figure's abdomen (as in figure 9.26), or in the back or head. Then they release the figure's power by driving in one metal nail or blade for each request for help. Once effective, the exact nail representing a particular request must be removed. This *Power Figure* is visually dramatic, with its compact form, expressive face, and bristling nails. Power figures are rarely used now, as African religions and religious prac-

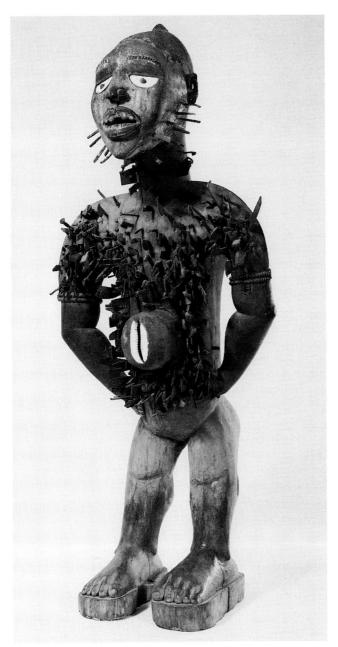

9.26 Power Figure (Nkisi n'kondi). Kongo, Zaire. Wood, nails, blades, medicinal material with cowrie shell. 46.75" high. c. 1875–1900. Detroit Museum of Art, Eleanor Clay Ford Fund for African Art.

tices are evolving and transforming, and rituals that were once practiced may be abandoned or amalgamated into other beliefs.

The creation of an African mask or religious sculpture is usually a two-part process, in which the sculptor creates the form and then the shaman instills the spirit in the piece. Paint is usually not regarded as visual decoration on sculptures, but rather as part of a ritual by which the spirit will occupy the sculpture. Some sculptures are used a long time, while others may be used only a few times and then abandoned if they seem to be ineffective.

We will now turn to the Hopis of North America, who make small sculptures that act as a form of prayer. The Hopis annually observe elaborate rituals to ensure the welfare of their community and sufficient moisture for their crops in the arid Southwest United States. The Hopi believe that spirits of dead ancestors dwell in their community for six months, roughly from the December winter solstice until the June summer solstice. These spirits are called Kachina and there are more than 250 distinct Kachina spirits, each responsible for some aspect of Hopi life. Male members of the Hopi community perform as Kachinas during religious festivals. Hopi religious observances are very complex, requiring a lifetime of religious education, beginning at age six.

Before the festivals, the performers prepare themselves for their spiritual role in the community by praying and observing secret rituals in kivas, which are round, covered, rock-lined holes in the ground, entered by a small opening in the roof. They don their costumes, the most important part of which is the mask, and appear in the community during festivals. Through rituals and dances, they maintain the harmony of the Hopi community and harmony with nature. Hopi women provide material support for religious ceremonies, such as food and kiva maintenance.

Text Link
An example of a kiva can be seen in the ruins of the Pueblo Bonito of the Anasazi people, who were ancestors of the Hopi. See figure 8.3.

Kachina performers also carve dolls that reproduce the costume of specific spirits. Our example, the *Ahola Kachina*, dated 1942, by Jimmie Kewanwytewa (figure 9.27), is the primary spirit at an important celebration that takes place in February, in which children are initiated into the Kachina cult and newly planted seed is force-sprouted as an omen for a good crop. The Ahola spirit is identifiable by the dome-shaped mask, white on one side and gray on the other, covered with small

crosses. Other identifying attributes of the costume include the large inverted black triangle on the face and the feathers from an eagle's tail that project from its head. The colors on the dolls, which reproduce the costumes, represent sacred directions: north is symbolized by blue or green; west by yellow; south by red; east by white; the heavens by multicolors; and the nadir by black.

The Kachina performers distributed these dolls during ceremonies for a variety of reasons. Children receive the dolls to educate them about the individual Kachinas and the elaborate costumes and rituals. Women receive them as symbols of fertility. The dolls are hung from rafters in houses as blessings and as prayers for rain and good crops. The dolls are traditionally carved from roots of cottonwood trees. Projecting forms are carved separately and glued or pegged onto the main trunk of the Kachina doll. Older dolls are stiffly posed, with arms drawn in and disproportionately large heads, sometimes as much as one-third the height of the doll. They were painted with locally acquired dyes and pigments and adorned with feathers. Newer dolls are more naturally proportioned, with action poses, and are painted with bright acrylic colors. As certain birds are endangered,

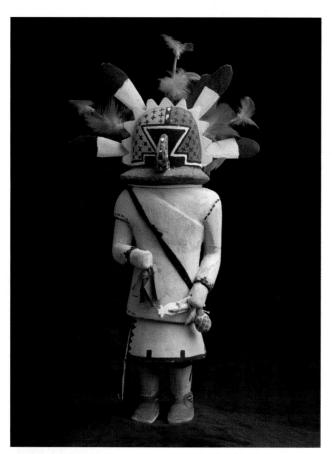

9.27 JIMMIE KEWANWYTEWA. *Ahola Kachina*. Cottonwood, paint, feathers, wool. Height: 13 inches. Hopi: Third Mesa, Oraibi. 1942. Museum of North Arizona.

the feathers on newer dolls are often carved rather than real. In the last few decades, Kachina dolls have been made for the museum/collector market, in addition to those made for ceremonial purposes. Hopi artists now sign the dolls they make.

THE COSMOS

Artists in various religious traditions have created artworks that map the cosmos. They provide a visual record of cosmic events and relations, for example, they may show the origin of the world, the place of humans in relation to the gods, or a diagram of time. We will look at three examples here.

Our first example is a mandala. A mandala is a radially balanced diagram consisting of circles, squares, rectangles, and/or radiating lines. Overlaying and augmenting our mandala diagram are images of deities, humans, and symbols of the universe. All together, they form a map of the structure and relationships between all entities of the cosmos, in accordance with Hindu or Buddhist beliefs. By meditating on the mandala, humans can begin to grasp these cosmic relations, and understand their place within them.

The mandala begins with a circle, which symbolized the void before all creation. Into this emptiness the image of the God will appear. In our example, the Mandala of Samvara dated c. sixteenth century (figure 9.28), the deity Samvara (also referred to in this work as Cakrasamvara, who rules and sets into motion the universe) erotically embraces his female Buddha consort, Vajravarahi. Samvara, an angry emanation of the Absolute Being, is shown with blue skin and multiple arms, symbols of his power and divinity. He is pictured here with a donkey face; those meditating on this image learn the illusory nature of the physical body, and gain other spiritual attainments. Radiating from this center are eight paths, which terminate at the sides or corners of a square. These paths refer to rays of light, the cardinal directions, and elements such as fire, water, wind, and earth. Other fierce deities, combinations of animal and human forms, occupy these paths. This entire retinue of deities is among the most important symbols in Tibetan Buddhism.

While the inner circles contain deities, the large outer circle touching the sides of the mandala encloses charnel fields, where vultures, wild dogs, or cremation fires consume the bodies of the dead; there are generally no graveyards in Southeast Asia. The details of hyenas, bones, entrails, and vultures are both gruesome and gleeful, vividly depicting harmful forces. Immediately outside the ring of the charnal fields are eight auspicious signs, such as a lotus blossom and a white conch shell, that represent divine gifts offered to Buddhas. The outermost areas of the mandala are populated with images of monks, mystics, and more deities.

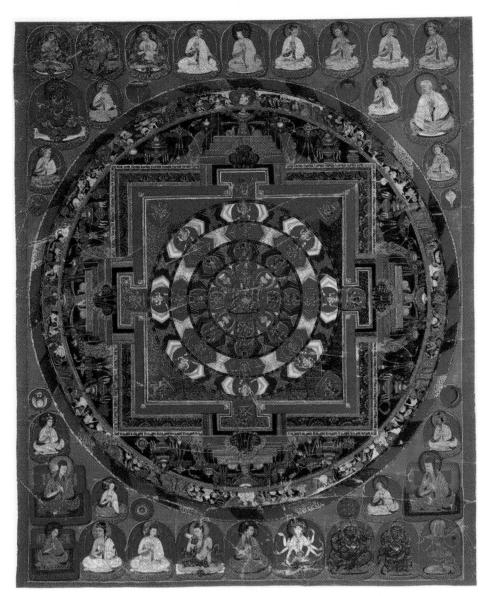

9.28 Mandala of Samvara (Kharamukha Cakrasamvara Mandala). Water-based pigments on cotton cloth. Height: 23", width 18". Tibet, c. sixteenth century. The Zimmerman Family Collection. See also figure 4.5 and the accompanying text for more on this artwork.

During meditation, the mandala can be followed from the outside inward to the center circle, indicating stages of increasing enlightenment. When followed from the center outward, the mandala represents the emanation of the creative force responsible for all life forms in the universe, a force originating from Samvara, the manifestation of the Absolute Being. The mandala reinforces the belief that the cosmos, including the physical and spiritual world, is an uninterrupted whole. All life is a manifestation of continually fluctuating energy states.

Red is a common color of Tibetan mandalas, and predominates here. The brilliant blue results from the use of lapis lazuli, an expensive pigment derived from grinding semi-precious stones. Thus, the work was probably commissioned by a wealthy patron. The detail work is extremely fine, especially in the portraits, the patterned scrolls, and the floral elements. The mandala is visually complex, with so many details, and at the same time very simple, because of the underlying geometric structure. It is therefore a wonderful visual equivalent to the Tibetan cosmology.

Text Link

A mandala can take other forms than a painting. For example, a human seated in lotus position can be overlaid on a square mandala, with the navel as the point of origin, and head as the center of energy. The plans of Hindu temples are mandalas, with the sacred chamber housing the deity at the center, surrounded by four walls with porches on each side. See figure 10.13e for the floorplan of the Kandarya Mahadeva Temple in India, which in some ways resembles the design of the mandala painting we have just studied.

Another example of a work of art depicting a particular religious view of the cosmos is the Aztec *Calendar Stone*, dated c. 1502–1520 (figure 9.29), a large relief carving weighing many tons. The sun was central to the Aztec religion, and the sun disk, a series of concentric rings with rays pointing outward, is a common symbol in Aztec art. It stands both for the sun deity and also for the Aztec cosmic eras. The Aztec believed that earth had existed through four previous eras or Suns, and was destroyed in sequence by jaguars, winds, fiery rains, and floods. In the current era, the gods created the sun at Teotihuacan, but the sun did not move without the self-sacrifices of the gods and repeated blood sacrifices from humans. The current era itself would be destroyed by future earthquakes.

Text Link

For more information on Teotihuacan turn to Chapter 10, figures 10.19 and 10.20.

The stone Calendar combines several important symbols, summarizing the major cosmic events in time and the large spatial divisions in the universe. Some areas of stone are deeply carved, creating rings of darker shadows, that help visually separate one area from another and make the complex pattern of symbols easier to decipher. While the entire work is a sun disk, the center contains the face of the earth deity, uniting cosmic opposites. Its claws are visible in circles on either side of its head. The X-shape around the earth deity is a glyph that stands for the specific year in the future when the current era would be destroyed. Oddly enough, creation was shown by destruction, for the destruction of the current era indicated its completion. Each arm of the X contains a small glyph indicating the years of the destruction of the four previous worlds. Other small glyphs stand for important dates in the rise of Aztec power. Outer rings of the stone calendar have symbols from the Aztec ritual calendar. Two dragons encircle the entire disk, with their heads meeting at the center bottom and their tails joined at the top. Death figures are in their mouths. The top of the circle indicates the heavens, while the center is the earth, and the bottom the underworld. The relief edges of the entire large circle are carved with symbols of the night sky and the planets.

Again, like the *Mandala of Samvara*, we have a work that is compositionally simple and at the same time iconographically complex. While the mandala is used in meditation, the exact use of the stone calendar has never been determined, nor has the reason for its unfinished edges come to light. It may have been intended to be installed in a temple, or may have been used in gladiator-like contests.

Let us look at one last example of cosmic imagery. The paintings on the walls and ceiling of the Sistine

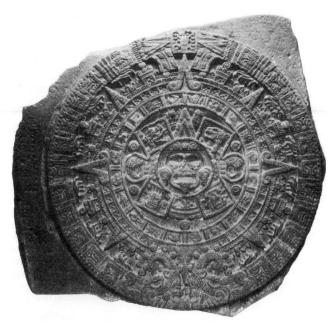

9.29 *Calendar Stone.* Relief carving. Diameter: approximately 11 feet 6 inches. c. 1502–1520. Aztec. Tenochtitlan, Mexico. Museo Nacional de Antropologia, Mexico City.

Chapel form an account of the origins of the universe, from a Christian point of view. The most famous of these paintings is the cycle of images on the Ceiling of the Sistine Chapel, painted by Michelangelo (figure 9.30) from 1508 to 1512. Pope Julius II commissioned the work, or better phrased, the pontiff's strong will triumphed and Michelangelo executed it. The artist was not enthusiastic at first, for he felt he was a sculptor, not a painter, and painting a ceiling was not as prestigious as creating a sculpture. He had to learn the technique of fresco painting, or direct painting on wet plaster, before he could begin. Originally the work was to consist only of the twelve apostles with some other ornamentation. But as Michelangelo proceeded, his creative vision expanded. As a result we have one of the finest masterpieces in Western painting.

Michelangelo changed the imagery from the apostles to nine scenes from Genesis, three of God creating the world, three of Adam and Eve, and three of Noah. In addition, there are panels with seven prophets, and five sibyls. The broad expanse of the ceiling is subdivided into individual panels by an architectural frame of "marble" piers and sculptures (all frame elements are only painted illusions). The nine Genesis scenes alternate between five large and four small panels, with the overall theme showing the formation of the universe, the creation of humanity, and the origin of evil in the world.

At the center bottom of figure 9.30 is a panel showing God as a powerful-bodied, older man in pink robes, separating the light in the lower right from the darkness in the upper left. In the panel just above, this same figure of God is shown rushing forward from the right,

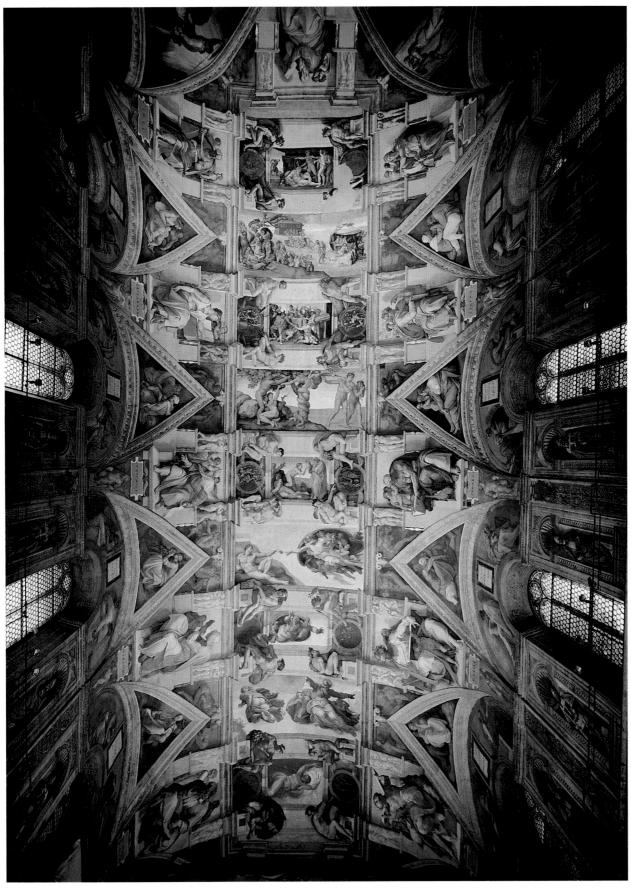

 $9.30 \; \text{Michelangelo}. \; \textit{Ceiting of the Sistine Chapel.} \; \text{Fresco, approximately } 128' \times 45'. \; \text{The Vatican, Rome, Italy.} \; 1508-1512.$

creating the sun and the moon and departing toward the left. The next four scenes show God separating the water from land; the creation of Adam, the first man; the creation of Eve, the first woman; and original sin, where Adam and Eve break God's commandment and are expelled from Paradise. The three center panels at the top are concerned with stories of Noah, the patriarch of the human race after a devastating flood destroyed most life on earth. These cosmic moments are depicted in bright clear colors against plain backgrounds, emphasizing the bodies' dramatic shapes.

The Creation of Adam (figure 9.31), one of the most famous panels from the Sistine Ceiling, shows the moment when God transmits the spark of life into the body of Adam, thus creating the human race. The cosmic relation between the human and the divine realm is depicted here. God's bursting energy contrasts starkly with the languor of Adam, clearly distinguishing the creator from the created. Yet, human and divine bodies are similarly powerful and similarly posed, indicating the Christian belief that humans are created in the likeness of God and, with God's help, humans can attain heaven. Surrounding God are a host of heavenly beings. Conspicuous is the woman peering from under his arm, identified as either Eve or as Mary with the child Jesus at her knee. Neither Eve nor Mary existed at the moment of Adam's creation. Their inclusion in this picture indicates the belief that God contains all potentiality, all creation, and the means of salvation at all moments in time.

The painted "architecture" provides spaces inhabited by nudes, prophets, and learned teachers from the Classical and Jewish traditions. The teachings of these sages pointed to the coming of Jesus. The nudes may symbolize ideal humans perfected through Jesus. The architectural framework also ties the ceiling images to those on the walls. All images, whether on walls or on the ceiling, are reenacted or commemorated in the Christian ritual of the Mass, celebrated on the altar of the Sistine Chapel. Thus the cosmic events of the past are repeatedly connected to the religious rituals of the present.

SYNOPSIS

Artists in different traditions use a number of devices to show the spiritual realm in their artwork.

In creating images of gods, goddesses, and other holy beings, artists use geometric symbols, symbols taken from the natural world, animal forms, and the human body. The geometric symbols most often used are the sphere, circle, square, and triangle. Animals can be used as symbols for gods, or in some cases the animals are the actual forms of the gods, as in ancient Egypt. Also, fantastic combinations of animal and human forms can allude to the divine realm, especially in Hinduism. Goddessess and gods have been shown in human bodies in many religions. Often, the human body is raised to idealized form when used to depict deities, as in the Greek, Roman, and some Christian art. In other Christian images, however, the vulnerable and weak indi-

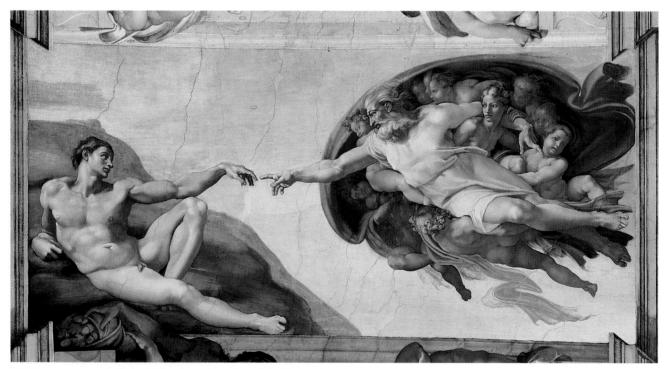

9.31 MICHELANGELO. Creation of Adam, from the ceiling of the Sistine Chapel. Fresco, 18'8" × 9'2". The Vatican, Rome, Italy. 1508–1512. See also the text accompanying figure 20.11 for more on Michelangelo and the creation of this work.

cate the divine. In Buddhism, the human body is stylized and simplified to represent transcendent states.

For some ancient religions that are no longer practiced, we rely on sacred images to give us basic information about those religious traditions, including the ancient Egyptian, the Minoan, the Aztec, and the Nazca.

Religions that worship many gods often assign particular spheres of influence to various deities. So, there are gods of war, love, music, wine, childbearing, the home, and so on. We looked at a few examples of deities concerned with food, especially water, rice, and corn.

Art is also part of the process of communication between humans and God. In some cases, art is a form of an offering as seen in the Kwakiutl people's *Great Winter Ceremonial*, or of thanksgiving, as in the *Offering with Cili Shaped Crown* in Bali, and in the Mexican *Retablo of Maria de la Luz Casillas and Children*. Or it may have shown an act of sacrifice as seen in the Mayan blood-letting ritual, the *Sacrifice of Isaac*, and in the sacrificial death of Christ. Or art may be a prayer in a colossal earth drawing as seen in the plains of Nazca in Peru; or in a ritual as performed with African or Hopi masks. It may be invoked as seen in the African *Power Figure*.

Finally, art has provided us with diagrams of the cosmos and images of creation. We saw examples from the Aztec, Christian, and Buddhist traditions. These works account for the relation of gods, human, and the planets from the viewpoints of particular religions.

FOOD FOR THOUGHT

There are many paradoxes and contradictions embedded in the human attempt to give image to the divine. For example, there are various strategies by which the visible serves as a vehicle to grasp the invisible. Diagrams of incredible complexity are paths for understanding Oneness. States of powerlessness, such as self-sacrifice, self-denial, or helplessness, can be required to come in touch with supernatural power. The material world can be both a manifestation of and also the total opposite of the divine.

- Paradoxes and contradictions in the visual arts are means of indicating both divinity and absurdity. Can you think of examples from art where contradictions are purposely used to point to the extraordinary?
- Why is it that human beings have often attempted to create images of divine or spiritual beings, only later in some cases to have them banned or destroyed?
- Is there an inherent need to see and understand a god or goddess in order to have the hope of surviving the finality of death?
- Or do these images and sculptures act as visual reminders of the inevitability of death, and possibly offer an explanation for it?
- Do you think that the artists who created images of spiritual beings were "divinely" inspired?

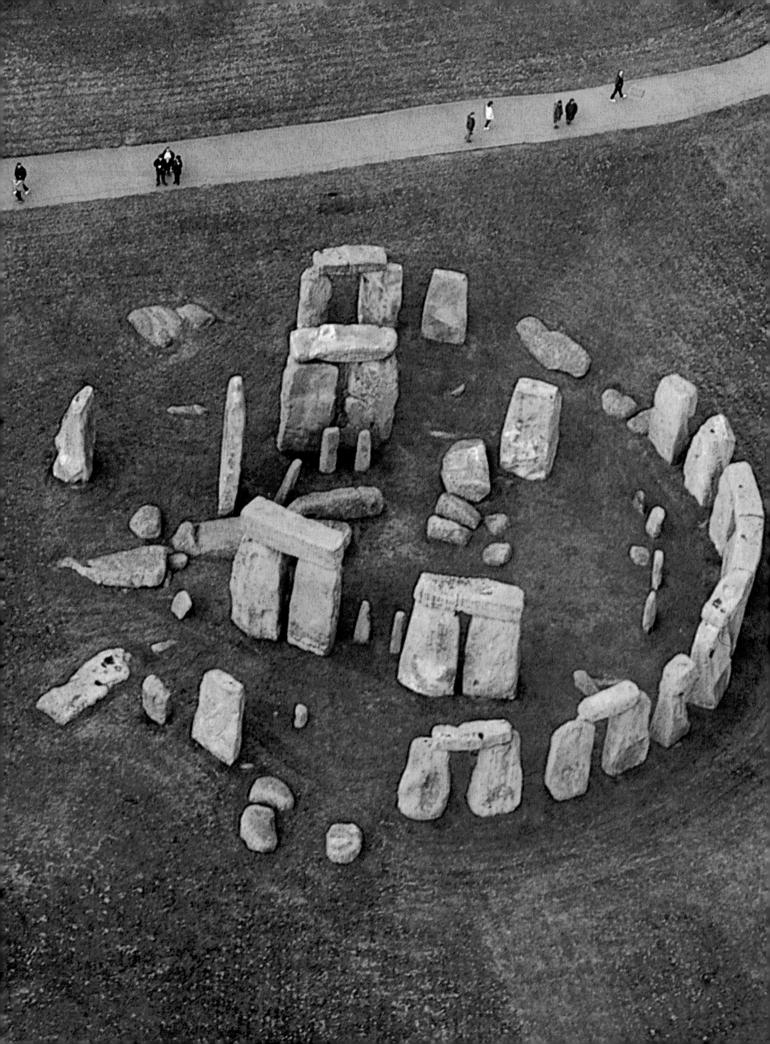

Chapter 10 Places of Worship

INTRODUCTION

Since prehistory, peoples have set aside special places for religious worship. For centuries, they have used art and architecture to distinguish these places, to make them special and reserve them from other uses. All places of worship, from simple to grand, are designed to reveal something of the spiritual realm and to give a person an experience beyond the normal and mundane.

This chapter covers some ways that different peoples have demarcated, organized, or designed sacred spaces. Some basic inquiries in this chapter are the following:

What are some general characteristics of places of worship?

How do people identify sacred space?

How do people shape architecture to make sacred structures?

How does the use and design of a sacred space reflect the religious experience there?

How do people use art forms other than architecture in sacred spaces?

How can large-scale sacred architecture also be an expression of political power?

GENERAL CHARACTERISTICS OF PLACES OF WORSHIP

How can humans create structures that seem divine or transcendent? Interestingly, certain characteristics appear repeatedly in places of worship across cultures and religions, as we see here:

- they incorporate elements of nature;
- they are traditional sites for the location of a religious celebration;
- the geometry used to determine their dimensions or location is symbolic;
- they house sacred images, sacred artifacts, or sacred writings;

- they incorporate the concept of journey, or are a destination for pilgrims;
- they shelter a congregation.

All places of worship incorporate some or all of these characteristics. Let us look at them one by one, in detail.

Elements of Nature

Places of worship can be natural sites: mountains, springs, and sacred trees or groves. Mountains have been meeting places between heaven and earth or dwelling places of divine beings. Rocks can be seen as containers or symbols for spirits and deities. The earth and water are the sources or sustainers of life. Trees may be seen as sources of truth and symbols of the cosmos, existing simultaneously in the underworld, the earth, and the heavens. Fire, light, and the sun are divine symbols or sometimes spirits themselves.

Later places of worship may be pyramids, temples, churches, or mosques, but they still incorporate or make reference to mountains, rock, water, trees, light, fire, or the movement of the sun. Or they have natural elements incorporated into their structure, in a way that maintains and emphasizes their natural quality.

The Ziggurat at Ur (figure 10.1), dated c. 2150–2050 BC, is an artificial mountain erected by the Sumerians of the city of Ur to honor their special deity from among the Sumerian pantheon of gods. Its corners point towards the four points of the compass, thus reflecting the movement of the sun. The word "ziggurat" itself means "mountain" or "pinnacle." It is a massive terraced tower built of rubble and brick. Surrounded by flat land, it seemed so high that it became a sacred place that reached into the heavens. The Ziggurat at Ur has three broad staircases of one hundred steps each that lead to a gateway approximately 40 feet above ground level. A temple-shrine atop the structure was dedicated to protective gods and goddesses, and attended to by special orders of priests and priestesses.

The Shinto religion in Japan teaches that forests and enormous stones are sacred dwellings of the gods, who are called the "Kami," the numberless and numinous powers inherent in nature, all connected to growth and renewal. Our example, the *Main Shrine at Ise* (figure 10.2), is located in a forest, on a holy site. Through ritual, the Kami are prevailed upon to enter the shrine, where their powers are worshipped and their aid solicited. A mirror placed inside facilitates the Kamis coming into the shrine. There are various sects of the Shinto

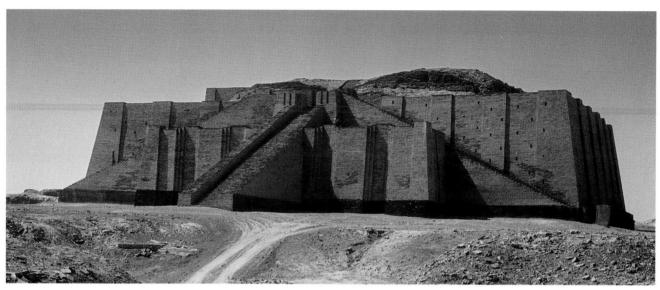

10.1 Ziggurat at Ur (partially reconstructed). Third Dynasty of Ur, Iraq, c. 2150–2050 BC © Hirmer Fotoarchiv.

religion, and no fixed dogma or sacred scriptures. Ancestor worship is also part of its beliefs.

The *Main Shrine at Ise* is made of natural materials, primarily wood and thatch. It is rebuilt every twenty years to exactly the same specifications, so what we see in figure 10.2 is both a new building and a structure that dates from 685. With each rebuilding, the builders observe careful rituals and express gratitude as they take

wood from the forest. Builders number every board as they cut it from the tree, so that boards taken from the same tree can be placed together in the building of the shrine. The wood is left plain and unpainted, so that it retains its natural character as much as possible. The structure is held together by carefully fitting the wood and joining it with pegs. Nails are not used. The golden color of the wood and the simple but striking geometry

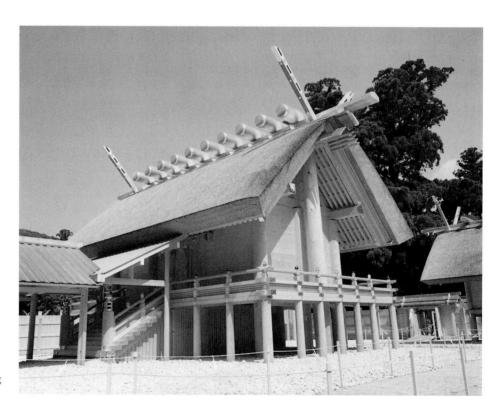

10.2 Exterior *Main Shrine at Ise.* Japan. c. 685, rebuilt every twenty years. See also the text accompanying figure 21.25 for more on this shrine.

make the Main Shrine at Ise dramatic, clean, direct, and impressive.

Text Link

Compare the similarities of the basic design and shape of the Shinto shrine to the Toba Batak House discussed in Chapter 8, figure 8.16.

Today Shinto shrines continue to be built anew, or rebuilt of old. While in the past they usually were constructed in natural settings, they can be found anywhere in the present day. They continue to be popular centers for community festivals and activities.

Sites of Sacred Ceremonies

Places of worship are sites where sacred ceremonies are performed. Sacred ceremonies may be distinguished by architecture—that is, they take place in a house, temple, church or mosque. But not always. Some sacred ceremonies are distinguished only by the use of the arts—music, dance, singing, literature, or the visual arts—and may take place on a patch of grass or an open field. Whichever is the case, the arts contribute essential elements to ceremonies and places of worship.

In the U.S. Southwest, the making of sand paintings constitutes an essential part of the Navajo religious ceremonies. The paintings themselves are made and destroyed in the course of the ceremony, and are thus impermanent. They are made directly on the clean-swept floors of houses. Navajos therefore perform ceremonies in various locations. In the long history in which sand paintings have been made, very few have ever been photographed or documented. However, the symbolism used and the rituals surrounding their creation are fixed and must be repeated for each act of worship. Native American religions are built around the powers of nature and spirit worship, and the paintings are a way to release these forces for the good of humans. Thus paintings are made for curing illness, for success in hunting, and for fertility. While chanting and praying, the artist-priest makes the painting using the natural elements of colored sand, crushed stones, charcoal, and pollen, while the person in need of the ceremony sits in the center of the painting to receive the power of the gods. Sometimes ceremonies are performed for the earth itself.

The iconography in sand paintings can be quite complex. In *Nightway: Whirling Logs* (figure 10.3), executed in the early twentieth-century by Franc J. Newcomb, we see logs whirling at the center, where rivers meet and the four sacred plants grow: yellow corn, white squash, blue beans and black tobacco. One deity appears at each of the four compass points in the painting. Some bring seeds, others bring medicine. Color in sand paintings

can vary from black to white, with red, blue, yellow and a full range of browns in between. Shapes are bold and geometric. Symmetry is a frequent component in the design.

The Navajos use ceremony and painting as a way to define a place of worship. Other cultures also have used or still continue to use ceremony and painting in that way, rather than using architecture to demarcate a place of worship. We saw some examples of this in Chapter 6, Food. In these cases, places of worship are created not through architecture, but by other art forms that are essential elements of the ritual or worship. Anthropologists believe that the making of the cave paintings at Lascaux in southern France were part of rituals that gathered the forces of nature to aid humans, whether to give them success in the hunt or to encourage the fertility of the earth from which the animals sprang. At Lascaux, the ritual act of painting may have transformed the caves into sacred sites. Also in Chapter 6, we saw how the Aboriginal people of Australia use painting to demarcate a place of worship. The Aboriginal people reveal their system of beliefs through chants, dance, and painting, using ancient symbols known only to certain members of a clan. Through their paintings, they account for life and death, and for aspects of the cosmos that are important to them. The Bamana people of Mali use masks in dances to invoke spirits who give them knowledge.

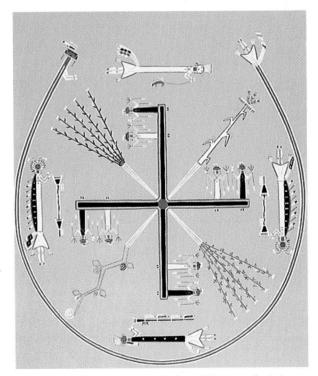

10.3 Nightway: Whirling Logs. Reproduction of Navajo sandpainting (painted by Franc J. Newcomb), before 1933. 22%" × 28%", Wheelwright Museum of the American Indian. Santa Fe, New Mexico. For more on this artwork, see the text accompanying figures 2.18 and 20.18.

Text Link
Early cave paintings (figure 6.1) may
have used ritual and worship for help to
attain food.

Let us turn to an example from Africa where a place of worship is demarcated because of the rituals performed there. Up through the mid-twentieth century, the Igbo peoples of Nigeria constructed mbari houses (figure 10.4). Our example dates from 1925. For the Igbos, the act of building the mbari was the religious event, demanded by specific deities, usually Ala, who was the Goddess of the earth. The building itself was made with great care, and with the best materials. It had a high roof line that often was covered with tin, while the low roofs of nearby houses were made of thatch, an inferior material to tin. The interior was lavishly decorated with murals and filled with numerous clay sculptures, all specially made by professional artists for this particular shrine. The *mbari* was constructed in private, behind a fence, and once completed was officially opened with public ceremonies as a sign that the Goddess had accepted the offering. Later, it was not used by worshippers, but allowed to disintegrate and eventually return to the earth. Thus, even though it was a building, the *mbari* shrine functions very much like the sand painting in Navajo ceremonies, as an activity that is the focal point for the ceremony, and then ignored (or destroyed) later.

The design of the *mbari* buildings were not fixed, but were modified through the nineteenth and twentieth centuries to use modern materials as they become available. Today, *mbari* shrines are rarely made, as the practice has apparently fallen into disuse.

Symbolic Geometry

In the course of this chapter, we will see many examples of architecture where sacred or symbolic geometry is essential to create a sacred space. In some, geometry that is symbolic and spiritually significant determines the placement or orientation of religious sites. In others, it determines a building's plan, layout, or elevation. Many cultures use geometry and symmetry to symbolize divinity, all-encompassing totality, perfection, and timelessness.

In prehistoric Europe, Neolithic humans placed large stones upright in geometric formations, presumably for religious and funerary purposes. Sometimes the stones were set in long rows running for several miles. For example, at the *Menec Alignment* in Carnac, northern

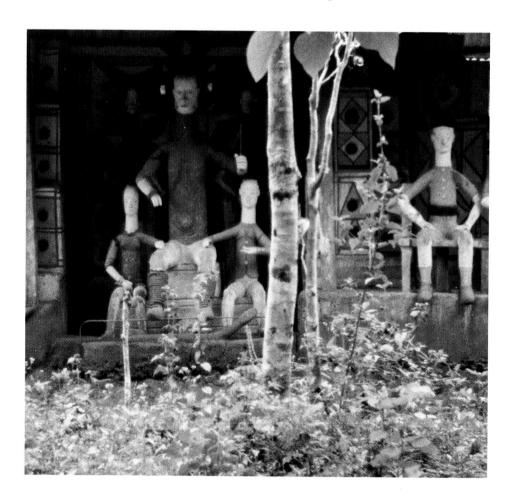

10.4 *Mbari House*. Igbo, Ndiama Obube, Nigeria, built c. 1960. Photographed in 1966.

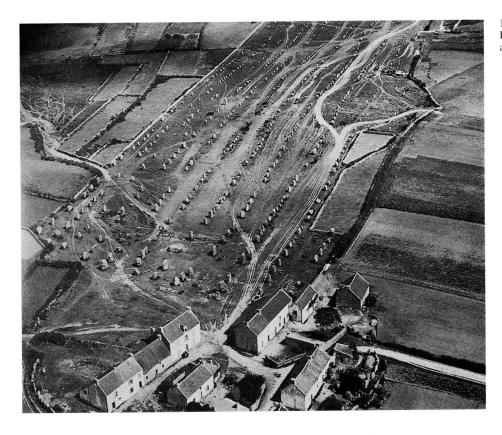

10.5 The *Menec Alignment*. Carnac, Brittany. 2500 BC. This particular alignment contains over 1,000 stones.

France in 2500 BC, thousands of colossal stones (figure 10.5) were set in long parallel lines. The alignment served religious purposes, either for sun worship or for cults of the dead. Other stones were set in circles, while still others stood alone. All stones culminate at a site presumed to be the stones of sacrifice. Each Carnac stone is irregular, unusual, and very distinct in appearance. Stonehenge, dated c. 2000 BC (figure 10.6), in Wiltshire, England, is perhaps the most famous Neolithic work in Europe. Stonehenge was built at a time when religion and

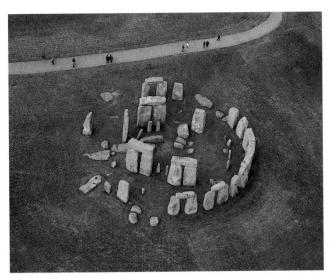

10.6 Stonehenge. Wiltshire, England. 97' in diamter; upright stone with lintel, approximately 24 feet high. c. 2000 BC.

science were not separate; they were a single unified means of understanding the forces in the natural environment. Thus *Stonehenge* is likely an altar for religious rituals as well as an astronomical device to calculate eclipses, the path of the sun, and lunar cycles. Its location and orientation in nature are important. The stone arrangement marks the midsummer solstice, which was essential knowledge to an agrarian civilization that was dependent upon successful crop planting. Other Neolithic stone arrangements in the area align with *Stonehenge*, creating a larger network that may have served to map force fields within the earth.

Stonehenge was built in various phases, the first of which was the digging of a gigantic circular ditch, with rubble piled to create an outer bank. The later core of Stonehenge consists of a ring of colossal sarsen stones, 97 feet in diameter, that surrounds an inner ring of smaller bluestones. The bluestones in turn surround a horseshoe-shaped stone arrangement and finally an altar stone in the center. A heel stone, separate from the circle, marks the solstice. The large sarsen stones were 24 feet high with their capping lintel; individual stones weigh up to 50 tons. They were dragged from a site 24 miles away and were likely set in place using ropes and earthen ramps. Unlike the stones at Carnac that were left unfinished, these enormous rocks were pounded and rubbed to shape and smooth them. The grouping, by itself, has a majestic presence. Stonehenge also includes several large rings of holes dug into the ground that conceptually connect the center stones to the surrounding earth.

10.7 Pantheon. Rome, Italy. Concrete and marble. Height from floor to opening in dome is 142 feet. AD 118–125. See also the text accompanying figure 3.13.

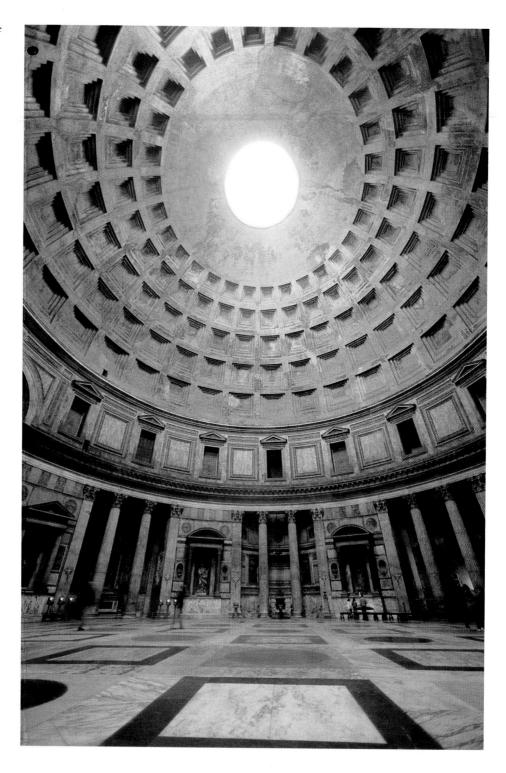

At *Stonehenge*, solar, lunar, and stellar movements are mapped upon the earth. The geometry of *Stonehenge* is therefore highly significant and also symbolic. Likewise, peoples in many cultures have found straight lines and geometric shapes oriented with celestial movements to be profoundly significant, and have used them to create places of worship that echo the heavens.

Centuries later, in the Roman shrine called the *Pantheon*, AD 118-125 (figure 10.7), we see simple

geometric shapes form the basis of a building design that alludes to divine qualities of perfection and completion. The *Pantheon* is a shrine to the chief deities of the Roman Empire. At the time of its construction, the view of *Pantheon's* plain exterior was mostly blocked by other buildings. The focus of the building is on its interior. A 142-foot-diameter sphere fits into the interior space, making the width of the building equal to its height. The dome, a perfect hemisphere, contains the

top half of that sphere. A 30-foot circle at the top of the dome opens to the sky, creating a shaft of sunlight that dramatically illuminates the interior. This opening is called the "oculus," meaning the eye of the structure. Squares are inscribed in the dome and wall surfaces, and are the basis of the pattern on the marble inlay floor. The entire structure is symmetrical, both inside and out, and has the impression of loftiness, simplicity, and balance.

In fact, we will see throughout this chapter that the circle and square are frequent religious symbols. In the Islamic, Hindu, and Buddhist traditions, the circle denoted the realm of heaven, while the square stood for the earthly and the physical. Other geometric attributes can have religious meaning. The Greeks balanced horizontality and verticality to express the harmony of the cosmos. In Catholicism, the verticality of the Gothic cathedrals stands for an aspiration to heaven.

In the examples to come, we will see repeatedly that geometry was important for the placement and orientation of sacred structures. Our examples of Mesoamerican and Egyptian temples are aligned to the four cardinal points of the compass, as their religions were closely tied to the sun's movements. The Chinese Buddhist temple faced south, as that direction was the source of life-giving sun versus the cold of the north. Gothic cathedrals usually point west, while Islamic worshippers face Mecca.

Housing for Sacred Objects

Many places of worship were built specifically to house a sacred image, text, or artifact of a religion. In the Jewish religion, the Temple of Solomon housed the sacred scriptures called the Torah and other sacred objects. The most holy structure was a special tabernacle that was used to house these sacred objects, called the *Ark of the Covenant*, as seen in figure 10.8. The Ark was constructed according to instructions from Yahweh given to Moses, so that the prophet could communicate and receive rev-

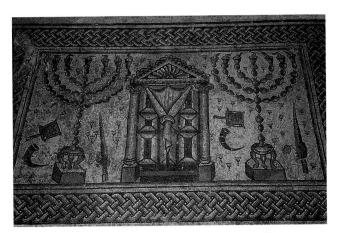

10.8 The *Ark of the Covenant* and sanctuary implements, Hammath near Tiberias, fourth century, Mosaic, Israel Antiquities Authority, Jerusalem. Photo: Zev Rodovan, Jerusalem.

elations from him during the exodus from Egypt. Our image is a mosaic from the fourth century AD, which depicts the Ark in the center of the composition. The tabernacle is flanked by sanctuary implements, including elaborate seven-branched candelabra.

Since the Jewish peoples had years of migration in their history, a tent was likely their early place of worship as well as a temporary temple. The Ark of the Covenant was always carried by special priests in their journeys. Later, King Solomon had the Temple in Jerusalem built, which housed the Ark and the Holy Scriptures, as well as an altar on which offerings and sacrifices would be placed. This temple was not a gathering place to worship, but an official priesthood attended to the temple and officiated at sacrifices there. Solomon's temple was destroyed in 586 BC, although today part of the wall remains where Jews from all over the world go to pray. Subsequently, the synagogue was evolved as a community house of worship, assembly, and study. Even modern synagogues, however, still house sacred objects, as each contains an Ark, scrolls of the Law, an "eternal" flame, and candelabra.

Text Link

The Roman Emperor Titus led troops into Jerusalem and destroyed the Second Temple in AD 70. Relief carvings on the Arch of Titus commemorate the emperor's victory in Jerusalem and depict his soldiers carrying the booty from the Temple in a victory parade. See figure 12.28.

Other religions also house sacred objects in their places of worship, as we shall see further in this chapter. Again, these are often specially constructed buildings such as temples or churches, but this is not always the case. For example, among many African religions, shrines that hold sacred objects are commonly part of ordinary houses. This is an important aspect to many African religions, as they weave spiritual forces with everyday life.

Destinations for Pilgrimages

A pilgrimage is a journey to a shrine or sacred place. Believers undertake pilgrimages hoping to receive special blessings or revelations because of their faith or the difficulty of their journey. The concept of journey is both metaphoric and actual, as the soul's spiritual search for understanding has been likened to a physical journey. Pilgrimages are required or strongly encouraged by many religions as a means of deepening a person's faith. Almost all major religions incorporate the concept of pilgrimages into their belief systems, and so Muslims journey to Mecca, Jews to Jerusalem, Catholics to various sites such as Lourdes, Hindus to shrines dedicated to various deities, and so on.

10.9 Shrine to Vairocana Buddha. Longmen, Luoyang, Valley of the Yellow River China: c. 600–650. Natural rock carving, 50' high.

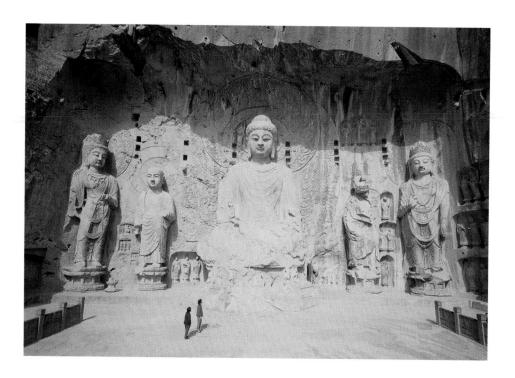

Our first example is from the Longmen Caves, a huge complex of cave-shrines housing thousands of sacred statues, which is a Buddhist pilgrimage destination. At Longmen, 1,352 caves have been carved into the limestone mountains, with over 97,000 statues and 3,600 inscriptions dedicated to Buddha. You can see the walkways that allow pilgrims to climb throughout the site and visit the many shrines. The largest of these is the monumental Shrine to Vairocana Buddha, dated c. 600-650 (figure 10.9), who is the universal principle dominating all life and all phenomena. He is attended by demons and lesser buddhas who govern their own worlds under the all-powerful spiritual Buddha. This belief in hierarchy was used by tyrant emperors as a model for and a justification for their own totalitarian rule, and in fact the carvings at the Longmen caves were supported by imperial patronage. The central figure of Buddha is serene, massive, and volumetric, with drapery defined with a few simple curves, to enhance the colossal scale of the carving.

Notre Dame du Haut, a Catholic chapel in the Vosges Mountains of France, built in 1950–1955, is an example of a church that is a destination for pilgrims. The design recalls praying hands, the wings of a dove, and the shape of a boat, all Christian symbols of divine generosity to humans (figure 10.10). Although architecture, Notre Dame is sculptural in shape, as it is built of concrete sprayed over a steel and mesh framework that allows almost any shape to be constructed. An underlying mathematical system governs the design of this church. As a mountain destination for pilgrims, Notre Dame du Haut had to accommodate very large crowds on holy

days, and so was fitted with an outdoor altar and pulpit (visible towards the right in this photograph), so that services could be conducted for 12,000 pilgrims on the lawn. For these events, the building's exterior becomes a piece of monumental sculpture, a dramatic backdrop for the religious event. The interior of *Notre Dame du Haut* is a relatively small space with limited seating, almost mystically dark and cave-like (figure 10.11). The inside lighting is dramatic. Irregularly spaced deep-set square colored-glass windows pierce the walls, and light filters in through gaps between the ceiling and the tops of the walls, making the roof appear to float. Inside and out, then, *Notre Dame du Haut* becomes two churches in one.

Sheltering Congregations

Many places of worship are shelter for the people who worship there. This is not always the case, as some allow only a few priests inside the structure, while all others remain outside. Those that are meant to be entered by the many are designed to have enough covered interior space to accommodate the congregations that use them. They help to create an atmosphere of holiness and to focus attention on the ceremonies.

Congregational places of worship run the gamut in terms of scale, from very modest to overwhelmingly grand. Later in this chapter, we will see some examples of very large structures. On the modest end of the continuum is our example now, the *Chapel of St. Peter and Paul* dated to the seventeenth–eighteenth centuries (figure 10.12), a Russian Orthodox church in a sparsely populated area of northern Russia. A belfry and small

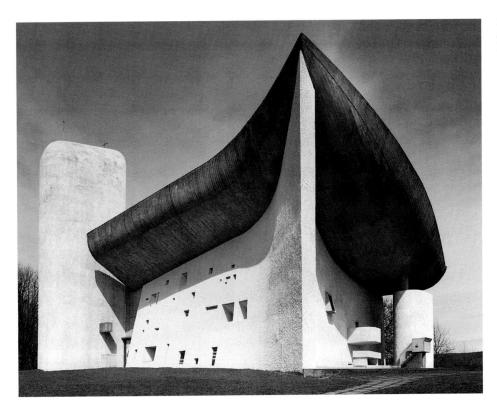

10.10 LE CORBUSIER. *Notre Dame du Haut*. Ronchamps, France. 1950–1955.

dome, each surmounted by a cross, distinguish this small wooden structure from what might be a house. Churches in this area provided shelter for more than religious rituals. They were also civic and social centers of villages. The sanctuary is located under the small onion dome, while the court of justice convened in the

antechamber under the large belfry, and social conversation took place on the broad porches. These old wooden churches were often located near bodies of water, and their belfries also served as beacons for safe navigation. The steep roof sheds the heavy winter snow. The body of the structure is constructed of interlocking

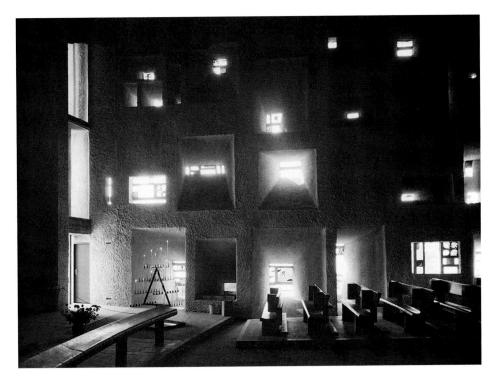

10.11 Le Corbusier. Interior, *Notre Dame du Haut*. Ronchamps, France. 1950–1955. See also the text accompanying figure 2.6.

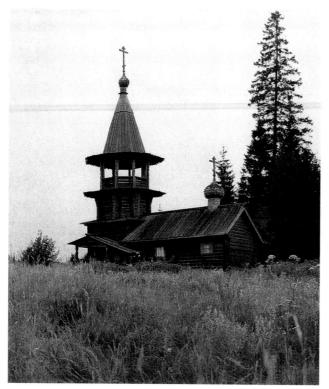

10.12 Chapel of Sts. Peter and Paul. Medvezhyegorsk district, Russia. seventeenth-eighteenth centuries.

logs. No nails were used to build this church, and axes were the only tools used to cut and shape the logs.

TEMPLE COMPLEXES AND LARGE-SCALE SACRED ARCHITECTURE

Now that we have seen some basic elements of places of worship, we turn to look at a selection of religious sites that are more grand, extensive, and complex than what we have already seen. These magnificent sites are among some of the most famous works of art in the world. They all incorporate the general characteristics of sacred sites that we have seen at the beginning of this chapter. But we shall see that they do infinitely more than that. They were built where a religion has become firmly established and tied to political or secular power. Because they were expensive, required enormous labor, and took a long time to build, a stable government usually supported them. Thus, grand places of worship tend to be expressions of both temporal and religious power. They embody an expression of that culture's major values, and that religion's major beliefs.

Text Link

We will use a number of architectural terms to describe these grand structures. Refer to Chapter 3, especially figures 3.2, 3.6, and 3.9 for descriptions and illustrations of terms. Size is an important characteristic of all of the structures we will see in this section. The most imposing ones are spectacles, amazing to see. Their size overwhelms the individual viewer, and is an integral part of the religious experience. Likewise, the individual often has only a minimal role in religious ceremonies there, but rather is more a spectator, an audience member. But that audience is important; as part of a throng, this massing of people adds to the religious importance of the site.

We will start by comparing the plans of six of the seven major sites we will study (figure 10.13). We will refer to each plan again, as we discuss each structure in depth. But for now, it is helpful to look at them as a whole. All are drawn to the same scale. None of the structures is by any means small, even the temple from India, the *Kandarya Mahadeva temple*, because it rises 130 feet high! The largest, the *Temple of the Sun* in Central Mexico, is truly enormous. The plans also reveal how important symmetry is in these designs. As we already saw, symmetry is part of the symbolic geometry used in sacred structures to suggest perfection, completion, and grave importance because of its formalness. In these large-scale structures, symmetry is an excellent visual metaphor for political power and divinity.

The plan of the seventh major site, the Buddhist *Temple of Heaven*, is shown in figure 10.28. The temple is integrated into the design of a quarter-mile-wide park, and will be discussed in that context.

Text Link

We have already seen the interior of a Jewish synagogue. Review the discussion of the Synagogue at Dura-Europus, figure 9.9.

Let us begin our study of religious compounds and large-scale sacred architecture with the Greeks.

The Greek Temple

In studying Greek temple design, we will use the Parthenon in Athens as our example.

The Temple Setting

Before we begin to to discuss the Parthenon, we must look first at the Acropolis, a flat-topped hill in Athens where shrines and temples were clustered. The city of Athens is situated on a plain surrounded by mountains. A high plateau in that plain, the Acropolis, originally was a fortress for the city. Eventually, as the city spread down into the plain, the Acropolis became a sacred area dedicated to Athens' patroness, Athena. So, although we will be looking at a temple on top of the Acropolis, it is important not to forget the mountain itself. The Acropolis forms a dramatic setting, gives great height to the temples on top of it, and is a mountain to climb in the pilgrimage journey.

As you approach the Acropolis, whether from the distant harbor or from within the ancient city, its white marble shrines rise impressively as if from the very rocks upon which they sit. The Greeks sited their temples so that they complemented and responded to their natural setting. At this time, temples and indeed cities themselves were not organized along conceptually clear, space-saving grids (see *Acropolis plan*, figure 10.13). The temples are arranged for visual drama. Smaller buildings, clustered along the steep approach to the Acropolis, contrast dramatically with the large temples and open space at the top. The *Parthenon*, 447–432 BC (figure 10.14) the largest temple atop the Acropolis, is positioned to be visually impressive from many surrounding viewpoints.

History of Temples on the Acropolis

Greece in the fifth century BC was not a unified nation, but a group of independent city-states. The complex of temples on the Acropolis was built at the time that Athens was at its most powerful among the Greek city-states, right after it led a confederation of Greek states to defeat their invading Persian neighbors. Athens was then ruled by Pericles, an ambitious and visionary leader who succeeded in making the other Greek city-states subject to Athens. The Acropolis, which had been ravaged during the Persian invasion, was rebuilt, expanded, and embellished under the direction of Pericles, to be a splendid religious shrine to Athena and an appropriate expression of the political power and culture of Athens (an art gallery was included among the temples). The most famous of all Acropolis structures is the *Parthenon*.

Text Link

The temple complex on the Acropolis was a costly project to build, with many structures using expensive materials constructed in a short time. For more on the financing of the Acropolis temples, and other forms of art funding, see the section entitled "Support for Art Making" in Chapter 20.

Temple Design

The *Parthenon* is a good example of the design of a standard Classical Greek temple. There are definitely other temple styles and variations, but the *Parthenon* illustrates many of the important concepts behind Greek temple design, and so we will focus on it. The *Parthenon* follows an established type of temple that the Greeks had been building for at least three hundred years previously. It is a two-room structure with pediments above the short sides and a colonnaded porch all around. Older temples were heavier-looking, frequently lower, and with thicker columns. While the *Parthenon* appears much more grace-

ful and refined than older temples, the basic model was still apparent in all. All Greek temples were covered using the post-and-lintel system. This particular style (or "order") of temple was called Doric, and could be easily identified by its column. The Doric column had no base, a simple cushion capital, and a shaft that was fluted, or carved from top to bottom with thin vertical channels. High-quality marble blocks were carefully stacked and finished so that the columns originally appeared seamless. The shaft of the Doric column swells slightly at the middle, called "entasis," to give the column a feeling of organic flexing.

Text Link

Other styles of Greek temples had their own distinct column and capital, called the Ionic and Corinthian orders. These orders were also carried over into Roman architecture, and can be seen, for example, on the Colosseum in figure 18.26. See also figure 3.5 for diagrams on the Doric, Ionic, and Corinthian orders.

In designing the *Parthenon*, the architects Iktinos and Kallikrates often treated it more like a piece of sculpture than architecture. It sits on a platform of steps, much like a statue on a pedestal. The steps that form the base of the structure are higher at the middle of each side, and lower at the corners. The Greek architect felt that straight steps would have the optical illusion of appear to sag in the middle. Thus, the *Parthenon* was optically designed. The columns at the corners are thicker and placed closer to neighboring columns to compensate for the glaring bright sky behind them that would appear to diminish their size. Outer columns lean slightly toward the middle of the building, to make the Parthenon more visually cohesive. With the bulging or entasis, the columns suggest the human body.

The *Parthenon* was meant to be entered only by a few priests, and so is not designed to shelter a congregation. Religious ceremonies took place on the exterior. The *Parthenon* had two interior rooms for housing sacred objects. One was a treasury, and the other a shrine to Athena. The shrine contained an enormous 38-foot-tall cult statue of Athena with all surfaces finished in gold and ivory. The statue was destroyed long ago, but we know much about it from ancient texts and Roman copies.

Sculpture and Relief Carving

Because the *Parthenon* exterior was all that most people saw, its outside originally was richly adorned with sculpture and brightly painted. There were large figurative sculptures of the gods in its pediment and various other areas near the roof. Also, a long band of sculpture (3'6" high, 524' long) called a frieze, girded the top outside walls of the *Parthenon*'s two inner chambers.

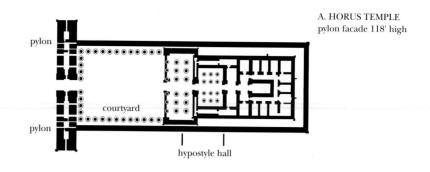

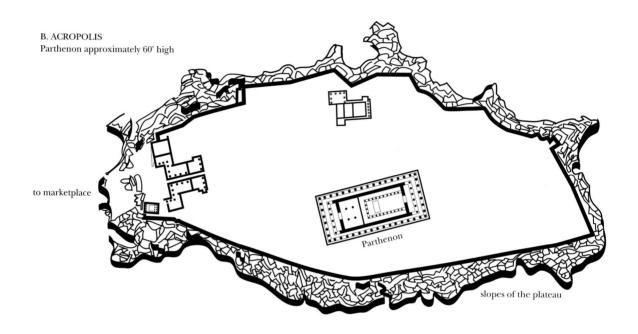

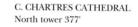

10.13 Comparison of the plans of various places of worship. Notice that all plans are drawn to the same scale, and vary tremendously in size. Heights vary tremendously also; they are marked in the boxes next to each plan. A. Horus Temple (top left), B. Aeropolis (middle left), C. Chartres Cathedral (lower left), D. Pyramid of the Sun (top center), E. Kandarya Mahadeva Temple (right), F. Masjid-i-Shah (lower center). See figure 10.27 for the plan of the Buddhist temple compound, the Altar of Heaven, which is too large to be shown at scale with the rest of these plans.

Carved in c. 440 BC, the frieze shows a long line of Greek worshippers in a procession from the marketplace below the Acropolis and then climbing up to the *Parthenon*. There are marshals, youths, maidens, jar carriers, horsemen, and charioteers, some bringing

animals for sacrifice. At the beginning of the procession, shown on the west side of the *Parthenon*, the worshippers are raucous and unorganized, like our *Horsemen* (figure 10.15). Gradually the worshippers become solemn and orderly at the east end as the

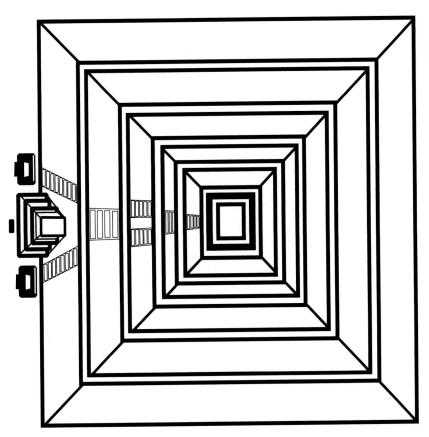

D. PYRAMID OF THE SUN 215' high

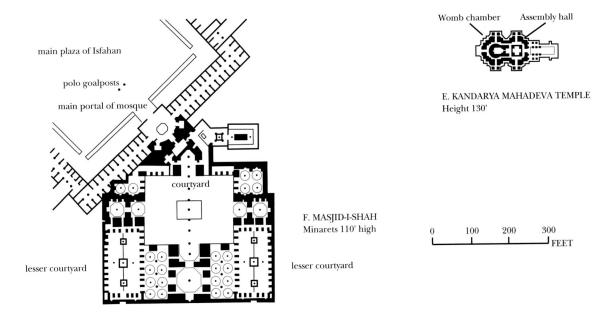

mortals proceed to meet the gods. The frieze sculpture probably depicts an actual event, the Panathenaic Festival procession, a special celebration occurring only once every four years in which worshippers with musicians from the marketplace below bring a new

ceremonial tunic to the Acropolis to robe an ancient wooden statue of Athena.

The carving on the sculptural frieze is very high quality, an especially amazing feat given that the sculpture is almost twice the length of a football field, and was

10.14 IKTINOS AND KALLIKRATES. Parthenon. Athens. 447–432 BC. Pentelic marble. Height of columns 34', dimensions of structure 228' × 104'. See text accompanying figures 3.4, 20.17, and 21.8.

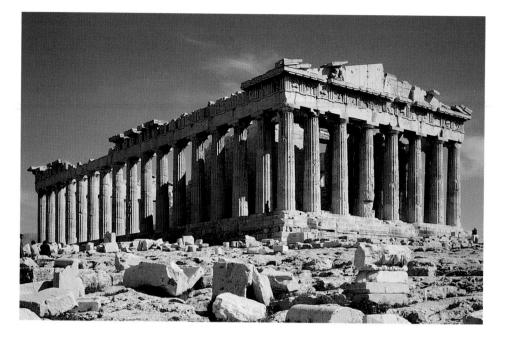

completed in less than a decade. The bustle at the beginning of the procession is communicated by overlapping, crisscrossing diagonals—horses legs, waving hands, flowing drapery. Eyes, hair, and drapery on sculpture were painted for emphasis and to give a more colorful effect than plain stone. Later in the procession, as the worshippers become more solemn and approach the gods. the figures are all vertical, with regular horizontal spaces between, and almost entirely without diagonals. All the figures, whether of gods or humans seem rounded and lifelike, with carefully carved muscles. They are dignified, composed, well-proportioned and idealized—at the prime of life, healthy, with attractive features and serene faces, etc. Indeed, the Greeks valued their culture and their people so much that there was a relatively narrow gap between their depiction of Greek humans and Greek gods.

Throughout its length, the frieze on the *Parthenon* is carved more deeply at the top and more shallowly at the bottom. It was located up high under the overhanging

roof and was illuminated only by the light that would bounce off the white marble walkway below. To viewers standing below, the increased amount of carving at the top made the figures clearer where the least light hit. Now that the *Parthenon* is a ruin, however, we see the frieze more intensely lit from above, as there is no longer any roof in that area.

Text Link

Who owns important cultural treasures? Much of the sculpture from the Parthenon is in the British Museum in London, and the Greek government has made efforts to have them returned. For more on controversies over ownership of art, see the section on "Keeping Art" from Chapter 21.

Mathematical Proportions and Greek Philosophy We have already discussed how the *Parthenon* was an expression of Athens' political power. How was it an

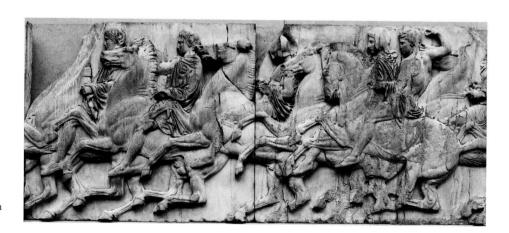

10.15 *Horsemen*. From the Parthenon frieze. c. 440 BC. Marble, 37" high.

expression of the beliefs of the ancient Greek religion? In building their temples, the Greeks made subtle adjustment in style and proportion. The Greeks strove to design ever-more-perfect buildings. In their science, geometry, art, religion, and philosophy, the Greeks were engaged in a search for perfection. For example, they believed that certain geometric ratios and certain musical intervals resonated with the cosmic order and were in tune with the heavens. When they built their temples like the Parthenon, they were searching for a set of proportions that echoed the cosmic order; geometry could be used to create a microcosm of the heavens. Thus, the overall length of the Parthenon is mathematically adjusted to be in pleasing proportion to the width, and a consistent set of proportions was used to determine the length and width of parts within. With its post-and-lintel structure, there was a balance of horizontal and vertical elements that gave the Parthenon a satisfying visual organization and a quality of aloofness and self-containment.

The *Parthenon* also reflects the Greek idea of the value of the individual. Its scale does not overwhelm a human being. Its style of sculpture is also significant. The ancient Greek religion worshipped a number of gods whose exploits echoed the best and worst of human beings. As the Greek concepts of deities and of human beings were significantly similar, then the individual man, humanistic education, and the arts and sciences were important too. Thus, in the *Parthenon* sculptures, contemporary Athenian mortals are immortalized next to the gods, and indeed look very much like the deities themselves.

Text Link Greek deities such as Zeus are depicted with idealized human characteristics. See figure 9.4.

The Egyptian Temple

Egypt produced a large number of temples and funerary shrines in the 3,000 years that the Pharaohs ruled. Because of space limitations, we will look at just one. Fortunately, Egyptian temple design remained relatively constant from 3000 BC onward, and so our study of one will illustrate the qualities of many temples.

Setting and History

Life in ancient Egypt was unusually stable. Flooded with endless sunshine, Egypt sat in the middle of a vast desert, on either side of a long river whose fertile banks were hemmed in by cliffs and mountains. The protective desert kept the Egyptians relatively free from foreign invasion for 3,000 years. Natural cycles, such as night

and day, the annual flooding of the Nile River, and birth and death provided rhythmic patterns and powerful symbols for the Egyptian religion. Ancient Egypt worshipped many gods, who were often associated with animals, environmental elements, or celestial bodies. Many were depicted in forms that combined human and animal features, as we saw in Chapter 9. The greatest among them was Re, the sun god, who created the Nile and by extension was the source of life.

The study of Egyptian architecture is really incomplete unless it is considered within the landscape made sacred by Egyptian beliefs. They used symbolic geometry to demarcate sacred alignments. The daily passage from east to west of the sun god, Re, symbolized life, death, and resurrection, and created one basic axis in that landscape. The second basic axis, north and south, paralleled the Nile River. The Egyptians built cult temples, which were used to worship gods, and usually located them on the east bank of the Nile, like the rising sun. In contrast, the Egyptian tombs and funerary temples, which were used for funerary rites or to house the souls of dead rulers, were on the west. Thus, for example, the cult temples at ancient Thebes were on the east river bank, aligned from north to south and connected by line of sphinxes that paralleled the axis of the Nile River. Across the river, along the east-west axis, was a complex of funerary temples and the tombs of the kings in the mountains behind them.

Text Link

The Egyptians were very concerned with the afterlife. Much of their architecture, such as the Mortuary Temple of Hatsheptsut (figure 11.6), consists of tombs and funerary temples, which are covered in the beginning of Chapter 11. We will also discuss their beliefs about the afterlife and about the human soul.

Temple Design

In this chapter, we are focusing on the Egyptian cult temples, which were used for their religious observances. The form for the Egyptian cult temple, once developed, remained fairly constant for centuries. Egyptian temples were often parts of extensive temple complexes that were located in sacred cities. Successive pharaohs would add new temples to the complex, or add new courtyards or halls onto existing temples, and thus expand and increase the glory of the temple precincts. The *Horus Temple at Edfu* is a fairly late, but still representative, example of Egyptian temples. Located on the Nile's west bank, it was dedicated to Horus, the sun falcon, son of Isis and Osiris.

Temples were seen as the dwellings of the gods, and were modeled after the residences of nobles and

pharaohs. The basic temple structure (see plan, figure 10.13) is laid out in courtyards and halls that were like reception rooms, leading to the sanctuary that corresponds to the private family bedrooms in residences. It was necessary to keep the temple pure, and so its foundations were protected by amulets and animal sacrifices and its outer edges were walled.

The front entrance of the temple is *The Great Pylon of the Horus Temple at Edfu* built c. 237–57 BC (figure 10.16). The massive structure consists of two large symmetrical geometric "mountains" flanking the large doorway. The image may have been derived from the Nile River flowing between the occasional cliffs, with the vast empty desert on either side. Visually, the pylons both define the entrance and are a barrier to entrance, and indeed, the lower classes of the Egyptian population were not permitted in the temples. Statues and carvings animated the great surfaces, and they had been painted so that at one time the temple façade was very colorful. The four vertical niches held tall poles from which banners were once flown.

The Temple Interior

Behind the pylon entrance was a courtyard, an open space with columns and roof only around the edges (see plan, figure 10.13). Two large statues of falcons flanked the doorway into the temple proper. All doorways and open areas were aligned to create a straight-line path that continues throughout the temple, much like the long path of the Nile River through the desert. The alignment and flow echoes the Egyptian's sanctified experience of nature. The floor of the temples were painted to depict a river flowing through them, and the ceiling was decorated with sun rays and the stars of the

night sky. Often appearing in temples were obelisks, the tall rectangular shaft with the pyramid top, represented a single ray of sun, or the male symbol of procreation.

Two covered rooms are located beyond the courtyard at Edfu. They were hypostyle halls, an architectural term referring to parallel rows of columns that supported the ceiling. Some hypostyle halls had taller columns down the center of the structure which raised the roof and created a clerestory that provided light to the dark space. In the First Hypostyle Hall at Edfu (figure 10.17), the columns are huge and closely spaced, filling and clogging the interior. Like the Greeks, the Egyptian temple was a post-and-lintel structure. But where the Greeks used lightweight wooden beams to cover their relatively spacious interiors, the Egyptians used stone beams, which are very heavy and cannot span a broad space. The stone roof necessitated the closely spaced supports, like a thicket of columns. The concept of the passageway is again emphasized, as the space is not really usable as a room.

The shapes of the columns and capitals were probably derived from organic matter used to build the very early Egyptian buildings, where bundles of reeds from the Nile marshes were probably mounted into stone bases to support a light, impermanent roof. The Egyptians, in their desire to express the permanence of the afterlife and the power of the gods, translated that original organic material into granite and limestone structures of incredible mass and monumental scale. The stone capitals often resemble lotus buds, blossoms, or palm fronds. The shaft of the columns swells like the flexing of organic materials, as if bending subtly while supporting an overhead weight. At Edfu, the columns of the hypostyle hall are 50 feet tall; at another temple site, Karnak, the

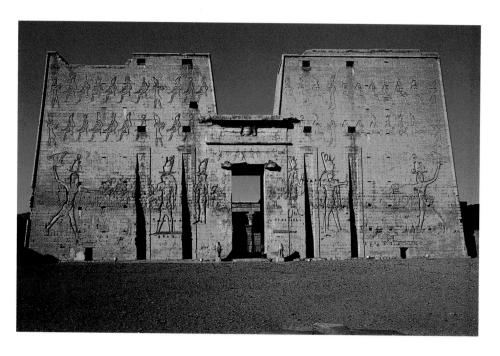

10.16 Great pylon of the Horus Temple at Edfu. c. 237–57 BC. Height of the pylons is 118 ft., and the facade is 230 ft. wide.

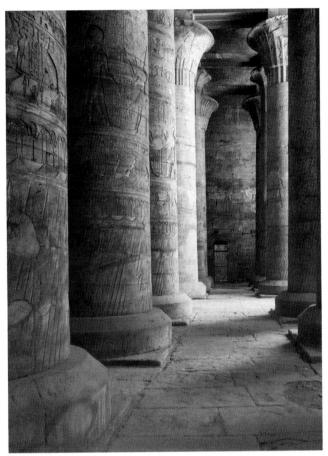

10.17 First Hypostyle Hall, Horus Temple at Edfu. The roof slabs are 50' from the floor. See also the text accompanying figure 3.3 for more on this hall.

central columns in the hypostyle hall are 66 feet high, and the capitals at the top are 22 feet in diameter, a space big enough for one hundred persons to stand atop them. No concrete was used in them; the massive stones were cut to shape and held in place by their tremendous weight.

The *Horus Temple at Edfu* was built to house the sacred image of Horus, which was kept in the sanctuary at the very back, to help protect its purity. Each successive area of the temple was sealed with heavy doors covered with bronze or silver and decorated with precious stones. The holiest areas were opened only on special occasions, and could be approached only by a very few. Light was significant in temple architecture. At Edfu, the courtyard is sunlight-filled, and then indirect light filters into the first hypostyle hall. The second hypostyle hall, directly behind it, was darker, mostly in shadow. This second hall had a lower ceiling and higher floor level than the first; in fact, from the entrance back to the rear of the temple, the floor level rises and the ceiling becomes progressively lower, until the priests would reach the ultimate holy room with a granite tabernacle that held the sacred image of Horus. This sealed-off "holy of holies" was small, dark, and thick-walled. The sacred image of Horus did not always reside in darkness, however. On certain special feast days, the image would be taken in a special barque to other sanctuaries along the Nile. And during New Year's celebrations, priests carried divine statues up inner staircases to the roof, so that the statues could be joined with the sun and recover their vigor.

Relief Carvings and Paintings

The large columns, walls, and pylons provide extensive surfaces that the Egyptians covered with relief carvings and paintings. The monochromatic impression we get by looking at temple ruins is inaccurate. The Egyptian temples were brightly painted, as evidenced by traces of paints still remaining in the stone. These carved and painted images depicted the gods, the pharaoh, priest, landscape elements, and temple rituals (figure 10.18). Some are located up so high or in such darkness that they could not even be seen from ground level. But the Egyptians apparently believed that the portrayal of a ritual would ensure its eternal reenactment. In style, the carvings were cut shallowly into the surface, so that the wall surface was still present and apparent. The figures are rendered in the formal, traditional style reserved for

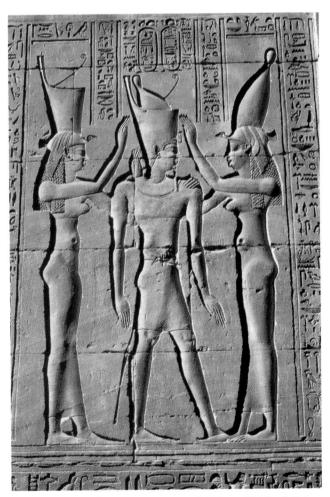

10.18 The Pharaoh Crowned by the Goddesses Nekhbet and Wadjet. Relief carving from the Horus Temple at Edfu, c. 180 BC.

10.20 Original west face, with stairway. *Quetzalcóatl Temple*, Teotihuacan. Stairway is lined with images of Quetzalcóatl, the Feathered Serpent. On the vertical faces, other images of Quetzalcóatl alternate with those of Tlaloc, the rain God. Built after AD 100.

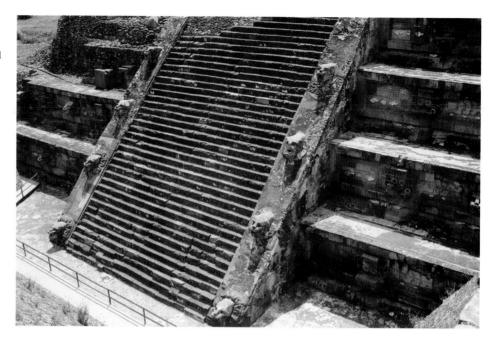

Tlalocan Painting (figure 10.21), that survives from a palace in Teotihuacán gives us an idea what these paintings may have looked like. A large frontal figure at the center is a water god with green water droplets springing from her hands. Plants populated with butterflies and spiders grow from her head, while two priests, shown symmetrically and smaller in scale, attend and make offerings. The colors in this restored version are bright, with an especially intense red background. The deity is distinguished by her larger size, frontality, and the profusion of symmetrical patterns that ornament her. In fact, the entire piece shows the Teotihuacános' fondness for elaborate symmetrical patterns, both in framing and in depicting characters.

Temple Precinct

The incredible scale of the Avenue of the Dead dwarfs any of the places of worship we have seen so far. The *Pyramid of the Sun* alone is much larger than any other structure in this chapter (see plans, figure 10.13), and it is only part of the enormous religious complex that stretches for more than two miles. Even though the sacred precinct is composed of many structures, it can be considered as a unified whole. The style of architecture is remarkably consistent throughout. And the overall design emphasizes both space and mass: the pyramids and platforms as solid mass; the plazas as voids that were often the same size as the bases of pyramids. Also, many areas we perceive now as being empty plazas were

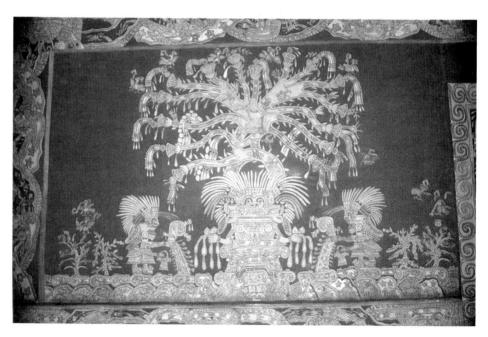

10.21 *Tlalocan Painting*, from Tepantitla compound, Teotihuacán. Copy by Agustin Villagra. Original: pigment on stucco.

probably courts for ball games, which in Mesoamerican cultures were important religious rituals. The ball was seen as a symbol for the sun, and thus the competing teams reenacted the cosmic struggles between the sun and darkness. At the end of the game, a ball player was ritually sacrificed, perhaps a member of the losing team, or perhaps the captain of the winning team, who then entered the realm of the gods.

Text Link

See figure 18.27 for an illustrated discussion of the ball

The very growth and building of Teotihuacán directly led to its decline. The colossal monuments of its religious center required enormous amounts of plaster, made from seashells or limestone burned in kilns. To fire these kilns, the forests surrounding Teotihuacán were leveled, resulting in soil erosion, failure of rains, and the decline of the city. These calamities may have prompted the Teotihuacános to cut down more forests to build more temples to placate the gods.

Even after Teotihuacán was abandoned in 650, the site was never lost and then later rediscovered, as were some ruins. The architecture of Teotihuacán influenced most other Mesoamerican civilizations. The Aztecs, who rose to power in the area around 1425, incorporated the remaining pyramids of Teotihuacán into their mythology. They named the place and believed the sun and the moon were born there. Aztec rulers made religious pilgrimages to Teotihuacán, and passed their mythology to the Spanish conquistadors who arrived in 1519.

The Hindu Temple

Theological Basis for Hindu Temple Design

In India, the temple form was developed from and based on two crucial but very different belief systems behind the Hindu religion. The first belief system was nature-based. From very early times, the native people venerated the various spirits who were responsible for the incredible abundance and variety of plant and animal life that flourished in the tropical Indian subcontinent. These native people celebrated the spirits of places and the powers of nature, for example, trees, rivers, rocks, and snakes. Around 1500 BC, invaders came to India from a drier, less fertile region to the northeast. Their religious beliefs centered on abstract deities who dwelled in the heavens. They conceived of the cosmos in symbolic, geometric terms: the circle stood for the totality of the universe; the square was that divine force made physical in life on earth; a vertical pole was the pillar between heaven and earth, a link that also ensured their separation. These two sets of beliefs came together to form Hinduism. From nature worship came the concept that life and death were part of the same process, an infinitely repeating cycle in which vital forces emerged as individualized life forms, only to submerge and then reemerge again—the concept of reincarnation. From the invaders came the belief that a good person would eventually break the cycle of rebirth and death, and move into a changeless, timeless union with the Supreme Consciousness, called Brahman or the Unbounded. That state is called nirvana, where all notion of individual form and identity is transcended.

From the very earliest surviving religious structures, it is apparent that the Hindu architect attempted to give form to spiritual beliefs, to make the invisible visible. The earliest temples were cave temples, carved right into the sides of mountains. These rock-cut temples were like opening the earth's womb to find the divinity inside, for a sacred image of a deity was enshrined on the back wall. The earliest rock-cut temples were very simple, but over the next thousand years they became more elaborate, with carved pillars, porches, relief images of deities, and intricate decoration.

At the same time, freestanding temples were also being built in stone that were in many ways similar to the rock-cut cave. The freestanding temples were simple structures conceived as residences for the deities enshrined within them. They consist of a cube, protected by very thick walls and a heavy ceiling. That cubic cell, called a womb-chamber, housed the cult image or symbol of the deity. A heavy tower, like an abstract mountain, was built above the womb-chamber and a few relief sculptures adorned the exterior. Worshippers prayed outside and individuals only entered the shrine for solitary meditation. Thus, the Hindu temple was more like sculpture, primarily to be viewed from the exterior, rather than like architecture in which large interior spaces were enclosed for congregational use. There is no collective service in the Hindu religion, and therefore no need for a large interior for people to assemble together. The temple is rather the dwelling of the deity, while worshippers bring offerings, meditate, and make sacrifices individually, but remain outside. Priests tend to the deities housed inside and to act as intermediary for the worshippers.

Later Temple Design

Later Hindu temples became much more elaborate than the early temples, not only in their individual design, but in overall grouping. Even in the most spectacular temple, however, the same basic formula of womb-chamber and mountain remains. We will look at one temple at a now-deserted site, Khajuraho, an important political capital in the tenth and eleventh centuries. Within Khajuraho was a grouping of thirty temples, symbolizing abundance and proliferation. One was the *Kandarya Mahadeva Temple*, dedicated to Shiva in his

manifestation as Mahadeva who maintains all living things. The *Kandarya Mahadeva Temple*, dated between the tenth and eleventh centuries (figure 10.22), is still an artificial mountain that surmounts the womb-chamber, which remains small, dark, cave-like and geometrically simple in shape. But it is also a fantastic sculpture, bursting with complex shapes that the Hindu relates to the abundance of life forms from the earth. The basic shapes are symbols of male and female sexuality, representing sexual energy and the procreative urge. They break down into multiplying, cascading forms that are fantastic in their variety and number. Several attached porches and a front assembly hall add to the proliferating forms.

Despite the multiplicity of forms, there is still an overall visual unity. The building seems monumental, like a mountain. All forms reach up and are united under the simple umbrella shape at top of the tallest tower, above the womb-chamber. The umbrella is a circle, which represents the Unbounded. The temple symbolizes the cycle of life, the repeated submerging of life forms into the Unbounded, only to reemerge and be made manifest again as individual life forms. The temple surface is not flat, but undulating, as elements are embedded in and emerging from one another, like birth in stone. They were not merely surface decoration, but stood for physicality, abundance, and fertility.

Thus, on a grand scale, the temple exterior was an instrument of meditation, which is fitting as worship occurs primarily outside the temples. From a closer point of view, the relief carvings become more readable, also to inspire meditation. The carvings created a lush and sensual surface, covering the temple with images of

deities and of smaller shrines. Many of the carvings are openly erotic, with nude, sleek, full-bodied figures dancing, twisting, or writhing. Figure 10.23 shows an erotic scene with intertwined voluptuous bodies. The Hindu religion openly celebrates sexual love, as erotic coupling reflects divine union with the Unbounded. To experience carnal bliss is a virtue and a path that leads to redemption.

Geometry and Its Significance

The Hindu religion expresses basic beliefs about the cosmos through geometry, and their temple architecture is a reflection of that, too. The Hindus believe that the gods measured the cosmos and thus separated it from chaos. Thus, measurement makes something real and separates it from the undivided whole from which all creation springs. At the time they were built (or conceived!), temples also had to be carefully measured and positioned. The Sanskrit word for the main part of the temple is vimana, which means "well-measured" or "wellproportioned." The Hindus believe that all life emanates from formlessness, symbolized by the temple wombchamber, and spreads in the four cardinal directions from the center. The core parts of the temple, therefore, were basically square in shape, which symbolized the divine force that created earthly life. It was absolutely essential that the square sides face north, south, east, and west. To ensure that, a pillar was ritualistically set at an auspicious location with a circle drawn around it. The shadow of the pillar was marked where it crossed the circle at the beginning and at the end of the day. Those marks, when connected, indicate east and west, and by drawing arcs, north and south can also be determined,

10.22 Kandarya Mahadeva Temple, at Khajuraho, India. tenth–eleventh centuries. This is one of thirty temples at this site, dedicated to Shiva. Vishnu, or Mahavira. Main tower is 130' high.

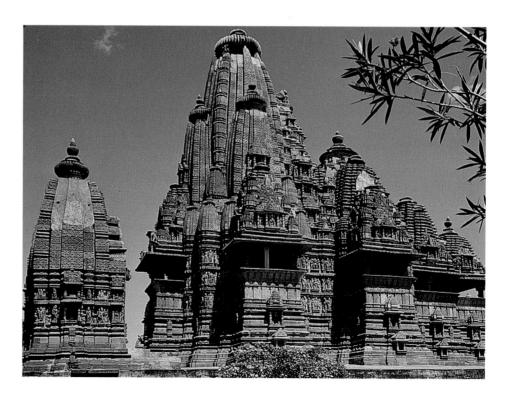

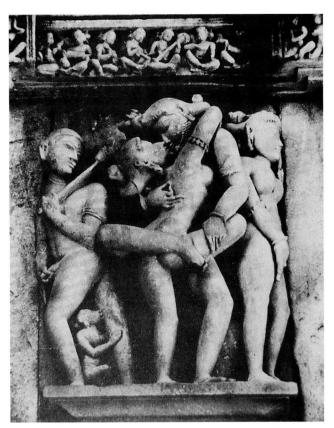

10.23 Relief Carving from the Kandarya Mahadeva Temple, at Khajuraho, India

and a square can be inscribed in the resulting shapes. The circle is the Unbounded Whole, the square its physical manifestation in the temple plan, and the pillar translates into the tower-mountain of the temple.

The plan of the temple (figure 10.13) is a mandala, which was a geometric drawing that symbolized the universe, often with a circle enclosing a square. The square is subdivided into 64 small equal squares, with the center small squares becoming the womb-chamber. The four sides are marked by four porches on the temple pointing in the cardinal directions. Then the squares and circles of the mandala are repeated, rotated, and overlaid, and then expanded into space, to create the fantastic compilation of shapes that form the outer layer of the temple. But because of the underlying mandala grid, the proliferating forms of the outer structure still relate to the inner sanctum.

Text Link

The mandala is not only used to determine plans and elevations of temples. Mandalas are sacred diagrams used for meditation by Hindus and Buddhists, as they map the parts and the interrelatedness of all parts of the cosmos. For more on mandalas, see the section on cosmologies at the end of Chapter 9, and especially figure 9.28.

Hindu religious life is full of festivals that often involve thousands of people who make pilgrimages to temple sites where fairs and great celebrations are held. Therefore, many temple complexes include huge kitchens and bathing places. Around the temples, smaller pavilions house sacred images, and halls where female dancers perform.

The Gothic Cathedral

The large, imposing, mystical **Gothic** cathedral is one of the most famous forms of a Catholic church. Interestingly, though, the very first Christians did not worship in churches, but in homes or in catacombs. Not until the fourth century, when Christianity became the official religion of the Roman Empire, were grand churches built, and then they indicated Christianity's political importance. These churches were based on the design of the Roman basilica, a large, grandly decorated hall that could house large assemblies of people.

Text Link
An example of a catacomb, the
Catacomb of Saints Peter and
Marcellinus, can be seen in figure
11.18. The Roman basilica is discussed
along with figure 8.29, the Basilica of

Constantine and Maxentius.

Development of Large Churches in Europe

In Northern Europe, large Christian churches that housed congregations at worship services were built from the ninth century onward. Christianity holds that the body and soul are split, with the body profane and sinful, while the soul is sacred. Holiness is present in heaven and in the church, but not in nature. Thus, the church building was seen as the heavenly Jerusalem on earth, and was meant to express divine transcendence. And Gothic churches, built generally from the twelfth through the sixteenth centuries, were no exception. Abbot Suger, a leading cleric during this era, remarked upon entering a Gothic church that ". . . I see myself dwelling in some strange region of the universe which neither exists entirely in the slime of the earth nor entirely in the purity of Heaven."

Although Gothic churches were meant to express heavenly purity, they also reflect shifting attitudes about the nature of human beings. Despite Suger's comment, the world was no longer seen simply as poisonous to the soul, as it had been in previous times. Attitudes toward women were changing, with an emphasis on Mary, mother of the savior Jesus, rather than sinful Eve as the model of all women. During the Gothic era, the modern humanist view that valued the individual was beginning to develop. The Gothic church is the material expression of these shifting

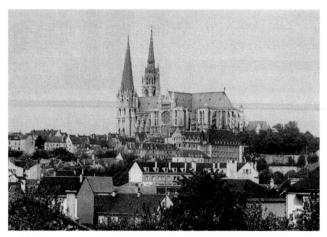

10.24 *Chartres Cathedral.* Chartres, France. On the west facade are the two towers and spires (south tower height 344', north tower height 377'); the cathedral itself is 427' long. A rose window is visible at the middle of the church. While parts of the west front date from 1145–1170, most of the exterior of this structure was built from 1194–1220. See also the text accompanying figure 20.7.

philosophies. These structures are remarkable human achievements. While they evoke the spiritual realm, they do so by giving pleasure to the senses.

Emphasis on Verticality

The overwhelming impression of a Gothic cathedral is its height, which is evident in Chartres Cathedral (figure 10.24), built in 1194-1220. The lofty structure already towers over the town around it, and the spires above the entrance raise it even higher, increasing the drama of its silhouette. These towers symbolized the Catholic church's role linking heaven and earth. Flat, blank walls are almost nonexistent at Chartres Cathedral. The stones have been cut, carved and stacked into high arches that seem to defy their heaviness. Large windows are filled with tracery, a lacy stone framework that holds sections of glass in place. Blank spaces are covered with figurative sculptures or decorative carvings. Overall, stone seems fantastically transformed. Flying buttresses create a visual pattern of forms that jog in and out, as can be seen at the right in figure 10.24. Towers, arches, buttresses, and arcades create vertical lines that continue from ground to roof.

The plan of *Chartres* is symmetrical, while its shape (figure 10.13) is a cross, symbolizing Jesus' crucifixion as the act of salvation that redeemed sinful humanity. The whole exterior is animated by images of Jesus, as well as other Christian saints, angels, kings, and queens. Some churches have gargoyles, like devils, perched on the roofs as gutter downspouts. Gothic sculptures are grouped thematically; for example, the south transept is dedicated to the Last Judgment, when all humans are judged at the end of time.

Inside *Chartres Cathedral*, the emphasis on verticality continues (figure 10.25). Long lines rise from the floor, up the piers, between the windows, and flow gracefully

across the vaulted ceiling. The ceiling's groin vaults are pointed rather that round, allowing for even greater height and sense of verticality. The vaults seem to billow overhead rather than being stone structures that weigh tons. However, on the interior there is also a strong horizontal pull towards the altar. The large windows at the apse end of the cathedral, like bright beacons, lead the eye to the sanctuary and invite approach. Thus, in Gothic cathedrals, the visitor looks up but also moves forward and arrives at the focal point of Catholic worship, the altar.

Window Design

The windows are an extremely important feature on Gothic cathedrals. Illumination was essential and light is one of the enduring divine symbols in the Christian religions. The opening up of walls with large stained-glass windows was not only an incredible technical achievement, but also a powerful symbol of heavenly radiance. Large churches built just prior to the Gothic era tended

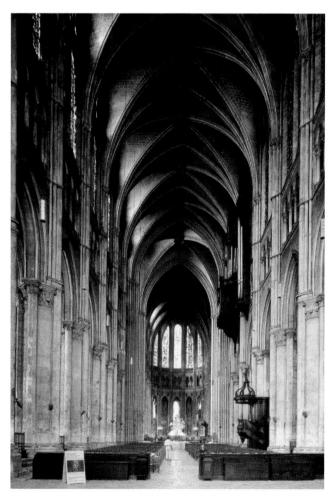

10.25 Interior of *Chartres Cathedral*. Chartres, France, completed 1194–1260. The center space, called the nave, is 130' long, 53' wide and 122' high. Clerestory windows can be seen below the vaults on the side walls and around the altar, at the center. See also the text accompanying figure 3.12.

to be very dark, which was seen as a shortcoming of their design. From the outside of *Chartres Cathedral*, the windows are set back, and appear as dark voids, with the tracery forming a lacy pattern across them. But inside, the windows are large and colorful, filling the church with muted light. They are almost as large as the ground-level arches. The flying buttresses on the outside make the large windows possible, because the buttresses and not the walls are holding up the vaults above.

The windows not only let in light, but they also contained imagery. The *Rose Window*, from 1233, on the north transept of Chartres (figure 10.26) shows Old Testament prophets in the outer ring of semicircles, Old Testament kings in the inner ring of squares, and Mary holding her child Jesus in the center. It illustrates the Christian concept that the Old Testament culminated in the birth of Christ. Mary's location at the center of this window is also an indication that the status of women was higher during the Gothic era than in previous times. (In fact, the complete name of the cathedral is Notre Dame de Chartres, or Our Lady of Chartres, and is dedicated to Mary.)

Geometry was used to locate the various small scenes in this window, by inscribing and rotating squares within a circle like the circle of heaven. The window is shaped like a blooming rose, a symbol of Mary. The images are made with pieces of colored glass, with painted details, held in place by strips of lead, iron bands, and the stone tracery. There is a dominance of a deep penetrating blue in the stained glass whose brilliance is rarely reproduced today.

Other Features

Set in stone in the floor of Chartres Cathedral is a round maze. It forms an intricate circle the size of the rose windows above. The maze recalls the concept of a wheel of fortune, and the idea of life as a sometimes arduous journey, the goal of which is heaven. Chartres and other Gothic cathedrals were pilgrimage churches, the destinations of the faithful who undertook arduous journeys to visit important Catholic shrines.

Chartres Cathedral, and all Gothic cathedrals, were also expressions of political power. They embody the rise in wealth and power of the Catholic church, the French monarchy, and the middle-class city dwellers. The "losers" in this power struggle were the French feudal barons. The barons, who controlled vast areas of the rural landscape, had lost much of their former power to the king. City populations were rising, and the wealth of the merchant class was growing. Also at this time, the Catholic church had reached the apex of its secular and political power, with supremacy over kings and with extensive land holdings.

The great French Gothic cathedrals were all funded by and built in cities—at Paris, Amiens, Laon, Bourges, Beauvais, Rheims, as well as Chartres. City churches were used not only for worship, but also for town meetings, concerts, and plays. Even the Catholic church hierarchy was feeling the shift, as prior religious centers had been remote monasteries in the countryside, but now the city cathedrals were supreme.

Text Link

Churches built in the Gothic style differ from country to country in Western Europe. For an example of the English style of Gothic architecture, see the Chapel of Henry VII attached to Westminster Abbey in London, England, in figure 11.20.

The Buddhist Temple

Buddhism originated in India, and spread throughout Asia. Distinct versions of Buddhist temples sprang up in India, Southeast Asia, Indonesia, China, Japan, and Korea. For now, we will confine our discussion to just one Buddhist temple compound from China, the *Altar of Heaven*, and to one temple with it, the *Temple of Heaven*.

Text Link

We have already seen an example of a Buddhist shrine in India, the Great Stupa at Sanchi (figure 9.6), and the ways that its form symbolizes the beliefs of Buddhism. Review that discussion in Chapter 9 for perspective on another kind of Buddhist temple design.

Buddhist Temples in China

Chinese architecture consists mostly of secular structures, and even religious buildings frequently have social/political functions. Buddhism first came to China from India during the first century AD, and reached the height of its influence from the seventh through the ninth centuries. The first Chinese Buddhist temples were adapted from the horizontal design for the great hall. Temples later became more vertical to accommodate large statues of Buddha. The pagoda was also used for temples. Pagodas are towers of superimposed stories, each level distinguished by a bold roof design and projecting eaves. Generally, each level on a pagoda is smaller than the one below it. The pagoda base could be either square or circular. Like all traditional Chinese architecture, wood is the normal building material. Upright posts support horizontal beams with multiple brackets, topped by a distinctive roof. Walls were not load-bearing.

The *Altar of Heaven* (figure 10.27), constructed over the fifteenth and sixteenth centuries, is a large temple compound located in Beijing, south of the palace core at the center of the city. Large trees fill much of the

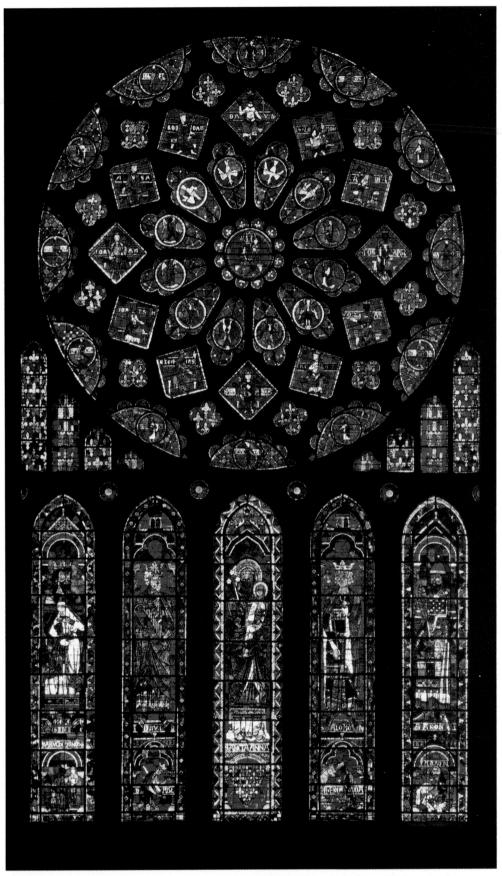

 $10.26\ \textit{Rose Window}.$ From the north transcept of Chartres Cathedral. Chartres, France, 1233. See also the text accompanying figure 22.8.

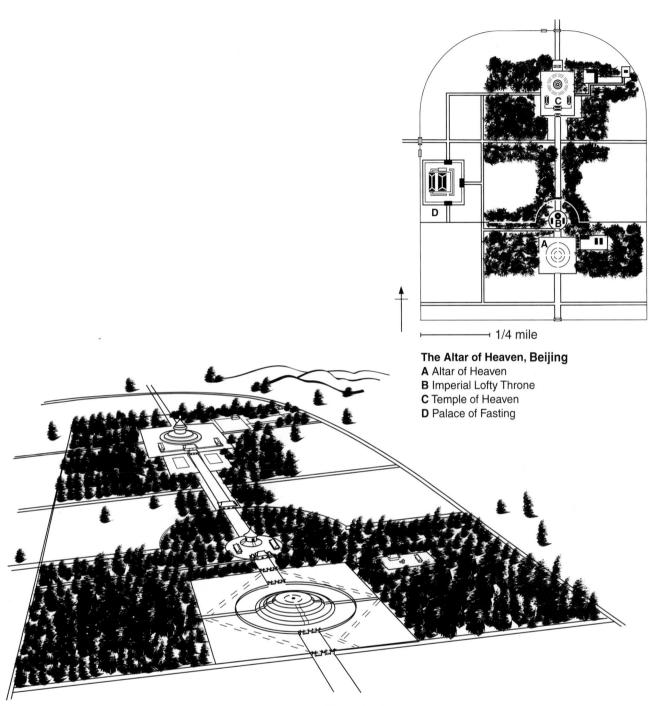

10.27 The Altar of Heaven. Beijing, China, fifteenth-sixteenth centuries. Plan and artist rendering.

compound, which is surrounded by a 4-mile-long wall. Seen from above, the southern end of the compound is square, while the northern end is semicircular. To the Chinese, the round shape symbolized the heavens, while the earth was represented by the square.

The major features and roadways of the complex are laid out on a north-south axis. Three main structures include the northernmost *Temple of Heaven* (also called the Hall for Prayer for Good Harvests), dating from 1420. To the south are the Imperial Lofty Throne (or

Imperial Vault of Heaven) from 1530, and finally the circular mound altar. Structures face south, because in Chinese tradition the south and southeastern exposures are sources of temperate weather and fruitful to vegetation, while the north was the source of evil influences. Temple complexes were also carefully sited relative to the forces of wind and water (*fengshui* means "wind and water"), as the Chinese believed that wind disperses the breath of life, and must be stopped by water. All structures in the *Altar of Heaven* are symmetrical, aligned, and

enclosed by walls, railings, terraces, or gates. These characteristics express the Chinese values of secludedness and order.

Design of a Pagoda Temple

The *Temple of Heaven* (figure 10.28) is the lofty three-tiered pagoda, a cone-shaped structure distinguished by its layers of eaves. The topmost roof is surmounted with a gilded orb. Its shape is a geometrically simplified mountain form, related to Hindu sacred architecture such as the *Kandarya Mahadeva Temple*, which we studied earlier. The entire structure is 125 feet high, and nearly 100 feet across. The wide eaves provide shelter from bright sun and rain. The colors in this wooden building are brilliant. It has a gently curving violet-blue tile roof, similar to the color of a dark blue sky. The outside walls are deep red, offset with bands of gleaming gold. The interior is red lacquer with foliage patterns in gold and blue, and green and white beams. Twenty-eight tall posts on the interior entirely support the roof. There are no

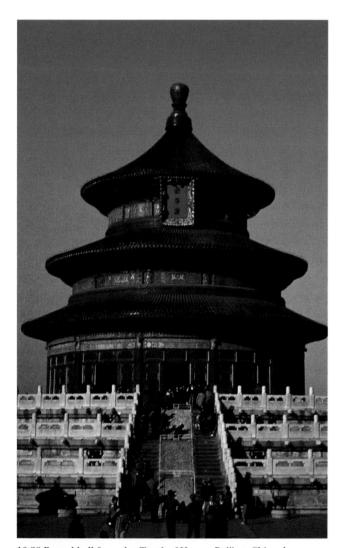

10.28 Round hall from the $\it Temple$ of Heaven. Beijing, China, begun 1420, restored 1754. Wood with tile roof.

walls, only door-like partitions pierced with latticework. The four central posts represent the four seasons, while other columns represent months of the year and the division of day and night. In the center of the stone floor is a marble slab with a dragon and phoenix design, which are symbols of emperor and empress.

The *Temple of Heaven* sits atop three terraces surrounded by richly carved white marble balustrades. The carvings on the balustrades are so fine and intricate that they appear lace-like, at a distance. Worshippers would circumnavigate the round structure to symbolize the achievement of wisdom; each higher level symbolized higher levels of enlightenment. The *Temple of Heaven* was used only three or four times a year in political-religious ceremonies officiated by the emperor. One such ceremony occurred at night on the winter solstice, as the emperor presided at solemn sacrifices to heaven. Other ceremonies were dedicated to the earth and its crops.

The *Altar of Heaven* was built during the Ming Dynasty, an era not known for architectural innovation. However, the *Altar of Heaven* is justifiably famous for its emphasis on geometry in its layout. Its buildings represent one of the finest achievements of traditional Chinese architectural design. The symmetry and order of its structures contrast strikingly with expanses of wooded areas. Its orderliness bespeaks the respect the Chinese hold for tradition and order. The exquisite pattern, color, and detail make its temples memorable.

The Islamic Mosque

The Islamic mosque was developed in response to the spiritual needs of Muslims, the followers of the Prophet Mohammed. Muslims believe that this prophet of Allah is the "final messenger" in a history of religious revelations that goes back to the Jewish prophets, beginning with Abraham through Moses. Jesus is also considered a prophet. "Islam" means to submit to Allah's will, and Muslims believe that the devine being is the same as in Jewish and Christian religions. This completes the divine plan of revelation, and the connection of the Jewish, Christian, and Islamic faiths.

Design of Early Mosques

The religion of Islam requires that its adherents pray five times a day while bowing towards Mecca, the birth-place of the prophet Mohammed. Usually these rituals can be completed anywhere, although all are encouraged to pray with others. On Friday, collective prayer services are required for men; women may also attend. The faithful are called to prayer and assemble together in buildings called mosques, a word that derives from the Arabic *masjid*, which means "prostration." All individuals have direct access to Allah through their prayers, but services may be led by a Muslim prayer leader called the *Imam*. The faithful ritually cleanse themselves and then assemble on rugs facing Mecca for

prayer, sermons, and readings from the Qur'an, or Koran, the Islamic book of sacred texts. Prayer rugs or cloths on mats were spread to deaden the noise and to enhance the beauty of the mosque.

It is thought that the plan of Mohammed's house in Medina influenced the design of early mosques. This house, where he first preached the new religion, had a large open courtyard with one shaded area. Early mosques, therefore, were simple, walled, rectangular structures with a large open courtyard with shaded walkways. On the far wall opposite the entrance was a covered area shading the wall that faces Mecca. The entire area, covered and uncovered, flowed together as a continuous space where members of the congregation could arrange themselves for prayer. On the wall facing Mecca was the *mihrab*, a special marker niche. A stepped pulpit called the *minbar* is usually located next to the mihrab, and the minaret, a tall tower from which a crier (muezzin) called the people to prayer (adhan). The tall minarets could be seen from afar giving hope to weary travelers.

There are no icons, statues, or images in Islamic worship or in mosques. A mosque is a sacred space because of the symbolism of the building and because of the prayer rituals observed there. It is also the heart of the community, where children and old alike come to learn the Koran and Islam, find help and support from other members of the community, often find a kitchen for the poor and an infirmary for the sick, and today find financial and educational support.

Later Developments in Mosque Design

One of the most beautiful mosques ever constructed is located in ancient Persia, now called Iran. Situated at the crossroads of vast continents, Persia has always been an important and influential culture among the world's civilizations, but it has not always been a separate nation. In the seventeenth century, after nearly a millennium of foreign domination, Persia became an independent nation ruled by the Safavid Dynasty. The fifth Safavid ruler, Shah Abbas I (the Great), sought to elevate Persia to become an important center and undertook an ambitious urban renewal program that transformed his capital city, Isfahan. It involved the construction of a new, grand plaza to be the city center; the redesign of thoroughfares; a water-diversion program; and the construction of bridges, palaces, and mosques.

The largest and most striking building of Shah Abbas' program is the *Masjid-i-Shah*, the Royal Mosque (figure 10.29), dated 1612–1637. Built some eight hundred years after the earliest mosques, it is an example of one way that mosque design developed and evolved. The individual parts of the mosque, which in early designs were relatively undefined and integrated into the whole, here have become elaborate and been given separate identity and set off from each other by use of patterned

tile work. The portals (called iwans), for example, have become separate, large structures that awe and draw in the viewer. The courtyard is no longer simple, but has evolved here into a two-story arcade, covered with bluepatterned tiles. It is punctuated on all four sides by huge porch-like portals, where schools of Islamic theology could be assembled. Interior and exterior spaces no longer flow together at the Masjid-i-Shah. The covered prayer hall here has become physically and conceptually separate from the open courtyard. A wall and portal divide the two spaces, and they are designed differently from each other. Worshippers move through a series of interlocking areas to leave the profane world and enter the sacred realm. The single minaret has here multiplied to four, two each to accentuate the main portal and the portal to the prayer hall.

The designs of Islamic mosques emphasize interior spaces. In fact, the *Masjid-i-Shah* is very roughly finished on most of its exterior, in contrast to the lavish decoration of the interior. The spaciousness of the mosque interior grew out of the need to assemble and shelter a large congregation who pray side by side on rugs, and who need simple architectural markings to orient themselves. In addition, however, the spaciousness of the mosque is an important religious symbol. It represents the infinity of Allah.

Symmetry is important in this mosque's design, as you can see in the plan in figure 10.13. The only break from the symmetry is the main portal, which is tilted at a 45-degree angle to the courtyard and prayer hall. The reason for this inconsistency was that the portal was part of Isfahan's central city plaza, but the mosque proper had to be oriented toward Mecca.

Pattern

If space is one important symbolic element of mosque architecture, the other is pattern. Intricate, abundant, and seemingly infinite, patterns cover the dome, the portals, the interior walls, and the courtyard. Muslim architects used tile work, brickwork, carved stucco, carved stone, and/or weavings to cloak the mosques in color and pattern. The profusion of ornamentation serves several purposes: 1) it symbolizes Allah in its suggestion of infinity; 2) it enhances the sacred character of the mosque; 3) it identifies and makes visually distinct the various parts of the mosque, so that portals, porches, windows, domes, and the mihrab are easily recognizable; and 4) the ornamentation disguises the mass and structural supports of the mosque, although not the form. The shapes of arches, domes, and porches are emphasized by the ornamentation, but the weight and thickness of the structure is diminished. The mosque walls seem to be merely thin screens of incredible color and delicate pattern, instead of being thick, heavy, massive brick walls. Mass and structure are transformed into shape and ornamentation.

10.29 Masjid-i-Shah, or Royal Mosque. Isfahan, Iran. 1612–1637. The arch of the main portal, to the left in this picture, is 90' high; the minarets are 110'. See also figure 20.21 and accompanying text for more on the dome design.

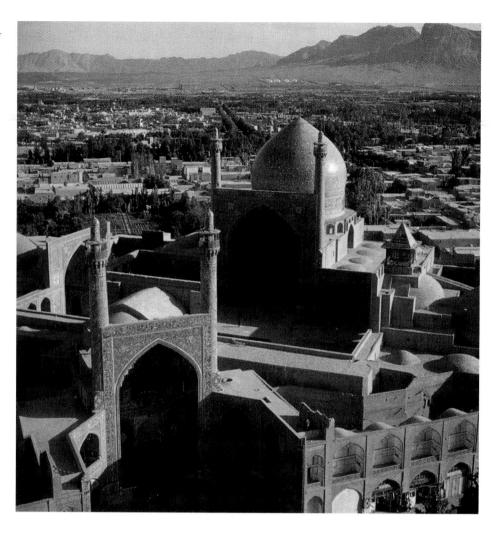

Other elements add pattern and also visually disguise the substance of the mosque. In the upper left in figure 10.30 are row upon row of quarter domes with their apexes hanging in space, called *mukarnas* vaults. The hovering shapes of the mukarnas vaults break up the structure and disguise the mass of the building. Light serves a similar purpose. Windows are frequent, and covered with decorative screens that break up the light into patterns as it reflects off the patterned tiles. Reflecting pools are common in important Islamic structures. When seen with their mirror images in pools, the buildings seem enhanced in beauty and visually reduced in mass. When the water is disturbed the image of the building vanishes. The large reflecting pool in the courtyard of the Masjid-i-Shah aligns with the four portals, unifying and multiplying them.

The entry portal of the *Masjid-i-Shah* (figure 10.30) provides us with a close-up look at Islamic ornamentation. The large, magnificent portal is lavishly covered with colored tile, carved stone spirals, and colored marble. The tile design in mosques, as exemplified here, usually consists of interlocking geometric shapes, vegetation or calligraphy. Although animals occasionally

appear in designs, there is a strong tradition against public images of humans or animals. Images of Allah do not exist and are not allowed. A line of decorative text running vertically on the portal gives glory to Allah and to Shah Abbas. Text passages on mosque walls are a favored form of decoration. Calligraphic lettering was stylized to become very elegant, and in some instances, almost indistinguishable from geometric or foliage patterns. All the pattern elements, whether letters or foliage or abstract shapes, form an overall unity despite the variety. All patterns branch or radiate or intertwine, and density is fairly consistent throughout. In many cases, both background and pattern can be read as pattern elements.

Islamic tile work was heavily influenced by tapestry design. The panels on either side of the doorway in figure 10.30 are especially reminiscent of Persian weavings and tapestries. To resemble fine weaving represents a high aesthetic achievement. In the Islamic world, weavings not only serve utilitarian functions in the home, palace, and mosque, but they are also gifts and signs of favor. As treasured portable objects, they recall the early nomadic Arabs and the founding of Islam.

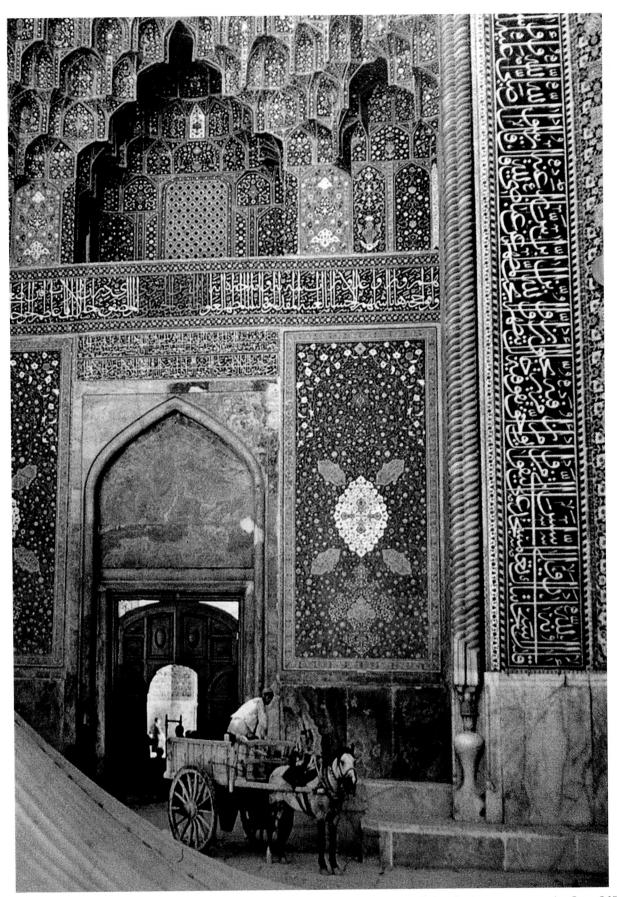

10.30 Detail of the main portal of the Masjid-i-Shah, or Royal Mosque. Isfahan, Iran. 1612–1637. See also the text accompanying figure 2.15.

The Dome

While ornamentation abounds in the Masjid-i-Shah, the entire complex is unified by the enormous turquoise dome that dominates the Isfahan skyline. This dome hovers over the holiest place in the mosque, the wall facing Mecca and the mihrab. The circular dome stands for the heavens and symbolizes the oneness of Allah. The dome is covered inside and out with an allover tile pattern of curling interlocking vines that symbolizes the infinity of creation. The pattern does not overwhelm the dome, but fills it and defines it.

Text Link

The Masjid-i-Shah is decorated primarily with colored tile. See the Taj Mahal in figure 11.22 for an example of a structure decorated with carved and inlaid stones.

SYNOPSIS

People in various cultures identify sacred space in many different ways. In some cases, an activity marks a sacred space. Wherever a community gathers in ritual worship, a sacred space is created. Other peoples mark sacred spaces in nature, such as the east-west axis of the sun, a cave in a mountain, the top of a plateau, or the course of a river.

Many cultures believe that building geometry can be symbolic and can make a site sacred. It is intrinsic in the plan of Hindu temples and gave religious meaning to the Egyptian landscape. It determined the shape of the *Parthenon* and gave it proportions that were believed to resonate with cosmic forces.

Sacred structures are designed to be architecturally distinctive. Most sacred architecture is extraordinary in some way that gives it a heightened sense of place. Location may be a factor, as with the *Parthenon* atop the Acropolis. The great height of Gothic cathedrals and the towers of Hindu temples impart this sense. Elaborate architectural forms and brilliant decorations, such as those on Islamic mosques, Hindu temples, and Mesoamerican temples, mark the buildings as extraordinary. Many also have a sense of monumentality, even relatively small structures such as the *Kandarya Mahadeva Temple*.

Much sacred architecture incorporates elements of nature. Many are artificial mountains, such as the *Ziggurat of Ur.* Water and light are significant in Islamic mosques. Egyptian temple complexes alternate light and

dark areas. The small dark womb-chamber of Hindu temples contrasts with the overwhelming sunlit exterior. The colored light transforms the interior of Gothic cathedrals.

A journey is seen in many cultures as a metaphor for the passage through life and to spiritual attainment. The concept of a journey is built into some sacred structures, such as the Egyptian temples, where the central pathway flows through the entire building, or at *Chartres Cathedral*, where entry is at the west end, and the goal, the altar is at the east end, and a maze lies on the floor in between. One must pass through a buffering walled courtyard and be ritually cleansed before entering the sacred space of the Islamic mosque. The *Parthenon* is surrounded by a frieze that recreates a procession of humans leaving the marketplace to ascend to the temples. Pilgrims travel great distances to visit major religious monuments, including Buddhist shrines, Hindu temples, Gothic cathedrals, and Islamic mosques.

The materials used in construction and decoration add meaning to sacred architecture. The permanence of stone was important in communicating the idea of eternity in Egyptian temples, while in the Hindu temple stone is associated with mountains. Unadorned natural wood of the Shinto shrine echoes the animistic beliefs of the religion. Materials that add brilliant color or radiance help relate the idea of transcendence, such as Gothic stained glass or Islamic tile work. Tin as a superior material to thatch is used on Igbo *mbari* shrines.

Very large religious structures are usually expressions of both religious and secular power. The overwhelming scale that inspires awe is part of the religious experience of these places.

FOOD FOR THOUGHT

Try to visit an important religious site during a ceremony, because sacred architecture can be appreciated fully only when people are using it in prayer. Then the place of worship becomes alive, an instrument for the realization of the spiritual realm. Other senses are invoked in rituals and processions: the sound of music and singing; the smell of incense, sacred oils, candles and sacrificial fire; shrines and relics to touch; moving in ritual with others, and so on.

- Could there be worship of a deity without the aid of the arts and architecture, or do human beings need some kind of image, space, song, story, or literature to comprehend and venerate a higher power?
- How has art or architecture been a part of your own religious experience?

Chapter 11 Mortality and Immortality

INTRODUCTION

Tombs are among the very oldest works of art that humans have constructed. They are at once a monument to human mortality, and at the same time a monument to the persisting human faith in immortality, in some form of afterlife.

The appearance of tombs within a culture signals the simultaneous arrival of religion. As long as 30,000 years ago, the deceased were buried with stone tools, animal bones, and pollen. This preparation for an afterlife indicates a belief in a person's spirit and, by extension, a spiritual realm. With the development of rudimentary beliefs in the afterlife, the roots of formal religion were formed, allowing humans to acknowledge, understand, or connect to the spiritual realm.

Funerary art exists to honor the dead. In some cases, wealthy and powerful individuals build ostentatious tombs for themselves. Some were lavishly furnished to provide for their afterlife, while others were ornate and impressive to preserve their fame with future generations. In other cases, tombs mark a spot where friends and relatives experience a continued personal connection with their departed loved ones. We also see funerary monuments built by governments for deceased leaders and heroes for patriotic or political purposes. Sculpture may also serve as memorial artwork, and in some cases the sculptures themselves are believed to be spiritually powerful.

Humans frequently expend considerable effort and expense using art to frame their experience of death. These efforts do not end with the erection of monuments. Elaborate rituals often accompany the burial of a person, and often continue on certain feast days and anniversaries. We shall see that funerary arts and rituals vary considerably among different religions and cultures. Think about the following questions:

How do tombs and funeral rituals reflect the cultures from which they come?

How do tombs reflect various concepts of the afterlife?

How do religions intertwine burial art and rituals? How can tombs and commemorative art be used for political and social purposes?

How does urban development and landscape design affect burials?

MOUNDS AND MOUNTAINS

The very earliest tombs in many cultures are shaped like hills or mountains. The Egyptians built pyramids, which were geometric mountains. Others built funeral mounds that look like naturally occurring grass-covered hills, some small and others quite large in size. They contained hidden burial chambers, usually for elite members of a society. Some were lavishly furnished. The locations of mound graves were often tied to significant natural phenomena, such as the movement of the sun or proximity to a particular body of water. Mound graves can be found in Europe, Asia, the Middle East, and the Americas.

Ancient Burials

The tombs we will see in this section date from periods in which funerary practices, religion, agriculture, and astronomy were often interrelated concerns.

Among the oldest tombs are the late Stone Age mounds in Western Europe. They were rock and earthen hills built over large stones that were set upright to form the walls of inner burial chambers. *Newgrange* (figure 11.1) is an early example of a mound grave, dating from 3200 BC. It is part of a complex of tombs and monolithic rock structures built by a flourishing civilization. One of the largest mounds ever built, *Newgrange*, is composed of 220,000 tons of loose stone with a white quartz–rock facing, ringed around the bottom with large boulders and covered on top with grass. A long, 36-inchwide passageway led to a cross-shaped interior chamber, made of 40-ton stones and sealed to prevent water seepage. Five bodies were buried there.

Many rocks along the passage were decorated with spirals, curves, or other geometric patterns, perhaps indicating celestial bodies. The builders of *Newgrange* had sophisticated methods of marking time. They oriented *Newgrange* so that for about two weeks around the winter solstice, a burst of brilliant morning sunlight shines through a specially constructed slit above the doorway, penetrates the entire passage and illuminates one patterned stone at the far end of the burial chamber. Early Irish literature associates *Newgrange* with the sun deity, Dagda. Coins and jewelry were left as offerings around the mound, some dating 35 centuries after *Newgrange* was constructed.

Over time, many mound graves erode and are blended into the natural landscape. After the fourth century, *Newgrange* was an abandoned and undisturbed site until 1699, when it was rediscovered by men quarrying for building stone.

Like *Newgrange*, the *Great Pyramids* of Egypt are very old, very large, very influential in style, and are oriented to the sun. They are the tombs of the pharaohs, the rulers of Egypt who were believed to be the sons of the most powerful of all the gods, Re, the Sun God. The pyramids, standing dramatically on the edge of the Sahara Desert, are artificial mountains on a flat, artificial plane. They are part of a necropolis, a city of the dead composed of tombs and mortuary temples, which extends for 50 miles on the west bank of the Nile across from cities for the living. The Pyramids of pharaohs *Menkaure*, 2525–2475 BC, *Khafre*, 2575–2525 BC, and *Khufu*, 2600–2550 BC (figure 11.2) are the largest among all the pyramids. The numbers associated with the very largest, the Pyramid of *Khufu*, are often recited, but still

inspire awe: 775 feet along one side of the base; 450 feet high; 2.3 million stone blocks; average weight of each block 2.5 tons. Adjoining the pyramids was a funerary complex, consisting of a chapel at one side of the pyramid and valley temple along the banks of the Nile. The chapel and valley temple were joined by a long stone ramp. Both structures were used for offering and ceremonies during and after the funeral of the pharaoh.

The Egyptians used the pyramid form to create the meeting place between earthly life and eternity. It is also where the "ka" and "ba" return to the mummified remains of the deceased. According to Egyptian belief, humans possessed both a "ka" and a "ba." The ba is part of the soul or spirit whose seat was the heart, or the abdomen in the body. It is depicted as a human-headed bird. When humans take their last breath, the ba flies from the body. It later returns after the body has been mummified seventy days later, hungry and thirsty for nourishment. A well prepared tomb is filled with provisions to satisfy the needs of the ba in the afterlife, such as water, wine, grains, dates, cakes, and even dehydrated beef and fowl. The ka part of the soul is the mental aspect of the human's personality. It is symbolized with two outstretched arms or by an attendant figure who represents the double of the personality. The ka dwells in a life-like statue of the deceased, which is placed in the tomb. It was important for both the statue and the sarcophagus to have a strong likeness of the dead person, so that the ba and ka could easily recognize their destinations. The ba and the ka were thought to enter the tombs by way of a small chimney or an air vent. Provisions for the ka would include chairs, beds, chariots, models of servants, kitchen utensils, dishes, and simulated food

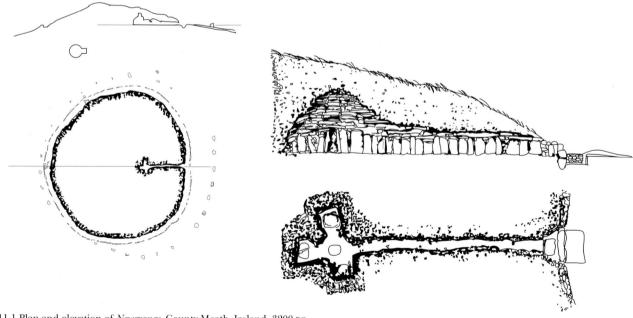

11.1 Plan and elevation of Newgrange. County Meath, Ireland. 3200 BC.

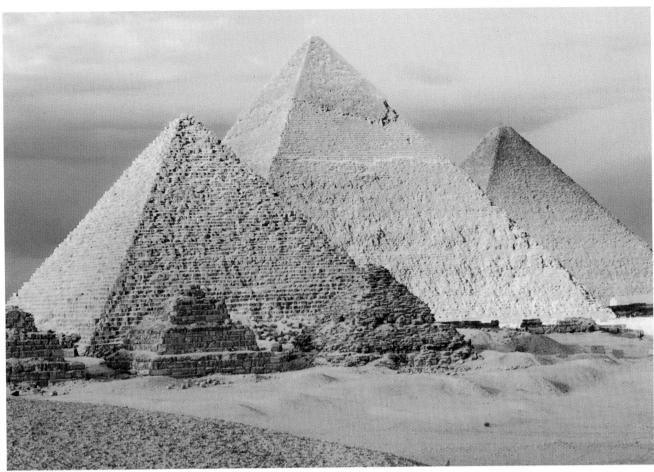

11.2 Great Pyramids. Gizeh, Egypt. From left, Menkaure, c. 2525–2475 BC; Khafre, c. 2575–2525 BC; Khufu, c. 2600–2550 BC. See also the text accompanying figure 20.1 for more on the building of the Pyramids.

(unlike the real food the ba required). Combs, hair pins, and ointments were also included, along with games for entertainment. Rich treasures of gold and silver, and carriages and boats for the ka's journey to heaven were also found in the more elaborate tombs.

In addition, the pyramids pointing to the heavens were a link for the deceased pharaoh to join his father, Re, the Sun God. The pyramid shape was associated with the worship of Re. Each face of the pyramids is oriented to one of the cardinal points of the compass, north, south, east, or west, and thus the very placement of the pyramid is determined by the sun and is a form of sun worship. The massive structure in stone expressed the permanence of the afterlife.

The pyramids may have evolved originally from simple mound graves, like *Newgrange*. Earlier Egyptian tombs were small flat mounds with rectilinear sides or modest pyramids with stair-step sides, similar to those in the foreground of figure 11.2. But the three *Great Pyramids* are impressive because of their greater height and more simply defined planes. Technical breakthroughs made them and their surrounding temples possible. Larger stones were used, which meant that correspondingly larger,

more stable structures could be built. Smaller stones tend to roll and subdivide when stacked too high. Also, large stones were easier to quarry and finish. Egyptians quarried stones by gouging notches in the rock wall and inserting dry wooden stakes. When soaked with water, the stakes expanded and split the block off from the rest of the rock. The block was then shaped and the sides planed smooth. Larger stones enabled this process to proceed more quickly.

Even so, the construction of these pyramids required an almost inconceivable amount of labor, as they are essentially solid masses of stone. Yet in all likelihood much of the work was done by skilled workers in addition to slaves, who would have lacked the technical knowledge and the desire to contribute enthusiastically to these colossal projects. We know from later accounts that skilled laborers lived in communities near tomb sites, constructed tombs for themselves and even went on strike if they were not paid for their work. Ancient tomb paintings show how teams of laborers hauled the heavy stones on wooden sledges, accompanied by priests and water bearers. A foreman would clap to coordinate the pulling effort. Oxen also may have been used to

move stones. Once at the pyramid site, blocks of roughcut stone were probably dragged on layers of wet silt, up a spiraling ramp that wound up and around the pyramid. These formed the core of the pyramid. Then starting at the top, finishing stones were installed and polished over the rougher core stones, and the ramp disassembled as the laborers worked their way downward. The pyramid of Pharaoh *Khafre* near the center of figure 11.2 still has some of its original finishing stone at the top. None of the others do, as they were stripped down to their core stones by later pharaohs and by Islamic builders for their own structures.

Thus, today, we mostly see only core stones. But in their original finished state, the pyramids presented a much different impression. They would have been gleaming and smooth, with clean, crisp outlines. The casing of polished limestone would have been so carefully cut that the joints would have been practically invisible. The *Pyramids* would be an abstract expression of the permanent, the powerful, the ineffable, the divine.

Disassembled and buried in a trench at the base of the Pyramid of Khufu were two wooden boats, called barques, discovered in 1954. These boats were made from long planks of cedars, imported from Phoenicia (modern Lebanon). One reassembled Barque, dated 2600-2550 BC (figure 11.3) has a cabin to house passengers or precious freight; ten rowing oars; two rear oars for steering; and a canopy to protect the crew from the fierce sun. It was entirely assembled with knotted cords. No nails, pegs, or rivets were used. Long and sleek, with distinctive stemposts, these boats were used to navigate the Nile during the pharaoh's lifetime; in death, they were used to bring the body and possessions of the dead pharaoh from the east to the west bank of the Nile, to the city of the dead. This last journey of the pharaoh recreated the path of his father, the sun God, in his chariot across the sky. Thus, these boats were called "solar barques." Like the pyramids themselves that face the

compass points, the Egyptian funeral ceremonies also reflect the movement of the sun.

Furnished Tombs

Now we will look at a group of mound and mountain tombs that were built to provide for the deceased in the afterlife. Many cultures believed that the afterlife was similar to this life, and that the dead continued to "live" in the tomb and needed furnishings like those used when they were alive, such as furniture, clothing, utensils and precious items. Furnished tombs were the privilege of high-ranking members of society. To some degree, all were hidden tombs. Some were intended to never be found (and were not until recently), while others were simply sealed. One can imagine how many more tombs filled with dazzling treasures remain sealed and undiscovered.

Egyptian Tombs and Mortuary Temples

The ancient Egyptians provide the supreme examples of furnished tombs. The *Great Pyramids* we have just studied have interior chambers that are quite small, and when opened in modern times, contained only empty stone crypts. Archeologists presume that the tombs contained scrolls, riches and provisions, but were robbed shortly after they were sealed. In an effort to thwart grave robbing, which was rampant in ancient Egypt, the pharaohs stopped building enormous, ostentatious tombs like the pyramids. Instead, they were buried in chambers cut deep into the sides of mountains, with hidden entrances. These hidden chamber burials were also considerably less costly than erecting pyramids.

Despite the pharaohs' efforts, however, royal tombs were still robbed long ago, except that of King Tutankhamen, which was only partly plundered, and then resealed. Ironically, it was saved from further theft by grave robbers stealing treasures from a nearby tomb, who happened to heap more debris on the entrance to

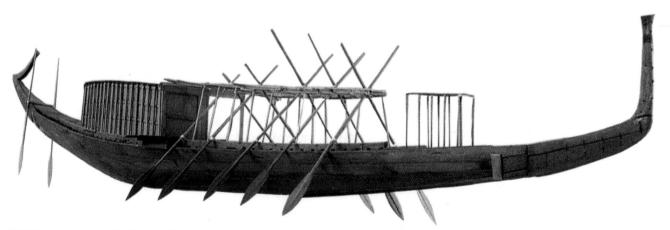

11.3 Funerary Barque of the Pharaoh Khufu, found at the base of his pyramid. Lebanon cedar, 143 feet long. c. 2600–2550 BC. Solar Barque Museum, Gizeh.

Tutankhamen's tomb, which remained undisturbed until 1922. Among the amazing treasures found in Tutankhamen's tomb was his *Innermost Coffin*, dated c. 1325 BC, in figure 11.4. It is beaten gold, weighing nearly three-quarters of a ton, and is inlaid with semi-precious stones. Two other larger coffin cases of gold fit over it, and together they encased the mummy. There were also inlaid chests, gilt chairs, and other wooden

11.4 Innermost Coffin of Tutankhamen, from his tomb at Thebes, c. 1325 BC. Gold inlaid with enamel and semiprecious stones, 6'1" long. Egyption Museum, Cairo.

items covered with gold; carved watchdogs, life-size guardian statues, jewels, and so on. To provide for the comfort of those of high rank, clay statues of servants were included in the tombs, to serve and to act as companions.

Tutankhamen was an Eighteenth Dynasty pharaoh who ruled for about nine years and died around the age of twenty. Because he died unexpectedly, there was little time to prepare his tomb, as mummification, funerary rites and burial had to be completed in 70 days. Archeologists believe that his tomb was surely less lavishly furnished than those of pharaohs with long rules. His burial chamber was small and decorated only with paintings, while other rulers buried near him were interred in large barrel-vaulted chambers with relief carvings on the walls.

Egyptian tombs were permanent dwellings, where the deceased's soul regularly returned to and continued to live in the corpse. The dead body was mummified, therefore, to preserve it as much as possible and to make it recognizable to the gods. The mummification process required 70 days, which included removing internal organs, chemically treating the cadaver, and wrapping and rewrapping the body in linen layers, while special prayers and anointings were performed. The process was successful, for many mummies thousands of years old exist to the present day. Nonetheless, the ancient Egyptians installed likenesses of the deceased in the tomb, to serve as substitute receptacles for the spirit should something happen to the mummy. For persons of lesser rank these portraits were paintings or wood carvings. For the pharaohs, however, the portraits were stone statues or effigies in gold, like the Innermost Coffin (figure 11.4) from the tomb of Tutankhamen. The wings of the god Horus protectively encircle the coffin, and Tutankhamen holds insignia of his rank. Certain features are standard on Tutankhamen's face: the distinctive eye makeup; the false beard, a symbol of power; the striped headcloth; the cobra head to frighten enemies. The face itself is stylized, meaning that overall it is simplified and made elegant. Despite all standard features and stylizations, however, the sculpted face is indeed a portrait of Tutankhamen. It contrasts with portraits of rulers that were not placed in tombs, and therefore could be very generalized. In addition, several other sculptural likeness were also placed in his tomb, to ensure that his spirit was recognized by the gods and his returning soul.

Many tombs were decorated with wall paintings and carvings that recreated the pleasures and labors of earthly existence. The *Fowling Scene*, a wall painting from the tomb of Nebamun, dated 1400–1350 BC (figure 11.5), shows an Egyptian noble hunting along the Nile River, taking pleasure in the abundance of fish, fowl, and flora in the fertile marshes. The air is filled with birds of all sorts, painted with care and distinction, and the water

is thick with fish. Pattern is an important element in this image. Water ripples were rendered as linear patterns; the birds in the nobleman's hand create a repeating image; and the tops of the marsh grasses fan out in a beautiful but rigid decoration. Depth is not shown in ancient Egyptian paintings, so everything is distributed vertically or horizontally, with no real receding space. The repetition of pattern elements is a visual metaphor for the seasonal cycles of the Nile, the rigidity of the culture, and the vast desert that surrounds the river valley.

In this wall painting, humans dominate the scene. The nobleman is shown in the formal manner reserved for exalted persons: head, shoulders, legs, and feet in profile; eyes and shoulders frontal. Size was an important indicator of rank, so the nobleman is larger than his wife and daughter, indicating their lower status. The standard poses could be eliminated for persons of very low social rank. Thus, servants could be depicted very informally.

Other tomb paintings show gardens, entertainers, feasts, religious rituals, and the entire gamut of Egyptian life. Even labors, such as hauling stones to build temples, were depicted in tomb paintings and reliefs. The bright colors of this example were typical of Egyptian tomb paintings, and added to the sense of pleasure surrounding these scenes. In many tombs, moisture and modern pollutants have caused the paint to disintegrate and totally fade away.

Text Link

The Egyptian tomb painting, Musicians and Dancers, in figure 18.20, is an example of a painting showing entertainment, containing images of people of lesser rank.

Now let us turn to another kind of Egyptian funerary architecture, the mortuary temple. When tombs became hidden in hillsides, then the funerary temples that formerly were appendages to pyramids were enlarged and emphasized. The *Mortuary Temple of Hatshepsut*, 1490–1460 BC (figure 11.6), of the Eighteenth Dynasty, shows this later development in Egyptian funerary architecture. While living, pharaohs worshipped gods in shrines in these temples, and when they died, their funeral rituals were performed there. Because her tomb is no longer visible, Hatshepsut's temple was the monument to her greatness. Hatshepsut's temple once housed two hundred statues of her and many brightly painted reliefs showing her divine birth, coronation, military victories, and other exploits.

The *Mortuary Temple of Hatshepsut* is impressively large, but its design is open, light, and clean, without the solid mass and ponderous weightiness of the earlier pyramids. The simple vertical columns contrast with the vertical

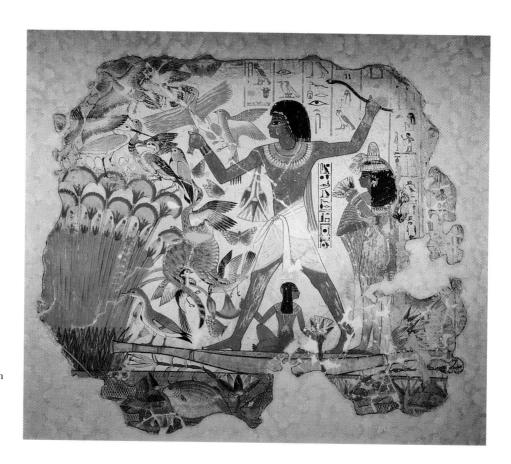

11.5 Fowling Scene, wall painting from the tomb of Nebamun, Thebes, Egypt. Paint on dry plaster, approximately 32" high. c. 1400–1350 BC. British Museum, London.

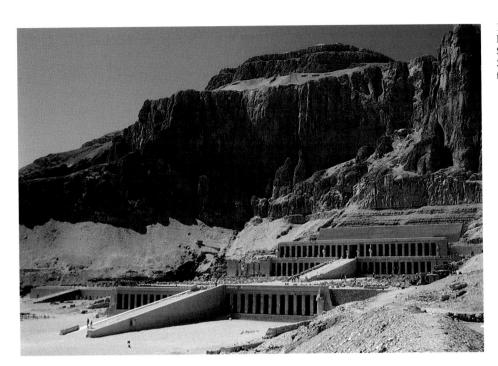

11.6 Mortuary Temple of Hatshepsut. Deir el-Bahri, c. 1490–1460 BC. See also the text accompanying figure 3.24 for more on the architectural features of this temple.

rock formations of the bare cliffs. The terraces in front were once verdant, filled with exotic plants and aromatic trees. A quarter-mile-long forecourt had contained a garden with a pool and papyrus, and rows of frankincense trees. The garden represented one of the great pleasures of Egyptian life, and thus was prominent in their afterlife imagery. An inscription from another tomb says: "May I wander round my pool each day for evermore; may my soul sit on the branches of the grave garden I have prepared for myself; may I refresh myself each day under my sycamore."

The Mortuary Temple of Hatshepsut was pillaged and vandalized shortly after her death by her successor, Pharaoh Thutmose III, who was angered that her two-decade rule had delayed his accession to the throne of Egypt. Almost all of her images were destroyed with the exception of her two obelisks at the Karnak temple complex.

Etruscan Tombs

The Etruscans were another ancient peoples who buried their dead in earthen mounds, and furnished them for the afterlife. The Etruscan civilization was a loose band of city-states in west-central Italy. It developed in the eighth and seventh centuries BC, flourished, and then bit-by-bit was conquered or absorbed by the expanding Roman Empire in the fifth and fourth centuries BC. Around the city of Cerveteri, the Etruscans buried their dead under row after row of earthen mounds arranged along "streets" in a necropolis, or city of the dead. Unlike *Newgrange* with a simple burial chamber, the Etruscan tombs often had several modest-sized rooms, laid out much like houses. These tomb chambers were

carved directly out of the soft bedrock, called tufa. Furnishings, such as chairs and beds and utensils, were sometimes carved in relief on the underground rock surfaces. The total effect was to recreate the comfort of a domestic interior. In contrast to other civilizations, the Etruscan tombs are not the grand monuments to powerful rulers, but rather are the product of a society that emphasized sociability and the pleasures of living.

The free-standing terra-cotta sculpture, Sarcophagus with Reclining Couple, c. 520 BC (figure 11.7), comes from a tomb in Cerveteri. The clay sarcophagus, with life-sized figures, was molded in four pieces. The couch resembles the furniture that was sometimes carved directly from the walls of other Cerveteri tombs. The wife and husband are shown at the same scale, reclining together at a banquet, sharing the same couch. This reflects the fact that Etruscan women had more rights than women in most other cultures. The facial features are similar and standardized on both figures, and their hair is handled as a geometry pattern. Their bodies are somewhat flattened and unformed from the waist down. Despite these nonnatural features, the wife and husband still give the impression of alert liveliness, health, and vigor. Their gestures are very animated.

Etruscan tomb art emphasizes pleasure. In tombs carved into cliffs near the Etruscan city of Tarquinia, the walls were often covered with paintings. One example is *Banqueters and Musicians*, from the Tomb of the Leopards, c. 480–470 BC (figure 11.8), so named for the leopards painted on the wall near the ceiling. To the left, banqueters recline on couches while servants bring them food and drink. The women are shown with light skin and men with dark, according to conventions of

11.7 Sacophagus with Reclining Couple, from a cemetery near Cerveteri, Etruria (Italy). Painted terra cotta. 45.5 inches tall. c. 520 BC. Museo Nationale di Villa Giulia, Rome.

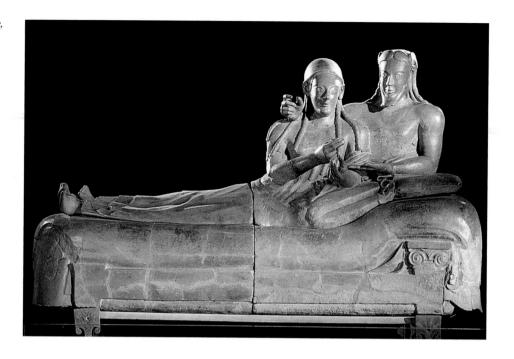

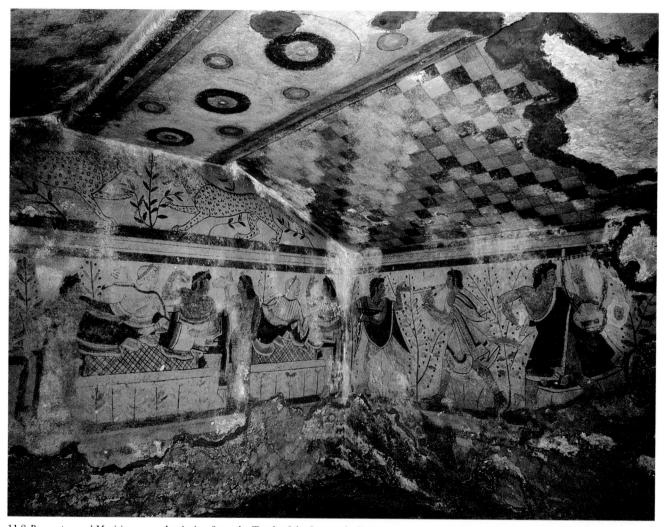

 $11.8 \ \textit{Banqueters and Musicians}, \text{ mural painting from the Tomb of the Leopards}. \ \text{From a cemetery near Tarquinia}, \ \text{Etruria (Italy)}. \ \text{c. } 480-470 \ \text{BC}.$

representation at that time. One man holds an egg, which was a symbol of rebirth. To the right, musicians dance across the wall. Gestures are lively and animated, and made more visible by the oversized hands. Golds, reds, and greens predominate, and the circle and checked patterns on the ceiling adds to the general cheeriness of the scene.

Bushes are shown between the musicians in figure 11.8. Although these were the only landscape elements in the Tomb of the Leopards, other tombs paintings at Tarquinia depict Etruscans enjoying the natural environment. Examples include multicolored dolphins leaping out of the seas, walls full of birds in flight, and scenes with people diving, swimming, and boating.

Funeral Complex of Shi Huangdi

One of the most extensive tombs ever constructed was that of Ying Cheng, who at age thirteen succeeded his father to become the ruler of the Qin state in 259 BC. By 221 BC, he had subdued the rival neighboring states to unify China and found the Qin Dynasty. He assumed the title of Shi Huangdi, the "First Emperor." To consolidate his power, Shi Huangdi ruthlessly homogenized Chinese culture. He decreed the burning of all historical books and had scholars burned or buried alive to eradicate old traditions and all opposition. He had the arms and fortifications of individual states destroyed, and former ruling families in rival states were forcibly moved to his capital, away from their land holdings and centers of power. He then reorganized the country into provinces administered by civil servants whom he selected and controlled, laying the groundwork for an administrative bureaucracy that continued for centuries in China. He had the Great Wall built for the northern defense of China, using forced labor from conquered tribes. New highways and canals facilitated travel throughout the recently unified lands. He standardized weights, measurements, axle widths, currency, and script styles.

Text Link
For more on The Great Wall of China, turn to figure
13.16.

Shi Huangdi's most extravagant projects were the palace where he lived, his funeral palace for the afterlife, and his tomb. The huge earthen mound of his tomb, 4,500 feet in circumference, is located halfway between a major mountain and river. The location was an important factor in ensuring eternal life. As we saw with Chinese temples, the Chinese developed an elaborate system of geomancy to help position important structures in auspicious settings in the environment. Shi Huangdi's tomb mound has not yet been excavated, but an account by the historian Sima Qian (145–c. 90 BC.) describes its furnishings:

... more than 700,000 [conscripted laborers] from all parts of China ... poured molten copper for the outer coffin; and they filled the burial chamber with models of palaces, towers and official buildings, as well as fine utensils, precious stones and rarities. Artisans were ordered to fix automatic crossbows so that grave robbers would be slain. The waterways of the empire, the Yellow and the Yang-tzu rivers, and even the great ocean itself, were represented by mercury and made to flow mechanically . . .

... once the First Emperor was placed in the burial chamber and the treasures sealed up, the middle and outer gates were shut to imprison all those who had worked on the tomb. No one came out. Trees and grass were then planted over the mausoleum to make it look like a hill.

In addition to the tomb, Shi Huangdi had an underground funeral palace, reputed to have been as large and lavish as the above-ground palace he used while he lived. Very little of it has been excavated. In 1974, peasants digging for a well uncovered pieces of a huge buried terra-cotta army, composed of more than 6,000 life-size figures, in all likelihood part of the eternal guard for the afterlife palace complex. Since then, archeologists have concentrated on excavating and restoring the terra-cotta army, as there is so much work to be done there. The tomb and underground palace remain buried, to be excavated at a later date.

One of the pits contains 3,210 foot soldiers in military formation for attack. The Soldiers from Pit 1 (figure 11.9), from 221-206 BC, are arranged in eleven columns, with four soldiers abreast in nine of the columns. What we see in our image is only one-eighth of one column of soldiers. Just imagine the total length of this column, eight times longer than what you see. Then multiply that by eleven columns wide, and then add at least two other pits also filled with life-size clay soldiers! Each soldier is made of low-fire ceramic clay mined from the area. The torsos are hollow, while the solid legs provide a weighty bottom to support and balance each soldier. The modeling on the bodies is standardized and formulaic: frontal, stiff and anatomically simplified. Certain features such as hands were mass-produced in molds. The repeated poses and stiffness give the figures a somewhat unnatural quality. In contrast, the heads are rendered with great naturalism and attention to detail. Remarkably, each of the thousands of faces is individualized, as we can see with the Infantry General (figure 11.10), and sculpted with great skill and sensitivity. No two are alike. The ceramic heads may have been likenesses of actual soldiers in Shi Huangdi's army. Their faces show ethnic differences, indicating that the soldiers were drawn from very diverse regions of China. Their carefully detailed hair shows individualized knotting and braiding, typical of the coiffures worn by the Chinese infantry of the past.

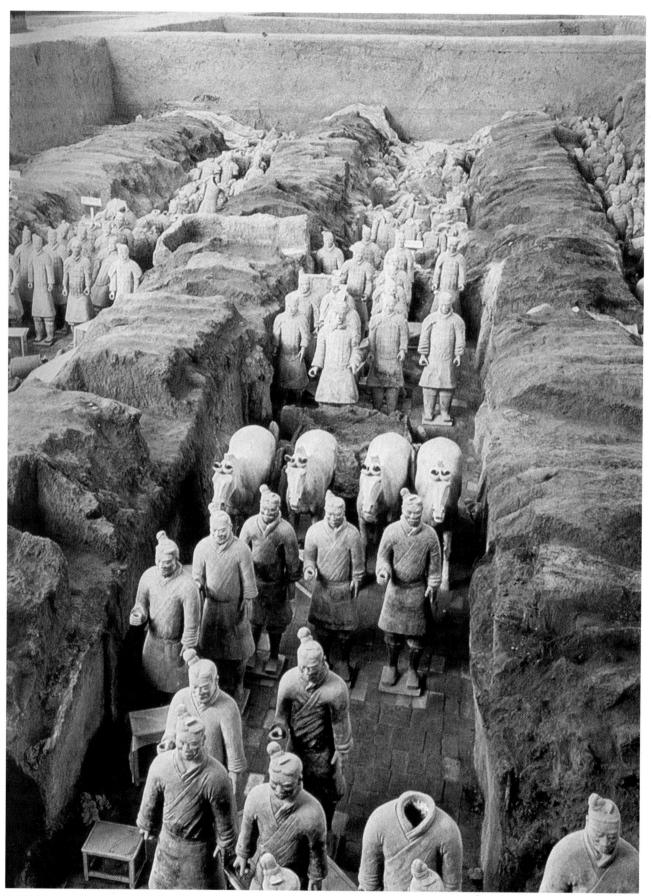

 $11.9\ Soldiers\ from\ Pit\ 1$, near the tomb of Shi Huangdi. Painted ceramic. Average figure height 5'9". Shaanxi, China. 221–206 BC. The soldiers visible in this picture represent only one-eighth of the length of one column, and there are eleven columns in all.

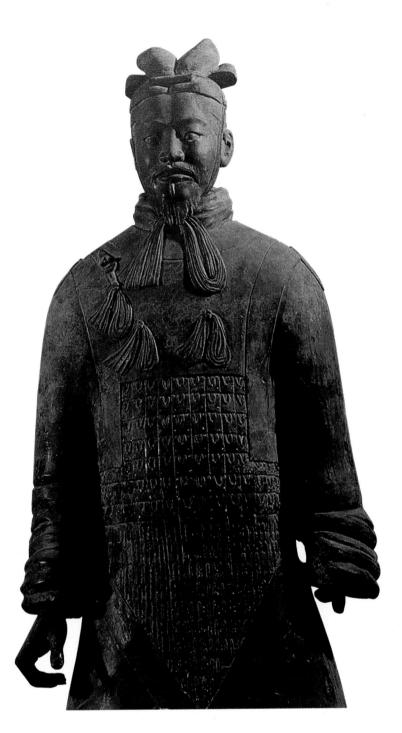

11.10 Infantry General, from the tomb of the emperor Shi Huangdi. Painted Ceramic. 6' 4" tall. Shaanxi, China. 221–206 BC. For more on this artwork, see also figure 2.5.

It is amazing that the high craft quality has been maintained for these thousands of ceramic sculptures, obviously requiring the efforts of many different artists and laborers and taking years to complete.

The soldiers in the foreground of figure 11.9 are wearing only clothing. Others visible behind them are only lightly armored. None wears a helmet. These lightly clad soldiers were quicker, more maneuverable, and highly successful against the more clumsy, heavily armored soldiers of the rival states. Qin soldiers were known to be fast and fierce in attack. Their relative lack of armor indicates an army designed to be always on the offensive, not a corps of defensive troops. Originally the

clay soldiers were outfitted with bronze spears, swords and/or crossbows. Qin crossbows were powerful enough to pierce armor, and their 20-foot-long spears protected horses from enemy soldiers. The person in figure 11.10 is presumed to be the commander of all the troops. He wears a helmet and more armor than any other soldier. In addition, he is 5 inches taller than the rest.

The soldiers were originally painted in vivid colors, adding to their grand appearance. Each column of this buried army stood on a brick "street" that was 15 to 20 feet below ground level. Separating the columns were rows of compressed, pounded earth that supported wood beams that once covered the entire pit. Fiber mats

and plaster were placed over the beams to seal the pits and prevent water seepage. Finally the entire roof of the pit was hidden under a low flat mound of dirt.

Shi Huangdi died in 210 BC, having spent considerable effort in his later years searching for the elixir of life. He was succeeded by ineffectual leaders, and beginning in 206 BC, a prolonged peasant revolt overthrew the Qin dynasty. In the course of the revolt, Shi Huangdi's above-ground palace was destroyed, and much of his underground project damaged, also. His clay army was broken and burned (evident in the background in figure 11.9 and most of their bronze and iron implements stolen. Ironically the ceramic sculptures could not be destroyed in the fire, only strengthened as if fired in a kiln again. But Shi Huangdi's efforts to homogenize Chinese culture and establish a bureaucracy were very successful. The unified Chinese state, existing to this present day, is his great legacy.

Royal Tombs of the Moche Civilization

In the late 1980s and 1990s, a series of lavish burials were uncovered from the Moche civilization, which flourished from the first through the eighth centuries along a series of short river valleys between the Andes Mountains and the Pacific Ocean, in an area that is now part of Peru. The Moche civilization was densely populated, with rich food supplies including river and ocean fish, and many crops grown successfully in the river valleys, along with domesticated animals and food from hunting and gathering. The Moche people constructed a complex irrigation system, built temples and palaces, and erected enormous pyramids of mud brick, some as high as 95 feet and containing millions of sun-dried bricks.

More than 350 Moche tombs have been carefully excavated and their contents examined, in addition to other tombs that have been robbed. The burials range from simple cloth-wrapped bodies in shallow pits, to elaborate burial chambers that held not only the dead but also a large number of lavish ceremonial items. This difference in burials indicates that the Moche society was highly stratified, with a continuum ranging from rich to poor. Without a doubt, furnished tombs were the privilege of rank within a prosperous society. Gold and silver metalwork was reserved for the elite, while pottery was available to all classes of people, and was not used as a mark of class distinction. A class of full-time artisans, who were extremely skilled and technically very inventive, created these ceremonial and funerary objects.

Warrior priests apparently ruled the Moche civilization, based on the fact that their grave sites were the most richly furnished. The primary reason for warfare in Moche society was to capture prisoners for sacrificial ceremonies. In these important ritual ceremonies, the elaborately garbed warrior priest, accompanied by other priests and attendants, would slit the bound prisoners' throats and drink their blood. Hands, feet, and heads of

the sacrificed victims were severed and used as trophies. Paintings on clay pots often show scenes of these ceremonies, which took place on the pyramids.

When warrior priests themselves died, they were buried in pits dug into these same pyramids. The chambers often contained other bodies; some were sacrificial victims, but others were women who had apparently died some years previously and whose bodies may have been included as attendants. Dead children in the tombs may have been included for good luck. The body of the warrior priest was separated from the others by mud bricks and contained within a wooden coffin. Hundreds of pottery vessels were placed in niches in the tomb. The entire chamber was often lined with red pigment and covered over with wooden beams, and then buried in soil. Over time, the burial chamber collapsed and filled in with silt.

Figure 11.11 shows one stage of the excavation of a Moche *Royal Tomb*, dated c. AD 300. At the top is the skull of the warrior priest. Around his neck are thousands of tiny shell beads that were assembled into flat mats that decorated his shoulders and chest. Large shiny gold and corroded silver peanut beads are also visible; assembled, these made a peanut necklace that can be seen in the reconstruction of the warrior priest attire in figure 11.12. Other disks of gold and corroded metals are also evident. Returning to the excavation picture in figure 11.11, we see part of the curved gold sheet that was worn at the top of the warrior priest's headdress, also visible on the mannequin, and the top of the scepter shown also in the right hand of the mannequin.

Text Link

Take a closer look at the amazing Peanut Necklace in figure 6.25.

All the objects and bodies from this tomb had to be painstakingly cleaned, sorted, identified, and reassembled, a process that took archeologists three years to complete. There emerged several sets of ceremonial gear for the warrior priest, including several layers of jewelry, breast plates, weapons, and ornamental feathers. The mannequin in figure 11.12 is dressed in only a small subset of objects found in the tomb. His body is covered with a cloth covered with gilded platelets, shell beads cover his wrists and shoulders, and his head was crowned by a truly striking helmet. Other face apparel included a nose plate that would be suspended from a hole in the nasal septum, and large ear ornaments. This nose plate is plain gold; others have elaborate decoration and inlay on them. From his waist hang crescent-shaped bells that would have jangled with every step.

Figure 11.13 shows one of a pair of *Warrior Ear Ornaments*. The central frontal figure is shown in an outfit very similar to the one worn by the mannequin,

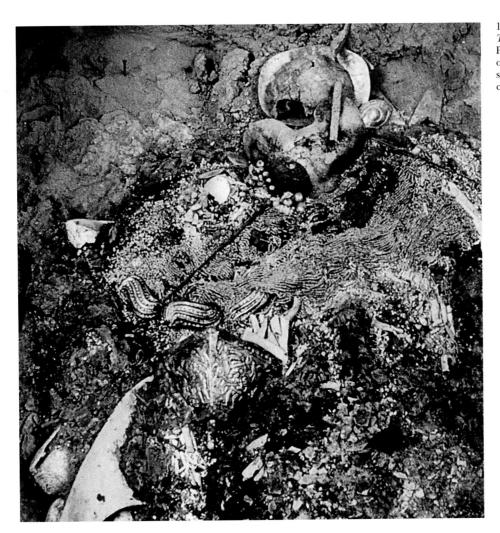

11.11 Excavation of tomb 1, *Royal Tomb* of Sipan, Moche civilization, Peru. Gold, silver, copper and shell ornamentation overlaying a human skeleton (cranium visible at top).

reproduced in small scale. Two symmetrical figures in profile on either side are lesser priests, indicated by their smaller size. The craft skills required to make this ear ornament are considerable; gold had to be cut, welded, cast, and hammered to create this work, plus small turquoise pieces inlaid. The degree of detail is astonishing: the small nose plate swings freely from the warrior priest's nose; the scepter can be removed from his hand, and the tiny owl-head necklace, strung with two gold threads, can be removed from his neck.

All items found in Moche royal tombs and paintings on pottery indicate that warrior priests wore spectacular outfits. The Moche aesthetic was marked by a taste for pageantry, with precious metals, brilliant colors, jingling sounds, and bright flashes of reflecting light. All individual pieces of ornament and paraphernalia were part of a ceremonial ensemble, designed to be striking in its visual effect.

In the Moche civilization, gold and silver were used in symmetrical and matching arrangements. The *Peanut Necklace* (figure 6.25) for example, contained ten gold peanut beads that were worn over the warrior priest's right shoulder, and ten silver ones over the left. An iden-

tical pair of weapons was found in one tomb, one in gold and one in silver. In another tomb, a gold ingot was found in the deceased's right hand, and a silver one in the left. Some examples of nose plates are fabricated in symmetrical halves, one gold and one silver.

Viking Ship Burial

The Vikings were maritime raiders from Scandinavia with settlements in areas as far-flung as Iceland, England, northern France, and Russia in the ninth and tenth centuries. Their tombs, therefore, reflect how important sea travel was to their civilization. The objects found in the Oseberg ship burial, excavated in 1904 near Oslo, Norway, are the richest source of information on Viking art and funerary practices.

The tomb of a high-ranking Viking woman from the ninth century was located under a mound approximately 20 feet high and 130 feet long. The tomb had been robbed centuries ago, as we have seen with other ancient tombs. There are traces of high-quality metal objects that once were buried there, but are long gone. Wooden items were left behind. The largest and most impressive find at the mound was the *Viking Ship* from

the early ninth century (figure 11.14), which has been heavily restored. In the center of the ship was originally a wooden cabin, which housed two beds with the body of a woman on each; one is presumed to have been a servant. The women were provided with quilts and pillows, and the chamber was lined in tapestries. Chests and looms were also included. The stern of the ship held

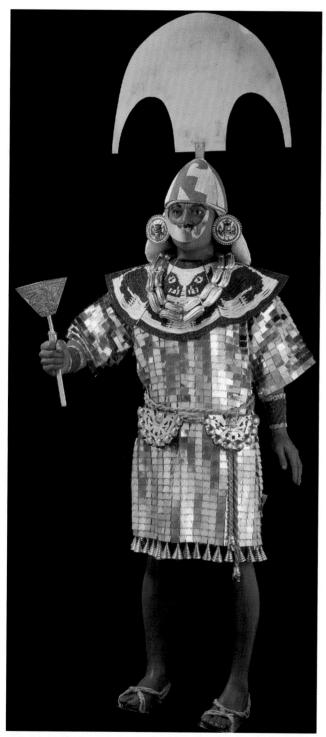

11.12 Mannequin dressed in replicas of some of the objects found in tomb 1, $\it Royal~Tomb$ of Sipan, Moche civilization, Peru. c. 300. For more, see figure 22.3.

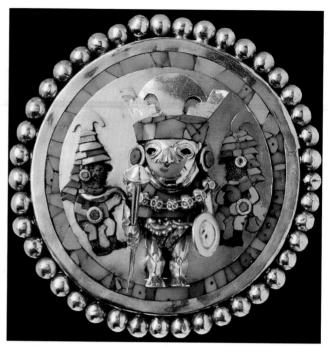

11.13 Warrior Ear Ornament, restored. Gold with inlay of turquoise. 9.4 cm. diameter. From tomb 1, Royal Tomb of Sipan. c. 300.

a carved four-wheel cart, three carved sledges, one plain sledge, three beds, two tents, a small chair, and various items for sailing. Ship, sledge, and cart provided mobility to the marauding Vikings, and tents, tapestries, and chests are portable items favored by all nomadic peoples across the globe. In and around the front of the ship were the skeletons of fourteen horses, an ox and three dogs, which are presumed to have been sacrificed at the time of the burial.

The ship was probably the private vessel of a wealthy family, intended for use near the coast and on inland waterways. It was outfitted with a mast and sail, and also rowlocks for 30 oarsmen. The graceful curves of the low, wide ship culminate with high, spiral posts at stem and stern; the one at the front is carved like a coiled snake. Rising up each post are relief carvings of animal forms that have been elongated and interlocked into a complex, twisting pattern. The animals' bodies form the main curves of the carving, while their long attenuated limbs interlock in thin lacy lines around them. Each animal's body is further adorned with crisscross or zigzag lines carved into its surface. While all the animals seem similar, each differs in its intricate detail work.

In addition to the stem and stern of the ship, the other wooden objects in the burial are covered with complex carvings, mostly with animal forms such as imaginary birds or totally unidentifiable beasts. In some, the individual animal forms are clear and large, while others are confused, entangled, and ambiguous. Yet all the animal carvings convey a feeling of wild agitation, firmly contained within the margins of the carving. They grip, bite, interpenetrate, and twist around each other.

The background wood has been carved away, so that the animal forms stand out in relief. Traces of paint in some sledges' carvings suggest that they were once painted with a black background and outlines of vivid color on the animals, enhancing and emphasizing the interlaced design.

The *Animal-head Post* (figure 11.15) from Oseberg conveys that same sense of ferociousness, agitation, and energy. Its mouth is drawn back, snarling and baring its large teeth. Its wide, short snout is covered with a pattern of squares, and its eyes bulge from striped sockets. Drastically elongated interlaced birds form a complex, curved pattern on the sides. This carving was executed

with such a level of precision, intricacy, and control that it may have been made by a jeweler. Similar animal interlaced designs are found on Viking jewelry.

DEVELOPMENT OF CEMETERIES AND GRAVE MONUMENTS

During the first millennium BC, there was a long transition from mound tombs to other forms of funerary art and architecture. A fundamental conceptual shift accompanied these changes: tombs no longer served as permanent homes for the dead, with the items they

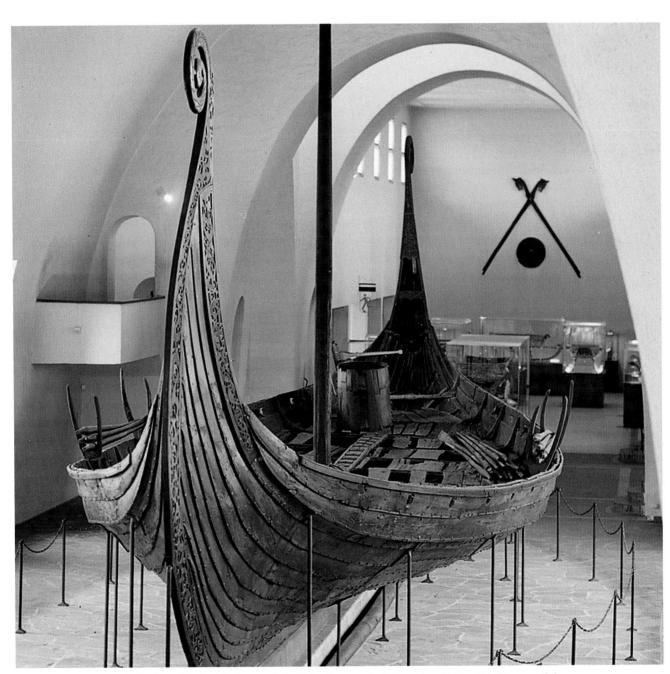

11.14 Viking Ship, from the Oseberg ship burial, Norway. Oak, 65 feet long, early ninth century. Viking Ship Museum, Oslo.

11.15 *Animal-head Post*, from the Oseberg ship burial, Norway. Wood, 5" tall, early ninth century. Viking Ship Museum, Oslo.

needed. Rather, tombs commemorated the departed persons.

The ancient Greeks developed the earliest commemorative funerary architecture in Europe and the Middle East. Among the wealthy and powerful, there arose the tradition of erecting very grand monuments, like temples, that housed the bodies of the deceased and elevated them to a semi-divine status. The most famous was the Mausoleum of Halicarnassus, built around 353 BC in an area of Persia under Greek cultural influence. It was

built for the ruler Mausoleus, from which the word "mausoleum" originated. This large building was a monument to the ruling family of a wealthy province. So famous was this structure that it was considered one of the Seven Wonders of the Ancient World. It was a rectangular structure, reputed to have had a colonnade of 36 columns, roofed with a tall pyramid topped by a four-horse chariot in marble. Other carvings and statues were said to adorn the building, although all that is left now is its foundation.

The rulers of ancient Rome also built large commemorative mausolea. Two of the most famous were the Mausoleum of Augustus, from the first century BC, and the Mausoleum of Hadrian, from the second century. Both were large round stone structures filled with earth, with lavish sculpture and decorative plantings adorning the exterior. These were prominent landmarks that symbolized the power and authority of the Roman emperors. Again, both of these structures have suffered badly in time and how they once appeared is largely speculative.

Text Link
Other unique forms were created to both
commemorate and contain the remains of
famous Romans, such as Trajan's
Column. Turn to figure 13.28.

While large mausolea were the privilege of the wealthy, cemeteries near Greek and Roman cities were laid out for the burial of the merchant and working classes. Among nomadic or farming communities, the disposal of the dead presents no problem. But as cities developed and populations become denser in and around them, cemeteries with small plots marked by upright monuments became practical.

In ancient Greece, the most common monuments were 1) small columns that supported vases, urns, or small statues; 2) life-sized freestanding figures of young men or women; or 3) relief carvings on stone slabs. The Grave Stele of Hegeso, c. 410-400 BC (figure 11.16), is an example of the third type. Hegeso is represented as a seated woman, whose servant has brought her a piece of jewelry to examine. Quiet, everyday moments were often depicted on Greek grave markers. A simple, architectural frame encloses the scene. The geometric curves of the chair make a pleasing transition from the straight edges of the frame to the complex folds of the drapery and the organic curves of the women's bodies. The bodies are rounded and naturalistic, but they also are idealized in their proportions and in their overall serenity and composure. Grave markers such as this were once painted and therefore colorful, indeed brightening up a gloomy graveyard.

Text Link

The style of carving on the Grave Stele of Hegeso is in keeping with major sculptural monuments of that time, such as the frieze on the Parthenon in Athens, which was covered in figure 10.15.

In ancient Rome, the dead were buried outside the city walls, along roadways entering the city, because Romans wanted their funerary monuments to be highly visible. The funerary monument was one important means of ensuring an individual's fame, and served as an enduring testament to the entire family's honor and standing in society. The Roman religion was a conglomerate of various beliefs and cults. Romans believed in a vaguely defined afterlife, in which the dead no longer resided in tombs, but lived in the underworld or in some celestial heaven. The departed were in contact with the gods and ancestor spirits, and could exert good or bad influences upon the living, depending upon the quality of their burial and the

11.16 *Grave Stele of Hegeso*, from the Dipylon cemetery, Athens, Greece, c. 410–400 BC. Marble, 5' 2" high. National Archeological Museum, Athens.

respect paid them by their descendants. The tomb was the meeting place of the living and the departed, and feasts would be held regularly at the family tomb in which all would partake; food and drink were poured out for the dead to enjoy. These sometimes-rowdy feasts were believed to be mutually consoling for the survivors and the deceased. For the less wealthy, these meals could be simple picnics, but banquets were served at tombs for the wealthy, which were outfitted with chairs, tables, blankets, cushions, and cisterns with fresh water. Some plots had small gardens with funds set aside for perpetual care.

Roman family tombs and mausolea were built in several styles. They could be altar-tombs. (See figure 11.25 showing the Pere Lachaise Cemetery in Paris for a modern example of this type of tomb.) Others were towers, modified Greek temples, diminutive Egyptian pyramids, and combinations of all of the above. Almost all afforded ample space for inscriptions and relief carvings, with narratives and details that announced the fame of the individual or family interred there. The sculpture on the tombs of the wealthy was lavish, and tended to imitate Greek styles, like the Grave Stele of Hegeso, with dignified, idealized figures filling an uncrowded space. The Funerary Relief of a Circus Official, dated AD 110-130 (figure 11.17) was produced for a working-class tomb, and is very different in style from that of the Grave Stele of Hegeso. The space on the Roman relief is cramped. However, its purpose was to tell complex ideas and narratives, so it features numerous characters, varying scale and symbolic details, all of which are absent in the Grave Stele of Hegeso.

The largest figure is that of the official himself, holding hands with his wife at the far left. In Roman art, the handshake symbolized marriage. The wife is smaller, as she is of lesser status, and on a pedestal as a sign that she had died before him. The faces of the official and his wife are frank, unflattering portraits. The Romans had a long tradition of realistic portraiture, where the unidealized likenesses of older persons were recorded in stone; in this case, with forehead wrinkles, protruding ears, and a drooping nose and mouth. The official and his wife are crowded to the side to give space for the Circus Maximus. Only one team of horses is shown, but they leap forward to communicate the speed and competitiveness of all the chariot teams that raced there. The space of the racecourse is tilted up and shrunken down behind the chariot, while the charioteer is shown twice, once driving the team, and again holding a palm branch of victory. The deceased may be officiating the race, or he may be the charioteer himself, shown again in his younger days.

ext Link

For an example of Roman portraiture, see Head of a Roman Patrician (figure 16.1), from Chapter 16.

11.17 Funerary Relief of a Circus Official. Marble relief, approximately 20" high. From Ostia AD 110–130. Vatican Museum, Rome.

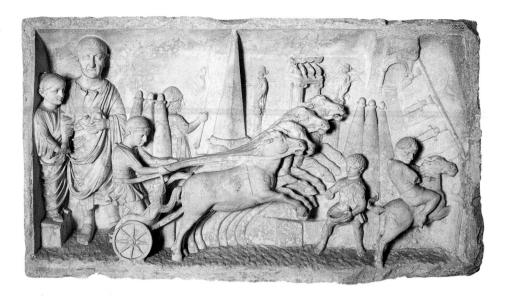

BURIAL IN PLACES OF WORSHIP

In some cultures, there arose a preference for being buried in holy sites. In this way, the deceased was seen as closer to God. This practice can also be a sign of prestige. The most sanctified places for burial were reserved for those with the greatest wealth, power, or religious standing.

Christian Burials

Early Christians buried their dead rather than cremating them, as was the common practice in the Roman Empire, because they believed the body would be resurrected and rejoin the soul at the end of time. Outside Rome and other nearby cities, the dead were buried in vast underground networks of tunnels and chambers called the catacombs, dug out of the same soft bedrock, or "tufa," as the Etruscan burial chambers. Catacombs were used from the second through the fourth centuries, and some were dug as many as five levels deep. Passageways were lined with openings the size of a body, one above the other, stack after stack. At death, a Christian's body would be placed into an opening, which was then sealed and decorated with painted plaster or carvings (such openings, now unsealed, are visible in figure 11.18). The air in the catacombs was fouled by the stench of rotting bodies, which must have seemed abhorrent to the pagan majority who practiced cremation. Eventually, four million bodies were buried in them.

Nevertheless, the catacombs became sanctified places, for a variety of reasons. The Roman imperial government periodically tried to suppress Christianity because its followers refused to recognized the divinity of the emperor or pay token tribute to Roman gods, and therefore was considered destabilizing to civil order.

There were two great periods of persecution, in 249–251 and again in 303–306, during which Romans killed, imprisoned, or harassed Christians for their beliefs. During times of persecution, the catacombs were used to bury martyrs, to hide fugitives from the Romans, and occasionally as places of worship.

At various intervals in the catacomb passageways, small rooms were carved to be used as mortuary chapels. These chapels were often plastered and painted. An example of a painted ceiling in a mortuary chapel from the fourth century is shown in figure 11.18, from the Catacomb of Sts. Peter and Marcellinus, in Rome. The style of the catacomb painting and much of its imagery are very similar to Roman secular painting. The feeding and resting lambs are taken from Roman landscape painting, for the Romans were very fond of pastoral scenes, often having them painted on the walls of their houses. But here the lambs are transformed into the Christian "flock" of followers who were protected by Jesus, the Good Shepherd, who is shown in the central circle of the ceiling painting. Decorative motifs of birds, foliage, little angels, and images of the seasons were also taken from Roman secular painting. The background of catacomb paintings was usually white, for better visibility in the dark tunnels, and wall surfaces were often subdivided by red and green lines. Figures were usually lively and energetic, rendered in quick sketchy brush strokes. There was no attempt to show deep space in perspective.

Themes in catacomb paintings were often salvation and resurrection, undoubtedly popular to the Christian communities when they were undergoing the terrors of persecution. Jesus was often shown as a young, comforting shepherd, never as crucified. Jonah and the Whale was one common story, and is illustrated in figure 11.18 in four half-circles. Only a few details of the story are shown, serving as notations to recall a much more

complex narrative and a larger body of meaning that would have been known to the faithful Christians. Other popular narratives of danger and deliverance were the Three Hebrews in the Fiery Furnace, Daniel in the Lion's Den, the Sacrifice of Isaac, Susanna and the Elders, and the Raising of Lazarus.

Christian martyrs who died during the persecutions were believed to be instantly transported to heaven. Early Christians believed that these martyrs had direct access to God, and could act as heavenly patrons for them. The martyrs' remains were believed to be points of access, so early Christians sought direct physical contact with the bodies, tombs, relics, and personal effects of the martyrs (see Reliquaries below). Ordinary Christians clustered their own tombs and mausolea near the holy sites of the martyrs' tombs. At some places, canopies or banqueting halls were built over the martyrs' tombs.

The status of Christianity changed radically under Constantine, the emperor of Rome from 306 to 337, who legalized Christianity in 313, and converted to that religion at his death. (Christianity became the official state religion of Rome in 380). During his lifetime, Constantine funded the construction of lavish churches

over the tombs of some of the most famous martyrs. One of these was Old St. Peter's in Rome, a church built over the tomb of St. Peter, the first head of Jesus' church. His tomb lay in the ground, but was marked by six twisting marble columns and a crown-shaped candelabrum. Persons wishing to be close to the body of the saint could be buried under the church's floor stones or in sarcophagi along the walls. Funeral meals were served in the lavishly decorated church interior. The site was visited by countless pilgrims.

By the sixteenth century, old St. Peter's, a timber church, had deteriorated and its size was no longer befitting the grandeur of the expanded Catholic church, and so a newer, grander St. Peter's in stone was constructed. However, the tomb of St. Peter continued to be the focal point of the new church, and a new canopy in bronze, called a *Baldacchino* (figure 11.19) was erected to mark the site. The canopy, designed by Gianlorenzo Bernini between 1624 and 1633, is a grand, lavish, richly decorated structure, taller than an eight-story building. But its design recalls the cloth canopies that originally covered the tombs of early martyrs, and its curving columns recall those placed by Constantine in Old St. Peter's. The vine-covered, twisting columns seem to leap up, and

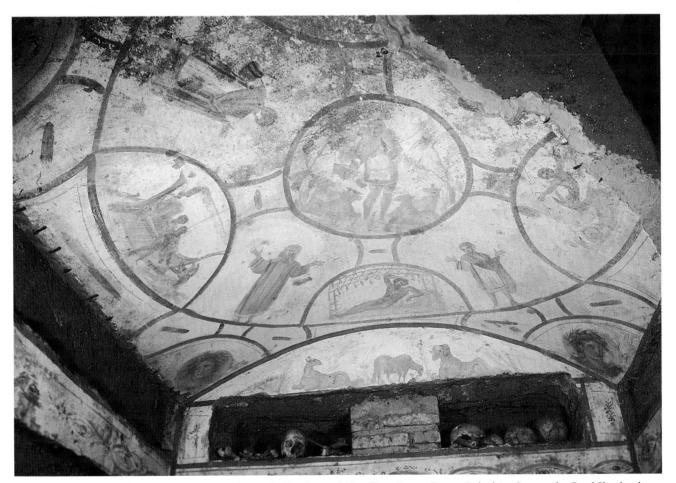

11.18 Ceiling Painting from a Cubiculum in the Catacomb of Sts. Peter and Marcellinus. Rome. Center circle shows Jesus as the Good Shepherd; surrounding half-circles show scenes from Jonah and the Whale. Fresco. Early fourth century.

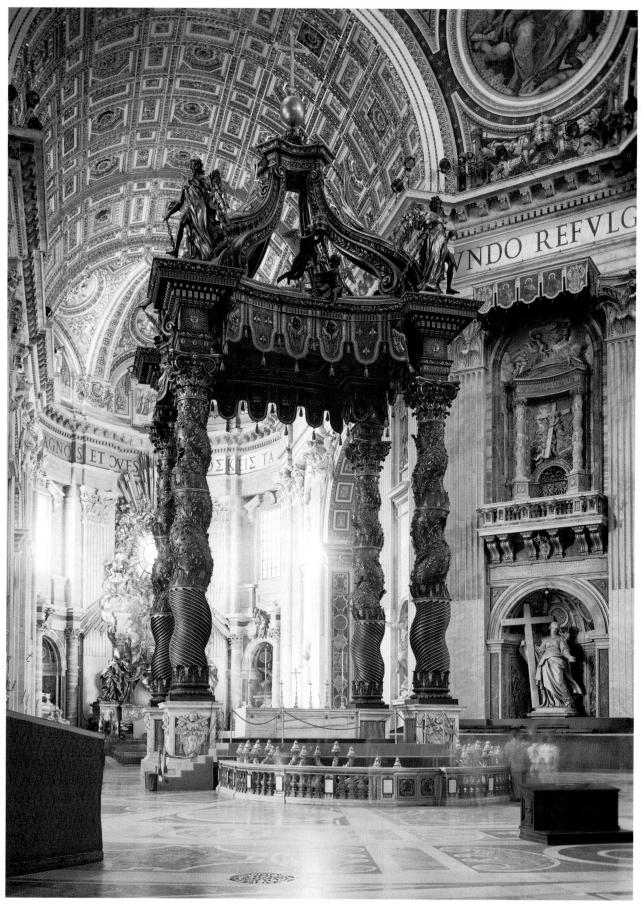

 $11.19\ Gianlorenzo\ Bernini.\ \textit{Baldacchino}.\ St.\ Peter's,\ Rome,\ Italy,\ gilded\ bronze,\ 100\ ft.\ high.\ 1624-33.$

support the grand canopy as if it were weightless, instead of tons of bronze (which was stripped from the nearby Pantheon (see figure 10.7) and melted to make the *Baldacchino*). Behind, at the back of St. Peter's, is another monument by Bernini with metal rays resembling beams of light that holds the relics of an ancient wooden chair, reputed to be St. Peter's chair when he headed the church. The grandeur of St. Peter's and the monuments in its interior are signs of a powerful religion, but they are also fundamentally monuments to tombs and relics, and indicate the strength of the cult of the martyr in early Christianity.

While the tradition of burying the dead in church developed very early in Christianity, it was discouraged repeatedly, as the interior of churches rapidly became completely overtaken by tombs. The poor and working classes were eventually buried outside in cemeteries and in rural parish churchyards. Despite periodic bans, the rich and powerful could continue to be buried in churches, in part because many churches were built and operated with the donations from the wealthy who wanted the prestige and protection of a church burial.

One spectacular example of church burial is the Chapel of Henry VII, dated 1503-1519 (figure 11.20), attached to Westminster Abbey in London, England. This large chapel, almost a separate church on the back of the older Abbey, was built for the burial of Henry VII and his wife, Elizabeth of York, and also to promote the growing cult of veneration around his already-deceased uncle, Henry VI, who was expected to be canonized a saint. After years of engaging in warfare and royal intrigue, Henry VII felt the need to include numerous provisions for the welfare of his soul in his will. He donated funds to Westminster Abbey for the construction of his chapel, and extra funds for the construction of other parts of the Abbey church proper. In addition, funds were provided for 10,000 masses to be said for him immediately upon his death, plus additional funds for three priests to pray continually in his chapel for the repose of his soul, which they did from his death in 1509 until 1547. He also donated money to many charitable institutions. The monks at Westminster Abbey had lobbied heavily for the chapel, as the royal burial represented such generous endowments and established the fame of the Abbey, making it a destination for pilgrims.

The chapel is built in the **English Perpendicular** style, a variation of the **Gothic** style. Here, the vaults are intricate, lacy, and elaborate. The ceiling seems to rise up on slender piers between the windows, and then fan out gracefully and drape downward. Window tracery and carvings add to the overall effect. Sculptures of saints fill the remaining wall space. The great height of the interior and its delicate patterning make a fitting symbol of royal power at the end of the Age of Chivalry. A carved wooden screen encloses the tombs of Henry VII and Elizabeth, which have bronze effigies atop them.

The tombs are located directly behind the altar, at the most venerable location in the chapel.

Westminster Abbey, with the *Chapel of Henry VII*, continued to be used for royal burials until the eighteenth century. Its fame was also enhanced by the numerous tombs and memorials it houses for illustrious persons, such as statesmen, military leaders, and poets.

Text Link

Compare the French Gothic cathedral emphasis of verticality with the elaborate Perpendicular style of the Chapel of Henry VII. See Chartres Cathedral, figure 10.25.

Islamic Mausolea

The wealthy and powerful among Islamic societies were sometimes buried in mausolea adjoining mosques. For example, Shah Abbas the Great, ruler of a great seventeenth-century Persian empire, was buried in a mausoleum attached to the *Masjid-i-Shah*, a mosque we saw in Chapter 10. Another earlier example is a complex in Cairo that contains the mosque, theological school, and mausoleum of Sultan Hasan, who ruled Egypt in the fourteenth century.

Text Link
The Masjid-i-Shah has an attached
mausoleum for Shah Abbas the Great.
Turn to figure 10.29 in Chapter 10.

Possibly the most famous Islamic mausoleum is the *Taj Mahal*, the final resting place of Mumtaz Mahal, wife of Shah Jahan, ruler of the Mughal Empire in India. Both Shah Jahan and Mumtaz Mahal were of Persian ancestry, descendants of invaders who established an Islamic state in northern India. She died in 1631 while giving birth to their fourteenth child. Mumtaz Mahal was apparently very beloved by the emperor; she may have been his trusted advisor. The *Taj Mahal* shows the influences of a number of cultures, including Afghanistan, Turkey, Iran, and indigenous India.

The *Taj Mahal*, built between 1632 and 1654 (figure 11.21), sits at the north end of an expansive walled and gated garden, like some in Turkey and Iran. These gardens symbolized and were earthly recreations of Paradise. The *Taj Mahal's* 35-acre garden was subdivided into four equal squares by cypress-lined canals that meet in the center at a large reflecting pool. Each four squares are further subdivided into four garden plots. The four canals symbolize the four rivers of Paradise in

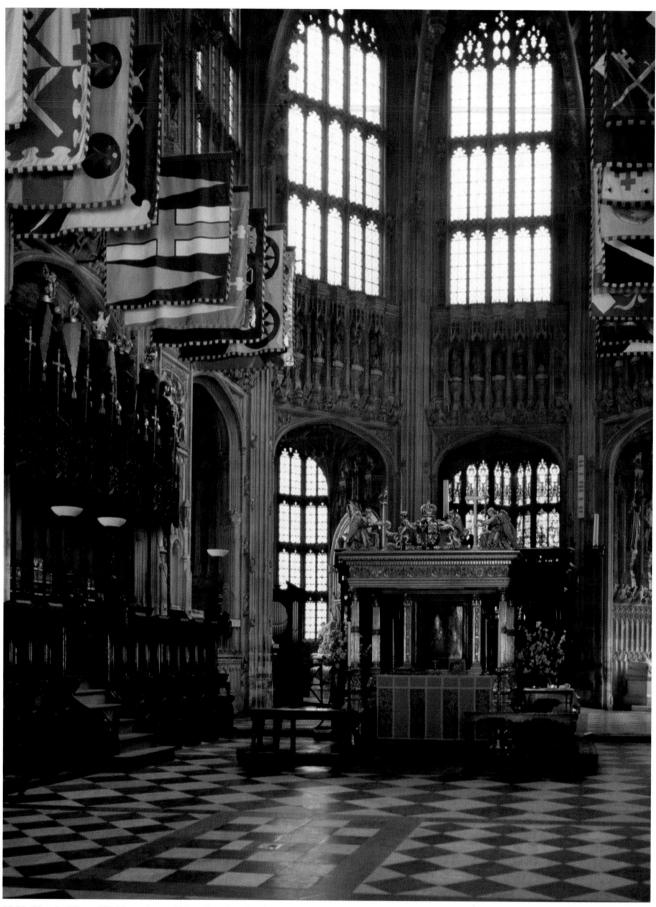

11.20 Chapel of Henry VII. Westminster Abbey, London, England. 1503-19. Interior towards east.

11.21 *Taj Mahal*. Agra, India. 1632–1654.

the Qur'an. An inscription on the main gate of the garden reinforces the association between the garden and paradise:

But O thou soul at peace,

Return thou to the Lord, well-pleased, and well-pleasing unto Him.

Enter thou among my servants,

And enter thou My Paradise.

The Qur'an Sura 89

The mausoleum sits at the far end of the garden, not central in it, so that the garden retains its autonomy and symbolic significance. The *Taj Mahal* itself symbolizes the throne of God, a celestial flowering that rises above Paradise, the garden. This divine vision is well buffered from the outside world, with a river to the north and a forecourt in front of the garden's main gate. In addition to symbolizing Paradise and also serving as a mausoleum, the entire complex may have also been intended as a monument to Shah Jahan's own greatness.

11.22 Two details from the interior of the *Taj Mahal*. Inlaid and carved marble. Agra, India. 1632–1654. See also the text accompanying figure 20.24.

Text Link

In the manuscript painting, Babur Supervising the Layout of the Garden of Fidelity (figure 19.14), we see an example of a walled garden from Persia.

While the Taj Mahal is located at the end of the garden, it is undoubtedly the focus for the entire compound. It is flanked by a mosque and by a guest house, both in red sandstone that contrasts with the white marble of the mausoleum. In this respect, the Taj Mahal differs from some examples where tombs are appendages to larger sacred structures. The Taj Mahal is a compact, symmetrical, centrally planned structure, on a raised platform surrounded by four minarets. The huge dome dominates and unites the entire structure, but the various parts, from arched portals to windows to porches, maintain their own identity while being integrated into the overall design. From a distance, its billowing dome and apparent whiteness make the Taj Mahal seem to rise up rather than weigh down; the sheerness and airiness of the structure, combined with its reflection in the pool, give an impression of floating.

The *Taj Mahal* has a primarily brick core, with some rubble. The building is sheathed in white marble and, in less-noticed areas of the interior, in white plaster. Up close, however, neither the floating whiteness nor integration of architectural features are its most striking features. Inside and out, the Taj Mahal is covered with an abundance of delicate floral decoration and elegant calligraphy, all set in stone (figure 11.22). The center area of the interior, under the dome, is enclosed by a screen of carved and pierced marble. It surrounds the cenotaphs, the false tombs that act as commemorative monuments to Shah Jahan and Mumtaz Mahal, whose bodies are actually buried in a crypt below. The cenotaphs themselves show an incredible richness of decorative

work. They are made of white marble into which have been laid strips and pieces of onyx, red sandstone, agate, jasper, cornelian, lapis, coral, jade, amethyst, green beryl, and other semiprecious stones. The walls throughout the *Taj Mahal* are decorated with inlaid or carved floral decoration, while the floor is white with black geometric patterns inlaid. In Islam, flowers are symbols of the Kingdom of God, springing forth from the waters of Paradise. Flowers are common in Iranian decorative designs, one influence on those in the *Taj Mahal*.

In addition to flowers, calligraphic writing set in black stone adorns the Taj Mahal. Calligraphy was considered the most noble artistic expression in the Islamic world at that time, because the calligrapher reproduced the word of God when transcribing the Qur'an. Twenty-two different Qur'anic quotes as well as full suras are used throughout the Taj Mahal, on the gate, on the interior and exterior walls, and on the cenotaphs. The design of the calligraphy on the Taj Mahal is particularly elegant and accomplished. The black shapes of the letters stand in strong contrast to the white marble and the colorful flowers. While the names of the architect and other artisans of the Taj Mahal are not known, the name of the calligrapher is: Amanat Khan, whose name is signed on the south portal of the structure. In addition to designing and placing the letters, Amanat Khan may have also chosen which quotations were to be used. In gratitude for his calligraphic work, Shah Jahan gave him an elephant as a gift.

The Taj Mahal took 22 years to complete. The cost of construction was steep, and thirty surrounding towns were taxed to pay for its upkeep. In time, the Taj Mahal suffered from neglect and vandalism. The inlaid work was damaged over the years by thieves who gouged out the semiprecious stones. The gardens were let to ruin, greatly diminished in size, and precious items were stolen. In 1830, the British governor of India planned to strip the Taj Mahal and sell its marble casing in England;

only the lack of a buyer caused the plan to fall through. The mausoleum and 35 acres of its garden were restored by Lord Curzon, who became British viceroy of India in 1900.

RELIQUARIES

In some religions, bones, tissues and possessions of deceased holy persons are kept and venerated. We saw earlier in this chapter how the faithful sought out the relics of Christian saints and martyrs for special intercession with God, ever since the first centuries after Jesus' death. The practice continued in Medieval Europe, where pieces of clothing or body parts were separated from the buried remains of saints, moved to major churches throughout Europe, and housed in small precious shrines, called reliquaries. Almost all prominent Medieval churches were pilgrimage sites, as the faithful would travel great distances to ask special intercession of a saint whose relics were located there. One example is the Head Reliquary of St. Alexander, from the early twelfth century (figure 11.23). Reliquaries frequently had sculptural representations of the body part contained within. Reliquaries were very expensive items to produce, as was appropriate to house precious relics. Reliquaries were more related to the jewelers' craft than to sculpture (indeed, few largescale sculptures were produced in Europe at this time). Our example is studded with jewels, small cast forms, and made of precious metals.

Let us look at an example of a reliquary from Africa. Rather than saints and martyrs, ancestors are venerated among most African religions. Many sculptures from Africa are part of rituals to honor ancestors. Ancestors are believed to affect the welfare of the living in many ways, and accordingly ancestors must be properly hon-

11.23 *Head Reliquary of St. Alexander.* From Stavelot Abbey, Belgium, 1145. Silver repousse (partly gilt), gilt bronze, gem, pearls, enamel. approximately 17.5 inches high. Musees Royaux, Brussels.

11.24 *Reliquary Guardian Figure.* Wood, brass, 24" high. From the Kota-Obamba regions of Gabon, Africa. Stanley Collection, University of Iowa Museum of Art.

ored with offerings at their grave site or at shrines dedicated to them. Ancestors are seen as essential links in the continuity of the group: all persons are expected to have children; only those with children become ancestors while those who are childless become wandering, malevolent spirits; ancestors are believed to inhabit newborn children.

One example of a sculpture used in the veneration of ancestors is the *Reliquary Guardian Figure* (figure 11.24) from Gabon in west central Africa. This kind of sculpture was placed on a bag or basket that contained the skull and long bones of the ancestors who founded a clan, both to protect these relics from any kind of evil and also to obtain help for food, health, or fertility from these ancestors. The sculpture, combined with the relics,

was considered to be the image of the spirits of those dead ancestors. Offerings were made to them.

This *Reliquary Guardian Figure*, and others like it, were constructed over flat, wide, wooden armatures, and then covered with brass or copper sheets or wires. The faces were oval and usually concave, with flat shapes projecting from the sides and top like the elaborate hairstyles traditionally worn in the area. The guardian figure probably evolved from full-body anthropomorphic sculptures with hollow torsos in which bones were originally placed, which became impractical as more bones were accumulated. In their present form, they could also be used in dances. These sculptures, when they first became known among European modern artists, were extremely influential in the development of twentieth century art styles.

MODERN COMMEMORATIVE ART

We will now look at some examples of commemorative art from the last two centuries. These examples are varied. They include monuments that deal with personal loss, memorials for large populations, and monuments for important political leaders. These works draw from fine art, popular culture, folk art, and craft. They all represent attempts to express loss, preserve memory, and transform the experience of death.

Modern Cemeteries

From the middle of the eighteenth century and into the nineteenth century, cemeteries within cities in Europe had reached a crisis point. Burials generally took place in churches or in the church yard, which had become overcrowded and often neglected. As urban populations increased, cities expanded and surrounded these cemeteries, which were believed to be sources of pollution and dangerous to health. As a result, civil authorities gradually removed control of burial practices from the churches, and established new large suburban cemeteries. The link between religion and burial ground had been broken; many new cemeteries buried the deceased who followed any (or no) religion.

While in Italy the new cemeteries were rigidly organized around tight grids, the picturesque cemetery was favored in northern Europe, for example, the *Père Lachaise Cemetery*, 1804 (figure 11.25), originally on the outskirts of Paris. The design of this cemetery was influenced by **Romanticism**, a major art and cultural movement of the nineteenth century, which emphasized a return to a simpler, rural way of life (if only in death!), just as the Industrial Revolution was creating ever more packed cities, greater pollution, and mechanization of life. The cemetery was laid out with meandering paths on a hilly site, with massive trees forming a canopy overhead. As families could own plots in perpetuity, they constructed often elaborate and fantastic memorials. The

monuments in *Père Lachaise Cemetery* run the gamut from Egyptian, Greek, Roman, Byzantine, Gothic, and modern art nouveau styles. In our illustration, you can see an art nouveau monument at left, dark in color with open arches. At top center is a white "Greek temple," with a "Roman" altar sarcophagus with a curved top in front of it. Urns, columns, and obelisks abound. Their exotic qualities are further manifestations of Romanticism. The famous and the obscure are buried together here, making it a national tourist attraction, like many burial places in this chapter.

Ophelia (figure 11.26), painted by John Everett Millais in 1852, is contemporary with some of the monuments in the Père Lachaise Cemetery. Ophelia is a character in the Shakespearean play, Hamlet, who becomes incapacitated from grief, falls into water, floats a while unknowingly, and then drowns. This painting exhibits the same feeling towards picturesque nature that is apparent in Père Lachaise. Nature is painted with deep color, lushness, accurate detail, and extraordinary delicacy. The beautiful, young Ophelia floats before us with gracefully outstretched hands, her flower-strewn dress and pose already suggesting the casket. The whole scene is lacking in the grisly details of madness and death by drowning, but rather is permeated with tragedy and poetic feeling. At Père Lachaise Cemetery, many monuments echo the sensibilities expressed in this painting, with sculptures of family members reaching for each other, or lying together in death.

The new style of European cemeteries influenced those in the United States. The pastoral Mt. Auburn cemetery in Boston, described in its day as an earthly paradise, featured sculptural works among winding avenues, artificial lakes, fountains, and floral displays. Planned cemeteries were (and still are) financially successful commercial enterprises, and their major selling point is their controlled, well-maintained, pastoral setting. In this, the cemeteries met more the needs of the living that the actual requirements of burying the dead. Planned cemeteries in nineteenth-century United States were recreational and cultural centers in overcrowded industrial cities. They predate large city parks, and in fact laid the foundation for the belief that cities should set aside large park spaces within their city limits.

One of the most famous planned cemeteries in the United States is Forest Lawn, in Glendale, California, a city in the greater Los Angeles metropolitan area. The planner of Forest Lawn aspired to create a culturally uplifting and happy cemetery, in a benevolent nondenominational Christian setting. Tombstones were forbidden, because they would be blots on the green rolling hills, so all grave sites are marked by inconspicuous bronze plaques set into the ground. Artwork plays a prominent part in the Forest Lawn landscape, as the theme of the park is "Great Art of the Western Civilization." While the collection contains many

11.25 View of the *Père Lachaise Cemetery*. Paris, France. Opened 1804.

original works, it is better known for its copies of masterpieces of the Italian Renaissance, like *Leonardo da Vinci's Last Supper* (figure 11.27) rendered in stained glass by Rosa Caselli Moretti between 1924 and 1930. Forest Lawn drew many visitors and was a cultural center for art in an era before many U.S. citizens traveled to Europe. It was an enormous success because of its benevolent, controlled, cultural atmosphere and its picturesque settings for remembrance of loved ones.

Text Link

But is it art? Forest Lawn's art collection includes not only the Last Supper in stained glass, but also copies in marble of every major Michelangelo sculpture. For more on the relationship between original work and copies, high and low art, popular culture and kitsch, see Chapter 1.

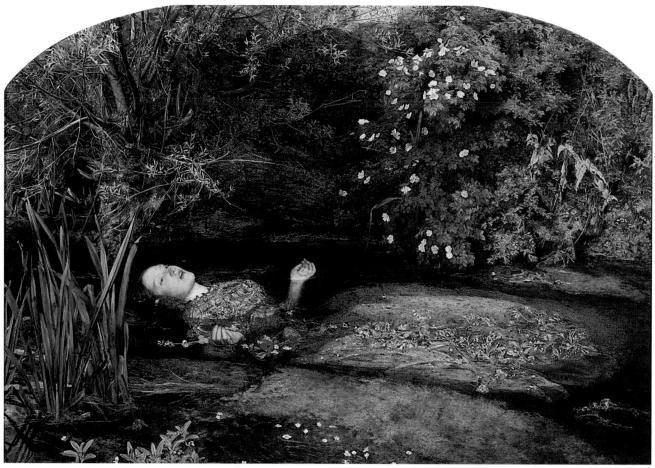

11.26 JOHN EVERETT MILLAIS. Ophelia. Oil on Canvas, 30" × 44", 1852. Tate Gallery, London.

Contemporary Memorial Art and Practices

The art and rituals that surround death serve broad social needs, as well as personal needs. We will conclude this chapter with examples of commemorative art that are also socially and politically potent.

Among Mexican populations, the Day of the Dead is a popular celebration. The feast day, a mixture of

Christian and Aztec beliefs, is celebrated in Mexico and in the United States with local variations. Marketplaces become sites for parades and spirited celebrations, with vendors selling drinks, treats, and flowers. In private homes, altars are set up commemorating the family's dead, with incense burned and pictures of the departed placed next to their favorite foods to welcome their

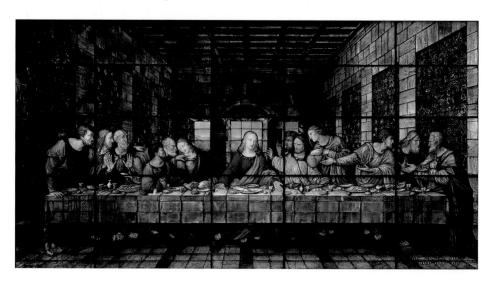

11.27 Rosa Caselli Moretti. *Leonardo da Vinci's Last Supper*. Stained glass, 29'10" × 13'9". 1924–1930. Forest Lawn Cemetery, Glendale, California, USA.

returning spirits. The day is an opportunity for the living to visit each other, also. Skulls and skeletons are everywhere, as masks, carvings, and as candy treats for children to eat. Families may spend the night at the graveyard with the deceased. After the grave sites are tended, hundreds of candles are lit throughout the vigil.

The Day of the Dead, since it acknowledges the ultimate end of all humans, also becomes an opportunity to address social and political wrongdoing. Satirical posters and handbills called *calaveras* (or skulls), featuring skeleton caricatures to criticize individuals in public life, are distributed at this time.

The Day of the Dead is so important that is depicted among a series of murals of Mexican history and culture that were painted by Diego Rivera in the Ministry of Education building in Mexico City. The painting *Dia de Los Muertos*, executed in 1923 (figure 11.28) shows the urban observance of this feast day; two other panels

depict more traditional rural observances. Great crowds fill the marketplace in a raucous celebration. In the foreground are food vendors and children in skull masks. Hanging under the awning in the background are satirical skulls and skeletons of various characters, including a priest, a general, a capitalist, and a laborer. Rivera painted his figures in a simplified, rounded, monumental style. He insightfully recorded different individuals' personalities, and also captured the crush and excitement of the crowd and the spirit of the event.

Complex memorial festivals are held among the peoples of New Ireland and nearby islands, which are located in the Pacific Ocean northeast of Australia. Both the festivals and the sculptures carved for the occasions are called "malagans" (also spelled malanggan). The purpose of the sculptures and festivals together is to honor ancestors, but they also serve to strengthen clanties and to stimulate the economy. When a member of a

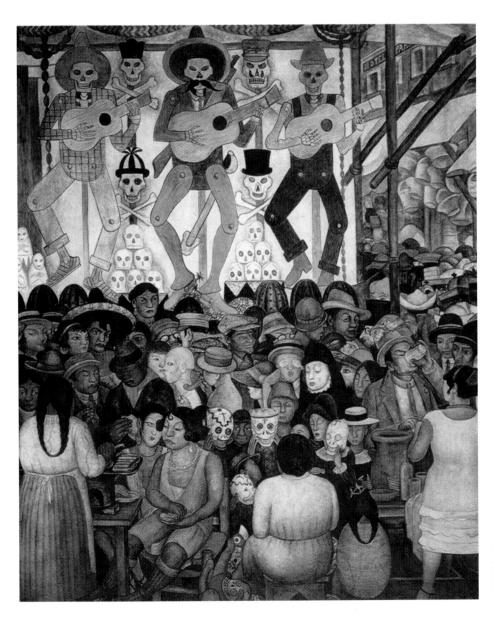

11.28 DIEGO RIVERA. Dia de Los Muertos (detail showing the city fiesta). South Wall, Court of the Fiestas, Ministry of Education, Mexico City, 1923. Fresco.

11.29 Horizontal Frieze, or Walik.
Malagan. Wood, fruit paste, vegetable fibers, glass beads, beeswax and sea snail valves. 14" × 125" × 7". Northern New Ireland. Ubersee-Museum, Bremen, Germany.

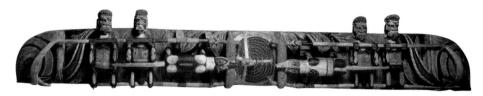

clan dies, the first phase of the mourning and burial rituals are held immediately. But several months or even years later, a village organizes a malagan that may commemorate several deceased clan members at once. Planning takes several months, as special crops must be planted, pigs for the feast are raised, and sculptures are carved for the occasion. The malagan, which lasts several days, involves a great expenditure of effort and wealth to appropriately honor the dead. It requires the coordinated efforts of several surrounding villages, resulting in the exchange of money and stronger intervillage alliances. Because they fulfill many purposes, malagan rituals continue to be enacted in New Ireland, although they have evolved due to foreign religious and political interference.

Malagan carvings, which are made for the event, are intricate sculptures of humans, birds, fish, snakes, and sometimes boars, combined together so that parts transform from one creature to another or merge together ambiguously. Figures often seem to swallow or struggle with other creatures. Only certain patterns of malagans are made, and a clan must buy the rights to use a pattern. There are several different types of malagans, including masks, pole sculptures, long horizontal friezes, and dance ornaments. The exact meaning of all carved elements is not known, as clans keep many of their rituals secret, and as missionaries and traders acquire sculptures without knowing or caring about their ritual significance. The rich and brilliant colors are symbolic. but the context changes the exact meaning. Red is usually associated with danger. The frieze in figure 11.29, called a "walik," has a fish head at each end of the carving, indicating a coastal clan. Two pairs of male and female figures (the deceased) clasp stretched snakes. The snakes and four-legged animals bite at the center, containing a fire eye. Visually, the malagan is complex: animal forms are detached from the background; the entire pieces is intricately cut and painted; the human heads, carved and attached separately vary the piece's silhouette. Friezes such as this are dramatically displayed in a ceremonial hut during the malagan festivities, while other malagans are used in dances. The rituals and sculptures together provide an opportunity for spirits to be present in a village. Once a ceremony is over, some malagans are never used again, and may be destroyed or sold to foreign collectors.

While malagans meet social and clan needs, other funerary artworks serve broad political needs. The *Mausoleum of Mao Zedong* (figure 11.30) not only houses the body of the leader of the Communist revolution in China, but it also asserts the authority of the Communist government to rule China after centuries of imperial rule. Mao came to power in 1949, after years of civil war and Japanese invasion. His historical accomplishments included helping to restore Chinese independence and redistributing land to the peasants.

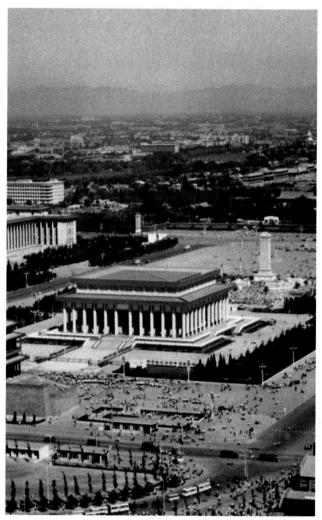

11.30 Mausoleum of Mao Zedong, in the center of Tienanmen Square, Beijing, China. The Forbidden City is in the background. Latter half of the twentieth century.

The layout of the Chinese capital city, Beijing, symbolizes the power of the ancient Chinese emperors. Its major axis runs north-south, and official buildings, palaces, public grounds, and city gates were placed along it. Also aligned on the axis is the Forbidden City, a walled complex with hundreds of buildings, including the Imperial Palace containing over 9,000 rooms. This alignment signifies the authority of the imperial dynasties. In front of the Forbidden City is Tienanmen square, a large important ceremonial space. In the middle of the square, along the major north-south axis of Beijing, is the Mausoleum of Mao Zedong, placed deliberately as a sign of the legitimate authority of the Communist leaders as the rightful successors to the emperors. Between Mao's tomb and the Forbidden City is an obelisk with reliefs, a monument to the Communist revolution.

Text Link
Look ahead to the discussion of the elaborate Forbidden City, and the Hall of
Supreme Harmony. See figure 12.16.

Mao's tomb resembles many other modern structures around the world. It contains a large hall with ramps, and visitors are hurried along them for a brief glimpse at the preserved body of Mao, in a clear coffin. Mao was a poet and calligrapher, both highly prized cultural accomplishments. Examples of his work are displayed nearby, establishing Mao as both a political and cultural leader. This entire site—tomb, square and Forbidden City—continues to be a point of economic change and political struggle. Next to Mao's tomb, students led an unsuccessful revolt to the oppressive Communist regime in 1989, while the world's largest fast food hamburger restaurant in 1996 was the McDonald's of Tienanmen Square.

Like the tomb of Mao Zedong, the *Vietnam Veterans Memorial* (figure 11.31) is located on politically significant ground, but the effect of this monument is very different from that of Mao's tomb. Built in 1982, the *Vietnam Veterans Memorial* is located on the Mall in Washington, DC, a long grassy park with several historical and patriotic monuments, surrounded by numerous government structures. The Mall is visible in figure 11.33. The memorial is not a tomb nor a mausoleum; no one is buried here. It commemorates almost 58,000 Americans who died in the Vietnam War, from 1959 until 1975, with the inscription of each of their names on its black granite face, like carving on gravestone.

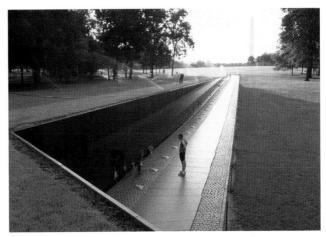

11.31 Maya Ying Lin. *Vietnam Veterans Memorial*. Washington, DC, USA. Black granite, 492' long; height of wall at center: 10' 1". 1982.

Their names are recorded chronologically over the years of the war, not alphabetically. The memorial is low, long, and v-shaped, set into the ground with one end pointing to the Washington Monument, a symbol of national unity, and the other end pointing to the Lincoln Memorial, a monument to a nation grievously divided by civil war. The Vietnam War was a lengthy conflict to which the U.S. population was never deeply committed, and about which it became more disenchanted and appalled as time passed. At the same time, there was considerable anguish over the soldiers who served and died in a war about which the nation was ambivalent. Magazine and newspaper coverage brought the blunt realities of the war into U.S. homes, as evident in Brigadier General Nguyen Ngoc Loan summarily executing the suspected leader of a Vietcong commando unit (figure 11.32),

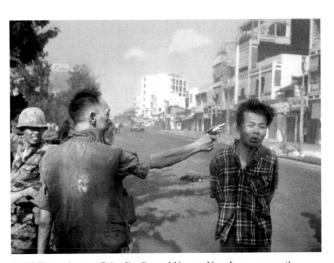

11.32 Eddie Adams. Brigadier General Nguyen Ngoc Loan summarily executing the suspected leader of a Vietcong commando unit. Saigon, South Vietnam. February 1, 1968. World Wide Photos. See also the text accompanying figure 18.6.

a war photograph from 1968 by Eddie Adams. This imagery informed people's concept of the Vietnam War. Its harshness contrasts severely with romanticized images of death, such as the *Ophelia* painting we saw above.

The proposal for the Vietnam Veterans Memorial, designed by Maya Ying Lin, received mixed responses of approval and disapproval. Once a negative criticism was voiced, many others responded and the project was put on hold. The demand for a more traditional figurative monument was made, and another design was added to the space. A figurative piece of three soldiers by Frederick Hart was commissioned and was placed in a small grove of trees across from Lin's wall. Later, a sculpture of three nurses was added. After all the controversy, the works in fact complemented one another, and satisfied all the critics. There is a humbling reverence and feeling of solemn sorrow felt as one walks by the names of the dead, which is also reflected in the faces of Hart's bronze life-size soldiers. They stare at the commemorative wall of the dead with an expression of bewilderment, disbelief, and shock.

The *Vietnam Veterans Memorial* is remarkable in that it avoids the impersonalness of many public monuments. While other monuments may be the sites of public parades, speechmaking, and demonstrations, the *Vietnam Veterans Memorial* moves observers to private meditation or mourning. Its polished surface reflects the faces of the living and superimposes them on the names of the dead, which forces a personal connection between the two. Relatives linger over the names of their loved ones, and place simple remembrances, such as flowers or flags.

AIDS Memorial Quilt, shown here in 1996 (figure 11.33), is a commemorative work with a personal and

public impact like the Vietnam Veterans Memorial. It is composed of thousands of individual 3' × 6' panels, approximately the size of a twin-bed blanket, which would cover the body of one person who died from AIDS. Each panel is submitted as a remembrance by friends or family, and is personalized, sometimes only with initials, but often more elaborately, with photographs, memorabilia, or details of a life story. The AIDS Memorial Quilt is not the product of a single artist. It is organized by a group called the Names Project in San Francisco, and most persons contributing quilt pieces have no art training. The format of a quilt is especially appropriate for this collaborative, grass-roots product of loving remembrance. After only a few years, the AIDS Memorial Quilt has become truly vast, and that size makes it a public spectacle. It also communicates the enormity of the epidemic and its toll in the United States alone. The quilt changes every time it has been displayed. The setting where it is shown contributes to the meaning. In figure 11.33, the quilt's proximity to the White House and governmental buildings means that the disease was recognized publicly as a crisis and a tragedy by the U.S. government. The quilt also changes because panels are always being added. Sometimes only a small section is exhibited in indoor galleries. When displayed in its entirety, it requires a large public space outdoors and is put up for a short amount of time, and then becomes a public performance.

The AIDS Memorial Quilt is a superb example of "outsider" art, that is, it is a unique artwork created by artists who have not been formally trained, and do not fit into any aesthetic tradition.

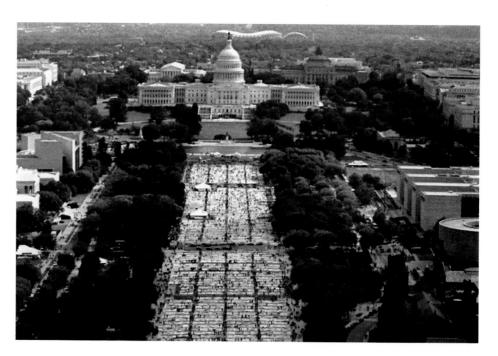

11.33 AIDS Memorial Quilt, displayed on the Mall in Washington DC, as seen on October 11, 1996. Organized by the Names Project, San Francisco. See also the text accompanying figure 20.9.

Text Link

The AIDS Memorial Quilt is representative of many new trends in art making, being a collaborative, performative work, created without traditional art materials. For more on other works like this, see Chapters 2 and 20.

SYNOPSIS

The living make tombs and commemorative art that express their ideas about death. Tombs and commemorative art reflect the values of the culture from which they come. Thus we saw ancient tombs oriented to the movements of celestial bodies, reflecting that spiritual, agricultural, and scientific concepts were intertwined. We saw that Day of the Dead celebrations not only remember the dead, but also reflect the Mexican family, community, and political scene. *Pêre LaChaise Cemetery* is the embodiment of what nineteenth-century Parisians considered romantic, exotic, and paradisaic.

Indeed, many commemorative monuments serve political and social purposes. The underground palace and tomb of Shi Huangdi was designed to establish the emperor's dynasty and his fame in his lifetime. The Mortuary Temple of Hatshepsut was a sign of her absolute power. The AIDS Memorial Quilt is both a commemorative work and a political event to bring public awareness to the epidemic. The Malagan rituals, which honor the dead, reaffirm clan ties, and stimulate the local economy.

Tombs reflect changing concepts about the afterlife. In cultures such as the Vikings or the Egyptians, wealthy and powerful persons built furnished, sealed tombs for themselves to function as permanent homes in the afterlife. In ancient Rome, Christian Europe, and other cultures, tombs contain bodies while spirits are believed to dwell elsewhere, in the heavens or in the underworld. Either kind of tomb serves as a commemorative monument, to preserve the memory of the deceased person.

Religion is closely tied into burial art and rituals, since humans use religion for understanding and mediating with the spiritual realm. For example, the religious and funerary functions of the Catacombs are inseparable. The *Reliquary Guardian Figure* from Gabon guards the bones of clan ancestors, and both sculpture and bones are powerful relics within that religion. Large tombs are usually funerary, religious, and political monuments, for example, the *Pyramids of Egypt*, the *Taj Mahal*, the *Henry VII Chapel*, and *Moche Pyramids*.

Urban and landscape design has influenced burials. Ancient Egypt and the Etruscan civilizations both established elaborate cities of the dead. In eighteenth- and nineteenth-century Europe, new ideas in city planning led to the development of the suburban cemetery. The location of the *Tomb of Mao Zedong* within the city plan of Beijing legitimizes the twentieth-century revolution and changes in Chinese government.

FOOD FOR THOUGHT

Birth and death are often linked in art. We saw the rising sun that shone into the tomb at *Newgrange*, the egg imagery in the Etruscan *Tomb of the Leopards*, and the continued living of the Egyptian soul in their tombs. We also saw the birth-death link in several works in Chapter 7, Reproduction.

- Are life and death linked in your experiences of death?
- If so, does imagery make that connection clear?
- How is death handled in the news media?
- Look at both the deaths of celebrities and the deaths of relatively anonymous persons. How are those deaths framed?
- Are they presented as inevitable, necessary, tragic, or natural?
- Could editors have presented them another way?
- We have seen a long history of humans elaborately burying their dead. Does this reflect only an underlying hope of afterlife, or does it in fact guarantee fame that is a form of life after death?
- Do human beings continue this practice in art and ritual in order to contend with their own mortality?

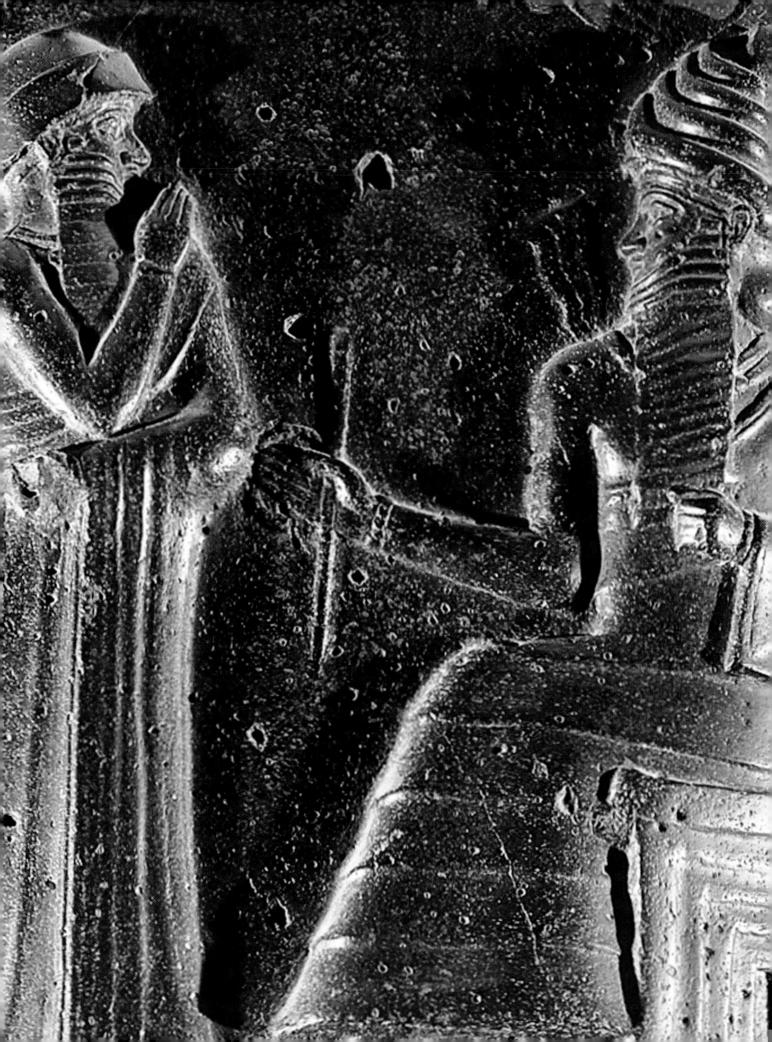

Section 3: The State

Rulers and governments understand well the power of art. They use it to celebrated and spread their earthly power. Art is also used in war, either for creating weapons and armor for it, or by making images that promote it. Art also gives us images of peacemaking and monuments for peace.

If art can be a powerful tool for the state, it can be an equally strong voice of protest. People who hold different values from their rulers use art to affirm their ideas, and to protest against warfare, social oppression or political policy.

*Chapter 12*Power, Politics, and Glory

Chapter 13 War and Peace

Chapter 14
Social Protest/
Affirmation

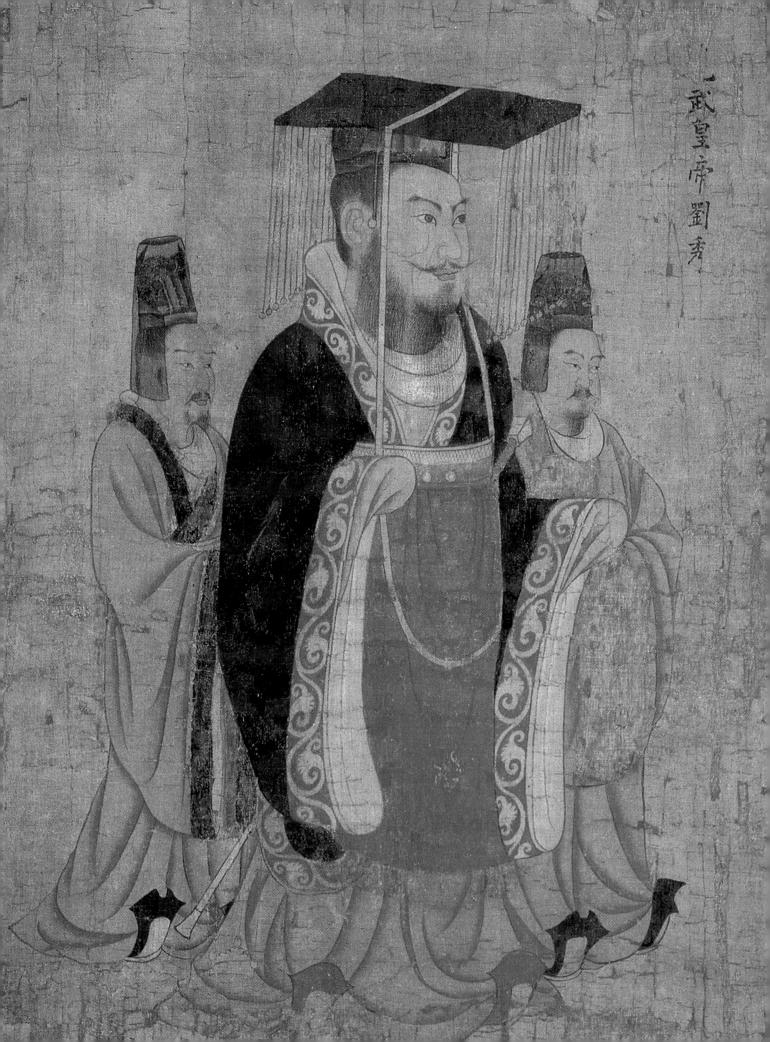

Chapter 12 Power, Politics, and Glory

INTRODUCTION

Throughout human history, a vast amount of artwork has been made in the service of rulers or governments. Art has glorified, empowered, popularized, and propagandized the state, as well as the heads of state. Such art is often intended to impress, overwhelm, and dominate its audiences, while aggrandizing or even deifying its subject matter. Think about the following questions while reading this chapter:

In the past, how has art glorified individual rulers?
How has architecture been used to represent the power and glory of a governmental state?
How has architecture been used by monarchies?
Do politics influence the design of architecture?
What role do monuments play in honoring the individual ruler and the state?

Is art essential for rulers and states to achieve glory and full power, and to accomplish their political agendas?

THE GLORY OF THE RULER

What kinds of imagery makes a ruler seem glorious? As we look at the art in this section, we will see that the following artistic devices are often used:

- the idealized image: the ruler's face or body, or both, would be depicted without flaw and often with youthful vigor; the idealized image often included a dignified demeanor;
- symbols: details would be included that indicate omnipotence, authority, or divine blessing;
- compositional devices: the ruler often occupies the center of a picture and may be shown larger relative to attendants, etc.; in addition the ruler's clothing is often brighter in color, with more pattern, to attract attention.

Divine Rulers and Royalty

We will begin our brief survey with portraits of rulers. Many heads of state through history considered themselves to be heaven-sent, or a member of a divine family. Images helped them to spread and communicate that idea.

An early example of a royal portrait is the Egyptian royal couple, *Menkaure and His Wife, Queen Khamerernebty* dated c. 2600 BC (figure 12.1). They stand in unison, placing the same foot forward. Both young, strong, and confident, they display the Egyptian ideal of beauty and maturity, as they proudly stand erect. The compact pose makes the sculpture more permanent, with few

12.1 Menkaure and His Wife, Queen Khamerernebty. Gizeh, Egypt. Dynasty IV, c. 2600 Bc. Slate, approximately 4'6.5" high. Museum of Fine Arts, Boston.

projecting parts that might be vulnerable to breakage. Images of the pharaoh were meant to be permanent, as befitting the descendants of the Sun God, Re. All pharaohs were believed to be sons of Re, and therefore divine themselves.

The sculpture was carved from a slate block, a very hard type of stone. The profile views of the figures were likely sketched on the sides, and the frontal view on the front and back, according to the Egyptian canon of proportions. The sculpture was then carved inward until all four views met. The figures separately emerge from the block of stone, yet remain as one unit through the queen's embracing gesture. The sculpture was evidently painted, as traces of paint were found on the piece.

Menkaure was the pharaoh who had built the third and smallest of the *Great Pyramids* at Gizeh (see figure 11.2). This shrine-like statue was found in Menkaure's valley temple, among many sculptures commissioned by the pharaoh to line the processional way to his pyramid. Note that Khamerernebty is shown as large as Menkaure, as pharaonic succession was traced through the female line.

Text Link

Look at another Egyptian portrait, the Seated Scribe (figure 16.15), to see how portraits of lesser officials were handled, as compared to rulers.

When rulers were considered divine, their portraits were handled with great care. The dynastic emperors of China were believed to be the Sons of Heaven. They ruled by "mandate from Heaven" as far back as the ancient Shang Dynasty of c. 1700–1100 BC. The Sons of Heaven were responsible for obedience to the divine moral law. The "Li" (the way), the principle of the natural order of things, would guide the emperor as the father of his people. His moral and political life were considered an entity, both being balanced together in harmony. This balance would give him the wisdom to prevail in maintaining Heaven on Earth.

The Chinese emperors took their celestial power seriously, and lived the part in pomp and elegance. These qualities can be seen in *Portraits of the Emperors*, painted by Yan Liben in the seventh century (figure 12.2). Yan Liben was a highly recognized painter during the Tang Dynasty. He and his successor painted the *Portraits* in ink and colors on a silk scroll. There were thirteen emperors depicted on the scroll from the Han Dynasty (200 BC) to the last of the Sui Dynasty.

While the thirteen emperors appear in a continuous format, visually they relate neither to one another nor to the background. Instead each is isolated, so that we can focus on his grandeur, elegance, power, and personal wisdom derived from Confucius. The ruler in our detail is likely Emperor Wu of the Northern Zhou. His elegant

robe appears to be silk brocade decorated with dragon figures. The dragon was the symbol of fertility and vigor. It became the emblem of the emperor in 200 BC, and has remained throughout the dynasties thereafter. The drapery and folds of the garment hang gracefully on his solid figure, giving a sense of power and stability. He is attended on each side by his officials who are smaller in stature, indicating their lower place in the hierarchy.

Yan Liben was a master at rendering volume through line. With very little shading, the emperor's figure has substance and weight. While the figures on the scroll are relatively small, the artists' consistent treatment, with a strong flowing line, maintains the monumentality of each individual. The idealized *Portraits of the Emperors* recorded the importance and self-assurance of the Sons of Heaven.

Another imperial portrait is Emperor Justinian and His Attendants, from the Church of San Vitale in Ravenna, Italy, built in the sixth century (figure 12.3). Justinian was a famous and powerful ruler of the Byzantine Empire, which was an outgrowth of the old Roman Empire. In this image, Justinian is located in the center and dominates the focus of the viewer, just as he dominated his empire. His reign was known as the "Golden Age of Justinian." In addition to being an able political leader, Justinian was a devout Christian, and so his portrait indicates his power base by framing him firmly between figures of the church at right, and of the military and state to the left. Facing the viewers stiffly and with little expression, the figures seem to be part of a solemn offertory procession, part of the Christian Eucharistic rite when bread and wine is brought forward. Justinian is holding a golden bowl that might contain the bread.

To convey the idea of a priest-king, Justinian wears garments and vestments symbolizing himself as secular and sacred ruler. As the head of state he is wearing a purple cloak and a magnificent jeweled crown. As head of the church he carries the golden bowl containing the bread that will be transformed into the body of Christ. To add to his sanctity there is a solar disk or a halo behind his head, a visual devise used in Egyptian, Persian, and late Roman art to indicate a divine status. The emperor is flanked by twelve figures, alluding to Christ and the twelve apostles. The clergy at right hold objects sacred to the Christian faith: the crucifix, the book of Gospels, and the incense burner. Given the sacred nature of the image, even the soldiers are marked with holy symbols: the shield at left displays an ancient symbol of Christ.

A similar mosaic, *Empress Theodora and Her Attendants*, faces the Justinian mosaic in the sanctuary of the Church of San Vitale. Theodora, Justinian's wife, was an able and effective co-ruler, and her image indicates her equal rank and power. In her mosaic, Theodora also wears a crown and halo, and she carries the wine to be used in the Eucharistic rite.

12.2 YAN LIBEN. Portraits of the Emperors (detail), China, seventh century, ink and colors on silk, 17.5" high. Museum of Fine Arts, Boston.

Interestingly, both the Chinese scroll by Yan Liben and the *Justinian-Theodora* mosaics depict divine right emperors, and their treatment of the figures are similar in their strong use of line and subtle shading. However while Yan Liben's figures are solid and fixed in their pictorial space, the figures of Justinian and Theodora and their entourage seem to floating in a celestial space. The mosaics present a new interpretation of the human form that differs from the earlier imperial Roman art. The figures have become elongated with very small feet, and their faces have been stylized into an almond shape pierced with oversized eyes. This style would continue to influence the early years of Christian art.

Let us turn to an example in which the head alone carries the exalted qualities of a ruler. In west-central Africa, several superb portrait heads were made in the twelfth to fifteenth centuries, each very much like the *Crowned Head of an Oni* (figure 12.4). They were rediscovered in 1938 at the Wunmonije Compound, from the ancient site of Ile Ife, the place where the world began, according to the Yoruba people of present day Nigeria.

The delicately detailed portrait is in a naturalistic style that contrasts with more abstracted art from much of Africa. The face has a remarkable sense of calm and serenity, with beautiful flowing features, making it an outstanding example of an idealized royal portrait.

Text Link

To see the range of styles in African art, contrast the naturalistic quality of the Crowned Head of an Oni with the more abstracted style of the Reliquary Guardian Figure (figure 11.24).

Scholars still debate the exact identity and use of these portrait heads, but many believe each head represents an "oni," a Yoruba or Benin ruler, who traces his rule back to the mythic first human ancestor, Odudua, who created the world. The crown on the head of the oni was likely a royal insignia. The lines on the face may

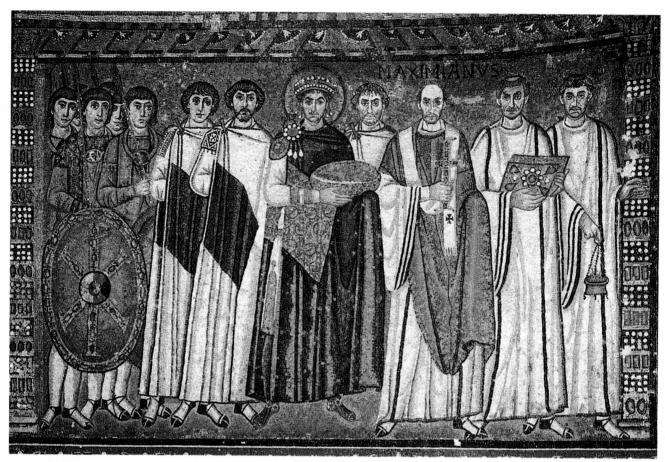

12.3 Emperor Justinian and His Attendents. Ravenna, Italy, Church of San Vitale, c. 547, mosaic on the north wall of the apse.

indicate scarification, or perhaps strings of a beaded veil. Also visible are neck rings that are similar to those worn today among the Yoruba.

$Text\ Link$

Yoruba leaders today are identified by headgear such as the Great Beaded Crown of the Orangun-Ila, in figure 16.19. These contemporary crowns are ancient forms that may date back to those worn by the early onis.

The making of this portrait required considerable skill, with highly sophisticated mold-making and metallurgy (see Chapter 2 for a description of the lost wax process) along with highly developed sculpting skills to create an image with such naturalism. These skills also set the work apart as fitting for royalty. When these oni portraits were first discovered, renowned scholars did not believe the art to be African. They believed that only the Greeks would be capable of such work, and contrived a theory that the source was a hypothetical ancient Mediterranean colony located off the coast of Africa, such as Atlantis. Many colleagues agreed. Much

later, African art scholar Frank Willett overturned the racial bias of his predecessors, showing that the sculptures were indeed of African origin and were related to the art of the earlier nearby Nok culture in southern Nigeria.

We could look at many other royal portraits from various cultures, and see repeatedly how similar attributes convey an exalted quality: the idealized face/body, the symbolic details, or the centralized composition.

Objects of Royalty and Prestige

Royalty have always availed themselves of exquisite objects of power, and have adorned themselves in elaborate garments and dazzling jewelry. We have already discussed crowned rulers and royal robes of the richest and rarest materials. If crowns and robes are lacking, some other object usually proclaims the ruler's exalted status.

In figure 12.5 we see an illumination from the Gospel Book of Otto III entitled Otto III Enthroned Receiving the Homage of Four Parts of the Empire, dating from 997–1000. Otto III was an ambitious ruler who wanted to recreate the glory of Charlemagne's Christian Roman Empire, and unite the eastern and western worlds. This illumination is filled with details that indicate Otto's royal status. Sitting on a throne, attired in a gold trimmed tunic and

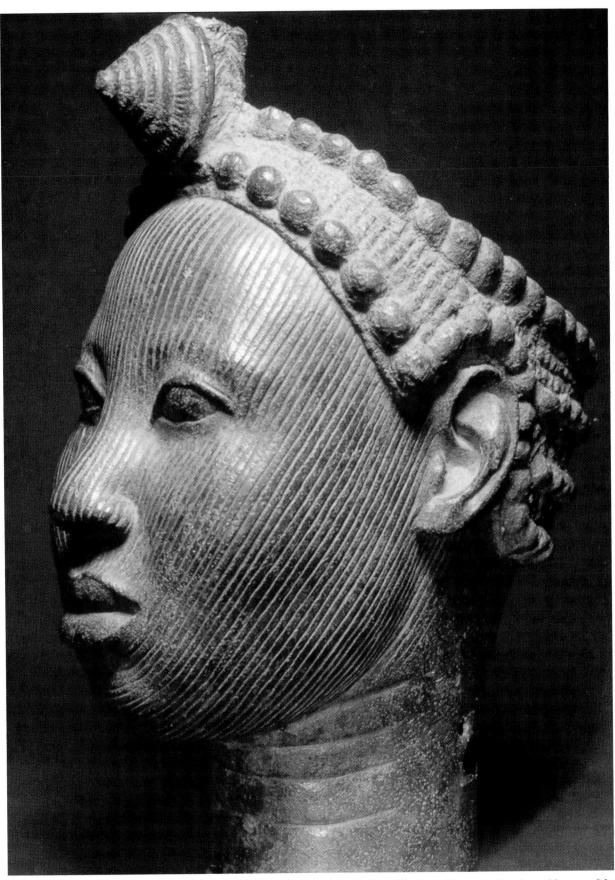

12.4 Crowned Head of an Oni. Nigeria, Wunmonije Compound, Ife, Yorurba culture, twelfth–fifteenth century. Zinc, brass. Museum of the Ife Antiquities, Ife, Nigeria.

what appears to be a green velvet cloak, the emperor holds a royal scepter and a cross-inscribed orb, symbolizing his authority over his realm. These objects were jewel-encrusted in silver or gold. The bird atop the scepter suggests the guidance and blessing of the Holy Spirit as Otto rules his Christian world, represented in the orb. These objects—scepter, robe, and orb—very likely existed and were used by Otto himself.

Otto III Receiving the Homage of the Four Parts of the Empire bears some similarities to Emperor Justinian and His Attendants. In both, similarly elongated figures filled the pictorial space in a shallow setting. However there are significant differences. While the figure of Justinian is the same size as his flanking figures representing the church and state, Otto III is larger and enthroned, with his flanking figures slightly turned and gazing at him instead of facing outward, as in the Justinian figures. We know by the position of the feet that Justinian is standing in front of the rest. But Justinian's authority has been visually represented as an equal to that of the church, while Otto, depicted by his size and emphasis as king, clearly has the highest rank in the hierarchy. Somewhat like the earlier mosaic, the illumination's linear rendering of Otto's face, hands, and drapery economically describe the subject matter.

However unlike the classic realism of the "antique" Greek and Roman style of art before, Ottonian art is becoming less naturalistic and more symbolic to convey

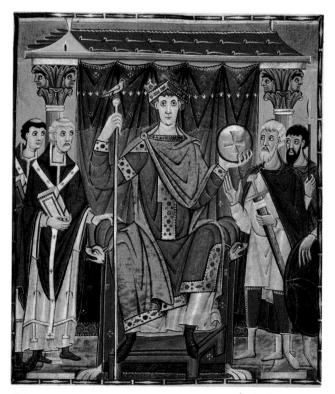

12.5 Otto III Enthroned Receiving the Homage of Four Parts of the Empire. From the Gospel Book of Otto III, illumination, $14" \times 10"$. 997–1000, European. See also the text accompanying figure 2.37.

its intended meaning. For example, the illumination of Otto III is not a natural portrait of the emperor, but rather an expression of his royal power. This abstraction in style would continue in Western medieval art as it served to educate and nurture the illiterate of the Christian religion. Richly painted in saturated color and highly detailed in black lines and gold leaf, illuminations such as *Otto III* have exquisitely illustrated the early Christian gospels, and have become visual treasures as well as objects of a priceless and lost art form.

Otto himself died at age 22, and was buried next to Charlemagne. After Otto III, petty princes in Western Europe rose up and established their own domains, and the nations of Western Europe began to form. One might speculate that Otto III's illumination represented the last of the old unified Western world and beginning of the new.

Like Otto III, two princes of the Incan dynasty in South America aspired to rule a great empire, and were outfitted in regalia appropriate to their rule. In our watercolor portraits, *Royal Incan Brothers, Huascar and Atahualpa* (figure 12.6a and 12.6b) from the sixteenth century, amateur artists have captured a glimpse of the elegance of these royal brothers. Both carry royal objects and are crowned with a similar headpiece, an indication of their claims to the same throne. Richly decorated clothing drapes their bodies. The rulers of the Incan Empire, known as the Sapa Inca, were believed to be the sons of the Sun-God Inti. It is chronicled that servants would tremble and quake in the ruler's presence, especially Atahaulpa's. They were indeed revered and feared as the sons of the sun.

The divine Inca ruler had many wives and concubines, and so there were many male heirs to the throne. The choice of heir was made by the father, who chose whom he thought was the most fit to rule rather than by the oldest in succession. While this system worked in earlier times, it aided in the tragic demise of the powerful Incan Empire. Huayna Capac chose Atahaulpa as his successor while some Inca nobles preferred his brother Huascar. Civil war broke out, weakening the nation and making it vulnerable to conquest. In 1527, Francisco Pizarro and two hundred Spanish soldiers captured Atahualpa and took over his army of 8,000 men. Huascar was imprisoned by his enemies and soon fell to the opposition. War, political anarchy, plunder, poverty, and diseases such as smallpox all contributed to the further decimation of the empire.

Royal objects were art forms in their own right and were appreciated as such on or off the royal subject. Like European royalty, Hawaiian royalty required impressive regalia, but they had a distinctive characteristic. Hawaiian royal objects were made of materials that were taboo to all others in the society, unlike the gold and gems found in a European crown, which any wealthy individual could possess. No one except royalty could

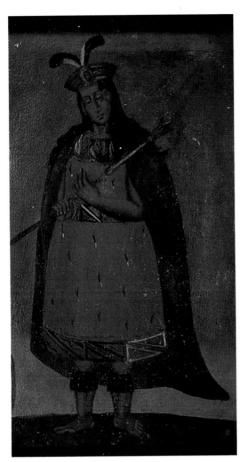

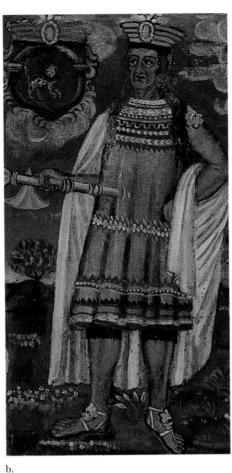

12.6 Royal Inean Brothers, Huascar (left) and Atahualpa (right). Spain, sixteenth century, Spanish album, watercolor, Musee de l'Homme, Thomas Gilcrease Institute of American History of Art, Tulsa.

a.

own or wear objects made of royal material, which in this case were the beautiful and sometimes rare feathers of Hawaii's indigenous birds, sea birds, and domestic fowl. Feathers were considered sacred and connected with the gods. Another interesting feature of Hawaiian royal objects is that they may originate from common items, but were transformed into luxury items, sometimes losing their functional appearance completely. This can be seen in the *Royal Kahili* (figure 12.7), from the eighteenth century, which basically were elaborate fly whisks.

The kahili was replete with mystery and hidden meaning, to which only its owner was privy. These royal feathered objects were signs of a maternal genealogy that joined new rulers with their previous rulers and divine ancestors. Held only by royal males, they marked the royal presence in houses, served as protective agents, and were carried in processions and state ceremonies. Averaging 10 feet tall and towering high above the men and boys who held them, the kahilis were displayed in splendid array, especially during funerals. Some were given names and all were regarded with awesome respect. Our example features the large black and green feathers of the frigate bird, which symbolized fearsomeness, set off against the more delicate red and gold feathers and trimmed with bowed ribbons.

Text Link
See Moctezuma's Headdress in figure 13.34 to

See Moctezuma's Headdress in figure 13.34 to compare Hawaiian and Aztec featherwork.

While the kahili may be a relatively unique royal object, the throne in various forms seems almost universal. The twentieth-century *Royal Stool* (figure 12.8) is from the Akan Asante people of Ghana. This stoolthrone was linked in the Asante cosmology to the original "golden stool," which had been sent from the sky with the nation's soul embodied in it. Its condition and survival were essential. If the stool were damaged, so would be the soul of the people, for they were inseparable. Thus the stool became an important part of the royal regalia to the Asantehene (chief). It also became a cult object. All chiefs would have their own stool made for them upon their inauguration. Some would also pass their stool-thrones on to their successors.

Our example is a delicately carved wooden stool trimmed in hammered silver, made for a queen mother. A delicately curved seat is supported by a pierced cylinder and two rings. The rings are decorated in a zigzagged silver strip and fringed on the outer rims with pierced scalloping. The base has triangular geometric

12.7 *Royal Kahili*. Feather work. Eighteenth century. Bishop Museum, Honolulu, Oahu, Hawaii.

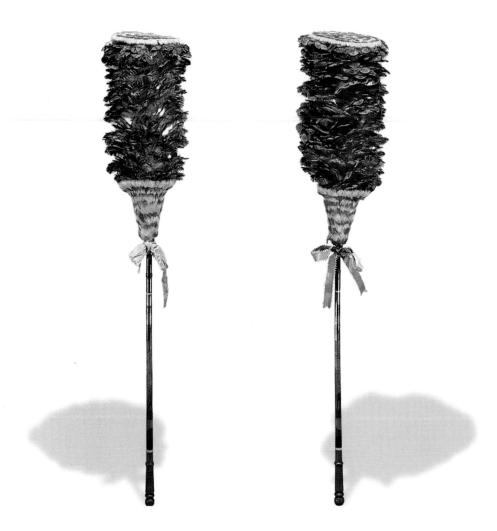

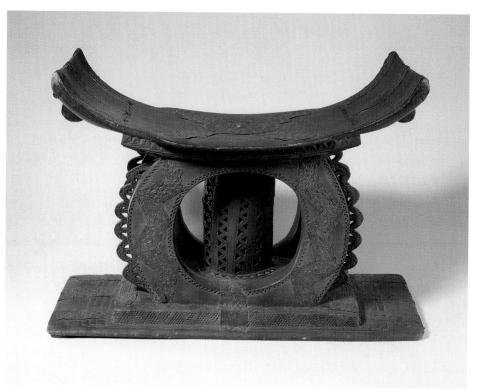

12.8 *Royal Stool.* Wood with hammered silver, 16" high. Akan, Ghana, twentieth century.

patterns. A cross intersects a circular shape on the center of the seat. One can see that great care was taken in the creation of this prized and prestigious object for a royal member of the Asante people. Some Asante stools were also made for common individuals, but they were much more modest than the one we have just seen.

Objects of prestige, therefore, are not necessarily limited to royalty. Among the Mesquakie people around Tama, Iowa, in the mid-1800s, grizzly bear claws were signs of high status, just as diamonds and pearls might be of value in other cultures. The bear was an awesome and formidable animal to hunt. The prairie grizzly's long nails—over 3 inches in length—were rare and difficult to acquire. Bear claws were considered a great trophy. Made into the impressive *Mesquakie Bearclaw Necklace* (figure 12.9), the claws represented the strength and tenacity of the creature, which added to the dignity of the owner as he wore it.

Our necklace contains long claws, otter pelts, glass beads, and silk ribbon. The unassembled materials would be given to the designated persons who owned the rights to create the neck piece. The beautifully curved claws are alternated with colored glass beads around the fur collar. This creates a striking repetition of delicate curves while visually suggesting the lethal potential of each claw. The pelt of the otter is decorated in beads and attached to the necklace to become an elegant train. Those who were adorned with such a fine work had to have been looked upon with great respect and esteem, and perhaps a bit of envy as well.

As we have seen, there is no specific object or material that universally denotes high status. Royal objects range from jeweled orbs, colorful robes, feathered fly whisks to bearclaw necklaces, and each through their royal use denotes prestige within their culture.

Contemporary Political Leaders

Images of contemporary political leaders are fundamentally different from those of the past, just as the concept of ruler has evolved. Today almost no rulers openly consider themselves to be of divine descent, although some are believed to be sent by a god. And photography has changed the way the images of rulers are delivered to us. Rather than coming as works of art, they often bombard us in our homes on the evening news or the newspaper's front page. And there is a great difference between the images that are produced under the ruler's control, versus those over which the ruler had little or no control.

Our first example is the *Princess Ka'iulani* (figure 12.10), in the last photo portrait taken of her in the late 1800s shortly before she died at age 23. The daughter of a Scotsman and native Hawaiian mother, she was the heir to the defunct Hawaiian throne, as the monarchy had been overthrown. As a sign of her royalty, she wears around her neck a highly treasured feathered lei to show her royal lineage back to the ancestral deities. (A vestige

12.9 Mesquakie Bearclaw Necklace. Otter pelt, grizzly claws, glass beads, silk ribbon, $164^{\prime\prime}$ long, $144^{\prime\prime}$ wide, $34^{\prime\prime}$ high. Tama, Iowa, USA, c. 1860. See also the text accompanying figure 2.38.

12.10 *Princess Ka'iulani*. Hawaii, Photograph, c. 1898. Bishop Museum, Hawaii.

of the royal Hawaiian lei remains in the flower and paper leis that are given today in welcome to tourists as they arrive on the warm breezy shores of the islands.) Otherwise, the princess is wearing the attire prescribed by the Christian missionary colonizers who dominated the islands. The photograph that captures her likeness is a Western invention, and in Western hands her image becomes pensive and almost melancholy, perhaps to suggest the loss of her glorious ancestral culture that would never be recovered. Her dark eyes, demure expression, and feminine beauty became an image of the exotic, which was one of the various ways that Western nations envisioned their colonized subjects.

A very different kind of ruler image comes to us in the film *Triumph of the Will* (figure 12.11), commissioned by Adolf Hitler in 1934, and directed by Leni Riefenstahl. The purpose of *Triumph of the Will* was to glorify the Führer, his military strength, and the Nazi order of Aryan supremacy. A work of brilliant propaganda, in essence Reifenstahl created in Hitler the first media hero of the modern age.

Given unlimited funding by Hitler, Riefenstahl had a staff and crew of over 130 people that included a police force and several private chauffeurs. She had built special ramps, platforms, bridges, and towers to get the effective shots she wanted with her sixteen cameras. She

utilized cranes and dollies to get dramatic angles, as well as mounting cameras on cars and trucks to get action shots. She created unique shots that would be integrated with scenes of dramatic speeches, ceremonies, and parades. Four sound trucks recorded the crowd's cheers along with the voices of troops singing while marching to drums and bugles. These sound tracks, plus additional layers of voice-overs and the music of the popular German composer Richard Wagner, were skillfully edited into the film.

Triumph of the Will documented a six-day rally celebrating Hitler at Nuremberg. The film was intended as a documentary, with the camera capturing an "eyewitness" image, in all its apparent honesty and truth. But in Triumph of the Will, the imagery was entirely staged. Of course, all photographic content is manipulated to some extent at the time the picture is taken. We saw that even with the portrait of Princess Ka'iulani. Photographs can be further manipulated when retouched. The same thing happens to film when edited. Photographic media can express anything the talented and skillful artist wants, no matter how false the illusion is compared to reality. In this case, Reifenstahl carefully set the scene so that Hitler is presented to and worshipped by the masses as Germany's savior.

The movie opens with a lovely sequence high up in the sky among luminous, billowing, cumulus clouds. It cuts to scenes of happy, busy youth, exercising and washing in preparation for some grand event. The musical score is rich and melodic. Once Hitler's plane arrives, he is met by a host of dignitaries and saluting crowds. There is a close-up of Hitler's smiling face as he is formally greeted; his charisma is evident. Finally, we see an impressive aerial shot of an enormous, troop-filled field, with flags, an elevated podium and monuments (figure 12.11). Here Riefenstahl brilliantly climaxes the powerful order and "will" of Hitler. A mass of military power in absolute formation is under Hitler's total control. This visual utopia of harmony and strength would appeal to those whose lives were in disorder, and human history would experience one of its most tragic and horrendous episodes. One can only speculate how much of an impact this film had on the people who were to go to war for him and turn their heads away from the impending holocaust.

One can also wonder about the motivation of Leni Riefenstahl. Perhaps she was a devout believer in the dogma of Hitler and his party, or perhaps she was seduced by the opportunity to work in a new art medium with unlimited funds at her disposal (an artist's dream indeed!). She says of her patron: "That the Führer has raised film-making to a position of such pre-eminence testifies to his prophetic awareness of the unrealized suggestive power of this art form" (Nagle 1993: 114, Riefenstahl in Barnow, 103).

Whatever the case, Riefenstahl created a prototype in film that would impact commercial campaigns for political elections, as well as lay the foundation for market advertising. Film as well as television are now the vehicles for commercialism and propaganda. Today they are even more fluid, as computer technology can change or enhance any of their images.

THE POWER OF THE STATE

Now we will look at palaces, government buildings, and monuments, to see how architecture can contribute to the power and glory of the state and the ruler.

Palaces

Some of the most incredibly ambitious building complexes have been designed to house those who have been divinely bestowed with the power to govern. Palaces are official residences of kings, emperor, and high-ranking religious leaders. In our brief survey here, we will look at five palace complexes from very different times and places. Interestingly, we will find some similarities among all of them:

- They all are marked from ordinary residences by their grand size. They are usually lavishly ornamented.
- Height is very often an important element.
- Art is featured prominently throughout palaces, to add to their importance.

Obviously, one main function of a palace as a royal residence is to augment the glory of the individual ruler. But palaces really belong to the state in several important ways. A palace is the visual representation of the power of the state. Often the government is administered in the palace, in audience rooms and executive chambers. Palaces usually represent a dynasty of kings rather than an individual ruler, since most palaces are used by several successive rulers.

An outstanding early example of a palace comes from the Achaemenid civilization in ancient Persia, the largest in the Near Eastern world. Cyrus, whose blood line supposedly goes back to the ancient mythical King Achaemenes, was the father of the Achaemenid dynasty. It lasted for two centuries, until conquered by Alexander the Great. The Achaemenid emperors were known to rule humanely, practicing justice and tolerance.

Text Link
The mosaic Alexander and Darius at
the Battle of Isus depicts the final defeat
of the Persians by the Macedonians. See
figure 13.20.

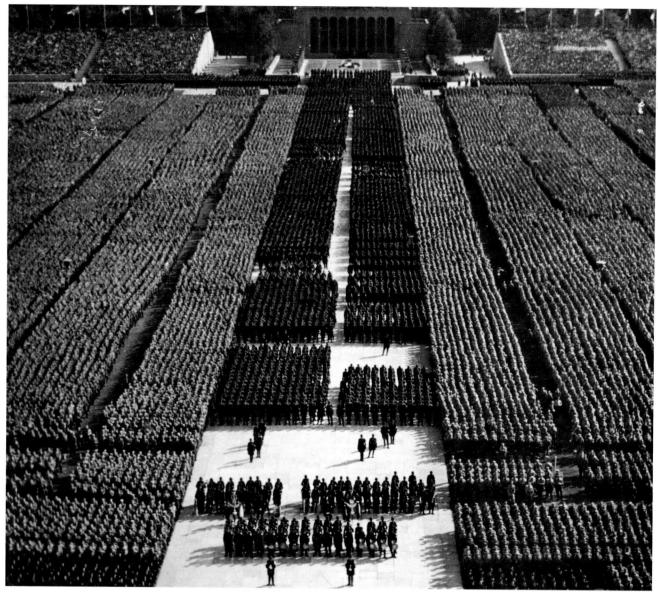

12.11 Scenes from Triumph of the Will, film directed by Leni Riefenstahl, 1934, Germany.

The Achaemenids produced a body of monumental art whose splendor was difficult to match. Impressive evidence of their fine art was found in the remains of the palace of Persepolis, begun by Darius I in 518 BC and destroyed by Alexander in 331 BC. It took 50 years to build. The heavily fortified palace citadel was located on a terraced platform measuring $1,500' \times 900'$, with mud walls that reached 60' high. There were a great number of rooms that included a grand audience hall, a throne room, and royal apartments. Most of the grand rooms and apartments were hypostyle halls, which were interior spaces where the roof is supported by columns. The windows were made of solid blocks of stone with cut-out openings. Stairs were also chiseled from stone blocks and then fitted into place. You can see examples of the columns, windows, and staircases in figure 12.12.

One of the most impressive halls at Persepolis was the Royal Audience Hall and its grand staircase (figure 12.12). The large space was 200 feet square, 60 feet high, and may have held up to 10,000 people. At the corners of the Audience Hall were four towers that contained guardrooms and stairs. On three sides of the structure were porticos. The walls of the grand staircase, cut directly from natural rock formations, were covered with reliefs depicting a procession of subjects presenting their tribute to the king, visible in the lower part of figure 12.12.

But it is the grand use of columns that makes Achaemenid architecture so unique. The columns were fluted drums of unequal heights. Their bases flared out a bit while the whole column was relatively slender. Crowning the top were elaborate capitals with curving scrolls and foreparts of bulls or lions. Some had human heads. These grand capitals supported the massive wood

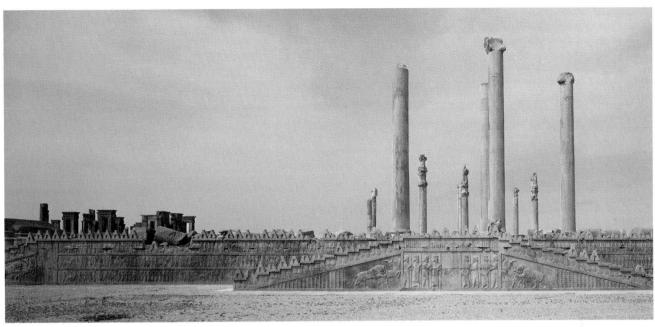

12.12 Royal Audience Hall and Stairway. Persepolis, Darius I, Persia (Iran), c. 500 BC.

beams of the ceiling. The *Throne Room* (figure 12.13) had 100 of these extraordinary columns. In our artist's rendition we can see the columns not only served a physical function, but they were monumental and beautiful as well. The forest of columns, tiled floor, and decorated beam ceiling must have made an unforgettable visual display. To the north side of this structure was a sixteen-pillared portico, with two huge guardian bull figures built into its towers. The heavy doors to the only entrance of the Throne Room contained reliefs of the king in battle with monsters, as well as him sitting on his throne. The royal treasury may have been on exhibition here while the king held court.

The art at Persepolis is eclectic, with Mesopotamian, Egyptian, and Greek elements. The overall design of the complex is Mesopotamian, with its artificial terraces, walls of mud brick that were sometimes ornamented with carved stone slabs and glazed brick panels, and the classic gates with their stalwart human/animal guardians (see a similar creature in the *Lamassu*, figure 12.26). Egyptian influence can be seen in the sculptures and reliefs. Ionic (Greek) elements are evident in the base of the columns as well as in the slightly softened figures which were usually stiffly carved in Mesopotamian reliefs. These various influences come together to create an art that is dynamic and visually striking.

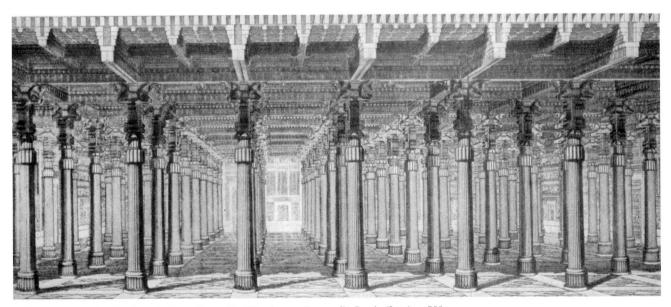

12.13 Reconstruction drawing of *Throne Room* with 100 columns. Persepolis, Persia (Iran), c. 500 BC.

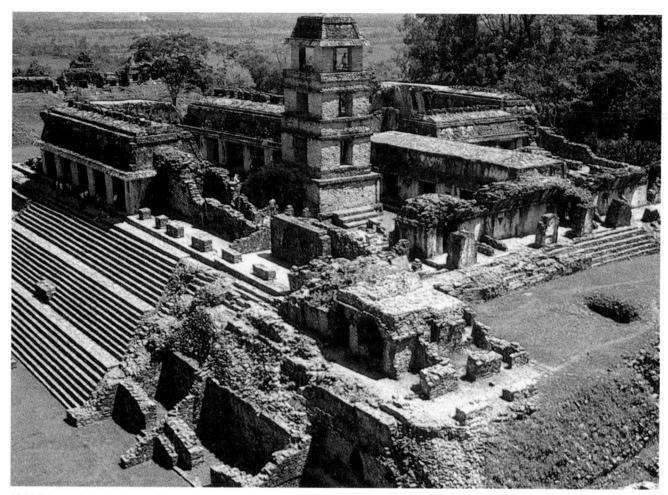

12.14 Palace at Palenque. Mayan, Chiapas, Mexico, AD 514-784.

Like the Persians, the Mayans of Central America used high platforms, relief sculpture, and large buildings to create palace structures. The Mayan culture at Palenque is dated c. 514 to 784 AD. Located deep in a rain forest, but abandoned before the Spanish conquest, Palenque remained unscathed but was completely overgrown by tropical flora until rediscovered in modern times. From the imagery on the reliefs and plaques, we can presume that Palenque likely not only had the living quarters for the Mayan royalty, but more importantly served as a center for religious rites, astronomical studies, and an administrative precinct. The center of Palenque itself probably held dominion over other Mayan cities, as its art and architecture relate its superior achievements.

Palenque prospered most under the outstanding King Pacal, who ruled for 68 years, beginning at age twelve in 615. Under his mandate, a great part of the *Palace at Palenque* (figure 12.14) was built. After his death, his son King Kan-Xul continued to enlarge the edifice and added the unique tower. He also beautified the buildings with brightly painted stucco reliefs and

stone carvings. Large painted stucco masks of human faces once adorned the ends of the terraces. The palace's design has four courts, each surrounded with rooms and galleries, likely used for administrative purposes. A number of thrones were found within the galleries. Built on a 30' high platform, it measures 250' long and 200' wide. A nearby vaulted underground aqueduct brought water to the *Palace*.

Height is important in creating the *Palace's* imposing impression. The tower on the southwestern corner adds verticality to the overall horizontal building. From the solid basement, the tower is 72' high and has three stories with three bays, all connected with inner staircases. There are large windows that open to the four cardinal points, which suggests its astronomical use as well as serving as an advantageous watch tower.

The palace interior was covered by parallel rows of corbel arches and vaults. This allowed for thin walls and large airy rooms that made life comfortable in the fierce heat and humidity of the tropics. The outer walls were pierced with T-shaped windows and doorways. The palace was profusely decorated, as were most of the

structures at Palenque. Besides the reliefs on the walls and piers, other important buildings were crowned with a classical Mayan art form called a "roof comb," a decorative wall rising high above the roof. These roof combs were intricately carved and brightly painted. The city gleamed with them, certainly a dazzling sight to the visitor.

One example of a typical relief found at the palace, and all through the city as well, is a pier carved in Classic Mayan style. Made of stucco and polychromed, the *Mayan Relief* (figure 12.15) shows figures holding a serpent, a symbol of their strength and authority. Subject matter found in the many reliefs ranged from celebrations of the installation of rulers, to Mayan lords pre-

senting symbols of their authority and rank. The Mayan artists' style was noted for its naturalism in their figurative renderings, with an emphasis on intricate detail. Emerging from a flat background, the busy scenes would have jumped out in profuse color. Interestingly, certain colors were used exclusively on selected subjects, for example the skin of humans was always painted red while the skin of a god was rendered in blue. The result most certainly impressed and awed the viewer.

We again see platforms and sculpture, this time in Chinese royal architecture. As mentioned at the beginning of this chapter, the emperors were "Sons of Heaven," fathers of the people, and responsible for maintaining Heaven on Earth. To assist them in

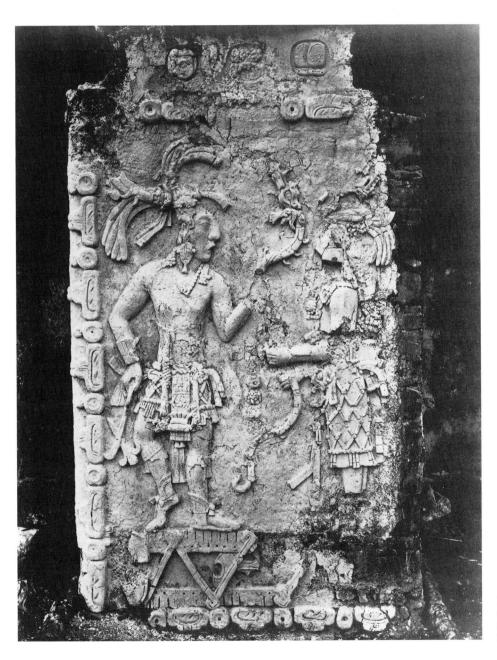

12.15 Mayan Relief decorating a pier on the Palace at Palenque. Classic style, stucco, figures are holding a serpent.

maintaining this awesome role, grand and sometimes overbearing structures have been erected, as part of each emperor's rich and sometimes brutal legacy. The rulers of the Ming and Qing Dynasties were exceptionally ambitious builders. The Ming emperors were responsible for the concept and early construction of the lofty and mysterious Forbidden City, a palace compound so enormous that it resembles a city unto itself, nestled within the capital city of Beijing.

Text Link

Other Chinese examples of ambitious royal building projects are the Soldiers from Pit 1 (figure 11.9) from the tomb of Qin emperor Shi Huangdi in Chapter 11, and the Great Wall of China (figure 13.16).

The main buildings of the complex were built during Emperor Yongle's reign in the early fifteenth century, and more would continue to be added through the years, especially in the eighteenth century under Emperor Qianlong. Twenty-four emperors ruled from this palace (the last being overthrown with the Revolution of 1911). The major structures of the Forbidden City have brilliantly decorated ceilings and walls painted a rich vermilion. They are roofed in gleaming yellow tiles, and are connected by pure white marble staircases and terraces, one courtyard after another. Along with the imperial buildings were mansions of princes and dignitaries, lush gardens, artificial lakes, theaters, and a library.

The overall complex was planned symmetrically, with a maze of courtyards and one-story buildings to maintain perfect balance and harmony. The design of the Forbidden City is a tangible expression of Daoist and Confucist values, as the Chinese chose an architectural style that would harmonize with nature rather than dominate it. The major axis of the city is north-south, with most structures facing south, as the South is the source of fruitfulness, while the North is the source of evil influences. Along with the various philosophies, numerology also had a part in the city's design. Odd numbers, especially the number nine, were particularly important, and it is said that the complex at one time had 9,999 rooms.

The Forbidden City's largest and most magnificent building is the *Hall of Supreme Harmony* (figure 12.16) a throne hall where the Sons of Heaven once sat and received petitions or conducted semi-sacred royal ceremonies. The $200' \times 100'$ hall sits high on a white marble, terraced platform at the end of an imposing courtyard enclosing a vast space. The roof is a double-hipped in

the classic Ming style. In Chinese architecture, high platforms and complex roof shapes signified buildings of great importance, and we see both features here. In addition, elaborate adornment both inside and out indicates importance. The *Imperial Throne Room* (figure 12.17) is one example of the inside decorative scheme. The high ceiling is covered with elaborate patterns subdivided by grids. The focus of the room, the throne, is framed by columns and elevated on a stepped platform.

In this huge overwhelming palace, all royal ceremonies and official activities of the state were conducted by an elite few. No commoner was allowed to enter. While the complex represented the absolute and divine power of the emperor, it also unfortunately resulted in the emperor's isolation from the people of his realm and his dependence upon his attending court. A sense of confinement and loneliness is still present within its walls. Today the Forbidden City is a museum, with flocks of tourists including, ironically, China's common citizens who are now free to roam its streets that were once forbidden to them.

A palace could be both a sign of power and an instrument for maintaining that power, as we will see in the case of *Versailles*, the palace built by King Louis XIV of France. This egotistical eccentric felt he was a divine presence on earth, and in being so, assumed absolute power over church and state in the course of his 72-year reign during the seventeenth century. He identified himself with Apollo, the sun god, and had operas written and fetes staged to celebrate this deity. Louis himself would be the star of these spectacles as the "Roi Soleil," the Sun King. The image of Apollo become his royal insignia.

Louis XIV dominated all of France, including the Church, nobility, and peasants, by controlling taxes, systematically centralizing the government, and imposing a strict hierarchy within it. At the top of the hierarchy, of course, was Louis himself, who said, "I am the State." With this vise-like control, Louis could satisfy his every whim no matter what the cost. Just as he controlled the state, Louis XIV controlled the arts, from the fine arts down to the latest fashion, to the proper manners and protocol he expected at his court. He became a great collector and patron of art, but he also controlled art standards and subject matter. He established the French Royal Academy of Painting and Sculpture which would assure him of a steady supply of works that would glorify his person and reign. He established academies in several other disciplines as well.

Text Link

For more on the French Royal Academy, see Chapter 20, Who Makes Art?

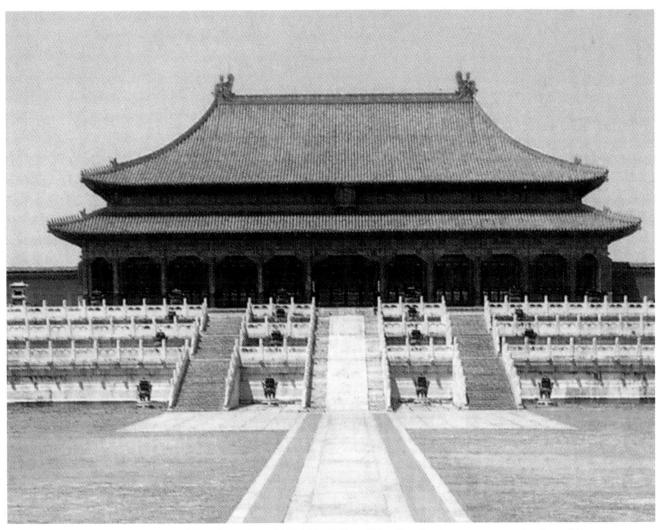

12.16 Hall of Supreme Harmony. Ming and Qing Dynasties, c. 1400–1911. Beijing, China. See also the text accompanying figure 3.7.

Louis XIV moved his entire court from the Louvre palace in Paris to the palace complex of Versailles (figure 12.18) in 1682. This huge compound became Louis' theater where he supremely ruled his domain, and played out his fantasies to the audience of nobility, who were forced to attend, much like inmates. Originally Louis' grandfather's hunting lodge, Versailles was extensively enlarged and remodeled, with several architects and artists working on it under the direction of Charles Le Brun, who was also the head autocrat of the Royal Academy of Painting and Sculpture. The first plan was designed by Louis Le Vau using the classical schema of symmetry, clarity, and geometric patterns. Grand spaces, dramatic embellishment, theatrical display, and high contrasts, all contributed to the "classical baroque" style. Sprawling out in a horseshoe shape, the connected buildings measure 2,000 feet wide. The repetitive façade has three levels of aligned windows, with porches on the second level bearing freestanding Corinthian columns. The roof is ornamented with statues, giving a hint of verticality to the palace's extreme horizontality.

The overall plan included not only the enormous palace, but also parks and terraces on the sloping land. Unlike the Forbidden City, Versailles architecture was meant to dominate nature rather than be in harmony with it, which clearly expresses the personality of the king who commissioned it. The designer of the profuse gardens was André Le Nôtre. He ambitiously transformed an entire forest into myriad flower beds, manicured shrubbery, exotic trees, lakes, canals, and fountains all embellished with classical sculpture that glorified the king. Outside "rooms" were created for the private rendezvous. Theaters, a zoo, and an orange grove containing over two thousand trees were also part of the gardens that, overall, covered seven square miles. Over 4 million tulip bulbs were planted in the flower beds. Although very formal in its geometric plan, the gardens are as breathtaking as the buildings, and are part and parcel of Versailles' elegance.

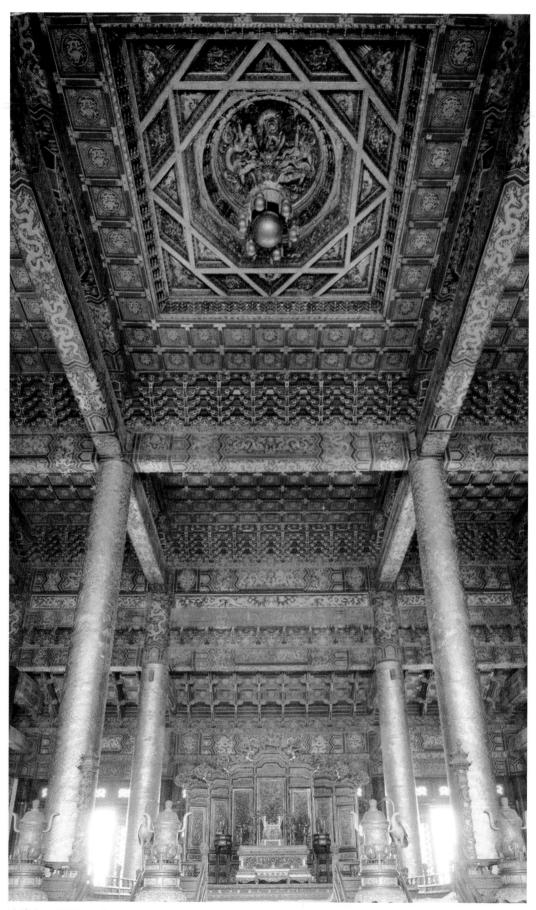

 $12.17\ \textit{Imperial Throne Room}\ in\ Hall\ of\ Supreme\ Harmony.\ Forbidden\ City,\ Beijing.\ See\ also\ the\ text\ accompanying\ figure\ 3.22.$

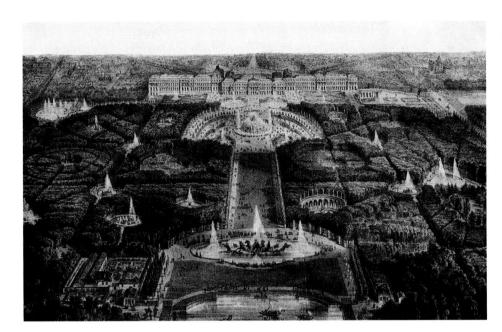

12.18 Versailles. Anonymous seventeenth century painting.

While the exterior of Versailles is visually overwhelming, the interior matches it, particularly in the *Hall of Mirrors* (figure 12.19). Measuring 240' in length, this grand corridor connects the royal apartments with the chapel. Decorated in a profusion of splendor, the seventeen mirrored arcades oppose the same number of full length arched windows facing the gardens. The ceilings were covered with marvelous frescoes, and the long room was embellished with gilded bronze capitals, sparkling candelabra and bejeweled trees. The whole effect is dazzling, with light pouring in through the huge

windows and splashing in glistening reflections from the mirrors. The light, always changing, gave an atmosphere of theatrical display as Louis paraded with his entourage to chapel. The *Hall of Mirrors* is but one of the sumptuous rooms at Versailles, all richly decorated with objects of silver, lace, brocade, china, crystal, woven carpets, and tapestries. Exquisite furniture of inlaid wood was exclusively created to add to the opulence.

Approximately 36,000 workers took twenty years to complete *Versailles* to Louis' liking. Once the complex was finished it included barracks for 15,000 servants, a

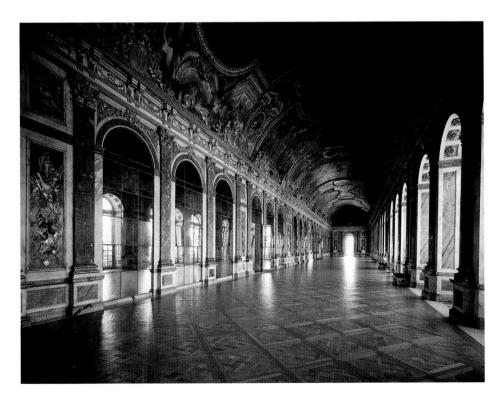

12.19 JULES HARDOUIN MANSART and CHARLES LEBRUN. *Hall of Mirrors*. c. 1680, Versailles, France. See also the text accompanying figures 3.10 and 20.3.

kennel, and a greenhouse, all to serve the king and his kept audience. This overindulgence was tolerated for a while, but because of its extravagance, the monarchy was brought down in 1789 under the reign of Louis XVI. Versailles, on the other hand, has survived, giving the visitor an opportunity to experience royal excess.

On the continent of Africa, elaborate palaces were also built by the Yoruba people in Nigeria. Adept farmers, the people lived together in city compounds, sometimes with hundreds of thousands of people. While the common citizen and lesser chiefs lived in a home that would have one or two courtyards, the palace of course was much larger with many rooms, courtyards, and verandahs. The "afin" (palace) was located in the center of the city, with the highest walls made of mud and palm oil, which were heavily thatched, as we see with the *Palace at Oyo* (figure 12.20). Cone-shaped thatched towers framed the entrance, which was created anew for each king, as the former king's doorway would be sealed after his death. The cone and umbrella shapes are Yoruba symbols of royalty.

The palace was embellished with exquisite carvings and sculpture, all likely painted. Yoruba kings would seek the best artists for artwork for their palaces, as a way to increase their prestige. Although names of the artists were usually unknown before the twentieth century, one in particular who became quite famous was Olowe of Ise (c. 1875–1938). His work was highly respected and he traveled extensively to complete his many commissions.

Often he would be given living and work space at a palace he was carving for, along with his several assistants. So excellent was this sculptor's work considered that songs or poems of praise (oriki) were composed about him:

Handsome among his friends.

Outstanding among his peers.

One who carves the hard wood of the iroko
tree as though it were as soft as a calabash.

One who achieves fame with the proceeds of his carving.

(BLIER 1998: 85)

Among his monumental sculptures, the column statues he carved for the Ikere palace are his most masterful works. Olowe spent four years (1910–1914) at the palace producing around thirty pieces, which include maternity, equestrian, and caryatid figures (female pillars that support a roof). We can only show a single example of his carving, but imagine yourself in a courtyard surrounded by several such sculptures. Our example of the Palace Sculpture (figure 12.21) shows the senior wife who is the queen, standing behind the enthroned king. She is significantly larger than the king, which emphasizes her importance in the royal hierarchy. Revered for her power to procreate, the royal female is held in awe, as are all Yoruba women. This procreative power is so important that it is the queen who crowns the new king. She is the source of his power. On top of his conical crown is a bird, which is a symbol for mothers, and all of

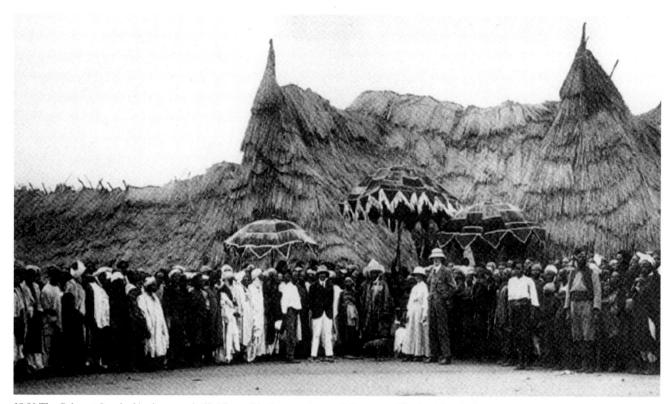

12.20 The Palace at Oyo, the king's son and officials stand in front, early twentieth century, Yoruba, Nigeria. See also the text accompanying figure 21.6.

the reproductive power that female ancestors, deities, and older women possess. Olowe skillfully captures these qualities in his work.

Olowe's style in the Queen and King pillar are clearcut organic forms that visually relate and almost interlock. Tall and balanced, they visually convey the ideas of monumentality and elegance. Attention to detail especially in the pattern of body scarification adds authenticity and authority to the sculpture. Yoruba aesthetic values are clearly evident in Olowe's work: "... clarity, straightness, balance, youthfulness, luminosity and character" (Blier 1998: 85). Interestingly the qualities required of Yoruba artwork could also be considered important attributes of a strong king or queen. Clearly they become one and the same in Olowe's exceptional work.

Thus, across several continents and several centuries, we have seen palaces built with certain distinguishing features: large size, height, lavish artwork, and/or terraces and platforms. The visual language for conveying the idea of exalted status translates across many different cultures.

Seats of Government

In addition to palaces, other structures have been built for governmental purposes. Social and political pressures help determine which styles of architecture are used in government buildings.

Let us look first at the forces that contributed to the design of England's Houses of Parliament (figure 12.22). In 1836 the old Houses of Parliament burned. A new design was needed to house England's seat of government and architects Charles Barry and August Welby Northmore Pugin were commissioned to do the job. Barry designed the general plan, while Pugin was be responsible for the exterior and interior ornamentation. The designing of the new Houses of Parliament coincided with England's desires to create a "national identity." A new style of architecture was required to express this new patriotic spirit. While most architecture at that time was influenced by Greek Classical orders, Barry and Pugin pursued a different direction. A renewed interest in Gothic aesthetics inspired their designs, for they felt that this style, the style of the magnificent soaring medieval cathedrals, would be appropriate for a Christian nation. And with the availability of new building materials such as cast iron, this Gothic Revival style evolved in its own right and flourished in England as well as in the Western world.

Text Link

Chartres Cathedral (figure 10.25) and the Chapel of Henry VII in Westminster Abbey (figure 11.20) are two examples of Gothic architecture, which inspired the design of the Houses of Parliament.

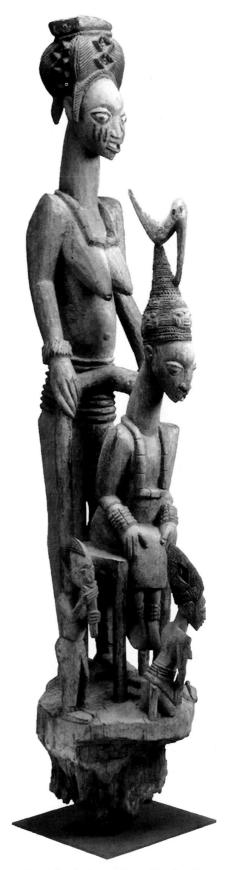

12.21 Olowe of Ise. Palace Sculpture at Ikere. Wood and pigment, $60\%^{\prime\prime}\times13\%^{\prime\prime},\,1910{-}14,\, Yoruba,\, Nigeria.$ See also the text accompanying figures 4.2, 5.13, and 20.4.

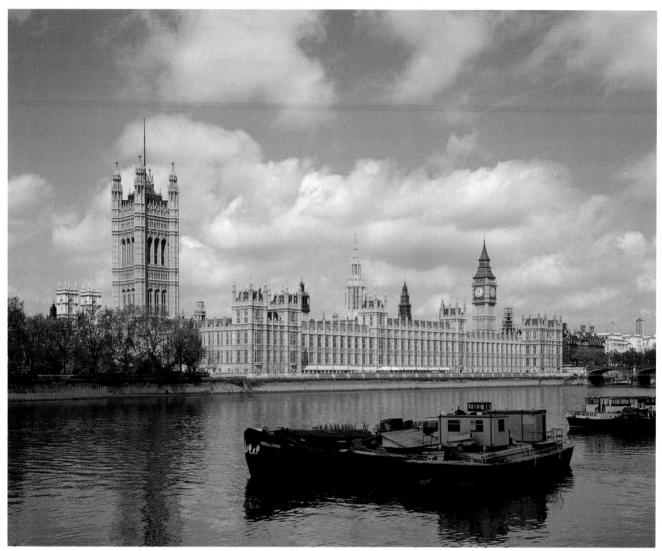

12.22 CHARLES BARRY and A. W. N. PUGIN. Houses of Parliament. 940' long. 1840–1860, London, UK. See also the text accompanying figure 22.4.

Using the Gothic Revival Style for the *Houses of Parliament* stirred up considerable controversy. Pugin and Barry were criticized for breaking away from neoclassic architecture, which had been used for public and government buildings in many Western nations, including England, France, and the United States. Pugin responded with his *True Principles of Pointed or Christian Architecture* (London 1984), in which he wrote:

1st, that there should be no features about a building which are not necessary for convenience, construction, or propriety; 2nd, that all ornament should consist of enrichment of the essential construction of the building. The neglect of these two rules is the cause of all bad architecture of the present time. . . . (Honour and Fleming 1995: 622)

The painter John Constable criticized the new Gothic Revival design of Parliament, stating that this style was a "vain endeavor to reanimate deceased art, in which the utmost that can be accomplished will be to reproduce a body without a soul" (Honour and Fleming 1995: 621). In response to this Pugin felt that Gothic art never died and therefore did not lose its "soul." Pugin felt that Gothic was a principal, rather than a style, "as eternally valid as the teaching of the Roman Church . . ." (1995: 621). With this strong conviction, he felt he was continuing this Christian principle in his architectural designs. On the other hand, Pugin reasoned that contemporary Greek temples would be mere imitations and would have no integrity. According to his *Principles*, only the continuation of the Gothic aesthetic would meet the requirements of good architecture.

As we look at the impressive structures we see a long horizontal block of buildings topped with a series of spires and towers. Victoria Tower is on one end while the famous clock tower, with "Big Ben," is on the other. Ironically, the building's plan is clearly symmetrical with repetitive ornamentation, which are in fact qualities of Classical architecture. However when one views the buildings, a medieval church or a castle-fortress comes to mind, visually housing Parliament in a metaphor of the church's strength and the government's power.

Just as a new architectural style was developed for the *Houses of Parliament*, a new form of architecture would evolve on the island of New Zealand, in response to political and social needs at that time. In the nineteenth century, the Maori nation was undergoing tremendous change due to European colonization. The Maori Meeting House was a visual representation of old tribal values that reaffirmed clan ties.

As in most Polynesian cultures, one's genealogy was of utmost importance. All Maori people traced their ancestry back to the original sailors of the "Great Fleet," powerful mythic figures who migrated in canoes to New Zealand's rugged shores over a thousand years ago. The genealogical heritage of each Maori child would be recited and preserved at every birth ritual and naming ceremony. Extended families became clans, which was the primary unit of social and political organization among the Maori. The descendent of the more important ancestor would become the clan chief, and the most respected of kinsmen. He was looked up to by his people and, along with his council, would be entrusted with the clan's lands. A system of mutual assistance was practiced among the community which provided economic security. No one went hungry or felt the cold of New Zealand's harsh climate. It was to preserve this community spirit and ancestral connectedness that the Meeting House evolved.

Our example of a Maori Meeting House is *Te Mana O Turanga Meeting House* (figure 12.23), from 1883. Originally, the clan would simply use the outside of their chief's simple house for meetings, and as a result, the Meeting House developed from the design of the chiefs' domiciles. However, the Meeting House is much more art-filled, elaborate, and symbolic than the chief's home. The entire house is transformed into the body of a powerful ancestor. Inside this potent environment, chiefs, priests, and house guests would conduct tribal affairs and ceremonies.

The metaphor of the body is carried throughout the meeting house. The porch is considered to be the brains of the ancestor, with an ancestor figure as a finial at the gable's peak. The barge boards of the overhanging roof symbolize the ancestor's arms and hands. The ridge pole (figure 12.24) of the roof represents the ancestor's backbone, and it terminates at the front with a mask of the ancestor's face. This pole runs the whole length of the house and supports the roof and rafters. Under the porch, the ridge pole has figures of a male and female, sometimes engaged in sexual intercourse, carved on it. They likely represented the original ancestral father, "Rangi," and mother, "Papa." The rafters and the wall slabs were the ancestor's ribs. The rafters are decorated with beautiful flowing intricate patterns that resemble the tendrils of a vine. Like a family tree this design delineates the growth of generations from this house. The wall boards have carvings that depict ancestors with genealogical notations. The whole effect visually and

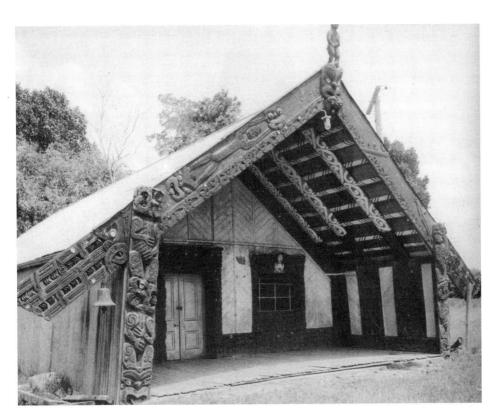

12.23 RAHARUHI RUKUPO AND OTHERS. Te Mana O Turanga Meeting House. Maori, 1883, New Zealand. See also the text accompanying figure 4.6.

physically connects the living Maori to their ancestors, and then to the ribs and backbone of the original ancestor, documenting their authentic pedigree.

The sculptures on Maori meeting houses are visually overwhelming and are meant to be. These profuse carvings, swirls, lines, and frightening imagery empower clan members, while intimidating any outsiders. The doorway of the meeting house had special significance as it was the entryway into the body of the ancestor. Once inside, the living become one with their ancestors. The doorway lintels might be carved in intricate spirals, with figures intertwined. Those figures might represent spirit messengers or states of Maori existence: the Nothingness, The Night, and the World of Light. We can see similar images on the ridgepole in figure 12.24.

Text Link

Pictures of Maori clan members and important people in their histories were made to cover parts of the walls in their Meeting Houses. For an example, see the Back Wall of a Maori Meeting House in figure 16.4.

Monuments

A final category of government art is the monument. Existing somewhere between sculpture and architecture, the monument can be an engraved marker, a statue, a pillar, or a building. Often located in open spaces, monuments can publicly commemorate a person, event, an era, or a culture, either past or present. Monuments need to be impressive to the viewer, and tell what is being commemorated. Therefore, many monuments

share features such as imposing size, mixture of architecture and sculpture, use of inscriptions, and/or figurative sculpture.

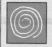

Text Link

The monuments in this section specifically relate to the power of the state. Other monuments in this book include the Vietnam Veterans War Memorial (figure 11.31), the Ara Pacis Augustae (figure 13.36), the U.S. Marine Corps War Memorial (figure 13.29) and the Portrait of George (figure 14.25), the monument to slain San Francisco mayor George Moscone.

Our first monument is a stele, which is an upright stone slab with an engraved inscription. The Hammurabi Stele (figure 12.25) stands about 7' 4" high, but our illustration shows only the top part. Even so, you can still see some of the inscriptions that cover the entire lower stele. Those inscriptions are the Code of Hammurabi, from the eighteenth century BC, one of the earliest cohesive body of laws instituted to govern a society humanely, which was a phenomenal achievement in its time. In the preamble of the code, King Hammurabi wrote the purpose of his laws: "to cause justice to prevail in the land, to destroy the wicked and the evil, that the strong might not oppress the weak" (Frankfort 1970: 119). The code has around three hundred entries, most of which deal with business and property sitiuations, for example, regulating the cutting down of a neighbor's tree. However, as many as 68 deal with domestic problems and 28 deal with assault. Decisions on degree of guilt and

12.24 Ridge pole of Te Horo Marae Waiapu Meeting House, Maori, New Zealand

12.25 *Hammurabi Stele*, relief detail, Hammurabi standing before the sun god Shamash, 28" high, 1792–1750 BC, from Susa (modern Shush, Iran).

subsequent punishment were determined by gender and class.

The carving at the top of the stele represents Hammurabi and Shamash, the supreme sun god and judge. Hammurabi considered himself a favorite of enthroned Shamash, and was inspired by him to render justice. There is a sense of solemnity as Shamash extends his hand that holds a rope ring and a measuring staff, the sacred symbols of his divine power. Hammurabi raises his hand in a worshiping gesture. The figures are roundly modeled and are cut fairly deeply into the relief. Their style resembles much of the freestanding sculpture of the day. Like Egyptian art, we see here combined frontal and profile views, but the soft modeling lessens the sense of contortion. Details are economically rendered as lines, as seen in Shamash's eight-horned headdress (only four of the horns are in seen in the profiled view), in the sun flames projecting from his shoulders, in the neck trim of his royal tiered tunic, and in the design of his throne. The god's beard is very stylized, in contrast with the fully carved eyes of both the figures that are transfixed upon each other. The material used for the stele is important, too. It is carved in basalt, a rich shiny black lava rock. The basalt emphasizes the grave importance of the code of laws it bears.

Text Link

For comparison, an example of Egyptian relief carving is The Pharaoh Crowned by the Goddesses Nekhbet and Wadjet (figure 10.19).

Our next example of a monument also comes from the ancient Near East, but with different effect and purpose. The mighty *Lamassu* (figure 12.26), from 720 BC, is an enormous sculpture that stood guard at the palace gates at Khorsabad, capital of the Assyrian Empire. The Assyrians, known for their ruthlessness and brutality, dominated the Near East for over three hundred years. They engaged constantly in battle in order to expand and defend their empire, and their art reflected this. The empire's main expansion occurred under the reign of Assurnasirpal II (883–859 BC), who was noted for his unrelenting lack of mercy. At its height, the domain included southern Turkey, Syria, Jordan, Lebanon, most of Palestine and modern Iraq, and northern Egypt.

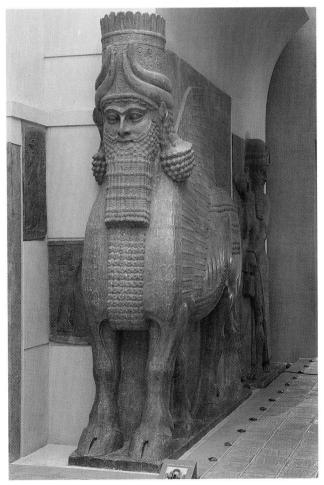

12.26 Lamassu, limestone, c. 14' high, 720 BC. Khorsabad, Iraq.

With its sheer size and glaring stare, the *Lamassu* was meant to terrify and intimidate all who entered the palace. A form of divine genie, the winged creature is part lion or bull, with the head of a human being. The three-horned crown symbolizes the divine power given to the king. Carved from one large block of stone, it was designed to fit into the palace wall; another Lamassu was placed on the other side of the entryway. One had to walk past these two huge threatening figures in order to enter the palace. The Lamassu has five legs, a clever device to show movement and stability at the same time. From the oblique vantage point, the Lamassu is striding forward toward the viewer. The front view, however, shows the beast at a stalwart standstill, now blocking the viewer's forward movement. No matter where the viewer stands, it dominates the space.

The *Lamassu* is carved more like a two-sided relief rather than a sculpture in the round. Much attention is given to detail. In stylized linear and repetitive patterns, human and animal hair are precisely depicted, as well as the graceful wings. The strong muscular legs are more naturally rendered as well as the facial features in the head. This combination of stylized and natural elements aptly expresses its human and fantastic make-up.

Text Link

We will look at other fantastic animals, and the reasons why humans invented them, in Chapter 19, Nature, Knowledge, and Technology.

The next monument is a triumphal arch, which is more like architecture than sculpture. The *Arch of Titus* (figure 12.27) was built along the "Via Sacra" (the Holy Road) in Rome, to commemorate the older son of Vespasian, who died in AD 81. Built by his brother Domitian, the monument records Titus' apotheosis in the inscription that appears at the top, which reads roughly, "[The Senate and the People of Rome]... dedicate this arch to the god Titus, son of the god Vespasian."

The triumphal arch is a Roman innovation that would endure for centuries. These arches were built to commemorate military victories or major building projects. The *Arch of Titus* could easily have been included in our Chapter 13, War and Peace. But it also glorified the emperor and the power he possessed, and in this case, documented his deification after his death.

This single passageway arch (others have two passageways, most have three) is a mini-barrel vault. The vault's opening is framed with engaged columns that are a composite of Ionic and Corinthian elements, a Roman synthesis of Greek orders. The columns support the entablature upon which rests the attic, the uppermost section with the inscription. In the spandrels, the area above the arch and below the entablature, are carved "winged victories," which symbolize Titus' military suc-

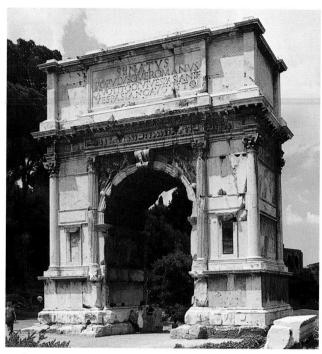

12.27 Arch of Titus. Marble faced on concrete core. 50' high, 40' wide, AD 81. Rome, Italy.

cesses. In the center on the ceiling of the vault a relief depicts Titus being carried up to heaven on the back of an eagle, giving a visual image of his deification.

On the inside walls of the arch are relief carvings of his military victories, including one of his most impressive exploits, the conquest of Jerusalem in AD 70. The Spoils of Jerusalem (figure 12.28) shows soldiers carrying pillaged items from the temple, such as a heavy menorah (the seven-branched candelabrum), probably made of solid gold, carried high by the victors so that all can see. Their return, orderly at first, breaks down as they rush forward and enter the arch of a city gate (or perhaps proceed through a triumphal arch much like the Arch of Titus). The figures were very much rounded, and there is a great sense of depth in the background. The feeling of movement is utterly convincing. The soldiers' arrival is trumpeted by the figures at right, whose long horns are arranged in dramatic diagonal lines. The carving is in a damaged condition, which is especially evident with the missing heads of the closest figure. Nevertheless, the Arch of Titus proclaims the power and glory of Titus and his empire of long ago.

The last monuments we will look at have always been a bit of a mystery. The *Monumental Heads*, "moai statues" (figure 12.29) on Easter Island, believed to date from the fifteenth century, have piqued the imagination of many, from anthropologists to science fiction writers. Twenty-two hundred miles off the coast of Chile, the triangular isle measures 14 by 7 miles, has two extinct volcanoes, and is considered part of Polynesia. The first immigrants called the island Rapanui. They arrived around 400–500,

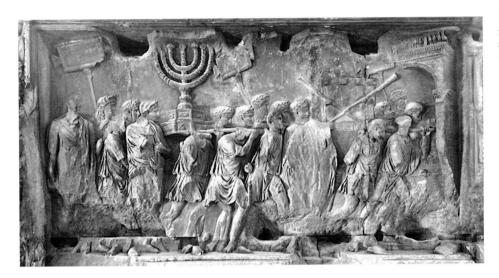

12.28 *Spoils of Jerusalem*. Relief panel from Arch of Titus. Marble, approximately 7' 10" high. See also the text accompanying figure 21.9.

probably from the Gambier or Marquesas islands. As in other Polynesian cultures such as the Maori, their genealogies were the source of their existence and importance in the community, and it was vital that they could be traced back to the original settlers. It is likely that the carvers of these gigantic figures linked them to their genealogies.

The statistics of these sculptures are phenomenal. The huge monoliths with their pensive faces cover the sparse and arid terrain on the small isolated island. Over six hundred heads averaging 12 to 25 feet in height have been found. An exceptional one measures 32' and weighs 50 tons, with a topknot that weighs 10 tons. The statues were carved in pits, out of volcanic rock called tufa, a fairly soft material that hardens with age. After completion, the piece would be raised and fitted together on a basalt platform without the use of mortar. The largest one found in a pit is 40' high and one started in a quarry is 69'. The largest topknot is estimated to weigh in at 30 tons.

Carved with primitive basalt hand-picks, the figures were rendered in large minimal forms. The eyes and topknot were added last. When fully exposed, the statues have full-length torsos with long slender arms. Most are male figures although a few females have been found. Now in pieces, the once-powerful ancestor or religious statues are strewn about the island. One cannot help but imagine them in their original positions looming above those who stood below them. Did they require votive attention or were they looked upon as power figures who in turn imbued their creators with power? Their blank expressionless stares do not give the viewers many clues.

We have chosen but a few monuments to study here. Undoubtedly, your city or state governments have erected many monuments to past events, political leaders, military victories, and so on. When you seek them out, you will find that many share the qualities seen in our examples here.

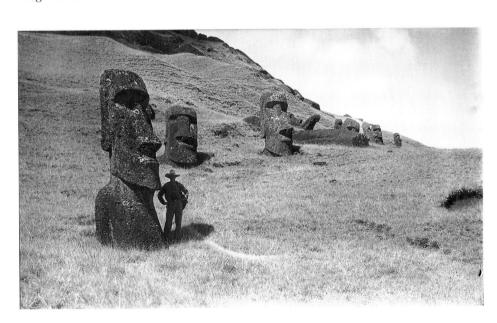

12.29 *Monumental Heads.* Volcanic tufa, Easter Island, Polynesia. c. 15th century.

SYNOPSIS

Art has played a tremendous role in promoting the power of an individual ruler. Chinese imperial emperors were lauded in their personal portraits while the Byzantine rulers, Justinian and Theodora, were presented as equals to the church and state in the impressive mosaics in San Vitale. Royal paraphernalia also denotes power, as seen in the images of the last two divine Inca kings, Huascar and Atahualpa. Although they never ruled, they were documented wearing the same crown, visually declaring their individual right to the same throne. Materials are important in the portraits of rulers. The ancient Egyptian King Menkaure and his queen have been captured permanently in stone, while an African Oni's beautiful portrait is expertly cast in bronze. The lovely and pensive Princess Ka'iulani was also captured in a sensitive photograph, perhaps expressing her loss of power rather than the boast of it.

Objects of royal paraphernalia affirm the authority of a monarch. Otto III appears in a book illustration, crowned and sitting on a throne, holding his royal staff and orb. Men from four parts of his empire give him homage. While the orb and staff signified royal authority in Europe, the feather kahili gave great power to a privileged few who were able to own or use it in the Hawaiian royal court. It was also displayed at important funerals glorifying the deceased in solemn splendor.

A throne is a common sign of royalty and power. We saw the delicately carved African Asante throne-stool made for a queen mother. In addition, prestige comes from the ownership of special objects. An outstanding example of this is the magnificent Mesquakie bear claw necklace. The wearer of this potent necklace received power from the ferocious black bear's claws, as well as respect from those in his community.

Political leaders have relied on art to proclaim their political achievements. In ancient Mesopotamia, Hammurabi had his code of law engraved on a stele, with the blessing of his god Shamash, which appears in the relief above. Centuries later Adolf Hitler exploited the latest art form of film when he commissioned Leni Riefenstahl to make *Triumph of the Will*, which glorified the Führer and all that his Nazi party stood for.

The state also benefits from the contributions of art, especially architecture and monuments. For centuries the enchanting and exclusive Forbidden City in Beijing, China, housed the emperors as Sons of Heaven, while the incredibly opulent *Palace of Versailles* expressed the state and mind of the French "Sun King" Louis XIV.

Persepolis was an impressive citadel where tribute was brought to Persian kings in an awesome setting. The highly ornamented Palace of Palenque deep in the rain forest became renowned in the Mayan world for its art and architecture. Yoruba palaces in Nigeria were decorated with fine sculptures carved by the best artists, such as the highly accomplished and respected master Olowe of Ise, giving the commissioning kings the prestige of having his work adorn their compound.

Government buildings were designed for political and societal needs. The *Houses of Parliament* housed Britain's governing bodies in a new Gothic style that expressed their emerging national identity. In New Zealand the Maori *Meeting House* evolved from the early chiefs' simple abode to a profusely and skillfully decorated environment that impressed the visitor with the clan's power, while it imbued its builders with the power of the ancestor it represented.

Monuments have expressed power and glory through their visual importance and impact. The mighty Lamassu guardian figure was a monument to Assyrian power in the ancient Near East. The Roman Arch of Titus commemorated Titus' military victories, apotheosis, and the overall glory of his empire. Monolithic looming heads and torsos on Rapanui, or Easter Island, were likely monumental shrines to their creator's genealogical heritage.

Our observations clearly indicate that art has contributed substantially to the power, politics, and glory of both the state and individual. It commemorates historic events and people, makes lavish the rulers' palaces, houses the workings of government, and keeps vividly alive the glory and greatness of past empires. In part, the rulers' greatness comes from the awesome works of art they had created for their own names and states.

FOOD FOR THOUGHT

As we review the art examples that pertained to power, politics, and glory, more questions come to mind.

- Can the extravagance and costs, both of money and lives, be justified in the opulent but superb art and architecture commissioned by "divinely empowered" individuals?
- By royal monarchies?
- By totalitarian rulers?
- Would works of art as excellent as we have seen in this chapter have been created without such commissions?

Chapter 13 War and Peace

INTRODUCTION

War or warfare is part of the history of most civilizations and cultures. War itself has many intertwined causes including religious and economic, and aggressive tendencies that have often surfaced in individuals and groups. Peace sometimes follows war, or sometimes the fighting merely ceases without resolving hostilities.

Our purpose in this chapter is to look at the ways that art, war, and peace overlap. Art has helped shape our reaction to war, as to whether war is glorious, horrific, or both. More recently, art has made war immediately present to people very far from the battleground.

War imagery appears in other chapters. In Chapter 12, Power, Politics, and Glory, the glorification of rulers often included their military might and victories. Art protesting against war appears in Chapter 14, Social Protest/Affirmation. In this chapter, we will look at art that deals with the following questions:

How have artists depicted warriors and peacemakers? What purposes does artful decoration serve on warriors' vestments and their weapons?

How have the designers of vehicles and objects of war included aesthetic consideration in their creations?

How has art become part of the aftermath of war, for both the victor and the vanquished?

How has war influenced the form and function of architecture?

How has art documented both war and peace? What kinds of monuments have been built to wars and to peace?

THE WARRIOR

Art Depicting Warriors

Warriors have been depicted in art since the earliest times, as far back as 8000 BC on rock walls. Warrior im-

ages exist in almost every culture since then. How is a warlike spirit conveyed in these works? How have warriors been made to appear menacing?

We will begin our brief survey in Mesoamerica, in the Toltec city of Tula in central Mexico. Impressive colossal *Tula Warrior Columns* were erected upon a pyramid between 900–1000 AD (figure 13.1). These tall, blocky figures loomed above on a temple platform and reached 16 to 20 feet high, three times life size. They were carved in basalt and painted in bright colors. Stiff, frontal, and

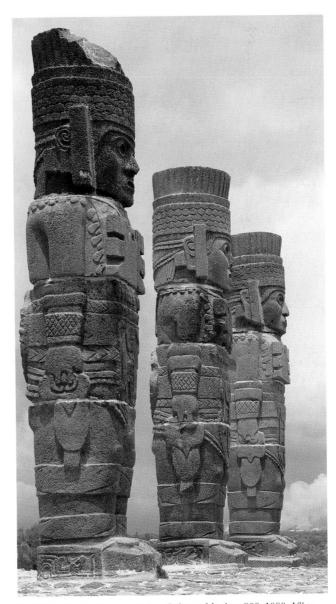

13.1 Tula Warrior Columns. Toltec Culture, Mexico, 900–1000, 16' to 20' high.

formal, these stalwart warriors seem immobile and stead-fast. No force nor enemy could fathom moving them, for their sheer size and deadpan faces (much like the guards at Buckingham Palace in England) make them seem inconquerable. This message of might and strength reflects the spirit and legend of ancient Tula (or Tollan), where the Aztecs trace their mythological roots. Aztecs glorified Tula in their legends as the "city of the giants," as the site of a golden age where culture and wealth reached its zenith.

The columns were made of four drums and held together by dowels. They were supporting structures, much like the Greek caryatids that functionally and aesthetically held up a temple roof. Carved in low relief, the warriors were adorned in Toltec garb with elaborated headdresses, and each held atlatlsspear-throwers-at their side. They were uniformly carved as well, giving one an impression of an army of robots that would crush anything in their path. Stylized butterflies, carved on their chests, were the souls of past warriors. Imposing and threatening, the huge figures proclaim the militaristic side of Toltec life, which was likely to be closer to the reality of Tula, rather than the glorified city of the Aztec tale. Tezcatlipoca, the warrior god, may have been the inspiration to the architects and artisans who made the warrior columns.

Before the modern era, the warrior on horseback was one of the most feared. Many cultures with the domesticated horse have produced artworks of the equestrian warrior on a horse, usually a king or a soldier. The strength and speed of the steed becomes joined with the determination of the rider, resulting in a striking image. A fine example of this art form is Andrea del Verrocchio's colossal bronze Equestrian Monument of Bartolomeo Colleoni (figure 13.2). Colleoni was a "condottiere" or mercenary soldier, who fought many campaigns for the city-state of Venice during the fifteenth century. When he died he left part of his fortune to the state of Venice with the stipulation that a bronze equestrian statue be erected as his memorial. A competition was held in 1480, in which the talented and well-established Verrocchio won the commission. Verrocchio was truly a multimedia artist and won fame for his sculpture, paintings, drafting, and goldsmith work. He had a successful workshop and trained many young apprentices, including the famous Leonardo da Vinci. For his entry, he sculpted a realistic life-size model in wood and covered it in black leather. He then went to Venice to direct the execution of the work in bronze. It was his last monumental masterpiece, as he died during its construction. The sculpture was finally completed in 1492 by his assistants.

Verrocchio's sculpting and casting skills were impeccable, as we shall see as we look at *Colleoni*. The statue is 15' in height and raised on a high pedestal. As one looks up from under the horse's raised hoof at this monument, the strength, determination, and aggressive spirit of the Renaissance can be felt. The combination of the horse's tense bulging muscles, the twisted attitude of the figure, the scowling face and determination in the eyes of its rider give the viewer the feeling that this soldier might charge at any moment. This statue does not seem static, but animated, as Colleoni holds back his steed. Verrochio captured the power and energy of Venice's champion warrior in a tall and looming bronze monument.

Text Link

See Chapter 2, the Language of Art, for more information on the technique of bronze casting.

Not as monumental in size as the Tula warriors or Colleoni, yet still splendid, the royal Benin plaques depict warrior kings in Nigeria during the seventeenth or early eighteenth centuries. In figure 13.3, we see a brass Plaque with Warrior and Attendants, which measures a little over 19 inches high, made by an unknown artist. In classic African figurative proportion, approximately three heads high, the warrior is in full regalia and focuses directly at the viewer, while his attendants, smaller in stature, take their hierarchical place in the pictorial space. His apron and shield have leopard imagery, which was the regal symbol. Dominating the composition are the warrior's spear, helmet, and shield. The Benin Warrior is depicted as powerful royalty, with his strength being his absolute authority, while at the same time appearing aloof.

Benin bronze plaques documented kings, warriors, and famous events, and they decorated the halls of Benin palaces. Only the king, or "Oba," could commission the art. The plaques represented both the king's power and literally were his image among his people, since he rarely appeared in public except to wage war and to officiate at religious ceremonies. The plaques were a constant reminder to the public of the Oba's supreme authority and were placed prominently on the great pillars that supported the palace, so that all could see. During times of conflict, art would be stored away for safekeeping.

Text Link

Some scholars suggest that these plaques influenced by the Portuguese, who had been trading in that area since the sixteenth century, as we saw with the Afro-Portuguese Saltcellar (figure 6.14). The fact that Benin artworks were sculptural reliefs in a rectangular format, rather than the more-common freestanding sculptures, is the reason for this.

The Edo dynasty (as the Benin people call themselves) continues today. Since art was commissioned only by the Oba, Benin art is literally Edo history,

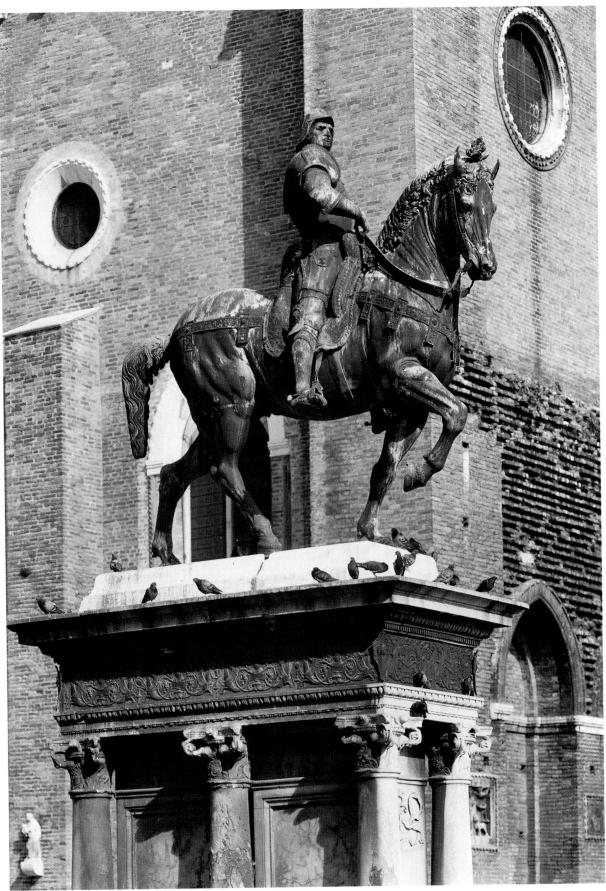

13.2 Andrea del Verrocchio. Equestrian Monument of Bartolomeo Colleoni. c. 1483–1488. Bronze, height 15', Campo SS Giovanni e Paolo, Venice, Italy.

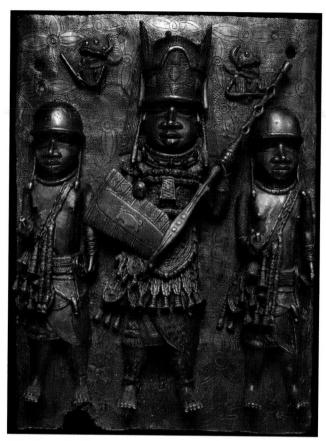

13.3 Plaque with Warrior and Attendents. Benin Culture, Nigeria, seventeenth or early eighteenth centuries, brass. 194" high.

representing their heritage and enshrining their past. Royal Benin art continues to be made today, existing alongside a thriving tourist trade for more marketable art. The same situation exists for several other ancient cultures in Africa, such as the Akan, Yoruba, and Kuba courts.

Our last image of a warrior is figure 13.4, the midnineteenth-century portrait of Chief Keokuk (c 1830) painted by U.S. artist George Catlin. Standing in a classic pose with all the trappings of a warrior, the chief is a noble and proud man. His complete regalia includes his shield, lance, tomahawk, bear claw necklace, and a "roach," a headdress made of animal fur and worn on a shaven head. The display of weaponry and armor are necessary ingredients for this image of a fearsome warrior, even though in fact Keokuk rose to power among his people because of his political maneuvering and oratory skills. Keokuk and Black Hawk were rival leaders of the Sauk and Fox nations at the time that white settlers advanced into their territories, which were primarily in Illinois and Iowa. While Black Hawk advocated armed resistance to the settlers, Keokuk argued for compromise.

Originally a lawyer, George Catlin dedicated his life to painting and writing about the life and traditions of the indigenous peoples of the Western Hemisphere. He painted prolifically while traveling extensively. Although Catlin's palette was limited to twelve colors and his paint application thin so he could roll his paintings, he managed to maintain the brilliance of Keokuk's costume and the intricacies of its details.

Thus in our brief overview, we have seen that warlike and menacing attitudes can be conveyed through art. Warrior images often are quite large, and emphasize armor and weapons. Facial expressions, however, can be impassive, stolid and aloof, or fiercely expressive.

Warrior Vestments

Now we will take a look at some examples of the headgear, dress, and armor worn by fighters. One obvious use of these vestments is to protect the soldier against his foe's formidable weapons. However, as we shall see, they are aesthetic objects, objects with symbolic meaning, and also serve ritual or religious purposes.

Figure 13.5 is an early *Bronze Helmet* from Inner Mongolia dated from the eleventh to fourth century BC. This helmet was excavated at a site thought to be from the Eastern Hu culture, which was located in southeastern inner Mongolia, western Liaoning, and northern Hebei provinces in China. These people were ancestors of the Xianbei, the Qidan, and the Mongols, from which descended the great line of Khans, from Genghis to Kublai. This warlike dynasty would impact or dominate much of the known world. Bones of animals including the horse were found at such sites, indicating that equestrian hunter-warriors were a prominent part of the culture.

Our Bronze Helmet was found specifically at the Nanshangen site in Ningchen County, southeastern Inner Mongolia, where ancient tombs held numerous bronzes along with human remains. In one tomb, the remains of men had helmets near their heads, and bronze swords at their sides. The Bronze Helmet is oval in shape and has a small rectangular opening projecting on top, which is thought to have held a leather strap that tied below the chin. The headgear has two semicircular openings in the front and back, and has vertical incised stripes that converge at the top. Circular shapes embossed in metal trim the helmet's edge. The helmet is carefully detailed, just as are the ritual bronze vessels also found at the site. The helmet was obviously intended as protection, while the decorative accents add to its handsome appearance.

The warrior who wore this helmet was likely from a long line of ferocious fighters, who were especially threatening to the Chinese. In fact, the bronze technology for the helmet may have come from Central China, the result of plunder and raids. Later in this chapter, we will see the *Great Wall of China*, built by the Chinese to defend against these raiders from the north.

Helmets are only one kind of warrior headgear. In figure 13.6, we see a magnificent *Sioux Eagle Feather War Bonnet*, complete with ermine tails, horsehair, and beadwork, dated around 1890. Rather than protecting the warrior, this fine regalia was meant to impress others, as

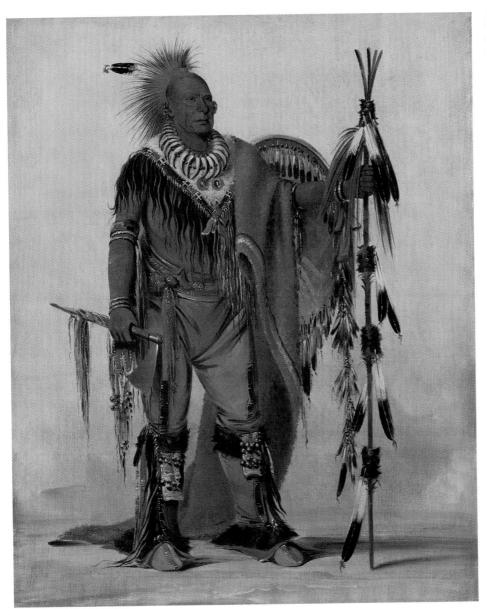

13.4 GEORGE CATLIN. Cheif Keokuk. USA, c. 1830, painting was executed with thinned paint. National Museum of American Art.

well as reward warriors for their actions. Military superiority was considered to be an essential qualification for becoming a chief in Native North American cultures of the Great Plains. All young men had the opportunity to prove themselves great warriors in order to become a chief. They would have to perform deeds of bravery, and among some cultures such as the Arapaho, they would have to physically encounter their enemy during battle. For each feat of bravery, warriors would be awarded an eagle feather for their bonnet. The feathers were marked or cut to signify the exact deed that was accomplished, a coding that would be recognized by several tribes. The warrior's headdress displayed his worthy reputation to both his enemies and his peers.

Along with the warlike actions and deeds it took to earn the war bonnet, the spirituality of the warrior was also important. Visions, dreams, and revelations were important in order to gain supernatural protection. The bonnet's precious material also aided the warrior spiritually. The feathers were taken mostly from the tails of eagles; the sacred birds were thought by many native North American cultures to correspond to the thunderbird, a powerful sky creature. Eagle feathers were thought to be imbued with the spiritual powers of the thunderbird, which would inspire warriors and help them do the right action in order to win a battle and to avoid death.

Text Link
Spiritual preparation was also required for another Native American work, the Potawatomi Love Doll (figure 7.8).

13.5 Bronze Helmet. 9½ inches high. Xiajiadian Upper Period, eleventh–fourth centuries BC, Inner Mongolia, China.

The eagle was also an important symbol to the Aztec culture several centuries earlier in central Mexico, and so was war. Warriors who died in battle or were sacrificed to the gods (the Flowery Death) would be rewarded a glorious afterlife. At a baby boy's birth, which was considered his first bloody battle, a midwife would chant to him: "Thy home is not here, for thou art an eagle or a jaguar. Here is only the place of thy nest. War is thy task. Thou shalt give drink, nourishment and food to the sun" (Flaherty 1992: 84). According to the Aztec religion, warfare and daily human sacrifice were necessary for the Sun God, who otherwise would succumb completely to the Moon Goddess and night.

Text Link

Mesoamerican ball games recreated the rivalry between the Sun and Moon, and ended with sacrificial victims. For more, see the Great Ball Court (figure 18.27).

The warrior class was very powerful in Aztec social hierarchy. As the Aztec warriors conquered their neighbors, they took care not to destroy their enemies nor their cities. Instead, intimidated into submission, the vanquished would supply rich tribute to their conquerors, which greatly increased the bounty, wealth and

power of the Aztec Empire. Thus warfare was integral to Aztec society and economy.

The highest earthly reward a successful Aztec warrior could receive was the induction into the Order of the Eagle or Jaguar Knights. Figure 13.7 shows a life-size ceramic sculpture of an *Eagle Knight* (c. fifteenth century). Like their later North American neighbors, the Aztecs considered the eagle to be fearless, brave, and daring. It could also gaze at the sun (which for the Aztec was looking directly at their God, a feat that humans dare not attempt). Built in five sections and precisely fitted together, the *Eagle Knight* quite accurately depicts the glory of the knight's formal dress uniform. An open-beaked eagle adorns the warriors' heads, while their arms are sleeved in full plumage. The surface of the figures was at one time covered with painted stucco feathers.

This sculpture was one of two excavated from the courtyard on the north side of the Great Temple, Templo Mayor, uncovered in 1978 in Mexico City. The life-size figures were like sentinels found at the entranceway to what is believed to be the Eagle Knights ceremonial rooms that were constructed alongside the

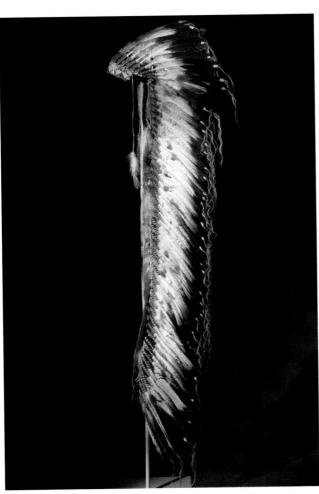

13.6 Sioux Eagle Feather War Bonnet. Feathers, ermine tails, horse hair and beadwork, 1890, USA.

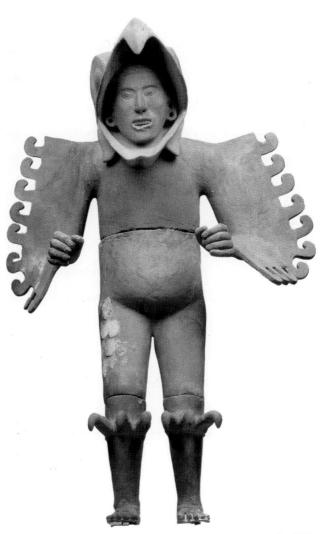

13.7 Eagle Knight. Aztec, earthenware and plaster, 66%" \times 46%" \times 21%", Museo Templo Mayor, Mexico.

temple. Members of this distinguished order received special privileges, which included keeping concubines, dining in the royal palace, and meeting in their own building in the palace to discuss military matters in the presence of their ruler.

Ironically, the Aztecs, who made war to achieve heaven, were conquered by the Spanish who made war to save "heathens" for their Christian heaven. Both of course were also motivated by material as well as spiritual gain. Our next example, *Boy's Dress Armor of Archduke Charles* (figure 13.8), was never used in battle, but may have resembled what some of the Conquistadors wore as they entered the Aztec's pristine city of Tenochtitlan. Impressive dress armor was designed not only to protect the warrior but also to impart fear in the foe. Imagine the daunting terror the Aztecs felt as they saw a steel covered man mounted on a steel covered horse, an animal they had never seen before. They thought these strange looking beings were god-like centaurs, part man part

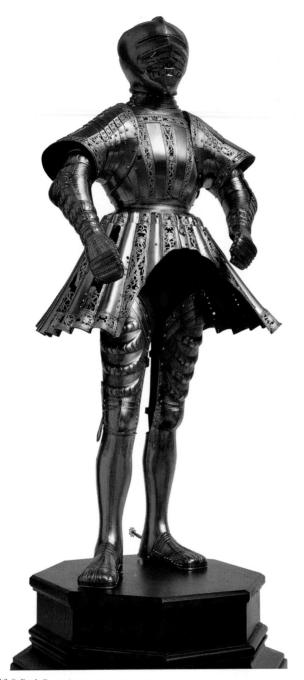

13.8 Boy's Dress Armor of Archduke Charles (later King Charles V). Steel, silver gilt, velvet, leather, 59" high, 27%" wide, 1512-1514, Spain.

beast, with deadly thunder sticks that blew humans apart.

The Boy's Dress Armor of Archduke Charles was commissioned by Maximilian I in 1512 for his twelve-year-old grandson, who later became Charles V of Spain. The designer, Konrad Seuseuhofer, was Maximilian's court armorer and gifted craftsman, and also a fashion designer. For Charles' armor, he created his design after the "long coat," which was the pleated skirt worn as part of men's clothing style in Dutch fashion. The cloaks were decorated with appliquéed borders. Seuseuhofer achieved this with gilded interlaced recessed bands of metal that

were attached to the front and back, the shoulders and knees, and on the skirt. Black velvet was inserted in the bands in order to enhance the detailing of the metal "lace." Symbols of the Cross of St. Andrew, the Order of the Golden Fleece, and the flint and sparks of Burgundy were interwoven throughout the bands. The front of the skirt is opened to a half circle in order to facilitate horseback riding. Inserts could close the skirt for protection during hand to hand battle when on foot. For the upper torso, the slatted broad flaring shoulders partially cover the snug-fitting vest. The Augsburg master Daniel Hopfer the Elder illuminated the other pieces in the armor with fabled creatures, putti, branches of pomegranates, star flowers, and other foliage. The etching and decoration in silver were executed by the best artists in Augsburg. The armor took great deal of time to make, which was a definite disadvantage when commissioned for a growing boy. Young Charles probably paraded in his splendid armor only once or twice before he outgrew it.

Body armor and shields were obviously made of a material that will withstand an enemy's attacking weapon. While heavy and awkward steel served the Spanish knight, other cultures made armor and shields from local materials. For example, in Oceania, combatants from the Gilbert Islands wore armor of thickly woven fibers. Likewise, nineteenth-century warriors on the Solomon Islands used woven wicker war shields, decorated with several hundred pieces of inlaid cut shells (figure 13.9). These War Shields gave both spiritual and physical protection during the frequent fights and hand-to-hand combat on these islands. The designs decorating the front of the shields are in both anthropomorphic and geometrical linear forms. They emphasize the verticality of the shape. Elongated figures with their arms raised are intertwined in the linear curves that follow the outline of the shield. Small faces appear near the center of the sides and at the bottom. The figurative images may represent a protective spirit while the small faces might suggest the human heads taken as trophy during headhunting forays.

Let us look at another shield, this time from the North American Plains peoples. Such shields were also constructed of local materials, often buffalo rawhide or buckskin, and decorated with materials such as eagle feathers, brass hawk bells, glass beads, or porcupine quills. The *Gros Ventre Shield* (figure 13.10), which belonged to the Native American warrior and holy man, Bull Lodge, provided him with both spiritual and physical protection, like the shields from Oceania. The quote below describes the spiritual vision of Bull Lodge, which occurred to him when the "Thunderers" (spirit beings) had given him his war shield:

... one summer day after he had finished crying (praying) around the deserted camp ground, he lay in the grass on his back . . . As he gazed upward, an object appeared, very small, but he could see that it

13.9 War Shields. Woven wicker with inlaid shells, Central Solomon Islands, nineteenth century.

was moving. It looked like a circling bird. . . . It came closer and closer, and the closer it came, the bigger it got, until it came within arm's length. It was a shield, with a string or fine cord attached to it leading up to the sky. . . . Then Bull Lodge heard a voice. . . . "My child, look at this thing. I am giving it to you from above. . . . I command you to make one like it for your own use. Your instructions for the shield's use will be given to you later. I will always be watching you from above." Then the voice left, and the shield rose up from Bull Lodge's chest and gradually disappeared into the sky. (Horse Capture 1980: 32–33, Penny 1992: 279)

Afterwards, Bull Lodge had the shield made and was from then on protected by the Thunderers. Thus, evidently, the shield symbolized a spiritual rather than a physical barrier against the holy man's foes. (Penny 1992: 27)

Thus, we see that warrior vestments cut across many categories. As aesthetic objects, they are works of art. As armor, they protect the body, and gather spiritual forces to help the warrior. They are visually very grand, to impress the lowly and intimidate foes.

Weapons

Like armor, weapons are often carefully crafted works of art, with decorations that imbue the weapon with more power or more beauty. Such weapons are also used as signs of prestige.

The dagger was an ancient weapon used in predynastic times in Egypt as well as throughout history. During the later Middle and New Kingdoms (c. 2100–1000 BC), the weapons were usually made of bronze or copper with gold decorations. Knives made of gold were made for royalty. Figure 13.11 is one of the daggers that was buried with Tutankhamen, and was made of hardened gold, glass, and semiprecious stones. A fine example of the mastery achieved by Egyptian craftsmen, the Tutankhamen's Knife is particularly detailed. On the top of the knife's pommel, the pharaoh's cartouches are embossed in gold surrounded by lily palmettes in cloisonné, which is a kind of enamel work in which colorful glass and semiprecious stones are set between thin gold partitions. Underneath the pommel are falcons holding the symbol of eternity. Continuing on the handle are alternating bands of geometric designs in granulated gold work with lily palmettes in gold cloisonné. The blade is of simple design that complements the richly ornamented handle. Two incised lines follow the length of the knife converging in a delicate design of palmettes with poppies at the blade's base.

The sheath of the blade is equally exquisite. The back is decorated in a feathered design of cloisonné, trimmed at the top with a band of palmettes and at the bottom with a head of a jackal. On the front of the sheath is an elaborately embossed relief on the surface. The scene starting from the top depicts an ibex being attacked by a lion; a calf being attacked by a hound, a leopard and a

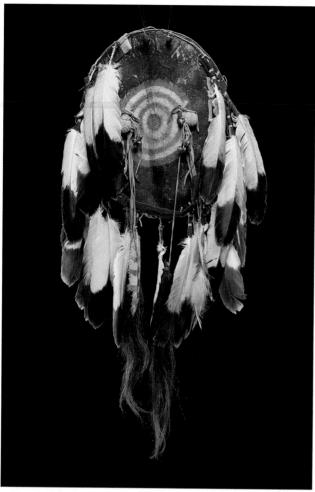

13.10 Gros Ventre Shield. Buffalo rawhide, buckskin, wool stroud, eagle feathers, brass hawk bells, glass beads, porcupine quills, length 44½", width 21", 1860, Montana, USA.

lion attacking a bull, and a calf in flight. Foliage fills the rest of the space. The style of the artwork is reminiscent of Assyrian work rather than in the typical Egyptian decorative style.

Looking more like precious jewelry than a lethal weapon, the skillfully crafted dagger could only belong to royalty. Whether the Pharaoh Tutankhamen used this ceremonial knife in life is not known, however he was indeed prepared with wonderful accounterments for his existence in the afterlife.

Text Links

See Chapter 12, Power, Politics, and Glory, for a discussion of other art object that were signs of a ruler's status.

For more on the riches found in Tutankhamen's tomb, see the Innermost Coffin of Tutankhamen (figure 11.4).

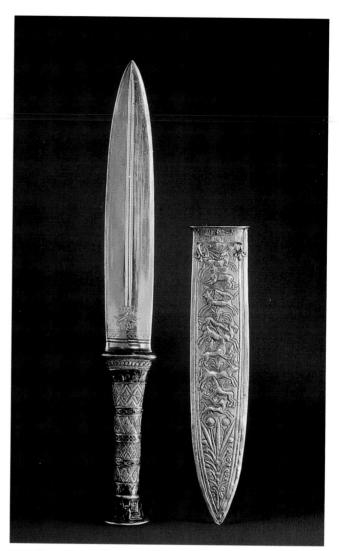

13.11 *Tutankhamen's Knife.* Gold, glass and semiprecious stones, length of dagger 15%", length of sheath 15%", 1352 BC, Egypt.

Another masterfully crafted weapon is the *Aztec Knife* (figure 13.12), from the thirteenth or fourteenth century. It has a chalcedony blade with a wood handle, which is decorated in a mosaic of turquoise, shell, and malachite. The handle is a crouching figure of an Eagle Knight warrior. The knife is thought to be ceremonial, more than likely used for human sacrifice. The knife may have been one of the gifts that the last Aztec ruler, Moctezuma, gave Cortés, the leader of the Spanish conquistadors, which later was sent to Spain for the emperor Charles V. Many exquisite items were preserved through such gifts as well as kept as souvenirs or taken as booty by the conquering Spanish.

Text Link

See the section on "Why Cultures Keep Art" in Chapter 21, for more on art taken as booty.

Although the knife is Aztec, it was likely crafted by Mixtec artisans. The Mixtec people lived in the area of the Oaxaca Valley in Mexico, and were contemporaries with the Aztec. They were masters at using the mosaic technique to decorate small objects, including knives, ear ornaments, pendants, mirrors, and masks. Mosaic stones were selected from rare and precious materials such as colorful sea shells, mother-of-pearl, lapis lazuli, pyrite, garnet, beryl, lignite, malachite, obsidian, jadeite, and turquoise. Each minuscule piece would be precisely fitted together and glued securely on a backing that was usually made of wood. Painstaking care is evident in the aesthetic arrangement and assembly of the work. One known Mixtec piece, a ceremonial shield measuring one foot in diameter, contains more than 14,000 chips.

Our next example is a highly ornamented Islamic Battle Axe (figure 13.13), which, like the Aztec Knife, was also probably used for ceremonial purposes. And as the Aztec ceremonial knife was likely kept for a souvenir, the axe was probably taken for booty from the Alexandria arsenal by the Ottoman victor Selim on his conquest of Egypt in 1520. The axe is inscribed with the name and titles of a Mamluk sultan, along with prayers for his victory and praise to Allah. There are two styles of calligraphy: an older square style on the axe socket where it meets the handle, and a newer curving style of calligraphy, which fits in the circle on the blade. Each style of calligraphy fits beautifully within the shape allotted for it. In addition, they contrast strongly with each other, adding to the decorative richness of the axe's design. Calligraphy is an important Islamic art form, and many variations have been developed. Also, the calligraphy complements the rest of the decorative patterns on the axe. The iron blade is damascened in gold with rich arabesques, while the shaft of the axe is partly faced and fluted for a better hand grip.

An elegantly curved weapon, which is pleasing to look at but packs a lethal punch, is the Ball Head Club (figure 13.14), made by the Eastern Sioux of North America around 1800. It was carved for function as well as spiritual power. A ferocious beast grips the club's ball in its mouth. The image may have encouraged spirits of the underworld to impart power into the weapon. Ball head clubs were considered sacred objects, which only warriors could touch. To the warrior, it was a great honor to fight in hand-to-hand combat using their spiritually powerful war clubs. Thus, many Native Americans preferred such clubs over the firearms used by white settlers and their armies. Warfare marked the "settling" of North America from the 1750s through the 1800s, and led to the tragic demise of Native American cultures throughout the Northeast, Midwest, South, and the Plains.

Intricately carved *Two Staffs and a Spear* (figure 13.15) from Luba, in central Africa, are both working weapons and objects of prestige. Made in 1907, they belonged to a chief, and were intended to impress visiting dignitaries. A carved standing figure is smoothly fitted into the elegant contour of the spear, near the bottom end. With its large head, compact pose, and crouched legs, the figure conforms to the standard African aesthetics for figure representation. The two ceremonial staffs are similar in many ways to the spear. The staffs have

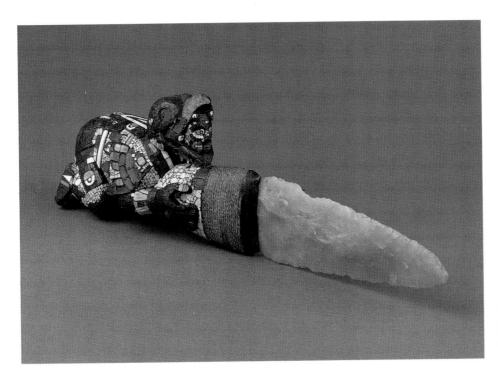

13.12 Aztec Knife. Chalcedony blade, wood handle with inlaid turquoise and shell mosaic, thirteenth–fourteenth centuries, Mexico. See also the text accompanying figure 21.10.

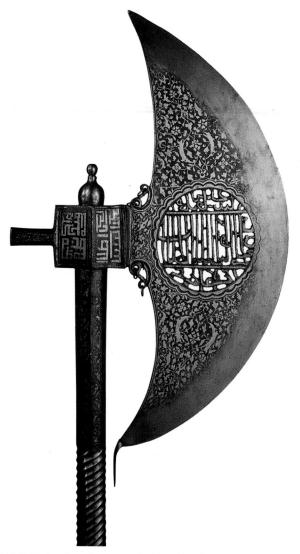

13.13~Battle Axe. Iron damascened with gold, 38% long, late fifteenth century, Mamluk, Egypt.

blade-like shapes that are decorated with incised lines. Spiral curves ornament the sleek shafts. Both staffs have a small head at the top of the shaft, crowned by a large flat wedge. The heads, similar to the head of the figure on the spear, wear very tall, elongated headdresses that are intricately incised. The headdresses may represent the ranks of the staff's owners. All three pieces are elegant in form and carved in detail.

Text Link
For a more complete discussion of African
aesthetics for figure representation, read
the description of the Male Figure
(Ancestor) from Baule (figure 15.13).

Thus weapons are not simply for killing, but are often fetish pieces, richly decorated, sometimes revered, some-

13.14 Ball Head Club. Eastern Sioux. Maple wood, leather, 23¼". c. 1800. Minnesota, USA.

times spiritually potent, and often designed to impress or intimidate.

WAR

Architecture of War

Architecture for war has ranged from ancient fortresses to modern military headquarters and bunkers. We will look briefly at two outstanding examples of fortifications, to see how aesthetic considerations are combined with defense.

One of the most ambitious and amazing accomplishments in the architecture of war is The Great Wall of (figure 13.16). Begun in the Qin Dynasty (221-201 BC) with the major additions during the Ming Dynasty centuries later (AD 1368-1644), this phenomenal wall is a "wonder of the world." It stretches well over 1,500 miles of China like a huge slithering snake and is visible from outer space, as far away as the moon. New pieces of it are still being discovered. The section near Beijing has been restored and is visited by Chinese and international tourists. The wall averages twenty-five feet in height and width, and is faced in brick. It creates a beautifully flowing line that defines and accents the curves of the hills. Its light colors contrast strikingly with surrounding vegetation. Its undulating length is punctuated by strategically placed watch towers that provide points of visual emphasis. The towers contained embrasures for cannons and were used as signal stations. To

13.15 Two Staffs and a Spear. Wood, 60%–63% inches. 1907, Luba, Zaire, Independent State of the Congo.

give warning of the approaching invaders from the north, smoke signals were used by day and fires by night. Today *The Great Wall* is a symbol of national pride and strong will. The past bonds with the present, as people of China flock to the wall with the zeal of patriotic pilgrims.

Another example of architecture motivated by war is the Incan fortress of *Sacsahuaman* located high in the Andes mountains on the west side of the city of Cuzco, Peru (figure 13.17). Sacred Cuzco was the center to the Incan cosmos. Fortified Sacsahuaman functioned as a ceremonial precinct and the seat of government. It contained within its walls several important Incan structures,

among them the holiest, the Temple of the Sun. Legend credits Pachacuti, the Incan king whose name means "shaper of the earth," with erecting new buildings at Sacsahuaman, and in the process, creating the canons of the Inca architectural style. During his reign (1438–1471) he launched campaigns of conquests from which he conscripted laborers for his projects, including 20,000 for the construction of the fortress of Sacsahuaman. Pachacuti consolidated his political authority through this ambitious architecture while quashing any possible resistance. Cuzco was eventually seized and conquered by the Spanish, led by Pizarro.

The aerial view of Sacsahuaman shows its layout and its many walls that still exist. On a steep slope there are three rows of megalithic stone ramparts constructed in a zigzag plan. Above it are other structures including the foundations of three towers. The huge masonry was made of hard limestone, with some stones in the lower walls reaching over 14 feet in height. Some Incan walls were composed of stones that were huge and irregular, yet amazingly were shaped to fit precisely against the adjacent stones, without using mortar (figure 13.18). Other walls were made of coursed rectangular blocks. Some walls were plastered and painted, while others were decorated with beaten gold—the gold removed to pay the ransom of Atahualpa (see figure 12.6), the Incan king captured by the Spanish. The walls were usually constructed thicker at the base tapering to thinner walls above in a gradual slope, and were pierced with goldtrimmed trapezoidal doors, windows, and niches. The roofs were covered in a lightweight patterned thatch. The tapered walls and light roofs made the structures able to survive the fierce earthquakes that plague this area. Many Incan walls still stand, while tremors have crumbled the later Spanish colonial structures built on top of them. Today Sacsahuaman is a place where a blend of Christian and Incan rituals are practiced, for it is still held traditionally as a sacred place to the sun.

Generally, ancient fortresses were situated on a mountain top, or near a body of water, and that natural feature was an essential part of their design and effectiveness. Today, war architecture consists of the military head-quarters such as the U.S. Pentagon building, officer's clubs for the military elite, military bases, missile silos, and elaborate secret bunkers to protect heads of state against any kind of attack. One only hopes that such architecture will become less prevalent in human history.

Art about War

Artists in many cultures throughout time have documented the events of war. In our examples, we will see three different approaches to depicting war. The first group of images presents war as a memorable, even glorious, action-filled event. The second group, from the nineteenth century, shows how art can document battles from various points of view. The last group, dating from the twentieth century, shows a distinct change in artistic

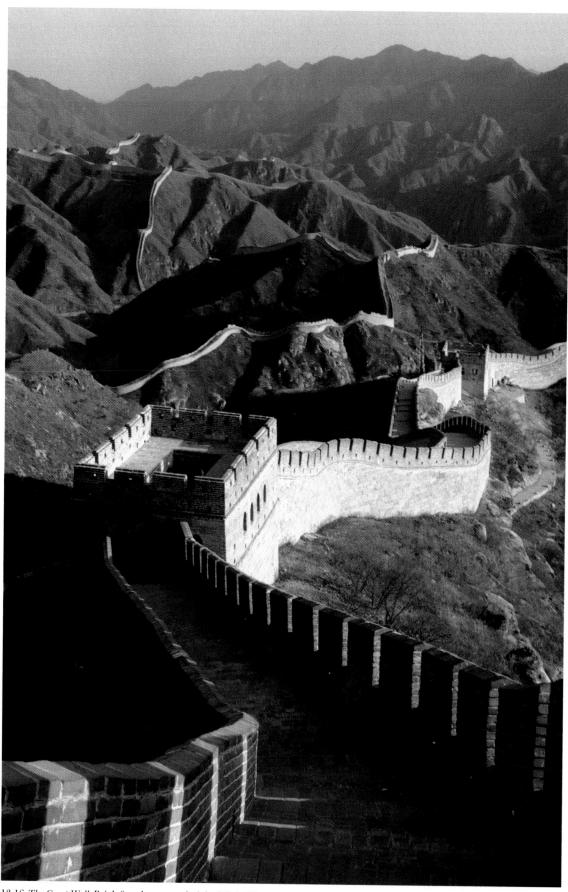

13.16 *The Great Wall.* Brick faced, average height 25', 1,500 miles long. Construction began in the Qin Dynasty 221–206 BC, with major work occurring in the Ming Dynasty AD 1368–1644. China

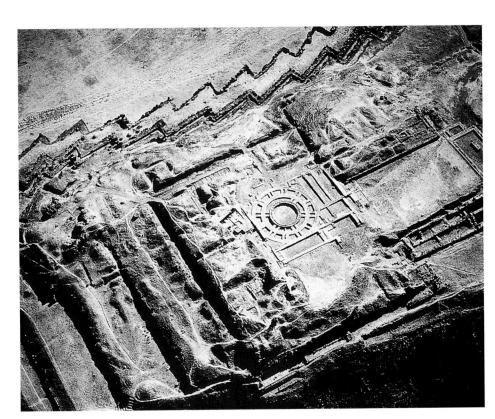

13.17 Overview of the fortress of *Sacsahuaman*, c. 1480, Incan, Peru.

13.18 *Incan Masonry*. Cuzco, Peru, c. fifteenth century. This shows a ten-sided stone that tightly fits without mortar.

depiction of war, in which the horrors of war become most emphasized.

Glorifying War

Our first example of art that glorifies war is the *Palette of King Narmer* (figure 13.19), a relief carving from ancient Egypt, dating from 3000 BC. The palette is a carved slate slab that would have been used to mix the black eye makeup both men and women wore to prevent eye infections and reduce sun glare. However this ceremonial palette did much more. It is a record of the forceful unification of Egypt five thousand years ago, when Narmer (also called Menes), king of Upper Egypt, was victorious in a war over Lower Egypt. He began the first of many Egyptian dynasties.

The *Palette of King Narmer* is larger than normal-size palettes found among ancient Egyptian artifacts, and is carved on both sides in picture-writings that set the style for future Egyptian art and also were the precursors of hieroglyphics. On the back side in the center of the top band is the pictograph of King Narmer's name. In the square is a horizontal fish which corresponds to "nar" and below it is a vertical chisel for "mer." This symbol appears on both sides of the palette. Flanking Narmer's name are two images of the cow goddess of beauty, love, and fertility, Hathor, who was the king's protector. In the next large register below in hierarchical order is the biggest figure on the palette, King Narmer. The king is wearing the tall white crown of Upper Egypt.

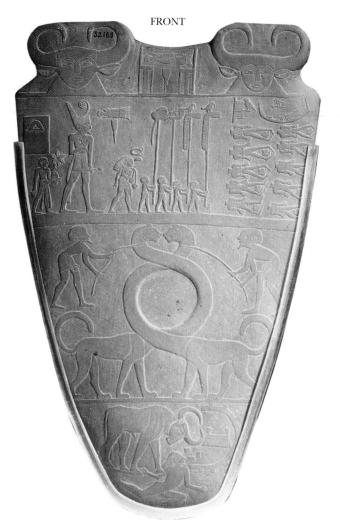

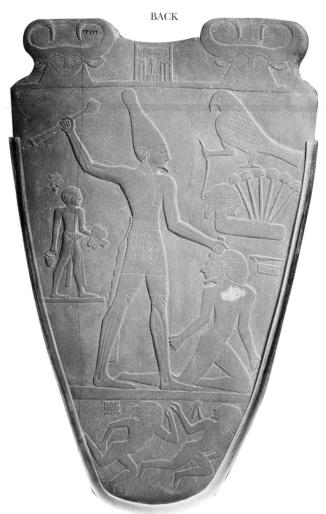

13.19 Palette of King Narmer, ca. 3100 BC, slate, 25" high, Egypt.

Repeatedly, the Palette of Narmer glorifies the king's unification of Egypt by means of war. On the back relief, he is holding the head of his enemy by his hair and about to execute the deadly blow with his mace. Behind him is a servant who is carrying his sandals, suggesting by his bare feet that this is holy ground and that this event was divinely predisposed. In front of the king and facing him is a falcon perched on a clump of papyrus plants. In one talon is a tether with a human head attached, which is also growing from the base of the plants. The falcon is the head of Horus, the god of Upper Egypt and it represents the divine aspect of King Narmer and his victory. The plant on which he triumphantly stands and the head he is holding symbolize the conquering of Lower Egypt. In the bottom register are dead prisoners. The small rectangular shape next to the left figure likely symbolizes a citadel or fortified city that has fallen with the enemy.

On the other side of the palette we again see the triumphal Narmer uniting Egypt by war. Once more, we see in the top band the heads of Hathor with Narmer's pictograph centered between them. In the register be-

low again we see the king who is now triumphantly wearing the cobra crown of lower Egypt. Again he is barefoot followed by a servant carrying his sandals. Narmer inspects the beheaded prisoners lined up in rows with their heads tucked between their feet. He is preceded by an elaborate entourage of standard bearers. In the next band we see two men holding two feline-like beasts with long intertwined necks forming a circular indentation in the palette. This area was used to prepare the eye makeup. Although scholars dispute the exact meaning of the beast imagery, it may represent unification of Egypt. In the bottom register we see a bull, a defeated enemy, and a citadel. The strength and dominance of Narmer is represented in the bull and his victory over his foes. Note the bull's tail tucked into Narmer's waistband on the back relief.

As we mentioned, the *Palette of Narmer* set precedents for Egyptian writing and art. Looking at the figure of Narmer we see the distinctive rendering of the human body that became so typical of the Egyptian style. As we see here and in later Egyptian art, not only are the proportions important and standardized, but also the pose,

which combines profile and frontal features, resulting in a contorted, but complete image of the subject. Size was also significant, as it indicated figures of greater or lesser status. Note also the organization of the palette. Divided into precise sections (or registers), the information can be read easily, without confusion.

Text Link

You can see another example of the Egyptian style of figure representation in Pharaoh Crowned by the Goddesses Nekhbet and Wadjet, in figure 10.19.

Another famous battle, Alexander and Darius at the Battle of Isus (figure 13.20), is the subject of a beautiful floor mosaic from an upper-class home in Pompeii, from the era of the Roman Republic. The House of the Faun dates back to the fifth century BC, and was elegantly decorated. Along with the beautiful mosaics in the home, classic sculpture also adorned the rooms, such as "The Faun," which was placed in a fountain in the atrium and thus gave the house its name. (A "faun" is a part man-part goat ancient Roman deity of the countryside). Our mosaic is in one of the main rooms, set directly into the pavement with small pieces of local colored stones and glass. The scene represents the last phase of the battle as the Persians start to flee the Macedonians, led by Alexander's charge. The Battle of Isus gave the young Macedonian king another victory to add to his long list of conquests.

The throng of soldiers and lances expresses the confusion and panic of a losing battle, while Alexander boldly and confidently makes his assault. The artist achieved a sense of a large crowd, when actually there are relatively few figures in the composition. The diagonals created by the lances increase the energy and action of the scene, adding much drama and tension to the

documentation of the event. The mosaic is a reproduction of an older Greek painting, variously attributed to Filosseno of Eretia, Aristide of Thebes, or Elena of Alexandria.

Next is a battle scene from medieval Japan, during the Kamakura Era, a particularly militaristic period in Japanese history. Japan was convulsed by civil war precipitated by prominent clans vying for power. It was also invaded twice by the Mongol emperor, Kublai Khan. Warfare and artistry were particularly interwoven at this time. Thus, Japanese armor and weapons were cleverly designed and refined with aesthetic sensibilities. The martial arts themselves were elevated to a precise art form. And literature featured long tales of war and battle, in contrast to the period immediately preceding that featured tales of courtly love. One of those tales, the Heiji Monogatari, tells the story of the Heiji insurrection, a power feud between two clans that lasted approximately four years in the twelfth century.

The literary tale is the narrative base for a thirteenthcentury scroll by the same name, the Heiji Monogatari. The scroll is a long horizontal band, a particularly effective format for illustrating stories that happen over a period of time. The nearly 23-foot-long scroll was meant to be unrolled from right to left to show one scene at a time, and to be viewed privately by two or three people. Our scene shows the Burning of the Sanjo Palace (figure 13.21), where the tumult and disorder of warfare is effectively illustrated. Flames and smoke erupt from the burning palace as the raiders dash away to the left, trampling their victims as they flee. Other victims are trapped in the burning rubble. To make the raid seem even more disorderly, the artist used strong visual contrasts. So the marauding soldiers and burning palace with their jumbled shapes are visually very different from the clean lines of the palace roof. The riot of charging soldiers and bright red flames fill the center of this detail, while

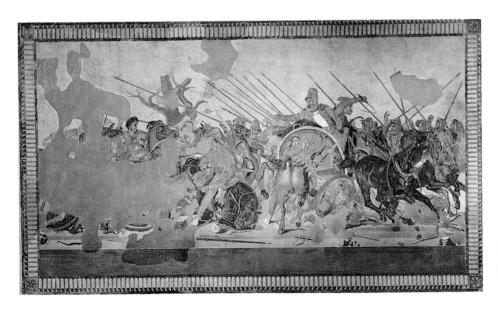

13.20 Floor mosaic of Alexander and Darius at the Battle of Isus, from the House of the Faun, Pompeii, Italy. $11' \times 19'$. Fourth century BC.

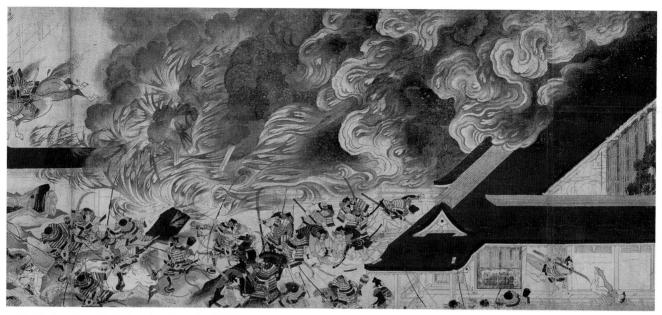

13.21 The Burning of the Sanjo Palace, from the Heiji Monogatari. Handscroll (detail), ink and color on paper. Height: 16.25", overall length 22 ft., 9 in. Japan, Kamakura period, late thirteenth c. Museum of Fine Arts, Boston. Fenollosa-Weld Collection.

to the lower right, we see in monochrome the death of a palace attendant. In fact, throughout the scroll the artist used contrast as a device to build and diffuse dramatic moments, such as some scenes that show turbulent masses of soldiers next to others that focus on a single horseman or archer.

19th Century Battle Scenes

Our next two examples of battle scenes show how art can do more than simply glorifying war. Our first is *Dead Confederate Soldier with Gun* (figure 13.22), a U.S.

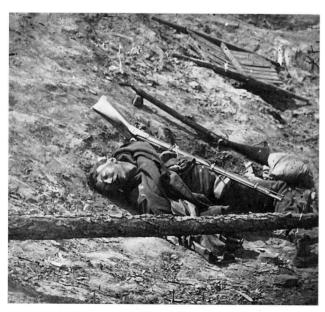

 $13.22~\mathrm{Mathew}$ B. Brady or staff. Dead Confederate Soldier with Gun. Civil War photograph 1865 USA.

Civil War photograph by Mathew B. Brady (or staff) from 1865. In previous examples we have just seen, the artists had license to exaggerate or even fantasize their interpretation of the battles and their heroes. The nineteenth-century invention of the camera changed that. While photographers could still make romanticized portraits of the War Hero, they also began to make gritty, horrific representation of the battlefield. Brady was an early pioneer in this style of photography, which was considered to be realistic photojournalism. Before the Civil War, Brady owned and operated a famous studio on Broadway in New York City, where he photographed portraits of the rich and famous, including Abraham Lincoln. He requested permission from the president to photograph the rebellion, mistakenly thinking the war would only last a few months. After four long years and much of his earlier earned fortune spent to finance this project, he had taken over 3,500 photographs covering both sides of the conflict, with scenes varying from soldiers' barracks and munitions to the destruction of war and the hideous human slaughter. For the first time a war had been photographically documented with the detail that only the camera can capture.

In making his images, Brady took care to frame and compose his shots, and often advantageously arranged "props," such as the rifles, to better compose his pictures and emphasize his subjects. *Dead Confederate Soldier with Gun* shows Brady's framing, which in this case both enhanced the visual beauty of the picture and emphasized the sense of tragedy. The rough texture of the ground fills the entire image, except for the dramatically lit planes of the soldier's face. The fallen tree trunk in the foreground forms a horizontal barrier that

Text Link
Contrast the staged Brady photograph with
the grisly immediacy of the Eddie Adams'
1968 photograph, General Nguyen
Ngoc Loan summarily executing the
suspected leader of a Vietcong commando unit (figure 11.32).

Brady used photography to record war, and photography is often associated with factual reporting. But "factual" reportage, by necessity, is edited or limited. With video, viewers may watch events as they happen, as with the World Trade Center disasters. But the video camera records only one point of view, and that can be edited. Photographers choose which pictures to "take," and which to ignore. Editors select only a few images to print. In the 1990s, with Desert Storm, the world witnessed a war happening before their very eyes on television. Such reportage again has the illusion of objectivity, but in fact the U.S. Pentagon controlled the press's access to events. In some cases, art can provide us with an alternative record of events, one that differs from the official record.

Let us look at an example of Native American art, the *Battle of Little Big Horn* (figure 13.23), painted in 1880 by the Sioux artist Red Horse. It presents the Native

American point of view, which was conspicuously absent in Western art and history. The painting is a colorful depiction of the defeat of General George Custer and his troops. The Sioux had been given land by treaty with the U.S. government, but the U.S. government then tried to revoke the treaty because of rumors that gold had been discovered there. In addition to the intrusion of settlers and miners, the Great Northern Railroad cut through the buffalo ranges, provoking the Sioux even more. To gain control over the rebellious Sioux, the flamboyant General Custer tracked Sitting Bull to Little Big Horn, thinking that his capture of this renowned chief would help him to be elected U.S. president. As the painting illustrates, Custer fell and the Sioux won their final victory. However, this battlefield victory was the last for the powerful Sioux nation.

In this image, Sioux warriors advance from the right, killing U.S. soldiers who fall from their horses. The dead and wounded from both sides occupy the bottom of the image. Red Horse's style combines overlapping and nonoverlapping figures, to convey at once the crowdedness of the battle scene, and also to record detail clearly. His sense of visual organization makes the message readable.

Twentieth-Century Images of War

In the twentieth century, photography was used increasingly to document war. In addition, in the early twentieth century, leaders of state and political groups were eager to use the new art form of film to record and glorify their history and to propagandize their mission. Other artists continued to use traditional media such as paint to express passionate opinions about national conflicts. While war is still glorified, the twentieth century

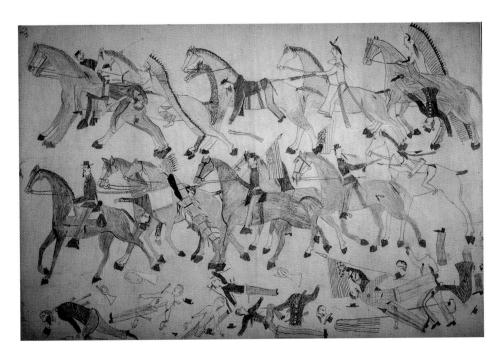

13.23 RED HORSE. Battle of Little Big Horn. Sioux. USA. 1880.

saw more and more images that present the horrific side of war.

Text Link

In Chapter 14 we will see several artworks effectively used in protest against war, like Francisco Goya's Executions of May 3rd, 1808 (figure 14.1).

Text Link

Not all twentieth-century images frame war as a horrific event. Adolf Hitler used film to glorify the military might of the Nazi party in Germany, as we saw in Leni Riefenstahl's 1934 film, Triumph of the Will, in figure 12.11.

After the revolution of 1917 in Russia, Communist leader Vladimir Lenin saw the advantages of film as a new medium and supported the development of film making. The government commissioned a filmmaker to have its revolutionary history captured on screen, and the artist who brilliantly achieved this was Sergei M. Eisenstein. Eisenstein glorified the collective heroism and martyrdom of the Soviet people in his masterpiece film, The Battleship Potenkin, made in 1925 (figure 13.24). Although a great admirer of the U.S. filmmaker D. W. Griffith, he expanded the expressive vocabulary of film. His camera shots varied from full, medium, close up, to extreme close up, and included pan, iris (blurred edges), and traveling (moving from front to back or back to front). Flashbacks and cross-cutting (two events edited together for dramatic effect) were also part of his compositions. But Eisenstein's genius was his editing. He used a rapid form of "montage," a kind of cinematic collage of images. The fast pace and juxtaposition of images allowed the viewers to conclude the action of the multiple scenes.

In the Odessa Steps Massacre sequence in Battleship Potemkin, Eisenstein bombards the audience with a climactic montage showing the horrendous results of a failed historic uprising against Czarist Russia in 1905. The story dramatically unfolds with 155 separate shots in four minutes and twenty seconds, all filmed from various camera angles. The sequence relates the moment when the people crowd into the port of Odessa to welcome the battleship Potemkin, which has just been successfully liberated. Above on the steps behind the crowd are the Czarist soldiers, who proceed to fire on the people. The horror and confusion is expressed with fleeting images of the soldiers firing, a mother holding a dead child, a soldier swinging a club, the bloodied face of a beaten woman, a baby in a carriage that careens down the steps, a horrified student, and the dreadful aftermath of the

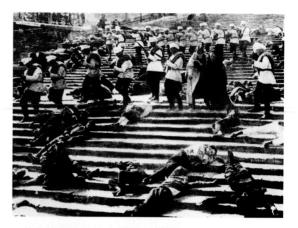

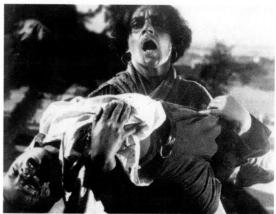

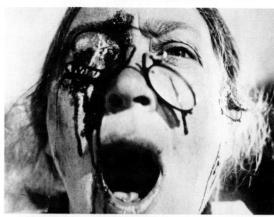

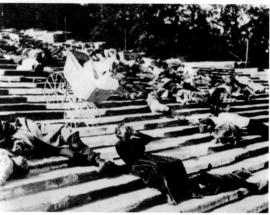

13.24 Sergei M. Eisenstein. Film stills from $\it The\ Battleship\ Potemkin$. Russia, 1925.

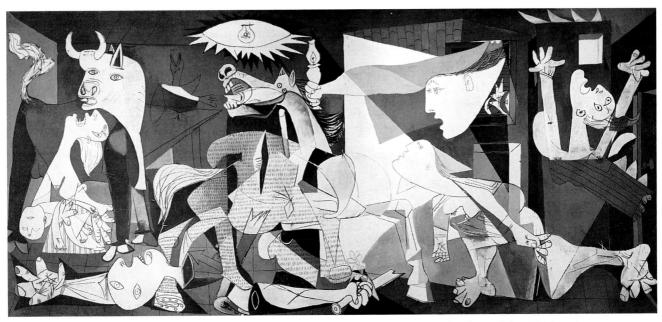

13.25 PABLO PICASSO. Guernica. Oil on canvas, 11' × 28'8". Spain, 1939. See also the text accompanying figures 2.3 and 5.10.

dead lying on the stairs of the port. With this technique the audience finds themselves caught in the action of the scene, enabling them to feel the terror and panic of the event portrayed in the movie.

One of the greatest twentieth-century paintings is Guernica (figure 13.25) by Pablo Picasso. Guernica was the capital of the Basque Republic in northern Spain that had been granted autonomy by the Spanish Republican government. When civil war broke out in Spain, fighting between General Francisco Franco's Fascist forces and the Republican Basque troops also began. In 1937 the Basque troops were retreating to Guernica by crossing over a bridge that led to the city. Franco and his officers decided that this bridge should be destroyed along with the city. He obtained the services of Germany to do this deed, which allowed the Nazis to experiment with a new form of saturation bombing, called the "blitzkrieg." Three forces of 33 planes, each armed with three thousand pounds of bombs and hundreds of incendiary cylinders, bombarded Guernica for three and a quarter hours. Three days later when the fires died down, fifteen square blocks and the humanity living there had been annihilated, while the bridge remained intact. Over one thousand people tragically perished.

As a supporter of the Spanish Republican government, the Spanish artist Picasso exiled himself to Paris. There he received the news of the Guernica massacre. Shocked and outraged, he immediately set down sketches for the painting. Ironically Picasso had been approached shortly before the raid by the exiled Spanish Republican government to paint a mural for the 1937 World's Fair in Paris. The mural would be for the entrance hall of the Spanish pavilion. Picasso had an immediate exhibition opportunity to show Guernica, which he finished on June 4th, only thirty-nine days after the bombing.

Using imagery that had been part of his visual vocabulary in previous works, Picasso blended the nightmarish aspects of Surrealism with his own style of Cubism to create a powerfully expressive work. The bull represents Fascist Spain, its darkness and brutality while under the rule of Franco. Under his evil forces, Spain would have the same fate of a bull in a bullfight; it would be tortured and suffer a slow inevitable death. The gored dying horse rearing in agony is the Spanish Republic, while the fallen soldier holding the broken sword represents the spirit of resistance against tyranny. The looming profiled head expresses shock while witnessing this suffering and carnage, as it gazes under the dimmed light of the oil lamp. The electric light bulb in the eyeshape at the top of the painting suggests that the world is being shown its inhumanity. The torment and anguish is detailed with a mother holding her dead child, a woman berating the horror with her uplifted arms, and another woman bent and crawling. All of the imagery, abstracted, contorted, and distorted, profoundly alludes to unbearable pain.

Besides the brilliant use of imagery, Picasso organized the pictorial elements in an effective composition. Using tones of white, black, and grays, he varied the values and overlapped the planes and textures to move the eye constantly back into the piece. A triangular shape gives focus to the imagery. The viewer remains caught in the center, visually surrounded by the human devastation represented in the work, unable to escape the imagery.

Picasso experienced a conversion after the holocaust of Guernica. In his work before he had not expressed his moral or political views, but was more concerned with the formalistic elements in art. Subsequently his role of an artist and his political commitment changed. He said "Painting is not done to decorate apartments. It is an instrument of war for attack and defense against the enemy." While the painting, Guernica, has always been seen as a major artwork, it has also been an important political symbol. Picasso lent Guernica to the Museum of Modern Art in New York until such time as a democratic form of government should be reestablished in Spain. Both the United States and Spain sought ownership of the famous painting, but finally in 1981, after the death of the Fascist leader Franco, the painting was returned to Spain.

War Trophies and Prisoners

Pillage and plunder have always been part of war. Victors often seize from the conquered lands everything of value, which can include human prisoners and art. This has been true throughout the history of human warfare, from ancient times to the present day. For example, at the beginning of World War II, the Nazis carried off art from areas they occupied in Western Europe and Eastern Russia. More recently, in the Iraq-Kuwait war in 1990, the entire Kuwait's collection of Islamic art was confiscated by the Iraqi forces, and Kuwait's museum was destroyed.

Text Link

The Arch of Titus is decorated with relief carvings showing Roman soldiers carrying away Spoils of Jerusalem (figure 12.28).

The Middle East has been a region for plunder through the centuries. Many conquering armies have invaded it, and have carried off its wealth of art and antiquities. Egypt has been hit particularly hard through the centuries. The French, led by Napoleon Bonaparte, did their part. In the late eighteenth century Egypt was ruled in name only by the Turkish sultan. In reality it was controlled by the Mamluks, who were a mercenary class who profited off heavy taxation. Napoleon took political interest in Egypt and its tremendous commercial potential. He was also concerned lest the British take over the strategically important Nile Valley. In 1798 he mounted an expedition to seize Malta and Egypt, and to build a canal at the isthmus of Suez. With his fleet and force of 38,000 men, he invaded Egypt near Alexandria. Included with the forces were 167 members of a special "Scientific and Artistic Commission," all carefully selected by Napoleon. The duty of the commission was to follow the French army, examine seized artifacts and art collections, and decide what would be taken for the

French Republic. The commission helped take art both from Italy and Egypt, and those treasures fill the Louvre today.

Despite invading Egypt and plundering its art monuments, the French made great contributions to the fields of Egyptology, or the study of Egyptian antiquities. Napolean established an institute for the study of Egyptian culture. One of his army's most valuable finds in Egypt was a basalt tablet inscribed with three different scripts, found in the delta town of Rosetta. The Rosetta Stone (figure 13.26) was the key to deciphering Egyptian hieroglyphics. The three scripts incised on the tablet were the formal hieroglyphs, Demotic (a late cursive script), and Greek. An English physician named Thomas Young linked some of the hieroglyphs to specific names in the Greek inscription. Later the Frenchman Jean François Champollion deciphered the stone by locating the names of the pharaoh King Ptolemy V and Cleopatra in the Egyptian scripts. He also found Ptolemy and Cleopatra's cartouches on the Philea obelisk, where he recognized four phonetic signs. These enabled him to attribute an alphabetical significance to other symbols. The door to understanding ancient Egyptian culture had been opened.

Eventually Britain's Admiral Nelson defeated Napoleon's fleet and his occupation ended in 1799. The plundered art was then taken by the British and the *Rosetta Stone* became part of the British Museum's collection. Both England and France have many Egyptian treasures on display in their museums today as a result of these wars.

While art objects and priceless artifacts have always been part of the spoils of war, human beings taken for sacrifice or slavery have been part of the atrocities of war. Above the fertile valleys in Oaxaca, Mexico, the remains of the ancient Zapotec ceremonial center of Monte Alban lies on a leveled mountain top. In one of the three courts constructed there, the Temple of the Danzantes is faced with reliefs bearing curious imagery. Our example, the *Danzante Stele*, roughly dated from the sixth-third centuries BC (figure 13.27), is one of more than four hundred stone slabs, each carved with limp, naked figures with closed eyes, open mouths, and some with mutilated genitalia. Most figures are in a frontal position or in three-quarter view, their heads always in profile. They all appear to be portraits and all are very dead. Some have glyph cartouches near their faces, while others have notations in the 52-year Calendar Round System. The inscriptions may have given the name of the figure or the date of the individual's death. Over three hundred slabs were carved and set in rows, while later one hundred more were redeposited in the construction of newer buildings.

Each slab or stele's image stands alone, and does not visually relate to the others. The figures are all drawn with contour lines only, and those lines have been

13.26 Rosetta Stone. Basalt slab, Egypt, New Kingdom. See also the text accompanying figure 21.11.

incised into the surface of the stone. The name "danzantes" was given to these unique reliefs because nineteenth-century scholars interpreted them as dancers. Later interpretations varied from sacrificial prisoners of war to actual portraits of the slain kings and rulers who were conquered by Monte Alban forces. These slabs altogether may have been a war memorial to proclaim the military strength, political power, and ferocity of Monte Alban.

War Monuments and Memorials

An entire book could be devoted to monumental art dedicated to the glory of victories, battles, and the dying of the brave. Patriotism and the display of power and might have inspired many great nations to create awesome structures of art in order to impress their citizens as well as their enemies. The structures usually commemorate a person or an event (or both), and usually take a massive form such as an arch, column, or greaterthan life-size sculptures.

One nation that especially displayed its imperial authority in official, public, and triumphant monuments was Rome. The Romans had much to commemorate and memorialize. They had highly organized armies, brilliant officers, efficient government, and the tremendous amount of booty and taxes raised from their conquests. One phenomenal monument among many is Trajan's Column (figure 13.28). Trajan was a great general and emperor of Rome while the empire was at its height in the second century AD. Erected in 113, the

13.27 Danzante Stele. Sacrificial prisoner incised in relief on a stone slab. 52%" high. Monte Alban I, Oaxaca. Mexico, c. 600–300 BC.

column celebrates Trajan's victories over Dacia (Romania) in 101 and 105–106 AD. The column soars 128 feet high. On the surface, spiraling upward is a long, continuous relief with 150 episodes showing the campaign against the Dacians. Inside the column is a spiral staircase leading up to a high balcony. At the top once stood a gilded statue of Trajan (now a statue of St. Peter). By climbing the stairs, citizens of Rome could pay homage to Trajan, for his remains were entombed in the column. Once at the top, they had a spectacular view of Rome.

The narrative spirals up the column, like a scroll unwinding. It is an ambitious carving, jammed with details. It contains 2,500 figures, and if unrolled, would be 656 feet long. While the top images are impossible to see from the ground, the column was originally located between a pair of two-story libraries (which contained scrolls) and other structures, and so the imagery would have been clear from a number of vantage points. The bottom part of the scroll is 3 feet high, which expands wider to 4 feet on the top for easier reading, and the relief is low and shallow so that deep shadows would not cover the imagery. The whole scroll was painted and

gilded, which may have also helped in deciphering the upper carvings. In order to "read" the entire narrative, one would have to circle the column 23 times, and without the aid of a rooftop, would definitely be in the need of binoculars.

The reliefs do not emphasize actual battles, but are focused on the order and discipline of the Roman army, along with their expertise in engineering. The Dacians are depicted as unruly, unorganized, and inferior, yet still as worthy opponents to the Roman army. The artist (perhaps Apollodorus) abandoned naturalism in order to pack information into the pictorial space in a most economical way. Trajan was the largest figure when he appeared. The architecture is shown as shrunken backgrounds behind the theatrical action of the figures in front.

Centuries later, the United States erected a monument that would capture the spirit of one of its fighting forces. The *USA Marine Corps War Memorial* (figure 13.29) sculpted by Felix W. Weldon and dedicated in 1956, commemorates those who died in the victorious battle for Iwo Jima Island in World War II. The island was strategically important as an air base for fighter escorts supporting long-range bombing missions against Japan. After 36 days of hard battle, the marines secured Iwo Jima. Casualties were heavy, with 6,800 U.S. soldiers and over 18,000 Japanese dead.

The war memorial recreates an actual event, in which marines charged up Iwo Jima's Mt. Suribachi and planted the U.S. flag there. The pose and figures in the sculpture were copied from an Associated Press News photograph taken by Joe Rosenthal, that was taken after the event. Rosenthal's photograph was staged, as this was the second time the marines raised the flag atop Iwo Jima; the first time the marines had used a smaller flag, one of their own photographers, and were interrupted by a grenade hurled by a Japanese soldier. Weldon's sculpture is an over-life-size bronze, grand and dramatic at the same time. The triangular shape formed by the figures suggests strength and solidity, while the numerous diagonals within give a sense of tumbling, hurrying forms. In the sculpture, the commemoration of the past event is blended with present-day reality: every day an actual flag is raised and lowered on the flag pole in the memorial. A popular monument, it has become a symbol of pride and patriotism to the American people.

PEACE

While there have been many works of art relating to war, those dealing with peace have been conspicuously few. Unfortunately humankind has celebrated in art its wars and war heroes to a greater extent than its peace and peacemakers. However there are some artworks that relate to peace which we will look at now.

13.28 *Trajan's Column*. Rome, Italy. c. AD 114. 126' high, marble.

Art about Peace

One image that expresses the concept of peace is Edward Hicks' *The Peaceable Kingdom* (figure 13.30), painted in 1830–1840. Hicks, a Quaker convert, based his image on the following biblical passage:

The wolf also shall dwell with the lamb, and the leopard shall lie down with the kid; and the calf and the young lion and the fatling together; and a little child shall lead them. And the cow and the bear shall feed; their young ones shall lie down together; and the lion shall eat straw like an ox. And the suckling child shall play in the hole of the asp, and the weaned

child shall put his hand on the cockatrices' den. They shall not hurt nor destroy in all my holy mountain; for the earth shall be full of knowledge of the Lord, as the waters cover the sea. (Isaiah xi)

Hicks was motivated in part by his own struggles with "drink and riotous living," but he was also inspired by the historical event of the Quaker William Penn and his treaty with the Indians, visible in the background, which we will discuss with figure 13.33. The metaphors he used in his painting have become standard language for expressing the concept of peace. A luminous sky glows in the background, while lush vegetation frames the

 $13.29~{\rm FeLIX}$ W. Weldon. USA Marine Corps War Memorial. Arlington, Virginia, 1954, cast bronze, over life-size.

foreground figures. The animals are rendered in a flat, decorative, imaginative style. Their wide staring eyes and the patterns of their fur are emphasized. There is a feeling of innocence and peace, without strife and turmoil. Hicks was not inhibited by academic rules of proportion and style. Along with his natural talent, his only art training occurred on the job as a sign maker and carriage decorator.

Let us turn now to an image of a peacemaker as represented in art. Mahatma Gandhi was born in 1869 in British India and was raised in a strict Hindu household. However his mother encouraged him to learn beyond the limitations of his caste and he "crossed the black waters" (meaning he violated the caste system) and went to England to study law. After he graduated he went to live in an Indian community in South Africa, where he took on the struggle against discrimination of his people by the white African rule, and for justice and equality through nonviolent means. His development as a pacifist grew from his Hindu roots, from the readings of

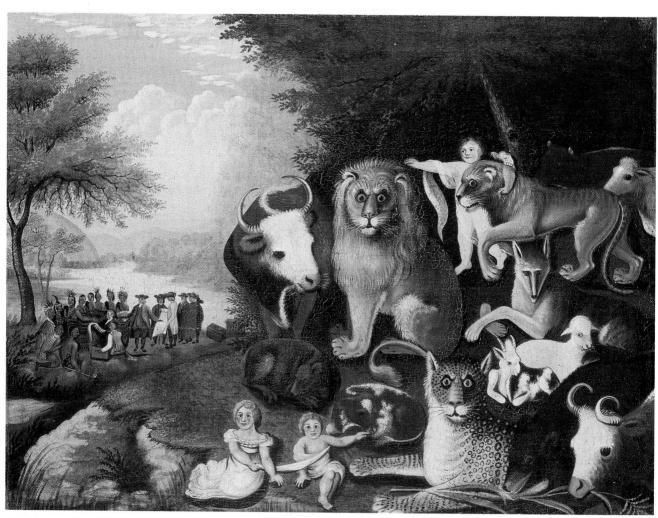

13.30 EDWARD HICKS. The Peaceable Kingdom. USA, 1780-1849, oil. See also the text accompanying figure 1.4.

13.31 Mohandas (Mahatma) Gandhi, enshrined between two goddesses on a Madras temple. India. Carved stone relief, twentieth century.

Christian gospels, Tolstoi, and David Thoreau, the originator of passive resistance. From Jainism came the renunciation of killing living beings, nor to consent to anyone else doing the same. Through his devout beliefs in and the practice of self-discipline, self-sacrifice, and moral purity, Gandhi conducted nonviolent campaigns for national unity, equality, and independence from Britain. He used strikes, street demonstrations, withdrawal of cooperation, and symbolic breaches of the law to exert pressure for change. For 40 long years Gandhi patiently and peacefully pursued his goals and finally India was granted its freedom in 1947.

In figure 13.31, we see Mohandas ("Mahatma") Gandhi enshrined in a temple frieze between two goddesses. The temple is dedicated to Durga, also known as "Maha Devi," the Great Goddess who dates back 5,000 years. Like Gandhi, she was a persistent force that could not be extinguished. She is Shiva's wife, Parvati, Kali, the Black Goddess who destroys evil, and Durga, who carries weapons in her arms to destroy evil. She is also found today enshrined in Indian homes as the beloved mother who protects them from evil. As we can see, Gandhi has been placed in the company of the Goddesses, who are among the most beloved and respected in India. Like the Goddesses, this man was and is also loved and respected by his people, along with many other people in the world. A humble man, he is shown standing in simple clothing. His attention is turned outward, and he does not seem to be posing for veneration. His sculpted form emerges from and contrasts with the deeply cut shadow areas behind.

Treaties

One of the oldest and perhaps the first peace treaty to be documented in art was the *Egypto-Hittite Peace Treaty* (figure 13.32) from approximately 1270 BC. It commemorates an extraordinary treaty between two powerful empires, the Egyptian and the Hittite, which had been at war for sixteen years. Each had formidable armies. Eventually, both agreed to peace, the Hittites in part because they were beset by internal divisions in the ruling family, and the Egyptian in part because Hittite chariots were very effective against their ranks. The peace treaty contained some extraordinary terms, among which were: both sides made land concessions; each agreed to come to the other's aid; and they agreed to a mutual nonagression pact. Copies of the treaty existed on silver tablets, papyrus, carved stone, and clay. In figure 13.32

13.32 *Egypto-Hittite Peace Treaty*, wall-stele of the temple of Karnak. 1270 BC, Egypt.

13.33 Benjamin West. *Penn's Treaty with the Indians.* Oil on canvas. 75.5×108.25 in. USA, 1771. Pennsylvania Academy of Fine Arts, Philadelphia.

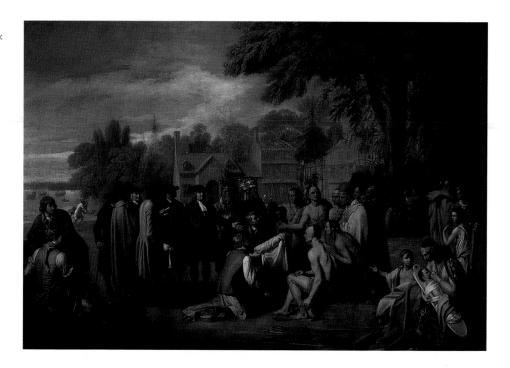

we can see the Egyptian documentation of the treaty, engraved permanently in stone on the walls of a temple at Karnak. Ramses II is depicted worshiping the gods in the scene at the top, who were witnesses to the event.

Another historical depiction of a peace treaty was painted hundreds of years later by the American-born artist Benjamin West, in Penn's Treaty with the Indians, dated 1771 (figure 13.33). William Penn was the Quaker leader, reformer and founder of Pennsylvania, who sought to live in peace with the Native Americans. West painted the figures in classic balance and composure, like figures in a Greek frieze. The Native Americans have idealized bodies, like Greek sculptures. They calmly and peacefully interact with the Quakers, who are also in the center of the composition. Additional figures on each side balance the central cluster. Settlers were placed in the left foreground and a nursing native mother with her children on the right, representing the two factions that might be opposed. Lights and darks are balanced in this composition, both in the landscape and in the foreground figures. Visually, the pacifist Quakers are shown as the mediators offering peace between the two groups who want to live in the same land. In this scene of treaty making, Penn and the Quakers not only promote a utopian new world, but project their new faith and life-style by this example.

By painting this scene in a classical, idealistic style, Benjamin West revealed his own artistic training. West was a self-taught painter whose early exposure to art in America were limner paintings (simple portraits), work signs, and etchings. Later he was influenced by the British portraitist John Wollaston, especially in his rendering of the shimmering silk and satin finery worn in that day. At age 22 West traveled to Rome where he had the opportunity to view classical Greek sculpture. Impressed with the classical art he saw and with his new friends, West developed a style of simplicity and grandeur and focused on making history paintings, which were large canvases that documented in an idealizing style the great moments in history. West's style was completely suited to expressing the utopian ideals that formed the basis of this historic treaty.

Peace Offerings and Peace Monuments

Art is used both as exchange offerings for peace and also to memorialize peace. First, peace offerings: when agreements are made and peace treaties are signed, gifts are often exchanged to seal the arrangement. Precious objects might also be offered to show submission or to avoid further confrontation.

Our first example is the splended *Moctezuma's Headdress* (figure 13.34), believed to have belonged to the last Aztec ruler. Moctezuma may have given it to the Spanish leader Cortés as a peace offering, or as a desperate last measure to avoid his own demise. Objects made of feathers are frail and feather-working is a rare skill. Not many examples of feather-work survived to this day. This one is exceptional. Moctezuma's 4-foot-high headdress is constructed of brilliant iridescent green feathers from the tail plumage of the Quetzal bird. It is trimmed in blue feathers of the Cotinga bird interwoven with small gold disks. The feathers came from royal aviaries that were attended by three hundred workers. The feather-work of our example is believed to have been woven by Moctezuma's wives and concubines.

369

13.34 Moctezuma's Headdress. Quetzal and Cotinga feathers, gold plaques. Aztec, c. 1319, Mexico.

A few centuries later, Native Americans created objects designed exclusively for peaceful exchange. Around 1820 the peoples in the Great Lakes area, specifically the Ottawa tribe, received the Presentation Pipe Tomahawk (figure 13.35). Its function as a weapon has been made void by its aesthetics and the ritual giving as a peace offering. Crafted only for "presentation" purposes, this fine example is made of hickory wood, silver, iron, and lead. On the handle top in a silver inlay is engraved the name "Ottokee," the name of the recipient of the gift. Inlaid also in silver in the handle is a naturalistic fish followed by an abstract curvilinear pattern. On the head and blade of the tomahawk is engraved an acorn, a heart, and a half moon. The style of the engravings are reminiscent of the Armor of Archduke Charles (figure 13.8), suggesting European influences. Not knowing the specific identification of the artist, this piece may have been crafted either by European, American or Ottowan metal smiths. Whoever crafted the piece, it was an elegant gift to receive.

Now, we turn to peace monuments. Again, unlike the multitude of monuments devoted to war and lost lives, peace monuments are fewer in number. One from Rome is the Ara Pacis Augustae (figure 13.36), from 13 to 9 BC. The monument was built upon the Emperor Augustus' return to Rome after he had been away to quell the civil wars between Spain and France. Augustus himself recalls when and why the Ara was built: "When I returned to Rome from Spain and Gallia, under the consulate of Tiberius Nero and Publius Quintilius, successful in their undertakings in these provinces, the senate decreed that the Ara Pacis Augustae (altar of the

Augustan Peace) should be consecrated for my return, near the Campus Martius, and ordered that magistrates, priests, and Vestal virgins should offer a sacrifice every year." (Bianchi 1994: 7)

The full monument consists of an altar on a podium that is enclosed by a rectangular wall. There are twelve steps to the entrance that opens to the altar. The walls are covered with reliefs inside and out. The lower section of the outer walls are decorated with a wide band of foliage ornamentation, while above are figurative reliefs of the Earth Mother Tellus, Aeneas, the legendary founder of Rome, and two long processions led by Augustus. The processions are informal and casual, and echo the Greek Hellenistic style of sculpture. Each face is a portrait, and each figure is placed in hierarchical rank in the parade. The processions wrap around three sides of the monument. The foliage designs are unwinding acanthus vines with vegetation and small animals incorporated in them. They symbolize the golden age of plenty and fecundity, ripeness, and peace, all under the rule of Augustus. The walls inside are decorated with garlands of fruit symbolizing the abundance of the empire. Interwoven in the garlands are heads of bulls indicating a sacrificial offering, along with a sheep, a heifer, and the "victimari" (humans for sacrifice). It is likely that the altar and enclosure were brightly painted.

Text Link

The Earth Mother Tellus relief, from the Ara Pacis Augustae, is discussed in figure 9.1.

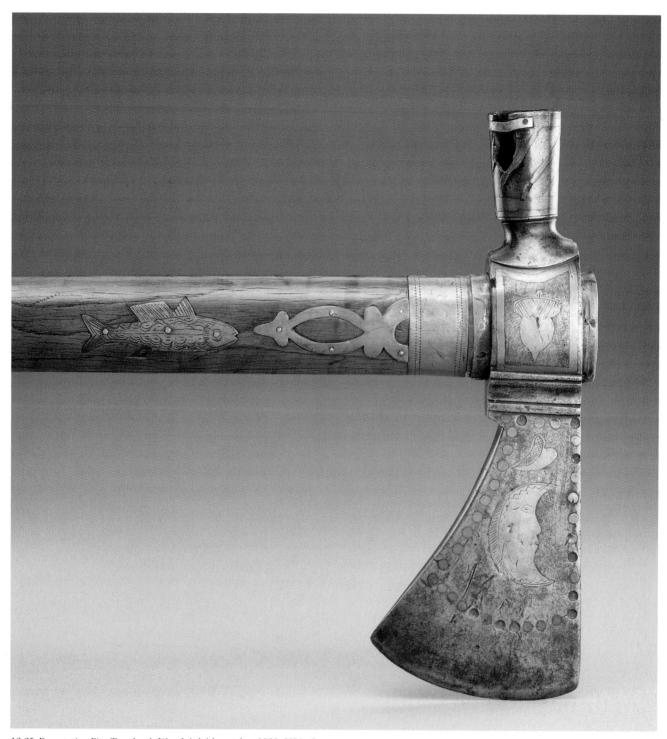

13.35 Presentation Pipe Tomahawk. Wood, inlaid metal. c. 1820, USA, Ottawa.

The *Ara Pacis* promoted peace as a value held dear by the Roman Empire and more specifically by the Emperor Augustus himself. Of course, in some ways, it can also be seen as a victory monument. Whether a vehicle of propaganda or personal aggrandizement, the *Ara Pacis* still symbolizes a celebration of peace.

Not long ago in the twentieth century a memorial to peace was constructed in Hiroshima, Japan, and in Los Angeles, California. The former enemies have constructed "peace parks" in their respective countries to heal the wounds of war. One can only hope that more monuments and memorials to peace be created and become part of human history.

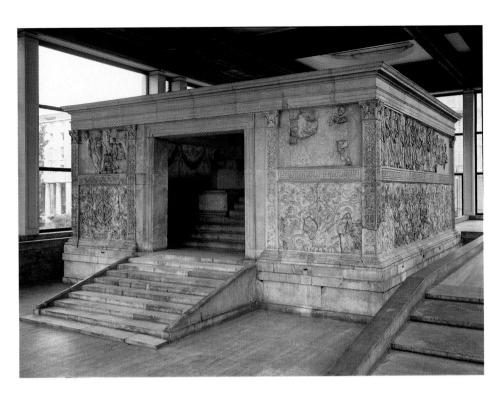

13.36 Ara Pacis Augustae. Marble, outer wall: 34', $5'' \times 38 \times 23'$, 13-9 BC,

SYNOPSIS

We have seen many examples of art relating to war and some relating to peace. Warriors and their vestments receive a great deal of attention from artists, as we see with *Chief Keokuk*, or in the *Boy's Dress Armor* of young Spanish Prince Charles V. Included in the warrior's paraphernalia, and especially in his weaponry, are aesthetic considerations regarding their making. Whether to enhance the spirit and function of the weapon, or to elevate the status and power of its owner, art has been part of weapon design and decoration.

Art also gives us many examples of war scenes. We saw a range of images, from those that exalted the drama of war, such as the *Heiji Monogatari*, to those that ritualized it, as in the *Palette of Narmer*. Some art gives unidealized or alternate views of battle, such as Mathew Brady's *Dead Confederate Soldier with Gun*, or Red Horse's *Battle of Little Big Horn*. Finally, some of the more recent images of war emphasize its horror, as in Sergei M. Eisenstein's film, *The Battleship Potemkin*, or Pablo Picasso's *Guernica*.

Protection from enemies during wartime was certainly important. Ancient China produced the incredible *Great Wall*, and the past civilization of the Incans created magnificent stonework for their fortress of *Sacsahuaman* in Peru. Art is also involved in the aftermath of war. The *Rosetta Stone* is one example of the treasures of Egypt that have been pillaged by invading countries. The *Danzante Stele* shows the fate of prisoners of war; such artworks become the boast of conquering nations.

War heroes have always been a popular subject in art. From ancient Rome, we have the *Column of Trajan* that commemorates the emperor's forays into Dacia. The *USA Marine Corps War Memorial* in Arlington Cemetery, Washington, DC, still evokes deep patriotism in many Americans.

On the other hand, peacemakers memorialized in art are few in number compared to war heroes. Mahatma Gandhi's image appears on a Madras temple in India, where he is placed alongside of Hindu deities. William Penn is immortalized in Benjamin West's large history painting, Penn's Treaty with the Indians. Peace itself is given an image in Edward Hicks' The Peaceable Kingdom. Beautifully crafted art objects given as peace offerings include Moctezuma's Headdress and the Ottawa Presentation Pipe. Finally, peace is celebrated in the Ara Pacis Augustae, where social order, abundant life and earth bounty are the rewards of a war-free civilization.

FOOD FOR THOUGHT

We have just analyzed war imagery in art from many different cultures. You can use the same tools to analyze imagery in popular culture.

 What are your impressions about the ways war and peace are presented now in contemporary mass media—in the comic books, television shows, movies, or computer games?

- How do mass media images of war immerse you in the action?
- Is there any relation between imagined battles to actual international disputes or local tensions?
- Does one group or the other seem to have justice on its side?
- How are warriors and battles framed and depicted?
- How are winners and losers presented?

- What gestures, body types, and expressions are used for each?
- How does music frame your reaction to the characters?
- Are there any parallels with the ways they have been presented in the chapter we have just finished here?
- Are there any instances in which peace or peaceful situations are fully imagined, visualized or explored?

Chapter 14 Social Protest/Affirmation

INTRODUCTION

Humans have done terrible things to other humans, and specific instances of injustice have spurred many artists to protest through their artwork. Art is a useful and effective tool here: villains can be pointed out, heroes honored, and causes promoted with emotional and visual impact unequalled by the written word.

We will focus our discussion on these questions:

Protests Against Military Action:

- When have most antiwar artworks been made?
- What kinds of events have they decried?

Fighting for the Oppressed:

- Whose causes have artists championed?
- What kinds of strategies have artists used to make their work more effective for political and social change?

Questioning the Status Quo:

- What is the "normal" in society?
- What do artists have to say about all-pervasive normalcy?
- What types of social power are used to control or oppress people?

Artists use all kinds of methods to get their messages across. Some use understatement and subtlety; some use humor; some use beauty or drama; some use shock, as harsh as a physical blow at times. Some of the artwork here is grisly or deeply depressing. Yet protest art is a form of affirmation, because behind it is the fundamental belief that the world of humans should be just and fair, that human dignity is important and must be respected, and finally that change is possible. Otherwise, why would artists bother to make these works? Implicit also is the belief that artwork should play a challenging role in society and politics.

PROTESTS AGAINST MILITARY ACTION

For thousands of years artists have made paintings and sculptures about war. In some cases, they have glorified victors, while others have also portrayed (sometimes with sympathy) the defeated, and those killed or wounded.

Text Link

See Chapter 13, War and Peace, as a corollary for the works presented in this section, in particular The Battleship Potemkin, directed by Sergei Eisenstein (figure 13.24).

But not until two hundred years ago have we seen any art that protests a particular war, or the idea of warfare altogether. One likely reason is that a sizable percentage of past art was made for political or religious leaders, usually victorious and powerful ones. Warfare was one means to gain power and art was a way to show it. The nineteenth century saw the first antiwar images in the West, while in the twentieth century, and especially in the last fifty years since World War II, artworks that protest military action have grown in number. The protested military action includes full-blown war, police actions, and guerrilla activity.

A pivotal piece in the history of protest art is *The Executions of May 3rd, 1808* (figure 14.1), painted in 1814. The artist, Francisco Goya, based his painting on sketches he had made of the actual event that had happened six years earlier. At the time of the painting, Goya was first court painter to the restored Spanish king, Ferdinand VII, reinstated after the expulsion of the French invaders, who had occupied Spain under Napoleon Bonaparte. This work represents the Spanish point of view in the conflict, but Goya's interpretation goes beyond partisanship. Goya's imagery is generalized enough that the painting could stand for any mass execution. As Goya has shown us, such events are horrible, where the soldiers have become killing machines, and the victims are real people who intensely want to live.

Goya's painting shows the result of an uprising by citizens of Madrid against the French army in 1808. In suppressing the uprising, the French soldiers captured many of the rioters, and executed them a short distance outside the city. In Goya's painting, our sympathy lies with the Spaniards about to die, as they tremble, pray, or protest at the moment they face the firing line. They all

14.1 Francisco Goya. *The Executions of May 3, 1808*. Oil on canvas, 104.75" × 135.75". Spain, 1814. Prado. Madrid.

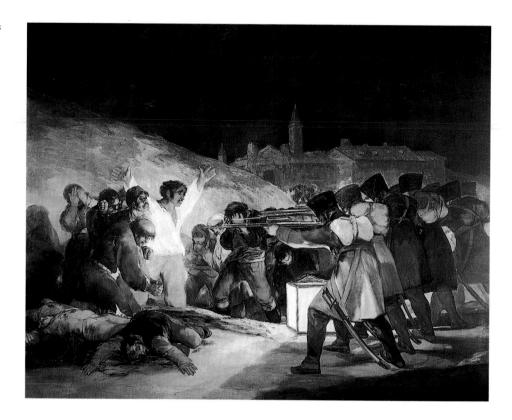

share a common fate, yet each is individualized—we see their faces and feel their emotions. Goya personalized them, so that we identify with them. We particularly focus on the man in white with outstretched arms who cries out against the executions. Goya has made him the central character by surrounding him in light colors, in contrast to the pervasive gloom. In contrast, Goya has depersonalized the French soldiers. Their poses are all the same. With their backs to us and heads down, we cannot see their faces. The barrels of their pointing rifles are rigidly organized like a war machine. There is no humanity here.

Like Goya, Käthe Kollwitz focused on the people involved in war. Kollwitz dedicated her art to ending war and poverty, and she always showed the faces of anger, betrayal, loss, and death. Kollwitz herself lived in Germany through the two world wars, losing a son and grandson in the fighting. In her artwork, however, she frequently turned to past conflicts as a way to show the destructive energy of war. Outbreak, dated 1903 (figure 14.2), is the fifth in a series of seven prints that tell of the Peasant War in Germany in the early sixteenth century. The peasants were miserably poor, worked the land under extremely difficult conditions, and were subject to all kinds of exploitation and abuse by the ruling class. In the first four prints in the series, we see the causes for the uprising: poverty, crushingly hard work, rape of the women. In the fifth image, Outbreak, the peasants revolt, charge forward, their wretched living conditions propelling them to rebel at any cost.

The composition of the work is remarkable. The fury of the peasants' charge is expressed in the postures of their bodies: the peasants gather steam at right, grouping and lurching forward, their bodies leaning forward, while already at the left side of the image they are propelled forward at deadly speed, nearly horizontal, attacking their oppressors with crude weapons and farm tools. The dark woman at the front becomes the leader and the conscience for the group. Her upraised arms incite them to action, while her bony, twisted hands and arms are documents to the incredible harshness of the peasant's life. Lights and darks alternate and flash across the image, visually conveying the emotions of the moment. The leaden quality of the bent backs, dull faces and twisted bodies are transformed; they release their energy in a flash, as bodies catapult forward with anger and speed. The figures are almost choreographed; the dance is one of anger and death. The colors are stark black and white

Kollwitz is obviously sympathetic to the peasants' cause. She shows a woman leading the revolt, breaking old stereotypes about women's passivity. This also attests to the misery of their lives that in the end the women rose up. The uprising was unsuccessful, as the forces of the ruling class suppressed the peasants with brutality. The last two prints of the Peasant War series show a mother who searches for her dead son among piles of bodies and peasant prisoners bound together awaiting execution. In the end, loss of life does not erase the causes of war.

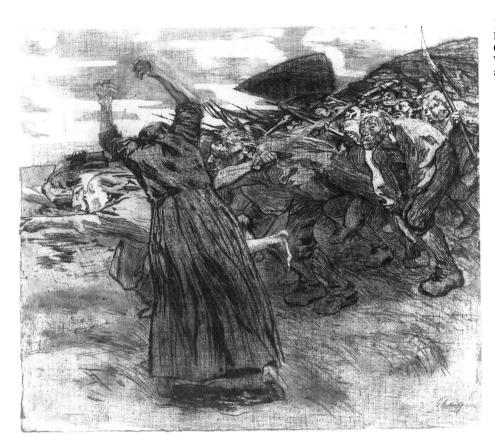

14.2 KĀTHE KOLLWITZ. Outbreak. Mixed technique print, 20" × 23.25". Germany, 1903. Library of Congress, Washington. See also the text accompanying figure 2.2.

Other artists who lived through the world wars dealt with their experience. Fit for Active Service (figure 14.3), a 1918 pen and ink drawing by George Grosz, exposed the behind-the-scenes workings of the German army in World War I. All armies are composed of two groups: the soldiers who fight on the front line, and in the background, the military machine that commands them. Grosz's image protests the bloated doctors and selfabsorbed officers, secure in their bureaucratic assignments, who sent elderly, sick, or very young men to the front lines to fight for Germany near the end of World War I. (All able-bodied men had already been sent out much earlier.) With grim wit, the artist's pen outlines the smug, laughing faces of the foreground officers who cynically continue the fighting although their soldiers are in pathetic condition. Farther back, two toadying soldiers stand at attention. Their conformism is made evident by the way the seams in their uniforms line up with the floor and the window frames. They are subsumed into the structure, and an independent conscience does not exist in them. The doctor at the center seems almost happy as his arm reaches around the skeleton, and his examination has found another body for the front lines. Outside, through the windows, we see factories contentedly belching out the machinery of war. In contrast to the spare and flattened manner in which the rest are portrayed, the skeleton is rounded, detailed and visceral, adorned with rotting organs and tufts of hair.

14.3 George Grosz. Fit for Active Service. Pen and ink, 14.5" \times 13.5". Germany, 1918. Museum of Modern Art, New York.

John Heartfield dedicated much of his art to exposing and condemning the horrors of Nazi Germany. Heartfield was born in Germany as Helmut Herzfelde,

14.4 JOHN HEARTFIELD. Goering the Executioner. Photomontage. German, 1933. Reproduced from "John Heartfield," by Wieland Herzfelde. Dresden: VEB Verlag der Kunst, 1964.

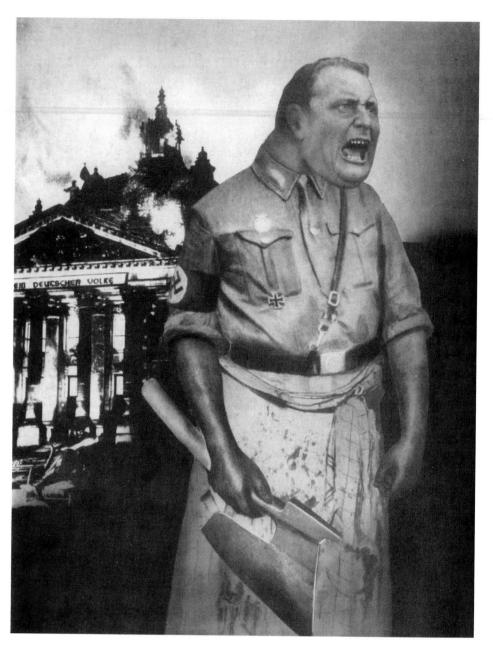

but later chose to anglicize his name. *Goering, the Executioner,* dated 1933 (figure 14.4), is a photomontage, in which news photographs are combined and manipulated with drawing to express Heartfield's outrage. The subject is Field Marshal Hermann Goering, one of the major leaders of the Nazi party. Heartfield pulled Goering's head forward, increasing the thickness of the neck and emphasizing the aggressiveness of his bullying face. Behind him burns the Reichstag, the German parliament building, that was destroyed in 1933 by an act of terrorism that was likely perpetrated by the Nazis, but "officially" blamed on communists. The burning of the Reichstag ended any vestige of a democratic government in Germany, and gave the Nazis the excuse to seize absolute power. This photomontage was the front-page

illustration for the September 14, 1933, edition of the newspaper, AIZ (Arbeiter-Illustrierte-Zeitung), published in Prague.

The use of black and white elements gives the image an unvarnished, blunt quality. The collaged photo elements almost look like a documentary of reality, while the drawing makes the image expressively powerful. Thus, Goering's meat cleaver and stained apron have the quality of factual truth, even though the artist added those props. Heartfield's warnings of Nazi bloodshed in this work proved to be prophetically true. Although it was made early in the Nazi era, it is a frightening, brutal image. Heartfield himself was forced to leave Germany during the 1930s and 1940s, spending much of that time in England.

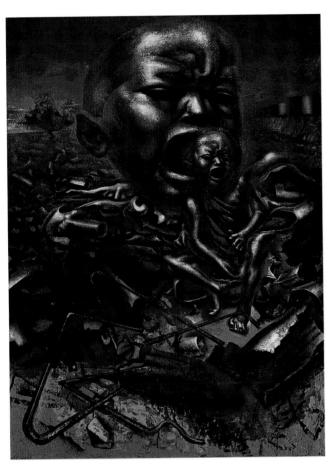

14.5 David Alfaro Siqueiros. *Echo of a Scream.* Duco on wood. Mexico, 1937. Museum of Modern Art, New York. $48'' \times 36''$. See also the text accompanying figures 1.5 and 2.24.

In the mid-1930s, Spain was engulfed in a civil war that in many ways was a prelude to World War II. In 1937, David Alfaro Siqueiros painted Echo of a Scream (figure 14.5) in response to the horror of the Spanish Civil War. There were many innocent victims of that war, including children, and David Alfaro Siqueiros uses the incessant scream of a pained child to express horror at the gross destruction of modern warfare. All of humanity, symbolized by the child, sits amid piles of debris. The child is alone and helpless, and knows only physical and emotional pain. The sky is filled by the large detached head—the child's head repeated—a massive cry that symbolizes the combined pain of all the victims whom we do not see. The dark tones and blue-gray colors of the painting add a somber note to the ugliness of the surroundings. The painting also alludes to the urbanization and industrialization that blots out nature, and the endless piles of waste that are the result of "progress" and "innovation."

Text Link

See Pablo Picasso's Guernica (figures 2.3 and 13.25) for another artwork that deals with the Spanish Civil War Siqueiros knew his subject matter firsthand. He was a Mexican citizen who fought in Spain as a volunteer in the International Brigade, along with volunteers from 50 other countries who were fighting for the Spanish Republic against the Fascists who were backed by Nazi Germany. He was also a political activist and social reformer, in addition to using his paintings as vehicles that called for change.

Robert Motherwell painted the Elegy to the Spanish Republic XXXIV from 1953 to 1954 (figure 14.6), several years after the Spanish Civil War. It was part of a series of paintings that amount to over 150 works, dedicated to mourning the loss of liberty in Spain after the Fascist forces were eventually victorious in the conflict. The paintings do not have narrative subject matter. They do not tell a story. However, Motherwell believed that abstraction communicated, in the most universal terms, the struggle between life and death and between freedom and oppression. The large size of the painting makes these struggles seem monumental. The use of black and white also suggests death and life. Motherwell was influenced by the Surrealist process of expression called "automatism," which incorporates intuition, spontaneity, and the accidental when creating artworks, similar to the Abstract Expressionist style. His black-andwhite forms suggests several Spanish motifs, according to Robert Hughes (1997: 496). They are bull's testicles, the patent leather berets of the Guardia Civil, and living forms represented by the large ovoid shapes that are being crushed by the black bands.

On the other side of the world, atrocities of war have also occurred. Tomatsu Shomei's Woman with Keloidal Scars (figure 14.7) is one of a series of photographs of victims of the atomic bombing of Nagasaki, Japan, at the end of World War II. The blast was so powerful that it actually vaporized the victims who were near the center of impact. The bodies of many were never found. Those farther away suffered terrible burns and injuries, with children stunted and deformed, and adults severely scarred. Tomatsu's photograph is technically beautiful, with a full range of deep blacks and silvery grays. The subtle textures would have been awesome had the subject been the rough bark of a tree trunk, or the lacy petal of a flower, instead of the leathery scarred skin of a woman survivor of Nagasaki seen twenty years later. Her skin's excessive fibrous tissue is stretched over her skull. Her pained, fearful expression seems withdrawn and reserved. Her injuries, although inflicted a long time ago, seem still fresh. Her suffering appears to be both physical and psychological. Yet at the same time there is an odd sense of normalcy, as she appears to be posed in front of a thriving city, from a high vantage point, almost as if she were out sightseeing. Tomatsu made this series for two reasons. First, he wanted to document past horrors. Secondly, he wanted to protest against U.S. troops stationed in Japan, who were used in U.S. military 14.6 ROBERT MOTHERWELL. Elegy to the Spanish Republic XXXIV. Oil on canvas, 80" × 100", USA, 1953–1954.
Albright-Knox Art Gallery, Buffalo, NY. See also the text accompanying figure 5.4.

14.7 Tomatsu Shomei. Woman With Keloidal Scars. From the Series, "11:02 - Nagasaki." Gelatin Silver Print, $11.5" \times 16"$. Japan, 1966. Collection of the artist.

actions against North Korea and in cold war standoffs with Communist nations in Asia. Since World War II, there has been a strong movement in Japan for complete, permanent demilitarization of the country. However, because of the presence of U.S. troops, Japan continued to be part of overall global military strategy.

Leon Golub's painting, *Mercenaries I* (figure 14.8), shows the violence and terrorism that occur whenever authority is imposed on unwilling people. In this painting from 1976, two "guns for hire" dangle a bound vic-

tim between them, using brute power in the service of a repressive government. These professional fighters are devoid of any ideological stance; they are simply paid thugs. The mercenaries are flattened figures against the flat background. The victim has no identifying traits and is totally dehumanized; it could be anyone; it could be us. Their larger-than-life size makes the mercenaries seem imposing and their brutality uncontrollable. They are pushed aggressively to the foreground, and we, the viewers, are dwarfed by the nearly 11-foot height of the painting. We have approximately the same view as the victim, looking up at the mercenaries. The paint, applied thickly at first, has been scraped and rescraped so that the surface seems raw and nasty. When rendered this way, flesh looks particularly repulsive, whether it covers the cruel face of the mercenary or the tortured back of the victim. The colors are jarring and acid.

Golub insists that his images realistically report every-day events in the world. Many of the conflicts of the late twentieth century have been guerrilla wars or ongoing civil wars, and the media broadcasts many videos and still photographs of atrocities. Golub works from news photographs to create his paintings. While Golub's images may refer to actions far from home, "out there," there is an immediacy to them for two reasons. First, the ugliness of the piece is overwhelming. And secondly, because the world's politics and economies are entangled, democratic governments often assist (directly or indirectly) regimes as repressive as those Golub shows.

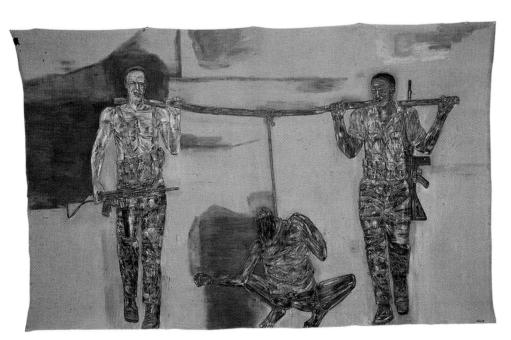

14.8 Leon Golub. Mercenaries I. Acrylic on canvas, 116" × 186.5". USA, 1976. Eli Broad Family Foundation Collection, Los Angeles. See also the text accompanying figure 5.6.

FIGHTING FOR THE OPPRESSED

This section looks at works by artists who are fighting for the rights of those who are economically or politically repressed. First we will look at the strategies artists use to make their points most forcefully. These include beauty, illustration, narrative, humor, and shock tactics. Secondly, we will look at art that affirms the values of those who have been held down or marginalized. We will also see that most social protest works are designed to affect public consciousness in general ways, rather than to prescribe specific changes.

Strategies for Protesting Oppression

Protest art generally carries with it some unpleasant messages. How can artists effectively communicate their difficult message to their audiences?

Interestingly, beauty and excitement can be very effective elements in protest art. In Eugène Delacroix's Liberty Leading the People, painted in 1830 (figure 14.9), Liberty has been personified as a partially nude woman-appparently flesh and blood-but reminiscent of a Greek goddess in her profile and in her idealized body. Energized and oblivious to danger, she carries a rifle and the flag of the French Revolution. She forms the peak of a triangle that is made up of merchants, students, laborers, soldiers, and even young boys rising up to follow her call. There is a growing excitement as they emerge from the smoke, debris, and dead bodies to move towards the light that surrounds Liberty. The lower and middle classes throughout Europe revolted many times against the ruling classes in their countries in the late eighteenth and early nineteenth centuries. Specifically, this work is an homage to the Paris revolt in 1830 to overthrow and replace a repressive monarch.

Delacroix's painting is a rather jarring mixture of realism, idealism, and romantic views about revolution. Realistic are the faces of the men who look like Parisians of the day, and the details of the clothing, weapons, and the Paris skyline in the background. Elements of idealism include the goddess-like figure of Liberty, and the belief that revolution will lead to a better way of life. The work is romantic in its portrayal of fighting as thrilling, dangerous, and liberating; added touches of romantic drama come from flashes of red in the painting and the brilliance around liberty in contrast to the overall gloom. Compare this work to Siqueiros' *Echo of a Scream*, (figure 14.5), to see a work in which warfare is not romanticized.

One of the most direct ways to make social protest art is to illustrate the oppressive situation. At the beginning of the twentieth century, sociologist and artist Lewis Hine used photographs to show the miserable labor conditions and slum housing of the poor in the United States. He was particularly known for his photographs of children working in mines and textile mills, as child labor was common and children were used for the lowest paying, tedious jobs. Because of their small size and agile fingers, children were often worked close to moving machinery where adults could not fit. Injuries and deaths as a result were not uncommon. Leo, 48 Inches High, 8 Years Old, Picks Up Bobbins at 15¢ a Day, from 1910 (figure 14.10) shows a young boy who dodges under textile looms to pick up loose thread spools. Children typically worked ten- to twelve-hour shifts, six days a week, in the mills. With schooling thus impossible, child laborers were destined to remain illiterate, poor, and overworked. Hine wrote detailed titles for his photographs, to fully document the youthfulness of the child laborers. Yet in some ways, the 14.9 EUGENE DELACROIX. *Liberty Leading the People*. Oil on canvas, approx. 8'6" × 10'8". French, 1830. Louvre, Paris.

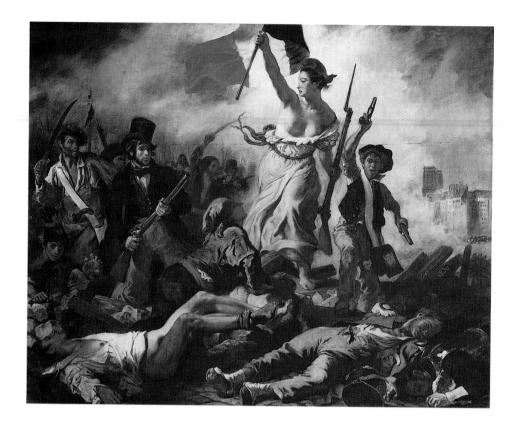

14.10 Lewis Hine. Leo, 48 Inches High, 8 Years Old, Picks Up Bobbins at 15¢ a Day. Photograph. USA, 1910. University of Maryland Library, College Park, MD.

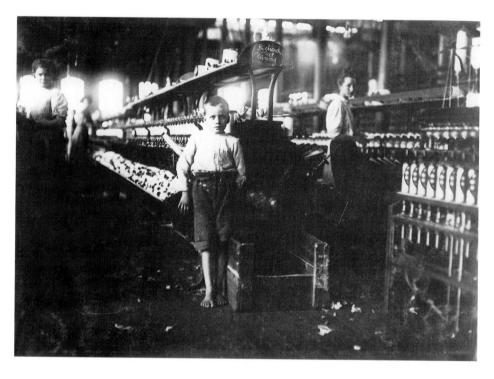

long titles were unnecessary. Hine carefully framed his images so that we could see the large scale of the weaving machines—their great length and height—that dwarfed the child. We can clearly see Leo's young face, his tentative posture, his bare feet. Also apparent is the gloomy darkness, poor lighting, and littered floor of the mill, and

the other workers who are women, another underpaid category of workers. Hine's photographs are particularly effective because his subjects become real to the viewer as thinking and feeling individuals, and thus the pictures are harder to forget than ideological arguments, pro or con, on labor conditions.

Hine was part of the loosely organized Progressive Movement of the early twentieth century, which sought reform for a number of problems resulting from urbanization and industrialization. Hine made photos for the National Child Labor Committee, a private group dedicated to protecting children in the work environment. He lectured widely, and his images were published in progressive magazines. With this backing, Hine's images were unusually successful in changing both public opinion and public policy. Child labor was eventually outlawed in the 1930s.

Ben Shahn used narrative as a means of social protest against injustice. He compressed space and time in the *Passion of Sacco and Vanzetti*, dated 1931–1932 (figure 14.11), to tell the story of the conviction and execution

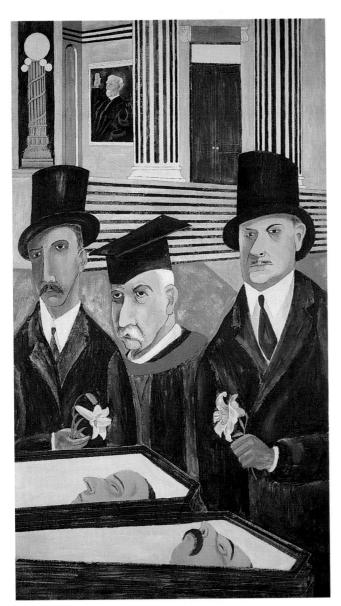

14.11 Ben Shahn. The Passion of Sacco and Vanzetti. Tempera on canvas, 84.5" \times 48". USA born Lithuanian, 1931–1932. New York, The Whitney Museum of American Art.

of Nicola Sacco and Bartolomeo Vanzetti in the United States in the 1920s. The political climate then was tense, as conservative elements felt threatened by extremist political groups and the large influx of immigrants. Sacco and Vanzetti were Italian immigrants who were active in labor organizations, avoided the draft in World War I, and were political anarchists. They were arrested and convicted for robbery and murder, despite several witnesses who testified that they were elsewhere at the time of the crime. Many people believe that Sacco and Vanzetti were convicted because of their politics, as the judge allowed the prosecution to make many inflammatory statements about their political beliefs during the trial. In his painting, Shahn collapses time, as we see simultaneously the courthouse steps, the framed portrait of the judge who presided over the original trial, and the ashen faces of Sacco and Vanzetti as they lie in their coffins. Prominent in the middle are the portraits of three commissioners who reviewed the trial and declared it to have been legal, thus allowing the execution to take place. The expressions of the three commissioners are dour and righteous; they seem unmovable; they are bolstered by institutional rigidity. The harsh colors of the painting, with the preponderance of blacks, the sickly blue tones in faces, the acid green grass, all express Shahn's distress at the death of the two men, whom Shahn and many others felt were heroes.

Jacob Lawrence also used narrative to tell stories, in this case in a series of paintings that recount the history, accomplishments, challenges, burdens, and oppressions of the African community uprooted to the Western Hemisphere by slavery. He made a series of 31 paintings on the life of Harriet Tubman and 22 on John Brown. The paintings often have lengthy, narrative titles to make the story even clearer. These works are meant to be reconstructions of the past, like history lessons. Our example is No. 36: During the Truce Toussaint Is Deceived and Arrested by LeClerc. LeClerc Led Toussaint to Believe That He Was Sincere, Believing That When Toussaint Was out of the Way, the Blacks Would Surrender (figure 14.12). It is one of 41 paintings Lawrence made from 1937 to 1941 on the life of Françoise Dominique Toussaint L'Ouverture, a slave who led a revolt on Haiti that resulted in the abolition of slavery there in 1794. After the revolt, Toussaint was able to establish a semi-autonomous black government and resist the French, English, and the Spanish attempts at control of Haiti, which earlier had been France's most prosperous colony in the slave era. In an attempt to retake the island and reestablish slavery, Napoleon Bonaparte sent his brother-in-law, Charles LeClerc, to Haiti, leading a large armed force. Although LeClerc deceived and captured Toussaint (who died a year later in a French prison), the French forces were eventually overcome, resulting in Haiti's complete independence from France in 1804, becoming the first blackgoverned country in the Western Hemisphere.

14.12 JACOB LAWRENCE. No. 36: During the Truce Toussaint is Deceived and Arrested by Leclerc. Leclerc Led Toussaint to Believe He Was Sincere, Believing That When Toussaint Was Out of the Way, the Blacks Would Surrender. Tempera on paper, 11" × 19", USA, 1937–1938. The Amistad Research Center's Aaron Douglas Collection, New Orleans.

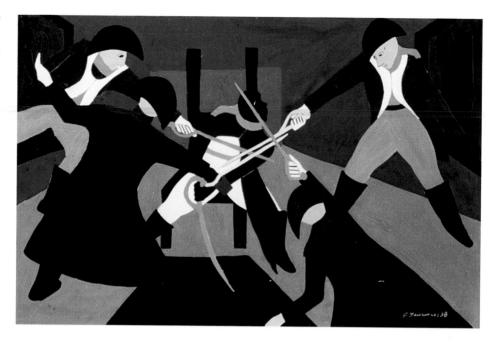

Lawrence worked on all 41 Toussaint paintings at once, completing all drawings before he began painting, and then painting on them simultaneously, so that the series has a remarkable formal cohesion, especially in color use and drawing style. Colors are limited, with black and white punctuating the images, giving them strength and starkness. No. 36 shows Toussaint's betrayal and capture by Napoleon's troops. The crossed swords in the center pin Toussaint; the four white faces that surround him symbolize his struggle against the better-supplied and better-trained forces of the French army. The floor tilts up, and the walls of the room trap him at the intersection of colors. The black chair he sits on reads like bars of a prison. Lawrence's style is bold, flat, and simplified. Broad sections of yellow and green in the background unify the image, while the center, with its greatest density of detail, provides a forceful focal point. By eliminating many details, Lawrence simplifies his scenes so that they read more universally. His images were not just of the past, but were meant for African Americans of today. His scenes of injustice and oppression were meant to be inspiring to all victims of oppression.

Lawrence's work grew out of the Harlem Renaissance, an African-American cultural movement of the 1920s and early 1930s, which promoted their literature and arts. Lawrence himself studied at the Harlem Art Workshop in New York City, from 1934 to 1936.

Text Link

James VanDerZee photographed the thriving Harlem community of the 1920s and 1930s, as you can see in Society Ladies, in figure 17.3.

The Rent Collection Courtyard, sculpted in 1965 (figure 14.13), is a contemporary Chinese sculpture that narrates instances of injustices from Chinese history in several tableaus. It is officially credited to an anonymous team of sculptors, although in fact it was produced by Ye Yushuan and others at the Sichuan Academy. With more than one hundred life-size figures in the total work, the Courtyard is grouped into several scenes. In our example, a bent, aged peasant farmer is bringing his harvest to the landlord to make his tax payments. Because of the landlord's excessive taxes, peasants remained in poverty, were often forced to mortgage their future crops, and many sold their children to servitude. In another vignette from the work, not shown here, the landlord's thugs seize a peasant, tie him, and take him to prison, while his family plead for him. One thug turns to kick the peasant's wife, groveling on the ground with an infant in her arms. In the final scenes in the original version of this work, the peasants are rising in revolt.

Text Link

The work was produced by an anonymous team of sculptors in the service of the state, indicating that art practice, in addition to land ownership, had also been reformed under the Communist state. Contrast the idea of the anonymous artist working at the service of others with the notion of art stars and artist as genius; see Chapter 20, Who Makes Art?

Viewers are definitely meant to be drawn into the work. Realistic details and life-size figures make viewers feel as if they are witnessing the actual event. The realism is meant to emphasize the fact that these things really happened. This is an emotional and dramatic work. The poses make clear where our sympathies should lie.

The peasant is bent and awkward, bowed in submission. The bones of his hands and feet are thick and twisted from hard labor; his clothing rough and ragged. In contrast, the seated figure is haughty. He is dressed in fine cloth and his slim, relaxed body showing no signs of labor. *The Rent Collection Courtyard* is a superb work technically, in a style that mixes traditional and imported influences.

It is interesting to compare The Rent Collection Courtyard with Lewis Hine's photograph of the child laborer, as both seem to depict injustice. However, where Hine's work protests an existing condition, The Rent Collection Courtyard dramatically presents a past situation. By doing so, the Courtyard was meant to validate the existing Chinese Communist government, which instituted land reforms in the 1950s that eliminated the powerful landlords. The Rent Collection Courtyard was first displayed in the courtyard of the mansion of one of these landlords (Liu Wencai in Dayi) where the events depicted actually took place. The work is a warning that the old regime oppression may return if people do not guard against it. It does not deal with the problems of the present. Although many have dismissed works like The Rent Collection Courtyard as propaganda for the state, it is a vivid and emotional record of events from China's history.

Text Link

The Rent Collection Courtyard is similar to the USA Marine Corps War Memorial in figure 13.29, in that both are highly realistic, both memorialize past events, and both essentially serve to affirm the existing government of each nation. They do, however, commemorate different kinds of events.

Shocking ugliness can be used in the service of protest art. In The State Hospital, from 1966 (figure 14.14), the artist Edward Kienholz criticizes the way society deals with people it deems incompetent. The outside of this work, not shown here, is a grim, box-like cell with bare reinforced walls and one barred, locked, grimy door. To look inside, one has to peer in between the bars of a small window to see the naked mental patient strapped to his bed. His mattress is thin and filthy; the bed pan below is streaked with excrement. His head is replaced by a fish bowl with two black fish swimming aimlessly inside. Encircled in neon is the cartoon balloon above his head that shows another image of himself. The patient has no world outside of himself and his wretched cell. He is completely isolated and does not leave this room. The State Hospital is so effective and gruesome in part because Kienholz used actual objects from such an institution: the bed frame, the urinal, the rolling table (barely visible at left). The strongest impact, however, comes from the pathetic body of the patient—his bony knees, his sagging, exposed genitals, his leathery skin. Like The Rent Collection Courtyard, the realism makes the sculptures seem more immediate to the viewers.

Kienholz worked for a short time in a state mental institution, and this work is based on his experiences. In Kienholz's account, this patient had been tortured by repeated hits in the stomach with a soap bar wrapped in a towel, so that there would be no surface bruises. The bedpan and feeding table show that bodily functions only are the concern of the hospital staff. But the artist's criticism does not stop with the institution. Once viewers look through the barred windows, they take on the role of guards. They view without making contact, like surveillance cameras. Thus Kienholz implicates everyone on the outside, the "normal" ones that set up institutions that sometimes deal with its "incompetent" members in inhumane or shocking ways. Too often dignity is

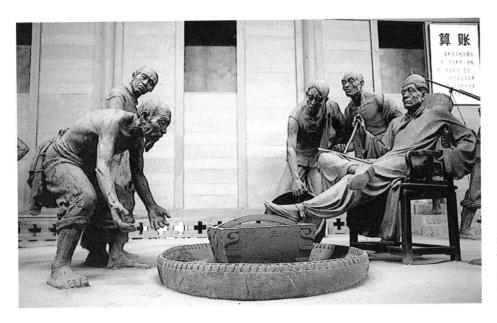

14.13 Anonymous team of sculptors (Ye Yushan and a team of sculptors from the Sichuan Academy of Fine Arts, Chongqing.) *The Rent Collection Courtyard* (detail). Clay, life-size figures. China (Dayi, Sichuan), 1965. See also the text accompanying figure 20.6.

14.14 EDWARD KIENHOLZ. The State Hospital (detail). Mixed Media, 8' × 12' × 10'. USA, 1966. Moderna Museet, Stockholm. © Edward Kienholz

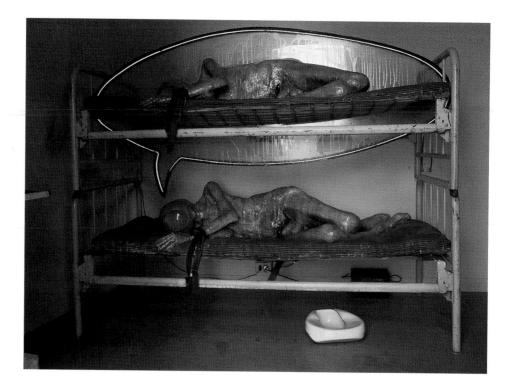

stripped from the aged, the infirm, the poor, and persons without power who must rely on social institutions for protection.

Finally, we will look at humor as another strategy for effective protest. In Sun Mad, dated 1981 (figure 14.15), Ester Hernandez takes familiar imagery from popular, commercial culture and subverts it with humor. The raisin growers around Hernandez's home town used insecticides heavily for decades. The insecticides seeped into and contaminated the ground water that the general population eventually used for drinking and bathing. Hernandez took the packaging of the best known raisin producer, Sun Maid, and changed the usual image of healthy eating into a message of death. Her work is effective precisely because it uses grim humor to turn around that which is familiar to us; it is memorable because the raisin industry advertising is so successful and we know the original image. Like advertising, Hernandez has chosen an art form that allows her to reach many people. This is not a single painting hanging in a gallery, but rather a color silk-screen design that has been reproduced and disseminated widely as T-shirts and postcards. Even though Hernandez was reacting to a specific instance of contamination, her work goes beyond the specifics of her situation. The fear and sense of betrayal extends to everyone who may unknowingly eat food tainted by pesticide residue. In addition, the work echoes the struggle of farm workers fighting for better pay and working conditions. For example, food industry owners would spray pesticides on a field while the farm workers were harvesting a crop, thereby exposing the workers to unacceptable levels of poisons.

Thus we have seen beauty, excitement, illustration, narration, shock tactics, and humor are all devices that are well used in protest art.

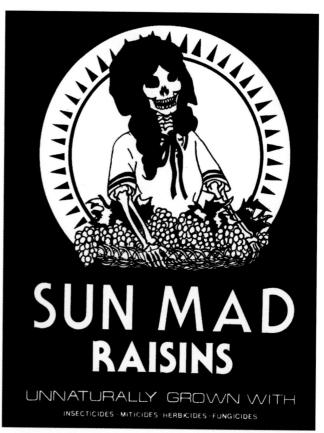

14.15 Ester Hernandez. Sun Mad. Color serigraph, $22^{\prime\prime}\times17^{\prime\prime}.$ USA, 1981.

Affirming the Values of the Oppressed

When a group of people are oppressed, their way of life and their values tend to be discounted or ridiculed. To be completely effective, protest movements not only must fight against unjust oppression, but also affirm the life-styles of the downtrodden group to increase their cohesiveness and bolster their sense of identity. Art is an especially effective tool for doing this.

Let us look first at two artworks from Brazil from the 1970s and 1980s. The first is called *Insertions into Ideological Circuits: Coca-Cola Project* (figure 14.16), by Cildo Meireles. Brazil in the 1970s was ruled by a military government whose policy was "selling" Brazil out to foreign investors, mostly from the United States, and thus supporting their regime with outside money. Much

of the natural environment in Brazil was destroyed, and continues to be destroyed, because of such policies, as are many animal species and the cultures of indigenous peoples. At the same time, the U.S. government was actively involved in developing Latin American countries into large markets (protestors would say "economic colonies") that would buy U.S. manufactured goods.

Meireles and others wanted to affirm and bolster Brazil's own autonomy and development. However, the Brazilian military government at that time censored and outlawed all protests against their self-serving policy. Art that was openly critical of the government would have been impossible. So Meireles took empty Coca-Cola bottles, silkscreened subversive messages on them and then returned them into circulation. Because Meireles' added

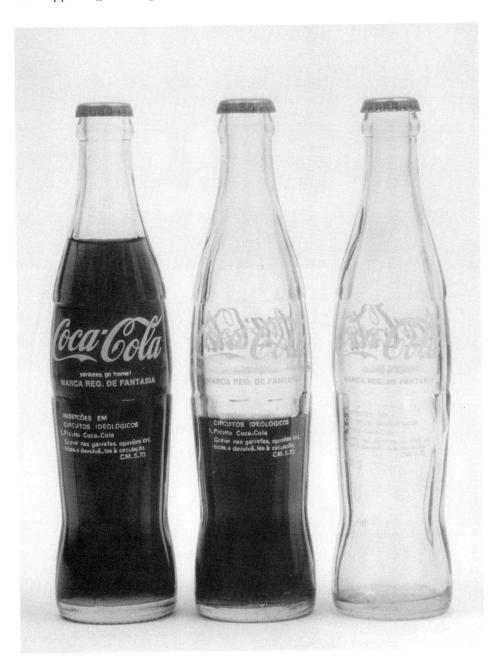

14.16 CILDO MEIRELES. Insertions into Ideological Circuits: Coca-Cola Project. Screenprinting on Coca-Cola bottles. Brazil, 1970. See also the text accompanying figure 4.13.

writing was unobtrusive, it was effective. As is evident in figure 14.16, the added writing on the bottles is almost invisible when the bottles are empty. Only the person holding the bottle close while drinking the soda can easily read the message. Using Coca-Cola bottles as vehicles for political messages was clever in many ways; first, because Coca-Cola is everywhere; secondly, because Meireles took advantage of the already-existing system of returning bottles; and third, because Coca-Cola is a popular symbol for U.S. culture. The guerrilla nature of his work makes it similar to some graffiti art and to "billboard corrections," where artists make additions to existing billboards to undermine the political or consumer messages they contain.

Text Link

Some would say that writing "yankee go home" on Coca-Cola bottles is not art. Others would argue that an artist's job is to increase the viewer's awareness. For more, see Chapter 4, How Does Art Work?

Now let us examine another artist's work from the same time and country. Mario Cravo Neto made a series of photographic portraits of people from Bahia, Brazil, a very diverse area with a mulatto majority, with a mix of Portuguese, African, and indigenous populations. It is an area with mixed religious beliefs, myths, and social customs. Many practice syncretic religions that combine the beliefs of traditional African and European religions. Voodoo Figure, dated 1988 (figure 14.17), is a photograph of a hunched, brooding man, a follower of Candomblé, African religion with elements of Roman Catholicism. Candomblé emphasizes the community over individual gain, as its spiritual and economic resources are shared among members to create a sacred sphere of mutual well-being. To worship spirits, the Candomblé follower performs ritual tasks, trances, and animal sacrifices. They also work among the community.

Voodoo Figure is the result of an actual ritual performed in Cravo Neto's studio. Rather than planning a shot, posing his subject and "taking" a photograph, Cravo Neto works with persons who know him well. The photographs are collaborations between himself and his sitter, and Cravo Neto does not know what will happen before the photo session starts. The Voodoo Figure loses his individual identity and becomes an image of a spiritual state, a portrait of mystical energy. He crouches in a body position like the Candomblé rituals. The photograph is visually rich. The muscles of the shoulders and arms are sculptural, while the hair, the woven fingers, and the paint splatters add textural variety. The lighting ranges from the abdomen in darkness to the well-lit shoulders. The pose is symmetrical overall. The paint splatters connote two things: first the working class, with

the splattered body of the laborer or housepainter; and secondly, the ritual experience, as the body is changed by the transformative power of religion.

Both Meireles and Cravo Neto work from a distinctly Brazilian point of view. Meireles protested foreign economic influence to preserve the Brazilian culture and natural environment. Cravo Neto's photographs affirm the strength of that Brazilian culture by documenting the continued presence of Brazilian groups who operate far outside the world of international politics and commerce. The work of both Meireles and Cravo Neto indicate the degree of divisions within Brazil itself. In the case of Meireles, the split is between those who are part of the Brazilian government or who support it, versus those who oppose it. In the case of Cravo Neto, it is between the upper and lower classes in Brazil, as those classes most involved in mystic religions are marginalized by Christian and capitalistic Western-influenced sectors in Brazil.

Let us look now at two works by Aboriginal artists that affirm the values of the Aboriginal culture that has been suppressed by the Australian descendants of the European settlers. European colonization of Australia has left a tragic legacy of land theft, displacement, genocide, and racism that continues to have consequences today. The Aboriginal people at present are still examining past injustices, reclaiming lost history and competing with descendants of colonists for political power, land, and a cultural voice.

While the rest of Australia was celebrating the 200th anniversary of Captain Cook's "discovery" of Australia,

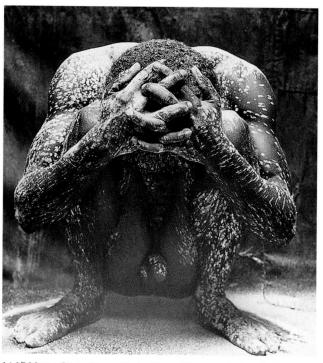

14.17 MARIO CRAVO NETO. Voodoo Figure. Photograph. Brazil, 1988.

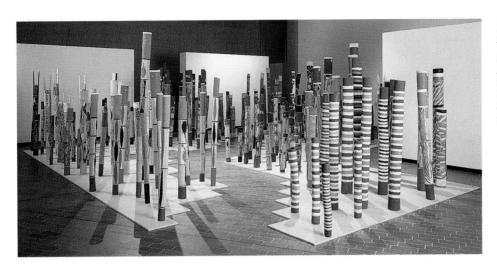

14.18 Paddy Dhatangu, David Malangi, George Milpurrurru, Jimmy Wululu, and Other Artists from Ramingining. *The Aboriginal Memorial*. Australia, 1988, Natural pigments on 200 logs, Heights: 16" to 128", National Gallery of Art, Canberra. See also the text accompanying figure 2.4.

the Aboriginal population commemorated "Invasion Day." Many artists collaborated to make The Aboriginal Memorial, installed in 1988 (figure 14.18). It is composed of two hundred logs, one for each year of settlement, hollowed out as traditional Aboriginal coffins. They are memorials to all the native peoples who died as a result of European settlement and were never given proper Aboriginal mortuary rites; thus they allude to the tragedies of the past. The logs were then painted by 43 different participating artists with their important clan Dreamtime symbols. In this way, the memorial also affirms the continued vitality of traditional Aboriginal culture which was undermined and at times outlawed. Aboriginal culture has great spiritual beliefs, strong ties to nature, and a great emphasis on ancestral beings, all contained in the symbols on the tree trunks. The artwork acknowledges the future, because while the hollow logs are coffins, they are also like new growth springing from the ground. Many of the poles are imposing in size, up to 10 feet high, and seem like a living forest with vibrating patterns and vigorous animals as one walks through the installation (Caruana, 1993: 206).

Text Link

For more on Aboriginal culture and Dreamtime imagery, see Witchetty Grub Dreaming in figure 6.2.

Lin Onus' *Dingoes; Dingo Proof Fence*, dated 1989 (figure 14.19), alludes to the difference between the Aboriginal land use and the European. The Aborigines hunted and gathered for what they needed, but left the natural environment relatively untouched and intact after they had passed. Europeans aggressively changed the natural environment for pastoral use; they cleared, fenced, farmed, or grazed it, and subdivided it with individual ownership. The competition for land resulted in land wars and skirmishes in which an estimated twenty

thousand aborigines and two thousand settlers died. In this piece, the dingo, a wild dog, is alert and energetic, with long curves that make its legs springy and quick. Like a spirit dog, it effortlessly passes through the fence. Onus' work upholds the animals' rights to the land, in the face of the thousands of miles of dingo fence erected by settlers to protect the grazing cattle and sheep that they introduced to the continent. In a twist of humor,

14.19 Lin Onus. *Dingoes; Dingo Proof Fence* (detail from the series, "Dingoes"). Synthetic polymer on fiberglass, wire, metal, height 37.5 inches. Aboriginal, Australia, 1989. National Gallery of Australia, Canberra.

the "dingo-proof fence" turns out to be considerably less than so. In non-Aboriginal slang, a dingo has come to mean a coward or contemptible person, but Onus reinvents the dingo as the first native of the land and its right to it has become a metaphor for Aboriginal rights (Caruana, 1993: 194). By painting the dingo sculpture red, yellow, black, and white, the four basic aboriginal colors, Onus identifies the wild dingo with the Aborigines and affirms their views of land use.

QUESTIONING THE STATUS QUO

The status quo is the existing state of affairs. It often appears natural, inevitable, or irreplaceable, as if it were the way things "always" have been, instead of constructed and evolving. In this section, artists take a critical look at the "normal," at all those underlying systems, beliefs and ways of operating within a culture that have become so accepted that they are almost invisible. Artists regularly produce works that try to shake viewers out of mental ruts and blind acceptance of their social and political surroundings.

The Social Environment

Our first group of artworks examines everyday life. They take apart the familiar and critique circumstances that may be considered normal.

William Hogarth satirized the English upper classes in many of his paintings and prints. In a series of six paintings called *Marriage à la Mode*, dated c. 1745, he sat-

irizes the upper-class practices, life-styles, and tastes, to show that they would lead people to ruin. In the second of the six images, Breakfast Scene (figure 14.20), the wall clock indicates past noon, but the couple is just meeting over the breakfast table. Hogarth does a great job of story-telling through body language and details. The large rooms filled with columns, rugs, and other finery that are signs of class. The disheveled, bored, sulky husband has been out all night. The puppy sniffs at his pocket where another woman's lingerie hangs. The young wife stretches after a night of cards and music. The overturned chairs indicate that the evening became a bit raucous. She casts a flirting glance at her husband, but he is completely unresponsive. The young couple is separated by the vacuum of unconcern, and their marriage is a legal agreement only, with no love between them. The paintings on the walls indicate a taste for sexual intrigues, despite the presence of classical busts and religious images for propriety. At left, a servant rolls his eyes at their life-style and marriage; unpaid bills are piled in his hand.

The tone of the *Marriage à la Mode* series is comic mixed with criticism and condemnation. In an earlier scene from this series, we learn that the young nobleman has no money; his father arranges for him to marry the daughter of a wealthy merchant to alleviate his financial problems. Through the arranged marriage, the girl's father has bought her social status; she has become Lady Squanderfield. The series, however, ends miserably with infidelity, scandal, and death by duel. Hogarth's

14.20 William Hogarth. Breakfast Scene. From Marriage à la Mode. Oil on canvas, $28" \times 36"$. England, c. 1745. National Gallery, London.

paintings were turned into inexpensive prints that were enormously popular and received widespread distribution. The English middle class, who bought the prints, enjoyed the comic, ridiculing, judgmental handling of the upper classes. Hogarth's scene also condemns the mercenary society that places so much importance on social status.

While Hogarth satirized the upper classes in England, George Tooker looked critically at the systems and structures of the modern world, showing them to be oppressive and inhuman. His paintings of places like subways and cafeterias show people pushed together in compartmentalized, tight, artificial environments, close to others, yet isolated from them, or even in fear of them. In Government Bureau, painted in 1956 (figure 14.21), Tooker attacks excessive bureaucracy spawned by large, unresponsive governments. Too many departments leave citizens trapped in long lines, filling out forms or searching for the proper paperwork. The deadening uniformity of the bureau's office is apparent: the architecture and furnishings subdivide space into a maze of cubicles for endless numbers of clerks, who peer or listen through holes, surveying the people outside. Tooker's scene is a distillation of every person's experience with modern governmental bureaucracies; who hasn't been frustrated with the Department of Motor Vehicles, or a university's registration department? In this painting, we never see the complete face of one of the clerks. No one has the power to resolve problems, nor takes any responsibility.

Yayoi Kusama looks at the commercial and gender underpinnings of society. *Accumulation No. 1*, dated 1962 (figure 14.22), is a fringed armchair covered obsessively with sewn, stuffed protrusions like phalluses. Kusama appropriated the male phallus and proliferates it outrageously. She has done similar work on a sofa, a vanity, an ironing board, a step ladder, a rowboat, and so on. Some also have spike heel shoes among the phalluses. While many are all white, some are made of polka-dot or stripped fabric. Taken together, they make a frightening, crude, and humorous ensemble of familiar domestic items engulfed by the groping, organic growths.

Kusama's work refers to many underlying presumptions and power relations that, almost unseen, make up the modern world. The profusion of phalluses that take over everything stems from her experience of Japan's

14.21 George Tooker. Government Bureau. USA, 1956. Tempera on gesso panel, 19%" × 29%". Metropolitan Museum of Art, New York, George A. Hearn Fund.

14.22 Yayot Kusama. *Accumulation No.* 1. Sewn stuffed fabric, paint, fringe on chair frame, $37 \times 39 \times 43$ in. Japan/U.S., 1962. Beatrice Perry Family Collection. See also the text accompanying figure 20.13.

traditional, authoritarian, patriarchal society. In contrast, Kusama herself sewed and stuffed all the phallic forms, thus mimicking traditional feminine work that tends to be undervalued, anonymous, and monotonous. The phalluses and high-heel shoes refer to the sex industry and sexual appetites that in many cultures exist sideby-side with religions that teach very different morals. In addition, her piece points out social conformism, with the uniformity of the soft forms covering this armchair and other pieces. It also refers to the consumer society, because the phallic forms are like the standardized objects in great numbers that surround us. Imagine the sameness and sheer numbers, if lined up before you right now were every bar of soap you will have used in your life, every candy bar you will have eaten, every tube of toothpaste, every box of breakfast cereal, every can of beer.

Kusama called her work Obsessional Art, because of the almost compulsive drive and amount of time required to make her repetitive forms. A kind of selfobliteration comes from constant, compulsive repetition, a tendency seen in the work of several Japanese visual artists and dancers at this time. It may have stemmed from the post-world war sense of void. As a teenager, Kusama experienced the annihilation of World War II and subsequently the postwar Americanization of Japan.

Magdalena Abakanowicz's Backs, dated 1976 to 1982 (figure 14.23), consists of eighty slumping, hollow backs that are more than life-sized, but without legs, heads, and hands. They hunch forward, immobile, in lines all facing the same direction. Backs alludes generally to the human condition in times of great distress. Abakanowicz herself lived in Poland during World War II, saw her mother's arm shot off at the shoulder, and witnessed a vast amount of death, pain, and destruction. In postwar Soviet-dominated Poland, she has encountered many hardships in her struggle to make artwork. Backs certainly recalls some aspects of World War II, especially the terrible maining and destruction, and the imprisonment of many in concentration camps. But it also suggests more generally the modern malaise of uniformity, of loss of self and of individuality.

All eighty backs were made by pressing organic fibers into the same plaster mold, so that each is very similar to the others. However, small degrees of individuality emerge. The fibers are not alike on any of them, and each back has a slightly unique posture because it distorted a bit after it was removed from the mold. The thick twisted fibers suggest wrinkled skin, knotted muscles and visceral tissue. The fibers are very organic, emphasize our physicality and our ties to the natural world. The surface is like old worn fur of great apes, and the hunching posture of orangutans. The backs seem weary, and at the same time suggest endurance and strength. They are expressions of survival, affirming the amazing reservoir of human endurance and toughness. The work

also changes depending upon where it is displayed. Outdoors, the figures seem rooted to the very earth, but that association is lost in the white gallery interior.

Jenny Holzer focused on the mass of implicit beliefs that are widely held and accepted in the United States today, in *Untitled (Selected Writings)* dated 1989 (figure 14.24). Holzer wrapped electronic signs around the spiral interior of the Solomon R. Guggenheim Museum in New York and placed a circle of red granite benches below. The stream of words jump out from the darkened interior of the museum. They start at the bottom, and then whirl around and up until they disappear far above at the top of the spiral. The phrases examine beliefs that are usually only partly articulated. They seem familiar,

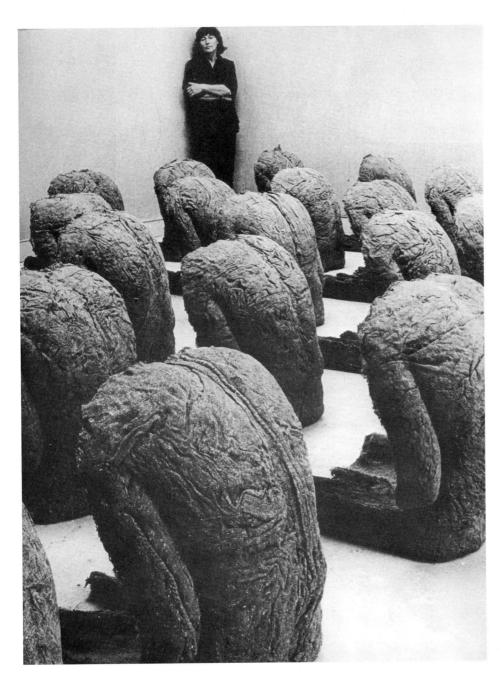

14.23 Magdalena Abakanowicz (shown here standing behind her artwork). *Backs*. 80 pieces, burlap and glue, each over life-size. Poland, 1976–1982. See also the text accompanying figure 2.34.

14.24 JENNY HOLZER. Untitled (Selected Writings). Extended helical LED electronic signboard, with selected writings; 17 Indian Red granite benches. Installation view at Solomon R. Guggenheim Museum. USA, 1989. Photo: David Heald, courtesy Solomon R. Guggenheim. See also the text accompanying figure 2.25.

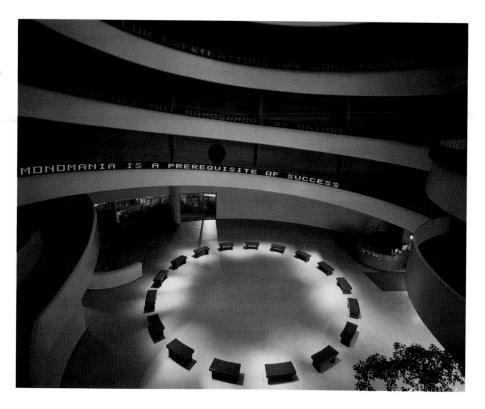

but when spelled out and taken as a whole, the phrases sound contradictory or a little idiotic. As Holzer herself says, "They're about how we drive ourselves crazy with a million possibilities that are half correct." (Auping 1992: 55) So, in addition to the phrases we see in our illustration, there are also lines like "A sincere effort is all you can ask," countered with "Enjoy yourself because you can't change anything anyway." Each is a partial truth that, taken together, leave us boggled about how a person should live. Another example is, "Protect me from what I want," written in a culture where money can buy a person almost anything. The phrase points out the negative aspects of consumer culture, and the high level of personal danger we accept in our surroundings.

Text Link

The architectural design of the Solomon R. Guggenheim Museum, which is so important to Holzer's piece, is described with figures 18.5 and 21.16.

Other words are carved into the tops of the illuminated stone benches. They are arranged in a circle as if around a fire, or for spectators watching an arena event. The short phrases seem to emanate from the human participants implied by the benches, or from us, the viewers, who stand in the space. It is important to consider the material Holzer uses in delivering her text. The electronic signs flash words at us quickly, like an attack. The phrases are fleeting, slipping away almost before we

can grasp them, like the barrage of messages in a media culture. In contrast, the words carved in the stone benches are permanent inscriptions, recording ideas that are like the foundations of our culture. Yet they are just as conflicting and contradictory. The sheer number of phrases, the speed at which we see them, and their contradictory messages destroy thought, although we normally think of words as the carriers of meaning.

Art vs. Politics

In Chapter 12, Power, Politics and Glory, we saw art that promoted the personal glory of a ruler or the power of a state. In this section, we will see art as the opposite, and look at art that does not dovetail with the political status quo.

Portrait of George, dated 1981 (figure 14.25), by Robert Arneson, is a bust portrait of George Moscone, a popular mayor of San Francisco in the late 1970s. Arneson's depiction of Moscone's face is vivid and animated. His big smile, with crooked teeth and squinting eyes, is distinct and alive, and the surface of splattered colors animates the face. The pose is alert. The carving and sculpting of the clay has left textured lines and strong highlights and shadows. The head is more than two feet high, its larger-than-life size adding to its presence. It sits on a column casually covered, graffiti-like, with phrases recalling Moscone's background, some of his more memorable sayings, and events from his life and death.

Arneson's piece was to have been placed in the Moscone Center, a new civic center in San Francisco

14.25 ROBERT ARNESON. *Portrait of George.* Glazed ceramic. $94 \times 29 \times 29$ in. USA, 1981. Foster Goldstrom Family Collection. See also the text accompanying figure 20.10.

named after the deceased mayor. Moscone had been assassinated three years earlier by Dan White, a San Francisco city supervisor who had recently resigned his position because of personal financial reasons, but later wanted his job back. Moscone refused to reinstate White, in part because they radically disagreed on most political points, including issues concerning homosexuals. After a violent argument in the mayor's office, White shot Moscone, and very shortly thereafter also killed another city supervisor, Harvey Milk, a prominent homosexual politician who was an ally of Moscone's.

Arneson's Portrait of George departs from the status quo of bland, bronze portrait heads of political leaders. We see such sculptures sitting passively in parks and in lobbies of many public buildings. In constrast, Portrait of George is irreverent, colorful, and very large, and as such, the viewer really cannot pass by without noticing it, as can be done with a lot of typical public sculpture. It was the pedestal below the head, however, that caused the greatest controversy. Among the words, bullet holes apparently pierce the column, making a comment on the ubiquity of guns in the United States today. A yellow phallic Twinkie is prominent. Dan White received a light sentence of voluntary manslaughter for his crimes. His lawyers claimed that he had been unbalanced at the time of the shootings because he had eaten too many Twinkie snack cakes. Many San Franciscans protested the lighter sentence; a large portion of the gay community saw it as a sign of institutionalized gay bashing. There was a night of rioting. Arneson's Portrait of George not only kept Moscone's personality alive but it also was a vivid, permanent reminder of the circumstances that surrounded his death, the recent riot, and the tensions in the city. One week after the unveiling at the Moscone Convention Center, politics intervened. Portrait of George was officially removed because the pedestal was "inappropriate." It was criticized for being crude and humorous and because it kept alive painful memories. It was later sold to a private collector.

Our next piece examines the ways art in the United States today has been used for political lobbying or public relations. Making and enjoying art are aesthetic pleasures. But the institutions that display artwork have economic needs and are subject to political influence. The art museum is a case in point. In the past few decades, many museums have found themselves increasingly in a financial crunch; as operating budgets increase, tax support decreases during recessions, and the cost of artwork skyrocketed in the 1980s. Increasingly, museums rely on corporate support for funding, but corporate motives for giving money to museums is often less than pure.

Hans Haacke's *MetroMobiltan*, dated 1985 (figure 14.26), deals with an art exhibition that was sponsored by a large corporation for political purposes. In the mid-1980s, Mobil Corporation was attacked by many groups for selling supplies to the South African police and military and for profiting from the violent enforcement of

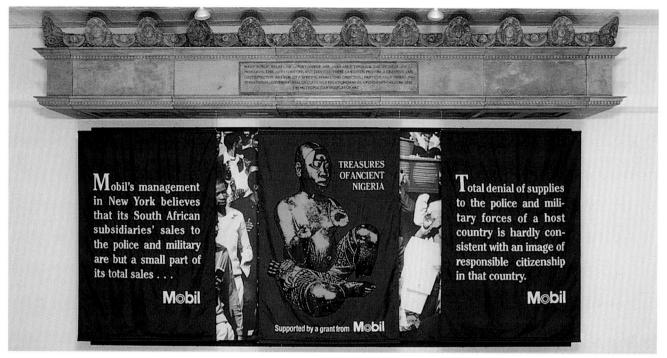

14.26 Hans Haacke. *MetroMobiltan*. Fiberglass construction, three banners, photomural. Photo on mural by Alan Tannenbaum, SYGMA; image on central banner is "Seated Figure" from Tanda, Africa, from National Museum of Logos, 140" × 240" × 60". Fabrication assisted by Max Hyder, Richard Knox and Paula Payne. USA, 1985. Artwork owned by the artist; first exhibited at John Weber Gallery, New York. Photo of installation by Fred Scruton. See also the text accompanying figure 4.9.

apartheid (the white South Africans' political and economic repression and segregation of the native African population). At the same time, Mobil gave considerable funding to sponsor the New York Metropolitan Museum of Art's blockbuster exhibition, "Treasures of Ancient Nigeria." While their sponsorship undoubtedly promoted the arts, many saw it as simultaneously a public relations move to counter negative image regarding apartheid.

Formally, *MetroMobiltan* is like a stately altar, raised on a platform, frontal and symmetrical, adorned with silk banners, with a large classical entablature like a roof above. The grand decor obscures a stark, black-and-white photomural, showing a funeral procession for black South Africans shot by police. The text on the end banners are excerpts from Mobil's board of trustees' refusal to church groups that had asked that Mobil stop supporting apartheid.

MetroMobiltan also points out the complicated ties between museum and corporation. The carved inscription on its entablature was taken from a Metropolitan Museum pamphlet encouraging corporate donations. It says, in part, that sponsoring museum programs offers "creative and cost effective answers" if a corporation is experiencing difficulties in "international, governmental or consumer relations." Thus the donation helps the money-starved museum and the corporation with image problems. The artist, Hans Haacke, used the entablature,

an imposing piece of classic architecture, to recall the majestic façade of a grand museum. In architecture, the entablature is a unifying element, so it works nicely here as a symbol for an institution that is the site for many conflicting political, economic, and cultural forces.

For our last example of protest art, we turn to contemporary El Salvador, with Miguel Antonio Bonilla's *The Knot* (figure 14.27), from 1994. The two standing ominous figures represent the country's police and politicians, who conspired in the 1980s to create an oppressive regime in El Salvador. The knot that connects

14.27 MIGUEL ANTONIO BONILIA. *The Knot.* El Salvador, 1994. Oil on canvas. Museum of Latin American Art.

them seems to be made of two extended, elongated phalluses. In this way, Bonilla makes reference to deeper social forces that support repression. In this case, chauvinism in his culture allows factions to dominate, be in control, and be in a position to do damage to others. On a domestic level, these same social forces result in violence and abuse in the home, which Bonilla addresses in other paintings.

Bonilla took a political risk in this painting because of its criticism of the political status quo. He also took artistic risks, because he chose to make the painting purposefully ugly, to shock. The style of this work was contrary to prevailing Salvadoran aesthetics for painting at that time.

SYNOPSIS

Francisco Goya's The Executions of May 3rd, 1808, Käthe Kollwitz's Outbreak, and Leon Golub's Mercenaries I vividly depict the cruelty and destruction of war as a means of protesting against it. George Grosz's Fit for Active Service and John Heartfield's Goering the Executioner present military leaders as cynically or viciously causing others to die. Siqueiros' Echo of a Scream and Tomatsu's Woman with Keloidal Scars hope to raise sentiment against war by showing the physical and emotional damage it does to its victims. Robert Motherwell's Elegy to the Spanish Republic XXXIV expresses in abstract terms the human struggle for liberty against the totalitarian forces.

Artists have protested many forms of oppression. The exploitation of laborers is decried in Lewis Hine's Leo, 48 Inches High . . . , and The Rent Collection Courtyard. Oppressive governments are opposed in Eugène Delacroix's Liberty Leading the People and in Ben Shahn's Passion of Sacco and Vanzetti. Acts of betrayal are exposed in Jacob Lawrence's No. 36. During the Truce Toussaint . . . and again in Shahn's work. Protests against colonization and affirmation of indigenous values are seen in Cildo Meireles' Insertions into Ideological Circuits: Coca-Cola Project, The Aboriginal Memorial, and Dingoes; Dingo-Proof Fence, by Lin Onus. Ester Hernandez made Sun Mad to oppose those who pollute in other persons' backyards. Edward Keinholz's State Hospital, Mario Cravo Neto's Voodoo Figure, and Magdalena Abakanowicz's Backs are moving portraits of the oppressed.

The conditions under which we all live and which we accept as normal are reexamined by artists, and in many cases found wanting. William Hogarth's *Breakfast Scene* is an unflattering picture of the life-style and morals of the English upper class. Stultifying bureaucracies, and the bureaucrats who operate them, are exposed in George Tooker's *Government Bureau*. Miguel Antonio Bonilla paints the human characters who run the police state. Jenny Holzer's *Untitled (Selected Writings)*

is a dizzying barrage of the contradictory half-truths that both confuse and motivate the general population in the United States today. Yayoi Kusama's *Accumulation No. 1* links consumerism, oppressive patriarchy, the status of women, and other current social phenomena. Hans Haacke looks critically at corporate funding for museums in *MetroMobiltan*. Robert Arneson's *Portrait of George* is a fascinating story of what happens when artistic expression, politics, and public art get tangled.

FOOD FOR THOUGHT:

Here are a few questions to think about in relation to protest art.

- To be effective, protest art must reach as many people as possible. That poses a problem for many artists. If protest art is shown only in galleries or museums, is it effective?
- Public art would seem to be one way to reach a broad audience. Public art is placed in well-traveled locations such as parks, airports, and mass transit terminals. Before public art can be installed, however, it is subjected to a lengthy review process that tends to diffuse any controversial work. What is the best way for protest art to reach the public?

Text Link

For more on the funding and selection processes involved in public art, see the section on "Support for Art Making," in Chapter 20.

- What is the relationship between protest art and propaganda?
- With protest art, the artist often has a clear political message to deliver, presents it in a persuasive way, and hopes to cause change. Is that different from propaganda?
- Can propaganda be art?
- Finally, some recent artists and art writers have been critical of social protest work like Hine's *Leo*, 48 Inches High.... They note that the photographer "takes" the pictures of the underprivileged, but does not provide them a forum for which to speak for themselves. In this case, Hine spoke for them about what he considered to be important. In addition, Hine's photograph does not really change the existing power structures, even if it did help to alter people's opinions about child labor abuses. The wealthy and privileged remain insulated. The

photographs enable them to gaze upon people like the mill workers (who cannot see them in return), but do not change the distance between them. The status quo is maintained, although the privileged may be moved to "reform" the situation out of their own benevolence. Or they may not. What do you think of criticisms such as this?

Chapter 15
The Body

Chapter 16
Clan and Class

Chapter 17
Race, Sexuality, and Gender

Chapter 18
Entertainment

Chapter 19 Nature, Knowledge, and Technology

Section 4: Self and Society

Art helps us understand ourselves and the world around us. What is the nature of humans in general? What is an ideal body now, and what are they in different cultures? Who are our families, our classes, our peers and superiors? Art deals with race, gender, and sexuality—three biological categories which are surrounded by culturally determined attitudes.

Art entertains us, pleases us, diverts, and educates us.

Art brings us the world around us, by depicting animals and the land, as well as human attitudes towards them. Art illustrates bodies of learning and looks into the nature of knowledge itself.

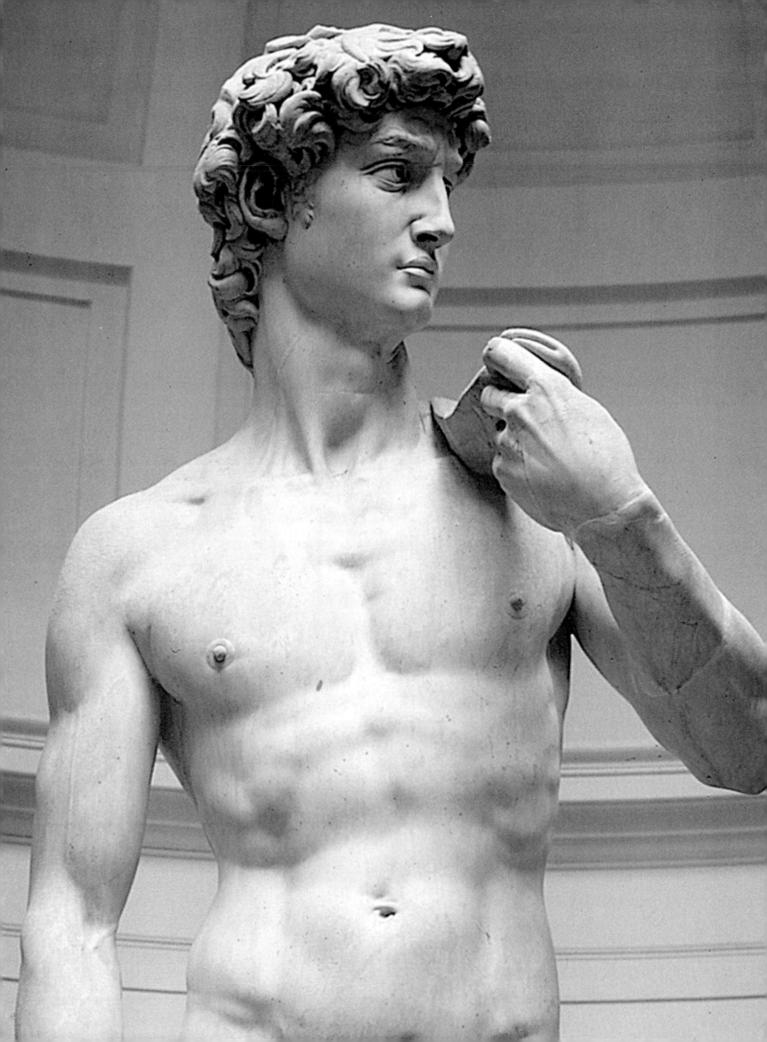

INTRODUCTION

The body is very personal: this is my body, this is me.

The body is very social: we look at each other; we use our bodies to communicate attitudes; the way we dress and walk is meaningful to the group.

We are fascinated by the look of our bodies and the bodies of others. The body reflects the personal experience of an individual. It also reflects larger social trends and ideas. By looking at art, we begin to grasp what different cultures understand an individual to be, and more broadly their concept of human nature. We can see what they consider to be the ideal, the powerful, the beautiful.

The subject of this chapter is the nature of the individual, and human nature in general, and how that is revealed through the body. But it is important to remember that the human body is amazingly pervasive in art, and is used for more than just alluding to the essence of human nature or revealing human personality. The body in art appears often in these chapters:

- Chapter 7—Reproduction: female and male bodies as powerful forces in the creation of offspring.
- Chapter 9—Gods and Goddesses: images of deities and how they compare to humans.
- Chapter 12—Power, Politics, and Glory: the imposing images of rulers.
- Chapter 16—Clan and Class: the importance of the images of family; representations of people that indicate different class levels.
- Chapter 17—Race, Sexuality, and Gender: How should men and women look?; what are the defining characteristics of race?; what is a sexual body?

In our current chapter, we have tried to show only images of human beings in art, although minor goddesses and mythic heroes have occasionally crept into our discussion, where they seem to illustrate important concepts of human nature. We will proceed with the following questions:

How does portraiture reveal the individual?
What do depictions of the body indicate more broadly about human nature?
What are the boundaries between the self and the world, both physical and spiritual?
What is the experience of sickness and death?
How is the human body used in art, both as material and as tool?

DEPICTIONS OF THE BODY

As we just mentioned in the introduction, the human body is a vehicle for revealing the individual person and human nature in general. How is that accomplished? In the next two sections, we will look at "Portraits" and "Self-portraits" that reveal some aspect of an individual. Later, we will see how art reflects ideas about human nature in general, under the heading "The Physical Body."

Portraits

In Oscar Wilde's nineteenth-century novel, *The Picture of Dorian Gray*, Gray remained handsome and youthful in appearance throughout his life. However, in his portrait, hidden away in a closet, Gray's face aged, becoming ugly and blemished as he lived a reckless and dissolute life.

Like the example from literature, a successful portrait in art is usually considered to be someone's likeness, both in face and in character. Portraits are relatively common in art, due at least in part to the importance of faces in our lives. That importance is to some extent hard-wired into us. The very first thing that a newborn child responds to is a face. Even the ubiquitous yellow happy face will elicit a response in a newborn, where other things will not. Later, we acquire the ability to "read" facial expressions. Humans are extremely perceptive in determining—or imagining— another's state of mind by nuances in their facial expressions. As adults we continue to study our own faces and the faces of others for hints of a person's character and experiences. Let us look briefly at a few portraits.

Text Link

In Chapter 16, we look at portrait likenesses that are used to strengthen clan ties, like the Head of a Roman Patrician, from Otricoli in figure 16.1.

The first attribute of a portrait is usually individualized features. We can see them in the Olmec Head (figure 15.1) from the Olmec culture that first thrived along the Gulf Coast of Mexico near modern Veracruz around 1500 BC. We really do not know much about the culture from which this piece came, or much about this piece itself. It may have been made originally as part of some kind of offering. What is striking is the remarkable modeling of the face, with subtle curves in the cheeks and brows, and a sensitive rendering of the mouth. The head was probably purposely deformed after birth, to conform to Olmec ideals of beauty. There are five locks of long hair that fall down the back of the neck, indicating that this is a woman. The face is individualized and human, so we understand this to be some specific person. It is not generalized to represent some role, such as "priestess," "queen," or "goddess." This head is ceramic, but other similar heads have been found that were carved from jade.

15.1 Olmec Head. Olmec, Mexico. Ceramic, 2 inches high, 900 BC. Museo Nacional de Arqueologia y Etnologia, Guatemala City.

Text Link

Another example of an ancient head modeled with refined, portrait-like sensitivity is Crowned Head of an Oni in figure 12.4. Like the Olmec Head, this castbronze portrait from Africa shows the distinct features of an individual, sensitively modeled.

In most faces we are tempted to read personality into the features. The Study for the Portrait of Okakura Tenshin, painted in 1922 (figure 15.2) records the face of a shrewd, intelligent individual who was at the center of social, political, and aesthetic controversies in Japan during his time. Okakura was a writer, aesthete, educator, and art curator who lived from 1862 until 1913, a time when rulers of Japan were ending three hundred years of isolation, and embarking on a period of rapid Westernization. Eastern-influenced music, literature, religion, and medicine were suppressed and replaced with Western modes. The one exception was the visual arts, where traditional and Western styles-and mixtures of the two-flourished. Traditional Japanese paintings and prints were popular and sold well not only in Japan, but also in the West. They influenced a number of Western artists, such as Vincent van Gogh (see figure 15.3).

Okakura and a U.S. scholar, Ernest Fenollosa, wrote the first Western-style history of Japanese art, establishing periods and categories by which the artworks were grouped. Prior to this, traditional Japanese paintings and prints had not been considered fine art in the Western sense of the word. Fenollosa believed that the contour lines and relatively flat colors of Japanese art were superior to Western art, especially Western realistic oil painting. Okakura and Fenellosa also established a Japanese museum, an academy of art and art appreciation societies, which were essentially Western cultural institutions. Later, Okakura wrote the book, The Ideals of the East, in which he created the concept of Asia as the East in contrast to Europe and the United States as the West. Eventually, he moved to the United States where he became an assistant curator in the Japanese and Chinese Department of the Boston Museum of Fine Arts.

The very style of *Study for the Portrait of Okakura Tenshin* reflects much of the controversy that raged around Japanese art during Okakura's time. The contour line that was so favored by Fenollosa is apparent here, especially in Okakura's left hand and sleeve, as lines clearly and delicately convey bending fingers, wrinkles, and folds of cloth. But the face and clothing are rendered with Western chiaroscuro, in contrast to traditional Japanese works, where volume is shown by outline rather than by dark and light shading. Okakura smokes

15.2 SHIMOMURA KANZAN. Study for the Portrait of Okakura Tenshin. Pigment on paper. 53.5" × 26". Japan, 1922. Art Museum, The Tokyo Museum of Fine Arts and Music.

a Western cigarette while wearing traditional Japanese garb. Okakura himself believed that modernism was vulgar and tradition was stilted. Only the combination of the two—modernism renewing tradition—meant progress in art. His face is the focal point of the composition, sitting atop the triangular shape of his body. The darkest darks (except for the table) are his hair, mustache, eyes, and eyebrows. His features make a great study of shrewdness, toughness, and perception.

Text Link

For an example of a face rendered in traditional Japanese style, with outlines only, see Komurasaki of the Tamaya Teahouse, in figure 16.27.

We may expect that most portrait artists purposely give us clues to the personality of their sitter. However, in the process, some portraitists end up revealing as much about themselves as they do about those they portray. When painting the Portrait of Dr. Gachet, dated 1890 (figure 15.3), Vincent van Gogh gives us an image of a free-thinking eccentric doctor. The foxglove flowers in the foreground likely refer to Gachet's profession of homeopathic doctor. Gachet's portrait is also a vehicle for van Gogh to make observations about modern urban life in general, which van Gogh found to be full of suffering. Gachet's face and body language express melancholy. He leans on two nineteenth-century novels about tragic and degenerate life in Paris. Van Gogh himself found life in Paris to be unhealthy and miserable, and sought a better life through his art, by living in the country and seeking medical help. At this time van Gogh was painting at an amazing rate, completing nearly one a day, but at the same time was less than two months away from his own suicide. In this painting, his

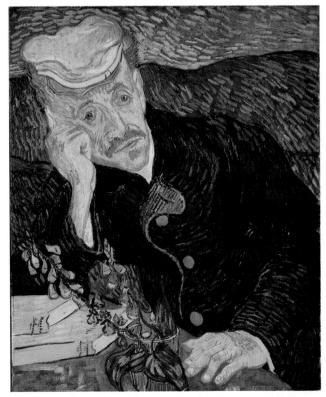

15.3 VINCENT VAN GOGH. *Portrait of Dr. Gachet*. Oil on canvas. Dutch, 1890. Photo courtesy Christie's. See also the text accompanying figures 5.12 and 20.12.

famous distinct, colorful brushstrokes are very evident. Thick paint animates the entire surface, with emphatic dashes and tight swirls. Van Gogh's paint strokes have often been seen as both an artistic device to model form and increase color saturation, and at the same time an indicator of van Gogh's own agitation and intensity. Thus, Gachet's likeness was an image of Gachet himself and a reflection of van Gogh's own inner state.

Portraits indulge us. They allow us to satisfy our curiosity fully about another person in an uninhibited way, just as children stare at the unfamiliar. In *Fanny (Fingerpainting)* dated 1985 (figure 15.4), the artist Chuck Close has painted an elderly woman's head in great detail, at an enormous scale (more than nine feet high). Her face fills the foreground space of the painting, pushing toward us her lizard-like eyelids, her watery eyes, the cracks in her lips, and the sagging puckered

skin of her neck. Aging has transformed her face, with changing muscles, patterns of wrinkles, and increasingly coarse texture of skin. With this painting, we can investigate the surface of another person's face intensely and minutely, in a way we could never do in U.S. culture, where it is generally considered impolite to stare or to stand very close to another person. In addition, our stereoscopic vision, eye fatigue, and constant involuntary movements of our bodies make it very difficult to focus for long periods at very close quarters. But this monumental, clear, and detailed face allows us to do so.

The woman's features are ordinary. The pose looks like an ID photo for a driver's license. She is lit unflatteringly from both sides, leaving dark shadows at the center of her face. While *Fanny (Fingerpainting)* is not an idealized portrait, the scale and amazing surface makes her face forceful and imposing.

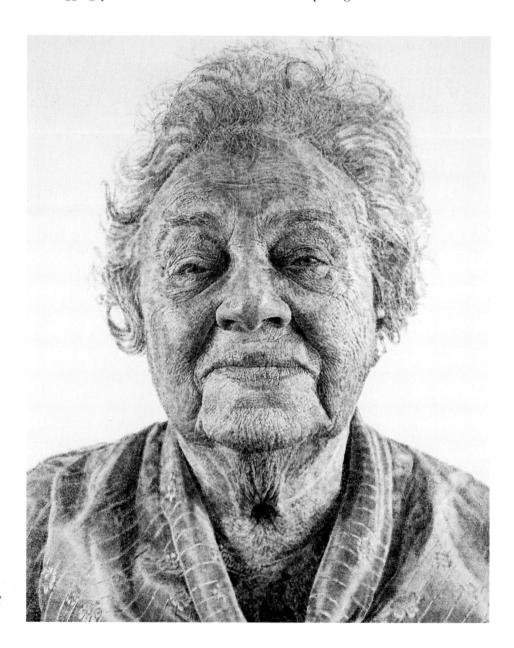

15.4 CHUCK CLOSE. Fanny (Fingerpainting). Oil on canvas, 120" × 84". USA, 1985. Washington, National Gallery of Art donation of Lila Acheson Wallace.

15.5 Nancy Burson. Untitled image from "Faces." Photograph, USA, 1933. Twin Palms Publishers, Santa Fe, New Mexico.

It is interesting to consider Fanny (Fingerpainting) in relation to photography. Close works from photographs. Like his photographic sources, this painting is in sharp focus in certain areas, with soft focus in others. The center of the face is clear, but all points closer (the tip of the nose) and more distant (the hair, base of the neck, and shoulders) fall out of the depth of field of the camera and are blurred. The expression of the woman's face also makes evident the photographic source: her eyes are focused on the camera that is close to her nose; and she seems both tolerant of and slightly affronted by the camera. The camera was an important aid for the artist, but that does not mean that a photograph could have achieved the same effect as this painting. The artist enhanced the texture and richness of the original photograph to make this image.

In the 1993 series called *Faces*, Nancy Burson also gives us the opportunity to indulge our curiosity about other people's faces. She used a cheap plastic camera to make grainy, fuzzy photographs of children with unusual faces, due to genetic conditions, accident, or disease. Burson recorded the subjects alone, or with their families or other children, in ways that reveal some aspects of their personalities, such as friendliness, dreami-

ness, caution, concern, curiosity, boldness, etc. Our example (figure 15.5), an untitled image from the series, reveals the different personalities of two boys, the one at left obligingly posing and encouraging the other to do so too; the other reluctant and a bit suspicious of manipulation. While facial expressions and postures indicate personality, the unusual framing is also an expressive device. The child at left seems to be in movement, just entering the picture, while the other appears more pinned at the center. The low-quality lens on the cheap camera resulted in a surprisingly beautiful image, blurred at the edges, with softened highlights and grainy but luminous shadows.

Burson's photographs not only reveal the sitter, but also act as a mirror to the viewers, who reveal themselves and their own personality when they react to the images. Burson noted that people who dwell on disaster see these children as disasters, whereas others react to them as they would to other children. Thus, degrees of "normal" and "abnormal" are the viewers' judgment, not any objective, external criteria. The artist's personal belief is that all faces are beautiful. Burson became very close with her subjects in this *Faces* series; they understood and supported her project.

Although the typical portrait may consist of only the head, or the head and upper torso, there are considerable numbers of full-body portraits. The inclusion of posture, body type, and sometimes the setting and clothing, enhances the portrait, revealing more about the sitter's personality and status. Lucian Freud's Leigh under the Skylight, painted in 1994 (figure 15.6) is a full-body, nude portrait, a common subject for Freud. In all such works, Freud's sitters pose in the neutral, anonymous space of the studio. Freud gets to know his sitters, to feel a rapport with them, so that the paintings become at once portraits that reveal his sitters and a reflection of the artist's own state of mind and anxieties. At the same time, he attempts to distance himself emotionally so that during the long process of sitting for a painting, the sitters unintentionally reveal clues about their most intimate selves, primarily through their poses and facial expressions. Other expressive elements are the paint surface and the general composition that the artist develops over the period of the sitting.

In our example, the figure of Leigh is massive, and from the low point of view assumed by the artist, he appears to be almost gigantic. Yet the flesh is soft. The crossed legs, deeply lined face and furrowed brow communicate a sense of tightness. The figure appears almost stuffed up against the space of the skylight, wary and exposed. The paint seems thick and buttery in certain areas, such as the lower legs and the top of the belly, but congealed and clotted elsewhere, such as the lower face, nipples, hands, and genitals. Freud's paint surfaces are thick and richly varied, fleshy like the body itself. The excess of texture is both fascinating and repulsive. It is interesting to compare the figure of Leigh in this painting with two sculptures which we will see in the next section on the "Physical Body." The idealized bodies and heroic poses of the Doryphoros and David sculptures read much more as depictions of Man than as revealing portraits of individual men.

Self-Portraits

Artists also make images of themselves. In some cases, they depict themselves so often that they leave a record of their lives. We will look at three such artists. Rembrandt van Rijn made at least 62 self-portraits. Frida Kahlo painted herself 55 times, which represents almost one-third of the artwork she did in her entire lifetime. Cindy Sherman has photographed herself dozens of times in various guises and settings.

Rembrandt's images of himself vary tremendously. He appears sometimes strong, sometimes vulnerable; sometimes cloddish and at other times sophisticated. His paintings are a record of his physical face, beginning with youthful portraits through the continuous transformations of aging. The paintings are emotional barometers as well, either happy, worried, sorrowful, humorous, or resigned. In all paintings, Rembrandt captured his

own introspective, penetrating look; his gaze was directed inward, evaluating and assessing every state of his life. In *Self-Portrait*, painted in 1669 (figure 15.7), Rembrandt records both a human face and also a

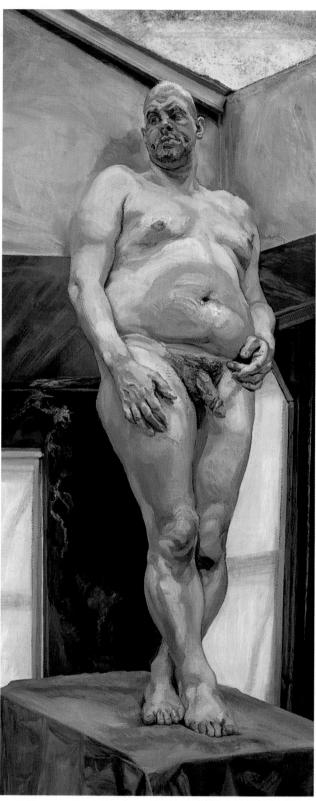

15.6 Lucian Freud. Leigh under the Skylight. Oil on canvas, $90"\times48"$ British, 1994. New York Acquavella Contemporary Art.

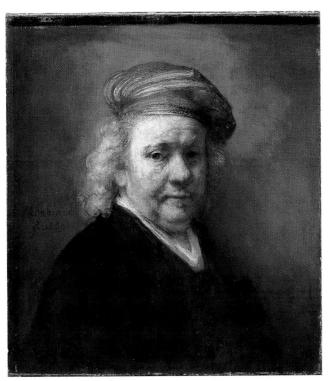

15.7 Rembrandt van Rijn. Self-Portrait. Oil on canvas, $23.25" \times 20"$. Dutch, 1669. The Hague, Mauritshuis.

human soul. He framed himself so that his face was the absolute focus; this is typical of many of his self-portraits. In this painting, as with many others, the background is a dark void from which his lit face emerged. The subtle expressions were Rembrandt's means of communicating his inner state. Light also was extremely significant. It seems to reflect off the surface of his face, and also emanate from inside the figure. In our example, the light glows from his forehead, and his right eye peers at us with an expression of gentleness, pain, and knowledge. The left side of his face is in soft shadow, a fitting visual metaphor for a man of wisdom facing his own death. In fact, Rembrandt died later that year. Earth tones, blacks, dull reds, and luminous yellows predominate in his paintings. The paint surface is rich and thick and luminous, standing for the sensual textures of cloth and skin, and also as a metaphor for the spiritual life of the soul. The rest is void.

In his concentration on the individual face, Rembrandt reflected the Dutch culture in which he lived and worked. The Netherlands were Calvinist Protestant, a religion that believed that the individual's own industriousness and spirituality was the measure of his or her worth. Humanist philosophy flourished in leading Dutch universities, and learning was valued; indeed, an unusually high percentage of the population was literate when compared to other European countries at that time. Power in the country was distributed among wealthy bourgeois families, rather than concen-

trated in a monarchy, as was most common in Europe. The center of life was the family home. Thus, Rembrandt intensively studied himself in a country where both religion and state promoted individualism.

In her 55 self-portraits, Frida Kahlo conducted a long inquiry into the exact nature of herself. Taken together, these paintings are pieces that build a picture of her inner and her outer being. Where Rembrandt used subtle variations in his face to express inner states, Kahlo's face stays almost the same in all her paintings. In looking at her self-portraits, we regularly encounter a reserved, distinctive, memorable face that gives away no emotion and an unblinking gaze that looks back. The face, almost always shown from the front, hardly changes, whether she is a child or near death in her paintings. Rather, she surrounds herself with signs and images of the different factors that have shaped her life: these include birth and death, her ancestry, her physical body, her near fatal accident and chronic pain, the indigenous Mexican culture, the landscape, the Christian religion, and her relationship with Diego Rivera, a prominent Mexican artist.

Text Link
We saw an example of Diego Rivera's
work, Dia de Los Muertos (figure
11.28).

Some of these factors and influences are apparent in *Self-Portrait with Monkey*, painted in 1938 (figure 15.8). In this painting, Kahlo's face is central, and confronts and studies us just as we confront and study her. Her face is neutral, showing no emotion, but her inner self is constructed from the many symbols and images that surround her. Kahlo's long hair is braided and pulled on top of her head. She wore her hair in traditional Mexican styles, and frequently dressed in native costume to publicly show her identification with the peasant culture. Lush foliage from the Mexican landscape surrounds her head. For Kahlo, the monkey was her animal alter-ego.

In other self-portraits, Kahlo uses even more symbols to define herself. Examples include butterflies which flutter about her, and hummingbirds, which recall the Mayans, who believed that the butterflies and hummingbirds were symbols of the souls of heroic dead warriors who triumphantly follow the sun as it travels across the sky.

Text Link

Butterflies as warriors' souls are visible also on the Tula Warrior Columns in figure 13.1.

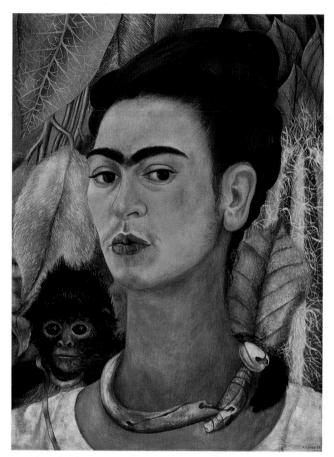

15.8 Frida Kahlo. Self-Portrait with Monkey. Oil on masonite, $16" \times 12"$, Mexico, 1938. Albright-Knox Art Gallery, Buffalo, NY. Bequest of A. Conger Goodyear, 1966.

Kahlo's symbols often are both very private and also broadly recognized. In some self-portraits, she is bleeding, sometimes from thorns. These allude to crippling injuries she suffered in a bus accident, and also to Mayan bloodletting ceremonies and the Christian crown of thorns. She used the black cat as a symbol of death, to represent her own debilitating illnesses, as well as several miscarriages she suffered. All her symbols are effectively woven into her compositions, as we see here with the patterns in the foliage and the rhythmic repetition of lights and darks.

Text Link
Look back to figure 9.22, Shield Jaguar
and Lady Xoc to see the Mayan relief depicting a bloodletting ritual.

Our last example of self-portraiture is different from the two we have seen above, where both Kahlo and Rembrandt let us glimpse the private inner self of a

unique, deeply feeling person. Cindy Sherman photographed herself hundreds of times, but the accumulated effect is not the piecing together of a unique individual. Each image of Sherman is molded from a socially given or media-disseminated role. Our example, Untitled Film Still #35 (figure 15.9), is one of a series of 69 fake film stills she made between 1977 and 1980. They were all black and white, $8" \times 10"$, the exact format of B-film stills. She wears a wide range of costumes, and posed in all kinds of settings, with all kinds of props. Sherman was both the artist who took the pictures and the woman in all the images. She poses for the camera, and at the same time poses as if unaware of the camera. And yet Sherman often reveals the mechanics of her selfportraiture; in this picture, the shutter release cable that Sherman operates is visible on the floor at left.

In the photos, Sherman is sometimes almost unrecognizable as she reenacts roles for women that are given to us by the media, such as the sweetheart next door, the

15.9 Cindy Sherman. *Untitled Film Still #35*. Gelatin silver print, $8" \times 10"$. USA, 1979. Collection of Eli and Edythe Broad, Los Angeles. See also the text accompanying figure 4.10.

housewife, or the girl left behind. In one still, Sherman is posed as a young, vulnerable hitchhiker on a deserted road at night; movie-goers would instantly recognize her as the young runaway who inevitably becomes the next victim in some conventional slasher film. In *Untitled Film Still #35*, Sherman appears as a poor woman who is hardened, trapped, sullen, and sexy. The grimy setting and costumes seems to be taken from the 1930s. The kick marks on the door allude to an atmosphere of violence. This image is the reversal of the role of independent, single, working girl who becomes the happy homemaker.

Sherman's work points up how we define ourselves according to mass-media models. She suggests that we have no in-built sense of identity, but rather compose ourselves with pieces of popular culture. The *Film Still* self-portraits are collectively a portrait of what women are supposed to be, as represented through the media. While none of the *Film Still* series copies actual movie characters or settings, they reenact the types, and thus seem very familiar. Together, the stills form a catalog of the media concept of U.S. woman, as defined by her roles as seen in popular media.

The Physical Body

Artists use the structure and appearance of the body to address ideas about the essence of humanity. What are human beings? What we should be? In some cases, humanity is highly idealized by the way the body is depicted. In other examples, the flaws of human nature are more emphasized. Through their work, other artists address the very essence of humanity: Are we more like machines, animals, or the gods?

The Idealized Body. Our first four examples present the human in ideal terms, although that is done differently and means different things in different cultures. Let us look first at the Torso, dated c. 3000 BC (figure 15.10), a very old carving from the ancient Harappan civilization that was centered on the Indus River in what is now Pakistan. Although we know very little about this culture, it had well-developed cities with drained streets and brick houses. Some small sculptures, but no large ones, have been found at these sites. The Torso is an idealized version of the human body. It is a supple, rounded form. The arm sockets suggests that the figure originally included several arms, possibly represented a youthful deity. The somewhat distended stomach also suggests a yogic breathing posture. The stone has been so sensitively shaped that it gives the feeling of living flesh, smooth muscle, and a little pad of fat. The outlines and forms are smooth and curving and seem very much like a youthful, living being, graceful and flexible, but also changing while developing. The rounded belly and curving back suggest sensuality and even vulnerability.

In the body of *Yakshi*, dated to the first century BC (figure 15.11), we see that later sculpture from India

15.10 *Torso*, from Harappa. Red sandstone, 3.5" high. India (Harappa, Pakistan), c. 3000 Bc. National Museum, New Delhi.

continued the rounded form and sensuality we just saw above. "Yakshi" is a nature spirit who represents fertility; her breasts are exaggerated to emphasize her powers, among which was her touch, which caused trees to flower. Her nearly nude body is curving and rounded, as revealed through her transparent skirt defined by the hemline draping across her shin. Not only her body type, but also her pose are distinctive and important. The *Yakshi* twists with incredible flexibility, looking natural in a pose that would leave her totally off-balance. Jewelry adorns her lower arms and legs, giving interest

 $15.13\ \textit{Male Torso (Ancestor)}.$ Baule sculpture, height 20.5 ". Africa London British Museum. See also the text accompanying figures 5.2 and 20.20.

are in parallel positions, legs both on the ground, head facing forward. This formal, frontal pose contributes to the dignified, almost solemn aspect of the sculpture. In contrast, the side view features counterbalanced parts: the abdomen and knees project forward, balanced by the buttocks to the back. Curving features are interspersed among the straight lines of the neck and back. The distinctive silhouette of the head is the focus for the entire work. This sculpture is likely the depiction of a deceased ancestor. Ancestors in many African cultures were important and powerful to the living, and thus accorded the idealizing treatment we see here.

Proportions were very important in carving a figure. In many African traditions, as we see here, the head and neck were considered the most important parts of the body, and thus were apportioned one-third the height of the entire figure. The torso occupied another third, and the last third were the legs. The first cuts the sculptor makes in the carving sets these proportions. The major forms were sculpted next. Finally, decorative patterns enliven the surface of the sculpture, balancing and contrasting with the smoothly polished wood in other areas. The patterns represent scarification and carefully

combed, braided, twisted, or beaded hair. The pattern elements are all expertly carved without mistakes or reworking. African sculptors generally were well-trained as apprentices, so that their work as professionals is marked by unerring, confident work. The *Male Torso* combines naturalistic and abstracted features; for example, the mouth, nose, and chest are relatively naturalistic compared to the stylized hands and eyes. This echoes tendencies in African sculpture as a whole, which runs the gamut from realistic (as we saw in the Ile Ife portrait in Chapter 12, Power, Politics, and Glory) to very abstracted.

Less-Than-Perfect Humanity. Having looked at idealized human forms, we turn now to some works that present a less idealized image of humanity. The first is Laocoön and His Sons, dated 300 to 100 BC (figure 15.14). In the two or three centuries that followed the making of the "perfect" image of Doryphoros the Greeks seem to have discovered an ever-widening gap between humans and the gods. Even though they continued to produce idealizing images of gods, athletes, and attractive young women, the later Greek artists (of the Hellenistic era) increasingly abandoned the Classical sense of restraint and balance. They depicted humans engaged in violent action, vulnerable to age, injured, diseased, and subject to feelings of pain, terror, or despair. Two cults were particularly influential in Hellenistic Greece: Stoicism, in which persons were urged to endure nobly their fate and state in life; and Epicureanism, which advocated intelligent pleasure-seeking in life as death was the end to existence. Both philosophies imply a kind of resigned acceptance of fate and a withdrawal from the Classic Greek ideal of the active, heroic, involved person.

Laocoön and His Sons shows these changing concepts of the human body and human nature. In Laocoön, the human bodies are impressive and realistically rendered in their musculature, an inheritance of the Classical Greeks. But formula of the balance of mind and body, and the contained emotion has here burst apart in a scene of high drama and sensationalism. Laocoön was a Trojan priest who tried to warn his fellow citizens against accepting the Trojan Horse as an apparent token of surrender from the Greeks who had been warring against them. The Trojan Horse actually hid Greek warriors, who were able to overcome the Trojan forces once the Trojans had pulled the horse inside their city fortifications. The gods, who sided with the Greeks against the Trojans, sent sea serpents to strangle and kill Laocoön and his sons, even as they were making offerings at an altar! The story of Laocoön seems to be one of great injustice, as a virtuous man who acts out of concern for his fellow citizens is cruelly crushed by the gods, even as he offers worship. Human vulnerability and lack of control of one's fate is well demonstrated.

The artists have depicted here the moment before death, as Laocoön and his sons struggle hopelessly and

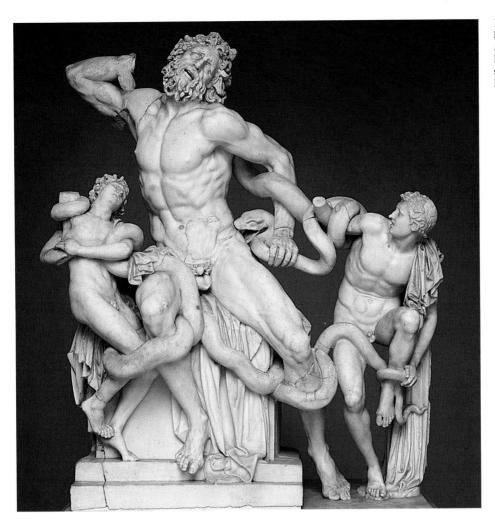

15.14 AGESANDER, ATHENODORUS, AND POLYDORUS OF RHODES. *Laocoon and His Sons.* Marble, 7' 10" high. Greek, Hellenistic (Roman patronage), late second, early first century BC. Vatican Museums, Rome.

cry out in terror and protest. The figures are like a group of actors on a stage, all facing forward as if performing for an unseen audience. Their struggles are theatrical, as their bodies pull away in violent movement, only to be drawn back again to their common fate by the binding serpents. Their bodies are idealized, but the father's is overdeveloped and muscle-bound, more a spectacle than heroic, as were the sculptures of Classical Greece in which mind and body were balanced. The style of carving of *Laocoön and his sons* increases its emotionality: the high contrast between the lights and the darks; the great space it occupies; the numerous negative spaces that add to the complexity of the piece; and the various textures and surfaces, from skin, to hair, to cloth, to serpent, adding a visual richness to the work.

The affluent Hellenistic Greeks and later the Romans who were great patrons of Greek art seemed to have had a considerable appetite for images showing the misfortunes of others. Other works surviving from this era include an old bent ragged women struggling to carry a load and a battered boxer with a scarred puffy face. These figures were individualized, but were not portraits, rather representations of a type. Works of great

sensual beauty were also produced, representing another form of emotionality.

In Medieval Europe, human nature was held in very low esteem, and their art reflected that belief. Medieval Christianity saw a great split between the goodness and purity of God's divine realm versus the natural world, a transitory place of sin and corruption. Humans were composed of both body and soul. The flesh of the mortal body was given over to appetites and lusts that led persons into sin and endangered their immortal soul. The invisible realm of God was accessible only through the Church, where the soul could receive the grace and guidance to stay on the path to salvation. In The Last Judgment, dated c. 1130 (figure 15.15) from the Church of St.-Lazare, human bodies are depicted as miserable, frail, and pitifully unattractive. The scene illustrates the end of time, when every person rises from the ground to be judged forever as worthy of heaven or condemned to hell. In the lower section of this carving, the cowering humans rise up from their box-like graves, and huddle in line until a pair of large hands, like oversized pliers, clamps around their head. All persons are then plucked up and deposited on the scales of Judgment, where they

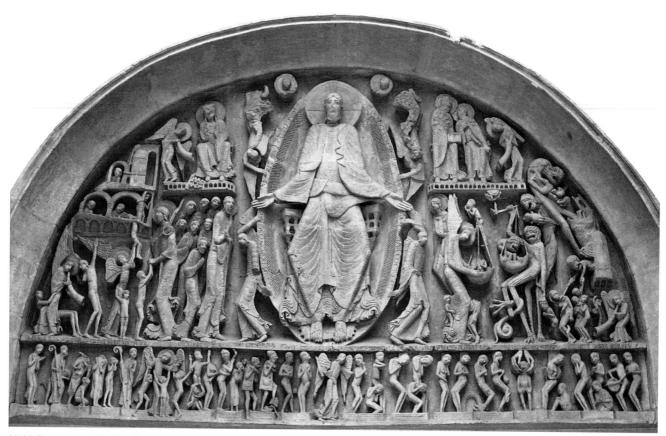

15.15 GISLEBERTUS. The Last Judgment. West tympanum of the church of St-Lazare, Autun, Burgundy. Stone carving, 21 feet wide \times 12 feet high. France, c. 1130. The bottom band shows humans raised from the dead on the last day, while Heaven is shown on the upper left, and the scales of Judgment and Hell are on the upper right.

will be snatched by demons and stuffed in hell for eternity if their souls are found heavy with sin. The saved clutch fearfully at the robes of the angels.

Since human nature was considered so worthless and troublesome, the Greek nude was inconceivable and the concept of naturalistic body as beautiful and good had long ago disappeared. The body in medieval art was distorted to communicate moral status. Thus, while the naked humans are puny, the good angels are elongated and serene, their anatomical distortions emphasizing their distance from earthly beings. The demons, however, seem to have been modeled on a flayed human corpse, with the exposed ribs and muscles of a tortured body, while their faces are grimaced horribly. Their claw feet are beast-like, and indeed the human body was associated with animals, which were seen as even more distant from God. Jesus is depicted in a grand manner reigning over heaven and earth, frontal and symmetrical, and much larger than any of the other figures. The Last Judgment is located over the main entrance of a church, which was considered the realm of heaven in a corrupt world.

Attitudes about human nature shifted again in Europe with the Renaissance in Italy. Humanistic philosophy of this time celebrated the glory of humanity: the Italian philosopher Giovanni Pico della Mirandola declared in the fifteenth century that "There is nothing to be seen more wonderful than man," reflecting an attitude very similar to the Greeks' "Man is the measure of all things." Michelangelo Buonarroti, the famous painter, sculptor, and architect of the Italian Renaissance, believed that the human form was the most perfect and important subject to depict. Like most other Italian artists of that time, he was strongly influenced by Hellenistic and Roman sculptures that were being excavated during that time in central Italy. The nude as an ideal form became popular again.

But nudes at this time were not exactly the same as the Classical nudes. On the one hand, the body was seen now as a work of God, and deserving of the same respect and honor that St. Francis of Assisi preached, that it should be given to all God's natural creations. Yet the Medieval influence remained strong: the soul is all that endures, and the body ages and rots and often leads humans into sin and damnation. During the Renaissance there was also a growing interest in scientific inquiry. The natural world was the subject of intense observation and even study by dissection, and this included the study of human anatomy. Michelangelo, Leonardo da Vinci, and other Italian artists dissected the human body. Treatises on the human body based on anatomical dissection became very popular, as they gave artists

detailed information about the body's muscle and bone structure.

Text Link

See Andreas Vesalius's Fourth Plate of Muscles (figure 19.21) for more on the Renaissance scientific studies of anatomy.

For the Renaissance artists in Italy, humanity was the supreme subject matter. Michelangelo felt that when he made art, his work was an echo of God's divine creation of humanity. David, dated 1501 to 1504 (figure 15.16), represents the Israelite youth who fought the giant warrior, Goliath. He saved his people from defeat at the hands of the Philistines, and went on to become the greatest king of the Old Testament. Michelangelo carved the young David as he first faces and assesses Goliath. His frown, the tensed muscles in his right leg and neck, and the protruding veins in his hands all attest to the tension of the moment. The sculpture is not self-contained, in contrast to Doryphoros (figure 15.12); the turning figure of David is "completed" by the unseen Goliath. The head and hands are oversized, indicating youthful potential still maturing, and a greater potential violence, all attributes that differ from the restrained Doryphoros. The knotted muscles of David's abdomen contrast with the smoother, relaxed torso of Doryphoros. The inner tension speaks of the core of being, the soul, that is separate from the body. There seems to be a tautness, vigilance, and self-conscious selfawareness about David. The body is ennobled and emphasized, but only as a vehicle for expressing the soul.

The ancient story of the hero David overcoming Goliath was very popular in the republic of Florence, the city-state in central Italy for which this sculpture was made. Florence was ruled by a group of its wealthy families rather than by a single leader, and Florentines saw themselves as much more self-determining and their city a place for individual opportunity than the other Italian city-states at the time, which were ruled by tyrants.

By the nineteenth and twentieth centuries, religious models for human nature held less sway in Europe, and were increasingly challenged and displaced by concepts of human nature based on scientific inquiry. This shift was apparent in artwork, also. One indicator was the training of young artists, who in the past picked up their trade by learning what they could from an established artist. In contrast, aspiring artists in the nineteenth century studied in academies, where art training was standardized and systematized. The focus was on the human figure. Anatomy was studied by dissections, by drawing from live models, and by studying and copying Classical artworks. Plaster casts, anatomical dissection, and models told artists and scientists how the motionless or dead body looked.

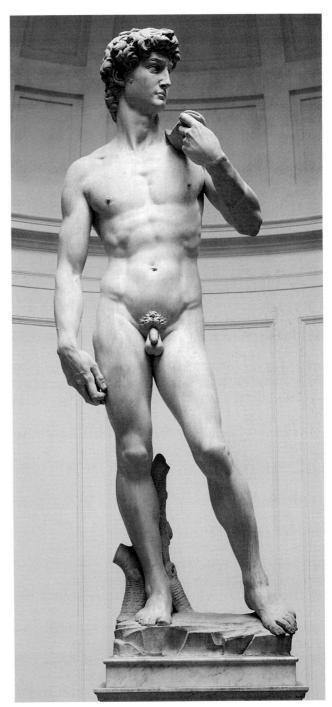

15.16 MICHELANGELO. *David.* Marble, 14' 3" high. Italian, 1501–1504. Galleria dell'Accademia, Florence, Italy.

But the new invention of photography changed the understanding of the human body. It provided the means of stopping and studying movement of the living human body in a way that had never been possible before. *Handspring, a flying pigeon interfering, June 26, 1885* (figure 15.17) is one of a series of photographic studies of the human body in action made by Eadweard Muybridge, subsequently published with other such

15.17 EADWEARD MUYBRIDGE. Handspring, a flying pigeon interfering, June 26, 1885. Print from an original masternegative, Plate 365 of "Animal Locomotion." British (Scottish?)-American, 1887. International Museum of Photography at George Eastman House, Rochester, New York. See also the text accompanying figure 2.28.

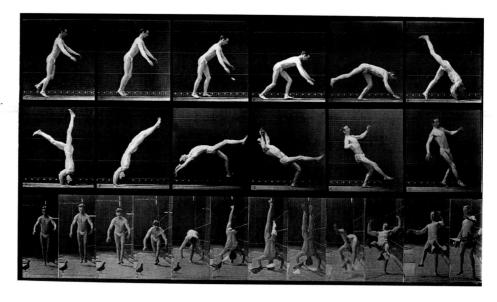

studies in the book, *Animal Locomotion*, Muybridge invented a special camera shutter and then placed twelve cameras so outfitted in a row. When the athlete performed the handstand, his movements broke the series of strings stretched across his path, and thus each of the twelve cameras was progressively triggered. He made similar studies for all kinds of human and animal movement. He also developed a cylindrical device that allowed his images to be mounted, rotated, and viewed to give the illusion of motion. In this respect, his work was a precursor of cinema.

Text Link

Look to Chapter 18, Entertainment, for a discussion of the way Muybridge's invention fits into the technological revolution in art that includes the invention of film and television.

Muybridge studied human motion in a detached systematic manner, from two different points of view, quantified by measurement in space and time. The figure in the small, grainy, black-and-white photographs are mere objects of scientific study. They have none of the powerful presence of *David* or the *Male Torso* from Baule. With Muybridge's investigation of motion, the concept of the human body was altered, and was recognized as being modified by time and space.

The Limits of the Self

Is the individual person a discrete entity? Is our skin the beginning and end of ourselves? What are the boundaries between the self and the environment, or between the self and the spiritual realm? Let us look at several examples in which the self is not simply the discrete individual, but continuous in some way with the surrounding world.

Many Oceanic cultures of the South Pacific conceive of the person as an amalgam of life forces, physical substances, and ritual knowledge that come from many sources. That amalgam of external forces, which is at this moment a particular person, is in fact constantly changing and transforming and also in danger of coming apart. All of existence is divided into two realms: first, the earthly world of light, and secondly, the domain of darkness, which includes the gods, fertility, creativity, and also dissipation and death. A newborn has just emerged from darkness and is considered sanctified, but also unstable and dangerous to the living. Birth was the result of powerful forces, forces that threatened the living, which had to be contained by ritual. The infant is not a complete being, but one that transforms through rituals at important stages of development: these include birth, initiation, circumcision, and marriage.

Ritual tattooing was one way of strengthening the individual. Tattooing was commonly practiced throughout the more eastern islands of the South Pacific. On the Marquesas islands, the entire body was tattooed, while tattooing was confined to the buttocks and thighs of the women of Fiji, and of the men of Samoa, Tahiti, and Tonga. While tattooing customs varied, they were generally associated with power and sexuality. Extensive tattooing subjects a person severe pain for a long time, but the end result was generally seen as a kind of ritual empowerment. Tattooing is often part of initiation rites that gradually harden the human body for adulthood. Extra eyes gave the tattooed person more power and decreased their vulnerability.

Text Link

For more on initiation rites, see the discussion of Sepik rituals with the cult house Waupanal (figure 17.17).

The tattoos of *Tomika Te Mutu of Coromandel* (figure 15.18), a nineteenth-century Maori tribal chief, were seen as an extra shell around the body that reinforced it and protected it. It added a new ritual skin. Tattooing was effective in war, as it distracted and confused opponents. The tattoos also identified the individual. Among the Maori, a person's tattooes were often considered more memorable than the features of their face. Certainly the tattoos of Tomika Te Mutu are memorable. The chiseled whorls on his face emphasize his scowl, piercing vision, hot breath and fierce mouth. Traditional Maori tattooing is done with chisels, which gouge deep grooves in the skin. Curves and spirals are common in Maori tattoos. In design, they are very much like the curving patterns in Maori wood carving.

Text Link

Turn to the Ridgepole of a Maori Meeting House, figure 12.24, to compare the similarity between tattoo designs and Maori wood carving.

Tattoos are treated in various ways once a tattooed person dies. The tattooed heads of deceased Maori chiefs were preserved by steaming, smoking, and oiling them. Then the similarity between the curving patterns of the tattoo and the curving patterns of Maori carving are especially apparent, and both convey concepts of power, ferocity, and vitality. In contrast, the people of the Marquesas rubbed the skin off a deceased relative to removed the tattooes, because the protection that tattoos give in life are a barrier to the person's reentering the realm of darkness when dead.

As tattooing grew out of religious beliefs that were contrary to Christianity, missionaries banned the practice, and it died out among the Oceanic peoples about a hundred years ago. At the same time, British sailors picked up the practice and spread it throughout the world. The current revival of tattooing seems to reflect some of the same motivations that marked Oceanic tattooing of the nineteenth century. It is linked to a desire of individuals for self-identification, self-adornment, and personal power. In Samoa, tattooing is currently being revived as an identifying sign of members of an extended family. Traditional Maori designs are also popular among gang members in urban New Zealand.

We have just seen with the Maoris that ritual beliefs can profoundly shape the concept of the human being. Scientific discoveries and technological advances can do so, also. In the last two hundred years, new discoveries in science have profoundly influenced the concept of the human being, and were reflected in art. When we looked at Muybridge's photographs, above, we saw that the human body was modified by time and space. Further scientific exploration revealed a whole range of environmental factors that influenced the living body.

The human being was no longer envisioned as a complete, separate individual, but rather as permeable and an integrated part of the total world.

In Unique Forms of Continuity in Space (figure 15.19), from 1931, the artist Umberto Boccione dissolves conventional limits of the body. The skin layer no longer defines the body's outer edge and outline. The body becomes a mass of wave energy defined by its movement through fluid atmospheric medium. Significantly, this work's title does not define the subject as human but as a form that is continuous with others in space. Muscle and bulk are implied, but the sculpture almost seems more of a map of the air turbulence that results from movement. In fact, Boccione was influenced by the study of aerodynamics and the distorting effects of air currents on forms. Boccione was part of an art movement called Futurism, which celebrated violence, energy, motion, force, and change. He was not interested in the fixed body, but with a definition of humanity as continuous with all forms of power and energy.

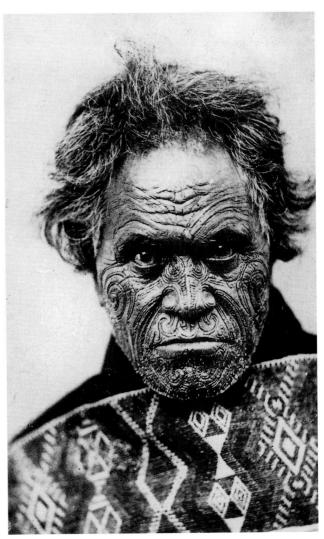

15.18 Tomika Te Mutu of Coromandel. Maori Chief. Maori, New Zealand, nineteenth century. Photo: John Hillelson Agency.

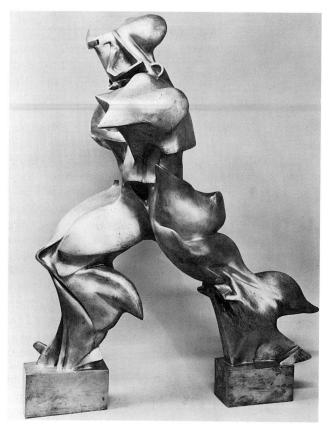

15.19 UMBERTO BOCCIONI. *Unique Forms of Continuity in Space*. Bronze (cast 1931), approx. 43.3" high. Italy, 1913. The Museum of Modern Art, New York; acquired through the Lillie P. Bliss Bequest. See also the text accompanying figure 2.27.

The body can also be affected by a host of internal forces. In The Scream (figure 15.20), painted by Edvard Munch in 1893, the distorted body is the vehicle for expressing inner terror. The fear depicted here emanates from inside the figure, and may or may not have an external cause. The image expresses visually modern anxieties and pressures. Realism has been abandoned to give form to these internal emotions. At this time, Sigmund Freud had propagated his theories of repression and neurosis, as both social and personal ills and Munch and other artists had been influenced by them. The figure seems to glance back at distant figures, but it is unclear whether they are part of the scene or disinterested bystanders. Whatever the situation, fear in the mind has twisted the body and reduced the face to a near-skull. The figure stands in complete physical and emotional isolation, cupping its hands over its ears and screaming at a pitch that reverberates in the landscape and in the sky. The waving lines of the composition are like sound waves, and the colors are emotionally distorted and heightened. The picture is of a mental condition expressed through the body, ground, and sky.

In the late twentieth century, you can change your body or enhance its image through products and procedures you can buy. In an era of consumerism, a person's worth is often determined by what they can purchase, not by their character, deeds, fate, or karma. Numerous

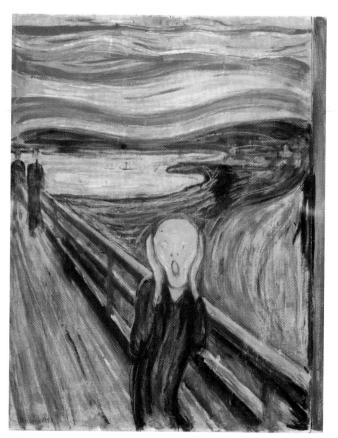

15.20 EDVARD MUNCH. *The Scream*. Oil painting. Norwegian, 1893. National Gallery, Oslo, Norway.

analyses have shown how advertising undermines people's self-esteem. By creating a sense of lack and need, advertisement successfully convinces people to buy certain products to improve themselves and their lives. And the body itself in an age of consumerism becomes something we can buy.

In the 1956 collage Just What Is It That Makes Today's Homes So Different, So Appealing? (figure 15.21), by Richard Hamilton, we see the aestheticized body ideals of the late twentieth century: the buff, muscular man of amazing sexual prowess (the Tootsie pop) and a super-thin sexy woman with fashion-model pouty face. The faces and bodies have been molded through implants, plastic surgery, and the latest abdominal workout machine. In addition, the couple's attractiveness is enhanced by their acquisition of trendy props, which in the 1950s included modern furniture, the latest appliances, and new media products. Hamilton took his imagery from popular magazines and billboards. The rug is a designer version of a Jackson Pollock action painting, which we will see at the end of this chapter. The cluttered composition, with all things new and chic, makes everything seem arbitrary and faddish. Hamilton's lampoon of modern consumer culture reveals the effectiveness and ridiculousness of advertising, because it projects ideal body images that are so extreme, to which we can never (but must always try to) measure up.

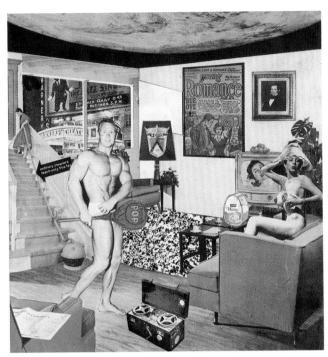

15.21 RICHARD HAMILTON. *Just What Is It That Makes Today's Homes So Different, So Appealing?* Collage, 10.25" × 9.75". Great Britain, 1956. Kunsthalle Tubingen, Germany.

Text Link

Hamilton's work is fine art with mass media imagery, and he is critical of both. For more on the interrelatedness of fine art and popular art, see the section, "High and Low Art, Popular Culture and Kitsch," in Chapter 1.

Sickness and Death

Sickness and death are realities of the physical body. In the art we will see, these experiences are mixed, both frightening and beautiful.

Intra-Venus, dated from 1992 to 1993, is a series of large-scale photographs that the artist, Hannah Wilke, had made with her husband, Donald Goddard, as she struggled with and eventually succumbed to cancer. In this series, both cancer and its medical cures transform and ravage Wilke's body. Blown up in many cases larger than life, the photographs present her body to us as it

weakened, bloated, and bled. The size makes the physical reality of sickness apparent; it is "in your face." In one bust-length portrait, we see her bald scalp, mottled skin and bleeding, pus-filled tongue, all resulting from her cancer treatment. Yet many of the images show that her body possessed a kind of monumental beauty, and that Wilke was still a person of humor and strength.

In three panels from *Intra-Venus* (figure 15.22), she assumes three poses derived from images of sexually attractive nudes taken from fine art and from magazines such as *Playboy*. Her glance implies the presence of a sexual partner, as she poses herself as the object of voyeurism. Her posture speaks of narcissistic pleasure. She is Venus, the goddess of love and beauty, even with the ravages of disease and surgery. Wilke reclaims beauty and sexuality for herself in sickness, and thus challenges conventional ideas of what encompasses attractiveness. In this, her last work is continuous with her earlier art. Before the onset of cancer, her body conformed to "fashion model" looks and she frequently used her body in her artwork to undermine or critique how female beauty is currently defined and consumed in the United States.

Text Link

For more about the sexual meaning of gaze and gender roles in images, see Olympia by Edward Manet, figure 17.12.

The Morgue (Hacked to Death II), dated 1992 (figure 15.23), is one of a series of twenty large-scale photographs by Andres Serrano, showing close-up details of the bodies of people in morgues who have died as a result of accidents, violence, or disease. The morgue location is not important, however, as Serrano's images are extreme close-ups that block out the surroundings. In some images, it is not clear if the person is lying on the side of a road or asleep in bed. No body is shown in entirety, so the persons have no identity. As a result they could be anyone. Serrano presents them up close and intimately. They are so close to us that we only see our own bodies or those near to us in this way.

15.22 HANNAH WILKE. *Intra-Venus*. Chomogenic supergloss photographic prints (½) Each panel: 26" × 39.5". USA, 1992–1993. Courtesy: Ronald Feldman Fine Arts. New York.

15.23 Andres Serrano. The Morque (Hacked to Death II). Cibachrome, $49.5"\times60".$ USA, 1992. Montreal, Musee d'Art Contemporain.

The Morgue (Hacked to Death II) is a disturbing image, not only for its content, because it is impossible to see this death as distant, as one would see a death on the evening news. We can see each hair as it grows out of the person's pores, study the dirt ground into the skin, trace the blood where it flowed and congealed. We cannot miss the dull, unfocused eye in dead center of the image. Serrano's framing, focusing, and manipulation of tones is artful and aesthetic; the refinement and beauty of the image jar with its content.

Text Link
Compare these images of death with those
from war, such as Mathew Brady's Dead
Confederate Soldier with Gun,
figure 13.22.

THE BODY IN ART AND AS ART

The body is not only depicted in art. It is used in making art, or is transformed to become artwork itself.

The Body as Art Material

The human body is material for art making. It can be painted or sculpted, or can be part of a performance or spectacle. In all these instances, the living body energizes, personalizes, or adds emotional content to the artwork. We have already seen an example of body art in this chapter, in the facial tattoo of the Maori chief, *Tomika Te Mutu* (figure 15.18). In tattooing, the body itself is the canvas upon which the artwork is made. The patterns and colors are expressive, meaningful, and aes-

thetically designed. The features of the chief's face are important elements in this work, as is his intense expression. The fact that this art has been gouged into a human face is important. The marks on the face of the *Male Torso (Ancestor)* (figure 15.13) from Baule may be scarification patterns. Let us look at other examples of artists using the human body for art.

The Mayan *Head from the Temple of Inscriptions* (figure 15.24), dated mid-seventh century from Mexico, shows how the human body is plastic and moldable, a kind of raw material from which works of art can be made. To the Mayans, a flat sloping forehead was beautiful and aesthetically pleasing, and so the Mayans purposely bound and compressed infants' heads to deform their shapes as they were growing to achieve the desired

15.24 Head from the Tomb of the Temple of Inscriptions, Palenque. Stucco, 43 cm high. Mayan, mid-late seventh century. Museo Nacional de Antropologia, Mexico City.

results. Hair was bluntly cut at different levels and woven with jade ornaments, cotton threads, and flowers. The stair-step cut on the sides and the top plume of hair were common designs. The resulting human head was a living artistic creation, the image of which is reproduced in this stucco sculpture in the round, which was once brightly painted. This portrait sculpture of a ruler known as Shield II (or Pacal II in Mayan) was found next to his tomb.

Body ornamentation is an art form in many traditional African cultures, where rituals are the supremely important events for the community, governing all aspects of life, death, everyday survival, and interaction with the spirit world. In many of these cultures, body painting is equivalent to wearing masks or costumes. Among the Ngere people in the late twentieth century, girls after initiation paint their torsos white and faces in brilliant colors for festivals. In Ngere Girl Prepared for a Festival (figure 15.25), the effect is very striking visually. The patterns of color are similar to the way the face can be abstracted and broken down into parts in sculpture, while the parallel lines in the white paint echo both chisel marks and sculptural hair patterns. Body painting, like tattooing, makes the living body into a work of art, expands its power and its protection, announcing the status of the person in the community; in this case, an initiated girl. Like all the pieces we discuss in this section, the presence of the real, living body as part of the art energizes the work.

The sculpting of the human body was the subject matter in Eleanor Antin's *Carving: A Traditional Sculpture*, documented in 1972 (figure 15.26). Her performance was the attempt to create a traditional Greek sculpture

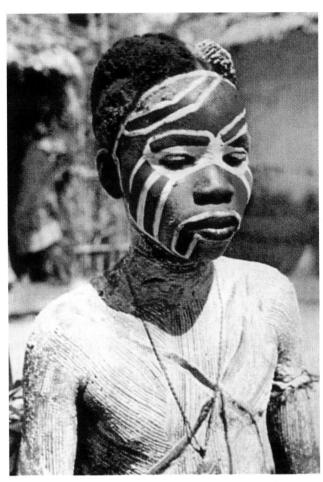

15.25 Ngere Girl Prepared for a Festival. Body painting. Africa, late twentieth century. Photograph by Dominique Darbois.

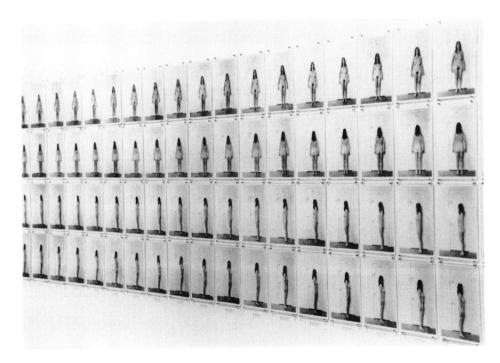

15.26 Eleanor Antin. Carving: A Traditional Sculpture. (Detail showing eight days) Photographic documentation. USA, 1972. Courtesy Ronald Feldman Fine Arts, New York.

from her own body, according to the process outlined in *Greek Sculptors at Work* by Carl Bluemel:

The Greek Sculptor worked at his block from all four sides and carved away one thin layer after another; and with every layer removed from the block, new forms appeared. The decisive point is, however, that the Greek sculptor always removed an entire layer right around the statue. He never worked just a leg or an arm or a head, but kept the whole in view . . . Thus the figure which started as a block was worked over by the sculptor at least a hundred times . . . becoming increasingly richer, more rounded and lifelike until it reached completion. (quoted in Sayre, *The Object of Performance*, 1989: 77)

Antin used her body as art material, and dieting was her method of removing layer after layer from her body until it "reached completion." She lost ten pounds over 36 days of dieting, and everyday photographed herself from all four sides to document her body's daily changes, minimal yet perceptible. All together, *Carving: a Traditional Sculpture* covered twenty running feet of wall space with nudes. Her work was finished when she, as artist, reached an "ideal image." Antin's photo documentation of her efforts to carve the ideal body show just the opposite: she (and in fact all other living women) always fall short. There is no defense against the gaze of a critical outsider who might, for example, suggest plastic surgery as a means to get those breasts up a little higher.

Antin's work points out that what appears to be her own concept of the ideal female form is the product of the fashion, fitness, and diet industry that glorifies thinness, and has created the contemporary phenomenon of eating disorders. Antin's photo documentation mimics the format of before/after make-overs that are common in fashion magazines. The format of her works also recalls Muybridge's studies of human and animal locomotion (see figure 15.17), giving them the quality of scientific documentation and investigation. It reveals how much science is based on and believes in the idea that vision/observation leads to truth.

Text Link
Body ideals change from era to era. For a
more round, corpulent version of the ideal
feminine figure that was associated with
health, wealth, and sexual desirability, see
Peter Paul Rubens's Abduction of the
Daughters of Leucippus in figure 17.21.

Ana Mendieta created a number of outdoor performances that dealt with her body directly or the trace of her body on the earth. Individual works in the series, called "Silueta" or Silhouette, were performed in Iowa

and in Mexico from 1973 until 1980 and exist now only as documentary photographs. In Arbol de la Vida, No. 294, dated 1977 (figure 15.27), Mendieta made herself into a body sculpture covered with mud and straw. She posed against a tree in a manner reminiscent of ancient fertility goddesses. Her coated body leaves traces of mud on the bark of a massive tree. The site of her performance was very dramatic. In other photo documents of this performance, seen at a distance, the imposing expanse of the enormous tree is visible, sitting high near a creek with deeply cut mud-lined banks. In other works in the Silueta series, she sculpted the mud or used stones or flowers to trace the outline of her body on the earth. It was important to use her living body in these performances because they became like rituals in which the energy of her living being was joined with that of the earth, which she believed was a force that was omnipresent and female.

Text Link

Review the discussion of ancient fertility goddesses, such as the Cypriotic Female Figure (figure 7.4).

Antin's Carving was first a performance (the artist losing weight) and later a display of photography (the documentation of that weight loss). Likewise, Mendieta's work is primarily performance, which is now known only through the photographs of it. Both Antin and Mendieta belonged to a growing number of artists at that time who made performance art, and for many their bodies were essential material for the performance. In some cases, the artists totally controlled the entire staging and action of the performance, but in other cases, the artists relinquished control. Yoko Ono wrote scripts that set up situations for artworks, but the exact outcome of the pieces was determined by chance or by spontaneous audience participation. In one 1964 performance of Cut Piece (figure 15.28), Yoko Ono entered an empty stage clothed in a black dress, and sat/knelt in a traditional position for Japanese women. She held aloft scissors and then placed them in front of herself, as if preparing for seppuku (ritual suicide). She then invited and encouraged audience members to cut away her clothing. As the performance proceeded, she sat without showing emotion. Long pauses occurred during the performance. Ono was influenced by John Cage, a composer who believed that the silences between sounds were as important as the music. More and more skin showed until she was nearly nude and bare chested, and the performance ended as she gasped and covered herself.

Cut Piece alludes to a number of ideas: the traditional male sexual prerogative over the female body; the display of the body for the consuming gaze; violation and control; and herd mentality among humans. Roles are confused in the piece: Ono, apparently the violated, also

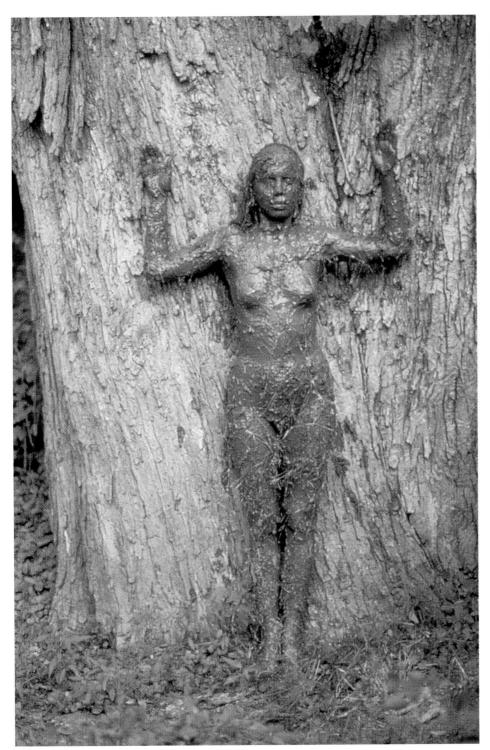

15.27 Ana Mendieta. Arbol de la Vida, No. 294. From the Arbol de la Vida/Silueta (Tree of Life/Silhouette) Series. Color photograph documenting the earth/body sculpture with artist, tree trunk and mud, at Old Man's Creek, Iowa City, Iowa. Cuban American, 1977. Collection Ignacio C. Mendieta, Courtesy of Gallery Lelong, New York.

seemed to set up the situation of her violation. Yet the audience members acted freely, as it was beyond her control to dictate what they did. The artist's body and the actions of the audience are the art piece, not the photo document we see in this book. The physical presence of real bodies, the quality of spectacle, the uncertainty, and the palpable experience of time passing are potent elements that a photo still cannot convey. Ono

was part of the **Fluxus** movement in New York, which sought to create a kind of anti-art or non-art. The defining limits by which art was traditionally known were knocked down, and the tendency among artists to create unique, precious, salable art objects was challenged. In Fluxus, art was conceived as an artist-initiated experience rather than an object. The audience participated and helped to make the event, affecting its outcome.

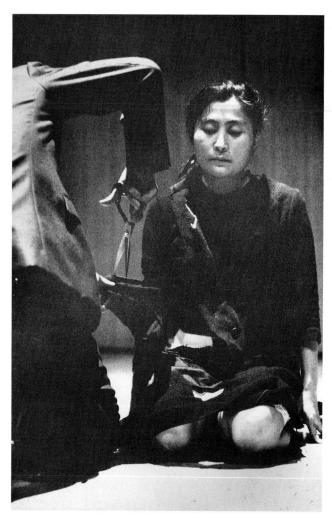

15.28 YOKO ONO. *Cut Piece*. Photo documentation of performance at Yamaichi Concert Hall, Kyoto, Japan 1964 Collection of the artist, courtesy Studio One. See also the text accompanying figure 21.30.

Text Link

Look ahead to the section on "The Visual Arts Within the Performing Arts" in Chapter 18 for a discussion of performance art and happenings.

The human body, as we have seen, can be sculpted, painted, or carved, making it one of our primary and important art materials.

The Body as an Art Tool

The artists' first and most important tools are their bodies: their fingers, hands, and arms, guided by their minds. In making works of art, artists continually touch the entire surface of their works. This is obvious with sculptors who model clay with their hands. But even painters work the entire surface of their images with sensitive brushes, and often adjust or finish their work with their fingertips. While the touch of photographers and computer artists may leave no mark on their works, their

hands are nonetheless essential and present. In Fanny (Fingerpainting), which we saw in figure 15.4, the artist Chuck Close created the woman's enormous head in great detail, showing the texture of her hair, skin wrinkles, her watery eyes, and the cloth of her dress. The entire work was painted with the artist's hand and fingerprints. Although the large painting looks like a photograph, the face in fact is a mass of marks, the artist's hand's marks. The painting is a record of everywhere he touched, almost like a planar sculpture in which the surface of the clay is worked by the hand. The mark of the hand relates to some of the oldest marks we know, such as fossils and the handprints in prehistoric cave paintings. It also relates to the first marks we made as children.

When Jackson Pollock painted *Lucifer* (figure 15.29) in 1947, the motion of his entire body was very significant. This style of painting is called "gestural abstraction" or "action painting." The "action" came from the movement of the artist himself. The canvas was laid down upon the ground, and Pollock poured, dripped and flung paint upon it as he stood at the edges or walked across the surface. Pollock used his whole body in the making of the work; he lunged and swirled about in furious outbursts, which were followed by periods of reflection. His efforts were fixed and recorded in the paint surface, which was a rhythmic mesh of drips, congealed blobs and looping swirls.

Pollock's act of painting and the painting itself, relative to the human body, were frequently described in quasi-combat terms. To the painter, the canvas on the ground was a plane of action; hanging on the wall in front of the viewer, it became a plane of confrontation. Pollock himself saw his spontaneous, energetic painting style as fitting to the moods of the United States immediately after World War II. Other qualities were associated with Pollock's work. The artist was in psychoanalysis at the time, and believed that the power of his unconscious mind was being released by his body in action painting. While his works are uncategorically modern, much of what he was doing was related to Eastern philosophies, where mark-making is carried to extreme refinement, and to European concepts of primitives and savages, as his painting style was seen as a kind of burst of primal energy and a release from civilized constraints. The action painter was seen as being an isolated genius, almost always male, who produced in bursts of wild energy and whose work was removed from the concerns of the world. There were no morals, no narrative to the work, just pure paint and pure body action.

In this respect, Pollock echoes some of the sociological concerns of the 1950s, the decade which emphasized conformity for the corporate and government good. Some writers and sociologists argued against conformity, and the transformation of "man" into social and corporate cog, instead of an individual whose body acted

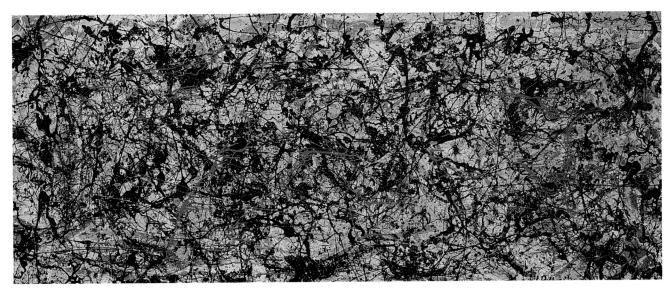

15.29 Jackson Pollock. *Lucifer.* Oil, aluminum paint and enamel on canvas, approx. 3' 5" × 8' 9". USA, 1947. Collection of Harry W. and Mary Margaret Anderson. See also the text accompanying figure 4.4.

freely on sexual, aggressive, or expressive impulses. Pollock as a painter of action reflected the ideas that made the cowboy or the "rebel without a cause" so appealing.

Pollock's work was important in mid-twentieth-century aesthetics. *Lucifer* was described as "pure painting" in the sense that there was no distracting content or narrative to the work, but only the actions of the artist's body and the resulting display of paint as nothing but paint. Pollock's poured and dripped paint resulted in viscous, thick, gooey, watery, dripping surfaces, which were seen as sophisticated handling of paint and a mark of artistic genius. Even the liquid nature of his poured paint was seen as being a truer expression of paint than were the brushstrokes of thick, creamy oils.

Thus the human body is an important art-making tool. Fingers, arms, and bodies leave gestural marks in art materials that enrich their surfaces.

SYNOPSIS

Our survey of the body began with portraiture, where we saw just a few examples of the many portraits in art. In each of these, we intimately encountered a unique individual, with the exception of the *Film Still* series of Cindy Sherman, where the individual conforms to mass media types.

Next we saw several examples of the idealized body in art and how they alluded to a range of ideas about human nature. Idealization could take different forms in India (*Torso* from Harappa, *Yakshi*), Greece (*Doryphoros*), and Africa (*Male Torso* from Baule). We then turned to images emphasizing more the tragic or the debased in human nature, especially in the *Last Judgment* at the Cathedral of Autun. Finally, the body is measured

and studied like a machine or animal in Eadweard Muybridge's photographs of *Animal Locomotion*.

We then began to consider the human not as a separate entity, but as part of the larger physical and spiritual world. This dissolving of boundaries transforms the human body, first at the skin layer with the Maori tattooing, and then below the skin with the very structure of the skeleton and muscles. We saw the body distort under the influence of aerodynamics (Boccione's Unique Forms of Continuity in Space), of mass culture (Just What Is It That Makes Today's Homes So Different, So Appealing?), and of psychological pressures (Munch's The Scream).

A brief look at the body in sickness and death included Hannah Wilke's *Intra-Venus* and Andres Serrano's *Hacked to Death*, where both the horrible and the beautiful are mixed.

Finally, we studied artwork where the body was used as either art material or very overtly as art tool. The body is malleable and can be marked or sculpted (Maori tattooing, Head from Palenque, and Eleanor Antin's Carving). It is also a "canvas" that can be painted (Ngere Girl Prepared for a Festival, or Ana Mendieta's Arbol de la Vida, No. 294). It is a primary element in performance art (Mendieta, again, and Yoko Ono's Cut Piece). And as we saw in Chuck Close's Fanny (Fingerpainting) and Jackson Pollock's Lucifer, the body is the most wonderful art making tool we have.

FOOD FOR THOUGHT

The individual is more than just one body.

• How do family, class, race, religion, gender, or sexuality contribute to personal identity?

A number of the artworks we studied in this chapter seem to fall outside of strict definitions of art. In the United States, we generally do not consider tattooing as art, nor body painting, losing weight, or hair styling. Yet probably we have all seen examples of tattooing, hair cutting, and styles of dressing that seemed like artistic expressions. In some cases, the boundary between art and fashion was hard to determine.

 What do you think are the most powerful ways in which individuals express themselves visually in your world today?

Science measures and compares human bodies as a way to learn more about them. However, the fascination with measurement and comparison can result in disaster. In the late nineteenth century, criminologists believed that certain skull shapes indicated persons of deviant behavior; thus you could be condemned if you looked like a criminal. Similarly, anthropologists studying human skulls noticed physical differences in the shapes, which were then identified with "primitive" human groups, or "civilized" groups. The result was social Darwinism, which posited that certain races were inherently "inferior." The idea contributed to the Nazi atrocities of World War II and continued to surface throughout the world in the twentieth century.

 What social tools do we have to keep in check the excesses of science?

INTRODUCTION

Humans are social beings. We seek community. Our very selves are developed by imitating others, or reacting to them. Most people live intimately within families or clans. Most regularly socialize within their class. Since such community is so central to our lives, it is hardly surprising that it figures prominently in many works of art.

A clan is a group of people joined by blood and marriage ties. It could be as small as a single household, with perhaps as few as two people living together. In its more extended form, a clan is a group of families with a common ancestor, who bear the same name and recognize one member as a leader. In some cultures, even deceased ancestors are a vital part of the clan and important to the everyday functioning of the living.

A class is a group of people who are economically or socially similar. They share common interests, culture, and financial means. Class divisions may be completely rigid in some cultures, but may be fairly permeable in others, with persons moving up or down the "social ladder." Members of the same class generally hold similar values, although some people find greater commonality with those in other classes.

What is the relationship between art and class? How does art function within a family or clan setting? Let us focus on the following to get specific answers to our questions:

How does art identify a clan?

When are ancestors important to a clan, and how does art help to make that relationship possible? How do paintings and drawings give us images of the ways different classes live?

How does art reflect the tastes, ideas, and needs of different classes?

Why does possessing a certain kind of art indicate a person's class status?

CLAN

In the first part of this section, we will see how art can help to solidify extended families. Afterward, we will look at art that depicts the smaller nuclear family, and what it says about relationships within it.

The Extended Family

If art can help solidify extended families, how exactly is that accomplished? Three points are important: 1) art makes major ancestors available to the living clan members; 2) art depicts important events in the clan's history; and 3) art is an important element in rituals that bring the entire clan together. Let us look at examples of how this happens.

Ancestors

The founding members of a clan are extremely important to the living clan. Clan founders have a major impact on the prestige of the living persons, and on their ability to function with power and authority among the living. Obviously, however, since clan founders are deceased, the living need ways to make them accessible to themselves. In many cultures, art accomplishes that.

To the ancient Romans, their ancestry was tremendously important. They preserved images of their ancestors and venerated their memory, as a way of establishing their own importance as they went about the business of living. They had portraits made of their ancestors, and kept them as proof of their lineage. At first, these ancestor portraits were simply death masks, made by pressing soft wax on the face of a deceased family member shortly after death. However, the wax masks deteriorated after a few years. So around the first century BC, affluent Romans began having copies of the death masks made in marble. The marble busts had the advantage of permanence, and in addition could be sculpted so that the face appeared lifelike, energetic, and alive, even monumental. This was very different in effect from a wax death mask in which tissue sags, eyes sink in their sockets, and the rigidity of death is apparent. The faces alone, sometimes including shoulders, were deemed enough for the Romans, who were not interested as the ancient Greeks in sculpture that integrated the head and body of a figure.

In *Head of a Roman Patrician*, from Otricoli dated c. 75–50 BC (figure 16.1), we have an excellent example of a Roman portrait bust made for ancestor worship and to glorify the lineage. The face of the Roman is aged and full of deep folds. The bust has a sense of a determined, experienced, prosaic individual. The Romans wanted a factual record of the ancestor's appearance, but we might read personality in the wrinkles of the brow and the curling lip. Ancestor portraits were treated with respect and were frequently copied for various family members. Our example is a copy from a now-lost original bust made some 50 years prior to this copy. The image of the ancestor is what was desired, not the idea of originality in art or a unique art object.

These portraits were kept in a shrine in the family home. They were brought out at funerals. On specific days during the year, food and drink were offered in remembrance at family ceremonies. Upper-class Romans were very proud of their lineage, and would ridicule prominent persons who could not produce and display

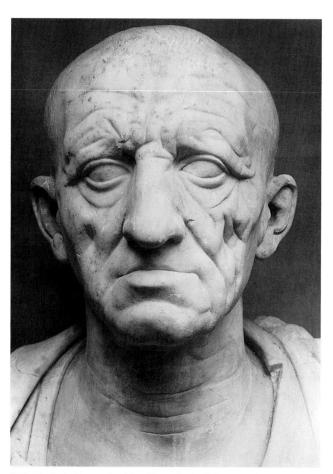

16.1 *Head of a Roman Patrician*. From Otricoli, Rome, c. 75–50 BC. Marble, approximately 14" high. Museo Torlonia. Rome.

impressive ancestor busts of their own family. Some Romans even had their own image sculpted, showing them holding busts of their ancestors in their arms.

Let us look at another example of ancestor portraits. Among the Zapotec people of Oaxaca in southern Mexico, ancestors were so important for the living that the dead were interred in tomb chambers under their houses. Anthropologists surmise that for the last several centuries, the Zapotec lived in close association with the dead, regularly consulting the deceased on pressing problems confronting the living, asking the dead for advice or requesting intercession. Founding ancestors and the recently deceased continue to be part of clan life, just as they were when they themselves were alive. Figure 16.2 shows the lavish Zapotec tomb, Interior of Tomb 5, at a site called Cerro de la Campana, dated c. 700. The tomb is laid out like the house above it, with a sunken central patio surrounded by rooms. The most important rooms were raised on platforms, as we can see in the center of our image. The walls were lavishly decorated with paintings, or with stone relief carvings and stucco sculptures which were painted red.

In the tomb, several bodies had their femurs missing. The house above is presumed to have been the residence of a ruler for the area, and by displaying their ancestors' leg bones, the rulers ensured their rights to rule. Images in paint and in stucco on the walls of the house above show family members holding the femurs of the deceased.

Sculpture and painting in tombs helped make ancestors available to the living. Figure 16.3 shows Portrait Heads from Tomb 6, from the town of Lambityeco, in Oaxaca. They are life-sized heads sculpted in stucco, and date from 640-755. The heads seem very lively and create a strong presence. The male head on the left has goatee, beaded necklace, earrings, and hair pulled up and tied in a bun above his forehead. Lines through his eyebrows and below his eyes are actually ancient symbols of glyphs that identify him. The wife's head, to the right, is lined with age. Her hair is styled with ribbons very much like that of Zapotec women of today. Faces have individualized features and are definitely portraits. They likely represent the founding parents of a clan. Both were important as lineage was traced through the male and female sides. These portrait heads are located on the lintel above the entrance to the tomb. They were probably the first ones buried within.

Important ceremonies for living members of the clan took place in ancient Zapotec tombs. The tombs would be reopened every time the head of the clan died, which was a profoundly important event for the entire clan. The deceased was seen as a giver. The power, energy, and wealth of the deceased were released to the living, and the power structures within the clan shifted. In contrast, the birth of a new clan member did not cause such a

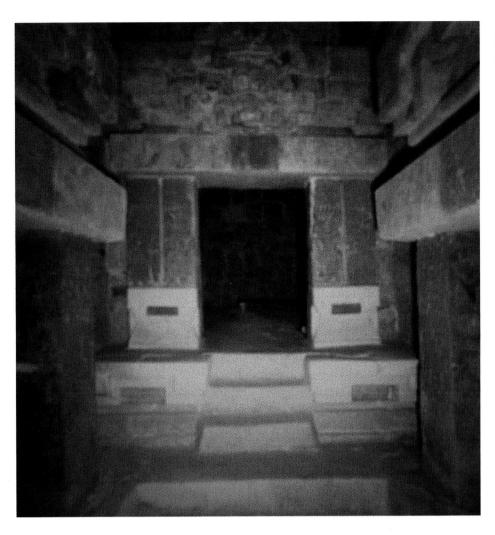

16.2 Interior of Tomb 5. Cerro de la Campana, Oaxaca, Mexico, c. 700. Stone and adobe walls, paint and stucco decoration.

profound change. The newborn was passive and powerless within the clan.

Text Link

Among the present-day Zapotec, this belief in the power of the dead continue. In their funerary rituals, wealth is transferred and clan hierarchy shifts. The spirits of the dead continue to occupy their houses for several days, and are invited back for years for Dia de Los Muertos. For more, see Diego Rivera's Dia de Los Muertos (figure 11.28).

Clan history

Art is also instrumental in preserving clan history, which helps ensure clan cohesion and thus increases its power.

The Maori, the native peoples of New Zealand, developed a form of architecture called the "meeting house," that helps to preserve the clan and clan history. The 1800s were times of great stress for the Maori. European settlers arrived in great numbers, taking the land that belonged to and served as the power basis of the various Maori clans. Missionaries undermined the native religion. In the 1860s, land wars broke out between settlers and natives, and the best Maori land was confiscated or sold over the next 40 years. To make matters more difficult, the era saw increased warfare among Maori tribes themselves.

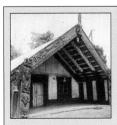

Text Link

The overall structure of the Maori meeting house was covered in the discussion of Te Mana O Turanga, seen in figure 12.23.

Eventually, land courts returned a portion of the tribal lands. To receive their land back, clans had to establish their tribal identity in ways that met European expectation. The meeting house became a tool for recreating and maintaining clan identity of sub-tribes of the Maori during a time when other pressures were causing

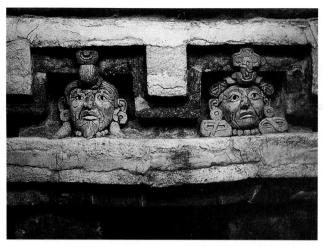

16.3 Portrait heads from Tomb 6. Lambityeco, Oaxaca, Mexico, 640–755. Stucco, each head 10.5" × 11.5". Photo by Arthur G. Miller.

their social order to degenerate. The meeting houses are expressions of strength and tribal identity that challenge outsiders and empower clan members.

The interior back wall of *Te Mana O Turanga* (figure 16.4), from 1883, contains various carvings of ancestors and images from the history of the tribe, concentrating on battles, migrations, and land and fishing rights. The images are not meant to be merely looked at. In meeting houses, the young hear inspirational stories about clan heroes that are recorded on the wall. The oral and visual combine to pass on clan history, traditions, and values. They reinforce the Maori belief that ancestral spirits protect and guide the living. Thus, not only is the past pre-

served, but some part of the Maori way of life is guaranteed for the future.

The variety of styles shows that this house dates from a period of transition for the Maori, as it combines traditional-style carving with those showing European influence. The most important figures are those carved on the center pole, which represent the ancestors Taua, Mahaki, and Hauiti, founders of several clans. These carvings represent the spirit and power of these individuals. The giant bird is a mythic creature that brought food to an early ancestor's children. Other characters represent more recent clan members. The carvings show that Maori clan identity was based on blood lines, religious beliefs, and historical developments. On the lower left is a European-style portrait of Agnew Brown and his dog, a settler who gave money to help build the meeting house.

The rafters throughout the meeting house, which are visible above the back wall in figure 16.4, are covered with curvilinear patterns running down the rafters. They are abstracted representations of the vines of gourd plants. In many meeting houses the number of curves in the vines signifies the number of generations between the founding member and ancestors shown on side walls. Colors among the curves are significant. Red stands for prosperous times, while black indicates times of adversity for the clan.

The design of the meeting house was associated with chief's homes and churches. In fact, the carvings themselves were usually made by chiefs or persons from ranking families. Carving was seen as an activity close to the

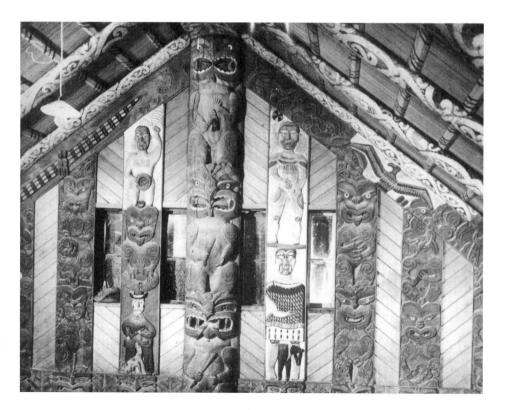

16.4 Raharuhi Rukupo and others. Interior back wall of the Maori Meeting House called *Te Mana O Turanga*, Whakato marae, Manutuke, New Zealand, opened 1883. Carved and painted wood. See also the text accompanying figure 20.25.

gods, and only to be entrusted to a person with political power and authority.

Text Link

Sculpture like that in the Maori meeting house is not always categorized as fine art, but is sometimes classified as folk art or cultural anthropology. Who holds these ideas? What is the source of this distinction? Is this distinction valid? See Chapter 21, What Do We Do with Art?

Other groups that use art to celebrate their clan lineage are the native peoples of the Northwest Coast of North America (currently Alaska, Washington state, and far western Canada). The *Interior House Post*, dated 1907, in figure 16.5 was one of four carved by Arthur Shaughnessy for the Raven House of the John Scow clan. House posts physically support the house. Their bases are buried in the ground, while their tops cradle the horizontal roof beam. In addition, house posts symbolically represent the spiritual and mythical foundation of the clan.

First, a word about the Raven House, which was completed in 1916. It was a lineage house, a structure that would be built when a new lineage was founded, due to death or marriage. When first built, these houses were used for festivities when the head of a new lineage assumed his ceremonial name. Guests would be invited to several-day celebrations called potlatches, with elaborate singing and masquerades. At the end of the celebrations, the interior was subdivided, for living quarters for several clan families.

Text Link

For more on the potlatch, with its story telling, performances, gift-giving, and feasting, see Chapter 4, Deriving Meaning from Art, and also Charles James' Feast Dish, figure 6.28, which was carved for a potlatch.

The carvings in lineage houses were visual aids that accompanied the telling of clan legends and history. The carvings were concentrated in significant areas, specifically around doorways, on totem poles that stood in front of the houses, and on the house posts, as we have seen. Sometimes the carvings symbolically represented specific ancestors of the lineage, like animals in European families crests. In other cases, the animals represented deities who were important to the lineage, or a human in animal form. Different tribes used different symbols, and the meanings for any of these various symbols might change depending upon their combination.

The top of our *Interior House Post* has a thunderbird with spread wings, a mythical being of great power that represents a chief. Its powerful curved beak and curved

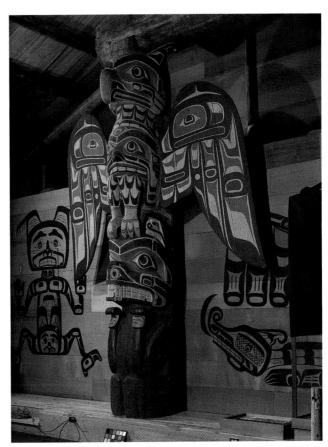

16.5 Arthur Shaughnessy. *Interior House Post.* Kwatkiutl, Gilford Island, British Columbia, Canada, 1907. Carved and painted red cedar, $190'' \times 134'' \times 34''$. Seattle Art Museum. See also the text accompanying figures 2.16 and 4.14.

ears suggest supernatural powers. Extra eyes are placed on the wings and torso, again to imply power. The main pole is a trunk of a red cedar tree, while the wings of thin cedar boards make the carving more dramatic and dynamic. The thunderbird is always shown with spread wings to create a large, imposing shape. The feathers are examples of formline design, typical of much Northwest Coast art. The formline (figure 16.6) swells and diminishes, and delineates smaller units within a larger form. They divide and merge creating a continuous flowing grid which beautifully unifies the overall decoration. The "ovoid" is always convex on its upper side with the lower side slightly concave, and was originally connected to the elliptical spots on a ray fish. We also see two examples of the "U" forms. (Holm 1995: 29, 37-41) Black emphasizes the major shapes, while red, white, green, and yellow are added for brightness and high contrast. For this Interior House Post, Shaughnessy used formline design extensively in the thunderbird's wings, painted with newly available commercial paint for brighter colors. Older works were painted with natural pigments, so their color is less saturated.

The figure below the thunderbird is a bear, a common figure on family crests, often associated with an

16.6 Examples of formline design in Northwest Coast Art. A: ovoid form; B: Typical U complex with semiangular curves; C: Split U with outline. (After diagrams by Bill Holm)

elder or high-ranking person. It has bared teeth and the upturned nose with circular nostrils. Its arms and legs are drawn up in a compact position, that is also used in rendering figures of humans and other four-legged animals. Bodies were usually compressed, but heads were oversized, often one-third the total figure. Essential features were emphasized and shown in a highly stylized manner, while less important features were understated or even omitted. Eyes were symbols of power, and frequently many sets would cover a figure. In this example, the bear's claws are given prominence—an extra face is painted on each paw—while the torso is generalized, without musculature or surface detail. The claws and muzzle were separate pieces added to the trunk, again increasing the dynamism of the carving.

The purpose of the Northwest Coast artist is not to invent new forms, but to invest old ones with new life and energy. The poses and details of figures are very standardized and usually repeated over and over again. Despite standardization, the carvings seem to have a great vitality and energy, because carvers combined and elaborated the symbols for the most impressive visual effect. Carvings were meant for frontal viewing only, while the backs were left rough. Totem poles were similar to house posts, except that they were much taller, with more figures, and were located in the front of the lineage house for public display. Like house posts, the figures on the totem poles indicate clan history, its descent, its power, and its social standing. Artists can freely arrange figures on the totem pole for dramatic effect, as location does not indicate who came first or last, or who was most important.

Art Used in Clan Rituals

Clan ties are strengthened through rituals, and art is often an essential part of those rituals. We have seen that to some extent with the *Interior House Post*, as a visual component to potlatch ceremonies. An even more dramatic example comes from the Asmat people of Irian Jaya, of Western New Guinea.

After several Asmat clansmen had died, the living engaged in elaborate rituals to pass on the life force of the deceased clansmen to the rest of the group. They carved and erected tall poles called *Bis* or *Bisj Poles* (figure 16.7), up to 16 feet high, that are used for ritual feasts. The stacked figures were each named and represented the deceased clansmen, now called ancestors. The large openwork projections between the legs of the top figures are penises, representing power in warfare and in fertility. The height, intricate carving, and painting make the poles impressive. The high-contrast colors, negative and positive shapes, and snarling faces speak of bristling warlike energy.

As recently as the 1950s, the Asmats were headhunters, and part of their rituals involved avenging a clansman's death, as they believed that death is not natural, but caused by enemy warfare or magic. After the men carved and painted the *Bisj* poles, the ritual feast prepared them for actual headhunting. Warriors stood before the poles and bragged about their power and received the strength of the ancestors for success in headhunting. These rituals were also tied to fertility, as successful warriors were rewarded with sexual favors.

After the rituals, the poles were traditionally left to rot in groves of sago palms, where they would pass their vitality on to the plants that provide a staple food for the Asmats. Art for the Asmats, then, was the experience of the rituals and the feasts, not the preserved art object. Now headhunting has been suppressed by political authorities and Christian missionaries. But the Asmat continue to carve Bisj poles and conduct the rituals concerning ancestors and life force among clansmen. Recently, some Bisj poles have been sold after rituals to collectors and museums rather than rotting, while others were made exclusively for the tourist trade.

Text Link

Is a work of art any less authentic because it has been made for tourist trade rather than indigenous use? Why are some made for tourists and others not? For more on the ways that tourist art supports, influences or undermines "authentic" art, see the section, "Support for Art Making," in Chapter 20.

Art, ritual, and clan identity are intertwined among the Yoruba people of west central Africa. Much of it involves storytelling. Male elders of a family group recite extended lineage histories, including information about

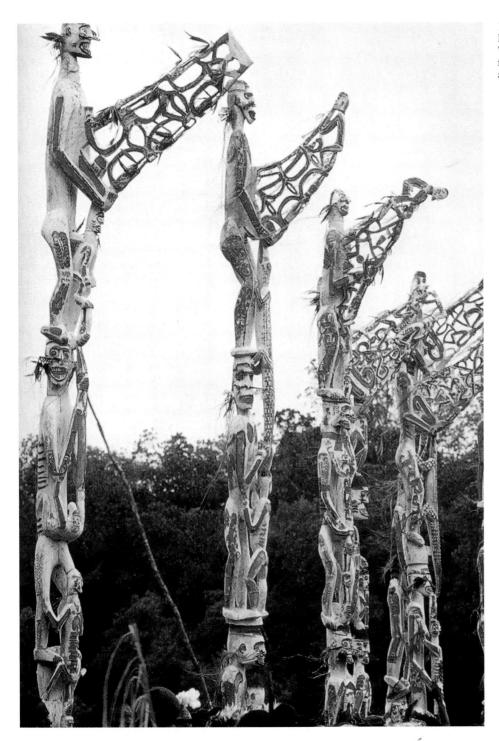

16.7 Bisj Poles. Asmat, Buepis Village, Fajit River, southwest New Guinea. Wood and paint, approximately 16 feet high. See also the text accompanying figure 21.28.

the departure of one family group from another, the difficulties of traveling to a new area, the joys of founding a new household, and subsequently the names of all men and women who brought fame to the household. Women sing praise poetry, some of which honors the lineage, and some of which honors particular individuals within the family. In addition, the Yoruba hold the Epa Festival every other year for three days in March to promote fertility and the well-being of the community. The Epa headdress is used during celebrations and masquerades to honor the family. During the festival, boys and young men perform athletic and strenuous dances wearing large, unwieldy Epa headdressses, weighing between 50 and 60 pounds, on top of their heads.

The base of an Epa headdress is a helmet that fits on top of the performer's head, and it is carved with grotesque Janus-like heads, front and back. Above the helmet is a large structure with numerous figures. Our example is the Epa Headdress called "Orangun" (figure 16.8), sculpted by Bamgboye of Odo Owa. It consists of

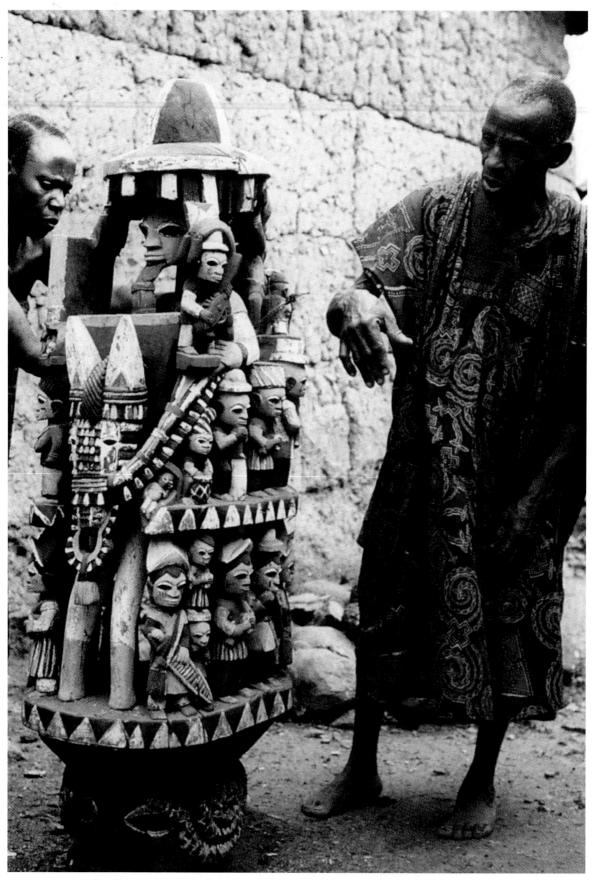

16.8 Bamgboye of Odo Owa. *Epa Headdress called "Orangun."* Yoruba, Erinmope, Nigeria, 1971. Wood and paint. (Photo: John Pemberton III.) See also the text accompanying figure 21.3.

Thus we have seen that clan strength and identity are often tied to art, because art gives access to ancestors, records clan history, and figures prominently in clan rituals.

The Nuclear Family

We have just seen how important the extended family is in many cultures. In highly industrialized societies, where individuals have great mobility, the extended family has lost much of its strength because people frequently live far away from their blood relatives. In these instances, the clan has dwindled to the nuclear family, which may be no more than parent(s) and/or child(ren). Artists have examined the nuclear family, to find its strengths, its changes, and its points of tensions. Our examples here come from Europe and the United States in the nineteenth and twentieth centuries.

Edgar Degas' painting, *The Bellelli Family*, dated 1858 to 1867 (figure 16.9), is a record of one nuclear family. Like all families, this one is not static, but a group of persons enmeshed in shifting affections and tensions. At the time of his painting, Degas' Aunt Laura, the mother, had grown distant from her morose and moody husband, the politician and publicist Baron Gennaro

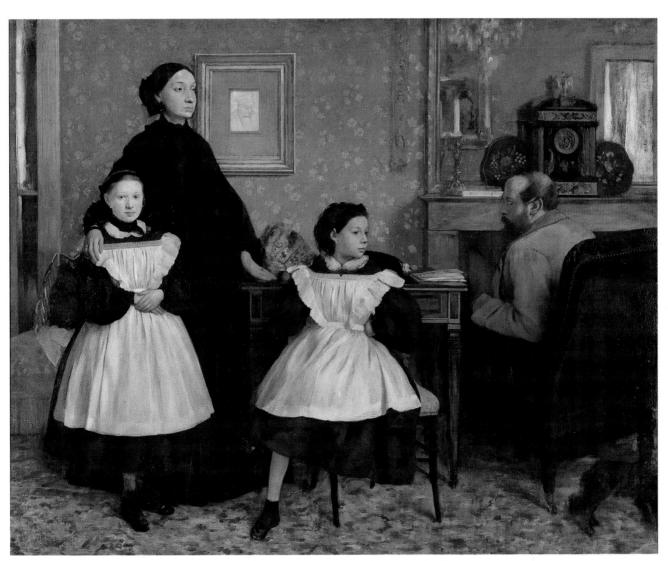

16.9 EDGAR DEGAS. The Bellelli Family. France, 1858-1867. Oil on canvas, 80" × 98". Paris: Musée d'Orsay.

Bellelli. Laura Bellelli is shown as proud, dignified, and aloof. She is protective of her older daughter Giovanna, who resembles a Renaissance saint with pale face and demure pose, standing completely within the outline of her mother's form. In contrast, the younger daughter, Giulia, twists and fidgets on the stool between her parents. The baron's morose personality is clear with his shadowed face, hunched body, and back turned to the viewer.

We know from surviving family letters that Degas did not like the uncle but was exceedingly fond of his aunt and cousins, whom he portrays sympathetically and with bonds of affection. Degas painted them in the form of a triangle, common in family portraits, to express generation from parent to child and the stability and strength of that bond. The baron is like an intruder in the scene, separate and distant from his family. The gap between mother and father is expressed in both spatial and in psychological terms. A vertical barrier created by the edge of the mirror, fireplace, and table legs separates the baron from the rest. The faces and bodies and gestures are insightfully rendered psychological studies. Blue tones predominate, with faces contributing the only warm tones.

The Family, dated 1962 (figure 16.10), by the artist Marisol, presents us with a mother and her children arranged as if sitting for a photographer. Feelings of both mutual affection and personal awkwardness emanate from the three older children, as they present themselves as family and as individuals to the world. The mother in the center is dignified, solid, and thoughtful, but not elegant. She links all the figures and elements. The doors and decoration behind suggest the domestic setting, but they seem generally poor. Marisol's figures

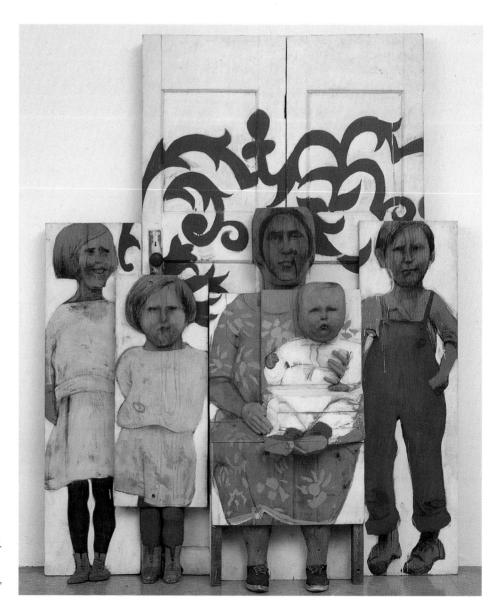

16.10 MARISOL. *The Family.* USA, 1962. Mixed media construction. Museum of Modern Art, New York. For more about formal qualities of this artwork, see figure 2.32.

16.11 ELIZABETH MURRAY. Sail Baby. USA, 1983. Oil on three canvasses, 126" × 135". Walker Art Center, Minneapolis, MN. For more about the meaning of this artwork, see figure 4.8.

are blocks of wood, drawn on and minimally carved, each maintaining its own separateness and also interlocking with the group. The shoes and doors are real, found objects that Marisol incorporated into her work. *The Family* contrasts with the uniformity, happiness, and affluence of the nuclear family as it was commonly presented on U. S. television in 1962, with shows like "Leave It to Beaver" and "Father Knows Best."

Artists sometimes allude to their subject without presenting it literally. Such is the case with Sail Baby, dated 1983 (figure 16.11) by Elizabeth Murray, which is a painting about family life. Three rounded canvasses suggest the bouncy, energetic bodies of infants or children. The bright colors recall the palette of childhood. The yellow shape becomes a cup, referring to the role of parents, the domestic sphere, and feeding. The grouping of the three shapes suggests the closeness of siblings, all with similarities and at the same time each a unique individual. The ribbon of green is like their relatedness and the intimacy of their lives. The artist, in fact, has said that the painting is about her own siblings and her children, while other abstract paintings of hers refer to other family relationships such as mother-daughter, and husband-wife.

As the twentieth century drew to a close, the definition of family had been expanded. Baby Makes 3 (figure 16.12) is from the late 1980s, by General Idea, the Canadian collective of three artists, A. A. Bronson, Felix Partz, and Jorge Zontal, who had been working together since 1968. General Idea presented a homosexual approach to the nuclear family, showing three men in bed in the clouds, looking tranquil and impish. The work both ridicules the idea of the happy nuclear family and at the same time shows how gays and lesbians recreate family and social structures. Baby Makes 3 also alludes to recent discoveries in science, that suggest the possibility of means other than heterosexual reproduction generating a biological family. The image appeared on the cover of File, which was General Idea's parody of *Life* magazine. General Idea critiqued many aspects of popular culture that so heavily promote the heterosexual nuclear family. They created their own versions of TV dinners, postage stamps, boutique items, videos with commercials, etc. With their versions blending into the popular culture mainstream, General Idea hoped that the preconcieved ideas of that mainstream would be altered, specifically in the case of the nuclear family.

16.12 General Idea. Baby Makes 3. Canada, 1984–1989. Lacquer on vinyl, $78.75^{\circ}\times63^{\circ}$.

Our last example in this section deals with the deterioration of the nuclear family, as twentieth-century stress and opportunities have often split off the individual from family ties. We could have picked from numerous fine art or cinema examples of individual alienation, but will limit ourselves to an image from the classic 1941 film, *Citizen Kane*, written and directed by Orson Welles, who also starred as the main character, Charles Foster Kane. The main theme of the film is Kane's rise to power and eventual collapse, starting when he is a young boy and is removed from his poor family when a huge fortune unexpectedly comes their way.

An important element throughout the film is Kane's inability to form any true lasting personal relationships. He becomes estranged from his wife, loses his son, and alienates his friends. In a still from a dining scene (figure 16.13), we view Kane and his first wife from the level of their ankles. The extremely low viewpoint was used effectively in the film to make Kane into a towering figure, as he rose to power and wealth through newspaper publishing and politics. His emotional separation from his wife is also expressed visually in this scene. The long table divides them, the arched ceiling puts them in two separate realms, and they are absorbed in their reading to the exclusion of each other. Their marriage disintegrates. Later, she leaves him, as others do also. At the end Kane has built himself a palace and has accumulated a vast amount of possessions and artworks, but he is bitter and alone. Welles effectively used many expressive devices such as camera angle, lighting, and props to visually present the inner state of a human being.

16.13 Orson Welles (Director, writer, producer). Film still from *Citizen Kane*, with Orson Welles as Charles Foster Kane, and Ruth Warrick as his first wife, USA, 1941. See also the text accompanying figure 20.16.

CLASS

A group of persons sharing the same economic, social, or ruling status comprises a class. Class becomes like a very large extended family, a group in which individuals often find their identity and their social circle. Art and class structure can be linked in several ways: 1) members of different classes may be depicted with different body styles and poses; 2) artwork can show the environment, accouterments and activities that mark members of a certain class; and 3) a work of art can be a status item in and of itself, so that possessing it can indicate the class of the owner.

Class Status and Body Styles

Can the way a person's body is depicted in art act as an indication of class? In ancient Egypt, the human body was sculpted in different ways, depending upon the class of the person. Upper classes, consisting of the pharaoh and his family, the nobility, and the priests, were depicted in formal, highly standardized ways that indicated immediately their importance in the social hierarchy. The four gigantic statues at the *Temple of Ramses II* at Abu Simbel, dated c. 1270 BC (figure 16.14) are examples of

official images of the pharaoh. As fitting his semi-divine status, he is enormous in size. The repetition of the image reinforces the idea of his imposing grandeur (and as if four large seated images were not enough, there are another eight standing statues just inside the doorway, each standardized, each 32 feet high!). The seated pose is frontal, composed and symmetrical, with few breakable parts. It is absolutely standardized, the formula used over and over again for depicting the divine ruler of Egypt. The expressionless face and staring eyes look outward in timeless serenity. The body of Ramses II is welldeveloped and flawless, frozen forever in idealized vouthful prime. Smaller figures at Ramses' knees and feet are members of his family, their smaller size indicative of their lesser rank. Enormous projects of this kind were very costly and demanded the skills of the best carvers, and thus become another sign of the very highest class ranks. The formula we see for sculptures of the pharaoh is also used for images of nobility, who are also shown with idealized bodies, in large size, taking standardized poses.

The colossal statues of Ramses II were intended to be permanent memorials to him, as befitting his rank. In 1968, the statues were raised to higher ground and

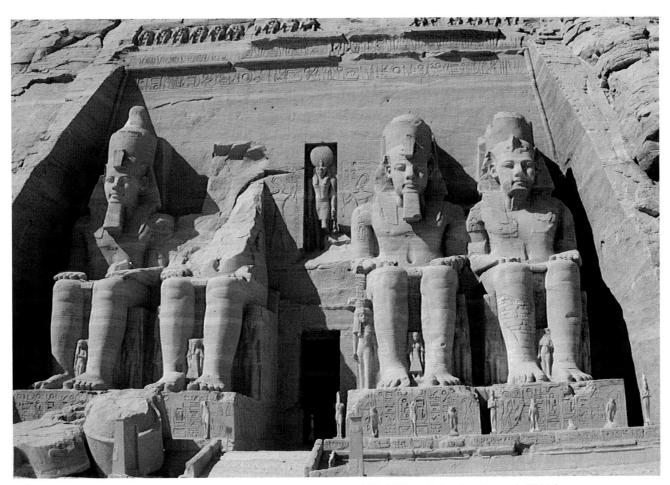

16.14 Temple of Ramses II. Abu Simbel (now relocated), Egypt, XIX Dynasty, c. 1275–1225 BC. Each colossal statue is 65' high.

affixed to artificial cliffs in order to avoid their being submerged in the back pools of the new Aswan Dam. Their permanence remains.

Text Link

The Egyptians were not the only peoples to create idealized images of their leaders. See images of rulers in Chapter 12, such as The Emperor Justinian and His Attendants (figure 12.3).

By contrast, the Seated Scribe, dated 2500–2400 BC (figure 16.15), is a portrait of an Egyptian court official of much lesser rank than the pharaoh. The sculpture is limestone, a relatively soft, inexpensive stone that was considered to have an unattractive finish, and so the work was painted. The result is more lifelike, and thus less eternal and permanent than the monumental stone image of Ramses II at Abu Simbel. As befitting those of lower class, there is much less formality and idealization in the portrait of the scribe. His pose is more relaxed and the figure is cut away from all backing stone. His face is expressive and personalized, rather than eternally calm and divine. He seems intelligent, alert, and aware. His body shows the effects of age, with sagging chest muscles and a pot belly, attributes that would be considered disrespectful in a portrait of a pharaoh.

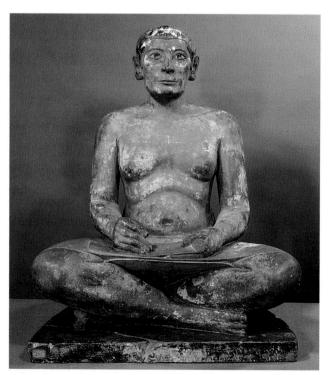

16.15 Seated Scribe. From a mastaba tomb at Saqqara, Egypt, V Dynasty, c. 2500–2400 BC. Painted limestone, approximately 21" high. Louvre, Paris.

Text Link

Most Egyptian sculpture was tied to their funerary and religious practices, which you can review with works such as the Horus Temple at Edfu (figure 10.17) or the Great Pyramids at Gizeh (figure 11.2)

While the Egyptians used different body styles to depict class, people's class is more often marked in art by their dress, their environment, the things they hold or use, and what they are doing. Our next section looks at art showing the life-styles and activities of various classes.

Class Activities and Life-styles

Art records not only the life-styles of the rich and famous, but also the more mundane existence of the lower classes. We will look at a cross-cultural selection of images that reflect class activities and class life-styles. It is important to remember that the great majority of these images are made by the ruling class or middle class, often of themselves but also of classes below them.

The Ruling Class

The life of the ruling classes is well-recorded in art from many cultures. Waiting for Guests by Lamplight (figure 16.16), by Ma Lin, is an example of life of the court class in thirteenth-century China. The fan itself, to which such a painting was attached, was an upper-class luxury item. The painting probably originally was accompanied by lines of poetry, which have been lost. The subject of the scene may have been a nobleman waiting for his guests for an evening of pleasure, as the title suggests. More recent research suggests that the nobleman was sitting up all night as the fragile apple blossoms bloom, because by morning they will have faded and fallen (Cahill, 1996: 34). Either subject still indicate the upper class, as those of lower rank could scarcely afford either occupation or the pastoral palace. The palace's grand architecture, the loveliness of the gardens, and the beautiful vistas beyond speak of the wealth, power, and leisure of the ruling class. The sense of luxury is conveyed also in the beauty of the painting: the open space, the delicate colors, and the atmospheric rendering of the distant mountains. The pointed palace roof and the sloping mountains, separated by the diagonal of the tree, give the painting a subtle and delicate balance. The colors are very rich, from the glow of the palace door, to the pale white of the blossoms, to the variations of ink tone throughout.

Upper-class and ruling families in Europe in the last millennium have used art to define and maintain their high rank. Portraits were often records of high positions.

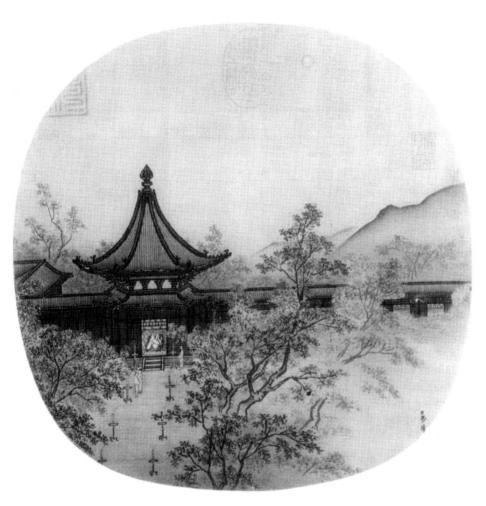

16.16 MA LIN. Waiting for Guests by Lamplight. China, early thirteenth century. Fan-shaped album leaf, ink and color on silk, 9.5" × 10". National Palace Museum, Taipei.

The title of Las Meninas (figure 16.17), painted by Diego Velazquez in 1656, means "Maids of Honor," which by itself marks the upper class. At the center of the composition is the blond Infanta Marguerita, the daughter of King Philip IV and Queen Mariana of Spain, the center of considerable attention and energy. She is shown almost casually in the painter's studio. The informality about this painting is understandable, because it was not meant for public display, but for the king's private office. Although the Infanta is not painted in a throne room or with a crown, we can understand her exalted position through many elements in the painting. Her location at the center of the picture, the light that floods her, and her glowing white dress all mark her as the most important figure. As the presence of servants is also a sign of rank, she is attended by two young ladies in waiting, two dwarfs, and two adult chaperones, male and female, in the shadowy right background. Her parents, the king and queen, are reflected in the mirror against the back wall; presumably they are standing where the viewer of the painting would be.

The space of the painting is majestic: light floods the foreground; the room is grand; the deep space extends

back in the distance. The space is also made complex by mirrors. One we see. The other we cannot, but its presence is implied by the fact that Velazquez peers outward, presumably into a mirror, to paint himself. Velazquez is the standing figure at the left of the painting, working on a large canvas, perhaps this very picture.

Size is important. This painting is $10.5' \times 9'$. A physical object this large is a sign of rank and a mark of distinction, as well as is owning, possessing, or commissioning such an artwork. Diego Velazquez also was a celebrated and famous artist. His prestige is an important addition to the royal commissions.

Sometimes class is indicated also by its members' activities. *The Swing* (figure 16.18) painted by Jean-Honoré Fragonard in 1766, shows the frivolous sexual escapades of the French aristocratic class in the mid-eighteenth century. During that period, they enjoyed tremendous wealth and privilege, and had few responsibilities, as most of their power had been assimilated by the French king, and most of their duties assumed by an ever growing middle class. The aristocracy was effectively transformed into a leisure class, with little to do but become embroiled in their own intrigues.

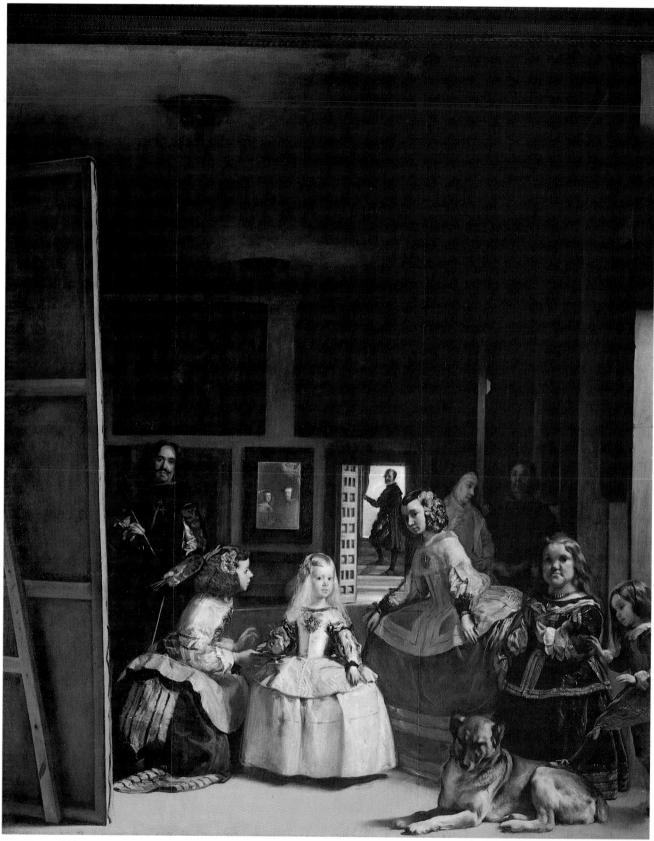

 $16.17\ Diego\ Velazquez.\ \textit{Las Meninas}.\ Spain,\ 1656.\ Oil\ on\ canvas,\ approximately\ 10'\ 5"\times 9'.\ Museo\ del\ Prado,\ Madrid.$

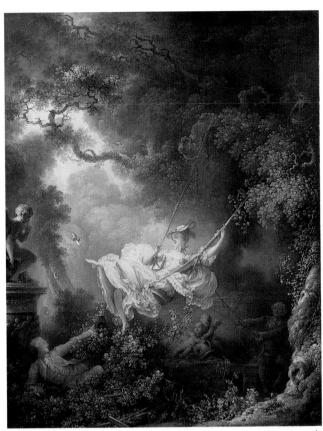

16.18 JEAN-HONORE FRAGONARD. The Swing. France, 1766. Oil on canvas, 35" × 32".

In The Swing, a young aristocratic woman enjoys a moment of swinging, assisted by the bishop in the shadows who pulls the ropes. Hidden among the bushes in the lower left is a young nobleman, enjoying a peek up the woman's skirt as she playfully kicks off her pink shoe at a statue of Cupid. All details speak of the wealth and the lack of purpose of the aristocracy: the lush parks of their beautiful estates, sprinkled with statuary; their rich clothing; the complete frivolity of their days' activities; and their interest in sexual intrigues. Fragonard's rich colors, delicate details, and sensual textures lend a sweetness to the scene, and a sense of fragility. In fact, the aristocratic class was shortly to be brutally eliminated by the French Revolution, which began in 1789.

Dress and other paraphernalia are often a sign of rank. We see this often among royalty and nobility, as well as with members of the military and even the Boy or Girl Scouts. Priests of most religions dress distinctively to show their status. We could look at hundreds of examples in art where class hierarchy is made apparent by dress, but will limit ourselves to just one example, specifically, the Great Beaded Crown of the Orangun-Ila (figure 16.19), from the Yoruba peoples of Nigeria, Africa. The image not only shows the crown, but also the robe and staff that are signs of rank.

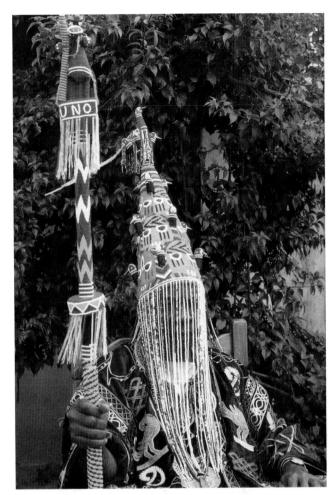

16.19 Beadworkers of the Adesina Family of Efon-Alaiye. Great Beaded Crown of the Orangun-Ila. Yoruba, Ila, Nigeria, twentieth century. Photograph by John Pemberton III. See also the text accompanying figure 21.7.

Crowns such as this one are worn by high-ranking territorial chiefs who are seen as lesser in rank than the supreme king, called the Oni. The crown is similar to the headgear worn by priests and the Oni himself. Rank is made apparent through dress in a number of ways: 1) the shapes of the clothing or headgear; 2) the materials used; and 3) the meaning of the decorative symbols. The conical shape of the crown is a highly significant Yoruba symbol. It represents the inner self, which in the case of those of rank is connected with the spirit world. The cone shape is repeated in the umbrella that protects the chief from the sun, and the peaked-roofed verandas where he sits while functioning as the ruler. The material used in crowns is also significant, as beads have been used in Yoruba crowns at least since the 1550s, and in all likelihood even earlier. The birds on the chief's crown and robe represent generative power, closely associated with women's reproductive abilities and the life-giving, stabilizing structure of Yoruba society. The long white feathers at the top of 16.22 Georges Seurat. La Grande Jatte (also called A Sunday Afternoon on the Island of La Grande Jatte). France, 1884–1886. Oil on canvas, 6' 9" × 10'. The Art Institute of Chicago. Helen Birch Bartlett Memorial Collection. For more on the cultural context surrounding this painting, see figure 5.15.

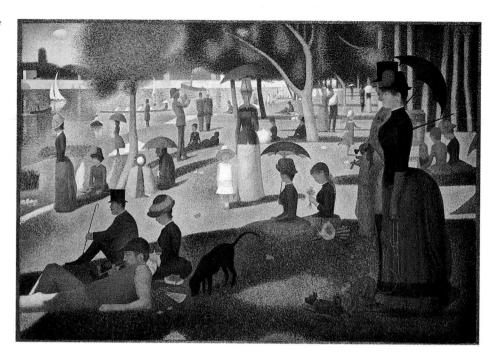

womanhood at that time: virtue, modesty, hard work. As a middle-class country without a king or aristocracy, the Netherlands focused on the family and family life and the individual. Portraits were common, as were moralizing genre scenes that criticized vices such as laziness, drunkenness, and lust.

Text Link
The Self-portrait (figure 15.7) by
Rembrandt van Rijn reflects the same
sense of individual worth and the
sacredness of a modest life as Vermeer's
Kitchen Maid.

In A Sunday Afternoon on the Island of La Grande Jatte, dated 1884–1887 (figure 16.22), Georges Seurat has painted the middle class that was enjoying increased wealth and leisure with nineteenth-century industrialism. The very creation of parks was the result of the affluent middle class's desire to reintroduce nature into increasingly crowded cities. The painting shows a collection of strangers outdoors on a modern holiday. Unlike villagers attending a local festival, the groups do not know each other. The figures are proper, composed, and orderly. Details of middle-class dress are carefully recorded. Almost all are shown rigidly from the side, front, or back. Diagonals are reserved for the left side of the painting, and are stopped by the orderly verticals on the right. Shadows mass in the foreground, and light in the back.

The painting reflects the growing emphasis on and awareness of science. The woman in the right foreground

holds a monkey on a leash, and the similarity between the monkey's curved back and the bustle on her dress shows an awareness of Charles Darwin's theories of evolution and the resulting social Darwinism, which placed women closer on a continuum to the rest of nature than men were placed. Also, Seurat was influenced by the science of color and optics, especially the works of the scientist Eugène Chevreul, as he painted with small dots of intense colors laid side by side. He followed Chevreul's theories in the placements of contrasting colors to either intensify or nullify each other. The dots of bright colors eliminated muddy mixtures, and in fact this painting up close is a somewhat dizzying and disorienting mass of small dots of bright colors. So labor-intensive was this process that it took Seurat more than two years to complete the work.

The Poor

Art provides us a record of the poor, their way of life and their struggles. Art itself, however, is often an upper- or middle-class luxury, and so the following images represent how the more affluent classes saw the very destitute. In the last two cases, the images reflect a growing political pressure for change to alleviate the plight of the poor.

Text Link

For an example of how the poor might view the rich, see The Rent Collection Courtyard, figure 14.13, which shows an instance of exploitation and oppression.

Roaming Beggars (Grotesque Figures) (figure 16.23) was painted by Zhou Chen during the late fifteenth or early

16.23 ZHOU CHEN. Roaming Beggars (Grotesque Figures) (two sections). China, late fifteenth—early sixteenth centuries. Ink and color on paper. Honolulu Academy of Arts.

sixteenth century. Four portraits show homeless peasants, a relatively common sight in China in the fifteenth century, when taxes, natural disasters, and the grasping aristocracy combined to uproot many from the lands where they had long lived and worked. These ink-and-color sketches capture the precarious, desperate, and crazed existence of these people, as they resort to scavenging or looting for food. The line quality is quick, jagged, and spare. The faces are scruffy or demented and the bodies lean, some to the point of emaciation. The figure on the left scavenged for firewood, while that on the far right survived by catching snakes, which was a kind of side-show entertainment. The snakes could also be sold to be eaten as a delicacy.

Honoré Daumier became concerned with the plight of the poor in nineteenth-century Europe. Industrialism had created a mass of poor people in addition to the increasingly wealthy middle and upper classes that we saw in *La Grande Jatte*, painted just a few years later. In *Third-Class Carriage*, dated 1862 (figure 16.24), Daumier showed a crowded train compartment where women in

humble attire clutch meager belongings and attend to their children. Top-hatted men of slightly more wealth sit nearby. Daumier painted the women with compassion: they seem resigned but dignified. The painting is unfinished, as we can still see the grid lines that are often used by painters to sketch in the basic composition. Even so, the somber colors and masses of deep shadows speak of the chronic struggle and dim hopes of the poor. Like La Grande Jatte, the work shows the modern urban phenomenon of loneliness in the crowd, where hoards of people are all together but are isolated and alone, knowing no one, in contrast to earlier European villages in which everyone knew everyone else.

Migrant Mother, Nipomo Valley (figure 16.25), photographed by Dorothea Lange, is one of many workers who were starving at a migrant camp Lange visited in 1936. Lange's field notes tell us about the woman: "Camped on the edge of a pea field where the crop had failed in a freeze. The tires had just been sold from under the car to buy food. She was 32 years old with seven children." The woman's face and pose express both strength

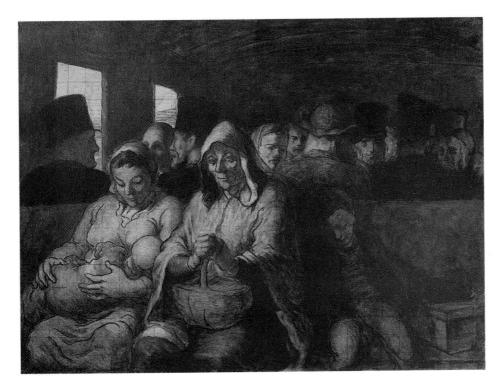

16.24 Honoré Daumier. *Third-Class Carriage*. France, 1862. Oil on canvas, 25.25" × 35.5". Metropolitan Museum of Art, New York. Havemeyer Collection, bequest of Mrs. H.O. Havemeyer, 1929.

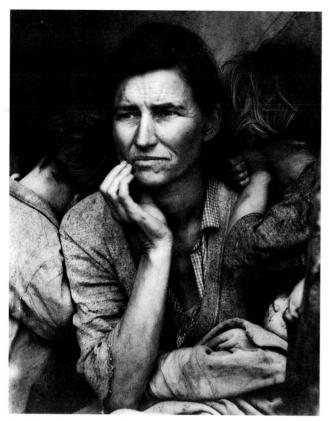

16.25 DOROTHEA LANGE. *Migrant Mother, Nipomo Valley*. USA, 1936. Gelatin Silver Print. Dorothea Lange Collection, Oakland Museum of Art. See also the text accompanying figure 4.1.

and desperation. Skin, clothes, and hair show signs of poverty and hard times. Fear and uncertainty permeate the scene, made more acute because we also see the emotional ties of the family and the fear of the children. *Migrant Mother, Nipomo Valley* is an example of documentary photography, which purports to record facts objectively and in a straightforward manner. In actuality, we know that this family posed for Lange, that she made several exposures of them, and she edited her prints for the most effective image. Nevertheless, it is important that we understand the photograph to be factual, whether or not it was staged or manipulated. We are more moved by the image because photography here seems to record facts, and does not appear as artistic invention.

Text Link

For more on the apparently objective nature of photography, see Chapter 4, Deriving Meaning from Art and Architecture

Lange was a New York commercial photographer who was moved by the plight of migrant workers in the United States. during the Great Depression. She was hired by California and federal agencies to document migrant farm workers in the United States. Her depression-era photographs were especially effective be-

cause she made her subjects so human and so immediate. Readers of newspapers and magazines who saw these images felt connected to and were moved by her images. Her photographs were credited with improving conditions for migrant workers in California. The black-and-white photograph was an especially effective medium to use to express conditions of poverty, to concentrate on the facial expression, and to lend the aura of truth.

Text Link

Many other U.S. artists have taken up the cause of the poor or laboring classes throughout the nineteenth and twentieth centuries. Look back to Chapter 14 to see Lewis Hine's photograph of a child laborer, Leo, 8 Years Old . . . (figure 14.10) or Ester Hernandez' memorable print, Sun Mad (figure 14.15).

Art Objects That Indicate Class Status

Finally, different kinds of art are often indicators of class. Art objects are made for and reflect the needs and tastes of specific classes. Again, we could have chosen from almost innumerable examples to illustrate this concept, but we will focus first on three from the era of the Tokugawa Shogunate (1573–1868) in Japan. Then, we will conclude with an example from the United States of the twentieth century.

Historically in Japan, classes were kept rigidly distinct. The ruling class in Japan, beginning around 1600, consisted of two groups: 1) the emperor and his family, who were only nominal rulers; and 2) the warrior class, led by the shogun, who divided the land and who actually ruled the country, much like feudal barons in medieval and Renaissance Europe. The very poorest class consisted of the peasants. They were totally subjugated, with neither power nor mobility, and farmed the land that belonged to the members of the warrior class.

In addition to the warriors and peasants, a middle-class of urban dweller began to rise, starting in the mid-1600s and continuing into the twentieth century. This class was composed primarily of merchants, manufacturers, and laborers, and the largest center of them was in the city of Edo, known today as Tokyo. As each group was kept separate and distinct, they all developed their own cultural spheres. For example, the emperor and warrior class preferred a restrained, sophisticated, understated style of theater known as Noh, while the middle class favored the more expressive Kabuki theater.

Likewise, different art styles developed for each class. The warrior-rulers built for themselves splendid stone castles that were both fortresses and self-aggrandizing monuments. Because of the stone construction, these castle rooms were large, gray, and dimly lit. The warrior-rulers commissioned large screens, sliding doors, and wall

16.26 *Uji Bridge.* Momoyama period, sixteenth to seventeenth centuries. Six-fold screen, color on paper, 62" high. Tokyo National Museum.

paintings to lighten and decorate the dark, drab interiors. For example, *Uji Bridge*, from the sixteenth or seventeenth century (figure 16.26), is a large screen more than five feet tall. The bridge arcs across the top of the screen, partly obscured by mists. In the foreground, the river rolls past a water wheel. On the left is a bare willow, while budding branches fill the right. The dark branches stand in stark contrast to the golds and reds of the background. The painting expresses qualities of simplicity and beauty, perishable with the passing of the moment.

Other large screens from this era show similar qualities. They are beautiful, poetic and decorative. Bridge and river scenes are common. Many have surfaces covered with goldleaf and gold sand. Boats and waterfowl appear in many. Some especially long ones show a panorama that encompasses the four seasons. Other less-common themes included nobles relaxing in palace interiors or cityscapes. These screens and large paintings are luxury art items, for their large size and the rich materials used, and for the sense of uncluttered space and outdoor expansiveness that only the rich could own. In addition, they required a lot of interior space, something only the upper classes could boast of having. The gold background on the work reflected light in the dim castle interiors and brightened them. The gold leaf and rich pigments also convey a sense of luxury.

In contrast, ukiyo-e prints were made for the merchant class, and reflect the tastes and finances of that group. As previously mentioned, ukiyo-e means "pictures of the floating world," which referred to the theater district and pleasure quarters of cities, populated by middle-class urban dwellers especially in Edo. The middle class patronized the expressive and energetic Kabuki theater. Merchants visited the pleasure quarters, where beautiful geishas would entertain male patrons with song, charm, and conversation, and also the bath houses for personal hygiene and sexual favors.

The artwork of the middle class was likely the ukiyo-e print. These prints were modest in size and produced in large numbers, so that the cost of each was within the reach of the middle-class merchant. They were kept in drawers and therefore did not require a castle to house them, as did the gold screen we just saw. The ukiyo-e prints were eclectic in style, combining Japanese, Chinese, and later Western styles. Because they were inexpensive to produce, the artist who drew the original design was able to be innovative. For lavish screens like the *Uji Bridge*, artists had much less latitude in the designs they produced.

Ukiyo-e prints showed generally one of three subjects: famous Kabuki actors, beautiful young women, and landscapes. Komurasaki of the Tamaya Teahouse (figure 16.27), done by Kitagawa Utamaro in 1794, is an example of the beautiful woman theme, showing the courtesan Komurasaki. The image is beautiful, but fleeting and simple. The woman is charming but human existence is transitory; thus the beautiful can make humans ache all the more for its passing. This wistfulness is a quality of many Japanese images, as we saw even with the Uji Bridge screen. The colors are exceedingly delicate, with yellow ochers, oranges, dull reds, grays, and blacks-not blazingly bright. The line quality of the prints was splendid-delicate and fine, curving and graceful (or in the case of prints of the energetic Kabuki actors, vigorous and even wild). The lines in the face and hair are especially refined, while the folds of the drapery are expressed in bold marks and curves.

The pose and facial expression of this beautiful woman was considered to be delicate, charming, and melancholy. Geishas and courtesans were depicted in ways that would make them outlets for male desires; the market for these pictures would be married men who would see in these women for hire a fleeting beauty and erotic perfection that they desired. Especially famous courtesans and geishas would be depicted in popular prints, and their images circulated and collected.

Another example of a ukiyo-e print is *Beneath the Waves off Kanagawa*, dated 1831 (figure 16.28) by Katsushika Hokusai. The fierce waves are crashing down upon the helpless and doomed boatmen, transporting

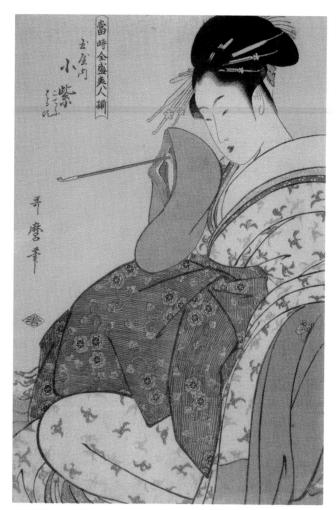

16.27 KITAGAWA UTAMARO. *Komurasaki of the Tamaya Teahouse.* From the series, "A Collection of Reigning Beauties," Japan, 1794. Multicolor woodblock, 10" × 15". Tokyo National Museum. See also the text accompanying figure 20.14.

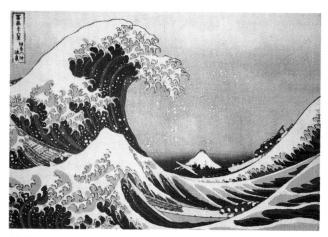

16.28 Katsushika Hokusai. Beneath the Wave off Kanagawa. From the series, "Thirty-six views of Mt. Fuji," Japan, 1831. Multicolor woodblock print, 15.25" \times 10.25". Museum of Fine Arts, Boston. Spalding Collection.

fresh fish along the Japanese coast. Almost lost in the background is Mt Fuji, with its symmetrical perfection (the print is part of an ingenious series entitled "Thirty-six views of Mt. Fuji"). The basic composition is very simple, with great arching and curving lines. The impending tragedy is obscured by the majestic wave. Indeed, this reflects the Japanese beliefs in the transitory nature of human life and the Shinto belief that gods inhabit perfect forms in nature. Hokusai was the first ukiyo-e artist to give landscape the prominent role in his prints. His innovative prints were popular not only in Japan; they were widely circulated in the West. They influenced not only Western visual artists, but others; in particular, this print was the inspiration for Claude Debussy's symphonic work "La Mer."

Text Link

You can read more about ukiyo-e prints with The Lovers (figure 7.20) and Interior of a Kabuki Theater (figure 18.2). The production of ukiyo-e prints, and the printers, carvers, and artists who contributed, are discussed in Chapter 20, "Who Makes Art?"

Our last example, Watts Towers (figure 16.29), was made by a working-class man for a working-class neighborhood in Los Angeles. Beginning in the 1920s when he was in his late forties, Simon Rodilla (also called Simon or Sam Rodia) labored for more than 30 years in his backyard to erect a nine-part sculpture, more than 100 feet high. It was an amazing artistic and physical effort. The tower forms rise dramatically against the sky, while the openwork pattern adds an element of rhythm. The Watts Towers is constructed of rods and bars shaped into an openwork sculpture. The concrete coating on the Towers was encrusted with ceramic pieces, tiles, glass, seashells, mirror pieces, and other shiny or broken castoffs, creating a glittering mosaic-like surface. An immigrant from Italy, Rodia wanted to construct a monument to give tribute to his adopted land.

Rodia was not academically trained as an artist, and his work does not reflect the major art trends of his day. His work was not made for an upper-class audience. As a result, many critics place *Watts Towers* in categories outside of fine art. It has been variously described as folk art, outsider art, or naive art. The dense and shimmering surfaces have caused some to relate his work to crafts and decorative arts. Some have even called it "kook" art, claiming that Rodia was trying to make a transmitter to contact aliens. Some of these descriptors ("naive," "kook," "decorative," etc.) have more or less pejorative connotations, while "folk" suggests an art category of less value than fine art. But there is no denying how powerful and memorable *Watts Towers* is.

Text Link

Another work of "folk art" is the Retablo of Maria de la Luz Casillas and Children (figure 9.21). Read about that work, and also review the discussion of "High Art, Low Art and Kitsch" in Chapter 1.

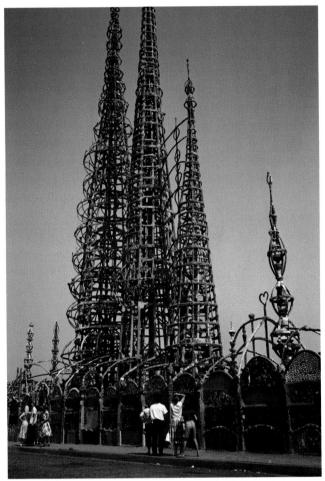

16.29 SIMON RODIA. Watts Towers. Los Angeles, California, USA, 1921–1954. Reinforced concrete with mixed media and found materials, height: 100 feet.

SYNOPSIS

The very identity of a clan is often supported by artwork. Art celebrates a clan's common ancestry and makes their history visible. Ancestor images sometimes are used to validate the power of the living rulers. We saw examples in Head of a Roman Patrician and in the Zapotec Portrait Heads from Tomb 6. Other ancestor images figure prominently in clan identity and in rituals to enhance clan strength, such as the carvings of the Maori meeting house, the African Epa headdress, and the Bisj poles of southwest New Guinea. Others are used in the telling of the clan's oral

history during feasts and celebrations; an example is the *Interior House Post* from the Northwest Coast.

We also saw how the nuclear family is depicted in art. Edgar Degas' *Belleli Family* shows the family unit as a complex entity, with strong alliances, conflicting emotions, and tensions. Elizabeth Murray expresses parenthood and the closeness of siblings through primarily abstract means in *Sail Baby*. The family is shifting, redefined, or falling apart in Marisol's *The Family*, in General Idea's *Baby Makes 3*, and in the film *Citizen Kane*.

Next we turned to class, and saw how upper and lower classes were depicted differently in ancient Egypt in the statues of Ramses II at Abu Simbel and the Seated Scribe. That led to a greater investigation of the depiction of classes in a variety of cultures. The ruling class was shown in Diego Velasquez' Las Meninas, the Great Beaded Crown of the Orangun-lla, Jean-Honoré Fragonard's The Swing, and Ma Lin's Waiting for Guests by Lamplight. In each example, class rank and distinction were made clear, often by the large amounts of space (both interior and exterior) the ruling class occupies, the leisure of their pursuits, and the luxury of their surroundings. The modest, virtuous, or bustlingly busy middle class could be seen in Jan Vermeer's Kitchen Maid, Zhang Zeduan's Spring Festival along the River, and Georges Seurat's La Grande Jatte. The poor barely survive their extreme conditions. Poverty, desperation, or fear mark the figures in Honoré Daumier's The Third-Class Carriage, Dorothea Lange's Migrant Mother, Nipomo Valley, and Zhou Chen's Roaming Beggars.

In the last section, we saw three Japanese artworks that were directly related to class because of the subject shown, the size, and the materials used. *Uji Bridge* is a large gold screen made for the castles of the warrior-ruling class, while *Komurasaki of the Tamaya Teahouse* and *Beneath the Waves off Kanagawa* are two inexpensive prints made for the merchant class. Finally, we looked at *Watts Towers*, and engaged in a discussion on its style and the classifications given to art produced by the working class.

FOOD FOR THOUGHT

Almost every art form is a reflection of the class for whom the art is made. We see repeatedly the most lavish works made for upper classes, while more modest works are for the lower classes.

What about access to art? In many cases, the wealthy are the only ones who can afford to purchase high-profile art, or develop collections around well-known artists. Most private collections are not accessible to the public. Eventually, some art collections owned by wealthy individuals end up in museums.

- Does the museum redress issues of ownership and access to art?
- Who controls what art gets into museums?
- Are there any forms of art that transcend class?
- Art is made by humans for humans, so shouldn't everyone feel comfortable with it, no matter of what clan or class?

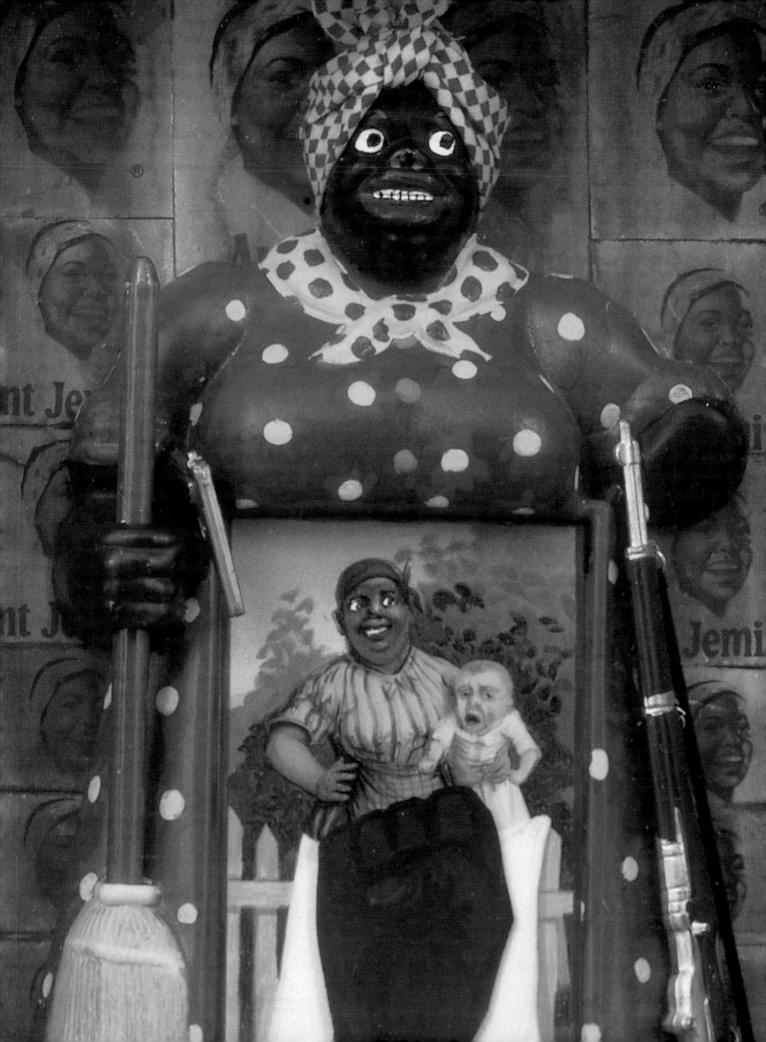

Chapter 17 Race, Sexuality, and Gender

INTRODUCTION

Race, sexuality, and gender are all properties of an individual person. Each of us is a particular combination of racial background, gender, and sexual orientation. Obviously, race and gender are the result of a person's genetic makeup; increasingly, scientific research is indicating that sexual preferences may also be genetically coded.

The personal attributes of race, gender, and sexuality are not only private issues, but are matters of intense social concern. Our attitudes about race, gender, and sexuality are not built in genetically, but rather are constructed within a society. They change in different cultures and at different times. For example, in ancient Greece, it was considered normal for men to have both male and female sexual partners, but homosexuality and bisexuality is taboo to many people in the world today. At their extremes, racial differences can cause riots and genocide, or on the other hand can be completely unnoticed. The seeds of prejudice and discrimination have unfortunately too often been woven into the human experience. Waves of prejudice have inundated the United States ever since its colonization, and likely even before among the indigenous peoples as well. Racism rears its ugly head in many forms. And while gender may be a matter of genetics, gender roles are not. How should men and women look? What roles should they have in society? How should power be distributed between them?

Untitled (Your Body Is a Battleground), dated 1989 (figure 17.1) summarizes both the shifting attitudes and the heated conflicts that surround gender, race, and sexuality. The artist, Barbara Kruger, took a political slogan from the 1960s and combined it with a photograph of a woman's face, split down the middle, positive image on one side and a negative on the other. She looks like a model from a perfume or makeup ad in a fashion

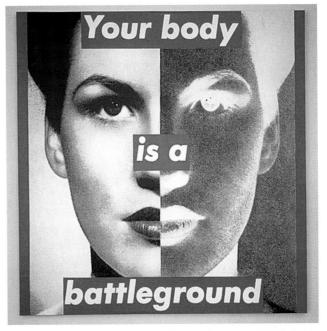

17.1 BARBARA KRUGER. Untitled (Your Body is a Battleground). USA, 1989. Photographic silkscreen on vinyl. 112" × 112". Eli Broad Family Foundation Collection, Los Angeles. See also the text accompanying figures 1.9 and 21.14.

magazine. We viewers become part of the piece, as the staring woman makes us either identify with her or see her as opposite to ourselves. Depending upon the genetic makeup and the politics of viewers, they may see the "battleground" of this piece as race (black/white), gender (male/female), or sexuality (homo/hetero). In fact, this image originally was part of a poster promoting an abortion rights rally.

In English, the pronouns "you" and "we" are not fixed. To whom does "your" refer in Kruger's work—we the viewers or the staring woman? Kruger uses pronouns that are gender neutral, with no fixed subject, to imply that attitudes about race, sexuality, and gender are not fixed by nature. Kruger sees these categories as changing entities under social, political, and religious influence. Yet Kruger recognizes how harshly divided the rhetoric can be in these areas. The division down the middle, with black and white sides, indicates how polarized societies can be on these issues.

Text Link

Kruger's background is in both fine arts and in the mass media. For a period in the 1980s she was chief designer for the popular fashion magazine, Mademoiselle. Her artwork resembles the pasting of text over images, a design technique commonly found in magazines today. For more on the increasingly blurred relationships between fine art and the mass media, see the section on "Categories of Visual Arts" in Chapter 1.

Many artists are of course concerned with the controversial topics of race, sexuality, and gender. Some works in this chapter reinforce existing attitudes and ideas, while others use images to subvert them. In any case, the works are highly charged, powerful images that create or perpetuate ideas about morality, beauty, personal worth, and sexual desirability. The works in this chapter are not always easy. They deal with issues that are currently in conflict.

Some questions for this chapter are:

How does art help forge racial identity?

How is gender tied to ideas of what is beautiful or what is heroic?

How should men and women look? How does art make that clear?

How does art show sexuality as a libidinal drive? How does it show it as social choreography with predetermined roles?

RACE AND ART

In this section, we will look at a number of artworks that deal with race. In some instances, art is used to purposefully form a cohesive identity for a racial group, by memorializing their history or recording their distinct ethnic culture. Others challenge negative attitudes that majorities develop about minorities living among them. Still others look beyond national boundaries, to see ourselves as others see us.

Art That Promotes Ethnic History and Values Let us look first at four examples of artwork that seek to create or preserve racial identity and heritage. These works of art examine or illustrate the history or values of a certain ethnic group, in order to preserve or promote these ideas.

Our first example deals with the Jewish population in Russia in the nineteenth century and the beginning of the twentieth, a time of great stress and change for that group. Jews in Russia were a large, distinct, ghettoized group. They were outsiders within Russian society because of laws and traditions originated both by the Jews and by the Russians. The Jews actively maintained their own identity by speaking their own language and supported a separate educational system. But Russian law also enforced separateness, as Jews were allowed to live only in certain areas, and were restricted from attending universities. That separateness often seemed passively acceptable, but at times Jews were massacred and villages burned in acts of anti-Semitic terrorism. Even so, Jews were often cultural innovators within Russia and in many cases known throughout Europe as artists, musicians, and writers. This was in part because religions began to weaken their hold in Europe at this time, and secular humanism arose, which allowed like-minded people to seek the good in all humans, regardless of their religion.

Marc Chagall was a prominent Jewish artist who grew up in Vitebsk, a small village in Russia, but spent almost all of the rest of his long life in Paris, France. Many of his paintings imaginatively recreated Jewish village folk life in Russia at the turn of the twentieth century, which was in fact disintegrating due to political, religious, and economic pressures. Chagall's imagery was not always clear, as it was a personal, sometimes incoherent, reordering of bits and pieces of his experience. Nevertheless, he depicted many aspects, both negative and positive, of Jewish village life in Russia, including folktales, festivals, marriages, funeral practices, and suffering and death as a result of anti-Semitic terrorism. In Over Vitebsk, dated 1915–1920 (figure 17.2), Chagall painted a large solitary figure floating over his own village. The figure symbolizes the thousands of Jewish refugees displaced from their homes in Eastern Europe by World War I who fled to Russia. Many of these people later immigrated to the United States. In Yiddish, "passing through" is expressed as wandering "over the village," which Chagall painted literally by means of the floating figure, the refugee. The picture is pervaded with a sense of unrootedness in a topsy-turvy world, a sense that one no longer belonged, that one's community was quickly ceasing to exist, itself, in the upheaval of the twentieth century. The space in the foreground of the picture appears fractured, and Chagall used the cubist device to represent instability. The picture contains Chagall's memories of Vitebsk, its architecture, its streets, its icy winter landscape. The colors are Fauvist, an art movement that originated in Paris in which color was exaggerated in paintings for greater power and expression. Thus, Chagall was an amalgam of influences, both Russian and French.

Let us look now at the work of James VanDerZee, a commercial studio photographer whose works are a record of the Black Renaissance of Harlem, generally

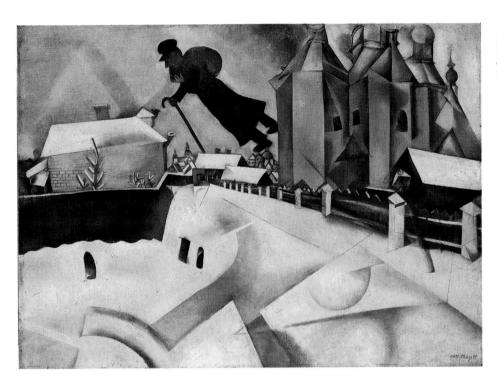

17.2 Marc Chagall. Over Vitebsk (after a painting of 1914). Russia/France, 1915–1920. Oil on canvas, 26.5" × 36.5". Museum of Modern Art, New York. Acquired through the Lillian P. Bliss Bequest, 1040.

dating from 1919-1929 (he continued to photograph the Harlem residents through the 1940s). VanDerZee's photographs contrast strongly with the two kinds of images of African Americans from that time. The most common were crude popular images of African Americans from postcards, comics, and cards with insulting racial caricatures. The other kinds of images were those made by a few photographers who depicted African Americans as helpless victims of racism, and their situation as a problem to be solved. VanDerZee, however, was photographing his peers, his friends, and his community. In his images, African Americans were confident, autonomous, healthy, and self-aware. VanDerZee was part of the black middle class like the women pictured in Society Ladies, photographed in 1927 (figure 17.3). They were intellectuals, merchants, and writers who demanded full participation for blacks in U.S. politics and culture. His well-dressed sitters are surrounded by the furniture and trappings of comfort. Their poses convey a variety of emotions including confidence, humor, directness, and dreamy wistfulness.

Text Link Another artist of the Harler

Another artist of the Harlem Renaissance, Jacob Lawrence, painted the history of African Americans in the Western Hemisphere. For more, see No. 36, During the Truce, Toussaint . . . (figure 14.12).

As a commercial portrait photographer, VanDerZee practiced a trade not traditionally considered part of the

fine arts. Yet the distinction is ungrounded, as he was a creative artist in his production of these remarkable images. VanDerZee and his sitters collaborated in the making of his photographic portraits. VanDerZee was influenced by films of the 1920s and 1930s, and encouraged sitters to take poses from the films. However, these borrowed poses convey such a strong sense of personality in his sitters that they appear fully individualized. At times, VanDerZee provided costumes and props that allowed his sitters to expand and convey their personalities. He manipulated and retouched his images. The results were confident, proud portraits that cannot be seen as racial caricatures or victims. Of course, VanDerZee and his sitters were well aware that most in the United States at this time still thought that "Negroes" were inferior. VanDerZee continued to make such images through the Great Depression, a period of economic hardship for Harlem.

Lorraine O'Grady produced a body of work called "Sisters" in which she looks into African history and how it has been categorized and subdivided. As a young student, O'Grady had been mystified because images of Egyptians in books looked like her family, and yet they were identified as Middle Eastern. Her work protests the tendency in popular thought and scholarly works to split ancient Egypt from the rest of Africa and to consider it "Caucasoid." (Generally, scholars still split Egypt from any study of Africa.) By reintegrating it with Africa, O'Grady augments the African heritage. O'Grady's work produces evidence that the ancient Egyptian civilizations were African, or at least racially pluralistic. She emphasizes that Africans have had a powerful influence in several mulatto cultures, including that of ancient Egypt.

17.3 JAMES VANDERZEE. Society Ladies. USA, 1927. Black and white photograph. Donna Mussenden VanDerZee.

Her work also points out that the contemporary United States is a mulatto culture. In "Sisters," O'Grady photographed her immediate family and juxtaposed the pictures with reproductions of ancient Egyptian busts, showing the similarity of facial features. Our example is Sisters #2: Nefertiti's Daughter Merytaten/Devonia's Daughter Candace, dated 1988 (figure 17.4). The shape of the face,

the heavy brows, the lips and nose are all physical evidence in support of O'Grady's arguments. The images are presented as straightforward documentation, without embellishment.

Our last example in this section was used very differently than the first three that we have just seen. This painting was used to promote racial superiority in an

17.4 LORRAINE O'GRADY. Sisters #2: Nefertiti's Daughter Merytaten/Devonia's Daughter Candace. USA, 1988. Cibachromes, 26%" × 38%".

oppressive culture, specifically Germany in the 1930s. In some periods like Nazi Germany, racial differences are translated into prejudices that often lead to judgments of inferiority and superiority. In some cases, the results are disastrous. The twentieth century unfortunately has seen many instances of ethnic violence, ethnic cleansing, and genocide.

The Kalenberger Bauernfamilie, painted in 1939 (figure 17.5) by Adolf Wissel, shows three generations of a German farming family in an image of simplicity, peace, and harmony. The center of the composition is the mother who holds her child in a pose that is similar to Christian images of Mary holding Jesus, while the attentive father and grandmother help with the children and the maintenance of the family. The fair-skinned, fairhaired family dominate the warm-toned painting, with fragments of the family home and farmland behind them to establish their context and the wholesomeness of their situation. While not rich in possessions, the family seem somber and well-behaved. Formally, the composition adds to the message of the entire piece. All elements are balanced and orderly. The composition's center is the young boy who faces out at us, the male child who is the hope of the future. The highest figure is the father, who is head of the family. The women do not look out at us, but are all engaged in "appropriate" activity.

Of course, there is nothing inherently objectionable in Wissel's painting itself. However, the National Socialist (Nazi) party in Germany in the 1930s had established a broad program to use cultural objects like the *Kalenberger Bauernfamilie* to eliminate all aspects of society and culture that the party leaders considered

immoral or impure. The Nazis promoted racial purity, the "natural" role of woman as mother and homemaker, a return to nature, the importance of the German homeland and the need for ordinary persons to act heroically. The farm family therefore is presented as a both a racial and moral ideal, and diverging from that ideal was not tolerated. The Nazis were interested in images that would counter the falling German birthrate since the 1920s. They saw the family as the salvation of the future. They also wanted to bring art into everyday life in a way that they considered uplifting. They promoted those works that depicted the human form as a standardized ideal. The racial purity promoted by the Kalenberger Bauernfamilie and other Nazi visual art was an important part of an overall political program responsible for horrendous acts of genocide. The Kalenberger Bauernfamilie was owned by Adolf Hitler, while "degenerate" art was banned. "Degenerate" art included abstractions, non-"realistic" imagery, "indecent" imagery, or works by non-Aryan artists or other "enemies" of the state. Of course, the exact meaning of each word was defined by the Nazi party. "Degenerate" artists had to cease making art entirely, and their old work was destroyed.

Text Link

In the United States today there are many questions concerning artists' right to freedom of expression and audience's rights, and how to deal with contemporary art that some sections of society may consider amoral. For more on these questions, see the "Food for Thought" section in Chapter 21.

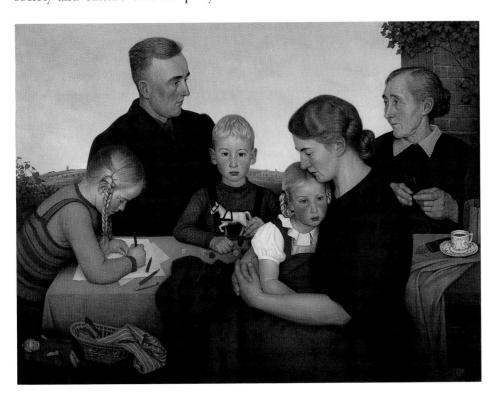

17.5 Adolf Wissel. *Kalenberger Bauernfamilie* (Farm Family from Kalenberg). Germany, 1939. Oil on canvas, 150 cm × 200 cm. Munich: Oberfinanzdirektion, Munchen.

Art That Criticizes Racism

Now we turn to three examples in which artists criticize racism.

Unflattering images of African Americans have been common in popular culture, such as the pickaninny, Little Black Sambo, and Uncle Tom. These images have been widely circulated in advertisements, magazines, and children's books. Another example is Aunt Jemima, a domestic servant whose title of "aunt" was a commonly used term of subordination and familiarity for African-American domestic servants, nannies, and maids. Aunt Jemima is a caricatured jolly, fat woman. The character and name is over a hundred years old, and has been used recently to sell commercially prepared pancake mix. These unflattering images, created by groups in power, are racist because

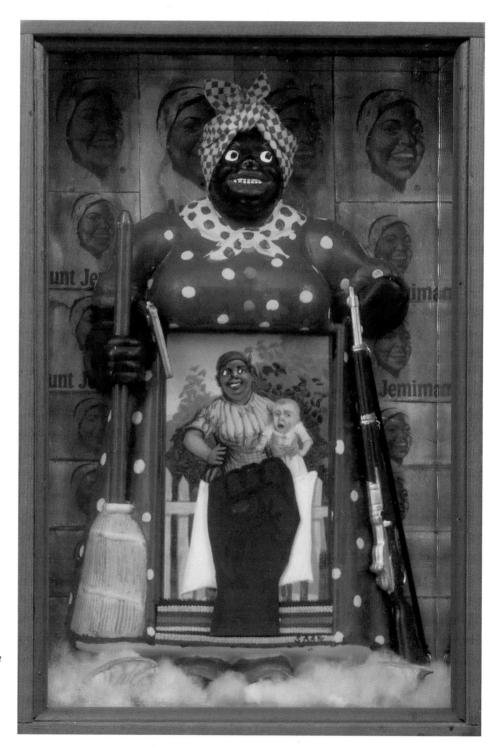

17.6 BETYE SAAR. The Liberation of Aunt Jemima. USA, 1972. Mixed Media, 11.75" × 8" × 2.75". University Art Museum, University of California, Berkeley. Purchased with the aid of National Endowment for the Arts funds.

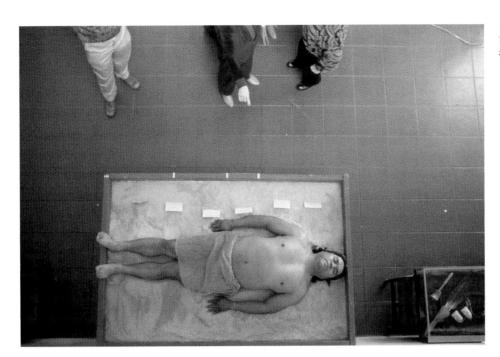

17.7 JAMES LUNA. *The Artifact Piece*. USA, 1986. Installation/performance at the Museum of Man, San Diego.

they often demean or ridicule subjugated groups. Rather than try to ignore or suppress these images, however, many artists have chosen to use, address, or transform them.

In the 1971 mixed-media piece, *The Liberation of Aunt Jemima* (figure 17.6), Betye Saar shows us three versions of Aunt Jemima in a shallow display box. The oldest version is the small image at center, in which a cartooned Jemima hitches up a squalling child on her hip. In the background, the modern version shows Jemima with thinner, lighter skin, deemphasizing her Negroid features. Neither version is respectful to African-American women, as the older one makes Jemima a caricature, while the new one implies she is more attractive if she appears less black.

However, the middle Jemima is the largest figure, and most emphasized. Her checked and polka-dotted clothing is very bright and colorful. Her black skin makes her white eyes and teeth look like dots and checks, too. This Jemima holds a rifle and pistol as well as a broom. A black power fist makes a strong silhouette shape in front of all of them. Militant power is now introduced to these images. The idea of Aunt Jemima, in any of its forms, can no longer seem innocuous. Saar enshrined these images in a glass box and to made their spirit and energy venerable. Symmetry and pattern are strong visual elements.

In *The Artifact Piece*, performed in 1986 (figure 17.7), the Native American artist James Luna challenged the way contemporary American culture and museums have presented his race as essentially extinct and vanished. In this performance piece, Luna "installed" himself in an

exhibition case in the San Diego Museum of Man in a section on the Kumeyaay Indians who once inhabited San Diego County. All around were other exhibition areas with mannequins and props showing the long-lost Kumeyaay way of life. Among them, Luna posed himself, living and breathing, dressed only in a leather cloth, with labels around him pointing out his scars from wounds suffered when drunk and fighting. Various personal items were housed in a glass case, including contemporary ritual objects used currently on the LaJolla reservation where Luna lives, recordings by the Rolling Stones and Jimi Hendrix, shoes, political buttons, and other cultural artifacts. The mixing of elements are the results of a living, developing culture.

In this striking piece, Luna challenged the viewer to reconsider what museums teach about cultures and what is a cultural artifact. Such museum displays feature various artifacts, but objects included often seem arbitrary. They may be simply the things that, by chance, happened to survive. In other cases, the white culture chooses to keep and view certain objects and yet ignore or destroy others. Thus, we learn less about Native American culture than we learn about the white museum's ideas about Native American cultures.

In addition, museums often discount or eliminate living cultures of today. Museums (and museum-goers!) are often only interested in their own preconceived idea of "cultural purity." "Authentic Indians" are those that are long dead. Native Americans who are alive today are less interesting to museums, because they are cultural mixtures, influenced both by Native and by Anglo culture. They may wear Reeboks rather than moccasins.

Dear Friend,

I am black

I am sure you did not realize this when you made/laughed at/agreed with that racist remark. In the past, I have attempted to alert white people to my racial identity in advance. Unfortunately, this invariably causes them to react to me as pushy, manipulative, or socially inappropriate. Therefore, my policy is to assume that white people do not make these remarks, even when they believe there are no black people present, and to distribute this card when they do.

I regret any discomfort my presence is causing you, just as I am sure you regret the discomfort your racism is causing me. Sincerely yours, Adrian Margaret Smith Piper

17.8 Adrian Piper. My Calling Card #1. USA, 1986–1990. Printed card, 2×3.5 inches.

Luna sees himself in a new way. While he still considers himself a warrior, he is a new one who uses art and the legal system to fight for Native Americans. In *Artifact Piece*, Luna also touches on the effects of alcohol on Native Americans.

In My Calling Card #1, 1986–1990 (figure 17.8) the artist Adrian Piper addresses the countless times in conversation that members of a group may make racist remarks when they believe that no African-Americans are present. My Calling Card #1 has a section of text neatly printed on a 2×3.5 inch standard business card, that begins, "Dear Friend, I am black." Piper herself has fair skin, and she would hand out the card to people who had made casual racist remarks because they believed her to be white. After several lines, the text concludes with, "I regret any discomfort my presence is causing you, just as I am sure you regret the discomfort your racism is causing me."

In other works, Piper continues to expose instances of racial stereotyping and racist preconceptions that may never be articulated, but nevertheless persist. In one piece, she makes the point that a large percentage of white Americans have racially mixed ancestry, exploding the myth of difference between whites and blacks. Other artists have worked in this same area, illuminating the ways that humor and advertising are racist. This is especially important because in many circles, overt raciam may be no longer acceptable, but it may continue to be perpetuated in conversation, in folklore, in jokes and so on. These artists have "gone public" with this material, forcing people to examine their own attitudes, even those people who do not believe themselves to be racist.

Who Is Looking at Whom?

In the United States, an avalanche of images are produced every week for fine art, commercial, and popular consumption. Many of our images deal with other cultures, so we develop ideas about Chinese people, or

Africans, or any other foreign or ethnic group from the images we consume. But who is making those images of others, and why? And what about the viewer? The position of the viewer is a privileged position. The viewer gazes at, or "consumes" the images of other people without directly interacting with them.

Text Link

We encountered the issue of the gaze before, with Lewis Hine's Leo, 48 inches high . . . (figure 14.10), especially in the "Food for Thought" section of Chapter 14.

When considering the issue of the gaze, we are thinking beyond the obvious subject matter of an artwork, and considering how the artwork is used, by whom, and for what purpose. How can imagery reflect a power relationship in the "real world," or how might it be used to maintain it? Let us study first an example of the gaze and how it works in racial situations.

Tseng Kwong Chi turns around the act of looking in a series of photographic self-portraits, such as Disneyland, California, photographed in 1979 (figure 17.9). Western industrial countries have produced a wealth of images of peoples from the rest of the world, for example, in magazines such as National Geographic, but also in many many other publications. Tseng Kwong Chi has produced images of Asians looking at the West, and has made them for a Western audience. In his many self-portraits, he posed in front of tourist sites in the United States, such as the Grand Canyon, Mount Rushmore, and the Statue of Liberty. In all his images, he wears a Mao jacket to emphatically identify himself as Chinese, rather than Japanese, Korean, or any other Asian ethnicity. He takes his own picture—the shutter release cable is evident—to show that he is the author of his own image. He is a tourist, but with mirror glasses. We cannot see his eyes, while he critically appraises what he sees of the West from an Asian point of view. He is unyielding and severe next to the goofy, grinning Mickey Mouse. We, the actual viewers of this photograph, have been displaced from our positions of power, as Tseng has taken on the role of the noninteractive viewer.

Tseng also takes on the issues of individuality in situations where racial stereotypes make everyone in a group seem all alike. Tseng's rigid pose was repeated in all the self-portraits in this series to emphasize his unmistakable, unique individuality from picture to picture. This was to counter the stereotypes that Asians are all alike, that they shun any show of public individuality, or that they avoid making themselves stand out.

We will be investigating the topic of the gaze of the viewer in greater depth in the remaining sections of this chapter. The gaze features prominently in works that deal with sexuality and gender.

17.9 TSENG KWONG CHI. Disneyland, California. China/USA, 1979. Silver Gelatin print, $36" \times 36"$.

EROTIC SEXUALITY

We now turn to artworks that deal with sexuality. Sexuality is a libidinal urge that is gratifying, positive, and even energizing. But it is also surrounded with cultural strictures and power relations. Both aspects can be seen in art.

Images of Sexual Union

In Chapter 7, we looked at art that dealt with procreation, which obviously also addressed human sexuality. We take up the topic again here, to show how sexuality might be constructed differently in various eras and culture. We are also focusing here on sexual pleasure, rather than procreation.

Text Link

Works from Chapter 7 that are related to this topic are A Pair of Lovers, by Kitagawa Utamaro (figure 7.20), and Jeff Koons' Made in Heaven (figure 7.21).

Images of ideal erotic sexuality were relatively common in India, both as sculptures from Hindu temples and also in a number of miniature paintings from northern India from the seventeenth and eighteenth centuries. *Krishna and Radha in a Pavilion*, dated c. 1760 (figure 17.10), shows Radha, a shepherdess, and Krishna, one of the incarnations of the God Vishnu, in a scene of tender lovemaking. They sit beneath a golden pavilion, surrounded by rich weavings, delicate flowers, and ripe fruit, as the lightning of their passion flashes across the sky. Krishna is conventionally depicted as blue. Both Krishna and Radha are graceful, serene figures, bedecked in jewels, outlined with flowing lines and filled out with delicate details. They are placed in the center, and their forms emphasized by the white bedding and dark background. The gold pavilion and red cloth frame them. Ornate patterns and textures add to the visual delight of the painting.

Text Link

For an example of an Indian temple carving with erotic imagery, see the relief carving from the Kandarya Mahadeva Temple, figure 10.23.

Krishna is a deity and the scene is highly idealized and represents an uneven power relationship between the two characters. But the mutual pleasure, affection,

17.10 Krishna and Radha in a Pavilion. India, from Punjab, c. 1760. Opaque watercolor on paper, 11" × 7.25". National Museum, New Delhi.

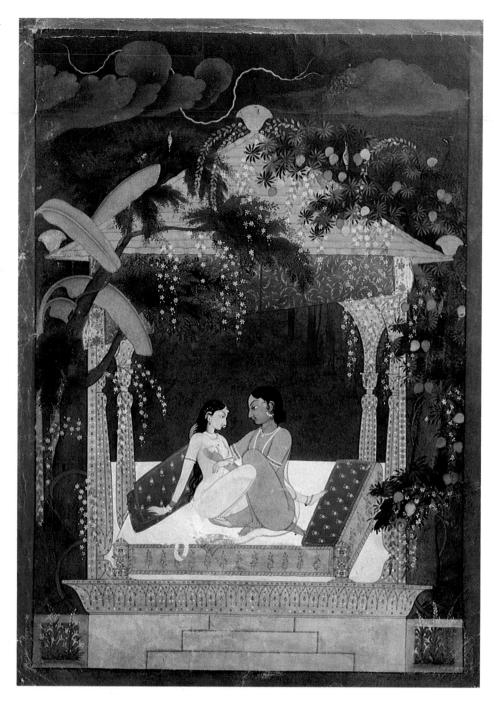

sweetness, and erotic energy he shares with Radha were meant to be like the physical and spiritual union that all humans could experience through lovemaking. That union in lovemaking, by extension, was also like union with God. In this case, the sexual "encounter" was not so much between viewer and art imagery. Images such as *Krishna and Radha in a Pavilion* were meant to be instructive, and the mythical sexual act was intended to be reincarnated regularly among living couples.

We could have included other images of sexual union, both heterosexual and homosexual, but will limit ourselves to this one, and move on to other sexual representations in art.

The Female Body and the Gaze

How does sexuality work in an image when only a single figure is depicted? Let us look at female nudes in nineteenth-century Western art. They have been the subject of considerable critical writing recently, which deals with the idea of the gaze, women as the object of the gaze, and men as the ones for whom the images were made. We already saw the gaze in relation to Tseng Kwong Chi's *Disneyland*, *California*, in figure 17.9.

The *Grande Odalisque* (figure 17.11) was painted by Jean-Auguste-Dominique Ingres in 1814. It is a long horizontal painting of a nude woman seen from behind. The title indicates that she is an odalisque, a member of

a Turkish harem. Blue, gold, and cream tones predominate in the painting. The curve of the upper body echoes the curve of the hanging blue drapery. Accents occur at the woman's face and at her hand, holding the peacock-feather fan. Her back is extremely long, creating a sensual flow that complement the curves of her legs, arms, breast, and buttocks. Outline is emphasized and the soft, flawless skin is delicately shaded. The smooth flesh contrasts with the patterned and textured cloth, feathers, and beads that surround and adorn the woman. Her pose is sensually relaxed.

Nineteenth-century female nudes in Europe and the United States were made for nineteenth-century men. They were the privileged audience for such pictures, as viewers whose gaze completed the sexual exchange implied in the painting. As the critic Linda Nochlin wrote:

As far as one knows, there simply exists no art, and certainly no high art, in the nineteenth century based on women's erotic need, wishes or fantasies. Whether the erotic object be breast or buttocks, shoes or corsets. . . . , the imagery of sexual delight or provocation has always been created *about* women for men's enjoyment, by men. . . . Controlling both sex and art, [men] and [their] fantasies conditioned the world of erotic imagination . . . (Nochlin 1988: 138–139)

The fact that only the female is present in a sexual scene is significant. Without a lover in the scene, the odalisque is sexually available for the viewer—presumably the European male—who gazes upon her. Again, the

position of the viewer is privileged, one who sees and consumes without being seen or consumed himself.

The Grande Odalisque reflects other European sexual attitudes. In the nineteenth century, sexuality was limited by social mores and by the Christian religion. Moral sexual activity was restricted to those in monogamous marriage. Divorce was taboo, and all single persons were expected to be celibate. These ideas were very influential, whether or not everyone followed them. At the same time, Europeans developed an ongoing fascination with sexuality in other cultures, ones that Europeans considered to be primitive, exotic, or buried in the past. Men in these other cultures were imagined to be free from burdensome social restrictions that hampered sexual urges, spontaneous feelings, personal power, energy, and creativity. The Grande Odalisque was painted during the height of Europe's colonization of vast areas of the world. The Turkish harem girl was exotic and sexually appealing. Her nudity was acceptable in European society because it was presented as somehow distant. The male viewer took the place of the imagined Turkish sultan, a man of apparently great sexual appetite who would have many such women at his disposal.

Our next painting, Edward Manet's *Olympia*, from 1863 (figure 17.12), is superficially similar to the *Grande Odalisque*. But *Olympia* scandalized the Paris public, in part because its sexuality and nudity were not of a distant place and time. The title of the painting came from the assumed name of the nude woman, Victorine Meurant, a known Paris courtesan who was the "companion" of wealthy men. Olympia looks back at the viewer with an

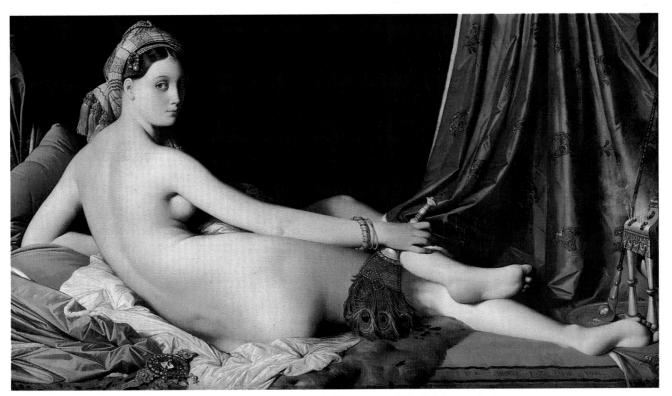

17.11 Jean-Auguste-Dominique Ingres. Grande Odalisque. France, 1814. Oil on canvas, $35" \times 64"$. Louvre. Paris.

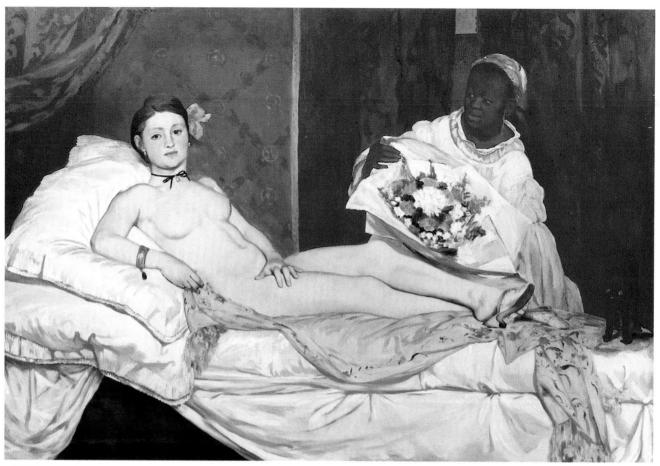

17.12 EDWARD MANET. Olympia. France, 1863. Oil on canvas, 51.25" × 74.75". Musee d'Orsay. Photo: Musees Nationaux.

understanding that sex and money will be exchanged in her associations with wealthy men. Olympia's gaze identifies and implicates the viewer, whereas with the *Grande Odalisque* the nature of the viewer is less explicit.

Manet's painting is similar to a famous Italian Renaissance painting of Venus. Even the name, Olympia, refers to the dwelling of the Greek gods. But this Olympia was not a heavenly goddess, rather a woman who was successful at her business and apparently pleased with herself. Manet revealed that, in fact, nineteenth-century Europe had conflated the concepts of prostitute, courtesan, and goddess. Olympia makes evident the sexual nature behind many artworks with mythological subject matter, showing that mythology was merely an acceptably distant way to present the nude woman for the pleasure of the male viewer. Nineteenth-century wealthy men disguised and insulated their sexual activities. Their "companions" were euphemized socially as embodiments of beauty, like goddesses. Manet's painting shattered those illusions. The unromantic expression on Olympia's face shows that the sexual transactions were in fact very similar to those of a street prostitute. The wealthy were horrified that their sexual dalliances could be seen in that light.

Manet's painting also reveals the social status accorded different races, with the African woman in the role of maid, the white woman as mistress.

While Manet's painting was attacked as scandalous, it did have its defenders. But they often defended the work based on its innovative paint quality, and usually left the subject matter alone because it was too sensational. Manet painted thickly, directly on the white surface of the canvas ground, in a style called "alla prima" painting. His colors were flatter and brighter than the subdued tones of traditional academic painting. The body of Olympia is brightly lit. Light areas are separate from the dark, as distinct from most previous oil paintings since the Renaissance where midtones predominate. Manet's brushwork was obvious, distinctive, and personal. His painting style, individualistic and thickly applied, led to many of the painterly concerns of twentieth-century painting.

Text Link

Jackson Pollock's Lucifer (figure 15.29) is an example of individualistic and distinct paint application that was so important in the mid-twentieth century.

In Laura Aguilar's 1991 photograph, *In Sandy's Room* (Self-Portrait) (figure 17.13), we find an ambiguous sexual

relationship between viewer and viewed. The artist has made a picture of herself reclining in front of a fan. Because her pose somewhat echoes Manet's Olympia, the sexual relationships in Manet's painting act as background for understanding this photograph. In this case, the artist/woman has made her own image, in contrast to Olympia and Grande Odalisque above, where male artists made sexual images of women. Aguilar appears to be self-pleasured with her relaxed body, the blowing fan and a drink in her hand. She also appears at ease with both her body and her homosexuality. She does not look outward to the presumed viewer, and so her photograph subverts the traditional message and purpose of nudity in European painting. The nature of the sexuality of the image has been purposely confused; viewers do not automatically know their roles in their act of looking. The tradition of positioning the male as the presumed viewer is also challenged, since Aguilar is a lesbian. Aguilar's self-containment is a call to revise the codes of desire and desirability we saw in *Grande Odalisque* and *Olympia*.

Her body as an odalisque sets up new standards for defining desirability. Her physique does not match popular standards of beauty, as fat is taboo in the United States today, despite the large percentage of overweight Americans. Aguilar's work makes us question why that taboo is so strong today. Aguilar's body does not appear exotic, but as part of U.S. life today. The room and furniture that Aguilar occupies are the ordinary furnishings of middle-class American homes.

Finally, the sexual relationship between the viewer and the viewed in media culture is explored in *Deep Contact*, from 1990 (figure 17.14). The artist Lynn Hershman has created a complex interactive computer-video installation that deals with the ways sexuality is delivered in our culture. In Hershman's piece, the "guide" or hostess is Marion, dressed in sexually seductive

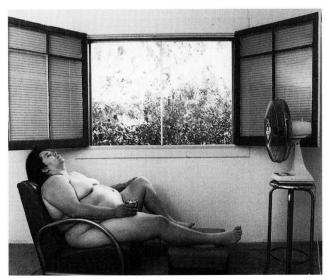

17.13 LAURA AGUILAR. In Sandy's Room (Self-Portrait). USA, 1991. Black and white photograph, 16" × 20". Collection of the artist.

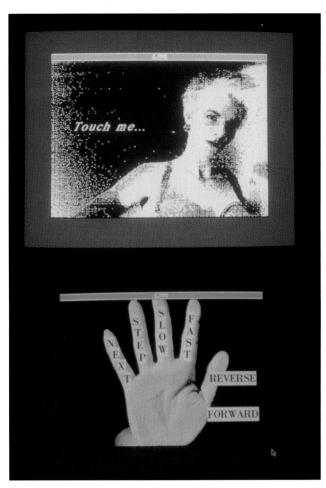

17.14 Lynn Hershman. *Deep Contact.* USA, 1990. Interactive computer-video installation at the Museum of Modern Art, San Francisco. See also the text accompanying figures 2.31 and 21.22.

clothing, who knocks at the window-like surface of the screen and asks the viewer to touch her to begin the performance of the artwork. The touch-sensitive screen responds to the viewers, giving them different choices when touching Marion's head, torso or legs. After the head is touched, the viewer sees video clips of commentators talking about reproductive technologies, women's bodies, and the hand extending into the screen through touch-sensitive technologies, like phantom limbs. When touching her body, viewers have the option to create interactive fictions. When touching the legs, the viewer enters a paradise garden, with various characters including a demon and a Zen master.

Obviously, the entire content of *Deep Contact* is not sexual. Even so, everything in the piece has been eroticized, including ideas about technology, self-awareness, and intimacy. The viewer of *Deep Contact* cannot be passive—if you do nothing, nothing happens. The actions required are emotionally involving. You have to commit yourself by making choices, and then touching a body part on the screen to activate those choices. The viewer's distance and anonymity are gone. At times, a surveil-lance camera mounted nearby interposes the viewer's

image on the screen in the midst of a performance of *Deep Contact*. Once again the basic relation between viewer and the art object has been disrupted. The viewer is dislodged from the position of voyeur.

Deep Contact is designed to mimic the voyeuristic dimension in entertainment or advertising, as sexually attractive people sell us products, give us the news, or host game shows. Deep Contact takes the structure of a seduction, however, and turns it into a piece of self-discovery. Through choices they have made, viewers find out about themselves. They have options to experience different things, change gender and identity, but all adventures are illusory in the end. There is no coherent narrative through the entire piece—various choices seem to be equally weighted and equally arbitrary.

Abstracted Sexual Imagery

Sexual imagery in art can be abstracted. Its forms may allude more or less to the human body, but humans themselves need not be represented, as we will see in two examples.

Georgia O'Keeffe's Grey Line with Lavender and Yellow, dated 1923 (figure 17.15), is an enlarged flower image. The simple, near-symmetrical composition is suffused with subtle color gradations interrupted by occasional lines. O'Keeffe, throughout much of her life, painted natural objects that verged on abstraction, with simplified forms and heightened color that increased a sense of beauty and desirability. She used these forms to express emotions rather than copying nature slavishly. Many critics, artists, and viewers have associated her flower imagery with the female body, especially female genitalia, as the structures of both can often be similar. Feminists have seen in her work a series of positive, female-based imagery that glorifies and beautifies female sexuality, that contrasts with the Grande Odalisque and Abduction of the Daughters of Leucippus, which we will see in figure 17.21. As such, she has been an influence on many subsequent feminist artists.

Text Link

Georgia O'Keeffe denied throughout her life any intention to image female genitalia in her flower imagery, and distanced her work from feminist art. How important is the artist's intention versus the critical response to the work? For more on this discussion, see the "Food for Thought" section of Chapter 4.

Louise Bourgeois' abstracted imagery is much more explicitly sexual than Georgia O'Keeffe's. In *Blind Man's Bluff*, dated 1984 (figure 17.16), the "body" is sexual, as the sculpture is like a large phallus covered with round, bulbous organic forms somewhere between breast-like and penis-like. In this way, the piece blurs simplistic gender dualism that has been seen as the discrete elements

17.15 GEORGIA O'KEEFFE. *Grey Line with Lavender and Yellow.* USA, 1923. Oil on canvas, 48" × 30" The Metropolitan Museum of Art, New York. See also the text accompanying figure 4.15.

that make up sexuality. In its appearance and name, *Blind Man's Bluff* invites touch. The marble at center is polished to a silky finish, while the top and bottom are left rough-cut. The piece is fetish-like, suggesting a fixation on sexual body parts without necessarily any attachment to an individual as a whole. The plethora of organs has the quality of pleasure overload. Bourgeois seeks to eroticize life in pieces such as these, and to suggest a hypersensitivity of touch, of sensation.

An important quality to Bourgeois' body parts is their ambiguity, although they are plentiful. The bulbous forms may also represent the sensitive nerves in the tongue or in genital organs, as well as breasts. With Bourgeois' work, multiple interpretations of the forms are often possible, and always subjective. Bourgeois' work is an example of the use of female sexual anatomy by a woman artist, which revises the traditional male-based sexual imagery. Bourgeois created her own

17.16 LOUISE BOURGEOIS. Blind Man's Bluff. USA, 1984. Marble, $36'' \times 35.5'' \times 25''$. Robert Miller Gallery, New York. See also the text accompanying figure 2.13.

sensual and ambiguous sexual imagery, which is a challenge to traditional gender roles where men perceive female sexuality solely in terms of their own satisfaction.

GENDER ISSUES

Every culture sets up standards and roles to which both genders are expected to conform. Society dictates and constrains acceptable behavior for women and for men. Artwork from different eras and cultures often give us clues about those social restrictions, and in some cases are actually part of making them.

Art and Ritual Perpetuating Gender Roles

We will begin by examining gender concepts, ritual, and art among the Sepik people of New Guinea in the South Pacific, focusing on the early twentieth century, before foreign influences had seriously disrupted the indigenous social order and religion. Gender differences and the power relationships between men and women were extremely important to the Sepik tribes. Men dominated women in much of Sepik life. They made art and

practiced complex rituals that reinforced and dramatized these gender power relationships.

These rituals began at infancy and continued through old age. Men produced a great amount of visual art in association with their rituals, collectively called "Tambaran." Almost all of Sepik art making asserted phallic power, while women are generally kept from any kind of art making at all. Tambaran are still secret rituals, but it is known that the initiate undergoes some ordeal at the hands of masked elders, such as a beating, scarification, ritual bleeding, or some other form of ritual violence. The rituals were meant to give men strength, vigor, and spiritual power that would ensure their domination over women and over warring men from other tribes.

These Tambaran rituals took place in large, decorated cult houses that were generally A-frame in design, with carved beams and paintings on the gables and ceiling. Our cult house example, *Waupanal* (figure 17.17) is from 1973. The houses contained the sacred carvings, masks, and musical instruments used in initiations. Cult houses often had an open feeling; however, when rituals were in progress, woven mats cover the entrances and preserve secrecy. The largest cult houses were built by the Abelam tribe, and were 80 to 100 feet high. The

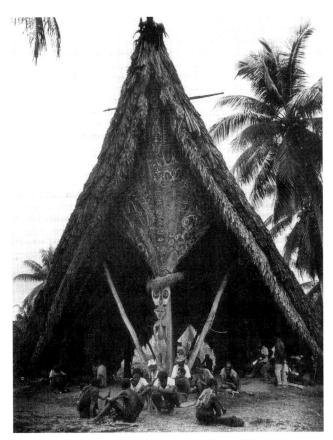

17.17 Waupanal. A men's cult house in the village of Bagwis, Kwoma tribe, Sepik region, Papua New Guinea, 1973. Copyright Ross Bowden. Photo Supplied by the Department of Reprography, La Trobe University, Melbourne.

house itself created a dramatic silhouette, the A-frame giving it a very high profile.

The cult houses were gendered; that is, the Sepik men saw the ridgepole as phallic and the interior of the house as the belly of a woman, so the house itself was a reenactment of the fertility and creativity of the sexual act that results eventually in a new birth. Men saw their rituals as creating men from infants. This is unlike Western notions that an individual exists from birth. Many South Pacific ritual practices were based on the idea that a person's very being is built through the religious experiences of a lifetime. Their rituals thus mimicked or usurped women's creative powers of giving birth.

The large cult houses were very hard and dangerous to build. One of the most difficult operations, as we can see in figure 17.18, was the hoisting of the ridgepole, the long horizontal beam weighing as much as a ton that must be lifted up and secured to the top of the vertical poles. The participating men ritually purified themselves

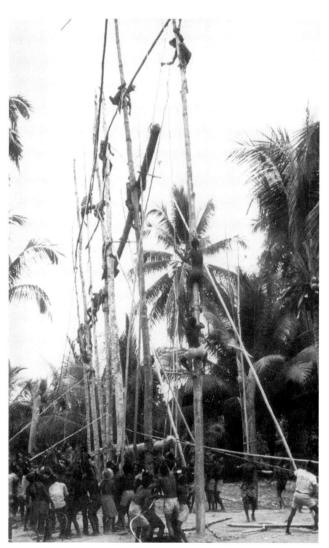

17.18 Hoisting a ridgepole of a ceremonial house in East Sepik, Papua New Guinea, 1971. Photo: Donald Tuzin.

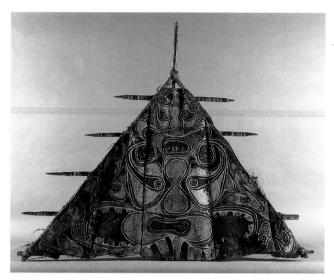

17.19 *Painting from a Cult House* at Slei, Middle Sepik Region, Papua New Guinea. Palm leaves on a bamboo frame, painted with earth pigments, 44" × 61.5". Museum für Völkerkunde, Basle. See also the text accompanying figure 20.19.

before attempting the feat. When finished, the large houses seemed almost miraculous, even to those who built them. The men believed that the spirits accomplished the feat. Yet at the same time the house affirmed the men's own strength, creativity, and domination.

Paintings and carvings were also important in maintaining gender roles and power. Men believed that they invested their vigor and spirit in paintings, which then hung in the cult house. Through the paintings, the spirits of older men could be passed to those at lower stages of initiation. The men who made the paintings did not own them, but in fact must give them away to fulfill their function. The paintings do not explain the Tambaran cult or illustrate it, as images in Christian religions might. Rather, the paintings become effective or invigorated in cult rituals. Geometric designs were most common, incorporating zigzags, curves, and spirals, as they seem to best express vitality.

In our example, Painting from a Cult House at Slei (figure 17.19), from the early twentieth century, the curves create multiple faces, with gaping tooth-filled mouths, large noses, and numerous eyes. Faces can be read stacked or superimposed on each other. The curves and spirals fill the triangular shape of the painting, cramped and small at the edges, swelling into large aggressive forms in the middle. The colors—black, red and offwhite—are bold and striking in their color range and the contrast from dark to light. Major forms, such as mouths and eyes, are outlined repeatedly in alternating black and white lines, resulting in vibrating patterns that express the idea of fearsome vigor. The arrangement of the paintings in the cult house indicated the specific family and clan relationships among the men. The paintings were made on the barks or natural fibers from trees in the area.

Even utilitarian items were decorated to reinforce phallic power. Hooks like the *Yipwon Figure* in figure 17.20 were used for hanging things from the walls and ceilings of houses. The men designed and decorated them beyond what is necessary for the hooks to be functional, strictly speaking. Yet the Sepik believed that these aesthetic additions made the hooks function better. The hook has many aggressive phallic shapes, arranged in a rhythmic series of C-shapes. Like the paintings, the carvings are seen as active. Their rhythmic lines or repeated curves invigorate the spirits and increase spiritual power. The men of Sepik tribes also practiced body art. They cut their hair distinctively, practice scarification, and otherwise adorn their bodies to make them more powerful and effective.

Thus we have seen how gender roles are related to power relationships and art making. Although we focused only on the Sepik people, similar discussions could be made for most cultures, past or present.

Gender Reflected in Art, Architecture, and Fashion

We will now turn to some examples from Western cultures to see how gender roles may be illustrated in art, and also are reflected in architecture and fashion.

Our first work, the *Abduction of the Daughters of Leucippus*, painted by Peter Paul Rubens in 1617 (figure 17.21), is on the one hand another example of the European fascination with sexual exotica, like *Grande Odalisque*. The scene is taken from Greek mythology. Castor and Pollux are twin sons of Zeus who captured a philosopher's two daughters as they were out horseback riding. Aided by Cupids who hold the horses' reins, the two immortals lower the women who resist with dramatic but ineffective, fluttering gestures. Interestingly, this painting is also commonly referred to as the *Rape of the Daughters of Leucippus*, as an old usage of "rape" meant "the carrying away of someone by force."

Blue skies, shimmering cloth, and a variety of textures add to the rich surface of the image and the sensual color harmonies. The composition places all figures in a diamond shape, which is compact and yet expressive of movement because of its instability. Darks predominate on the left, acting as a foil to the lighter areas in the center and right. The forms are modeled in color and lit with a marvelous glow. Various textures, such as armor, satin, flesh and hair, are all expertly painted.

Through poses, behavior, and clothing, the painting is indicative of what was considered masculine and feminine during that era. All figures represent ideal body types for their time. The women's voluptuous fleshiness was considered sexually attractive and a sign of health and wealth. The artist, Peter Paul Rubens, was extremely skilled in depicting the mass and surface of human flesh, the softness, roundness, fleshiness of the pale-skinned

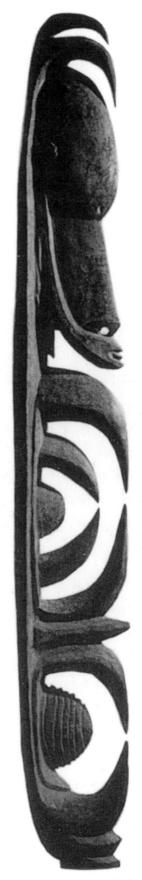

17.20 Yipwon Figure. Yimar, Upper Korewori, Sepik, Papua New Guinea. Wood, height 46". Collection Ronald Clyne.

17.21 PETER PAUL RUBENS. Abduction of the Daughters of Leucippus. Flanders, 1617. Oil on canvas, 7'3" × 6'10". Alte Pinakothek, Munich. See also the text accompanying figure 20.5.

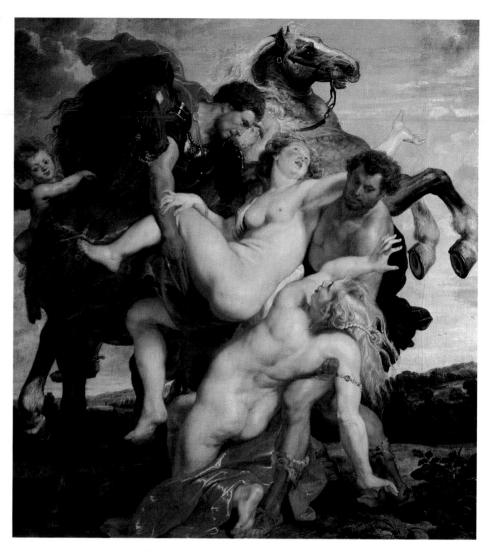

women in contrast to the tanned, muscular men. Outdoor activity was appropriate for the darker skinned men versus the fair-complected women who occupy the domestic interiors. Not only does the painting represent ideal body types, however; it also represents current ideas of gender behavior. Men have privilege over women's bodies. Women learn to be helpless, and social structures need to exist to protect the virtue of women. The expressions of the men are subdued and determined, while the women's bodies and faces are much more emotional. The men are at least partially clothed—one is in armor—while the women are unclothed and displayed. Throughout Western art history, we see numerous examples of the female nude providing lascivious pleasure for male viewers, legitimized because it was "art."

Clothing is often an important indicator of gender, and also of class. In the *Portrait of a Gentleman*, dated 1663 (figure 17.22) by Gerard ter Borch, we have an example of a painting that reflects changing social tastes and standards in masculine dress. The painting is bare

and simple. A standing figure forms a vertical in the composition, balanced by horizontal lines in the chair and table. His clothing hangs out in diagonal lines that unite the elements within the picture. During that time the middle-class Dutch, who were very successful as merchants and traders, were becoming increasingly wealthy. They were adopting more decorative styles of clothing to indicate their upward mobility and to more closely resemble aristocratic styles of clothing throughout the rest of Europe. They wanted to appear more like nobility or persons of leisure. A number of Dutch writers and Calvinist preachers labeled these new styles as unmanly, weak, and womanly. Certain points seemed to have been especially problematic for the critics of Dutch dress: the long, curly hair; the lavish use of ribbons and lace; the fancy shoes and petticoat. The clothing formed a number of triangular shapes, which were seen as indicative of the feminine.

In the painting, however, gender distinctions are still maintained, even as they are being changed. The "unmanly" dress is countered by the sitter's somber mien and sense of self-control, qualities considered manly by the Dutch. Color is drained from the gentleman's attire, and made more drab in comparison to the red velvet upholstery in the background. Again, manliness is reasserted. In addition, masculinity is defined in context; if this piece had hung near an image of a woman who was also decked out in stylish attire, she would have likely worn much more colorful, decorative, and lavish clothing, thus by contrast preserving the masculinity of the male subject (Kettering 1997: 41–47).

All kinds of trappings could serve as indicators of masculinity or femininity. In the *Oath of the Horatii*, painted in 1784 (figure 17.23), by Jacques-Louis David, the artist represents a scene from the early history of ancient Rome, in which three brothers vow to represent the Roman army in a fight to the death against three representatives of an opposing army. Their father hands

them their swords, reminding them of the manly virtues of courage and patriotism, while their sisters swoon at the right, in dread and sorrow at the anticipated killing (one of the sisters was to marry a representative of the opposing army). Heroic actions are a mark of masculinity, reinforced by the women's passivity. In a moment of male bonding, forged in the face of danger, the three brothers become a single force, a part of each other, and each willing to die for the others and for an external cause.

There are other gender indicators. The male dress is rendered in angular lines that contrast with the soft curves of the female attire. The men hold weapons as their job is war, while women's jobs are concerned with children. The architecture's symmetry and the composition's overall balance suggest the orderliness of this world. In this work, images both reflect the "reality" of

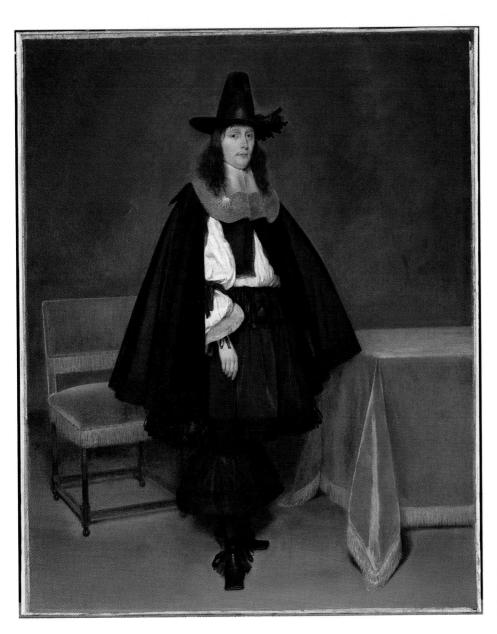

17.22 Gerard Ter Borch. *Portrait of a Gentleman*. Dutch, 1663. Oil on canvas, $26" \times 20.75"$. National Gallery, London.

17.23 Jacques-Louis David. Oath of the Horatii. France, 1864. Oil on canvas, 10' 10" × 14'. The Toledo Museum of Art. See also the text accompanying figure 4.7.

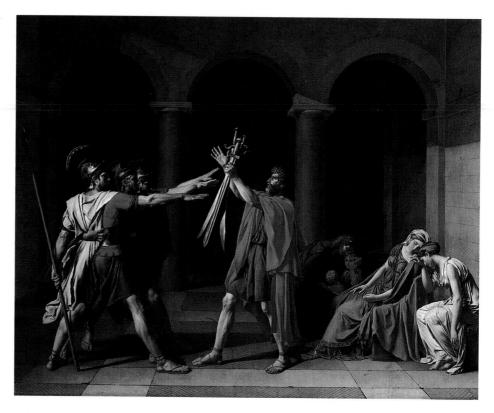

gender roles and also create that "reality." They spring to some extent from existing social conditions, but they also entrench those conditions and make them seem "natural," not just social conventions. The more we see such works, the more we believe them.

In this painting, the use of the classical architectural background is an indicator of masculinity, which was popular during the French Revolutionary era when this painting was executed. The use of classical elements in art and architecture at this time formed a style called Neo-Classicisim, which was a revival of Greek and Roman aesthetics after the discovery of Pompeii and Herculaneum. Also at this time, the French citizenry were about to overthrow the oppressive, parasitic French monarchy and aristocracy. Royal tastes in Europe ran toward the delicate and decorative, which was considered feminine. We already have seen examples of this, in dress, in the Ter Borch painting, above. They also favored highly decorative architecture called Rococo, such as that seen in the Hall of Mirrors, dated 1734-1739 (figure 17.24), by François de Cuvilliés. Rococo architecture was seen as female, with its emphasis on the decorative, the curving, the colorful. Pale pastels, creams, and golds made interiors delicate and pretty. The Hall of Mirrors has almost no right angles or flat surfaces. Square walls and ceilings dissolve in curves, and these curves themselves dissolve under the abundance of nature-based decoration and the reflecting mirrors, crystal, and silver. The ceiling appears to be an open sky, with birds flying from branch to branch of gold-leafed stucco trees. All

attributes—the architectural shell, the precious materials, the detailed, graceful decorations—contribute to the entire exquisite effect. The French middle class, on the verge of revolt, chose the clean, simple austere architecture that we see in the background of *Oath of the Horatii* to distinguish themselves from the aristocracy, and as an appropriate symbol for their ideas.

Text Link
The Swing (figure 16.18) is a Rococo
painting by Jean-Honoré Fragonard, and
reflects the same sensibilities as the Hall
of Mirrors.

Indeed, in Western culture, architecture is gendered; that is, different styles come to mean or be associated with certain qualities, and those qualities in turn are associated with masculinity or femininity. This goes back at least as far as the ancient Greeks, who saw the Doric order as masculine, and the Ionic as feminine. So the bare stone walls and unadorned arches of the architecture behind the Horatii was considered manly and virtuous in comparison with the *Hall of Mirrors*, which was considered feminine and elegant. There is nothing inherent in these styles which requires them to have been understood in this way; it was the political and social usage that attached these meanings to the architecture. In another

situation, there is no reason why the Horatii background could not be considered, for example, as bare, prison-like, and oppressive, and the *Hall of Mirrors* to be considered uplifting and stirring to the imagination. The gendered associations of Western architectural styles continues into the twentieth century. Critical writers commonly associated the modern, bare, high-rise sky-scrapers of the late 1960s and 1970s with masculinity.

Text Link
The Doric and Ionic Orders are illustrated in figure 3.5.

As we just saw, then, gender roles can become symbolic of different political positions during times of change or transition. Let us look at another example. Japan in the early twentieth century was industrializing its economy after centuries of being an agrarian, feudal state. It was also expanding its influence in China and throughout Asia. Both of these developments were seen as Western influences, which Japan had begun to

embrace enthusiastically after a long period of isolation. Western ideas were also influencing the roles of women in Japanese society: younger "modern girls" were dressing in Western style, wearing short Western haircuts with bangs, smoking, drinking, and holding jobs, while the older generation of Japanese women led traditional lives of domesticity and submission to male authority.

While modernism was embraced, nevertheless the Japanese government saw the independence and sexuality of modern girls as dangerous to the social order. The government commissioned the creation of numerous inexpensive prints showing modern Japanese women as "bijin," as traditional, innocent, beautiful women. These beautifully executed, inexpensive prints were inspired by the popular seventeenth to nineteenth–century Japanese ukiyo-e prints which were avidly collected among the Japanese middle class. The women depicted in ukiyo-e prints, while they were beautiful and unassuming, were however often geishas, paid companions, courtesans, or prostitutes.

Text Link

Komurasaki of the Tamaya Teahouse (figure 16.27) is an example of a ukiyo-e print featuring a geisha.

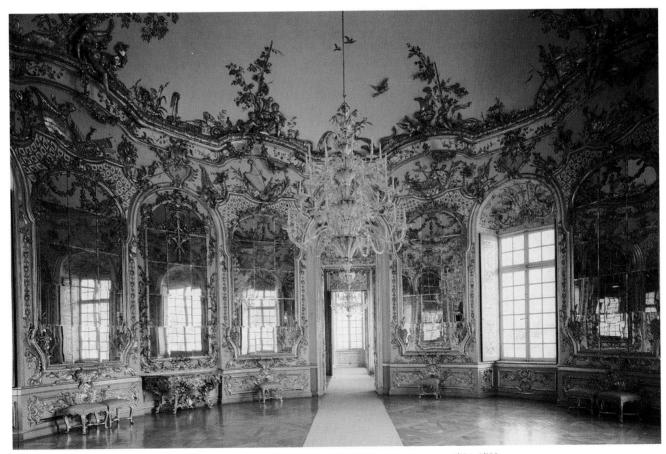

17.24 Fraçois De Cuvilliés. Hall of Mirrors. Amalienburg, Nymphenburg Park, Munich, Germany, 1734–1739.

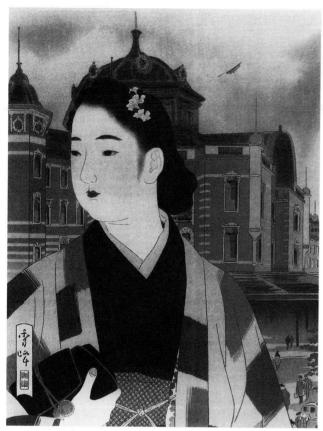

17.25 Yamakawa Shuho. *Tokyo Station As It Is Now.* Japan, 1942. Color woodblock on paper, 18" × 13.5". Anonymous collection.

Our current example is Tokyo Station As It Is Now (figure 17.25), by Yamakawa Shûhô, a print made in 1942, in the midst of World War II. A young woman dressed like a geisha stands in front of the Tokyo Railway Station. The traditional garb of the geisha has been desexualized, however, and here represents the traditional demure Japanese woman. In fact, the modest woman in a kimono with flowers in her uncut hair represented the idealized woman who existed in Japan's past (Brown 1996: 7), not the independent, smoking, working girl of modern Japan. The woman's appearance is at odds with the small male figures in the lower right who wear Western coats and hats and carry briefcases. All the attributes of the best Japanese prints are here. The lines are delicate and subtle, and details such as the edge of the hair handled with great skill and finesse. Color and composition are also beautifully handled and balanced. The woman forms a vertical against the horizontals of the background, while her turning head is framed and offset by the architecture behind her. The rigid rectangles of the station windows are echoed in the soft squares of her kimono.

Prints like this one were meant to make traditional roles for women fit in with the rest of industrialized,

Westernized Japan, despite the fact that a sizable percentage of younger, modern Japanese women no longer conformed to that role. Other government-sponsored prints from the 1930s and 1940s show kimono-clad girls gazing into mirrors, visiting shrines, viewing cherry blossoms, and so on. But the symbolic content of the print goes even further than that. The print was meant to support the idea of Japan dominating all of Asia, as was their intent in World War II when they invaded China and conquered most of the Pacific Island nations. The Japanese sought to present themselves as industrial and cultural leaders of Asia. The kimono-clad woman was a gendered symbol for the "high" qualities of traditional Japanese culture. The Tokyo Railway Station represents Japan's industrial power, which at that time exceeded that of any other Asian nation. The governmentsponsored print commemorated the 70th anniversary of the Japanese Government Railways, which were essential to the Japanese wartime efforts, although no sign of war machinery is apparent.

Critiquing Gender Roles

We have just seen that rituals, art making, kinds of behavior, architectural styles, and modes of dressing can be associated with masculinity and femininity, and can reinforce existing gender roles. Now we will turn to art that critiques socially restrictive gender roles.

In many cultures, people change their very bodies to enhance their femininity or masculinity. This is done by dieting, plastic surgery, implants, scarification, and various bindings that mold the body, most often on the skull, waist, neck, or feet. These practices can be widely accepted at times. But in times of cultural change, they can become very controversial.

Text Link
Eleanor Antin's Carving: A Traditional

Eleanor Antin's Carving: A Traditional Sculpture (figure 15.26) examined the notion of dieting and body perfection.

In her work, the artist Hung Liu has examined foot-binding, practiced in China from the Song Dynasty (960–1279) until the beginning of the twentieth century. Many Chinese women's feet were bound from birth to artificially confine their growth, distorting them into small, twisted fists that were sexually attractive to men. With bound feet, walking was extremely difficult, but their mincing steps were considered delicate and lovely. Bound feet left women handicapped, which also ensured that they remained subservient. One Liu piece

called *Trademark* (not shown here) shows a row of traditionally dressed Chinese women from the early twentieth century who were caught in that period of change when footbinding was being suppressed. Previously women of high fashion, they were suddenly forced into prostitution when the imperial Chinese government was overthrown, and the new Chinese government of the twentieth century mandated physical labor for all able-bodied citizens. These women became prostitutes because their bound feet made walking—much less manual labor—impossible.

Liu ties oppressive gender practices to broader political repressions. In *Trauma*, dated 1989 (figure 17.26), Liu returns to the motif of bound feet with the large figure at center, a woman, who publicly shows her bound feet. While bound feet were considered erotic in private, public exposure was a shameful act. Below her is an image of a dead Chinese student, killed by Chinese government forces when they violently crushed the demonstrations for freedom in 1989 in Tienanmen Square. Liu sees the killings in Tienanmen Square as a

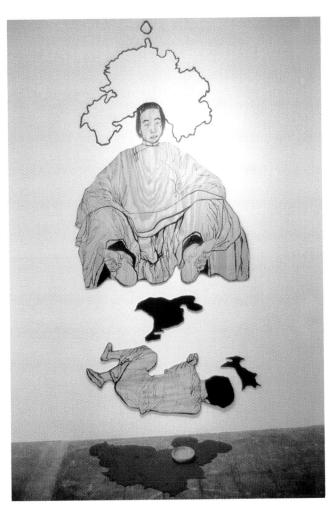

17.26 Hung Liu. Trauma. China/USA, 1989. Ink on plywood cutouts, acrylic on wall, felt cutout and wooden bowl, $108"\times52"\times26"$.

shameful event for China. The outline map of China behind the woman's head is upside down, while its reflection below, cut out of red felt, becomes a bloodstain on the floor below the student. The bowl is a symbol Liu sometimes uses. It is a vessel often emptied and filled, but never in exactly the same way. Poetically, the empty bowl represents China and the artist herself, emptied and then refilled by the cycles of history. With China's long history, the Chinese commonly make associations between contemporary events and events of the distant past, a habit of thought that is evident in Liu's work. For Liu, it is also a way to translated her personal rage at the practice of footbinding into a broader commentary on contemporary society and politics.

Aspects of Liu's work resemble contemporary Western works of art, even though she lived in China most of her life, and only came to the United States in 1984. *Trauma* is a mixed-media installation, currently a popular mode of art presentation. But Liu also references her native country. She begins with historical images of China, and translates them into Western works of art. The two figures in *Trauma* are painted in ink, recalling the great tradition of ink painting in China.

Since the 1970s, gender issues have been hotly contested in the United States, with topics ranging from sexual harassment, to equal pay, women in the military, working women both as homemakers and in the business world, and so on. Gender conflict is the theme of Punch and Judy: Kick in the Groin, Slap in the Face (figure 17.27), an animated neon sculpture by Bruce Nauman from 1985. The work's title is taken from the popular comic puppet show in which a husband and wife quarrel constantly and violently. In this piece, this kind of humor is reduced to domestic violence endlessly repeated, as the neon blinks out a short sequence in which a male figure slaps a female figure in the face and the female kicks the male in the groin. This work arouses fear that sexual relationships may be reduced to abuse. Neon is not a traditional art material. In this case, it is fashioned to look like familiar commercial signs, like those that might be seen at bars, singles spots, and pick-up joints. The use of neon ties this work to popular culture and the pervasiveness of violence in family settings. The neon sequence also reduces the action and the figures to mere slapstick caricatures, focusing on the violence of the action without addition of reasons, excuses, personalities, or extenuating circumstances. The balance between the two figures, and their facing each other, suggests two polarized positions, and a conflict almost incapable of being resolved. In this respect, the balance and symmetry operate as in Barbara Kruger's Your Body Is a Battleground (figure 17.1).

Do Women Have to Be Naked to Get into the Met. Museum?, from c. 1986 (figure 17.28) is an artwork by the Guerrilla Girls that seeks to correct a specific kind of gender

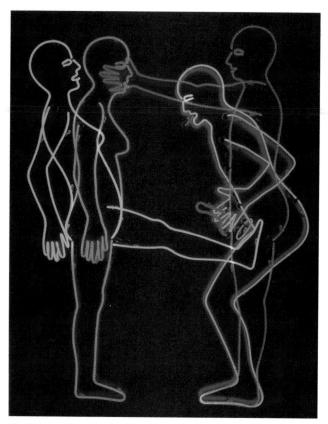

17.27 Bruce Nauman. Punch and Judy: Kick in the Groin, Slap in the Face. USA, 1985. Neon tubing mounted on an aluminum monolith, $77" \times 61" \times 14"$. Private Collection, Switzerland.

discrimination. At the time the poster was made, highprofile art exhibitions in prestigious museums often included very few women artists. In other words, a naked woman painted by a man might be shown in a museum, but a painting by a woman artist was not likely to be. The poster pointed out how few women artists had work in the Modern Art section, but how often they are used as models. On the poster, the woman's body is that of *Grande Odalisque* (see figure 17.11) whose aesthetically pleasing elongated torso reclines on cushions, on display for male viewers to enjoy and "consume." However, her head has been obscured by a gorilla mask, like those the Guerrilla Girls wore in public appearances to maintain their anonymity and to liken themselves to revolutionary guerrillas who seek to overthrow a dominant power.

The Guerrilla Girls is a collective of anonymous women artists and arts professionals protesting racial and gender discrimination in the art field. Their posters feature text, image, and humor presented with a strong graphic design sensibility. The punch of their message is delivered like a well-designed advertisement. The posters were mass produced and relatively inexpensive. They would show up outside of galleries and museums hosting high-profile art events where women were underrepresented. The Guerrilla Girls in masks would often show up also, in performance, to protest the event. The purpose of their work was to cause exposure, embarrassment, and, eventually, change.

The Guerrilla Girls also protested other instances of gender discrimination in the art world, noting that women artists had fewer exhibition opportunities, had fewer tenure-track teaching jobs in universities, made approximately 33 percent the income from art that male counterparts earned, were infrequently discussed in scholarly works, and so on. Later posters were concerned with both gender and racial imbalances in museums, exhibitions, and teaching opportunities. The Guerrilla Girls were successful in changing attitudes in the art world, although some argue that the changes were merely superficial. Without a doubt, their barbed humor and effective graphics were the major weapons of the Guerrilla Girls.

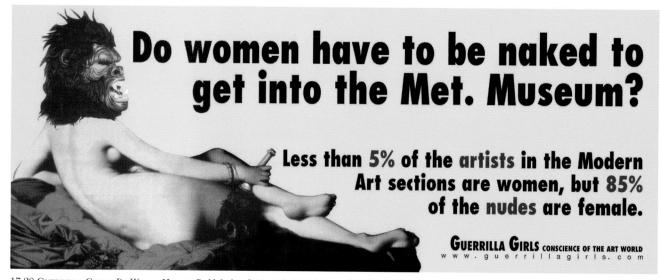

17.28 GUERRILLA GIRLS. Do Women Have to Be Naked to Get into the Met. Museum? USA, 1986. Street Poster. See also the text accompanying figure 4.12.

SYNOPSIS

Barbara Kruger's *Untitled (Your Body Is a Battleground)* indicates how attitudes on race, sexuality, and gender are contested in society and religion today, and how personal attributes can become controversial political battles.

We looked at a number of artworks that seek to preserve racial identity, and others that protest racial oppression. Marc Chagall's *Over Vitebsk*, James VanDerZee's *Society Ladies*, Lorraine O'Grady's "Sisters" series, and Adolf Wissel's *Kalenberger Bauernfamilie* all preserve the history or values of an ethnic group. Adrian Piper's *My Calling Card #1* and James Luna's *Artifact Piece* turn negative stereotypes and racist habits into forceful criticisms of racism. Tseng Kwong Chi turns the Asian into the one who judges and consumes U.S. culture in *Disneyland*, *California*.

In two similar paintings, *Grande Odalisque* and *Olympia*, a nude woman is on display for implied male viewers. Sexuality was made acceptable because it was distanced in the former image, and sensational because it was integrated into contemporary society in the latter. Laura Aguilar takes the odalisque again and transforms it into a contemporary statement on sexual preference and body types in *In Sandy's Room (Self-Portrait)*. *Krishna and Radha in a Pavilion* shows an idealized sexual encounter. Sexual energy is the perceived content in Georgia O'Keeffe's *Grey Line with Lavender and Yellow* and Louise Bourgeois' *Blind Man's Bluff*. Lynn Hershman's *Deep Contact* envelops high technology, mass media, and personal choices in sexual wrappings.

Gender roles are reinforced or challenged in the artworks we saw in this section. We saw a number of works from the Sepik region of Papua New Guinea, where gender identity is formed through rituals and art. We next looked at the gender influences that affect our interpretation of various European artworks, specifically with Peter Paul Rubens' Abduction of the Daughters of Leucippus, Gerard ter Borch's Portrait of a Gentleman, Jacques-Louis David's Oath of the Horatii, and François de Cuvilliés' Hall of Mirrors. Gender practices can also symbolize broad political trends. In Yamakawa Shûhô's Tokyo

Station As It Is Now, conservative gender roles for women symbolized the Japanese government's desire to preserve traditional Japanese culture despite industrial modernization. In Hung Liu's *Trauma*, the oppressive practice of foot binding is linked to the Chinese government's brutal suppression of student revolts in 1989. Abuse and intimacy are linked in Bruce Nauman's *Punch and Judy*. The Guerrilla Girls used posters like *Do Women Have to Be Naked*... to protest unequal pay and opportunities for women in the art world.

FOOD FOR THOUGHT

We saw the odalisque appear in several guises in this chapter, as harem girl, as Paris prostitute, as a lesbian, and on a protest poster. Thus, an image like the odalisque carries with it all its past meanings and also new meanings given to it by each successive artist.

 How do we determine when an image is being used for oppressive ends, or not?

We also saw racism challenged in many works of art. Glorifying racial identity may have positive results. Racial glorification mixed with ideas of racial superiority lead to disaster.

• When does promoting the beautiful get confused with superiority?

We spent some time discussing gender concepts among the Sepik of Papua New Guinea, a culture that may seem very distant from the United States today. However, are there similarities between the two cultures?

- For example, are some fraternities like men cults?
- What products and practices reinforce gender roles in the United States today?

In this chapter, we did not look at art that referenced the elderly. But let us consider aging for a moment.

- What images of old people do we get from fine art and popular art forms?
- How do they compare to your own experience of old men and old women?

INTRODUCTION

"Entertainment" means "diversion or amusement." The verb "to entertain" also means to admit into or to hold in the mind, which suggests the presence of ideas.

Those two definitions form the basis of this chapter. Art can be diverting or amusing, and at the same time cause us to admit into or hold in our minds an idea, a fact, a drama, a melody, or an image. Art can certainly be entertaining while being informative and provocative.

In this chapter, we will be looking at examples that are unquestioningly accepted as art. For instance, art museums and opera houses, as well as what goes on inside them, are considered art. They are sites that we visit primarily as leisure-time activities, and thus fall into the category of entertainment. However, other examples in this chapter are not so clear-cut in terms of their cultural category. Is a classic film like Gone with the Wind a work of art? Or is it just Hollywood? Is the Open Air Museum in Hakone, Japan, an art museum or a park? The boundaries of such categories are not fixed. There is no clean break along the continuum of what is art and what is entertainment. It differs from time to time within a single culture, and of course changes from culture to culture. To complicate matters, in some artworks, ritual is combined with art and entertainment. For example, the masquerades in several African cultures incorporate visual arts, are entertaining, and may be religious ceremonies.

In this chapter, we will look at areas where visual art and performing arts overlap. We will look at ways that architects have designed houses and other sites for the arts. We will see art forms that also commonly fall into the category of entertainment, such as film and television. And finally we look at various sport structures and sport activities as part of what we do with our leisure time.

Keep in mind the following questions as we observe the art and architecture of entertaiment:

How is art in its various forms entertaining?

How has architecture facilitated the performing arts?

Arts and recreation? Arts and education?

How have visual artists contributed to theater and music?

Where are arts and crafts used in drama and performance?

In what areas do the visual and performing arts overlap?

What kinds of imagery have artists made that depict various forms of entertainment?

"HOUSES" FOR THE ARTS

Theaters, Museums, and Opera Houses

The design of museums and performance spaces must meet certain criteria. They must function well; that is, the audience in attendance has to be able to see the art clearly, while in relative comfort. In addition, these spaces must "look the part." Visually, they must conform to the aesthetic sensibilities and the values of the audience. In addition, the exterior design must reflect the kinds of entertainment that go on in the space. This also holds for many recreational and educational sites such as libraries, history museums, planetariums, and aquariums. We will look at a few examples of "houses" for the arts to see how different architects have met the criteria for successful design.

The earliest form of theater in Western cultures dates back to ancient Greece where dramatic rituals for Dionysos, god of wine and fertility, were performed in the hollow of hills. These ritual dramas dealt with human conflict in the forms of comedies and tragedies, and were only performed once during sacred festivals. The human conflict usually was concerned with issues and relationships between human beings and the gods, community, and fate. The plays, which included music and dance, continued for hours on end of continuous action. The actors wore elaborate costumes with even more elaborate oversized masks, emphasizing the emotion of the characters while amplifying the actors' voices

as the mouth area was shaped to act as a megaphone. Thousands of people attended these dramas.

Text Link
The cult of Dionysos is also background material to the paintings in the Villa of Mysteries at Pompeii, Italy, such as the Initiation Rites of Bacchus (figure 7.12). Bacchus is another name for Dionysos.

Eventually magnificent theaters were designed to hold a multitude of people where all could see and hear the drama, and have easy access into the structure. One such fine example is the Theater at Epidauros (figure 18.1), designed by Polykleitos the Younger around 350 BC. It was built in the hill sanctuary of Asklepios, god of resurrection and healing. Its plan references the Classical Greek ideal shape, the circle, although it is only a little more than a semicircle with a 387-foot diameter. The "theatron," or seating area, has 55 tiers of stone and marble benches, rising at a high angle to give clear view to each spectator. Each section is connected by stairs. The audience entered the theater through passageways at each end of the semicircle. At the very center was the orchestra platform, a circle where the chorus would dance near or around the altar of Dionysus. Behind the orchestra is a long rectangular structure used for the stage. Behind the stage was the "skene," a building that provided a backdrop for the plays and contained dressing rooms and scenery.

This brilliantly designed theater could accommodate over 12,000 people and was acoustically perfect. No matter where one was seated, whether in the front row or high up in the "bleachers," everyone could hear perfectly. Greek theater must have been both entertaining and an unforgettable experience, with the theater's geometric order, the distinctive costumes and masks, the elaborate stage machinery, and the chorus and musicians. One can imagine the anticipation of the Greek community while waiting for the first theatrical event of the year to begin.

The Theater at Epidauros has had many descendants through the centuries, some copying its design quite faithfully, while others vary considerably from its plan. For example, the Globe, an English Elizabethan theater where William Shakespeare's plays were first performed, was an open courtyard encircled by three levels of galleries. It was a smaller, much more intimate structure, holding only 2,500. The audience, often a rowdy group well inebriated with the flowing ale sold by roving theater venders, varied from aristocratic men and women wearing masks, to guild members, shop keepers, students, laborers, and peasants. All levels of society could go to the theater as long as a ticket was purchased, but there were cheap seats for the poor, and more elegant galleries for the rich. The price of the ticket and the design of the Globe Theater kept the classes separated, but the plays were for all to enjoy.

A very different theater was designed for the Japanese "kabuki," a popular form of entertainment that was started in the early seventeenth century by a woman temple dancer named Okuni. The audience for this new theater form was made up of the common folk, as the already existing Noh theater was generally reserved for the upper class. The word "kabuki" literally means "song, dance, and acting." The subject matter for kabuki performances came from Noh dramas, historical plays, and domestic themes that were especially enjoyed by the

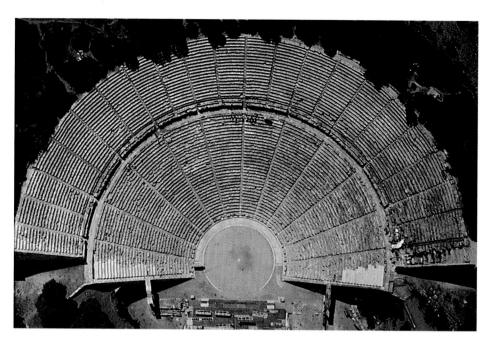

18.1 POLYKLEITOS. *Theater at Epidauros*. Greece, c. 350 BC.

harmony with the art of human beings, which is not always the relationship between humans and their planet. To walk through this environment is both inspirational and enthralling.

The outdoor exhibition space covers an area of 70,000 square meters. It has exquisitely manicured lawns, woods, and gardens that complement the many works displayed there. Works of English sculptor Henry Moore are well suited to this setting, as open space is part of the vocabulary of his sculpture. The collection contains 26 of his major works. Among the indoor spaces on the grounds is the Main Gallery, which houses works by celebrated sculptors including Brancusi, Boccioni, Miró, Calder, Dubuffet, Morie Ogiwara, and Kotaro Takamura. The Painting Gallery displays renowned twentieth-century Japanese and European artworks. The Picasso Pavillion is the world's first privately installed Picasso Museum, containing 230 of this prolific artist's paintings, ceramics, sculptures, tapestries, and works in glass.

We have looked at park settings that feature the arts, but of course farther along on the park and recreation continuum we find gardens, wild animal parks, amusement parks, and theme parks. Even park-like cemeteries may contain art (see figures 11.25 and 11.27). All of these are the work of architects, engineers, artists, and designers. This category includes such well-known sites as Tivoli Gardens in Copenhagen, Denmark; Coney Island in New York; and Disneyland in Anaheim, California. The oldest of these, Tivoli Gardens, features extensive flower gardens with amusement parks, open air pavilions, restaurants, fireworks, and symphony and ballet performances. These parks are part of popular culture rather than part of the fine arts, but they are the "first cousins" of art parks. In addition, they are influential sites that are discussed frequently in relation to contemporary culture and theory, and they are powerful in the imaginations of many.

THE VISUAL ARTS WITHIN THE PERFORMING ARTS

Art and Theater

The visual arts have long been part of theater productions. We will now look at several examples where these areas overlap the visual aspects of theater significantly, focusing on masks, puppetry, set design, costumes, and graphics. Theater has in turn influenced the visual arts, and we will look at one area in particular, a new genre called Performance Art.

Let us start with the topic of masks. When looking at the *Theater at Epidauros*, above, we mentioned that oversized masks were part of the theater productions, making characters identifiable and audible to the entire audience. Masks continue to be used in theater productions all over the world. In some other cultures, masks are used in performances that are partly entertainment and partly ritual. One example are the multipurpose female masks of the Guro people of the Ivory Coast in Africa. The Gu Mask (figure 18.9) is used in performances that have many functions, one of which is to entertain. When worn in full masquerade, the Gu Mask embodies the female spirits as well as the Guro standard of ideal beauty and fashion. It often appears in dance together with the male counterpart wearing a "Zamble" mask. Their story-dance might mock or comment on gender relations, truly a universal source of material, and one utilized by entertainers worldwide! The costumes and masks are owned by individual families or dancers. The masquerade performers with their bands perform at regional festivals, local community events, marriages, or funerals. Recently they have included tourists in their audiences and perform at hotels.

Taking a closer look at the mask itself, we see a finely carved and polished work of art. Much like the

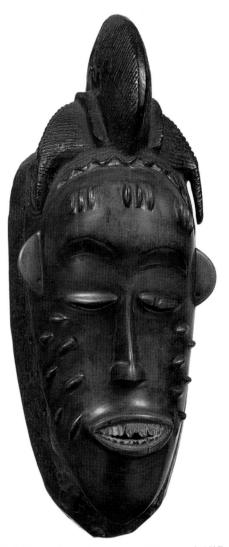

18.9 *Gu Mask*. Guro culture, Ivory Coast, Africa, wood, 12½". University of Iowa Museum of Art, Iowa City.

naturalistic masks of the Dan and Baule peoples, the *Gu Mask* is a long flow of gentle curves. The high bulging forehead extending below an elegant coif, the scarification of the face, and the filing of the teeth are all in Guro fashion for female beauty. For performances, brightly patterned cloth can be attached to the edges of the mask. Only when worn in full costume and seen in dance movement with music, however, can the full impact of the excitement and spirit of the *Gu Mask* be felt. (For an image of African masks being used in dance, see the Kanaga Masked Dancers, figure 18.18).

The entire category of masks and masquerades is an example of where one culture's concepts and uses of art do not translate cleanly into another culture's. The masquerade is an important art form in many African cultures. The masquerade is performed in open spaces, and its components are entertainment, art, music, drama, and often religion and ritual. Artists and community all participate and are integral to its success. However, when Western art museums present the masquerade, they retain the mask only, and do not present the entire ritual, music, and performance. Only the mask is considered to be art, and is removed from its context and enshrined in a museum's glass box.

Text Link
Ritual dances with masks have often had significant religious meaning, For example, see the discussion of the Kwakiutl Transformation Mask (figure 9.18).

Akin to masks and costumes is puppetry, an old art form that has existed for at least 4,000 years. In Japan, an early form of puppetry was the "doll drama" called *Bunraku*, which was performed by traveling troupes who made their way across the country. Most of these troupes came from Osaka and from the Awa on Shikoku Awaji Island in Osaka Bay. Today, at these sites, there still exist puppeteers and puppet workshops that continue to work in the old tradition (figure 18.10).

In the doll drama, the puppeteer with puppets was accompanied by a singer-narrator and a musician playing a three-stringed instrument called a "samisen." The singer would describe the scenes, voice all the roles and make any needed comments to enhance the drama. The style of singing was rooted in the Japanese kabuki theater (see figure 18.2), and singers would achieve fame in their own right. The musical background would create the mood of the play as well as the tempo, and would also help punctuate the action and important moments of the story. The story themes came from previous Noh dramas, legends, and historical events, and generally

18.10 Bunraku performance on stage, Japan, c. twentieth century.

dealt with human conflict concerning duty and desire, condemned love, and self control.

The naturalistic puppets are one-half life-size and have articulated hands, head, eyes, brows, mouths, and legs for the male characters. Female puppets were dressed in long robes that made legs unnecessary. Originally the puppets did not have movable parts, but they were developed later as the craft was perfected. The puppets are operated by three people: the master puppeteer, whose face we see, and two assistants, who are robed in black. The master wears elevated sandals so that he can be above the other two. He holds the puppet up and works the head and facial features with one hand while manipulating the doll's right hand with the other. The other assistants work the left hand and the feet. All the manipulations are done in full view of the audience on a long narrow stage. On the front of the stage is a low fence that visually anchors the puppets to the ground. Working together as one, the puppeteers, the singer, and the musician have to be in precise synchronization in order for the drama to work, indeed an accomplishment requiring lengthy practice and discipline. It is no wonder that Japan recognizes artists and art forms such as Bunraku as national treasures.

Puppetry continues to be a favorite entertainment, and has taken a new form in the Broadway stage play, Disney's *The Lion King* (figure 18.11), from the mid-1990s. The musical drama deals with the rites of passage of a young lion king, as he struggles to find his place in life. One of the show's elements that makes it so exciting is the unique combination of human-puppet characters, created and directed by Julie Taymor. Taymor's background ranges from Indonesian masked dance to Bunraku puppetry to Wagner and Stravinsky opera. She enables the audience to see the puppeteer-actor work the puppets while they are enacting the story, so both the story and the process of the

story-telling spontaneously unfold before the audience. Her animal-and-human characters come alive through the elements of puppetry, costumes, masking, and acting, all maintaining their integrity, yet working as one theatrical entity. As the story is about animals who endure human-like experiences, the design of the characters is especially appropriate. In our example, the costumes of the performers mesh with the design of the zebra puppet, and bodies and movements mesh as well. Stripes predominate throughout, on the set backdrop, on costumes and in face paint, uniting the design of all.

Let's look at another area where the visual and performing arts overlap. Visual artists have produced graphics for the performing arts. Henri-Marie-Raymond de Toulouse-Lautrec lived in the cabaret and theater district of Montmartre, Paris, in the 1880s. There he became friends with the entertainers, street people, prostitutes, and other artists that frequented the area, and many of them became the focus of his work. He did not go along with his culture's ideals of beauty and propriety, nor with the Western aesthetic of deep perspective and realistic styles. Rather he preferred the flattened or shallow space, decorative application of color, and the fluid contour line, as seen in Japanese prints. Although from a wealthy family who allowed him to live and work in his chosen life-style, Toulouse-Lautrec augmented his income by designing lithographic posters for dance halls and theaters.

Text Link

Toulouse-Lautrec was influenced by the line quality and broad areas of colors of Japanese prints like Katsushika Hokusai's Beneath the Waves off Kanaga (figure 16.28)

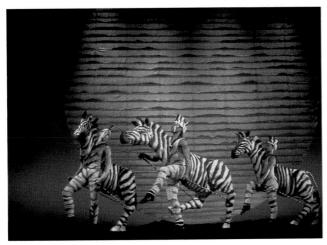

18.11 JULIE TAYMOR, designer and director. A costume in the Lion King. New York City, USA, opened mid 1990s.

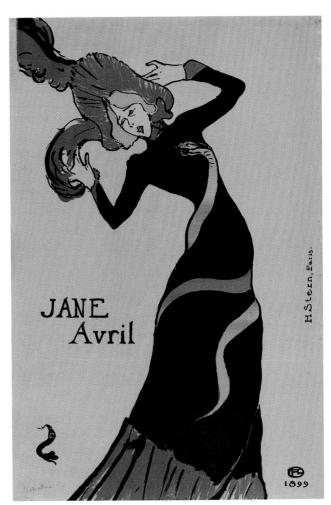

18.12 Henri De Toulouse-Lautrec. *Jane Avril.* Paris, France, 1899, lithographic poster, $22'' \times 14''$. The Museum of Modern Art, New York City, USA. See also the text accompanying figure 1.2.

His work was seen everywhere in the streets, reaching an audience who were barred from attending the Paris galleries and salons. A favorite subject of his was Jane Avril (figure 18.12), a singer and dancer at the famous cabaret Moulin Rouge. This famous poster from 1899 captures the provocative entertainer as she sings her song, inviting the public to come and see more. He caught her in costume and makeup, as if under theater lights, showing off her bright red hair and large plumed hat. With simple fluid shapes filled with bright flat colors, Avril's graceful contour is silhouetted against a flat negative space that, in juxtaposition, becomes equally important in the composition. The curves of her figure are superbly emphasized by the coiling snake. The serpent imagery also suggests that she is a temptress like Eve was to Adam, enticing her audience to come to her sensuous performance.

Toulouse-Lautrec was a master of design, which is quite evident in his revolutionary poster art. Not only did he play with positive and negative elements in his work, a technique he learned from Japanese art, but he

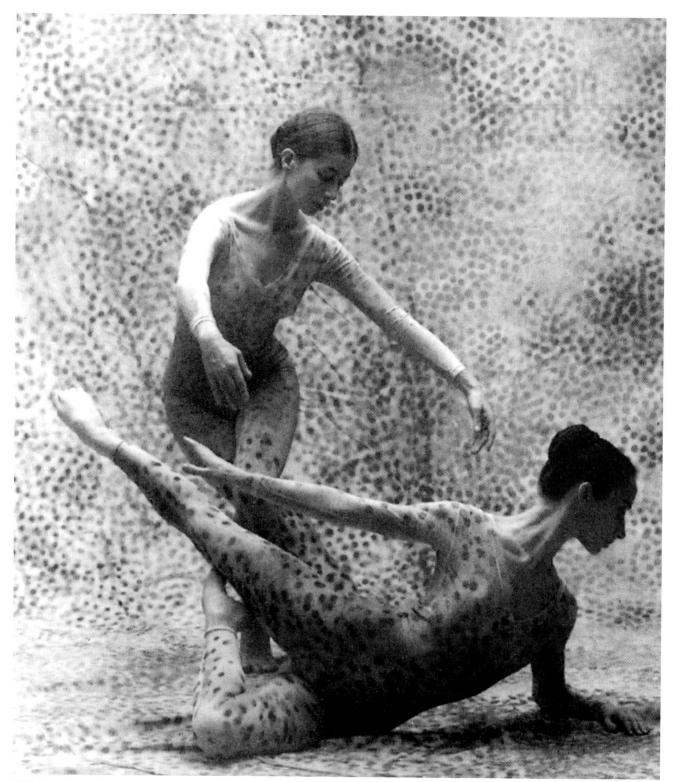

18.13 JOHN CAGE, MERCE CUNNINGHAM, and ROBERT RAUSCHENBERG. Summerspace. Black Mountain, North Carolina, USA, 1958. Music by John Cage, choreography by Merce Cunningham, set and costumes by Robert Rauschenberg.

also incorporated the printed information into the composition using his own font design. The printed matter was not just placed conspicuously so that it could be read easily, but rather placed precisely to work with the other

elements in the work, as we can see in *Jane Avril*. Her name balances the negative space and at the same time visually supports her exaggerated back bend. Toulouse-Lautrec was one of the first to bring fine art to the

graphics world. He was a strong influence on graphic designers and the poster became an exciting new art form, a far cry from the bland printed announcements that were customarily slapped on city walls.

Set design is another area of significant overlap between the visual arts and performing arts. Visual artists have tried their hands at set design, with U.S. artist Robert Rauschenberg one of them. Rauschenberg, choreographer Merce Cunningham, and composer John Cage created an innovative and provocative work entitled *Summerspace* (figure 18.13), commissioned by and performed at Black Mountain College in North Carolina, in 1958. Rauschenberg designed the set and costumes, Cage the music, and Cunningham the movement. Although a collaboration, each component was designed to be performed spontaneously yet independently from one another, with all three parts using techniques of improvisation and chance.

In designing the choreography, Cunningham conceived of space as a continuum, without a focal point for the dancers, as was common in traditional dance. The dance space was handled more like an abstract painting where all points in (pictorial) space are considered equally important in the composition, in lieu of a vanishing point as the center of attention. Cunningham's choreography made all points on stage equally important and interesting to the dancer's movement. In addition to abstract painting, Cunningham is also influenced by Albert Einstein's theory of relativity, which posited that there are no fixed points in space.

Text Link

Jackson Pollock's Lucifer (figure 15.29) is an example of an abstract painting without a single fixed focal point. The overall activity of paintings such as this influences Cunningham's choreography.

Rauschenberg based his set and costume design on Cunningham's choreography, on the dance that had no center point, but moved from all points on the stage. Rauschenberg turned to the French Impressionist **Pointillist** style, and painted the sets and designed the costumes with small painted dots (or points) in several colors. Visually, the dancer's costumes were the same as the set, or vice versa, giving each of these elements in the piece equal importance and interest.

Text Link

Georges Seurat's A Sunday Afternoon on the Island of La Grande Jatte (figure 16.22) is an example of the Pointillist style of painting. Close examination of its surface shows it to be made up of thousands of dots of paint.

In recent years, the performing arts have had a great influence on the visual arts, especially in an area called "performance art." Performance art is live-action art that incorporates mixed media and is presented before an audience. While owing much to theater, performance art is definitely a visual art form. Performance art in the United States dates back to the 1960s and was spearheaded by artist Allan Kaprow's "Happenings." Happenings mixed traditional media with found and junk objects; it involved all the senses along with the visual (touch, sound, taste, smell), and added chance in the artwork's process. In these, Kaprow and other artists moved away from creating an object of permanence and preciousness to creating art that was a passing event of pure experience. Kaprow believed that art, like life itself, should be unstable, transitory, and unclear, a belief that was in opposition to much previous Western thought that positioned an artwork as a pure, transcendent, universal object meant to endure. Kaprow felt that art should be mixed with actual life experience, rather than being a painting or sculpture that interpreted a life experience after the fact. He found the subcategories of sculptor or poet to be irrelevant. Art should be intermeshed with life.

For this new art form, Kaprow coordinated happenings by setting the scene in which improvisation could take place. In his happening entitled *Household*, Kaprow planned carefully and chose a dump area in Ithaca, New York, close to Cornell University. On a day in May at 11:00 A.M., the men participants built a tower of garbage, as the women participants built a nest of twigs and string, suggesting the traditional domain of each gender. From inside the nest the women began screeching at the men. A wrecked car was then brought to the site on which the men spread strawberry jam. The women then left their nest and began licking the jam off the car (figure 18.14), during which time the men proceeded to destroy their nest. The men then returned to the car

18.14 ALIAN KAPROW. *Household*, performance "Happening," commissioned by Cornell University, New York, May 1964. See also the text accompanying figure 2.29.

and began wiping the jam off the car with white bread then eating it. While the men were busy in that activity the women avenged the destruction of their nest by decimating the men's tower. The event continued with violence as the men demolished the car with sledge hammers and then set it on fire. With the final and fierce destruction of the car, the tension between the sexes lessened. In silence together they watched it burn, and then without words they departed from the site.

Indeed a bizarre and surreal enactment, the meaning of *Household* is as ambiguous as a dream. Kaprow would welcome individual interpretation, but offer no stock meaning to the work. *Household* also blurred the distinction between participants and audience; they were not clearly distinguished during the event. Kaprow would however likely agree that the process of the work as it *happened* was the important part of the work, and that its meaning was unclear, unstable, and passing.

Art and Music

The visual arts and music also overlap, but in ways that are different from visual art and theater. We will look in this section at musical instruments designed by artists.

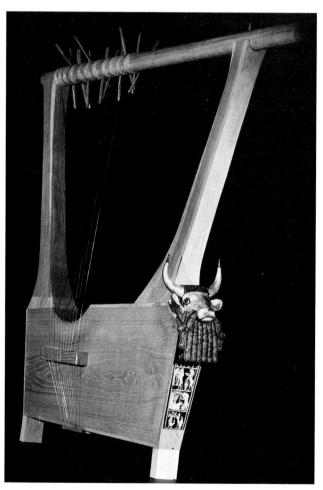

18.15 *Lyre.* Soundbox from tomb of Queen Puabi, Ur, Iraq, c. 2685 BC, wood, gold and shell inlay, lapis lazuli, 5'5" high.

In the ancient city of Ur, exquisite art and artifacts were found in royal tombs. Chariots, sculpture, jewelry, elaborate headdresses, and a musical instrument were found in the tomb of Queen Puabi dated c. 2685 BC. One of the most remarkable pieces uncovered was the beautifully crafted *Lyre* made of wood, lapis lazuli, and gold and shell inlay (figure 18.15). The lyre is a stringed instrument similar to a harp. The instrument's sound box and body are made up of clean rectangles and subtle curves in wood, with its function dictating its form. Decorative sculpture and scenes accent the front of the sound box, yet do not detract from the precise lines of the instrument.

Text Link

For other examples of lavishly furnished tombs for royalty in other cultures, see the section in Chapter 11 on "Furnished Tombs."

The stunning head of a blue-bearded bull is made of gold and lapis lazuli, an imported semi-precious stone. The meaning of this image is unknown, but very likely connected to religious and ritual symbolism. Bearded bulls are a symbol of royalty. The bull's head is remarkably naturalistic in form, but also has highly stylized details such as the outlined eyes and the patterned curls of the beard.

Text Link

Bulls are ancient symbols in art that appeared as far back as 7000 BC at Çatal Hüyük in rooms presumed to be shrines (figure 8.2).

Beneath the bull's head are four scenes made of shell inlaid in bitumen. They may depict a fantastic banquet, or they may illustrate fables, something like Aesop's animal characters did for the Greeks. Characters include a young man who may represent the legendary hero of Gilgamesh, flanked by two human-headed bulls. Animal composite imagery was common in Near Eastern as well as Egyptian art. More whimsical four-legged creatures are depicted standing upright on two feet, performing menial tasks of servants. A dog with a dagger is bringing in a table followed by a lion carrying a platter and a large jar. Below them is a donkey musician playing a lyre like the one it adorns, and finally on the lowest frame there is a gazelle presenting goblets to a humanoid scorpion. The style of the art has echoes of Egyptian formalism, but is less restrained. The figures, although on a ground line, may overlap other images, giving them a

less static feeling and more a sense of movement. Action is suggested not only as we look from frame to frame, but also through the poses of the animals on two feet. It appears that we have a lively celebration going on here, complete with food, drink, and the music of the lyre.

Text Link

The human-headed bulls may be guardian figures like the Lamassu sculpture we saw from Assyria (figure 12.26).

Another form of a musical instrument in which art has been interwoven is the drum, a percussive instrument nearly universal in human cultures. Melanesia is no exception and some of the finest examples of finely crafted drums are found there. Created for male musicians only, there are three types of drums that vary in size: large slit drums, small hand drums, and the water drum. The slit drums are hollowed out tree trunks with a long narrow vertical slit carved into them. They stand upright on the ground and are struck with long poles. The overall form is carved to resemble a stylized animal or human being, and may be as tall as 15 feet. In contrast the smaller hand drum (figure 18.16) is carried in one hand and the lizard skin head is struck with the other. Among the Asmat in Papua New Guinea the hand drum was used in ceremonies for a boy's initiation, to placate ancestor spirits who died because of an enemy raid, and for magical rites. The slender hourglass drums were usually decorated with ancestral and head-hunting symbolism, represented in the heads of the hornbill birds, "ghost-elbows" and stylized hands. The complex symbolism relates to the former head-hunting and cannibalistic tradition of the Asmat.

Text Link

For more information about the culture and wood carvers of the Asmat, see figure 16.7 Bisj Poles.

Dance

When there is a calling drum beat or an inviting melody, human beings are inevitably drawn to the movement of dance. The dance could be a form of spontaneous self-expression or it could be strictly choreographed with precisely prescribed steps. It may be performed as a sacred ritual or for sheer entertainment, or both. The complicated and difficult *Hoop Dance* of the North American Sioux is both a spiritual celebration and a diversion, and is strictly choreographed.

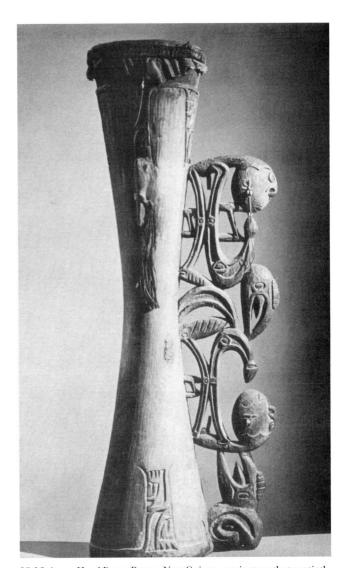

18.16 *Asmat Hand Drum.* Papua, New Guinea, c. nineteenth-twentieth centuries, wood, lizard skin, fiber, beads, 37½" high. Museum of Primitive Art, New York City, USA.

The Hoop Dance (figure 18.17) was part of the annual celebration of the springtime rebirth of nature. Performed with 28 hoops made of wood or reeds, each movement the dancer makes has a spiritual significance. Visual images are created with the complicated manipulation of the hoops with the performer's body, all the while dancing to a rapid rhythm. The images connote the unity of all things in the universe, although they individually grow and change. Some parts of the dance recreate the image of an eagle soaring in flight. The eagle suggests that part of nature (including human beings) is not of this earth, but of the domain of the spiritual world in the heavens. Another configuration represents the early form of life of a caterpillar, which will become in the dance a graceful butterfly. Growth, change, and metamorphosis, all part of nature, are seen in the dance. The rigorous performance is climaxed with the "Hoops of Many Hoops" in which the visual 18.17 KEVEN LOCKE. Performing the *Hoop Dance*. Twentieth century, Sioux culture, USA.

image relates that all things come together; the earth, sun, moon, light, all life, and the spirit of humans are all interconnected. It also symbolizes a hopeful Sioux prophecy for peace among all people. This dance, with its many hoops, is an elaborate variation of older forms of dance that has been developed because of the interest of tourists. Once again, entertainment and ritual mix.

For the Dogon people in Mali, Africa, the dance, costume, and the Kanaga mask are also interconnected (figure 18.18). The dancers perform at public events, usually funerals (similar to the Guro masked dancers discussed earlier in this chapter). The performers are members of a male masked society called the "awa," who, in their dance, preserve their culture's rich mythology. At a funeral, the dancers move vigorously around the deceased, accompanied by chants sung in a secret language that tell the story of how death entered the world through the disobedience of young men.

The dancers are costumed in vegetable fiber skirts that have been dyed red. The color red has the power to drive out the spirit of the dead person from their house. The masking and the color of the costume are believed to catch and manipulate vital forces that could pose potential danger to the community if unleashed. These forces, however, can be controlled and bestowed in a beneficial manner though the performance of the awa society. The Kanaga mask is worn by awa initiates when the spirit of the deceased is believed to leave the body on the third day after the death.

The Kanaga masks are carved by the performers. The mask has several interpretations according to scholars, such as a bird in flight, a mythological crocodile, or a god in the act of pointing toward the sky and earth, or creating it. The Kanaga dance movements and high

leaps express a vital force, through the interaction of mask, costume, and choreography.

Music and Dance Imagery

Let us now take a look at a few examples of artworks that depict music and dance. In each case, the works not only tell us about the musical forms of cultures now long lost, but also something of the social, political, and religious framework into which music fits.

In the Cycladic Islands off of Greece, sculptures of male musicians were found along with plank marble goddess figures buried in graves. The musicians were of two kinds: the harpists who were seated holding their instruments on their laps (figure 18.19); and the woodwind players who were depicted standing. The presence of both fertility goddesses and music makers in the grave suggest that life after death was looked upon as a positive and rewarding step.

Text Link
The Idol from Amorgos (figure 7.3) is
the kind of goddess figure that was found
with the Cycladic sculptures of male
musicians.

Our *Harp Player*, from 2500–1100 BC, is like the female goddess figures in being smoothly carved with clear, well-defined forms. Precise attention was given to the detailing of the hands and fingers, as we can see his thumb plucking the invisible strings. The upper torso is somewhat exaggerated, with elongated arms reaching across

the harp. The figure's face and ears are simply stylized and the head is a bit extended as well, perhaps indicating a cap, as traces of paint were found on the heads of some musician figures. The proportions of the musician figures appear to have be standardized, with fixed ratio of height to width, which may have been a reflection of the mathematical relationship of musical intervals. The *Harp Player* is better viewed from profile, rather than from the front. In this respect the sculpture seems related to Egyptian sculpture, where one viewpoint was also indicated, unlike sculpture in the round, which would have many "correct" views.

Text Link

Like the Harp Player, the Egyptian sculpture Menkaure and His Wife, Queen Khamerernebty (figure 21.1) is best seen from one point of view. Its formality contrasts with the liveliness of the figures in Musicians and Dancers.

18.18 Kanaga Masked Dancers. Dogon culture, Mali, Africa, twentieth century. See also the text accompanying figure 2.26.

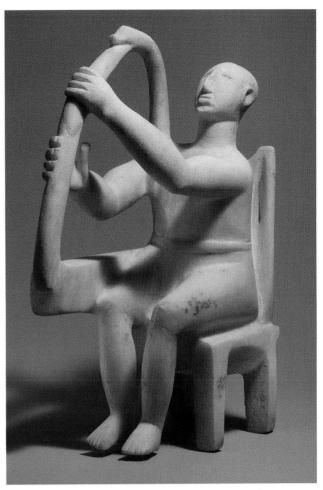

18.19 Harp Player. Cycladic culture, c. 2500–1100 BC, marble, approximately 14" \times 3". Metropolitan Museum of Art, New York City, LICA

In another grave, this time in Africa's Egypt during the Eighteenth Dynasty, we see a wall painting of Musicians and Dancers (figure 18.20), in the tomb of Nebamun, dated c. 1400 BC. It was traditional for living relatives to celebrate rituals and the anniversaries of their dead in their tombs, some of which were quite large and elaborate, consisting of many rooms. The many tomb frescoes depict a wide range of subject matter. This one shows ancient forms of entertainment that were enjoyed by the living as well as the dead. In Musicians and Dancers we see four finely dressed women seated very casually, with one playing an oboe-like instrument while the others clap along in rhythm. Note the cone shape on top of their heads which is made of perfumed animal tallow; this would melt and run down their bodies, covering them with a fragrant grease. To the right are barely clad dancers, and also stacked wine jars.

The painting style of this fresco is as relaxed as the seated figures that appear in it, which contrasts with depictions of high-ranking Egyptians. The ladies' hair is loose, the soles of their feet are shown, and two face the viewer head-on rather than in the typical Egyptian profile. The dancers are depicted smaller, indicating

18.21 Judith Leyster. Boy Playing a Flute. Dutch, 1630–35, oil, $28\frac{1}{2}$ " \times 24\%". National Museum, Stockholm, Sweden.

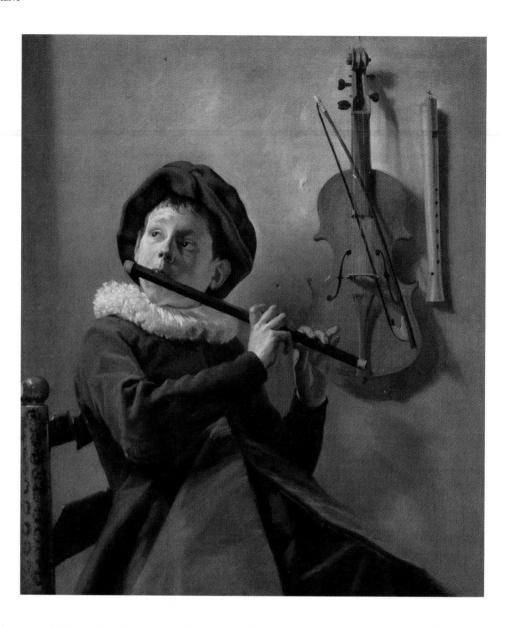

their lesser rank in the Egyptian social hierarchy. They are not rigid figures, but in lively movement, another unusual quality for standard Egyptian art. The whole scene gives the feeling of levity and pleasure meant for both the spirit of the deceased and for the living.

Text Link
The Fowling Scene (figure 11.5) shows how highranking Egyptians were depicted in painting.

18.20 Musicians and Dancers. From the tomb of Nebamun, Thebes, Egypt, c. 1400 BC, wall fresco, 12" × 27".

Centuries later in seventeenth-century Holland, Judith Leyster painted a young boy engrossed in playing his flute (figure 18.21). Leyster was a prolific artist whose work became known at the time, a rare accomplishment for a woman in a predominantly man's art world. *Boy Playing a Flute,* from 1630–1635, is considered her masterpiece. In the lyric painting she captures the pride and the enthusiasm of the young musician as he glances at his audience, likely looking for their approval. The soft tones of the painting suggests the soft tones of the flute. In the shallow space, the boy is balanced compositionally with the instruments hanging on the wall.

Holland at the time was predominately middle-class and Protestant, and so their music was not written for grand productions for the nobility, nor for elaborate rituals for the Catholic church. Rather, music was mostly performed by ordinary people and enjoyed in their middle-class homes. Most surviving music notation from this time is in handwritten copies for home use. There are even musical scores for multi-part singing that are laid out to be easily read and performed by family and friends sitting around a square supper table. Each person would sing the part that conveniently faced their direction. Leyster's painting reflects this middle-class self-reliant approach to music. The boy is not a professional, nor a person gifted with special talent, nor someone ordained into a special role. He is an ordinary child, playing for his own pleasure and that of his family, in a home graced with several musical instruments.

THE TECHNOLOGY REVOLUTION IN ENTERTAINMENT

Technology has had an enormous impact on entertainment. In just a little more than one hundred years we have seen the development of film, television, and digital imaging media. Despite their short history, these new media of entertainment already are mainstays of popular culture. Video and film are also art media, and many artists have plunged into exploring the many possibilities they inherently contain. In this section, however, we will focus on examples aimed at a broad audience, that fit more closely into the category of entertainment.

Text Link

Nam June Paik's multi-imaged Megatron (figure 19.34) is a good example of art that refers to entertainment technologies.

Film and Television

The first of the technological revolutions in entertainment is the motion picture, born of the marriage of

photography and electricity. One of the first to experiment with the notion of giving motion to still photos was Eadweard Muybridge. He placed several sequential stills taken of a specific action in a wheel called a "zoopraxiscope," which, when spun, gave movement to the images.

Text Link

An example of Eadweard Muybridge's sequential images, which are early experiments to capture motion with photography, is Handspring, with pigeon interfering, June 26, 1885. (figure 15.17).

George Eastman invented the celluloid film that allowed the images to be photographed on one long negative, so that the individual images were strung together. In 1894 Thomas Edison produced the first "movie" entitled "Fred Ott's Sneeze," while soon after the first working projector was built in France in 1895. At last the motion picture, a series of still images, could be projected at 24 frames per second, giving full action to the scenes. The very first film sequences did not have much of a plot—like "Fred Ott's sneeze"—as just seeing something come alive on a screen was fascinating enough. But quickly films became staged dramas with experienced actors starring in them. Very soon, however, film became distinct from theater. The movable camera removed all boundaries from the staged space, and filming locations varied from elaborate sound studios to on-site shoots anywhere in the world. Sound was added to the action in 1927, which made or broke many actors'—as well as directors'—careers.

There are many films that are considered classics, even works of art, in addition to their entertainment value. It is beyond the scope of this book to cover film history. However, we will look at one now, *Gone with the*

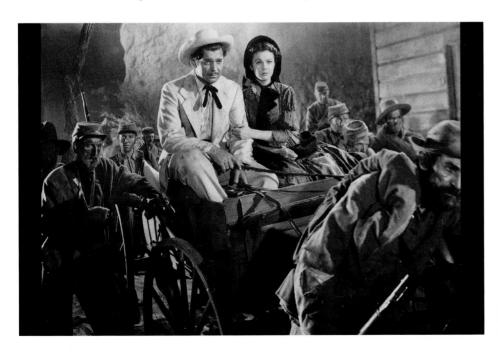

18.22 Gone with the Wind. MGM film, 1939, starring Clark Gable and Vivian Leigh. See also the text accompanying figure 21.23.

Wind (figure 18.22). This famous film is an excellent example of the type of entertainment that came out of the MGM studios during the 1930s and 1940s. It is a glossy and expensive production, romantic and melodramatic, that essentially promotes conventional values. The film is replete with lush musical score, and symphonic accompaniment. This epic story of the old South before and during the Civil War dealt with love and family conflict along with the hardships and horrors of war. Big screen color played an important part in the magnificence of this motion picture, not only in depicting the grandeur and glory of the old South, but also in the mood of the film. The color red bombards the senses in the picture, underscoring the fiery spirit and burning desires of Scarlett, and also the city of Richmond and Southern life in general going up in torrid flames. Selznick soaked the screen in red at precise and integral passages that emphasized the heat of the fire as well as the romance, the southern soil as well as the blood of its soldiers. The filmic use of color fits well with the personality of the main character, Scarlett. Gone with the Wind continues to be popular, as it has been recently restored and re-released.

Text Link

For more on the recently released version of Gone with the Wind, see figure 21.23, and the controversy it sparked, see the section on "Restoration" in Chapter 21.

Another medium had so great an impact on the world that it would change it forever. Television in essence "shrank" the world as human beings could witness events from far-off places on the small screen right in their living rooms. There was not a lot of demand for television at its beginning. The first broadcast in the United States was at the World's Fair in 1939, but television did not become broadly popular until the 1950s. Television's legacy began with radio, and most of the early types of television shows evolved from radio programs, such as the quiz show, talk show, travelogue, and the "sitcom" or situation comedy. Eventually television would rob radio of a great part of its audience. Television entertainment expanded to investigative reporting, political coverage, and world events. Educational programs were also developed, as well as specialty programming. Music videos are a recent popular phenomenon, offering fans the opportunity to watch as well as listen to music. With satellite and cable hook-up, so much is available now that there is an overabundance of choice.

Nevertheless no matter how many choices are offered in TV programming, the sitcom is one of the most popular of all, and the granddaddy (or better, "grandmama") of them all was *I Love Lucy* (figure 18.23). Families and friends across the United States who had TV sets gathered every Monday night to watch the antics of Lucy, Ricky, Fred, and Ethel. Performed and taped before a live audience, this sitcom was number one among all the programming available at the time. In fact, more people watched the episode in which little Ricky was

18.23 *I Love Lucy*. Television video, situation comedy (sitcom) c. 1950–60s. CBS Entertainment, A Division of CBS, Inc. See also the text accompanying figure 21.21.

born than tuned in to the inauguration of President Dwight D. Eisenhower, which aired the same night in 1953. While the scripts were undoubtedly effective, much of the humor was communicated through facial expression, gesture, and body language. Notice how the exaggerated facial expressions and tilted heads create the idea of a carefree outing. Still in syndication, *I Love Lucy* continues to be seen on TV and remains a popular favorite. In essence, it has become a video icon of American family humor.

Animation and Digital Imaging

Cartoons are another popular entertainment form. They have a long history in drawing and printmaking, where they entertain or promote political causes. They appear prominently in newspapers. More recently, cartoons have been made both for film and television. We will briefly discuss three methods for animating cartoon imagery. All forms of animation are labor-intensive, requiring the talents of a large number of artists working within a hierarchy, in which only a few designers at the top determine the creative content and coordinate the efforts of all subordinates.

The earliest form of animation grew out of flip books, in which a series of drawn images seem to move as book pages are rapidly flipped. Early animation features gained a wide following beginning in the 1930s. They require literally thousands of drawings to create the illusion of movement; as an indication, approximately 14,000 drawings on average are required for a ten-minute animation sequence. The animated images are drawn on transparent sheets, so that the foreground action figures, which move many times per second, can be separated from the background scenes that may remain constant for a while. The individual foreground scenes are then sandwiched with their appropriate background and each shot as a single frame of film. Disney and Warner Brothers were two pioneers in the industry, producing a number of animated features, but other studios and independent producers now exist.

Claymation is another relatively early form of animation, which combines sculpture with film technology. Clay figures are sculpted and then made to make tiny movements, each of which is captured in a single film frame. *Gumby* was an early example of claymation, while *A Close Shave* (figure 18.24), featuring Wallace and Gromit, is a more recent production from the 1990s. *A Close Shave* is remarkable for the quality of movement, its complex and charming character development, and, visually, for its rich colors, intricate patterns and textures, and overall detail. The fact that it is all clay in motion adds a dimension of amazement and incredulity to watching the cartoon.

Computer animation is a new form that has developed as a result of computer technology, which allows

18.24 NICK PARK. Wallace and Gromit, A Close Shave. Claymation film, 1995. BBC Video, UK.

images to be converted to digital information. With computer animation, characters can be plotted as a series of points and vectors and made to move through mathematical computation. A Toy Story, released by Disney in 1995, was the first full-length computergenerated film. The visual qualities of computergenerated animation are different from claymation and traditional animation, with a greater uniformity of line quality but a loss of plasticity.

SPORTS AND SPORTS ARENAS

In the final section of this chapter, we will look at various recreational sites and sporting activities. We will see, however, that our sport examples have political or religious implications, and were seen as more than simply a game. This attitude exists not only in the past or in distant cultures. Even today, for example, sports commentators often cast professional baseball in terms of personalities and human drama, rather than simply describing the play-by-play.

Art and architecture give visual form to sport activity, which helps to conceptualize the meaning of these activities beyond simply leisure or game. Art leaves a record of images, while architecture provides the framework in the form of place or site.

Sport Sites

One of the most famous works in recreational architecture is the *Colosseum*, or the Flavian Amphitheater (figure 18.25). The Colosseum was a sports arena in Rome that also served a political agenda. It was built in 70–82 by the emperors Vespasian, Titus, and Domitian of the Flavian dynasty, all who succeeded the infamous tyrant Nero, the last Juno-Claudian emperor. Their motivation was to return to the people what Nero had taken away, so the *Colosseum* was built on what had been Nero's artificial

18.25 *Colosseum*. Rome, AD 70–82 aerial view. See also figure 21.1.

lake in his private park, where a colossal statue of the emperor stood. (Hence the name *Colosseum* was given to the structure built next to the statue. The statue was made over to represent Apollo after Nero's death.) With a stone foundation and concrete core walls covered with rich veneers of marble, tile, plaster, and bronze, the *Colosseum* was a feast for the eyes, which we can see reconstructed in the drawing in figure 18.26. It was built to enclose a huge space and house thousands of spectators in a brilliant environment. This structure, which evolved from the Greek theater (the amphitheater is two theaters joined together) would become the format of the sports arena that would continue to be built throughout the ages into contemporary time.

The stadium covers six acres and seated 50,000 spectators, with standing room for thousands more. A complex design of ramps, arcades, barrel and groin vaults, halls, and passageways efficiently managed the flow of human traffic. The spectators were given numbered tickets to guide them to their arcade and then easily to their seats. Admission to the events were always free to all no matter what class; however, the seating was reserved by rank. The crowds were protected from the hot sun by a huge cloth canopy that was secured to 240 timber poles, and was maneuvered by a special detachment of the navy. The center area originally had a wooden floor that was covered with sand for chariot races, hunting sports, and gladiatorial games, or filled with water to enact

18.26 *Colosseum*. Restored Interpretation, 1989.

mock sea battles in which up to 3,000 people participated. Later Domitian added complex underground passages, rooms, and elevators, so that animals, scenery, and prisoners made dramatic entrances to the spectacles. Those passages are visible as the deep trenches at the center of figure 18.25.

As outstanding as the interior was, the exterior equaled it. The 160-foot-high outer wall has a unique as well as beautiful façade. The building is encircled by four horizontal bands, with arched openings in the lower three. All arches are covered by lintels and flanked by Greek Classical columns, starting with the Doric on the first level, Ionic on the second, and Corinthian on the third. The uppermost horizontal band has no arches, but only a grid of columns and lintels. This harmonious arrangement of architectural elements not only unified the structure aesthetically, but also monumentally celebrated the art of Greco-Roman architecture.

Text Link
See Chapter 3, figure 3.5, for a diagram of Greek
columns, figure 3.2 for a diagram on post-and-lintel
architecture, and figure 3.9 for arch construction.

After more than ten years of construction, Titus inaugurated the fabulous stadium with incredible extravagant celebrations that lasted for months. The *Colosseum* was dedicated to blood sports. It is estimated that 5,000 animals were put to death, not to mention the number of humans who perished in the gruesome games. Emperors would continue to competitively sponsor the games for four centuries, with the last production given in AD 523.

On the North American continent, the Mayan culture developed a sport that was a form of ritualistic entertainment. A ball game of endurance and skill was played in ball courts specially designed for the sport. One of the finest and largest of these ball courts is located in Chichén Itzá, Mexico (figure 18.27), originating in the eleventh to thirteenth centuries. The great court is about the size of a U.S. football field, measuring 272' long and 99' feet wide, with walls 27' high. It is an "I"-shaped court, with two short parallel areas at each end of a long alley. Stone rings were mounted in the wall eight feet above the ground. The game was quite long and rigorous, lasting until one of the teams scored by striking the stone rings in the court's walls. To make the game even more challenging, the players could not touch the

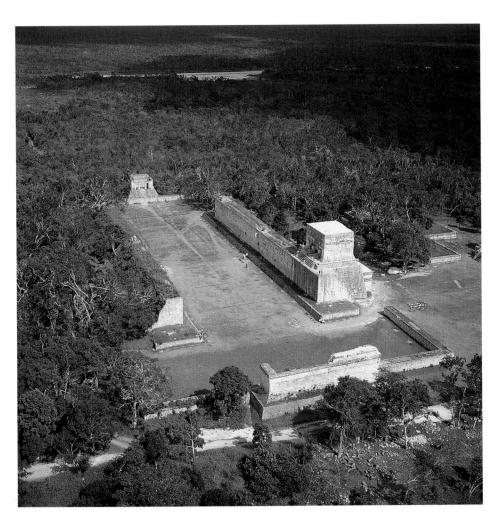

18.27 *The Great Ball Court.* Chichén Itzá, Mexico, Mayan-Toltec cultures, eleventh–thirteenth centuries, stone, 567' × 228', "I" shaped.

heavy ball with their hands. Much like a contemporary soccer game, the players had to use their heads and bodies to project the hard ball, which took much strength and skill. The Mayan people saw the ball game as a metaphor for the epic journey through the Underworld taken by the hero twins, the Sun and the Moon, with an underlying meaning about the conflict between good and evil, and cycles of heavenly bodies. At the end of the game, one player (or perhaps one team) became a human sacrifice to the gods of the cosmos.

The ball court features the Temple of the Jaguar on the long east wall, and another temple at the far north end. Phenomenal decorative reliefs cover the walls in this court. One of the most astounding is of two teams of players in all their regalia facing one another. The first player on the right team has been decapitated, his body still kneeling in front of a large ball that is marked with a laughing skull. From the neck of the victim, serpent-like spurts of blood project profusely. Similar scenes are depicted in six other reliefs, which express the gravity of the game. The acoustics of the court are also phenomenal. A person standing on one temple at the far end of the court can hear a conversation being spoken on the temple at the other end.

Ballcourts existed at most major urban centers, both Mayan and those of other Mesoamerican peoples, with some variations in the designs. The game persisted for centuries and was likely played in remote areas even after the Spanish conquest. Today many of the ball courts still stand.

Sport Imagery

Our first image shows some of the very ball players who would have competed on Mayan ball courts. The vase painting *Ball Players* (figure 18.28) shows two players,

covered with elaborate dress and heavy padding. The padding is especially visible on the chest and knees. The game was played with a large hard rubber ball, making the padding necessary as protection from blows. Patterns and insignia cover their clothing, and they are adorned with earrings and a large animal headdress. In usual Mayan fashion, the figures on this vase are easily read, combining dark silhouette forms, strong outlines, and patterned areas. The figures, while stylized, seem strong and large, yet bend and move with grace and suppleness. Their powerful forms and impressive regalia show that ball players enjoyed considerable status in Mayan society.

Also from Mexico comes the *Acrobat* (figure 18.29), from the ancient village of Tlatilco located outside of Mexico City. In 1940, archeologist and artist Miguel Covarrubias uncovered a fairly large village with a residential complex and two hundred graves sites, all under a working brickyard. The graves were complete with burial offerings which included figurines of females, ballplayers, musicians, dancers, and acrobats. The female figures are likely fertility charms, and many were found in the graves. Bowls and long-necked jars were also among the items excavated. Clearly these artifacts indicate that these ancient peoples prepared for an afterlife full of entertainment.

The Tlatilco artists were accomplished sculptors. Looking at our *Acrobat*, from 1500–500 BC, we see a somewhat naturalistic face framed with a stylized incised hair treatment. The smooth, contorted and truncated body has detailed extremities as seen in the articulation of the feet and toes. The head is disproportionately large, with a concentrating, straining expression. The design and balance of the piece are seen in the bent arms and legs, which create diagonals that frame the

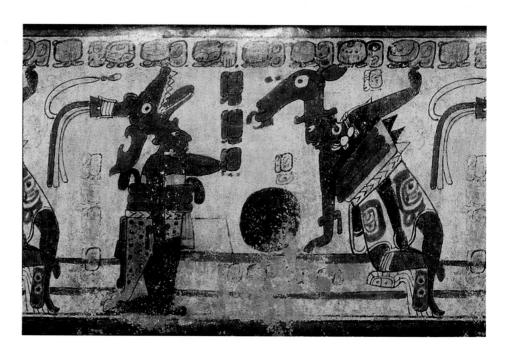

18.28 *Ball Players*. Vase painting, Mayan Culture, Mexico, eleventh–thirteenth centuries.

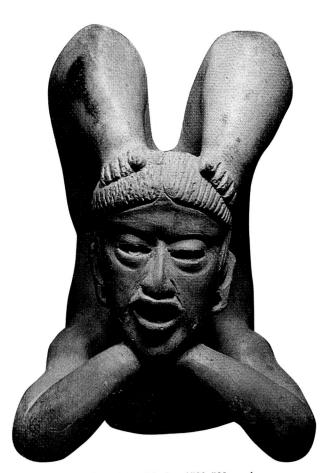

18.29 Acrobat. Tlatilco culture, Mexico, 1500-500 BC, clay.

face, and the strong horizontal curves at the eyes at mouth. The incised lines defining the toes parallel the lines of the hair.

From the Minoan culture on the island of Crete comes the wall painting *Bull Jumping* or *Toreador Fresco* (figure 18.30), dating from c. 1550–1450 BC. A dark-skinned man is doing a handstand on the back of a prancing bull, caught in mid-air as he vaults over the animal. To the right of the bull is a light-skinned women, who seems to be preparing to make her vault. Indicating gender with lighter or darker skin tones was common throughout the ancient Mediterranean civilizations. On the left side is another figure holding the bull by the horns. The fresco is framed in decorative vertical and horizontal registers, one of which contains a pattern of overlapping oval shapes. The fresco is part of a group of murals that have bulls as the subject matter, located in a room in the east wing of the palace at Knossos.

This fresco may refer to an early Minoan legend dealing with the "minotaur," a half-man and half-bull beast, that was born from the union of King Minos' wife and a sacred white bull. The Athenian hero Theseus killed the minotaur, releasing Athenians from Minoan bondage. There were also early Greek legends telling of the sacrifice of young men and women to the minotaur. Besides associations with the mythological creature, the bull also symbolizes fertility and strength. Perhaps the dance of the bull jumpers alluded to the impact of divine forces on human lives, and how it is faced head on; the

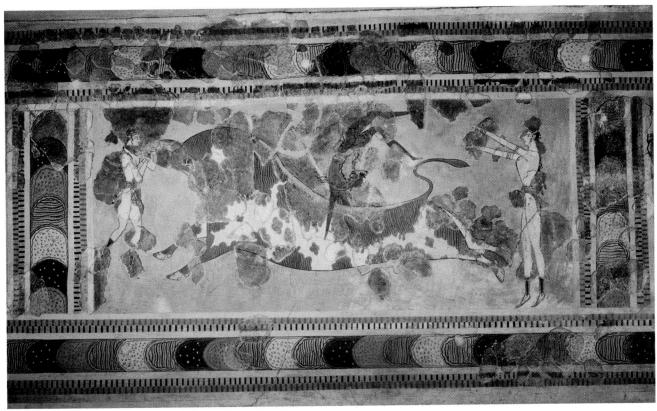

18.30 Bull Jumping. Palace complex at Knossos, Crete, c. 1550-1450 BC, wall painting, 241/2" high.

contestant's demonstrate their courage as they challenge the fury of the bull with every vault.

The style of Minoan art is distinctive. The overall forms are flowing, undulating, and floating, like the ocean that surrounds their islands. As we look at our fresco, we can see that the powerful bull, a beast of mass and strength, is expressed in graceful curves. He appears almost weightless as he leaps forward. The figures are also weightless, which suggests effortless movement, much like being suspended in water. The entire scene also seems effortless and fearless, like a skilled acrobatic act performed at a circus.

In our last example we see an image of horseback riding, an activity that has been sport to some, work to others. Here it is presented as the privilege of the upper classes. In *Eight Riders in Spring* (figure 18.31), the artist

Chao Yen, son-in-law to the Chinese emperor, captured the pleasure of noblemen on an equestrian outing, accompanying in all likelihood their emperor, the figure in the center with the raised crop. The scene takes place in a simple setting which is divided by a balustrade, indicating the palace courtyard. The riders stand out in brightly colored garb in the foreground below.

The artist's style is a crisp and pristine rendering in a well-balanced composition, which is very much the heritage of the Tang painting tradition of the tenth century. The background of the landscaping and the courtyard enclosure in the upper half are masterfully counterbalanced by the eight mounted figures in the lower half of the composition. The range of the intense colors worn by the figures is also counterbalanced by the muted tones seen in the ornamental rock, the trees, and in the

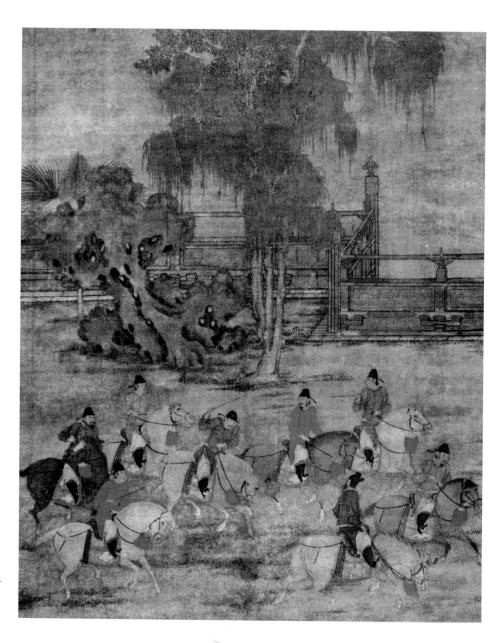

18.31 Chao Yen. Eight Riders in Spring. China, tenth century, hanging scroll, ink and colors on silk, 40%" wide. Palace Museum Collection, Taiching.

sky and ground. All is in harmony in accordance with Yin and Yang philosophy, which was rooted in Chinese thought. This rich scroll of silk conveys a pleasant sojourn of human beings enjoying (and in a sense dominating) a moment in and with nature.

Text Link

Review the section "Class Activities and Lifestyles" in Chapter 16, for more images of upper-class leisure, such as Jean-Honoré Fragonard's The Swing (figure 16.18).

SYNOPSIS

As we review the art of entertainment we certainly see a large range of diversified genres. One of the earliest established architectural forms in the West was the theater, already well-developed at the time that the sophisticated and elaborate *Theater at Epidaurus* was built in c. 350 BC. It featured excellent acoustics, while seating thousands of spectators. This prototype would become the point of departure for the Roman amphitheater, which in turn, would influence today's modern sports area. In Japan, the type of performance dictated a the theater design. In the print, *Interior of a Kabuki Theater*, we see how the stage design allows the spaces of the audience and the actors to mix for a kabuki production.

Other "houses" for the arts include the art museum and the opera house. Frank Lloyd Wright designed the unique Solomon R. Guggenheim Museum with flowing form intended to facilitate art viewing. The Opera in Paris, designed by Charles Garnier, is an opulent "flamboyant baroque" structure for the ballet, an art form previously performed only for royalty. A later twentieth-century Opera House in Sidney, Australia, took reinforced concrete to its limits. Architect Joern Utzon designed the structure in an assembly of flowing forms so finely arranged that it appears more of a sculpture than a building.

The visual arts, theater, music, recreation, and education are combined in some locations. In Rome we saw the luxurious *Baths of Caracalla*, which combined personal hygiene and fitness with entertainment and the arts. Landscape architects have created beautiful environments for the arts, recreation, and education, such as *Central Park*, located in the heart of New York City, and the Hakone *Open-Air Museum*, perched high in a mountain range in Japan.

Artists contribute to the performing arts in several ways. For example, the people of the Ivory Coast in Africa wear a finely carved *Gu Mask* in full masquerade when entertaining at public events. Set designs are at times the work of visual artists. In the performance piece of *Summerspace*, Robert Rauchenberg collaborated with choreographer Merce Cunningham and composer John Cage; his set design reflected the French Impressionist

pointillist style. Henri de Toulouse-Lautrec used lithography to produce his colorful posters advertising the cabaret and theater district in Paris. In his print of Jane Avril, we see the shapely performer enticing viewers to come to the show. In Japan, puppetry was raised to an art form in their "doll dramas" called Bunraku. The fine carving of the dolls and their masterful manipulation by the puppeteer, who is in full view of the audience, have become a Japanese national treasure. Influenced by Bunraku and Indonesian masked dancers, director-designer Julie Taymor has brought a wonderful new genre of puppetry to the Broadway theater in New York. She blended her creative mask designs, puppets, and actors together into individual characters for Disney's Lion King.

Art and theater combined to create a new art medium in the 1960s when Allan Kaprow invented the "Happening." In a happening performance, the audience members are the participants. They might use all their senses, and the element of chance is incorporated in the activity. In *Household*, Kaprow set the scene of the event in a junkyard, leaving much room for improvisation. The results were strange and unclear, and left to individual interpretation.

Artists have designed or decorated musical instruments, such as the sound box of a *Lyre* from the tomb of Queen Puabi, found in Ur, Iraq. On the front of the *Lyre* is a stunning blue-bearded head of a bull made of gold and lapis lazuli. Beneath it is a story depicted in shell inlay. The wooden drum is an instrument artists often have decorated, as seen in the *Asmat Hand Drum* of Papua New Guinea, Melanesia. Dancers have used visual imagery in their movements as part of their choreography. The Sioux *Hoop Dance* uses precise and vigorous dance steps to create specific imagery such as an eagle. The *Kanaga Masked Dancers* of the Dogon people of Mali also dance vigorously, using masks they individually have carved.

Artists have made images of musicians through the ages. Along with the early Cycladic female fertility figures found in the tombs on Crete, male *Harp Players* have also been found carved in the same style. In Egypt *Musicians and Dancers* decorate the tomb of Nebamun, where living relatives celebrated the dead. Much later in Europe Dutch painter Judith Leyster captured the proud performance of a *Boy Playing a Flute*.

Entertainment in the twentieth century has felt the impact of new technologies. The development of film dates from the late nineteenth century, but has become an enormous cultural influence in our era. One of the classics of Hollywood's productions is MGM's *Gone with the Wind*, directed by David O. Selznick. This film about the old South during the U.S. Civil War is still a popular favorite. Another technology that affected both art and the entire world was television. Taking more the format of radio than cinema, television programming includes the talk show and the "sitcom." *I Love Lucy* set the standard for many family comedies to come. Animation is

another popular form of entertainment that relies heavily on the visual arts. We discussed hand-drawn animation, claymation, and computer animation. A Close Shave, by artist Nick Park, is an example of claymation with detailed visual effects and charming character development.

The visual arts have provided a framework for understanding the ritual or political meanings behind sports. We saw the *Colosseum* in Rome, a lavish sports structure built for political purposes. In Central America, elaborate ball courts were constructed for ritual ball games, as seen at Chichén Itzá, Mexico. With the Mayan vase painting, *Ball Players*, we can see the men who played on those Central American ball courts. The *Bull Jumping* fresco in the palace complex at Knossos, Crete, shows us an ancient game that likely had ritual meaning. Ceramic figurines of *Acrobats* were found in the graves of the ancient village of Tlatilco near Mexico City. In China an elegant hanging scroll depicting *Eight Riders in Spring* was painted by Chao Yen, showing nobility on a outing with the emperor.

FOOD FOR THOUGHT

As we observed the many forms of art and architecture that pertain to entertainment, we saw that some of those forms were traditional while others were unconventional and controversial. Some questions come to mind concerning the unconventional.

- Have the new technologies such as television and the computer changed the practice of the artist for better or worse?
- Has Western art come full circle . . . has the art begun to leave the museum and opera house, and intermingle more with life, as it does in some non-Western cultures?
- Should art and life become more fluid, as U. S. artist Allan Kaprow believed?

Some performance art includes actual sexual intimacy and contains acts of violence. For example, in one famous performance, the artist Chris Burden had himself shot as part of the artwork. We have also seen Jeff Koons' work in Chapter 7, Reproduction, in which a performance included sexual acts.

• How far should "life" be a part of art?

Chapter 19

Nature, Knowledge, and Technology

INTRODUCTION

Artists make art that imitates, admires, and judges the world around us. That world is composed first of nature, the animals, and land. Later, humans have added the things we have constructed: our knowledge systems, our technology, our cities. For this chapter, the basic questions are:

What do we consider ideal in nature?

How do animals in art reflect desirable or despicable qualities in humans?

What do we know about the world around us through art?

How does art advance knowledge?

When does knowledge advance the well-being of humans and the world, and when is it oppressive, manipulative, or too unwieldy to be helpful?

What are our attitudes regarding the things humans have constructed in the world?

How is technology helping us, and how is it hurting us?

Under Nature, we will look at a wide range of images of animals, a very complex topic indeed. Humans admire, hunt, distrust, and fear animals. We love them deeply, scapegoat them, sacrifice them, denigrate them, and some eat them. They are part of industry, as we breed some and extinguish others. We identify with animals, and project our highest aspirations and deepest fears onto them. Likewise, landscape imagery, both the wild and the cultivated, is a site where humans project their own ideals.

Knowledge has been greatly aided by artworks, ranging from educational illustrations to the inquiry of self-knowing. We will look at some examples that exist in this wide range.

Technology is always a basis of art production. Consider ceramics, architecture, or film. A great amount of technology is required to produce objects in these media. Ancient buildings (and modern) are amazing feats of technology. Even the invention and manufacture of painting materials is technology-laden. And now we have computer art. However, we have limited ourselves to art that comments on technology, reflecting our mixed attitudes and relation to it. On one hand, we have proliferated technology wildly, and appreciate it for the advantages and comforts it gives. On the other hand, in recent times, we have begun to hate it for its polluting side effects, for the global political entanglements our dependence upon it may cause, and for the uneasiness about who exactly is in control, humans or the machine.

Text Link

The construction of Chartres Cathedral (figure 10.25) was an amazing and innovative technological feat, as were many other ancient structures.

We will start the chapter with NATURE and our relation to it through art.

NATURE

Our natural world consists of the earth and its flora and fauna. All figure prominently in art.

Animals

Animals appear in art in every culture, in forms that are both real and imagined. As far as we know, animals were pictured in the first drawings by humans. Animals figure in the creation stories, in many myths and important religious narratives, such as "Noah and the Ark" and in the *Ramayama*. Animals have been admired for their own qualities, and have been observed and recorded in great detail in art. Animals have also been used as symbols for humans, and human nature, and as vehicles for expressing ideas about the world at large. And, finally, as if animals like aardvarks, armadillos, and narwhals were not fantastic enough, humans have invented bizarre creatures pieced together with parts of other living beings.

garden, surrounded by an abundance of decorative flowers and plants. The colors are rich and brilliant. The details are delightful, all distributed in a flat pattern that fills the space from top to bottom with carefully rendered colorful flowers. The unicorn has a lively and soulful expression on its face. It is surrounded by a fence, wearing a jeweled collar, and chained to a pomegranate tree.

The unicorn represented at least two different sets of meanings in these tapestries. One is that of Jesus. The unicorn cleanses the water of life for all of creation. He is hunted by men and brutally killed. In the last scene, shown here, he is the indestructible, eternally Risen Christ. However, there is another set of meanings, that is, that the images represent the course of true love, with the unicorn as the chivalrous male and the virgin the object of his desire, and the unicorn in this set of tapestries has had to endure terrible ordeals to win his beloved. The collar represents a chain of love, mentioned in medieval allegories as a sign that a gentleman submits to his lady's will. The pomegranates above the unicorn drip their red juice onto its coat; the pomegranate is both a symbol of Christ's resurrection and also of human fertility.

All kinds of animals, real and imagined, had symbolic meanings during the Middle Ages, such as the dog representing fidelity, the rabbit fertility, and pheasants jealousy. Many had dual meanings, as we saw with the unicorn, and those dual meanings sometimes were even contradictory of each other. The lion, for example, was believed to be the guardian of the faithful, but it could also be the source of evil and danger, a creature that could tear and devour the soul. The many layers of meaning associated with one animal was a way to acknowledge the complexity of life in Medieval times.

The Shaman's Amulet, dated c. 1820-1850 (figure 19.3), is an example where the combinations of animal forms is a power source. An amulet is a small ornament that is believed to protect the wearer, or to give the wearer power. This amulet was used by priest-healers among the peoples of the Northwest Coast of North America. A shaman, a person having supernatural powers, was believed to be a bridge among the human, animal, and spirit worlds. The combination of animal and human forms in the amulet was both symbolic and functional; they were an outward sign of the shaman's power, and also extended his power. The most prominent animal is the sea serpent, whose head is to the right, swallowing a human. This indicated that the shaman could take on the forms of certain animals, and operate both in the animal and human realm. Other animals include a bear, for its strength, and a bird, for its ability to fly.

The design of the amulet is marvelous, as there are many details of animal forms to hold one's interest. All these details are united and contained within the smooth arching outline of the amulet. To emphasize that curved outline, many of the internal forms, such as folded arms, lines of feathers, and the serpent's mouth, echo the amulet's outer shape. The internal details are heightened by the dark patina, which makes the details stand out in a more pronounced way and adds to the volumetric quality of the work. The shape and size of the amulet enabled it to fit easily in the hand.

Another example of fantastic creatures comes from Thailand, a country that is abundant with plant and animal life. The forests and jungles are thick and lush. The monsoon rains fall in deluges and the humidity is heavy during the rainy season. Plants, birds, and beasts abound in traditional Thai art. Many of the powerful ones are composite beasts, but others are snakes and birds that have been associated with forces in nature, in this case, water and the sun, respectively. Most images have more than one meaning. Monkeys, for example, are common wild animals in Thailand, and they are metaphors for humans, who aspire to be gods. They figure in many Hindu and Buddhist tales, where they indulge in behavior and emotions unfit for humans or gods, such as lust and drunkenness. Monkeys can present the realistic side of human nature in contrast to the idealized.

Mask of Hanuman (figure 19.4) is a headpiece representing Hanuman, the white monkey-hero and loyal follower of Rama, who is an incarnation of the Hindu God, Vishnu, in the story, the Ramakien (called the Ramayama in India). This mask was worn by performers enacting the part of Hanuman in dances. Hanuman was a fabulous creature, a divine monkey with white fur, jeweled teeth, and a white crest of hair atop his head that shone like diamonds. His heroic exploits were many, including helping Rama rescue his wife from a demon, and bringing a mountain of medicinal plants to cure the wounded in battle. The Mask of Hanuman is equally fabulous. The entire helmet mask is covered with mother-of-pearl, with its subtle colors and gleaming iridescence. Red, black, and green dramatically outline his facial features. His

19.3 Shaman's Amulet. Tlingit, Alaska/British Columbia, c. 1820–1850. Sperm whale tooth, 6.5" long. Indiana University Art Museum, Bloomington, Indiana. Raymond and Laura Wielgus Collection (RW 60–197).

19.4 Mask of Hanuman. Thailand. Mother-of-pearl, gilt, gems and other materials, fits over a human head. National Museum of Bangkok.

bulging eyes and snarling mouth are visually arresting, alert, and ferocious at the same time. Curves and spirals mark the contours of his cheeks and skull. Gold serpents curl at his ears. As fabulous as he is, Hanuman is modeled from an actual monkey, the leaf-eating langur from India (Taylor 1994: 35–38).

Observed Animals

Animals are magnificent creatures. Their vitality, shape, color, and texture have captured the imagination of many artists and cultures. In many instances, the likeness of animals as they actually are—without embellishment—is sufficient justification for a work of art. Yet humans also feel the need to dominate animals, even destroy them.

An ancient set of stone reliefs show this contradictory relation with animals very well. The lions in *Ashurbanipal Hunting Lions*, 650 BC (figure 19.5), are shown in great detail. Their muscles, veins, and bones are emphasized to express their tremendous strength. The fierce expres-

sions on their faces are carefully recorded, and their flexible bodies are capable of tremendous leaps. It is obvious that the ancient Assyrians who had these sculptures made greatly admired the strength and beauty of the living lion. At the same time, however, many lions in these sculptures are dead or dying, victims of a public spectacle, the royal lion hunt. Lions in cages were released in an enclosed arena, where the king, Ashurbanipal, accompanied by bowmen and spearmen, would slaughter the animals. The fact that the lion is a strong and admirable animal made the king's courage in facing them all the greater, as did the large number of lion carcasses piled behind him. The Assyrians believed that the longer a man or beast took to die, the higher layer of heaven was attained in the afterlife. This dreadful notion accounts for the depiction of the slow slaughtering of these magnificent beasts.

The Assyrians made many such relief carvings to line and adorn the mud-brick palace walls. Scenes in the carvings boasted the power of their kings in many circumstances, including lion hunts, battle campaigns, and

19.5~Ashurbanipal~Hunting~Lions. Assyria, from the Palace of Ashurbanipal, Nineveh, c. 650~BC. Limestone Relief, approximately 60'' high. British Museum, London.

accompanying the gods. They were carved in low relief, which made the production of so many carvings possible. It is a testimony to the skill of the Assyrian carvers that the bodies of the lions seem so rounded and their muscles so evident despite the shallowness of the carving. The silhouettes of the lions are particularly effective, because the long, curving lines express their supple strength.

Vessel in the Form of a Monkey, made between 800 and 900 (figure 19.6), is an example of a monkey carefully observed, this time from the Pre-Columbian Veracruz culture in Mexico. Vessels in the shape of animals were common in many Mesoamerican and South American cultures. The monkey's squatting pose, with its arms overhead grasping its own tail, and its facial structure are convincingly naturalistic to the point that its species can be identified: it is a spider monkey. The artist has captured the animated expressions and energy of the animal. In addition, small rocks sealed inside in hollow pockets rattle when the vessel is shaken, mimicking the monkey's chatter. Monkeys were kept as pets and were featured in the mythology of many Mesoamerican peoples. They were also linked by some to dancers, due to their quick, agile movement, or to uninhibited sexuality (Pelrine 1996: 75). The monkey in this example has pierced ears, like humans. On the formal side, the vessel can be enjoyed for its design: the monkey's belly in front and expanded back become the vessel. The opening is behind the monkey's

head. Rounded belly shapes contrast with angular forms of the arms, as do the concentrated facial details

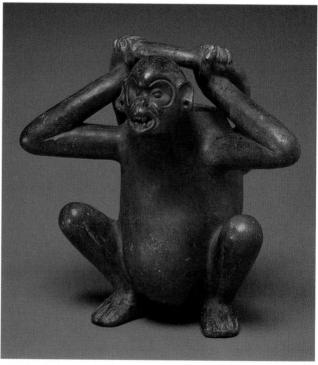

19.6 Vessel in the Form of a Monkey. Veracruz, Mexico, late Classic period, 800–900. Clay, Height: 8.5". Indiana University Art Museum, IUAM 100.7.4.75 (RW 62–233).

19.7 Ren Renfa. Three Horses and Four Grooms (detail). China, late thirteenth-early fourteenth centuries. Ink and color on silk. Cleveland Museum of Art.

with the smooth abdomen. Protruding forms, negative spaces, and dark hollows all add to the vessel's visual richness.

Horses have been admired in many cultures. In a detail of a small scroll entitled Three Horses and Four Grooms, dated from the late thirteenth or early fourteenth century (figure 19.7), the artist Ren Renfa has portrayed two stallions with sure outlines and wonderfully subtle color. The horses seem very strong and at the same time delicately light on their feet, with silken hair and carefully observed details in their heads and feet. The horses stand out against the plain background as beautiful shapes, with deep chests, long bodies, and arched necks. This artist was famous for his renderings of horses. Horses in general were especially prized in China during the era of Mongol domination. The Mongols under Genghis Khan in the thirteenth century established an empire from Turkey, Eastern Europe, Russia, Northern China, and Korea. The success of the Mongol army was due to the mobility and maneuverability of the Mongol cavalry; their horses were fast and capable of traveling long distances. Under Mongol law, stealing a horse was a crime punishable by death. It is interesting that the grooms are depicted as Chinese, while the painting was probably commissioned by a Mongol patron.

The Land

The land figures prominently in art. In this section, we will see four groups of land-based artworks. In the first, the land is the subject of paintings and photography. The second group deals with planned gardens and cultivated flowers. The third covers art in which earth is used as sculptural material. Finally, we will see art that addresses ecological concerns.

Landscape Imagery

The landscape is an obvious source of pleasure—natural formations, trees, water, mountains, green grasses, etc. But a picture of the landscape offers a different experience from the enjoyment of the actual outdoors. Most landscape images are highly aestheticized, in either their compositions, their materials, or marks used to make

them. In addition, most landscape imagery carries with it deeper social or religious meanings.

Landscape imagery is common in Chinese and Japanese paintings. In many cases it was especially popular among urban populations, at times of relatively great affluence among the upper and middle classes. The wealth of cities brought with it then, as now, certain negatives such as overcrowding, noise, and pollution. In the seventeenth century, when Sheng Maoye painted Beyond the Solitary Bamboo Grove (figure 19.8), the economy of the major city of Suchou was booming due to silk trade with Europeans and was a major tourist attraction. One popular park in particular in Suchou was so overcrowded that a local artist called it "squalid," with "visitors flock[ing] there like flies swarming on meat" (Cahill 1996: 87). Through paintings such as our example, pristine nature is once again available to the merchant or affluent city dweller. Landscapes were displayed on large hanging silk scrolls, on fans, or on smaller album leaves for private viewing, and so were enjoyed in many ways. Our example shows the subtle blurring effects of mist, the isolated hut, and the distinctive silhouettes of various trees with a naturalism that seems effortless. The effects of the painting are achieved mostly through subtle washes of ink and light color, expertly painted. In the composition, verticals are grouped on the left while, on the right, diagonals lead our eyes into the distance, where we become lost in the mist.

The scene evokes a dreaming, pensive mood, one of beauty and at the same time some mystery, so that viewers who study the picture can get lost in it, and can revel in it. It was common practice at this time to include poems on paintings. This poem by Chia Tao accompanies another painting in this series: "Birds roost in the trees beside the pond,/A monk beats by moonlight on the temple gate" (Cahill 1996:112). Such poems would not be literally illustrated in the paintings, but rather artists would use them to fuel their imaginations. Poetry was an important inspiration for landscape imagery.

Landscape painting was a revered art form in China. In addition to its lyric or evocative powers, many landscape paintings reflected religious beliefs of Daoism (also spelled Taoism), which held that nature was a

19.8 Sheng Maoye. Beyond the Solitary Bamboo Grove. From an album of six leaves. Landscapes inspired by Tang Poems, c. 1625–40. Ink and color on silk, 11½" × 12". The Metropolitan Museum of Art (purchase, the Sackler Fund, 1969).

visible manifestation of the Absolute Dao, the ultimate substratum from which all things come. Nature also reflected Daoism in its rhythms, changes and transformations. Chinese landscapes are not copies of actual views, but rather are carefully composed imaginary scenes. Artists practiced their brushwork for years to achieve a sense of effortlessness and spontaneity, qualities valued in Daoism.

Landscape paintings were particularly common in the United States and in Europe in the nineteenth century. Landscapes tended to have a nationalistic look. For example, German landscapes often were marked by melancholy or morbidity. English landscapes, however, tended to emphasize the open-air expansiveness of the countryside. John Constable's *The Haywain*, from 1821 (figure 19.9) shows a broad meadow in the distance, while in the foreground a farmer with his wagon fords a stream next to a white cottage framed by dark trees. The composition seems casual, direct, natural, and unstudied. Tranquility pervades all, as a warm mellow light washes over the greens, golds, and browns of the land, and brilliant clouds play against the blue sky.

Constable communicated a sense of rightness, as humans on the farm live a healthy and virtuous life, at one with nature. The appeal of his work is due in part to the European population migrating in large numbers to

industrial cities and feeling a sense of loss from lack of contact with nature. Constable constantly sought communion with nature. His large canvasses were developed from numerous studies he made outdoors, as Constable tried to capture the harmony of colors and quality of light at different times of day. In the studio, he used small dabs of bright color and white to paint the shimmering of light in his large paintings; his method was important later to **Impressionism**.

In painted real landscapes, Constable's motivations were very different from Sheng Maoye's revelry. Constable's landscape is not an imaginary one, but the result of studies that Constable saw as being scientific. Meteorology was his avocation. Constable's work reflects a number of somewhat conflicting influences. First is the emphasis on science, which marked the nineteenth century. His work also grows from **Romanticism**, which emphasized nature and immediate experience. The "real estate" is also an economic basis of wealth, which in nineteenth-century England was shifting from landowners to industrialists.

Landscape painters in the United States were influenced by European models, but they produced more images of pristine, untouched nature versus farming scenes. They were inspired by undeveloped areas of the Midwest and West. This tendency can also be seen in the

work of Ansel Adams, although he was a photographer who lived in the twentieth century. He was particularly well-known for landscape photographs of remote areas of the West, as exemplified in *Clearing Winter Storm, Yosemite National Park, California*, 1944 (figure 19.10). His photographs were particularly grand and romantic, with broad expanses of sky, dramatic peaks, and the sensual textures of flora and rock. In our example, the mist- and cloud-covered mountains are the focal point, balanced by the white-lit clouds above whose wispy forms contrast with the textured expanse of trees below.

Adams worked very hard to get his negatives, exploring, studying, and waiting until the light and form created a brilliant effect. In this case, the light had to catch the waterfall while the surrounding cliff was in dark shadow. The thin, bright, white line of water against the dark ridge becomes the focus of the work. Of course, the clouds and snowfall added further uncertainty to getting the right shot. Adams carefully framed the picture so that the squared peaks on the left balance with the pointed peaks on the right; the center remains clear for the seemingly infinite recession of space. Finally, Adams manipulated the photographing and printing of his im-

ages until he achieved the full range of tone available in black-and-white photography. Brilliant white contrasted with the darkest blacks.

Clearing Winter Storm, Yosemite National Park, California, 1944 conveys the atmospheric brilliance of the immense western landscape, its clarity and luminosity. It promotes the beauty of nature unaltered by the human hand, a very different ideal than Constable's Haywain. The "beauty" of Adams' image parallels to some extent the Native American idea of the sacred places in nature. Adams' landscape photographs were so brilliant and visually splendid that they were influential in creating public support for national parks and for the environmental movement in general.

Flowers and Gardens

Flowers and gardens are enormously appealing to humans. Their visual beauty is unsurpassed. They seem to promote an inner peace. They often carry symbolic meaning.

Art about flowers gives us a framed, composed, distilled, and transcendent image that is based on, but different from, the real experience of flowers. As far as

19.9 JOHN CONSTABLE. The Haywain. England, 1821. Oil on canvas, 4'3" × 6'2". National Gallery, London.

19.10 Ansel Adams. Clearing Winter Storm, Yosemite National Park, California, 1944. USA, 1944. Photograph. Copyright © 1993 by the Trustees of the Ansel Adams Publishing Rights Trust. All rights reserved.

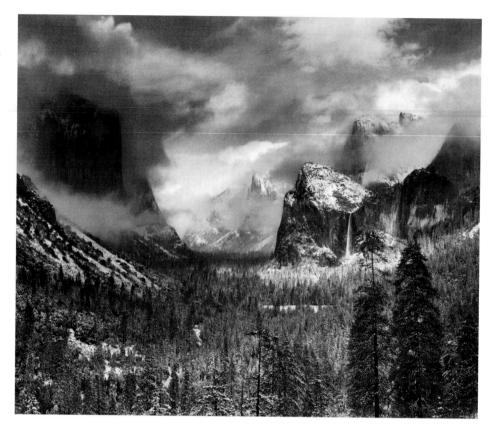

gardens are concerned, all are works of art to some degree. Ground, rock, wood, and plants are part of a living sculpture. Gardens are ideal pieces of landscape, highlighting the fruits and flowers of the earth, and arranged for human enjoyment. They are exotic refuges from the harsher aspects of both nature and city. Water is frequently a central motif for a garden, essential to all life. Gardens exist in all sizes and for all purposes, from the humble but beloved backyard garden, to botanical gardens that delight urban dwellers, to vast gardens for the enjoyment of the very wealthy. Paintings of gardens attempt to capture that same sense of pleasure and release.

Two millennia ago, gardens were popular among the Romans. Like the Europeans and the Chinese discussed on previous pages, the Romans at this time had shifted from being an agrarian people to urban dwellers with the success of their empire, but never lost their love of the country and their tendency to idealize life surrounded by nature. Roman cities were large and dense, with multistoried apartments, bustling marketplaces, government buildings, and private dwellings for the rich. The very wealthy could afford the expense of a villa in the country. Others with means would have small courtyard gardens and the walls of their houses covered with paintings, often of scenes with distant vistas. *The Gardenscape*, dated c. 30–20 BC (figure 19.11), is a detail of the painting that covered all walls of a partly underground room of an im-

perial villa. From floor to ceiling, the enclosing walls of the room are dissolved by the airy depiction of flowering plants, flying birds, fruit-bearing trees, and pale blue skies. While nearby forms are painted in great detail, distant trees are pale and blurred, dissolved by atmospheric perspective. A low garden fence separates the space of the painting from the actual space of the room. The overall tones of blue and green are accented by the occasional splash of orange, white, or red fruit. In this painting, the appeal of the garden is apparent.

Like gardens, flowers are sites of pleasure and vehicles for greater understanding. In Japan, flower arranging is considered an important art form, on the level of painting, calligraphy, and pottery. Flower paintings were particularly popular in both China and Japan. An example from China is Apricot Blossoms, dated early thirteenth century (figure 19.12) by Ma Yuan, a lyric painting with lines of poetry by Empress Yang, which read: "They greet the wind with artful charm;/ Boasting pink beauty moist with dew." Ma Yuan's brushwork is refined. The blossoms are outlined in elegant curves, while the ink strokes that make the branch are crisp and angular. The twisting branches bend and display themselves in an offbalance, irregular composition that captures the unexpected forms in nature. Branch and poem both seem to be suspended in the space. The rich golden color of the background and delicate whites and pinks of the blossoms contrast with the dark branch. The beauty of the

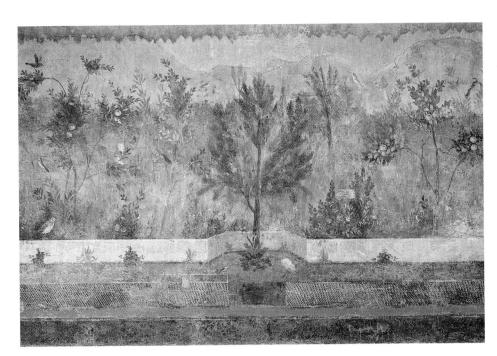

19.11 *Gardenscape.* Roman, Second Style wall painting from the Villa of Livia, Primaporta, c. 30–20 BC. Approximately 6'7" high. Museo Nationale Romano, Rome.

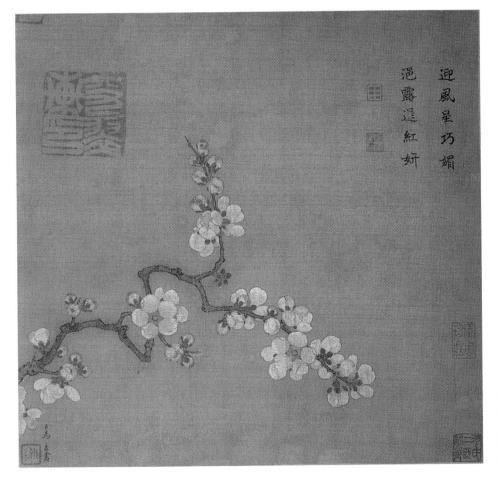

19.12 Ma Yuan. Apricot Blossoms. China, Southern Song Dynasty, early thirteenth century. Album leaf with ink and color on silk, height 10 inches. National Palace Museum, Taiwan. For more about this artwork, see figure 1.3.

blossoms is simple and timeless, but the flowers last only a short time.

Ma Yuan was a professional court painter whose style reflected that of the imperial family and nobility. He collaborated with Empress Yang on other works as well. Professional painters like Ma Yuan produced large quantities of small works, with poems penned by the emperor or his circle, to be given away as gifts and favors. The combination of poetry and painting was common; both poet and painter were believed to have the capacity to express ineffable beauty. Brushwork was an exacting art. Like the landscape artist we saw previously, all Chinese painters were experts only after long practice at making subtle washes and dark strokes that captured the essence of the plant. Also, it was important that an artist know

how to select, combine, and distill from the experience of many apricot blossoms, so that his art suggested the whole experience of the short-lived blooms, including their smell and their movement in the wind. Working from just one sample would likely result in detailed drawings that were painstaking but dull.

Flower paintings have also been very popular in the West. In Jan Bruegel's *Little Bouquet in a Clay Jar*, dated c. 1599 (also known as *Iris Bouquet*) (figure 19.13), the bouquet fills the frame with a joyful display of rich colors and delicate shapes. The image is teeming with vitality, not only with the lovely flowers that speak of the freshness and pleasure of life, but also with moths, flies, beetles, slugs, and butterflies. To better capture the subtle coloration of flowers, Bruegel layered his paint so that,

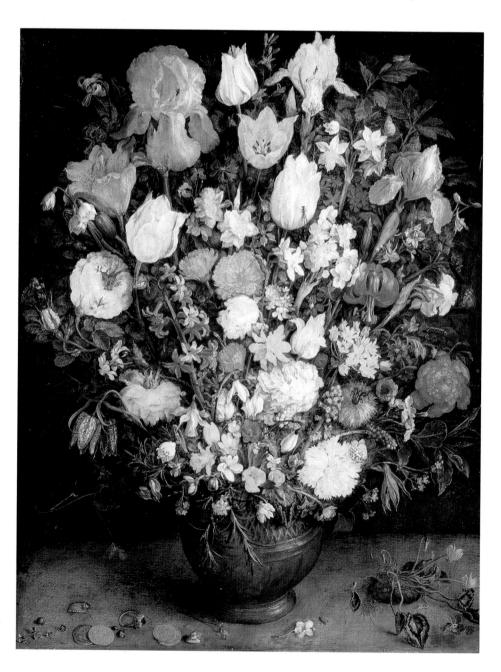

19.13 Jan Bruegel. Little Bouquet in a Clay Jar. Flanders, c. 1599. Oil on panel, $20" \times 15.75"$. Kunsthistorisches Museum, Vienna. For more about this artwork, see figures 5.1 and 20.2.

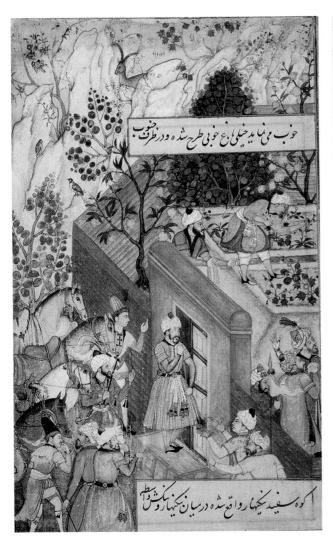

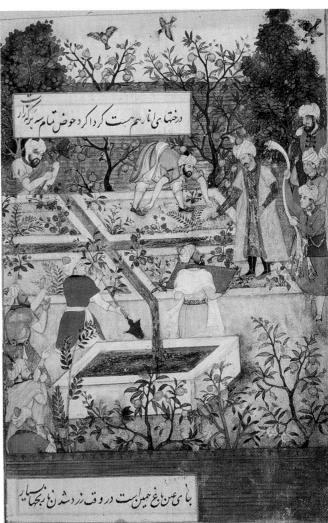

19.14 BISHNDAS, PORTRAITS BY NANHA. Babur Supervising the Layout of the Garden of Fidelity. Mughal, India, c. 1590. Manuscript painting, gold and gouache on paper, 8.75" × 5.75". Victoria and Albert Museum, IM 276–1913. For more about this artwork, see figures 2.23 and 20.26.

for example, pale blues might show through under bright yellows without turning into green. He was unsurpassed at painting the silkiness and translucency of petals. He claimed that they were more lovely than gold and gems, proving it by the rings and coins at the lower right in the painting.

Bruegel's flower paintings were a vision beyond reality. His flower arrangements never existed in actual life. His bouquets are composed of local meadow flowers and exotic varieties, and in a single vase he combines flowers that bloom in different climates and in different seasons. However, Bruegel painted the individual flowers only from life, using a magnifying glass to better see each flower, studying it like a scientist. He sometimes waited months for a certain specimen to bloom, at other times painting in the botanical gardens of the nobility. Bruegel's flower paintings are like little pictures of paradise. He was undoubtedly aware that flowers had been sacred symbols since Medieval times. The iris is the sym-

bol for Jesus, while the rose stood for Mary, and so on. The symbolism may have enriched the meaning of the painting for Bruegel's patrons.

We return to gardens in this next example, Babur Supervising the Layout of the Garden of Fidelity, from c. 1590 (figure 19.14). Gardens were very popular among the ruling classes of Persia, central Asia, and Mughal India, all areas under Islamic rulers (these are modern-day Iraq, Iran, Afghanistan, Pakistan and northern India). Islamic gardens often represented Paradise. The Garden of Fidelity is another example of the Islamic paradise garden. Water is symbolic, functional, and central to the garden's design. Water is usually channeled in stone courses in four directions, each set 90 degrees apart, representing the four rivers of Paradise. A large catch-basin in the foreground sits on a lower level, creating falling water and terraces that are especially attractive elements in these gardens. The basin also traps overflow and allows silt to settle. These streams subdivide the garden

into squares blocks that became the basic garden module. Squares are especially suited to the design of Islamic gardens because they can be infinitely proliferated without destroying the integrity of the original layout. Thus, squares can be added easily around the edge of the garden, or existing blocks can be further subdivided to create more squares. The proliferation of squares represents the abundance of Allah's creation. In all cases, the Islamic gardens are typically geometric in design.

Text Link
Review the discussion of the Taj Mahal
(figure 11.21) for more on Islamic gardens symbolizing Paradise.

The sensual appeal of Babur's garden is apparent in the lush flowering and fruit-bearing trees that line the edges of the garden with their luxurious and decorative foliage. Birds nest in the trees, and ducks and fish appear in the cool water. Trees were generally planted in large groves, in straight lines, or on a grid. The outer wall provides privacy for the garden, and also protects it from desert wind and sand; note the contrast between the lush foliage inside and the bare hills outside the wall. The colors are delightful: the bright flowers and fruits, the richly colored robes, the gray-green tree foliage, and the terra-cotta wall. The English word "paradise" comes originally from ancient Persian words for "walled garden," and most images of paradise from any culture are based on gardens. Many Persian gardens were originally oases in the desert, and there are many written accounts by early European travelers crossing the dry, harsh desert, who stopped with joy when they reached a blooming garden in the midst of the bare sand and vicious heat.

Babur Supervising the Layout of the Garden of Fidelity is a book illumination, beautifully detailed, with ornamented pages. This delicate, decorative, and detailed illustration is from the memoirs of Emperor Babur, who created many gardens throughout the lands that he ruled, both garden oases in deserts and hanging terraces on mountainsides. Every place he went he planted a garden; if there was already one there, he enlarged and improved it. Babur was a botanist who took great interest in planning the layout of the gardens, including the Garden of Fidelity, which he called the Bagh-i Wafa. He decided which plants to plant, including pomegranates, oranges, plantains, and sugar cane. In our example, we see Babur standing near the right edge, directing an engineer holding plans, as a workman behind measures a section of a plot.

For Babur, the garden was not only a pleasurable refuge. Gardens were also important in establishing his identity and securing his power. Babur was merely a minor prince before he began a series of conquests over much of central Asia and northern India. To bolster his legitimacy as a ruler, Babur emphasized that he was a descendant (a very distant one to be sure) of two great conquerors, Ghengis (Chingiz) Khan and Tammerlane (Timur). Establishing gardens was one way to do this, because it linked him to the great rulers of the past, as horticulture was a prerogative of princes, and the garden physically separated the prince and his court from the common people. In addition, the symmetry and geometry of gardens like the Garden of Fidelity provided a visible sign of order. Babur believed his rule created order out of the chaos of the world around him.

Text Link

Expansive gardens were in many cultures the privilege of the ruling class and a sign of their power. Review one famous garden that surrounds the palace at Versailles (figure 12.18).

In Japan, there are a couple of different traditions for gardens. One kind is planned around a pond (or lake, in larger versions). Rocks, plants, landforms, winding paths, buildings, and bridges are arranged so that as visitors pass through the garden, they are constantly delighted by views that are new, fresh, and changing. Everything about these gardens is deliberate, down to the way the plants are pruned. In this way, the gardens are an echo of paradise. Like other artworks, the viewer's vision is completely controlled; for example, a path might be smooth in one area where one can enjoy the views, but very rocky, almost treacherous, in other areas, where visitors have to watch their feet, because the garden designer did not want to emphasize the views right there.

A different tradition in Japanese garden design is exemplified in the Ryoan-ji Zen Garden of Contemplation, dated c. 1488-1499 (figure 19.15), in a courtyard in a Buddhist temple in the city of Kyoto. This kind of garden is laid out to be completely visible at once from one point of view. In fact, the visitor does not walk through this garden; no one does except one who rakes the stones. Stillness is emphasized, as one sits in a veranda along one edge and meditates on the minimal elements, consisting of large dark boulders amid raked luminous white quartz gravel. Yet as one meditates, the experience of the garden becomes richer. The garden landscape parallels both the cosmos and Buddhist philosophy. The white quartz represents the void of both the universe and of the mind; the dark rocks represent material substances and worldly events that float through the

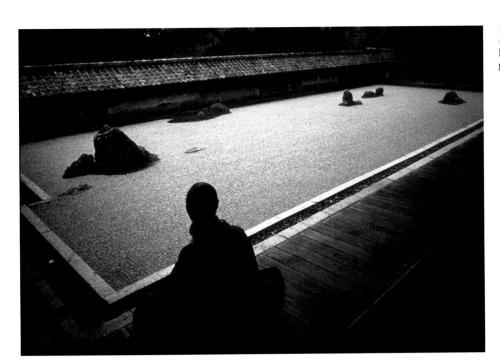

19.15 Ryoan-ji. Zen Garden of Contemplation. Daiju-in Monastery, Kyoto, Japan, c. 1488–1499. Walled garden.

universe and through the mind. The white quartz is also likened to an ocean or a journey; it has been raked in long parallel lines to represent waves, except for the circle patterns around each boulder, which now stand for mountains. The fifteen large rocks, each of a distinctive shape and outline, are arranged in five groups. Their shapes, sizes, and orientations contrast with each other, creating visual tension and variety.

The Ryoan-ji Zen Garden of Contemplation is very small in size, but seems bigger from the entrance as the largest boulder is to the front and the smaller to the back, creating the visual illusion of great depth. That illusion of greater depth becomes a reality as one meditates in the garden, filling it with one's own thoughts and finding numerous ways that the rock arrangements are like conditions in one's own life. The rock garden is a reflection of Zen Buddhist beliefs, which held that the world was full of change and disorder, but by silent meditation one could transcend it to reach an intuitive understanding of the oneness of the universe.

Earthworks and Site Pieces

The earth itself is sculptural material. In its most common form, it is the clay used for the millions of pots humans have made since the beginning of time. Here we will focus on monumental works of art made essentially of earth.

Hundreds of years ago, native peoples of North America used dirt to construct large ceremonial mounds. Mounds and pyramids were relatively common in the ancient world. We saw them, for example, in Egypt, in Mesoamerica, and in the Moche civilization of ancient Peru, where they generally served a burial or religious purpose. Unique to the North American mounds are those that are animal-shaped, like the *Serpent Mound*, dated c. 900–1300 (figure 19.16) in Ohio. The distended jaw of the 1,400-foot-long serpent is pointing to the lower left, its body curves in rhythmic U-shapes, and ends with its spiraling tail. An oval shape inside the serpent's jaw, measuring 24 × 48 meters, encircles a plateau with a pile of stones in the center, which may have been an altar. The exact purpose for this monumental sculpture is unknown, and in fact it could only be realized in the minds of those who built it, as they never enjoyed an aerial view of it. But those who built it undoubtedly had a great admiration for the snake to stamp its form so

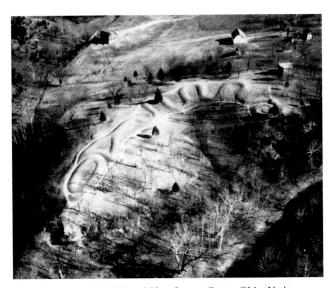

19.16 Serpent (or Snake) Mound. Near Locust Grove, Ohio, Native American, c. 900–1300. Earthen sculpture, 1,400 feet long.

dramatically on their landscape. This shape was created by mounded earth, requiring the efforts of many of the surrounding population, who would have dug and carried earth to the site. In 1846, the snake's body was 5 feet high and 30 feet wide, but it has since eroded to 4 feet by 20 feet. The serpent's body follows a natural ridge in the land near a small river, visible at the right. The natural formation of the landscape may have suggested the serpent shape to its ancient makers.

Text Link
The enormous drawing, Spider (figure 9.24) from Nazca, Peru, is another ancient earthen art work.

Contemporary earthworks are large-scale environmental pieces in which the earth itself is an important component. Earthwork artists not only use natural materials, but are responsive to their sites. While they are influenced by ancient earthen works, the monumental scale of their work is definitely an attribute of modern art, as well as the minimalist emphasis on simple shapes. Robert Smithson's *Spiral Jetty*, dated 1970 (figure 19.17), was made of rocks, dirt, salt, and water, extending below the broad, bright sky and into the flat, unmoving surface of the Great Salt Lake. The large spiral in the vast expanse suggested an incredible potential force to Smithson, like a dormant earthquake or a raging cyclone storm immobilized. Spiral Jetty reflects the monumental scale of the landscape, and also other earthen artworks and the Serpent Mound above. The work is located in a remote site. Few people saw it at the time it was made. It is now inundated and invisible because of the rising lake level.

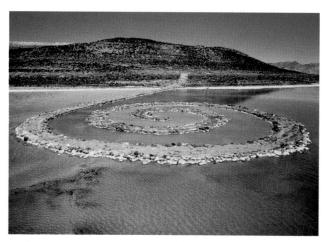

19.17 ROBERT SMITHSON. Spiral Jetty. Great Salt Lake, Utah, USA, 1970. Black rocks, salt, earth, red water, algae, 1,500 feet long. See also the text accompanying figure 20.10.

Smithson was interested in moving his art outside of the gallery, and away from using traditional art materials. He saw his earthworks as unifying art and nature. Human design is of course absolutely evident in this work, as the spiral shape contrasts completely with the surrounding landscape, despite the use of earth as an art material. Less evident is what went into making the piece, including heavy earth-moving equipment, engineering skills and a number of workers.

Text Link

Earthworks exist outside the gallery not only by virtue of the materials used, but also because they cannot be bought and sold. How are such artists and artworks financed? See Chapter 20, Who Makes Art?, for more.

The Lightning Field, dated 1971–1977 (figure 19.18), by Walter de Maria, consists of a large flat plain surrounded by mountains in New Mexico, and 400 stainless steel poles arranged in a rectangular grid one kilometer by one square mile in size. The weather pattern there brings occasional electrical storms at certain times of year. This work of art is not fixed, but ever changing, depending upon season and weather. On clear days, the tall bright poles with sharpened points catch the sun and glow against the distant mountains and natural vegetation. On stormy days, an occasional bolt of lightning may strike a pole, creating a fleeting, but dramatic visual effect. The work requires some effort and endurance on the part of viewers. Like Spiral Jetty, Lightning Field is remotely located. To see it, one must get permission from the Dia Foundation, which commissioned the work. Once on site, the viewer waits for whatever happens, which may be spectacular for a split second, but most likely not, as lightning strikes are relatively few. Lightning Field is better known through photographs that document it in different conditions, than it is by actual experience. In this respect, the work is also a conceptual piece, existing primarily in the viewer's mind who contemplates the contrast between constructed and natural elements, the passage of time as the minutes crawl by in the desolate environment, and the imagined experience of the work as known through various photographs.

Ecological Concerns

We will now turn to a few works that directly address ecological issues, which are increasingly becoming of concern to artists. Neil Jenney's *Meltdown Morning*, dated 1975 (figure 19.19) conveys with poetic simplicity the natural loss that would result from a nuclear accident or nuclear war. It presents a thin slice of a landscape, a view we do not normally see, with a section of a tree trunk. In the distance, in pale pinks, purples, and golds, a mushroom cloud from a nuclear explosion billows in the sky. The mushroom cloud's color is pretty, like the tints of a

19.18 Walter De Maria. The Lightning Field. New Mexico, USA, 1971–1977. 400 Stainless steel poles, average height 20'7", land area 1 mile \times 1 kilometer. For more about this and other earthworks, see figure 2.39.

 $19.19 \; \text{Neil Jenney}. \; \textit{Meltdown Morning}, \; \text{USA}, \; 1975. \; \text{Oil on panel}, \; 25.5 \text{"} \times 112.5 \text{"}. \; \text{Philadelphia Museum of Art.}$

sunset, seemingly innocuous and comfortingly distant. The thick tree trunk with its rough bark looks substantial, but the clusters of delicate leaves, like graceful green umbrellas, make it clear how vulnerable the natural world is. The sky is luminous. There is a long history of landscape painting that aspires especially to capture the quality of light; Constable's *Haywain*, above, is one. That luminosity, especially lovely at sunset and dawn, has always been one of the pleasures of human existence. Here it is caused by a hazy nuclear glow. The thick frame, which is part of the painting, acts like the black border of an obituary notice, or the thin viewing slot of a reinforced bunker.

Social Mirror, dated 1983 (figure 19.20) by Mierle Laderman Ukeles, focuses on the problem of waste made critical by growing populations and consumerism. Ukeles had a clean New York City garbage truck fitted with gleaming mirrors. The mirrors brilliantly reflect the sun, transforming and making us newly aware of the shape of the garbage truck, like a piece of sculpture. The

Social Mirror also has a performance element. In this photograph, the truck is part of a parade, and its mirrors are reflecting the images of the parade watchers, the general public. It is intended to make everyone aware that they make trash and are responsible for its impact. The mirrors also glamorize the garbage truck, and raise the status of sanitation workers, whose jobs are not respected, but who, according to Ukeles, keep New York City and other urban centers alive. All of Ukeles' work since the mid-1970s has focused on ecological issues of maintenance, recycling, waste management, and landfill reclamation.

KNOWLEDGE

We have just finished looking at several examples of art that let us experience nature. But humans also systematically study and examine our world in an attempt to understand (and often control) its course. Humans have built up a mass of knowledge that is our current 19.20 MIERLE LADERMAN UKELES. The Social Mirror. USA, 1983. 20-cubic-yard New York garbage collection truck fitted with handtempered glass mirror with additional strips of mirrored acrylic. For more about this artwork, see figure 2.40.

understanding of our environment and ourselves. This section focuses on art that deals directly with a body of knowledge (although all art, in some way, is reflective of a kind of knowing). The first group are informative images, where art helps explain a specific body of learning. The second group provides glimpses into areas of intuited knowing. Then we will see art that critiques what we consider to be knowledge.

These same ideas—scientific knowledge, intuited knowledge, or critiquing knowledge—are found in other areas, and are historically and culturally specific. The German philosopher Immanual Kant (1724–1804) challenged people to strive toward knowledge and reason, and epitomized the era of the Enlightenment. Later, the French philosopher Henri Bergson (1859–1941) promoted the value of intuition over intellect for understanding the world. Finally, the wars of the twentieth century have caused many to question what it is that we call knowledge.

Informative Images

There are numerous examples of art that illustrate and make clear a specific body of knowledge. In the Low Countries in 1543, Andreas Vesalius of Brussels published *De Humani Corporis Fabrica*, a study of bones, muscles, and internal organs based on the dissection of human bodies, which is considered the beginning of modern science. Prior to that time, knowledge of the human body was based on the ancient Greek, Roman, and Medieval Arabic writings. These sources contained numerous inaccuracies, which Vesalius' studies corrected; also, Vesalius' work added a tremendous amount of new knowledge. Important, however, is the fact that Vesalius'

book is a major work of art in its illustrations of human anatomy, the typography, and overall book design. It continues to this day to be a reference book on anatomy for figurative artists.

In The Fourth Plate of Muscles, dated 1543 (figure 19.21), the dissection process Vesalius used to understand the body is evident. He gradually stripped the outer muscles from the cadavers he studied, but left them partly attached to make clear their relation to deeper muscles just exposed. Nonetheless, the body is standing as if alive, moving, and turning, with weight on one leg, because Vesalius wanted to emphasize the structure and workings of the living, moving body, instead of the separated parts of the dead. The engravings themselves are excellent works, in which the musculature is clearly studied and rendered, and at the same time superbly drawn and pleasing to see. The poses are expressive, which makes the drawings more interesting. The figure stands imposingly against a distant landscape. Altogether, there are eight plates of muscles that make a lurid and fascinating narrative of dismemberment. In the First Plate of Muscles the skin is removed and the muscles are exposed but intact; the body stands like a classic statue, with an aura of grandeur mixed with a sense of pathos. Our Fourth Plate is both fascinating and horrible. By the time we arrive at the seventh or eighth plates, the cadaver is dangling on ropes, disjointed and grotesque, with most muscles hanging loose or stripped away. The works comment both on the splendidness of the human body, and its inevitable disintegration.

De Humani Corporis Fabrica is a collaborative work. Vesalius drew some of the drawings from which the engravings were made, but most were from the hands of other artists who worked from Vesalius' sketches and notes. Vesalius himself had become very busy and quite famous in his lifetime, and was often called upon to give medical advice to the reigning kings of Europe. The landscape backgrounds were drawn by another unknown artist. When all the plates are placed side by side, the backgrounds make a large, continuous landscape of the Italian countryside. The engraver who made the printing plates had to be extremely skillful, otherwise the expressive and informative content of the pictures would have been lost.

Another famous illustrated study is John James Audubon's *Birds of America*, a very large book that contained 435 plates. The printed images were based on Audubon's original watercolor studies of the birds of North America; Robert Havell Jr. made most of the

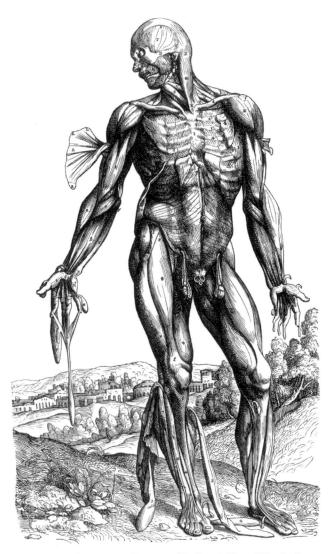

19.21 Andreas Vesalius of Brussels. *The Fourth Plate of Muscles*, from *De Humani Corporis Fabrica*, Flanders, published in 1543. Engraving.

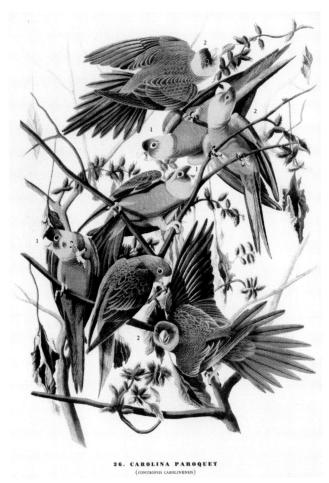

19.22 JOHN JAMES AUDUBON. *Carolina Parroquet*. Original for Plate #26 of *Birds of America*. USA, 1827–1838. Watercolor, 29.5" × 21.25". New York Historical Society, New York. See also the text accompanying figure 20.15.

printing plates from the original paintings. Birds of America is an outstanding work, both artistically and scientifically. Carolina Parroquet, dated 1827-1838 (figure 19.22) shows several birds of the species in a tree in their natural habitat. The various poses show in scientific detail all the markings of their bodies, on back, front, and on both sides of the wings, and the differences between male and female. The background is eliminated to emphasize the defining silhouettes of the parakeets. Audubon flattened the space, so that the birds all seem to sit equally close to the viewer, to make all details clearer. The coloration of the birds was carefully recorded. All the qualities that make this work a valuable scientific record also make it visually compelling. The arrangement of the birds and branches visually counterbalance each other. Look at the direction of the main stem. The birds are arranged in two arcs, one that echoes, and one that opposes, the shape of the stem. The pattern of the birds' shapes against the blank background makes a decorative pattern which is enhanced

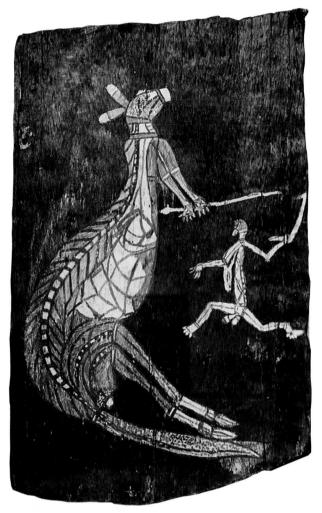

19.23 *Hunter and Kangaroo.* Oenpelli, from Arnhem Land, Australia, c. 1913. Paint on bark, $51" \times 32"$. National Museum of Victoria, Melbourne, Australia.

by the bright colors. The flattened space adds to the decorative quality. The whole book taken together, with its hundreds of plates, is colorful, lively, and shows how passionately Audubon loved his subject.

Drawings in the service of science continue to be made to the present day, even though photography might seem to be an adequate substitute for them. But artists can make drawings to illustrate specific features which either do not stand out in photographs or become lost in the wealth of detail. Medical books are still enhanced with drawings, and medical illustrations are essential aids for study. Drawings also are used in studies of plants, insects, and for things very small in size.

Our next example is an educational aid. *Hunter and Kangaroo*, c. 1913 (figure 19.23), is from the Aboriginal people of Australia. The painting on bark shows the instant that the hunter's spear is about to enter the animal. The figures are shown in x-ray style, meaning that both external silhouette and internal organs are evident. We can see the kangaroo's backbone, heart, and intestines.

In size, the kangaroo is larger than the hunter, because it is the subject of the painting. This work, and others like it on bark and on the walls of cave shelters, were meant to be educational and perhaps also ritually powerful. Showing the animal's internal organs assisted the hunter in the slaughter. The style of the painting implies movement and energy.

Text Link
Other Aboriginal paintings transmit
knowledge from one clan member to another, as we saw in Paddy Carrol
Tjungurayi's Witchetty Grub
Dreaming, figure 6.2.

Some works of art are experiential in a way that is both conceptually interesting and also educational. For example, we will look at a painting in the Optical Art (or Op Art) style, that enjoyed popularity in the United States and Europe in the 1960s. Bridget Riley's *Current*, dated 1964 (figure 19.24), is a precisely painted pattern of undulating lines that affect our visual perception. The pattern produces visual ambiguity that makes it seem not static, but pulsating and flickering. The work is similar to experiments by visual psychologists who test the limits of visual perception to better understand how our vision works. It is also related to mathematics, as each line is a sinusoidal curve, where the interval between each dip increases as your eyes move away from the cen-

19.24 Bridget Riley. Current. Great Britain, 1964. Synthetic polymer paint on composition board, approximately $58.5" \times 58.5"$. Museum of Modern Art, New York.

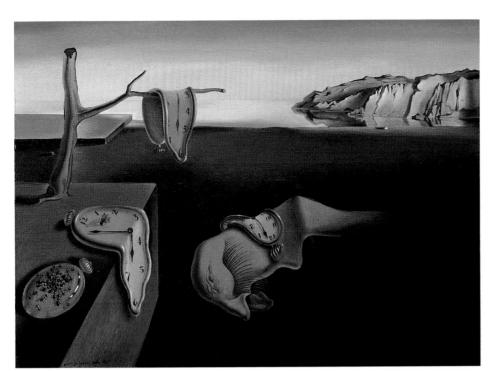

19.25 SALVADOR DALI. The Persistence of Memory. Spain, 1941. Oil on canvas, 9.5" × 13". Museum of Modern Art, New York. For more on the meaning of this artwork, see figure 4.11.

tral horizontal axis of the painting. *Current* makes evident that our vision is based on nerves, because our eyes experience discomfort if we stare at the image too long. Its large size means that, up close, the work encompasses our entire visual field, both the sharp foveal vision at the center and our peripheral vision at the edges.

Text Link

Georges Seurat also relied on the science of optics in his work. Take another look at La Grande Jatte (figure 16.22).

Art and Intuited Knowledge

For humans, the "world" consists not only of the external environment, but also of the internal realm of the mind and the metaphysical world. Art also deals with knowledge that humans can intuitively grasp without necessarily being able to articulate it. This kind of knowing is the product of internal feelings, dreams, visions, and speculative guessing. It is not necessarily systematic, organized, or scientific.

Surrealism was an early twentieth-century art movement in Europe and the United States that explored the internal realm of the unconscious, especially through dream imagery. Surrealists posited that this unconscious or dream world was at least as real as, and probably more important than, the ordered and regimented external world in which humans functioned. In his paintings such as *Persistence of Memory*, dated 1931 (figure 19.25), Salvador Dali was presenting the space of

imagination, dreams, or memory. Watches are devices of knowing and a means of maintaining external order, but here they are limp, flaccid, and useless. The land-scape stretches out, vast and empty. The sky glows in splendid blues and golds, while the absolutely still water reflects the sun-bathed cliffs like a flawless mirror. Nothing makes "sense," but Dali has painted everything with rigorous detail and convincing realism so that book-learned knowledge fades in importance, and we enter the eerie scene with a kind of intuited knowing. Swarming ants and a fly allude to the horror dimension in dreams.

Other works of art refer to knowledge that cannot be clearly articulated in words. Mark Rothko made a series of paintings in which he was alluding to the sublime. Although he started as a figurative painter, he abandoned imagery that reflected the physical world for abstractions that hint at a transcendent state of being. This series of paintings contained large rectangles, sometimes only vaguely defined, against a field of other colors. Each color area was subtly modulated, so that the shapes, and alternately the background, seemed to emerge, float, and glow, as in Green, Red and Blue, 1955 (figure 19.26). Rothko painted in thin "veils" of paint that soaked into and stained the canvas, and then applied many layers on top to create shapes that seem present and yet hard to define, hovering in a space that is real, and yet again not wholly knowable.

Rothko turned to abstraction as a means to address these broad and fundamental feelings/ideas, because figurative or narrative imagery was too specific and too limiting. In addition, Rothko's abstractions were meant 19.26 MARK ROTHKO. *Green, Red, Blue.* USA, 1955. Oil on canvas, 81.5" × 77.75". Milwaukee Art Museum Collection.

to provide a kind of direct physical experience to the body. Another 1950s painter, Robert Motherwell, expressed these ideas in this way:

The emergence of abstract art is a sign that there are still men of feeling in the world. . . . From their perspective, it is the social world that tends to appear irrational and absurd. . . . Nothing as drastic as abstract art could have come into existence save as the consequence of a most profound, relentless, unquenchable need. The need is for felt experience—intense, immediate, direct, subtle, unified, warm, vivid, rhythmic. If a painting does not make a human contact, it is for nothing. But the audience is also responsible. Through pictures our passions touch. . . . The act of painting is a deep human necessity. . . . (O'Hara 1965:45, 50)

The Critique of Learning

Let us now turn to the last two works in this section, each of which examines instances when knowledge might be useless, misleading, or esoteric. Gods of the Modern World, dated 1932–1934 (figure 19.27), painted by José Clemente Orozco, is a strong critique of sterile knowledge. It is a warning against the aca-

19.27 Jose Clemente Orozco. Gods of the Modern World, Twelfth panel in a cycle of murals entitled, "An Epic of American Civilization," executed at the Baker Memorial Library, Dartmouth College, Hanover, New Hampshire. Mexico, 1932–1934. Fresco, $126^{\circ}\times176^{\circ}$.

demic who is completely occupied with research or learning that has no value outside of academia. The black-clad university scholars line up like midwives to watch a skeleton give birth to miniature scholarskeletons and stacks of obscure books. Orozco believed that sterile education passes for knowledge, but it actually keeps the young busy without giving them any real wisdom or understanding. The lurid red background suggests urgency, as if the world is on fire, but no guidance or concern can be found among the "learned." Their posture is aloof, frontal, stiff, and unresponsive. The style of the work is very striking. The rhythm of the lines is strong, from the verticals of the academic robes, to the black and white of the skeleton's ribs, to the swaying parade of book spines below. Significantly, this painting is in the library of a prestigious U.S. college, to be seen by all students and professors.

In Breaking of the Vessels, dated 1990 (figure 19.28), the artist Anselm Kiefer looks at knowledge on many different levels. The piece consists of a three-tiered bookshelf filled with massive volumes whose pages are made of sheets of lead. The books sag perilously, some about to fall from the shelf. Glass shards from the books have fallen and their shattering has covered the floor all around. Above, a half-circle of glass has written the Hebrew words, "Ain Soph," meaning "the Infinite." Dangling copper wires connect thick stumps projecting from the sides. The piece is 17 feet high and weighs over 7 tons. The shattered glass covers several square yards of floor all around.

The piece contrasts the infinity and clarity of the spiritual realm with the thick, dull, ponderous containers of human knowledge. Human knowledge, as contained in and symbolized by the books, is limited and sagging under its own weight. Visually, the heavy lead pages are like the blackened pages of burned books. The knowledge contained within them seems inaccessible to most people; the book format hides knowledge rather than exposes it. The books seem as though they might even be rotting away, ready to crash to the floor. The sheer mass of the sculpture becomes a metaphor for the accumulated struggles for acquiring and keeping human knowledge. But books and their contents disintegrate. The work alludes to the fact that all human endeavor is cyclical like nature; it is subject to periods of decline and entropy that eventually result in regeneration.

The *Breaking of the Vessels* alludes to an even wider range of related ideas. The title is taken from mystical Hebrew writings (the Kabbalah), in which was written about the awesome, uncontainable Divine essence whose power filled and shattered the fragile vessels of the universe upon Creation. It symbolized the introduction of evil into the world. It also refers to the atrocities of the Kristallnacht (the Night of Crystal or the Night of Broken Glass), when the Nazis broke windows, burned synagogues, and destroyed Jewish businesses, terrorizing

19.28 Anselm Kiefer. *Breaking of the Vessels.* Germany, 1990. Lead, iron, glass, copper wire, charcoal and aquatec, height 17 feet. The St. Louis Art Museum.

Jewish neighborhoods in Germany and Austria in November, 1938.

TECHNOLOGY

Technology is the last component of the outside world that we will see in this chapter in relation to art. The first works deal with technological advances as good, healthy, exciting, and even aesthetically pleasing. The second

19.29 Farm Scene. China, Sung dynasty, c. 1000–1240. Ink and color on silk

group evaluates our constructed world for both its positive and negative impact.

Technological Advances

In Farm Scene, dated c. 1000-1240 (figure 19.29) we see that in fact, technology has long been part of human history, and has often made life easier. A farmer and his wife operating a foot-driven pump that diverts water to flood their rice field. Beneath a shed a water buffalo turns a larger pump for similar results. A boy fishes in the background, a boat is moored to a river bank, and a footbridge spans the water between clumps of land. Pumps, bridges, boats, and fishing poles—all pieces of technology—fit comfortably into the overall scene. Well-placed trees shade all workers, and the generous river waters stretch out for long distances in the background. Harmony and serenity abound. Human handiwork and nature seem to belong together. The emphasis on horizontal lines, the orderly diagonals in space, the blended ochers, greens, and browns all turn what could be a scene of hard labor into an image of peaceful coexistence.

When we consider technology today, however, we most likely think of the world since the Industrial Revolution of the nineteenth century, and more recently development in transportation, manufacturing, and communication. Technology advanced rapidly in the early twentieth century, resulting in the growth of cities, with structures in shapes and sizes never seen before. Particularly striking were bridges, factories, skyscrapers, ocean liners, and fast trains. Many artists were inspired by these forms, among them Fernand Léger. His painting, *The City*, dated 1919 (figure 19.30), was a tribute to the geometric forms of industrial structures and the pre-

cision and efficiency of machines, all of which struck Léger as forms of beauty. The city of Léger's painting is rendered in abstract forms, but speaks of its concrete, steel, electrical power, and transportation systems. The repetition of the colors and shapes suggests the staccato of city sounds. Letter forms suggest billboard advertisements. The colors are bright and artificial. Other shapes resemble a jumble of roofs and walls, bridge trestles, or factory smokestacks. Even humans are robot-like as their bodies are composed of geometric volumes. The space seems shallow, as all forms are compressed and pushed forward, in contrast to the open horizon and distant spaces in paintings showing rural scenes.

David Smith's Cubi XXVI, dated 1965 (figure 19.31) is abstract art imitating some qualities of machines. Smith used industrial fabrication to create this stainless steel sculpture and others in this series. He learned this technology as a factory worker. He constructed sculptures with sheet metal, an industrial rather than fine art material. The material retained its industrial look, an innovation of Smith's that was very influential for future sculptors. His works are marked by a machine aesthetic, and thus his processes and materials were the same as those that would be used to make a locomotive. The large geometric shapes of cube, rectangle, and cylinder look machine-manufactured, with clean edges, flawless welding, and precise fits. They resemble mass-produced items. The structure, unsoftened, is almost brutally emphasized. Strong, balanced forms seem to defy their weight. The metal surfaces, however, were abraded to give them a spiral pattern that seems to dissolve the solidity of the volumes. Smith emphasized gesture, so that the sculpture seems to be moving forward, like an animated stick figure of a walking person. The forms suggest vectors in space, some in opposition to each other. The work also suggests forces suspended and in movement, like components of a machine.

Evaluating the Constructed World

We have already seen Jenney's *Meltdown Morning* and Ukeles' *Social Mirror*, which were highly critical of human technology and its impact on the land. Certainly, a nuclear catastrophe and enormous piles of trash are disastrous results of technology and industrialization. Yet, as we also seen, technology can be very beneficial. The following artists present technology to us in a way that makes clear its mixed impact.

In The Fighting 'Temeraire' Tugged To Her Last Berth To Be Broken Up, dated 1838 (figure 19.32), Joseph Mallord William Turner criticizes the notion that all innovations are forms of progress. He painted the tall shimmering white form of the elegant sailing vessel against the new powerful tug boat, which is squat, dark, and smoky. By this time, sailing vessels were obsolete for war or commerce, superceded by more modern technology. Turner marked the "Temeraire's" passing by the

19.30 FERNAND LÉGER. The City. France, 1919. Oil on canvas, 90.75" × 117.25". Philadelphia Museum of Art.

19.31 David Smith. *Cubi XXVI*. USA, 1965. Steel, approximately $10' \times 12'6'' \times 2'3''$. National Gallery of Art, Washington DC. For more about the formal qualities of artwork, see figure 2.17.

splendid glowing sunset (blotched by the tug's smoke!)—both ship and sunset were soon to be lost forever. Turner was well-known for his facility with paint; thick blobs become an array of golden clouds, brushy strokes blend where mist meets blue sky. The scene is a conflict between light and darkness, and light is just about to be eclipsed.

Without a doubt, Turner was romanticizing archaic technology, in response to the latest innovation that seemed ugly to him. He painted this work in his old age, as a sign of his own life drawing to a close. It was a farewell to the sailing ships he had so often painted and the elegance of a way of life he remembered from before steam technology. The beautiful colors and expressive handling of the paint convey the poignant feeling of beauty and loss, transforming an otherwise nondescript harbor scene along the Thames River in London into a picture of poetic beauty.

Jean Tinguely's *Homage to New York*, dated 1960 (figure 19.33), looked like a whimsical, playful, absurd

19.32 Joseph Mallord William Turner. The Fighting "Temeraire" Tugged To Her Last Berth To Be Broken Up. England, 1838. Oil on canvas, 35.25" × 48". The Tate Gallery, London.

machine. Tinguely constructed it with the help of an engineer, using junkyard machine parts. The work was designed so that it would destroy itself in one evening in the gardens of the Museum of Modern Art in New York, which it did, but not according to plan. A fire in some parts necessitated the unscheduled participation of the New York Fire Department. Tinguely was mocking the machine, and yet also celebrating it for qualities very different from Léger's *The City*. To Tinguely, the machine

was not magnificent because of its clean design nor its efficiency, but for its unexpected results. Machines never work in exactly the way that we expect them to, and we never anticipate all the results of using them. Tinguely's satirical work references the frenzy of the machine age and by extension the city of New York at that time, which in some ways could be seen as a large machine, absurd in its size, its complexity, its haphazard workings, and its entertainment value.

19.33 Jean Tinguely. Homage to New York: A Self-Constructing, Self-Destructing Work of Art. Swiss, 1960. Mixed media sculpture, photograph of the work as it self-destroyed in New York on March 17, 1960. (Photo by David Gahr.) See also the text accompanying figure 2.29.

Text Link

Homage to New York was both an environmental sculpture and a happening. For more on the late twentieth-century trend that deemphasizes art as an object and emphasizes art as an event, see the sections on "Engaging All the Senses" and "Chance/Improvisation/Spontaneity" in Chapter 2.

For us now, technology includes the age of computers and televisions. For nearly forty years, the artist Naim June Paik has been exploring what that means and its impact on us as humans. *Megatron*, dated 1995 (figure 19.34), is composed of over 200 screens divided into two groups, displaying video clips, digital distortions, and animation sequences. Paik's images are from high and

19.34 NAIM JUNE PAIK, in collaboration with Shuya Abe. *Megatron* (three views), Korean, 1995. Eight channel video and two-channel sound installation in two parts, overall size 12 feet × 33 feet × 2 feet. Courtesy Holly Solomon Gallery, New York. For more about the imagery in this piece, see figure 1.10.

20.1 Great Pyramids. Gizeh, Egypt. From left: Menkaure c. 2525–2475 BC, Kahfre c. 2575–2525, Khufu c. 2600–2550 BC. Stone blocks. See also the text accompanying figure 11.2.

self-supporting. But that still means that extra money from some source can be devoted to art training.

Text Link

A few important related areas on the art as a social product are discussed in other chapters. Many people develop the meaning of a work of art, as we saw in Chapter 4. What people do with art once it is made is also a social process. See Chapter 21 for more.

ABOUT ARTISTS

The Creative Act

The fact that art is a social production does not diminish the importance of artists. Artists are creative people with exceptional skills. They are able to take meaningful ideas—social ideas, intensely personal ideas, spiritual ideas, political ideas—and embody them in a visual form that holds our attention, grips our emotions, or engages our imagination. Artists' works are either unique and innovative, or are vital restatements of traditional ideas.

Creativity is an attitude, of which some artists and psychologists have identified risk-taking, spontaneity, persis-

tence, curiosity, and courage as components. Artists understand visual organization and communication. Artists learn from the works of other artists. Other bodies of knowledge may influence artists: the artwork from other cultures; the writings of critics, art historians, and museum personnel; and a host of other areas such as history, anthropology, engineering, religion, psychology, mysticism, the natural sciences, and so on. Artists are likely affected by the politics of the time and the general economic conditions. Personal experiences and those of their families and friends affect them.

Training of Artists

How do artists learn their profession? Almost all are trained in art techniques, skills, styles, and even the nitty-gritty of running a small business.

A lot of artists are taught by family members. Jan Bruegel the Elder, whose painting of flowers is exemplified by *Little Bouquet in a Clay Jar*, dated c. 1599 (figure 20.2), was part of a large family of famous artists. His father was the landscape and genre painter Pieter Bruegel the Elder. His brother was Pieter Bruegel the Younger, who painted in his father's style. Jan Bruegel the Elder continued his father's tradition of landscape painting

20.2 Jan Bruegel. Little Bouquet in a Clay Jar. Flanders, c. 1599. Oil on panel, 20" × 15.75". Kunsthistorisches Museum, Vienna. To reveiw information on this painting, see figures 5.1 and 19.13.

and also specialized in painting flowers, which he did with great skill and sensitivity. His son, Jan Bruegel II, painted so much like his father that many of their works are indistinguishable.

Text Link
Pieter Bruegel the Elder painted The Harvesters
(figure 6.18).

Historically, many artists were trained by the apprentice method. A promising young person works directly as an apprentice with a practicing artist to learn materials, manual skills, and styles. Some very skilled appren-

tices actually make part of the master's artwork, but the final product is owned by and credited to the master artist. Leonardo da Vinci was apprenticed for many years to the artist Andrea del Verrocchio, and painted parts of Verrocchio's paintings, for example, the face of an angel in one Verrocchio baptismal painting. Michelangelo was apprenticed to the Florentine painter, Domenico Ghirlandaio, and he also worked with the sculptor Bertoldo di Giovanni, in addition to studying the art of previous Italian artists and the art of ancient Rome. Among the Yoruba artists in modern Africa, "the final sharp cutting is best done by the master" while apprentices do the "mechanical aspects of the work, and as their skill increases, more and more is

entrusted to them" (Fr. Kevin Carroll, quoted in Willett 1993: 236).

Specialized societies sometimes preserve technical information important in the training of artists, and regulate art making. Guilds in Medieval Europe were prime examples of such organizations. Guilds were unions that protected artists' interests, just as they did for other professionals like goldsmiths, stone workers, weavers, barrelmakers, bakers, and so on. Sometimes, guilds resulted in unusual groupings. For example, in Medieval Florence, painters belonged to the guild of "Medici e Speziali" (physicians) and sculptors belonged to the "Fabbricanti" guild (builders) or to the Goldsmiths guild, which included jewelers.

Art academies are a more recent invention for the training of artists, where systematized art instruction occurred in schools. Among their many functions, academies generally 1) provide art training for students; 2) sponsor lectures in theory and set aesthetic standards; and 3) accept mature artists as members, which allow them to receive more commissions.

An early example of academy-like training comes from thirteenth to seventeenth-century Persia (Iran). The "kitab-khana" were libraries that produced fine illuminated manuscripts executed by highly trained Islamic artists from these periods. The libraries were centers of learning and studios of book production, where students were taught the fine art of calligraphy and illumination. The kitab-khana eventually spread to India under the Mughal shahs, where this tradition of art training continued.

Text Link

Babur Supervising the Layout of the Garden of Fidelity (figure 19.14) is an example of a royal manuscript produced in Mughal India.

The first academy in Europe appeared in fifteenthcentury Italy. In part, academies helped break the power of the guilds, which to some extent were stifling innovation because their regulations imposed uniformity. Academies were usually supported by the state or some powerful patron, and often used by them. For example, in 1648, France's King Louis XIV founded the powerful Royal Academy (Académie Royale de Peinture et de Sculpture). Through his ministers, the king controlled high-level art production throughout France to promote his own power and fame. This included the decorative arts, architecture, painting, and landscape architecture. The Hall of Mirrors (figure 20.3) at Versailles is but one example of art produced through the academy. Among mature artists, only those whose work conformed to certain standards received commissions.

Modern art education in the United States now takes place most often in a college or university. Many artists now have a Master of Fine Arts degree from a university as their final art training, although most MFA programs date only from the 1960s. Prior to that time, most U.S. artists were either academy-trained or studied with established artists. Even in the university, however, the apprentice method persists in internships, where students receive college credit for working with art professionals.

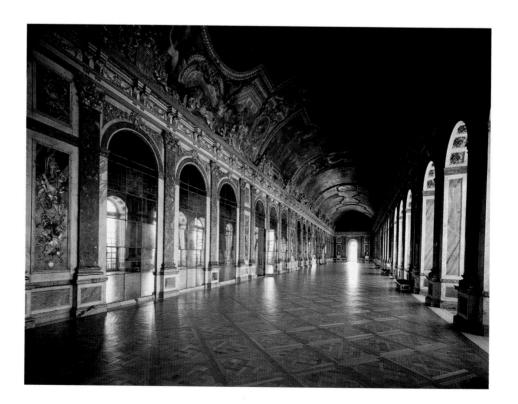

20.3 Jules Hardouin Mansart, Charles Le Brun. *Hall of Mirrors*. Versailles, France, c. 1680. See also the text accompanying figures 3.10 and 12.19.

Some artists are self-taught, meaning that they have received no formal art training. Many self-taught artists have learned from other images and works of art, and so their art reflects the current culture. Others work in isolation. Their output is generally categorized as naive art, primitive art, or folk art, since it is produced without education, and outside the current aesthetic standards.

Text Link
Simon Rodia's Watts Towers (figure
16.29) are the product of an untrained
artist.

The Context for Art Making

Who makes the art object? Sometimes the artist, and sometimes others, as we will see.

Workshops

Workshops are businesses composed of apprentices, assistants, and specialists who operate under the name of a master artist. The specialists might prepare art materials, excel at certain crafts, or handle the workshop's business affairs. Workshops can produce a prodigious amount of artwork.

Workshops associated with famous artists are fairly common among important sculptors in Africa. The Yoruban sculptor, Olowe of Ise, was so prominent and respected that he was responsible for carvings in a number of palaces in Nigeria, such as the *Veranda Sculptures* for the Palace at Ikere, dated 1910–1914 (figure 20.4). After receiving an important commission, he and his assistants often traveled to the site, where they would be housed and fed while they completed their work.

Likewise, much European art of the last several centuries is the product of workshops. Peter Paul Rubens was an enormously successful artist who is credited with producing a vast number of important paintings for many of the nobles and royalty of Europe in the early seventeenth century. However, to meet the demand for his work, Rubens employed at times as many as two hundred assistants and apprentices. Rubens himself would generally develop the color scheme and composition for a painting, often as a very small oil sketch. Assistants would enlarge the sketch as a drawing, prepare a canvas, transfer the drawing to canvas, and put down underpainting. Rubens' best assistants painted much of the final work. Anthony Van Dyck, who became a well-known portrait painter after working in Rubens' workshop, painted substantial amounts of Rubens' Abduction of the Daughters of Leucippus (figure 20.5), from 1617. Rubens would do important parts such as the faces, and then

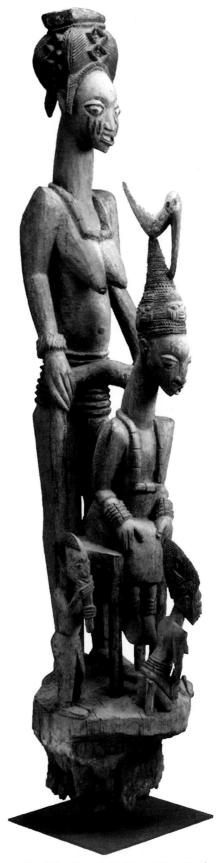

20.4 Olowe of Ise. *Palace Veranda Sculpture at Ikere.* Yoruba peoples, Nigeria, 1910–1914. Wood and pigment. See also the text accompanying figures 4.2, 5.13, and 12.21.

20.5 PETER PAUL RUBENS. Abduction of the Daughters of Leucippus. Flanders 1617. Oil on canvas, approximately 7'3" × 6'10". Alte Pinakothek, Munich. This painting is also discussed in Chapter 17, figure 17.21.

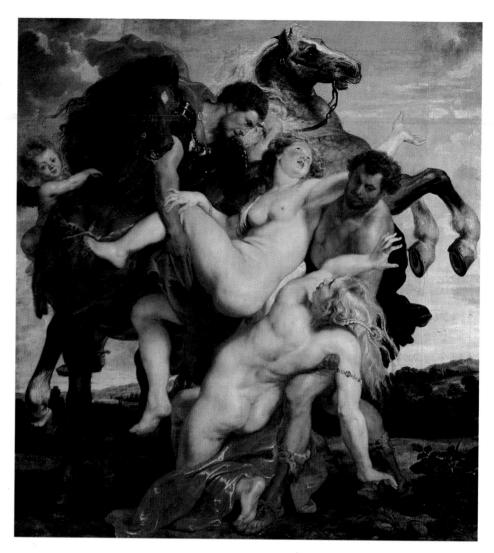

finishing touches once the painting was installed in its final location.

Rubens was assisted also by other established professional artists. For example, a landscape professional would do landscapes in his paintings. Jan Bruegel, whose Little Bouquet in a Clay Jar we have seen, worked on some of Rubens' paintings, doing the flowers and background landscapes. Bruegel himself maintained a busy workshop for his own work, which was highly successful.

If patrons were important enough, they might specify in a contract that more of the final painting was to be done by "the master," Rubens himself. For example, Rubens apparently painted almost entirely by himself a cycle of paintings for the Queen Mother of France, Maria de' Medici.

The Rent Collection Courtyard, dated 1965 (figure 20.6) is the product of artists working in a workshop-like situation. The Rent Collection Courtyard is a tableau of over one hundred life-size figures made out of clay that illustrate scenes of repression from China's past, when powerful landlords grimly exploited peasant laborers, whom we

see here offering their harvest to pay the landlord's excessive rent and taxes. The work was completed by a team of amateur and professional sculptors working together, under the leadership of Ye Yushan at the Sichuan Academy. Almost any work of art that is large in scale requires the coordinated efforts of a workshop.

Community Art Making

In community art making, large groups of people contribute directly to the production of a work of art. In some cases, they control to some extent what their contribution looks like. In community art making, the art is produced by people not normally considered specialists.

In community art making, large groups of people collectively realize a big project. One example is *Chartres Cathedral*, dated 1194–1220 (figure 20.7), one of the large, impressive churches built in northern Europe from the twelfth through the fourteenth centuries. These churches were almost all located in cities, and were symbols of community pride. Their construction required the collective effort of an army of craftsmen,

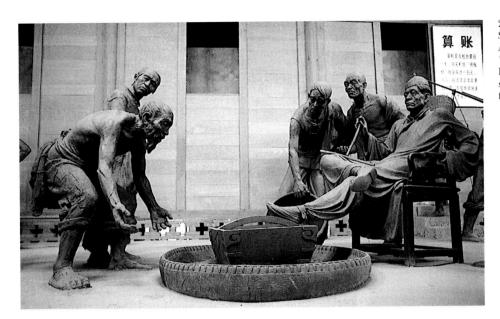

20.6 YE YUSHAN AND A TEAM OF SCULPTORS FROM THE SICHUAN ACADEMY OF FINE ARTS, CHONGGQING. The Rent Collection Courtyard (detail). Dayi, Sichuan, China, 1965. Clay, lifesize figures. To review this work, see figure 14.13.

from sculptors to stained-glass makers, to stone masons, woodworkers, and so on. But the people of Chartres, from the wealthy to the poor, also contributed. Not only did they substantially pay for the church, which we will discuss more on page 559, but they contributed their labor. Abbot Haimon wrote an eyewitness account in a letter that describes the townspeople dragging building materials and food to the construction site:

... Who has ever seen!—Who has ever heard tell, in times past, that powerful princes ... nobles, men and women, have bent their proud and haughty necks to the harness of carts, and that, like beasts of burden, they have dragged to the abode of Christ these waggons, loaded with wines, grains, oil, stone, wood and all that is necessary for the wants of life, or for the construction of the church? (Holt 1947: 45)

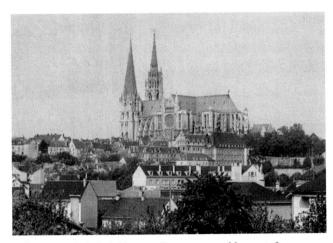

20.7 Chartres Cathedral. Chartres, France, some older parts from 1145–1170, bulk of exterior from 1194–1220. See also figures 10.24, 10.25 and 10.26.

Among the Hindu-Balinese people on the South Pacific island of Bali, almost everyone makes art, either visual art, dance, or music, although certain persons are recognized as teachers or people of superior ability. Art, religion, and social institutions are completely intertwined. The visual arts alone consist of stone temples with carved reliefs, wooden pagodas, wooden statues for smaller shrines, paintings, large decorated cremation towers used in funerals, items for personal adornment, masks for performances, textiles, small sculptures made of baked dough, and food offerings for temples. An example of a temple food offering is Offering with Cili-Shaped Crown, dated c. 1985 (figure 20.8). Offerings like this exist but a short time, but the obvious care and skill that went into this indicate the significance of art in everyday life. A ceramic basin forms the base, onto which are artfully arranged flowers, colored rice cakes, and palm leaves cut and woven into intricate patterns.

The AIDS Memorial Quilt, begun in 1989 (figure 20.9), provides us with another example of community art making. The AIDS Memorial Quilt is a composite of thousands of 3' × 6' panels, each made by an ordinary person who lost someone to AIDS. It is a collection of individual remembrances, and each remembrance is an equal contribution to the fabric of the whole. The people who made the panels communicated their love and loss in ways that may be naive or may be sophisticated, but collectively are very moving.

The Quilt is an ongoing project, ever growing in size, that is organized by the Names Project, begun by gay activist Cleve Jones in San Francisco in the 1980s. It is also used as a fundraising tool for AIDS research. As an ongoing community work in progress, it welcomes contributions from whoever puts themselves forward. The Quilt can be found on the Internet, again a sign of accessible community-level art. It has been the subject of

20.8 Offering with Cili-shaped Crown. Bali, c. 1985. Flowers, fruit and palm leaves, approximately 24' tall. See figure 9.20 to review this work and sacred offerings.

20.10 ROBERT SMITHSON. *Earthwork*. Great Salt Lake, Utah, USA, 1970. Black rocks, salt crystal, red water, algae, 1,500 feet long, 15 feet wide. To review this artwork see figure 19.17.

books and documentaries, and was nominated for the 1989 Nobel Prize for Peace.

Hiring Out the Making of Art

A lot of artists hire others to make their artwork, either totally or partially. Many printmakers hire other printers to make their editions of prints. Many artists hire fabricators to make part or all of their artworks, especially if the fabrication requires skills that the artists do not have. Many sculptors make their work in clay, and then have a commercial foundry cast the work in bronze.

Robert Smithson's *Spiral Jetty*, dated 1970 (figure 20.10), is a long spiral of rock that extended outward into the Great Salt Lake in Utah. Smithson required the assistance of an engineer to plan the work, and then hired a construction crew to make this piece about the

20.9 AIDS Memorial Quilt. Displayed on the Mall, Washington D.C.; organized by the Names Project, San Francisco, USA, October 11, 1996. Look back to figure 11.33 to review information on the Quilt.

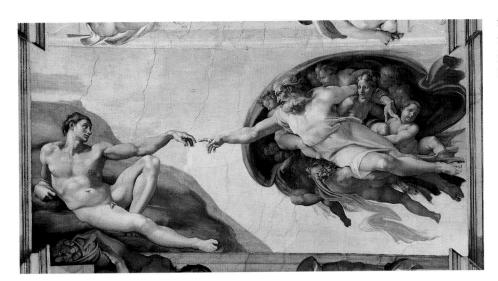

20.11 MICHELANGELO. Creation of Adam. The Vatican, Rome, Italy, 1208–1512, Fresco, 18'8" × 9'2". Review figure 9.31 for more on this painting.

human manipulation of the earth, energy potential, and the passage of time.

The Artist as Object Maker

In many cases, individual artists make their own artwork. This happens most often (but not always!) with relatively small scale work where hands-on involvement is easier. Some enjoy the pleasure of making art along with the pleasure of conceiving of it. But there are other reasons, too.

Michelangelo Buonarroti did most of the painting on the colossal *Sistine Ceiling* because he was dissatisfied with the work that collaborators did. The *Creation of Adam*, 1508–1512 (figure 20.11), about 170 square feet, is only one-thirtieth of the entire ceiling area! Michelangelo had a theological advisor help determine the themes of the panels, and assistants who helped him prepare to work. He also had others help paint decorative detail, and some of the early figures. But the vast majority of the ceiling's three hundred human figures, so grandly drawn and brightly painted, were from Michelangelo's hand.

We saw that Peter Paul Rubens would complete a work with his own hand if an important patron insisted upon it. And although he ran a successful workshop, Jan Bruegel likely painted the Little Bouquet in a Clay Jar, (figure 20.2). Vincent Van Gogh painted all his own paintings, such as Portrait of Dr. Gachet, dated 1890 (figure 20.12). He worked at an amazing pace. He painted 70 paintings in the last 65 days of his life. Van Gogh saw the act of painting as overwhelmingly important. He wrote to his brother Theo, "In life and in painting too I can easily do without God, but I cannot—I who suffer—do without something that is bigger than I, that is my life: the power to create." Van Gogh's strong colors and bold slashes of paint reflect his own passionate involvement with art making. Because of the way he worked and his ideas about creativity, it would have been inconceivable for Van Gogh to hire someone else to work on his art.

Much of Yayoi Kusama's work is incredibly laborintensive, such as *Accumulation No. 1*, dated 1962 (figure 20.13), where she sewed phallic-like protrusions onto a chair, which became part of a whole environment similarly covered. She applied other kinds of patterns to other surfaces in a similarly overwhelming, almost menacing way. The labor-intensive quality of her work fit its themes, which included compulsion, self-obliteration, "women's work," uncontrolled consumption, problematic sexuality, and the effects of pervasive

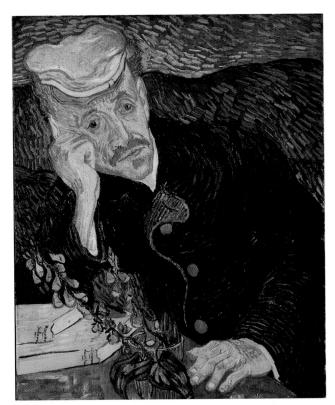

20.12 Vincent Van Gogh. Portrait of Dr. Gachet. Dutch, 1890. Oil on canvas, $26^{\prime\prime}\times66^{\prime\prime}.$ See also the text accompanying figures 5.12 and 15.3.

20.13 Yayoi Kusama. Accumulation No. 1. Japan, 1962. Sewn stuffed fabric, paint, fringe on chair frame, 37" × 39" × 43". Beatrice Perry Family Collection. Look back to figure 14.22 for more on this sculpture.

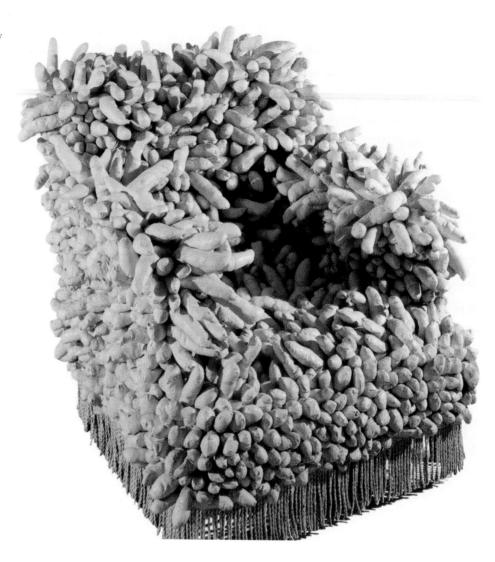

paternalism on the human individual and the human environment.

Collaborations

There are many instances in which art making is a collaborative activity among professionals of equal standing. The knowledge and skill of each collaborator is essential to the final art product. Let us look at a few instances now.

Ukiyo-e prints from Japan are the products of professional collaboration, although usually only the artist's name is associated with an edition of prints. *Komurasaki of the Tamaya Teahouse* (figure 20.14) is credited to the artist Kitagawa Utamaro, who created the original drawing in black ink on thin paper. The next step was completed by the engraver, who glued the original drawing to a plank of cherry wood and cut out the printing block right through the original drawing, destroying it. The block had to be carefully cut to retain the amazingly graceful and fluid line quality. Once the first block was

completed, a proof was made and the artist would add color to the proof. Then other blocks were cut, one each for every color to be printed. Each block had to be the same size and perfectly aligned with all the other blocks.

The printer is the one who actually made ukiyo-eprints. The printer carefully applied paint thickened with rice paste to the surface of the block, placed a piece of mulberry-bark paper on top, and hand-rubbed the paper so that the paint transferred from the block to the paper. The printer really acted more as a painter, carefully mixing colors to get the right tones, subtle color transitions, and the correct edges. Each piece of paper had to be printed from several blocks until all colors were applied in order and the print was finished.

Two more professionals made substantial contributions to the production of a ukiyo-e print. The publisher commissioned the prints, selecting the three professionals to make an edition, paying the costs, and then distributing the final product. We know the names of many important publishers, such as Tsutaya Jusaburo and

Eijudo. The paper makers were the other important contributors to this process. The mulberry bark paper had to be tough, resilient, and beautifully textured. Colors had to print well on it. The performance and look of the paper were as essential to the final product as were any of the other processes.

Another example of artistic collaboration is the work of John James Audubon, who is well known for his books on birds and mammals of North America, such as *Birds of*

America. Carolina Parroquet, dated 1827–1838 (figure 20.15), is one of 435 plates from the book. Audubon himself created the original watercolors for the book, but it required the work of other professionals to bring Birds of America to fruition. The naturalist William McGillivray helped write the text for this book. Robert Havell, Jr., was the professional engraver who transformed almost all of Audubon's bird paintings into engravings that could be printed. Havell's contribution was essential for a

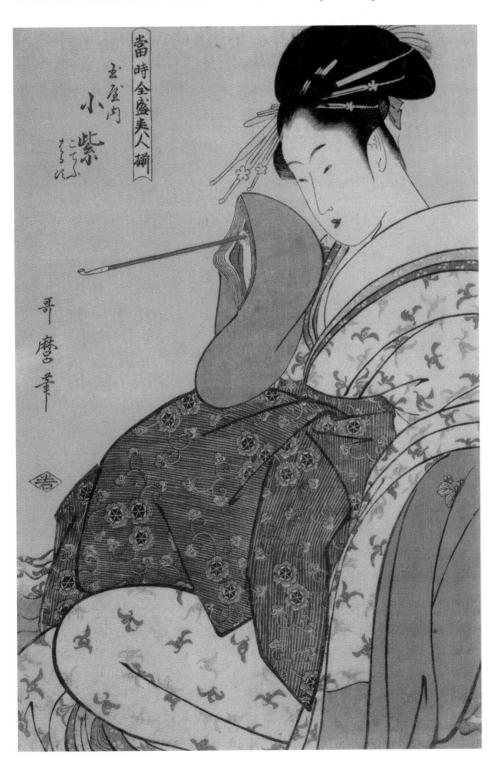

20.14 KITAGAWA UTAMARO. Komurasaki of the Tamaya Teahouse. Japan, 1794. Multi-colored woodblock print from the series "A Collection of Reigning Beauties". 10" × 15". Tokyo National Museum. Review figure 16.27 where this print's theme is discussed and also the relationship between class hierarchies and different kinds of art in nineteenth-century Japan.

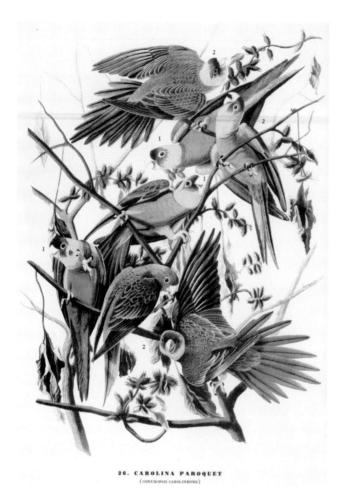

20.15 John James Audubon. Carolina Parroquet. USA, 1827–1838. Watercolor, 29½" × 21½". Original for Plate #26 of Birds of America. New York Historical Society, New York. Review information on this work accompanying figure 19.22.

successful book. So important was engraving quality that Audubon traveled to Europe to seek out the best professionals, not trusting anyone in North America at the time to have sufficient experience and skills.

If there was ever an art form where the collaboration was absolutely essential, it is film. Without the professional contributions of many, a film cannot be made, even though the director is usually given credit. An interesting example is *Citizen Kane*, dated 1941 (figure 20.16), a film by Orson Welles. Indeed, Welles deserved the credit more than most other directors do, because he also wrote and starred in the film, in addition to directing it. Yet even in this extreme example where one person is responsible for several aspects of the film, Welles still depended upon other actors, set builders, makeup artists, costumers, lightning technicians, camera operators, and so on.

THE ROLE OF ARTISTS IN VARIOUS CULTURES

Now that we have some information about artists, how they are trained, and how artwork is made, let us look at the different roles artist fill within their cultures. The artist's position in society reflects how that culture uses art, how it values art, and what it expect the artists to do. Let us look first at instances when art making is an activity linked to gender.

Art Making Based on Gender

In some cultures, certain art objects are made by men and others by women. This usually reflects the different roles, rights, and responsibilities of males and females

20.16 Orson Wells. Citizen Kane. USA, 1941. Written, directed, produced, and starring Orson Wells. Look back to the discussion of the content and significance of the film accompanying figure 16.13.

20.17 Iktinos and Kallikrates. Parthenon. Athens, Greece, c. 447–432 bc. Pentelic marble, height of columns 34', dimensions of structure $228'' \times 104''$. See also the text accompanying figures 3.4, 10.14, and 21.8.

within their social groups. For example, the major architectural monuments and the sculpture of the ancient Greeks, such as those on the *Acropolis* in Athens, dated 447–432 BC (figure 20.17), were all made by men. These monuments were symbols of the political power, leadership role, and achievements in the arts of the city-state of Athens. The fact that men only were responsible for the design and building of these monuments reflects the realities of Greek society, where women were secluded in their homes and excluded from political and public life.

Figure 20.18 is an example of Navajo sand painting, entitled Nightway: Whirling Logs. We will discuss this painting in greater depth later in this chapter, but for the moment what is important is that Navajo sand paintings are almost all made by men. This is because the sand paintings are part of ritual ceremonies, and men are the ceremonialists among the Navajo. Women produce other arts, primarily the weavings. Interestingly, this reflects broader Navajo philosophy about the nature of men and women. In order for sand paintings to be effective, each must look like its traditional prototype, or the ceremony may not achieve its desired results. That strict conformity to tradition fits the Navajo concept of men, who are seen as being static in nature. Women, by contrast, are seen in Navajo philosophy as dynamic, and in their weaving designs they are always aspiring to innovation and unique designs. Each work is new. (Anderson 1990: 98, 107)

Among the various tribes of the Sepik region in Papua New Guinea, art making is men's work and they produce a vast amount of visual art for ritual purposes. Art making and rituals create male solidarity in a tribe, and protect their power from threats posed by women in general, or by hostile men in other tribes. Men collectively build large cult houses and then fill these houses

with sculptures and paintings, such as the *Painting from a Cult House* at Slei (figure 20.19). Individual men, with the help of a master artist, also produce paintings and carvings, and then through rituals invest their spirit and power in these works. The art is the vehicle by which an

20.18 Nightway: Whirling Logs. Reproduction of a Navajo sandpainting, painted by Franc J. Newcomb. Native American, prior to 1933, 22%" × 28%". Wheelwright Museum of the American Indian, Santa Fe, New Mexico. See also the text accompanying figures 2.18 and 10.3.

20.19 Painting from a Cult House at Slei, middle Sepik region, Papua New Guinea, c. 20th century. Palm leaves on a bamboo frame, painted earth pigments, 44" × 61.5". Museum für Völkerkunde, Basle. Review the information on Sepik rituals and artworks with figures 17.17 through 17.20.

older man can pass his spirit to a younger man at an earlier stage of ritual development. That younger man, in turn, will later do the same. By these means, the collective power and knowledge of the men is preserved within their group.

The Artist as Skilled Worker

In some cultures, artists are skilled workers or laborers. The names of the craftsmen who worked on *Chartres Cathedral* are unknown to us today, as were almost all medieval artists. Medieval artists were not famous "personalities," but more like union members, people of skill who were part of a new, emerging middle class.

Among the Baule people of Western Africa (Ivory Coast), artists are skilled professionals. A sculpture like the Male Torso, dated c. nineteenth to twentieth century (figure 20.20), required considerable time to make. Very skilled carvers are accorded great honor and prestige and are paid well. However, among the Baule, the name of the owner is associated with a sculpture, not the artist who made it. This is because the spiritual purposes for which the work was made are more important than its appearance, and it is the owner of the piece who performs rituals and develops its spiritual cult. A sculpture such as this can be equally effective ritualistically, whether it is well made or badly made. In addition, a spirit piece would be less effective the more its human maker was emphasized. For all these reasons, artists are remotely connected to the work they make. Interestingly, Baule artworks are not meant for sustained visual display, like Western art. Our example was likely hidden away in a personal shrine in the home, and may not have been seen even by other family members. Even for Baule masks, which are made for elaborate public

rituals, the visual impression is usually blurred, as each mask is used in dance for only a short time along with singing, dancing, and dramatic effects. At other times, the mask is kept out of public sight.

We see a variation of the artist as skilled worker in the Rent Collection Courtyard (figure 20.6), which is officially credited to an anonymous team of eighteen amateur and professional sculptors. In fact, we do know the names of many who worked on this large piece. But significantly, the posture of anonymity and collective action was important for all artworks sponsored by the Communist government of China from the 1950s until the late 1980s. Like the rest of the Chinese economy, where private gain was outlawed and replaced by collective ownership of all Chinese assets, the practice of art also was reformed by Mao Zedong. Artists did not make names for themselves, but produced work for the common good, without seeking personal glory or self enrichment.

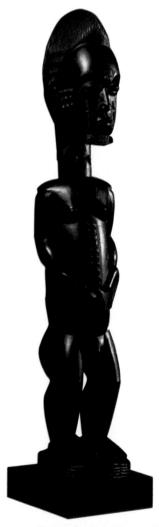

20.20 *Male Torso* (Ancestor figure). Baule sculpture, Africa, c. twentieth century. Wood, 20.5" high. The British Museum, London. See also the text accompanying figures 5.2 and 15.13.

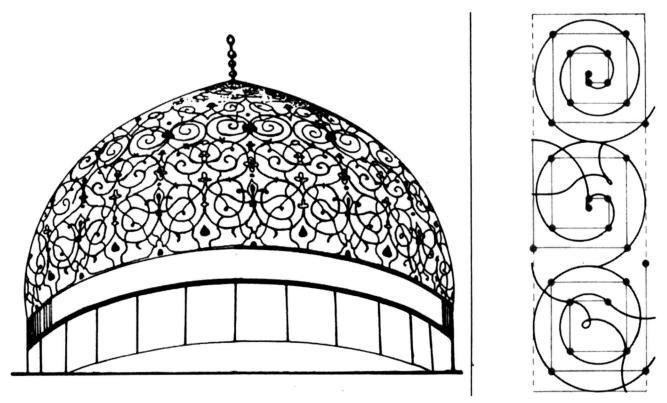

20.21 Diagram of the dome of the Masjid-i-Shah, or Royal Mosque. Iran, Islamic, 1612–1637. The left diagram shows the pattern design on the dome, while the three on the right show the interrelatedness of the square and circle, and the geometric basis of the patterns. Review the information on the Masjid-i-Shah mosque in Chapter 10, figures 10.29 and 10.30.

The Artist Scientist

What is the relationship between art and science, mathematics and geometry? Are these unrelated disciplines, even polar opposites? In some cultures, art and science are seen as related means of understanding the spiritual or natural world. Let us look at a few instances of that now.

Art, mathematics, geometry, and architecture are all means of finding sense and order in the cosmos in many Islamic cultures, especially those of Persia and the Middle East. Over and over again, Islamic artists and architects combined art and geometry into patterns that were both visually beautiful and religiously significant. In the Islamic religion, the Creator is considered one with creation. The entire universe is of one unity, although there seems to be a great deal of diversity or even chaos in nature. Islamic math, geometry, art, and architecture emphasize pattern as a means of overcoming the apparent contradiction between unity and diversity. Pattern can seem infinitely varied and proliferate in many directions, but the element of repetition gives all its abundance an underlying geometric unity.

We will look now at a drawing of the pattern on the dome of the *Masjid-i-Shah*, or Royal Mosque of Isfahan, dated 1612 (figure 20.21). The dome patterns express endless variety, but we can unify the pattern through its

underlying geometric grid, which implies the Creator behind the created. The intricate designs have no beginning and no end, a metaphor for the infinite spirit and energy of Allah. The three smaller diagrams to the right show how the curvilinear pattern on the dome was developed geometrically through spirals superimposed on squares. The interrelatedness of curve and square was elaborated by Islamic philosophers from the tenth century, when they saw the square as representing what was rigid, inert, cold, and earthbound, like rocks and crystals, whereas the circle represented heat, organic things, movement and closeness to the Creator. The dome shape also is significant. The circular base of the dome has no beginning and no end, and so also expresses infinity. The circular dome (= heaven) sits above the square structure below (= earth).

At various times, the role of scientist has been combined with that of artist, mostly for the purpose of understanding, depicting, or manipulating the physical world. One of the most famous of all Western artist-scientists is Leonardo da Vinci. While he is well-known for two paintings, the *Last Supper* (figure 20.22) and the *Mona Lisa*, he also wrote many notebooks full of scientific information, based on his own observations. The notebooks cover the study of plants (botany), the human

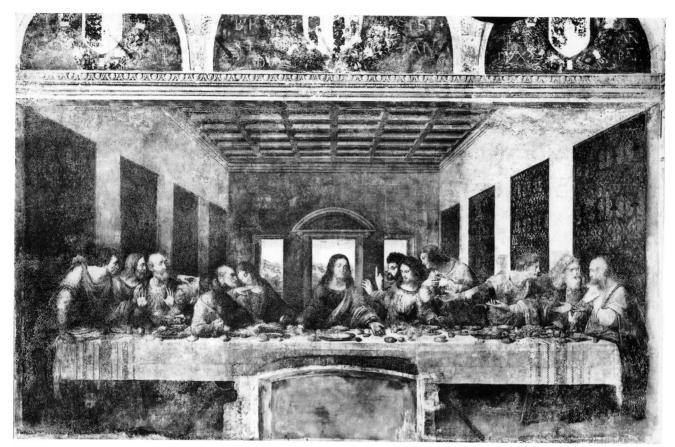

20.22 LEONARDO DA VINCI. Last Supper. Milan, Italy, 1495–1498. Experimental paint on plaster, $14'5'' \times 28'$. See also the text accompanying figures 2.21, 6.27, 21.4, and 21.24.

body (anatomy), water movement (hydraulics), animals (zoology), rocks (geology), vision (optics), and physics, including mechanics, light, and weapon design. In a letter to the duke of Mantua, Leonardo outlined his many skills, as he was seeking a position in the duke's court. Interestingly, he does not list his skills as an artist first:

I have a sort of extremely light and strong bridges, adapted to be most easily carried, and with them you may pursue, and at any time flee from the enemy. . . . And if the fight should be at sea I have kinds of many machines most efficient for offence and defence; and vessels which will resist the attack of the largest guns. . . . In case of need I will make big guns, mortars and light ordnance of fine and useful forms. . . . In times of peace I believe I can give perfect satisfaction. . . . in architecture and the composition of buildings, public and private; and in guiding water from one place to another. . . . I can carry out sculpture in marble, bronze, or clay, and also I can do in painting whatever may be done, as well as any other, be he whom he may (Holt 1947: 169–170).

Leonardo da Vinci relied on his keen visual observation to investigate and even excel in all these areas of activity. To Leonardo, observation was essential to understanding the mechanics and the beauty of the world, and thus the foundation of both science and art. Careful observation held more authority for Leonardo than did the authority of religion or the art and writing of antiquity. In this, he very much reflected a growing attitude in the Renaissance, an attitude we see in Leonardo's own writing:

... Now do you not see that the eye embraces the beauty of the whole world? It is the lord of astronomy and the maker of cosmography; it counsels and corrects all the arts of mankind; ... it is the prince of mathematics, its sciences are certain; it has measured the heights and sizes of the stars, it has found the elements and their locations ... has generated architecture, perspective and the divine art of painting. (Hartt 1969: 387)

Leonardo never realized most of his ideas, although his writings continue to inspire the imaginations of inventors and thinkers to the present day. Some ideas were ahead of their time, such as an automotive machine equipped with a differential transmission, but which lacked a power source to make it move. Sometimes Leonardo's inventiveness resulted in disaster. The *Last Supper* is in a ruined state. Leonardo experimented with

a new painting medium combining oil- and water-based paint that could be painted on a plaster wall and also dry slowly. His new medium did result in a painting that was more subtle than fresco's normally bright colors and harsh edges, and the *Last Supper* was immediately admired as a masterpiece. But within twenty years, the experimental medium had already begun to deteriorate.

Text Link

The Last Supper has been recently restored again, as have Michelangelo's paintings on the ceiling of the Sistine Chapel. Both restorations resulted in brighter colors than most people expected, and also controversy about whether too much old paint had been removed during the cleaning process. For more, see the section on "Restoration" in Chapter 21.

As we previously mentioned, John James Audubon's *Birds of America* is recognized as the outstanding work in ornithology of its day. Although he is occasionally criticized for placing birds in fanciful poses, Audubon's images and notes are valuable scientific records. For example, he wrote the following eyewitness account about the passenger pigeon, a bird once common in North America. "The air was literally filled with pigeons; the light of noonday was obscured as by an eclipse..." he wrote (from the article, "Animal Behaviour" in Britannica Online). He made mathematical calculations about the numbers of pigeons, estimating better than one billion birds in a single flock. Since the passenger pigeon was hunted to extinction by 1900, Audubon's records are particularly important.

The Artist Priest

Art is often a vehicle for spirituality. The artist who makes spiritual art is sometimes also a holy person, priest, or shaman.

The sculpture *God Te Rongo and His Three Sons*, dated c. 1800–1900 (figure 20.23) is a representation of a deity from the Cook Islands in Polynesia and is connected to virility and human reproduction. A carving such as this was used and reused in religious rituals, passed down through generations, and only the group's most important leaders would have access to it. The sculptors who created ritual pieces such as *Te Rongo* were specialists called Ta'unga, a word that also means priest. Such sculptors were trained for a long time as apprentices, not only to learn the skills of carving and finishing pieces, but also to attain the spiritual knowledge to tap into and control the inherent power of their tools and the materials they used.

There is sometimes a tie between sacred writing and art making. During the early Medieval period in Europe, one of the major art forms was illuminated manuscripts, which were hand-written and illustrated prayer books or

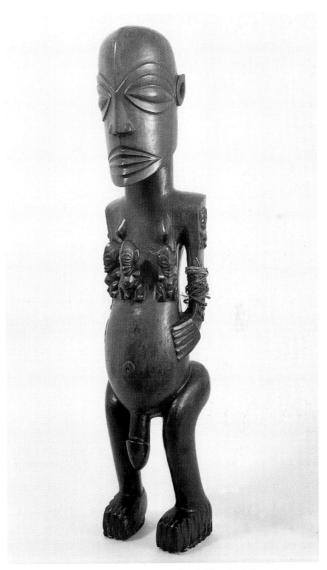

20.23 God Te Rongo and His Three Sons. Cook Islands, Polynesia, c. 1800–1900s. Wood, 27%" high. British Museum, London. See figure 7.5 to review the information on the meaning behind this sculpture.

Bibles. Monks in monasteries made them. Calligraphic writings of 22 verses of the Quran adorn the Taj Mahal (figure 11.21) and the calligraphy was designed by the artist Amanat Khan, who also selected many of the verses. The combination of his knowledge of the Quran and his skill as an artist/calligrapher was considered so significant and essential that of all the craftsmen, builders, and architects who worked on the design and construction of the Taj Mahal, Amanat Khan is the only person whose name we know. His signature appears on the south portal of the Taj Mahal. Calligraphy is an important Islamic art form. Amanat Khan's calligraphy is particularly refined and accomplished and excellent. Other anonymous craftsmen enlarged his calligraphic letters, transferred the design to stone, cut the black stone into the shapes of the calligraphic letters, and then inlaid the black into white marble. You can see an

20.24 Two details from the interior of the Taj Mahal, Agra, India, 1632–1654. Marble inlaid with colored tile and semiprecious stones. See figures 11.21 and 11.22 for information on the structure of this building, its history, its decoration and the significance of its gardens.

example of calligraphic lettering from the Taj Mahal in the left of figure 20.24.

As we have seen, the men who make Navajo sand paintings are also the ones who perform sacred ceremonies called sings. Sings are held to cure someone who is sick, for success in hunting, for the fertility of the earth, or for general well-being. The longest and most elaborate sing may last nine days and nights, with singing all through the night, chants and prayers by day, ritual cleaning, and sand painting. The narrative in sings most often recalls mythic beings and stories of creation, harking back to the origin of time when all was filled with beauty, harmony, and health. Our example, Nightway: Whirling Logs (figure 20.18), was made to promote fertility. With other paintings done for healing ceremonies, the patient sits in the center of the painting to absorb the healing power. Certain pigments of the painting are rubbed onto the person's body to ensure the ritual's effectiveness. All sand paintings are made from memory, but must conform to the ancient prototype to be effective. And they can be quite large, as much as 25 feet across. Obviously, then, the Navajo sand painters are persons of amazing skill and ritual knowledge.

The Creative Genius

Some cultures believe that an artist is a creative genius, with almost transcendent abilities, operating in some way differently or on a higher plane than regular humans. The act of creating art is something extraordinary, magical, or divinely inspired, and beyond instruction or understanding.

Interestingly, the first name of an artist in recorded history has been associated with the concept of genius. Imhotep was an ancient Egyptian architect, priest, scribe, physician, and minister to the pharaoh. He was responsible for the design of the first pyramid, which predates by about 25 years the oldest of the *Great Pyramids* that we saw in figure 20.1. After his lifetime, Imhotep was worshiped as one of the Egyptian gods.

From Africa we have examples of artists whose abilities were so great that they were referred to in heroic and grand terms. Olowe of Ise, whose work we mentioned above (figure 20.4), was the subject of a poem of praise that referred to him as "handsome among his friends, outstanding among his peers" and speaks of the fame of his carving. Artist-geniuses seem to be above making mistakes, as seen in this description of another Yoruba artist named Bandele:

"No matter how complicated a work may be and though he has no drawing to guide him, Bandele never cuts away by accident any wood he may need later; he would be ashamed to have to add another piece." (Fr. Kevin Carroll, quoted in Willett 1993: 156)

However, the artist-genius does not emerge from just any environment, but is the product of favorable social circumstances:

"Constant suitable work is necessary for the full development of a carver's abilities. It was the group of carvers in a district—repeating the same themes and only gradually introducing new ones—which built up a cumulative genius capable of supporting the less gifted carvers. It was . . . this evolution as a group, rather than the religious intensity or emotion of the carvers, which gave much of its artistic power to the old carving. If sufficient carvers could be similarly employed—and fully employed—in modern times, the artistic level of the whole group would rise and individual geniuses would emerge." (Fr. Kevin Carroll, quoted in Willett 1993: 22–23)

In Europe the concept of the artist as a creative genius begins to emerge during the Renaissance, around the fourteenth century. As we have seen, prior to that time, in Medieval Europe, artists were considered skilled workers. But the rise of the philosophy of humanism changed that attitude. Humanism stresses the nature,

ideals, and interests of humans, while decreasing emphasis on the supernatural. Humanism asserts the dignity and value of individual persons. Learning is emphasized, especially in the humanities, science, and the arts. Humanism fosters an interest in the beauty of nature and human beings. The model person was not the holy recluse who rejected the world, but the intelligent, thoughtful, soulful person of the world.

During the Renaissance, the best artists were seen as possessing the divine gift of genius. The reward of genius was the cult of fame, a kind of immortality in which later generations would remember individuals' names and honor their achievements. Of supreme importance was human vision, both for science and for art, as we have seen with Leonardo da Vinci. The ability to see resulted in scientific discoveries and high achievements in art. The genius did not *blindly* follow the authority over personal observation.

Among the many artists of great ability working during the Renaissance, Michelangelo Buonarroti must rank near the top. His *Creation of Adam* (figure 20.11) reflects both the humanism of the era and the concept of genius. In Michelangelo's portrayal, Adam, the first human in Judeo-Christian sacred writings, looks very much like God, thus elevating humans to a God-like status. Significantly, this image illustrates a creation story. The artist is like God, whose divine energy brings life to inert material.

During the Romantic era in Europe, roughly 1750 to 1850, the notion of the artist as creative genius was augmented. The Romantics emphasized freedom, uniqueness, feeling, individuality, and imagination, and saw it exemplified in artist freedom and expressiveness. They were also interested in the sublime in art and in nature. These attitudes developed at the same time as capitalism was rising in Europe and the bourgeoisie saw themselves as self-made, unique individuals. The Romantic notion of artists as free, sensitive, individualistic, and strongly feeling persons contributed to the idea of the creative genius, unfettered by convention and social boundaries, but free feeling and moved by the heart instead of by reason.

A final variation of the idea of creative genius is the artist as the troubled, tragic, or alienated genius. Vincent van Gogh is a good example of such an artist. He was raised in a religious family, and worked for a while as a lay minister among the poor, but became exhausted in mind and body. When he turned to painting, he threw himself into his work between bouts of mental illness. His life was unhappy, as he was unable to make friend-ships and human connections that he sought. He committed suicide at age 37. However, his fame since then has grown tremendously as large exhibitions of his works have drawn record crowds to museums. His images appear on countless posters, and he has been celebrated as a tragic genius even in pop music!

The tragic, damaged, or alienated artist has become a kind of hero in industrialized nations today. Yayoi Kusama, who made *Accumulation No. 1* (figure 20.13), has voluntarily lived in a mental institution in Japan since 1977. She suffers from compulsive behavior and visual hallucinations. Her childhood was scarred by her early family life, the oppressive Japanese right-wing political state, and the devastation and deprivations of World War II. The following quote is from a recent museum catalog:

Daring—for better or worse—can be a by-product of true obsession, and Kusama has been daring, creating the art that she must against great odds. At another time we might have mythologized her in the manner of Vincent van Gogh and Jackson Pollock, romantic figures whose obsessive need to create was paralleled by an even stronger inclination to push the emotional and physical boundaries to the edge of self-destruction. If Kusama is heroic, it is for an opposite and arguably more prosaic reason. Rather than suffering for her art, she has used it to fight psychic disintegration. . . . Today, in the United States, much of the art world is disenchanted with movements . . . and global theories. Kusama—offbeat, relentless, and female—may be the only kind of hero that we can accept. (Zelevansky 1998: 31)

Rulers as Artists

Rulers sometimes have been responsible for the creation of important artworks. We will look at four instances below in which rulers either directly created artworks, or oversaw the creation of vast monuments according to their particular vision, and pushed forward by their own wills. Their motivation was either to promote group or national unity, or to promote their own personal power and prestige.

The Acropolis in Athens (figure 20.17) is the result of the vision of Pericles, a well-educated son of a nobleman and military leader, who ruled Athens from 449 until 429 BC. Athens had just been victorious in war, and the heroic spirit of the age moved Pericles to have several magnificent temples built on the Acropolis in a mere 23year time span. As he himself said, "What I would prefer is that you should fix your eyes every day on the greatness of Athens as she really is, and should fall in love with her" (Thucydides 1954: 118, 121). Pericles assembled an outstanding group of sculptors and architects, including Phidias, Mnesicles, Iktinos, and Kallikrates to design and supervise the work. But Pericles' vision was behind the totality of the project. Pericles also supported theater productions, gave all citizens free tickets to dramatic productions, and had built a music hall.

Among the Maori of New Zealand, sculptors were usually chiefs or members of ruling families. This was especially true for carvings in meeting houses, which are so important that it is seen as a fitting activity only for a leader. The meeting house reinforced clan identity. The clan gathered there for political and social events. Children were educated in clan history, with the carvings on the walls that represent their ancestors, like those on the back wall of *Te Mana O Turanga* (figure 20.25) from 1883. Thus the meeting house consolidates the group, just as effective leadership should.

Other leaders use art much more for personal prestige and power. In Western Asia, rulers have claimed the princely right to establish and lay out gardens. Garden building was considered an act of bringing order out of chaos, which is in a sense the role of a ruler. But the garden is also an environment of lushness and luxury, appropriate for royalty, especially in the harsh dry climate of the Middle East and Central Asia. The walled garden also separated the royal court from the rest of the people. Figure 20.26 shows Babur Supervising the Layout of the Garden of Fidelity. Babur was a Central Asian prince especially well known as a garden builder. This small painting, a hand-painted illustration from a book on Babur's life, shows Babur actively supervising planners and workers to determine the garden design and decide where the plantings should go.

Louis XIV, king of France from 1643 until 1715, is not considered an artist. However, he was responsible for the concept and the building of the opulent *Palace of Versailles*, with its vast gardens and lavish interiors. Unlike Pericles, who sought to glorify Athens, *Versailles* became the visual testament and the vehicle for creating Louis XIV's unparalleled greatness. An indication of the ex-

tent of Louis' influence is the fact that his name is more immediately associated with Versailles than is the name of any of its major architects or designers (Charles Le Brun, Jules Hardouin-Mansart, Louis Le Vau, or André Le Nôtre). Paintings, sculptures, architecture, furniture, and tapestries of the day were done in the "Louis XIV Style," as seen in the *Hall of Mirrors* (figure 20.3). Louis XIV recognized the power of art to communicate his fame and his power. He exercised his control by organizing the arts under the Royal Academy (see page 540). He was an absolute ruler, and that included ruling the arts.

SUPPORT FOR ART MAKING

There has to be support for artists to make art. Even though art is essential to a culture, it is an activity that can occur only when there is some kind of surplus—time, food, or money. Art reflects the needs, ideas, and aspirations not only of the artist, but also of the persons who pay for it.

There are three ways to support art making: 1) providing for the artists' living, by giving material goods or money; 2) commissioning artists to make a particular work of art and paying for it; and 3) buying a work of art that the artist has already made.

Family Support

In many cases, artists are supported by their family in their art making, either in the form of money or as released time from other responsibilities. Students, for

20.25 Raharuhi Rukupo and Others. Interior back wall of a Maori meeting house called *Te Mana O Turanga*, opened 1883. Carved and painted wood. See also figures 4.6, 12.23, 12.24, and 16.4 for more information on the entire Meeting House.

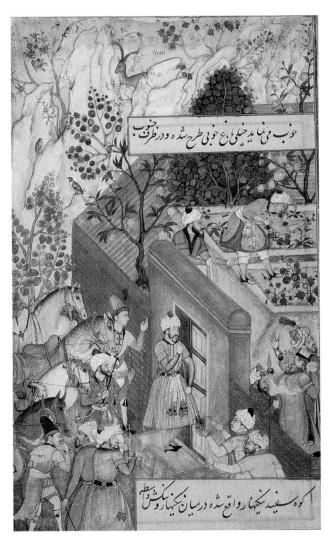

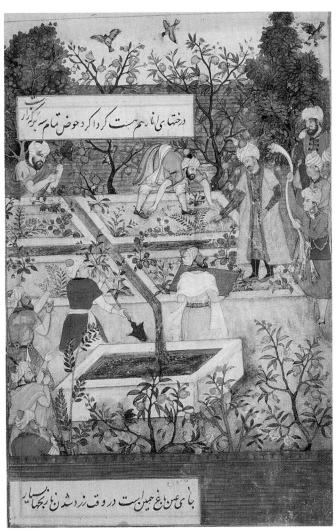

20.26 BISHNDAS, portraits by NANHA. Babur Supervising the Layout of the Garden of Fidelity. Mughal, India, c. 1590. Manuscript painting. Gouache and gold on paper, 8.4" × 5.5". Victoria and Albert Museum. See figures 2.23 and 19.14 to review the life of Babur, the use of gardens in Islamic cultures and the style of this work.

example, generally receive monetary support from their families. Sepik men work part-time as artists, and rely on their wives to attend to the tasks of day-to-day living to support their families. John James Audubon's wife helped support the family while he made the paintings for *Birds of America*, in addition to his being a taxidermist, portrait painter, and drawing instructor. Later in life, his sons assisted him in his paintings.

Vincent van Gogh was dependent upon his brother Theo for emotional and monetary support. As an art dealer in Paris, Theo introduced Vincent to Impressionist painting. He supported Vincent when he needed money, bought his art supplies, and paid for his trips to the south of France which were so influential on Vincent's style. In return, Vincent sent most of his finished paintings to Theo in Paris, and confided in him in long letters. Theo inherited Vincent's unsold paintings after Vincent's death.

Ordinary People

Ordinary people, as individuals and in groups, support art that is important to them.

We saw that ordinary people assisted in the building of *Chartres Cathedral* (figure 20.7), and also paid for it, along with funding from royalty, nobility, and leading churchmen from around France. In addition, people from all over Europe made pilgrimages to Chartres' religious shrines and donated money for the building of the church.

Much of Baule sculpture like *Male Torso* (figure 20.20) is commissioned by ordinary individuals for their personal shrines. Among the Baule, all artwork is owned by individuals. People either commission art to be made, or they inherit the work from another in their family. When they commission a piece, they usually specify how they want it to look, which they have determined either through their dreams or with the help of

diviners. The cost is high, and so everyone cannot afford sculpture.

The AIDS Memorial Quilt (figure 20.9) is funded by private donations.

The University

In the United States today, many contemporary artists make their livings as teachers in colleges and universities. Artist-teachers have a stimulating work environment, a living wage, and sufficient free time to make their work. Art making is generally seen as a form of research, and the mission of the university is to promote learning and research in all disciplines. The support of universities makes it possible for artists to make work that is not market-driven; in other words, artists are not dependent upon sales to keep working. This allows them freedom to experiment with new art forms.

Religions

In earlier chapters in this book, we have seen that a lot of art throughout the world is made for religious reasons: to honor a deity, to provide a place of worship, or to tend to the dead. These religious works of art may be made as part of everyday life, as with Balinese religious art. They may be financed by ordinary people, such as *Chartres Cathedral*, funded by rulers (see below), or commissioned by religious groups.

Michelangelo's painting of the *Sistine Ceiling* (figure 20.11) was financed by Pope Julius II. Julius was both a religious and secular leader. In addition to leading the Catholic church, he also ruled over large areas of central Italy, undertook a war against France, subdued the nobility under his control, and began a program to rebuild and modernize Rome. When Julius first proposed the project to him, Michelangelo tried to get out of it, claiming to be a sculptor rather than a painter. The relation between Michelangelo and Julius was often stormy for the four years it took to complete the work. Julius once hit Michelangelo with a cane and also threatened to throw the artist off the scaffold, so impatient was the pope to see the painting done.

Rulers as Patrons

A tremendous amount of the art produced all over the world serves the purposes of rulers. Already in this chapter, we could include Prince Babur and Louis XIV as great patrons of the arts. The money rulers have spent on artwork came from taxes levied on the general population, trade tariffs, tribute payments by satellite states, and profits from wars.

The pharaohs Menkaure, Khafre, and Khufu had the pyramids built not only to be their final resting place, but also to be monuments to their greatness as sons of the Egyptian sun god. The *Taj Mahal*, in figure 20.24, was built by Shah Jahan, the ruler of the Mughal Empire in India. It was made as a final resting place for himself and his wife, Mumtaz Mahal. Shah Abbas, ruler of

Persia, had the *Masjid-i-Shah* (figure 20.21) built as part of an overall urban renewal plan for his capital city of Isfahan. Local rulers in Nigeria commissioned Olowe of Ise to make carvings for their palaces, like the Palace at Ikere. An early supporter of the publication of Audubon's *Birds of America* (figure 20.15) was the king of England.

The Medici were a famous and powerful family who produced four generations of rulers in Italy. Not only were they leaders, but they championed the arts and were patrons to many fine artists during the Renaissance, including Michelangelo and Verrocchio. Two of these famous patrons, referred to as "merchant princes," Cosimo and Lorenzo the Magnificent, commissioned artists as well as poets and musicians to create several works of art. Cosimo was a great patron of architecture, and also founded the Academy of Design in 1563. Later, another Lorenzo of the Medici family had his own tomb designed by Michelangelo.

Rubens, whom we have already seen in connection with workshop activities, was a favorite of the aristocracy and certain segments of the Catholic church. He himself lived like a prince. While he was an artist of outstanding skill, he also was urbane, articulate, and intelligent. He was a courtier and diplomat, and the court painter to the dukes of Mantua, friend of King Philip III of Spain and his advisor on art collecting, and permanent court painter of the Spanish governors of Flanders. He painted for King Charles I of England and completed a large cycle of paintings for Maria de' Medici, queen consort and queen mother of France. She enjoyed her conversations with him.

The Market

Many artists create for the open market. They work on speculation, meaning that they make a large quantity of works that they later try to sell, either directly or through agents. This is the opposite of working on commission, when artists make specific works for clients.

The Fine Art Market

In the fine art market, artists make works to sell through commercial galleries. Dealers not only sell work, but they promote the artist's career, for example, by arranging museum exhibitions for them. In exchange for these services, the sales price of artwork is usually split 50/50 between artist and dealer.

The fine art market is very competitive, with more artists wanting to display their work than there are galleries to accommodate them. Artists often strategize to make their way in this environment. When Yayoi Kusama arrived in New York from Japan in 1958 at age 29, a lot of artists were competing for attention, and the market favored male artists. She created some spectacular and controversial works that got attention in the art press and in the daily newspapers. She also enlarged her previously small work, making it as big at 33 feet long, so

that it fit the expectations of the art market at that time. In the late 1950s, easel-sized works were seen as passé, unheroic, and conservative. Works like *Accumulation No. 1* (figure 20.13) were variations on pop art and minimalism, both important movements of the 1960s. She also made friends with some of the most prominent artists in New York and in Europe.

The fine art market also consists of auction houses, where art is resold. A few works of art have brought fabulous prices in auctions. In 1990, Japanese businessman Ryoei Saito bought Van Gogh's Portrait of Dr. Gachet (figure 20.12) at Christies' auction house in New York for \$82.5 million, a record at that time. Since auction houses resell art that was already in the hands of collectors or museums, artists are not directly benefited by auction house sales. However, in the 1980s and early 1990s, higher prices in auction sales corresponded with higher prices paid for art of living artists that was shown in commercial galleries, which did benefit artists. (Interestingly, however, some artists were appalled at the lavish consumerism and elitism of high-priced art, and turned to making public art, performance, video and installation, art forms that may be accessible to more people or are not as easily bought and sold.)

Tourist Market

Traditional indigenous artworks sometimes are sold in the tourist market. These artworks are made specifically for foreign collectors or tourists. The work that artists make for the tourist trade is high-quality, professional work. But it does not have the meaning or the spiritual dimension of the work they make for their own culture. Baule artists often work for both the tourist trade and for local clients. The art they make for local clients is done on a commission basis, and has the spiritual and private uses that we discussed in connection with the *Male Torso* (figure 20.20). The art made for the tourist trade is done on speculation.

The tourist market may help local art production to survive. For example, in Papua New Guinea, the making of ritual art and tourist art are mutually dependent enterprises, each supporting and invigorating the other. On other more remote islands, where there is little tourism and therefore little tourist trade, the visual arts are falling into a general decline. In these remote places, the indigenous culture and religion are changing because of foreign influence. The old ritual reasons for making art have lost validity, but no new demand for artwork has taken its place (Lewis 1990: 149–163).

The Art Collector

Art collectors support artists by buying art on a regular basis. Collectors include royalty, military commanders, nobility, religious leaders, scholars, adventurers, diplomats, wealthy industrialists, and ordinary individuals. Collectors vary tremendously in their budgets, in their art historical knowledge, and in their reasons for collecting. Some may be interested in art as an investment, or as

a status symbol, while others seem truly taken with the work. Some collectors have researched, organized, documented, and publicized their personal collections; some even have established private museums to house them.

Text Link

The Solomon R. Guggenheim Museum (figure 18.5) began as a personal art collection. Very prominent personal collections often end up in museums, as we will see in Chapter 21.

A few collectors become great personal supporters of the artists they collect, in addition to buying their work. The first owner of Jan Bruegel's *Little Bouquet in a Clay Jar* (figure 20.2) was the wealthy nobleman Cardinal Federigo Borromeo, who had a substantial personal art collection, including many floral still life paintings which he particularly enjoyed "when winter encumbers and restricts everything in ice" (Sutton 1993: 501). Borromeo wrote of Bruegel, his lifelong friend:

Even the most insignificant works of Jan Bruegel show how much grace and spirit there is in his art. One can admire at the same time its greatness and its delicacy. They have been executed with extreme strength and care, and are the special characteristics of an artist enjoying, as he does, a European reputation. So great will be the fame of this man one day, that my panegyric will prove to the less than he deserves. (Sutton 1993: 16)

The "Dr. Gachet" of Vincent van Gogh's Portrait of Dr. Gachet (figure 20.12) was a patron of several French Impressionist and Post-Impressionist painters, including van Gogh. After a mental breakdown and a prolonged stay in a mental hospital, van Gogh settled in Auvers under the care of Paul Gachet, who strongly encouraged van Gogh's work. Dr. Gachet was a painter himself, and an art collector, who especially liked etchings and engravings. As both an artist and a medical doctor himself, Dr. Gachet was interested in the creative abilities of artists, which led him to free-thinking speculation and some unusual proposals. For example, he proposed a mutual autopsy association, where after death painters would leave their brains to be analyzed and studied. Gachet's art collection, with various French Impressionist paintings among other works, is now housed in the Louvre Museum.

Another example of an art collector and patron was Gertrude Stein, who was born in the United States but lived in Paris from 1903 until 1946. With her brother, Leo Stein, she bought art that was considered innovative during the early twentieth century, including works by Pablo Picasso and Henri Matisse. Not only did Stein financially support artists through purchase of their works, but she also opened her home to be a gathering place for artists, writers, and art collectors. While she

and her brother later parted, Stein continued to be an active presence in the Paris art scene with her partner, Alice B. Toklas.

Collectors do not always physically possess art objects. For example, Robert Smithson's *Spiral Jetty* (figure 20.10) was financed by Virginia Dwan, who once was the owner of the Virginia Dwan Gallery in New York City. She gave \$25,000 for the construction of the large earth-and-rock sculpture built in the Great Salt Lake in Utah, a sculpture that is only rarely seen due to recent high water levels in the lake.

Tax-Supported Art

Taxes have paid for a lot of art production, in one of two ways: 1) artists receive government-sponsored stipends or grants; or 2) tax monies finance specific buildings, paintings, or sculptures. Almost all public monuments, government buildings, and palaces are paid for by tax revenues, including Louis XIV's *Versailles*. All tax monies come eventually from ordinary people and the agriculture and commerce they generate.

The shrines of the *Acropolis* (figure 20.17) in Athens, Greece, were built with subverted tax monies. The Greek city-states formed a mutual defense league after defeating the Persians in 480 BC. Pericles took the money for Greek defense to have the new Acropolis shrines built. The other city-states protested and accused Pericles of being a tyrant, abusing his power, and taking funds from subject states. The misappropriation of funds was one factor in the eventual downfall of Athens, because it caused in part a protracted and disastrous civil war between Athens and the rival city-state, Sparta. Athens lost.

In Japan, taxes support traditional Japanese art forms. Traditional artists are designated as Living National Treasures (Ningen Kokuho) because they are Bearers of Important Intangible Cultural Assets. Ningen Kokuho include musicians, dramatists, and visual artists; in the visual arts, the categories include ceramics, weaving, stenciling, dyeing, lacquer, metal, wood and bamboo, doll making, and paper making. Ningen Kokuho receive approximately \$6,000 per year to support themselves and to train apprentices. Outstanding fine artists, such as painters and printmakers, may be honored by being appointed to the two hundred-member Japan Art Academy. They also receive an annual stipend, and advise the Japan Ministry of Education on matters concerning the arts.

Text Link
Bunraku puppetry (figure 18.10) is an
example of a traditional Japanese art

example of a traditional Japanese art form whose practitioners can be considered Living National Treasures. European countries, such as the United Kingdom, France, and Austria, set aside tax monies to support artists and art making. The Austrian government actively supports artists in part because the fine art market is not very large in Austria. Also, Austrian citizens pay higher taxes (as much as 60 percent of their income) to support the increased government programs for all kinds of cultural purposes. Art galleries too can receive government support when they participate in international art fairs, where galleries from many industrial countries come together to display the artists they represent.

In the United States, the National Endowment for the Arts (NEA) was established to support artists and arts organizations. Recently, however, Congress has withdrawn support for individual artists and severely cut other funding because some tax-supported art was controversial. In debates around this issue, some argue that tax payers' money should be given to artists whose work meets certain social standards, while others argue that artists should be given freedom to create whatever they want.

Text Link

Read more about Freedom of Expression issues in the "Food for Thought" section in Chapter 21.

Tax support for art in the United States includes Percent for the Arts Programs, in which one-half or sometimes one percent of the cost of any public building goes to purchase art for that building. In many states, Percent for the Arts Program covers any federal, state, county, or city buildings, as well as private ventures that receive tax abatements in redevelopment zones. Percent for the Arts Programs represent considerable income for some artists. These programs have also enriched the urban environment with murals, installations, or sculptures.

The process of making public art, getting approval for work and completing the project is hemmed in with committee review. In some cases, a competition is held, with artists invited to submit written proposals for works that are site-specific, addressing the history of that location or the needs and values of the people who use that site. Committees of artists, members of the public, and government representatives choose a winning proposal, and/or oversee the completion of the work. A few commissions go awry. For example, a public arts commission invited the artist Robert Arneson to do a work on George Moscone, the assassinated mayor of San Francisco, for the new Moscone Center. Arneson made the *Portrait of George* (figure 20.27), an informal, colorful bust mounted on a column pedestal that contained references to Moscone's killer. An arts committee rejected the work, Arneson was not paid, and the bust was

20.27 ROBERT ARNESON. *Portrait of George*. USA, 1981. Glazed ceramic, 94" × 29" × 29". Foster Goldstrom Family Collection. See figure 14.25 to review the information on this piece and the circumstances surrounding Moscone's assassination.

returned to him one week after it had been installed in the Moscone Center. Arneson's gallery later sold the work to a private collector.

SYNOPSIS

The question of "who makes art?" is answered by researching a number of issues: who conceives the idea; who actually makes the object; who supplies materials and instruction for art making; and who supports art making.

We saw that artists may learn their profession through families, as apprentices, in art academies, or in modern universities. Artists also learn by exposure to other artists and artworks. Non-art ideas, disciplines, and events may also have a profound influence.

The actual art object may be made in many ways. In some instances, the artists do the work, such as Vincent van Gogh with *Portrait of Dr. Gachet*. Sometimes workshops make the art, especially when a single project is very big, such as the *Rent Collection Courtyard*, or when there are far more commissions than the master artist can meet, as with Peter Paul Rubens and the *Abduction of the Daughters of Leucippus*. Sometimes others are hired to make the art, as Robert Smithson did when he hired a construction crew to assist with the *Spiral Jetty*. Large teams of laborers may make truly colossal projects like the *Great Pyramids* of Egypt. And finally, a community may put forth their efforts, as we saw with the *AIDS Quilt* and with *Chartres Cathedral*.

Artists themselves fill many different roles within their cultures. Art making may reflect broader gender roles within that culture, as with Sepik art or Navajo sand painting. Artists may be considered skilled workers as we saw in Medieval Europe with Chartres Cathedral, or Communist China, with the Rent Collection Courtyard. Science, geometry, and mathematics have overlapped in the role of artist in Islamic architecture and decoration (the Masjid-i-Shah), during the Renaissance in Europe (Leonardo da Vinci) and finally in the United States in the nineteenth century (John James Audubon's Birds of America). Artists can be priests, shamans, or ritualists, in cultures where art making is connected with religion or rituals. Artists as creative geniuses date back as long ago as Imhotep in ancient Egypt, but surface again in Renaissance Europe. We saw just a few examples, such as Michelangelo and Vincent van Gogh. Leaders also act as artists, as with the Maori Meeting House carvings, Louis XIV and Versailles, and Pericles' vision for the Acropolis in Athens.

The people who support art making enable artists to do their work, and sometimes greatly influence how that art looks. For example, Louis XIV's control of the Royal Academy and of the art style in France had a tremendous influence over the artists, designers, and architects who worked on the Palace at *Versailles*. And the Baule sculptors produce spiritually active carvings that conform to the visions of the clients who commission them. Other forms of support for artists include the fine art market, the tourist market, and art collectors. Taxes can be used to support art making in a number of ways, ranging from the building of the *Acropolis* shrines in Athens, to the Living National Treasures of Japan, to Percent for the Arts Programs in the United States.

Finally, artists' livelihoods can be supported by families, by stipends and grants, and by the university.

FOOD FOR THOUGHT

Let us conclude this chapter with a few controversial ideas that are related to the concepts we have just covered. What do you think of them?

- Creativity can seen as being the "job" of the artist in societies where most other kinds of work are no longer seen as being creative. Then creativity can seem to be cut off from "real" life, and become superfluous, self-indulgent, or unnecessary. How do you perceive creativity in this society, in commerce, in the arts, in different kinds of jobs?
- There is a popular myth about artists being completely asocial, isolated geniuses who produce work whose importance is not recognized. Do you think that the nonconformist (or even tragic) artist might be an important role in a particular society?
- When people from "first world" nations buy the art of "third world" countries, they often want something "authentic," meaning that the artwork conforms to traditional styles. Museum collections also favor traditional styles. But artists alive today are subject to influences from all over the world, through media, travel, and trade. Contemporary art is often a mixture of foreign and indigenous influences. What is authentic art?
- If a traditional, indigenous art object were made for the tourist market, is there any reason why it should

- be inherently more or less valuable than a work made for local cult use?
- Artists have tailored their work to suit the market or the tastes of a particular patron. Leonardo da Vinci was willing to devote his time to whatever activity the Duke of Mantua dictated, including either weapons building or painting. Artists making public art projects work with committees, politicians, and architects. How does this dovetail with the idea of art as personal creative expression?
- The public art process is hemmed in by review committees composed of politicians, the public, and artists. Can public art (or any art by committee) ever be controversial? Should it be? If taxes are used to support art making, should that art reflect the ideas of the population? What percentage of it?
- Michelangelo's Creation of Adam and Leonardo da Vinci's Mona Lisa have been (mis) used for commercial reasons, appearing on beach towels, food commercials, communications advertisements, and so on. Figure 20.28 is a souvenir pen from a traveling Vatican exhibition with a detail of Michelangelo's Creation of Adam. When you move the pen, Adam's hand floats toward God's, through the liquid contained in the pen barrel. The message on the other side is "Keep in touch." The sale of such souvenirs to tourists supports museums and traveling exhibitions. How does this relate to the tourist trade that we discussed above in relation to indigenous art? How do commercial art and fine art support each other? Do they invigorate each other?

20.28 Souvenir Pen from a traveling exhibition of angels from the Vatican. The right end of the barrel contains a detail of Michelangelo's *Creation of Adam*, suspended in liquid. On the reverse appears the words "Keep in Touch."

Chapter 21 What Do Humans Do With Art?

INTRODUCTION

A vast quantity of art treasures, from both the recent and distant past, are with us today. What happens to art once it has been made? What do communities, nations, institutions, religious groups, armies, scholars, and others do with it?

Of course, the answer is varied, within different circumstances and different cultures. There also can be a gap between what people should do with art, and what they actually do with it. The following questions will guide us in this chapter:

How is art displayed or performed?

How does the display of an art object change its use?

Why do nations and cultural groups keep art?

Who assembles art collections and why?

What kinds of museums keep art and how do they operate?

For what reasons does art deteriorate?

How can art be preserved or restored?

How much effort, time, and money should be devoted to preserving and restoring art?

Why do humans purposefully destroy art? What academic disciplines study art?

This chapter deals with art in the hands of groups or cultures. Chapter 22 deals with your personal use of art.

USING ART

Once an art object is made, people use it, either through performance or display. What does that mean? What are the varieties of ways that art is used?

The *Colosseum* (figure 21.1), built between 70 and 82 in Rome, was used for centuries, from 83 until 532, to entertain the citizens of Rome. It was intended both for performance and for display. Its massive size and lavish decoration constitute the elements of display, while the extravagant spectacles that took place within were the performance elements. The *Colosseum* events served an important purpose. The Roman emperors funded the events (with tax money) to reinforce links between the leaders and the common people. The events were free to all Romans of any class.

Much Yoruba art is made for religious festivals, and so their art is used for performance. Masks, music, song, and dance combine in masquerades that entertain, reinforce leaders' roles, reaffirm social order, and bring cohesion of the group. When festivals are held, the masks (worn by dancers) emerge from the houses of elders

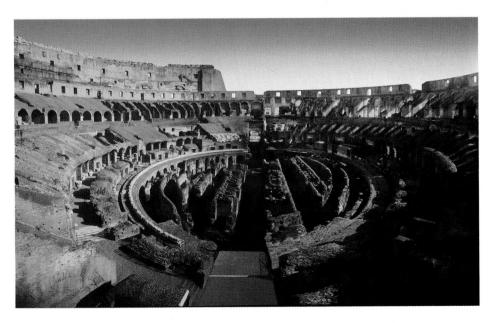

21.1 *Colosseum*. Rome, Italy, AD 70–82. See also the text accompanying figure 18.25.

21.2 *Epa Festival* at Otun, Ekiti, Nigeria, Yoruba culture.

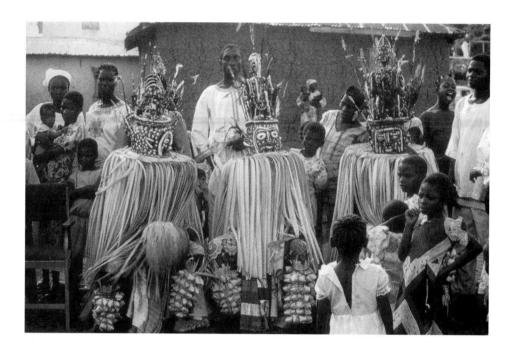

(figure 21.2). The first mask to appear in an Epa festival is that of the bush spirit (called Oloko) who gave agriculture to the people. Chiefs dance with the masquerader, while members of the community shout names of praise. Masks of ancestor warrior chiefs follow next. *Orangun*, by Bamgboye of Odo-Owa from 1971 (figure 21.3), represents a warrior chief who founded a new prosperous community. Next come masks representing herbalist priests, who possess spiritual knowledge. The final mask of the festival represents female power and the future of the community.

In Western cultures, since the Middle Ages, much art is made for display, but even displayed art is being used. Leonardo da Vinci painted the *Last Supper* (figure 21.4) on the walls of a monastery dining room in the late fifteenth century. Through the painting, the monks who ate there linked their every meal to the sacred Christian event of Jesus' Last Supper.

Of course, the uses for art change if art is taken from its originally intended environment and placed in a museum. For example, small religious devotional images, such as the Retablo of Maria de la Luz Casillas and Children, from 1961 (figure 21.5), can be seen hanging by the dozens as prayer offerings from certain statues in pilgrimage churches in Mexico. The effect of all the prayer offerings on statues, surrounded by candles in the church environment, is to increase the cult of that particular saint. On the other hand, retablos can be found hanging in museums and commercial galleries in the United States. There, the exact same painting is no longer a prayer offering, but a work of art. The clean white bare spaces of museums and galleries isolate art objects and emphasize their formal qualities. People still use the art in museums, but for aesthetic experiences.

Of course, this is only a brief discussion of the ways people use art. Now let us move on to reasons why people keep it.

KEEPING ART

Why do groups of people hold on to art, often beyond its original use? In this section, we will focus first on the reasons, and then turn our attention to how they keep it. We will discuss art collections, both public and private, and the purposes and functions of museums. Finally, we will cover museology, art preservation, restoration, and the surprising controversies surrounding some of these seemingly mundane topics.

Why Cultures Keep Art

Cultures and groups keep art because it is meaningful to them, enriches their lives, and benefits them in many ways. We will look at four main reasons why art is kept:

- 1) for aesthetic, civilizing, or educational purposes;
- 2) for religious reasons; 3) for politicized purposes; and
- 4) for commerce.

Art as Aesthetic, Civilizing or Educational

We keep art because it is very enriching to us as humans. People seek out art, especially in museums, because it is pleasurable, aesthetic, and stimulating. Some even find art gives them a transcendant or spiritual experience. Let us use the mask, *Orangun*, as a model for discussing how art can be aesthetic, civilizing and educational, but almost any other work of art would do as well.

An art object is aesthetic. Formally, *Orangun* makes a tall silhouette, with a whole hierarchy of details from the

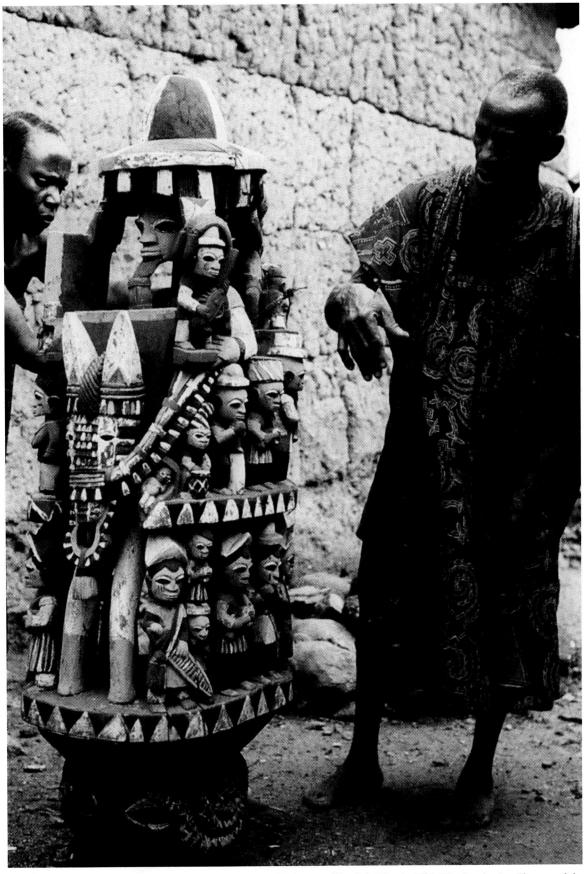

21.3 Bamgboye of Odo Owa. *Epa headdress* called "Orangun," Erinmope (Yoruba), Nigeria, 1971. Wood and paint. Photograph by John Permberton III. Look back to figure 16.8 to review information on this piece.

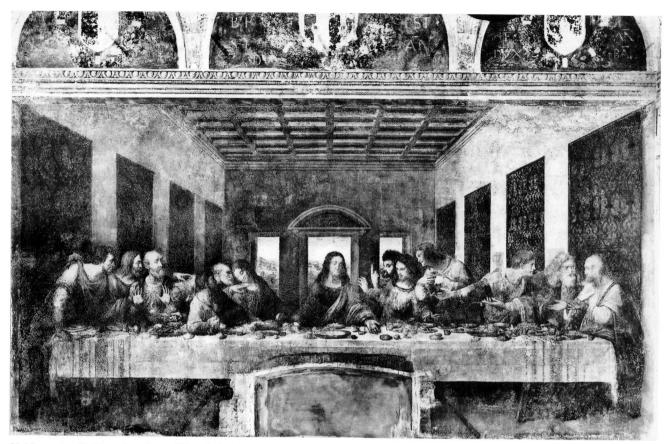

 $21.4 \ \text{Leonardo Da Vinci}. \ \textit{Last Supper}. \ \text{Milan, Italy}, \ 1495-1498. \ \text{Experimental paint on plaster}, \ 14.5" \times 28". \ \text{See also figures} \ 2.21, \ 6.27, \ 20.22, \ \text{and} \ 21.24.$

largest head to the smallest pattern. It is filled with contrasting large and small elements, geometric and figurative, light and dark. There are strong visual rhythms. Height is an important quality, especially when the mask is balanced on the head of a dancer, but the verticality is balanced by the bands of horizontal pattern. The work is carefully made, and its formal qualities are well expressed through the material used.

The study of *Orangun* is both a sensual experience and also demanding intellectually. The mask helps us to expand and enrich our definition of art, and learn about Yoruba culture. By extension, we think of family structures in our own cultures, and the rituals and social structures that reinforce family functioning. *Orangun* provides a broadening experience, as we learn from this and other works what art means and how it functions in different cultures. Like *Orangun*, all art is visually rewarding and challenging.

Text Link

In Chapter 22, we describe in depth where you can find art today in your community, and how that art can be an enriching, educational experience in your life.

Religion

Many works of art have sacred qualities. On an individual level, people keep them as aids in religion or ritual. We have seen many such examples in this book. On an institutional level, many major religions have priests or officials who preserve sacred art. They are responsible for major religious shrines that often are outstanding pieces of architecture in and of themselves.

Text Link

Review the many examples of religious structures that are famous works of architecture in Chapter 10.

Religious shrines often house valuable art objects that add to the sacred nature of the site. Collections have been made around religious shrines in Africa, Japan, and in Islamic countries. Major Christian churches often have museums attached to them. In Mesoamerica, fabulous temples housed statues, manuscripts and smaller art objects of precious metals, all like the works described so enthusiastically by Albrecht Dürer, on page 569. When the *Parthenon* was a temple, it housed the now-lost cult statue of *Athena*, *Goddess of Wisdom and Warfare*, which was a major work of art by the sculptor Phidias. Many

mosques are lavishly covered in mosaic or decorative carving, and are furnished with woven rugs and beautiful lamps.

Politicized Uses of Art

Art can be a means of strengthening ethnic identity. It can be used as part of a nation's glory.

Let's cover ethnic identity first, with a look once again at Yoruba art and culture. The Yoruba is a large ethnic group of approximately 20 million people in Western Africa. They share a common language source and ethnic heritage, as well as some social customs and political structures. Yet many factors divide the Yoruba. Various subgroups have their distinct customs and speak local dialects. The Yoruba are not a single political unit. They live in Nigeria and also in the neighboring countries of Benin and Togo. Among themselves, the Yoruba are split into and owe allegiance to more than 50 separate citystates. At times, these city-states have waged fierce wars against each other. They follow various religions, which include versions of their native religions, Christianity or Islam. Some follow more than one religious creed. Slave trade and British colonial rule disrupted the Yoruba politically and culturally.

Despite disruptions, the identity of the Yoruba is intact, in part due to their artistic heritage, which dates back nine centuries. A substantial amount of their art is devoted to political or religious purposes, which have the effect of reinforcing group cohesion. Let us look at two such works, the *Palace at Oyo*, built in the early twentieth century (figure 21.6), and *The Great Beaded Crown of Orangun-Ila* from the twentieth century (figure 21.7). Both are intended to dramatically represent and consolidate the power of Yoruba leaders. *The Great Beaded*

Crown of Orangun-Ila is an ornate and symbol-filled work. The tall cone shape is called "ibori" and it represents a related cluster of concepts, including power, links to the spirit world, and links to nature. Notice that the tall cone shape we saw in the king's crown reappears in the palace silhouette. It is a persistent symbol that serves as a visual emblem of Yoruba leadership across the centuries, and that leadership implies group cohesion and continuity. The cone also can be used to represent an important meeting place, or act as a ceremonial marker. The persistence of significant forms gives identity to a group for whom these forms are meaningful.

Text Link

Two other works that deal with Yoruba rulers and sources of power are the Crowned Head of an Oni (figure 12.4) and the Palace Sculptures at Ikere by Olowe of Ise (figure 12.21).

We have already seen an example of Yoruba art made for religious rituals. The Epa headdress called *Orangun* (figure 21.3) was carved for a ritual masquerade that reenacts the social roles that are the underpinnings of Yoruba social structure. Thus the rituals themselves reinforce Yoruba social structure and the Yoruba identity as a whole. Masquerades reinforce group identity because group efforts, communal creativity, and group cohesion are required to stage such elaborate ceremonies.

Another politicized reason for keeping art is national glory. Art is part of a nation's pride. It is a visual symbol that stands for the nation, or it is part of the nation's aesthetic achievements.

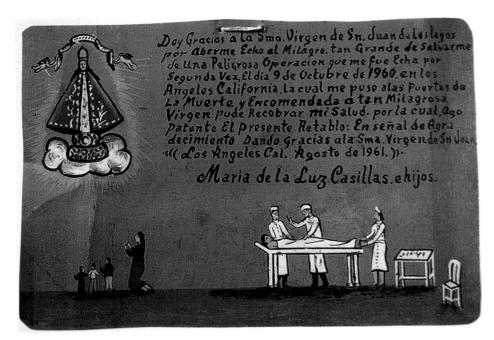

21.5 Retablo of Maria de la Luz Casillas and Children. Mexico, 1960. Oil on metal, 7" × 10.5". Durand-Arias Collection. The painting style and religious use of this retablo were discussed in the text accompanying figure 9.21.

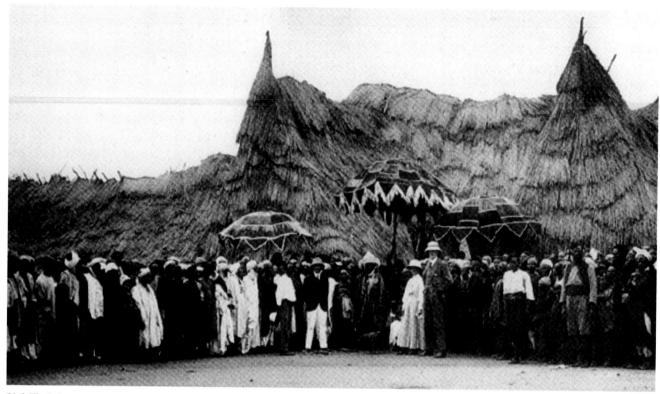

21.6 *The Palace at Oyo.* Nigeria, Yoruba culture, twentieth century. The king's son and officials stand in front. Foreign and Commonwealth office, Library and Records Department. To review information on the palace as a sign of royal status, see also the text accompanying figure 12.20.

Almost every nation has distinctive artwork that it has claimed as particularly representative of itself. The Statue of Liberty, Mount Rushmore and the Capitol Building are all works of art that are associated with the United States. The United States is also known for initiating and disseminating modernism throughout the world in the 1950s and 1960s, and thus modern art and architecture of that time are often related to the United States. To take another example, Greece is perhaps best known and associated with the ancient monuments such as the Parthenon, dated 447-432 BC (figure 21.8). Even though Greece has an extensive history since then and is a modern nation, the fame of the Parthenon is so great that for many it is the image that represents Greece. In addition to such famous works of art, many countries have established bureaucracies that manage national landmarks, monuments, museums, and preservations.

Text Link

Look back to Chapter 20, to the section on "Tax Supported Art" for comments on Japan's "Living National Treasures," such as the Bunraku (figure 18.10).

Another part of a nation's treasure is the art it seizes as booty. When one nation conquers another, its armies sometimes destroy the art of the conquered nation, as we will see on page 585. But in many other cases, the vic-

tors carry off the art they want, either as war trophies that indisputably prove their conquest, or because of sincere admiration for the work.

We see an image of looting after war in the Roman relief sculpture, *Spoils of Jerusalem*, dated AD 81 (figure 21.9) from the *Arch of Titus*. In this relief, Roman soldiers return triumphantly to Rome after putting down an uprising in Judaea and destroying the Temple. They are carrying several sacred items taken from the Temple, including a seven-branch candlestick (menorah) and sacred trumpets. Even in this relief carving in stone, the body language of the soldiers communicates a sense of speed, celebration, and triumph.

Transportable objects often "leave" their native country when it is conquered by another. The ceremonial Aztec Knife, dated 1300–1400 (figure 21.10) was probably one of many items that the Spanish conqueror of Mesoamerica, Hernando Cortés, accepted as tribute or took as plunder from the Aztecs, and then sent to the Spanish king, Charles V. The knife is now in the British Museum. The plunder from the New World consisted of a few manuscripts, many costumes, and other curiosities, as described by the German artist Albrecht Dürer, when he saw them in Brussels:

Also I saw the things which were brought to the King from the New Golden Land: a sun entirely of gold, a whole fathom broad; likewise, a moon, entirely of silver, just as big; likewise sundry curiosities

21.7 Bead Workers of the Adesina Family of Efon-Alaiye. *Great Beaded Crown of the Orangun-ila*. Yoruba culture, Ila, Nigeria, twentieth century. Photograph by John Pemberton III. Review information about this crown with figure 16.19.

from their weapons, armor, and missiles; very odd clothing, bedding, and all sorts of strange articles for human use, all of which is fairer to see than marvels. These things were all so precious that they were valued at a hundred thousand guilders. But I have never seen in all my days that which so rejoiced my heart, as these things. For I saw among them amazing artistic objects, and I marveled over the subtle ingenuity of the men in these distant lands. (Miller 1986: 202)

However, unlike Dürer, most Spaniards valued the gold used in Aztec art more than they valued the artworks themselves. Among the objects Dürer saw, every one made of gold or silver was melted down for its precious metal.

Egypt in particular has suffered from having its art treasures hauled off by foreign invaders, much to the detriment of Egypt itself. The ancient Romans took a large number of Egyptian artifacts to Rome. Some of those same objects were still around centuries later, to reawaken European interest in Egypt from the fifteenth through the nineteenth century. Napoleon Bonaparte led French troops in 1798 to invade and occupy Egypt for a short time. Napoleon was motivated in part by the desire to regenerate ancient Egypt under French rule, and also in part to disrupt Britain's colonial empire. With his invading army, Napoleon sent a team of scholars to form an Egyptian Institute and seized a number of treasures. One of the most famous is the Rosetta Stone, discovered in 1799 (figure 21.11), an extremely important artifact that helped decipher the meaning of hieroglyphic writing. Napoleon's army also invaded and seized art in Italy. French artists and scholars justified

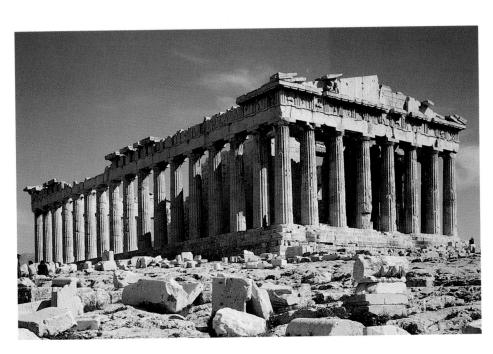

21.8 IKTINOS AND KALLIKRATES. Parthenon. Athens, Greece, c. 447–432 BC. Pentelic marble, height of columns 34', dimensions of structure 228" × 104". See also the text accompanying figures 3.4, 10.14, and 20.17.

21.9 *Spoils of Jerusalem*. Relief panel from the Arch of Titus, Rome, Italy, AD 81. Marbled face on concrete core. To review information on this sculpture and the Arch of Titus, see figures 12.27 and 12.28.

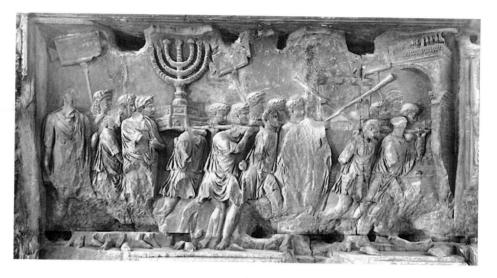

Napoleon's actions, because they believed that contact with great art had a civilizing effect on the French population. While many Egyptian artworks ended up in the Louvre Museum in Paris, the *Rosetta Stone* and other objects were turned over to the British after they defeated the French in the Battle of the Nile. The *Rosetta Stone* is now in the British Museum.

Foreigners were often a mixed blessing for Egypt. Throughout the nineteenth century, foreign armies, traders, adventurers, and plunderers took large amounts of ancient Egyptian art, in some cases hacking them out of buildings and thus damaging the remaining structures. These plundered objects then became the core of many foreign museum collections. At the same time, traveling scholars and tourists were recording the monuments, preserving a record of their former condition. Foreigners increased interest in ancient Egyptian sites, and began the first intensive, comprehensive study of the Egypt of the pharaohs.

Plundered art from World War II continues to be an issue today. The Nazis stole thousands of works of art, and many are still missing or are in dispute. Some have turned up at art auctions, in private collections, or in public museums. The heirs of the original owners have sued for their return. In addition, Russia still holds many artworks that their armies seized after World War II from 325 German museums, which in part are works that the Nazis seized from Jewish collectors in the 1930s. Attempts to have the stolen art returned have caused international uproars. An on-line registry of missing or stolen art has recently been posted on the Internet, listing 3.6 million looted art objects from World War II, with detailed descriptions of 35,000.

Text Link

As an adjunct to this section, read the information on "War Trophies and Prisoners" in Chapter 13.

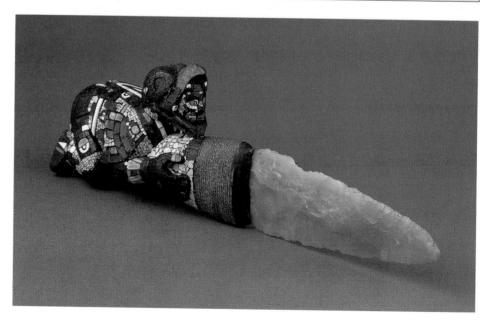

21.10 Aztec Knife. Mexico, thirteenth–fourteenth centuries. Chalcedony blade, wood handle with inlaid turquoise and shell mosaic. British Museum. See also the text accompanying figure 13.12.

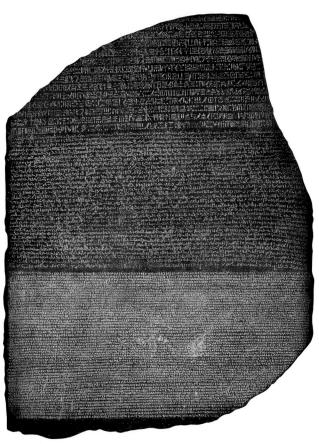

21.11 Rosetta Stone. Eygpt, New Kingdom, c. 1500–500 BC. Basalt slab. The British Museum. See also the text accompanying figure 13.26.

We have seen that victorious armies have seized small art objects. What about large monuments and buildings? The Greeks built the Parthenon (figure 21.8) to be a temple to the Goddess Athena. But a succession of conquerors modified it for their own uses. The Romans used it as a brothel, but left the structure and sculptures essentially in original form. In the fifth century AD, when it was turned into a Christian church, the interior was remodeled and the large cult statue of Athena was removed and subsequently destroyed. In the fifteenth century, the Turks of the Ottoman Empire seized control of Greece and transformed the Parthenon into a mosque, adding a minaret to its southwest corner. Later, during a war with the Venetians, the Turks used the Parthenon to store gunpowder. In 1687, during a battle between the Venetians and the Turks, the Parthenon was severely damaged when an artillery shell exploded the gunpowder inside it. After 1,800 years of existence, the Parthenon was a ruin, but it still functions well in its most recent reincarnation: the Parthenon now is a major tourist attraction.

Art as Commerce

Art helps the economy and is good for business. Art is an economic asset that attracts tourists. The presence of a major archeological, religious, or architectural site stimulates the entire economy, as tourists spend money on

hotels, rentals, airfares, restaurants, other nearby attractions, shopping, and so on. Thousands of local jobs are created as a result. This is true around the world, whether at the *Parthenon*, as we just discussed, or at the *Great Pyramids*, ancient ruins in Mexico, *Versailles*, or the *Forbidden City* in Beijing.

Popular traveling art exhibitions are also great for the economy. The Egyptian treasures from Tutankhamen's tomb and the paintings of Vincent van Gogh toured the United States, and both drew record crowds. In 1999, a traveling exhibit of Van Gogh paintings from Amsterdam was reported to have been the most economically beneficial single event that ever happened to the city of Los Angeles.

Art is also bought and sold in commercial galleries and auction houses, which contributes to overall economic activity. Many dealers make their livings from art sales, including original art objects, multiples such as prints, mass-produced reproductions of artworks, and functional art (furniture, dishes, and other utilitarian art).

Art is used in advertising, to sell products, promote causes, and encourage spending, travel, and donations to certain institutions. Art of course is featured prominently in museum promotions. For example, the Smithsonian Museum used an Akua'ba, similar to the *Akua'mma* (figure 21.12) we saw in Chapter 8, in recent promotional campaigns. It appeared with an array of

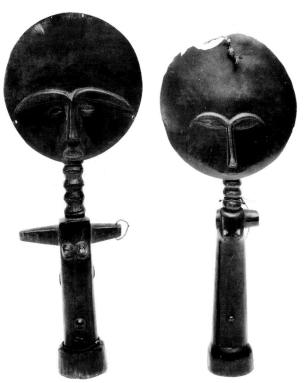

21.12 *Ashanti Ak'ua Mma Dolls.* Ghana, c. twentieth century. Wood, 29" high. The British Museum. This art is also discussed in connection with figures 1.1 and 7.13.

21.13 The Smithsonian Institution's 150th Anniversary Float in the 1996 Rose Parade in Pasadena, California. Photograph courtesy of the Pasadena Tournament of Roses. See also the text accompanying figure 1.11.

other symbols and items on the Smithsonian's 150th Anniversary Float (figure 21.13) in the 1996 Rose Parade in Pasadena, California. The float's six-foot high replica of the Akua'ba was covered with glossy black seaweed with other small flowers. Some similar images, including the same Akua'ba sculpture, were repeated and used for posters and greeting cards for "America's Smithsonian: An Exhibition Celebrating 150 Years."

Text Link

In the "Food for Thought" section of Chapter 20, we saw that Michelangelo's Creation of Adam was used on souvenir pens sold with a traveling exhibition of art from the Vatican.

However, art is used to sell other things besides museums. The *Creation of Adam* has also been used recently in

ads for computer technology and telecommunication systems. Some statue fragments from the *Parthenon* appeared recently on billboard ads promoting the gambling casino, Caesar's Palace, in Las Vegas, Nevada. The headless statues are next to the words "Losing Your Mind?" followed by the apparent remedy, a weekend of gambling and entertainment in Las Vegas. *Untitled (Your Body Is a Battleground)* (Figure 21.14) by Barbara Kruger has been used to advertise abortion rights rallies.

Art Collections

Much of the art in this book is part of an art collection. An art collection is an accumulation of related art objects that are publicly held, or owned by private individuals. Collections can be made according to 1) media, such as ink paintings on paper; 2) theme, such as portraits; or 3) time period and source, such as early twentieth-century sculpture from western Africa.

Museums and Private Collections

The desire to collect art has a long history. Since ancient times, rulers, nobility, priests, and the upper classes have collected art, and have kept it in palaces or temples for aesthetic pleasure, for personal or ritual use, or as displays of power. Today, many art collections are housed in museums, which is a relatively recent phenomenon. The Greeks were the first to use the term "mouseion," which is the ancient source for our word "museum." But "mouseion" refers to institutions of philosophy, learning, debate, and contemplation, and was more like the modern university than a twenty-first-century museum. An example of a Greek "mouseion" is the Museum of Alexandria in Egypt, founded by the Greeks as a center for learning, with gardens, libraries, lecture halls, and banquet halls. In ancient Rome, art was also displayed in baths, such as the Baths of Caracalla, as we saw in Chapter 18.

The term "museum" was resurrected in fifteenth-century Europe, but then it was used to refer to collections, not buildings. From the sixteenth through the eighteenth century, these "museums" consisted of paintings, sculptures, coins, curios, and natural objects like ostrich eggs, and were often associated with libraries. Not until the late seventeenth century was the term museum first used to refer to a collection of objects in a building dedicated to housing them. By the nineteenth century, however, that was the common meaning of the word.

In the late eighteenth and nineteenth centuries, many industrialists and entrepreneurs began their own private collections of art, joining the ranks of the nobil-

21.14 BARBARA KRUGER. *Untitled (Your Body is a Battleground)*. USA, 1989. Photographic silkscreen on vinyl, 112" × 112". Eli Broad Family Foundation Collection, Los Angeles. See also the text accompanying figures 1.9 and 17.1.

ity as art collectors. What happened to these private collections? Some were eventually dispersed. Some collectors started their own private museums, such as the Solomon R. Guggenheim Museum, which we will see on page 576. Some remain simply within the family or the corporation, as individual artworks displayed in the home or office. But many collectors donated or sold their collections to public museums, for one of four reasons: 1) for personal gain, to make a profit on their investment; 2) for personal glory, to be remembered, or for social prestige; 3) to advance knowledge and culture by making their collection available to the public; and 4) to ensure the continued life of their collection, that it would not be dispersed, broken up, lost, or stolen.

Museums became common in Europe, especially in the nineteenth century. While the rise in private collecting was an important factor, other influences were significant, too. The intellectual climate behind collecting art was shaped both by the Enlightenment period of the eighteenth century, which emphasized knowledge, reason, and cultural achievement, and also the Romantic movement of the early nineteenth century, with its fascination for the unknown, the sensual, and the exotic. Museums were seen as having uplifting and civilizing influences on the general population. Capitalism emphasized ownership, control, and possession. Colonialism was another factor. It provided great wealth to Europeans, which made art collections possible, and the art of colonized countries filled European museums. Another result of colonialization was that the Europeanmodel museum spread to the rest of the world.

The wealthy private collector remains an important and influential person with museums, as few museums have sufficient funds to buy a lot of art outright. Collectors often sit on museum boards of directors that determine the mission, budget, staffing, and exhibition calendars. Museums today are still seen as uplifting, civilizing, and educational institutions. In addition, museums have always had an element of entertainment to them. More recently, museums have become research centers, as they accumulate research around their collections, sponsor new scholarly work, and develop education departments.

In the next four sections, we will look at different kinds of museums that deal with art. Each type is unique, regarding what it shows, how it functions, and how it is funded. In order, we will see national museums first, then art museums, followed by regional museums. Finally, we will look at the most recent, the new technology-based museums.

National Museums

The national museum is a large institution with collections in several areas. Many were founded in the eighteenth and nineteenth centuries, under the same

general atmosphere that led to the development of the encyclopedia. Because of their size, almost all are funded by national governments. Their holdings are made up largely of donated or purchased private collections. Our discussion will focus on the British Museum in London, but much of it also applies to museums like the Louvre in Paris, the Smithsonian in Washington, DC, the Vatican Museum and Galleries, and so on.

The *British Museum* (figure 21.15) was founded in 1753 for the "inspection and entertainment of the learned and the curious, [as well as] for the general use and benefit of the public." It was started with the combined collections of three private collectors, who also became its first trustees. These first collections focused on classical art: ancient Greece and Rome and Renaissance Italy, as these were believed to be the highest achievements in art. Other collections were added, such as the Elgin Marbles, which are the original sculptures from the *Parthenon*, which were purchased by the museum in 1816. The Elgin Marbles had been the private property of Thomas Bruce Elgin, the Earl of Kincardine.

After a real power struggle in the museum and a protracted debate about what art is, the British Museum began accepting collections of art from other cultures of the world. These new acquisitions were largely drawn from private collectors, such as nobility, military men, traders, businessmen, clergy, academics, and middleclass entrepreneurs, whose collections were bought by or donated to the museum. Now the British Museum collections include archaeological objects, art and artifacts excavated from ancient civilizations, and ethnographic art, which is the artwork of nonliterate peoples. There are also major collections from some non-Western countries, notably Chinese porcelain and sculptures from

India. It has an impressive collection of Western prints and drawings dating from the Renaissance to the present day. In addition, it is the national museum of Great Britain, housing many important art objects from its past. (The British collection of European paintings, however, is housed in the separate National Gallery of London.) The collections of the British Museum are heavily drawn from countries that were colonized by Britain (for example, Nigeria, India, the Middle East, and certain South Pacific islands). Large museums in general benefited from conquest and colonization. Likewise, the collection of the Louvre was greatly expanded by Napoleon, especially in Egyptian antiquities.

Text Link

During the colonial era, the European fascination with "the exotic" was reflected not only in their art collections, but also in the way they conceived gender relations. See the discussion of the painting by Ingres, the Odalisque (figure 17.11).

The holdings of some large museums are truly vast. Museums were rapidly expanding their collections in the nineteenth century, but many private collections were added that were never completely catalogued. The museums therefore lacked a comprehensive inventory of their holdings. Many items have been "rediscovered" in museum storage. The British Library, which was part of the British Museum until 1972 and housed there until 1997, recently "discovered" a rare Mesoamerican manuscript, the *Calacoayan Landbook*. A 56-page Mesoamerican manuscript, the *Madrid Codex*, dating

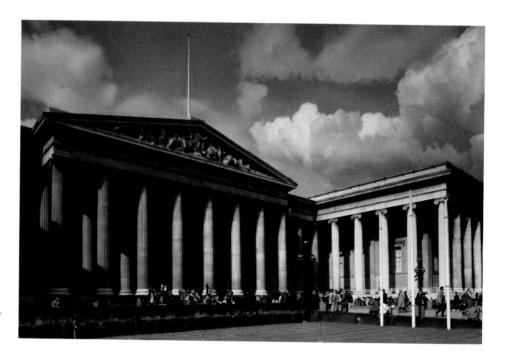

21.15 SIR ROBERT SIDNEY SMIRKE. *The British Museum*. Portico, south facade, London, Great Britain, 1823–1847.

from the 1400s, with a wealth of astronomical and divinatory information, was found in two sections in two different locations in Spain in the 1860s, and is now in the Museum of America in Madrid. The *Paris Codex*, dealing with Mayan ritual and ceremony, was "discovered" in 1859 in an obscure section of the Bibliothèque Nationale in Paris.

The national museum is still evolving. For example, the British Museum over the years has expanded, has subdivided, and has changed its mission. And there are problems. Space is a constant one. There are often money problems caused by the need to maintain holdings and research in many fields, which results in insufficient staffing and disputes over priorities. A relatively recent problem is claims from other countries to have their native artwork returned. As we have stated, a portion of the collections in some national museums were taken from countries that were conquered, colonized, or otherwise forced to give up their art. For example, the Greek government has frequently demanded that the British Museum return the Parthenon sculptures. The British Museum has refused, claiming that it legally owns the works and that it saved them from damage and destruction. The former British Museum director, Sir David Wilson, wrote:

... we are a storehouse of the world's treasures—useful and unique. We will not return any material which we legally own: if we did, demands would increase and one of the greatest museums of comparative culture in the world would be destroyed for narrow nationalistic purposes: an ironic outcome in an age of internationalism. (Wilson 1989: 11)

Art Museums

The art museum displays art objects. Traditionally these include painting, sculpture, printmaking, and decorative arts, but they may also include functional arts, such as furniture. More recently, photography, technology-based arts and installations have been included in art museums. Art objects are displayed in art museums to maximize their formal visual qualities: their design, texture, composition, color palette, scale, etc. Historical, social, or political information is not usually displayed with the art. The purpose of art museums has been fairly constant throughout the course of their existence: to provide aesthetic experiences. Like national museums, they are also intended to be civilizing and uplifting. To some degree, they are meant to be educational. Art museums may be private institutions, public museums supported by tax money, or university-run museums.

Art museums are recent inventions, yet their mission has already evolved. In the first U.S. art museums from the 1800s, the prides of their collections were plaster copies of famous classical sculptures, already in European collections. However, by the beginning of the twentieth century that changed:

... the contents of [early art museums]—what then constituted high art—would in some respects surprise today's museum-goers. When the Corcoran Gallery opened in 1874, it was primarily a museum of casts and replicas of Greek, Roman and Renaissance art, and what was true for the Corcoran was also true for most other art museums of the period.... Through the study of replicas, the museumgoing public became familiar with such canonical works as the . . . 'Laocoon' . . . When in the early 1900s, leading art museums began to relegate cast collections to basement warehouses and hence to oblivion, the change represented a crucial shift in the definition of art and the goals of the museum. . . . the experience of high art became wholly identified with seeing original works of art in museums. Art museums thus shifted their emphasis from traditional forms of artistic education to spectacular displays of cultural property, a move entirely consonant with a new age of conspicuous consumption. (Wallach 1998: 3-4)

Text Link

Review Laocoön (figure 15.14), which was particularly famous and influential in nineteenth-century Europe and the United States.

The art museum's shift in priorities corresponded to other changes: 1) painting became more important than sculpture at that time, and the unique marks made by the hand of the artist-genius made copies unacceptable; 2) modern art of the twentieth century emphasized abstract, formal attributes rather than traditional figure painting based on classical sculpture; 3) wealthy industrialists who were art collectors had collections of original contemporary works to donate to museums; 4) art history developed as a discipline that was concerned with authenticity, attribution, and influences of a work of art.

Museums of modern art are a subset of art museums. They are dedicated to the most current art, which is often unusual or challenging to the general public. One example is the Solomon R. Guggenheim Museum in New York City (figure 21.16), a private museum housed in a famous 1950s structure designed by Frank Lloyd Wright. It contains Solomon R. Guggenheim's collection of modern art. All modern art museums are faced with an intrinsic problem: as time passes, their collection grows old. As more works are acquired, gradually more of the museum's space, budget, time, and resources go to maintaining their collection, which severely curtails their ability to acquire new works. In time, the "modern art" museum ceases to be so. Recently, a number of contemporary art centers have sprung up. They generally mount exhibits of contemporary art, but maintain no permanent collections.

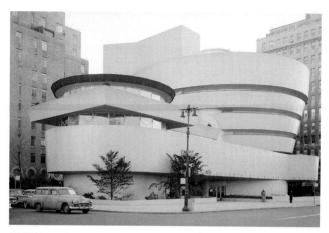

21.16 Frank Lloyd Wright. *Solomon R. Guggenheim Museum*. New York City, USA, 1957–1959. See figure 18.5 to review the information on the design and uses of this building.

Regional Museums

Regional museums serve the interests of specific localities and reflect that area's cultural history. For example, in China, the Museum of Qin Figures was established to house and preserve the clay figures (figure 21.17) and other grave goods from the tomb compound of the emperor Shi Huangdi.

There is a great variety in regional museums' missions, their collections, and the programs they sponsor. Regional museums also tend to be the most experimental type of museum, much more so than either the national museum or the art museum. Let us look at one example, the Anthropological Museum at the University of Ibadan, in Nigeria. It is located in central Nigeria, in the heart of the lands inhabited by the Yoruba. The museum founded in 1963 by British scholars (Nigeria was a British colony) and emphasized European-style research in archeology and museum curatorship. But this model had little appeal for African students. After independence, the museum evolved from its original mission of training academics and curators. Rather than focusing on the past, the museum looks to the future.

Most of [the museums in Africa] are colonial in character and are consequently very divorced from the settings and surrounding which contain vital nuclear elements of African peoples' traditions of visioning and thinking, and ways of praying, designing, planning, speaking and doing things; of organizing socio-politically and of exploiting the natural resources of their environmental setting. . . .

In the [non-colonial] African setting, . . . the museum was a temple as well as a forum—a vigorous meeting place where issues were discussed, where new breakthroughs in political crafting as well as domestic and industrial crafts were invented, tested and put into practice, and where those which stood the test of time were preserved, protected and improved as circumstances dictated. (Andah 1997: 15–16)

Thus the collections of the Museum at Ibadan are seen as directly connected with present life and part of research at the university where the study of the past and the present are linked (Andah 1997: 17).

Museums and New Technology

Recent technology has had a great influence on art, resulting in new categories such as computer-based art, interactive art, video, and to some extent film. These new technologies have resulted in two innovations in the idea of the museum: 1) the introduction of the media museum; and 2) the virtual museum.

Media museums are still very few in number at this time, and none has been in existence longer than fifteen years. Yet as more and more artists use new technology in their artwork, the number of media museums is only likely to increase. Like the art museum, the media museum exists primarily to display works of art. However, the design and function of media museums are influenced by a wide range of modern phenomena. For example, one media museum in Germany, the Center for Art and Media Karlsruhe, dated 1997 (figure 21.18), sees itself as resembling not only art museums, but also radio and television archives, film museums, and science centers such as the Exploratorium in San Francisco, and in addition, lists amusement parks such as Disney World as influential because they have raised the exposure and expectations of the general public to the potential of computer-based art (Schwarz 1997: 26-33).

One special problem faced by media museums is that they must store obsolete hardware and software to view older artworks, in addition to collecting art. Because of the difficulty and cost of maintaining old computer and video equipment, one trend in media museums is not to show older works in their entirety, but to simply present stills or documentation, with a discussion of the cultural impact of the piece. Viewers do not experience the entire work of art. They are provided commentary on the work, and excerpts or documentation about it.

Even mounting an exhibit of current media-based artworks presents great challenges in a media museum environment:

But who is really prepared for the maintenance requirements of a Reality-Engine 2 or for correctly putting on head mounted displays or whole body suits? Who knows what strength a glass fibre cable must have, in order to transport an appropriate amount of image information to the work of art, or which LCD projector is powerful enough to provide the necessary image brightness for a work of art while maintaining a humane room brightness? Not to mention the almost insoluble problems caused by painfully competing soundtracks. There is still no model, no useful solution for how media art can be displayed appropriately and presented in a technically flawless way. A huge amount of pioneering work has to be carried out in this respect. (Schwarz 1997: 13)

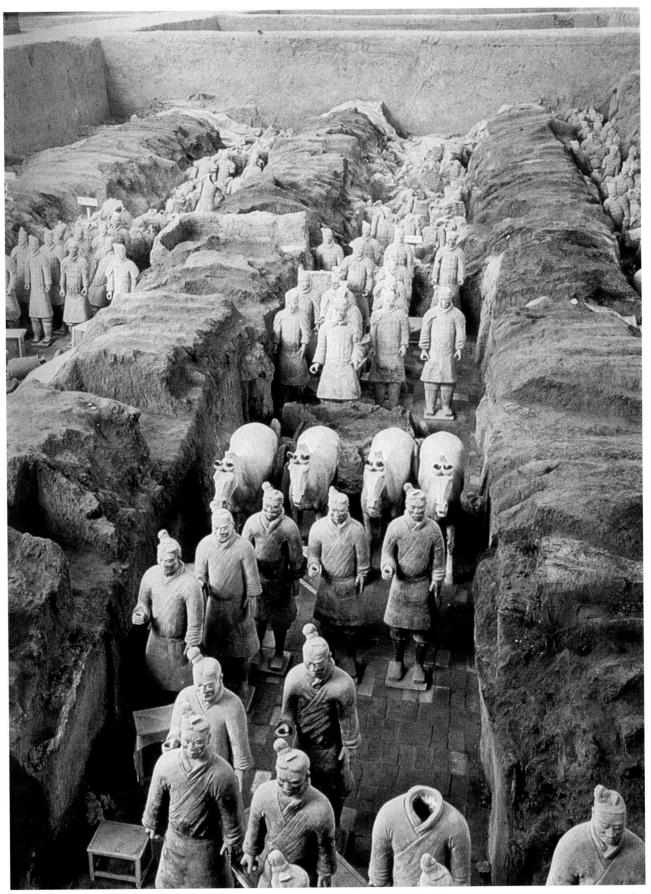

21.17 Solders from Pit 1, near the tomb of Shi Huangdi, Shaanxi (Xian) China, 221–206 BC. Painted Ceramic, average figure height 5'9". Look back to figure 11.9 to review information on this terra-cotta army.

21.18 View into the Media Museum. Computer simulation. Center for Art and Media Karlsruhe, 1997.

Many media museums also envision themselves as artists' studios. Because high-end computer and video equipment is so expensive, some media museums award grants to artists to use museum equipment to produce new artworks. Thus the Center for Art and Media Karlsruhe functions both as display gallery (the Media Museum) and artist workspace (the Institute for Visual Media). And the museum is better able to archive older media works, if many artists were using the same equipment to produce works of art.

Besides the media museums, we also now have virtual museums. New technology has allowed institutions, organizations, and individual artists to develop exhibition sites for the Web. The virtual museum allows all kinds of work to be displayed to the public, where before it was housed within museums and galleries, with curators and collectors normally determining what art got seen. In some cases, these virtual museums contain media art pieces made specifically for the Web, so that what you are seeing is the original work itself. In other cases, the images shown are digital pictures of other kinds of artwork, in which case the virtual museum really cannot replace the traditional museum nor the experience of looking at actual art objects.

Museum Designs

The architectural design of museums is significant, and influences or "mediates" to a great extent the way viewers approach the artwork inside it. Museum architecture also reflects the cultural and social circumstances at the time it was built.

The former director of the British Museum, Sir David M. Wilson, has described the outside of the British Museum as a monumental artwork in and of itself that influences museum-goers in the following way:

Its great Greek Revival façade is almost the symbol of a museum. . . . Its entrance instills a sense of awe and security which enables the visitor to appreciate the treasures and the curiosities it houses not only as something it is a privilege to see, but also as something that is cared for on behalf of the whole world. (Wilson 1989: 7)

The British Museum's Greek Revival architecture (figure 21.15), designed by Sir Robert Sidney Smirke in the early 1800s, was modeled after ancient Greek temples such as the *Parthenon*. It was an appropriate style of architecture for a museum that, at its founding, was dedicated to displaying classical art. Many European intellectuals and heads of state believed that classical art was the highest human cultural achievement. The Greek or Roman Revival styles, therefore, have the weight of institutional solidity. The style was also used for many government buildings that were erected at this time in Europe and in the United States (for example, the Capitol Building, the White House, and many state capitol buildings).

The design of the Solomon R. Guggenheim Museum (figure 21.16) is very different from that of the British Museum, yet it also reflects the art it houses and many broadly held ideas of its day. Like the art inside, this museum building emphasizes abstract geometric form and monumental scale. Decoration is eliminated. Its building material, reinforced cast white concrete, is treated plastically. It twists upward in a large spiral, balanced by squares and circles, like a piece of modern sculpture. The design of the Guggenheim was a radical innovation in museum design, a great break from previous art museums and museums in general. In this, it reflects one of the major tenets of modern art in the United States, which held that modern art should be innovative, and not imitative. The modern era was seen as new, heroic, and progressive, and not dependent upon the past.

The interior of the *Center for Art and Media Karlsruhe* (figure 21.18), shown here in computer simulation, resembles a number of functional, non-art structures of the late twentieth century, including industrial spaces and shopping malls. The architecture is open, with no fixed walls, allowing for flexible configuration of smaller dark projection rooms or soundproof spaces. Visually it resembles diagrams of computer architecture and

flowcharts used in software programming. The physical structure is apparent, including the columns rising from foundation to roof, the floor supports, and the prefabricated ceiling grids. The museum design affirms that the art forms contained inside have ties with industry and entertainment.

Art Maintenance

As we have seen, artworks are very valuable economically, culturally, or historically. The loss of these artworks can be almost unthinkable to those who possess them. Therefore, huge amounts of human efforts, study, and financial resources are devoted to preserving art from the ravages of time, the environment, industrial byproducts, and even other human beings. Restoring works that are already damaged presents an entirely different set of problems, and we will look at them, also.

Museology

Today's caretakers of the modern museum are for the most part highly trained. Degrees are offered in Museology, or Museum Studies, at major universities in cooperation with major museums. This program of study covers practical and theoretical issues of museums, and can range from space design to ethics. The curator or director of a museum, no matter its size, has a tremendous amount of responsibilities. The following are just some of the concerns that fall to curators and their staff:

- collecting
- aquisitions and deacquisitions (purchases and sales)
- research and education
- security
- public relations

- booking, planning, designing, and scripting exhibits
- borrowing and lending of artifacts
- catalogs and literature
- financing, budgeting, fund raising
- ethics
- technology
- administration and staffing
- receptions
- preservation and restoration.

Preservation

Nothing on earth lasts forever, including art, which is subject to decay. But many societies today devote a great deal of human energy and resources to preserving some art intact forever. Art preservation comprises all the human efforts to counteract the decaying process, whether from aging, weathering, pollution, or human damage.

Small art objects are the easiest to preserve, because they can be kept in an environment where humidity, temperature, and light are controlled, and where no one can touch them. Museums and art storage warehouses provide this kind of crowd- and climate-controlled environment. These preservation measures change how we think about art objects, because we only see them enshrined in hallowed cold storage and no longer consider them as useful things, part of everyday life. It becomes hard to remember that works of art were made for many different human purposes, and that few works of art were ever designed specifically to end up in a museum.

For very famous works of art, the protective measures may become obstacles for seeing the work at all. For example, the curators of the Louvre Museum have surrounded Leonardo da Vinci's *Mona Lisa* (c. 1503–1506) with walls and bulletproof glass (figure 21.19).

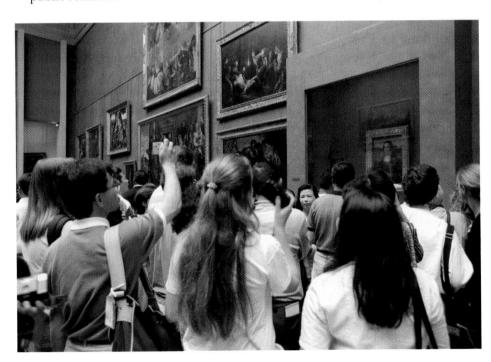

21.19 LEONARDO DA VINCI. *Mona Lisa*, as it is currently displayed behind a bulletproof glass at the Louvre Museum, Paris. Oil on wood, 30.25" × 21", Italy, c. 1503–1506.

The lighting on the painting itself is very subdued to better preserve it. However, the *Mona Lisa* is now almost impossible to see, due to the brighter room lighting, reflective glass and large crowds craning to glimpse the work. The measures were considered necessary to protect the painting from vandals who at times have been known to attack famous works of art with knives, hammers, etc.

If art does not fit into a climate-controlled building, preservation is much more difficult. For architectural sites, preservation must counter: 1) normal weather (wind, rain, sun, temperature variations), which rusts metal, fades paint, and erodes and cracks wood, stone, plaster, or clay; 2) environmental pollutions, such as smog, which deteriorate materials at an accelerated rate, and noise pollution and vibrations, which shake apart buildings; 3) wear and tear from tourists, including their feet, their fingers, and their breath; 4) damage by souvenir hunters, plunderers, adventurers, and vandals; and 5) damage from war. Saving monuments and architecture from all these eroding forces is very hard, and continues to become even more so with every succeeding generation.

The wall paintings in the prehistoric caves at *Lascaux*, France, dated c. 15,000–10,000 BC (figure 21.20), first discovered in 1940, were in splendid condition, having been sealed underground for thousands of years. The

paintings caused an immediate sensation, as visitors flocked to see them. However, increased humidity caused by tourists' breath and sweat resulted in mold growing on the walls and ceilings, causing the paintings to quickly disintegrate. The caves were closed to visitors in 1963. A replica was built nearby, and opened in 1983, but it also was so overwhelmed with visitors that access had to be limited.

Tourists wear away ancient monuments. Where they go in great numbers, ancient stone steps and walkways become rutted and worn. Ancient relief carvings, decorations, and inscriptions on stone walls are disappearing because of tourists' touch. Yet tourists are also a financial asset to an area, and so are encouraged to come.

The modern world threatens the survival of artworks as never before. Vibration from traffic is causing certain ancient Roman ruins to crumble. *The Colosseum* (figure 21.1) was for years in the middle of a traffic circle in Rome, and the constant rumble of cars, trucks, and buses was shaking apart the structure. Emissions were and are a problem, too. Airplane traffic has been restricted over the *Acropolis* in Athens to preserve the ancient temples, including the Parthenon.

Air pollution presents an even greater threat to works of art. The modern world burns a lot of fossil fuels, such as gas in cars and oil in heaters. The by-products of the burnt fuel combine with humidity in the air to form a

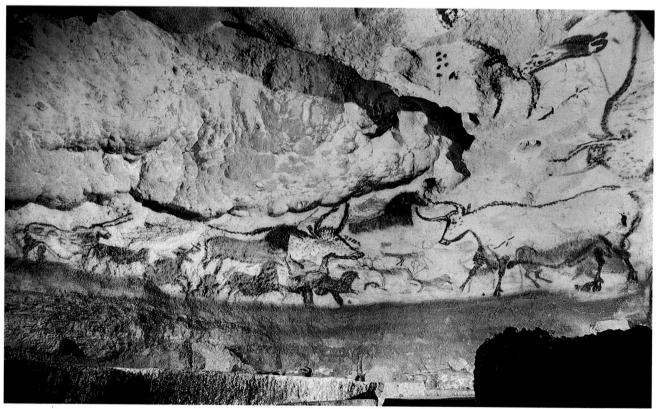

21.20 Hall of Bulls. Lascaux, Dordogne, France, cave painting, left wall, c. 15,000–10,000 BC. Natural pigments, The content, style and use of this work were discussed with figure 6.1.

21.21 *I Love Lucy*, television videos, situation comedy (sitcom), USA, 1950–1960s. CBS Entertainment, A Division of CBS, Inc. This work was discussed with figure 18.23.

weak sulfuric acid, which we experience as acid rain or acid fog. That acidity eats away stone. The threat is worldwide. Ancient Egyptian monuments are crumbling, their wall paintings fading, and their sculptures washed away, thin layer by thin layer. In Mexico, air pollution has been particularly bad for a long time, but has recently been aggravated by the burning of emissions from new oil wells. That pollution is eating away at ancient Mayan temples in the Yucatan peninsula. In Athens, a thin layer of marble from the *Parthenon* and other monuments gets washed away with every downpour of acid rain.

The nation of Greece, recognizing the aesthetic, cultural, and economic value of the *Parthenon* and other ancient Greek monuments, has considered many possible solutions to the problem of air pollution. At one time there was a proposal to cover the entire *Acropolis* with a geodesic dome. Now the government has initiated a long-term plan to replace all diesel public vehicles with electric ones. Meanwhile, all sculpture from the *Acropolis* have been removed to a climate-controlled building, and have been replaced on site with cast concrete copies.

Preserving film, video, and computer art presents a whole new set of problems. Old nitrate-based film stock gets gummy, brown, and finally can self-combust into flames. Of all the U.S. films before 1951, only half survive in any form. Old films on nitrate stock can be copied onto newer acetate safety film stock, which is more durable. But even the basic copying process takes

an enormous amount of time and money. To complicate matters, however, in most cases older films also have to be restored, as discussed on the next page.

Three-strip Technicolor film stock is relatively durable. But today that has been replaced by the current single-strip emulsion color film, with colors that can shift and fade in as few as five years. Single-strip film is being specially stored in below-freezing, low humidity vaults. This special storage will only slow down, but not stop, the decaying process in current film stock.

A lot of old television and video has been lost. Many old live television programs were never recorded. Others are lost because the tape was improperly stored and was damaged or destroyed. Rebroadcasts of early videos of *I Love Lucy* vintage (figure 21.21) tend to be low quality, especially when they are copies of copies. No one knows how long videotape lasts. Estimates vary wildly, on the low end ranging between five and twenty years, versus the more optimistic guesses of one hundred years. Another complication to video archiving is that old videotapes were created on equipment that is now obsolete. Even if you do have old intact videotape, you may have trouble finding equipment on which to play it.

As we have already seen, computer-based art is plagued by rapid obsolescence. Interactive art, for example, requires the software and hardware of its time in order to be able to access it. Lynn Hershman's 1990 work, *Deep Contact* (figure 21.22), also requires the storage of

21.22 LWN HERSHMAN. *Deep Contact.* USA, 1990. Interactive computer-video installation at the Museum of Modern Art, San Francisco. See figures 2.31 and 17.14 to review information about this artwork.

the necessary computers, software, and video equipment in order for future viewers to experience the entire work of art as an interactive piece. Maintaining arcane computer systems becomes costly, space consuming, and difficult. Even printed-out computer art suffers archiving problems, as many of the inks, binders, and other materials used in printing are known to be impermanent.

Restoration

Art restoration is the collective technologies and efforts designed to "fix" art that has been damaged or has deteriorated, and to bring it back to its original condition as much as possible.

A massive effort is underway to restore the terracotta army surrounding the tomb of the first emperor of China, Shi Huangdi. The army, consisting of more than six thousand clay soldiers, was broken and burned in a revolt only five years after the emperor's death. In the pit in the foreground of figure 21.17 are soldiers in the process of restoration, while in the background are many that are still in pieces. The pits beyond contain still more soldiers. Each soldier was once brightly painted with

mineral colors, which have almost entirely worn away. There were also weapons, iron farm tools, silk, bone, linen, and jade objects buried with the soldiers. The clay horses of the charioteers had bronze and leather bridles, and pulled now-disintegrated wooden chariots.

The restoration of Shi Huangdi's terra-cotta army presents two major problems that frequently confront art restorers. The first is the cost. In many countries, the demands of the living compete against the relics of the past. With so many current needs, how much time, money, and energy should go to restoration efforts? According to current estimations, many generations will pass before Shi Huangdi's twenty-square-mile funeral complex has been fully excavated and restored. The emperor's actual tomb, reputed to be full of lavish treasures, has not even been opened yet because of lack of funds and personnel.

The second problem confronting restorers is: How can we "restore" works of art, when we do not know what they looked like in their original condition? While works of art like the terra-cotta army are painstakingly excavated in ways that preserve all archeological evidence of their original appearance, the fact is that there is still much guesswork and dispute about that evidence. It is important to remember that restored artwork represents what modern restorers think that ancient artwork should look like, rather than its original condition.

Even the restoration of modern artworks requires combining scientific technology with much detective work, guesswork, and aesthetic judgments. Let us look at film. At the minimum, faded colors and color shifts have to be corrected. Soundtracks need restoration, too. *Gone with the Wind* (figure 21.23) made in 1939 but recently restored, had its color and soundtrack "enhanced" during restoration. Who is to say whether the "enhancement" really represent the original film version, or merely modern tastes for richer colors and fuller sound? In more complex film restorations, where the film stock has suffered from severe deterioration, various copies of the film have to be located and spliced together, so that damaged segments can be replaced and missing footage restored.

Sometimes the art is damaged even more while it is being "restored." In the early twentieth century, steel I-pins were embedded into the *Parthenon's* stones to strengthen it by locking adjoining blocks together. These embedded pins eventually rusted inside the stones and expanded in size, causing the marble to crack apart from the inside. Rain seeped into these cracks and froze in winter, crumbling the blocks much more than normal wear and tear might have. To undo this art "restoration," the entire Parthenon had to be x-rayed to locate each pin, and then each had to be removed.

Questionable restoration practices continue to be used. Centuries-old temples in Southeast Asia, overgrown with tropical vegetation, have been scrubbed with modern detergents and sprayed with modern herbicides, in efforts to clean off mold and fungus and to keep back new plant growth. Yet no one knows if the stones and carvings may have suffered long-term damage by the application of these strong chemicals.

Leonardo da Vinci's Last Supper has been badly restored many times in the past, overpainted with glues and varnishes to keep the original paint from flaking off. Restorers have also painted over it, trying to return it to its original form. Added in were layers of soot from burning lamps that lit rooms before electricity. By the twentieth century, very little of the Last Supper was actually Leonardo's painting. In the 1990s, Dr. Pinin Brambilla Barcilon supervised the most recent attempt to uncover and clean the Last Supper. Every bit of paint was removed from the wall, chip by chip, separating off the top from the bottom layers. Then the very bottom layers, those believed to be by the hand of Leonardo, were reglued to the wall surface. Needless to say, this was tedious work. The result is surprisingly bright and lightfilled (figure 21.24), and conflicts with traditional views of Leonardo's work as smoky, moody, brooding, dark, and somber.

The Last Supper restoration caused a lot of controversy. Who is to say where Leonardo's paint stops, and the first layer put down by the first restorer begins? Some experts accuse restorers of removing too much old surface, hypothesizing that the resulting bright colors are underpainting, and the restorers removed some of the more modulated colors that were the artists' final touches. The bright colors may be the result of overcleaning.

Text Link

Michelangelo's paintings on the Sistine Ceiling (figure 9.30) have also been recently cleaned, with similar bright results, and many experts say that the restorers removed Michelangelo's final layer of paint, in addition to the restorers' layers.

Sometimes restoration may present an artificially complete view of a work when in fact there is very little of the original left. *Last Supper* restorers have added watercolor painting between the old paint chips, to fill in blank areas, to provide visual continuity, and to make it "look better." But the question still remains. How much of what we are looking at is Leonardo's work, and how much is what we wished it looked like? The *Parthenon* has several parts replaced with concrete replicas. How do we regard this, especially if it is considered along with the Shinto *Main Shrine* (figure 21.25), from Ise, Japan? This work is dated 685, but the total structure has been ritually rebuilt every twenty years, following the original plan. What you see is less than two decades old.

WHEN ART IS NOT SAVED

If art is so powerful and influential that great efforts go into owning, displaying, and preserving it, then the destruction of art becomes an equally powerful act, but for different reasons. Sometimes art is purposefully destroyed when one culture seeks to obliterate another. In other instances, art is created, dynamically used, and

21.23 Gone With the Wind. MGM film, USA, 1939, starring Clark Gable as Rhett Butler and Vivian Leigh as Scarlett O'Hara. See also the text accompanying figure 18.22.

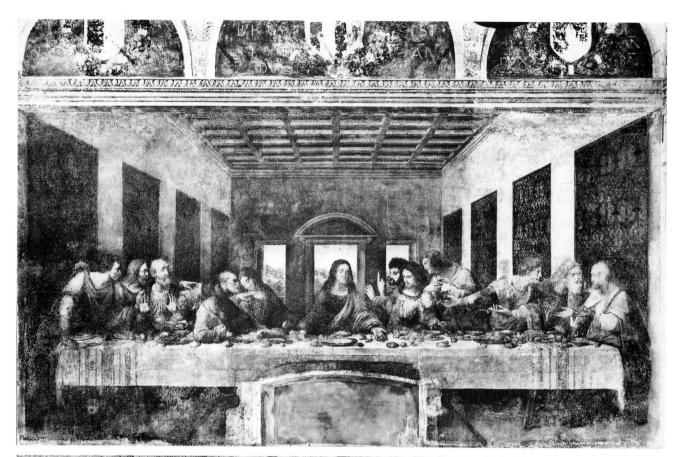

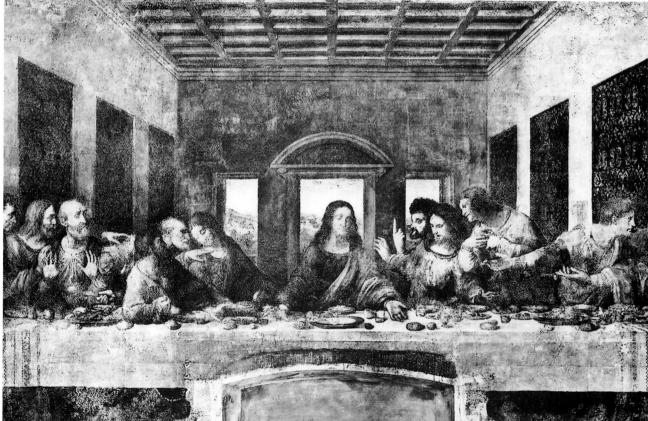

 $21.24\ LEONARDO\ Da\ VINCI.\ Last\ Supper\ Restoration\ of\ the\ Last\ Supper\ by\ Dr.\ Pinin\ Brambilla\ Barcilon.\ Photographed\ before\ and\ after\ restoration\ in\ the\ early\ 1990s.\ For\ more\ on\ the\ Last\ Supper\ and\ its\ meaning,\ see\ also\ figures\ 2.21,\ 6.27,\ 20.22,\ and\ 21.4.$

21.25 Main Shrine at Ise. Japan, c. 685, rebuilt every 25 years. Look back to figure 10.2 to review more on this shrine.

destroyed as it serves its purpose in rituals. Some artists choose not to make enduring art objects.

Art Destroyed in Conflicts

In national, religious, or ethnic conflicts, art is often destroyed. It may be one more insult the victors inflict upon the conquered. Or the victors may be merely negligent. At times it is done for religious reasons. Or it may be part of the horrible phenomenon of ethnic cleansing. We will look at several historical examples when art was destroyed, but the destruction continues today. Recently in Afghanistan, Islamic militants have begun to obliterate ancient Buddha statues.

During the seventh and eighth centuries, early Christian icons became a source of conflict, which resulted in many being destroyed. Some Christian factions of the time connected the devotion to these portable religious images, usually of the Holy Family and saints, to committing the sin of pagan idolatry. Known as "iconoclasts" (the breakers of images) they sought to ban and destroy these images. At that same time in history, the Arabs invaded Persia, Byzantium, and Constantinople, bringing the religion of Islam. The Christian emperors of the eighth century thought that God was punishing them for their idolatry by permitting the Arab invasion, and prohibited the use of religious images. The reign of iconoclasm resulted in the ruthless destruction of thousands of these precious religious icons for a whole century.

Many monuments from ancient Rome were damaged or destroyed because Medieval Europeans were indiffer-

ent to their artistic merit. The *Spoils of Jerusalem* (figure 21.9) from the Arch of Titus was damaged during the Medieval era, as heads were knocked off from the carving and holes punched into the top and bottom of the relief when the arch was incorporated as a doorway of a Medieval home. The *Colosseum* (figure 21.1) was stripped of its marble facing and metal pins were dug out of its stones by Medieval peoples. We have seen that the *Parthenon* was greatly damaged during the years that the Ottoman Turks dominated Greece.

Other acts of destruction are much more intentional and thorough. During World War II, the Nazi Germans purposefully destroyed ancient Byzantine religious icons and many monuments during their occupation of western Russia, in an effort to wipe out Slavic cultures.

After the conquest of Mesoamerica, Spanish missionaries arrived to convert the native peoples to Christianity. Diego de Landa was a Spanish Franciscan priest and the first Christian bishop of the Yucatan. He was sympathetic to the native peoples, trying to help them as they suffered from European diseases, especially smallpox, and to protect them from the terrible treatment they received from Spanish authorities. He wrote the most important early book that recorded much information about Mayan civilization, called *Relación de las cosas de Yucatán*. He made the first European drawings of Mayan buildings.

Landa, however, was horrified by the native religions of Mesoamerica, especially the practice of human sacrifice. In his religious fervor, Landa ordered the destruction of all idols and books. He wrote, "We found a great number of these books in Indian characters and because they contained nothing but superstition and the Devil's falsehoods we burned them all; and this [the Indians] felt most bitterly and it caused them great grief." Landa's book burning has subsequently caused great grief to modern historians, archeologists, art historians, and anthropologists. The great libraries of books that he had burned contained not only religious practices, but also splendid artwork and the histories of many Mesoamerican civilizations. So much was lost. Yet scholars are also indebted to Landa, as his manuscript, Relación de las cosas de Yucatán, which was rediscovered and finally printed in 1864, gave vivid accounts of sixteenth-century Mayan life. It also contained 30 Mayan characters next to their Spanish letters, enabling scholars to decipher about one-third of the Mayan hieroglyphics.

The burning of books did not wipe out Mesoamerican religions. European missionaries discovered that because they were ignorant of native religious practices, they could not recognize and eradicate them. To educate missionaries, Franciscan priests began working with native scribes to make books on histories, genealogies, almanacs, and native practices, with spaces left for missionaries' notations. The Primordial Male and Female Forces: *Ometecuhtli and Omecihuatl*, dated c. 1525 (figure 21.26), is a page from the *Codex Borbonicus*, made by Aztec scribes under Franciscan supervision, just four years after Cortés' conquest. Ironically, it is a work of art that was made to help eradicate a culture. The page in our illustration shows the Aztec concepts of the beginning of time, the establishment of night and day, the origin of fire, and the first human couple.

In the course of making such books, some missionaries seem to have developed a great appreciation of the native Mesoamerican arts and traditions. One thirteenvolume book, the *Florentine Codex, the General History of the Things of New Spain* of 1566–1585, by Father Bernardo de Sahagún with native scribes, records aspects of Aztec life with great interest and zeal. Ironically, therefore, missionary efforts resulted simultaneously in the greatest destruction of and the greatest preservation of Mesoamerican culture and religion.

Missionaries to other areas of the world have contributed to the destruction of native cultures. In the case of the *Figure of a Deity: A'a Rurutu*, dated 1820 (figure 21.27), now in the British Museum, missionaries preserved the art object and sent it back to Europe, but we have no information on the meanings or the indigenous uses of this piece. In other instances, a change in religion has meant the wholesale destruction of the

21.26 Ometecuhtli and Omecihuatl. The Primordial Male and Female Force, Codex Bordonicus, Mexico, 1525. Aztec, Bibliotheque de l'Assemblée nationl francaise, Paris, France. To review information on this codex, turn to figure 7.16

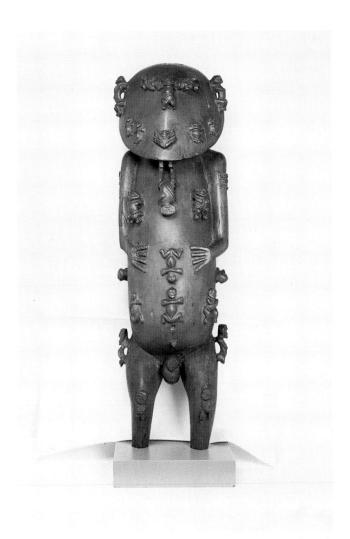

21.27 Figure of a Diety: A'a Rurutu. Austral Islands, Polynesia, collected in 1820. Wood, 44' high. The British Museum, London. See figure 7.6 to review ways that this sculpture and other art is intended to ensure human fertility.

previous religion. Hindu temples in Northern India are totally gone, because the conquering people, who were followers of Islam, destroyed all traces of Hinduism in areas under their control.

Art Used Dynamically in Rituals

We have seen several examples in this book in which art objects are lost or destroyed as part of rituals or dramatic performances. The *Bisj Poles*, dated c. nineteenth to twentieth centuries (figure 21.28), carved by the Asmat people on the southwest coast of New Guinea, are created as part of rituals that fulfilled a variety of complex purposes, including promoting male power, passing the power and spirit of the dead on to the living, and revenging the death of deceased clan members. Afterwards, the poles were left to rot away among the sago palms, the Asmat's primary food source, to promote their fertility. Thus, the deterioration of the art was an important part of rituals that redirected the human spirit after the death of that person.

Navajo sand paintings are also destroyed to complete the ritual for which they are made (figure 21.29). Navajo attitudes about beauty (and also art) are expressed in the following:

A Navajo experiences beauty most poignantly in creating it and in expressing it, not in observing it or preserving it. The experience of beauty is dynamic; it flows to one and from one; it is not in things, but in relationships among things. Beauty is not to be preserved but to be continually renewed in oneself and expressed in one's daily life and activities. (Witherspoon 1977: 178)

Interestingly, some museum curators, scholars, and tourists make efforts to preserve the art that the Navajos themselves do not keep. So now, sand paintings have been made for tourist trade on boards covered with glue. And some museums have commissioned the making of "permanent" sand paintings within the museum.

Text Link
For more about Navajo sand painting, see
Nightway: Whirling Logs (figure 10.3).

Non-Object Art

Some artists choose not to make art objects. They are motivated in part by a desire to make art an experience for people, rather than a collectible or a luxury item. Performance art is a good example of this kind of work. Yoko Ono's *Cut Piece* (figure 21.30) from 1964 no longer exists in any material form, except for photographs that document the event. In other cases, artwork that can be easily copied or broadcast has a similar effect of emphasizing the experience of a work rather than its physical value. Some video artists and Web artists make their work available to many people at minimal cost

STUDYING ART

Among the many things we do with art, we study it. Art is part of many academic disciplines, including art history, archeology, cultural anthropology and some areas of psychology. Interestingly, all of these disciplines are fairly recent in development, dating from the nineteenth and early twentieth centuries. Each discipline is also actively evolving, with changes in scope of study or methodology.

Art History

Art history is the historical study of the visual arts. Art historians treat artworks as their primary material of

21.28 Bisj Poles. Asmat, Buepis Village, Fagit River, southwest New Guinea, c. nineteenth—twentieth centuries. Wood and paint, approximately 16' high. Photograph by Tobias Schneebaum. See figure 16.7 to review the discussion of the rituals and meaning attached to the Bisj Poles by the Asmat people.

study, much as historians may study archives. They develop a kind of connoisseurship: that is, art historians are able to study an unfamiliar art object and attribute it to a period, a style, an artist (even specifying early or late production), and determine whether a work is authentic or a copy. Their expertise is based on years of scholarly study and intense looking at art. They need sensitivity and keen judgment in their work.

In its earliest beginnings, four hundred years ago, the scope of art history was fairly narrow, limited to artists'

biographies and the stylistic and formal analysis of art objects. Art historians studied primarily Western painting, sculpture, architecture, and prints. In recent decades, art historians have broadened their study of art to include the other arts, language, and the broader culture. While art's formal and stylistic qualities are still important, they are studied within political, social, religious, and economic contexts. Art historians have also changed what they studied: in addition to painting, sculpture, architecture, and prints, art historians also

study photography, film, and other media as part of their discipline proper. Compared to the past, more art historians now are specializing in art of Africa, the Americas, Oceania, and Asia.

Highly important related areas include popular culture and concurrent literature. Psychology is important, as recent artists' biographies are less exclusively fact-based, and more attempts to reconstruct the artists' personalities. Art historians also study the structure of the art world: the workings of museums, the art academy and the education of artists, the functioning of the gallery, the role of the collector and critic, and so on, and how each of these contributes to the "making" of art.

Text Link

See the section on "Art Writing" in Chapter 4 for more on the kinds of literature that art historians and critics produce.

Aesthetics and Criticism

Other disciplines that study art are aesthetics and art criticism. Aesthetics is a branch of philosophy that focuses on that which pertains to the beautiful, its understanding, and appreciation, both "universally" and within specific cultural contexts. Questions of what is

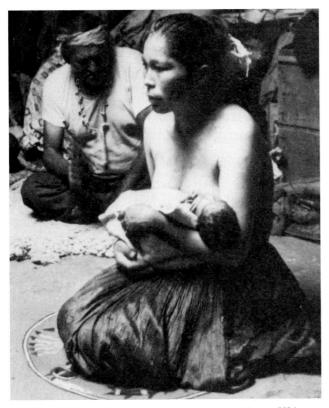

21.29 Sand Painting. Ritual for a sick child, Navajo, Arizona, USA, 1954. Photograph by Lee Boltin.

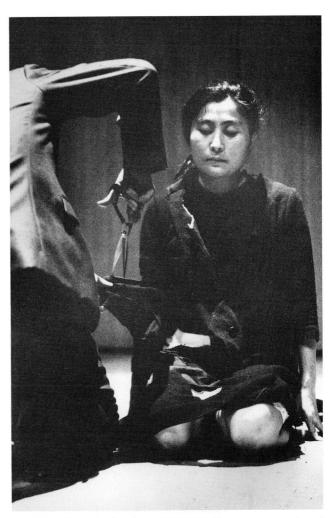

21.30 Yoko Ono. *Cut Piece.* Japan/USA 1964. Photo documentation of performance at Yamaichi Concert Hall, Kyoto, Japan. Collection of the artist, courtesy Studio One. Turn back to figure 15.28 to review the discussion about this performance piece.

beautiful are of constant debate, especially when applied to art objects. Aesthetics is a challenging and provocative vehicle for deriving meaning in art.

Art criticism examines art and makes value judgments about it, pro or con. Critics evaluate art exhibits and events, and then publish or express their opinions in newspapers, magazines, radio, television, and video. While critics evaluate artwork, they also educate the public. Critic Robert Hughes says: "Criticism isn't about saying 'I think this, therefore you should think this.' It's about getting people to look and to think and to do it on their own" (Preble, Preble, Frank, 1999: 113). See Chapter 4 for a description of the major philosophical approaches behind twentieth-century art criticism.

Archeology

Archeology is the scientific study of the physical remains of past human life and activity. It includes all things that are buried or thrown away, such as bones, stone tools, art objects, weapons, utensils, and other functional objects. It also includes monuments and buildings. Archeologists conduct fieldwork, where they carefully excavate, classify, and date the materials they find. They record their findings with pictures, precise verbal descriptions, and measurements. They then place the artifacts into historical context, complementing what is known about a civilization from written records.

In the early 1800s archeology was in the formative state. There was a great interest in ancient ruins in Greece, Rome, and Egypt, but it was not entirely scholarly. Sites in ancient Egypt, as we have seen, were visited (and plundered) by European armies, adventurers, scholars, and government agents. Objects were carelessly removed, often causing damage to what was left. There was no record of what was taken or what the site was supposed to look like undisturbed. Much valuable information was lost. Finally, in 1863, the Egyptian Service des Antiquités was founded to check digging on ancient sites.

By the end of the 1800s, archeology had matured into a scientific, academic discipline. Controlled excavations were conducted, which revolutionized archeology. New U.S. or European research in Egypt is done in cooperation with the Egyptian government, and the goal of such research is the acquisition of knowledge rather than the taking of artifacts for foreign museums.

Cultural Anthropology

Cultural anthropology is the study of humanity within cultures. It covers all aspects of culture, including human behavior, social organization, and the creation and use of objects. Cultural anthropology uses the methods, concepts, and data of archeology, ethnology, ethnography, folklore, and linguistics, and sometimes also draws on sociology and psychology. For living cultures, the cultural anthropologist does fieldwork (i.e., living with the peoples) and collects data on human behavior and social organization. The visual arts are important to the cultural anthropologist in that they show the social structure, religious beliefs, and domestic practices. Or they reflect the aspirations or fears of a people.

The anthropological study of art is more compelling in some areas of the world than the more narrow scope of traditional art history. We have already discussed the Anthropological Museum at Ibadan, which is integrated with departments of African Studies, archeology, and more recently with anthropology. The purpose of archeology and the study of art objects at Ibadan differs dramatically from the traditional European studies of art and archeology. Departmental research at Ibadan since 1980 has included a wide range of topics, including "past climates and environments of Nigerian habitats," "early crop agriculture," "the development of towns and complex societies in African settings," "the development of metal technology in parts of Nigeria," and so on. (Andah 1997: 21)

Psychology and Human Development

Art has also been used to study human development. Various theories of human growth and acquisition of cognitive and conceptual skills have been based on the study of drawings and diagrams made by children, adolescents, and adults. The Swiss psychologist Jean Piaget developed theories on the formative stages of childhood, based in part on the study of children's drawings.

Art therapy is an area of medical treatment that uses the artwork of mental health patients to help diagnose and treat their illnesses. Since art is another language, information can be brought forth from a patient visually, when perhaps words cannot be uttered.

SYNOPSIS

Groups of peoples do many things with art, as we saw in this chapter. Art is experienced through performance or display. Sometimes, the location of art changes its use. The *Retablo of Maria de la Luz Casillas and Children* is used differently in a pilgrimage church in Mexico as opposed to in a museum in the United States.

We spent much time discussing why people keep art. The reasons included:

- art provides people with aesthetic, civilizing, or educational experiences
- because much art is sacred, individuals keep it for their own spiritual observances, and religious institutions maintain sacred sites, often with collections of sacred art.
- there are many politicized uses for art, including strengthening ethnic identity. Another reason for keeping art is to promote national glory. Art is a symbol for a nation's power, and in times of conflict, a sign of domination of one country over another.
- art is part of commerce. Art helps the general economy through tourism. Art is used in advertising. The buying and selling of art is a thriving business.

Next, we covered art that is kept as part of art collections. We looked at the relationship between private collecting and museums. Looking in depth at museums that collect art, we saw the large national museum (the British Museum in London), the art museum (the Solomon R. Guggenheim Museum in New York), the regional museum (The Anthropological Museum at the University of Ibadan, in Nigeria) and the museum devoted to new technologies (the Center for Art and Media Karlsruhe, Germany). We saw how each could be private or public, how they served different audiences, how their attitudes toward displaying art were different, and how their architecture reflected their different functions.

The knotty economic and aesthetic problems associated with art preservation and restoration were next. We revisited the *Parthenon* to discuss past restoration

attempts that were actually destructive, and the negative impact of noise and air pollution on it. Also covered was the restoration of the terra-cotta army of Emperor Shi Huangdi, a process likely to take decades—perhaps even centuries—to complete. Media arts, such as film and computer-based art, present special problems in preservation and restoration. Much film and video stock deteriorates quickly. Proper storage requires darkness, low temperatures, and low humidity. The hardware required to view old computer-based art and video becomes rapidly obsolete and almost impossible to maintain, making it difficult to view such works even when they have been properly stored.

Not all people are interested in preserving works of art. Invading armies often destroy the art of those they vanquish. Navajos dynamically use sand paintings during the ritual, so no object remains at the end. After ceremonies and feasts, the Asmat people leave their carved Bisj poles to rot, contributing literally and ritualistically to the earth's fertility. Performance artists do not make art objects.

Various academic disciplines study art. Art history has the most narrow and intense focus on art, although recent art historians are expanding art history to include political, economic, and social issues. The study of aesthetics analyzes the notion of beauty with cultural contexts, while art criticism analyzes art's strong and weak points. Archeologists study the buried or discarded remains of past civilizations. Cultural anthropologists have the broadest scope of study, covering all aspects of human behavior, customs, language, and production within a particular culture. Art is also studied in psychology, as regards the development of human cognitive and conceptual skills.

FOOD FOR THOUGHT

In addition to everything else that happens to art, sometimes it gets censored. Censorship is the prohibition of certain art for moral, political, religious, or sexual reasons. The German Nazis in the 1930s and 1940s practiced an extreme form of censorship. They seized or destroyed art from public and private collections that varied from the official art style, which was idealized and naturalistic

and promoted Nazi policies. Artists could be banned from making art, or imprisoned if they produced abstract or surreal art, or if they were non-Germanic by birth.

In the United States today, questions of censorship come up in a variety of circumstances associated with art making and art exhibitions. Sometimes there are actual criminal charges. In 1990, the director of a Cincinnati museum was placed on trial for obscenity. His institution had hosted a large photographic exhibition, among which were seven images that many people thought were sexually offensive. The jury acquitted him. Sometimes, though, the censorship means lack of funding or other support. In the 1990s, the National Endowment for the Arts withdrew money grants that had already been awarded to four artists because of the pressure of some politicians who found their art to be offensive. In 1999, the Brooklyn Museum drew the fire of New York Mayor Rudolph Giuliani for an exhibit called "Sensation." The pressure can result in self-censorship, where museums do not book an exhibition, or artists do not make certain work, because of the possibility of becoming embroiled in controversy that is too time-consuming and costly.

- The First Amendment of the U.S. Constitution states that "Congress shall make no law . . . abridging the freedom of speech." Historically, the courts have viewed art as a form of speech. Some speech, however, is constitutionally banned: libel, slander, hate speech and obscenity. But one person's opinion of obscenity differs from the next, and certainly community standards of obscenity change from era to era. What is obscene? What is acceptable material for an adult, versus an adolescent?
- Some people claim that tax dollars should not support art that some find offensive. Is that position different, or not, from people objecting to tax dollars supporting a military project that they find wasteful, or medical research that some find unethical?
- Should all individuals decide for themselves what they can read, look at, or listen to? What happens if they conflict with community standards?
- Is it a requirement of art to be uplifting? Moral?
- Should certain material be banned from the Internet, or certain lyrics from popular music?

This subject continues to be an area of conflict in the United States today. You can expect to see more controversies like this during your lifetime, and your vote and opinion on such issues will count.

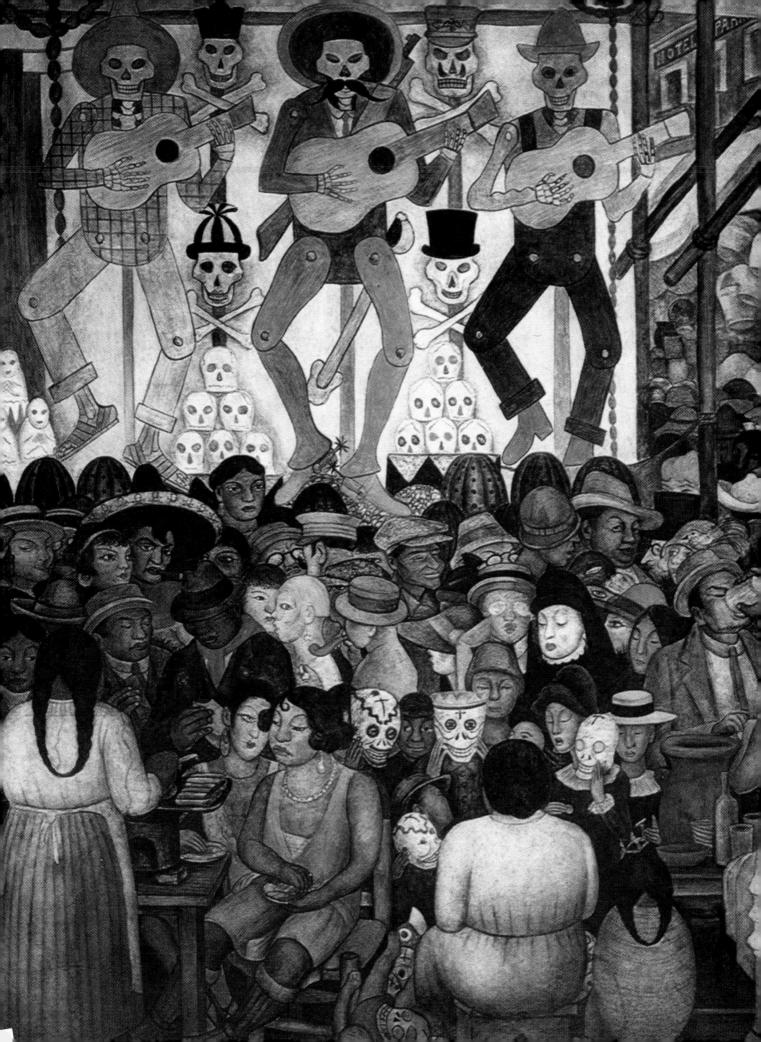

Chapter 22 Where Do You Find Art and How Can You Use It in Your Life?

INTRODUCTION

The overall purpose of this book has been an inquiry into human creativity, and therefore our own creativity. We have seen that art is something that human beings have to do, through the ages, throughout the world.

And what about you? Art is already part of your life. With a little effort, you can make it even more enriching for you. This chapter does not deal with art that is fabulous or remote, or beyond your intellectual or financial reach. We will be talking about art in your everyday life, as part of your visual pleasure, your cultural heritage, or your spiritual growth. These questions may help:

Where can I find art in the community? How is art a part of my life? How can I enjoy art more?

ART IN YOUR COMMUNITY

If you want to see original artwork, in person, you probably have many opportunities in your own community, or within a reasonable drive from your home. Here are some places to seek out art.

Museums and Galleries

Millions of visitors flock to museums every year, for both a transformative and pleasurable experience. Visitors find aesthetic objects, a broadening of outlook, a cultural or spiritual education, and the relaxing pleasure of a leisure-time outing. The largest and most prestigious museums contain many famous works of art. Indeed some of the visitors to the opening of the Solomon R. Guggenheim Museum in 1959 must have been surprised (figure 22.1). Not only were they seeing the art of the avant-garde, but they also experienced a most unusual and innovative way to view art in a spiral space. This museum is in New York City and is a must to visit for both the native and the tourist.

Do not forget, however, the museums and galleries in cities all across the United States. Most communities support museums and galleries, ranging from modest to grand. Whatever their size, they are well worth the visit, and may surprise the first-time visitor. Plan to take enough time to look carefully. While local museums may not display the most famous "masterpieces," they contain works of real value that are rewarding to study. Like all things in life, "famous" does not always mean profound, and in the same way, sometimes real jewels sit in unassuming surroundings. Ask the staff questions about the work. Go with a friend and discuss what you see.

Schools

Schools are exciting places to look at art, because there is an extraordinary amount of inventiveness, spontaneity, expression, and even marvelous "mistakes." Go to see this work with a generosity of spirit. It is not important whether you are seeing the work of a future Van Gogh or not. There is much for you to learn and enjoy.

Art exhibits can be found in elementary and secondary school systems, and they are absolutely delightful. The hallways are usually dazzling with art, in all forms and bright colors. In figure 22.2, we see a painting that was done by Kimberly Schlesier in the first grade, for an exhibit sponsored by the John Deere Company, manufacturers of farm machinery. The children were asked to paint their impressions of an Iowa farm scene. Children are without inhibitions and easily express what they perceive, making their art so refreshing. Middle schools and high schools usually have many artworks on display which may range from a formal show in a gallery, an informal exhibit in a school corridor, to a mural on a school wall.

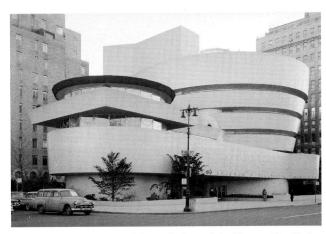

22.1 Frank Lloyd Wright. Solomon R. Guggenheim Museum. New York City, USA, 1943-1959. See also the text accompanying figures 18.5

22.2 KIMBERLY DAWN SCHLESIER. A Farm is a Place to Grow. Dubuque, Iowa, 1970. Kimberly was 6½ years old when she painted this piece. Tempera paint on paper. See also figure 1.7.

On a very different and professional level, you can find art at most college and university art departments. These schools have exhibition spaces for student and faculty shows, and often show the work of professional artists both to enrich the art program and to expose the academic community to their work. These exhibits are often free and open to the public. Specialty exhibits are also planned on many campuses, such as a major exhibition of Peruvian Moche art at a University of California at Los Angeles gallery (figure 22.3). A phone call to the school is all it takes to find out about the schedules of the exhibits.

Public and Private Buildings

Often government buildings have been designed by accomplished architects and the buildings are examples of fine works of architecture. Post offices, courthouses, and the like often have distinctive designs. Look at the ones in your community. For example, Washington, DC, is filled with all kinds of architecture, such as the Capitol Building, which reflects Greek and Roman design. In England the *House of Parliament* is filled with Gothic elements, giving it the appearance of a medieval fortress (figure 22.4).

While these structures are splendid in themselves, often they are filled with paintings, sculptures, and art treasures. The Ministry of Education in Mexico City, as well as several other buildings, has been adorned with paintings by the highly talented Mexican muralists. In the Ministry of Education Diego Rivera painted his 1923

mural, *Dia de Los Muertos* (figure 22.5), which celebrates a popular Mexican fiesta.

Other places to look for art in your community are in libraries and hospitals. Many of these institutions have their own collections that enhance their interiors. Often libraries will have exhibition space available to their communities and will host artworks by local artists. Some hospitals collect art. For example, an impressive collection of contemporary artwork can be found in the University Hospitals of the University of Iowa in Iowa City. What a happy addition to the traditionally sterile hospital walls.

The United States has a great tradition of art in public places. In the 1930s the U.S. government funded artists who painted murals, decorated, and provided sculpture in public buildings. Are there any in your community? More recently, the existence of Percent for the Arts Programs has meant that art is incorporated into all new government-funded buildings, and also in redevelopment areas where private investors are receiving tax abatement. You can find excellent art there.

Look also in corporate buildings for art. Some corporations have taken great care regarding the architecture that houses their headquarters. In figure 22.6, we see the *Bank of China*, designed by the renowned architectural firm of I.M. Pei and Partners. A new interpretation of the classic skyscraper, this structure pays attention to every aesthetic detail, both in its interior and its exterior. Along with their buildings, many corporations have invested in fine art. They may display this collection within

their buildings, or build a separate space dedicated to art. These collections are usually open and often are free to the public. Again, a phone call, or announcements in the press can give information to their schedules.

The homes of historic or celebrated persons sometimes become museums for public viewing. One of the most innovative museum-homes, *Monticello*, was built by Thomas Jefferson (figure 22.7). This house is full of art

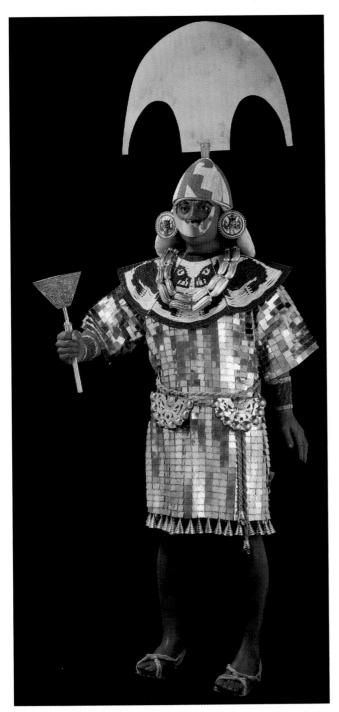

22.3 Mannequin dressed in replicas of some of the objects found in tomb 1, *Royal Tomb of Sipan*. Moche Civilization, Peru, c. AD 300. See figure 11.12 to review the meaning of this work.

treasures and his own amazing inventions. The gardens have experimental flowers, plants, and all kinds of vegetables. Beside the relatively small residence of *Monticello*, other palaces and mansions of the past have also become museums. The Palace of *Versailles* and the *Forbidden City* are now open to everyone, examples of magnificent opulence originally known to only a few. In the United States there are several mansions formerly belonging to wealthy entrepreneurs who bequeathed their estates as museums. Every city and town has a chamber of commerce that can aid the visitor in finding these interesting sites.

Places of Worship

Churches, temples, synagogues, and mosques are rich places to look for art. Besides their architectural designs, they likely are decorated with old and contemporary artworks. A place of worship may have exquisite stained-glass windows, as seen in the twelfth-century *Chartres Cathedral* (figure 22.8), fine paintings, sculptures, or elaborate tile work. Generally, one does not have to be affiliated with the respective religion in order to gain access to these worship spaces, but inquire first. Many welcome visitors to their services, and may be open to the public all day. Some religious institutions conduct tours through their structures for a low free or a small donation. These places are often rich in their histories.

Parks

Everyone loves to go to the park and practically every community has one. Many parks are designed by land-scape architects in which the gardens, walks, lakes, etc. are carefully planned. The Boboli Gardens in Florence, Italy, boast of two museums. The well-known *Central Park* in New York (figure 22.9), planned in the nineteenth century, has an art museum, several theaters, a zoo, and many more features. It is also the home of several commemorative sculptures. The open-air park brings art and nature into one enjoyable and relaxing environment. Most community parks are free to the public or charge a small parking fee to help with maintenance.

Art Online

Art is available in many forms on the Internet. Most museums and many galleries have Web sites where you can get information about current exhibitions and permanent collections. Commercial galleries also have Web sites, but they are focused on the sale of artwork, and less on providing enriching or educational experiences.

Artists have their own Web sites that feature their work. To find artists' Web sites, inquire at arts organizations, or do a Web search on art resources or media art centers. They will likely have links to artists' pages, or feature recent artists' projects.

22.14 Andy Warhol. Heinz 57 Tomato Ketchup and Del Monte Freestone Peach Halves. USA, 1964. Silkscreen on wood, $15" \times 12" \times 9.5"$. For more on this artwork, see figure 6.4.

through the *Forbidden City*, or experiencing the space in the church of *St. Peter's* in Rome. The textbook images you have studied are there right before you! Of course travel is expensive, and if actual travel is not possible, then journey with videos and television travelogues. However, it is worth every penny if you can take a trip to see a famous work of art in your own or a distant country.

Art in Your Own Home: Start Your Own Collection

There's no place like home, especially for art. Start or continue your own collection of work you enjoy and like to look at. There are several resources from which to draw your collection, and the first is right in your home. Frame some work of your own or that of a family member. Children are prolific artists and will have several selections for you to choose from as we see in figure 22.15, *Dinosaur Eating a Man* by Julia Lazzari-Dean. Along with home resources, there are several others we can list for relatively reasonably priced artworks:

Art Schools—Often there are student exhibits and art sales where art can be purchased at affordable rates. Students are usually enormously encouraged and gratified when someone buys their work.

Artists Studios—Make an appointment to see artists and their work in their studio. Often prices can be negotiated, as well as the method of payment. Some artists are open to barter or swapping services in place of a cash transaction.

Museum and Gallery sales—Many museums have "museum stores" where reproductions of major works are sold at affordable rates. Sculpture replicas are also available. If you prefer original art,

22.15 JULIA ROSE LAZZARI-DEAN. Dinosaur Eating a Man. USA, 1997. Julia was 4 years old when she drew this piece. Markers on paper, $8" \times 6"$. See also figure 1.8.

some museums have sales—rental galleries. By paying a low fee, you can rent an original work of art, usually for two months, and then exchange it for another. Finally, check out the art shown at commercial galleries. If you prefer to start modestly, start with holiday sales at the end of the year that feature small works by many artists at generally lower prices.

Arts and Crafts Fairs—These events are fun and great for purchasing artwork directly from the artists. The artists set up displays of their work and sell it directly to the public. They are usually happy to bargain. Many of the artists are working on the site, which makes these fairs all the more interesting and enjoyable.

SYNOPSIS

Art can be found throughout the community in museums, galleries, schools, public and private buildings, places of worship, and parks. We all live with art in our everyday routine. This art is both functional and also enriches our lives. We are also exposed to art in the imagery of popular culture.

Art can be enjoyed by our becoming more visually alert, developing our own artistic expressions, studying studio and art history courses, and by self-teaching. Travel to see artworks on site. Starting one's own art collection also greatly adds to the enjoyment of art.

FOOD FOR THOUGHT

Congratulations! You have finished this book. Our final food for thought for this chapter and this text is a challenge.

- How else can you approach art to increase your understanding of it and your culture?
- How can you increase your own creativity?

The authors wish you well as you personally meet this challenge and continue on your journey into the art world, which is **your** world.

Abakanowicz, Magdalena ah-bah-kah-NOH-vich, Fragonard, Jean-Honoré frag-uh-NAR, zhan on-ohr-AY mag-dah-LAY- nah **Ashurbanipal** AH-shure-BAH-nee-PAHL G Atahualpa aht-teh-WAHL-pah Gabon gah-BOHN Garnier, Charles gar-NYAY, sharl Ghiberti, Lorenzo В ghee-BAYR-tee, loh-REN-zoh Gislebertus Babur **BAH-ber** gheez-lay-BERT-oos bas relief Gizeh BAH ree-LEEF GHEE-zah Gogh, Vincent van **Baule** bau-LAY go, vin-SENT van Benin Golub, Leon GOL-ub, LEE-on be-NEEN Bernini, Gianlorenzo Goya, Francisco GOY-yah, fran-SIS-koh bair-NEE-nee, Grosz, George GROHS, jorj jahn-loh-REN-zoh Boccione, Umberto Grünewald, Matthias GRU-nuh-valt, mah-TEE-as boh-CHOH-nee. Guanyin oom-BAIR-toh gwahn-YEEN Guernica bodhisattva boh-dih-SAHT-vah GWAR-nih-kah **Bourgeios**, Louise boohrz-WAH, lweez Brancusi, Constantin brahn-KOO-see. Hardouin-Mansart, Jules ar-DWAN-man-sar, zhool KOHN-stahn-teen Hatshepsut Bruegel, Jan hat-SHEP-soot BROY-gul, YAHN Hogarth, William hoh-GARTH Bruegel, Pieter, the Elder BROY-gul, PEE-ter Huáscar Buonarroti, Michelangelo WAHS-kar bwoh-nar-ROH-tee, mee-kay-LAN-jay-loh I **Byzantium** bih-ZAN-tee-um **Ikere** i-KEE-ree **Iktinos** EEK-tee-nos \mathbf{C} **Imhotep** im-HOH-tep Catal Hüyük chah-TAHL huh-YUCK Inca ING-kah Chagall, Marc shah-GAL, mark Ise EE-say Chartres SHAR-tr' chiaroscuro kee-ah-roh-SKOOR-oh K Cicciolina chee-choh-LEE-nah Ka'Iulani ka-ee-oo-LAH-nee Colleoni co-lay-OH-nee Kabuki kah-BOO-kee contrapposto kohn-trah-POH-stoh Kachina kah-CHEE-nah Cuvilliés, Francois de kyu-vee-YAY, fran-ZWAH duh Kahlo, Frida KAH-lo, FREE-dah Cycladic sik-LAD-ik Kandarya Mahadeva gan-darh-ree-ah mah-hah-DAY-vuh D Kaprow, Allan KAP-ro, al-un Dali, Salvador dah-LEE or DAH-lee. Katsushika Hokusai kat-s'-SHEE-kah HOH-k'-sve sal-vah-DOHR Keokuk KEE-uh-kuhk Daumier, Honoré DOH-mee-ay, on-ohr-AY Kitagawa Utamaro kee-tah-gah-wah David, Jacques-Louis dah-VEED, ZHAK loo-EE oo-tah-mah-roh Degas, Edgar deh-GAH, ed-GAR kiva KEE-vah Delacroix, Eugène del-uh-K(R)WA oo-ZHEN Kollwitz, Käthe KOHL-vits, KET-uh **Dionysos** die-uh-NEE-sus Krishna KRISH-nah Dogon DOH-gahn Kusama, Yayoi koo-SA-ma, yay-yoy-ee **Doryphoros** doh-RIFF-oh-rus Kwakiutl kwah-kee-OOT-'1 Dürer, Albrecht DOO-ruhr, AL-brekt L \mathbf{E} Lange, Dorothea lang, dor-uh-THEE-ah Eisenstein, Sergei EYE-zen-stine, sair-gay Laocoön

Lascaux

lay-AH-coh-on

las-COH

Eyck, Jan van

IKE, yahn vahn

Le Brun, Charles	leh-BRUN, sharl	R	
Le Courbusier	leh kor-byoo-see-AY	Radha	RAD-uh
Le Nôtre, André	leh NOHTr', an DRAY	Ramayama	rah-MAH-yuh-muh
Le Vau, Louis	leh VOH, lwee	Raphael	rah-fay-el
Léger, Fernand	lay-ZHAYR, fer-NAN	Rembrandt	REM-brant van RIYN
Leonardo da Vinci	lay-o-NAR-doh da VEEN-chee	Renoir, Pierre Auguste	ren-WAR, pee-AYR oh-GOOST
Leyster, Judith	LIE-stur, YOO-dit	Riefenstahl, Leni	REE-fen-stahl, len-EE
Lin, Maya Ying	lin, MY-ah yeeng	Rivera, Diego	ree-VAY-ra, dee-AY-go
Lorenzetti, Ambrogio	loh-rent-SAYT-tee,	Ryoan-ji	ryoh-an-jee
	am-BROH-joh	, ,	, ,
	3	S	
M		Saarinen, Eero	SAR-uh-nen, EER-oh
Ma Yuan	ma yoo-an	Sacsahuaman	sack-say-hwua-MAHN
Mali	MAH-lee	Safdie, Moshe	SAHF-dee, MOSH-eh
Maori	MAH-oh-ree	Sanchi	SAHN-chee
Marisol	mah-ree-SOL	Sanzio, Raphael	SAHN-zee-oh, rah-fay-el
Masaccio	muh-SAT-choh	Seurat, Georges	sue-RAH, zhorzh
Maya	MAH-yah	Shi Huangdi	SHI(r) HWANG-dee
Menkaure	men-KOW-ray	Shiva Nataraja	SHIH-vah nah-tah-RAH-jah
Michelangelo	mee-kay-LAN-jay-loh	Sioux	SOO
Millais, John Everett	mil-AY, jan EV-ruht	Siqueiros, David	see-KAYR-ohs
Moche	MOH-chay	Stupa	STOO-pah
Moctezuma	MOCK-teh-SOO-mah	_	
Monticello	MON-teh-SELL-oh	T	The state of the s
mosque	mahsk	Tenochtitlan	tah-NOHCH-tee-TLAHN
Mu Qi	moo kee (or) moo chee	Teotihuacán	tay-oh-tee-hawh-KAHN
Mughal	MUH-ghel	ter Borch, Gerard	ter BOHRK, GAH rart
Munch, Edvard	mungk, ED-vard	Tingueley, Jean	tan-GLEE, zhon
Muybridge, Eadweard	MY-brij, ED-wurd	Tlingit	TLING-git
Many arrange, Zaram ear a		Toulouse-Lautrec, Henri de	too-LOOZ low-TREK,
N			on-REE deh
Nam June Paik	nahm joon pahk	Tutankhamun	too-tahn-KAHM-un
1 tuni juni 2 tuni		U	
0		Ukeles, Mierle Laderman	oo-KEL-leez, murl LAD-er-man
Odalisque	OHD-'l-isk	Utzon, Joern	UT-zone, YOHR-'n
Olmec	AHL-meck	Cizon, Joern	C 1-zone, TOTIK- II
Orozco, José Clemente	oh-ROHS-coh,	v	
orozeo, Jose Cremente	ho-SAY cleh-MEN-tay	van Rijn, Rembrandt	van RIYN, REM-brant
	,	Velasquez, Diego	vay-LAS-kas, DYAY-go
P		Vermeer, Jan	ver-ME(U)R, yan
Palenque	pah-LENG-kay	Verrocchio, Andrea del	vur-ROHK-kyoh,
Palladio, Andrea	pul-LAY-dee-oh, an-DRAY-uh		an-DRAY-uh del
Papua New Guinea	PAHP-uh-wah noo GHIN-ee	Versailles	vair-SYE
Persepolis	per-SEP-uh-lis		
Polykleitos	pal-ee-KLIY-tos	W	
Pompeii	pom-PAY	Warhol, Andy	WOR-hal, AN-dee
Potawatomi	PAHD-eh-WAHD-eh-mee		
Pueblo	PWEB-loh	Y	
	- · · · · · · · · · · · · · · · · · · ·	Yakshi	YAK-shee
		Vosselo	VI III roo bah

Yoruba

ket-SAHL-kwaht-'l

Q Quetzalcoatl YOH-roo-bah

A

- **Abstraction** Visual imagery in art that does not copy reality. This might be achieved by simplifying, distorting, exaggerating objects from nature, or it may be expressed in completely nonobjective forms.
- **abstracted texture** The treatment an artist gives to the element of texture in their work that is a distortion, simplification, or exaggeration of an actual texture.
- **Abstract Art** An art style that came about in Western cultures in the second decade to the middle of the twentieth century. Its imagery ranged from somewhat abstract to nonobjective forms. Its roots are accredited to Cubism.
- **academy** Institutions that were developed in various cultures that set strict standards and guidelines for artists. Some such academies began in France and Japan in the seventeenth and eighteenth centuries.
- accent Special attention given to any element of a composition in order to attract the viewer's eye to it. This may be done by giving an element a brighter color, isolating it, or enlarging it in order to accent it. Any visual devise may be used in an accent.
- achromatic Without color, consisting only of grays.
- **acrylic** A water soluble permanent synthetic paint that was developed in the 1960s.
- **actual shape** Clearly defined positive areas, not ambiguous.
- actual space Areas that exist in reality.
- **actual texture** Surface qualities that exist in reality and can be felt by touch.
- additive color system Color that is created by mixing light rays. When the three primary colors (red, blue, and green) are mixed together, a white light is produced. Cyan, yellow, and magenta are the secondary colors in this system.
- **adobe** Sun-dried brick made of straw and clay.
- **aerial perspective** The blurring of forms, colors, and values as they recede into the background. This is sometime referred to as "atmospheric perspective," as receding forms in space take on the colors and tones of the natural atmosphere.
- **Aesthetics** A branch in Western philosophies that is concerned with the meaning of beauty. The notion of what is beautiful is a cultural value and therefore would have an enormous range in meaning.
- **afterimage** A phenomenon that occurs after staring at an area of color for a while, then glancing at a white ground. The eye will see the complementary color.

- **agora** An open square surrounded by colonnades and porticos where markets and places of business were located in a Roman city.
- **alla prima** A technique in painting in which pigment is laid directly on the surface without any under painting.
- ambient light The light all around us in the world.
- **amulet** A charm worn to protect one from evil.
- **analogous colors** Colors that are close to each other on the color wheel.
- **Ancestor Dreaming** A system of spiritual beliefs for the Aboriginal people in Australia that accounts for creation and the cosmos.
- **animism** The belief that all things in nature contain a spiritual force or soul.
- **anthropomorphic** Giving a nonhuman being human characteristics and attributes.
- **apotheosis** The raising of human beings to a divine level, or to be deified.
- **appliqué** Designs made of cut out material joined (usually sewn) to another piece of material.
- apse Vaulted semicircular area at the end of a building, usually seen in Roman basilicas, churches, and mosques.
- **arabesques** Intricate interlocking surface decorations usually of spiral forms, knots, and flora. There is no suggestion of human forms in the designs.
- **arcade** A line of arches placed side by side on piers or columns that may be freestanding or attached to a wall.
- **arch** A curved structure made of stone or brick that supports weight over an opening such as a door or window.
- architectural systems Organized structures that result in functional and durable buildings. These systems must endure the forces of gravity and weather, and forces within the building itself.
- **armature** The underlying framework on which clay, wax, or plaster is placed; used in making sculpture.
- **Art Nouveau** A western art movement in the early twentieth century that included art forms that were based on natural forms and could be mass produced in the age of technology and industrialism.
- **artifact** Objects made by human beings and usually categorized by time and culture.
- **ashlars** Precisely cut regular shaped and fitted stone used in masonry constructed without mortar.

assemblage Sculptures made from various found objects or prefabricated parts that are put together

asymmetry Balance that is achieved with dissimilar objects in a composition, yet have equal visual weight and attention.

atlatl A stick thrower, or a devise that aids the projection of a stick or spear.

atlantid See caryatid.

atmospheric perspective See aerial perspective.

atrium The entrance room with an open sky light in a Roman house. Also the attached open colonnaded court at the entrance of a Christian basilica.

attic The uppermost story in a structure.

avatar In Hinduism, the manifestation of a deity, or an aspect of a deity.

B

ba Part of the human soul, in ancient Egyptian beliefs. *See also* **ka.**

balance Elements in an artwork that have been organized by weight and attention to achieve a visual equilibrium in the composition. Types of balance are symmetrical, asymmetrical, radial, and crystallographic.

baldacchino A canopy placed over a throne or altar, sometimes resting on columns.

balustrade A railing supported by short pillars.

bargeboards Boards that conceal roof timbers projecting out over gables; often decorated.

Baroque style Sculpture and art in western cultures (most specifically in Europe) that have similar characteristics in the seventeenth and eighteenth centuries. These characteristics are exaggeration, overstatement, and a flare for the theatrical and artifice.

barrel vault See vault.

bas relief See relief.

basilica A Roman colonnaded hall consisting of a nave and two side aisles, sometimes with an apse attached to the short ends. It was usually a place of business or government. The Christians adapted this plan for the development of their worship space.

bay A division of interior space that is usually defined by architectural supports such as columns or buttresses.

belfry A tower that houses a bell.

binder A liquid, into which pigments are ground, that dries to create a paint layer

bitumen A natural tar-like substance.

black figure style Greek pottery that has been decorated with dark figures placed on a lighter background of red clay.

bodhisattva In Buddhist beliefs, those humans who have attained the level of Buddhahood but choose to postpone their achieving Nirvana to remain on Earth to help others.

bronze An alloy of copper and tin.

Buddhism An Asian religion with the belief that the rejection of personal desires will lead to Nirvana.

bust A sculpture of a human being that includes only the head and shoulders.

buttressing A mass of brick or stone that supports a wall or an arch; a flying buttress is a buttress placed some distance from the structure it is supporting, and it is connected to the main structure with an arch.

 \mathbf{C}

calligraphy Handwriting that is considered exceptionally beautiful.

canon A rule of proportion that meets the requirements of a specific cultural aesthetic.

cantilever A structure in architecture that extends or protrudes horizontally beyond its support.

cartouche An oblong oval or scroll shape that usually contains glyphs or a heraldic devise.

caryatid A supporting element, like a column, that is carved to represent a female figure. A male supporting figure is called an atlantid.

catacombs Subterranean chambers used for the burial of the dead.

cenotaphs A coffinlike monument commemorating a person who has died, but is buried at a different location.

ceramic Pottery and objects made of clay.

Chi Rho The initial of Christ's name in Greek.

chroma Brightness or dullness of a hue, or intensity **cire perdue** *See* **lost wax.**

cili An ancient symbol of wealth, fertility, and luck. It appears in the shape of a woman's head with a large fanlike headdress radiating from it.

Classical The art of ancient Greece during the fifth century BC, based on ideal proportion grounded in the human figure. It also refers to a style that is clear and rational. Western art aesthetics are heavily influenced by Classical Greek art, which was seen in Roman, Romanesque, Renaissance, and Neoclassical styles.

Classical Baroque The Baroque style that also contains classical characteristics, especially in architecture. *See* **Baroque.**

claymation A method of animation using clay figures in place of drawings.

cloisonné A method of fusing enamel in metal compartments with the application of heat.

collaboration When two or more artists work together on one artwork.

collage A two-dimensional composition in which paper, cloth, or such materials are glued to a surface.

colonnade A row of columns that support an entablature or arches.

color wheel A circular arrangement of the hues of the spectrum.

column A cylinder consisting of a base, shaft, and capital (top element) that usually supports a roof. However freestanding columns sometimes functions as a monument. See Orders.

complementary colors Hues that are located directly opposite to each other on the color wheel.

composition The unified organization of the elements of an artwork in such a way that harmony and balance are achieved.

concentric Spheres or circles having the same center.

conceptual Artwork whose primary purpose is to convey an idea or a concept in any media. Printed text is often used.

contained style In a sculpture, all the forms are kept within the overall outer shape.

contour line The outline of a shape.

contrapposto When standing, the body weight resting on one leg, with the other leg posed forward, giving the human form an 's' shaped curve.

cool colors Generally, blues, greens, and purples.

Corinthian See Orders.

cosmos A systematic, orderly, harmonious universe.

cross hatching See hatching.

cross vault See vaulting.

crystallographic (balance) Equal emphasis is given to all the elements in a two-dimensional composition so that there is the same visual weight wherever the viewer looks.

Cubism An art movement that represents multiple viewpoints or facets on a two-dimensional picture plane. Analytical Cubism broke down forms, while Synthetic Cubism used collage and assemblage to represent parts of objects in order to visually play with illusions and reality.

curvilinear Visual elements that are made up of or allude to curved lines.

D

damask An elaborately patterned fabric woven on a Jacquard loom.

damascened Ornamentation created on a metal surface, such as iron or steel, using wavy patterns or inlaid work of precious metals.

Daguerreotype A photographic process invented in the nineteeenth century for fixing an image on a silver-coated metal plate.

dealer A person whose business is to buy artwork directly from the artist and then sell it, or take artwork on consignment.

decorative (space) Pictorial space in a two-dimensional work that remains true to the picture plane and shows very little depth.

distortion When an accepted perception of a form or object is changed so that it may be barely or not recognizable.

dome A hemisphere used to cover an open interior space, made of an arch rotated 360 degrees on a vertical axis.

Doric See Orders.

dymaxion A term invented by R. Buckminster Fuller where he combined the words "dynamic", "maxium", and "tension" to describe his direction in architecture that is economical and does more with less.

 \mathbf{E}

eclectic Consisting of many varied elements.

elements (formal) That which makes up an artwork. The elements are line, value and light, color, shape, space, texture, volume and mass, time, and motion.

emphasis A device in art that draws the attention of the viewer to one or more focal points in an artwork.

encaustic A paint medium in which pigments are mixed into heated beeswax.

engaged column A column partly embedded in a wall.

engraving The process of incising or scratching lines on a hard material such as wood or a metal plate.

entablature In classical Greek architecture, the part of the building that is above the capital of the supporting columns. It consists of three parts: the architrave, the frieze, and the pediment.

entasis An apparent swelling or bulging in the shaft of a Doric column.

Environmental art A form of art that surrounds and affects the viewer; it may be in an interior space or out in nature.

ephemeral arts Artworks that are fleeting or transitory, and not permanent. Examples include the masquerade from Africa, and also twentieth century Performances or Happenings.

equestrian An artwork that depicts a figure mounted on a horse.

Eucharist The Sacrament of Holy Communion in the Christian faith. The ritual involves the symbolism or actual transformation of the bread and wine into the sacrificial body and blood of Jesus Christ.

Expressionism An art movement in early twentieth century Europe that focused on capturing the subjective feeling toward objective reality. The movement developed a bold, colorful, and vigorous style, especially in painting.

F

façade The front facing of a building.

faience Highly colored designed earthenware or pottery.

Fauvism An early twentieth-century movement in Europe led by Henri Matisse that focused on bright colors and patterns. It literally means "wild beasts."

fecundity Prolific or fruitful.

fetish An object that is empowered with magic that can heal and protect, also known as a power figure.

filigree Delicate ornamental work.

finial A crowning ornament or knob.

flying buttress See buttressing.

focal point Main area of visual concentration in an artwork.

form The total appearance and organization of the physical and formal qualities of an artwork.

formal qualities All that makes up an artwork such as the formal elements (line, value and light, color, shape, space, texture, volume and mass, time, and motion), the medium, proportion, size, and subject matter.

forum A central open space surrounded by public buildings in ancient Roman cities.

found objects Actual everyday objects, such as shoes, tools, and so on, that are incorporated into artworks.

French Gothic See Gothic.

French Impressionism A movement of the early twentieth-century France where artists sought to capture the changing effects of light and color as the eye perceived it.

fresco Water-based pigments painted directly on a wet lime plaster ground, which binds with the plaster when dry.

frieze A decorative band in the central section of the entablature in classical Greek architecture, or a decorative band on a building.

frontal Sculpture whose focal point or emphasis is placed on the front side of the piece.

futurists See Italian Futurists.

G

gable See pediment.

gallery In Christian church architecture, an upper story over an aisle opening onto a nave. In secular architecture, a large room in which items of art are displayed.

gargoyle A carving of a grotesque human figure or animal that is incorporated into a roof to function as a waterspout.

genre painting Paintings that contain subject matter of everyday life.

genres Various categories of paintings, as well as arts in general.

geodesic dome A dome shape made of framework consisting of interlocking polygonal units, developed by R. Buckminster Fuller.

geometrical Objects, lines, or shapes based on mathematical concepts such as the circle, square, rectangle, etc.

gesture A quickly sketched image that captures the essence of the form of the subject.

gilding Coating or layering a surface with gold, gold leaf (a very thin layer of gold), or a gold color.

glyph A figure or character that has symbolic meaning, and is most often carved in relief.

graffito Writing or drawing written or painted on public walls. Plural: graffiti.

Greek/ Revival A style of architecture that visually echoes Greek Classical architecture. This style was popular in nineteenth-century Europe and United States.

grillwork Metalwork, usually of iron, that adorns windows and doors while also protecting the building against intruders.

groin vault See vaulting.

guilds Organizations of merchants, artisans, and craftsmen that developed in medieval Europe.

H

Happenings An art event that is planned by the artist, that may be performed spontaneously and solicit participation of its audience. This art form was invented by Allan Kaprow.

harmony The quality of relating the visual elements of a composition through the repetition of similar characteristics. A pleasing visual interaction occurs through harmony.

hatching The placing of lines together side by side to create values and tones. Lines that are layered and cross over the layer beneath create cross-hatching.

hieratic A system of proportion of figures or subject matter in a work of art that gives emphasis to what or who is considered to be the most important, for example, the largest figure would be the most important or highest in rank.

hieroglyphics Ancient picture writing especially used by the Egyptian culture.

hilt The handle of a sword, dagger, knife, or tool.

Hinduism The dominant religion of India whose basic beliefs encompass the cycle of reincarnation and the strive to achieve Nirvana.

hip roof A roof with sloping ends and sides.

horizon line In linear perspective, a horizontal line that represents eye level.

hue The pure state of color that the eye sees in the spectrum.

Humanism A system of thought in which the efforts, values, and achievements of human beings is the central focus.

hydra A Greek ceramic water jar.

hypostyle A large hall in which rows of columns support the roof.

I

ibex A wild goat with long back-curving horns found in Eurasia and North Africa. This animal is found in prehistoric iconography.

iconography The study of visual images and symbols within their cultural and historical context.

icon An visual image, picture representation, or symbol that may have religious or political connotations.

idealism An artistic interpretation of the world as it should be according to respective cultural aesthetics. Generally, all flaws and imperfections found in nature are removed.

illumination Hand-printed manuscripts that have been decorated with drawings or paintings.

imago mundi Image of the world.

impasto Paint that has been thickly applied to the ground.

implied line Missing areas of a drawn line that is visually completed by the viewer.

impluvium A small pool that collects rainwater located in the atrium of a Roman house.

inlay To piece together or insert materials such as ivory or colored woods into a surface.

installation An art piece usually of mixed media that is designed for a specific space.

intensity Brightness or dullness of a hue, or chroma.

intermedia The mixing and overlapping of any medium and or discipline in an artwork.

International style A style developed in thirteenth and fourteenth centuries in Europe with characteristics of French Gothic and Sienese art. Later in the twentieth century, a style of architecture based on simple geometric forms without adornment.

invented texture An imaginary surface quality created by the artist.

Ionic See Orders.

Islam The religion of Muslims as revealed to the prophet Mohammed and recorded in the Holy Koran or Qur'an.

isometric projection A perspective system for rendering a three-dimensional object on a two-dimensional surface by drawing all horizontal edges at a 30-degree angle from a horizontal base. All the verticals are drawn perpendicularly from the horizontal base.

Italian Futurists Developed in Italy in 1909, the artists were influenced by Cubism and intrigued with light and movement. They were also fascinated with the sensation of speed and the mechanics of the machine age, as well as the dangers of war.

J

jamb The vertical sides or posts of a doorway.

Jihad A holy war in the Islamic religion.

Judeo-Christian Characteristic of cultures whose roots are made up of both the Jewish and Christian traditions.

juxtapose To place contrasting elements, images or ideas side by side.

K

ka Part of the spirit or soul of a human being in ancient Egyptian culture. *See also* **ba.**

Kachina A spirit doll of the Pueblo culture in North America.

kitsch Works that are done in what is considered to be poor taste.

Kiva Underground circular ceremonial centers of the Pueblo culture in North America.

kou A native wood in Hawaii, which is used to carve ceremonial bowls.

L

labret A mouth ornament.

lacquer A resinous varnish that adds a rich sheen to a surface.

lei A Hawaiian necklace usually made feathers or flowers.

limner A painter or a draftsman.

line An element in art with length but negligible width.

lithography A form of printmaking, invented in the nineteenth century, based on the principle that water and oil do not mix.

lost wax [cire perdue] A cast is made from a wax model by coating it with an investment material that can be heated to high temperatures. The wax is melted away, leaving a negative mold of the model, in which a molten metal is poured or clay is pressed, leaving a positive object of the original wax model.

lotus A water lily. In some cultures it was thought to induce a state of contented forgetfulness.

low key Any values or tones and colors that have a value level of middle gray or darker.

luau A Hawaiian feast.

luminosity Radiating or reflecting light.

M

mana Prestige or power in Oceanic cultures.

mandala A Buddhist diagram of the cosmos: The Human Sphere of Desire, the Bodhisattva Sphere of Form, and the Buddha Sphere of Formlessness.

masquerade A ceremony or a festive gathering where masks and costumes are worn.

mass (volume) An area of occupied space. Mass usually refers to a solid occupying a space, while volume may refer to either a solid mass or an open framework occupying a space.

mausoleum A stately tomb usually built above the ground.

media The plural of medium. Traditional and non-traditional materials used to make art such as: charcoal, paint, clay, bronze, video, computers, etc.

minaret A prayer tower that is part of an Islamic mosque.

Minimalism A nonobjective art movement in the twentieth century in the United States where artists reduced their images and objects to pure form. These images and forms were called "primary structures."

mixed media The mixing of art materials and forms in creating the artwork. *See* **intermedia.**

modular A composition that incorporates modules, or visual units or sections.

monochromatic An artwork that contains the hue, tints, and shades of only one color.

monolith A large single block or column.

mortise (and tenon) A notch or a slot in a piece of wood made to receive a tenon. A tenon is a projection

at the end of a piece of wood made to fit into the mortise to create a joint.

mosque An Islamic place of worship.

motif A repeated design or image in a composition that takes on visual significance.

mudra A hand gesture with symbolic meaning in Hindu and Buddhist art.

N

nadir The lowest point.

narrative An artwork that relates a story.

natural pattern Repeated elements resemble each other, but are not exactly alike; the interval between elements may be irregular.

Naturalism A style of art with imagery that resembles what we see in the world around us.

nave The tall center aisle of a church or a basilica, usually flanked with side aisles.

necropolis The city of the dead.

negative space Voids within an artwork

Neolithic A period of the Stone Age in which humans used polished stone tools.

neophyte A new convert to a faith or a belief.

niche A recess in a wall, usually designed to hold a decorative or votive object.

Nirvana The ultimate release from the cycle of reincarnation in the Buddhist and Hindu faiths, achieved by the expulsion of individual passion, hatred, and delusion. The attainment of total peace.

nonobjective Artwork that has no imagery that resembles the natural world.

\mathbf{o}

obelisk A tall four-sided monolith that is tapered at its apex with a pyramid form.

oblique projection When a three-dimensional object is rendered two-dimensionally with the front and back sides parallel.

obsidian A dark volcanic glass.

odalisque A Turkish harem girl.

one-point perspective A drawing in which all front-facing planes are shown as parallel to the picture plane, and all other planes recede to a single point.

onion dome A pointed dome whose middle diameter swells outward, creating a smaller diameter at its base.

Orders In Classical Greek architecture an Order consists of a column with a base, a shaft, a capital, and an entablature that is decorated and proportioned to the Classical Greek canon. The types of Orders are:

Doric, Ionic, Corinthian, Tuscan, Roman Doric, Composite.

Organic architecture A style of American architecture developed by Louis Sullivan and Frank Lloyd Wright that incorporated flowing natural forms in its design.

organic shape Shapes that seem to be drawn from nature or are naturelike, not geometric.

ornithology The study of birds.

orthogonal The converging lines that meet at the vanishing point on the horizon line in linear perspective.

P

pagan A follower of a polytheistic religion, or an irreligious or hedonistic person.

pagoda An Asian towerlike temple with upward sweeping roofs over each story.

Paleolithic Prehistoric Stone Age, dating from 25,000 to 8000 BC.

palmette Various palm leaves or palm leaf shapes that may be rendered in art.

Panathenaic A celebration for the pantheon of gods. **pathos** The power to provoke compassion.

patriarch The male head of a family or family line.

patron A person who supports the artist and the arts.

pattern In art, a repetition of any element in the composition.

pedestal The base of a column or colonnade in Classical architecture, or a base on which a sculpture or a vase may be placed.

pediment A low pitched gable resting on columns, a portico, a door, or a window.

pendentive The triangular concave sections that are created when a dome is supported by a base of arches.

Performance Art Influenced by the "Happening," performance art consists of live-action events staged as artworks.

peristyle A colonnade around the inside and or the outside of a court or room.

Perpendicular Style Also known as the "Tudor" style, an English Gothic style of architecture that has strong vertical emphasis and dense ornamental vault ribs that serve only for decoration.

perspective A system of rendering the illusion of three-dimensional depth on a flat two-dimensional surface.

photojournalism News reporting in which photographs are more important than the text.

photomontage A composition of many photographs, or of one using many prints to create a new image.

photomural A mural made up of one or more photographs, or a photomontage.

piazza An open court or plaza.

picture plane The flat two-dimensional surface of a drawing, print, or a painting.

pier A solid stone or masonry support, not a column.

pigments Colors in powder form, mixed with binders to create paint.

pilaster A pier that projects somewhat from a wall. Also a rectangular column that would be designed after one of the Classical Orders.

pillar Any free-standing column-like structure that does not conform the Classical Orders. It may or may not be cylindrical.

pinnacle Usually a pointed or conical ornamentation that is placed on a spire or a buttress.

plan A diagram showing the ground plane of a building.

Pointillism An art movement in Europe in the early twentieth century in which artists applied daubs of pure pigment to a ground to create their imagery, which is blended within the vision of the viewer.

pommel A knob that is attached to the hilt of a knife or sword.

Pop Art An art movement in the mid-twentieth century that used popular commercial items as subject matter, such as newspapers, comic strips, popular and political personalities, Campbell soup cans, and CocaCola bottles. Usually created as satire, the movement glorified the products of mass popular and elevated them to twentieth-century icons.

porcelain High-fired, light-weight, white ceramics.

portal An opening, door, entrance, or gate.

post and lintel A method of construction that uses posts to support a crossbeam that can bear the weight of the roof.

power figure A carved figure that is empowered with magic, which can heal and protect. *See* **fetish.**

Precisionism An art movement in the United States in the first half of the twentieth century that was concerned with rendering human-made environments and the beauty of precise and perfect machine forms in a clear and concise manner. Their style of painting was flat and decorative.

primary colors In any medium, those colors that, when mixed, produce the largest range of new colors.

proportion The size relationship, or relative size, of parts of objects or imagery to a whole or to each other.

putto (putti) A young plump child used as subject matter in Italian sculpture and painting.

pylon A truncated pyramid form usually seen in Egyptian monumental gates.

R

radial balance When all of the elements in a composition visually radiate outward from a central point.

Realism A nineteenth-century style of art that depicts everyday life without idealism, nostalgia, or flattery.

rectilinear Consisting of straight lines set at 90-degree angles in a composition.

relic A sacred fragment of an object, a deceased saint, or ancestor.

relief Sculptures that are partly projecting from a flat surface. When the sculptural forms are at least half round or more, it is called a high relief; when they are less, it is call a low or bas relief.

reliquary A vessel or receptacle designed to house a holy relic.

Renaissance A rebirth of learning and the arts in the fourteenth- through seventeenth-century Europe, along with the revivial and study of ancient Greek and Roman cultures.

render To depict or execute in an art form.

repetition When the same element is used over and over again in a composition, similar to pattern.

retable An architectural wall or screen behind and above an altar. It is usually richly decorated with painting, sculpture, or carved ornamentation.

retablo A small votive painting.

rhythm A form of repetitive beats that are visually seen in a composition usually as a pattern. This is accomplished with the repetition of one or more of the formal elements in the organization of a work.

ribbed vault See vaulting.

roach A Native American headdress made of animal fur and worn on a shaven head.

Romanticism An art movement in nineteenth-century Europe that focused on the intuitive, emotional, and picturesque, a spirit that was felt between human beings and nature. It rejected the carefully planned and rationalized compositions of the Renaissance, and added a sense of mysticism to art.

roof comb A decorative architectural element that crowned Mayan temples and palaces.

rotunda A round building usually roofed with a dome.

rubble Broken bits and pieces of brick, and gravel, that was used as fill in the structure of Roman architecture.

S

saltcellar A dish or a container designed to hold salt.sanctuary A sacred or holy place in a church or temple.

sarcophagus A coffin.

sarsen A type of sandstone monolith found in ancient ruins such as Stonehenge, England.

scale The size of an object or image that is measured by its relationship to other objects and images that are recognized for their normal or actual size.

scarification The cutting or scratching of the skin in various designs that will heal as permanent body decoration.

scroll work An architectural ornamentation that echoes the form of a partially unrolled scroll. Ionic and Corinthian columns have scroll work in their capitals.

secondary colors Colors that result when any two primary colors are mixed in a particular medium.

secular Of nonreligious matters.

seppuku A Japanese ceremony of taking one's life.

serigraphy A printmaking technique in which ink is applied to a stencil that has been temporarily adhered to a stretched cloth.

shade The addition of black to a hue.

shaman A person, priest, or priestess who is empowered to use magic to cure and heal, imbue magic on an object, control spirits and commune with ancestors, and foretell the future.

shape A flat, two-dimensional element with a defined outline and usually without interior detail.

shrine A receptacle for holy objects. A holy place or site. A site of the entombment of a saint. A place devoted to a deity or a holy person.

silk screen See serigraphy.

simulated texture Texture rendered in a composition to look like the actual or natural texture in reality.

skeletal In architecture, a building with a framework of steel that is covered with a "skin" of glass or other light materials.

space An area in which objects or images can exist.

spandrel The area between two arches, or along side of one arch, or the space between the ribs of a vault.

spectrum The breakdown of white light into its components of red, orange, yellow, green, blue, indigo, and violet.

sphinx A figure made up of a human head and a lion's body, likely of Egyptian origin.

spire A pointed roof of a tower or steeple.

squinches The spatial areas created when a dome is placed on a square or a polygonal base.

stele (**stela**) A stone slab or tablet that is carved with images and or inscriptions usually in commemoration of a person or an event.

stoa A roofed colonnade in Ancient Greek architecture that may or may not be attached to another structure.

stucco A plaster material that may be used for reliefs and architectural ornamentation such as moldings and cornices. It is also a wall covering made of a thin layer of cement.

style Specific recognizable attributes and characteristics that are consistent and coherent in the artwork within a historical period, a cultural tradition, or of an individual artist.

stylization The distortion of an image or a figure according to an artistic convention or canon.

subject matter The specific idea of an artwork.

subtractive color system Mixing of pigment to create a color.

subtractive method (sculpture) When a sculptural material such as clay or wood is carved away to produce a form.

Surrealism An art movement in early twentieth-century Europe influenced by the work of Sigmund Freud. Fantastic and dreamlike imagery drawn from the subconscious was executed through automatic drawing similar to doodling.

suspension (bridge) The deck of the bridge is suspended by rope or cables that are attached by two piers.

sutra A documented sermon or a dialog of the Buddha.

symmetry When the balance in a composition has equal weight distributed evenly throughout. If an imaginary line could be drawn vertically down an artwork that has symmetrical balance, one side would mirror the other.

sympathetic magic A form of a ritual or a prayer that is directed to an image or an object in order to bring about a desired result, such as a successful hunt.

syncretism The blending of different religious beliefs and rituals.

T

tabernacle A sacred place that holds the Holy Eucharist in the Christian religion.

taboo Sacred rituals, places, or objects that are forbidden for general use.

Tenebrism A style of painting perfected by Italian Baroque artist Caravaggio in which most of the images are in shadow while some are brightly illuminated.

terra cotta A low-fired ceramic clay, such as found in red-earth flower pots.

tertiary colors Colors that result from the mixing of one primary color and a neighboring secondary color.

tetrahedron A solid contained by four plane faces.

thatch A roof covering made of straw or reeds.

three dimensional An object or an image that actually has or appears to have height, length, and depth.

three-point perspective A drawing in which only one point of each volume is closest to the viewer, and all planes recede to one of three points

tone See value.

tooth The surface texture of paper.

torso The trunk of the human body from the shoulders to the hips.

totem The emblem or symbol of a family clan.

Tourist Art Art that is based on a particular ethnic tradition, but is specifically created to sell to tourists.

tracery The ornamentation of the upper part of a Gothic window. Plate tracery was carved through solid stone, while Bar tracery was incorporated with mullions in the glass window frame.

transept The crossing arm (space) that intersects the nave (forming a cross) in a basilica or a church.

truss Wooden or metal beams arranged in connected triangles to make a framework.

tufa A porous rock formation formed from deposits of springs. The material can be easily carved when first exposed to air, then hardens with age.

two dimensional An object or image that actually has or appears to have height and length, without significant depth.

two-point perspective A drawing in which no planes are parallel to the picture plane, but all recede to one of two points on the horizon.

U

unity A quality achieved in an artwork when the artist organizes all the elements together in a composition so that they all visually work together as a whole.

V

value The relationship of lights and darks in a composition, sometimes referred to as tones.

Vanitas A style of Dutch painting in which the theme is the transitory nature of earthly things along with the inevitability of death.

variety Opposing or contrasting visual elements in a composition, that adds interest to it without disturbing its unity.

615

vaulting A system of masonry roofing or ceiling constructed on the principle of the arch. There are several types of vaults: the barrel vault is a single arch extended in depth from front to back, forming a tunnel-like structure; a groin or a cross vault are barrel vaults positioned at 90-degree angles so as to cross or intersect one another; a ribbed vault is a variation of the groin vaulting system in which arches diagonally cross over the groin vault forming skeletal ribs; a dome is arches rotated on their vertical axis to form a hemispheric vault.

vignette A decorative design that might be used on a page of a book, or a drawing, print, or painting whose

outer edges of the composition are softened or blurred.

visual texture The rendering of illusionary texture on a surface or a ground. This texture may be simulated, abstracted, or invented.

volume See mass.

W

warm colors Generally, reds, oranges, and yellows.

Y

Yin-Yang Ancient Chinese symbol of balance and harmony.

- Abbate, Francesco, ed. *Precolumbian Art of North America and Mexico*. Translated by Elizabeth Evans. London: Octopus Books, 1972.
- Abbott, Helen, et al., eds. *The Spirit Within: Northwest Coast Native Art from the John H. Hauberg Collection.* New York: Rizzoli International Publications, 1995.
- Abiodun, Rowland, Henry J. Drewal and John Pemberton III, eds. The Yoruba Artist: New Theoretical Perspectives on African Arts. Washington DC: Smithsonian Institution Press, 1994.
- Adachi, Barbara. "Living National Treasures." *Japanese Encyclopedia*. Tokyo, Japan: Kodansha Ltd., 1983. pp. 60–61.
- Adams, Laurie Schneider. A History of Western Art, New York: McGraw-Hill Companies, Inc., 1997.
- Albarn, Keith, Jenny Miall Smith, Stanford Steele and Dinah Walker. The Language of Pattern: an Inquiry Inspired by Islamic Decorations. New York: Harper and Row, Publishers, 1974.
- Alva, Walter, and Christopher B. Donnan. Royal Tombs of Sipan. Los Angeles: The Fowler Museum of Cultural Heritage, University of California, Los Angeles, 1993.
- American Film Institute. "American Film Institute" Web site at http://afionline.org. Section on Preservation. Accessed [7/16/98].
- Andah, Bassey W. "The Ibadan Experience to Date," from *Museums and Archeology in West Africa*, edited by Claude Daniel Ardouin. Washington, DC: Smithsonian Institute Press, 1997.
- Anderson, Richard L. Calliope's Sisters: A Comparative Study of Philosophies of Art. Englewood Cliffs, NJ: Prentice Hall, 1990.
- "Animal Behaviour: Behaviour of Animals in Groups" in Britannica Online. http://www.eb.com:180/cgi-bin/g?DocF=macro/5000/62/94.html [Accessed 19 May 1998].
- Ardouin, Claude Daniel, ed. *Museums and Archeology in West Africa*. Washington, DC: Smithsonian Institute Press, 1997.
- Arnason, H.H. *History of Modern Art*, Englewood Cliffs, NJ: Prentice Hall, 1986.
- Atkins, Robert. Art Speak, A Guide to Contemporary Ideas, Movements, and Buzzwords, 1945 to the present. New York: Abbeville Press Publishers, 1997.
- Auping, Michael. Jenny Holzer. New York: Universe Publishing, 1992.Baines, John and Malak, Jaromir. Cultural Atlas of the World: Ancient Egypt, New York: Facts on Files Publishers, 1994.
- Barrie, Dennis. "The Scene of the Crime." In Art Journal, Fall 1991, Vol. 50, No. 3, pp. 29–32.
- Barrow, Terrence. An Illustrated Guide to Maori Art. Honolulu: University of Hawaii Press, 1984.
- Barrow, Tui Terrence. *Maori Wood Sculpture of New Zealand*. Rutland, VT: Charles E. Tuttle Company, Publishers, 1969.
- Baumann, Felix, and Marianne Karabelnik, eds. *Degas Portraits*. London: Merrell Holberton Publishers, 1994.
- Beaver, R. Pierce, et al., eds. Eerdmans' Handbook to the World's Religions. Grand Rapids, MI: William B. Eerdmans Publishing Co., 1982.
- Beck, James and Michael Daley. Art Restoration: The Culture, the Business and the Scandal. New York: W. W. Norton and Company, 1993.
- Becker, Carol. "Art Thrust into the Public Sphere." In *Art Journal*, Fall 1991, Vol. 50, No. 3, pp. 65–68.
- Beckwith, John. Early Medieval Art. New York: Praeger Publishers, 1973.
- Bennett, Jonathan. Ukiyo-e to Shin Hanga: The Art of Japanese Woodblock Prints. USA: The Mallard Press, 1990.
- Benton, Janetta Rebold, and DiYanni, Robert. Arts and Culture: Volume II, Upper Saddle River, NJ: Prentice Hall, 1998.

- Benton, Janetta Rebold. *The Medieval Menagerie: Animals in the Art of the Middle Ages.* New York: Abbeville Press, 1992.
- Bernadac, Marie-Laure. Louise Bourgeois. Paris: Flammarion, 1996.
- Berrin, Kathleen, ed. The Spirit of Ancient Peru: Treasures from the Museo Arqueológico Rafael Larco Herrera. London: Thames and Hudson, 1997.
- Bersson, Robert. Worlds of Art. Mountain View, CA: Mayfield Publishing Company, 1991.
- Bertelli, Carlo. Mosaics. New York: W. H. Smith Publishers, 1989.
- Bianchi, Emanuela. Ara Pacis Augustae. Rome, Italy: Fratelli Palombi Editori, 1994.
- Blake, Nayland, Lawrence Rinder and Amy Scholder, eds. In a Different Light: Visual Culture, Sexual Identity, Queer Practice. San Francisco: City Light Books, 1995.
- Blier, Suzanne Preston. *The Royal Arts of Africa*, New York: Harry N. Abrams, 1998.
- Blunden, Caroline, and Elvin, Mark. *The Cultural Atlas of the World: China*. Alexandria, VA: Stonehenge Press, 1991.
- Blunt, Wilfrid. Isfahan, Pearl of Persia. London: Elek Books, 1966.
- Boardman, John. Greek Art. London: Thames and Hudson, 1996.
- Boyd, Andrew. Chinese Architecture and Town Planning 1500 B.C.-A.D. 1911. London: Alec Tiranti, 1962.
- Brainard, Shirl. *A Design Manual*, Upper Saddle River, NJ: Prentice Hall, 1998.
- Brotherston, Gordon. Painted Books from Mexico: Codices in UK Collections and the World They Represent. London: The British Museum Press, 1995.
- Brown, Kendall H. et al. *Light in Darkness: Women in Japanese Prints of the Early Shôwa (1926–1945)*. Los Angeles: Fisher Gallery, University of Southern California, 1996.
- Buehler, Alfred, Terry Barrow and Charles P. Mountford. *The Art of the South Sea Islands*. New York: Crown Publishers, Inc., 1962.
- Burson, Nancy. Faces. Santa Fe, NM: Twin Palms Publishers, 1993.
- Burton, Rosemary, and Richard Cavendish. Wonders of the World. Chicago: Rand McNally, 1991.
- Bushnell, G. H. S. Ancient Arts of the Americas, New York: Frederick A. Praeger, 1965.
- Cahill, James. *The Lyric Journey: Poetic Painting in China and Japan.* Cambridge, MA: Harvard University Press, 1966.
- Cameron, Elisabeth L. Isn't S/he a Doll? Play and Ritual in African Sculpture. Los Angeles: University of California at Los Angeles Fowler Museum of Cultural History, 1996.
- Canaday, John. Mainstreams of Modern Art. New York: Holt, Rinehart and Winston, 1959.
- Cantrell, Jacqueline Phillips. Ancient Mexico: Cultural Traditions in the Land of the Feathered Serpent, Dubuque, IA: Kendall/ Hunt Publishing, 1984.
- Carpenter, T. H. Art and Myth in Ancient Greece. London: Thames and Hudson, 1991.
- Caruana, Wally. *Aboriginal Art.* London: Thames and Hudson, 1993. Casson, Lionel. *Ancient Egypt*, New York: Time-Life Books, 1971.
- Caygill, Marjorie, and John Cherry. A.W. Franks: Nineteenth Century Collecting and the British Museum. London: The British Museum Press, 1997.
- Center for African Art, The. ART/artifact, African Art in Anthropology Collections. New York: Prestel Verlag, 1989.
- Chandra, Pramod. *The Sculpture of India 3000 BC-AD 1300*. Washington DC: The National Gallery of Art, 1985.
- Chicago, Judy. Through the Flower: My Struggles as a Woman Artist. Garden City, NY: Doubleday and Co., Inc., 1975.

- Chui, Hu. *The Forbidden City, Collection of Photographs*. Beijing: China Photographic Publishing House, 1995.
- Clark, Kenneth. Animals and Men: Their Relationship as Reflected in Western Art from Prehistory to the Present Day. New York: William Morrow and Company, Inc., 1977.
- Clark, Kenneth. *The Nude: A Study in Ideal Form.* Princeton, NJ: The Princeton University Press, 1956.
- Clearwater, Bonnie. Mark Rothko: Works on Paper. New York: Hudson Hills Press, Distributed in U.S. by Viking Penguin, 1984.
- Cocke, Thomas. 900 Years: The Restorations of Westminster Abbey. London: Harvey Miller Publishers, 1995.
- Coe, Michael, and Dean Snow and Elizabeth Bensen. *The Cultural Atlas of the World: Ancient America*. Richmond, VA: 1990.
- Coe, Michael D. *The Maya*, New York: Thames and Hudson, 1982. Collcutt, Martin, Marius Jansen, and Isao Kumakuro. *Cultural Atlas of the World: Japan.* Alexandria, VA: Stonehenge Press, 1991.
- Collier's. Photographic History of World War II. New York: P. F. Collier and Son Corporation, 1946.
- Collignon, Maxime. *Manual of Mythology in Relation to Greek Art.* New Rochelle, NY: Caratzas Brothers, Publishers, 1982.
- Colton, Joel. Twentieth Century Great Ages of Man. New York: Time-Life Books, 1968.
- Colvin, Howard. Architecture and the After-life. New Haven and London: Yale University Press, 1991.
- _____. Compassion and Protest: Recent Social and Political Art from the Eli Broad Family Foundation Collection. New York: Cross River Press, a Division of Abbeville Press, Inc., 1991.
- Corbin, George A. Native Arts of North America, Africa, and the South Pacific. New York: Harper and Row, 1988.
- Cotterell, Arthur. *The First Emperor of China*. New York: Holt, Rinehart and Winston, 1981.
- Cowart, Jack, et al. *Georgia O'Keeffe: Art and Letters.* Washington, DC: The National Gallery of Art, 1987.
- Craven, Roy C. Indian Art, A Concise History. London: Thames and Hudson, 1997.
- Culbertson, Judi, and Tom Randall. Permanent Parisians: An Illustrated Guide to the Cemeteries of Paris. Chelsea, VT: Chelsea Green Publishing Co., 1986.
- Cunningham, Lawrence S., and John J. Reich. *Culture and Values: A Survey of the Western Humanities Volume II*, Fort Worth, TX: Harcourt Brace College Publishers, 1998
- Davies, J. G. Temples, Churches and Mosques: A Guide to the Appreciation of Religious Architecture. New York: The Pilgrim Press, 1982.
- Dawson, Barry, and John Gillow. *The Traditional Art of Indonesia*. London: Thames and Hudson, 1994.
- de Zegher, M. Catherine. *Inside the Visible: An Elliptical Traverse of 20th Century Art.* Cambridge: The MIT Press, 1996.
- DeMott, Barbara. Dogon Masks: A Structural Study in Form and Meaning. Ann Arbor, MI: UMI Research Press, 1982.
- Denyer, Susan. African Traditional Architecture. New York: Africana Publishing Company, 1978.
- Derson, Denise. What Life Was Like on the Banks of the Nile, Egypt 3050–30 BC, Alexandria, VA: Time-Life Books, 1996.
- Desai, Vishakha N., and Darielle Mason. Gods, Guardians and Lovers: Temple Sculptures from North India A.D. 700–1200. New York: The Asia Society Galleries and Mapin Publishing Pvt. Ltd., Ahmedabad. 1993.
- Dewald, Ernest T., *Italian Painting*. New York: Holt, Rinehart and Winston, 1965.
- Dickens, Roy S. Of Sky and Earth: Art of the Early Southeastern Indians, Exhibit Catalog October 1—November 28, 1982. The High Museum of Art, Atlanta, Georgia. Dalton, Georgia: Lee Printing Company, 1982.
- Dickerson, Albert I., ed. *The Orozco Frescoes at Dartmouth.* Hanover, NH: The Trustees of Dartmouth College, 1962.

- Drewal, Henry John, and John Pemberton III, with Rowland Abiodun. *Yoruba, Nine Centuries of African Art and Thought*. New York: The Center for African Art, 1989.
- Durand, Jorge, and Douglas S. Massey. *Miracles on the Border: Retablos of Mexican Migrants to the United States.* Tucson and London: University of Arizona Press. 1995.
- Ebrey, Patricia Buckley. Cambridge Illustrated History of China. London: Cambridge University Press, 1996.
- Edwards, Jim. Precarious Links: Emily Jennings, Hung Liu, Celia Munoz. San Antonio, TX: San Antonio Museum of Art, 1990.
- Edwards. I. E. S. *The Treasures of Tutankhamun*. New York: Penquin Books, 1977.
- Encyclopedia Americana. Danbury, CT, Grolier Incorporated, 1986.
 "Central Park" by Harry L. Coles, "China: 15. Theater" by Chiapao Wan, "Globe Theater" by Bernard Beckermen, "Japan 22: Doll Drama" by Donald Richie, "Disneyland and Disney World," "Epcot," "Palenque" by Pedro Armillas, "Zoological Gardens" by William Bridges.
- Etienne, Robert. *Pompeii: The Day a City Died.* New York: Harry N. Abrams, 1992.
- Ezra, Kate. Art of the Dogon. New York: The Metropolitan Museum of Art. 1988.
- Fagan, Brian M. Rape of the Nile. Rhode Island: Moyer Bell, 1992.
- Fagg, William. Yoruba: Sculpture of West Africa. New York: Alfred A. Knopf, 1982.
- Feder, Norman. American Indian Art, New York: Harry N. Abrams, 1995.
- Feest, Christian F. Native Arts of North America, New York: Oxford University Press, 1980.
- Fichner-Rathus, Lois. *Understanding Art.* Englewoood Cliffs, NJ: Prentice Hall, 1994.
- The Field Museum Centennial Collection. *Pacific, A Companion to the Regenstein Halls of the Pacific,* ed. Ron Dorfman. Chicago: Field Museum of Natural History, 1991.
- Fiero, Gloria. The Humanistic Tradition, Madison, WI: WCB Brown and Benchmark, 1995.
- Fiodorov, B., ed. Architecture of the Russian North, 12th through 19th Centuries. Leningrad: Aurora Art Publishers, 1976.
- Fisher, Robert E. Mystics and Mandalas: Bronzes and Paintings of Tibet and Nepal. Redlands, CA: The University of Redlands. 1974.
- Flaherty, Thomas H. ed. Aztecs: Reign of Blood and Splendor. Alexandria, VA: Time-Life Books, 1992.
- Flaherty, Thomas H. *Incas: Lords of Gold and Glory*. Alexandria, VA: Time-Life Books, 1992.
- Flaherty, Thomas H. *The American Indians: The Spirit World*, Alexandria, VA, Time-Life Books, 1992.
- Flaherty, Thomas H. *The Mighty Chieftains*. Alexandria, VA: Time-Life Books, 1993.
- Fleming, William. *Arts and Ideas*. New York: Holt Rinehart and Winston, Inc., Third Edition.
- Franciscis de, Alfonso. *Pompeii Civilization and Art*. Naples, Italy: Interdipress, 1997.
- Frankfort, Henri. *The Art and Architecture of the Orient*. New Haven, CT: Yale University Press, 1970.
- Furst, Peter T. and Jill L. *North American Indian Art.* New York: Rizzoli International Publications, 1982.
- Gardner, Joseph L. *Mysteries of the Ancient Americas*, Pleasantville, NY: The Reader's Digest Association, Inc., 1986.
- Gardner, Paul. Louise Bourgeois. New York: Universe Publishing, 1994.
- Getty Museum, The J. Paul. The J. Paul Getty Museum Handbook of the Collections. Malibu, CA: The J. Paul Getty Museum, 1991.
- Getty, Adele. *Goddess, Mother of Living Nature.* London: Thames and Hudson, 1990.
- Getz-Preziosi, Pat. Early Cycladic Sculpture: An Introduction. Malibu, CA: The J. Paul Getty Museum, 1994.

- Gilbert, Creighton. History of Renaissance Art Throughout Europe. New York: Harry N. Abrams, 1973.
- Gillon, Werner. A Short History of African Art. New York, Penguin Books, 1991.
- Goggin, Mary-Margaret. "'Decent' vs. 'Degenerate' Art: The National Socialist Case." In Art Journal, Winter 1991, Vol. 50, No. 4, pp. 84–93.
- Goodman, Susan Tumarkin, ed. Russian Jewish Artists in a Century of Change 1890–1990. Munich: Prestel-Verlag, 1995.
- Gowing, Lawrence. *Lucian Freud*. London: Thames and Hudson, 1982.
- Graves, Eleanor. Life Goes to War, A Picture History of World War II. Boston, MA: Little, Brown and Company, 1977.
- Graze, Sue, Kathy Halbreich and Roberta Smith. Elizabeth Murray: Paintings and Drawings. New York: Harry N. Abrams, in association with the Dallas Museum of Art and the MIT Committee on the Visual Arts, 1987.
- Greenberg, Clement. "Avant-Garde and Kitsch." In Partisan Review 6 (Fall 1939); reprinted in Greenberg, Art and Culture: Critical Essays. Boston: Beacon Press, 1961.
- Gregory, Richard L. Eye and Brain: The Psychology of Seeing. Princeton, NJ: Princeton University Press, 1997. (5th edition)
- Grolier Encylcopedia. WEB "Pacifism and Non-violent Movements" and "Gandhis's Campaigns," 1996.
- Grube, Ernst J. The World of Islam. New York: McGraw-Hill Book Company, 1977.
- Gruzinski, Serge. The Aztecs, Rise and Fall of an Empire. New York: Harry N. Abrams, 1992.
- Guiart, Jean. The Arts of the South Pacific. New York: Golden Press, 1963
- Hadington, Evan. Lines to the Mountain Gods. New York: Random House Inc. 1987.
- Hagen, Victor W. von. The Desert Kingdoms of Peru. London: Weidenfeld and Nicolson, 1965.
- Hanson, Allan, and Louise Hanson, eds. Art and Identity in Oceania. Honolulu, HI: University of Hawaii Press, 1990.
- Harle, J.C. The Art and Architecture of the Indian Subcontinent. London: Penguin Books, 1986.
- Harris, Ann Sutherland, and Linda Nochlin. Women Artists 1550–1950. New York: Alfred A. Knopf, 1984.
- Hartt, Frederick. History of Italian Renaissance Art: Painting, Sculpture, Architecture. Englewood Cliffs, NJ: Prentice Hall, Inc., 1969.
- Haruzo Ohashi. The Japanese Garden, Islands of Serenity. Tokyo: Graphic-sha Publishing Co., Ltd., 1997.
- Hawthorn, Audrey. Kwakiutl Art. Seattle and London: University of Washington Press, 1979.
- Hay, John. Masterpieces of Chinese Art. Greenwich, CT: The New York Graphic Society, 1974.
- Heartney, Eleanor. "Pornography." In *Art Journal*, Winter 1991, Vol. 50, No. 4, pp. 16–19.
- Helm, Mackinley, Mexican Painters, Rivera, Orozco, Siqueiros, and Other Artists of the Social Realist School. New York: Dover Publications, Inc., 1941.
- Hershey, Irwin. Indonesian Primitive Art. New York: Oxford Press, 1991.
- Heusinger, Lutz. Michelangelo. Antella, Florence, Italy: SCALA Instituto Fotographico, Editoriale s. p. a., 1989.
- Hillier, J. Japanese Colour Prints. London: Phaidon Press Limited, 1991.
- Hoffman, Katherine. Concepts of Identity: Historical and Contemporary Images and Portraits of Self and Family. New York: HarperCollins, 1996.
- Holm, Bill. Northwest Coast Indian Art: An Analysis of Form. Seattle: University of Washington Press, 1995.
- Holt, Elizabeth Gilmore, ed. Literary Sources of Art History: An Anthology of Texts from Theophilus to Goethe. Princeton, NJ: Princeton University Press, 1947.

- Holt, John Dominis. The Art of Featherwork in Old Hawaii. Honolulu: Topgallant Publishing Co., Ltd., 1985.
- Honour, Hugh, and John Fleming, *The Visual Arts: A History*. Englewood Cliffs, NJ: Prentice Hall, 1995.
- Hooks, Bell. Art on My Mind: Visual Politics. New York: The New Press, 1995.
- Hopkins, Jerry. Yoko Ono. New York: Macmillan Publishing Co., 1986.
- Howard, Jeremy. Art Nouveau: International and National Styles in Europe. Manchester, UK: Manchester University Press, 1996.
- Hughes, Robert. American Visions. New York: Alfred A. Knopf, 1997.Hulton, Paul, and Lawrence Smith. Flowers in Art from East and West.London: British Museum Publications, Ltd., 1979.
- Huntington, Susan L., and John C. Huntington. Leaves from the Bodhi Tree. Seattle: The University of Washington Press, 1990.
- ... Identity and Alterity: Figures of the Body 1895–1995. Catalog of La Biennale di Venezia 46. esposizione internationale d'arte. Venice, Italy: Marsilio Editori s.p.a., 1995.
- Ivory: An International History and Illustrated Survey. New York: Abrams, 1987.
- Janson, H. W. History of Art. New York: Harry N. Abrams, 1995.
- Jellicoe, Geoffrey, and Susan Jellicoe. *The Landscape of Man.* London: Thames and Hudson, 1987.
- Jonaitis, Aldona. From the Land of the Totem Poles. New York: American Museum of Natural History, 1988.
- Jones, Alexander. The Jerusalem Bible. Garden City, NY: Doubleday and Company, Inc., 1966.
- Jones, Amelia, ed. Sexual Politics: Judy Chicago's Dinner Party in Feminist Art History. Berkeley: University of California Press, 1996.
- Kaprow, Allen. Assemblage, Environments and Happenings. New York: Harry N. Abrams, Publishers, 1961.
- Kessler, Adam T. Empires Beyond the Great Wall, the Heritage of Genghis Khan. Los Angeles, CA: Natural History of Los Angeles County, 1994.
- Kettering, Alice McNeil. "Gentlemen in Satin: Masculine Ideals in Later Seventeenth-Century Dutch Portraiture." In Art Journal, Vol. 56, No. 2, Summer 1997, pp. 41–47.
- Kienholz, Edward, and Nancy Reddin Kienholz. Kienholz: A Retrospective. New York: Whitney Museum of American Art, New York: 1996.
- Kirsh, Andrea. Carrie Mae Weems. Washington DC: The National Museum of Women in the Arts, 1993.
- Kitchen, K. A. Pharaoh Triumphant, The Life and Times of Ramesses II. Cairo, Egypt: The American University in Cairo Press, 1982.
- Koons, Jeff. The Jeff Koons Handbook. New York: Rizzoli. 1992.
- Kopper, Phillip. The Smithsonian Book of North American Indians Before the Coming of the Europeans. Washington DC: Smithsonian Books, 1986.
- Kulka, Tomas. Kitsch and Art. University Park, PA: The Pennsylvania State University Press, 1996.
- Kundera, Milan. *The Unbearable Lightness of Being*. Trans. by Michael Henry Heim. New York: Harper and Row, 1984.
- Kuroda, Taizo, Melinda Takeuchi and Yuzo Yamane. Worlds Seen and Imagined: Japanese Screens from the Idemitsu Museum of Art. New York: The Asia Society Galleries and Abbeville Press Publishers, 1995.
- Laude, Jean. African Art of the Dogon. New York: The Viking Press, 1973.
- Lauer, David A., and Stephen Pentak. *Design Basics*. Fort Worth, TX: Harcourt Brace College Publishers, 1995.
- Lazzari, Margaret, and Clayton Lee. *Art and Design Fundamentals*. New York: Van Nostrand Reinhold, 1990.
- Lee, Sherman E. A History of Far Eastern Art. New York: Harry N. Abrams, 1973.
- Levenson, Jay A. Circa 1492. New Haven, CT: Yale University Press, 1991.

- Levi, Peter. *The Cultural Atlas of the World: The Greek World.* Alexandria, VA: Stonehenge Press, 1992.
- Lewis, Bernard. Islam and the Arab World. New York: Alfred A. Knopf, 1976.
- Lewis, Phillip. "Tourist Art, Traditional Art and the Museum in Papua New Guinea," from Art and Identity in Oceania, Allan Hanson and Louise Hanson, eds., Honolulu, HI: University of Hawaii Press, 1990.
- Lincoln, Louise. Assemblage of Spirits: Idea and Image in New Ireland. New York: George Braziller. 1987.
- Linker, Kate. Love for Sale: The Words and Pictures of Barbara Kruger. New York: Harry N. Abrams, 1990.
- Lippard, Lucy R. Mixed Blessings: New Art in a Multicultural America. New York: Pantheon Books, 1990.
- Lippard, Lucy. *The Pink Glass Swan: Selected Feminist Essays on Art.* New York: The New Press, 1995.
- Lossing, Benson J. Mathew Brady's Illustrated History of the Civil War. Washington DC: Fair Fax Press, Barre Publishing, 1912.
- Lowe, Sarah M. Frida Kahlo. New York: Universe Publishing, 1991.
- Lundquist, John M. *The Temple: Meeting Place of Heaven and Earth.*London: Thames and Hudson, 1993.
- Lyle, Emily, ed. Sacred Architecture in the Traditions of India, China, Judaism and Islam. Edinburgh: Edinburgh University Press, 1992.
- Machida, Margo. "Out of Asia: Negotiating Asian Identities in America," in Asia America: Identities in Contemporary Asian American Art. New York: The Asia Society Galleries and The New Press, 1994.
- Mackenzie, Lynne. Non Western Art, A Brief Guide. Upper Saddle River, NJ: Prentice Hall, 2001.
- Malone, Maggie, and Hideko Takayama. "A Japanese Buying Spree: The Tycoon Who Spent \$160 Million at Auctions." *Newsweek*, May 28, 1990, p. 75.
- Mann, A. T. Sacred Architecture. Rockport, MA: Element, Inc., 1993.
 Marcus, George E. "Middlebrow into Highbrow at the J. Paul Getty Trust." In Looking High and Low, ed. by Brenda Jo Bright and Liza Bakewell. Tuscon, AZ: The University of Arizona Press, 1995.
- Mariani, Valerio. Michelangelo the Painter. New York, Harry N. Abrams, 1964.
- Matilsky, Barbara C. Fragile Ecologies: Contemporary Artists' Interpretations and Solutions. New York: Rizzoli International Publications, Inc., 1992.
- Matt, Leonard von, Mario Moretti and Guglielmo Maetzke. *The Art of the Etruscans*. New York: Harry N. Abrams, 1970.
- McLanathan, Richard. *The American Tradition in the Arts*. New York: Harcourt Brace and World, 1968.
- Mead, Sidney Moko. *Te Maori: Maori Art from New Zealand Collections*. New York: Harry N. Abrams, 1984.
- _____. Media Scape. New York: Solomon R. Guggenheim Museum, 1996.
- Miller, 1st Lieutenant Kimberly J. "Battle for Iwo Jima." United States Marines Web Page, at http://www.usmc.mil 1997.
- Miller, Arthur G. The Painted Tombs of Oaxaca, Mexico: Living with the Dead. Cambridge: The Cambridge University Press, 1995.
- Miller, Mary Ellen. The Art of Mesoamerica from Olmec to Aztec. New York: Thames and Hudson, 1986.
- Mitchell, W. J. T., ed. *Art and the Public Sphere*. Chicago and London: University of Chicago Press, 1992.
- Monod-Bruhl, Odette. *Indian Temples*. London: Oxford University Press. 1951.
- Morgan, William N. Prehistoric Architecture in the Eastern United States. Cambridge, MA: The MIT Press, 1980.
- Moynihan, Elizabeth B. Paradise as a Garden in Persia and Mughal India. London: Scolar Press, 1979.
- Munroe, Alexandra. *Japanese Art After 1945: Scream Against the Sky.* New York: Harry N. Abrams, 1994.
- Murray, Jocelyn. *The Cultural Atlas of the World: Africa*. Alexandria, VA: Stonehenge Press, 1992.

- Murray, Peter and Linda. *The Art of the Renaissance*. New York: Praeger Publishers, 1963.
- Nagle, Geraldine. *The Arts-World Themes*. Madison, WI: Brown and Benchmark, 1993.
- Nemser, Cindy. Art Talk: Conversations with 15 Women Artists. New York: HarperCollins, 1995.
- Newhall, Beaumont. History of Photography from 1839 to the Present Day. New York: Museum of Modern Art, 1964.
- Newton, Douglas. New Guinea Art in the Collection of the Museum of Primitive Art. New York: Publishers Printing-Admiral Press, 1967
- Nochlin, Linda. Women, Art, and Power and Other Essays. New York: Harper and Row, 1988.
- Norwich, John Julius, ed. *Great Architecture of the World*. New York: Bonanza Books, 1979.
- Nou, Jean-Louis, Amina Okada and M. C. Joshi. *Taj Mahal*. New York: Abbeville Press, 1993.
- O'Hara, Frank. Robert Motherwell. New York: Museum of Modern Art, 1965.
- O'Neill, John P., editor in chief. *Mexico: Thirty Centuries of Splendor.* New York: The Metropolitan Museum of Art, 1990.
- Ocvirk, Stinson, Wigg, Bone, and Clayton. Art Fundamentals: Theory and Practice. Madison, WI: Brown Benchmark, 1998.
- Oliver, Douglas L. *The Pacific Islands*. Honolulu: University of Hawaii Press, 1989.
- Papanek, John L., ed. *Ancient India, Land of Mystery*. Alexandria, VA: Time-Life Books, 1994.
- Papanek, John L., ed. Africa's Glorious Legacy, Lost Civilizations. Alexandria, VA: Time-Life Books, 1994.
- Papanek, John L. *Mesopotamia: The Mighty Kings*. Alexandria, VA: Time-Life Books, 1995.
- Pasztory, Esther. Aztec Art. New York: Harry N. Abrams, 1983.
- Pelrine, Diane M. Affinities of Form: Arts of Africa, Oceania and the Americas from the Raymond and Laura Wielgus Collection. Munich: Prestel-Verlag, 1996.
- Pendlebury, J. D. S. A Handbook to the Palace of Minos at Knossos. London: Macmillan and Co., 1935.
- Penny, David W. Art of the American Indian Frontier: The Chandler-Pohrt Collection. The Detroit Institute of Art. Seattle: University of Washington Press, 1992.
- Perani, Judith, and Fred T. Davidson. *The Visual Arts of Africa: Gender, Power and Life Cycle Rituals.* Upper Saddle River, NJ: Prentice Hall, 1998.
- Perchuk, Andrew. "Hannah Wilke [exhibition at] Ronald Feldman Fine Arts." *Artforum*, April 1994, pp. 93–94.
- Phipps, Richard, and Richard Wink. *Invitation to the Gallery*. Dubuque, IA: Wm. C. Brown Publishers, 1987.
- Pierson, William H., and Martha Davidson. Arts of the United States, A Pictorial History. New York: McGraw-Hill, 1960.
- Preble, Duane and Sarah. *ArtForms*. New York: Harper Collins College Publishers, 1994.
- Ragghianti, Carlo Ludovico, and Licia Ragghianti Collobi. *National Museum of Anthropology, Mexico City.* New York: Newsweek (Simon and Schuster), 1970.
- Ramseyer, Urs. *The Art and Culture of Bali*. Singapore and Oxford: Oxford University Press, 1986.
- Rawson, Jessica, ed. *The British Museum Book of Chinese Art.* London: Thames and Hudson, 1992.
- Rhodes, Colin. *Outsider Art, Spontaneous Alternatives*. World of Art. New York: Thames and Hudson, 2000.
- Richter, Anne. Arts and Crafts of Indonesia. San Francisco: Chronicle Books, 1994.
- Rochfort, Dennis. *Mexican Muralists*. New York: Universe Publishing, 1993.
- Ross, Doran H. "Akua's Child and Other Relatives: New Mythologies for Old Dolls." In *Isn't S/he a Doll? Play and Ritual in African Sculpture*, by Elisabeth L. Cameron. Los Angeles: University of

- California at Los Angeles Fowler Museum of Cultural History, 1996, pp. 43–57.
- Rowland, Anna. Bauhaus Source Book. New York: Van Nostrand Reinhold, 1990.
- Roy, Christopher. Art and Life in Africa: Selections from the Stanley Collection, Exhibitions of 1985 and 1992. Iowa City: The University of Iowa Museum of Art, 1992.
- Rubin, Barbara, Robert Carlton and Arnold Rubin. Forest Lawn: L. A. in Installments. Santa Monica, CA: Westside Publications, 1979.
- Santini, Loretta. Pompeii and the Villa of the Mysteries. Narni-Terni, Italy: Editrice Plurigraf, 1997.
- Sasser, Elizabeth Skidmore. The World of Spirits and Ancestors in the Art of Western Sub-Saharan Africa. Lubbock, TX: Texas Tech University Press, 1995.
- Saunders, J. B. de C. M., and Charles O'Malley. The Illustrations From the Works of Andreas Vesalius of Brussels. New York: Dover Publications, Inc., 1950.
- Sayre, Henry M. The Object of Performance: The American Avant-Garde since 1970. Chicago: University of Chicago Press, 1989.
- Schmitz, Carl A. Oceanic Art, Myth, Man and Image in the South Seas. New York: Harry N. Abrams, 1971.
- Schwarz, Hans-Peter. *Media-Art-History*. Munich: Prestel-Verlag, 1997. Seaford, Richard. *Pompeii*. New York: Summerfield Press. 1978.
- Setton, Kenneth M., et al. *The Renaissance, Maker of Modern Man.* Washington DC: National Geographic Society, 1970.
- Sharp, Dennis. A Visual History of Twentieth Century Architecture. Greenwich, CT: New York Graphic Society, 1972.
- Shearer, Alistair. *The Hindu Vision: Forms of the Formless.* London: Thames and Hudson, 1993.
- Sickman, Lawrence, and Alexander Soper, *The Art and Architecture of China*. New Haven, CT: Yale University Press, 1971.
- Silva, Anil de, Otto von Simons, and Roger Hinks. Man Through Art, War and Peace. Greenwich, CT: New York Graphic Society, 1964.
- Simmons, David. Whakairo Maori Tribal Art. New York: Oxford University Press, 1985.
- Simon, Joan, general ed. Bruce Nauman. Minneapolis: Walker Art Center, 1994.
- Sitwell, Sacheverell. *Great Palaces*. New York: The Hamlyn Publishing Group Limited, 1969.
- Skira, Albert. Treasures of Asia: Chinese Painting. Cleveland, OH: The World Publishing Company, 1960.
- Slatkin, Wendy. Women Artists in History: From Antiquity to the Present. Upper Saddle River, NJ: Prentice Hall, 1997.
- Smith, Bradley, and Wan-go Wen. *China: A History in Art.* New York: Doubleday and Company, Inc., 1979.
- Snellgrove, David L., general ed. The Image of the Buddha. Paris: UN-ESCO (United Nations Educational, Scientific and Cultural Organization) and Tokyo: Kodansha International, 1978.
- Solomon-Godeau, Abigail. "The Other Side of Vertu: Alternative Masculinities in the Crucible of Revolution." Art Journal, Vol. 56, No. 2, Summer 1997, pp. 55–61.
- Sontag, Susan. Against Interpretation and Other Essays. New York: Farrar, Strauss and Giroux, 1966.
- Spayde, Jon. "Cultural Revolution," in *Departures*, Sept./Oct. 1995, pp. 115–123, 154–157.
- Sporre, Dennis J. The Creative Impulse: An Introduction to the Arts. Upper Saddle River, NJ: Prentice Hall, 1996.
- Staccioli, R. A. Ancient Rome: Monuments Past and Present. Via G. Banti, 34–Roma (Italy): Vision s. r. l., 1989.
- Staniszewski, Mary Anne. Believing Is Seeing: Creating a Culture of Art. New York: Penguin Books, 1995.
- Stanley-Baker, Joan. *Japanese Art.* London: Thames and Hudson, 1984.

- Sterling, Charles. Still Life Painting: From Antiquity to the Twentieth Century. Second Revised Edition. New York: Harper and Row, Publishers, 1980.
- Stewart, Gloria. Introduction to Sepik Art of Papua New Guinea. Sydney, Australia: Garrick Press Pty. Ltd., 1972.
- Stewart, Hilary. Looking at Indian Art of the Northwest Coast. Seattle: University of Washington Press, 1979.
- Stierlin, Henri. Art of the Aztecs and Its Origins. Translated by Betty and Peter Ross. New York: Rizzoli International Publications, 1989
- Stierlin, Henri. The Pharaohs Master-Builders. Paris: Terrail. 1992.
- Stooss, Toni, and Thomas Kellein, general editors. *Nam June Paik: Video Time–Video Space*. New York: Harry N. Abrams, 1993.
- Stuart, Gene S. and George E. Lost Kingdoms of the Maya. Washington DC: National Geographic Society, 1993.
- Sullivan, Michael. Art and Artists of Twentieth-Century China. Berkeley, CA: University of California Press, 1996.
- Sutton, Peter C. *The Age of Rubens*. Boston: The Museum of Fine Arts, Boston: 1993.
- Swann, Peter C. Chinese Monumental Art. New York: The Viking Press, 1963.
- Tadashi Kobayashi. Ukiyo-e, An Introduction to Japanese Woodblock Prints. Tokyo: Kodansha International, 1992.
- Tallman, Susan. "General Idea." Arts Magazine, May 1990, pp. 21–22.
- Tannahill, Reay. Food in History. New York: Stein and Day, 1973.
- Tansey, Richard G., and Fred S. Kleiner. Gardner's Art Through the Ages. Fort Worth, TX: Harcourt Brace College Publishers, 1996.
- Taylor, Pamela York. *Beasts, Birds and Blossoms in Thai Art.* Kuala Lumpur, Malaysia: Oxford University Press, 1994.
- Taylor, Simon. "Janine Antoni at Sandra Gering." Art in America, Vol. 80, Oct. 1992.
- Tello, J. C. "Arte Antiguo Peruano." Inca: Revista de Estudios Antropolico, V. II, Universidad de San Marcos de Lima. 1924.
- Terrace, Edward L. B., and Henry G. Fisher. *Treasures of Egyptian Art from the Cairo Museum*. London: Thames and Hudson, 1970.
- The Center for African Art. Art/artifact: African Art in Anthropology Collections. New York: Prestel-Verlag, 1989.
- Thomas, Nicholas. *Oceanic Art.* London: Thames and Hudson, 1995.
- Thucydides. *The Peloponnesian War.* Trans. by Rex Warner. Baltimore: Penguin, 1954.
- Time-Life Books. Lost Civilizations: Anatolia—Cauldron of Cultures. Richmond, VA: Time-Life Inc., 1995.
- Tom, Patricia Vettel. "Bad Boys: Bruce Davidson's Gang Photographs and Outlaw Masculinity." Art Journal, Vol. 56, No. 2, Summer 1997, pp. 69–74.
- Townsend, Richard F., ed. *The Ancient Americas, Art from Sacred Land-scapes.* Chicago, IL: The Art Institute of Chicago, 1992.
- Tregear, Mary. Chinese Art. London, UK: Thames and Hudson, 1991.
- Truettner, William H. *The Natural Man Observed: A Study of Catlin's Indian Gallery.* Washington DC: Smithsonian Press, 1979.
- Turner, Jane, ed. *The Dictionary of Art.* New York: Grove Dictionaries Inc., 1996.
- Vercoutter, Jean. The Search for Ancient Egypt. New York: Harry N. Abrams, 1992.
- Vickers, Michael, ed. Pots and Pans. Oxford: Oxford University Press, 1986.
- Vogel, Susan Mullin. *African Art, Western Eyes*. New Haven and London: The Yale University Press, 1997.
- Vogel, Susan. Africa Explores, 20th Century African Art. New York: The Center for African Art, 1991.
- Von Blum, Paul. The Art of Social Conscience. New York: Universe Books, 1976.
- Vroege, Bas, and Hripsimé Visser, eds. Oppositions: Commitment and Cultural Identity in Contemporary Photography from Japan, Canada,

- Brazil, the Soviet Union and the Netherlands. Rotterdam: Uitgeverij 010 Publishers, 1990.
- Wallach, Alan. Exhibiting Contradiction: Essays on the Art Museum in the United States. Amherst, MA: The University of Massachusetts Press 1998.
- Wallis, Brian, ed. Hans Haacke: Unfinished Business. New York: The New Museum of Contemporary Art and Cambridge, MA: M.I.T. Press, 1986.
- Washburn, Dorothy, ed. Hopi Kachina: Spirit of Life. California Academy of Sciences. Distributed by the University of Washington Press, Seattle and London. 1980.
- Weibiao, Hu. Scenes of the Great Wall. Beijing: Wenjin Publishing House, 1994.
- Weintraub, Linda, ed. Art What Thou Eat: Images of Food in American Art. Mount Kisco, NY: Moyer Bell Limited, 1991.
- Wescoat, James L. Jr., and Joachim Wolschke-Bulmahn. Mughal Gardens: Sources, Places, Representations and Prospects. Washington, DC: Dumbarton Oaks Research Library and Collection, 1996.
- Wheat, Ellen Harkins. *Jacob Lawrence: American Painter.* Seattle: University of Washington Press, 1986.
- Willett, Frank. African Art. New York: Thames and Hudson, 1993.
- Willett, Frank. Ife in the History of West African Sculpture. New York: McGraw-Hill Book Company, 1967.
- Willis, Deborah, ed. Picturing Us: African American Identity in Photography. New York: The New Press, 1994.
- Willis-Braithwaite, Deborah. Van Der Zee Photographer 1886–1983. New York: Harry N. Abrams, 1993.
- Wilson, David M., and Ole Klindt-Jensen. *Viking Art.* Minneapolis: University of Minnesota Press, 1980.

- Wilson, Sir David M., ed. The Collections of the British Museum. Cambridge: Cambridge University Press, 1989.
- Wingert, Paul S. Art of the South Pacific. New York: Columbia University Press, 1946.
- Wingert, Paul S. An Outline of Oceanic Art. Cambridge, MA: University Prints, 1970.
- Winkelmann-Rhein, Gertraude. The Paintings and Drawings of Jan "Flower" Bruegel. New York: Harry N. Abrams, 1968.
- Witherspoon, Gary. Language and Art of the Navajo Universe. Ann Arbor, MI: University of Michigan Press, 1977.
- Wolff, Janet. The Social Production of Art. New York: New York University Press, 1984.
- Yau, John. "Hung Liu [exhibition at] Nahan Contemporary." Artforum, March 1990, p. 162.
- Yenne, Bill, and Susan Garratt. North American Indians. China: Ottenheimer Publishers, Inc., 1994.
- Yood, James. Feasting: A Celebration of Food in Art. New York: Universe, 1992.
- Zarnecki, George. Art of the Medieval World. New York: Harry N. Abrams, 1975.
- Zelanski, Paul, and Mary Pat Fisher. *Design Principles and Problems*. Fort Worth, TX: Harcourt Brace College Publishers, 1996.
- Zelevansky, Lynn, et al. *Love Forever: Yayoi Kusama 1958–1968*. Los Angeles: The Los Angeles County Museum of Art, 1998.
- Zigrosser, Carl. Prints and Drawings of Käthe Kollwitz. New York: Dover Publications, Inc., 1969.

1.1: Photo © British Museum. 1.2, 1.5: Photo © 2000 The Museum of Modern Art, New York. 1.6: Courtesy of the artist and Immaculate Conception, Inc. 1.10: Photo reproduction courtesy Nam June Paik and Holly Solomon Gallery, New York. 1.11: Photo courtesy of the Pasadena Tournament of Roses.

2.1: Jennifer Steele, Department of Aboriginal Affairs 2.3: Institut Amatller d'Art Hispanic © Museo del Prado. 2.4: By permission of the National Gallery of Australia and Artists' Rights Society, New York. 2.5: The Rainbird Publishing Group, 36 Park Street, London WIY 4DE, U.K. 2.6: Photo Tom Haartsen. 2.8: Erich Lessing/Art Resource, New York. 2.12: Photo copyright © 2001 Whitney Museum of American Art. Licensed by VAGA, New York. 2.13: Photo courtesy Robert Miller Gallery, New York. 2.14: Scala/Art Resource, New York. 2.15: Photo Wim Swaan. 2.16: Gift of John H. Hauberg, Seattle Art Museum. 2.17: © 2001 Estate of David Smith/Licensed by VAGA, New York. 2.18: Photo courtesy Wheelwright Museum of the American Indian, Santa Fe. 2.19: Photo Albright-Knox Art Gallery (bequest of A. Conger Goodyear). 2.21: AP/Wide World. 2.24: Photo © 2000 The Museum of Modern Art, New York. 2.25: Photo David Heald, courtesy Solomon R. Guggenheim Museum. 2.26: The Hutchison Library, London. 2.27: Photo © 2000 The Museum of Modern Art. New York. 2.29: © 2001 Allan Kaprow. Used by permission of The J. Paul Getty Museum, Los Angeles. 2.30: © 2001 David Gahr. 2.32: Photo © 2000 The Museum of Modern Art, New York. 2.33: Photo © 2001 Metropolitan Museum of Art, New York. 2.34: Courtesy of Marlborough Gallery, New York. Licensed by VAGA, New York. 2.35: Saskia Ltd. Cultural Documentation. 2.36: Naturhistorisches Museum, Vienna. 2.37: Bayerische Staatsbibliothek. Munich. 2.38: Photo archive of the National Museum of the American Indian. 2.39: Photo John Cliett, © Dia Art Foundation. 2.40: Courtesy of the New York Department of Sanitation.

3.1: Linden Museum, Stuttgart. 3.3, 3-13: Henri Stierlin. 3.4: Studio Kontos. 3.7, 3.22: Hu Chui/China Photographic Publishing House. 3.9: Robert Harding Picture Library. 3.10: Scala/Art Resource, New York. 3.11: Fototeca Unione. 3.12: Photo Francois Lauginie. 3.15: Chicago Historical Society/photo Hedrich-Blessing HB-1932-E. 3.16: ESTO ⊚ Ezra Stoller. 3.17: Photo Researchers. 3.19: Ian Lambot, courtesy Pei Cobb Freed & Partners. 3.20: Comstock. 3.21: ⊚ 1997 Norman McGrath. 3.22: China Photographic Publishing House, Beijing. 3.23: Chicago Historical Society. 3.24: Wim Swaan. 3.25: The Arkansas Office, Inc. 3.26: Royal Tropical Institute, Amsterdam.

4.1: Copyright © The Dorothea Lange Collection, The Oakland Museum of California, City of Oakland. 4.2: Photo © The Art Institute of Chicago. All Rights Reserved. 4.3: Ian Lambot, courtesy Pei Cobb Freed & Partners. 4.4: © 1995 The Pollack-Krasner Foundation/Artists' Rights Society, New York. 4.7: Louvre, Paris, photo R.M.N. 4.9: Photo courtesy of the artist. 4.10: Courtesy of the artist and Metro Pictures. 4.11: Photo © 2000 The Museum of Modern Art, New York. 4.12: Courtesy Guerrilla Girls. 4.13: Photo courtesy of the artist. 4.14: Gift of

John H. Hauberg, Seattle Art Museum. **4.15:** Photo © 2001 Metropolitan Museum of Art, New York.

5.2: Photo © British Museum. 5.3: Saskia Ltd. Cultural Documentation. 5.4: Photo © 2001 Metropolitan Museum of Art, New York. 5.7: Photo courtesy Ester Pasztory. 5.8, 5.9: Photo Museum of Anthropology at the University of British Columbia, Vancouver. 5.10: Institut Amatller d'Art Hispanic © Museo del Prado. 5.12: Photo Christie's Images Inc. 5.13: Photo © The Art Institute of Chicago. All Rights Reserved. 5.15: Photo © The Art Institute of Chicago. All Rights Reserved.

6.1: Photo Hans Hinz. 6.2: Jennifer Steele, Department of Aboriginal Affairs. 6.3: Photo Pascal James Imperato. 6.5: Courtesy Gil Michaels, Galerie St. Etienne, New York. 6.6: Photo 1935 Ares Publishers. 6.7: Brooklyn Museum of Art (gift of Fernandez Arman to Jennie Simpson Educational Collection of African Art). 6.8: Photo Ashmolean Museum. Oxford. 6.10, 6.16: Photo Peter Furst. 6.11: Photo Frank J. Thomas, Los Angeles. 6.13: Photo The British Library, London. 6.14: Permission of Museo Nazionale Preistorico e Etnografico Luigi Pigorini, Rome. 6.15: Photo © The British Museum 6.17: Photo Kunstsammlungen zu Weimar. 6.18: Photo © 2001 Metropolitan Museum of Art, New York. 6.19: Fine Arts Museums of San Francisco (gift of Mr. & Mrs. John D. Rockefeller III). 6.20: Scala/Art Resource, New York. 6.21: Photo Shimizu Kohgeisha Co. Ltd. Permission Ryokoin Management. 6.22: Louvre, Paris, photo R.M.N. 6.23: Courtesy George Eastman House, Rochester, New York. 6.24: Photo copyright © 2001 Whitney Museum of American Art. Licensed by VAGA, New York. 6.25: Photo courtesy Fowler Museum, University of California at Los Angeles. 6.27: Alinari/Art Resource, New York. 6.28: Photo Museum of Anthropology at the University of British Columbia, Vancouver. 6.29: Photo Freer Gallery of Art, Smithsonian Institution, Washington, D.C. 6.30: Copyright © Judy Chicago 1979, photo copyright © Donald Woodman. Courtesy Through the Flower. 6.32: Courtesy the Estate of Duane Hanson. 6.33: Courtesy of the artist and Immaculate Conception, Inc.

7.1: Naturhistorisches Museum, Vienna. 7.2: James Mellaart, London. 7.3: The Ashmolean Museum, Oxford. 7.4: Photo The J. Paul Getty Museum, Los Angeles. 7.5, 7.6, 7.13: Photo © British Museum. 7.7: Photo Petri Collection, University College, London. 7.8: Photo © The Detroit Institute of Arts. 7.9: Photo courtesy Galerie Carrefore, Paris. 7.10: Hirshhorn Museum, Smithsonian Institution, Washington, D.C. 7.11, 7.12, 7.25: Scala/Art Resource. 7.14: Photo © 2001 Metropolitan Museum of Art, New York. 7.15: Canali. 7.16: Bibliotheque de l'Assemble national française, Paris. 7.17: Bodleian Library, photo Peter Furst. 7.18: The National Gallery, London. 7.19, 7.23: Museo Arqueologico Rafael Larco Herrera, Lima, Peru. 7.20: V&A Picture Library. 7.21: Copyright © Jeff Koons, courtesy Jeff Koons Productions. 7.22: © Justin Kerr. 7.24: © Dirk

8.1, 8.2: James Mellaart, London. 8.3: Photo Paul Logsdon. 8.4, 8.5, 8.31: Eliot Elisofon Collection, National Museum of African Art, Smithsonian

Institution, Washington, D.C. 8.6: The Arkansas Office, Inc. 8.8: Henri Stierlin. 8.9: Photo © Jean-Paul Descoecudres. 8.11: Erich Lessing/Art Resource, New York. 8.12, 8.33: Scala/Art Resource, New York. 8.14: © Don Carl Steffen/Photo Researchers. 8.15: Photo © Nelson-Atkins Museum of Art. 8.16: Royal Tropical Institute, Amsterdam. 8.17: Dallas Museum of Art. 8.18: Linden Museum, Stuttgart. 8.19: Photo National Museum of Natural History, Smithsonian Institution, Washington, D.C. 8.20: ESTO © Ezra Stoller. 8.21: Fototeca Unione. 8.22: Chicago Historical Society/photo Hedrich-Blessing HB-1932-E. 8.23: Chicago Historical Society. 8.24: Comstock. 8.25: Ian Lambot, courtesy Pei Cobb Freed & Partners. 8.26: © 1997 Norman McGrath. 8.27: Fototeca Unione Accademia Americana, Rome. 8.29: Permission of VISION S.r.l., Rome. 8.30: © Angela Fisher, courtesy Robert Estall Agency. 8.32: Photo Sekino Masaru, Tokyo. 8.34: Canali.

9.1: Saskia Ltd. Cultural Documentation. 9.2: Leonard von Matt/Photo Researchers. 9.3: Photo Costa, Cairo. 9.4: Nimatallah/Art Resource. 9.5: Photo Robert L. Brown. 9.6: Robert Harding Picture Library. 9.7: Photo John C. Huntington. 9.9: Jewish Museum NYC/Art Resource, New York. 9.10: Erich Lessing/Art Resource, New York. 9.12: Scala/Art Resource. 9.13: National Museum of Anthropology, Mexico City. 9.14: Photo © 2001 Metropolitan Museum of Art, New York. 9.15: Resink Collection. 9.16, 9.20: Hans Hinz. 9.17, 9.18: American Museum of Natural History, New York. 9.19: Photo Museum of Anthropology at the University of British Columbia, Vancouver. 9.21: Photo Jorge Durand. 9.22: © Justin Kerr. 9.23: Scala/Art Resource, New York. 9.24: Henri Stierlin. 9.27: Photo Museum of Northern Arizona, Flagstaff. 9.28: Photo Otto Nelson. 9.30, 9.31: Photo Vatican Museums.

10.1: Photo Erwin Bohm. 10.2: Kyodo News International. 10.3: Photo courtesy Wheelwright Museum of the American Indian, Santa Fe. 10.6: Pubbli Aer Foto. 10.7: Henri Stierlin. 10.9: Cultural Relics Publishing House, Beijing. 10.10: Ralph Lieberman. 10.11: David Austin/Tony Stone Images. 10.12: Photo V. Savik, Aurora Art Publications, St. Petersburg. 10.14: Studio Kontos. 10.14: DAI, Athens. 10.16: Ronald Sheridan Ancient Art and Architecture Library. 10.17, 10.18. 10.20: Henri Stierlin. 10.19: Photo courtesy Ester Pasztory. 10.21: Photo Mary Ellen Miller. 10.22: Photo Robert L. Brown. 10.23: Holle Bildarchiv. 10.25: Koneman GmbH/photo Achim Bednorz. 10.26: Angelo Hornak Library. 10.28: © Jian Chen/Stock Connection/Picturequest. 10.29: Photo Roger Wood. 10.30: Photo Wim Swaan.

11.1: Adapted from A. T. Mann, Sacred Architecture, 1993, p. 61. Used with permission of Element Inc., Rockport, Massachusetts. 11.2: Bill Gallery/Stock, Boston. 11.3, 11.21: Henri Stierlin. 11.4: Boltin Picture Library. 11.5, 11.6, 11.23: Photo © British Museum. 11.7: Mike Andrews/Ronald Sheridan Ancient Art and Architecture Library. 11.8: Hirmer Fotoarchiv. 11.9, 11.10: Cultural Relics Publishing House, Beijing. 11.11, 11.12, 11.13: Photo courtesy Fowler Museum, University of California at Los Angeles. 11.14, 11.15: Photo University Museum of

National Antiquities, Oslo, Norway. 11.16: Saskia Ltd. Cultural Documentation. 11.18 Madeline Grimoldi. 11.19: Scala/Art Resource, New York. 11.20: CORBIS. 11.22: (left) Dinodia, (right) Black Star. 11.25: Photo Howard Colvin. 11.28: Photo © Bob Schalkwijk. 11.30: © Sovfoto/Eastfoto/Picturequest. 11.31: © Frank Fournier/Contact Press Images/Picturequest. 11.32, 11.33: AP/Wide World.

12.3: Canali Photobank. 12.5: Bayerische Staatsbibliothek, Munich. 12.8: Photo © British Museum. 12.9: Photo National Museum of the American Indian, New York. 12.11: Kobal Collection. 12.12: Oriental Institute, Chicago. 12.13: Reconstruction by Charles Chipiez from The Art and Architecture of the Ancient Orient by Henry Frankfort, 1970, pp. 360-61. Used with permission of Yale University Press. 12.14: Photo Mary Ellen Miller. 12.15, 12.29: American Museum of Natural History, New York. 12.16: Picturequest. 12.17: China Photographic Publishing House, Beijing. 12.18: © Bettmann/CORBIS. 12.19: Scala/Art Resource, New York. 12.20: Photo C. T. Lawrence, Photographs of Nigeria, 1907-1923, Vol. 16, Foreign and Commonwealth Office, Library and Records Department, London. 12.21: Photo © The Art Institute of Chicago. All Rights Reserved. 12.22: Photo A. F. Kersting. 12.23, 12.24: From Whakairo Maori Tribal Art by David Simmons, 1985, pp. 38-39. Reprinted by permission of Oxford University Press, New York. 12.25: Musee de Paris, R.M.N. 12.26: Art Resource, New York. 12.27: Saskia Ltd. Cultural Documentation. 12.28: Alinari/Art Resource, New York.

13.1: Superstock. 13.2, 13.36: Scala/Art Resource, New York. 13.3: Photo Peabody Museum of Archaelogy and Ethnology, Harvard University 13.5: Collection of Chifeng Municipal Museum 13.6: Photo Denver Art Museum. 13.7: Cnca-Inah-Mex Templo Mayor, Mexico City. 13.8, 13.13: Kunsthistorisches Museum, Vienna. 13.9: Photo Cambridge Museum of Archeology and Anthropology, Cambridge, U.K. 13.10, 13.14, 13.35: Photo © The Detroit Institute of Arts. 13.11: Boltin Picture Library. 13.12, 13.26: Photo © British Museum. 13.15: American Museum of Natural History, New York. 13.16: © Michael Howell/Index Stock Imagery/Picturequest. 13.17: Courtesy Marilyn Bridges. 13.18: Courtesy Susan A. Niles. 13.19: Jurgen Liepe, Berlin. 13.20: Canali Photobank. 13.22: Library of Congress. 13.23: National Anthropological Archives, Smithsonian Institution, Washington, D.C. 13.24: Kobal Collection. 13.25: Institut Amatller d'Art Hispanic © Museo del Prado. 13.27: Photo Michael D. Coe. 13.28: Alinari/Art Resource, New York. 13.29: © Andre Jenny/Focus Group/Picturequest. 13.31: G. Nanja Nath/Black Star. 13.32: Photo Kenneth A. Kitchen, Woolton, Liverpool, U.K. 13.34: Robert Harding Picture Library.

14.1: Institut Amatller d'Art Hispanic © Museo del Prado. 14.3: Photo © 2000 The Museum of Modern Art, New York. Licensed by VAGA, New York. 14.4: VEB Verlag der Kunst, Dresden, 1964. 14.5: Photo © 2000 The Museum of Modern Art, New York. 14.7: Courtesy of the artist. 14.9: Louvre, Paris, photo R.M.N. 14.10: Library of Congress. 14.11: Photo copyright © 2001 Whitney Museum of American Art. 14.13: Freer Gallery of Art, Smithsonian Institution, Washington, D.C. 14.15: Photo © Ester Hernandez. 14.16: Photo Pedro Oswaldo Cruz, Galerie LeLong, New York. 14.17: Courtesy Sicardi Gallery. 14.21: Photo © 2001 Metropolitan Museum of Art, New York. 14.22: Photo supervised by Peter Brenner at L.A.C.M.A. 14.23: Photo Dirk Bakker.

14.24: Photo David Heald, courtesy Solomon R. Guggenheim Museum. 14.25: M. H. de Young Museum, Fine Arts Museums of San Francisco. 14.26: Photo courtesy of the artist.

15.3: Photo Christie's Images Inc. 15.5: Used with permission of the artist. 15.6: By permission of the artist, photo courtesy Acquvella Contemporary Art, New York. 15.9: Courtesy of the artist and Metro Pictures. 15.10: © Justin Kerr. 15.11: Robert Harding Picture Library. 15.12: Saskia Ltd. Cultural Documentation. 15.13: Photo © British Museum. 15.15: Ronald Sheridan Ancient Art and Architecture Library 15.16: Canali Photobank. 15.18: John Hillelson Agency. 15.19: Photo © 2000 The Museum of Modern Art, New York. 15.23: Courtesy Paula Cooper Gallery, New York. 15.24: Photo © 2001 Metropolitan Museum of Art, New York. 15.25: Photo Dominique Darbois. 15.27: Courtesy Galerie Le-Long, New York. 15.28: © Yoko Ono, courtesy of Lenono Photo Archive.

16.1: DAI, Rome. 16.2, 16.3: Photo Arthur G. Miller. 16.4: From Whakairo Maori Tribal Art by David Simmons, 1985, pp. 38-39. Reprinted by permission of Oxford University Press, New York. 16.5: Gift of John H. Hauberg, Seattle Art Museum. 16.6: Reprinted from Coast Indian Art: An Analysis of Form by Bill Holm, 1965, p. 32. Reprinted by permission of University of Washington Press. 16.7, 16.24: Photo © 2001 Metropolitan Museum of Art, New York. 16.8, 16.19: Photo John Pemberton III. 16.9, 16.15: Photo R.M.N. 16.10: Photo © 2000 The Museum of Modern Art, New York. 16.12: By permission of General Idea. 16.14: John P. Stevens, Ronald Sheridan Ancient Art and Architecture Library. 16.17: Institut Amatller d'Art Hispanic © Museo del Prado. 16.18: Photo Wallace Collection, London. 16.22: Photo © The Art Institute of Chicago. All Rights Reserved. 16.25: Copyright © The Dorothea Lange Collection, The Oakland Museum of California, City of Oakland. 16.29: © Bettmann/CORBIS.

17.2: Photo © 2000 The Museum of Modern Art, New York. 17.3: © Donna Mussenden VanDerZee. 17.4: Courtesy of the artist. 17.8: Courtesy of the artist and Holly Solomon Gallery, New York. 17.9: © Tseng Kwong Chi. 17.11, 17.12, 17.23: Photo R.M.N. 17.13 Courtesy of the artist and Susan Vielmetter Gallery, Los Angeles. 17.15: Photo © 2001 Metropolitan Museum of Art, New York. 17.16: Photo courtesy Robert Miller Gallery, New York. 17.18: Photo Donald Tuzin. 17.24: Scala/Art Resource. 17.26: Courtesy of the artist. 17.27: Photo Claude Berri, Paris. 17.28: Courtesy Guerrilla Girls.

18.1: DAI, Athens. 18.3: Art Resource, New York. 18.4: Photo Researchers. 18.5: © Bettmann/ CORBIS. 18.6: Reconstruction in the Museum of Roman Civilization, Rome. 18.7: © Underwood & Underwood/CORBIS. 18.8: Courtesy Japan National Tourist Organization. 18.10: © 1978 Harri Peccinotti. 18.11: © 2001 Joan Marcus. 18.12: Photo © 2000 The Museum of Modern Art, New York. 18.13: Merce Cunningham Dance Co. Photo Richard Routledge. Licensed by VAGA, New York. 18.14: © 2001 Allan Kaprow. Used by permission of The J. Paul Getty Museum, Los Angeles. 18.15: Photo University Museum, University of Pennsylvania, Philadelphia. 18.16: Photo Charles Uht, Museum of Primitive Art, New York. 18.17: Photo Bruce Wendt, Judson, North Dakota. Courtesy Makoche Recording Company. 18.18: The Hutchison Library, London. 18.19, 18.27: Photo © 2001 Metropolitan Museum of Art, New York. 18.20: Photo © British Museum.

18.22: Kobal Collection. 18.23: CBS/AP/Wide World 18.24: © Aardman Animations Ltd. 18.25: Fototeca Unione. 18.26: R. A. Staccioli. 18.28: © Justin Kerr. 18.29: Photo Constantino Reyes. 18.30: Scala/Art Resource, New York.

19.1, 19.2, 19.8: Photo © 2001 Metropolitan Museum of Art, New York. 19.4: Photo Pam Taylor. 19.5: Photo © British Museum. 19.10: © Ansel Adams Publishing Rights Trust/CORBIS. 19.15: © John Launois/Black Star/Picturequest. 19.16: National Anthropological Archives, Smithsonian Institution, Washington, D.C. 19.17: Courtesy James Cohan Gallery, New York. 19.18: Photo John Cliett, © Dia Art Foundation. 19.20: Courtesy the New York City Department of Sanitation. 19.24, 19.25: Photo © 2000 The Museum of Modern Art, New York. 19.27: Hood Museum of Art, courtesy of the Trustees of Dartmouth College. 19.29: Photo C. C. Wang. 19.32: Tate Gallery/Art Resource, New York. 19.33: © 2001 David Gahr. 19.34: Photo reproduction courtesy Nam June Paik and Holly Solomon Gallery, New York.

20.1: Bill Gallery/Stock, Boston. 20.3: Scala/Art Resource, New York. 20.4: Photo © The Art Institute of Chicago. All Rights Reserved. 20.8: Hans Hinz. 20.9: AP/Wide World. 20.10: National Anthropological Archives, Smithsonian Institution, Washington, D.C. 20.11: Photo Vatican Museums. 20.12 Photo Christie's Images Inc. 20.13: Photo supervised by Peter Brenner at L.A.C.M.A. 20.17: Studio Kontos. 20.18: Photo courtesy Wheelwright Museum of the American Indian, Santa Fe. 20.20, 20.23: Photo © British Museum. 20.21: © Jian Chen/Stock Connection/Picturequest. 20.22: Alinari/Art Resource, New York. 20.24: (left) Dinodia, (right) Black Star. 20.25: From Whakairo Maori Tribal Art by David Simmons, 1985, pp. 38-39. Reprinted by permission of Oxford University Press, New York. 20.27: M. H. de Young Museum, Fine Arts Museums of San Francisco.

21.1: Fototeca Unione. 21.2: Photo William Rea. 21.3: Photo John Pemberton III. 21.4: Alinari/Art Resource. 21.5: Photo Jorge Durand. 21.6: Photo C. T. Lawrence, Photographs of Nigeria, 1907-1923, Vol. 16, Foreign and Commonwealth Office, Library and Records Department, London. 21.8: Studio Kontos. 21.9: Alinari/Art Resource, New York. 21.10: Scala/ Art Resource, New York. 21.11, 21.12, 21.27: Photo © British Museum. 21.13: Photo courtesy of the Pasadena Tournament of Roses. 21.15: CORBIS. 21.16: © Bettmann/CORBIS. 21.17: Cultural Relics Publishing House, Beijing. 21.18: Complete simulation of the Media Museum by Armen Oulikhanian (© ZKM). 21.19: © Robert Holmes/CORBIS. 21.20: Photo Hans Hinz. 21.21: AP/Wide World. 21.23: Kobal Collection. 21.24: (top) AP/Wide World (bottom) Alinari/Art Resource, New York. 21.25: Kyodo News International. 21.26: Bibliotheque de l'Assemble national française, Paris. 21.28: Photo © 2001 Metropolitan Museum of Art,

22.1: © Bettmann/CORBIS. 22.3: Photo courtesy Fowler Museum, University of California at Los Angeles. 22.4: Photo A. F. Kersting. 22.5: Photo © Bob Schalkwijk. 22.6: Ian Lambot, courtesy Pei Cobb Freed & Partners. 22.7: © Don Carl Steffen/Photo Researchers. 22.8: Angelo Hornak Library. 22.9: © Bettmann/CORBIS. 22.10: Photo © British Museum. 22.11: Photo National Museum of Natural History, Smithsonian Institution, Washington, D.C. 22.12: ESTO © Ezra Stoller. 22.13: Chicago Historical Society/photo Hedrich-Blessing HB-1932-E.

Italic page numbers refer to art reproductions and illustrations.

Abakanowicz, Magdalena, Backs, 41, 42, 43, 390-391, 391 Abbas, Shah, 273, 558 Abduction of the Daughters of Leucippus (Rubens), 467-468, 468, 541-542, 542 Aboriginal Memorial (Dhatangu), 22, 22, 28-29, 387, 387 Aboriginal people of Australia Aboriginal Memorial (Dhatangu), 22, 22, 28-29, 387, 387 Dingoes; Dingo Proof Fence (Onus), 387-388, 387 food and art. 134-135 Hunter and Kangaroo, 524, 524 Witchetty Grub Dreaming (Aboriginal painting), 20, 20, 21, 29, 39, 46, 134-135, 135 Abstract art, 525-526 Abstract Expressionism, 77-78, 81-83, 114, 377 Abstracted nature of volume, 31 Abstracted sexual imagery, 464-465 Abstracted style, 94-95 Abstracted texture, 29 Accents, 42 Accumulation No. 1 (Kusama), 389-390, 390, 545-546, 546, 555, 559

Achaemenids, 323-325 Achromatic value scale, 22-23, 25

Acrobat (Tlatilco), 500-501, 501 Acropolis, 254-255, 256, 549, 549, 555, 560, 580, 581 Acrylic paint, 46 Actual lines, 19, 20

Adam and Eve, 171-172, 242, 242, 545, 545, 555 Adams, Ansel, Clearing Winter

Storm, Yosemite National Park, California, 513, 514

Adams, Eddie, Brigadier General Nguyen Ngoc Loan summarily executing the suspected leader of a Vietcong commando unit, 307-308, 307

Additive color system, 24, 26 Advertising, 571-572 Aegean civilizations, 104, 162-164 Aerial perspective, 23, 32 Aesthetics, 7, 64-70, 589 Africa. See also specific countries and cultures

body painting, 419, 419 culture and art, 110-111 male ancestor figure, 94, 95, 409-410, 410, 418, 550, 550,

557-558, 559 masks, 99, 236, 247, 485-486

museums, 576 places of worship, 248 Africa. See also specific countries and cultures—Cont. portrait heads, 315-316, 317 religions, 235-237 reliquaries, 301-302

saltcellar, 141-142, 144 storage container for liquids from, 140, 142 workshops, 541

African Americans art criticizing racism against, 456-457 Harlem Renaissance, 382,

459-453 photography of, 452-454

Agesander, Laocoon and His Sons, 410-411, 411

Agora, 187 Agriculture. See Farming Aguilar, Laura, In Sandy's Room (Self-Portrait), 462-463,

Ahola Kachina (Kewanwytewa), 237-238, 238

AIDS Memorial Quilt, 308, 308, 543-544, 544

Air pollution, 580-581 Ak'ua Mma dolls (Ashanti), 6-7, 6, 13, 14, 169-170, 170,

571-572, 571, 596, 600 Alexander and Darius at the Battle of Isus, 357, 357

Alexander the Great, 220, 323 Alien, 506

Altar of Heaven (China), 269, 270,

270 Alternating rhythm, 40 Ambient light, 23

Amplified perspective, 33 Analogous colors, 25 Anasazi, 183-184

Anatolia. See Çatal Hüyük Anatomical drawing, 47, 522-523, 523

Ancestors, 425-427 Ancient China. See China Ancient Egypt. See Egypt

Ancient Greece. See Greece Ancient Near East culture and art, 103

Hammurabi Stele, 336-337, 337 Lamassu, 337-338, 337

Angels, 225, 226 Animal Locomotion (Muybridge), 414, 420

Animals, 505-511. See also specific animals, such as Bull

imagery Animation, 497

Anthropological Museum at University of Ibadan, 576,

Anthropology, 590 Antin, Eleanor, Carving: A Traditional Sculpture, 419-420, 419

Antoni, Janine, Chocolate Gnaw, 10-11, 11, 159, 159

Apartheid in South Africa, 83, 84, 393-394, 394

Apartments, 188 Apprentice method, 539-540 Apricot Blossoms (Ma Yuan), 9, 9, 514, 515, 516 Ara Pacis Augustae, 369-370, 371 Arbol de la Vida (Mendieta), 420,

Arcades, 57, 58 Arch of Titus, 338, 338, 339 Archeology, 589-590 Arches, 57, 58

421

Architecture. See also Shelter; and specific buildings aesthetic design decisions, 64-70 arches, vaulting and domes,

57-59, *58* commercial architecture, 197-202

definition of, 51 domestic architecture, 181-197 engagement of all senses in, 67-68

English Perpendicular style, 297 food imagery on buildings, 146-147

gender issues, 470-471 group living, 181-186 homes, 186-197

improvisation and spontaneity in, 67

of indigenous people, 73 International Style, 61, 114, 201 landscape architecture, 70-71 load-bearing construction, 51-52 meaning in, 75-92

natural environment and, 70-73 organizing principles, 68-69 ornamentation, 69-70

post-and-lintel system, 52-53, 53, 255 public architecture, 202-209

recent methods and materials, 59-64 reinforced concrete, 61-63, 65,

66 steel frame construction, 60-61, 63, 64

structural systems, 51-64 traditional building methods, 51-59

truss and geodesic construction, 64 visual elements, 64-68

of war, 352-353 wood frame construction, 53-57,

106 Ark of the Covenant, 251, 251 Armor of Archduke Charles, 347-348, 348, 369

Arneson, Robert, Portrait of George, 392-393, *393*, 560-561, *561*

Art. See also Artists academic disciplines on, 587-590

as aesthetic, civilizing or educational, 564, 566 Art. See also Artists-Cont. aesthetics and, 7

artistic expression and creativity, 10-11, 538, 554-555 artist's response to world, 8-9

categories of visual arts, 11-17 as commerce, 571-572 community locations for,

593-596

composition principles, 39-44 content of, 6-7, 77-86 creation of, 7-11

definition of, 5-7, 11-12 destruction of, 583, 585-587 enjoyment of, 599, 601-603

in everyday life, 596-598 formal elements of, 19-39

function of, 5-6 high art, 13

keeping art, 564-583 kitsch, 14-16

materials for, 44-45 meaning in, 75-92

media for, 44, 46-48 as mimetic, 89

as performative, 89, 90 politicized uses of, 392-395,

567-571 popular culture, 13-14, 598-599 production of, as social activity,

537-538 using art, 564-565

visual form of, 6 visual perception and, 8, 23, 26 Art academies, 540

Art collections, 572-579, 602-603 Art collectors, 559-560, 573,

602-603

Art criticism, 81-86, 91, 589. See also Meaning in art and architecture

Art galleries, 571, 593, 595, 603 Art history, 587-589, 596, 599 Art maintenance, 579-583

Art materials body as, 418-422 definition of, 44 found objects, 45

natural materials, 44-45 synthetic materials, 45 Art media

color properties in various media, 25-26, 27

definition of, 44 painting, 46-47 printmaking, 47 sculpture, 47-48

style and, 93 technology-based media, 48 Art museums, 482, 482, 573, 575,

576, 591, 593, 602-603. See also Museums Art schools, 540, 602

Art tools, body as, 422-423 Art writings, 80-86, 90-91 Artichoke Halved (Weston), 150,

Artiface Piece (Luna), 457-458, 457

625

Artificial light, 22 Artistic expression and creativity, 10-11, 538, 554-555 Artists. See also Art; and specific artists art collectors and, 559-560, 573 art making based on gender, 548-550 art production as social activity, 537-538 collaborations, 546-548 community art making, 542-544 context for art making, 541-548 creative genius, 554-555 creativity and, 10-11, 538, 554-555 family support, 556-557 fine art market, 558-559 hiring out the making of art, 544-545 market for artworks, 558-560 as object makers, 545-546 ordinary people's support for, 557-558	Australia. See also Aboriginal people of Australia culture and art, 112, 247 Sydney Opera House, 480-482, 481 200th anniversary of Cook's "discovery" of, 386-387 Aztecs Calendar Stone, 240, 240 Eagle Warrior, 48, 347, 347 Knife, 350-351, 351, 568-569, 570 Marriage Couple, 172-173, 174 Moctezuma's Headdress, 368, 369 primordial and human couples, 172-173, 173, 174, 586, 586 Sahagún's book on, 586 warriors, 346-347 B Ba and ka, 278-279 Babur, Prince, 32, 35, 517-518, 517, 556, 557, 558 Babur Supervising the Layout of the Garden of Fidelity, 32, 35, 517-518, 517, 556, 557
priest artist, 553-554	Baby Makes 3 (General Idea), 435,
religious support for, 558 role of, in various cultures, 548-556	436 Backs (Abakanowicz), 41, 42, 43, 390-391, 391
rulers as, 555-556	Balance
rulers as patrons of, 558	in architecture, 68
scientist artist, 551-553	asymmetrical balance, 39
self-taught artists, 541	definition of, 39
as skilled workers, 550	in performance art, 39-40
studios of, 602	radial balance, 39
support for art making, 556-561	symmetrical balance, 39
tax-supported art, 560-561, 594	Baldacchino (Bernini), 295, 296,
tourist market, 559, 562, 562	297
training of, 538-541	Bali, 228, 230, 543
university support for, 558	Ball courts, 499-500, 499
Web sites, 595	Ball Head Club (Sioux), 351, 352
workshops, 541-542	Ball Players (Mayan), 500, 500
Arts and crafts fairs, 603	Bamana peoples
Asente. See Ashanti	Chi Wara Dance Headdress,
Ashanti	135-136, <i>135</i> , 247
Ak'ua Mma dolls, 6-7, 6, 13, 14,	Female Figure, 166, 167
169-170, <i>170</i> , 571-572, <i>571</i> ,	Bamgboye of Odo Owa, Orangun,
596, 600	431-433, 432, 564, 565, 566,
Royal Stool, 319, 320, 321	567
Ashlars, 183-184	Bandele, 554
Ashurbanipal Hunting Lions,	Bank of China (Pei), 64, 68, 68,
509-510, <i>510</i>	76-77, 77, 201, 201, 594,
Asmat Bisj Poles, 430, 431, 587, 588	598
Asmat Hand Drum, 491, 491	Baroque period, 110-111
Assemblages, 47	Barrel vaults, 57-58, 58
Assurnasirpal II, 337	Barry, Charles, 333-335, <i>334</i>
Assyrian Empire, 337-338, 509-510	Base of column, 53, <i>55</i> Basilica Nova, 203-204, <i>203</i> , <i>204</i>
Asymmetrical balance, 39	Basilica of Constantine and
Athena 954 955 566 571	Maxentius, 203-204, 203,
Athena, 254, 255, 566, 571	204, 206, 207-208
Athenodorus, <i>Laocoön and His</i> Sons, 410-411, 411	Basket weaving, 139-140
Athens. See Greece	Baths of Caracalla, 483, 483, 573
Atmospheric/aerial perspective,	Battle Axe, 351, 352
23, 32	Battle of Little Big Horn (Red
Atomic bombing, 377-378	Horse), 359, 359
Atrium, 187-188, 188	Battleship Potemkin, 360-361, 360
Auction houses, 559, 571	Baule people, Male Figure
Audubon, John James	(Ancestor), 94, 95, 409-410,
Birds of America, 523-524, 523,	410, 418, 550, 550, 557-558
547-548, <i>548</i> , 553, 557, 558	559
Carolina Parroquet, 523-524, 523,	Baverische, Otto III Enthroned
547-548, 548	Receiving the Homage of Four

Augustus, Emperor, 369-370, 371

Aunt Jemima, 456-457, 456

```
Bearclaw Necklace, 44, 45, 321, 321
                             "Beauty and the Beast," 506
                            Beauty of food, 147-151
                             Bellelli Family (Degas), 433-434, 433
                             Beneath the Waves off Kanagawa
                                    (Hokusai), 447-448, 448
                             Benin art, 342, 344, 344
                             Bergson, Henri, 522
                             Bernini, Gianlorenzo
                               Baldacchino, 295, 296, 297
                               Ecstasy of St. Theresa, 226, 226
                             Beyond the Solitary Bamboo Grove
                                    (Sheng Maoye), 511, 512
                             Binder, 46
                             Biomorphic shapes, 31
                             Birds of America (Audubon),
                                    523-524, 523, 547-548, 548,
                                    553, 557, 558
                             Bisj Poles (Asmat), 430, 431, 587,
                                    588
                             Blind Man's Bluff (Bourgeois), 29,
                                    30, 31, 464-465, 465
                             Bluemel, Carl, 420
                             Boboli Gardens, 595
                             Boccioni, Umberto, Unique Forms
                                    of Continuity in Space, 36, 37,
                                    415-416, 416
                             Body. See also Erotic sexuality;
                                    Reproduction
                                as art material, 418-422
                                as art tool, 422-423
                                class status and body styles,
                                     437-438
                                depictions of, 399-418
                                female body and the gaze,
                                     460-464
                                idealized body, 407-410
                                less-than-perfect body, 410-414
                                limits of the self, 414-417
                                physical body, 407-414
                                portraits, 399-404
                                self-portraits, 404-407
                                sickness and death, 417-418
                              Bonilla, Miguel Antonio, Knot,
                                     394-395, 394
                              Borbonicus Codex, 172, 173, 586,
      33, 432, 564, 565, 566,
                                     586
                              Borromeo, Cardinal Federigo, 559
                              Bounty of food, 145-147, 148
                              Bourgeois, Louise, Blind Man's
                                     Bluff, 29, 30, 31, 464-465,
                                     465
                              Boy's Dress Armor of Archduke
                                     Charles, 347-348, 348, 369
                              Brackets, 54, 56, 69
                              Brady, Mathew B., Dead Confederate
                                     Soldier with Gun, 358-359,
                              Brahma, 218
                              Brancusi, Constantin, Torso of a
                                      Young Man, 166-168, 168
                              Brazil, 386
                              Breaking of the Vessels (Kiefer), 527,
                              Brigadier General Nguyen Ngoc Loan
                                      summarily executing the
                                      suspected leader of a Vietcong
                                      commando unit (Adams),
      118, 550, 550, 557-558,
                                      307-308, 307
                              British Museum, 190, 574-575, 574,
                                     578
                              Bronson, A. A., 435
     ving the Homage of Four
                              Bronze Helmet (Mongolia), 344, 346
Parts of the Empire, 42-43, 44,
                              Brooklyn Museum, 591
```

44, 316, 318, 318

Bruegel, Jan II, 539 Bruegel, Jan the Elder, 538-539, 542, 559 Little Bouquet in a Clay Jar, 93, 94, 516-517, 516, 538, 539, 545, Bruegel, Pieter the Elder, 538 Harvesters, 146, 148 Bruegel, Pieter the Younger, 538 Bryant, William Cullen, 483 Buddha, 218, 219, 220-221, 221, 252, 252 Buddhism beliefs, 105, 219, 221 in China, 106 Great Stupa, 219-220, 220 Guanyin, 221, 222 images of spiritual beings, 219-221, 221, 222 in India, 105 in Japan, 155, 175-176 Library of Long Xing Si, 206 mandalas, 78, 79, 238-239, 239 pilgrimage site, 252 Seated Buddha, 220-221, 221 tea ceremony, 155 temples, 269, 271-272 "ukiyo" or "floating world," 175-176, 447-448 Zen Buddhism, 148, 155, 518-519 Zen garden, 518-519 Bull imagery, 182-183, 490-491, 580, 580 Bull Jumping/Toreador Fresco, 501-502, 501 Bull Lodge, 348-349 Bunraku puppetry, 486, 486 Buon fresco, 46 Burden, Chris, 504 Burials. See Mortality and immortality; Tombs Burning of the Sanjo Palace, 357-358, 358 Burson, Nancy, Faces, 403, 403 Buttressing, 57, 58 Byzantine Empire, 108 Caesar's Palace, 572 Cage, John, 489 Calabashes, 142-143 Calacoayan Landbook, 574 Calendar Stone (Aztecs), 240, 240 Calligraphy, 213, 300, 351, 553-554, 554 Canaday, John, 80-81 Cantilevers, 55, 56, 57, 197 Capitol Building, U.S., 190, 568, 578, 594 Carolina Parroquet (Audubon), 523-524, *523*, 547-548, *548* Carson Pirie Scott building (Sullivan), 60, 64, 69-70, 72, 198-199, 198, 199, 597, 601 Cartoons, 497 Carving, 47 Carving: A Traditional Sculpture (Antin), 419-420, 419 Catacomb of Sts. Peter and Marcellinus, 294-295, 295 Catacombs, 294-295 Catal Hüyük architectural design of, 182, 182

Catal Hüvük—Cont. Female Fertility Figure, 162, 162 shrines, 182-183, 183 Cathedrals. See Churches and cathedrals; Places of worship; and specific cathedrals Cating, 48 Catlin, George, Chief Keokuk, 344, 345 Cave paintings at Lascaux, 133-134, 134, 247, 580, 580 Cemeteries and grave monuments. 291-294, 302-303 Censorship, 585-586, 591 Center for Art and Media Karlsruhe. 576, 578-579, 578 Central Park (New York City), 72, 483-484, 484, 595 Ceremonies. See Religious ceremonies Chaco Canyon, 183-184, 183 Chagall, Marc, Over Vitebsk, 452, Champollion, Jean François, 362 Chance as formal element of art, 36-38 Chao Yen, Eight Riders in Spring, 502-503, 502 Chapel of Henry VII, 297, 298 Chapel of St. Peter and Paul (Russia), 252-254, 253 Charles I, King of England, 558 Charles V, King of Spain, 348, 350, Chartres Cathedral, 59, 61, 64, 256, 268-269, 268, 270, 542-543, 543, 550, 557, 558, 595, 599 Chevreul, Eugène, 444 Chi Wara Dance Headdress (Bamana peoples), 135-136, 135 Chia Tao, 511 Chiaroscuro, 23 Chicago, Judy, 91 Dinner Party, 91, 155-156, 157 Chicken Cup (China), 140, 142 Chief Keokuk (Catlin), 344, 345 Child labor, 379-381 Childbirth, 177-178. See also Reproduction Children's art, 11, 12, 593, 594 China architecture, 53-57, 106, 191-193, 197 Bronze Helmet, 344, 346 brush painting, 148 Buddhist temples, 269, 271-272 Communist government, 382-383, 542, 550 culture and art, 105-106 dishes and utensils for serving food, 140-141, 142 emperors, 314, 327-328 Farm Scene, 528, 528 flower paintings, 514-516 footbinding and women, 472-473 Forbidden City, 328, 571, 595, Great Wall of China, 352-353, 354 Hall of Supreme Harmony, 55, 56, 328, 329, 330 Han Ceramic House Model, 191-192, 192

China—Cont. houses, 191-193 Imperial Throne in Hall of Supreme Harmony, 69, 70, 328, 330 Infantry General, 22, 23 landscape imagery, 511-512 Library of Long Xing Si, 206-207, 207, 209 Mausoleum of Mao Zedong, 306-307, 306 Museum of Qin Figures, 576, 577 palaces, 327-328 Roaming Beggars (Zhou Chen), 444-445 Shi Huangedi's funeral complex, 285-288, 576, 577, Spring Festival Along the River (Zhang Zeduan), 442-443, storage containers from Ancient China, 138-139 Three Horses and Four Grooms (Ren Renfa), 511, 511 Tienanmen Square massacre, 473 Waiting for Guests by Lamplight (Ma Lin), 438, 439 wood frame construction in, 53-57, 106 Chocolate Gnaw (Antoni), 10-11, 11, 159, 159 Christ. See Jesus Christianity. See also Jesus; Mary burials, 294-298 in Byzantine Empire, 108 churches and cathedrals, 22, 24, 59, 61, 64, 230, 252-254, 542-543, 550, 557, 558, 595, 599 Constantine the Great and, 203, 995 Day of the Dead, 304-305 human nature in Middle Ages, 411-412 iconoclasts, 585 illuminated manuscripts, 553 images of spiritual beings, 223-226 mother and child imagery, 179 offerings, 230-232 as official Roman religion, 203, 995 pilgrimage site, 269 retablos, 231-232, 564, 567 in Roman Empire, 108 sacrifices, 234-235 symbolism, 78 Chroma, 24 Chromatic value scale, 23, 25 Church of San Vitale, Ravenna, 314 Church of Santa Maria della Vittoria, 230 Churches and cathedrals, 22, 24, 59, 61, 64, 230, 252-254, 253, 254, 542-543, 550, 557, 558, 595, *599. See also* Places

of worship; and specific

Cire perdue (lost wax casting), 48

churches

Cincinnati Museum, 591

Citizen Kane, 436, 436, 548, 548 City (Léger), 528, 529 City parks, 483-485, 595 City plans, 190, 262-265 Civil War, 358-359, 358 Civilization, 97 ancestors, 425-427 art used in clan rituals, 430-433 definition of, 425 extended family, 425-433 history of, 427-430 nuclear family, 433-436 Class activities and life-styles, 438-446 art objects indicating class status, 446-449 class status and body styles, 437-438 definition of, 425, 437 poverty, 379-381, 444-446 ruling class, 438-442 working class, 442-444 Classic style, 95, 96 Classical housing, 186-191 Classical style, 95-96 Claymation, 497 Clearing Winter Storm, Yosemite National Park (Adams), 513, Cleopatra, 362 Close, Chuck, Fanny (Fingerpainting), 402-403, 402, 422 Close Shave, 497, 497 Coca-Cola, 87, 88, 385-386, 385 Coca Pod Shaped Coffin (Kwei), 152-153. 153 Codex Borbonicus, 172, 173, 586, 586 Coe, Sue, There Is No Escape, 136-137, 136 Coffers, 59 Collaborations, 546-548 Collage, 45 Collectors of art, 559-560, 573, 602-603 Colleoni Equestrian Monument (Verrocchio), 342, 343 Colonnade, 52, 53 Color additive color system, 24, 26 ambient light and, 23 analogous colors, 25 in architecture, 65-66 color wheel, 24-25, 27 complementary colors, 25, 27 cool colors, 28 hue, 23-24 intensity in, 24 local colors, 27 primary colors, 24, 25-26, 27 relativity of color perception, 26, 28 secondary colors, 24, 26, 27 shade of, 24 spectrum of, 23 subtractive color system, 24, 27 as symbolic, 28-29 tertiary colors, 24 value in, 24 in various media, 25-26, 27 warm colors, 28 Color wheel, 24-25, 27

Colosseum, 497-499, 498, 563, 563, 580 585 Columns, 52, 53, 55, 57 Commemorative art. See Mortality and immortality Commercial architecture, 197-202 Commercial uses of art, 571-572, 598-599 Community art making, 542-544 Community locations for art, 593-596 Complementary colors, 25, 27 Complete frame system, 54-57, 56 Composite Order, 53, 55 Composition balance, 39-40 definition of, 39 emphasis, 42-43 proportion, 41 rhythm, 40-41 scale, 41-42 unity, 43-44 variety, 43-44 Computer-based art. See Digital imaging Coney Island, 485 Confucius, 105, 314 Constable, John, 334 Haywain, 512, 513, 521 Constantine the Great, 203, 204, 295 Content in art and architecture art writings, 80-86, 90-91 definition of, 6-7, 77 feminist criticism, 86, 91 formalist criticism, 81-82 iconography, 78-80 ideological criticism, 82-83 personal interpretation, 86 psychoanalytic criticism, 85-86 structuralist-based criticism. 83-85 style and, 93 subject matter and, 77-78 subtexts, 77 Context in art and architecture, 87 Contour lines, 21 Cool colors, 28 Corinthian Order, 53, 55, 499 Cornaro chapel, 230 Cortés, Hernando, 350, 368, 568 Cosmos, 238-242 Cravo Neto, Mario, Voodoo Figure, 386-387, 386 Creation of Adam (Michelangelo), 242, 242, 545, 545, 555, 562, 562, 572 Creation of art. See also Artists artistic expression and creativity, 10-11, 538, 554-555 artist's response to world, 8-9 visual perception and, 8 Creative genius, 554-555 Creativity, 10-11, 538, 554-555 Crete. See Minoans Crimp, Douglas, 84-85 Criticism, 81-86, 91, 589. See also Meaning in art and architecture Critique of learning, 526-527 Critiques of artworks, 11 Cross vaults, 58-59, 58 Crowned Head of an Oni, 48, 315-316, 317

Egypt—Cont. Dogon people—Cont. Crucifixion (Grünewald), 224, 225 Dance, 35, 37, 38, 488, 489, Meeting House, 205-206, 205 491-494 Cubi XXVI (Smith), 31, 31, 33-34, Primordial Couple, 40, 41, Danzante Stele, 362-363, 364 528, 529 170-171, 171 Cubism, 32-33, 113-114 Daoism, 105, 106, 511-512 Domes, 58, 59, 62, 276, 551, 551 Darwin, Charles, 444 Cult houses, 465-466, 465, 466, Domestic architecture. See Shelter 549-550. 550 Daumier, Honoré, Third-Class Domitian, Emperor, 497, 499 Carriage, 445, 445 Cultural anthropology, 590 Doric Order, 53, 55, 255, 470, David, Jacques-Louis, Oath of the Cultural styles, 97-99 Horatii, 80-81, 81, 86, 190, Culture. See also specific groups Doryphoros (Polykleitos), 41, 43, 44, 469-470, 470 and countries Aegean civilizations and Ancient David (Michelangelo), 413, 413 94, 95, 408-409, 409 Drum, 491 Greece, 104, 162-164 Day of the Dead, 304-305 Drypoint, 47 De Heem, Jan Davidsz, Table of Africa, 110-111 Dürer, Albrecht, 566, 568-569 Ancient Egypt, 103-104 Deserts, 47, 149, 150 Dwan, Virginia, 560 Ancient Near East, 103 De Humani Corporis Fabrica Dymaxion house (Fuller), 199-200 (Vesalius), 522-523, 523 art as aesthetic, civilizing or De Maria, Walter, Lightning Field, educational, 564, 566 45, 45, 520, 521 artists' role in various cultures, Eagle Feather War Bonnet, 344-345, 548-556 Dead Confederate Soldier with Gun 347 (Brady), 358-359, 358 Australia, 112 Eagle Warrior (Aztec), 48, 347, 347 China, 105-106 Death, 417-418. See also Mortality and immortality Earth Mother, 214-215, 217 cultural styles, 97-99 Earthworks and site pieces, 47, Deconstruction, 83-85 definition of, 97 Etruscan art and culture, 107 Decoration, 30 114, 519-520 Easter Island Monumental Heads, Deep Contact (Hershman), 37-38, Europe and United States in 338-339, 339 39, 41, 463-464, 463, late eighteenth through 581-582, 582 Eastman, George, 495 nineteenth centuries, Definition of art, 5-7, 11-12 Eating, 153-159 119-113 Degas, Edgar, Bellelli Family, Eating Outdoors, 141, 143 Europe from Middle Ages to Eccentric rhythm, 41 433-434, 433 1780, 109-110 Echo Mask (Kwatkiutl), 97-98, 98, Deities. See Gods and goddesses India, 104-105 102, 229-230, 231 Delacroix, Eugène, Liberty Leading Indonesia, 111 the People, 379, 380 Echo of a Scream (Siqueiros), 9, 10, Islamic art, 108-109 11, 33, 36, 229, 231, 377, Japan, 109 DeMott, Barbara, 171 377 Desert Storm, 359 Mesoamerica and South Ecological concerns, 73, 520-521. Destruction of art, 583, 585-587 America, 106-107 See also Nature and natural Native North Americans, 107 Dewi Sri, 228, 228, 229 Dhatangu, Paddy, Aboriginal environment Neolithic culture, 102-103, 161, Ecstasy of St. Theresa (Bernini), 226, 162, 182-183, 248-250 Memorial, 22, 22, 28-29 226 Dia de Muertos (Rivera), 46, 305, Oceania, 111-112 Edison, Thomas, 495 Paleolithic culture, 102, 305, 594, 597 Dia Foundation, 520 Education 161-162, 182 aesthetics and criticism, 589 Diagonal lines, 20-21 reasons for keeping art, archeology, 589-590 Diagrams, 30 564-572 art history, 587-589, 596, 599 Digital imaging, 48, 463, 497, Rome and Roman Empire, of artists, 538-541, 602 581-582 107-108 Dingoes; Dingo Proof Fence (Onus), cultural anthropology, 590 styles of artists within their psychology and human cultures, 99-102 387-388, 387 development, 589, 590 styles of major cultures, 102-14 Dinner for Threshers (Wood), 146, studio classes in art, 599 148 timeline of, 116-123 Egg tempera, 47 Dinner Party (Chicago), 91, twentieth century, 114-115 world maps, 124-127 155-156, 157 Egypt air pollution, 581 Cunningham, Merce, 488, 489 Dinosaur Eating a Man Ancient Egypt, 103-104 (Lazzari-Dean), 11, 12, 602, Current (Riley), 524-525, 524 deities, 215-216, 216 Curved lines, 20-21 fertility figures, 165-166 Dionysian mysteries, 168-169, 169, Custer, George, 359 food in tomb paintings, 145 170, 477-478 Cut Piece (Ono), 420-421, 422, 587, Direction of lines, 20-21 hieroglyphics, 362 589 Horus Temple at Edfu, 52, 54, Dishes and utensils, 140-144, Cuvilles, François de, Hall of 256, 259-262, 260, 261 Mirrors, 470-471, 471 142-147 Menkaure and His Wife, 313-314, Cycladic Islands Disneyland, 458, 459, 485 Disneyland, California (Tseng Harp Player, 492-493, 493 Mortuary Temple of Hatshepsut, Idol from Amorgos, 163, 163 Kwong Chi), 458, 459 Divine rulers and royalty, 313-316 71, 71, 282-283, 283 CYMK primary colors, 26 Museum of Alexandria, 573 Divisionism, 101-102 Cypriot Female Figure, 163-164, 164 Musicians and Dancers, 493-494, Do Women Have to Be Naked Cyrus, 323 494 (Guerrilla Girls), 86, 86, Palette of King Narmer, 355-357, 473-474, 474 356 Dada, 114 Dogon people peace treaty, 367-368 architectural design for group Daggers. See Knives and daggers plundered art from, 362, living, 184-185, 184 Daguerre, Louis, 48

Granary Shutters, 137-138, 138

Kanaga Masked Dancers, 35, 37,

38, 492, 493

Daguerreotypes, 48

Dali, Salvador, Persistence of Memory,

85, 85, 525, 525

569-570, 574

Pyramids, 278-280, 279, 314,

537, 538, 554, 558, 571, 601

Rosetta Stone, 362, 363, 569-570, Seated Scribe, 438, 438 Temple of Ramses II, 437-438, 437 temples, 259-262, 437-438 tombs and mortuary temples, 280-283 Tutankhamen's Knife, 349-350, Egypto-Hittite Peace Treaty, 367-368, 367 Eiffel Tower, 198 Eight Riders in Spring (Chao Yen), 502-503, 502 Einstein, Albert, 489 Eisenhower, Dwight D., 497 Eisenstein, Sergei M., 360-361, 360 El Salvador, 394-395 Elegy to the Spanish Republic XXXIV (Motherwell), 377, 378 Elgin, Thomas Bruce, 574 Elgin Marbles, 574 Elizabeth, Queen, 481 Emperor Justinian and His Attendants, 314, 315, 316, 318 Emphasis, 42-43, 69 Empress Theodora and Her Attendants, 314-315 Encaustic paint, 46 English Perpendicular style, 297 Engraving, 47 Enjoyment of art, 599, 601-603 Enlightenment, 522, 573 Entablature of column, 53, 55 Entasis, 255 Entertainment animation, 497 bathhouses, 483 dance, 491-494 definition of, 477 digital imaging, 48, 463, 497, 581-582 film, 495-498 museums, 482, 571-579, 591, 593, 595 music, 490-495 opera houses, 479-482 parks, 483-485, 595 puppetry, 486-487 sport imagery in art, 500-503 sports arenas, 497-500 technology revolution in, 495-497 television, 496-497, 581 theater productions, 485-490 theaters, 446, 447, 477-479 visual arts within performing arts, 485-495 Epa mask/headdress, 431-433, 432, 563-566, 564, 565, 567 Equestrian Monument of Bartolomeo Colleoni (Verrocchio), 342, Erotic sexuality. See also Reproduction abstracted sexual imagery, 464-465 in digital imaging, 37-38, 39, 41, 463-464, *463*, 581-582, *582* female body and the gaze, 460-464

Hindu temple, 266, 267, 459

Erotic sexuality. See also Female Figure (Bamana peoples), Formal elements—Cont. Ghana Reproduction—Cont. 166, 167 value, 23 Ashanti Ak'ua Mma dolls, 6-7, obscenity versus, 591 Feminist criticism, 86, 91 volume, 31 13, 14, 169-170, 571-572, in performance art, 176-177, Fengshui, 271-272 Formalist criticism, 81-82 596, 600 Fenollosa, Ernest, 400 176 Fortress-Temple of Sacsahuaman, 353, Coca Pod Shaped Coffin (Kwei), sexual union, 175-177, 459-460 Fertility figures, 165-168 355 152-153, 153 Etching, 47 Fertility goddesses and gods, Found objects, 45 Royal Stool, 319, 320, 321 Ethnicity. See Race 41-42, 43, 161-165, 553 Fourth Plate of Muscles (Vesalius), Ghiberti, Lorenzo, Sacrifice of Isaac, Etruria, 107 Fertility rituals, 168-170 47, 522-523, 523 234-235, 234 Etruscans Fertility Statuettes (Egypt), 165-166, Fowling Scene (wall painting from Ghirlandaio, Domenico, 539 art and culture, 107 166 Giant Pithoi/Storage Jars (Minoans), tomb of Nebumun), tombs, 283-285 Fighting 'Temeraire' Tugged To Her 281-282, 282 137, 137 Europe Last Berth To Be Broken Up Fragg, William B., 170 Giovanni, Bertoldo di. 539 Baroque period, 110-111 (Turner), 528-529, 530 Fragonard, Jean-Honoré, Swing, Giovanni Arnolfini and His Bride cemeteries, 302, 303 Figure of a Deity, A'a Rurutu 439, 441, 441 (Van Evck), 173-174, 174 Enlightenment, 522, 573 (Austral Islands), 165, 165, Francis of Assisi, St., 412 Gislebertus, Last Judgment, food imagery in still lifes, 149 586, 587 Franco, Francisco, 361 411-412, 412 Gothic period, 109-110 Films, 36, 37, 48, 322-323, 324, "Fred Ott's Sneeze" (Edison), 495 Giuliani, Rudolph, 591 Impressionism, 101-102, 413-414, 414, 420, 436, 436, Free-standing sculpture, 47 Globe Theater, 478 112-113, 512 495-498, 548, 548, 581, 582, Frescoes, 46, 148, 168-169, 169. Glory of rulers. See Power, politics, landscape paintings, 512 170, 493-494, 493 and glory late eighteenth through Fine art market, 558-559 Freud, Lucian, Leigh under the Gnaw (Antoni), 10-11, 11, 159, 159 nineteenth centuries, Fine arts versus popular culture, Skylight, 404, 404 God Te Rongo and His Three Sons, 112-113 13-14 Freud, Sigmund, 85, 416 164-165, 164, 553, 553 Middle Ages, 109, 411-412, Fit for Active Service (Grosz), 375, Frieze, 255-258, 258, 306, 306 Goddard, Donald, 417 506-508, 540, 553, 554, 375 Fuller, Buckminster, 199-201 Goddess Hathor and the Overseer of 585 Flavian, Emperor, 497 Dymaxion house, 199-200 Seals, Psamtik, 216, 216 museums, 573 Flower arranging, 514 geodesic domes, 64, 200-201 Gods and goddesses Neoclassicism, 112 Flowers and gardens, 513-519, 556, U.S. Pavilion at World's Fair Buddhism, 219-221 Post-Impressionism, 102, 113 Expo 67, 64, 68, 69, ceremonies, 229-230 Realism, 112 Fluxus movement, 421 200-201, 200 Christianity, 223-226 Renaissance, 110, 207, 412-413, Function of art, 5-6 Flying buttresses, 57, 58 cosmos, 238-242 552, 554-555 Food Funerary art. See Mortality and Earth Mother, 214-215, 217 Rococo style, 110 art in industrial societies. immortality Egyptian deities, 215-216 Romanesque Period, 109 136-137 Funerary Barque of the Pharaoh fertility goddesses and gods, Romanticism, 112, 512, 555, art of hunters, gatherers, and Khufu, 280, 280 41-42, *43*, 161-165, 553 farmers, 133-136 Funerary Relief of a Circus Official, Greek gods, 217 tax-supported art, 560 beauty of, 147-151 293, 294 Hinduism, 217-219, 227-228 twentieth-century art, 113-114 bounty of, 145-147, 148 Futurism, 114, 159, 415 human response to, 228-238 Executions of May 3rd, 1808 (Goya), dishes and utensils for serving, images of spiritual beings, 373-374, 374 140-144, 142-147 213-228 Expressive/expressionist styles, 95 eating, 153-159 Gachet, Dr., 100, 100, 102, Judaism, 221-223 Expulsion from Paradise (Masaccio), glorification of, through art, 401-402, 401, 545, 545, 559 of Mesoamerican cultures, 171-172, 172 145-153 Galleries, 571, 593, 595, 603 226-227 Extended family, 425-433 in industrial societies, 136-137 Gambling casinos, 572 offerings, 230-232 Eye structure, 8 in nonindustrial societies, Gandhi, Mahatma, 366-367, 367 paradoxes and contradictions, 133-136 Gardens and flowers, 513-519, 556, 243 ritual meals, 153-156 557 prayers, 235-238 Faces (Burson), 403, 403 securing food supply and art, Gardenscape (Roman), 514, 515 sacrifices, 233-235 Fallingwater (Wright), 62, 65, 68, 133-137 Garnier, J. L. Charles, Opera House, for special purposes, 226-228 71, 196-197, 196, 597, 601 still lifes, 147-151 479-480, 480 Gods of the Modern World (Orozco), Family storage containers for, 138-140, Gaze, 458, 460-464 526-527, 526 ancestors, 425-427 139-142 Gender issues Goering, the Executioner extended family, 425-433 storage structures for, 137-138 in art, architecture, and fashion, (Heartfield), 375-376, 376 nuclear family, 433-436 as symbol of honor, 151-153 Goldsmith Cupids, 188, 188 as support for artists, 556-557 Forbidden City, 328, 571, 595, 602 art making based on gender, Golub, Leon, Mercenaries I, 95, 96, and training of artists, 538-539 Forentine Code, 586 548-550 378, 379 Family (Marisol), 39, 40, 45, 47, Forest Lawn (California), 302-303 critiquing gender roles, Gone with the Wind, 495-496, 495, 434-435, 434 Formal analysis, 75-77 472-475 582, 583 Fanny (Fingerpainting) (Close), Formal elements female body and the gaze, Gospel Book of Otto III, 316, 318, 318 402-403, 402, 422 chance/improvisation/ 460-464 Gothic cathedral, 59, 61, 64, Fantastic creatures, 506-509 spontaneity, 36-38, 67 feminist criticism, 86, 91 267-270, 542-543, 550, 557, Farm Is a Place to Grow (Schlesier), color, 23-29 perpetuation of gender roles, 558, 595, 599 11, 12, 593, 594 definition of, 19 465-467 Gothic period, 109-110 Farm Scene (China), 528, 528 engagement of all senses, 38-39, General Idea, Baby Makes 3, 435, Gothic Revival Style, 333-334 Farming, 135-136, 146, 148, 214, 67-68 Gothic style, 297 528 light, 22-23 Genius artist, 554-555 Gothic vaults, 59, 61 Fauvism, 113, 452 line, 19-22 Geodesic construction, 64, 67, 69, Gourds, 142-143 Feast Dish (James), 97-98, 98, 102, motion, 35-36 200-201 Government buildings, 333-336, 154-155, 155 pattern, 29-30 Geometric patterns, 29 594-595 Feast Ladle/Sheephorn Ladle, 144, shape, 30-31 Geometric shapes, 30-31 Government Bureau (Tooker), 389, space, 31-35 Geometry. See Symbolic geometry 389 Female Fertility Figure (Çatal texture, 29 Germany. See Nazi Germany Goya, Francisco, Executions of May Hüyük), 162, 162

Gesture lines, 21

3rd, 1808, 373-374, 374

time, 35-36

297, 551, 558, 567

Impulvium, 187, 188 Hine, Lewis, 379-381 Granary Shutters (Dogon people), Haacke, Hans, MetroMobiltan, 83, Leo, 48 Inches High, 8 Years Old, In Sandy's Room (Self-Portrait) 137-138, 138 (Aguilar), 462-463, 463 Picks Up Bobbins at 15 Cents Grande Jatte (Seurat), 101, 101, 84, 393-394, 394 Habitat (Safdie), 72-73, 72, a Day, 379-381, 380 Inca 102, 444, 444 Hippodamos, 186-187, 190 Fortress-Temple of Sacsahuaman, Grande Odalisque (Ingres), 460-461, 185-186, 185 353, 355 Hiring out the making of art, Haimon, Abbot, 543 461, 474 masonry, 353, 355 Hakone Open-Air Museum, 484-485, 544-545 Grave monuments and cemeteries, rulers, 318, 319 Hitler, Adolf, 322-323, 324 484 291-294, 302-303 Hall of Bulls, 580, 580 Hogarth, William, Marriage à la India Grave Stele of Hegeso, 292, 293, 293 Hall of Mirrors (Cuvilles), 470-471, art training, 540 Mode, 388-389, 388 Great Ball Court, 499-500, 499 Hokusai, Katsushika, Beneath the culture and art, 104-105 Great Beaded Crown of the dishes and utensils for serving Waves off Kanagawa, Hall of Mirrors (Versailles), 58, 59, Orangun-Ila (Yoruba), 447-448, 448 food, 141, 143 331, 331, 540, 540, 556 441-442, 441, 567, 569 Gandhi in, 366-367, 367 Great Pyramids, 278-280, 279, 314, Hall of Supreme Harmony (China), Holzer, Jenny, Untitled (Selected gardens, 32, 35, 517-518, 556, Writings), 34-35, 36, 55, 56, 328, 329, 330 537, 538, 554, 558, 571, 601 557 391-392, 392 Great Stupa, 219-220, 220 Hamatsu Great Winter Ceremony, Homage to New York (Tinguely), 37, Islam in, 109, 587 229, 230 Great Wall of China, 352-353, 354 38. 529-530, 530 Kandarya Mahadeva Temple, 254, Hamilton, Richard, Just What Is It Greece 257, 265-267, 272 Acropolis, 254-255, 256, 549, 549, That Makes Today's Homes So Homes. See Shelter Krishna and Radha in a Pavilion, Honor, food as symbol of, 555, 560, 580, 581 Different, So Appealing?, 416, 459-460, 460 air pollution, 581 151-153 Hammurabi Stele, 336-337, 337 Hoop Dance (Sioux), 491-492, 492 Taj Mahal, 297, 299-301, 299, Ancient Greece, 104 553-554, 554, 558 Han Ceramic House Model, 191-192, Hopi Kachinas, 237-238, 238 architecture, 53, 55, 186-187, 192 Horizon line, 32, 33 Yakshi, 47, 407-408, 408 255 Indonesia Horizontal lines, 20-21 Handspring, a flying pigeon deities, 162-163, 217 interfering (Muybridge), 36, Horsemen (Parthenon), 256-257, culture and art, 111 fantastic creatures, 506 258 houses, 193-195 37, 413-414, 414 fertility goddesses and gods, Horses, 511 Toba Batak House, 57, 73, 73, Hanson, Duane, Self-Portrait with 162-163 193-194, 193, 194 Model, 157, 158, 159 Horus Temple at Edfu, 52, 54, 256, idealized body in sculpture, 41, Infantry General, 22, 23, 285, 286, Harappan civilization, Torso, 407, 259-262, 260, 261 43, 44, 94, 95, 408-409, 409 Hospitals, 594 287 mathematical proportions and 407 Informative images, 522-525 philosophy, 258-259, Harlem Renaissance, 382, House of Parliament (England), 333-335, 334, 594, 596 Ingres, Jean-Auguste-Dominique, 408-409 452-453 Grande Odalisque, 460-461, House of the Vettii, 71, 187-188, 187, Harp Player, 492-493, 493 mausolea and grave 461, 474 Harvesters (Bruegel the Elder), 188 monuments, 292 Initiation Rites of Dionysos, 168-169, House posts, 31, 31, 39, 89-90, 89, Parthenon, 52, 53, 55, 68, 189, 146, 148 429-430, 429, 430 169, 170 254-259, 256, 258, 549, 566, Hatching, 21 Ink wash, 46 Household, Performance "Happening" 568, 569, 571, 572, 575, Hathor, 216, 216 (Kaprow), 36-37, 38, 39-40, Innermost Coffin of Tutankhamen, 578, 581, 582, 583 Havell, Robert, Jr., 547-548 41, 489-490, 489 281, 281 Priene houses and urban Hawaii Insertions into Ideological Circuits: dishes and serving utensils, Housing. See Shelter design, 186-187, 186 Huascar, 318, 319 Coca-Cola Project (Meireles), storage containers for liquids 143-44, 145 87, 88, 385-386, 385 Princess Ka'iulani, 321-322 Hue of color, 23-24 (hydria) from, 139, 140 royal objects, 318-319, 320 Hughes, Robert, 589 Installation Art, 34-35, 114 temples, 254-259 Insulae, 188 Haywain (Constable), 512, 513, Humanism, 554-555 theater, 477-478, 485 Hunter and Kangaroo, 524, 524 Intaglio, 47 Greek Hydria, Women at the Fountain 521 Hunters' and gatherers' art, Intensity in color, 24 Head from the Temple of Inscriptions House, 139, 140 (Mayans), 418-419, 418 133-136 Interior House Post (Shaughnessy), Green, Red and Blue (Rothko), 31, 31, 39, 89-90, 89, Head of a Roman Patrician, 426, 426 525-526, 526 429-430, 429, 430 Greenberg, Clement, 13, 81-82 Heartfield, John, Goering, the I Love Lucy, 496-497, 496, 581 Intermedia work, 34-35 Grey Line with Lavender and Yellow Executioner, 375-376, 376 International Style, 61, 114, 201 Heiji Monogatari, 357-358, 358 Iconoclasts, 585 (O'Keeffe), 90-91, 90, 464, Iconography, 78-80 Internet, 595-596 Heinz 57 Tomato Ketchup and Del Intra-Venus (Wilke), 417, 417 Groin vaults, 58-59, 58 Monte Freestone Peaches Icons, 108 Idealized body, 407-410 Intuited knowledge, 525-526 (Warhol), 47, 136, 136, 151, Gros Ventre Shield, 348-349, 350 Invented nature of volume, 31 599, 602 Ideological criticism, 82-83 Grosz, George, Fit for Active Service, Idol from Amorgos (Cycladic Invented texture, 29 Heraclitus, Scraps of a Meal, 29, 30, 375, 375 Ionic Order, 53, 55 Islands), 163, 163 Group living. See Shelter 147-48, *149* Hernandez, Ester, Sun Mad, 384, Igbo Tribe, Mbari shrine, 248, 248 Iraq-Kuwait war, 362 Grünewald, Matthias, Crucifixion, Iris Bouquet (Bruegel). See Little Iktinos, Parthenon, 52, 53, 55, 68, 224, 225 384 Hershman, Lynn, Deep Contact, 189, 254-259, 256, 258, 549, Bouquet in a Clay Jar Gu Mask, 485-486, 485 555, 566, 568, 569, 571, (Bruegel) 37-38, *39*, 41, 463-464, *463*, Guanyin, 221, 222 572, 575, 578, 581, 582, 583 Irregular shapes, 31 581-582, 582 Guernica (Picasso), 21, 21, 23, Illuminated manuscripts, 553 Ise Shrine, 245-247, 246 32-33, 99, 99, 361-362, 361 Hicks, Edward, Peaceable Kingdom, Islam Guerrilla Girls, Do Women Have to 9, 10, 10, 365-366, 366 Imhotep, 554 Battle Axe, 351, 352 Immortality. See Mortality and Hieratic scaling, 42 Be Naked, 86, 86, 473-474, calligraphy, 213, 300, 351, Hieroglyphics, 362 immortality 553-554, 554 Guggenheim Museum (Wright), 482, High art, 13-14 Impasto, 102 culture and art, 108-109, 213 Imperial Throne in Hall of Supreme 482, 573, 575, 576, 578, Hinduism gardens, 32, 35, 517-518, 556, beliefs, 105, 217-218, 265 Harmony, 69, 70, 328, 330 593, 593 deities, 213, 217-219, 227-228 Implied lines, 19-20 Guilbaut, Serge, 82 mausolea, 297, 299-301 Impressionism, 101-102, 112-113, mandalas, 78, 79, 238-239, 239, Guilds, 540 mosques, 29-30, 41, 272-276, 267 519 Gumby, 497

Improvisation, 36-38, 67

temples, 265-267, 459, 586

Guru people, 485-486

318

Kiva, 183

602

Isometric perspective, 32, 34 Knife (Aztec), 350-351, 351, Iwo Jima memorial, 364, 366 Ka and ba, 278-279 568-569, 570 Kabuki theater, 447, 478-479, 479, Knives and daggers, 349-351, 350, 486 *351*, 568-569, *570* Jahan, Shah, 299-301, 558 Kachinas, 237-238, 238 Knot (Bonilla), 394-395, 394 Jainism, 105, 367 Kahlo, Frida, 404, 405-406 Knowledge James, Charlie, Feast Dish, 97-98, Self-Portrait with Monkey, 405, 406 critique of learning, 526-527 98, 102, 154-155, 155 Self-Portrait with Thorn Necklace informative images, 522-525 Jane Avril (Toulouse-Lautrec), 7, 8, and Hummingbird, 31-32, 32 introduction to, 521-522 14, 47, 487-489, 487 Kahn, Louis, 202 intuited knowledge, 525-526 Japan Ka'iulani, Princess, 321-322, 322 scientific knowledge, 522-525 architecture, 57, 109, 197 Kalenberger Bauernfamilie (Wissel), Kollwitz, Käthe, Outbreak, 20, 20, atomic bombing, 377-378 454, 455 21, 23, 35, 374, 375 Burning of the Sanjo Palace, Kallikrates, Parthenon, 52, 53, 55, Komurasaki of the Tamaya Teahouse 357-358, *358* 68, 189, 254-259, 256, 258, (Utamaro), 447-448, 448, class status, 446-447 *549*, 555, 566, 568, *569*, 546, 547 culture and art, 109 571, 572, 575, 578, 581, Koons, Jeff, Made in Heaven, flower arranging, 514 582, 583 176-177, 176 gardens, 518-519 Kami, 245 Krishna, 218, 459-460 gender issues in early twentieth Kanaga Masked Dancers (Dogon Krishna and Radha in a Pavilion, century, 471-472 people), 35, 37, 38, 492, 459-460, 460 Hakone Open-Air Museum, Kruger, Barbara, Your Body Is a 484-485, *484* Battleground, 14, 14, 451, Kandarya Mahadeva Temple (India), landscape imagery, 511 254, 257, 265-267, 266, 267, 451, 572, 573 Main Shrine at Ise, 245-247, 246, 272 Kulka, Tomas, 14-15 579 583, 585 Kant, Immanuel, 522 Kundera, Milan, 14 Ningen Kokuho (Living Kaprow, Allan, Household, Kusama, Yayoi, 555, 558-559 National Treasures), 560 Performance "Happening", Accumulation No. 1, 389-390, 390, Leyster, Judith, Playing a Flute, puppetry, 486 36-37, 38, 39-40, 41, 545-546, 546, 555, 559 Shinto religion, 245-247 489-490, 489 Kuspit, Donald, 85-86 tax-supported art, 560 Keeping art Kuwait, 362 tea ceremony, 155 art collections, 572-579, Kwatkiutl people theater, 446, 447, 478-479 602-603 Echo Mask, 97-98, 98, 102, 229-230, 231 Uji Bridge, 447, 447 art maintenance, 579-583 ukiyo-e prints, 175-176, 447-448, art museums, 575 Interior House Post 471, 546-547 commercial uses of art, 571-572 (Shaughnessy), 31, 31, 39, Java, 228 cultures' reasons for, 564-572 89-90, 89, 429-430, 429, 430 Jefferson, Thomas, 189, 190-191 digital museums, 578 Transformation Mask, 229-230, Monticello, 190-191, 190, 595, media museums, 576, 578-579 231 museology, 579 Winter Ceremonies, 229-230, Jenney, Neil, Meltdown Morning, museum designs, 578-579 230, 231 520-521, 521, 528 museums and private Kwei, Kane, Coca Pod Shaped Coffin, Jesus, 213, 223-224, 507, 508, 517. collections, 573 152-153, 153 See also Christianity national museums, 573-575 Catacomb of Sts. Peter and plundered art during warfare, Marcellinus, 294, 295 362, 568-571, 574 La Grande Jatte (Seurat), 101, 101, Crucifixion (Grünewald), 224, politicized uses of art, 567-571 102, 444, 444 preservation, 579-582 Lamassu, 337-338, 337 Last Judgment (Gislebertus), regional museums, 576 Land, 511-521 411-412, 412 religious reasons for, 566-567 Landa, Diego de, 585-586 Last Supper (Leonardo da restoration, 582-583 Landscape architecture, 70-71 Vinci), 32, 34, 36, 153-154, technology and museums, 576, Landscape imagery, 511-513 154, 551, 552-553, 564, 566, 578 Lange, Dorothea, 446 583, 584 Kennedy International Airport, Migrant Mother, Nipomo, Madonna de Latte (Lorenzetti), California, 48, 75-77, 75, 179, 179 Kenya, Milk Storage Jar, 140, 142 87-88, 445-446, 446 Madonna of the Meadow Kewanwytewa, Jimmie, Ahola Laocoön and His Sons, 410-411, 411 (Raphael), 23, 24, 26-27, Kachina, 237-238, 238 Las Meninas (Velazquez), 439, 440 26, 224, 224 Keystone, 57 Lascaux cave paintings, 133-134, Jews, 452, 527, 570. See also Khafre, 278-280, 558 134, 247, 580, 580 Judaism; Nazi Germany Khan, Amanat, 553-554 Last Judgment (Gislebertus), Jones, Cleve, 543 Khufu, 278-280, 558 411-412, 412 Judaism. See also Jews Kidder Figure (Maya culture), 177, Last Supper (Leonardo da Vinci), Ark of the Covenant, 251, 251 177 32, 34, 36, 153-154, 154, images of spiritual beings, Kiefer, Anselm, Breaking of the 551, 552-553, 552, 564, 566, 221-223 583, 584 Vessels, 527, 527 sacrifices, 234 Kienholz, Edward, State Hospital, Laurentian Library (Michelangelo), Julius II, Pope, 240, 558 383-384, 384 207-209, 208, 209 Just What Is It That Makes Today's Kinetic sculpture, 47 Lawrence, Jacob, No. 36: During the Homes So Different, So Kitab-khana, 540 Truce Toussaint Is Deceived, Appealing? (Hamilton), 416, Kitchen Maid (Vermeer), 443-444, 381-382, 382 443 Lazzari-Dean, Julia Rose, Dinosaur Justinian, Emperor, 314, 315, 316, Kitsch, 14-16 Eating a Man, 11, 12, 602,

Le Brun, Charles, 329 Hall of Mirrors, 58, 59, 331, 331, Le Corbusier, Notre Dame du Haut, 22, 24, 252, 253 Le Nôtre, André, 329 Le Vau, Louis, 329 Leaf from an Album of Landscapes with Figures after Tang Poems (Sheng Maoye), 46 LeClerc, Charles, 381-382 Léger, Fernand, City, 528, 529 Leigh under the Skylight (Freud), 404, 404 L'Enfant, Pierre, 190 Lenin, Vladimir, 360 Leo, 48 Inches High, 8 Years Old (Hine), 379-381, 380 Leonardo da Vinci, 85, 412-413, 539, 551-553, 555 Last Supper, 32, 34, 36, 153-154, 154, 551, 552-553, 552, 556, 564, 583, 584 Mona Lisa, 551, 562, 579-580, Leonardo da Vinci's Last Supper (Moretti), 303, 304 494-495, 494 Liberation of Aunt Jemima (Saar), 456, 457 Liberty Leading the People (Delacroix), 379, 380 Libraries, 206-209, 540, 585-586 Library of Long Xing Si, 206-207, 207, 209 Licinius, 203 Lidded Bowl (Hawaii), 143-44, 145 Life and death. See Mortality and immortality Light. See also Value ambient light, 23 in architecture, 22, 24, 64-65 artificial light, 22 definition of, 22 natural light, 22 Lightning Field (De Maria), 45, 45, 520, 521 Lin, Maya Ying, Vietnam Veterans Memorial, 307-308, 307 Lincoln, Abraham, 358 Linear elements in architecture, 64 Linear perspective, 32, 33 actual lines, 19, 20 in architecture, 64 contour lines, 21 definition of, 19 direction of, 20-21 gesture lines, 21 hatching, 21 implied lines, 19-20 media and materials for, 22 outlines, 21 shape and, 21 in three dimensions, 21-22 tones and, 21 Lintels. See Post-and-lintel system Lion King, 486-487, 487 Lions, 509-510 Lithography, 47 Little Bouquet in a Clay Jar (Bruegel), 93, 94, 516-517, 516, 538, 539, 545, 559

Mexico. See also Aztecs; Meaning in art and Liu, Hung Marriage. See Primordial and Trademark, 472-473 human couples architecture—Cont. Mayans—Cont. Pyramid of the Sun, 96, 97, 257, Marriage à la Mode (Hogarth), formal analysis, 75-77 Trauma, 473, 473 262-263, 263, 264 Load-bearing construction, 51-52 388-389, *388* formalist criticism, 81-82 iconography, 78-80 Quetzalcóatl Temple, 262, 263, 264 Martyrs. See Saints and martyrs Local colors, 27 retablos, 231-232, 564, 567 ideological criticism, 82-83 Longmen Caves, 252, 252 Marx, Karl, 82 Mary, 224, 267, 269, 507, 517 Lorenzetti, Ambrogio, Madonna de personal interpretation, 86 Shield Jaguar and Lady Xoc, psychoanalytic criticism, 85-86 233-234, 233 Latte, 179, 179 Madonna de Latte (Lorenzetti), Lorenzetti, Pietro, 179 reading the content, 77-86 Temple of the Sun, 254 179, 179 temples, 262-265 structuralist-based criticism, Lost wax casting (cire perdue), 48 Madonna of the Meadow Louis XIV, King, 98-99, 328-329, 83-85 Tula Warrior Columns, 341-342 (Raphael), 23, 24, 26-27, 331-332, 540, 556, 558, 560 in study of art, 589 Vessel in the Form of a Monkey, 26, 224, 224 510-511 Retablo of Maria de la Luz Casillas subject matter, 77-78 L'Ouverture, Toussaint, 381-382 Mezhirich, Ukraine, 182 subtexts, 77 Louvre Museum, 574, 579-580, and Children, 231-232, 232, Michelangelo Buonarroti, 95, 564, 567 ways for encountering art, 87-90 Virgin of San Juan de los Lagos Media 412-413, 539, 555, 558 Lovemaking, 175-177, 459-460. See statue, 232 color properties in various Creation of Adam, 242, 242, 545, also Erotic sexuality media, 25-26, 27 545, 555, 562, 562, 572 Masaccio, Expulsion from Paradise, Lucifer (Pollock), 77-78, 81-82, David, 413, 413 422-423, 423 171-172, 172 definition of, 44 Masjid-i-Shah (Royal Mosque), painting, 46-47 Laurentian Library, 207-209, 208, Luna, James, Artiface Piece, printmaking, 47 209 29-30, 30, 41, 257, 273-276, 457-458, 457 274, 275, 297, 551, *551*, 558 sculpture, 47-48 Sistine Chapel Ceiling, 224-225, Luncheon of the Boating Party Mask (Zaire), 99, 99, 236, 236 240-242, 241, 242, 545, 545, style and, 93 (Renoir), 101, 101, 102, Mask of Hanuman (Thailand), 156-157, 158 technology-based media, 48, 555, 558 576, 578 Micronesia, 112 508-509, *509* Lyre, 490-491, 490 Middle Ages, 109, 411-412, Media museums, 576, 578-579, Africa, 99, 236, 247, 485-486 578 506-508, 540, 553, 554, 585 Medici family, 207-208, 542, 558 Middle East. See Islam Ma Lin, Waiting for Guests by Epa mask/headdress, 431-433, Mies van der Rohe, Ludwig, 201 Lamplight, 438, 439 432, 563-566, 564, 565, 567 Meeting places Migrant Mother, Nipomo, California Dogon meeting house, 205-206, Ma Yuan, Apricot Blossoms, 9, 9, Greek theater, 478, 485 (Lange), 48, 75-77, 75, 205 514, 515, 516 Kanaga Masked Dancers (Dogon examples of, 203-206 87-88, 445-446, 446 Made in Heaven (Koons), 176-177, people), 35, 37, 38, 492, Military. See War; Warriors Maori meeting houses, 79-80, 176 of Kwatkiutl, 97-98, 98, 102, 80, 87, 335-336, 335, 336, Military protests, 373-378 Mademoiselle, 14 229-230, 231 427-429, 428, 555-556 Milk, Harvey, 393 Madonna de Latte (Lorenzetti), Thailand, 508-509 Megatron (Paik), 14, 15, 48, Milk Storage Jar (Kenya), 140, 142 179, 179 531-532, *531* Millais, John Everett, Ophelia, 302, Madonna of the Meadow (Raphael), Mass, 31 304 23, 24, 26-27, 26, 224, 224 Meireles, Cildo, Insertions into Materials Mimetic art, 89 Madrid Codex, 574-575 body as, 418-422 Ideological Circuits: Coca-Cola definition of, 44 Project, 87, 88, 385-386, 385 Minimalism, 114 Main Shrine at Ise, 245-247, 246, 583, 585 found objects, 45 Meltdown Morning (Jenney) Minoans 520-521, *521*, 528 Bull Jumping/Toreador Fresco, Malagan carvings, 305-306, 306 natural materials, 44-45 501-502, *501* Mendieta, Ana, Arbol de la Vida, Male Figure (Ancestor) (Africa), 94, synthetic materials, 45 95, 409-410, 410, 418, 550, Mathematical proportions and 420, 421 food in art of, 145-146 Giant Pithoi/Storage Jars, 137, Greek philosophy, 258-259, Mendoza Codex, 172-173, 174 557-558, 559 Mali. See Bamana peoples; Dogon 408-409 Menec Alignment, 248-249, 249 137 Menkaure, 278-280, 313-314, 558 Missionaries, 585-587 Matisse, Henri, 559 people Menkaure and His Wife, Queen Mixtec people, 351 Mandala of Samvara, 78, 79, Mausolea. See Mortality and 238-239, 239 immortality Khamerernebty, 313-314, 313 Mnesicles, 555 Mercenaries I (Golub), 95, 96, 378, Mobil Corporation, 393-394 Mausoleum of Hadrian, 292 Mandalas, 78, 79, 238-239, 239, Mausoleum of Halicarnassus, 292 379 Mocha Jug (Wagenfeld), 144, 147 267 Mesoamerica. See also Aztecs: Mausoleum of Mao Zedong, 306-307, Moche Manet, Edward, Olympia, 461-462, Mayans; Mexico House Model, 52, 52, 69, 195, 195 306 462 culture and art, 106-107 Maxentius, 203 Peanut Necklace, 151, 152 Mannered/mannerist style, 95 gods and goddesses, 226-227 Pot Depicting a Woman Giving Maximilian I, 348 Mansart, Jules Hardouin, Hall of Birth, 177-178, 177 manuscripts, 574-575 Mirrors, 58, 59, 331, 331, Mayans Pottery Depicting Sexual 540 Ball Players, 500, 500 Spanish missionaries in, 585-586 Great Ball Court, 499-500, 499 temples, 262-265 Intercourse, 173, 173 Mao Zedong, 550 Royal Tombs, 288-289, 289, 290, Tula Warrior Columns, 341-342 mausoleum, 306-307, 306 Head from the Temple of Inscriptions, 418-419, 418 Mesquakie Bearclaw Necklace, 44, 45, 594, 595 Maori Moctezuma, 350, 368 meeting houses, 79-80, 80, 87, Landa's book on, 585-586 321, 321 Metaphors, 78 Moctezuma's Headdress, 368, 369 335-336, 335, 336, 427-429, Palace, 326-327 Modeling, 48 Pregnant Figure Kidder Figure, MetroMobiltan (Haacke), 83, 84, 428, 555-556 393-394, 394 Modern Art, 81-82, 85, 113-114 177, 177 tattooing, 415, 415, 418 Mexico. See also Aztecs; Mayans Modernism, 568 Relief, 327, 327 Maps, 124-127 Mohammed, 108, 272, 273 Marine Corps War Memorial Mbari shrine (Igbo Tribe), 248, 248 Acrobat, 500-501, 501 McGillivray, William, 547 air pollution, 581 Mohandas ("Mahatma") Gandhi, (Weldon), 364, 366 Danzante Stele, 362-363, 364 367, 367 Marisol, Family, 39, 40, 45, 47, Meals, 153-159. See also Food 434-435, 434 Day of the Dead, 304-305 Mona Lisa (Leonardo da Vinci), Meandering lines, 20 551, 562, 579-580, 579 Market for artworks, 558-560 Meaning in art and architecture murals on government buildings, 594 Monkeys, 510-511 Markets, 59, 60, 197-199, 202, art writings, 80-86, 90-91 Olmec Head, 400, 400 Monte Alban, 362-363, 364 207-208 context and, 87

Olmec Relief, 506

Pyramid of the Moon, 262

Monticello (Jefferson), 190-191,

190, 595, 598

Markets of Trajan, 59, 60, 197-198,

197, 202, 207-208

deconstruction, 83-85

feminist criticism, 86, 91

Muslims. See Islam

Monumental Heads (Easter Island), Muybridge, Eadweard, 495 Navajo sand painting, 31, 32, 45, 338-339, 339 Animal Locomotion, 414, 420 247, 247, 549, 549, 554, Monuments Handspring, a flying pigeon 587, 589 interfering, 36, 37, 413-414, government monuments, Nazca culture, Spider, 235, 235 336-339 414 Nazi Germany, 322-323, 324, peace monuments, 369-370 My Calling Card #1 (Piper), 458, 454-455, 527, 570, 585, 591 war monuments, 363-364 458 NEA. See National Endowment for Moore, Charles, Piazza d'Italia, the Arts (NEA) 64-68, 70, 201-202, 202 Near East. See Ancient Near East Nagasaki atomic bombing, 377-378 Moretti, Rosa Caselli, Leonardo da Nefertiti's Daughter Vinci's Last Supper, 303, 304 Names Project, 543-544 Merytaten/Devonia's Daughter Morgue (Hacked to Death II) Napoleon Bonaparte, 190, 362, (O'Grady), 454, 454 (Serrano), 417-418, 418 569-570, 574 Negative space, 34 Mortality and immortality Napoleon III, 479 Nelson, Admiral, 362 ancient burials, 277-280 Narmer, King, 355-357, 356 Neo-Classicism, 112, 189, 190-191, burial in places of worship, National Endowment for the Arts 294-301 (NEA), 560, 591 Neolithic art, 102-103, 161, 162, cemeteries and grave National glory, 567-568 182-183, 248-250 monuments, 291-294, National museums, 573-575 Nero, Emperor, 497-498 302-303 Native North Americans. See also New Guinea. See Papua New Chinese funeral complex of Shi Northwest Coast Native Guinea Huangedi, 285-288, 576, Americans New York Central Park, 72, 483-484, 577, 582 Artiface Piece (Luna), 457-458, 484, 595 Christian burials, 294-298 457 New Zealand. See Maori Egyptian tombs and mortuary basketry, 139-140, 141 Newgrange, 277-278, 278 temples, 280-283 Battle of Little Big Horn (Red Ngere Girl Prepared for a Festival, Etruscan tombs, 283-285 Horse), 359, 359 419, 419 furnished tombs, 280-291 Chief Keokuk (Catlin), 344, 345 Nigeria Islamic mausolea, 297, 299-301 fertility figures, 166, 167 Anthropological Museum at Gros Ventre Shield, 348-349, 350 memorial art and practices in University of Ibadan, 576, contemporary societies, Kachinas, 237-238, 238 304-308 Mesquakie Bearclaw Necklace, 44, Benin art, 342, 344, 344 Moche royal tombs, 288-289, 45, 321, 321 decorated gourds, 142 594, 595 Epa mask/headdress, 431-433, Mother and Nursing Child modern commemorative art, (Cahokia), 178-179, 179 432, 563-566, 564, 565, 302-308 Navajo sand painting, 31, 32, 45, 567 247, 549, *549*, 554, 587, *589* reliquaries, 301-302 Great Beaded Crown of the Viking ship bural, 289-291 overview of, 107 Orangun-Ila, 441-442, 441, Mortuary Temple of Hatshepsut, 71, Penn's Treaty with the Indians 567, *569* 71, 282-283, 283 (West), 368, 368 Palace at Oyo, 332, 332, 567, Mortuary temples, 71, 282-283 Presentation Pipe Tomahawk, 369, 568 Mosaic, 29, 30 370 Palace Sculpture at Ikere, 76-78, Moscone, George, 392-393, 393, Pueblo Bonito, Chaco Canyon, 76, 100, 100, 332-333, 333, 560-561, 561 183-184 541, 541, 558 Mosques, 29-30, 30, 41, 272-276, Serpent Mound, 519-520, 519 Yoruba storytelling, 430-433 Nightway: Whirling Logs, 31, 32, 45, 297, 551, 558, 567 serving dishes and utensils, 144, Mother and child, 23, 24, 26-27, 247, 247, 549, 549, 554 26, 178-179, 224 Sioux Ball Head Club, 351, 352 Ningen Kokuho (Living National Mother and Nursing Child Sioux Eagle Feather War Bonnet, Treasures), 560 (Cahokia), 178-179, 178 344-345, 347 No. 36: During the Truce Toussaint Is Motherwell, Robert, 526 Sioux Hoop Dance, 491-492 Deceived (Lawrence), Elegy to the Spanish Republic tipis, 195-196, 196, 597, 601 381-382, 382 XXXIV, 377, 378 Natural light, 22 Nochlin, Linda, 81, 86, 461 Motion, 35-36, 68 Natural materials, 44-45 Noh theater, 446, 478, 486 Mt. Auburn cemetery (Boston), Natural patterns, 29 Nonobjective style, 94 302 Naturalistic style, 93 Northwest Coast Native Americans Mount Rushmore, 568 Nature and natural environment art and culture of generally, 107 Mu Qi, Six Persimmons, 148, 149, animals, 505-511 Echo Mask, 97-98, 98, 102, 149 architecture and, 70-73 229-230, 231 earthworks and site pieces, 114, Mukarnas vaults, 274, 275 Feast Dish (James), 97-98, 98, Multipoint perspective, 32-33 519-520 102, 154-155, 155 Munch, Edvard, Scream, 416, 416 ecological concerns, 73, 520-521 Interior House Post Murray, Elizabeth, Sail Baby, 82, flowers and gardens, 513-519, (Shaughnessy), 31, 31, 39, 82, 435, 435 556, 557 89-90, 89, 429-430, 429, 430 Museology, 579 incorporation of, into potlatches, 154-155 Museum of Alexandria, 573 constructed environment, totem poles, 430 Museum of Qin Figures, 576, 577 71-73 Transformation Mask, 229, Museum stores, 602 land, 511-521 229-230, 231 Museums, 482, 571-579, 591, 593, Winter Ceremonies, 229-230, landscape architecture, 70-71 595, 602-603 landscape imagery, 511-513 230, 231 Music, 490-495 places of worship, 245-247 Notre Dame du Haut, 22, 24, 252, Musicians and Dancers, 493-494, Nauman, Bruce, Punch and Judy: 253 494 Kick in the Groin, Slap in the Nuclear family, 433-436

Face, 473, 474

Nudes. See Body

Oath of the Horatii (David), 80-81, 81, 86, 190, 469-470, 470 Oblique perspective, 32, 34 Obsessional Art, 390 Oceania culture and art, 111-112 fertility gods, 164-165 tattooing, 414-415, 415, 418 War Shields, 348, 349 Offering with Cili-Shaped Crown, 230, 232, 543, 544 Offerings to deities, 230-232 O'Grady, Lorraine Nefertiti's Daughter Merytaten/Devonia's Daughter, 454, 454 "Sisters," 453-454 Oil paint, 47 Okakura Tenshin, 400-401, 401 O'Keeffe, Georgia, 90-91 Grey Line with Lavender and Yellow, 90, 90, 464, 464 Olmec Head, 400, 400 Olmec Relief, 506, 506 Olmsted, Frederick Law, Central Park, 483-484, 484, 599 Olowe of Ise, 554, 558 Palace Sculpture at Ikere, 76-78, 76, 100, 100, 332-333, 333, 541, 541, 558 Olympia (Manet), 461-462, 462 Ometecuhitli-Omecihuatl, 172, 173, 586, 586 One-point perspective, 32, 33 Ono, Yoko, Cut Piece, 420-421, 422, 587, 589 Onus, Lin, Dingoes; Dingo Proof Fence, 387-388, 387 Op Art, 524-525 Opera House (Garnier), 479, 480 Opera houses, 479-482 Ophelia (Millais), 302, 304 Oppression affirming the values of the oppressed, 385-388 strategies for protesting, 379-384 Optical Art, 524-525 Orangun (Bamgboye of Odo Owa), 431-433, 432, 564, 565, 566, 567 Organic shapes, 31 Organizing principles in architecture balance, 68 emphasis, 69 proportion, 68 rhythm, 68 scale, 68-69 unity, 69 variety, 69 Ornamentation, 69-70 Orozco, José Clemente, Gods of the Modern World, 526-527, 526 Ottawa tribe, Presentation Pipe Tomahawk, 369, 370 Otto III Enthroned Receiving the Homage of Four Parts of the Empire (Baverische), 42-43, 44, 44, 316, 318, 318 Outbreak (Kollwitz), 20, 20, 21, 23, 35, 374, 375

Outlines, 21

Over Vitebsk (Chagall), 452, 453 Penn's Treaty with the Indians Physical body. See Body Polynesia—Cont. Piazza d'Italia (Moore), 64-69, 70, (West), 368, 368 Overlapping, 32 Percent for the Arts Programs, 201-202, 202 560, 594 Picasso, Pablo, 559 Pachacuti, King, 353 Père Lachaise Cemetery, 293, 302, Guernica, 21, 21, 23, 32-33, 99, 99, 361-362, 361 303 Pacific Islands calabashes, 142-43 Performance art Pico della Mirandola, Giovanni, malagan carvings, 305-306 balance in, 39-40 412 Pie Counter (Thiebaud), 28, 29, 29, Pacific Northwest. See Northwest definition of, 114, 489 Coast Native Americans erotic sexuality in, 176-177, 176 41, 151, 151 "Happenings," 489-490 Paik, Nam June, Megatron, 14, 15, Piers, 57 human body, 419-420 48, 531-532, 531 Pigments, 24, 46 non-object art, 587, 589 Pilgrimages, 251-252, 269 Painting, definitions on, 46-47 space in, 34-35 Piper, Adrian, My Calling Card #1, Painting from a Cult House at Slei, Performance arts, dance, 35, 37, 458, 458 466, 466, 549-550, 550 Pair of Lovers (Utamaro), 47, 38, 488, 489, 491-494 Places of worship Buddhist temple, 269, 271-272 175-176, 176 Performative art, 89, 90 Palace at Oyo (Yoruba), 332, 332, Performing arts burial in, 294-301 567, 568 music, 490-495 characteristics of, 245-254 Palace of Versailles, 58, 59, 328-329, opera houses, 479-482 churches and cathedrals, 22, 24, 59, 61, 64, 230, 252-254, 331-332, 331, 540, 540, 556, theaters and theater 253, 254, 295-297, 542-543, 560, 571, 595 productions, 446, 447, 477-479, 485-490 550, 557, 558, 595, 599 Palace Sculpture at Ikere (Olowe of as community sites for art, 595 Pericles, 255, 555, 560 Ise), 76-78, 76, 100, 100, 332-333, 333, 541, 541, 558 Peristyle, 187, 188 Egyptian temple, 259-262 Persepolis palace, 324-325, 325 Gothic cathedral, 59, 61, 64, Palaces, 323-333. See also headings beginning with Palace Persia 267-270, 542-543, 550, 557, Palenque Palace, 326-327, 326, 327 558, 595, 599 art training, 540 Greek temple, 254-259 Paleolithic art, 102, 161-162, 182 kitab-khana, 540 Palette of King Narmer, 355-357, 356 palace, 323-325, 325 Hindu temple, 265-267, 459 Persistence of Memory (Dali), 85, 85, housing for sacred objects, 251 Palladio, Andrea, 189-190, 202 Islamic mosque, 29-30, 41, Villa Rotonda, 189, 189, 190, 208 525, 525 272-276, 297, 551, 558, 567 Personal art collection, 602-603 Pantheon, 59, 61, 62, 250-251, 250 Mesoamerican temple, 262-265 Papua New Guinea Personal interpretation, 86 Asmat Hand Drum, 491, 491 Perspective natural sites, 245-247 amplified perspective, 33 pilgrimage destinations, tourist market for art, 559 251-252, 269 Waupanal (Sepik cult house), atmospheric/aerial perspective, 465-467, 549-550 23, 32 sheltering congregations, definition of, 32 252-254 Paris city plan, 190 horizon line and, 32, 33 Paris Codex, 575 sites of sacred ceremonies, Park, Nick, Close Shave, 497, 497 isometric perspective, 32, 34 247-248 Parks, 483-485, 595 linear perspective, 32, 33 symbolic geometry, 248-251, 266-267, 269 Parliament (England), 333-335, multipoint perspective, 32-33 synagogues, 223, 223 334, 594, 596 oblique perspective, 32, 34 Parthenon, 52, 53, 55, 68, 189, temples, 52, 54, 71, 254-276, one-point perspective, 32, 33 254-259, 256, 258, 549, 566, 282-283, 437-438, 482, three-point perspective, 32, 33 568, 569, 571, 572, 575, two-point perspective, 32, 33 582-583, 587 Planar space, 31-32 578, 581, 582, 583 vanishing point and, 32, 33 Partz, Felix, 435 Peru. See Moche; Nazca culture Plague with Warrior and Attendants Passion of Sacco and Vanzetti Pharaoh Crowned by the Goddesses (Benin culture), 342, 344, (Shahn), 381, 381 Nekhbet and Wadjet (Horus Playing a Flute (Leyster), 494-495, Patrons of artists, 558 Temple), 261, 262 Pattern Phidias, 555, 566 191 Plundered art during warfare, 362, in architecture, 67 Philip III, King of Spain, 558 as decoration, 30 Photography. See also specific 568-571, 574 photographers Poem of the Pillow, 175-176 definition of, 29 Pointillism, 101-102, 489 African Americans, 452-454 diagrams and, 30 geometric patterns, 29 child labor, 379-381 Politicized uses of art, 392-395, 567-571 natural patterns, 29 children's faces, 403 Peace. See also War Civil War, 358-359, 358 Politics. See Power, politics, and daguerreotypes, 48 glory art about, 365-367 peace offerings and peace definition of, 48 Pollock, Jackson, 416 monuments, 368-370 Eastman's contributions, 495 Lucifer, 77-78, 81-82, 422-423, treaties, 367-368 human body, 413-414 423 Japanese women after atomic Peace monuments, 369-370 Polydorus of Rhodes, Laocoön and bombing, 377-378, 378 His Sons, 410-411, 411 Peace treaties, 367-368 Peaceable Kingdom (Hicks), 9, 10, landscape imagery, 513-514 Polykleitos, Doryphoros, 41, 43, 44, 94, 95, 408-409, 409 10, 365-366, 366 migrant mother, 48, 75-77, Peanut Necklace (Moche), 151, 152 87-88, 445-446 Polykleitos the Younger, Theater at Epidauros, 478, 478, 485 Sherman's self-portraits, 84-85, Pei, I. M., 201 Bank of China, 64, 68, 68, 76-77, 404, 406-407 Polynesia 77, 201, 201, 594, 598 sickness and death, 417-418 culture and art, 112

Vietnam War, 307-308, 307

Voodoo figure, 386-387

Easter Island Monumental Heads,

338-339, 339

Pendentives, 58, 59

Penn, William, 365, 368, 368

fertility gods, 164-165, 553 Pomo tribe, Basket, 140, 141 Pompeii floor mosaic, 357, 357 House of the Vettii, 71, 187-188, 187, 188 Poor, 379-381, 444-446 Pop Art, 114 Popular culture, 13-14, 598-599 Porcelain Stem Cup (China), 140, 142 Portrait heads (Africa), 315-316, Portrait Heads from Tomb 6 (Zapotec), 426-427, 427, 428 Portrait of a Gentleman (Ter Borch), 468-469, 469 Portrait of Dr. Gachet (Van Gogh), 100, 100, 102, 401-402, 401, 545, 545, 559 Portrait of George (Arneson), 392-393, *393*, 560-561, *561* Portraits, 48-469, 399-404, 433-434, 438-439. See also Self-portraits Portraits of the Emperors (Yan Liben), 314, 315, 315 Poseidon, 217, 217 Post-and-lintel system, 52-53, 53, Post-Impressionism, 102, 113 Postmodernism, 82-86, 113, 114, 202 Potawatomi Male Figure, 166, 167 Potlatches, 154-155, 229 Poverty, 379-381, 444-446 Power Figure (Zaire), 236-237, 237 Power, politics, and glory contemporary political leaders, 321-323 divine rulers and royalty, 313-316 glory of rulers, 313-323 government buildings, 333-336 594-595 monuments, 336-339 national glory, 567-568 objects of royalty and prestig 316-321 palaces, 323-333 power of the state, 323-339 "Prairie Houses" (Wright), Prayers, 235-238 Pregnancy, 177. See also Reproduction Pregnant Figure Kidder Figu culture), 177, 177 Presentation Pipe Tomaha tribe), 369, 370 Preservation, 579-582 Priene, Greece, 186-1 Priest artist, 553-554 Primary colors, 24, 2 Primordial and hun 40, 41, 170-1 Primordial Couple (40, 41, 170 Primordial Male a Ometecuh 173, 586 Princess Ka'iula Printmaking,

Prisoners of war, 362-363 Private art collections, 573, 602-603 Procreation. See Reproduction Progressive rhythm, 41 Proportion, 41, 68 Protagoras, 408 Protest. See Social protest/affirmation Protest Art, 114 Psychoanalytic criticism, 85-86 Psychology and human development, 589, 590 Ptolemy V, King, 362 Puabi, Queen, 490 Public architecture, 202-209, 333-336, 594-595 Public art, 560-561, 594-595 Pueblo Bonito (Chaco Canyon), 183-184, 183 Pugin, August Welby Northmore, 333-335, 334 Punch and Judy: Kick in the Groin, Slap in the Face (Nauman), 473, 474 Puppetry, 486-487 Pyramid of the Moon (Mexico), 262 Pyramid of the Sun (Mexico), 96, 97, 257, 262, 262-263, 263, 264 Pyramids, 278-280, 279, 314, 537, 538, 554, 558, 571, 601 estioning the status quo, 388-395 dcóatl Temple (Mexico), 262, 263, 264 g racism, 456-458 ethnic history 452-455 also Race re (Maya uk Ottawa 5-26, 27 an couples, Dogon people), ad Female Force: 171,171 dicomecihually 72, 750 ni, 321,322, 322 Jefinitions on, 47

Relief sculpture, 47, 261-262, 266, 267, 327, 338, 339, 355-357. 509-510 Religion. See Gods and goddesses; Mortality and immortality; Places of worship; and specific religions Religious ceremonies, 229-230, 247-248 Religious support for artists, 558 Reliquaries, 301-302 Reliquary Guardian Figure, 301-302, Reliquary in Shape of Head, 301, 301 Rembrandt van Rijn, Self-Portrait, 404-405, 405 Ren Renfa, Three Horses and Four Grooms, 511, 511 Renaissance, 110, 207, 412-413, 552, 554-555 Renoir, Pierre-Auguste, Luncheon of the Boating Party, 101, 101, 102, 156-157, 158 Rent Collection Courtyard, 382-383, *383*, 542, *543*, 550 Reproduction. See also Erotic sexuality childbirth, 177-178 fertility figures, 165-168 fertility goddesses and gods, 41-42, 43, 161-165, 553 lovemaking, 175-177 mother and child imagery, 178-179 pregnancy, 177 primordial and human couples, 40, 41, 170-174 rituals and fertility, 168-170 Restoration, 582-583 Retablo of Maria de la Luz Casillas and Children, 231-232, 232, 564, 567 Retablos, 231-232, 232, 564, 567 Reviews of artworks, 11 Rhythm alternating rhythm, 40 in architecture, 68 definition of, 40 eccentric rhythm, 41 progressive rhythm, 41 regular rhythm, 40 Ribbed vaults, 58, 59, 61 Riefenstahl, Leni, 322-323, 324 Riley, Bridget, Current, 524-525, 524 Rituals art used in, 430-433, 587 clan rituals, 430-433, 587 fertility and, 168-170 neals, 153-156 ra, Diego, Dia de Muertos, 46, 305, 305, 594, 597 र Beggars (Zhou Chen), 4-445, 445 le, 110, 470 n, Watts Towers, 448, Order, 53, 55 29, 30 od, 109 189, 512, 555,

pire

25-426

recreational architecture, 483 Trajan's Column, 363-364, 365 Trajan's Market, 59, 60, 197-198, 197, 202, 207-208 war monuments, 363-364, 365 Rose Window, 269, 270, 599 Rosetta Stone, 362, 363, 569-570, Rothko, Mark, 91 Green, Red and Blue, 525-526, 526 Royal Audience Hall (Persepolis), 324-325, 325 Royal Kahili, 319, 320 Royal Stool (Ghana), 319, 320, 321 Royal Tombs (Moche), 288-289, 289, 290, 594, 595 Royalty. See Power, politics, and glory; Rulers Rubens, Peter Paul, 541-542, 558 Abduction of the Daughters of Leucippus, 467-468, 468, 541-542, 542 Rulers. See also Power, politics, and glory as artists, 555-556 contemporary political leaders, 321-323 divine rulers and royalty, 313-316 objects of royalty and prestige, 316-321 as patrons of artists, 558 Ruling class, 438-442 Russia Battleship Potemkin, 360-361, 360 Chapel of St. Peter and Paul, 252-254, 253 Jews in, 452 plundered art in, 570 shelter in Upper Paleolithic period, 182 Ryoan-ji Zen Garden of Contemplation, 518-519, 519 Jemima, 456, 457 ceremonies

Rome and Roman Empire—Cont.

Arch of Titus, 338, 338, 339

architecture, 53, 55, 106,

187-188, 197-198

Basilica of Constantine and

204, 206, 207-208

Colosseum, 497-499, 498, 563,

bathhouses, 483, 573

563, 580, 585

147-148, 149

gardens, 514, 515

187, 188

housing, 187-188

250

mausolea, 292, 293, 294

culture and art, 107-108

food imagery in art, 29, 30,

gods and goddesses, 214-215

House of the Vettii, 71, 187-188,

Pantheon, 59, 61, 62, 250-251,

catacombs, 294-295

Ara Pacis Augustae, 369-370, 371

Maxentius, 203-204, 203,

Saar, Betye, Liberation of Aunt Saarinen, Eero, 480 Sacco, Nicola, 381 Sacred ceremonies. See Religious Sacred geometry, 248-251, 266-267, 269 Sacrifice of Isac (Ghiberti), 234-235, 234 Sacrifices, 233-235 Sacsahuaman fortress-temple, 353, 355 Safdie, Moshe, Habitat, 72-73, 72, 185-186, 185 Sahagún, Bernardo de, 586 Sail Baby (Murray), 82, 82, 435, 435 Saints and martyrs, 225-226, 295, 301.585 St. Peter's Cathedral, 295-297, 296, 602 Saito, Ryoei, 559 Saltcellar, 141-142, 144 Sand painting (Navajo), 31, 32, 45, 247, 247, 549, 549, 554, 587, 589 Sarcophagus with Reclining Couple, 283, 284 Scale, 41-42, 68-69 Schlesier, Kimberly Dawn, Farm Is a Place to Grow, 11, 12, 593, 594 Schools, 593-594, 594. See also Education Scientific knowledge, 522-525, 551-553 Scraps of a Meal (Heraclitus), 29, 30, 147-48, 149 Scream (Munch), 416, 416 Screen printing, 47 Sculpture, 33-34, 47-48 Seated Buddha, 220-221, 221 Seated Scribe (Egypt), 438, 438 Secco fresco, 46 Secondary colors, 24, 26, 27 Self-Portrait (Rembrandt), 404-405, Self-Portrait with Model (Hanson), 157, 158, 159 Self-Portrait with Monkey (Kahlo), 405, 406 Self-Portrait with Thorn Necklace and Hummingbird (Kahlo), 31-32, 32 Self-portraits, 404-407, 462-463. See also Portraits Semiotics, 83 Sepik people, 465-467, 549-550, 550 Serpent Mound, 519-520, 519 Serrano, Andres, Morgue (Hacked to Death II), 417-418, 418 Set design, 489 Seurat, Georges, Sunday Afternoon on the Island of La Grande Jatte, 101, 101, 102, 444, 444 Sexuality. See Erotic sexuality; Reproduction Shade of color, 24 Shading, 23, 32 Shaft of column, 53, 55 Shahn, Ben, Passion of Sacco and Vanzetti, 381, 381 Shakespeare, William, 478 Shaman's Amulet, 508, 508 Shape in architecture, 67 biomorphic shapes, 31 definition of, 30

Shape—Cont.	Smirke, Sir Robert Sidney, British	Status quo	Style—Cont.
geometric shapes, 30-31	Museum, 574, 578	art vs. politics, 392-395	Japan, 109
irregular shapes, 31	Smith, David, <i>Cubi XXVI</i> , 31, <i>31</i> ,	questioning of, 388-395	of major cultures, 102-14
lines and, 21	33-34, 528, <i>529</i>	social environment, 388-392 Steel frame construction, 60-61,	mannered/mannerist style, 95 Mesoamerica and South
organic shapes, 31 regular shapes, 30-31	Smithson, Robert, Spiral Jetty, 520, 520, 544-545, 544, 560	63, 64	America, 106-107
Shaughnessy, Arthur, Interior House	Smithsonian Institutes' 150th	Stein, Gertrude, 559-560	Native North Americans, 107
Post, 31, 31, 39, 89-90, 89,	Anniversary Rose Parade	Stein, Leo, 559-560	naturalistic style, 93
429-430, 429, 430	Float, 16, 16, 572, 572	Steinbeck, John, 87	Neolithic culture, 102-103, 161,
Sheephorn Ladle/Feast Ladle, 144,	Smithsonian Museum, 16, 16,	Stele, 292, 293, 336-337, 362-363,	162, 182-183, 248-250
146 Shaltan Sasalas Anghitastuna	571-572, 572	364 Still lifes beauty of food in	nonobjective style, 94
Shelter. <i>See also</i> Architecture Classical housing, 186-191	Snake Goddess, 215, 215 Social environment, 388-392	Still lifes, beauty of food in, 147-151	Oceania, 111-112 Paleolithic culture, 102,
commercial architecture,	Social Mirror (Ukeles), 45, 46, 521,	Stolen art, 362, 568-571, 574	161-162, 182
197-202	522, 528	Stone Age mounds, 277-278, 278	Rome and Roman Empire,
domestic architecture, 181-197	Social protest/affirmation	Stonehenge, 103, 133, 249-250, 249	107-108
group living, 181-186	affirming the values of the	Storage containers, for food,	stylized style, 95
homes, 186-197	oppressed, 385-388	138-140, <i>139-142</i>	twentieth century, 114-115
libraries, 206-209 markets, 197-199	art versus politics, 392-395 fighting for the oppressed,	Storage structures for food, 137-138	Subject matter, 77-78 Subtexts, 77
meeting places, 203-206	379-388	Structural systems in architecture	Subtractive color system, 24, 27
modern U.S. homes, 196-197	protests against military action,	arches, vaulting and domes,	Suger, Abbot, 267
public architecture, 202-209	373-378	57-59, <i>58</i>	Sullivan, Louis, Carson Pirie Scott
traditional homes, 191-196	questioning the status quo,	load-bearing construction,	building, 60, 64, 69-70, 72,
in twentieth century, 185-186	388-395	51-52	198-199, 198, 199, 597, 601
Sheng Maoye	social environment, 388-392	post-and-lintel system, 52-53, <i>53</i> recent methods and materials,	Summerspace, 488, 489 Sun Mad (Hernandez), 384, 384
Beyond the Solitary Bamboo Grove, 511, 512	strategies for protesting oppression, 379-384	59-64	Sunday Afternoon on the Island of La
Leaf from an Album of Landscapes	Social Realism, 114	reinforced concrete, 61-63, 65,	Grande Jatte (Seurat), 101,
with Figures after Tang Poems,	Society Ladies (VanDerZee), 453,	66	101, 102, 444, 444
46	454	steel frame construction, 60-61,	Support, in painting, 46
Sherman, Cindy, 404, 406-407	Soldiers from Pit 1 (China), 285-288,	63, 64	Support for art making, 556-561
Untitled Film Still #35, 84-85, 84,	286 Salaman B. Cauggamhaim Musaum	traditional building methods, 51-59	Surrealism, 114, 377, 525 Survival issues. <i>See</i> Food;
406-407, 407 Shi Huangedi's funeral complex,	Solomon R. Guggenheim Museum (Wright), 482, 482, 573,	truss and geodesic construction,	Reproduction; Shelter
285-288, <i>286</i> , <i>287</i> , <i>576</i> , <i>577</i> ,	575, <i>576</i> , 578, 593, <i>593</i>	64	Sweet Briar College, 596
582	Sontag, Susan, 16	wood frame construction, 53-57,	Swing (Fragonard), 439, 441, 441
Shield Jaguar and Lady Xoc, 233-234,	South African apartheid, 83, 84,	106	Sydney Opera House (Utzon), 63, 66,
233	393-394, <i>394</i>	Structuralism, 83	480-482, 481
Shimomura Kanzan, Study for the Portrait of Okakura Tenshin,	South America, 106-107. See also Inca	Structuralist-based criticism, 83-85 Study for the Portrait of Okakura	Symbolic geometry, 248-251, 266-267, 269
400-401, 401	Space	Tenshin (Shimomura	Symbols, 78
Shinto religion, 245-247	in architecture, 67	Kanzan), 400-401, 401	Symmetrical balance, 39
Shiva, 218, 265-266	definitions of, 31	Stupa, 219-220, 220	Synagogue at Dura-Europos, 223,
Shiva Nataraja, the Lord of the Dance,	negative space, 34	Style	223
218-219, <i>218</i> Shunga print, 175-176	in performance art, installation,	abstracted style, 94-95 Aegean civilizations and Ancient	Synthetic materials, 45
Sickness and death, 417-418	and intermedia work, 34-35	Greece, 104, 162-164	T
Sierra Leone, Saltcellar, 141-142,	perspective and, 32-33	Africa, 110-111	T.W.A. Terminal, Kennedy
144	planar space, 31-32	Ancient Egypt, 103-104	International Airport, 4
Sight. See Visual perception	in sculpture, 33-34	Ancient Near East, 103	Table of Deserts (De Heem), 47
Simulated nature of volume, 31	in two-dimensional art, 31-33	of artists within their cultures,	150
Simulated texture, 29	Spanish Civil War, 361-362, 377	99-102 attributes of 93.97	Tactile texture, 29 Taj Mahal, 297, 299-301, 299
Singha protective figure, 194, 194 Sioux	Spectrum, 23 Sphinx, 506	attributes of, 93-97 Australia, 112	553-554, <i>554</i> , 558
Ball Head Club, 351, 352	Spider (Nazca culture), 235, 235	Byzantine Empire, 108	Taoism, 105, 106, 511-512
Eagle Feather War Bonnet,	Spiral Jetty (Smithson), 520, 520,	China, 105-106	Tattooing, 414-415, 415, 4
344-345, <i>347</i>	544-545, <i>544</i> , 560	classic style, 96	Tax-supported art, 560-56
Hoop Dance, 491-492, 492	Spoils of Jerusalem, 338, 339, 568,	classical style, 95-96	Taymor, 486-487
tipis, 195-196, 196, 597, 601	585 Spontagaity 36.38, 67	cultural styles, 97-99	Te Horo Marae Waiapu
Siqueiros, David Alfaro, Echo of a Scream, 9, 10, 11, 33, 36,	Spontaneity, 36-38, 67 Sport imagery in art, 500-503	definition of, 93 Etruscan art and culture, 107	House, 336, <i>336</i> Te Mana O Turanga (N
377, 377	Spring Festival Along the River	Europe and United States in	meeting house
"Sisters" (O'Grady), 453-454	(Zhang Zeduan), 442-443,	late eighteenth through	87, 335-336, <i>3</i>
Sistine Chapel Ceiling	442	nineteenth centuries,	428,556,556
(Michelangelo), 224-225,	Squinches, 59	112-113	Te Rongo, 164-165, 1
240-242, 241, 242, 545, 545,	Stained-glass windows, 268-269,	Europe from Middle Ages to	Tea Bowl (Japan), 1
555, 558 Site-Specific Works, 47, 114,	270 State. See Peace; Power, politics,	1780, 109-110 expressive/expressionist styles,	Tea ceremony, 157 Technology
519-520	and glory; Social	95	definitions on
Sitting Bull, 359	protest/affirmation; War	idealized style, 93-94	media, 4
Six Persimmons (Mu Qi), 148, 149,	State Hospital (Kienholz), 383-384,	India, 104-105	digital imagi
149	384	Indonesia, 111	581-582
Skinner, Alanson, 166	Statue of Liberty, 568	Islamic art, 108-109	entertainm

Technology—(Tlingits	Tutankhamen, King, 280-281, 281,	Utamaro, Kitagawa	
evaluation of constructed world,		basketry, 140	349-350, 571	Komurasaki of the Tamaya	
528-532		Feast Ladle/Sheephorn Ladle, 144,	Tutankhamen's Knife, 349-350, 350	Teahouse, 447-448, 448, 546	
	ıms, 576, 578-579	146	Twentieth-century art, overview of,	547	
museums and, 576, 578		serving dishes and utensils, 144,	114-115	Pair of Lovers, 47, 175-176, 176	
technological advances as		146	Two Staffs and a Spear (Zaire),	Utzon, Joern, Sydney Opera House,	
	of artworks, 528	Shaman's Amulet, 508, 508	351-352, <i>353</i>	63, <i>66</i> , 480-482, <i>481</i>	
virtual museu		Toba Batak House, 57, 73, 73,	Two-point perspective, 32, 33		
Television, 496-		193-194, 193, 194	**	V	
Tellum people, Tellus, 214, 215		Toklas, Alice B., 560	U Uii Pridge 447 447	Vairocana Buddha, the Brilliant One	
Tempera, 47		Tokyo Station As It Is Now (Yamakawa Shûmô), 472,	<i>Uji Bridge</i> , 447, <i>447</i> Ukeles, Mierle Laderman, <i>Social</i>	252, 252 Value. <i>See also</i> Light	
Temple of Danza	intes 369	(1amakawa 3numo), 472, 472	Mirror, 45, 46, 521, 522, 528	achromatic value scale, 22-23,	
Temple of Heaver		Tolstoi, Lev, 367	Ukiyo-e prints, 175-176, 447-448,	25	
271-272,		Tomatsu Shomei, Woman with	471, 546-547	atmospheric perspective, 23	
	es II, 437-438, <i>437</i>	Keloidal Scars, 377-378, 378	Unicorn in Captivity, 507-508, 507	chiaroscuro, 23	
Temple of Solo		Tomb of the Leopards, 283, 284, 285	Unicorns, 506-508	chromatic value scale, 23, 25	
Temple of the Sur	n (Mexico), 254	Tombs	Unique Forms of Continuity in Space	in color, 24	
Temples, 52, 54		ancient burials, 277-280	(Boccioni), 36, 37, 415-416,	definition of, 22	
282-283,	, 437-438, 482,	Chinese funeral complex of Shi	416	emotions and, 23	
582-583,	, 587. See also Places	Huangedi, 285-288, 576,	United States	media and materials for, 23	
of worsh		577, 582	AIDS Memorial Quilt, 308,	shading and, 23, 32	
Teotihuacán ci	ty plan, 262-265	Egyptian tombs and mortuary	543-544, <i>544</i>	value scale, 22-23, 25	
	rard, Portrait of a	temples, 280-283	art as national glory, 568	Value scale, 22-23, 25	
	an, 468-469, 469	Etruscan tombs, 283-285	art education, 540	Van Dyck, Anthony, 541	
Tertiary colors,	, 24	furnished tombs, 280-291	art museums, 575	Van Eyck, Jan, Wedding	
Texture abstracted te	vturo 90	Moche royal tombs, 288-289, 594, <i>595</i>	art vs. politics, 392-394	Portrait/Giovanni Arnolfini	
in architectu		Viking ship bural, 289-291	cemeteries, 302-303 censorship, 591	and His Bride, 173-174, 174 Van Gogh, Theo, 557	
definition of		Zapotec tombs, 426-427, 427,	child labor, 379-381	Van Gogh, Vincent, 10, 101-102,	
invented text		428	housing and commercial design,	400, 555, 557, 559, 571	
simulated tex		Tomika Te Mutu (Maori chief), 415,	196-197, 210	Portrait of Dr. Gachet, 100, 100,	
tactile textur		415, 418	Impressionism, 112-113	102, 401-402, 401, 545, 545	
visual texture		Tones and lines, 21	landscape paintings, 512-513	559	
hailand, Mask	k of Hanuman,	Tooker, George, Government	late eighteenth through	VanDerZee, James, 452-453	
508-509,		Bureau, 389, 389	nineteenth centuries,	Society Ladies, 453, 454	
	uros (Polykleitos	Tools. See Art tools	112-113	Vanishing point, 32, 33	
the Your	nger), 478, 478, 485	$To read or Fresco/Bull\ Jumping,$	Marine Corps War Memorial, 364,	Vanzetti, Bartolomeo, 381	
	heater productions,	501-502, <i>501</i>	366	Variety, 43-44, 69	
	, 485-490	Torso (Harappan civilization), 407,	modernism, 568	Vaults and vaulting, 57-59, 58, 274	
	Japan), 479, 479	407	National Endowment for the	275	
	press, 314-315	Torso of a Young Man (Brancusi),	Arts (NEA), 560, 591	Vaux, Calvert, Central Park,	
a	<i>tpe</i> (Coe), 136-137,	166-168, <i>168</i> Totem poles, 430	Neoclassicism, 112 parks, 483-485, 595	483-484, 484, 599	
	226, 226	Toulouse-Lautrec, Henri de,	performance art, 489-490	Velazquez, Diego, Las Meninas, 439, 440	
	220, 220	487-489	Post-Impressionism, 113	Venus of Willendorf, 41-42, 43,	
	lie Counter, 28,	Jane Avril, 7, 8, 14, 47, 487-489,	poverty, 379-381	161-162, <i>161</i>	
i.	151	487	Realism, 112	Vermeer, Jan, Kitchen Maid,	
	umier),	Tourism, 559, 562, 562, 571,	Romanticism, 112	443-444, <i>443</i>	
149,		580	tax-supported art, 506-561,	Verrocchio, Andrea del, 539, 558	
1.,		Toy Story, 497	594	Equestrian Monument of	
	(Ren	Trademark (Liu), 472-473	twentieth-century art, 113-114	Bartolomeo Colleoni, 342, 34	
300,	_	Traditional building methods,	Vietnam Veterans Memorial,	Versailles, 58, 59, 328-329, 331-332,	
1	γ,	51-59	307-308, 307	<i>331</i> , 540, <i>540</i> , 556, 560,	
		Training of artists, 538-541, 602	U.S. Capitol Building, 190, 568,	571, 595	
18,00	λ \	Trajan's Column, 363-364, 365	578, 594	Vertical lines, 20-21	
18,594		Trajan's Market, 59, 60, 197-198, 197, 202, 207-208	U.S. Pavilion at World's Fair Expo 67 (Fuller), 64, 68, 69,	Vesalius, Andreas	
	ating	ransformation Mask (Kwatkiutl),	200-201, 200	De Humani Corporis Fabrica, 522-523, 523	
Me	eting	229-230, <i>231</i>	Unity, 43-44, 69	Fourth Plate of Muscles, 47,	
	00.	ma (Liu), 473, 473	Universities	522-523, 523	
rac	ori 79.80,80, 7.428,429,	and travelogues, 601-602	art exhibits, 594	Vespasian, Emperor, 497	
\mathcal{C}	3 428	g art exhibitions, 571	support for artists, 558	Vessel in the Form of a Monkey,	
3	25, 428, 429, 553 64, 553, 553	f the Will, 322-323, 324	University of Ibadan,	510-511, <i>510</i>	
	1 222	67, 68	Anthropological Museum,	Vettii, House of, 71, 187-188, 187,	
	64,553, 55,156 based	y Chi, Disneyland,	576, 590	188	
	5 Jaset	ia, 458, 459	University of Iowa, 594	Video, 48, 531-532, 581	
	20108	umns, 341-342,	Untitled Film Still #35 (Sherman),	Vietnam Veterans Memorial (Lin),	
	techi,	11 J TATELLE -	84-85, 84, 406-407, 407	307-308, <i>307</i>	
	B 18, 463, 01	llord William, raire' Tugged To	Untitled (Selected Writings) (Holzer),	Viking ship bural, 289-291, <i>291</i> , 292	
	ng, to 195-49.	vaire Tuggea To To Be Broken	34-35, <i>36</i> , 391-392, <i>392</i> Upper class, 438-442	Villa of Mysteries, 168-169, 169, 170	
64. 356 55, 356 rechnology based rechnology based rechnology based rechnology 495, 497, en and 495,497		o Be Bloken	Ur, <i>Lyre</i> , 490-491, <i>490</i>	Villa Rotonda (Palladio), 189, 189,	
	ent		Using art, 564-564	190, 208	

144, 147 Waiting for Guests by Lamplight (Ma Lin), 438, 439 Wall Painting from the Tomb of

Wallace and Gromit, 497, 497

Nebamun, 281-282, 282

Web sites, 595-596 Wedding Portrait (Van Eyck), 173-174, 174 Weldon, Felix W., Marine Corps War Memorial, 364, 366 Welles, Orson, 436, 436, 548, 548

Yakshi (India), 47, 407-408, 408 Yamakawa Shûmô, Tokyo Station As It Is Now, 472, 472 Yan Liben, Portraits of the Emperors, 314, 315, 315 Yang, Empress, 514, 516

Yipwon Figure, 467, 467 Yoruba people apprentice method, 539-540 artist-genius, 554 Epa mask/headdress, 431-433, 432, 563-566, 564, 565, 567 ethnic identity, 567 Great Beaded Crown of the Orangun-Ila, 441-442, 441, 567, 569 Palace at Oyo, 332, 332, 567, 568 Palace Sculpture at Ikere, 76-78, 76, 100, 100, 332-333, 333, 541, 541, 558 storytelling, 430-433 Young, Thomas, 362 Your Body Is a Battleground (Kruger), 14, 14, 451, 451, 572, 573 Mask, 99, 99 Power Figure, 236-237, 237 Two Staffs and a Spear, 351-352,

Zapotec culture ancestor portraits in tombs, 426-427, 427, 428 Danzante Stele, 362-363, 364 Zen Buddhism, 148, 155, 518-519 Zen garden, 518-519 Zhang Zeduan, Spring Festival Along the River, 442-443, 442 Zhou Chen, Roaming Beggars, 444-445, 445 Ziggurat at Ur, 245, 246 Zontal, Jorge, 435

				3 2	
	× .	*			
		,			
			1 · · · · · · · · · · · · · · · · · · ·		
	2 12 12 12 12 12 12 12 12 12 12 12 12 12				
,					